ART AND ARCHITECTURE OF IRELAND

IN FIVE VOLUMES

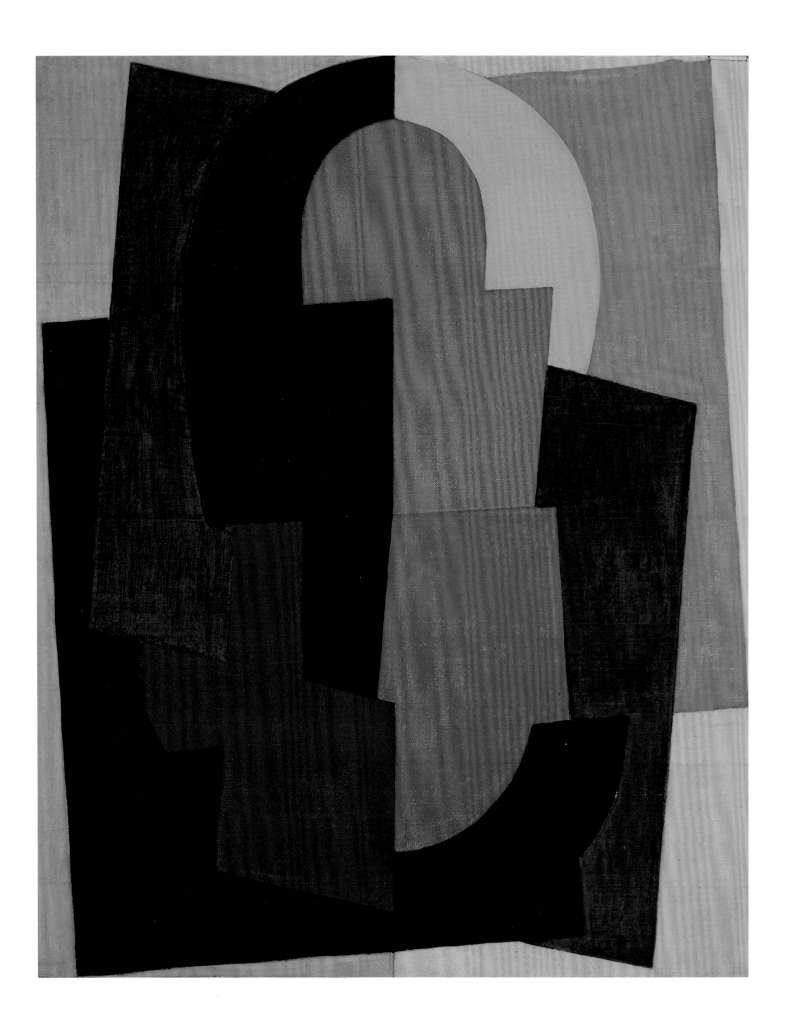

ROYAL IRISH ACADEMY
ACADAMH RÍOGA NA HÉIREANN

ART AND ARCHITECTURE OF IRELAND

Andrew Carpenter, General Editor

VOLUME V

Twentieth Century

Catherine Marshall, Peter Murray

Editors

Penny Iremonger

Jenny Fitzgibbon

Kathryn Milligan

Research Assistants

Published for the Royal Irish Academy and The Paul Mellon Centre by

Yale University Press

DUBLIN – NEW HAVEN – LONDON

Typeset in Frutiger LT and Minion Pro
Designed by Emily Winter
Printed in Italy

LIBRARY OF CONGRESS CATALOGING-IN-PUBLICATION DATA
Art and architecture of Ireland.
 pages cm
 Includes bibliographical references and index.
ISBN 978-0-300-17919-4 (v. 1)
ISBN 978-0-300-17920-0 (v. 2)
ISBN 978-0-300-17921-7 (v. 3)
ISBN 978-0-300-17922-4 (v. 4)
ISBN 978-0-300-17923-1 (v. 5)
1. Art, Irish. 2. Architecture–Ireland. I. Moss, Rachel (Rachel Laura), editor of compilation. II. Figgis, Nicola, editor of compilation. III. Murphy, Paula, editor of compilation. IV. Loeber, Rolf, editor of compilation. V. Marshall, Catherine, editor of compilation.
N6782.A83 2014
709.415--dc23
 2013044526

FRONTISPIECE
Mainie Jellett, *Abstract Composition*, 1922, private collection

PAGE X
William Orpen, *Man of the West, Seán Keating, c.* 1930, Limerick City Gallery of Art

PAGE XXIV
Gerard Dillon, *Island People* (detail), *c.* 1950
Crawford Art Gallery, Cork [see 141]

ART AND ARCHITECTURE OF IRELAND

IN FIVE VOLUMES

Published for the Royal Irish Academy and The Paul Mellon Centre

by

Yale University Press

DUBLIN – NEW HAVEN – LONDON

The five volumes of *Art and Architecture of Ireland* provide a comprehensive, authoritative and fully illustrated account of the art and architecture of Ireland from the early Middle Ages to the late twentieth century. Each volume has its own expert editor or editorial team and covers a specific area or chronological period. More than two-hundred-and-fifty scholars, from all over the world and from many academic disciplines, have been invited to contribute to the five volumes.

The research has been undertaken and prepared for publication under the auspices of the Royal Irish Academy with support from private donors, particularly the Naughton Foundation, the Irish government through the Department of Arts, Heritage and the Gaeltacht, and the Paul Mellon Centre for Studies in British Art. The work, though it builds on many fine scholarly works of the past, contains much new scholarship and is the most comprehensive and ambitious undertaking of this kind ever attempted. It reflects our current understanding of the contribution of Irish men and women to the visual arts and the built environment, and enables anyone interested in Irish culture to gain new insights into the strength, depth and variety of Ireland's artistic and architectural heritage.

I. MEDIEVAL *c.* 400–*c.* 1600

Rachel Moss, Editor

II. PAINTING 1600–1900

Nicola Figgis, Editor

III. SCULPTURE 1600–2000

Paula Murphy, Editor

IV. ARCHITECTURE 1600–2000

Rolf Loeber, Hugh Campbell, Livia Hurley, John Montague, Ellen Rowley, Editors

V. TWENTIETH CENTURY

Catherine Marshall, Peter Murray, Editors

FOREWORD

As the *Art and Architecture of Ireland* (*AAI*) reaches publication, the Royal Irish Academy wishes to acknowledge those who brought the idea of this major project to the Academy and to express its gratitude and appreciation to the funders who made such an ambitious undertaking possible.

In the spring of 2007, two art historians from University College Dublin, Nicola Figgis and Paula Murphy, asked the Academy to consider supporting a project to update Walter Strickland's celebrated *A Dictionary of Irish Artists* (1913). I, as president, turned to one of the Academy's members, Carmel Naughton, for advice and direction. We organized a series of meetings with the proposers from which emerged a proposal to publish a five-volume scholarly assessment of Irish art and architecture from medieval to modern times.

In the ensuing months a comprehensive plan involving editors and advisory bodies was developed and agreed with the Academy's council. The plan was put to the Naughton Trust and the Irish Department of Arts, Sports and Tourism (DAST), and funding agreed in late 2007. The project was given the green light officially in October 2008.

The Academy records its gratitude particularly to the Naughton family for its generous financial support; to the Department of Arts, Heritage and the Gaeltacht (formerly DAST) and particularly to ministers Seamus Brennan, Martin Cullen, Mary Hanafin, Jimmy Deenihan and Heather Humphreys, and officials Niall Ó Donnchú and Chris Flynn; to the Paul Mellon Centre for Studies in British Art; to Yale University Press and its commissioning editor, Sally Salvesen; to the Irish Museum of Modern Art for having seconded Catherine Marshall to the project; to Michael O'Mahony and Colin Kavanagh for legal advice and to the many libraries, cultural institutions and individuals for providing images.

The Academy wishes to thank University College Dublin and the curator of Newman House, Ruth Ferguson, for providing accommodation in Newman House for the project team, and to thank its School of Art History and Cultural Policy for its exceptional support for the project.

The Academy records its gratitude to Andrew Carpenter, Howard Clarke and Roger Stalley, members of the executive board, for their diligent management of the project. The board acknowledges the late Paddy Buckley for his wise counsel and support, particularly in the early stages of the project, and the support of Laura Mahoney and the administrative and library staff at the Academy. The continuing encouragement given by the succeeding presidents of the RIA, Nicholas Canny and Luke Drury, was important in ensuring the project's success, as has been the support of all members of the administrative, publications and library staff at the Academy.

The executive board wishes especially to thank Anita Griffin, the project manager, for her professionalism, for her tireless devotion to the project and for her unremitting attention to every detail. The board also acknowledges the valuable contribution made by Paddi Leinster at a significant time in the life of the project.

The publication has only been possible because of the untiring work of the volume editors, Rachel Moss, Nicola Figgis, Paula Murphy, Rolf Loeber, Hugh Campbell, Livia Hurley, John Montague, Ellen Rowley, Catherine Marshall and Peter Murray. Each has been ably supported by a team of scholars, whose names are listed in the acknowledgements in the relevant volume, and by Jonathan Williams, who has acted as copy-editor for all five volumes.

Finally, the Academy wishes to express its wholehearted appreciation to the community of art historians and scholars throughout Ireland and beyond whose support for the project – as members of volume advisory boards, as second readers or as contributors – made it possible. The publication is an enduring testament to the scholarship and commitment of this community.

JAMES SLEVIN
Chairman, AAI Executive Board

GENERAL EDITOR'S PREFACE

Though the five volumes of this project are closely linked with each other and, together, constitute a wide-ranging assessment of the art and architecture of Ireland as seen at the beginning of the twenty-first century, they differ from each other in scope and structure. The editor or editors of each volume, with the guidance of its advisory board, decided on its contents and scope as well as on its illustrations, bibliography and internal organization. It was decided to end substantive coverage at the year 2000, but the relevant volumes contain material indicating how the art or architecture of Ireland has been developing since that date.

Obviously, there are occasional overlaps between the volumes, sometimes because an artist's output straddled the year 1900 – the terminal date for volume II and the starting date for volume V – or because he or she worked in more than one medium. If there are several articles on an architect, artist or topic, they are cross-indexed.

The Honorary Academic Editor of the RIA, Peter Harbison, has given me much helpful advice over the years for which I am very grateful.

The editors of these volumes have worked tirelessly at this project for the last five years, undertaking far more than is traditionally required of scholars filling a position described as that of 'editor'. Each has written a considerable portion of the volume with which they are associated – three-quarters of the text in one case, and substantial quantities in the other cases. Their own scholarship and extensive new research lie behind the many articles they themselves have written for the *AAI*. In addition, the editors have commissioned the contributions of other scholars and managed all peer reviews as well as necessary correction and rewriting. Their scholarship inspired the volumes and their creative, editorial and research input has shaped each one.

ANDREW CARPENTER

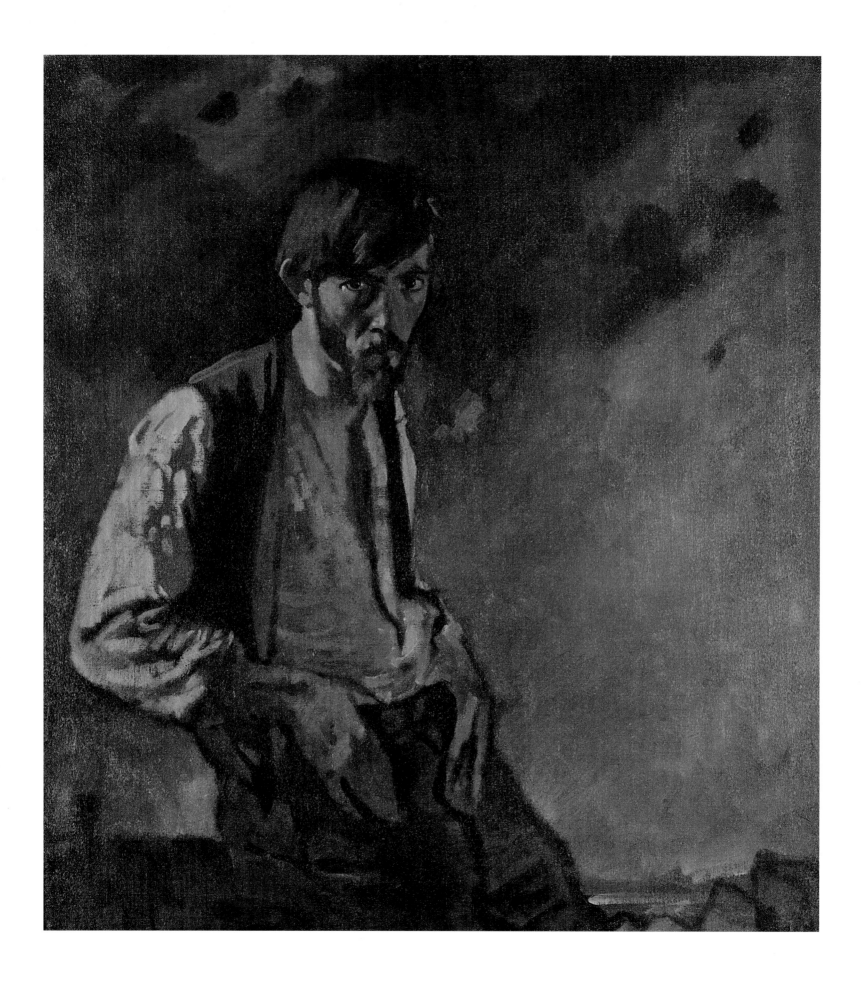

CONTENTS

Twentieth Century is the fifth and final volume of *Art and Architecture of Ireland*, a project that emerged from a proposal to mark the centenary of the publication of Walter Strickland's seminal *Dictionary of Irish Artists* in 1913. A hundred years after its publication, Strickland's Dictionary remains the foundation stone upon which our understanding of Irish art history is based, and is warmly acknowledged as such by scholars, students and general readers. The decision of the editors and advisory board of this volume to stay with the brief to bring Strickland's Dictionary up to date was arrived at after much discussion, during which we remained aware that when Strickland assembled his great work, he did so within an approach to art history that reflected the connoisseurial and aesthetic proclivities of his time.

Much has changed since then. In choosing to keep Strickland's alphabetical structure, but expanding it to accommodate the cultural contexts of a century that witnessed declining empires, the emergence of Modernism and postmodernism, and technological advances beyond the wildest imaginings of anyone in 1913, the editors felt that we were offering the sincerest form of homage we could to an art historian whose values we respect even as we critique them. While acknowledging the earlier work, this volume takes Irish art history into areas of enquiry that in 1913 were just beginning to be hinted at outside Ireland by Strickland's more famous contemporary, Heinrich Wölfflin.

Art and Architecture of Ireland: Twentieth Century deals with the visual arts throughout the century. However, since a separate volume in this series focuses exclusively on sculpture and another is devoted to architecture, references in this volume to sculpture and architecture have been kept to a minimum. Whereas Strickland dealt exclusively with artists, art historians nowadays recognize that art requires, and is shaped by, supporting cultural frameworks and social contexts that are both challenging and stimulating for creative talent and which must also be considered. The editors and advisory board decided, therefore, to limit the selection of artists' biographies presented in volume v to those who were representative of particular periods, styles and practices, and whose profiles were validated by such factors as their having been the subject of significant exhibitions in public museums and galleries, having represented Ireland abroad, having their work collected by important publicly funded collections, being members of significant professional organizations, or contributing to art education in an enduring way through their practice.

A few artists who had flourishing careers in the nineteenth century but who went on to produce some of their best work in the twentieth century, such as Sir John Lavery, Roderic O'Conor and Sarah Purser, are covered in the present volume and also in Volume II (*Painting 1600–1900*), although the concentration in each case is on the work relevant to the period covered by the volume. For the main part, however, artists born before 1875 are covered only in Volume II. Whereas Strickland wrote all the entries in his Dictionary himself, scholars from all over the island of Ireland and from the Irish diaspora were invited to write new essays on topics designed to introduce readers to the fullest experience of twentieth-century Irish art that could be accommodated within the confines of the volume. Artists' biographies and the thematic essays are arranged alphabetically, and while the resulting order creates some unusual bedfellows, the result seems to us to provide an exciting and entirely appropriate point of departure for the reader wishing to experience the diversity and surprise that is to be found in twentieth-century Irish art.

To assist the reader, brief recommendations for further reading are to be found at the end of each essay, but those seeking fuller information about Irish art should look to the general bibliography. A glossary of terms used within the volume is provided, but readers should note that this was never intended to be a comprehensive dictionary of terms used in twentieth-century art.

Throughout this volume, the city is referred to as 'Derry' and the county as 'Londonderry' except in instances where a different usage is historically correct.

CATHERINE MARSHALL AND PETER MURRAY

ACKNOWLEDGEMENTS

The five-volume *Art and Architecture of Ireland*, including this volume *Twentieth Century*, would not have been possible without the generous and continuing support of those named in Jim Slevin's chairman's foreword, particularly the Royal Irish Academy, Carmel Naughton, the Naughton Trust and the Irish government. We reiterate those thanks and would also like to express our gratitude to Jim Slevin himself, to Andrew Carpenter and to Sally Salvesen of Yale University Press.

We wish to thank all those who have helped to shape and progress this volume, from its earliest moments to its final conclusion. *Twentieth Century* presented special challenges because of our proximity to the period, leading the editors to make heavy demands on the volume's advisory board: Dr Yvonne Scott, Trinity College, Dublin; Patrick T. Murphy, Director of the Royal Hibernian Academy/Gallagher Gallery; Dr Niamh O'Sullivan, Professor Emeritus, Visual Culture, National College of Art and Design; and Dr S.B. Kennedy, art historian and former Director of Visual Arts at the Ulster Museum. The members of the advisory board not only contributed to the volume directly by advising about its content and structure and by writing for it, but they also read and commented on many of the essays as they were received.

Artists all over Ireland helped us by sharing their images with us and talking about their work. This book would have been inconceivable without their generous support. Major gratitude is due to all our contributors who gave their expertise and time to researching and writing for the volume. A further debt of gratitude is due to those generous people who acted as additional external readers: Julian Campbell, Valerie Connor, Riann Coulter, Oliver Dowling, Clare Doyle, Nicola Figgis, Gary Granville, Angela Griffith, Jenny Haughton, Josephine Kelliher, Mairéad Breslin Kelly, Róisín Kennedy, Stephanie McBride, Kathryn Milligan, Brenda Moore-McCann, Anna Moran, Gavin Murphy, Paula Murphy, Helen O'Donoghue and Vera Ryan. Thanks are also due to the many artists who personally checked data for us.

We would also like to thank those colleagues who helped us by sharing their expert knowledge and recollections with us. They include Val Ballance, Nicola Gordon Bowe, Campbell Bruce, Noreen and John Casey, Christine Casey, Annette Clancy, John Coolahan, Anne Crookshank, Annie Dibble, Nicola Figgis, Sarah Finlay, Maurice Foley, Rebecca Grant, Brian Hand, Susan Keating, Tanya Kiang, Monika Kinley, Christina Kinsella, Joe Lee, Paula McCarthy Panczenko, George McClelland, Edward McParland, Rachel Moss, Paula Murphy, Ciarán Nicholson, Éimear O'Connor, Terry O'Farrell, Deirdre O'Mahoney, Michael Purser, Hilary Pyle, Ellen Rowley,

Michael Ryan, James Thompson, Jon Thompson and Mary White. Although they died before this project began and so were never directly involved in it, we can never sufficiently thank Gordon Lambert and Rachel McRory for their unflagging and inspirational support for contemporary art and art history which has helped to make this project possible.

Many institutions and individuals helped us with images. We would particularly like to mention Eddie Murphy, Donna Romano and Marta Bustillo (National Irish Visual Arts Library); Irene Stevenson (Library Department, Irish Times); Helena Gorey and Pascal Letellier (Arts Council/An Chomhairle Ealaíon); Helen O'Donoghue, Christina Kennedy, Johanne Mullan, Sean Kissane, Nuria Carballeira and Shauna Sweeney (Irish Museum of Modern Art); Marie McFeeley and Louise Morgan (National Gallery of Ireland); Anne Boddaert, Dawn Williams and Elena Rossi (Crawford Art Gallery); Barbara Dawson, Jessica O'Donnell, Liz Forster and Logan Sisley (Dublin City Gallery The Hugh Lane); Jacquie Moore and Adrian Kennedy (Office of Public Works); Catherine Giltrap (Trinity College, Dublin); Yvonne Davis (University of Limerick); Jennifer Goff (National Museum of Ireland); Honora Faul (National Library of Ireland); Michelle Ashmore (Ulster Museum); Ciara Timlin (Royal Hibernian Academy); Anna O'Sullivan, Ailis Feehan and Bairbre-Ann Harkin (Butler Gallery); Liz Burns (Firestation Studios); John McHugh and the committee at the Heinrich Böll Cottage; Elizabeth Kirwan (National Photographic Archive); Catherine Bowe (Wexford Arts Centre); David Caron (National College of Art and Design); Carissa Farrell (formerly at Visual, Carlow), Aoife Ruane (Highlanes Gallery); Emer McGarry (Model Arts and Niland Gallery); Peter Cody (Boyd Cody Architects); Tommy Graham, (History Ireland); Clare Tilbury; Maureen Porteous (Allied Irish Banks); Derville Murphy (formerly of Bank of Ireland); the Kerlin, Rubicon, Taylor and Green on Red commercial galleries in Dublin and the Fenderesky Gallery, Belfast; and many private and corporate collectors who freely gave us access to their collections but who prefer to remain anonymous. A number of auction houses helped us to secure images: these include David Britton of James Adams and Adelle Hughes of Whyte's. The Irish Visual Artists' Rights Organisation was essential to us in securing copyrights, as was the RTÉ Stills Library. Photographer Denis Mortell and publisher John O'Regan were especially generous in their assistance.

We wish to thank the following people for assistance with this volume: Maggie Armstrong, Ruth Hegarty, Kashif Iqbal, James McGuire, Niall O'Leary, Bill Riordan, Fidelma Slattery, Emer Kennedy, Clare Rogers and Sarah Maguire.

The project was tightly structured in terms of word limits and deliverables. The editors could not have met or managed the targets we so ambitiously envisaged at the outset without the support of the Royal Irish Academy's project team of Anita Griffin and Paddi Leinster and their staff, including the IT team at the Academy. We can never repay Penny Iremonger for her administrative and research skills and her untiring eye for detail, Kathryn Milligan, her occasional assistant, and Órfhlaith Flynn, who was helpful across a range of activities. No request ever seemed to stretch their commitment, patience and ingenuity. The hundreds of images, so crucial to this publication, were sourced and selected from a far greater number by Jenny Fitzgibbon and her team, particularly Angela Cullen, and we thank them for the flair with which they completed this enormous task. Finally, but no less gratefully, we would like to thank Jonathan Williams for his vigilant copy-editing across all volumes, imposing consistency when it seemed an impossible dream, and Elizabeth Mayes, who helped us to shape our bibliography. To Claire and Emily Marshall, Nicky Coghlan and Sadhbh Marshall Coghlan, Sarah Iremonger and Daniel Murray, and all our families and friends who helped us throughout the four-year gestation of this book, we would like to say a sincere thank you.

CATHERINE MARSHALL AND PETER MURRAY

CONTRIBUTORS

EDITORS and PRINCIPAL AUTHORS

Catherine Marshall is an art historian, curator and critical writer. She was appointed as first head of collections at the Irish Museum of Modern Art in 1995, and adviser to the Arts Council's Touring Experiment.

Peter Murray is director of the Crawford Art Gallery, Cork, and a member of the National Council of Cultural Institutions. He has published widely, in addition to curating many exhibitions of twentieth-century and contemporary Irish art.

Martyn Anglesea is former keeper of fine art at Ulster Museum. He is an honorary member of the Royal Ulster Academy.

Fionna Barber is principal lecturer for contextual studies in the Manchester School of Art. She is the author of *Art in Ireland since 1910* (London 2013).

Ruth Barton is assistant professor in film studies at Trinity College, Dublin. Her publications include *Irish National Cinema* (Oxford 2004).

Ciarán Bennett, writer, critic and curator, is a former president of the International Association of Art Critics – Ireland.

Marie Bourke, keeper and head of education, National Gallery of Ireland, is adjunct professor at University College, Dublin, and author of *The Story of Irish Museums, 1790–2000* (Cork 2011).

Carla Briggs is slide curator in the School of Art History and Cultural Policy at University College, Dublin. Her special-interest areas include Margaret Clarke (1884–1961).

Julian Campbell, member of the advisory board for Volume II of the *AAI*, formerly of The Crawford College of Art and Design, Cork, is author of *The Irish Impressionists: Irish Artists in France and Belgium* (Dublin 1984).

Valerie Connor works as a visual-arts adviser and project curator. She lectures on the photography programme at the Dublin Institute of Technology.

Patrick Cooke is a lecturer in the School of Art History and Cultural Policy at University College, Dublin. His research interests are in cultural policy and management.

Riann Coulter is an art historian and curator of the F.E. McWilliam Gallery and Studio, Banbridge. She specializes in Irish and British modern and contemporary art.

Thomas Duddy taught philosophy in the School of Humanities at the National University of Ireland, Galway, until his death in 2012. His many publications include *A History of Irish Thought* (London 2002).

Jane Eckett is an art historian based at the University of Melbourne, Australia. She was formerly a director of Whyte's auctioneers, Dublin.

Brian Fallon, art critic for the *Irish Times* from 1963 to 1998, has written several books, including *An Age of Innocence: Irish Culture, 1930–1960* (Dublin 1998).

Jenny Fitzgibbon is an art historian and illustrations manager for the *AAI*. Her interests include Irish performance and video art and its international contexts.

Joan Fowler is lecturer in contemporary art theory, Faculty of Visual Culture, National College of Art and Design. She was co-editor of *Circa* in the 1980s, and is a prolific writer on critical theory.

William Gallagher, art historian, lecturer, writer and former curator of Glebe House and Gallery, Donegal, is author of *National Self-Portrait Collection of Ireland: Volume 2, 1989–90* (Limerick 2006).

Luke Gibbons is professor of Irish literary and cultural studies at the National University of Ireland, Maynooth. His many publications include *Edmund Burke and Ireland: Aesthetics, Politics and the Colonial Sublime* (Cambridge 2003).

Lisa Godson is a lecturer in history of design and material culture at the National College of Art and Design. Her expertise includes material culture in Ireland and contemporary design practice.

Angela Griffith lectures at Trinity College, Dublin. Her specialist research is on the graphic arts in Britain and Ireland from the nineteenth century to the present day.

Francis Halsall is a lecturer in visual culture at the National College of Art and Design. He works on the history and theory of modern and contemporary art.

Susan Keating, an art historian and graduate of Trinity College, Dublin, has been deputy editor of the *Irish Arts Review* since 2002.

Liam Kelly is professor emeritus of Irish visual culture at the University of Ulster, and author of *Thinking Long: Contemporary Art in the North of Ireland* (Kinsale 1996).

Niamh Ann Kelly lectures in critical theory at the School of Art, Design and Printing, Dublin Institute of Technology. She has curated public-art projects and events.

Christina Kennedy is senior curator and head of collections at the Irish Museum of Modern Art. She is joint editor, with Enrique Juncosa, of *The Moderns: The Arts in Ireland from the 1900s to the 1970s* (Dublin 2011).

Róisín Kennedy is an art historian, former Yeats Curator at the National Gallery of Ireland, and lecturer in art history at University College, Dublin. Her work focuses on modernist art and its critical contexts.

S.B. Kennedy, member of the advisory board for Volume v of the *AAI*, is former head of fine and applied art at the Ulster Museum, and author of *Paul Henry: Paintings, Drawings and Illustrations* (New Haven and London 2007).

Linda King teaches design history/theory at Dún Laoghaire Institute of Art, Design & Technology. She is co-editor of *Ireland, Design and Visual Culture: Negotiating Modernity, 1922–1992* (Cork 2011).

Seán Kissane is curator of exhibitions at the Irish Museum of Modern Art. He is editor of *The White Stag Group* (Dublin 2005) and *Creative Ireland: The Visual Arts* (Dublin 2011).

Christa-Maria Lerm Hayes is professor of iconology at the Belfast School of Art and Design, University of Ulster. Her books include *Joyce in Art: Visual Art Inspired by James Joyce* (Dublin 2004).

Declan Long lectures in the Faculty of Visual Culture, National College of Art and Design. He writes for *Artforum* magazine and was a judge of the 2013 Turner Prize.

Declan McGonagle, chair of the advisory board of Volume iii of the *AAI*, is director of the National College of Art and Design.

Donal Maguire is administrator at the Centre for the Study of Irish Art, National Gallery of Ireland. His areas of interest include modern and contemporary Irish art and collection management.

Alyce Mahon is senior lecturer in the history of art at the University of Cambridge. Her publications include *Surrealism and the Politics of Eros* (London 2005), and *Eroticism & Art* (Oxford 2005).

Brenda Moore-McCann is adjunct lecturer at the School of Medicine, Trinity College, Dublin, and author of *Brian O'Doherty/ Patrick Ireland: Between Categories* (Farnham 2009).

Johanne Mullan is a curator and coordinator of the National Programme at the Irish Museum of Modern Art.

Gavin Murphy is a lecturer in art history and critical theory at Galway–Mayo Institute of Technology. He is widely published on contemporary art practice.

Patrick T. Murphy, member of the advisory board for Volume v of the *AAI*, is director of the Royal Hibernian Academy/ Gallagher Gallery, and a former director of the Institute of Contemporary Art, Philadelphia, and of the Douglas Hyde Gallery.

Colm Ó Briain is a former director of the National College of Art and Design and of the Arts Council. He was founding chairman of the Project Arts Centre.

Dáire O'Connell has contributed to many catalogues, including those for the Mainie Jellett and Patrick Swift retrospective exhibitions. She now works in the field of arts and health.

Éimear O'Connor is a research associate in TRIARC (Irish Art Research Centre, Trinity College, Dublin). Her specialist area is the development of Irish art within socio-political, economic and cultural contexts, both nationally and internationally.

Helen O'Donoghue is senior curator and head of education and community programmes at the Irish Museum of Modern Art.

Marianne O'Kane Boal is an art and architecture critic. She is curator of the art collection at Belfast Harbour Commissioners and a member of the Association International des Critiques d'Art.

Niamh O'Sullivan, member of the advisory board for Volume v of the *AAI*, is professor emerita of visual culture, National College of Art and Design, and curator of Ireland's Great Hunger Museum in the USA. She writes on nineteenth-century Irish art, Irish-American art and popular culture.

Frances Ruane is an art consultant who has written and lectured widely on contemporary Irish art, and has curated major exhibitions.

Yvonne Scott, chair of the advisory board of Volume v of the *AAI*, is associate professor and head of department, History of Art and Architecture, Trinity College, Dublin, and director of TRIARC (Irish Art Research Centre, Trinity College, Dublin).

John Turpin, a former director and professor of art history, National College of Art and Design, is honorary professor of art history, Royal Hibernian Academy. He has published extensively on Irish art.

ABBREVIATIONS

a.	*ante* (before)
AAI	Artists Association of Ireland
AAI	Art and Architecture of Ireland
AC/ACE	Arts Council/An Chomhairle Ealaíon
ACNI	Arts Council of Northern Ireland
AIB	Allied Irish Banks
AICA	Association International des Critiques d'Art
ARA	Associate Member of the Royal Academy (London)
ARE	Art and Research Exchange (Belfast)
ARHA	Associate of the Royal Hibernian Academy of Arts
ARUA	Associate of the Royal Ulster Academy
BA	Bachelor of Arts
BAS	Belfast Art Society
BBC	British Broadcasting Corporation
BI	British Institution
BL	British Library
BM	British Museum
BNL	Belfast News-Letter
BoI	Bank of Ireland
c.	*circa* (about)
CAG	Crawford Art Gallery, Cork (since 2005); formerly Crawford Municipal Gallery, Cork
cat.	Catalogue
cat. no.	catalogue number
CBL	Chester Beatty Library (Dublin)
CEMA	Council for the Encouragement of Music and the Arts
CE Scheme	Community Employment Scheme (FÁS)
CIAS	Contemporary Irish Art Society
CIE	Córas Iompair Éireann (Irish transport authority)
CRC	Cultural Relations Committee of the Department of Foreign Affairs
CSD	Cork School of Design
CTT	Córas Tráchtála Teoranta/Irish Export Board
d.	Died
DAC	Dublin Art Club
DAHG	Department of Arts, Heritage and the Gaeltacht (2011–); formerly Department of Arts, Culture and the Gaeltacht (1993–97); Department of Arts, Heritage, the Gaeltacht and the Islands (1997–2002); Department of Arts, Sport and Tourism (2002–10); Department of Tourism, Culture and Sport (2010–11)
DAST	Department of Arts, Sport and Tourism (2002–10)
DCM	Dublin Civic Museum
DFA	Department of Foreign Affairs
DHG	Douglas Hyde Gallery, Trinity College, Dublin
DIB	*Dictionary of Irish Biography from the earliest times to the year 2002*, eds J. McGuire and J. Quinn 9 vols (Cambridge, 2009)
DIT	Dublin Institute of Technology
DLIADT/DLCAD	Dún Laoghaire College of Art and Design (DLCAD) established in 1979; renamed Dún Laoghaire Institute of Art, Design & Technology in 1997, and since 2000 the IADT Dún Laoghaire
DMSA	Metropolitan School of Art, known as the Dublin Metropolitan School of Art; renamed the National College of Art (1936) and the National College of Art and Design (1971)
DOEHLG	Department of the Environment, Heritage and Local Government
DOENI	Department of the Environment, Northern Ireland
DRUI	Design Research Unit of Ireland
DSA	Department of Science and Art (South Kensington)
DSC	Dublin Sketching Club
ed./eds	editor/editors
edn.	Edition
EEC	European Economic Community
EU	European Union
EV+A	Exhibition of Visual + Art
FAS	Fine Art Society (London)
FÁS	An Foras Áiseanna Saothair (Irish National Training and Employment Authority)
fig.[s]	figure number[s]
FNCI	Friends of the National Collections of Ireland
FSA	Fellow of the Society of Artists
GAA	Gaelic Athletic Association
GPA	Guinness Peat Aviation
GSD	Graphic Studio Dublin
HC	Heritage Council
HL	Hugh Lane Gallery, officially known as Dublin City Gallery The Hugh Lane; previously known as the Dublin Municipal Gallery of Modern Art (1908–1975); also known as the Hugh Lane Municipal Gallery of Modern Art (1975–2002)
HRHA	Honorary Royal Hibernian Academician
HSA	Hibernian Society of Artists
IACI	Irish American Cultural Institute
IADT	Institute of Art, Design and Technology, Dún Laoghaire; previously known as Dún Laoghaire Institute of Art, Design and Technology (DLIADT) from 1997 to 2000
IAR	*Irish Arts Review*
ICA	Institute of Contemporary Arts (London)
IDA	Industrial Development Authority
IELA	Irish Exhibition of Living Art

IFAS	Irish Fine Art Society		RDS	Royal Dublin Society
IFI	Irish Film Institute		repr.	reprinted/reproduced
IHT	Irish Heritage Trust		RHA	Royal Hibernian Academy of Arts/Academician of the RHA
IMMA	Irish Museum of Modern Art		RIA	Royal Irish Academy
I Ind	*Irish Independent*		RIAI	Royal Institute of Architects of Ireland
IRA	Irish Republican Army		RIBA	Royal Institute of British Architects
IS	Irish Statesman		RSA	Royal Scottish Academy
IT	*Irish Times*		RSBA	Royal Society of British Artists
KDW	Kilkenny Design Workshops		RTÉ	Raidió Teilifís Éireann
LCGA	Limerick City Gallery of Art		RUA	Belfast Art Society (1890–1930); Ulster Academy of Art (1930–50); Royal Ulster Academy of Art (1950–); also Academician of the RUA
Lit.	Literature			
LSAD	Limerick School of Art and Design			
MA	Master of Arts		SDP	Society of Dublin Painters
MFA	Master of Fine Arts		SKSA	South Kensington School of Art (London)
MoMA	Museum of Modern Art (New York)		SSI	Sculptors' Society of Ireland; renamed Visual Artists Ireland in 2005
MPhil	Master of Philosophy			
MSc	Master of Science		*Sun Ind*	*Sunday Independent*
ms./mss	manuscript/manuscripts		SWA	Society of Women Artists
n.d.	no date given		TBG&S	Temple Bar Gallery and Studios
NAI	National Archives of Ireland		TCD	Trinity College, Dublin
NCA/NCAD	National College of Art and Design since 1971; previously known as the Dublin Metropolitan School of Art (1877) and renamed the National College of Art (1936)		trans.	translated (by)
			TRIARC	Trinity Irish Arts Research Centre, Trinity College, Dublin
			UCC	University College, Cork
NEAC	New English Art Club		UCD	University College, Dublin
NGA	National Gallery of Australia (Canberra)		UDA	Ulster Defence Association
NGI	National Gallery of Ireland		UL	University of Limerick
NGL	National Gallery (London)		UM	Ulster Museum (formerly the Belfast Museum and Art Gallery)
NGW	National Gallery of Art (Washington)		UU	University of Ulster
NIVAL	National Irish Visual Arts Library		UVF	Ulster Volunteer Force
NLI	National Library of Ireland		V&A	Victoria and Albert Museum, London
NMI	National Museum of Ireland		VAC	Visual Arts Centre (Dublin)
NMNI	National Museums Northern Ireland		VAI	Visual Artists Ireland; previously Sculptors' Society of Ireland until 2005
n.p.	*not paginated*			
NPA	National Photographic Archive		VEC	Vocational Educational Committee
NPG	National Portrait Gallery		WAAG	Women Artists' Action Group
NSF	National Sculpture Factory		WCSI	Water Colour Society of Ireland
NSPC	National Self-Portrait Collection (Limerick)		YBAs	Young British Artists
NT	National Trust		YCBA	Yale Centre for British Art (New Haven, Connecticut)
NUI	National University of Ireland			
NYT	*New York Times*			
OAE	Oireachtas Art Exhibition			
OPW	Office of Public Works			
OWS	Old Watercolour Society (founded 1804); after 1881 the Royal Watercolour Society			
PCAS	Per Cent for Art Scheme			
PhD	Doctor in Philosophy			
PMSA	Public Monuments and Sculpture Association (UK)			
PRHA	President of the RHA			
PRIA	*Proceedings of the Royal Irish Academy* (Dublin, 1836–)			
QUB	Queen's University, Belfast			
RA	Royal Academy/Royal Academician (London)			
RBA	Royal Society of British Artists			
RCA	Royal College of Art (London)			

CHRONOLOGY

WORLD EVENTS	IRISH EVENTS
1899 Publication of Freud's *Interpretation of Dreams*	1899 Irish Literary Theatre's first production
1901 Death of Queen Victoria	
1903 First aeroplane flight by the Wright brothers	1903 Wyndham Land Act
1904 Exhibition of the Work of Irish Painters at the Guildhall, London	1904 James Joyce left Ireland for Paris. Opening of Abbey Theatre
1905 *Les Fauves* exhibition, Paris. Albert Einstein published his *Special Theory of Relativity*	1905 Synge's *The Playboy of the Western World*
1907 Picasso painted *Les Demoiselles d'Avignon*	1907 First of the annual Oireachtas exhibitions held in Dublin
1908 John Ford launched the Model T	1908 Municipal Gallery of Modern Art opened in Dublin. National University established
1910 Kandinsky painted his first abstract painting, Munich	
1912 RMS *Titanic* sank on her maiden voyage	
1913 Armory Show held in New York and included work by Jack B. Yeats	1913 Dublin Lockout took place
1914 First World War commenced	
1915 Death of Sir Hugh Lane	
1916 Launch of Dada movement, Zurich. Battle of the Somme	1916 Easter Rising: HQ of the Royal Hibernian Academy destroyed by fire
1917 Bolshevik revolution, Russia	
	1918 Sinn Féin elections. Women given the vote. Countess Markievicz elected as first female MP. Sinn Féin MPs refused to take up seats in Westminster
	1919 War of Independence commenced (concluded in 1921)
	1920 Society of Dublin Painters established
	1921 Northern Irish Parliament established at Stormont
1922 T.S. Eliot's *The Waste Land*	1922 Irish Free State established; partition of the island of Ireland led to the outbreak of civil war. James Joyce's *Ulysses* published.
	1923 Mainie Jellett and Evie Hone showed the first abstract paintings in modern Ireland
1924 Surrealist manifesto by André Breton published	1924 O'Casey's *Juno and the Paycock*. *Freeman's Journal* closed. Friends of the National Collections of Ireland founded
	1925 Waddington Gallery opened in Dublin
1927 First 'talking' film—*The Jazz Singer*	1927 Electricity Supply Board established
1928 Discovery of penicillin	1928 Gate Theatre opened. John Lavery's portrait of his wife Hazel appeared on Irish banknotes
1929 Wall Street Stock Exchange collapsed. Museum of Modern Art, New York, opened	1929 Censorship of Publications Act
1932 Walt Disney won a special Academy Award for the creation of his animated film character Mickey Mouse	1932 Eucharistic Congress in Dublin
1933 First Nazi concentration camp	
1934 Mao Zedong began the Long March	1934 Robert J. Flaherty's film *Man of Aran* released
1936 Civil War in Spain began	1936 Dublin Metropolitan School of Art restructured as the National College of Art. Limerick City Gallery of Art established
1937 Picasso painted *Guernica*	1937 Constitution of Ireland published
1939 Second World War commenced	
1939 World's Fair, New York, with Irish Pavilion designed by Michael Scott	
1940 Battle of Britain	1940 First issue of *The Bell*. Lyric Theatre Company established. White Stag Group established in Ireland
	1942 Louis le Brocquy's painting *The Spanish Shawl* rejected by the RHA
	1943 First Irish Exhibition of Living Art held
	1944 Council for the Encouragement of Music and the Arts established in Northern Ireland. American troops arrive in Northern Ireland. Francis Bacon showed *Three Studies for Figures at the Base of a Crucifixion*. Opening of the Dawson Gallery

WORLD EVENTS	IRISH EVENTS
1945 Atomic bombs dropped on Hiroshima and Nagasaki. First computer built	
1946 Institute of Contemporary Arts (ICA) founded in London	
	1947 ESB's Rural Electrification Scheme to bring electricity to the country commenced
1948 Assassination of Mahatma Gandhi	
	1949 Declaration of Irish Republic signed by the president. Bodkin report presented
1950 Korean War commenced	1950 Ireland represented at the Venice Biennale. Exhibition of contemporary Irish art, organized by the Cultural Relations Committee, travelled to venues in Canada and the US
	1951 Arts Council/An Chomhairle Ealaíon (AC/ACE) established. Church opposition to a health scheme for mothers and children brought down the government. Dolmen Press founded
1952 American Abstract Expressionist paintings shown in London	1952 An Córas Tráchtála established. John Huston's film *The Quiet Man* released
1953 Discovery of DNA	1953 World Congress of International Association of Art Critics held in Dublin
	1954 William Scott and Francis Bacon represented Britain at the Venice Biennale. AC/ACE's Joint Purchase Scheme for artworks initiated
	1955 Ireland joined the United Nations. *Waiting for Godot* by Samuel Beckett performed in London. AC/ACE toured the Haverty Trust Collection to twenty-one venues around the country
	1956 Louis le Brocquy won the Premio della Prealpina at Venice. Hendriks Gallery opened
1957 USSR launched Sputnik I and II	1957 First Dublin Theatre Festival. Death of Jack B. Yeats. Victor Waddington Gallery moved from Dublin to London.
	1958 T.K. Whitaker's *First Programme for Economic Expansion* published. Patrick Collins won the national prize at the Guggenheim International Award. CIÉ art collection and Trinity College picture hire scheme both initiated
1960 Sharpeville Massacre, South Africa. Introduction of the birth-control pill. Alfred Hitchcock's film *Psycho* released	1960 Broadcasting Authority Act passed into law. Irish soldiers killed in Congo. Independent Artists Group established. Graphic Studio opened in Dublin
1961 Soviet Union sent first man into space	1961 Launch of RTÉ
1962 Cuban Missile Crisis. Andy Warhol produced his first set of paintings of Campbell's soup cans. Vatican II began	1962 *Design in Ireland* published. Contemporary Irish Art Society and the Niland Collection, Sligo, both set up
1963 Beatles first album released. John F. Kennedy assassinated	1963 Kilkenny Design Workshops established. History of art degree course introduced in UCD
	1964 *Art USA Now. Johnson Collection of Contemporary American Painting* exhibited at the HL. P.J. Carroll prizes at the IELA
	1965 Foundation of the Cork Arts Society
1966 Cultural Revolution began in China	1966 History of art degree course introduced in TCD
	1967 Northern Ireland Civil Rights Association founded. Free secondary education introduced; first Rosc Exhibitions' Project '67, which led to the Project Arts Centre opening in Dublin
1968 Student riots in Paris and other cities. Assassinations of Martin Luther King and Robert F. Kennedy	1968 Bank of Ireland bought the first work for its art collection
1969 First moon landing	1969 Student protests in Dublin and Belfast. The 'Troubles' began in Northern Ireland. Minister for finance announced tax exemptions for artists. Robert Ballagh and Gerard Dillon withdrew from the Belfast IELA in protest at the presence of British troops in Northern Ireland. *The Táin* by Thomas Kinsella, illustrated by Louis le Brocquy, published
	1971 Irish feminists organized the contraceptive train to Belfast. Decimal currency introduced. Internment began in Northern Ireland. National College of Art and Design established out of a restructured NCA. *Irish Imagination* exhibition curated by Brian O'Doherty shown as part of Rosc and toured to Boston, Philadelphia and Washington
1972 John Berger published *Ways of Seeing*	1972 Fourteen people died as a result of shooting on Derry's 'Bloody Sunday'. Society of Designers in Ireland founded
1973 US withdrew soldiers from Vietnam	1973 Ireland joined the EEC, later the European Union. Ban removed on married women workers in the public service. The McGee case allowed the import and use of contraceptives for personal use. 1973 Arts Act
1974 President Nixon resigned following the Watergate scandal	1974 Opening of Wexford Arts Centre and Grapevine Arts Centre, Dublin. First Kilkenny Arts Festival. HL Gallery given a budget for acquisitions. Joseph Beuys travelled around Ireland, lecturing to students
	1976 Publication of the report *Provision for the Arts* led to the appointment of the first regional arts officers
1977 First mass-produced computers issued by Apple. Anti-apartheid leader Steve Biko tortured to death	1977 First EV+A held in Limerick. Death of Leo Smith of the Dawson Gallery

WORLD EVENTS	IRISH EVENTS
1978 Election of Polish Cardinal Karol Józef Wojtyła as Pope John Paul II	1978 Triskel Arts Centre, Cork. opened. First Galway Arts Festival took place. Douglas Hyde Gallery (DHG), Taylor Galleries and the Gallery of Photography opened. Office of Public Works launched its Per Cent for Art scheme
1979 Margaret Thatcher became Prime Minister of Britain. Ayatollah Khomeini became leader of Iran	1979 Publication of the Benson report, *The Place of the Arts in Irish Education*. Éigse Carlow began
	1980 Frances Ruane appointed as consultant to the Allied Irish Banks art collection. Artists Association of Ireland founded. *A Sense of Ireland*, a festival of Irish Arts, held in London
1981 Human immunodeficiency virus (HIV)/acquired immune deficiency syndrome (AIDS) virus identified	1981 Ten prisoners died on hunger strike at the Maze prison. Aosdána and the Tyrone Guthrie Centre at Annaghmakerrig both launched. First issue of *Circa* art magazine appeared. Guinness Peat Aviation Awards for Visual Arts introduced. Black Church Print Studio opened
	1983 *Audiences, Acquisitions and Amateurs* published by the AC/ACE. Temple Bar Gallery and Studios opened
1984 Turner Prize for British Art established	1984 First issue of the *Irish Arts Review*
1985 Famine in Ethiopia. First Live Aid concert organized by Bob Geldof and Midge Ure	1985 Anglo-Irish Agreement signed. Cork Artists Collective established
1986 Explosion at a nuclear power plant at Chernobyl	
	1987 White paper on *Access and Opportunity* published. Artists in Prison Scheme began. Kerlin Gallery moved to Dublin. Women Artists' Action Group set up. Exhibition *Divisions, Crossroads, Turns of Mind* went on tour. Graphic Studios opened a gallery
1988 *Freeze* exhibition of work by students from Goldsmiths College. Emergence of the Young British Artists (YBAs)	
1989 Students protested in Tiananmen Square, Beijing. Berlin Wall collapsed	1989 Rubicon Gallery, Dublin, opened. Blue Funk established
1990 Nelson Mandela released from prison	1990 Mary Robinson became Ireland's first female president. Series of exhibitions, *A New Tradition: Irish Art of the Eighties*, shown at the DHG
1991 Gulf War began. Soviet Union collapsed. South Africa repealed its apartheid laws	1991 Ireland signed the Treaty on European Union. Dublin became European City of Culture. Model Arts Centre, Sligo opened. Irish Museum of Modern Art (IMMA) opened. Survey exhibition *Irish Art and Modernism* shown at the HL
	1992 *Source* photographic review launched. Green on Red Gallery, Dublin, opened. James Coleman showed at Documenta. Ballinglen Arts Foundation established. *Unspoken Truths* at IMMA
1992 Cold War officially ended. Nelson Mandela was elected President of South Africa	1992 Downing Street Declaration acknowledged the right of the Irish people to self-determination. First Cabinet minister with responsibility for the arts appointed. Ireland resumed participation at the Venice Biennale after an absence of thirty-three years
	1993 *From Beyond the Pale* exhibitions began at IMMA
1994 Rachel Whiteread exhibited *House*	1994 Opening of Arthouse Multimedia Centre, Temple Bar, Dublin. Glen Dimplex Artists' Award launched at IMMA. Willie Doherty received his first nomination for the Turner Prize
	1995 Kathy Prendergast won the Premio Duemila at the Venice Biennale
	1996 IMMA launched its first national programme exhibitions, *Literary Themes* and *Figuration*, at Dundalk County Museum
1997 Dolly the sheep was successfully cloned	1997 National Cultural Institutions Act passed into law. Nissan Public Art Project launched. National Irish Visual Arts Library opened at NCAD
1998 India and Pakistan tested nuclear weapons. President Clinton of the USA was impeached	1998 Good Friday Agreement accepted by voters North and South. Francis Bacon studio acquired by the HL. IMMA became the first national museum to house an outsider collection when it accepted a long-term loan of the Musgrave-Kinley Collection of Outsider Art
	1999 *0044* and *Irish Art Now: From the Poetic to the Political* toured to venues in the US, Canada, Britain and Ireland

ART AND ARCHITECTURE OF IRELAND

TWENTIETH CENTURY

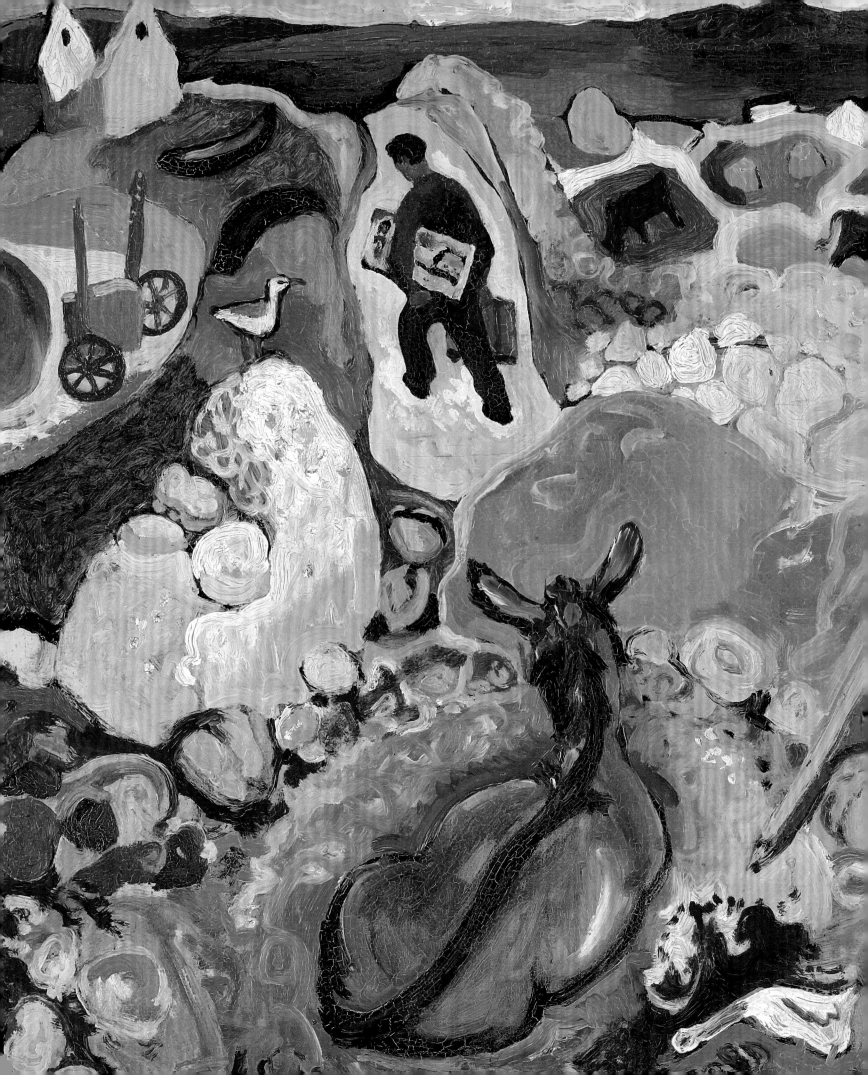

INTRODUCTION

The changes that swept through all aspects of social and intellectual life in the Western world during the twentieth century mark it as a century of revolution rather than of evolution.

Although innovation and change in the world of art may not have been immediately apparent to those living in Ireland at the beginning of the century, political, economic and social transformations throughout the island (as well as fundamental reforms in land ownership) were to put unprecedented pressure on attitudes to art, its function, its production and exhibition; equally open to scrutiny was the relationship to artistic innovation abroad as well as its relationship to politics at home. Four years into the twentieth century, the first exhibition of Irish art was presented at the Guildhall in London. Four years later again, its curator, Hugh Lane, had opened the first museum dedicated to modern art, not just in Ireland, but in the world, in the Municipal Gallery of Modern Art, Clonmel House, in Dublin. Within a decade the country was struggling with a War of Independence which culminated in its partition and signalled the break-up of the British Empire.

1900 was the year in which Picasso came to Paris and 1910 is the date usually given for the introduction of the first 'abstract' paintings in such far-flung places as Moscow, Paris, Amsterdam and Berlin. The fact that the first Irish abstract paintings did not appear until 1922 is often cited as a sign of the backwardness of the country's art at that time. However, another interpretation of this might view a time lapse of only twelve years, between the first international manifestations of this new approach to art-making and its appearance in Ireland, as a sign of extraordinary innovation, given the general state of art awareness, allied with the country's preoccupation with revolutionary and civil wars in the interim. Ireland's political history influenced every aspect of social life, from religion and gender roles to aesthetics, so it is hardly surprising that Irish artists trod a challenging developmental line between engagement with, and withdrawal from, the new art 'isms' – Cubism, Expressionism, Dadaism and Surrealism – and their many offshoots, for a good part of the century. Yet relative to the size of the population, sliding from five million in 1900 to as few as 2.8 million in 1960, before picking up again from the 1970s, the achievements of artists such as Jack B. Yeats, Mainie Jellett, Francis Bacon and Louis le Brocquy were particularly significant, even if they had sometimes to look outside the country for a supportive audience. Witness the similar trajectories of Picasso himself (Spain to France) or Sidney Nolan, who left Australia for Europe for considerable periods of his career.

Within the hundred years of the twentieth century, all, to misquote W.B. Yeats's famous phrase, has 'changed utterly'. Thus, if the early decades of the century are described as the years of Ireland's Literary Renaissance, the last few decades of the century might legitimately claim to be those of an Irish Artistic Renaissance, albeit with more emphasis on 'birth' than 'renewal'. Since the 1970s, Irish art and artists have come of age: Brian O'Doherty has published one of the century's most influential items of art theory ('Inside the White Cube: The Ideology of the Gallery Space', *Artforum*, 1976), Declan McGonagle has become the only curator ever shortlisted for the Turner Prize at the Tate Gallery in London (1987), Brian Cronin's graphic images frequently grace the covers of *Time*, *Newsweek* and *The New Yorker*, Kathy Prendergast has won the Premio Duemila at the Venice Biennale (1995), and in 2012 James Coleman had an acclaimed retrospective exhibition at the Reina Sofía Gallery in Madrid. In addition, although supporting infrastructure for the visual arts was in serious deficit for much of the century, a change in attitudes towards the arts in general resulted in the foundation, in 1991, of the first Irish Museum of Modern Art (IMMA); within a decade, IMMA had captured international attention for its innovative approaches to access and collecting, while its exhibition programme initiated exhibitions such as the Leon Golub retrospective (1999) which, when it travelled from Dublin to Brooklyn and then Chicago, could be said to have revived Golub's reputation in his own country. At the same time, exhibitions and artworks from Ireland travelled to many parts of the world.

In planning *Art and Architecture of Ireland: Twentieth Century*, the editors and members of the advisory board took cognizance of existing scholarship on Irish art in this period. It is a field of study that expanded dramatically towards the closing decades of the twentieth century, but for generations the most important markers, for art historical scholarship, had been those laid by Walter Strickland's *Dictionary of Artists*, published in 1913, when Ireland was still part of the British Empire and World War I had not yet taken place. Strickland confined his *Dictionary* to biographies of artists who had lived and worked up to that period, but, despite S.B. Kennedy's scholarly examination of Modernism in Ireland up to 1950 (*Irish Art and Modernism*, 1991), and a later overview of modern art in Ireland in the second half of the century by Dorothy Walker (*Modern*

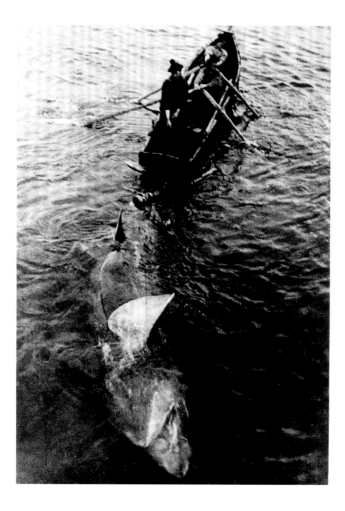

1. Robert J. Flaherty, *Man of Aran*, 1934, 91 min, courtesy of Irish Film Institute

2. Tony O'Malley, *Winter Orpheus, 1964*, 1964, oil on board, 120 x 60 cm, Irish Museum of Modern Art

Art in Ireland, 1997), no comprehensive study of Irish art dedicated to, and encompassing, the entire twentieth century has existed until now.

It can be argued that five strands dominate the published literature on Irish art in this period: survey and monograph histories written largely from a connoisseurial point of view; official reports commissioned to look into the state of the visual arts and design; catalogues of exhibitions and collections; articles in critical journals and newspapers; and, towards the end of the century, published conference papers. Familiarity with those publications offered one a useful framework for shaping this volume. An equally important influence was the awareness of the advisors and editors of aspects of that history which had not been analyzed in those earlier works. While we make no claims to any comprehensive restoration of material previously omitted from the narratives of Irish art, we believe that this volume will introduce into the discourse significant aspects of the history of visual culture which have been overlooked or neglected in the past. It is important to note from the outset that, because architecture and sculpture are the subjects of separate volumes, they will not be discussed in this volume, or in the brief literature review in this introduction.

Strickland based his extensive information about Irish artists on existing records and documents and his work remained the most comprehensive reference book on Irish art for many years until it began to be displaced by research from the new history of art departments at University College Dublin and Trinity College Dublin (see Niamh O'Sullivan's essay 'History of Art: The Academic Discipline'). The historiography of Irish art to date has been overwhelmingly directed towards the lives and work of individual artists, with little emphasis on the cultural and political environments in which they worked. Survey histories of Irish art by Bruce Arnold (*A Concise History of Irish Art*, 1969) and Anne Crookshank and the Knight of Glin (*The Painters of Ireland*, 1978; *The Watercolour Painters of Ireland*, 1994; *Ireland's Painters*, 2002) continued where Strickland left off, essentially adding images and expanding the timeframe and, in the case of Crookshank and Glin, matching documentary references to artworks which successfully established the reputations and careers of Irish artists who were known, until then, only through fleeting references. The connoisseurial approach to art history that was Crookshank and Glin's most significant legacy was reflected in the universities in an approach which led to monographic studies of Irish artists, although that has changed considerably since 2000. The process of rediscovering Irish artists from the past, so securely represented by the work of Crookshank and Glin, lay behind later scholars' and researchers' studies of individual artists or groups of artists from the twentieth century. These include Theo Snoddy, Hilary Pyle, S.B. Kennedy, Bruce Arnold, Dorothy Walker, Nicola Gordon Bowe, Brian Fallon, Aidan Dunne, Julian Campbell, Kenneth McConkey, Éimear O'Connor, Sinéad McCoole and Brenda Moore-McCann. The same monographic approach has dominated the editorial policy of the *Irish Arts Review* since its foundation in 1984. Lavishly illustrated books on William Orpen, Mainie Jellett, Louis le Brocquy, Tony O'Malley, Camille Souter, Sean Scully, Hughie O'Donoghue, Patrick Scott and others reflected Ireland's increased prosperity towards the end of the century. These books, some led by scholarship and the desire to allow well-reproduced images to speak as eloquently as text, and others prompted by the art market, suggested that the Irish artist had finally, somehow, arrived.

The publication of Jeanne Sheehy's *The Rediscovery of Ireland's Past: The Celtic Revival, 1830–1920* (1980) inspired an important new direction in Irish art scholarship. By defining and analyzing the ideas behind the Celtic revival in the nineteenth century, and by considering the link between the leaders of that movement and revolutionary nationalism in the colonial situation of the time, Sheehy exposed realities not obvious in the work of Crookshank and Glin, and provided a model of art writing predicated on the conditions of art-making, rather than on individual achievement. Her book was building on foundations laid by Cyril Barrett in 'Irish Nationalism and Art' (1975) and by Thomas MacGreevy in his articles in the *Capuchin Annual* in the 1940s. Sheehy's contextual approach can be discerned in much modern critical writing on Irish art: this includes the work of Fintan Cullen on visual culture and politics, Luke Gibbons on film and visual arts in relation to the wider culture, Linda King and Elaine Sissons on aspects of design, Brian P. Kennedy on state responsibility for the arts, and other scholars on topics from landscape and furniture to the institutions of art and women artists. Under the influence of feminist writing and the

'New Art History' movement, as well as of the increasing politicization of artists, a new type of artist and art writer emerged in Ireland from the late 1970s leading to a multidisciplinary approach to art practice and to new audiences for art. Vera Ryan's three volumes of interviews with artists, curators, collectors and other people involved in the world of art in Ireland also contributed significantly to the literature. Brian O'Doherty's work as a critic and, especially, as the author of 'Inside the White Cube', while not directed towards Ireland, provided one of the most influential deconstructions of the Modernist gallery as the location for the reification of the individual artist and the separation of art from life beyond the gallery. His writing was important for curators, artists and critics in his native country as well as internationally.

Earlier in the twentieth century, concerns in government circles about the need to present Ireland well abroad and to improve the quality of industrial design led to a number of well-researched reports. The Bodkin Report, delivered to government in 1949, and the Scandinavian Design Report (1962) revealed shocking neglect in art education and a lack of provision for the visual arts in the country; direct results of these reports were the foundation of the Arts Council/An Comhairle Ealaíon in 1951 and the Kilkenny Design Workshops in 1963. Later reports commissioned by the Arts Council, such as the Richards Report (1976), the Irish Marketing Survey (1980) on artists' living conditions, and the Benson Report, *The Place of the Arts in Irish Education* (1979), opened up rich debates about the importance of the arts for the wider well-being of the nation and paved the way for action by the Arts Council and individuals.

Another aspect of Irish art writing that has made its presence felt is a fast-growing number of catalogues of exhibitions and collections. These include catalogues from the Rosc exhibitions (1967 onwards), the Arts Council's touring exhibitions, such as *The Delighted Eye* (1980), those produced by the National Gallery of Ireland and the Douglas Hyde Gallery in the 1980s, and by IMMA, the Hugh Lane Municipal Gallery, the Crawford Gallery, Cork and the Ulster Museum in the 1990s; these catalogues have provided outlets for thematic explorations of issues such as the relationship of heritage to the contemporary (*Inheritance and Transformation*, 1991), the shift from a focus on a poetic Celtic mysticism to politics (*Irish Art Now: From the Poetic to the Political*, 1999) and the experience of living and working outside Ireland (*Distant Relations*, 1996 and *0044*, 1999). Exhibition catalogues have widened the sphere of discourse significantly, especially when they have incorporated essays by a number of different writers, so bringing together curatorial experience and academic research with voices and insights from other disciplines.

The periodical *Circa*, which grew out of Arts Research Exchange in Northern Ireland in 1981, quickly revealed itself as an important forum for multi- and interdisciplinary debate from a body of writers more reflective of new art-college education than the universities. As Róisín Kennedy points out in her essay 'Critical Writing and the Media': '*Circa* challenged the presentation of Irish art as essentially apolitical and linked to a perennial Celtic gene. The journal attempted to set agendas for

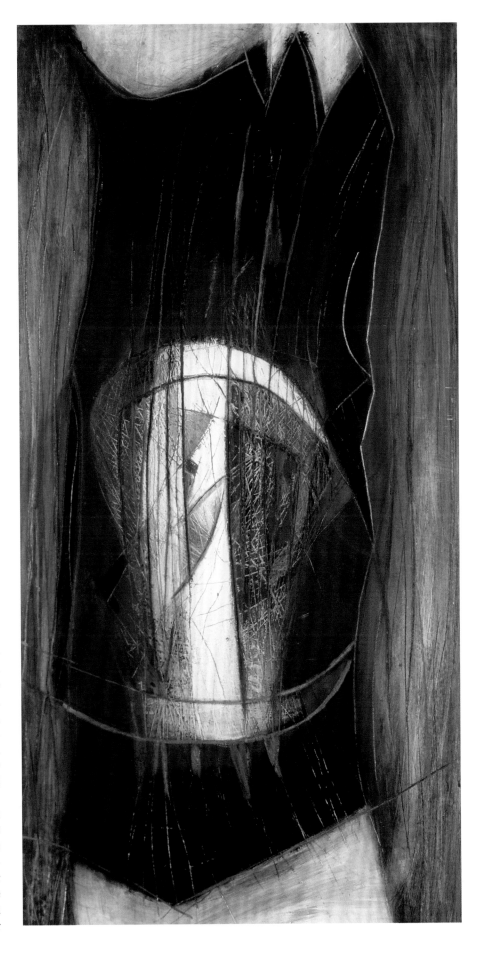

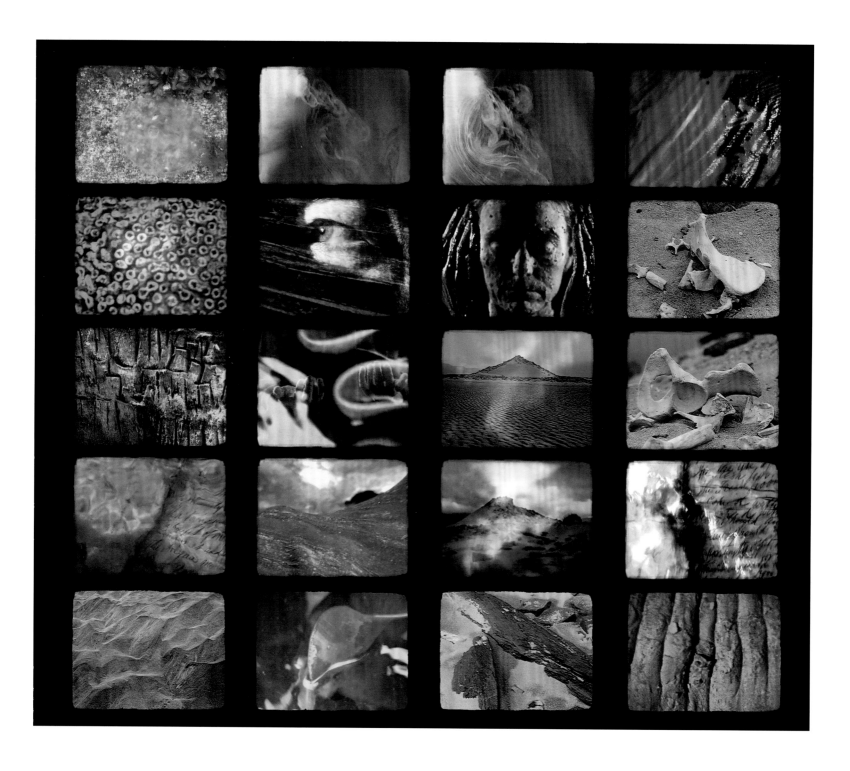

3. Alanna O'Kelly, *No Colouring Can Deepen the Darkness of Truth*, from the series 'The Country Blooms a Garden and a Grave', 1992–95, video, mixed media installation, Ireland's Great Hunger Museum, Quinnipiac University, Connecticut

artists, and challenged existing stereotypical interpretations of Irish art. It allowed writers familiar with critical theory, such as Joan Fowler, to identify contexts in which, Fowler claimed, art practice could potentially contribute to the formation of cultural democracy ('Regionalism reconsidered', *Circa*, no. 50, 1990, 23–25). Essays by Tom Duddy and Mary Cosgrove challenged the isolationism of art historical writing that evaluated Irish art against criteria based on a mythical Celtic past, in favour of a more global view.

The issues and concerns raised in *Circa* were paralleled in publications of papers offered at conferences, many of them multidisciplinary, which emerged with some frequency from the 1990s onwards as the academic study of art history matured in Irish universities and art colleges and was increasingly linked with projects emanating from Irish studies programmes around the world. Topics covered included curating, access and the contemporary museum at IMMA (2004, 2006 and 2008), matters raised during the 'Civil Enquiry' discussions at Dublin City Arts Centre (2002–06), the position of the arts in Ireland in an international context (Cork Caucus, 2005) and 'Irish Women Artists: Familiar but Unknown' (TCD, 2009); other conference papers focused on material culture and critical theory.

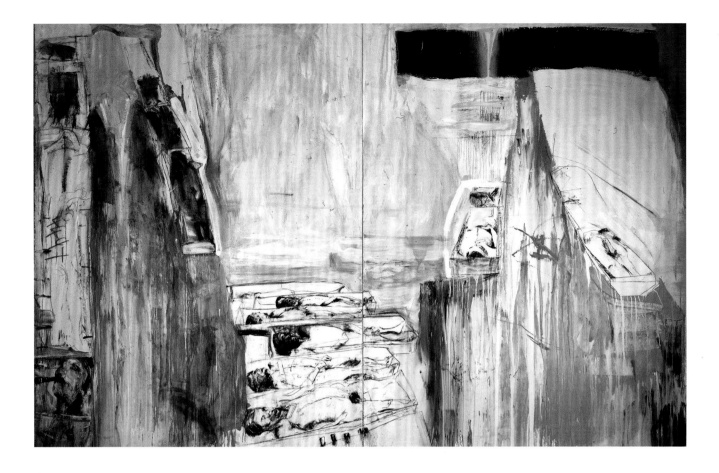

4. Brian Maguire, *Memorial*, 1998, mixed media on linen, 269 x 424 cm, Irish Museum of Modern Art

Writers from outside Ireland have also thrown useful spotlights on Irish art and its scholarship. James Elkins, in an afterword to a book on the representation of contemporary art by the Fenton Gallery, Cork, offered a framework for looking at Irish painting that can usefully be applied to wider practices in Irish art. Elkins suggested that 'a country's art can be measured by the way that its artists and critics (a) declare their national affinities, (b) say they are automatically Irish, or (c) present themselves, more or less persuasively as citizens of the world' ('The Fenton Gallery in the Context of International Art', in Nuala Fenton (ed.), *Representing Art in Ireland: The Fenton Gallery*, Cork 2008, pp. 218–21).

Elkins proposed viewing Irish painting under a number of headings: presence or absence of Irish themes; evidence of the influence of major modern movements (or 'isms') in Irish practice; and landscape. His framework is useful, but the situation is far more complex than his formula for analysis permits. As Lucy Cotter and others have pointed out, the impact of colonization takes many forms and, although the effect of British cultural domination of Ireland still remains to be fully acknowledged and analyzed, Irish art cannot be understood separately from it.

In escaping from British imperialist government in 1922, Ireland did not automatically recognize the extent of the cultural impact of centuries of its colonization. As late as 1994, a major reference book on Irish painting (Crookshank and Glin, *The Watercolours of Ireland 1600–1914*) could begin with an apology for the absence of artists of the calibre of the leading British painters of the day. It offered no explanation for the perceived discrepancy in quality between Irish and English artists, leaving the reader to accept the cliché that the Irish are visually naive.

If Irish art, like Dutch art in the seventeenth century and art by women or 'outsiders' (see 'Outsider and Folk Art') and others at many stages in history, developed outside a dominant critical framework, it is easy to see how assumptions about visual illiteracy arise. The international recognition given to the work of Irish artists since the late 1980s, however, shows how unsustainable such an assumption is. Instead of being seen as an irreversible cultural gene, the absence of Irish artists in the Western canon can be explained by examination of a number of factors. Among these are ambivalences about Irishness, not just as Elkins pointed out among artists, but among critics and historians also; the failure of independent Ireland to provide for audiences for, and makers of, the visual arts; rejection of certain kinds of progressive art, such as the Cubist experiments of Mainie Jellett by post-colonial governments on the basis that they were too associated with the old regime; the emigration of many artists for both aesthetic and economic reasons; and a critical climate limited by population size and geographical isolation.

The lack of clarity about which artists are actually Irish is a recurring issue and cannot be ignored in a book dedicated to *Irish* art. Writing about the 1997 acquisition by the Victoria and Albert Museum, London, of a drawing by the eighteenth-century painter Hugh Douglas Hamilton, Fintan Cullen noted

that '[B]y boldly declaring it to be a major British object, the museum ignored not only the artist's Irish origins, but also its wider European associations'. Cullen went on to conclude: 'If one wishes to be cynical, one could surmise that when a work is of high aesthetic quality it can be British but if not it can remain Irish.' (Cullen, *Sources in Irish Art: A Reader*, Cork 2000, p. 17) Jack B. Yeats, born in Ireland, and clearly associated with the country throughout his career, is listed as a 'British' artist in the Metropolitan Museum in New York, simply because, born before the establishment of the Irish Republic, his passport designated him as British. He is just one of many, though Mainie Jellett, similarly born before Ireland became independent, was not usually claimed as British. Instead her considerable contribution to Irish Modernism and her indefatigable efforts on behalf of the visual arts in the country were not accorded the accolades they merited because the new nationalist ruling elite found the fact that she was female, Anglo-Irish, protestant and an active promoter of international Modernism too difficult to reconcile with their narrow cultural perspectives.

In considering the Irishness or otherwise of two other examples of Irish emigrant artists, Francis Bacon and William Orpen, both of whom were born and raised in Ireland but subsequently moved to England, Lucy Cotter argues that we cannot decide about these issues separately from the postcolonial debate (Cotter, 'Art Stars and Plasters on the Wounds: Why Have There Been No Great Irish Artists?' in *Third Text*: *Special Ireland Issue*, XIX, no. 5, September 2005, 581–92, 591). Her words are borne out by Maija Koskinen's speculation that the reason Irish artists she spoke with in the course of curating *Something Else: Irish Contemporary Art* (Turku Art Museum, Finland, 2002) were slow to describe themselves as Irish was because they felt they would be seen as inferior to British artists. Even if there is only a partial truth in Koskinen's hypothesis, we know that Irish communities in Britain – that is, in the country of their former colonial ruler – had a different experience of migration from those who went elsewhere (see Mary Hickman in Trisha Ziff (ed.), *Distant Relations*, New York 1995).

Irishness as an identifier was clearly difficult throughout the period of study for reasons that are primarily connected with the colonial experience. Questions of Irish identity and art, as well as official attitudes to this issue, are discussed in several essays in this volume but particularly in essays by Luke Gibbons and Pat Cooke.

The experience of colonization may also have blocked the development of Irish artists as history painters – the perceived domain of the 'great' artist, at least in institutional terms – until the end of the nineteenth century. While this may have directed Irish creativity at a certain moment in history to concentrate on literature, Dorothy Walker, writing in 1974, noted that 'the visual arts are still in full reaction to the overpowering influence of language in all its forms, literature, drama, poetry, even oratory and conversation. A certain distrust is prevalent among Irish artists at the idea of an art movement based on language, a feeling that they will be swallowed again by the writers who have already devoured for themselves the art reputation of the country in this century, Yeats, Shaw, O'Casey, Joyce, Beckett.' (Walker, 'James Coleman', *The Arts in Ireland*, III, no. 3, 1974, 14) From another perspective, Pat Cooke in his essay on 'Cultural Policy' points to the way overriding nationalist concerns about restoring the Irish language in the Free State led to the foregrounding of verbal skills and the consequent marginalization of the visual.

Questions of quality lie at the heart of the debate, but we must be clear about the criteria underlying value judgments and their exclusive nature. Svetlana Alpers convincingly argued that Dutch art in the seventeenth century suffered from an art historical methodology and discourse that prioritized Italian classicism (Alpers, 'Art History and its Exclusions', in Norma Broude and Mary D. Garrard (eds), *Feminism and Art History*, New York 1982). Alpers believed that Dutch art did not fit the rhetoric of art and the canon of art history derived from Italian Renaissance practice, and so was automatically marginalized by that discourse. Her interrogation of the discipline as it applied to artists and practices outside the classical canon is relevant in Ireland since that particular canon dominated Irish art-writing until the 1980s. In inheriting a culture that predicates greatness and universality over participation, Irish writing about Irish art tamely acceded to a long tradition. Countering this, the critical studies that emerged from Feminism and Postmodernism challenged concepts of greatness, positing other critical frameworks – the national, local, global and international – in their place. In Cotter's words, 'National economic and cultural conditions inform the nation's relationship to modernity, which then establishes its critical position within postmodernity.' (op. cit., 582) Yet Cotter's question 'Why have there been no great Irish artists?' continues to gnaw away at national self-confidence. Discussing unacknowledged grief at the suffering caused by famine, poverty and emigration in the nineteenth century, Richard Kearney pointed to its negative effects on the national psyche (Kearney, lecture delivered at the Dublin Institute of Technology, 25 April 2012), while the argument that this legacy has limited certain forms of artistic creativity has also been advanced (Catherine Marshall, 'History and Memorials: Fine Art and the Great Famine in Ireland', in Ciara Breathnach and Catherine Lawless (eds), *Visual, Material and Print Culture in Nineteenth-Century Ireland*, Dublin 2010).

Repeated apologias for the absence of 'great' artists are interesting also if balanced against some recent achievements. Irish participation at the Venice Biennale is a good case in point. While Irish artists showed sporadically in the early days of the event, it was not until 1950 that the nation was officially represented there. A proposal to build an Irish pavilion in Venice disrupted the country's participation between 1960 and 1993, when, still without a national space and still working with a tiny budget, Ireland resumed showing. Notwithstanding those limitations, Ireland won the main prizes in 1956 and 1995 in the persons of artists Louis le Brocquy and Kathy Prendergast. A few years later, James Coleman was one of a handful of living artists commissioned by the Louvre to make artwork in response to the collection there. The country's failure to widely recognize those achievements suggests that cultural attitudes in Ireland are still blinkered by a sense of inferiority and the link between the former experience of colonization and poverty, the latter of which has a particular bearing on the visual arts.

Attempts to create a national visual identity foundered when the Free State sought, conservatively, to revive a pre-colonial one, extolling the Early Christian period as a golden age for Irish art. Fitting that aesthetic to the mid-twentieth century proved impossible. The Department of Education, which had control over education at all levels, including authority over the National Gallery, the National Museum and the National Library, was under siege for decades to the Gaelic revival movement, which allowed it to promote linguistic development but had little interest in the visual arts. The primary school curriculum introduced in the 1920s and not changed until 1971, was not only *not* supportive of education for the arts, but quite consciously opposed to it. As Helen O'Donoghue points out (see 'Education in the Visual Arts'), Eamon de Valera, as Taoiseach of the country in the 1940s, urged teachers to resist the impulse to arouse children's interest in anything other than the three 'Rs' (reading, writing and arithmetic [sic]). He instructed them to concentrate on securing good examination results and to ignore imaginative 'frills'. The essays by O'Donoghue, Pat Cooke and John Turpin in this volume offer greater insights into that history. In view of the hostility to creative development suggested in de Valera's speech, the Arts Council looked instead for international validation of Irish artists who worked in a Modernist idiom and made that the focus of its work in its first decades. While that strategy met with some success, it had the effect of emphasizing international celebrity at the expense of support for wider participation at home.

In 'Lecture XXIV' of his *Leaves from a Prison Diary* (1885), Michael Davitt put forward the radical proposition that bringing art to the people was as important as providing for their economic well-being. Having experienced extreme poverty, eviction, life in a workhouse, emigration and child labouring in England, Davitt, later a Fenian activist and famously founder of the Land League, knew about economic need. Considering the demands of his socialist activism, his endorsement of the arts is as unusual as it is strong. In asserting the importance of art for all the people, Davitt differed fundamentally from the critical and establishment views, not only those held in his own time but for the greater part of the twentieth century, despite occasional rhetoric to the contrary. Studies of the art literature of the century, of institutional practice, of the lives of the artists and the social conditions that governed the production of art, show constant ratification of canonical standards in visual art in opposition to actual engagement with creativity. Things did begin to change as the century progressed, however. The importance of the arts for the people was stressed by the community arts movement (see 'Participatory Arts') from the late 1960s, by projects associated with regional arts festivals (see 'Regional Developments'), and by innovative outreach programmes at the Grapevine Arts Centre, Dublin, at IMMA and at other venues. Curriculum changes and better educational access, including the introduction of art appreciation at second level for the first time in 1971, all contributed to a greater awareness of contemporary art, and to the growth of more demanding and discriminating audiences.

In intermingling the stories of artists' lives with essays about the critical, social and aesthetic realities surrounding art

practice during our period, this volume reflects the interdependence of artists and the world they inhabit and the significance of social conditions in the art of any community. In looking at artists' lives, we were mindful of Fintan Cullen's comment that 'When examined critically, artists, all too often, do not lead lives but satisfy myths.' (*Sources on Irish Art: A Reader*, introduction to Section 1, 2000, p. 29) It has not generally been our practice to invite biographical information that is readily available elsewhere in the vast hard-copy and online data already in existence. Instead we invited writers to give a critical interpretation of artists' careers in the particular context of their day and, thanks to the space limitations imposed on us by our brief, confined our individual focus to a small number of representative artists; many more are, of course, referenced in essays on different aspects of art practice. The volume does not, then, attempt to reiterate the work of Theo Snoddy's *Dictionary of Irish Artists:*

5. Helena Gorey, *Windy Drawing*, 1988, pencil on paper, 28 x 21 cm, private collection

20th Century or books on individual artists. Instead, the biographical entries provided here should serve as a counterpoint to the many thematic essays, and as a reminder of the central part played by the artists. Without them, there would be no reason for this book. In our selection we have looked at artists born in Ireland or connected to Ireland through very strong ancestral links, such as Hughie O'Donoghue and Charles Brady, or born elsewhere but who lived in Ireland for most of their working lives, such as Camille Souter and Barrie Cooke. We have noted the importance for artists of periods of time spent working in other cultural environments, and the sometimes desperate need to be away from restrictive conditions at home. We have spread our choice of artists over the whole century and based our selection on the need to represent different aspects of history and practice; since Volume II in this project covers artists active to the year 1900, we have included here only those born after 1875, whose practice relates almost entirely to the twentieth century. Inevitably, tough decisions on inclusion and exclusion had to be made, since the 500 or so pages of the volume have to contain not only text but images. In opting to focus on those artists whose work was reflective of important aspects and developments of the twentieth century, we hope to bring a greater understanding of the forces at play in the development of a vibrant visual arts culture in Ireland.

It made sense, too, to look at the visual arts in Ireland under some traditional headings: at the styles, movements and genres that were particularly important in twentieth-century Ireland. In doing so, we find ourselves at times echoing James Elkins's recommended categories, although we have found it useful to add genres such as portraiture and history to his choice of 'landscape'. We have also found it necessary to look at forms of practice and media, such as installation, time-based art, drawing and photography, reflecting important innovations and new theoretical positions throughout our period. The gradual change from traditional art history to that of visual culture, embracing a variety of disciplines not formerly seen as art, is mirrored here in essays on topics such as design and material culture, film, stained glass and tapestry, book arts, and on participatory, outsider and folk art.

In addition to the editors, some forty-five writers were commissioned to undertake new research or to write biographical entries, while a team of second readers confirmed a scholarly standard. Between them they represent expertise drawn from universities and art colleges both in Ireland and abroad, senior curators in leading institutions, and those who have had direct experience of working at the highest level in making Irish art available to the wider public or to its academic study. Many of these writers hold critical positions that are controversial and sometimes challenge others within the volume. That was a deliberate choice on the part of the editors and advisory board in order to give scope to different viewpoints and experience. Thus, Colm Ó Briain, writing about the Arts Councils, brings his experience as a former director to the task, while Pat Cooke's essay on cultural policy takes a more critical position in relation to some of the same material, just as Christa-Maria Lerm Hayes presents a very different view of Modernism to that of Francis Halsall (see 'Conceptual Art' and 'Modernism and Postmodernism'). If there are omissions in the publication they are attributable to our ambition to cover such a wide field of art endeavour in our allocated space and time. Rather than attempting to provide a seamless and exhaustive representation of Irish art, we felt it was more important to facilitate different perspectives, to introduce aspects of the subject that, we hope, will be more comprehensively dealt with in the future, and to reflect current thinking. In taking this position, the volume echoes the view of art history offered by Declan McGonagle in one of his inaugural interviews as the founding director of IMMA in 1991. McGonagle challenged the notion that 'there's an art history that's finished, and is by definition over and its meaning is fixed. I keep thinking of this image of the train coming into the station and stopping.' ('The New Directors', *Irish Arts Review Yearbook*, 1991, 74) The history of Irish visual culture in the twentieth century is not over, and the voices in this volume simply offer interpretations for today, in keeping with Walter Benjamin's suggestion that we cannot change the past but we can alter its meaning.

The editors have learned a great deal from this exercise over the past four years. Most of all we have been confirmed in our conviction that the visual arts are as central to the Irish imagination as to that of any culture. They are far too important to be thought of in merely recreational or commercial terms. This is not a new discovery. As we can see from Michael Davitt's recommendations nearly one hundred and thirty years ago, it is a view that has been with us for a long time, albeit a minority one. For many, art is nothing more than a luxury commodity to be enjoyed and traded on. Others – unfortunately including generations of Irish politicians – have seen the visual arts only of benefit if they help to present an attractive image of the country abroad to boost tourist revenue, or help to improve the appearance of Irish goods for export. The efforts and sacrifices that artists have made during the twentieth century in Ireland, and ultimately the integrity of their vision, should serve to remind us that Irish art has far more challenging and rewarding goals.

Catherine Marshall

ABSTRACTION. Abstraction was among the defining innovations of Modernism (qv), a summit of avant-garde ambition to remake, from first principles, an art for a new age. Although abstract forms had appeared in many cultures and periods, its potential in 'high' European art was limited by the primacy of the academic tradition. Since the invention of photography (qv), however, the theoretical premises for abstraction had gained strength, marked by such milestones as Whistler's lawsuit of 1878, defending his equation of musical and visual forms. Yet the establishment of pure abstraction by a few pioneer artists around 1910 still came as a shock and a challenge to the mainstream. Its acceptance was a barometer of Modernist 'advancement' wherever it emerged.

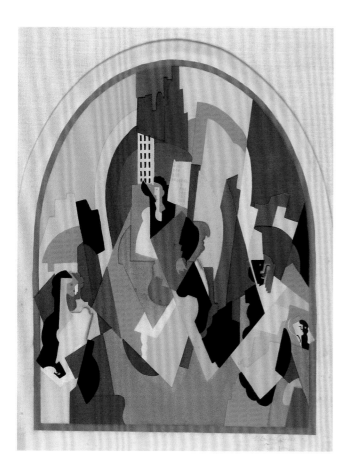

Unquestionably the leader and driving force of abstract art in Ireland, as both an artist and campaigner, was Mainie Jellett, assisted by her friend Evie Hone (qqv). From the beginning Jellett aimed to transcend the limitations of local academic conformity and connect with the bigger ambitions of a European avant-garde. A student of Orpen (qv), whose superbly crafted realism (qv) beguiled much of her generation, she instead sought the language of modernity in London and Paris. Finding the accessible tuition and tempered Cubism (qv) of André Lhote insufficiently advanced, she and Hone persuaded the Cubist Albert Gleizes [6, 100] to accept them as pupils in 1921. Gleizes later described how their determined engagement drove him to clarify his own ideas, published in 1923 as *La Peinture et ses Lois*. Already since 1910/11, interpreted and developed in varied and conflicting ways, Cubism was there reformulated as a systematic, rational abstraction, constructed through Gleizes's method of 'rotation and translation'. Working together, the trio sought – as had earlier abstractionists – an art that was spiritual and immaterial, though in their case also connected with the egalitarian values they saw in medieval painting. In 1923 Jellett exhibited two abstract compositions at the group show of the Dublin Society of Painters, including *Decoration* [7]. While Modernist works had already been shown in Dublin, Jellett's abstractions met with incomprehension and derision, even from progressives such as George Russell (qv), who described an 'artistic malaria', while the *Irish Times* compared *Decoration* to a misshapen onion in an entry entitled 'Two Freak Pictures' (20 October 1923). Thus encapsulated, the beginning of abstraction in Ireland can be presented as an identikit Modernist trope of innovation and rejection, albeit distinguished by local nuance.

If in 1923 Ireland was in the throes of political reinvention, there was no revolution in visual culture to parallel that inspiring the invention of abstraction in Russia and Europe shortly before. Just as Joyce in *Dubliners* (1914) represented a hopeless stasis, Irish art also reflected inertia, inwardness and revivalism. A nationalist gravitation towards native beauty marked even such ventures into Modernist forms as Paul Henry's (qv) 'abstracted' Whistlerian landscapes. Jellett's (and Hone's) Modernism remained a step too far. Yet behind *Decoration*'s alien newness lay direct connections with Irish tradition – its religious content, for instance – while Jellett later stressed the importance of abstraction in early Celtic art. The politics of class, gender and culture also coloured its reception. Though she was from an establishment background, her gender made Jellett

6. Albert Gleizes, *Composition (Pochoir) (Arched)*, 1920, gouache on paper, 42 x 33 cm, Dublin City Gallery The Hugh Lane

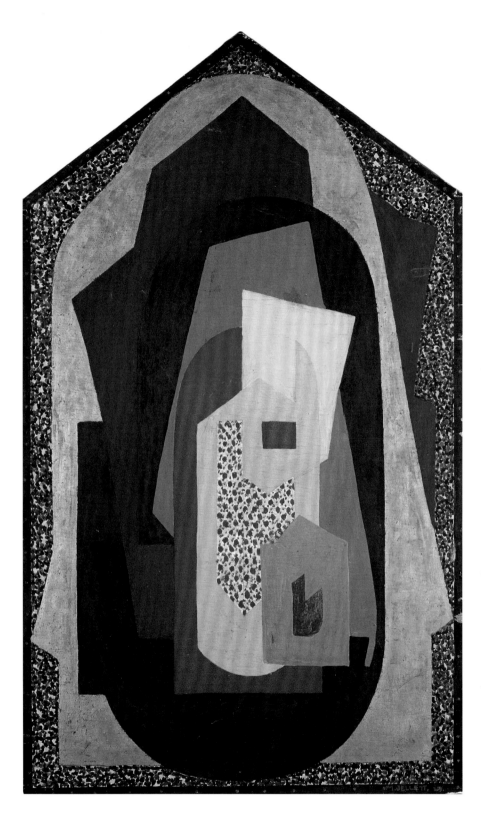

while lamenting Irish isolationism. Her abstraction, at its height during the 1920s, essentially stood alone, although Hone increasingly adapted to her work in stained glass what they had learned (see 'Stained-Glass, Rug and Tapestry Design'). By the later 1930s Jellett had embraced influences from Chinese art and, re-emphasizing figuration (which she had never abandoned) her work became more accepted. Its significance remains contested; subject of the first major retrospective at the new Irish Museum of Modern Art (IMMA), she was presented both as the artist who 'created and led the Irish Modernist Movement' (Bruce Arnold in *Mainie Jellett*, exh. cat. IMMA, Dublin 1991, p. 15) and as a dryly academic Cubist lacking the 'necessary requirements of Modernism – innovation, novelty and aesthetic anarchy' (Paula Murphy, ibid., p. 33). The collaborative openness of her art may now seem its most prophetic aspect; at any rate she could be said to have created the forum for, if not the actual forms of, abstract art in Ireland.

Jellett had company in her remaking of pictorial form, again among women from advantaged circumstances. Mary Swanzy had been familiar with avant-garde ideas since witnessing the Fauve sensation in Paris in 1905, and may have painted Cubist works before Jellett (some dating remains uncertain). Today often called 'abstract,' these compositions mostly have a representational underpinning, and a less rigorous conception of Cubist construction. Swanzy left behind this adopted idiom, and others she explored, as she settled on her own more original, expressive figuration in the 1930s. She had meanwhile left Ireland, as had Eileen Gray (qv). Now celebrated internationally as a key Modernist designer, Gray's abandonment of ornamentation informed a small number of paintings (relating to decorative plans) which she executed in a pure, formal abstraction (*Black with a Red Square Carpet Template, c.* 1925, NMI collection).

By the time of Jellett's early death in 1944, abstraction still barely registered in Ireland, but her lead was beginning to find support. Basil Rákóczi and Kenneth Hall (qqv), the founders of the White Stag Group (qv), arrived in Ireland in 1940, renewing the connection with continental Modernism, attracting younger artists such as Patrick Scott (qv). Scott was then studying architecture and his early surviving paintings from around 1942 already have a geometric surface emphasis, as do those of the youngest member, Bobby Dawson, 'perhaps the most abstract of this group' (S.B. Kennedy, 1991, p. 105). Another of the group, Nick Nicholls, pursued a Klee-like graphic flatness in oils such as *Untitled* (1941, illustrated in *The White Stag Movement*, OPW, Dublin 2003, cat. no. 38), and abstraction was also an objective of Thurloe Conolly (qv). The impact of the White Stag Group was limited; writing to Scott in 1945, Margot Moffett, organizer of a London show of their work, pointed to 'the old problem, namely, the utter lack of awareness in Dublin's cultural life of the significance of contemporary trends in the arts (and in non-representational painting in particular)' (Kennedy, ibid., p. 103).

By 1950 artists internationally, from Kupka to Pollock, had taken abstraction in many directions. In Ireland, its popular profile remained the much-lampooned expressive 'distortions' of Jack B. Yeats (qv). But the 1950s, though often decried as a decade of stagnation, in fact saw a growing context for Modernist

7. Mainie Jellett, *Decoration*, 1923, tempera on panel, 89 x 53 cm, National Gallery of Ireland

an artistic outsider, and her imported, newfangled style could be perceived as irrelevant, even condescending, to newly empowered 'Gaelic' interests – as much as it might baffle those of her own social world. But where others of her class or outlook (Mary Swanzy, William Leech (qqv)) left Ireland, Jellett stayed, painting, teaching and campaigning, maintaining links with Gleizes,

innovation with the advance of the Irish Exhibition of Living Art (qv), the founding of the Arts Council (qv), and more adventurous, informed patronage (qv) from forward-looking business leaders. In particular, the spread of the Modernist style in architecture visibly signalled the shift away from tradition, and architects such as Michael Scott (and later Ronald Tallon and Liam McCormick) led both through support for abstract works and in the creation of settings to which they could relate.

A central figure is Patrick Scott, a Modernist architect (with the firm Scott Tallon Walker) and designer (mosaics for Busáras, Dublin). He was self-taught as an artist, modernity being his starting point, while art schools remained grounded in tradition. From the first, his paintings had a stripped-down aesthetic that was sympathetic to the clean, linear simplicity permeating architecture, with abstraction not such a daunting hurdle. Like architecture's International Style, Scott's universal idiom was supple enough to reprise subjects exhausted in the local tradition ('Bogland' series, early 1960s) and less obviously an exotic import than much Cubist-based Modernism. By 1964 his hard-edged Minimalism (qv) was defined in the 'Goldpainting' series, since then the basis for explorations ranging through spirituality, oriental philosophy and Celtic forms (as invoked earlier by Jellett).

Richard Kingston (1922–2003) inaugurated other avenues of abstraction equally early but, since his engagement was less visibly concentrated, he is less prominent today (absent, for instance, from IMMA's exhibition, *The Moderns*, 2011). Self-taught like Scott, and with a farming background, Kingston became an artist full-time only in the 1960s. Before this he had made seminal works such as *Vertigo, after first flight; Dublin to London 1949* (1949) [8], establishing connections with both American Abstract Expressionism and French *tachisme* in a risky emotionalism directly opposed to Scott's cool formality.

The acceptance of abstraction grew slowly. The Contemporary Irish Art Society (CIAS), founded in 1962, saw as its 'first purpose ... to correct an extraordinary anomaly – that no funds whatever are available to the Hugh Lane Gallery for purchasing modern works of art'. Thus prefaced, their 1965 exhibition *Paintings and Sculptures (1945–65) from Private Collections in Ireland* at the Dublin Municipal Gallery of Modern Art (HL) could by contrast boast a range of abstract works by artists including Karel Appel, Antoni Tàpies, Anne Madden (qv), Deborah Brown and Ian Stuart. The loan of the celebrated Johnson collection to the Hugh Lane boosted the profile of innovative art, and the exhibition there of the 1916 Rising commemoration *Cuimhneachán* in 1966, maybe a benchmark of official taste, endorsed abstract works such as Seán McSweeney's *Mór mo Náir* (a prizewinner) and John Kelly's (qqv) *Painting for 1916*. The first Rosc exhibition (qv) in 1967 further identified abstraction as a norm rather than a deviation, by which time independent innovations – less adherent to established Modernist prototypes – were emerging in the work of painters like Jonathan Wade or Noel Sheridan (qqv). Abstracted imagery and forms increasingly outshone hackneyed, literalist representations of Irish life and landscape among this generation of ambitious artists. Patrick Collins's (qv) poetic, floating colour-fields evoked a Celtic mystique more powerfully than could

8. Richard Kingston, *Vertigo, after first flight; Dublin to London 1949*, 1949, oil and mixed media on board, 37 x 24 cm, private collection

any academically correct views. This shift was reflected in the ultimate acclamation of the work of Tony O'Malley (qv). His integration of abstracted forms with specific, local patterns of landscape, from terrain to history (his 'sense of place'), though in fact rooted in the idioms of the St Ives School, effectively naturalized abstraction in an Irish context.

If by the later 1960s abstraction had gained some authority, it remained commercially precarious. Cecil King (qv), a founder of Rosc, had achieved some security as director of a printing firm before committing himself to painting in his forties, and was able to pursue an unflinching painterly austerity, while the equally considered canvases of Michael Byrne (1923–89) [9] were largely made possible by his teaching.

Abstraction could be presented by its proponents, in Modernist terms, as the highest progression, Patrick J. Murphy, for instance, remarking that King had started 'in a figurative manner Later he graduated to linear abstraction.' (Ryan, 2003, p. 110) Already, however, the process could be reversed. Camille Souter (qv) had made adventurous calligraphic abstractions on newsprint in the 1950s, but moved to a rich, visceral figuration in the 1960s. More strategic was the rejection by Micheal Farrell (qv) of his stylish but impersonal hard-edged formalism in favour of a politically engaged narrative idiom, paralleling Philip Guston's apostasy in America.

9. Michael Byrne, *Yellow Square*, 1968, acrylic on canvas, 102 x 108 cm, Arts Council/An Chomhairle Ealaíon

The cultural landscape evolved with Ireland's modernization through the 1960s. New arrivals, such as Alexandra Wejchert (qv *AAI* III) from Poland in 1965, brought an altogether different inheritance. Showing at the IELA and Hendriks Gallery, Dublin, Wejchert's sculptural constructions in plastic colours asserted new formal possibilities, while somewhat more classic compositions won prominence in commissions such as *Freedom* (1985, AIB collection). Major innovative buildings, like Tallon's Bank of Ireland headquarters on Baggot Street, became a launch pad for new forms (Michael Bulfin, *Reflections*, 1972, painted steel). John Burke's public sculptures in Cork had an equivalent impact, as did his teaching at the Crawford College of Art, which helped break the traditionalist stranglehold for young artists from Vivienne Roche to Eilís O'Connell. The transformation of art teaching in the early 1970s cemented abstraction as a legitimate starting point, and created a forum that was an important buffer against indifference outside.

By the late 1970s abstraction, less a forbidding challenge, had been absorbed at diverse levels, from popular 'art on the railings' to the more demanding practice of artists such as Charles Tyrrell or Ciarán Lennon (qqv) who led, and benefited from, a more discriminating audience, sensitive to the narrative of pure form. The minimal (though not Minimalist) sculptures of Michael Warren won many public commissions in Ireland, but also worldwide. At the same time, abstraction remained the lightning rod for popular disgruntlement over perceived elitism and difficulty in modern art. A succession of protests have erupted or been contrived around public expenditure on such works since the HL's acquisition of Agnes Martin's *Untitled No. 7* after *Rosc '80* (the infamous 'blank-canvas'), or their Michael Warren, whose monumental *Gateway* (2002) was recently removed from Dun Laoghaire, in echo of Serra's *Tilted Arc* (1981). The prominent room now dedicated to Sean Scully in the HL may stand as some redress to past controversies.

Abstraction in Ireland today is complex beyond summary. Authoritative voices either laud or decry particular manifestations as vacuous or profound, while its language, forms and significance continue to evolve towards new possibilities.
WILLIAM GALLAGHER

SELECTED READING Cunningham and Gleeson, 2008; Jackson, 2008.

AESTHETICS IN TWENTIETH-CENTURY IRELAND. For the purposes of this short essay, the term 'aesthetics' will be understood in a relatively strict sense to refer to that branch of philosophy that deals with questions about certain valued qualities that are perceived to exist in the natural world or in the humanly created world of various arts and crafts, from painting and architecture to music and literature. Aesthetics, on this understanding, is a reflective, analytic discipline, primarily concerned with the ways in which human beings value or appreciate certain things or certain features of things. More specifically, it is concerned with the making of certain kinds of judgments, primarily judgments about the beauty or otherwise of a natural object or about the 'goodness' or 'badness' of a work of art or design. Aesthetics, so understood, does not generally have very detectible effects on the work of artists, and is treated here as a form of thought that has its own validity, regardless of possible influences on artistic practice. The most direct influence of aesthetics tends to be on other people engaged in aesthetics – that is, on people seeking answers to questions about the nature or value of art – rather than on artistic practice as such.

The first part of this writing will deal with five Irish thinkers who have reflected upon some issues in aesthetics with an appreciable degree of thoughtfulness and originality. The second, shorter, part will deal with the Irish scholarly contribution, mainly in the form of translation and transmission, to aesthetics.

Thomas William Rolleston (1857–1920) was born in Shinrone, Co. Offaly. His name is most readily associated with the Irish literary revival and with the collection of folklore. Rolleston's *Myths and Legends of the Celtic Race* (1911), later retitled *Celtic Myths and Legends*, is regularly reprinted. His interest in science, ethics and art resulted in the publication in 1908 of his *Parallel Paths: A Study in Biology, Ethics and Art*. In the first part of the book, Rolleston defends an evolutionary approach to the study of nature. In the second part, he offers a life-centred conception of ethics, defining as good only those actions that preserve and enhance life as a whole. In the third part, he takes his biocentrism into the field of aesthetics, claiming that art, like ethics, is a mode of action in which life and life-values are expressed and celebrated. He begins by expressing agreement with Tolstoy's belief that art is a means of joining together people in the same feelings, but then disagrees emphatically with Tolstoy's particular application of his principle of emotional infectiousness, on the grounds that it leads him to value works that are indiscriminately infectious, as if it did not matter what feelings are communicated. For Rolleston, only certain feelings are best communicated through art, namely, feelings that are 'expressive of life' (Rolleston, p. 250).

Rolleston makes a distinction between the 'presentative' and the representative arts. The presentative arts, of which music is the paradigm, do not borrow their content from the external world but are pure creations of order, rhythm and variation. He places the decorative arts, including architecture, under the last rubric. The essence of the decorative arts is to add an expression of rhythm and harmony to useful objects, which they do by either altering the substantial structure of the object or by adding ornament to its surface. Architecture offers examples of both forms of design. A Greek temple 'shows us power, braced and conscious, but in repose' (p. 257), and succeeds in avoiding monotony through both slight deviations from strict symmetry and the decorative use of frieze, pediment and capital.

The work of Arthur Little (1897–1949) also reflects the influence of Tolstoy. Born in Dublin, Little was educated at Belvedere College and at Trinity College, Dublin, and entered the Society of Jesus in 1914. In *The Nature of Art or The Shield of Pallas* (1946) he rejects Jacques Maritain's view that in contemplating beauty we touch a transcendental reality 'and thus the very likeness of God' (Little, p. 33). In Little's view, the spiritual beauty of God is inaccessible to the kind of natural contemplation induced by great art, and he proposes instead a 'humanistic' view of art, according to which delight is explained 'by some manner of the contemplation of the only other spiritual object that pertains to our life, the human soul' (p. 74). Little goes on to argue that a work of art must exhibit originality in the sense that it must have the quality of vitality, of communicating 'the continuously moving experience of man'. He describes the relationship between maker and receiver as the closest possible approximation of 'the direct kindling of consciousness from consciousness' (p. 170).

In two chapters on originality and tradition, Little tries to maintain a balance between the claims of idiosyncrasy and the claims of the permanent and common facts of human nature. He sees idiosyncrasy as a means to an end, never as an end in itself. Hence, he says, 'the value of a work of art must be estimated by the intensity of its common humanity, but not at all by the stridency of its individual oddity' (p. 179). The work of James Joyce gives Little some difficulty, since it seems to him to err on the side of idiosyncrasy. He is more impressed by Harry Clarke's (qv) attempt to balance idiosyncrasy against traditional forms and conventions of communication which enable him as an artist to enlarge human experience in general: 'When Clarke, the stained-glass artist, went to the Byzantines for his models, he did not adopt their cold formalism. But he adopted their architectural dignity and invested it with a flame of religious emotion.' (p. 186)

Iris Murdoch (1919–99) [10] was born in Dublin. A novelist, academic and philosopher, she wrote on issues in ethics and aesthetics, often linking the two areas together. In *The Sovereignty of Good* (1970) she argues that virtue, perception and reality are so closely allied that the task of really perceiving any particular thing is a moral one. Anything that alters consciousness in the direction of unselfishness, objectivity and realism is to be connected with virtue. Natural beauty offers the sorts of occasions in which 'unselfing' can take place to good effect: 'I am looking out of my window in an anxious and resentful state of mind, oblivious of my surroundings Then suddenly I observe a

10. Steve Pyke, *Iris Murdoch*, Oxford, 13 November 1990

hovering kestrel. In a moment everything is altered. The brooding self with its hurt vanity has disappeared. There is nothing now but kestrel And of course this is something that we may also do deliberately: give attention to nature in order to clear our minds of selfish care.' (Murdoch, p. 84)

In these situations, we take a self-forgetful pleasure in the independent, natural, 'pointless' existence of animals, birds, stones and trees. Murdoch makes the same connection between art and virtue that she makes between virtue and the perception of natural beauty, suggesting that the enjoyment of art is a kind of training in the love of virtue. 'Good art reveals that we are usually too selfish and too timid to recognize the minute and absolutely random detail of the world, and reveals it together with a sense of unity and form. This form seems to us mysterious because it resists the easy patterns of the fantasy, whereas there is nothing mysterious about the forms of bad art since they are the recognizable and familiar rat-runs of selfish day-dream.' (pp. 86–87) Both nature and art, properly attended to, serve to improve the quality of consciousness by opening windows on to realities outside of, or beyond, ourselves.

Denis Donoghue was born in Tullow, Co. Carlow, in 1928, and was brought up in Warrenpoint, Co. Down. He currently holds the Henry James Chair of English and American Letters at New York University. Known mainly for his contributions to literary criticism, he has also engaged with fundamental issues in aesthetics, especially in sections of *The Arts without Mystery* (1982) and in his more recent *Speaking of Beauty* (2003). In the former he expresses a serious 'misgiving' about any approach to art that is reductively analytical or explanatory, making the case for an approach that acknowledges that the arts 'have a special care for those feelings and intuitions which otherwise are crowded out in our works and days'. He accepts that the arts are marginal: 'I want to say that the margin is the place for those

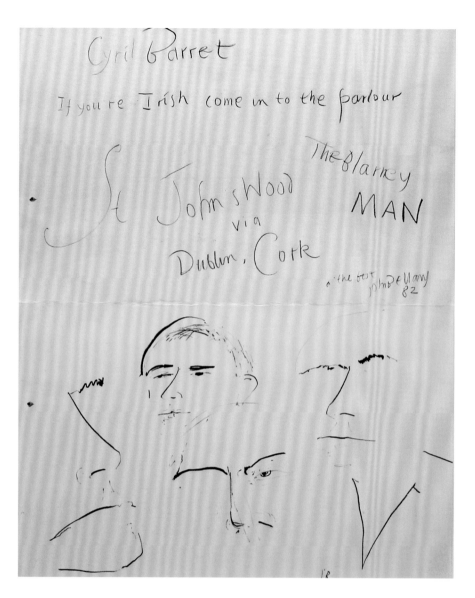

feelings and intuitions which daily life doesn't have a place for, and mostly seems to suppress.' (Donoghue, 2003, p. 129) Long on citation – deliberately so – and short on analysis, *Speaking of Beauty* is an attempt to reduce the reader's anxiety about talk of beauty. Donoghue muses not only on different conceptions of beauty, but also on instances of beauty so diverse in their nature that an all-embracing definition seems as impossible as it is unnecessary. His observation on Robert Herrick's poem 'Upon Julia's Voice' is exemplary of his approach. While convinced that the poem is beautiful, he is happy to admit that he can 'only point to certain details and hope that you will take [his] word for them as manifestations of beauty categorically undefined and indefinable'. He settles for saying the little he can, 'consigning the remainder to an implicative silence ...' (p. 48).

William Desmond was born in Cork in 1951. He is currently Professor of Philosophy at the Institute of Philosophy, Katholieke Universiteit, Leuven in Belgium. In *Philosophy and Its Others* (1990) he identifies a number of ways of 'being in the world' and being mindful of it. These ways of being mindful include the religious way, the ethical way, and the aesthetic way. The aesthetic state or mode of being in the world is characterized by the impulse towards self-expression, imaginative articulation, and a degree of openness to otherness, 'such that we are capable of a *chivalry towards being*' (Desmond, p. 82). Art begins as self-expression but, at its best, it is also at the same time communicative. Not unlike Rolleston and Little, Desmond characterizes the artist as being 'one with others by being spokesman for the sense of life that is at work in the intimacy of being that is otherwise busily unspoken' (p. 101).

Critical of a utilitarian, consumerist approach to art, and of an excess of stimulation that leads to 'anxious, harried seeing that is sightless seeing', Desmond reminds us that great art calls for silence and slowness, 'for patience in perception'. Desmond returns to the theme of art as transcendence in his later book *Art, Origins, Otherness: Between Philosophy and Art* (2003), in which he discusses the aesthetic philosophies of Kant, Hegel, Schopenhauer, Nietzsche and Heidegger.

The scholarly contribution
Irish scholars, by way of translation and interpretation, have made a small but significant contribution to aesthetics during the twentieth century. One such scholar is James Creed Meredith (1875–1942), who was born in Dublin. A member of the Irish judiciary, he was also a scholar and translator. He translated Immanuel Kant's third critique, *The Critique of Aesthetic Judgement* (1911), with seven introductory essays and extensive notes. These seven essays amount to a book-length explication, interpretation and commentary on Kant's aesthetics, with each essay focusing on a key concept in the Critique, such as 'The Beautiful', 'The Sublime' and 'Art and the Artist'. The translation was reissued in 1952 as *The Critique of Judgement*, but without Meredith's introductions or notes.

Cyril Barrett (1925–2003) [11] was born in Dublin. In 1942 he entered the Society of Jesus and was ordained in 1956. In 1965 he edited *Collected Papers on Aesthetics*, a well-judged anthology of essays by innovative thinkers in philosophy of art and criticism. He subsequently edited Wittgenstein's *Lectures and Conversations on Aesthetics, Psychology, and Religious Belief* (1966) containing previously unpublished materials by Ludwig Wittgenstein, including some of the German-born philosopher's reflections on aesthetics. He edited the second volume of Władysław Tatarkiewicz's three-volume *History of Aesthetics*, translated from the Polish by R.M. Montgomery (1970). He also published *An Introduction to Optical Art* (1971).
Thomas Duddy

SELECTED READING Rolleston, 1908; James Creed Meredith (trans.), *The Critique of Aesthetic Judgement* (London 1911); Little, 1946; Barrett, 1965; Murdoch, 1970; Donoghue, 1983; Desmond, 1990; Duddy, 2002; Donoghue, 2003.

11. John Bellany, *For Squirrel Barrett [Cyril Barrett, SJ]*, 1982, crayon drawing, 72.5 x 57.2 cm, University of Warwick

AOSDÁNA (derived from the Gaelic words *aos* meaning people and *dána*, of poetry) [12] is an organization that was established by the Arts Council (AC/ACE) (qv) in 1981, under the Directorship of Colm Ó Briain, in response to a government report the previous year on artists' living conditions, and a proposal from Anthony Cronin, arts advisor to Taoiseach Charles Haughey. Aosdána functions both as a vehicle to honour 'outstanding contribution to the arts', similar to the *Académie Française*, and also as a means to 'encourage and assist members in devoting their energies fully to their art' (AC/ACE website, accessed 18 June 2010). This combination of honorific and support functions attracted considerable interest internationally and in 2007 the Scottish Assembly announced that it would introduce a similar scheme in Scotland.

Membership of Aosdána, capped at 250, is conferred through peer nomination and election on artists born in, or resident in, Ireland for a minimum of five years, who have, in the opinion of their peers, produced a distinguished body of work. In the early decades, the art forms represented were Visual Arts, Literature and Music, but this was extended in 2010 to include both Architecture and Choreography. Entry is limited to ten new members in any given year, although replacements to fill vacancies caused by death or resignation are permitted outside this figure. The organization meets in General Assembly once a year, when elections to membership take place and issues relating to the organization and the arts are discussed. Aosdána is hierarchical, with an elected committee of ten *Toscairí* responsible for such tasks as vetting membership proposals and organizing the General Assembly, and a group of *Saoi* (sages), of which there are seven. The office of *Saoi* is the highest honour conferred within the arts in Ireland and is given to those considered by the general membership to be outstandingly creative and original. The role of *Saoi* is for life and is conferred by the Head of State.

An important aspect of Aosdána from its foundation is the annual *cnuas* or stipend, subject to review every five years, which is given to assist members who need it to concentrate on their art, free from the pressure of alternative employment. Described by one artist as 'I will not starve money' (Kinsella, p. 45), the *cnuas* is means-tested and pitched at a level below the maximum bursaries paid to artists by the Arts Council, suggesting that artists seek entry to Aosdána for the status and the sense of community that membership confers, rather than for any direct financial gain.

Aosdána's biggest single achievement has been to switch the emphasis in state support from institutions to individual artists, with beneficial effects for those artists privileged to be counted among its members and envied in this regard by artists from abroad. Yet it has not been without its detractors. Journalist and art historian Bruce Arnold saw the body as cliquish, elitist and patronizing, telling Lara Marlowe that '... entry is clearly not on merit but on the basis of who is appropriate for the agenda of those who control it, combined with the belief that artists need help to make a living' (Marlowe, 'Plots and infighting with the "immortals"', *IT*, 13 December 2003). Arnold saw it as an instrument of Charles Haughey, its founding mentor, noting, 'He sought to create an inner circle of art experts focused on

12. A general view of Aosdána in session, 15 April 1983, Irish Times Archive

himself'. This criticism is compounded by a lack of information about the criteria governing the selection of the original eighty-nine members, and since the organization is self-regulating, the circumstances of its establishment remain an influencing factor. The sculptor Eamonn O'Doherty accused Aosdána of being a 'closed-shop', claiming that membership conferred favours to its members, over non-members, in relation to official commissions (O'Doherty, letter to *IT*, in Kinsella, p. 6). The notion of being part of an establishment elite worries some artists, not because they fear exclusion, but rather because, like the painter Hughie O'Donoghue (qv), they are afraid of compromising their artistic freedom (Sylvia Thompson and Belinda McKeown, 'Is it worth joining Aosdána?', *IT*, 21 December 2001).

More seriously, there is confusion about Aosdána's precise role. In 2005 the then Director of the Arts Council, Mary Cloake, acknowledged that 'It can be confusing to look at Aosdána from outside. There's the honorific side and there's the financial side.' (Ryan, 2006, p. 365) In answer to Cloake's concerns about representation, membership has been increased and two new art forms added, but some confusion remains. When the prize-winning novelist and critic John Banville resigned in 2001, to make way for a needier artist, he recommended that the organization develop an emeritus group over and above the 250 members. Responding to the resignation, Anthony Cronin, who had advised the Taoiseach at the time of Aosdána's foundation, defined it as a community of people with similar interests and difficult vocational choices, which, he pointed out, 'monetary, or even critical success, does little to validate' (Cronin, letter to *IT*, 20 December 2001).

Michael D. Higgins (Minister for Arts, Culture and the Gaeltacht, 1993–97) also expressed a concern. 'I think there is a problem about Aosdána, in terms of definition. Is it fully representative of Irish arts and letters or is it an academy of letters, or is it representative of Irish life at the time [1980s]?' (Ryan, 2003, p. 221) The issue of equality of representation has been raised by

Christina Kinsella, who pointed out that the proportion of male to female visual artists, although more balanced than in other art forms, favours men by approximately thirty per cent (Kinsella, Appendix A, pp. 4–8).

In 2010 the General Assembly was held in Armagh in acknowledgement of Aosdána's long tradition of cross-border collaboration. CATHERINE MARSHALL

SELECTED READING Victoria White, 'Banville yields Aosdána seat to needier artist', *IT* (13 December 2001); Ryan, 2003 and 2006; Kinsella, 2008.

ART MARKET. Around 1900 the Irish art market, while modest, chiefly hinged upon the sale of antiques and Old Master paintings. Dutch genre scenes and Italianate landscapes, collected by grand tourists, provided the focus of trade, alongside eighteenth-century portraits and nineteenth-century hunting scenes. Better-known artworks and collections were usually sent to London for sale, while antiques, decorative art, and paintings by lesser masters remained in Dublin. Consequently, art market reports were generally confined to accounts of the London salesrooms. A notable exception to this pattern occurred in 1906, when Bennett's on Ormond Quay sold a Frans Hals painting to a London dealer for £3,650. The *Irish Times* journalist believed this figure would 'impart a pleasant thrill of excitement to the ordinary citizen, and may, perhaps, inspire the civic Philistine with a new respect for art as a profession' (*IT*, 7 April 1906). 'Ordinary citizens' had little chance of attending fine art auctions, since sales took place on weekdays limiting the clientele to trade buyers and those of independent means.

Living artists had few opportunities to present their work to the public outside the context of jury-selected group exhibitions organized by the Royal Hibernian Academy (RHA) (qv), the Watercolour Society of Ireland, and regional art societies whose functions were educational and promotional, rather than commercial. Purchases from the RHA were largely dependent on the fund-raising efforts of such bodies as the Art Union of Ireland, which between 1874 and 1902 purchased 754 works from the RHA at a cost of £17,523 (*IT*, 21 April 1902). Art unions existed well into the twentieth century and partly compensated for desultory patronage by an aristocracy struggling to maintain their estates and a middle class as yet uninformed about fine art.

Artists had to organize their own exhibitions. Those few with well-furnished studios issued invitations to private viewings; others hired public halls, defraying costs by charging admission. In 1901 Sarah Purser (qv) generously arranged a loan-exhibition of work by John Butler Yeats and Nathaniel Hone, while George Russell (qv) and Count and Countess Markievicz held joint shows in Dublin's Leinster Hall. In 1911 Dermod O'Brien (qv), newly elected president of the RHA, formally opened the Irish Art Companions Gallery, run by Charles Tindall Gatty, at 23 Clare Street, Dublin, proclaiming it the only venue where a representative selection of work by living Irish artists could be viewed outside of the Academy's annual shows ('New Picture Salesroom', *IT*, 20 November 1911).

Despite the efforts of Purser, Hugh Lane, Ellen and James Duncan, Sarah Celia Harrison and others to promote the production of Irish art and crafts, artists struggled to find support. The early years of the Irish Free State inaugurated a period of official neglect of the arts. Addressing the RHA in 1928, President W.T. Cosgrave 'discouraged the idea that the State should become a direct financier of the arts' since it would lead to 'dependence on the part of the artists' ('Art in Ireland', *IT*, 2 April 1926). Lack of patronage (qv) was coupled with a protectionist policy, which imposed a tax on imported artworks, including printed reproductions. The result, as Arnold Marsh bemoaned, was that artists had no models by which to judge their work. In the absence of Irish artworks to show students, educators such as Marsh had to apply to the London, Midland and Scottish Railway for posters featuring Paul Henry's (qv) work (Marsh, 'Art in a Free State', letter to the editor, *IT*, 7 December 1933).

A handful of Dublin picture-framers, such as Combridge's, Daniel Egan and James Joseph Gorry, displayed the work of living artists alongside older works left in for framing or cleaning. Combridge's gave Paul Henry several exhibitions in the 1930s and '40s and specialized in images of rural Ireland, appealing specifically to overseas visitors. Gorry's son, James Adolphus, showed the work of artists he had befriended while studying at the Dublin Metropolitan School of Art (DMSA) from 1920 to 1923. His son, another James, took over the business in 1967 and, while specializing in older Irish paintings, has exhibited the work of several contemporary artists in the academic tradition. Joseph Egan, son of Daniel, opened a salon at 38 St Stephen's Green in 1925, instituting regular exhibitions of Irish art and renting the space to artists and groups such as the New Dublin Art Club. The Daniel Egan Gallery rapidly expanded, with an art supplies shop opening in Molesworth Street in 1931, and a second hire-venue, the Angus Gallery, at 36 St Stephen's Green in 1932. However, Egan's diary reveals the vicissitudes of dealing in art during this period; he recorded each sale as a small miracle, and despaired, 'I don't think I will ever shake the sleep from Dublin' (Egan, *Diary of My Art Activities*, 1915–36, p. 63, NIVAL). Egan sold up and moved to London in 1937.

The main dealer of contemporary art during the early years of the Irish Free State was Victor Waddington, who opened a gallery on the first floor of 28 South Anne Street, Dublin in 1925 and a picture-framing business at 19 Nassau Street in 1939. This arrangement lasted until 1942, when the original gallery was given over to framing and print-selling, and new premises for exhibitions were opened at 8 South Anne Street. Waddington targeted 'buyers of moderate means', exhibiting the work of artists such as Seán Keating, Frank McKelvey (qqv), Moyra Barry and Douglas Alexander, well known from their regular appearances at the RHA ('To interest USA in Irish Art – Dublin Expert's Plan', *Dublin Evening Mail*, 13 March 1939). Waddington promoted his artists by touring their work nationally and internationally (sending exhibitions to the USA in 1939 and 1950), enlisting the press to publicize his shows, printing catalogues for each exhibition, and in 1940 publishing a colour-illustrated monograph, *Twelve Irish Artists*. He also placed their work with other galleries such as the Goodwin Gallery in Limerick, thereby boosting the reputations and sales of these artists outside Dublin. In 1943, at the suggestion of his assistant, Leo Smith,

Waddington gave Jack B. Yeats (qv) an exhibition. Seven further shows followed during Yeats's lifetime, and Waddington became known as 'the Yeats man'. At the same time he began to show the work of younger experimental artists, such as Gerard Dillon, Colin Middleton and Daniel O'Neill (qqv), offering them the support of a guaranteed income in return for first refusal of their work. He used the profits from sales of the work of more conservative artists to subsidize his support of those who were more challenging and less commercially rewarding. In 1957, following Yeats's death, Waddington moved to the family's current gallery in Cork Street, London.

Leo Smith, Waddington's former assistant, opened the Dawson Gallery in 1944. Smith championed a number of artists whose work Waddington had overlooked, including William Leech and Mary Swanzy (qqv), both of whom were then living in England. He also showed the work of artists closely associated with the Irish Exhibition of Living Art (IELA) (qv), such as Evie Hone, Norah McGuinness, Patrick Scott, Camille Souter, Louis le Brocquy (qqv) and Jack Hanlon, who switched from Waddington's to Smith's stable in 1962. After Smith's death in 1977, le Brocquy moved to the Taylor Galleries, opened in 1978 by John Taylor, who had worked for Smith since 1964 and who, with his brother Patrick, continues to run the Taylor Galleries in Kildare Street. Thus a strong lineage of dealers was created, from Waddington to Smith to Taylor, spanning eight decades.

Ireland's neutrality during World War II attracted artists from abroad such as Kenneth Hall and Basil Rákóczi (qqv), while Irish-born artists were confined at home by the conflict. Consequently, artistic activity increased and, with it, the pace of art dealing ('Ireland's increased interest in art', *IT*, 11 December 1944). By 1944 the Waddington and Dawson galleries were joined by a number of more short-lived commercial ventures such as Deirdre McDonagh and Jack Longford's Contemporary Pictures Gallery, established in 1938 at 133 Lower Baggot Street; the Picture Hire Club, which operated out of Trueman's art supplies shop, 24 Molesworth Street, from 1941 to 1944; and Arts Limited, where contemporary art hung amidst 'Barbola Mirrors, Wedgwood Vases, Exquisite Glassware, Old and Modern China and a host of rare and lovely things', at 19 O'Connell Street, from 1944 to 1945 (advertisement, *IELA*, 1944, n.p.) [13]. More significantly, 1943 saw the advent of the IELA, while a number of regional galleries mushroomed throughout the 1930s and '40s, increasing opportunities for artists to exhibit and sell their work.

Yet while shortages in the supply of gold, silver and furniture during the Emergency caused their prices to increase exponentially during the later 1940s, art remained a relatively cheap commodity, despite the scarcity of painting materials. Exhibition catalogues from these years list few works priced above £50, and in 1953 the *Irish Times* could assert that most Irish paintings sold for between thirty and a hundred guineas ('Pictures in the home', *IT*, 23 May 1953). These were gallery prices; works fetched considerably less on the secondary market at auction. Irish women artists fared worst, charging prices that were a fraction of those of their male colleagues. For instance, Estella Solomons (qv) usually priced her landscapes at no more than twenty guineas, while Paul Henry and Seán Keating charged more than five times this amount (Miller, 1973a, p. 44). This

13. 'Wherever did you get that lovely thing?', advertisement for Arts Ltd from the *Irish Exhibition of Living Art* catalogue (Dublin 1944)

price discrepancy increased later in the auction rooms, so that by the 1990s museum-quality works by women artists, such as Mainie Jellett (qv), rarely fetched more than £20,000, while works of similar quality by male artists, such as Yeats, fetched sums in excess of £200,000.

Nevertheless, the *Irish Times* reported in 1949 that 'about fifty people in Ireland … live exclusively from the sale of paintings, or drawings', and another sixty or more supplemented their incomes by working as 'commercial artists, art teachers, architects and window display designers' ('Painting is becoming profitable', *IT*, 26 August 1949). The same report claimed that the salaries of the thirty-six best-selling artists were on a par with those of doctors or higher civil servants, and that while 'the rest hardly do as well … they are far from starving'.

In the 1950s and '60s the market softened after its wartime high. Few galleries existed other than the Dawson and the Hendriks, established by David Hendriks in 1956. Where the Dawson represented mainly older, 'school of Paris', artists, the Hendriks showed the work of younger artists working in a highly subjective, expressive manner, such as Basil Blackshaw, Patrick Collins and Barrie Cooke (qqv), and those who experimented with hard-edge pop and abstraction (qv) such as Robert Ballagh, Cecil King (qqv) and Erik van der Grijn. A small pool of collectors existed, notably Sir Basil Goulding, principal patron to several artists, and Gordon Lambert, who later donated the

greater part of his collection to the Irish Museum of Modern Art (IMMA).

Corporate collecting (see 'Private and Corporate Collecting') made a tentative start around this time when tobacco manufacturers P.J. Carroll's began sponsorship of the IELA in 1964, and shortly thereafter started to form a collection under the guidance of architect Ronald Tallon. Chairman of the company, Denis Carroll, was also on the Bank of Ireland's board of directors and, in 1971, upon completion of its headquarters on Baggot Street, authorized the bank to begin buying contemporary art (O'Kane, 39–42). Allied Irish Banks began collecting art in 1980 and, after an initial period spent gathering a collection representative of Irish art since the late nineteenth century, switched its main focus to contemporary Irish artworks. These corporate collectors boosted confidence in the market, encouraging both government and private collectors to follow suit.

In the late 1960s and early 1970s keen interest in Irish art was demonstrated in the auction rooms, although prices remained modest. Most Irish paintings were sold in Dublin through the James Adam Salesrooms. Established in 1887 as a firm of house-contents auctioneers, at 17 Merrion Row, Adam's shortly thereafter opened a fine art salesroom at 19 St Stephen's Green, whence was sold period furniture and paintings (Brian Coyle, 'A century of experience and service', IAR, Autumn 1987, 60–62). In 1968 the firm expanded into new premises at 26 St Stephen's Green and began conducting specialist sales of Irish art. At one of the earliest of these sales, several oils by Nathaniel Hone sold for between £100 and £250, an Evie Hone gouache fetched £21, a Gerard Dillon watercolour made £10, and a Nano Reid (qv) watercolour £9 (Jonathan Fisher, 'Modest prices paid for Irish paintings', IT, 22 July 1968). A notable exception to this pattern of low prices occurred at Adam's in 1973, when Nesbit Waddington bid £15,500 for Jack B. Yeats's A Palace, which had formerly hung in Jammet's restaurant. While nostalgia for the legendary restaurant (closed in 1967 after some sixty years of business) may have contributed to the price, the record was in line with others being set internationally, as investors globally began speculating in art as a hedge against inflation, during the 1960s, and as an alternative investment during the oil crises of the early 1970s.

The introduction of both the Wealth Tax and the Capital Gains Tax in Ireland in 1975 caused the dispersal of many valuable collections and heralded the golden age of the big house sales. Conditions were ripe for the arrival of the leading international firms, Christie's and Sotheby's, both of which had expanded outside the UK in the late 1960s. Christie's first Irish sale was held in May 1976 at Malahide Castle, where the Talbot family's 800-year-old collection was auctioned to pay death duties. Christie's, represented by Desmond FitzGerald, the Knight of Glin, and working in conjunction with Keane Mahony Smith, totalled receipts of £529,173. Gabrielle Williams later recalled the sale for both its 'splendour and … sadness' ('Fine Arts', IT, 28 December 1979). Between January 1978 and September 1983 Christie's, working with different Irish partners, sold the contents of Senator Edward A. McGuire's Newtown House, Blackrock, for £318,018;

Clonbrock, Ballinasloe, raising £278,640, plus a further £265,000 for the library; Charleville at Enniskerry, Co. Wicklow, totalling receipts of £290,000; Belvedere House near Mullingar, fetched £146,000 in a sale of just thirty-nine lots; and the contents of Adare Manor, Co. Limerick, owned by the Earl and Countess of Dunraven, sold for £945,000. Their largest sale was the contents of Luttrelstown Castle, in September 1983, when the collection of mainly eighteenth-century furniture, portraits and trinkets amassed by the Guinness heir Eileen Plunkett, was sold for £2,955,119.

Meanwhile, in October 1975, Sotheby Parke Bernet appointed Gertrude Hunt and Mary Boydell as consultants and began seeking consignments, primarily of silver and glass. The following year the firm announced its association with Keane Mahony Smith and the appointment of Lord Mount Charles as their representative in Ireland, with an office at Slane Castle, Co. Meath (Gabrielle Williams, 'Sotheby moves into Irish market', IT, 23 October 1976). Twelve months later Mount Charles became 'an international representative', and Nicholas Nicholson took over the Irish position, continuing to act from Slane Castle. While Sotheby's secured several country house sales, their main activity in Ireland was the staging of five sales of fine and decorative Irish art at Slane between 1978 and 1981. The first of these raised £245,674, with record prices being set for Paul Henry (£3,600), Erskine Nicol (£13,000) for An Ejected Family (NGI collection), William Brocas (£7,400), William Orpen (qv) (£9,000) and Andrew Nicholl (£1,500). However, interest lay mainly in the decorative arts and antiques, which attracted largely British and American collectors. Sotheby's second sale in Ireland, in June 1979, raised an impressive £328,665, but subsequently they saw a tailing off in prices: in May 1981 they raised £239,803, and at their final sale, in November 1981, they made just £217,064, of which the paintings totalled only £102,401.

Economic recession in the early 1980s meant that Sotheby's reported losses of £2,121,000 worldwide for 1982, as opposed to profits of £4,060,000 in 1981, and their total sales in the UK and Ireland in 1982 were £31,080 million, as opposed to £36,632 million in 1981 (Gabrielle Williams, 'Sotheby's make light of losses', IT, 22 January 1983). The recession brought about a temporary cessation of activities in Ireland between 1982 and 1985 on the part of the London houses, although Sotheby's opened an office in Dublin in 1984, and Christie's retained Irish representatives.

In 1982, to counter the economic recession, the Irish government cut taxes and lowered interest rates, marking the start of that buoyant consumer culture that became known as the 'Celtic Tiger'. Alan and Mary Hobart of the Pyms Gallery, London, were prescient enough to begin specializing in Irish art at this time. They arranged a series of high-profile exhibitions such as The Irish Revival (1982), Celtic Splendour (1985) and Irish Renascence: Irish Art in a Century of Change (1986), which, with their lavish catalogues, helped generate interest in nineteenth- and early twentieth-century Irish art beyond the confines of the small circle of collectors who tended to buy mainly from the Cynthia O'Connor, Neptune and Gorry galleries in Dublin. By the mid-1980s prices for twentieth-century Irish art

began to rise. In 1986 Sotheby's raised £590,000 at a sale at Mount Juliet, while Christie's did likewise at Belfast Castle in 1988, selling John Luke's (qv) *The Bridge*, estimated at £10,000–£15,000, to Pyms Gallery for an unheard of £176,000. In 1989 Christie's held two sales in Belfast and two in Dublin, and in 1990 repeated this pattern, selling £2 million worth of art in Ireland. Significantly, fine art now outsold antiques and decorative art at auction.

Local auction houses enjoyed a similarly rising tide. John de Vere White entered the market in 1985, holding sales in conjunction with the Taylor Galleries and specializing in contemporary Irish art, largely neglected by both Adam's and the London houses. In annual reports de Vere White proselytized on the financial benefits of investing in this undervalued field. However, the highest prices throughout the 1980s were paid for 'traditional' art, both in terms of subject matter – such as McKelvey's nostalgic paintings of women feeding chickens

– and in terms of long-established 'blue-chip' investments, resulting in Michael Smurfit paying a staggering £280,000 for Yeats's *Harvest Moon* at Adam's in 1989. Indeed, that year saw a peak in the number of Irish records broken at auction, with many records set then remaining in place until 2006 (Burns, p. 36). The desire of collectors to create 'the semblance of a heritage' fuelled the demand for west of Ireland imagery (The Polly Devlin Collection, Adam's, 15 December 1999, p. 7). Market analysts predicted that the market for Irish art would be the successor to that of the Scottish Colourists; both largely overlooked up until the 1980s, both dependent on newly buoyant economies, and both appealing primarily, but not exclusively, to local collectors, reflecting a desire for the work to be considered independently of British art, under which category they had previously been subsumed (Kirk-Smith, 24–25; Gertrude Prescott Nuding, 'The Year in the Art Market', *IAR*, VII, 1990/91, 244).

14. Jack B. Yeats, *Tinkers' Encampment: The Blood of Abel*, 1940, oil on canvas, 91.5 x 122 cm, private collection

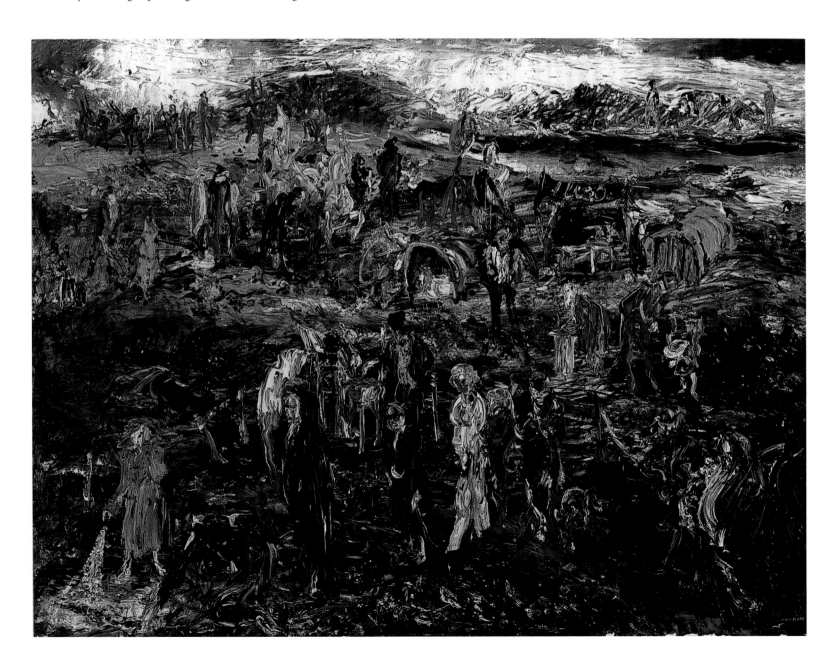

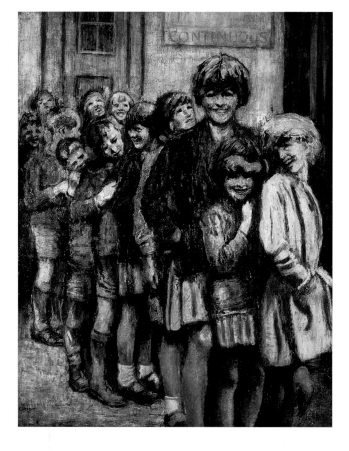

15. William Conor, *Picture House Queue*, 1930–34, oil on canvas, 90 x 70 cm, National Museums Northern Ireland, Collection Ulster Folk and Transport Museum

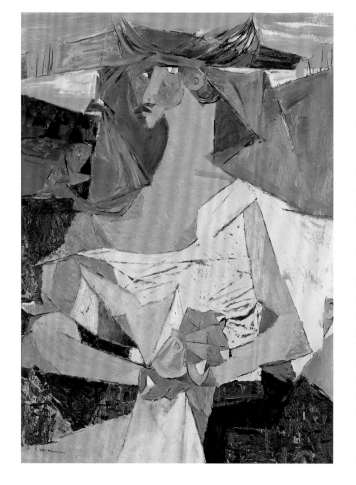

16. Louis le Brocquy, *Tinker Woman with Newspaper* (also known as *Travelling Woman with Newspaper*), 1947–48, oil on gesso-primed hardboard, 127 x 89 cm, private collection

Another recession forced Christie's to cancel two of its four Irish sales in 1991, when it sold only £186,000 worth of Irish art, as opposed to £2 million the year before. Robert O'Byrne characterized it as a difficult market, while Prescott Nuding warned of the susceptibility of the market to the presence or otherwise of just one or two major collectors (O'Byrne, 'Art sales in Ireland', *IAR*, IX, 1993, 259; Prescott Nuding, 'Irish art in the London salerooms', *IAR*, IX, 1993, 258). By way of example she listed the Trinity Gallery, Jersey, which had purchased approximately twenty of Yeats's late works at high prices in 1988 and offered them unsuccessfully for resale, before Sotheby's brokered a discount deal to sell them to a consortium headed by Sir Anthony O'Reilly (Prescott Nuding, 257; Burns, p. 37).

In the mid-1990s prices again rose. Despite his emphasis on contemporary art, de Vere White made headlines in 1994 by setting a new record for Yeats, whose *Tinker's Encampment: The Blood of Abel* [14] sold for £505,000. In 1995 Sotheby's instituted its annual Irish Sale in London and Christie's followed suit the following year. Phillip's also secured the occasional good picture and set some briefly held records. The record for Yeats was broken again in 1996, when Sotheby's sold *A Farewell to Mayo* for £730,000 sterling. In 1997 Christie's set record prices for Harry Clarke (qv), Louis le Brocquy and John Luke. That same year Sotheby's did likewise for William Leech, whose *Les Soeurs du Saint-Espirit, Concarneau* fetched £254,500, and William Scott (£117,000), and nearly trebled the previous record set for Sir John Lavery (qqv), selling his *Playing Golf at North Berwick* for £727,500. Christie's set the most impressive records in 1998, with Orpen's *A Mere Fracture* fetching £716,500 (previous record £290,000) and a Walter Osborne making £370,000 (previous record £271,000). In December that year Sotheby's sold Lavery's *The Bridge at Grez* for IR £1,321,500 – the first 'Irish' picture to break the million pound barrier (though it should be noted that Lavery is claimed equally by the British, Scottish and Irish markets). In May 1999 Sotheby's again broke the record for a Yeats (£1,233,500), while also setting records for Paul Henry (IR £210,500) and William Conor (qv), whose *Picture House Queue* [15] fetched IR £89,500. This litany of records was roundly capped in May 2000 when Sotheby's set a new record for le Brocquy, with his *Tinker Woman* [16] fetching £1.1 million sterling – the highest price then paid for the work of a living Irish artist.

Over the century the Irish art market witnessed considerable change and expansion, although, even at the turn of the millennium, little support existed outside state-run galleries for installation, Conceptual (qqv) or performance art. Some galleries, such as the Kerlin, Green on Red, Rubicon and Fenderesky, attempted to create a broader market for Irish work by participating in international art fairs. The auction trade saw an increasing demand, and consequently soaring prices for Irish art, enticing firms such as de Vere's and Whyte's to enter the fray in 1985 and 1999 respectively. As was the case with art markets across the globe, the greatest growth was in contemporary art, even if it remained orientated around traditional media. By 2000, when a work by le Brocquy became the first by a living Irish artist to fetch over a million pounds, the market for Irish art had, at last, come of age. JANE ECKETT

This essay on the Art Market summarizes the story of the art-work's passage from the artist's studio to its acquisition by a collector, the various agencies and individuals (artists, agents, dealers and auctioneers) who engage with it along that journey, and the history of the rising market for Irish art, nationally and internationally, as it has developed over the twentieth century. Since the economics of the visual arts in Ireland involve wider forces, a little more information might also be useful here.

While there is little in the way of scientific data about the early years of the century, the fact that no state body had responsibility for the arts provides a strong indication of the hardships artists faced (see 'Arts Councils', 'Commercial Galleries', 'Artists' Support Groups'). In debating the 1951 Arts Bill, which led to the founding of the Arts Council, the Taoiseach, John A. Costello, noted that the £20,000 budget proposed for the new organization represented spending of only one and a half pence per person in the country, yet while this was small it represented a step in the direction of support for the arts (*Dáil Debates*, CXXV, 24 April 1951, col. 1290). In fact, the actual amount the new Council had to spend when it took up office in 1951 was a mere £11,100, and this sum had to last until March 1953. It was not until 1959/60 that the budget of £20,000 was realized, although this figure increased within two years to £30,000, and when Charles Haughey, as Minister for Finance in 1967, announced a grant-in-aid of £60,000, state funding for the arts at last began to become a reality. The most flamboyant gesture towards artists was made in 1969 when the minister announced a tax exemption on artists' earnings. While this benefited a small number of high-earning writers and artists, the vast majority were unaffected financially since their earnings did not meet the basic threshold for tax payments. By 1982 the Council's annual grant had risen to nearly £4 million, and it became nearly £10 million a decade later, reaching over £47 million by 2002. Other financial benefits to the visual arts accrued from the 1984 Finance Act which offered tax benefits in return for sponsorships, and Section 1003 of the 1997 Act provided for tax exemptions in return for donations of artworks and other items of heritage value to the national cultural institutions. Of more direct benefit to artists was the introduction of Per Cent for Art Schemes by the Office of Public Works in 1978 and the Arts Council in 1985.

Trends in the distribution of the largesse described above are important to note also. The AC/ACE showed a marked preference for assistance to artists and arts events in the Dublin area in the early decades. A review of spending in twelve counties in 1961/62 revealed that nothing at all had been spent in five of them, while five years later, seven counties out of the twelve received nothing. It was not until the 1970s and '80s that this began to change (see 'Regional Developments'). Furthermore, while the government spent £17,000 on *Rosc '71* alone, less spectacular events were relatively ignored; for instance, the Project Arts Centre received a mere £3,000 to support its entire multidisciplinary programme from 1969 to 1973.

Arts-Council assistance for the visual arts initially took the form of support for purchases and exhibition opportunities, but by the 1970s this had expanded to include direct bursaries and grants (see 'Patronage and Awards'), aided by growing grants-in-aid from government and increased attention to audience growth through formal and informal education initiatives. The Richards Report to the AC/ACE in 1976 paved the way for the funding of arts organizations, and two reports on the living and working conditions of artists provide an indication of how artists fared in the prevailing economic climate from the 1970s to the early twenty-first century. The Irish Marketing survey of 1980, commissioned by the Arts Council, found that 75 per cent of Irish artists were obliged to take up other employment in order to live, and almost the same figure had no pension and claimed that their income was volatile. A frightening 23 per cent received no income at all for at least one month per year. The report found that 50 per cent of the money spent on art went to only 18 per cent of artists.

The AC/ACE and the ACNI jointly commissioned another report, *The Living and Working Conditions of Artists in the Republic of Ireland and Northern Ireland* (2010) by Clare McAndrew and Cathie McKimm. This detailed even poorer working conditions despite greater state provision over the intervening years. This study showed that most artists had to spend one-third of their working time on non-creative work in order to make a living, and that only two out of five visual artists could work as artists full-time, while most worked a minimum of forty hours per week, and many regularly worked fifty-five hours per week. Twenty-three per cent of artists in 2008 were registered as unemployed, most artists lived in the Dublin area, and while 52 per cent of working artists were female, they earned considerably less than their male counterparts. Fifty-six per cent of artists needed the support of the AC/ACE and ACNI to continue. Stability of employment and pension provision had remained unchanged since 1980, while, significantly, one-third of artists did not request written contracts for work undertaken. Many cited financial difficulties as the main impediment to their careers.

Most disturbingly, a comparison of working conditions between the two reports reveals falling incomes for artists relative to other workers, with artists in 2008 earning less than half what those with equivalent levels of education received.

	1978	2008
Artist earned	£4,636	€25,085
Average worker	£3,674	€38,916
Administrative Officer in Civil Service	£4,139	€32,558
Principal Officer (entry level)	£8,272	€84,066

Despite this negative picture, four out of five artists questioned said that they would make the same career choice again. Overlaps with other sectors, such as health, science, education, technology, community and youth organizations, were all seen as positive.

The report also revealed that between one in six and one in seven artists in Ireland now work in collectives all the time,

two-thirds do it some of the time, while 73 per cent in the Republic of Ireland and 85 per cent in Northern Ireland have a dedicated studio space.

Artists' reproduction rights were protected by the 2000 Copyright Act, and Visual Artists Ireland (VAI), the professional body set up at the same time to represent them, established the Irish Visual Artists Rights Organization to assist artists in collecting their copyright entitlements. A year later, the 2001 Artists Resale Rights, through which artists are entitled to royalty payments on sales of their work beyond the first one, became law, while VAI's regular programme of professional practice workshops does much to advise artists of their rights.

Writing about the arts in general, in 1994 Joe Durkan pointed out that the arts benefit the country's economy, citing a sum of €225–250 million generated through arts activities and employment figures of 14,200, but cautioned against evaluations of the arts based on economic impact studies alone. He claimed that the 'real benefits of the arts accrue to those who produce or avail of the arts, and it is this that is the prime justification for public expenditure in relation to the arts' (Durkan, introduction, *The Economics of the Arts in Ireland*, Dublin 1994). Whatever the positive outcomes of artistic endeavour for the country, the words of one artist ring true for all: 'The Irish market appears to be very small, and it is difficult to make a living out of it. I think we need to become part of a truly global market in order to make a living.' (McAndrew and McKim, 2010, p. 173).
Catherine Marshall

SELECTED READING Kirk-Smith, 1990; O'Kane, 2000; Eckett, 2004; Burns, 2008.

ARTISTS' STUDIOS AND RESIDENCIES. The availability of studio space is essential to the development of the visual arts. In Paris in the early twentieth century, a former factory converted into studios, and nicknamed Le Bateau-Lavoir, became not only a workplace for Picasso, Juan Gris and other artists, but also a meeting place, facilitating the exchange of new ideas. In contrast, for the greater part of the twentieth century artists in Ireland worked in relatively isolated conditions rather than in collective studios contained within larger buildings. From 1980 onwards, however, studio collectives, where groups of artists rented buildings and divided them into individual working spaces, were established in various Irish towns and cities. While most of these collectives were initially self-financing, with artists paying commercial rents for spaces in run-down warehouses, during this period government support for such initiatives began to increase. The relatively straightforward provision of studio space differs greatly from residencies; these can take many forms and are generally offered to artists by host organizations. Residencies may or may not include elements such as living quarters and studio space. The majority of residencies within Ireland was funded by local authorities and by the Arts Council (AC/ACE) (qv) and saw artists working in a variety of locations, such as schools, hospitals and prisons.

However, for most artists the need for long-term working space remained an acute reality of life. In 1976 an Arts Council report, *Provision for the Arts*, by J.M. Richards, made no mention of artists' studios, while six years later another Council report, *Living and Working Conditions of Artists*, although identifying in its summary the need for adequate studio space, repeated the omission of this fundamental requirement, dealing instead with issues such as membership of trades unions, access to social security, and attitudes of the public to the role of the artist in society. In spite of this seeming indifference, the Arts Council did begin to recognize the need for artists to have working spaces. Arising from an initiative of Oliver Whelan and Gabriel Murray, the Visual Arts Centre (VAC) was first established in 1979 by Eithne Jordan and Cecily Brennan (qqv), in a building on South King Street, Dublin, close to the corner of St Stephen's Green. This was the first in a series of artist-led initiatives which included New Art Studios and Temple Bar Studios. These initiatives received Council funding and, in the years following, state support for artists' collectives began to increase substantially (Burke, 1).

By the early 1990s, it was evident that while initiatives in Dublin, such as Temple Bar Gallery and Studios (TBG+S) (founded in 1981), were receiving substantial developmental support, many of those outside the capital city were less fortunate, and survived mainly through subsidies from local authorities. There were over 300 artists working in collectives throughout Ireland, signifying a flourishing demand, yet in most cases these studios offered limited facilities. The Backwater Studios in Cork, founded in 1990, was initially located in a disused warehouse on Pine Street, and differed little from its equivalent in other cities, such as Galway's All+10 Sorts, or the World's End Studios in Dublin. Housed in old warehouses, the tenancies were limited, and lasted only until more commercially attractive options presented themselves to the owners of the buildings. Recognition of these realities led directly to the Arts Council's development of long-term projects such the Fire Station Artists' Studios, the Black Church Print Studio and Temple Bar Studios, all of which received substantial state aid, in the form of capital grants, to bring their buildings up to a reasonable standard as professional workplaces.

In Dublin, the Graphic Studio, founded in 1961, and the Black Church Print Studio, established in 1982, were two of the earliest artist-led co-operatives. Originally based in Upper Mount Street, the Graphic Studio moved first to Hanover Street in the Dublin docklands, and then to a renovated building on the North Circular Road. As well as providing printing facilities, and displaying and selling important art, a valuable aspect of its support was storage for artists' work. The Black Church Print Studio, named in anticipation of its occupying a disused church of that name in the north inner city, found more suitable accommodation in Ardee Street, but was relocated to Temple Bar when that premises was destroyed by a fire in 1990. The print co-op, Cork Printmakers, started to research and to provide facilities for 'green' printing, using less toxic materials, prompted in part by a perceived risk of cancer to printmakers from using nitric acid to etch metal plates.

In 1981 Jenny Haughton, a freelance curator, founded Temple Bar Gallery and Studios in a former textile factory in Dublin's city centre. Numbering among its members Brian Maguire, Cecily Brennan, Patrick Graham (qqv), Robert

Armstrong and Seán Fingleton, TBG+S later provided space for Michael Duhan, Michael Boran, Mark Clare, Patricia Hurl, Margaret Tuffy, Linda Quinlan, Ronan McCrea and Gary Coyle (qv). The success of this, and other artist-led initiatives, within the inner city's Temple Bar led to the area becoming designated as Dublin's 'cultural quarter', which gained momentum with the Temple Bar Area Renewal and Development Act of 1991. With funding provided by the government, the European Union and the Arts Council, a variety of buildings in Temple Bar were acquired and redeveloped as studios, galleries and offices for arts organizations. The original factory housing TBG+S was demolished and replaced by a purpose-built building with exhibition, work and office spaces. By the late 1990s the visual arts facilities in Temple Bar, supported by the Arts Council, included the Children's Culture Centre, The Ark, the Design Yard, the Irish Film Centre, the Project Arts Centre, Arthouse (which also housed the Artists Association of Ireland), the Black Church Print Studio, the Graphic Studio Gallery, the Gallery of Photography and TBG+S. The studios thus formed the centre of a vibrant visual arts complex catering for the fullest range of practices. At 11 and 16 Eustace Street in Temple Bar, Independent Studio Artists Ltd provided space for artists, including Felicity Clear and Wendy Judge. However, many artists were hesitant to move into this rapidly developing quarter since it became identified also as a magnet for tourism.

Across the river, the north inner city offered an alternative haven, with studios located in a variety of warehouses and former factories, and also in a number of fine early eighteenth-century houses on Henrietta Street [17]. The VAC, two years after its establishment, relocated to 20 Great Strand Street, renting from Córas Iompair Éireann what had previously been a shoe factory, where the artists using the studios included Rob Smith and Anthony Little. The first artists' collective studios to be sponsored by the Arts Council, the VAC then moved on to St Michan's Street, before finally settling at 32 North Brunswick Street, Stoneybatter, in Dublin's north inner city. With active and successful artists such as Gwen O'Dowd, Richard Gorman, Donald Teskey (qqv), Blaise Drummond, Cathy Owens, Theresa McKenna and Janet Mullarney as members, the VAC was one of the most significant collective studios to contribute to Irish art during the last two decades of the twentieth century.

In 1982 the New Art Studio, in Mary's Abbey, was founded by graduates of the National College of Art and Design (NCAD), including Brian Cronin (qv) and Mary Burke. One of the longest established collectives in the north inner city, the New Art Studio provided work space for artists such as Mark O'Kelly, Siobhán Cuffe, Eithne Carr and Geraldine O'Reilly. In 1991 Start Studios, at 170 Parnell Street, was founded by Cathy Callen, Brian Garvey, Shane Cullen (qv), Brendan Gaule and Eibhlin Kelly, while artist Martin Folan was based in a studio above nearby Walden's Garage. At the Worlds End Studio, at 17–23 Foley Street, artists included Aidan Linehan, St John Hennessy, Kyntrich and Martina Galvin. Founded by Brian Duggan and Mark Cullen in 1996, Pallas Studios provided sixteen work spaces in a former knitting factory on Foley Street. In 2000 the knitting factory was redeveloped and, in a former factory in Castleforbes Business Park, off Sheriff Street, Pallas II emerged.

17. Studio of Kathlyn O'Brien, 7 Henrietta Street, 13 March 2013

In close proximity, the Phoenix Studios also provided working spaces. Pallas Heights, another extension of the original Pallas Studios, was located in Seán Tracey House on Buckingham Street, a block of 1960s' flats slated for demolition. Among the artists in Pallas Heights were Aidan Smyth, Conor O'Donnell, Gavin Murphy, Katarzyna Gatarzyna, Eóin Butler and Gary Farrelly. Artist Garrett Phelan covered his flat in graffiti, while Brendan Earley decorated his as if it were a set from Stanley Kubrick's *2001: A Space Odyssey*.

Separately, the Stoneybatter Studios, led by Claire Halpin, provided space for Suzanne Collins, Vanessa Marsh and Boz. Other artists' spaces on Dublin's northside included the Broadstone Studios, located in the Hendron building near the King's Inns, the Artbase Studios at 9 North Great George's Street, and Aldborough House, a late eighteenth-century townhouse on Portland Row. Among the artists in the Broadstone Studios were Cian McLoughlin, Don Sheehan, Stephen Loughman, Fiona Dowling, Gerard Byrne (qv), Sarah Pierce, Alan Phelan and Finbar Kelly. A disused button factory provided space for Kate Murphy, Philip Jenkinson and Anne Kelly, while Antoin O'hEocha led the Archway Studios at Seville Terrace. In 1995 a significant Arts Council-funded studio project involved the renovation of a disused fire station on Lower Buckingham Street in the north inner city. Under the successive directorships of Robbie McDonald, Tony Sheehan and, later, Clodagh Kenny, the Fire Station Artists' Studios developed a particular ethos, with a strong commitment to socially engaged practices. Among the artists it housed over the years were Patrick Graham, Patrick Hall (qqv), Jesse Jones, Kate Murphy, Declan Clarke and Niamh O'Malley. In Balbriggan, Co. Dublin, the Sunlight Studios at Railway Street provided accommodation for artists in north county Dublin.

The Arts Council of Northern Ireland echoed the pattern of state funding in the south. In the late 1990s, the main studio complex, and home to the Artists Collective of Northern Ireland, was the Queen Street Studios, Belfast, where artists included Joanna Cantillon, Jack Pakenham (qv), Jennifer Trouton, Terry McAllister and Colin McGookin. Initially based at 22 Lombard Street, Belfast, Art and Research Exchange (ARE) was set up in 1978 and continued until the late 1980s. Associated with *Circa* magazine, ARE organized a public-art programme specializing in exhibitions in non-gallery settings. An important studio complex was Catalyst Arts, at 5 Exchange Place, off Donegall Street. Among the artists working at Array Studios, 48 King Street, was Amanda Dunsmore, while Rita Duffy (qv) was based at the Gasworks Studios on the Ormeau Road, and Ian Charlesworth at Proposition Studios in the North Street Arcade. This arcade was also the location for 'The Emperor's New Clothes', an artist-led group that included Áine Nic Giolla Coda, Susan MacWilliam (qv) and Aisling O'Beirn. Performance artist Julie McGowan was based at Blackstaff Studios on the Springfield Road, while Niamh O'Malley was one of the artists at the Orchid Studios on King Street. Other studios in Belfast included the Creative Exchange Studios at 168 Castlereagh Road, Flaxart Studios on the Crumlin Road, and the Paragon Studios at 1 Lower Crescent and later at 18 Donegall Street (McGookin, p. 3). Artists Bill Drummond and Susan Philipsz were among the founders of an artists' residency centre in the Cushendall Tower, while in Derry studios included the Void Art Centre on Patrick Street. In Bangor, Co. Down, the Seacourt Print Workshop provided facilities for printmakers.

In Limerick, facilities for artists included Contact Studios behind St Joseph's Hospital, the Limerick Artists' Studios on James Street, and Limerick Printmakers, housed in a renovated stone warehouse on Robert Street. In County Clare, Loophead Studio was set up in 1999 by Naomi Wilson and Brian Doyle, both graduates of NCAD, who had worked in film and television media in New York. Space was provided in the Courthouse Gallery and Studios in Ennistymon, and the Tulla Stables Studios in Ennis. In the south-east of Ireland there was also a wave of new initiatives in the 1990s, including the 'Art Incubator Unit' and the Garter Lane Arts Centre in Waterford. In Cobh, Co. Cork, the Sirius Arts Centre, founded by Peter Murray and Sarah Iremonger in a renovated former yacht club, and directed by Peggy Sue Amison, provided fine gallery space and residencies.

In Cork, the three most important studio facilities for artists were the National Sculpture Factory (NSF), the Backwater Studios and the Cork Artists' Collective. Founded in 1989 by a group of sculptors, including Maud Cotter, Eilís O'Connell and Vivienne Roche, the NSF, located in a former tramway building near the city centre, provided ample space for large-scale sculpture fabrication. Under the directorship of Norah Norton, and later Mary McCarthy, the NSF organized seminars, training for sculptors, residencies and the commissioning of new work. In 1996 Cork Printmakers, occupying a building on McCurtain Street, amalgamated with the Backwater Studios, based in Pine Street. The two organizations then moved to Wandesford Quay and a former printworks renovated by Cork City Council, with assistance from EU structural funds.

In the late 1990s, an exodus of artists, mainly from Dublin where property had become overpriced, saw counties such as Mayo, Clare, Monaghan, Roscommon and Sligo emerging as centres for the visual arts. In Sligo the Model Arts Centre, founded by artists including John O'Leary and Seán McSweeney (qv), and run in its initial years by Sheila McSweeney, provided exhibition space and studios in a former school building. In County Leitrim, the Buckhill Bar Studios, set up *c*. 1990 by Niall Walsh and Anna McLeod, provided facilities for artists at Dromahair, while the Leitrim Sculpture Centre, founded in 1997 by Jackie McKenna, and directed for several years by Robbie McDonald, was located in a former bakery in Manorhamilton and provided bronze-casting facilities for sculptors. A renovation of the Custom House in Westport, Co. Mayo, saw studios and exhibition spaces incorporated into this historic building.

Residencies for artists became increasingly important during the last decade of the twentieth century. In 1993 a residency programme at the Irish Museum of Modern Art (IMMA) [18] was initiated in a range of former stables, at first under the direction of Mary McCarthy, Orla Dukes and, later, Janice Hough. The Artists' Work Programme, as it was initially called, facilitated Irish and international artists to work alongside each other in the context of a museum, especially a national one, interacting with the exhibitions, the collection and the community. The National Sculpture Factory in Cork offered residencies to artists working in both traditional sculpture modes, as well as in digital and new media. The NSF has participated in the European Pépinière programme since 1990. Residencies for artists were, and are, offered at the Tyrone Guthrie Centre, a large country house at Annaghmakerrig, Newbliss, Co. Monaghan,

18. Alice Maher at work in a studio in the Irish Museum of Modern Art, 1996

bequeathed to the state by the theatre producer after whom it is named. Under the directorship of Bernard Loughlin and successors, it established a reputation as a creative centre for writers, composers, and, as studios were later added, for visual artists. Other key residency centres include Cill Ríalaig in Ballinskelligs, Co. Kerry, an artists' village founded in 1991 by Noelle Campbell-Sharp, and the Ballinglen Foundation in County Mayo, founded the following year by Margo Dolan and Peter Maxwell. Through the 1990s, the Ballinglen Centre grew steadily to incorporate a print workshop and art library. Under the direction of Mayo Arts Officer John McHugh, the Heinrich Böll Cottage on Achill Island [19] was renovated in 1990 to provide temporary spaces for visiting writers and artists. On Inis Oírr, the smallest of the Aran Islands, a residency programme attracts contemporary artists to work within an Irish-speaking environment. Thousands of artists, from Ireland and abroad, have availed of residencies offered in these rural retreats, set in areas of great natural beauty.

Internationally, there were residency opportunities for Irish artists, although distinction should be made between those available to artists from the Republic of Ireland and those available only to artists from Northern Ireland, such as fellowships at the British School in Rome. From the early 1980s onwards, one of the most important residencies available to all Irish artists, at PS1, now Location One [20], in New York, was funded by the AC/ACE in co-operation with Ireland/America Arts Exchange and the Irish American Cultural Institute. The PS1 programme, which included both accommodation and studio space, was important in launching the careers of artists such as Gerard Byrne and John Kindness (qv).

Between 1980 and 2000 there was an unprecedented period of growth of artists' collectives and studios, as well as residency opportunities. Initially, the studios were often independent, self-financing and housed in redundant buildings, but a growing awareness, mainly on the part of the AC/ACE, resulted in the creation of first-rate studio complexes, and a consequent improvement in working conditions for many artists throughout Ireland. The availability of residencies attracted a wide variety of artists from overseas; many were drawn to Ireland by the natural beauty of the landscape, but from 1990 onwards,

particularly through the IMMA programme, a significant number of conceptual (see 'Conceptual Art') and multi-media artists availed of opportunities to contribute to the vitality of the visual arts in Ireland.

PETER MURRAY

SELECTED READING Burke, 1998; McGookin, 1999; Lalor, 2011.

ARTISTS' SUPPORT GROUPS (see also 'Artists' Studios and Residencies' and *AAI* III, 'The Sculptors' Society of Ireland'). Throughout the twentieth century, the visual arts in Ireland received financial support, mainly from the public sector through direct government funding, but also, from 1951 onwards, from the new state agency for promoting the arts, the Arts Council/An Chomhairle Ealaíon (see 'Arts Councils'). Support from the private sector came mainly with the purchase of artworks by private individuals, companies and institutions, and from the sponsorship of exhibitions and arts festivals by commercial organizations. However, perhaps the most tangible subsidy for the visual arts came from artists themselves, who, throughout the century, provided skills and resources by setting up co-operatives, collective studios and residencies. The majority of these initiatives were established without state funding, but as time passed, many did receive support from local authorities and agencies such as the Arts Council (AC/ACE) or FÁS, formerly the national training and employment authority. In addition to the Council's support for artists in Ireland, the Cultural Relations Committee (CRC, renamed Culture Ireland in 2005) supported exhibitions of Irish art overseas. Also funded by the government, an academy of artists and writers, Aosdána (qv), was established in 1981. Aosdána, while providing much-needed support and validation for artists, otherwise played a limited role in Ireland's cultural life.

19. Artist's residence and studio, Heinrich Böll Cottage, Achill Island, Co. Mayo

20. Andrew Duggan, *BUNKR*, Location One Fellowship, New York, 2005, cardboard, tape, projector, theatre lights

For most of the century there was comparatively little education in relation to professional practice in Irish art colleges and, as a result, several support organizations for artists, separate from the Arts Council but dependent on it for funding, came into existence. The Artists Association of Ireland (AAI), which operated throughout the 1980s and '90s, provided information on copyright issues, social welfare, exhibition payment rights, sources of funding, and other information of relevance to artists. The Sculptors' Society of Ireland (SSI), established in 1980, grew to some 350 members. Both the AAI and the SSI published magazines giving detailed information on the work of their members, while the field of Irish contemporary art was covered in greater detail by the monthly magazine *Circa*, a publication founded by a group of artists in Belfast in 1981. In 2005 the SSI, renamed Visual Artists Ireland (VAI), had absorbed many former AAI members, and began a new expanded phase of its existence. The VAI ran a regular newsletter which kept artists in touch with current events, open submission events and competitions, including public art opportunities. In Dublin, Cork, Limerick and Galway, artists' co-operatives concentrating on printmaking (qv) were formed in the late twentieth century, enabling artists to gain access to otherwise inaccessible studio and printing facilities.

The extensive state subsidy for artists' support organizations, evident in the last quarter of the twentieth century, contrasted sharply with the situation that had obtained in the years around 1900. Those artists' support initiatives founded then, such as An Túr Gloine, the Clarke studios and the Cuala Press, were necessarily commercial, or received patronage and support from private philanthropic sources. There were also not-for-profit societies, formed to promote the objectives of groups of artists. Since women were barred from attending university in Ireland in the late nineteenth century (although Trinity College Dublin did admit female students earlier than its British counterparts), many enrolled in art colleges, and, partly because oil painting was considered to be a male preserve, they often specialized in watercolour painting. Before 1893, women were not even admitted to the schools of the Royal Hibernian Academy (RHA) (qv), membership of which remained almost entirely male for the first half of the twentieth century and where, today, men still predominate. Moreover, because in Edwardian society it was considered unseemly for middle-class women to earn a living, many talented female artists of those times described themselves as 'amateur', although this was often far from the truth.

Founded in the late nineteenth century, the Water Colour Society of Ireland (WCSI) evolved from an earlier organization, the Irish Amateur Drawing Society, which numbered among its members Frances 'Fanny' Currey (1848–1917), Harriet Keane (d. 1920) and her sister Frances Keane (d. 1917), Henrietta Phipps (1841–c. 1910) and Frances Musgrave (d. 1918). In the 1920s exhibitors with the WCSI included May Guinness, Evie Hone, Letitia Hamilton (qqv), Eva Hamilton and Lilian Davidson. Rose Barton and Mildred Anne Butler were also long-time members, Barton showing works between 1872 and 1928, and Butler between 1892 and 1938. Initially sustained by the participation of mainly amateur artists, the WCSI survived

and prospered throughout the twentieth century, with many professional artists, such as Moyra Barry, Dorothy Blackham, Stella Frost and George Pennefeather, becoming members. Both Evie Hone and Mainie Jellett (qqv) brought a flavour of the avant-garde to the exhibitions of the Society. Nano Reid (qv) was a regular exhibitor in the 1940s while Kitty Wilmer O'Brien was president from 1962 to 1981. Madge (Ross) Sherlock (1885–1966) showed works influenced by her time in India, and Richard Caulfield Orpen (1863–1938) exhibited works between 1908 and 1936. In the 1940s, artists such as Sylvia Cooke-Collis and Father Jack Hanlon carried on the tradition of watercolour painting, showing in their work a moderate influence of 'School of Paris' Modernism.

Around the turn of the century, a number of societies for artists, such as the Dublin Sketching Club, flourished. Among the members of the Club were Augustus Burke, Nathaniel Hone, John Butler Yeats and Sarah Purser (qv). However, by the 1930s, the Sketching Club was almost defunct. In the North, the Belfast Ramblers' Club, later known as the Belfast Art Society, was founded in the 1890s, while in east County Cork, the Queenstown Sketching Club (Beatrice Gubbins was a member) was active up to the 1920s. With less imperative to achieve sales, and indeed with membership by professional artists barred in some cases, many of the works produced by these societies, particularly in watercolour, possess a quality unmatched in the more commercially driven output of members of the RHA. However, their work was for the most part conservative, based primarily on nineteenth-century realism. Tuition in these societies was sometimes provided by well-known artists such as Paul Naftel, who, although based in London, critiqued the work of Queenstown Sketching Club members by mail, with members signing their works with code names to ensure impartiality. With the onset of the War of Independence, followed by the Civil War, societies devoted to activities such as watercolour painting and lacemaking declined in popularity. However, the WCSI sustained a relatively high level of activity throughout the century, and while it continued to attract members and hold exhibitions, its contribution to Irish art was not as significant as in earlier years. A representative collection of work by members of the Society is housed at the University of Limerick.

Another support organization was the short-lived Academy of Christian Art, which operated mainly in Dublin in the 1930s. Founded in 1929, the Academy was intended to promote interest in church architecture and decoration, stained glass and other art forms often used in religious buildings. It had been established partly in response to a perceived indifference on the part of the RHA towards the promotion of a national art revival. Progressive artists criticized the RHA for its rejection of Modernism (qv), but equally it was castigated for not promoting art that was overtly historical or sentimental. Among the members of the Academy of Christian Art were Seán Keating, Maurice MacGonigal (qqv), George Collie and Albert Power, with Margaret Clarke (qv) an associate member. According to S.B. Kennedy, only Catholics were eligible for membership (Kennedy, p. 161). The founder of the Academy was George Noble, Count Plunkett, Director of the Science and Arts

Museum (later National Museum) from 1907 to 1916, who served as Minister of Fine Arts in the second Dáil (August 1921 to January 1922), a non-cabinet portfolio.

In 1931 a *salon de refusés*, intended for artists rejected by the RHA, was founded by Ben O'Hickey. Initially named the Associated Irish Artists' Society, O'Hickey's initiative evolved into the Academy of Irish Art, its members including Michael O'Beirne, William Brett, Marion King, Mary Power and Jim Fitzpatrick. However, the Academy of Irish Art lasted for just eight years and had little influence (Kennedy, p. 160). In the 1920s a group of moderately progressive artists, led by Paul Henry (qv), founded the Society of Dublin Painters (SDP), and a series of exhibitions was held at the Society's gallery in St Stephen's Green. Among the artists who showed at the SDP's gallery were Hilda Roberts, Beatrice Glenavy (née Elvery), Mary Swanzy (qqv), Lilian Davidson, Stella Frost, Joan Jameson and Brigid Ganly. Mainie Jellett also became a member after the first exhibition. However, the members of the RHA, over which James Sleator (qv) presided, who regarded themselves as 'professional' artists, greeted the more progressive art styles of the SDP with a certain amount of derision. Sleator himself was a founder member of the Dublin Painters, but withdrew after the first exhibition, presumably because of the non-academic approach of most of the other members. The SDP provided a valuable opportunity for progressive women artists to show their work, and, as was the case with many such societies, clearly emerged in reaction to the policies of the RHA.

Before World War II, a group of artists in London, led by Basil Rákóczi and Kenneth Hall (qqv), formed the White Stag Group (qv). The aim of the Group was to promote new forms of art that were rooted in the subconscious. Influenced by new developments in psychology, and by the writings of Sigmund Freud and Carl Jung, Rákóczi and the psychologist Herbrand Ingouville-Williams organized a series of lectures and exhibitions. The work produced by members of the Group was primarily inspired by artists such as Klee and Picasso. Although small in size, the White Stag Group was comparatively influential in a country cut off from the intellectual life of continental Europe. In Dublin, Irish artists such as Patrick Scott, Thurloe Conolly (qqv) and Brian Boydell were, to a greater or lesser extent, inspired by the teachings of the Group. The first White Stag exhibition, held in April 1940, included works by Mainie Jellett. Several exhibitions were held over the following years, along with readings and lectures. After the war, Rákóczi and Hall returned to England and the influence of the White Stag on Irish art, although still important, began to dwindle.

In 1943, prompted by the example of the lively and well-attended White Stag exhibitions held in Dublin, and by the continuing hostility of the RHA to progressive art, the Irish Exhibition of Living Art (IELA) (qv) was initiated by a group of people including Mainie Jellett and Sybil le Brocquy, mother of Louis le Brocquy (qv), whose work had been rejected the previous year by the Academy. At the first IELA meeting held in May, Mainie Jellett was elected chairman. The committee was composed of Evie Hone, Father Jack Hanlon, Norah McGuinness (qv), Louis le Brocquy, Margaret Clarke, Elizabeth Curran, Ralph Cusack and Laurence Campbell. Their first exhibition was held in September 1943 at the National College of Art (now NCAD) and included nearly 200 works of art by these and other artists. Owing to the destruction of their original premises on Middle Abbey Street in 1916, the annual exhibitions of the RHA were also held at this time in NCA. Maurice MacGonigal, then treasurer of the RHA, must have been tacitly supportive of the IELA initiative because he was also Professor of Painting at NCA at this time. Seán Keating, surprisingly, participated in the first Living Art exhibition, and his *Tip Wagons at Poulaphouca* (ESB collection) received critical praise. The IELA demonstrated that there were many artists working in Ireland outside of the academic realist tradition (see 'Realism'). The early exhibitions included works by Mary Swanzy, Grace Henry, Nano Reid, Patrick Scott, Gerard Dillon (qqv), Yvonne Jammet and Frances Kelly, and the range of stylistic influences included Fauvist-inspired work by McGuinness, the Cubist styles of Doreen Vanston and Jellett, and the Surrealism (qv) of Colin Middleton (qv) and Nick Nicholls (Kennedy, pp. 115–46). IELA exhibitions were important opportunities for artists to sell their work, and private art collections, such as that assembled by Ernie O'Malley and Helen Hooker O'Malley Roelofs during these years, reflect the commercial aspect of the Living Art organization. In 1941 new initiatives in the visual arts in Dublin also included a Picture Hire Club, an innovative way of encouraging people to acquire moderately progressive art for their homes at a time when few people could afford to buy art. The journal of the Club, *Commentary*, edited by Seán Dorman, was published regularly until 1946.

Around Ireland, there were several artists' organizations active during this period. In Cork, the Munster Fine Art Society flourished from the 1930s through to the 1970s, holding annual exhibitions of members' and invited artists' work. The Cork Arts Society received support from its membership association, as did the Sligo Art Gallery. Founded in 1942, the Limerick Arts Society, originally named the Limerick Arts Club, organized annual exhibitions of members' work, as did its counterparts in other towns and cities.

In Northern Ireland, a number of societies and organizations, often closely echoing those in the Republic of Ireland and in Britain, were formed to support the visual arts. Founded in 1930, the Ulster Academy of Arts evolved from the earlier Belfast Art Society (see 'Royal Ulster Academy' (RUA)). The work shown at the Ulster Academy differed little from the annual exhibitions of the RHA, with the emphasis being on landscapes (qv). In 1943 the Council for the Encouragement of Music and the Arts (CEMA) was founded. Initially funded by the Pilgrim Trust and the Northern Ireland government, in 1962 it was renamed the Arts Council of Northern Ireland (ACNI). During 1943 and the following year, the first CEMA touring exhibition, featuring work by living Irish artists, toured to several venues in Northern Ireland (Kennedy, p. 153). In 1947 CEMA acquired a gallery at 55A Donegall Place, Belfast and for the next decade this was important to the visual arts in the North, hosting a variety of exhibitions, including work by Dillon, George Campbell (qv), Arthur Campbell and Thomas McCreanor. In 1958 the gallery at Donegall Place closed, but a new venue opened two years later at Chichester Street.

21. Installation shot of *Art Rebels* exhibition, Catalyst Arts, Belfast, 1996

In 1944 the Progressive Painters Group, with members including George Campbell, Dillon, Daniel O'Neill (qv) and John Turner, was founded to promote awareness of Modernist art movements. However, the growth of the left-wing artists' organization in Britain, the Artists International Association, which also attracted Campbell and Turner, led to the demise of the Progressive Painters. Although not radical in practice, the Association had a Marxist agenda, and was intended to counter fascist art movements. Several exhibitions were held in Belfast, including one at the Ulster Museum in 1947, in association with CEMA.

Founded in 1933 by poet John Hewitt, the Ulster Unit evolved from the short-lived Ulster Society of Painters and modelled itself on the London-based Unit One of Paul Nash and Herbert Read. Of the artists involved in the group, Middleton, John Luke (qv), George MacCann and Romeo Toogood went on to establish significant reputations. Most of the younger artists involved in the Ulster Unit's single group exhibition at Locksley Hall, Belfast, in December 1934, had themselves studied or worked in London. In 1957 Gladys Maccabe founded the Ulster Society of Women Artists. Group 63, a loose affiliation of artists, including John Breakey, R.J. Croft, David Crone and Jack Pakenham (qqv), organized its first exhibition in 1963 at the Magee Gallery in Belfast. Other members of the Group included Malcolm Bennett, Noel Millar and Cecil McCartney. A second exhibition, held in 1965 at Queen's University Belfast (QUB), was followed by another, two years later, also at QUB, in which the original artists were joined by Padraig MacMiadhachain. The group showed regularly until 1973, when the last exhibition was held at the Arts Council Gallery in Belfast. Like the IELA in

Dublin, Group 63 regarded itself as an organization for avant-garde artists, in contrast to the conservative fare found at exhibitions of the RUA. The name was inspired by the Italian 'neoavantguardia' association, Gruppo 63, whose members included Umberto Eco.

The Independent Artists Group (its name similarly a nod to the Society of Independent Artists, organizers of an influential 1917 exhibition in New York) was founded in Dublin in 1960 by a group of artists including Barrie Cooke and Camille Souter (qqv), who, dissatisfied with the direction being taken by both the RHA and the IELA, set out to give recognition to artists who were being excluded from the exhibitions of these two organizations. Some artists were thought to be overlooked by selectors of the IELA because they were not sufficiently 'Modern', while others were rejected by the RHA because their work was too Expressionist (see 'Expressionism and Neo-Expressionism'). Among the founders of the Independent Artists was Owen Walsh, an artist who, in 1954, had used the Macaulay Fellowship to travel to Spain to study art. Refusing an offer of associate membership of the RHA in 1960, Walsh resigned as chairman of the Independent Artists that same year. Artists represented in the Independent Artists' exhibitions included Charles Brady, Charles Harper (qqv), Brian Henderson, Mary Duffy and Gerard Cox. Other leading members were the Expressionist painter Michael Kane (qv) and James McKenna. Kane's essays and woodcuts, and his often contrarian views on the Arts Council, published in the magazine *Structure*, added a zest to the dialogue in the Irish art world at the time. Artists such as John Kelly, Brian Bourke (qqv) and others used the Independent Artists as a platform to voice their dissatisfaction with the art 'establishment' of the time, railing against both the conservatism of the RHA and the espousal of International Modernism by the Arts Council. The annual exhibitions of Independent Artists often took place in the large ground-floor atrium of the Bank of Ireland headquarters on Lower Baggot Street, a Modernist building that was also the venue for other exhibitions, including the *Figurative Image* group show, held in October during these same years. The founding of the Project Arts Centre was linked to the need for new and independent arts spaces. One of the founders of the Project, Colm Ó Briain, was in 1975 appointed director of the Arts Council, reflecting the rapid changes taking place in Irish society at the time.

Also linked to this outburst of energy, and side-stepping the traditional art schools and academies, the Graphic Studio, Black Church Print Studio, Limerick Printmakers Studio, Cork Printmakers and other artists' co-operative societies provided support and printmaking facilities for their members. In Belfast, Catalyst Arts [21] provided both a forum and a voice for contemporary art.

A problem that resulted from the growth of collective studios and workshops in the 1990s was the marketing of artists' work. In many cases, works of excellence were being produced which did not find a ready market, in spite of the positive response and critical acclaim afforded these artists. With relatively few commercial galleries in Ireland, and disposable personal income restricted by taxation and a high cost of living, artists found it difficult to identify a consistent and regular

market for their work. By forming collectives, artist-led groups and organizing touring exhibitions, artists took a lead in presenting their work to audiences around the country. The Arts Council encouraged this by providing grants specifically for touring exhibitions. In Dublin in the 1980s, the Grapevine Arts Centre in North Frederick Street, an artists' co-operative space, provided an alternative to mainstream galleries, where artists, including performance artists, could present their work. The Project Arts Centre provided both exhibition space and rehearsal and theatre space. An organization called CAFÉ, or 'Creative Activity for Everyone', founded in 1983, specialized in community arts initiatives. CAFÉ secured funding and provided support and advice for artists working in community arts practice throughout Ireland. In 2005 it was renamed CREATE.

In the late 1980s an area of Dublin's inner city, bounded by TCD, City Hall, O'Connell Bridge and the headquarters of Dublin City Council, was designated a cultural quarter. Although the initiative for this was provided by Jenny Haughton, who set up Temple Bar Galleries and Studios in a disused clothing factory, the project rapidly became an integral element of government economic policy, linking culture with tourism development. With government funding and tax incentives, a company, Temple Bar Properties, set about developing the area as a haven for the visual arts. However, some artists' organizations in the new cultural quarter, supported and nurtured by the Arts Council in the early 1990s, saw their funding withdrawn after a number of years, the most notable being the Artists Association of Ireland (AAI) and Arthouse. One of the keynote buildings in Temple Bar, Arthouse, which had provided training courses for artists in digital media, closed its doors after eight years of struggling unsuccessfully to establish a distinctive identity. Housed in a Modernist building designed by architect Shay Cleary, Arthouse invested heavily in programmes such as Artifact, a digital database for artists, that ultimately came to little. In retrospect, a key flaw in the concept was confusion between two different cultures: that of the physical city, rooted in a particular sense of urban time, place and personal experience, and that of the internet, which can be accessed almost anywhere in the world.

In 2002 the demise of the AAI, also based in Arthouse, came as a surprise to its 1,200 members. Founded by artist Robert Ballagh (qv) and others in the early 1980s, the AAI was an advocacy organization initially based in Liberty Hall, home of the Irish Transport and General Workers' Union. Chaired by artists such as Brian Maguire (qv) and Una Walker, the AAI mounted successful campaigns for the professionalization of the arts in Ireland, and for the recognition of the term 'artist' as a bona-fide occupation. Under the directorship of Stella Coffey, the AAI also published a monthly journal, *The Arts Bulletin*, which provided information for visual artists. In the two decades of its existence, the AAI did valuable work, including publishing *The Irish Visual Artists Handbook*, 1994, undertaking a strategic review of the visual arts market (qv) in Ireland, becoming a member of the European Forum for Arts and Heritage and various UNESCO and EU committees, and even advising former Soviet bloc governments on developing support systems for artists. The assertively independent stance adopted by the AAI may have led to its

demise. By taking positions on issues such as 'droite de suite', positions that did not necessarily tie in with government policy, the Association appears to have alienated itself from its key funder, the Arts Council. After the AAI ceased operations in 2002, much of its role was taken over by the SSI which began publishing the *Visual Arts Newsletter* six times a year. It also published *Printed Project*, a more substantial journal, appearing twice a year, documenting contemporary art practice, in the form of a carefully curated publication, rather than a newsletter. In addition to organizing seminars, developing a photographic slide archive and publishing a quarterly newsletter, the SSI acted as a liaison between artists, the Arts Council and the Royal Institute of Architects in Ireland. In 1992 the SSI staged a sculpture symposium at the Tyrone Guthrie Centre at Annaghmakerrig, one of a number of such symposia held throughout Ireland during these years, including previous ones in counties Sligo and Wicklow, which provided valuable opportunities for Irish artists to work alongside international practitioners. The SSI also held seminars, the first in 1980, in conjunction with the Independent Artists Group, a change that reflected a broadening of its membership base to include many artists who did not describe themselves as sculptors. In 1992, after a conference at IMMA, Anne Seagrave founded Random Access, an artist-led initiative that specialized in live art and new technology. Linked to the SSI, but broadening its remit into areas not traditionally considered as sculpture, Random Access organized video and sound works projects. The main artists involved were Stephanie Condon Casey, Kimberly Dunne, Toby Fitzpatrick, Iain Keeny, Fergus Kelly, Tony Patrickson and Colin McKeon. Three years after its founding, Random Access cut its links with SSI and became Critical Access, under which name it held conferences on public art and education in 1998, on 'Women in Irish Art' and other events. The activist Women Artists Action Group, or WAAG, was founded in 1987 by artists Pauline Cummins (qv) [22], Una Walker, Marja van Kampen, Louise Walsh, along with art historian Fionna Barber and curator Jenny Haughton. The first exhibition of work by WAAG members was held in the Guinness Hop Store in 1987 and the Group stayed in existence for several years (see 'Women and the Visual Arts').

22. Pauline Cummins in her studio in the 1970s, RTÉ Stills Library

relevant, and retain funding, while also highlighting injustices and attempting to change the status quo. The role played by individual artists in these organizations cannot be overestimated. PETER MURRAY

SELECTED READING S.B. Kennedy, 1991; *Disability and the Arts Council*, AC/ACE Report (Dublin 1998); MacNally, 2002; Butler, 2010.

THE ARTS COUNCILS AND THE VISUAL ARTS

Early in 1951 the government published *A Report on the Arts in Ireland* which it had commissioned from Dr Thomas Bodkin, Professor of Fine Arts at the Barber Institute at Birmingham University, and previously Director of the National Gallery of Ireland (NGI) (1927–35). State funding had been provided to the Abbey Theatre since 1925 and orchestral music was subvented since 1948 with the establishment of the Radio Éireann Symphony and Light Orchestras. Bodkin's report, presented in 1949, and the 1951 Arts Act that followed, were generally perceived as a visual arts initiative. They led to the establishment of the Arts Council, An Chomhairle Ealaíon (AC/ACE) in 1951 [24].

After fifty years in operation, the Arts Council was described as the only body in the country providing consistent direct support to artists to make work, develop their artistic practice, pursue opportunities for further studies and work internationally. Yet its first three chairmen/directors had no direct association with the visual arts. The first chairman/director (a combined role under the Arts Act) was Patrick Little, a member of Dáil Éireann. As Minister for Posts and Telegraphs, under Taoiseach Eamon de Valera, he had set up the Symphony and Light Orchestras under the auspices of the national radio station.

The Arts Council of Northern Ireland (ACNI) originated in the Council for the Encouragement of Music and the Arts (CEMA), initiated in Northern Ireland and Britain during World War II to raise public morale; it was heavily inspired by the work of the poet, art critic and curator John Hewitt. CEMA was incorporated under the Companies Act of 1947 and in 1963 it changed its name to the ACNI. The activities of CEMA prompted Little to bring proposals for a Council of Culture in the Republic to the Irish government in 1945 and 1948. However, Eamon de Valera rejected both proposals on cost grounds.

It was Taoiseach John A. Costello who brought forward legislation to set up an Arts Council, claiming that it was 'a personal ambition'. The legislation reflected the thinking of both Paddy Little and Thomas Bodkin in how the Council was to be structured: it was to be an autonomous state-sponsored body, not an advisory one; it would report to the Department of the Taoiseach, not to the Department of Education (the guardian of heritage institutions, such as museums and galleries, since the foundation of the state, and it would have explicit statutory discretion on the allocation of its budget. These important principles were to define a public body that worked tirelessly from then on to stimulate public interest in the arts, to promote knowledge, appreciation and practice, and assist in improving standards in the arts.

23. Kilkenny Collective for Arts Talent (KCAT), which opened formally in 1999, where artists and students from different backgrounds and abilities can work and create together

In the 1990s increased recognition was given by the Arts Council, mainly through Arts & Disability Ireland, to supporting artists with disabilities. A number of similar organizations, including Very Special Arts Ireland, Open Arts, Adapt NI and the Northern Ireland Arts and Disability Forum contributed to opening up arts venue access, programming and opportunities for the disabled. Based at Ardkeen Hospital, the Waterford Healing Arts Trust did valuable work in promoting art as a pathway to overall health. Founded in 1999, the Kilkenny Collective for Arts Talent (KCAT) [23] provided courses, mentoring, studio and exhibition space for visual art and theatre for artists with learning disabilities.

Although from the 1980s onwards, Ireland was diligent in following international trends, in terms of affording recognition and support to artists from differing backgrounds, artists with disabilities, and those who did not fit easily within conventional social categorizations, before that decade the visual arts were not markedly open or accessible to such sections of society. The struggles encountered by the painter Christy Brown, vividly and accurately portrayed by the actor Daniel Day Lewis in the film *My Left Foot*, illustrate the reality facing artists from poor backgrounds, and those growing up with disabilities in 1950s' Ireland. For the greater part of the twentieth century, the visual arts were a safe haven for the middle classes, with the concept of support groups being confined largely to membership-only clubs and societies. The rise in working-class access to art colleges in the 1970s spelled the end of a complacency that had created conditions for the production of art that was largely irrelevant to the social and political changes that transformed Ireland during the course of the century. The rise of more socially motivated support organizations in the last two decades of the twentieth century reflects the ending of that culture of complacency, but often these organizations themselves had a patchy history, as they struggled to remain

The Council found it difficult in the 1950s to make an impression on either the public at large or on the political establishment. Ireland, then, was, according to Sean Ó Faoláin, 'snoring gently behind the green curtain that we have been rigging up for the last 30 years' ('Autoantiamericanism', *The Bell*, 6 March 1951, 22). The Council's secretary at the time, Dr Liam O'Sullivan, wrote 'our greatest difficulty is the lack of the right cultural values ... there is a sullen and unexpressed hostility to cultural activities due to an ingrained suspicion that art and culture are anti-national and snobbish' (Kennedy, p. 115).

An early initiative of Little's directorship was the establishment of specialist panels, including one for painting and one for architecture, each with seven members. The earliest ventures the Council supported financially were the setting up of the Institute of the Sculptors of Ireland, the holding in Dublin of the Fourth International Congress of Art Critics (both in 1953), and several exhibitions devoted to art in industry.

In spite of little support from his party colleagues in Fianna Fáil, Little managed to have the Council's annual grant from government increased from £9,314 to £17,000 over his five-year term of office, ignoring disparaging remarks from Patrick Kavanagh that 'men who in a well-ordered society would be weeding a field of potatoes or cutting turf in a bog are now making loud pronouncements on art' ('Four Pillars of Wisdom', *Kavanagh's Weekly*, 19 April 1952). The stature of the Council increased when, in 1956, Sean Ó Faoláin was appointed to be its second chairman/director, despite forceful objections from the Catholic Archbishop of Dublin, John Charles McQuaid. The focus of Ó Faoláin's part-time directorship was on the independence of the Council, while a standing order agreed by the Council in 1957 read: 'Future policy, while not failing to encourage local enterprise, would insist on high standards.' Such standards were clear in the major retrospective exhibition, assisted by the Council, of work by Evie Hone (qv), who had died in 1955. The installation (qv) in the Great Hall of University College Dublin of ninety-five artworks, twenty-nine of them windows, with pride of place given to *My Four Green Fields*, was particularly dramatic.

The Council saw its role initially as financial underwriter of this and similar exhibitions, but it was also empowered to organize exhibitions 'of works of art and artistic craftsmanship' (Arts Act, 1951, 3(1)d). However, efforts by the first two Councils to get approval for the appointment of an exhibitions officer did not succeed. Its limited capacity meant that until the 1960s the Council was mainly a reactive organization, unable to implement ideas or projects of its own. On the other hand, at several stages during those early years a number of forceful individuals, with a strong public profile in the visual arts, were identified with the Arts Council. Dr Michael Scott, the distinguished architect and founder of Rosc (qv), was a member for nineteen years, and Father Donal O'Sullivan, S.J., was chairman and director for thirteen of the seventeen years of his membership of the Council. Dr James White, who brought energy and vision to his work as director of the NGI, having previously rejuvenated the Municipal Gallery of Modern Art (HL), was a member of the Council for sixteen years, five of them as chairman.

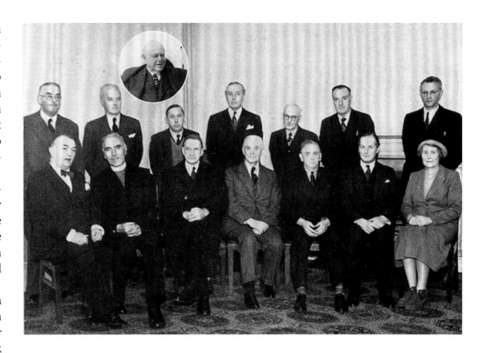

24. Members of the first Arts Council, 1951, Arts Council/An Chomhairle Ealaíon

Art collections of the two Arts Councils

During the 1950s, the ACNI, following the lead of other Arts Councils in the UK, began to purchase art works by living artists. In 1953 the Dublin Council decided to introduce a scheme 'for the purchase of pictures for, and the decoration of, public buildings ... as a means of educating our people, and of supplying an inspiring market for our best artists' (AC/ACE Annual Report 1953). This was followed by a letter from the director to city and county managers offering to co-purchase artworks approved by the Council for public buildings, subject to a maximum subvention of £50 for each artwork. The Joint Purchase Scheme, as it was called, was under-used initially but took off following a request from Dr C.S. Andrews, chairman of CIÉ, for co-funding to purchase art for display in the company's hotels, and the scheme was extended to other hotels. A cross-section of the Irish public encountered these works in a setting that minimized for them what the historian Robert Hughes memorably called 'the shock of the new'. Members of the Council also became proficient in purchasing work for 'the Arts Council Collection', set up because no public gallery in the Republic had a budget for purchasing works by living artists. A preference in the early years for abstract works of the international hard-edge style inevitably led to accusations of favouritism in the newspapers and subsequent threats of legal action. As the Councils developed other means of supporting artists, such as bursaries and the subvention of artist-support organizations, the significance of Council purchasing was diluted (see 'Artists' Support Groups'). However, by the turn of the twenty-first century, the Councils, North and South, had acquired in excess of 2,000 works of art, with the consequential curatorial and storage responsibilities. Since 2000, in the face of rising maintenance costs, the ACNI has decided to disband its collection and to present it instead, at no cost, to accredited museums throughout Northern Ireland.

25. Fr Donal O'Sullivan speaking at the inauguration of the Exhibition Hall, Trinity College Dublin, 1967

Exhibiting art

Father Donal O'Sullivan, whose 'only interest was in promoting modern painting by young Irish artists' (C.S. Andrews, *Man of No Property*, Cork 1982, p. 294), achieved the appointment in 1961 of an exhibitions officer [25]. Finding that painting and sculpture had received a mere 13 per cent of the Council's funding over the previous decade, he persuaded the Council to increase this to 35 per cent in his first year as director, culminating in a 65 per cent allocation after five years. The exhibitions officer's role enabled the Council to contribute significantly to the public profile of the visual arts. The Council approached embassies in Dublin and encouraged international touring exhibitions to include Dublin in their itineraries. One such exhibition was *Art USA Now: The Johnson Collection of Contemporary American Painting* (1964, HL), a ground-breaking show for an Irish public isolated from international developments in the visual arts. The AC/ACE drew on members' personal contacts to bring about a major retrospective in the mid-1960s of the work of Francis Bacon (qv) and supported exhibitions in the Hugh Lane Gallery (HL) of the work of Irish artists Mary Swanzy and Louis le Brocquy (qqv).

Following the death of Gerard Dillon (qv) in 1971, James White proposed a retrospective exhibition to the ACNI, which would open in Belfast and then be shown in Dublin, and would have a catalogue that White himself would write. The Arts Council in Dublin, with Oliver Dowling as exhibitions officer, not only agreed but decided that in future a programme of annual retrospectives would be jointly organized by the two Arts Councils. There followed, from 1974, exhibitions devoted to Nano Reid, Colin Middleton, Patrick Collins, John Luke, Tony O'Malley, William Scott, Tom Carr (qqv) and Oisín Kelly (qv *AAI* III). These exhibitions and associated publications increased public awareness of the visual arts in the country, North and South, at a time when civil unrest over partition and the status of Northern Ireland as part of the United Kingdom was building in intensity.

The exhibitions required large-scale venues, such as the Ulster Museum (UM), the HL and the Crawford Gallery in Cork (CAG), so the fact that the Arts Council did not have its own gallery was not an issue. When the Council first moved its offices from 45 St Stephen's Green to 70 Merrion Square in 1959, the two large, first-floor reception rooms were adapted for exhibition purposes, and were so used until concerns about the load-bearing capacity of the Georgian building forced discontinuation of this arrangement. In the late 1970s the Council seriously considered setting up its own gallery, but opted instead to partner Trinity College Dublin (TCD) in the running of the new Douglas Hyde Gallery (DHG) there.

Professor George Dawson, a Council member from 1968 to 1973, was the driving force in providing an exhibition space in the new Arts Building, then under construction in TCD. He engaged enthusiastically with the Council to bring the proposed partnership into being. The DHG showed artists from abroad long before they had made their reputations, in the process building up an impressive international network. By catering for an informed visual arts public, artists themselves and students, the DHG is rightly considered to be an important contemporary gallery internationally.

During 1984 the government provided funds directly to the Royal Hibernian Academy (RHA) (qv) to enable the Gallagher Gallery to be completed. The Arts Council was persuaded, reluctantly at first, to engage with the Academy in subventing the running costs of the gallery. As relations improved between the Academy and the Council over the ensuing years, so did funding. By the time the Council celebrated its fiftieth anniversary in 2000/01, the annual grant to the RHA was in excess of €337,000, including a contribution to capital costs.

The Arts Council Gallery in Belfast played a central role in the exhibitions' programme of the ACNI for almost forty years. The first gallery was opened in the late 1950s with Ken Jamison as its exhibition programmer, assisted from 1966 by the painter Brian Ferran (qv). By the end of the 1960s, Jamison was director of the ACNI, to be succeeded in due course by Ferran. Both men played a crucial role, not only in leading the Council's work and in promoting the visual arts across the province for the remainder of the century, but also in enabling and developing a framework for collaboration between the two Arts Councils on the island. Practical engagement between the two Councils was

based at all times on collegial solidarity and mutual respect for political, cultural, legal and administrative realities on both sides.

In the early years of the ACNI gallery, the practice began of sharing the origination costs of exhibitions for Belfast by working in conjunction with commercial galleries in Dublin, the Hendriks Gallery in particular. Solo artists' exhibitions, seen in both Belfast and Dublin under this arrangement, included those of Victor Pasmore, Bridget Riley and Peter Sedgley, as well as a group show of kinetic art. These exhibitions also provided opportunities for social contacts between staff and members of both Councils and helped to develop a constructive working atmosphere between Dublin and Belfast. The ground was ready for a positive response to the suggestion, when it came, of collaboration in mounting the Gerard Dillon retrospective.

The ACNI Gallery in Bedford Street, Belfast, continued in existence, when it was believed that 'no private entity or voluntary consortium would undertake the endeavour' (Brian Ferran interviewed by the author, March 2010), until the early 1990s when it was damaged in a bomb blast. With the opening of the converted Ormeau Baths Gallery in 1995, the ACNI handed over the temporary exhibition role to a separate and autonomous board of trustees with its own director. In March 1996 this gallery won second place in Britain's National Art Collections Fund prize in recognition of its contribution to 'the increase of public enjoyment and awareness of the visual arts'. Despite this auspicious start, the gallery had a troubled history, leading to its closure in 2011.

Grants and bursaries

A significant development in the Republic resulted from a direct donation of money from William J.B. Macaulay, a former Irish Ambassador to the Vatican. In 1958 he sent a cheque for £20,000 to the Arts Council, an amount equal to the Council's annual state grant at the time. Macaulay's gift provided for a Council-run foundation to award fellowships to creative workers under thirty years of age in a number of disciplines, including painting and sculpture. The Macaulay Fellowship brought prestige, not only to the recipients over the years, but also to the Council itself. For many years it was the only form of direct grant assistance available to creative artists. The Council had decided, as a guiding principle in 1955, not to allocate any state funds for grants to individuals. In response to lobbying to provide assistance to the writer Patrick Kavanagh, the Council decided that 'The Director is to inform all individual applicants for financial assistance that the Council would not entertain such applications.' (Kennedy, p. 115)

Policy change on direct assistance to artists came in the wake of the 1973 Arts Act. A newly appointed Council, whose membership now included nine practitioners of the arts – amongst them two sculptors and a painter – decided that future policy would be informed by five broad guidelines. These included an intention to encourage creative artists by providing direct grant assistance to them. There followed a varied programme of bursaries, travel, studio and materials grants, and one-off awards across all art forms over the ensuing years. The grants are offered annually and applications are peer assessed by panels of practitioners. They have continued to be central to the Council's policy of supporting artistic practice.

However, the tendency to favour emerging artists through the competitive process needed to be adjusted. Furthermore, an annual framework for awards was not responsive to creative projects requiring a number of years of dedicated work. To build a greater public awareness of the economic realities faced by artists, the Council commissioned and published research on the living and working conditions of artists in the late 1970s (Irish Marketing Surveys, *Living and Working Conditions of Artists*, 1980), in addition to publicizing the recipients of its own awards and their artistic work. This was a prelude to the setting up of Aosdána (qv) in 1981.

Cultural advisor to the Taoiseach, Anthony Cronin sought a meeting with the director of the Council in 1980 at which he presented a list of writers whom he felt would not enter a competitive process for the bursaries offered by the Council. A different approach was needed to support established writers. The Council explored various options for a support mechanism. Recognition of excellence was to be the foremost consideration. It was also vital that an 'arm's-length' principle should apply, so that the state would not be seen to encroach on the creative independence of artists. The opportunity to set up a forum for discussion among artists was encouraged. All creative arts practices would be embraced in the new arrangements. Any financial dimension would be entirely separate from artistic considerations.

Aosdána

Aosdána was established as a self-governing voluntary body in 1981. The Council invited artists in all disciplines to apply for membership, and a sub-committee of the Council determined the initial membership, with subsequent admissions to be elected by Aosdána members themselves. Eligibility for nomination, requiring that 'the artist shall have produced a body of original and creative works of distinction in one or more of the following forms: literature (poetry, fiction, drama), visual art (painting, sculpture, printmaking, photography, film or video) and music' and should live on the island of Ireland was agreed by the members (Aosdána, Arts

26. Artist Tony O'Malley with President Mary Robinson, on his election as *Saoi* of Aosdána, 19 January 1993

27. Artists Barbara Allen, Catherine Brophy and Geraldine O'Reilly at the Tyrone Guthrie Centre, Annaghmakerrig, 1988

Council, Dublin 1987). Distinguished achievement is recognized by an honour known as *Saoi*, only seven of which are held at any one time [26]. To assist Aosdána artists financially, and to 'encourage and assist members in devoting their energies fully to their art' a scheme of *cnuas* awards (annuities) was instituted. The annual rate of *cnuas* in 1999 was £8,700.

With an upper limit of 200 on the number of members of Aosdána, by 1999 there were 84 visual artists (51 of whom received a cnuas), 76 writers (43 receiving a cnuas) and 17 composers (9 in receipt of a cnuas). These figures show the relative strength of the status of the visual arts in Ireland in comparison to the other art forms and how the situation of visual artists had improved over the latter part of the twentieth century. In his report *The Creative Imperative*, published by the two Councils in 2000, Professor Anthony Everett stated: 'Aosdána is a remarkable innovation in European arts funding and is recognized to have done much to enhance the status of artists in Ireland as well as providing practical support for ... visual artists ... in late and mid-career.' (Everett, p. 25)

Supported studios and residencies (see 'Artists' studios and residencies')
Another practical contribution to assist artists in their working lives arose from the development of the workplace retreat at Annaghmakerrig, Newbliss, Co. Monaghan. Because of the positive, informal contacts between the two Arts Councils during

the 1960s, the theatre director Sir Tyrone Guthrie offered to turn his family home at Annaghmakerrig into a retreat for artists, jointly managed by the two Councils. In 1966 both Councils agreed to this arrangement, but Dublin procrastinated, so Guthrie changed his will before he died in 1971, leaving Annaghmakerrig to the Minister for Finance in the Republic on condition that the costs of running it as a retreat for artists were met by the two Councils. Nothing happened until 1978 when the ACNI invited the Irish Council to a joint meeting in Belfast to discuss future co-operation, including possible arrangements for Annaghmakerrig [27]. A return meeting in Dublin led to a formal decision by the Minister for Finance, George Colley, to transfer Guthrie's house to the two Arts Councils and to its opening in 1981, with residential and working facilities for artists, including a painting studio and a sculpture workshop. Fully equipped workshops were generally beyond the financial reach of artists.

When the Dublin Graphic Studio was established in 1960, the Council provided a grant to cover losses. Later, when the Black Church Print Studio was founded to meet increased demand, the Council also gave financial support. Similarly, the ACNI set up the Belfast Print Workshop when it moved its premises to Riddel Hall in Stranmillis Road. In Cork, the AC/ACE agreed to cover the annual running costs of the National Sculpture Factory, when it opened in 1987 in a disused tramway building and grant-aided the purchase of heavy machinery. In the 1990s the Council acquired the lease of the Buckingham Street Fire Station in Dublin, with a view to housing the Artists Association of Ireland (AAI). The Council subsequently allocated money to support it as a centre for practising artists instead. With a board for the Fire Station Artists' Studios appointed initially by the AC/ACE, the enterprise was spearheaded by Mick Rafferty of the North Centre City Community Action Project and by Robbie McDonald. The Studios not only became a working space for professional visual artists, but a strong collaborative arts practice also developed with the local community of the inner city. From the outset, the Council and Leitrim County Development Board supported the Leitrim Sculpture Centre in 1997; a comprehensive range of workshops developed out of this initiative, led by the artist Jackie McKenna, including hot glass and ceramics facilities, serving artists from across the north-west region and beyond.

Funding for the arts
The 'infinitesimal' funding allocated by government to the Arts Council in Dublin in the 1950s led to a low public esteem for the arts. The first draft of the Arts Act had included a provision for a maximum government grant to the Council of £20,000, which represented a mere one and a half pence per head of population. Although this limit was not specified in the final statute, it took ten years before this level of funding was exceeded. Even in the economic climate of the 1950s, the Council's grant was, according to the *Irish Times*, 'a microscopic sum' (*IT* editorial, 22 December 1956) which did little for the Council's profile and credibility.

As the rising economic tide in the 1960s 'lifted all boats', the Council's financial position improved. By the general election of

1973 and the Arts Act of that year, the government grant to the AC/ACE had increased fivefold. The restructured Council received improved allocations, and some of the arts-related grants and resources previously administered by the Department of Finance and Bord Fáilte (the Irish Tourist Board) were transferred to the Council. In 1978 Council chairman Patrick Rock stated that the level of government funding in that year was equivalent to 50 pence per head of population, in contrast to Northern Ireland where it was 78 pence (Kennedy, p. 189). By 1981 government funding to the AC/ACE had more than doubled, and in 1984 stood at IR£1.39 per capita, although ACNI state funding was still ahead, at ST£1.86 per capita.

By the 1980s the Council's objective was for the arts to be seen as an integral part of the country's public administration, rather than consigned to a marginal 'elitist' role. Its own increasing credibility helped to 'mainstream' all arts disciplines but led, inevitably, to significant growth in the number of funding applications. Very soon demand outstripped available resources. As the government battled a 'double-dip recession' in the 1980s, the Council incurred its wrath when it planned to devote the cover of its 1984 annual report to a collage of press cuttings about the underfunding of the arts. Although the Council succumbed to political pressure and did not proceed with the intended cover, the media campaign which Adrian Munnelly (AC/ACE director, 1983–96) successfully embarked upon won widespread acceptance for the proposition that the arts were entitled to more financial support.

Although government arts grants had reached £2 per capita in 1989 and £3 per capita by 1992, these increases were undermined by inflation which meant that, year on year, grant aid was decreasing in real terms. In 1986 the Council submitted a five-year development plan (1987–91) to the Department of the Taoiseach. But although the government published a white paper on the arts in January 1987 which proposed 'a target of doubling (in real terms) of the Council's funding ... by 1990', this target was not met, perhaps because of the change of government later that year. Funding to the Arts Council was spread across responsibilities, of which the visual arts were only a part. Between 1951 and 1973 the visual arts absorbed 52 per cent of the Council's resources. This dropped to 15 per cent in 1975 and to around 9 per cent by 1995. However, these last percentages do not include expenditure on festivals, arts centres, local authorities and Aosdána, which include support to the visual arts.

Regionalization (see 'Regional developments')
Until 1973, 73 per cent of Arts Council funding was spent on arts activities in Dublin. The Council sought to redress geographic imbalance, firstly in collaboration with regional development organizations. Under Adrian Munnelly, the Council encouraged the appointment of county arts officers, starting with County Clare in 1985 [28]. This was followed in 1987 by a 'two-year arts development programme' jointly funded by the AC/ACE and Limerick Corporation. Munnelly patiently engaged with every local authority in the country. By 1999 a network of thirty-one local authority arts officers was in place, each with an arts funding programme. In an initiative to promote better provision for the visual arts, the Council assisted counties

Cavan, Kerry, Kildare, Limerick and Meath to develop visual arts strategy plans. Local authorities provided grants to local artists, as well as exhibition opportunities, contributing significantly to the well-developed infrastructure for the visual arts in Ireland, which Anthony Everett noted in *The Creative Imperative*. [29]

Long-term planning
By the end of the 1980s the status of the AC/ACE was well-established. However, when the Irish Museum of Modern Art (IMMA) was set up by the Department of the Taoiseach in 1991, Council involvement was not sought. Following the establishment of a Department of Arts, Culture and the Gaeltacht in 1993, with Michael D. Higgins as the first arts minister at cabinet level, the government recognized the strategic role of the Council. The Fianna Fáil/Labour Programme for government contained a commitment to an arts plan drawn up by the Council. That three-year plan (1994–96) set a funding target of £26.1 million or £7.2 per capita. The target took four years, not three, to realize in full but the forward planning approach was to become an engine for increased investment in the Council's work.

This first arts plan envisaged a 76 per cent increase in spending on the visual arts. Specifically noting that provision for the visual arts in Dublin outstripped that in the remainder of the country, the Council declared its intention to develop Cork City as a centre of excellence in this art form through a framework of support for the infrastructure, comprising, among others, the Triskel Arts Centre, the National Sculpture Factory, the Cork Arts Society, Blackwater Studios and the Cork Artists' Collective. While the Council's 'centre of

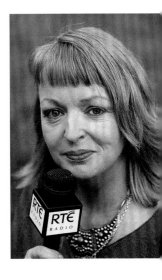

28. Kay Sheehy, Arts Officer, Co. Clare, 1985–88, the first such appointment to be jointly funded by a County Council and the Arts Council

29. Mural painted by children in collaboration with artist Helen O'Donoghue for the Murals in Schools Scheme, St Edmund's National School, Sligo, 1982

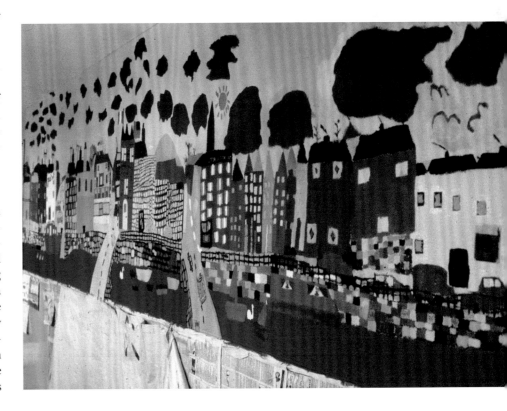

excellence' approach was mirrored, sometimes controversially, with emphasis on other art forms in particular cities, the development of the visual arts infrastructure in Cork proceeded successfully.

The ACNI also adopted a strategic approach during the 1990s. A five-year plan, *Towards the Millennium*, was published in 1995 and an Order in Council constituted the ACNI as a new statutory body, with its membership appointed by central government for the first time. Its autonomy was reasserted by a commitment to the arm's length principle of administration. In 1998 the Good Friday Agreement brought an end to direct rule from Westminster and with it the new Department of Culture, Arts and Leisure took over responsibility for the ACNI from the Department of Education.

Both Arts Councils in Ireland had the advantage of having particularly distinguished and articulate chairmen between 1993 and 1998. Ciarán Benson, professor of psychology at UCD and author of *The Place of the Arts in Irish Education* (1979), held the chair in Dublin while Donnell Deeny, Queen's Council at the Courts of Belfast, was appointed to the ACNI chair. Both engaged with great energy and understanding with their respective arts' sectors and also with local and national media.

Patricia Quinn, director in Dublin (1996–2004), had responsibility for developing the next arts plan, *The Arts Plan 1999–2001*, subtitled *A plan for government, a strategic framework for the arts* (1999). It targeted an increase in funding to IR£37.9 million by 2001 – IR£10 per head of population – which was met on schedule. In the new framework, the Council positioned itself as a development agency for the arts which would measure the impact of arts expenditure against targets agreed with funding recipients, having developed performance indicators and evaluation procedures for all its funding programmes. A radical departure from the annual budgeting cycle was introduced, with a move to multi-annual grant allocation to enable organizations to develop a strategic approach to their programming. During 2000 the Council moved over 30 per cent of recurring supports from one-year to three-year funding to arts organizations whose work 'represents the backbone of the arts in Ireland'. The new approach to funding caused antagonism from arts organizations that were not designated for the three-year cycle and difficulties for others that were included. For the AAI, originally set up at the instigation of the AC/ACE itself in 1981 as a membership services organization, such difficulties were to be terminal. The move, away from an annual grant 'hand-out' to an evidence-based approach, exposed frailties in the finances and governance of the Association which resulted in its demise.

In 1999 the Council bemoaned the recognized decline in the general quality of Ireland's architectural design in the latter part of the twentieth century 'due to international trends of short-sighted commercialism, and a deficit in public understanding of the value of architecture' (*The Arts Plan 1999–2001*, p. 32). Publications, exhibitions and award schemes funded by the Council had modest success in changing attitudes. In 1963 the Planning and Development Act had nominated the AC/ACE as one of four prescribed bodies to be informed by local authorities of relevant planning applications. The volume of work required

with the meagre resources available resulted in a 'hit and miss' approach by the Arts Council. Nevertheless, it became involved in a number of planning controversies concerning the demolition of heritage Georgian buildings in public ownership. The Council's engagement with planning matters ultimately led to the establishment of strong working links between the Council and the Office of Public Works, the Royal Institute of Architects of Ireland, the Irish Architectural Archive and the Heritage Council.

Under Patricia Quinn's directorship, the Council appointed the first architectural consultant, and architecture was given its own separate budget. The Council focused on four matters: Planning and Architecture, Education, Advocacy and Building for the Arts. In 1998 six architects were commissioned to design projects for a teenage audience on the theme of 'A Room of My Own', and an 'Architect-in-Schools' programme was initiated. In 2000 the Council co-funded, with the Cultural Relations Committee, the Irish Pavilion at the Seventh Architecture Biennale in Venice.

Over sixty years, the AC/ACE has achieved successful outcomes for the Irish public and for the visual culture of the country. Based on a British example, but using the state-sponsored body model, long established in Irish public life, to enable positive state engagement with both commercial and non-commercial activities, it represents one of the best examples of this approach. The Government Review of Arts Legislation – *Towards a New Framework for the Arts* (2000) – cites Council of Europe concerns that the 'arm's length' approach to the arts has inherent dangers: that cultural decision-making is withdrawn from genuine public view or accountability, with potential neglect by the government of a sector it does not directly control. Nonetheless, the Arts Act 2003 reiterated the independence of the Arts Council in allocating the monies voted to it by the houses of the Oireachtas; this had been one of the Council's strengths from the beginning. The Act also fine-tuned some structural matters for the Council, while clarifying, for the first time, the specific role of the Minister for the Arts.

The status, prestige and influence of the Council were enhanced after this legislation. Membership of the Council continued to be sought after. The professional knowledge and expertise of the staff of both Councils were invariably of a high calibre, and through a consistent policy of research, publications, seminars, public consultations and invited submissions from arts organizations, they established an ethos of constructive engagement with artists and arts organizations. Through a process of identifying their own responsibility for delivering specific objectives, commissioning performance studies and publishing the results, the Arts Councils have earned the respect and support of artists and arts practitioners, politicians and the wider public.

Whatever the challenges of the twenty-first century will be for stimulating and promoting the arts, including the visual arts, the Arts Councils have now established themselves as 'fit for purpose'. COLM Ó BRIAIN

SELECTED READING Bodkin, 1949; B.P. Kennedy, 1990; published papers and reports from the ACNI and the AC/ACE.

BACON, FRANCIS (1909–92) [30], painter. The acquisition, by the HL in 2000, of Francis Bacon's studio at Reece Mews, Kensington, London, was an important step in the recognition of this key twentieth-century painter in his native country. The careful reconstruction of the studio, along with its contents, was an ambitious project that attracted worldwide praise. Although Bacon had paid scant regard to his Irish birth and upbringing, much of his creative imagination can be traced to his childhood and adolescent years spent in Ireland. A nihilistic view of the world is central to Bacon's art, and the similarities between this bleak outlook, and that of his contemporary Samuel Beckett, are close. An admirer of James Joyce, Bacon was deeply interested in literature and film, and his paintings contain passages that could equally have found expression in a literary or cinematic context. He saw accident and risk as playing an important role in life and was fascinated by the animal and human body, by violence and transgression. At a time when it was illegal in Britain, Bacon was actively homosexual and this, coupled with his liking for haunts such as the Colony Room in London's Soho, meant that he acquired a reputation as a bohemian and a rake. In fact, he was a hard-working and dedicated artist, who kept his studio practice separate from his social life. He was self-critical, and while over 600 of his canvases survive today, many were destroyed, particularly works created before 1944. At the time of the acquisition of his studio by the HL, there was not one of Bacon's paintings in a public art collection in the Republic of Ireland, and only one, *Head II* (1949), in the UM in Northern Ireland. The HL collection now includes six unfinished paintings by Bacon, among them *Untitled (Self Portrait)* [31].

The contents of the studio, a chaotic mess of magazines, photographs, half-finished canvases and the detritus of everyday life, reveal much about Bacon's working methods and sources. He was interested in the photographs of Eadweard Muybridge, and in films such as Sergei Eisenstein's *Battleship Potemkin* and Luis Buñuel's *Un Chien Andalou*. Identifying with the doomed protagonists in the films of Marcel Carné, Bacon also revelled in the Expressionist freedom of Fritz Lang's *Metropolis*. In the spilt seconds of reality captured in photographic and filmic images, Bacon found not only intimations of mortality and the history of his own times, but also a visual language that he felt went to the heart of human psychology. Photographs and film stills inspired his tortured imagery. His visual sources ranged from newspaper photographs of victims of oppression, to grainy images of natural disasters. Specific passages in his paintings have been compared to photographs and scenes from films. Most famously, the release in 1956 of *Lust for Life*, Vincente Minnelli's film on Vincent van Gogh, spurred Bacon to create a series of imagined portraits of van Gogh. Such was the speed with which he worked, that when the portraits were shown in the Hanover Gallery, London in March of that year, the paint had not fully dried on the canvases.

Photographs were not the only visual source Bacon used. He was also deeply interested in the painting and compositional techniques of artists ranging from Velázquez and Michelangelo to Manet and the Post-Impressionists. From the outset, his art, while remaining figurative, was infused with the spirit of abstraction (qv). He preferred painting on to raw, rather than primed, canvas. His compositional devices also became standardized, with a single figure positioned in the centre of a pictorial space. The confines of this space are indicated by a backdrop, often of a uniform background colour, and by framing devices added to create a sense of depth. The floor upon which Bacon's figures stand or sit is often indicated in the form of a circular dais, or stage, such as might be found in the strip clubs of Soho.

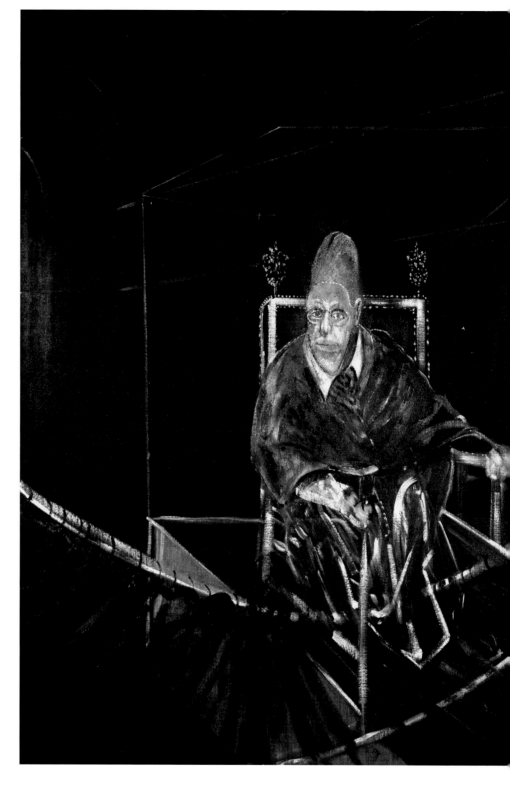

30. Francis Bacon, *Pope/Study after Pope Innocent X by Velázquez*, 1951, oil on canvas, 197.8 x 137.4 cm, Aberdeen Art Gallery and Museum

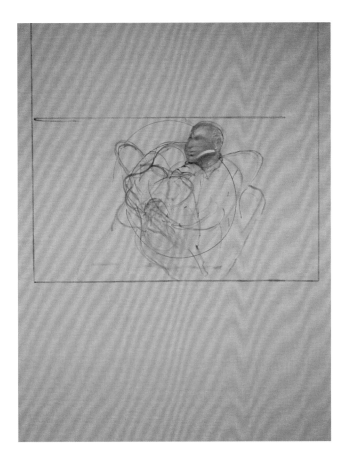

31. Francis Bacon,
Untitled (Self-portrait),
1992, oil on canvas, 198 x
147 x 2.5 cm, Dublin City
Gallery The Hugh Lane

During this period, Bacon worked as an interior designer, and an exhibition of his Modernist furniture and rugs was held in his studio flat in 1929. A participant in the thriving gay scene in London by 1930, he was part of an artistic set that included the Australian painter Roy de Maistre, and the collectors Samuel Courtauld, Michael Sadleir and Douglas Cooper. His interior design work was championed by Dorothy Todd, former editor of *Vogue*, and her lover Madge Garland. Although he began to enjoy success as a designer, Bacon turned increasingly to painting. In 1933 he moved to 71 Royal Hospital Road, Chelsea, and in October of that same year his *Crucifixion* was reproduced in Herbert Read's book *Art Now*, and shown in an exhibition at the Mayor Gallery where it was acquired by Michael Sadleir. Disillusioned by his lack of success, from 1935 Bacon gave up painting and spent his time in London's demi-monde, gambling and drinking. When war broke out, his chronic asthma meant that he was deemed unfit to join the armed forces.

In 1940 Bacon's father died. Both his brothers were also dead by this time, while his two sisters had moved to Rhodesia. Shortly afterwards his mother remarried and moved to South Africa. During the Blitz, Bacon worked in the Civil Defence Corps, until asthma forced him to move to Hampshire. In 1943 Graham Sutherland introduced him to Lucian Freud, and later that year Bacon, Eric Hall and 'Nanny' Lightfoot moved to 7 Cromwell Place, South Kensington, where a large billiard room at the back of the house served as a studio by day and an illegal casino at night. By April 1945, when he showed *Three Studies for Figures at the Base of a Crucifixion* (*c.* 1944) [41] and *Figure in a Landscape* (*c.* 1945, Tate) at the Lefevre Gallery, Bacon was becoming recognized as one of the most important young painters in England. By 1946, having shown several times at the Lefevre Gallery and enjoying critical and some financial success, Bacon was in Monaco, which was to remain his main residence for the next four years.

The first major institution to acquire Bacon's work was MoMA, New York, when in 1948 Alfred H. Barr Junior purchased *Painting* (1946). Another important museum acquisition was his 1952 *Study for Crouching Nude*, purchased by the Detroit Institute of Arts. After the death of Jessie Lightfoot in 1951, Bacon moved from his Cromwell Place studio and travelled extensively in Europe, spending time in Italy, Algeria, gambling in Monte Carlo, painting at St Ives (1959), and it was ten years before he acquired his permanent Reece Mews studio. Through the 1960s and '70s, Bacon was acknowledged as the leading artist of the 'School of London', and a major retrospective in 1962, curated by David Sylvester, brought him international fame. In the 1960s he produced many portraits of friends, mainly painting their heads. He preferred to work on particular themes, such as the Crucifixion or portrait heads, painting many works in a series, before moving on. The suicide of his lover George Dyer in 1971 resulted in more introspective works, many dealing with the theme of death.

Bacon remained ruthless in his critical assessment of his own work, and on his death a number of canvases remained in his studio with the heads cut out, ensuring that they could not be

Once adopted by the artist, this visual vocabulary remained relatively unchanged, even within the triptych format the painter often used.

Born in Dublin, to English parents, Bacon spent his childhood moving between Ireland and England. In 1911 the family was at Cannycourt House in County Kildare, where his father, a former officer in the British army, trained racehorses. Two years later, the family settled in London, where his father worked at the War Office. The year after the Armistice, the Bacons returned to Ireland, where Francis was sent to live for a time with his maternal grandmother, 'Granny' Supple, at Farmleigh in Abbeyleix, Co. Laois. They lived in constant fear that the house might be attacked by the IRA. In 1924 the family returned to England, to Gloucestershire, where Bacon was a boarding pupil at Dean Close School, Cheltenham. However after just two years they were back in Ireland, living at Straffan Lodge, near Naas. It was here that a row resulted in Bacon's tyrannical father expelling him from the family home after he had discovered the teenager wearing his mother's clothes. Bacon's mother gave him an allowance and at the age of seventeen he travelled to Berlin and then to France, living for a time near Chantilly, before settling in Montmartre in Paris, where he saw exhibitions of the work of Picasso, Soutine and de Chirico. In the late 1920s Bacon moved between Paris and Munich, but by the end of 1929 he had settled in London, at 17 Queensberry Mews West in South Kensington, where he was later joined by his former nanny, Jessie Lightfoot.

sold in future years. These mutilated works are a particularly poignant part of the HL Gallery's reconstruction of the artist's studio.

Bacon is represented in a great number of museums internationally, most notably Tate, Art Institute of Chicago, MoMA, Centre Georges Pompidou, Museum Ludwig in Cologne, Peggy Guggenheim Collection in Venice, as well as the national galleries of Japan, Australia, Canada, Spain, France, Germany and Scotland. PETER MURRAY

SELECTED READING Harrison, 1999; Grey Gowrie, Louis le Brocquy, Anthony Cronin, Paul Durcan, Margarita Cappock, David Sylvester, *Francis Bacon in Dublin*, exh. cat. HL (Dublin and London 2000); David Sylvester, *Looking Back at Francis Bacon* (London 2000); Michael Peppiatt, *Francis Bacon: Anatomy of an Enigma* (London 2008); Matthew Gale and Chris Stephens (eds), *Francis Bacon* (New York 2009).

BALLAGH, ROBERT (b. 1943), painter, designer. Born in Dublin, where he continues to live, Robert Ballagh studied architectural draughtsmanship initially and played in a successful show band, The Chessmen. In 1967 he made an assertive arrival to the visual arts with a successful entry into the IELA (qv), followed by a solo exhibition at the Brown Thomas Gallery two years later. Ballagh's first works were remarkable for the independence of spirit they displayed. Ignoring the Irish penchant in the 1960s for academic art in the style of Paul Henry and Seán Keating, and the Cubist-inspired Modernism (qv) of Cecil King and Micheal Farrell (qqv), he threw down the gauntlet at artistic pretension by making artwork from the least stylish of new materials to form objects in a jubilantly new pop-art language. His IELA entries, *Pin Ball* and *Torso*, spoke unashamedly to younger, urban audiences, displaying a confidence and self-belief especially unusual among self-taught artists.

To compensate for his lack of academic training, and encouraged by the first *Rosc* exhibition (qv) in 1967, he boldly employed techniques more familiar to graphic designers and the advertising industry than to fine art, as the basis for his early work. The result was a series of large-scale paintings of everyday objects, for example *Dolly Mixtures* (1968) [382] and *People looking at Paintings* (1974–75), some of which were displayed in the headquarters of the Bank of Ireland, Baggot Street, and in a supermarket in Clonmel, Co. Tipperary, as well as in the David Hendriks Gallery until the death of the owner in 1983. His work, even at that early stage, was guided by a desire to be accessible, as was his commitment to exhibit his work beyond the hallowed precinct of the gallery. While Ballagh's work has always been political in the broadest sense of the word, following the outbreak of the 'Troubles' in Northern Ireland in 1969 he began to tackle social and political issues more overtly, making artwork about civil rights' transgressions, not just in Ireland, but all over the world (see 'The Troubles and Irish Art' and 'Politics in Irish Art'). Worried that his pop re-creations of famous 'political' paintings by Goya, David and Delacroix in 1970 were not understood when shown at venues in the Republic and Northern Ireland, Ballagh issued a pamphlet, describing his intentions, but was forbidden to hand out copies at Dublin's HL. In 1972,

shocked at the British Army's shooting of thirteen civilians during an anti-internment march in Derry, he made more explicit work in chalk and blood on the floor of the Project Arts Centre [32] and assisted Brian O'Doherty/Patrick Ireland (qv) in his famous name change [337, 379], in protest at the presence of British troops in Northern Ireland. Other socially engaged work followed, some of it allied to campaigns to free political prisoners such as Nelson Mandela and the Birmingham Six. Simultaneously, Ballagh painted images in which he set out to demystify the role of the artist in Western art and to overturn traditional presentations of masculinity and femininity (see 'The Body'). The 'Number 3' paintings (1977–82, UM and other collections), depicting the artist himself and/or members of his family, are examples of this, as are such paintings as *The Conversation* (1977, private collection), in which he is seen talking to the Dutch seventeenth-century painter Vermeer.

An important strand of Ballagh's work has been his portrait practice (see 'Portraiture'), some of it in response to commissions but other works, like his portrait of the politician Dr Noel Browne [389], and his posthumous portrait of his friend and first mentor Micheal Farrell, were painted because it is a form of expression that he enjoys and to which he brings considerable sensitivity, frequently enriched by a sense of humour. 'I've always enjoyed "quotation"; the concept of a play within a play', he told Brian McAvera (*IAR*, Autumn 2006, 71). This is particularly evident in his portraits of Micheal Farrell where the legs are left drawn but unpainted, in mimicry of Farrell's own work, or in his portrait of former Taoiseach Charles J. Haughey [111], in which the man is dwarfed by one of his own political images, the scale of which clearly exposes the process of political myth-making. It is because of his love of puns and humour that Ballagh is drawn to the work of Laurence Sterne, James Joyce and Joseph Sheridan Le Fanu, whose portraits also feature in his work. The first portraits were commissioned by Ballagh's friend, the collector Gordon Lambert; Ballagh's portrait of Lambert [400] employs such techniques from advertising as the silk-screen

32. Robert Ballagh, *Northern Ireland, the 1,500th Victim*, 1976, print with incised sanded surface, wax, edn 4/5, 27.5 x 50 cm, Irish Museum of Modern Art

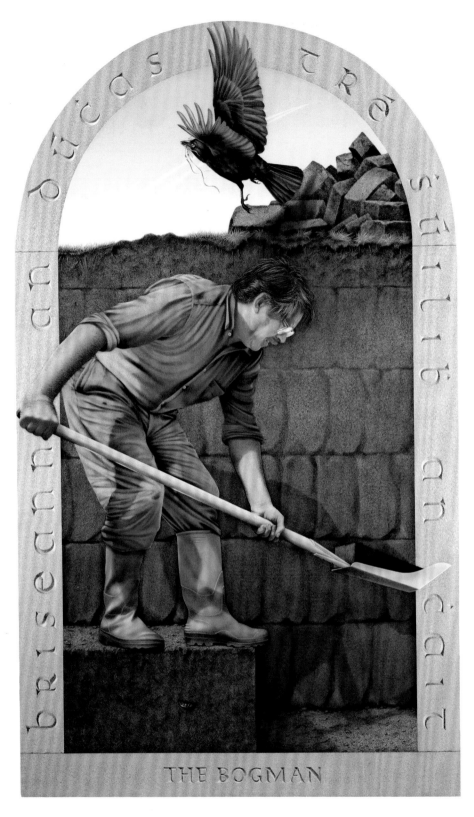

33. Robert Ballagh, *The Bogman*, 1997, oil on canvas, 200 x 122 cm, private collection

the other was a pillar of academia. Perhaps it is in his self-portrait *The Bogman* [33] that the puns are most obvious. Ballagh casts himself as a man carefully cutting turf, but the relationship of the man to a bird above his shoulder reminds the initiated of the Oliver Sheppard statue of Cú Chulainn, legendary hero of Ancient Ireland, in Dublin's General Post Office. This, combined with the activity, the rural setting, and the inscription in Irish which frames the image, suggests that when this work was painted, Ballagh, the Modernist, was ready to embrace his Irish heritage in its totality.

Alongside his role as a painter, Ballagh has enjoyed a distinguished career as a designer. Ever since the early 1970s, the state has favoured him with commissions for postage stamps and banknotes. Unsurprisingly, these have given Ballagh an opportunity to combine national heritage with a celebration of new technologies and to project a modern image of Ireland. In 2003 he was called upon to design the stage setting for the Special Olympics Summer Games in Dublin's Croke Park. Corporate commissions include his much-acclaimed designs for *Riverdance*, and he has designed stage sets for plays by Samuel Beckett and Oscar Wilde.

Despite official commissions, Ballagh successfully challenged the Irish government in the courts for its failure to implement an EU directive about Artists' Resale Rights in 2006. Throughout his career he has been an active campaigner for improved conditions for artists, and was a founder member of the AAI, a member of the International Artists Association, and its treasurer for several years. He is also a member of Aosdána (qv). Ballagh's work can be seen in the collections of IMMA, NGI, HL, CAG, UM and the Albrecht Dürer House, Nuremberg. He has had solo exhibitions in Cork, Dublin, Lund, Moscow, Sofia and Warsaw.

Ballagh has been the subject of a BBC documentary, directed by Paul Muldoon, and an Irish-language film *Robert Ballagh*, directed by Anthony Byrne (Igloo films, 2001).
CATHERINE MARSHALL

SELECTED READING Catherine Marshall, 'Choosing the Battleground: Robert Ballagh's Paintings', *IAR Yearbook* (1996), 147–55; *Portrait of the Artist: Micheal Farrell and other works by Robert Ballagh*, exh. cat. CAG (Cork 2003); Peter Murray, 'The Portraits of Robert Ballagh', *IAR*, xx, no. 3 (2003), 74; Ciarán Carty and Declan Kiberd, *Robert Ballagh, Artist and Designer: A Retrospective*, exh. cat. RHA Gallagher Gallery (Dublin 2006); Ciarán Carty, *Robert Ballagh: Citizen Artist* (Queensland 2010).

BELTON, LIAM (b. 1947) [34], painter. Born into a Dublin business and political family, Belton received his early education with the Christian Brothers at Synge Street, before going on to attend NCA. Both Belton's father, and his paternal grandfather, had studied at this same college. In 1966, in common with third-level institutions throughout Europe, the NCA was struggling to cope with a post-war generation that had rejected both authority and tradition. A series of sit-ins and occupations led eventually to the college's closure for almost a year. The demands of the students were finally met and the constitution of the college now incorporates innovations fought for by Belton and his

print, the cut-away frame and a cast of the sitter's hands, made by the sculptor Brian King (1975). The positioning of the writer J.P. Donleavy in Ballagh's 2006 portrait pays humorous homage to Edward Maguire (qv), with whom Ballagh has been compared, ironically, since the latter is defiantly self-taught, while

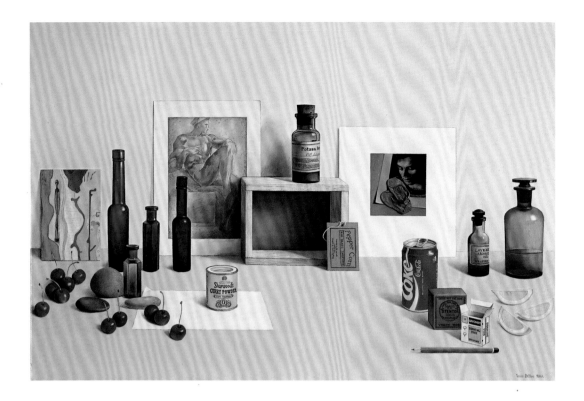

contemporaries, most notably an independent board. Belton remained a student at NCA for six years (1966–72), firstly in pre-diploma and then in the School of Painting, under Professor John F. Kelly.

After leaving college in 1972, Belton taught art at St Joseph's School for the Visually Impaired, in Drumcondra, for twenty-three years, as well as teaching evening classes at the Technical Institute on the North Strand. In persevering with these teaching jobs, Belton was motivated by the same political beliefs that had activated his protests at art college. Elected a member of the RHA (qv) in 1991 and appointed Keeper four years later, he played an active role in re-establishing the Academy's schools.

Belton's carefully crafted realist paintings often take the form of still lifes, with objects arrayed on a table. The objects depicted frequently refer to aspects of history and ancient civilizations. In *Time and the Hour*, painted in 1985, Belton painted a series of objects placed on a windowsill in a derelict house, among them pebbles, an ink bottle and a clock. In a series of large canvases such as *Continuum* (1997), *Equus* (1999) and *Perpetuum* (2000), objects such as eggs, fragments of Greek or Etruscan statues, and archaic pottery vessels appear in more than one painting. He also paints landscapes, inspired by Neolithic monuments such as Newgrange. In spite of his early rejection of antiquated approaches to art education, it is clear that in his analysis of form, careful employment of tonal values, and sparing use of colour, Belton asserts his commitment to Classical traditions in art. His approach to his own art is as methodical as his analysis of the role of art in society.

Belton is represented in the collections of the UL, AIB, OPW and Greyfriars Municipal Art Gallery, Waterford, as well as in many private collections. PETER MURRAY

SELECTED READING Peter Murray, 'A Transcendental Timelessness: The Paintings and Sculptures of Liam Belton', *IAR* (Summer 2001), 133–45; OPW, 2001.

BEWICK, PAULINE (b. 1936) [35], painter, illustrator and author. Perhaps the most interesting aspect of Pauline Bewick's career is her ability to engage with the arts in their broadest application. Familiar to a wide public as an illustrator and a painter, she has also applied her creative energies to printmaking (qv), sculpture in bronze and ceramic, as well as writing, and, since 2000, she has begun work on an opera. Bewick's ability to tackle projects that other artists might shy away from undoubtedly derives from two things: an unusual childhood, spent in Ireland, Wales and England, which involved living in a caravan, a houseboat and a railway carriage, as well as in more conventional houses, and the unstinting encouragement she received at all times from her mother, Harry.

Bewick's artwork has always had considerable popular appeal, especially as disseminated through her publications and illustrations, which began in 1955 with a commission to illustrate Thomas Kinsella's poems for the Dolmen Press and a children's story, *Little Jimmy*, for the BBC. Since then she has collaborated with Ulick O'Connor and with the poet Rita Kelly, who in 2001 wrote *Kelly Reads Bewick*, in which the poet interprets the artworks. In 2007 Bewick illustrated, in both print and tapestry, the seventeenth-century Irish poem *Cúirt an Mheán Oíche* (*The Midnight Court*) by Brian Merriman. Her own published books, which combine writing and illustration, include *South Seas and a Box of Paints* (London 1996) recording a year in the South Seas, and *The Yellow Man* (Dublin 1995) about an idealized man. Her painting has always remained figurative. Art

34. Liam Belton, *He had Diamonds on the Soles of his Shoes*, 1997, oil on canvas, 61 x 91.5 cm, private collection

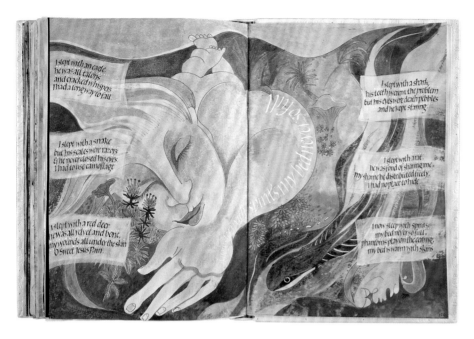

35. Pauline Bewick, illustration from *The Great Book of Ireland*, a vellum manuscript edited by Theo Dorgan and Gene Lambert, bound by Anthony Cains, 1991, University College Cork

critic Dorothy Walker, writing in 1980, noted that 'Bewick's paintings and drawings fit into the renewed interest in narrative painting; her work has always looked as if waiting for a suitable story-book' (Walker, 1980, 106, 110–11).

Although her work has not been widely collected by the national art institutions, in 2006 the state accepted a donation of 500 artworks from the artist, the majority of which are housed at the Waterford Institute of Technology and in public offices in County Kerry. An exhibition, *Two to Fifty*, was shown at the Guinness Hop Store, CAG and the UM in 1985. Bewick is a member of Aosdána (qv) and is the subject of a documentary film by David Shaw Smith. CATHERINE MARSHALL

SELECTED READING James White, *Pauline Bewick: Painting a Life* (Dublin 1985); Alan Hayes (ed.), *Pauline Bewick's Seven Ages* (Galway and New York 2005); Pauline Bewick official website, http://www.paulinebewick.com.

BLACKSHAW, BASIL (b. 1932) [36, 37], painter. An artist who has always followed his own instincts, Basil Blackshaw can best be described as a lyrical Expressionist (see 'Expressionism and Neo-Expressionism'). Hovering between figuration and abstraction (qv), his paintings are at once exuberant and playful, controlled and chaotic. His work can be compared to that of Patrick Collins or Charles Brady (qqv) in its intuitive use of colour, strong sense of composition, and simultaneously loose but controlled handling of paint. Blackshaw's art lacks the angst and alienation often found in the work of painters of his generation, while he equally avoids the social commentaries that form a central part of the work of younger contemporaries such as Patrick Graham or Brian Maguire (qqv). Although he has never visited the United States, his gestural brushstrokes evoke the work of the Abstract Expressionists, as exemplified in paintings such as *The Liffey* (1977). At its most lyrical, Blackshaw's approach to painting is reminiscent of Cy Twombly. He himself admires the work of Georg Baselitz, and the unexpected twists, turns and occasional tilts in his paintings are reminiscent of Baselitz's upturned world.

In the introduction to Eamonn Mallie's monograph on Blackshaw, Brian Fallon gave a perceptive appraisal of the artist: 'We are dealing with a very special case: an artist who is simultaneously straightforward and sophisticated, folkish and ultra-contemporary, with deep roots in tradition and yet with antennae sensitized to the present and its vibrations. He is original without being revolutionary, continually searching without being outwardly challenging, combining a blunt earthiness with temperament and imagination.' (Eamonn Mallie (ed.), *Basil Blackshaw*, Mallusk 2003, p. 25) Fallon praises Blackshaw's ability to combine his local roots with the wider European artistic tradition, his command of draughtsmanship, coupled with an ability to handle paint, and acknowledges that Blackshaw's work is therefore difficult to categorize, concluding that 'he is like nobody except himself'.

Blackshaw has remained something of an outsider in the wider art world, possibly because of his reluctance to travel far from his home in County Antrim. He is celebrated in both Northern Ireland and the Republic, but rarely shows in London or other international centres. His development as an artist has been uneven, with changes dictated by his own wish to explore new approaches, rather than by any settled pattern. As S.B. Kennedy points out, unlike Paul Henry, Gerard Dillon or George Campbell (qqv), Blackshaw has continually developed and reinvented his approach to painting, with the result that his paintings from the 1990s and from the first decade of the twenty-first century are free of any sense of repetition.

Although his approach and style may have changed, there is a consistency in the subject matter. Apart from landscape (qv), horses, dogs and birds often feature, while the female nude is a recurring motif, with many of his paintings featuring the same model, Jude Stephens. Blackshaw's portraits, often depicting artists and writers, are fine works of art, expressive and free, yet also conveying a real sense of the presence of the sitter. His portrait of the novelist Jennifer Johnston, painted in 1973, is in the Ulster Museum. He has also painted portraits of Douglas Gageby, David Hammond, Brian Friel, Michael Longley and Ted Hickey. His method of working is to create an image from observation, then almost totally obliterate it, before recreating it as a painting. In his landscapes, sometimes an individual building will become a focal point, as in *The Barn (Blue II)* (1991/92, NMNI collection). One of his largest works, *Grand National (Foinavon's Year)* (1977, private collection), depicts a melee of horses and jockeys at one of the jumps at Aintree – a subject close to the artist's heart because Blackshaw trained horses professionally.

Born at Glengormley House, Co. Antrim, the son of a horse-trainer who had moved from Derbyshire to Ulster, Blackshaw attended Belfast College of Art from 1947 until the early 1950s and was taught by Romeo Toogood, a member of the progressive Ulster Unit. Blackshaw's early paintings were a conscious attempt to emulate the work of Franz Marc and Oskar Kokoschka, although he was also an admirer of the work of the Academician Alfred Munnings. A fellow student was T.P. Flanagan (qv) with

whom Blackshaw, in later years, continued to share an eye for the everyday and an appreciation of nature and landscape. In 1951 Blackshaw received a CEMA scholarship which enabled him to travel to London and Paris and familiarize himself with post-war British and French art. When he returned to Northern Ireland, his work was first shown in a joint exhibition in 1952. This was followed by a solo exhibition, held two years later, under the auspices of the Belfast Museum and Art Gallery authorities.

Championed by the writer and critic John Hewitt, Blackshaw's painting *The Field* (1953) was acquired by the UM while his *Dromara Landscape* was purchased by CEMA, which also sponsored his second solo exhibition the following year. He was married for a time to the Australian abstract painter Anna Ritchie, and painted a number of portraits of her. He showed jointly with Ritchie at the Hendriks Gallery in 1960, but their marriage broke up in the years following.

Blackshaw showed work at the IELA (qv) in 1955, where the Haverty Trust purchased the painting *Landscape for Melodeon Music*, and he showed at the IELA again from 1959 to 1961. A gap in his output lasted until 1971 when he again submitted work to the IELA. Three years later his first retrospective was held at the Arts Council Gallery in Belfast. He also had regular selling shows at the Hendriks, Caldwell and Kerlin galleries and built up a devoted following among collectors. Although Blackshaw was included in the Rosc exhibitions (qv) of 1971, 1980 and 1988, and was recipient of the IMMA/Glen Dimplex Award for a sustained contribution to Irish art in 2000, appreciation of his work remains largely confined to Ireland. He was represented in a *Young Contemporaries* show at the Leicester Galleries in London, and his work was included in *The Delighted Eye*, a group exhibition shown in London in 1980. He also participated in the *Six Artists from Ireland* exhibition, curated by Dr Frances Ruane, which toured to several European countries in 1983. That year also, a fire in his County Antrim studio destroyed many of his paintings, but with the support of his partner Helen Falloon, he was able to resume working, and the tragedy ultimately provided him with the impetus to bring his work in a new direction.

A retrospective exhibition of Blackshaw's paintings was held at the Ormeau Baths Gallery in 1995 and at the RHA Gallery in 1997, confirming his place as a leading contemporary Irish artist. Five years later a valedictory exhibition was held at the UM to mark the artist's seventieth birthday. This latter show contained several large canvases, based on the motif of the window, which are among the most impressive paintings created by the artist. In 2008 four paintings from this window series were donated to IMMA by the family of the late Vincent Ferguson, while in 2012 an exhibition to celebrate his eightieth year was held at the F.E. McWilliam Gallery and Studio, near Belfast, and at the RHA.

Blackshaw's work can be found in the collections of the NSPC, ACNI, AC/ACE, HL, TCD, BoI and AIB. PETER MURRAY

SELECTED READING Brian Ferran (ed.), *Basil Blackshaw: Painter* (Mallusk 1995); S.B. Kennedy, *Basil Blackshaw: Paintings 2000–2002* (Belfast 2002); *Blackshaw at 80*, exh. cat. F.E. McWilliam Gallery and Studio (Banbridge 2012).

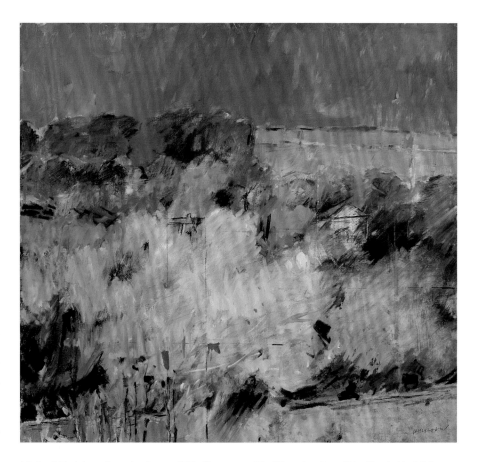

36. Basil Blackshaw, *Green Landscape*, 1980, oil on canvas, 70 x 76 cm, Arts Council/An Chomhairle Ealaíon

37. Basil Blackshaw, *Red Barn*, 1991, oil on canvas, 61 x 51 cm, Dublin City Gallery The Hugh Lane

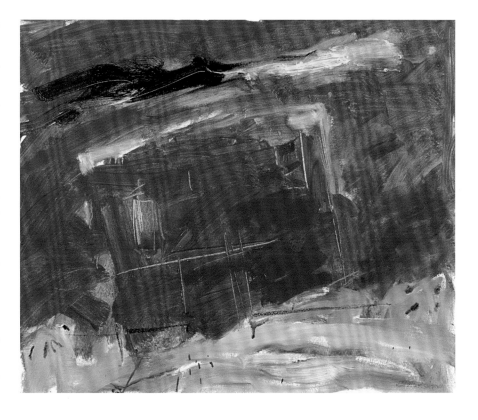

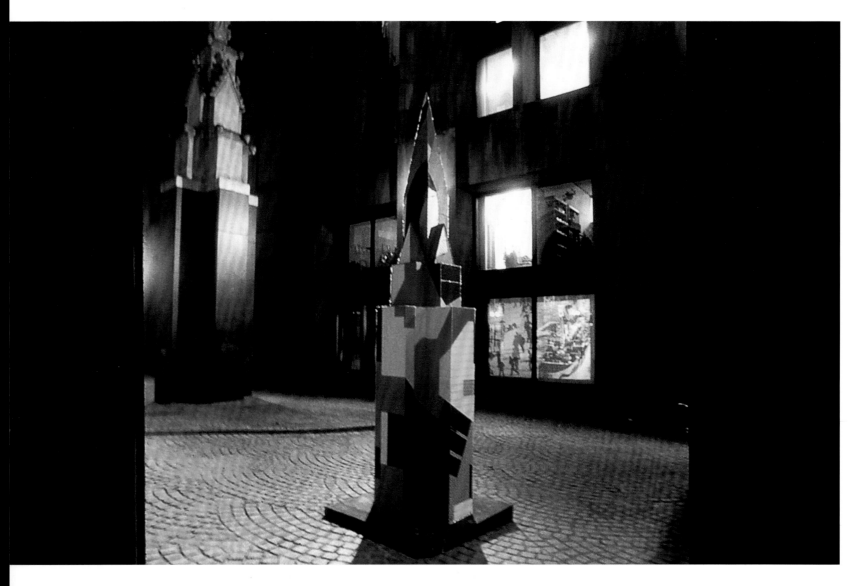

BLUE FUNK (1989–94) [38, 39] was a group of artists, recently graduated from the National College of Art and Design, who collaborated, initially to establish a studio and, later, to explore identity politics and the use of 'time-based' media (see 'Time-based Art'), being aware of the aesthetic impact of the intermixing of these concerns and technologies and of similar developments abroad. The group was made up of Evelyn Byrne, Valerie Connor, Brian Cross (until 1991), Tom Green, Brian Hand, Jaki Irvine (qv) and Kevin Kelly. The name of the group, from the dictionary definition: 'Brit, n. inf. a state of Great Terror', offered a coded signal of the group's intention:

> ... to address statutory and folk myths generated by questions of identity in gender, class, and nationality against an historical background. Throughout the history of the state, the debate surrounding art and politics has rested primarily in literary fields. Blue Funk aims to enter this debate through exhibitions and approaches to questions about the interrelationships of art, the artist and contemporary Irish society.
> (Blue Funk press statement, http://www.theartistledarchive. com, accessed 23 April 2012)

The group was committed to the use of time-based media, accepting the political implications of this, in the belief that they offered the most suitable vehicles for complex concepts. Its emergence reflected a new emphasis on critical, post-colonial, psychoanalytic and film theory at art colleges in the 1980s, which in turn was reflected in the group's clearly articulated press statements and exhibition proposals. The strategy was two-fold: to set up a studio to facilitate work in new media and to hold exhibitions (see 'New Media Art').

Blue Funk first came to public attention through its exhibition *Ekker*, curated by Tom Weir, at the City Centre Art Gallery, Dublin, in 1991, which travelled to the Institute of Contemporary Art in Perth and other Australian venues in the same year. It was assisted in this by Noel Sheridan (qv) and Joan Fowler. A showing of the group's work, *A State of Great Terror*, at the DHG followed in December 1992, and Blue Funk was invited to participate at *Sonsbeek '93*, curated by Valerie Smith in Arnhem, the Netherlands, an exhibition described by critic and artist Dan Cameron as 'one of the most serious and uncompromised attempts to provide a context for contemporary art that I have lately come across' (Cameron, 'Sculpting the Town', *Artforum*, November 1993). In a forum that included Miroslaw Balka (Netherlands), Ann Hamilton (USA), Juan Muñoz (Spain), Vong Phaophanit (Laos) and Mark Quinn (Britain), Cameron considered the work of Blue Funk to be among the more ambitious pieces. In the same year, participation in *Other Borders*, Grey Gallery, New York, drew press attention in the USA.

Although the group was short-lived, its influence in Ireland was considerable. This was especially evident in the art colleges and on later organizations like Critical Access, and was sustained by the members' individual practices and published writing. In 1998/99, *c oblique o: a film for Evelyn Byrne* (who died in 1993 from cystic fibrosis), was shown at the Irish Film Institute, Dublin, Centre Culturel Irlandais, Paris, Mount St Vincent University Gallery, Halifax and the Galway Arts Centre.

CATHERINE MARSHALL

SELECTED READING Joan Fowler, *Blue Funk: Ekker* (Perth 1991); Aidan Dunne, 'A shared belief that things are not as they seem', *IT* (1991); Elizabeth Hartigan, 'Blue Funk', *Portfolio*, no. 1 (Kinsale 1991); Paul O'Brien, 'Blue Funk: City Arts Centre Gallery', *Circa* (Nov./Dec. 1991).

THE BODY (see *AAI* III, 'The Nude'). How the body is represented in art depends on how art is defined at particular moments in history. The body in classical art is idealized, controlled and perfected. It represents the view that art should elevate the body and the mind, that artifice must improve nature. The body in Modern and Postmodern art (see 'Modernism and Postmodernism'), in contrast, is typically brutally realistic or dramatically distorted for psychological effect; in both, it is frequently erotic since eroticism offers a means of exposing the ambitions and vulnerabilities of society at large as well as the individual human psyche. In modern art, social change and existential angst are given voice through images of the body, whether as hero, fallen woman, totemic family or the flesh itself. In Postmodern art, corporeal imagery and socio-political concerns are extended as artists increasingly use new art forms to explore sexual, racial and gender politics.

Accordingly, the body in Irish art has mirrored the Irish body politic. It appears in many stylistic schools and genres – but all the time Irish artists have used it to examine a changing society. History, religion and subjectivity are all interwoven through representations of the body, allowing tradition and modernity, the sacred and the profane, private and public identities, to be mapped out on its contours. The Irish Self, represented in male and female forms, shifts as Ireland's history shifts: from Celticism to Anglo-Norman colonization, from industrial advance in the 1920s to the battle for civil rights in Northern Ireland in the late 1960s, to the rise of a feminist art movement in the 1980s and then post-modern pastiche as Irish artists reflect on the tension between the national and transnational. If, as Seamus Heaney once wrote, the Irish personality is 'full of impacted history, impacted Christianity, impacted self-denial', it is a personality which may be repressed in society but finds a voice in Irish artists' work (Maguire et al, 35).

Though wonderfully diverse, two dominant characteristics may be identified in Irish artists' depictions of the body: firstly, the representation of Ireland in corporeal and gendered terms as an exposed nude (usually female) body, braving the past and future, or specifically, as Aoife, Roisín or Mother Ireland; secondly, a consciousness of the geopolitical position of the Irish artist, fusing the local and the global, adapting international styles or concerns to the peculiarities of the Irish cultural arena – for example, in the Cubist Madonnas of Mainie Jellett (qv) or the Surrealist-influenced sculptures of Dorothy Cross (qv) (see 'Cubism' and 'Surrealist Art').

While the rich Celtic tradition in visual art declined under English – and then British – colonial rule, in the eighteenth century an internationally oriented, neoclassical fine art emerged in the work of Irish painters such as James Barry (1741–1806). Barry stands at a turning point in Irish art history, having mediated between his Irish, Catholic self and Ireland's ruling neighbour, and he was one of the few members of the Royal Academy (RA) to turn to the nude as a potent ideological referent in history painting (qv). Barry's painting *The Education of Achilles* (1772) demonstrates his Hellenic belief in the didactic role of the body in art, suggesting a close relationship between virtue and patriotism, in keeping with the enlightened debates of the period, but with Irish nationalist overtones. His reference to Minerva, the goddess of wisdom, poetry and magic, carved into the plinth behind the centaur, may be interpreted as an effort to link ancient Greece and Egypt with ancient Ireland through the educated, virtuous female form. Hence, he alludes to an alliance that covertly challenges Britain's colonizing mission in Ireland and, by extension, the RA, where the painting was first exhibited (Cullen, 1997, pp. 27–30).

The nineteenth century witnessed what Thomas Crow has termed a 'masculinization' of human qualities in cultural, political, civic and military spheres (Crow, *Emulation: Making Artists in Revolutionary France*, 1995, p. 2). Such gendering was evident in the work of artists such as Daniel Maclise (1806–70), also born in Cork and also a member of the RA. Maclise's highly academic history painting *The Marriage of Strongbow and Aoife*

38. Installation on Bobkin Lane from *Other Borders*, Grey Art Gallery, New York, 1993, video projection, ambient audio and speakers, wood, rubber

39. *A State of Great Terror*, Douglas Hyde Gallery, 1992, video projection, monitors, synchronized audio, still and synchronized carousel projectors, shuttle projector, text

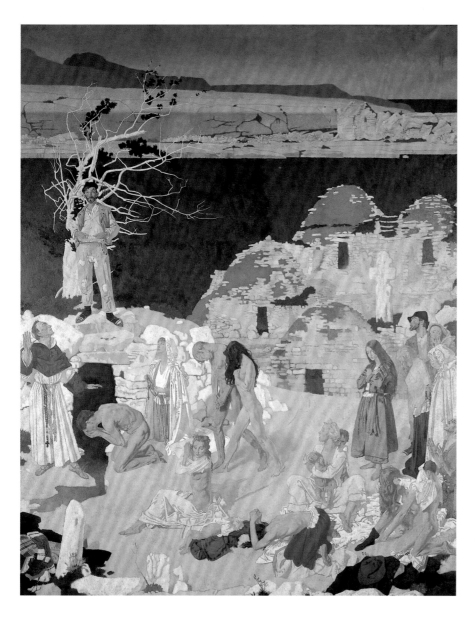

40. William Orpen, *The Holy Well*, 1916, tempera on canvas, 234 x 186 cm, National Gallery of Ireland

virginal white and patriotic green, with eyes downcast, she arguably stands as a victim in the new political arrangement – a sense compounded by the pathos of a bare-breasted woman in the left foreground, who pleads to the heavens with her arms outstretched, as if in a crucifixion, and with a dead child in her lap. As Brian Fallon has noted, her dramatic pose is reminiscent of Delacroix's monumental painting *Massacre de Scio* (Chios) of 1824 (Fallon, 1994, p. 36). That depiction of a bloody episode in the contemporary Greek war of independence is often said to have typified French antipathy toward the Ottoman Empire.

Thirty-two years after Maclise painted Aoife as a kind of Mother Ireland, the young Roderic O'Conor (1860–1940) arrived in Paris to a city full of bustling promenades, grand department stores, bourgeois entertainments and bohemian desire. Trained at the Metropolitan School of Art and the Royal Hibernian Academy (RHA) (qv) in Dublin, and at the atelier of Charles Auguste Emile Durand in Paris, O'Conor's *Reclining Nude Before a Mirror* (1909, NGI collection) recalls earlier works, bearing a marked resemblance in the pose to Diego Velázquez's *Rokeby Venus* (1647–51) and to Edouard Manet's *Olympia* (1863) in the rendering of the sheets upon which the nude reclines. However, O'Conor portrays his nude in warm, *intimiste* tones, her head and pubic hair being highlighted by the strong natural light reflected in a mirror that acts as a formal, not allegorical, device. His later nudes are even more realistic, such as *Reclining Nude on a Chaise Longue* (1915) where the model is sleeping, or *Nu Allongé* (1924), where the viewer's gaze is directed downwards onto the woman's back. In O'Conor's nudes we are presented with real women (often modelled by his mistress Renée Honta) in contemporary settings, portrayed in Expressionistic, *impasto* brushstrokes.

European art during and after World War I was shaped by various, often competing forces: a return to pastoral regionalism, a machine aesthetic, and a transgressive, international avant-garde. In Irish art, a tension between rural landscape, urban modernity and the body was evident. In *The Holy Well, Ireland* (1916) [40], the interest of William Orpen (qv) in the Gaelic Revival was evident in his depiction of Ireland as a group of figures in various states of undress, apparently tormented by sin, and seeking forgiveness from a priest. The composition centres on a couple like Adam and Eve, ashamed of their nakedness, stepping uncertainly towards the future or trying to shed their pasts, and flanked by a dozen others who will presumably follow their path. Ireland is portrayed with heavy symbolism as a collection of wretches in a primitive landscape of rocks and beehive huts. But the scene is surveyed by a cipher of the modern Ireland which was to begin emerging in the Easter Rising: a young Gael stands, fully dressed and in a commanding pose against the horizon and a windblown tree. Staring out of the scene at the painting's viewer, his presence points ambivalently to a transformation from subservience to autonomy and from religion to realism. Indeed, it is important to recall that in addition to his portraits, Orpen was well-known as a war artist whose scenes of living and dead soldiers chillingly evoked the brutality of mechanized killing in World War I.

That the young Gael in Orpen's painting was modelled by the artist Seán Keating (qv), one of Orpen's students, points to

(1854) was one of several works depicting the history of Britain and its colonies, commissioned from various artists to decorate the rebuilt Palace of Westminster, which had been destroyed by fire in 1834 (Síghle Bhreathnach Lynch, 'Imaging the Past: The Marriage of Strongbow and Aoife', *The Irish Review*, no. 29, Autumn 2002, 95–104; Cullen, 1997, pp. 48–49). Accordingly, it portrays Aoife, the dutiful daughter of the King of Leinster, about to enter an arranged marriage to the conqueror Strongbow (Richard de Clare, Earl of Pembroke) in the wake of his victory at Waterford. The offering of one's daughter to the victor was not unusual in medieval war, and there is enough military pomp and majesty in the painting to account for its approval by the Royal Commission of Fine Arts, which commissioned it. In Maclise's painting, the body serves a rhetorical function, denoting the political unification of Britain and Ireland. But the painting carries at least as much tragic as heroic meaning. While Strongbow's foot desecrates a Celtic cross, the sword he holds in his left hand is clearly what enables him to hold Aoife in his right. Wearing

the further evolution of Irish art towards Modernism in the former's work. In particular, Keating's paintings typify the move towards Social Realism which characterized much art in the aftermath of the Great War. In *Night's Candles are Burnt Out* (1928/29) [418], Keating presents Ireland emerging from its recent Civil War (1922/23) into the future prosperity offered by the Ardnacrusha hydroelectric power station, featured in the background, the first step in the electrification of the country under the new Free State government. On the left of the composition we find Ireland's past, symbolized by a skeleton and a poor farmer holding an oil lamp; in the centre, a gunman is juxtaposed with a businessman, pitting the revolutionary against the capitalist; and, on the right, the artist (in a self-portrait) is shown as an enlightened figure who celebrates technology as he and his wife point out the new dam to their children. One of a series of works Keating produced for the Electricity Supply Board, and for which he had privileged access to the Ardnacrusha site, the artist's optimism for Ireland is given a clear voice in a Social Realist style which serves the painting's nationalism, and by arranging a variety of human bodies against the enormous concrete and steel engineering of the dam which appears to anchor the whole scene in place.

Mainie Jellett brought Modernism to Irish art in a different, more spiritual way, adapting Cubism to her needs as a figurative artist working with religious subjects, and seeking to provide opportunities for the display of abstract art (see 'Abstraction') in Ireland in co-founding the Irish Exhibition of Living Art (qv) in 1943 (see Ciarán Benson, 'Modernism and Ireland's Selves', *Circa*, January/February 1992, 18–23). In her crucifixion image *The Ninth Hour* (1941) and in *The Virgin of Éire* (1943) [243], where the Madonna is portrayed alongside St Patrick and St Brigid, Jellett's bold attempt to marry the principles of Cubism and Catholicism through the sacred female form is evident. Her canvases bring to bear on traditional subjects a variety of experimental techniques – elemental shapes, restricted palettes, framing devices and mixed media (notably the use of sand),

and the Cubist technique of 'rotation and translation'. Though Ireland's relationship with continental European Modernism was a battle between 'the provincialism of the right (nationalism) and the provincialism of the left (modernism)', as Brian O'Doherty (qv) put it in *The Irish Imagination, 1959–1971* (1971), Jellett's work reminds us that Irish artists were always looking to their European neighbours and adapting their styles to their own agendas (O'Doherty, 1971, p. 20). With Jellett, we find an international Cubist purism successfully tempered by an Irish religiosity and through the eyes and brush of a woman artist who fused the modern with Mariolatry (see 'Religion and Spirituality').

World War II prompted Patrick Hennessy (qv) to fuse a surreal landscape of the mind and wartime ruin in his painting *Exiles* (1943) [208]. Composed of a male figure before an apocalyptic landscape with a female figure in the distance, the man's ragged clothes, bare upper torso, and drooping shoulders all indicate despair. The brown palette, jagged rocks, positioning of the figure and distortion of scale to disorientate the viewer are not dissimilar to Salvador Dalí's paintings, such as *Weaning of Furniture-Nutrition* (1934). Francis Bacon (qv) also focused on the psyche in his images of the body, which were described by David Sylvester as a manifestation of 'paint that brings flesh into being and at the same time dissolves it' (Sylvester, 'In Camera', *Encounter*, April 1957, 22). Bacon's fragmented images of the body explore taboo and transgression, from the Christian torment of the crucified flesh and the body-as-carcass in *Three Studies for Figures at the Base of a Crucifixion* (1944) [41] to secular studies of man as father, lover or child, as in *Man and Child* (1963), and studies of the female nude such as *Henrietta Moraes* (1966). When Bacon paints the body, he seems to flay it, attacking the canvas with his paint, and twisting the human torso as if it were a carcass. In this, Bacon's work shows the influence of Chaim Soutine (1893–1943), especially Soutine's expressive paintings of sides of beef.

41. Francis Bacon, *Three Studies for Figures at the Base of a Crucifixion, c.* 1944, oil paint on 3 boards, each 94 x 73.7 cm, Tate

The art of Louis le Brocquy (qv) may not share Bacon's sense of abjection but it is equally fascinated with humanity. Le Brocquy's paintings of the 1950s and early 1960s were devoted to a theme perhaps best summarized by the title of his canvas *Isolated Being* (1962). His technique involved a gradual paring away of the material subject to a kind of abstract ethereality, creating a transformation from the particular to the universal similar to the contemporary shift towards an existential art style by Alberto Giacometti. Thus, le Brocquy's 1959 painting *Woman* depicts a female torso in a predominantly white-grey canvas lit with daubs of red to emphasize the torso's spine and, hence, the body's vulnerability. Le Brocquy based this image on fellow-artist Anne Madden (qv), whom he married in 1958, and who was undergoing a series of operations on her spine at the time. But he went further than portraiture (qv) in the painting: the wound acts upon the viewer's consciousness, suggesting the slippage between life and death. In this way, the layers of paint denote the physical inscription of the very passing of time itself.

Micheal Farrell (qv) presents a radically different painterly discourse on the body and body politic. *Madonna Irlanda or The Very First Real Irish Political Picture* (1977) [377] is one of a series of works he produced on the theme of 'Mother Ireland' which portrays Ireland as whore. It is a parody of the painting *Nude on a Sofa (Louise O'Murphy)* (1752) by French artist François Boucher (1703–70), reputedly a portrait of Louis XV's Irish mistress Louise O'Murphy. Farrell engages with the subject of nationalism from the vantage point of self-imposed exile, having left Ireland for France with his family in 1971. His image examines the politics of representation and the representation of politics in a parodic image of the nude. Where Boucher portrayed Miss O'Murphy's buttocks with a typically Rococo rosy palette and soft brushstroke, Farrell conspicuously whips them with colour so that they smart under his intense gaze (in a self-portrait in the top right corner of the painting) and that of the emasculated Vitruvian man (a miniature rendition of da Vinci, in the top left corner). Between the Renaissance and Modern periods, Ireland appears to have sold her soul, having prostituted herself to the British in Farrell's eyes, so that her saintly halo becomes a mere accessory in her tainted boudoir. Farrell explained, 'Ireland is getting fucked by the opposition, getting screwed up by Britain, by the Protestants … a real Irish stew' (David Farrell, *Micheal Farrell: The Life and Work of an Irish Artist*, Dublin 2006, p. 80). The artist's cutting of the buttocks of this Madonna allows for a clever pun (*boucher* is French for 'butcher') but in another of his Mother Ireland works Farrell invokes paramilitary activity: in *Miss O'Murphy, A Shorter History* (1982) he divides the nude into choice cuts of meat, each with its own caption (*le cul, gigot, fourquarters* [*sic*]). The caption 'kneecap' below the woman's left knee alludes to the 'knee-capping' (gunshots to the knees) sometimes inflicted as punishment by paramilitaries in Northern Ireland at that time. Beneath the image stands the ironic assertion in block capitals, 'The Very First Real Irish Political Picture'. Following a series of attacks by the Royal Ulster Constabulary on civil rights' marchers in Derry in 1972, Farrell refused to exhibit in Britain. In these works he unapologetically attacks Britain's colonial rule but also portrays Ireland as mistress of her own unsatisfactory fate. The

political force of his work is further indicated by the fact that the Hugh Lane Gallery bought *Madonna Irlanda* in 1977 but did not exhibit it until ten years later (Aidan Dunne and Gerry Walker, *Profile 9 – Micheal Farrell*, Kinsale 1998, p. 15).

Micheal Farrell employed Robert Ballagh (qv) to help him in painting murals for the new National Bank building (now Bank of Ireland) on Suffolk Street, Dublin, in 1967. As with Farrell, Ballagh combines Pop art and Realism (qqv) in accessible, legible art which seeks to dismantle the institutions of Church and State. Ballagh's reading of Karl Marx, Herbert Marcuse, Che Guevara and James Connolly, coupled with the beginning of the 'Troubles' (qv) in Derry, led him in 1969 away from hard-edged paintings of objects. Producing *Series 4* – twenty works depicting marchers and stylized bodies whose united forms become blood-like waves across the picture plane – Ballagh presented what Conor Cruise O'Brien, who opened the exhibition in which it appeared, called 'the symbolic disasters of our time' (Ciarán Carty, *Robert Ballagh*, Dublin 1986, pp. 76–79). Ballagh's art has also been censored: his figurative kite for a public exhibition of kites organized by Barrie Cooke (qv) at the Kilkenny Arts Week in 1978 was a comic image in Pop art style. Presenting the artist as a flasher, his raincoat acting as the kite and his penis appearing almost as a point of gravity, the work was deemed 'inappropriate' by the organizing committee. As Ciarán Carty has observed, its banning became a *cause célèbre* in the Irish and British press where it was seen as an indication of the prudish attitudes of Irish people towards the explicit body and an attendant 'double standard of morality' in Ireland (Carty, p. 134). A social elite, it appeared, could enjoy art – erotic or otherwise – but the public needed protection from it. In *Upstairs No. 3* (1982) Ballagh portrays himself half-naked again, wearing only a white t-shirt and socks, and his wife Betty fully naked and reading a Japanese erotic pillow book. An intimate scene, it is still geopolitical in tone because James Gandon's King's Inns building and a US military helicopter are visible in the background through a window. Indeed, *Upstairs No. 3* is a reverse image of *Inside No. 3* (1979) in which Ballagh portrays his wife as a Duchampian nude descending a staircase, and demonstrates not only a reversal of gender roles but also a self-conscious exploration of the politics of seeing, sexual and political surveillance, and censorship. The politicization of the gaze is made all the more subversive by Ballagh's key-hole framing device which forces the viewer into the role of a 'peeping Tom'.

The depiction of domestic space for political purposes by a woman artist serves as an interesting counterpoint. In *Mother Ulster* and *Mother Ireland* (both 1989) [153a, 153b], Belfast painter Rita Duffy (qv) fused sexual, gender, racial and class politics by means of subversive humour. In *Mother Ulster* [153b] a working-class, unionist mother is portrayed as a glorious stereotype, with two children, a housecoat patterned with the Red Hand of Ulster, and a young Orange boy playing on his lambeg drum behind her. In *Mother Ireland* [153a] a buxom Catholic mother of four appears burdened by housework and the Church. Through the image of the mother as a political and religious icon for both communities in Northern Ireland, Duffy emphasizes the politics of space and tradition at work in that part of the world. Her art explores divisions of mind, family, class and creed

while revealing the absurdity of political sectarianism and the propagandistic role of mass media. Duffy also intimates that feminist politics have been forced to take a second place to national politics.

It was in this decade that the term 'Irish Expressionism' was first coined for the 1986 exhibition, *4 Irish Expressionist Painters*, held at Boston through a collaboration between Northeastern University and Boston College. The artists represented were Brian Maguire, Patrick Hall, Patrick Graham (qqv) and Timothy Hawkesworth, all of whom shared an interest in exploring subjectivity and emotion – or, as Maguire wrote of his work, 'images of sexual frustration, parental matters, intoxication, guilt from political violence, from separation, dependency, loneliness, ordinary things where I was coming from' (Maguire et al, 26). In Hawkesworth's works, their art explored the 'link between idea and emotional reality' (ibid., 29–30). The exploration is dominated by the body – the self-portrait, the lover, the individual – from Maguire's images of brutal urban realism as seen in the solitary figure standing in Belfast's *Divis Flats* (1986) [421] to his image of masturbation in *Children and Self (remembering)* (1986). Here, naked bodily desire and the freedom of the unconscious sleeping state compete with the entrapment that the family and Church impose, as indicated by the dark shroud about the family in the background and the hellish orange and yellow colours that encircle the boy.

Patrick Graham's *My Darkish Rosaleen (Ireland as a Young Whore)* (1982) [42] perverts James Clarence Mangan's love poem 'My Dark Rosaleen (Róisín Dubh)'. Graham's Rosaleen wears a garter belt and stockings before a litany of symbols of Ireland's identity as a sexually repressed, rural land where Fianna Fáil (symbolized by the potato) and Fine Gael (symbolized by the more luxurious turnip) battle over grass-root demands and a people who seem to be shedding the power of the Church only to replace it with that of Britain and America. For Graham, like Farrell, Ireland is selling herself; thus his gouging out of the female face and expressive use of funereal black paint allow us to read the work as a lament. It is not surprising that Aidan Dunne described Graham's art, and that of the New Irish Expressionists in general, as 'testosterone charged' (Dunne, 1994, 20–25).

A similar confrontational style of self-expression found an outlet in the performance art (see 'Time-based Art') of Nigel Rolfe (qv), who moved to Dublin from Britain in 1974. Seeking to challenge the spectator 'to consider the limits and influences on how you view the art object', Rolfe used both the everyday object as well as his own body to draw on collective history and create a space for a transformative experience (Rolfe, statement of 1978 in *Archive*, exh. cat. IMMA, Dublin 1994, n.p.). Works by Rolfe that focused on Irish identity included *The Rope that Binds Us Makes Them Free* (1983/84) – a work with three video monitors in which the left screen depicted the artist with his head bound in sisal rope against a green background, a middle screen displaying the legs of a champion traditional Irish dancer against a white background, and a screen on the right displaying the artist drenched in water against an orange background. The colour scheme symbolized the Irish tricolour, torn between repression and baptism,

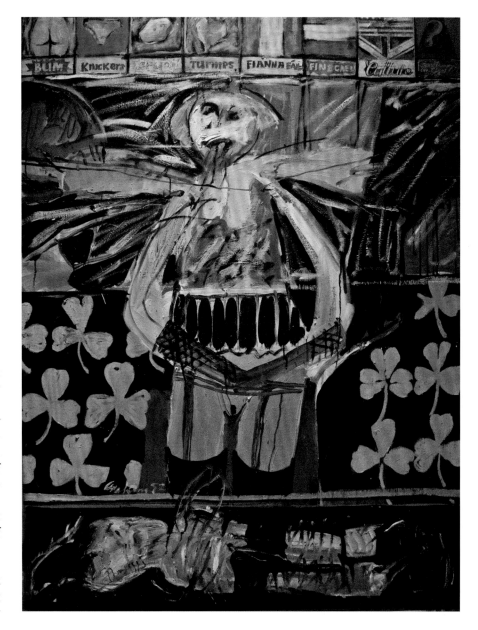

linked by dancing feet which represented culture, spirit and continuity – what Rolfe called the 'heartbeat' of the island – while a sound-track based on traditional Irish music played in the background. *Island Stories (The Ostrich)* (1985) went further in its critique of the nation. It addressed the story of Ann Lovett, a fifteen-year-old teenager from County Longford who died in a grotto to the Blessed Virgin in January 1984, having given birth to a baby boy, who also died. Rolfe explored this 'sad, slow stupid death for them both', comparing Ireland to an ostrich for refusing to face the consequences of sex outside marriage. The young mother's tragic tale was documented by juxtaposing projected images of the Blessed Virgin with a performance in which Rolfe buried his head in a mound of sand, against the musical backdrop of a lament by Christy Moore.

Billy Quinn (qv) also dealt with the subject of repression and taboo in Ireland in a series of works which staged supposed

42. Patrick Graham, *My Darkish Rosaleen (Ireland as a Young Whore)*, 1982, oil on canvas, 183 x 122 cm, private collection

sexual empowerment in what Cummins has called 'a tribal remembrance of women' (Cummins in conversation with Ailbhe Smyth, Beverley Jones and Pat Murphy, in 'Image Making, Image Breaking', *Circa*, January/February 1987, 8).

Dorothy Cross explores the domestic body from a more Surrealist perspective. As Joan Fowler has rightly observed, Cross focuses on 'the way in which concepts of femininity and masculinity, and the biological male and female have been prioritized' (Fowler in *A New Tradition*, 1990, p. 60). In *Kitchen Table* (1990, IMMA collection) woman is equated with vessel, with nurturing and with domesticity, in keeping with Freud's view of the feminine, and yet also with a sexual potency which Cross suggests by the inclusion of fossilized shark's teeth. In this detail, she nods to the fantasy of the *vagina dentata*, linking Freud's analysis of the male castration complex (symbolized by the 'devouring', castrating maternal sex) to society's general fear of the sexually active woman as *femme fatale*. In *Amazon* (1992), woman as sexual virago is again explored through found objects in a tailor's dummy covered in cow hide. Speaking to society's fashioning of sexual difference and gender roles, the work combines two aspects of woman: her domestic, craft-working side, as signified by the mannequin object, and her Amazonian, warrior-like side, as signified by the skin sculpted round one

43. Kathy Prendergast, *To control a landscape: Oasis*, 8/11 from the 'Body Maps' series, 1983, watercolour and ink on paper, 35 x 60 cm, Irish Museum of Modern Art (see [392])

sexual 'sinners' as saints. In his photographic self-portrait, *Billy* (1991) [416], Quinn alludes to religious iconography in his medieval Christ-like pose against a backdrop of gold and silver leaf; the inscription 'AIDS pushed me It pushed all of us Into the realization of our own mortality' alludes to the recent deaths of friends of the artist and the wider theme of a peculiarly Irish denial of the flesh and obsession with it. As Quinn explained, 'The Irish make the best saints, the best sinners and the best story-tellers – that's what I am. I love the fact that the Irish are so in touch with their bodily function. You know, like James Joyce writing to Nora, "I'd recognize my sweet Nora's fart in a roomful of farting women". That for me is the most romantic thing ever written – it's so real.' (Quinn, cited in Anna O'Sullivan, 'Irish Art in New York', *Circa*, no. 64, Summer 1993, 22)

The female body – a privileged site of abjection – took a different direction in the feminist art of Kathy Prendergast, Pauline Cummins, Dorothy Cross, Alice Maher and Alanna O'Kelly (qqv) in the 1980s and '90s. Indeed, their work exemplified the radical role of women artists in expanding the boundaries of Irish art in the modern era. Kathy Prendergast's series of 'Body Maps' (1983) [43], consisting of eleven large drawings of parts of the female body, mapped out with labels and mechanical parts, as if for a land surveyor from the nineteenth century, acknowledges the politics of the female nude as a traditionally passive form in art's history. In her art, Pauline Cummins also builds on tradition and the nude, having worked in craft forms (weaving and flax sculptures). Her slide/sound installation (qv) *Inis t'Oirr/ Aran Dance* (1985–86) [44] explored the body through a sequence of images of a woman's hands knitting, a man's torso in an Aran sweater, and then his naked torso underneath. As Cummins uses the moving image to frustrate passive viewing and reverse traditional gender roles, the man becomes the object of the gaze, and knitting, a female handicraft, becomes an act of

44. Pauline Cummins, *Inis t'Oirr/Aran Dance*, 1985–86, tape slide installation transferred to DVD, Irish Museum of Modern Art

large breast with an erect nipple (in Greek mythology Amazonian women cut or burnt off their right breast to make it easier for them to carry and use their bows and arrows). Continuing a Surrealist exploration of sexuality, exemplified by Meret Oppenheim's gazelle fur-covered cup and saucer, *Objet/ Déjeuner en fourrure* (*Object/Breakfast in Fur*, 1936), Cross presents woman as bearer of both maternal and phallic power.

A feminist exploration of the abject power of the female form is also present in the art of Alanna O'Kelly. When representing Ireland at the São Paolo Biennial in 1996, she produced Á *Beathú*, a mixed-media installation using video and sound, which explored the theme of the Irish Famine through the female body and nurturing. It is a work that might be understood as an exploration of the three functions of the feminine in western culture identified by Julia Kristeva: death-wife-mother are all framed 'within a totality where they vanish as specific corporealities while retaining their psychological functions' (Kristeva, 'Stabat Mater' in Leon S. Roudiez (ed.), *Desire in Language: A Semiotic Approach to Literature and Art*, trans. Thomas Gora, Alice Jardine and Leon S. Roudiez, New York 1982, p. 169). For this installation, the viewer stood in a dark room enveloped by an image of the nurturing female breast. As O'Kelly explained it, 'milk flowing from the breast

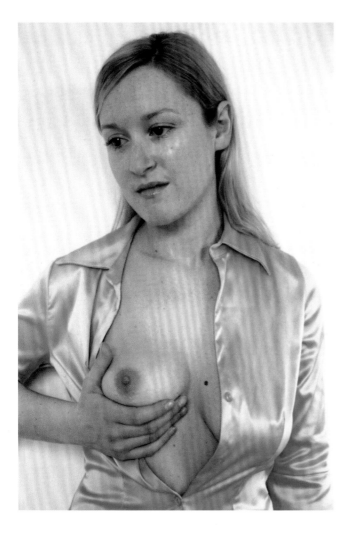

– it's a constant, flowing, it's endless, luscious, an image of total abundance. Interspersed into this you see the rapid-eye-movement of an eye of a young child…the eye of a baby who is moving in and out of deeper sleep, through different layers of consciousness. With the constant flow of the breast milk, it's sometimes very sensuous and very empowering.' (O'Kelly, 'Interview with Medb Ruane', *Circa*, Autumn 1996, 20–23, 22). O'Kelly turned to the maternal to transgress the taboo surrounding the woman's body in Catholic Ireland, further explaining, 'We live in such a repressive religious situation where we feel we can't talk about our bodies, or show our bodies. The only way some people see many women's bodies is in page three of the papers. I don't set out to right that in all my work but I'm bloody not afraid of addressing it.' And yet O'Kelly also wanted the work to go beyond the mother-child relationship and the Irish context, insisting in a later interview that she hoped to raise awareness about women's power globally as well as everyone's power to nourish, rather than oppress (Deepwell, 2005, p. 146).

Such fearlessness underpins younger feminist art practice too. In her 'Madonna' series (2000–10), Amanda Coogan (b. 1971) turns to both traditional religious iconography and the advances of feminist artists who have made their body their canvas. In *Madonna in Blue* (2001) [45], a photograph the size of a devotional postcard or sex-line advertisement, the artist wears a blue shirt and cups her bare right breast. It is based on a performance piece devoted to the Virgin Mary in which she stood in an elevated position (as in a public monument or outdoor grotto) remaining still for several hours until the audience left. The image and performance suggest the many functions of the breast (sexual organ, source of nourishment and symbol of Republicanism, as in France's bare-breasted *Marianne*). But her work also had a peculiarly Irish message in its reference to the many grottoes devoted to the Virgin Mary in Ireland and, specifically, to the case of Ann Lovett which, for Coogan, remained 'an iconic feminist story, a tragic story and quite specific to Ireland' (Mike Fitzpatrick, *Amanda Coogan – Profile 21*, Kinsale 2005, p. 17). The artist's use of her own body to represent religious, sexual and national identities, staging herself as *tableau vivant*, is intrinsically Postmodern in its performative element and yet Irish in its narrative. Moreover, in her practice Coogan also draws on her experience as the child of deaf parents and the fact that her first language was Irish Sign Language, communicated through gesture. In so doing her art builds on the political dimension of performance art, as does Rolfe's, and as does the feminist artist Marina Abramović, with whom Coogan studied in Germany. Silence, aloneness, endurance, the creating of a space within which to think and the effort to draw on the energy of an audience, all link the work of these performance artists.

That Irish women artists insist on articulating a changing, increasingly emancipated, female identity in Ireland is not surprising given that women share with Ireland a history of oppression as well as an emphatically gendered discourse. Woman has been 'colonized' by Western, patriarchal society and culture, specifically enshrined in Irish law as having a domestic, maternal, role in the nation. As Article 41 of the Constitution states: 'In particular, the State recognizes that, by her life within the home,

45. Amanda Coogan, *Madonna in Blue*, 2001, colour photograph from the 'Madonna' series 2000–10

woman gives to the State a support without which the common good cannot be achieved.' (*Bunreacht na hEireann*/Constitution of Ireland, 1937, Government Publications, 1990, p. 136)

The body in Irish art has thus shifted from the object to the subject to the situation as it has evolved from the Enlightenment to the Postmodern era. From the coded politics of Maclise's Aoife to the *intimiste* style of Roderic O'Conor's reclining nude, to the Surrealist-like art of Patrick Hennessy and Dorothy Cross, Ireland's many histories, belief systems and politics are consistently interwoven and mapped out on the body. The female body has had a particularly potent role in this narrative, whether as symbol of the beauty and potential of Mother Ireland, or as symbol of the oppression of woman and her reproductive life by Church and State. Negotiating between the peculiarities of the Irish Self and the international art world, Modern and Postmodern Irish artists have been notable in turning to the body to advance political debate, self-analysis and change. Irish artists, male and female, have sought to bring the personal and political, national and international, into the frame, expressing the gendered nature of Irish citizenship, giving a voice to an 'impacted' Irish identity, and frequently forging a new, liberated one in its place. Throughout the period documented in this essay, Irish artists have embraced the body in full knowledge of its controversial and multicultural potential. Building on the tradition and advances of earlier generations of national and international artists, Irish artists today use more irony and self-effacement than in the past but continue to reconfigure the body in empowering local and global terms. ALYCE MAHON

SELECTED READING Ryan-Smolin, Mayes and Rogers, 1987; Maguire et al, 1988; Mahon, 2005.

46. Frontispiece of *The Great Book of Ireland*, a vellum manuscript edited by Theo Dorgan and Gene Lambert, bound by Anthony Cains, 1991, 51 x 36 x 11 cm, University College Cork

BOOK ART (see 'Illustrations and Cartoons'). The poet Theo Dorgan and painter Gene Lambert (qv) initiated, in 1989, what was probably the single biggest collaborative project in the history of Irish art. One hundred and forty poets, one hundred and twenty artists and nine composers were invited to contribute pages for what was to become *The Great Book of Ireland* (1991, UCC) [35, 46], a late twentieth-century response to that other great Irish artists' book, the *Book of Kells*. Given the centrality of the book in Irish culture from the Early Christian period right up to the present day, with the island producing no fewer than four Nobel Prize winners for literature and perhaps the single most influential novel of the twentieth century, Joyce's *Ulysses*, it might seem surprising that Irish artists have not engaged with the book more than they have done. European artists generally avoided anything that reflected a post-Renaissance subordination to literature and struggled to shake off the impression that, at best, painting and sculpture were less demanding intellectually and therefore inferior to writing. For many, the twentieth century marked the first opportunity to assert the independent strengths of the image over the text. This was not the case in Ireland, where historic conditions particularly favoured the verbal over the visual, especially in the educational system, put in place after Irish Independence (see 'Education in the Visual Arts'). In view of that, the number of very fine books actually created by artists in Ireland is somewhat surprising and runs right through the century.

There are different interpretations of what artists' books actually are and this is fuelled by distinctions between books illustrated by artists, books generated by artists, and book projects developed by artists since the 1960s when the art form began to be recognized as a distinct genre, usually called 'Artists' Books' or 'Book Art', although there is debate about the correct nomenclature and even about its punctuation. For the purpose of this essay, the definition offered by the Rhode Island School of Design library will be used since it allows for consideration of a wide range of book art. It states that, 'In simple terms artists' books are books made by artists or works of art in book form.' (http://www.risd.edu, accessed 10 May 2012)

According to former Professor J.C.C. Mays, 'The Irish Book can claim to have the longest history in Europe, perhaps the world, if "book" is interpreted in a strict sense, in contradistinction from a codex or roll of parchment.' (Mays, p. 13) Of course, that is not the same as the Irish *artist's* book, although, as Mays goes on to point out, the manuscript tradition continued in Ireland for much longer after the introduction of the printing press, than is the case in other countries, suggesting a special interest in the look and feel of the manuscript, over and above the requirements of the printed text. Historically, book binding, an essential element in book art, was an important category in Irish art in the eighteenth and nineteenth centuries. Mays bemoans the destruction of the Public Record Office in the Civil War in 1922, in which 149 volumes, containing a 200-year-long series of parliamentary papers, were lost in the attack on the Custom House. He cites Maurice Craig's description of this loss as 'probably the greatest single artistic loss that Ireland has ever suffered, at least in modern times' (Mays, p. 25).

Notwithstanding this disaster, the art of the book got off to a good start in the first decade of the century with the founding of the Dun Emer Press (1903–08), later the Cuala Press (1908–85), both under the direction of Elizabeth (Lolly) Yeats until her death in 1940, and later, despite interruptions, directed and managed by other members of the Yeats family. Although not strictly artists' books, but rather fine press publications of poetry and essays in which the design, typesetting, materials and binding were of a particularly high order, the work of Cuala did much to call attention to the book in Ireland as a thing of beauty visually and in its contents. Elizabeth Yeats drew on the advice of her friend Emery Walker, a former adviser to William Morris's Kelmscott Press, and the assistance of her sister Susan (Lily) Yeats.

Dun Emer/Cuala [47] quickly became the most important literary publishing house in Dublin in the first half of the twentieth century, producing the first editions of several works by W.B. Yeats, as well as hand-coloured broadsides and greeting cards, using a second-hand Albion hand press built in 1853 and Irish paper and book cloth. By 1946 Dun Emer and Cuala had produced over seventy books by mainly Irish writers, including W.B. Yeats (the press's literary adviser), J.M. Synge, George Russell (qv), John Masefield, Katherine Tynan and Ezra Pound, with illustrations by Robert Gregory, T. Sturge Moore, Edmund Dulac and Lolly Yeats herself. The Lady Emer device was designed by Elinor Monsell and was first used in 1907. Lolly Yeats's familiar colophon at the end of all their books – 'Here ends ... by ... printed upon paper made in Ireland, and published by Elizabeth Corbet Yeats at the Dun Emer Press (later Cuala), in the county of Dublin, Ireland, finished the 16th day of July ...' – was lampooned by James Joyce as, 'Five lines of text and ten pages of notes about the folk and the fishgods of Dundrum, Printed by the weird sisters in the year of the big wind' (*Ulysses*, 1937, p. 11). Jack B. Yeats (qv) produced a long and very successful series of hand-coloured prints and *Broadsides* (see 'Printmaking'). They were issued by Dun Emer and Cuala, monthly, and with an annual subscription of 12 shillings. Cuala offered eighty-four of his poems, ballads and images in a limited edition of 300 and housed in a blue linen-covered portfolio. A highlight for Cuala came when books by the press were included in the Irish Art section of the New York World's Fair in 1939.

The aims of Cuala, like the Dun Emer Press before it, were to produce hand-printed books to be characterized by their legibility, simplicity, the use of a good type font, and chemical-free, Irish materials. The business experienced difficult times, especially during the War of Independence, when some of their staff were arrested as Republicans, and Lolly Yeats was not always realistic in her pricing. Yet their success can be judged by an article about Cuala in *The Bookman's Journal and Print Collector* in July 1922 by W.G. Blaikie Murdoch in its series on notable private presses. The article favourably compared Elizabeth Yeats with William Morris and Charles Ricketts, who were considered too decorative, and went on:

> Like the eighteenth-century artist in typography, she [Elizabeth Yeats] has marked well that in this, as in architecture, one sure road to merit lies in the very avoidance

47. Jack B. Yeats, *A Broadside* 'Come Gather Round Me Parnellites', Cuala Press publication, No. 1 (New Series) January 1937, edn of 300

> of embellishment. She has perceived that, given a beautiful type, like Old Face, the printing itself is the proper decoration of the page. Far from her is the noble austerity of those great Georgian printers who accepted the lead of Caslon. Yet the Irish artist, using always quite an unpretentious paper, has attained a rare beauty of the homely sort, as in the pictures of Chardin and the Dutchmen. (Miller, p. 78)

At her death in 1940, her sister Lily said:

> When Elizabeth Corbet Yeats started she had no knowledge at all beyond what she learned of the setting up of types in a few lessons at some woman's printing works in London. Of the Press work she knew nothing at all, she disliked machinery. Her assistants were only children who had just left school. The Press itself was bought for a few pounds through an advertisement in an Irish paper. (Miller, p. 95)

No books were produced by the press between 1946 and 1970. And while book production was resumed by Michael and Anne Yeats (qv) in conjunction with Liam Miller in 1970, the glory days of the Cuala Press were over.

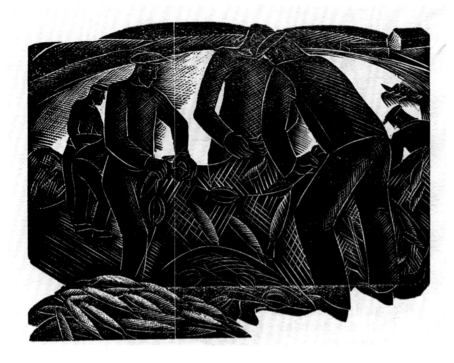

Other important Irish printing presses included Cecil Salkeld's (qv) Gayfield Press, which published a 'Poets and Artists' pamphlet series in the 1930s, and the Golden Cockerel Press in England, run by Corkman Robert Gibbings, while Liam Miller's Dolmen Press, founded in 1951, became the natural successor to Cuala in the 1960s and '70s. In its book production, the Dolmen Press's outstanding contribution to art history in Ireland was Miller's inspired commission to Louis le Brocquy (qv) to illustrate Thomas Kinsella's modern translation of the Táin legend. Other collaborations between artists and writers/poets, such as those between James Joyce and Henri Matisse (*Ulysses*, 1935), Stanley Hayter and Samuel Beckett (*Still*, 1973), Gene Lambert (qv) and Paul Durcan (*Land of Punt*, 1999), Donald Teskey (qv) and John Banville (*Conversation in the Mountains*, 2008), and between Seamus Heaney and Cecil King (qv) (*Glanmore Sonnets*, 1977), Barrie Cooke (qv) (*Bog Poems*, 1975), Felim Egan (qv) (*Squarings*, 1991), Hughie O'Donoghue (qv) (*The Testament of Cresseid*, 2004) and Jan Hendrix (*The Golden Bough*, 1992), while noteworthy in themselves, do not fit the definition of artist-led projects. That criterion is better met by Elizabeth Rivers's (qv) [48] *Stranger in Aran*, which, although published by Cuala Press as its last book in 1946, was initiated, written and illustrated by the artist herself, and Harry Kernoff's (qv) books of woodcuts, privately published in 1951, or by Cahill Printers (1942) and Three Candles Press (1944). The White Stag (qv) artists were deeply interested in the book but, of them all, only Basil Rákóczi (qv) initiated a book of his own, *The Painted Caravan: A Penetration into the Secrets of the Tarot Cards*, which was commercially published in 1954. Following the death of Mary Farl Powers (qv) in 1992, Paul Muldoon and James O'Nolan of the Graphic Studios invited a number of artists to produce visual tributes to her, which were published along with Muldoon's personal poetic homage in *Incantata* in 1994.

There was no equivalent in Ireland to the Artists' Book movement associated with Fluxus and the Conceptualist movement (see 'Conceptual Art') in New York and continental Europe in the 1960s. The most radical artist's reinterpretation of the book, this time the book as exhibition, by an Irish artist, was Brian O'Doherty's (qv), *Aspen 5+6* [49] in New York in 1967. Invited to edit the fifth and sixth editions of the radical critical magazine *Aspen*, as a special double edition, O'Doherty chose to produce a box in two equal sections, comprising twenty-eight units linked by a Set theory equation. These units were composed of a book, four films, five records, eight boards and ten printed data. O'Doherty called it his one-man show for that year in which the contributors became 'brushstrokes in my painting' (Brenda Moore-McCann, *Brian O'Doherty/ Patrick Ireland: Between Categories*, Farnham 2009, p. 75). It was seen as the first exhibition to dispense with the gallery as a model of institutional critique and was described by Alexander Alberro as 'the foundational moment in conceptual art' (p. 74). Contributors to the *Aspen Box* included Samuel Beckett, Alain Robbe-Grillet, Michel Butor, William Burroughs, Susan Sontag, Roland Barthes and George Kubler. Artists/musicians included Marcel Duchamp, Merce Cunningham, Morton Feldman, Robert Rauschenberg, László Moholy-Nagy, Hans Richter, Sol LeWitt, Dan Graham, Robert Morris and Tony Smith. Another Conceptualist artist, Timothy Drever, settled in Ireland in the 1970s and, under the name Tim Robinson (qv), has continued his art practice in the form of mapping projects and books, particularly about Connemara and the Burren. This is a particularly interesting development since J.C.C. Mays has identified a predilection for mapping as one of the characteristics of the Irish book (Mays, p. 27). Mapping, this time combined with spiritual and physical journeys, is again central to a long-term book project, the artistic notebooks of Caoimhghín Ó Fráithile. Moving between the Dingle Peninsula, New York and Japan, Ó Fráithile's extraordinary pages are densely packed with handwritten, hand-drawn and

painted illuminations of his chosen themes [50]. *Monster: A Concrete Poem*, 1966 [51], was written and published by Brian Coffey, poet, scientist and philosopher, at his own publishing enterprise, Advent Press.

The curator of the 1982 *Irish Exhibition of Living Art*, Declan McGonagle, was fully aware of the Conceptualists' endorsement of the artists' book, as well as O'Doherty's critique of the gallery as the primary venue for visual art. When lack of funds threatened the annual exhibition in that year, McGonagle opted to present an exhibition in the form of a book, with some artists, notably Ciarán Lennon (qv), rising magnificently to the challenge of presenting themselves in this alternative venue. McGonagle went on to work with New York artist Tim Rollins and Kids of Survival at the Orchard Gallery in Derry, in a project based on Stephen Crane's *The Red Badge of Courage*. Here, Rollins and K.O.S.'s destruction of the book and its reinvention as a piece of visual art, with teenagers in Derry at the height of the 'Troubles', echoed the rite of passage of the original. Tom Molloy (qv) in *Subplot* (2011) worked with an existing book, taking George Orwell's *Nineteen Eighty-Four* and obsessively mimicking selected text in hand-drawn graphite letters, in a font and point size that exactly replicate the original, with blank areas of page tellingly representing erasure.

The influence of Conceptualism on classical painting can be seen in the work of Hughie O'Donoghue. O'Donoghue took a 1938 edition of the *Encyclopaedia Britannica*, together with all that it represented, and remade it as a record of his father's wartime experience in *Anabasis* (2003, IMMA collection), drawing parallels between his father's military journey and that of the ancient Greeks escaping from hostile Persia. Ciarán Lennon, seeking alternatives to the gallery, created painted books with sculpted 'book shrine' cases similar to those made for Early Christian manuscripts.

Yet, for all these once-off projects by Irish artists, the post-1960s' phenomenon of the artists' book, which is fast gaining followers in North America and Europe where there are big collections of such artworks and college courses in book arts are offered, has attracted few Irish artists to date. This makes it all the more important that some of the leading practitioners from those places have, since the mid-1990s, established themselves in Ireland. Coracle [52] is the publishing imprint of American Erica Van Horn and Englishman Simon Cutts who started coming to Ireland in the early 1990s, spending two periods as artists in residence at IMMA, and producing a remarkable range of books from their County Tipperary studios. Their first Irish book was *14 Blackthorns* (1999), but other titles include *Eight Old Irish Apples* (2008) and *Some Words for Living Locally* (2001). An issue for them is the status of the book as an equivalent exhibition space for installation (qv). This can be seen in the catalogue for *lines of thin pale blue and red* (1990) by Simon Cutts and Ian Hamilton Finlay, published by APAC, Nevers, France, where the actual neon versions of the text were exhibited in a physical space as 'hidden' as the book itself. As Coracle sees it, 'books are a very empowered space' (Simon Cutts in conversation with the author, May 2012) and this was explored in greater depth by Coracle in a museum exhibition at Aichi University, Japan in 2008.

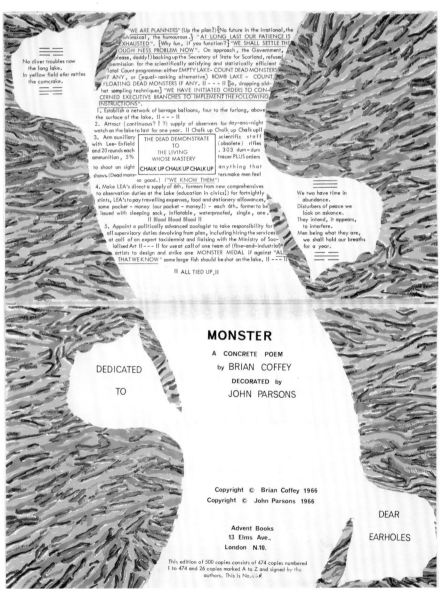

52. Selection of Coracle
books and printed items
in the 'Living Locally'
series of Erica van Horn,
1999–2009

for their artists' books here. Although moves in this direction
through projects such as Le Livre Sur Le Livre in the exhibition
Bookish, curated by Matt Packer at the Lewis Glucksman Gallery,
Cork (2008), and Packer's other show, *Wake Amusements*, at the
Millard Sheets Library, Otis College of Art and Design, Los
Angeles (2011) in which he took books by twelve contemporary
Irish artists to the USA, and the Wexford Artists' Book Fair is
beginning to arouse interest in the genre in Ireland. Digital net-
works make it possible for book makers to function internation-
ally too, displaying and marketing their books on the world-wide
web. However, artists' books have to appeal to collectors in a
very different way to conventional paintings or *objets d'art*. Since
collectors cannot easily display them, and they risk damage if
mishandled, artists' books rarely confer the kind of status that
many collectors expect from artworks, and only in exceptional
instances can they enhance their owners' decorative schemes.
Artists' book collections, therefore, tend to exist in libraries and
to be curated by librarians rather than professional art curators.
Fortunately, the most important collection of book art in Ireland
is to be found in the library of the National College of Art and
Design, under the capable curation of librarians Eddie Murphy
and Donna Romano, while there is a small but growing collec-
tion of artists' books at the Irish Museum of Modern Art.
CATHERINE MARSHALL

SELECTED READING Miller, 1973; Harmon, 2001; Mays, 2002;
Kuhl and Van Horn, 2010.

BOURKE, BRIAN (b. 1936) [53], painter, sculptor. More than
many of his contemporaries, Brian Bourke is an artist of a politi-
cally independent Ireland; not, however, the idealized nation
state that emerged from revolution and civil war but, rather, a
troubled country in which a generation had come of age experi-
encing the realities of religious repression, economic stagnation
and disappointment. Bourke's primary starting point for his art
has always been the landscape (qv), but his interest in literature
and myth elevates his local themes to a more universal plane.

Born in Dublin, Bourke passed through a number of art col-
leges, yet managed to emerge as a more or less self-taught artist.
As Brian Fallon pointed out, by the 1950s 'the National College
had largely become a club for untalented people They sat on
any independence.' (Ryan, 2003, p. 243) While this insistence
on conformity transformed Bourke and his peers into 'angry
young men', he fared little better at St Martin's and Goldsmiths
Colleges in London, claiming that he got his real education
from looking at the early Flemish and Italian work in the
National Gallery in London. A period spent in Germany,
where he absorbed the spirit of *Neue Sachlichkeit* art, was also
key to his development. Returning to Ireland in 1957, Bourke
became deeply involved with the Independent Artists, and his
work began to show the influences of Francis Bacon, Roderic
O'Conor (qqv) and Vincent van Gogh. Julian Campbell recalls
the shock he felt at Bourke's first one-man show at the Dawson
Gallery in 1965 which displayed self-portraits, naked or clad
only in a hat (*IAR*, November 2009 – February 2010, 47). Up to
this time, the theme of the nude had been restricted to art school
education, and Bourke's watchful self-portraits were intended to

Franticham, the combined name of Francis Van Maele from
Luxembourg and Antic-Ham from Korea, who settled in Achill
in the early 2000s, look directly to Fluxus and to the European
Dadaists for their sources. Franticham sees the book as a struc-
tural form and rejoice, as Fluxus did, in its portability, intimacy,
interactivity and the access opportunities it brings with it. Van
Maele's first Irish project was to produce a fine press edition of
the poems of John F. Deane through his printing press,
Redfoxpress, but his artistic vision is realized through the pure
artists' books and assemblings of Franticham. Projects range
from a large book of torn posters from Parisian metro kiosks,
and assemblings of different physical objects in artist-designed
boxes, to books about aspects of life on Achill. Carrying on the
same tradition, Mari-Aymone Djeribi of Mermaid Turbulence
began working in Ireland in the late 1990s, producing books
such as Paki Smith's *The Rose Hedge* (1999).

Another creator of artists' books, this time of unique books,
or books limited to editions of three or four, is the American art-
ist Sandra Landers, who came to Ireland, to the Dingle Peninsula,
in the early 2000s. Landers, whose archive of artists' books, pro-
duced under her married name, Sandra Lopez, is held at the
University of Washington (Seattle), works slowly and medita-
tively, allowing appropriate materials that she has gathered over
time to dictate the form of the books or assemblings that she
makes using her highly developed craft skills in book-binding
and type to carry them through. In May 2012, she, as part of the
Kerry artists' group i2i, helped produce an exhibition of new
book art for the Bealtaine Festival.

Like Coracle, Franticham look to book and art fairs outside
Ireland for exposure, since, to date, there are few opportunities

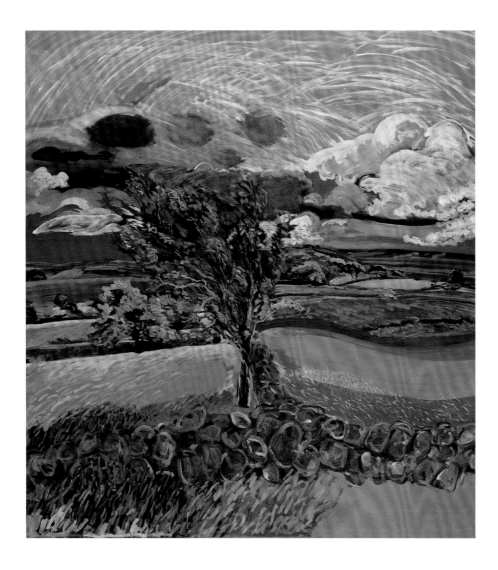

53. Brian Bourke,
*Knock-a-Lough (Summer
1977)*, 1977, oil on canvas,
127 x 117 cm, Arts
Council/An Chomhairle
Ealaíon

be challenging. He represented Ireland at the Paris Biennale in 1965, won prizes in the IELA (qv) in 1964, 1965 and 1967, was included in *Rosc (qv) 1980* and *1988*, and received the O'Malley Award from the Irish-American Cultural Institute in 1993.

Bourke likes to work in series, saying, 'I never do one-offs' (*IAR*, Winter 2006). These series include portraits and land-scapes, such as his depictions of Cardet in France, or his views of the west of Ireland seen in circular format, as if through a port-hole, as well as more narrative series such as prints, paintings and drawings based on Cervantes' novel *Don Quixote*. Bourke has also been inspired by the ancient Irish legend of the wander-ing madman *Sweeney*, as retold by Seamus Heaney, his drawings for which were shown at *Rosc 1988*, and more recently *Women Giving Birth to Men* (2001–03, IMMA collection). Although pri-marily a painter, Bourke has also produced a series of sculpted portraits (see 'Portraiture') in bronze, including self-portraits and one of his friend, the artist Tony O'Malley for his 1988 exhi-bition at the Taylor Galleries.

The critic Brian McAvera detects a strong influence of Impressionism in Bourke's work (*IAR*, Winter 2006), but Bourke's sources are at once too graphic and grotesque for Impressionism, rooted, in fact, in literature and in the same medieval sources as German Expressionism. Patrick Gallagher, writing about Bourke's work in the 'The Puritan Nude' section of *The Irish Imagination* (O'Doherty, 1971, p. 42), cites Bourke's interest in Nietzsche's nihilistic philosophy, quoting the artist as saying: 'For art is profane; it is anti-God, anti-soul, and eventually anti-man.' If there is no special place for man, only art, then Bourke's attitude is that art should deal with this situation honestly but lightly. This is best revealed in his mocking self-portraits, such as the death mask self-portrait, *Memento Mori* (1984, NSPC, UL).

Bourke's black humour and habit of self-deprecation made him an appropriate choice as artist-in-residence at the Gate Theatre during the Samuel Beckett Festival there in 1993, which was accompanied by an exhibition of his work at the DHG. Bourke is a member of Aosdána (qv). His work is included in the collections of IMMA, CAG, HL, UM, UL and AIB.
Catherine Marshall

SELECTED READING James White, *The Art of Brian Bourke* (Dublin 1982); *Women Giving Birth to Men: Paintings by Brian Bourke*, exh. cat. Taylor Galleries (Dublin 2002); Charlie McBride (ed.), *Brian Bourke: Five Decades 1960s–2000s* (Dublin 2010).

BRADY, CHARLES (1926–97) [54], painter. Speaking of artists' curricula vitae, the Dublin gallerist John Taylor, who had been Charles Brady's agent for the last twenty years of his life, said that Brady was an artist who wanted his CV made shorter as he got older (Ryan, p. 142). The comment provides insight into a prolific art practice that avoided the limelight, to concentrate on artwork that transformed utterly trivial objects into promises of understated grandeur.

Born into an Irish-American family in New York, Brady studied at the Art Students' League from 1948 to 1951, where he befriended Franz Kline and fraternized on the fringes of the circle surrounding Willem de Kooning and the Expressionists. Brady showed work in a group show at the Metropolitan Museum in 1950 and had a solo exhibition in the Urban Gallery, New York five years later. He came to Ireland in 1956 and settled there, following his marriage in 1959. However, he remained in contact with his American peers, showing with two of them at the Babcock Gallery, New York in 1967.

From the outset, Brady was deeply involved as a founder member of the Independent Artists' Group, serving on the committee for their first exhibition at the Building Centre, Dublin, in 1960 in which he showed four landscapes. Brian Fallon described his contribution to the Independents as generally overlooked, and Brady himself as 'outmanoeuvered and sidelined by fellow artists' (Ryan, p. 247). Whatever the precise history, he never again involved himself in the politics of Irish art, but his place in it was secure. Always appreciated by the critics from his earliest exhibitions at the Molesworth, Brown Thomas and Gerald Davis galleries, he won the Douglas Hyde Gold medal at the Oireachtas twice (1973 and 1995), the Player-Wills Open prize in 1969, and the Carroll's prize at the IELA (qv) in 1978. In 1981 he became a founding member of Aosdána (qv),

and showed regularly at the RHA (qv) from 1969 until his death. John Taylor, familiar with all aspects of contemporary Irish art from his work at Leo Smith's Dawson Gallery and later as owner of the Taylor Galleries, said, 'He was one of the two artists I wanted when I started out on my own ...' (Ryan, p. 132).

Brady's paintings have often been likened to the Italian painter Giorgio Morandi. While his paintings remain firmly figurative, it is clear that his subject is always painting itself. They have been perceptively described as 'in part, a witty commentary on the art critic Clement Greenberg's prescriptive theories on the flatness and depth in painting' (Dunne, 2007, p. 15). Generally painted in oil on linen or paper, but often resembling watercolour in their minimal delicacy and simplicity of execution, the objects Brady painted or presented in print, such as balls of wool, clothes' pegs, envelopes and wallets, reveal the power of painting to elevate the status of the object and to invest it with both mood and meaning. This is frequently achieved with wit, as in the case of *Joyce's Wallet*, shown open and empty, as the famous writer's so often was, or the rejection slip from the RHA which he showed in an exhibition with Brian Ballard at the Tom Caldwell Gallery in Belfast in 1984, or when he made a bronze cast of a used bus ticket only to paint it, playfully undermining with pigment the cult of the bronze object. The *Irish Times* accurately summed up his work as 'private rather than public ... marrying the most traditional and even trite subject matter to a thoroughly modern treatment' (*IT*, 4 May 1971).

Brady was the subject of a documentary film, *An American in Ireland*, shown on RTÉ in 1995, two years before his death. His work can be found in most major collections in Ireland, including the NGI (to which his widow, Eelagh, made a substantial donation in 2004), AC/ACE, IMMA, HL, CAG, TCD, and the main corporate collections. CATHERINE MARSHALL

SELECTED READING *Brian Ballard, Charles Brady*, 1984; Charles Brady and Desmond McAvock, *Works 9 – Charles Brady* (Dublin 1993); Sean Ó Mórdha, *An American in Ireland*, documentary film, RTÉ Archives (Dublin 1995); Ryan, 2006.

BREAKEY, JOHN (b. 1932), painter, printmaker. Born in Belfast, Breakey began his art studies with the painter Charles Lamb (qv) at Carraroe, Co. Galway. It was Lamb who imbued in him a (then unfashionable) respect for the practical considerations of picture-making, such as the preparation of canvases, the layout of paints on the palette, and so on. Thereafter, Breakey studied at the Belfast College of Art from 1953 to 1958, and at the Slade School of Fine Art in London from 1958 to 1960. As a student at the Slade, he was influenced by his teachers Stanley Jones, who later set up the influential Curwen Press, and Ceri Richards, who in turn had been influenced by Max Ernst. On leaving the Slade, Breakey returned to Northern Ireland to teach art in Carrickfergus, Co. Antrim, but he was soon back in London working as an artist. While there, he exhibited with the fashionable avant-garde 'Young Contemporaries' group. In the mid-1970s, however, he finally settled in Newcastle, Co. Down, establishing at his home a

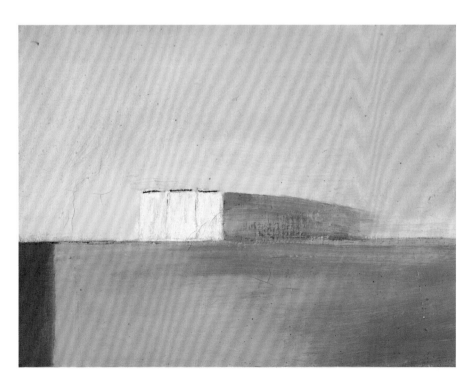

54. Charles Brady, *Matchboxes*, 1979, oil on canvas, 30 x 21 cm, Crawford Art Gallery

workshop for printmaking (qv) and a studio for painting. In these years he also taught at Rathfriland Secondary School, Co. Down. In 1986 he was elected an associate of the RUA (qv) and became a full member in 1990.

Breakey's early paintings, many of which he destroyed, were strictly abstract and hard edge in character, although at the time he also made a few perspex constructions, such as his *Pentarhythms* (1970, UM), which are essentially landscape in derivation. Indeed, his abstract phase apart, landscape is the basis for all Breakey's art, another influence that he attributes to Charles Lamb. After he settled in Newcastle, the landscape of the Mourne Mountains came to dominate his work for the rest of his career, pictures such as the strongly coloured *Autumn Orange Hill* (1995) being typical. In the 1990s he made a few compositions relating to the northern 'Troubles' – *A Field of Crosses for Ulster* (1990) and *Gorse Totem* (1992) are good examples – but these are rare excursions towards a more political subject matter. More recently, in pictures like *The Music of a Dark Sky*, *Spring was only Yesterday* [55] or *The Beach is the Beach*, all painted in 2007, his manner has become increasingly Expressionist, his brushwork *malerisch* and his colours often strident in their intensity, power and celebration of 'place'. S.B. KENNEDY

SELECTED READING Turner, 1989; Black, 2000; Croft, 2001; Brian McAvera, 'The Lithographer's Mark', *IAR*, xxv, no. 1 (Spring 2008), 70–77; S.B. Kennedy (ed.), *That Cold Crisp Day at the Beach: Paintings by John Breakey*, exh. cat. Naughton Gallery, QUB (Belfast 2010).

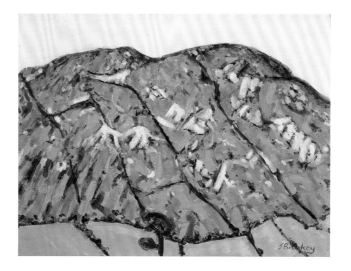

55. John Breakey, *Spring was only Yesterday*, 2007, oil on canvas, 91.5 x 122 cm, private collection

BRENNAN, CECILY (b. 1955) [56, 512], painter, sculptor and video artist. Although she began her practice as a painter, Cecily Brennan's career has developed to embrace sculpture and video work. All her activities, however, are linked by the common thread of her interest in the fragile and unstable nature of the body and the physical environment.

Active, since graduating from NCAD in 1978, in initiatives to improve the working conditions of artists, she was, along with Eithne Jordan (qv) and others, a founder member of the Visual Arts Centre, the first Arts Council-sponsored studios in Ireland, served on the board of the Project Arts Centre, and as a toscaire of Aosdána (qv). Brennan was an active and influential

56. Cecily Brennan with some of her paintings from Iceland at her exhibition in the Douglas Hyde Gallery, 6 November– 19 December 1991

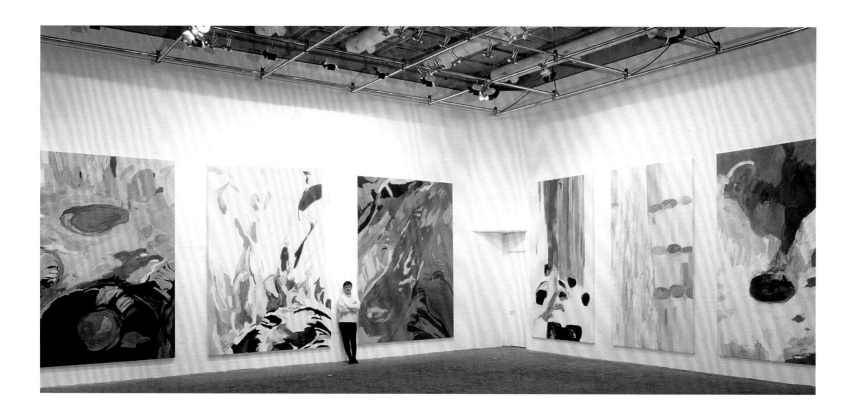

member of the Cultural Relations Committee in the 1990s, where she virtually single-handedly steered Ireland's participation in international biennales at that time. That valuable activity, however, is secondary to her creative work. Whether this is presented as landscape paintings (qv) and drawings of ordered gardens or the sublime, uncontrollable landscapes of Iceland, life-size steel sculptures of scarred supports or guards for body parts, pristine small paintings in tempera on gessoed ground, or video installation, all have been shaped by what Penelope Curtis identified as the constant presence in Brennan's work, 'a fascination with the tension between order and disorder, between chaos and control' (Curtis, n.p.). As Curtis perceptively points out, Brennan's 'Rhododendron Gardens' paintings and her large Icelandic landscapes do not record particular places so much as the activities that the landscape presents in certain locations, everything from erupting volcanoes, and crashing waterfalls to steaming geysers. In the 1996 series of paintings of Ben Bulben, the mountain has become a burial place, according well with the steel wrist and leg guards from the same period, bearing such titles as *Suicide Guard*, where the shining steel surface is gashed and split like the volcanic landscape of her earlier canvases.

Brennan's work during the later 1990s reversed the large scale of the Icelandic pictures in favour of intimate, fragile paintings in tempera on white plaster, in which body parts, disfigured by skin disease or scarred from suicide attempts, replace the earth as the subject. Colour seeps delicately over the plaster ground to define physical pain or psychological trauma, as if following an inner compulsion in the medium rather than a controlling hand. Fellow artist Jaki Irvine (qv) considered that 'Maybe it is the fragility and vulnerability of that stain which bears witness to a person's final loss of control of themselves or the shift from person to body', and suggests that Brennan's watercolours exploit the 'ordinary qualities of the medium, the subtle pleasures and anxieties of surface tension. But it is the ordinariness of this that is so disturbingly fitting. It does not disagree or struggle with the subject in hand, rather somehow seals it.' (Irvine, 21)

The videos that Brennan began to make by the end of the 1990s continue to deal with the struggle to retain control in the face of depression and despair. In *Melancholia* (2005, IMMA collection), a woman's naked body lies in a coffin-like space on a white sheet. Black liquid, reminiscent of the black bile associated in the medieval mind with depression, leaks slowly, apparently from her body since no source is visible, until the sheet is transformed from white to black and it forms pools on the floor underneath. By 2008 the black liquid had gained in strength and jets out of a pipe with sufficient power to repeatedly knock over the sole human presence, a woman, in another video work *Unstrung*. The woman stuggles again and again to withstand its onslaught. As in Brennan's Icelandic landscapes, there are no safe footholds or visible boundaries. Writing about that earlier work, Luke Gibbons had claimed that in her work bodily experience 'is not so much expressed as displaced onto the landscape, registering its own inwardness through other centres of existence' (Gibbons, n.p.). The video works show how prophetic his comment came to be.

Brennan has been invited to participate in major exhibitions of Irish art, including *Something Else from Somewhere Else* (Helsinki and other venues, 2003), *Irish Art of the Eighties* (Dublin, 1990) and *Irish Women Artists* (Dublin, 1987). Her work has been shown in Amsterdam, Baghdad, Berlin, Brussels, Dublin, Helsinki, Milwaukee, Strasbourg, Washington and other venues, and is included in the collections of the AC/ACE, IMMA, CAG, CIAS, UCD, UCG, and in leading corporate collections. Brennan was the recipient of the O'Malley Art Award from the Irish-American Cultural Institute for 2010.
CATHERINE MARSHALL

SELECTED READING Luke Gibbons and Penelope Curtis, *Cecily Brennan*, exh. cat. DHG (Dublin 1991); Caoimhín Mac Giolla Léith, 'Damage and Survival', in *Cecily Brennan: Selected Works, 1999–2007*, exh. cat. West Cork Arts Centre (Skibbereen 2007); Jaki Irvine, 'Profile: Cecily Brennan', *Art Monthly* (May 2007), 20–21.

BYRNE, GERARD (b. 1969), film/video maker, photographer and installation artist. Born in Dublin, Byrne has received world-wide critical attention and is internationally recognized for a series of multi-screen video installations that use actors to reconstruct previously published texts, primarily from the 1960s and 1970s. He often turns to out-dated magazine interviews as sources for scripts and extends the video reconstructions with still photographs related to their narrative themes (see 'Installation', 'Photography' and 'Narrative and Anti-Narrative').

Byrne first used magazine extracts as the basis for video scripts in *Why it's time for Imperial, again* (1998–2002), his dramatization of a 1981 *National Geographic* advertorial for the relaunch of the Chrysler Imperial luxury car. The text is a presumably fictional dialogue between Frank Sinatra and Chrysler chairman Lee Iacocca, which Byrne recreates with two actors walking through a run-down part of Queens, New York. The artificiality of the original text is heightened by Byrne's treatment, revealing stark changes in consumer culture over the intervening two decades. A sense of unease arises from the mismatch between the written and the spoken word, between the optimism of the script and the dreary visuals, between ideas that purport to be modern and are now patently out-of-date. Dislocation is a key element of Byrne's practice: he acknowledges the influence of Bertold Brecht and the latter's 'verfremdungseffekt', the estrangement or distancing of the audience.

New Sexual Lifestyles [57, 327], a three-channel video shown on monitors and supplemented by photographs, is taken from a 1973 article from *Playboy* magazine documenting a symposium on emerging sexual patterns. Byrne reconstructs the discussion in Basil Goulding's Modernist pavilion in Enniskerry, Co. Wicklow (1972, Scott Tallon Walker), using Irish actors and accents. The original conversations have undergone media transformations, from spoken word, to print, to script, to re-enactment, to video, so that there is a literal distancing from the original source. Placing overtly American dialogue into an Irish context and filming the sexually orientated dialogue in a cool

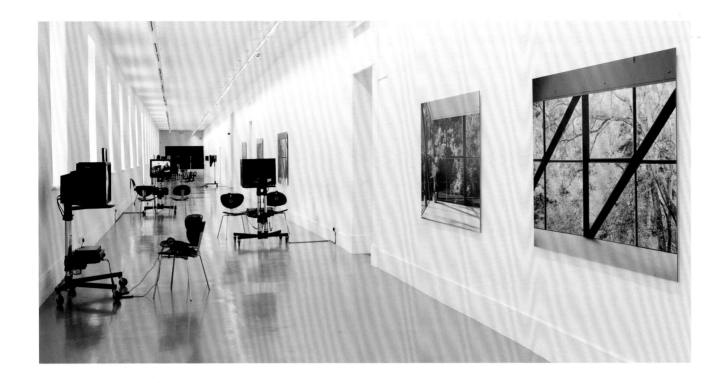

European glass 'box' enhances the sense of alienation. However, the primary source of estrangement arises from the temporal disconnection: ideas from the early 1970s sitting uncomfortably with the present.

This idea is extended in *1984 and Beyond* (2005–07), a three-channel DVD on LCD screens, with Byrne's reconstruction of a roundtable discussion published in two 1963 *Playboy* articles, in which twelve science-fiction writers projected their visions of the future. Tension arises from the mismatch between the real world of the 1980s and how these writers had optimistically imagined it two decades earlier. Byrne raises questions about the failure of modernity, about the obsolescence of ideas and technology, and about our estrangement from even the most recent past. The photographs that supplement this installation were expanded in a separate work, 'Images or shadows of divine things' (2005– ongoing). This series of still images in black and white appear to be photos from 1960s' America; however, nearly all were taken by Byrne and his assistant after 2005. In contrast to the science-fiction writers' projections which envisioned a space-age utopia, Byrne's photographs show a world four decades later which is disconcertingly unchanged.

Byrne continues to appropriate old magazines as the starting point for new work, identifying newsstands as repositories of popular culture, particularly consumer aspirations and identities. The source for *Homme à Femmes (Michel Debrane)* (2004) is a conversation between Sartre and a journalist about his relationship with women which appeared in a 1977 French news magazine. Although the script is in French, transcribed from the original article, English subtitles are taken from *Playboy*, where the original piece had been edited as well as translated. The resulting disconnection between French dialogue and English subtitles enhances the distancing effect. Commissioned for the Venice Biennale, **ZAN-*T185 r.1 (Interview) v.1, no. 4- v.2, no.6,*

19 (1969 - Feb. 1972); (Andy Warhol's (Interview) v.2, no. 21- v.3, no.9 (2007), a single-channel HD projection uses Warhol's *Interview* magazine as a source of celebrity interviews. Byrne turned to other archival material, as in *Untitled acting exercise (in the third person)* (2008), which was based on accounts of interviews with Nazis awaiting trial at Nuremberg in 1946. In 2009, commissioned to create a work that responded to the architecture and history of the University of Leeds, Byrne restaged fragments from the university archives.

One of the artist's most ambitious pieces, *A thing is a hole in a thing it is not* (2010) [315], addresses the 1960s' disputes about Minimalism (qv). The work is made up of five HD video projections: a video recreation of a 1964 radio interview with Minimalist artists Frank Stella, Donald Judd and Dan Flavin; a reconstruction of Robert Morris's 1961 performance of *Column*; another of Tony Smith's 1950s' drive through the unfinished New Jersey Turnpike; Hollis Frampton typing a letter about Carl Andre; and a video of a Minimalist exhibition with works by Morris, Andre, Stella, Judd and Flavin at the Van Abbemuseum in Eindhoven. The relationship between the art object and the viewer was an important part of the Minimalist debate and Byrne deals with this in the Eindhoven video by using the gallery like a stage set, with the viewers and technicians as players gravitating around solid objects. The piece also challenges Byrne's audience to consider the ephemeral and unfixed nature of contemporary practice and the way his own work is experienced. The irony implicit in Byrne's work is that although these dramatic re-enactments have a seductive documentary feel that should bring the viewer closer to the past, the Minimalist debate seems so foreign and Byrne's methods so deliberately artificial that the viewer remains estranged.

Byrne studied art at NCAD (BA, 1991) and subsequently spent a period doing postgraduate work in New York (MFA,

57. Gerard Byrne, *New Sexual Lifestyles*, 2003, 3-channel video monitor layout, approx. 54 min, 7 photographs, edn 1/3, Irish Museum of Modern Art (see fig. 327)

New School for Social Research, 1997/98; Whitney Independent Study Program, 1999). In 2007 he was selected to represent Ireland in the Venice Biennale. His work was included in ILLUMInazioni (Venice Biennale, 2011), Performa 11 (New York, 2011) and the biennales of Gwangju in South Korea and Sydney (2008), Lyon (2007), the Tate Triennial (2006) and the Istanbul Biennale (2003). Byrne's solo exhibitions include a significant survey show at IMMA (2011), as well as major one-person shows at ICA Boston (2008), Statens Museum for Kunst, Copenhagen (2008), Düsseldorf Kunstverein (2007), Charles H. Scott Gallery, Vancouver (2007), Frankfurter Kunstverein (2003) and the DHG, Dublin (2002).
FRANCES RUANE

SELECTED READING Maeve Connolly, 'Abstraction and Dislocation in Recent Works by Gerard Byrne,' *Circa*, no. 113 (2005), 31–42; Sarah Pierce and Claire Coombes (eds), *The Present Tense through the Ages: On the Recent Work of Gerard Byrne* (London 2007); Dillon, 2010; Pablo Lafuente (ed.), *Images or Shadows: Gerard Byrne*, exh. cat. IMMA (Dublin 2011).

CAMPBELL, GEORGE (1917–79) [58], painter. George Frederick Campbell, best known for his abstract compositions (see 'Abstraction') based on landscapes (qv) and still lifes, was one of a group of Belfast artists who brought new energy to the Irish art world in the 1940s. Although born in Arklow, Co. Wicklow, George, along with his brother Arthur, was raised in Belfast by their widowed mother, Gretta Bowen, who later became an artist herself. At the age of twelve, George was sent to the Masonic Orphan Boys' School in Clonskeagh, Dublin.

58. George Campbell, *Autumnal Complex No. 2*, 1975, oil on board, 60 x 50 cm, Arts Council/An Chomhairle Ealaíon

Largely a self-taught artist, he took up painting in Belfast during World War II, his first works being inspired by the bombing of the city by the Luftwaffe in 1941. He also visited Connemara, where he painted with his friend, Belfast artist, Gerard Dillon (qv). In 1944 Campbell's first exhibition was held at the Mol Gallery in Belfast, where he and his brother Arthur both showed. After six months in London, George's first one-person show was held at the Victor Waddington Gallery in Dublin in 1946. The following year, he exhibited for the first time at the RHA (qv), and over his lifetime showed over one hundred works at the Academy. In 1948 Campbell showed in London, along with Daniel O'Neill, Gerard Dillon and Nevill Johnson (qqv). Visiting Paris two years later, he became friendly with Ossip Zadkine, the distinguished Russian cubist sculptor, before returning to Ireland where he stayed and painted in Gerard Dillon's cottage on Inishlackan Island, off Roundstone in Connemara.

Although Spanish subjects begin to appear in Campbell's paintings around 1947, it was not until 1951 that he actually visited Spain. He returned regularly thereafter, travelling and painting in Catalonia, Málaga and Córdoba, absorbing the influence of the landscape, light and culture of the Iberian peninsula. His interest in Spain extended to his taking up the guitar and becoming proficient at flamenco. Over the following three decades, Campbell divided his time between Spain and Ireland, where he exhibited regularly at the Waddington Gallery and also, latterly, at the Hendriks Gallery. His best paintings date from the 1960s, when his appreciation of Spanish and Irish landscapes combined with a strong Cubist sensibility and a confident use of paint.

Campbell's paintings are generally abstract compositions, genuine abstractions in the sense they are clearly inspired by figures or landscapes, where dark rich earth tones contrast with flashes of lighter hues. As well as being a painter, Campbell was an accomplished musician, author and broadcaster. Retrospective exhibitions of his work were organized by CEMA in 1949, 1952 and 1960. There were also exhibitions in 1966 and 1972, organized by CEMA's successor, the ACNI. In 1973 he was the subject of an RTÉ film, *Things within Things*.

Campbell was elected an associate of the RHA in 1954 and a full member in 1964. His work is included in the collections of IMMA and CAG. PETER MURRAY

SELECTED READING George Campbell, *An Eyeful of Ireland* (Dublin 1973); William J. Hogan, *Out of Season*, illustrated by George Campbell (Galway 1978); Michelle Baily, 'The Life and Word of George Campbell RHA 1917–1979' in *George Campbell 1917–1979: A Retrospective Exhibition*, exh. cat. Droichead Arts Centre (Louth 1992).

CARR, TOM (1909–99) [59], painter, watercolourist. The son of a Belfast stockbroker, Tom Carr as a boy received lessons from the Swiss painter Hans Iten (qv), who settled in Belfast in 1904. Later, at Oundle School, Northamptonshire, he was taught by the Belfast-born E.M. O'Rorke Dickey (qv). In 1927 Carr went to the Slade School of Art, London, where he studied under Henry Tonks. After a brief period in Italy, he was associated first with the Objective Abstractionists, and then

with the Euston Road School. During February and March 1939 he visited Dublin with the South African painter Graham Bell (1910–43), one of the mainstays of Euston Road. They made a contract to hold an exhibition in Dublin after painting pictures of the city. In October 1942, Graham Bell shared an exhibition at the Leicester Galleries, London with three Euston Road pupils, Tom Carr, Anthony Devas and Lawrence Gowing. Carr was a much less intellectually analytic painter than the orthodox Euston Roaders, and less dogmatic than the Objective Abstractionists. He later used his 'objective abstraction' paintings to roof his beehives, saying in a letter to Mrs Quentin Bell in 1980 that he 'could not speak too highly of their weather-resistant qualities' (Mrs Bell in conversation with Martyn Anglesea, 1980).

By the outbreak of World War II, Carr had returned to Ulster and settled with his wife and family at Newcastle, Co. Down. He was an Official War Artist. In 1957, in partnership with the architect Robert McKinstry, he opened the Piccolo Gallery in Belfast. Carr was an Academician of the RUA (qv), and the only Northern Ireland member of the RWS. After the death of his wife, Carr went to live with his eldest daughter, Ann, and her husband, near Norwich. He died there after a short illness in February 1999. Ann Carr's son, James McKeown, taught by his grandfather, now works as a painter in Étretat, Normandy. Carr's paintings are included in the collections of the ACNI and the AIB. MARTYN ANGLESEA

SELECTED READING Anglesea, 1981; Harries and Harries, 1983; *Tom Carr Retrospective*, exh. cat. UM, Belfast and DHG, Dublin (Belfast 1983); Eamonn Mallie, *Tom Carr: An Appreciation* (Belfast 1989); Anglesea, 1996, 4; *Tom Carr 1909–1999: Compelled to Paint*, exh. cat. Eakin Gallery (Belfast 1999).

CLARKE, CAREY (b. 1936), painter. Born in Donegal and educated at NCA under Maurice MacGonigal in the 1950s, Clarke also studied at the Salzburg Academy of Fine Art, the Royal College of Art, London and under the Italian portrait painter Pietro Annigoni in Florence. He has been described as 'an academic painter without equal in Ireland today' (O'Byrne, 2010, p. 44). While Clarke's work is not known for its innovation, the academic tag does not do justice to his skills as a draughtsman, or to his understanding of light, qualities that are particularly evident in *The Tobacco Barn* (1980–82, private collection). Describing one of Clarke's remarkable outline drawings, *Reading the Headlines*, Noel Sheridan wrote, 'It is a drawing that tests the Henry Tonks' [1862–1937, influential academic teacher of William Orpen (qv)] ruling about the expressive power of boundary lines alone' (Sheridan, 1996, p. 114).

Despite cataclysmic changes in art practices and taste since the 1950s, Clarke has remained unswervingly loyal to the principles of academic realism (qv) while managing to retain a freshness of vision, in no small part attributable to his sensitivity to light and composition. That achievement is supported also by his technical virtuosity. In addition to his well-known oil and watercolour paintings, Clarke is proficient in the Renaissance craft of tempera painting, which can be seen at its

best in *Substance and Shadow: Still-life with a Shelf* [60]. While painters such as the English artist Lucian Freud have captured critical acclaim for their ability to convey flesh tones, Clarke's modest approach to his work belies a similarly convincing mastery.

Clarke taught painting at NCAD from 1963 to 1995 and was elected RHA in 1980 and PRHA from 1992 to 1996. He is highly regarded as a portrait painter (see 'Portraiture'), depicting people from all walks of Irish life, including Homan Potterton (director of NGI, 1980–88), Albert Reynolds (Taoiseach, 1992–94), Tomás Mac Giolla (Lord Mayor of Dublin, 1993/94), Dr Patrick Masterson (president of UCD, 1986–93) and Niall Crowley (former chairman of AIB). His work has been purchased by the Haverty Trust and can be found in the collections of the UM, UL, OPW and in many corporate collections. The Smurfit and AIB collections have fine examples of Clarke's still-life paintings. CATHERINE MARSHALL

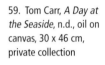

59. Tom Carr, *A Day at the Seaside*, n.d., oil on canvas, 30 x 46 cm, private collection

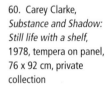

60. Carey Clarke, *Substance and Shadow: Still life with a shelf*, 1978, tempera on panel, 76 x 92 cm, private collection

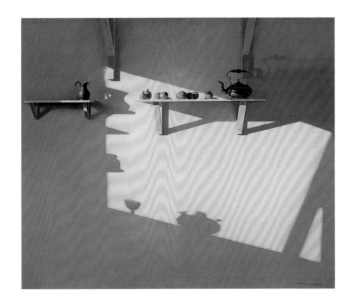

SELECTED READING Frances Ruane, *Carey Clarke*, exh. cat. Grafton Gallery (Dublin 1987); Aidan Dunne, 'Carey Clarke's exciting nuts and bolts', *Sunday Tribune* (22 November 1987); Bruce Arnold, 'A Master Craftsman: Carey Clarke, PRHA', *IAR Yearbook* (1996).

CLARKE, HARRY (1889–1931) [61], illustrator, stained-glass artist. The work of Harry Clarke, who is described as 'probably the finest Irish stained-glass artist ever' (Dunne, p. 6), is surprisingly little-known, undoubtedly because it has to be sought out in churches and institutions throughout Ireland, and as far away as Miami and Brisbane. Furthermore, Clarke's work in stained glass (qv) is so light-dependent that reproductions rarely do it justice. His extraordinary achievements, not just in stained glass but also in illustration (qv), are all the greater in the light of his chronic bad health, and the stresses of running his father's church decoration business on behalf of the family.

61. Harry Clarke, *Ligeia*, c. 1924, pen and ink on board, 28 x 21.6 cm, Crawford Art Gallery

62. Harry Clarke, *The Eve of St Agnes*, 1924, stained glass in 8 sections, 157.5 x 105 cm, Dublin City Gallery The Hugh Lane

Clarke's premature death from tuberculosis at the age of forty-one, and the unfortunate rejection of his finest work by the Irish government, resulting in its loss to the country, have also contributed to his being under appreciated as a major figure in Irish art.

Born in Dublin, Clarke studied briefly at the National Art Training School, South Kensington, until lack of money brought him back to Ireland. Scholarships enabled him to attend the DMSA, where fellow pupils included Seán Keating, Patrick Tuohy and James Sleator (qqv), and where Clarke managed to withstand the pervasive influence of William Orpen (qv) in favour of his own very distinctive style. His time at the DMSA served him well, enabling him to improve his drawing skills, to formally study the techniques of stained glass (already familiar from his father's business) under Alfred Ernest Child and introducing him to the artist Margaret Crilley (see 'Clarke, née Crilley'), who was to become his wife in 1914. The young Clarke created ripples of interest in 1911 in Britain and Ireland by becoming the first Irish stained-glass artist to win a Gold Medal at the South Kensington School's National Competition, going on to win two further gold medals in 1912 and 1913 in the same competition, as well as the RDS's Taylor Prize in 1912, while a travel scholarship from the Department of Agriculture and Technical Instruction in 1913 allowed him to travel to France to see medieval stained glass. Commissions for stained-glass panels began to trickle in, and while he rented studio space in his father's business, Clarke began to work on his own projects. As early as 1915 he was commissioned to do what was to be his biggest and one of his most successful projects, the eleven windows for the Honan Chapel in University College Cork, itself one of the most outstanding Celtic Revival buildings in the country. This commission, completed in just two years, established Clarke's reputation; even though surrounded by work by many of the most prominent arts and crafts artists of the day, Clarke's stood out. Simultaneously, he sought and received commissions to illustrate well-known poems and stories, the most important of which came from the London publisher George G. Harrap, for whom Clarke produced illustrations for an edition of Hans Christian Andersen's *Fairy Tales* in 1916 and, even more famously, illustrations for Edgar Allen Poe's *Tales of Mystery and Imagination* in 1919, and a further more lavish edition in 1923. A project to illustrate Coleridge's poem 'The Rhyme of the Ancient Mariner' was abandoned after most of the blocks were destroyed during the Easter Rising of 1916. Clarke's illustrated books were rapturously received, with the second version of his Edgar Allan Poe book running to three editions within its first five years.

Private commissions for domestically scaled glass panels provided opportunities for Clarke to unite his genius for illustration with a medium that embraced colour and light in a combination that could not be matched in painting. Always interested in John Millington Synge, whose writings on the Aran Islands prompted the first of Clarke's six annual visits to the islands in 1909, he executed nine small glass panels of Synge's poem 'Queens' (1917) for his most influential patron, fellow past-pupil of Belvedere College, Lawrence Waldron, Nationalist MP and *bon viveur*.

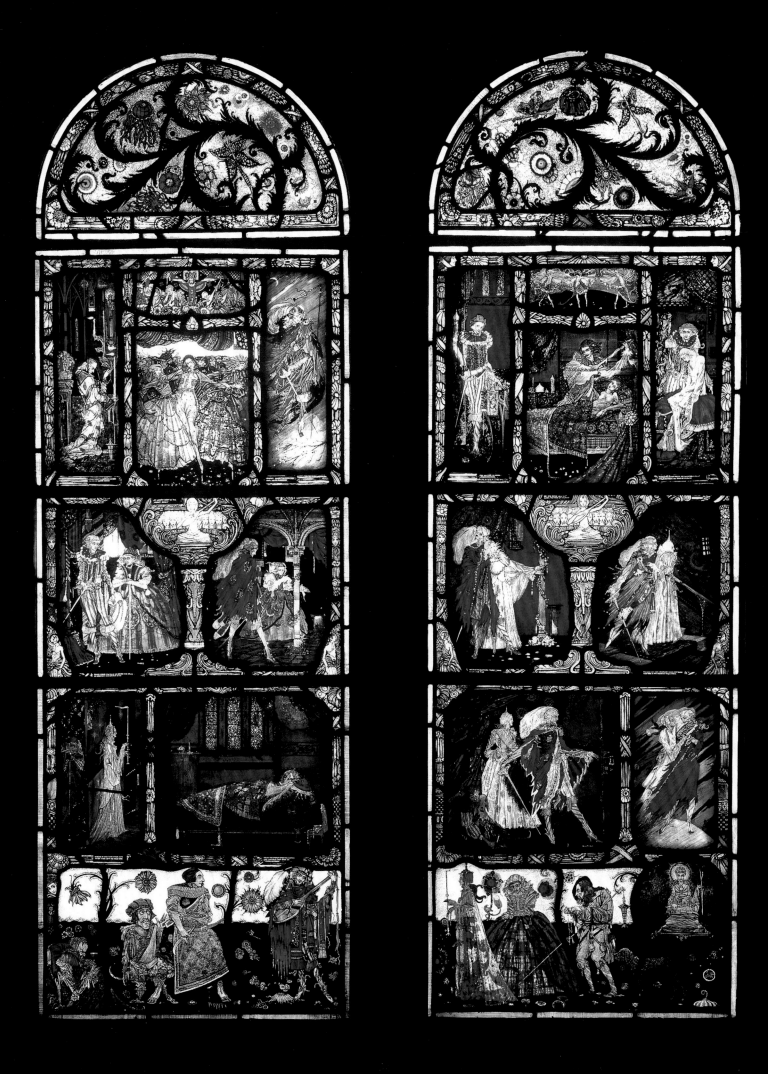

Illustration is central to all Clarke's work whether in the form of books, large church windows, or smaller panels for private schemes, such as the stained-glass window illustrating Keats's poem 'The Eve of St Agnes' [62]. Clarke had to produce hieratic images appropriate for the spread of religious fervour and devotion, while in his book work and his smaller stained-glass works he could deal with material that was far more disturbing and unsettling. He appears to have played a significant part in the choice of literary subjects for illustration. His diaries record his desire to illustrate Synge's 'Queens' and Poe's stories, suggesting that he may have prompted their selection. 'The Eve of St Agnes' tells the story of forbidden young love and its tragic outcome, in panels of exquisite detail, where languorous sexuality is offset by darker passages redolent with hostility, jealousy and the energy of a wild snowstorm. The influence of Art Nouveau, especially of Aubrey Beardsley and Gustav Klimt, and of the French Symbolists, is clearly evident in these works, as in his book illustrations, but those influences were fully integrated into his own distinctive style in which a love of *fin de siècle* detail and acid-enhanced colours are the hallmarks. As critic Aidan Dunne describes it, 'His inclination towards the proliferation of detail ran the risk of simply clogging up the compositional space, but in fact allowed him to create rippling, coruscating surfaces that come to life especially, even magnificently, in his glass work.' (Dunne, p. 6)

In 1924, the year in which *The Eve of Saint Agnes* window was shown to great acclaim at the *Áonach Tailteann*, Clarke became an ARHA and a full Academician a year later. He was highly regarded by his peers, both literary and artistic. The artist Nano Reid (qv), herself a fine illustrator, cited him as an important influence on her own work, and said of his graphic-design classes at the DMSA that '... it was wonderful to watch him draw when giving instruction. The ideas seemed to flow from the pencil like magic' (Snoddy, 2002, p. 90), while Evie Hone bought a piece of his work years before she herself turned to stained glass as an art form (Bowe, 1989, pp. 226, 272, ft. 24). His fellow student at the DMSA Seán Keating accompanied Clarke and his wife on several of their trips to the Aran Islands, leading Keating to paint Clarke in Aran *bainíns*, planning the design for his *St Gobnait* window in the Honan Chapel [463]. The critic, writer, and painter George Russell (qv) considered Clarke to be a genius; in Seanad Éireann, William Butler Yeats spoke of his admiration for him; the playwright Lennox Robinson was a personal friend, executor of his estate and travelled with him to Davos in Switzerland where his tuberculosis was treated. So popular was Clarke that when he and his wife held an exhibition at their studios in 1925, it was launched by President W.T. Cosgrave.

A year later, Clarke received a commission from the government to design and execute a window for the International Labour Building of the League of Nations in Geneva [365]. Clarke proposed that the subject should be Irish writers and, with the assistance of W.B. Yeats, then a senator, selected fifteen Irish writers. Although in rapidly declining health, Clarke pressed ahead with the project, completing it in 1930 when he showed it to government representatives. Ironically, in view of Clarke's position as the leading provider of religious imagery in churches, a letter from President Cosgrave expressed reservations about nudity in the work and suggested that '... the inclusion of scenes from certain authors as representative of Irish literature and culture would give grave offence to many of our people' (Dunne, p. 6). Instead of representing Ireland in Geneva, the window was housed in Government Buildings in Dublin and was not paid for until some weeks after the artist's death in 1931. The Clarke family later bought it back, but, failing to find an appropriate home for it in Ireland, sold it in 1988 to the Wolfsonian Foundation, Miami, so that it could be seen in a public museum.

Clarke's severe ill health and early death did not prevent him from accomplishing a prodigious amount of work. The *Irish Times*, reviewing his exhibition in 1925, remarked that 'The quantity ... is scarcely less remarkable than its quality' (Bowe, 1989, p. 182). At his death, he left behind 121 windows designed and, at least partially, executed by him, as well as illustrations for books and poems by such writers as Goethe, Perrault and Swinburne, in addition to those already discussed.

A retrospective exhibition of Harry Clarke's work was held at the HL in 1979. His work can be seen in the collections of the NGI, HL, NLI, CAG and UCC, in churches all over Ireland, in Brisbane, Glasgow and Durham. CATHERINE MARSHALL

SELECTED READING Nicola Gordon Bowe, *The Life and Work of Harry Clarke* (Dublin 1989); Nicola Gordon Bowe, 'A Regal Blaze: Harry Clarke's depiction of Synge's Queens', *IAR* (Summer 2006), 96–105; Lucy Costigan and Michael Cullen, *Strange Genius* (Dublin 2010); Aidan Dunne, 'A fresh window on Harry Clarke', *IT, Weekend Review* (15 May 2010).

CLARKE (NÉE CRILLEY), MARGARET (1884–1961), painter. Born in Newry, Co. Down, Clarke studied at Newry Municipal Technical College before gaining a scholarship to the DMSA, where she won numerous school and Board of Education national prizes. She married fellow student Harry Clarke (qv) in October 1914. Clarke taught life classes, both as William Orpen's (qv) teaching assistant (1911–14) and independently (1914–19). Orpen showed the high regard he had for her from her earliest days at the School, by purchasing her painting *Nude* (*c.* 1911–13, private collection) which he considered to be one of her finest works (Pyle, 88).

Exhibiting regularly at the RHA (qv) from 1913, Clarke became the second female artist to be elected a full Academician in 1927. She was also involved in the Radical Painters Group and the SDP (two solo shows in 1924 and 1939), and she participated in exhibitions in Ireland and in cities abroad, including London, Paris, New York and Chicago. While Clarke's training rooted her work within the prevailing academic realist tradition (see 'Realism'), she encouraged modern trends. She was a founding member of the IELA (qv), and certain of her works reflect an attraction to modern masters such as Gauguin and Matisse, for example, *Ann with Cat* (*c.* 1930/31, reworked *c.* 1943, private collection). While not the most innovative artist of her time, Clarke was nevertheless an important figure, and significant commissions include *St Patrick climbs Croagh Patrick* (1931, HL) for the Haverty Trust and a set of five poster designs for the Empire Marketing Board (1930, NLI).

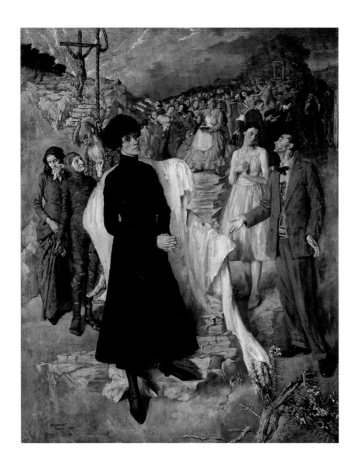

Design, London (1961–63), NCAD, Dublin (1963/64) and UCD, where he won the Purser Griffith Travelling Scholarship in European Art. He moved to Milan in 1964, where he studied at the Accademia delle Belle Arti di Brera (1964–67) and had his first professional solo exhibition in 1970. He is a highly influential figure among artists in Ireland and is critically acclaimed internationally.

Coleman lived in Milan until the early 1980s but also spent time in Ireland, especially in County Clare, and is now based in Ireland. A seminal early work, *Slide Piece* (1972–73) [64], in which the same slide image of a Milan street is described in minute detail, from different points of view, by a single narrator, set out his continuing concerns with language, perception and understanding, exploring the gaps between seeing, knowing and believing. Coleman was, and is, conscious of the unreliability of single agreed notions of reality and his determined use of new technologies of the time took his practice, at that point in the early 1970s, and for some time after that, beyond the normalizing conventions of art production. One could say that forms of art production had to catch up with Coleman's ideas and demands.

In a conversation with philosopher Richard Kearney in *Aspects Magazine* (Autumn 1982), at the time when his work was beginning to attract significant international attention, Coleman stated that '… in the work, "So different … and yet" [479], narration is proposed as a form for reading and conceiving a presented reality, not for establishing a structure on which to establish a true reality … narration is not intended to produce truth, though it may propose a form for conceiving or locating it'. This statement clearly positions Coleman's art as something made as a result of experience and not as a means to describe it. His work is demanding, certainly, but also empowering for the viewer/reader who engages fully to generate meaning, value and his/her own 'truth'.

Coleman moved quickly, from the very beginning of his career, to using mixed and multi-media. Over the decades, since the 1960s, the artist has used and experimented with a range of contemporary time/lens-based media (see 'New Media Art'). In each period, the available technological resources of the moment were used to create projection pieces, firstly, with basic tape/slide projection and voice-over, then video monitors and projection, and latterly with computer-controlled digital projection technologies. In projected pieces, the artist also pays considerable attention to the actuality of the space in which the public encounters his works and where the experience and the meaning are made. The scale, the lighting, the wall/floor coverings, the seating or absence of seating, and many other aspects of the space, are all addressed in finalizing a particular piece. This approach, which, in effect, includes the viewers'/readers' sense of their own presence and position in space, related to the vision and sound of the projected imagery, means that Coleman's work also has the properties of sculpture, defined to include the expanded field of media and location which developed in the last quarter of the twentieth century.

Box (ahhareturnabout) [228, 325], first shown in *Rosc '77* (see 'Rosc Exhibitions') in Dublin, is a projected film work of staccato black and white clips from the Dempsey versus

63. Margaret Clarke, *Strindbergian*, 1927, oil on canvas, 127.5 x 102 cm, National Museums Northern Ireland, Collection Ulster Museum

Her oeuvre, comprising portraits, landscape, still lifes and subject pictures, is not large, reflecting her commitments to family, her directorship of the Harry Clarke Studio from 1931, and her deliberate methodology, evidenced in numerous preparatory sketches and studies. Her drawings reveal an accomplished draughtsmanship and a sensitive study of light and shadow, as seen in *A Girl's Head* (1909, NGI). As a portraitist, her perceptive characterizations invariably elicited good critical comment, for example, *Dom Justin McCarthy* (1931, Mount St Joseph's, Roscrea), and among her best are those of family and close friends, such as *Dermod O'Brien, PRHA* (1934, Irish Agricultural Wholesale Society). Clarke's subject pictures, such as *Mary and Brigid* (1917, Mount Saint Vincent University, Nova Scotia, Canada), and especially those of the 1920s, among them *Bath Time at the Crèche* (c. 1925, NGI) and *Strindbergian* [63], gave scope to her original expression, and tested the conventions of the Irish academic tradition. CARLA BRIGGS

SELECTED READING Carla Briggs, 'Margaret Clarke', *Allgemeines Künstlerlexikon*, Bd 19 (Munich 1998); Ingrid Jenkner, 'Allegory, Portrait, or Genre? "Mary and Brigid" by Margaret Clarke', *IAR Yearbook*, XIV (1999), 148–51; Hilary Pyle, 'Darling Margaret: A look at Orpen's Favourite Pupil', *IAR* (Spring 2007), 86–91; Carla Briggs, 'Margaret Clarke's history paintings', in O'Connor, 2010.

COLEMAN, JAMES (b. 1941), artist. Born in Co. Roscommon, in Ballaghaderreen, James Coleman studied at the École des Beaux Arts, Paris (1960), the Central School of Art and

64. James Coleman, *Slide Piece*, 1972–73, projected images with synchronized audio narration, 35 mm slides, colour

FACING PAGE
65. James Coleman, *Strongbow*, 1978–2000, video installation, resin case, plaster cast mould Sony Art Couture monitor, polystyrene packing, scaffold tower, packing material, Irish Museum of Modern Art

Tunney World Boxing Championship of 1927, with an oppressive soundtrack of a fighter's inner voice, which is full of doubt. In an exhibition in the DHG, Dublin, in 1982, *Box* was shown at the bottom of a narrow spiral staircase, viewable by one person at a time, making it impossible not to be fully engaged in such a claustrophobic setting, where inner and outer, actual and re-presented realities merged.

Coleman's work operates between language and the visual and often deploys and, at the same time, fragments modes of narrative meaning in historical and 'modern' myth, but also in forms of popular culture, including comic storyboards and detective fictions. In *Seeing for Oneself* (1987/88), a multiple slide projection with synchronized audio narration, a historical murder mystery provides the basic format on which are then constructed other layers of possible readings and meanings.

While it can be hard to discern specific references to an Irish context, especially in later works, or any direct engagement with the unavoidable politics of the 'Troubles' over the last forty years, *Strongbow* (1978) [65] is probably the work that most clearly examines, not the phenomena of the 'modern' Troubles, but the underlying issues of division and duality in Ireland (see 'The Troubles and Irish Art'). Strongbow was the name given to the Norman knight Richard fitz Gilbert de Clare, the Earl of Pembroke, who became Lord of Leinster in 1170. In the work's first iteration, which was acquired by IMMA in 1991, a fibreglass cast of Strongbow's sarcophagus, which is housed in Dublin, was lit dramatically by a single theatrical spotlight in a confined, blacked-out room while, on a video monitor, to one side, a pair of hands, coloured orange and green, would reach a crescendo of clapping, stop and start again. The sound in that confined space became physical, the viewer unavoidably aware of his/her own body negotiating space, image and sound in three dimensions. The artist completely reconfigured the piece for inclusion in the survey exhibition *Shifting Ground* at IMMA in 2000 – an exploration of Irish art over five decades. The fibreglass cast was shown in a much larger, more brightly lit space in the museum which was shared with boxes and packing from items of digital equipment and some builder's scaffolding.

In relation to politics and political engagement, the writer Jean Fisher made a fundamental point about Coleman's practice in *Aspects Magazine* (Autumn 1982) and in the catalogue for the DHG and Ulster Museum exhibitions in the same year – that Coleman's art is, in fact, political, 'not in a conventional sense, but in the sense that it challenges the very basis of ideology'. The work is, therefore, fundamentally, rather than superficially, political because of the ways in which it 'challenges any system of predetermined meanings' and asks us to consider the reliability of any such system: how is it constructed and by whom? That

66. Michael Coleman, *Through Black*, 1979, mixed media, 150 x 173 cm, Irish Museum of Modern Art

question takes time and effort to experience in the form Coleman's work takes and may account for the fact that, although highly regarded, critically, and very influential, he has a low public profile – a condition he seems to prefer.

Coleman has had many one-person exhibitions and created new projects in a range of important galleries and museums in Ireland, Britain, the Continent and the USA. His works are in all the key international collections; his early work *Strongbow* was one of the first major acquisitions for the IMMA collection when the museum opened in 1991. This was followed up in 2004 when the Museum acquired three significant works, *Background* (1991–94), *INITIALS* (1993/94) and *Lapsus Exposure* (1992–94) – through the CNCI's Heritage Fund.

In the spring of 2009 six major artworks covering the period from 1980 to 2002 were shown simultaneously in IMMA, the RHA (qv) and in the Project Arts Centre in Dublin, providing a unique opportunity for people to experience a spectrum of challenging works by one of Ireland's leading contemporary artists. In 2012 the largest representation of Coleman's work to date was offered when the Reina Sofía Gallery in Madrid showed eighteen works in a major retrospective. DECLAN MCGONAGLE

SELECTED READING Fisher, 1983; Jean Fisher, Benjamin Buchloh and Lynne Cooke, *James Coleman: Projected Images 1972–1994*, exh. cat. Dia Art Foundation, New York and Kuntsmuseum, Lucerne (New York 1995); George Baker (ed.), *James Coleman: October Files 5* (Cambridge, MA and London 2003); Jacques Rancière, Jean Fisher, Luke Gibbons, Dorothea von Hantlemann, *James Coleman*, exh. cat. IMMA; Project Arts Centre; RHA (Dublin 2009); Rachel Haidu, Rebecca Coman, Michael Newman, Georges Didi-Huberman, Benjamin Buchloh, *James Coleman*, exh. cat. Museo Nacional Centro de Arte, Reina Sofía (Madrid 2012).

COLEMAN, MICHAEL (b. 1951) [66], painter. A graduate of the School of Art, Limerick, Dubliner Michael Coleman came to prominence early in his career when he won the Carroll's Open Award at the IELA (qv) in 1977 and by winning the Premier Award at the same event for the next two years. He was awarded the prize for painting at *EV+A* in Limerick (1979/80).

Following these successes, Coleman moved to Vienna where he lived for some years, but he has been based in Dublin since the late 1980s and has exhibited in Dublin, Vienna, Munich, London and New York. His 1994 exhibition of the 'Hoey's Court' paintings at the RHA Gallagher Gallery was well received, drawing particularly favourable comment from the critic Dorothy Walker (Walker, 1997, p. 161).

Coleman's art is marked by frequent changes of approach, but the innate desire to experiment with ground (whether canvas or paper, or a mixture of other materials, such as velvet and leather) pigment and the tools for applying it, remains a constant through all the phases of his practice. This has led him to make large charcoal drawings, to stitch paper and canvas, to leave gaping spaces that reveal underlying layers or empty space, as in *Verge* (1991, IMMA collection), or to aggressively knife his surfaces, spilling out the history of what might be deemed to be the canvas's private domain. Although his work since 2000 has

moved in the direction of figuration, with paintings of Dublin streets and interiors, Coleman is committed to formalism. His early canvases play with the richness of colour and texture which can be achieved through laying down dense layers of paint, in which each surface is altered and enlivened by the one beneath.

Aidan Dunne, writing of Coleman's 1986 paintings simply entitled, for example, *Blue Greens* and *Red Blues*, advised that an investment of time was required to reveal the complexity in these superficially monochrome works, saying:

> [Their] monochromatic skin, tonally varied, is generally fissured to reveal underpainting in different colours. The layering and duration of underpainting is vital to the final image, which comprises not only the exterior layer but the entire weight of the pitted, lumpy, discontinuous surface. (Dunne, 1990, p. 106)

Coleman's work can be seen in the collections of IMMA, HL, OPW, NSPG, AC/ACE, TCD, UCD, CIAS, and in many corporate collections. CATHERINE MARSHALL

SELECTED READING Dorothy Walker, Dennis O'Driscoll and Ciarán MacGonigal, *Michael Coleman: The Hoey's Court Paintings*, exh. cat. RHA Gallagher Gallery (Kinsale 1994); Walker, 1997.

COLLECTING ART IN TWENTIETH-CENTURY IRELAND

Background

For much of the twentieth century, notwithstanding the activities of certain innovative individuals, art collecting in Ireland can be described as cautious, conservative and provincial. There were few buyers, few exhibition opportunities and a diminutive art market; little was done to educate the public about the visual arts. At the turn of the twentieth century, the Royal Hibernian Academy of Arts (RHA) (qv) provided the only consistent outlet for Irish artists to exhibit and sell their work, although the leaders showed also at the Royal Academy (RA) in London. Since there was no national collecting institution, apart from the National Gallery of Ireland (NGI), official portraiture (qv) offered artists the best route to places in public collections (see 'Publicly Funded Collections' and 'Public Art'), such as those of the universities, hospitals and corporate boardrooms. Commenting on the difficulty of selling artwork, Sir William Orpen (qv) remarked bitterly that 'Dubliners preferred a £5 mock of Millet any day' to an original painting by Patrick Tuohy (qv) (Crookshank and Glin, p. 284). An exhibition of works by Nathaniel Hone and John Butler Yeats in 1901 led Hugh Lane to propose the formation of a national portrait gallery and to commission twelve portraits from Yeats for this. Yeats completed five while Orpen undertook the remaining seven. State patronage (qv), effectively non-existent until the establishment of the Free State in 1922, was limited. Even after that date, it was largely confined to academic artwork promoting a particular image of Irishness and to the commissioning of occasional sculpture, portraits of politicians or carpets for government buildings. The most outstanding of these was undoubtedly the group of paintings by Seán Keating (qv), recording the building of the new power stations, acquired by the Electricity Supply Board in the 1920s (ESB collection).

The situation remained so bad that, in a comprehensive report to the government in 1949, Thomas Bodkin (Director of the NGI, 1927–35) complained that 'no civilised nation of modern times has neglected art to the extent that we have during the past fifty years' (B.P. Kennedy, p. 65). Public representatives, on the whole, showed very little interest in the arts. Eamon de Valera (Taoiseach twice, and President 1959–73), revealed his priorities when he launched Radio Éireann in 1933. He spoke about the Irish language and learning, music and drama, but made no reference to the visual arts (B.P. Kennedy, p. 31). Ironically, it was an art collection that became the only issue in the arts to attract sustained attention from the first Free State government and continued to preoccupy political leaders for a good part of the century. In 1908, in an effort to encourage a distinctive Irish school of art, the collector Hugh Lane [67], backed by donations from the Prince and Princess of Wales and President Roosevelt and others, successfully campaigned for the opening of a Municipal Gallery of Modern Art (HL) in temporary premises in Dublin. Lane's own collection had been inspired by James Staats Forbes's collection of modern European art, which was offered for sale following his death in 1904. For seven years Lane pressed Dublin Corporation to build a gallery to

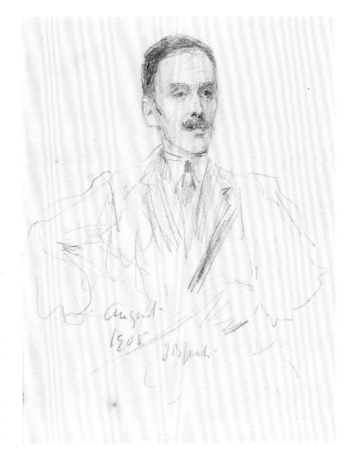

67. John Butler Yeats, *Sir Hugh Lane (1875–1915) later Director of the National Gallery of Ireland*, 1905, graphite on paper, 17.5 x 12.7 cm, National Gallery of Ireland

house a promised donation of his artworks. When this did not happen, he lent his thirty-nine best modern pictures instead to the National Gallery, London and formally willed them there in 1913. Following Lane's untimely death in 1915, an unwitnessed codicil to the will was found, reversing this decision again, in favour of Dublin. For the next sixty years successive governments struggled to have Ireland's moral claim to the collection validated. The considerable public interest aroused by this contest was as much nationalist as aesthetic, providing the impetus for the acquisition of Charlemont House in Parnell Square as a permanent home for the Municipal Gallery in 1928.

That contest may have prompted the speedy acceptance of other donations. Sir Alfred Chester Beatty offered his collection of nineteenth-century French pictures to the nation in 1950. A positive response certainly encouraged him to give his priceless oriental collection to the Irish state some years later. The experience also paved the way for the gift to the state of the collection of Sir Alfred and Lady Beit in the 1990s, despite several paramilitary inspired attacks on it during the 1970s and '80s.

Despite lack of education about visual art (see 'Education'), large numbers of people attended exhibitions of contemporary art in the early years of the twentieth century. In 1904, 80,000 visitors braved admission charges to attend the exhibition of Irish art in London's Guildhall, while 1,500 came daily to the Jack B. Yeats (qv) loan exhibition in 1945 in Dublin (B.P. Kennedy, p. 51). In Northern Ireland, public support was also more evident than that of officialdom. When Hugh Lane

loss of Sir Basil Goulding's collection of international abstract art in the 1970s, followed by the promise of a gift of Gordon Lambert's collection of contemporary artworks to the state, played a significant role in the foundation of the Irish Museum of Modern Art (IMMA) in 1991 [68, 69].

Developments and initiatives

While a few collectors bought international as well as Irish art, there was very little art buying until the 1970s. The Friends of the National Collections of Ireland (FNCI) was founded in 1924 to buy artworks and heritage items for Irish collections, and a number of important bequests, such as the Haverty Trust and the Gibson Trust, provided assistance to public collections to acquire artworks. Despite their efforts, official Ireland continued to isolate itself from modern art throughout the 1930s and '40s which was sadly exemplified by the initial rejection of offers of works by Georges Rouault and Henry Moore to the HL. Responding to the lack of an acquisition budget at the HL, a group of collectors and artists set up the Contemporary Irish Art Society (CIAS) in 1962 to assist it, and other galleries, to acquire artwork by living artists. A similarly philanthropic instinct led George Dawson (1927–2004), Professor of Genetics at Trinity College Dublin (TCD) [70], to initiate the College Gallery Picture Hire Scheme, with the aim of encouraging causal encounters with art for students and staff. Supported by the Calouste Gulbenkian and Trinity Trust, Dawson bought original works by leading Irish and international artists, which were lent to members of the college for set periods at affordable rates.

To promote collecting, the Arts Council (qv), established in 1951, began to collect contemporary Irish art in the 1950s, but its budget was limited and the Council had no premises in which to exhibit the works. A more significant impetus for collecting was the Council's Joint Purchase Scheme, in the same decade, which encouraged public organizations and collections to buy contemporary artworks. Under this scheme, the Arts Council and its purchasing partners each put up fifty per cent of the purchase price for approved artworks. Organizations like Bord Fáilte, Aer Lingus, Córas Iompair Éireann and RTÉ built up substantial collections with the aid of this scheme which was quickly extended to hotels, schools, local authorities and arts societies. In Northern Ireland, the Council for the Encouragement of

exhibited modern pictures in Belfast in 1906, the exhibition was well attended and acclaimed in the local press, but offers to donate some of the works to the city, to supplement a bequest of pictures and money from the estate of Sir Robert Lloyd Patterson, failed through lack of action by the authorities. Lloyd Patterson's generosity was to form the nucleus of an important collection of British art from the early twentieth century at the Belfast City Art Gallery, later the Ulster Museum (UM).

It was again pressure from the public and from private collectors (see 'Private and Corporate Collections') that finally influenced the foundation of the first national institution for the collection of modern and contemporary art in the Republic. The

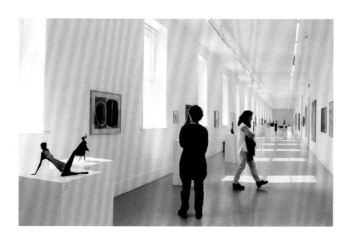

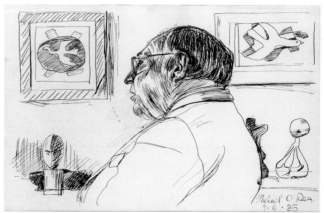

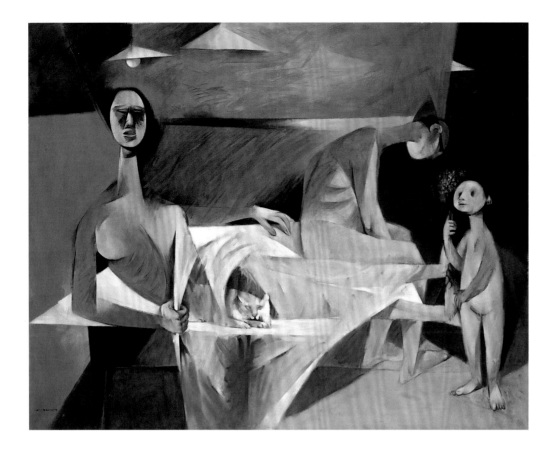

Music and the Arts (CEMA) was established in 1941 to improve wartime morale. In its later manifestation as the Arts Council of Northern Ireland (ACNI), it, too, worked to promote the collecting of contemporary art.

From the 1960s onwards, a new sense of nationhood, growing prosperity, and a consequent building boom, combined with increased foreign travel, led to more confident art collecting. The Rosc exhibitions (qv) from 1967 onwards, and increasing media coverage of art events, all began to make an impact on visual culture. New galleries appeared, and, as the century moved into its final decades, they were joined by Arts Council-promoted arts centres in every county. By the late 1980s, rising demand and prices for Irish art prompted a spate of Irish art auctions in Dublin and London. The consequent trickle of heritage artworks out of the country led to the introduction of tax incentives to Irish collectors to buy and donate artworks to Irish public collections. Other new developments included a Per Cent for Art Scheme whereby one per cent of monies spent on publicly funded building projects can be used to commission artworks. This was introduced in 1989 and has served to add important artworks to public collections all over the country, while in 2001 legislation was put in place to ensure royalty payments to artists on all sales of artworks after the initial one.

The Collectors
A handful of national institutions (see 'National Institutions of Visual Culture') carried responsibility for the collection of Irish art in the twentieth century. These were the NGI, UM, Arts Council, ACNI and the Office of Public Works (OPW), which were joined belatedly, in 1991, by IMMA. They had differing collecting remits, ranging from the need to sustain the art historical canon at the NGI, and the desire to encourage collecting to support artists represented by the two arts councils, to the OPW's responsibility to decorate government offices. Few of these institutions, apart from the NGI and IMMA, had clearly stated and coherent collection policies. In this they were little different from the local authority collections, such as the Crawford Art Gallery, Cork, the Limerick City Gallery, the Kilkenny Art Gallery Society, and the Model and Niland Collection in Sligo. The universities all have growing collections, of which the TCD collection is by far the oldest, while the University of Limerick has undertaken the establishment of a Self-portrait Collection.

Towards the end of the twentieth century the private collectors [71] were joined by a new breed of cash-rich collectors, who bought art as much for investment purposes as for its aesthetic appeal. The story of Irish art in this period must also include a number of corporate collections, which, from the 1960s until the 1990s, filled a void in state collecting. The main banks, joined by companies such as P.J. Carroll & Company in Dundalk and architectural firms such as Scott Tallon Walker, built up collections of artworks of a scale and style that were perfectly suited to Modernist architecture at a time when no Irish museums were budgeted to do this. Another important development has been the emergence of significant collections of Irish art abroad, most notably among descendants of Irish emigrants in the USA.

71. Louis le Brocquy, *A Family*, 1951, oil on canvas, 147 x 185 cm, National Gallery of Ireland donated by Lochlann and Brenda Quinn

An Irish canon

Hugh Lane sought to encourage the development of a distinctively Irish art, and scholars such as S.B. Kennedy have argued that there is such a thing (S.B. Kennedy, 1991, pp. 1–3). So, the question of an Irish canon arises. Is there one and how can it be recognized? No canons are static. All are difficult to define. While most canons appear to derive from the opinions of experts, who may be curators, critics and connoisseurs, recent publications on the Irish art market (see 'Art Market') make a convincing case for the view that the canon is closely linked to values on the art market, which are more influenced by availability, fashion and individual taste than by expert opinion. In the case of contemporary Irish art, for most of the twentieth century the authority usually conferred by museum acquisition was not a factor, since there was no major museum to play this role; the HL did not acquire an acquisition budget until 1969

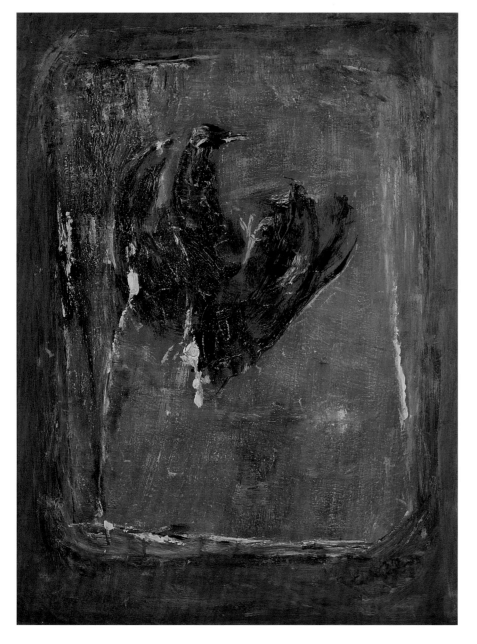

72. Patrick Collins, *Bird against the Window*, 1963, oil on hardboard, 61 x 46 cm, Irish Museum of Modern Art

and then it was so small, it hardly counted. The NGI did not buy the work of living artists and IMMA did not open its doors to the public until 1991. Whatever existing canon of Irish art there was, emerged from a confluence of factors: the opinion of peer artists, validation abroad, the views of foreign curators and critics, and, increasingly as the century drew to a close, the prices paid on the market.

Summing this up, the journalist John Burns concluded that it is difficult to tell one millionaire-businessman's collection from another. 'There is a set millionaire-Irishman collection, a join-the-dots assembly of Yeats, Osborne [qv *AAI* II], Orpen, Lavery, le Brocquy [qqv], not forgetting a few pictures of horses' (Burns, p. 60). Burns goes on to add Sean Scully (qv) and a number of other contemporary artists. His criteria for inclusion in the canon are crude, deriving only from auction house sales. They do not include the vast and growing number of Irish artists who have been validated nationally and internationally for artworks in new media (see 'New Media Art') that have not yet been exposed to the vagaries of the auction process, and which are less easily consumable. Thus, artists such as James Coleman, Dorothy Cross, Willie Doherty and Kathy Prendergast (qqv) have won prizes and been collected by major museums around the world. National canons do not exclude such achievements.
CATHERINE MARSHALL

SELECTED READING S.B. Kennedy, 1982; B.P. Kennedy, 1990; S.B. Kennedy, 1991; Mayes and Murphy, 1993; Crookshank and Glin, 2002; Somerville-Large, 2004; O'Molloy, 2005; Bruce and Marshall, 2006; Burns, 2008.

COLLINS, PATRICK (1910–94) [72, 73], painter. The second of four children, Collins was born in Dromana West, Co. Sligo. His mother, Mary Patricia McLaughlin, from County Cavan, had married William Collins, a policeman in the Royal Irish Constabulary, three years previously. Soon after Patrick's birth, the family moved to the village of Riverstown, Co. Sligo. When Patrick was four years old, his father contracted tuberculosis and had to retire from the police force. Patrick's younger sister Mary died, while he himself also contracted pneumonia. The family moved into Sligo town, where his mother ran a small grocery store. Suffering from ill-health, his mother unable to cope, Patrick was sent as a boarding student to St Vincent's Orphanage, Glasnevin, Co. Dublin. After leaving school, he worked for twenty years for an insurance company in Dublin, reading extensively in his spare time and attending evening classes at the NCA. He also studied life drawing under George Collie.

Around 1945, Collins became a full-time painter. He rented a tower in Howth Castle demesne which became a gathering place for artists and writers, including his friend the writer Aidan Higgins. In 1950, inspired by Joyce's *Ulysses*, Collins painted *Stephen Hero* (private collection). He first exhibited in the IELA (qv) that same year, and continued to show his atmospheric, misty paintings with the IELA over the following two decades. He exhibited at the Ritchie Hendriks Gallery, Dublin, from 1956 onwards. Collins's first 'Tinker' painting, *Travelling Woman*, now in the UM, dates from the following year. In 1958,

his *Liffey Quaysides* [270] was shown in the Irish section of the Guggenheim International, New York, where it was awarded a prize.

In 1964 Collins completed a series of fourteen paintings based on a religious theme, 'The Stations of the Cross' (private collection). During the early 1960s, inspired by megalithic tombs in Brittany and Ireland, he exhibited a number of 'menhir' paintings. Although Collins could clearly articulate what he set out to achieve in his paintings, the works themselves, in spite of a fragile beauty, often appear indecisive and lacking a sense of structure. Not long after painting *Travelling Tinkers* [356] in 1968, Collins spent nearly a year in Connemara digging ditches, which in turn led to a series of taut paintings inspired by bog landscapes.

In some ways Collins was the inheritor of the tradition of Jack B. Yeats (qv), especially since both artists hailed from County Sligo. However, the literary and autobiographical strains in the work of Yeats remain muted in Collins's evanescent landscapes, which hover on the fringes of figuration. From an early age, Collins was interested in the natural world, and aspects of woodlands, birds and lakes frequently appear in his paintings. Perhaps the most outstanding aspect of his art is his exquisite sense of colour – pale tints of blues, greys or pinks, sensitively applied, sometimes with slight impasto, otherwise as pale misty washes. The atmosphere created is one of extraordinary delicacy, akin to that in the work of the French painter Fragonard. The watery environment represented in many of his paintings corresponds with the idea of 'inner space'. Frances Ruane points out that Collins was not interested in explicitly describing everything he saw (Ruane, 1982). In many of Collins's artwork the central motif is 'framed' by a border several inches deep, a device that serves to further isolate the subject or content of the painting from the world of reality. His work suggests a world folded so as to be accommodated within the frame of the painting, but it is a world that stretches to infinity outside the frame.

While offering commentaries on some of his paintings, Collins preferred to leave their interpretation to the observer, acknowledging that the viewer creates the work of art at the moment of apprehension. Thus, the painting can mean different things to different people, a vagueness Collins encouraged; his deliberate use of indistinct forms, engulfed or surrounded by an almost tangible atmosphere, freed the art work from the specific and the everyday. Collins's works are dream landscapes, or landscapes drawn from memory. Collins explained *The Rook: Bird in a Tree* (private collection) as an allegory of his years in an orphanage; the bird, her head facing away, represents his mother, standing outside the nest where her offspring wait. Brian O'Doherty (qv) described Collins's paintings as 'perilous and strange, the product of a rare imagination' (O'Doherty, 51).

An artist who combined painting with a keen interest in literature, Collins aspired to achieving in paint what had been achieved by Yeats and Joyce in Irish literature; hence, his desire to be free of Irish constraints, and to 'seek his soul' by living abroad for a period. 'I knew everyone in Ireland that painted, I knew their opinions, and I wanted to get away and look at things

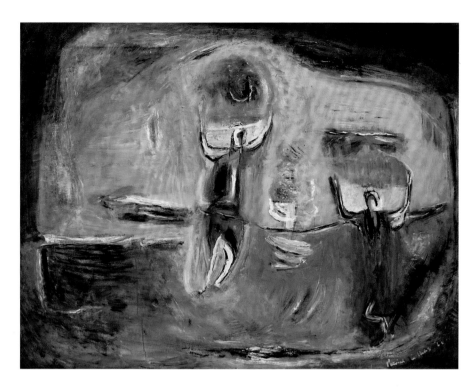

73. Patrick Collins, *Children Playing*, 1962, oil on canvas, 108 x 140 cm, Arts Council/An Chomhairle Ealaíon

from outside.' (Collins in conversation with Des Moore, quoted in Ruane, 1982, p. 67)

In 1971 Collins moved to Paris, where he lived in poverty, walking the city and moving from one temporary accommodation to another. He shared a studio for a time with the Spanish artist Leopoldo Novoa. During this period he was friendly with the poet John Montague, who was teaching at the Sorbonne, and who helped Collins as best he could. In June 1972 at the David Hendriks Gallery, Dublin he exhibited a small number of works painted in France in which mythology and autobiography overlap. This show was the first of his works painted outside Ireland, and included *Light in the Forest* (1972, private collection). The following year Collins moved to the town of Orne in Normandy, where he stayed for three years, before settling in a village near Nice. After six years in France, Collins returned to Ireland to live at Kindelstown House in Delgany, Co. Wicklow. In his *Field of Old Stones* (1978, IMMA collection), the abstract motif of the field is framed by vertical lines on either side, as if to fix it more firmly in memory (Ruane, 1986, p. 47; see also Ruane, 1995, p. 136). Elected an honorary member of the RHA (qv) in 1980, he received an Arts Council (qv) bursary that same year, and the following year was elected a member of Aosdána (qv). A retrospective exhibition of his work was held at the DHG in 1982. He died in 1994 in Monkstown, Co. Dublin.

Patrick Collins's work is included in the collections of IMMA, HL and CAG. PETER MURRAY

SELECTED READING Brian O'Doherty, 'Ambiguities: The Art of Patrick Collins,' *Studies* (Spring 1961), 50–51; Frances Ruane, *Patrick Collins* (Dublin 1982); F. Ruane, 1986 and 1995; Aidan Higgins, 'The Bosky Dew', in Higgins, 2005, pp. 205–09.

COMERFORD, OLIVER (b. 1967) [74], painter. Born in Dublin and educated in Ireland, the USA and England, Oliver Comerford first came to attention in the mid-1990s with a series of paintings of the landscape (qv) presented as though viewed through the windscreen of a moving vehicle. Prompted by his observations of contemporary life, themes of transition and of movement through space are defining motifs in his work. The windscreen, as Fintan O'Toole has commented, has disconcerting similarities to a cinema screen – wide-angled, with images constantly moving across it (O'Toole, 'Diamonds on the windshield', in Moore, pp. 109–11). The scenes projected by Comerford similarly evince the anonymity of passing landscapes, and the mundane repetition and blandness of aspects of present-day, popular culture.

Comerford adopted a technique of dragging and blurring the painted surface of that mediated world to suggest the effect of movement both on the retina and on the camera lens. The perspectives are those from the low vantage-point of the driver, looking up towards overhead telegraph wires, or passing between thickets of cultivated trees, or with the single vanishing point of the roadway directly ahead, lit by the tail-lights of the car in front. Lateral views depict fenced and hedged spaces, sliding by at eye level.

This ongoing series serves to highlight the shift in the sense of space and the relationship of urban and rural as juxtaposed regions linked and traversed by motorways. In a similar vein, some images depict a single mobile home in an unremarkable rural terrain, suggestive of the transient nature of holidays and the impermanent connection to place of such abodes.

While maintaining essentially an urban perspective, Comerford's more recent imagery is typified by the depiction of remote outposts, whose accessibility is conditional on transport networks, and whose desolation is emphasized by the lingering sense of what has been left behind: places are not complete in themselves. Throughout his work, Comerford uses effects of light for emotive and atmospheric potential. In some cases he adopts the strategies of romantic painting, with objects silhouetted against a twilit sky, while in others he presents the temporal ambiguity of light in nordic regions, where day and night may be indistinguishable.

Comerford's contribution to art rests on his observation and recognition of contemporary lifestyles, the dominant place of technological means for mediating experience, and the new viewpoints on the world that these have generated. He translates traditional methods of romantic painting to inject a pathos that is compelling without being cloying. YVONNE SCOTT

SELECTED READING Catherine Marshall, *Talk To Me*, exh. cat. Hallward Gallery, Dublin and Living Art Museum, Reykjavik, Iceland (Dublin 1998); Madeleine Moore (ed.), *Oliver Comerford: Works 1996–2010*, exh. cat. RHA (Dublin 2010).

COMMERCIAL GALLERIES. Leslie Waddington alluded to the difference between the gallery's potential as agent for good art and a mere shop for selling pictures when he said, 'I think there is an immense difference between marketable art and great art, although often great art becomes marketable art' (Isaacs, 78). Until the end of the twentieth century, the commercial gallery was, for many, the pre-eminent place to encounter contemporary art. According to Jeremy Isaacs, galleries preceded museums and public collections (see 'Publicly Funded Collections') for the main part and provided the place where specialists, such as curators, critics and collectors, first encounter the art of their own time (Isaacs, 77). That function was especially important in Ireland where public initiatives to develop audiences for visual art were neglected for much of the twentieth century. A small number of commercial galleries filled gaps left by the National Gallery's rule of not showing the work of living artists, the Dublin Municipal Gallery of Modern Art's (HL) lack of a purchasing and exhibition budget before 1969, the conservative nature of the Royal Hibernian and Royal Ulster Academies' (RHA and RUA) (qqv) exhibitions, the absence of a national museum for Modernist and contemporary art until 1991, and the avoidance in Northern Ireland until the twenty-first century of acquisitions of art of a political nature.

Until the 1920s there were virtually no outlets for art display other than the annual exhibitions of the RHA and the Royal Academy. The exhibitions that were held outside those venues were generally organized by the artists themselves and took the form of tea parties in their studios. Artists' organizations such as the Society of Dublin Painters, founded in 1920, ran successful exhibitions through which their members could sell their work, but they could not take on the business of promoting and representing each other commercially (see 'Artists' Support Groups'). Although the opening of Charles Tindall Gatty's Art Companions Gallery in Clare Street, Dublin, in 1911 was greeted by the *Irish Times* as 'the only venue where a representative selection of work by living Irish artists could be viewed outside of the Academy's annual shows' ('New Picture Salesroom', *IT*, 20 November 1911), and a number of picture framers and conservators, such as the Gorrys, Combridges and the Egan

74. Oliver Comerford, *Out Here III*, 2003, oil on canvas over board, 153 x 229 cm, Irish Museum of Modern Art

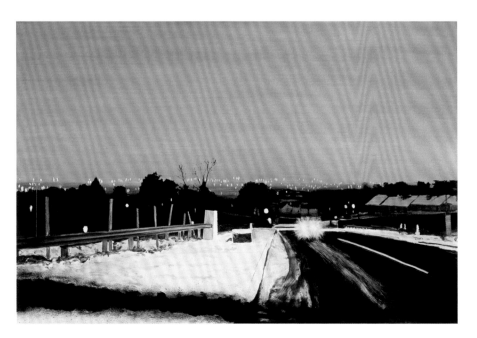

family, operated successful galleries from the 1920s onwards, it was not until Victor Waddington opened his gallery in 1925, originally at 28 and later at 8 South Anne Street, Dublin, that the concept of the commercial gallery in the modern sense was introduced to Ireland.

Leslie Waddington outlined the responsibilities of the dealer as, firstly, to help the artist by giving him/her the means to work and maintain a studio, and secondly, to promote the artist nationally and internationally (Isaacs, 77–79). In this, Waddington was summing up the innovative practice initiated by his father, Victor, in Dublin and, from 1957 onwards, in London. Victor Waddington [75] paid for his first art-dealing activities in 1921 with his winnings from professional boxing, and soon became the pre-eminent art dealer of the Irish Free State. His view of his work goes beyond the prosaic summary offered by his son. 'The just critic', he said (*IT*, 28 March 1952), 'might argue that the dealer in the works of living artists contributes as much to art as the man whose works enrich him; that he too makes his act of creation – the creation of the artists.'

As Jane Eckett has pointed out (see 'Art Market'), Waddington targeted 'buyers of moderate means', and initially showed work by traditional painters such as Seán Keating, Maurice MacGonigal and Frank McKelvey (qqv) as part of a strategy to sell Irish art in the United States of America ('To interest USA in Irish Art – Dublin Expert's Plan', *Dublin Evening Mail*, 13 March 1939). Waddington's support for artists was innovative and multi-stranded. He enabled emerging artists such as Colin Middelton, Gerard Dillon and Daniel O'Neill (qqv) to paint full-time by paying them a monthly stipend and giving them art materials in return for the first refusal on sales, and he used income from sales of conservative paintings to facilitate the promotion of more experimental, less immediately saleable work. Open-minded in his conception of art, Waddington showed work by the ceramic artist John ffrench alongside painting and sculpture. More importantly, he supported artists through targeted promotion of their work, publishing catalogues for their exhibitions, persuading the press to review them, and helping them to tour nationally and internationally. He sent an exhibition of 270 Irish paintings by twenty Irish artists to New York in 1939 and another, of Irish Modernists, to thirteen cities in the USA in 1950, while his 1940 publication, *Twelve Irish Artists*, was the first full-colour illustrated book on Irish artists. His efforts were rewarded when his exhibition of the work of Patrick Swift (qv) in 1952 was favourably reviewed in *Time* magazine ('Life with a Shillelagh', *Time* magazine, XL, no. 17, 20 October 1952).

Although interested in contemporary art, Waddington was a late convert to Modernism (qv). It was not until 1943 that he took on Jack Butler Yeats (qv), possibly at the suggestion of his assistant Leo Smith. Yeats had shown regularly with Jack Longford at the Contemporary Picture Galleries, but had never had an exclusive arrangement with a dealer. From 1943, however, he showed only at Waddington's, where he had eight solo exhibitions, and it was Yeats's death in 1957 that finally led Waddington to close his Dublin gallery and move to London, where he continued to show the work of Yeats and, occasionally, other Irish artists such as Middleton. Although the 1940s had

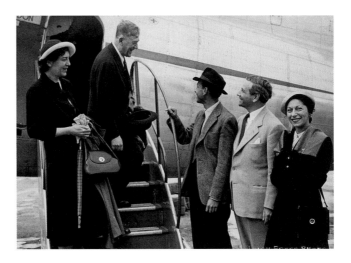

75. Victor Waddington (second from right) with Oscar Kokoshka and his wife, Mabel Waddington and James Plaut, director of Boston Museum of Fine Arts, Dublin Airport, 1946

been difficult years for his gallery, Waddington never stinted in his paternalistic support for artists. By 1945 the gallery was losing about £80 a week, a significant sum for those days; nevertheless, Waddington wrote encouragingly to Middleton 'ultimately we will build a market outside these shores, which will be healthy and which will come up to my expectations' (Coulter, p. 128).

Waddington professionalized gallery practice, drew contemporary Irish art into the international arena, and made a serious contribution to Irish Modernism both at home and abroad. His move to London was a serious loss, especially to the northern artists he had supported, but the opening of the Dawson Gallery, under Leo Smith, helped to defray its negative impact. The Dawson Gallery (Dawson Street, Dublin) gave many younger artists, including Noel Sheridan and Micheal Farrell (qqv), their first exhibitions. Its successor since 1978, the Taylor Galleries (Kildare Street), showed a stable of artists, mainly painters, who included William Leech and Mary Swanzy in the early days, followed by Louis le Brocquy, Tony O'Malley, Patrick Scott, Camille Souter (qqv) and since the 1990s, younger artists such as Cecily Brennan (qv) and Janet Mullarney. The reputation of the gallery, and its unbroken lineage from Waddington to Smith to John Taylor, Smith's former assistant and his brother Patrick Taylor, guarantees its artists a place in Irish art and the public forum they need. It was a conversation in the Dawson Gallery that led to the founding of the Contemporary Irish Art Society in the early 1960s.

David Hendriks [76] had something more innovative in mind when he opened the Ritchie Hendriks, later the David Hendriks Gallery, in St Stephen's Green, Dublin in 1956. If Waddington's established a blueprint for how a gallery could support and nourish creativity, Hendriks provided a social space where artists and audiences could meet and talk about art. Paintings were hung against elegant striped wallpaper, overseen in the early years by the Parisian chic of Hendriks's assistant Mme Guinoiseau, providing a domestic ambience that gave way to a more neutral grey-walled space when Hendriks bought and moved to 119 St Stephen's Green in 1965. The new environment reflected the emergence of the corporate buyer. It was the social aspect of his gallery that Frances Ruane singled out for special

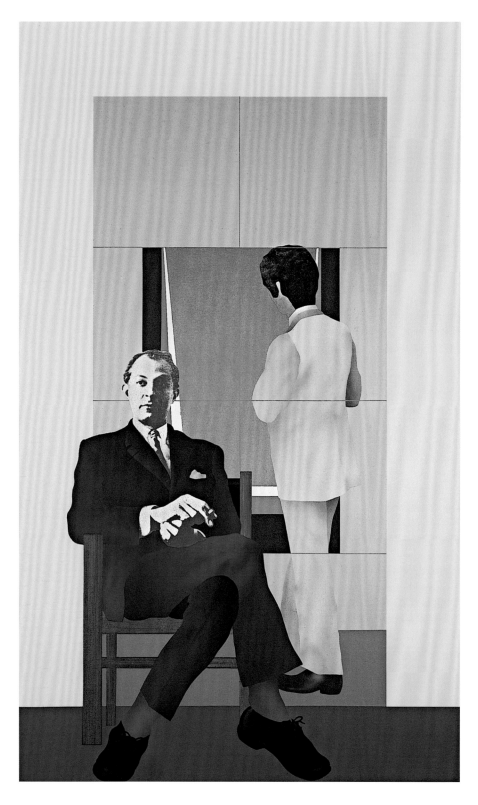

76. Robert Ballagh, *Portrait of David Hendriks*, 1972, acrylic on canvas, 101 x 61 cm, Irish Museum of Modern Art

students and artists as well as by wealthy buyers. Comparing her nurturing relationship with Hendriks to her experiences in London as a young artist, Deborah Brown said the London galleries were:

> Terrifying! ... an awful experience. They treated you like a provincial – which I was – but gave you no confidence or help The gallery was important in the 1960s as you really had to be part of a stable for people to take you seriously I remember David Hendriks saying to me after I returned to figuration: "What are you doing to me?".... He told me he sat up all night until 3am before he realized what I was up to and saw the sense of it. (Brown, 'A life in the round', interview with Brian McAvera, *IAR*, Autumn 2011, 68–75)

From the outset, Hendriks mixed local and international art. His opening exhibitions included Picasso's *Vollard Suite* of etchings, ceramics by Fabian Lacaf, and work by a number of established Irish artists, such as Seán Keating, Patrick Hennessy and Tom Ryan (qqv). By 1960 the gallery had found its voice. Hendriks sought more challenging artists such as Basil Blackshaw, Patrick Collins, Cecil King, Robert Ballagh (qqv) and Deborah Brown. Highlights in its history include the presentation of exhibitions of Op, Pop and Kinetic art with artists such as Jesús Rafael Soto, Victor Vasarely, Julio Le Parc, Patrick Caulfield and Valerio Adami in the 1960s, and *Arte Povera*, curated by Cermano Celant in 1971 (see 'Pop Art' and 'Exhibitions'). The impact of this programming on Irish audiences was considerable. Four thousand visitors thronged into small gallery spaces for the *Kinetic Art* show in 1966, a year ahead of the sensational, state-funded *Rosc '67*, while Hendriks's invitation to Celant to lecture on Arte Povera marked a new stage in audience development by a commercial gallery. If awareness of American Abstract Expressionism was growing as a result of the exhibition of the Johnson Collection at the HL in 1963, the Hendriks Gallery did much to introduce Latin American and European Modernism to Ireland.

As innovative as these exhibitions were, Hendriks was also important, as Brian Fallon and others have pointed out, for showing work that was not generally seen as saleable at the time (McCrum and Lambert, p. 66). This included work by James Coleman and Brian O'Doherty (qqv), both already known outside Ireland but championed by Hendriks at home, and exhibitions of sculpture by F.E. McWilliam and Edward Delaney, for which a market in Ireland barely existed.

As well as bringing foreign art into Ireland and showing it on the same terms as the less-known Irish artists of the 1960s and '70s (Ballagh and Cooke), Hendriks also played a big part in promoting Irish art abroad. He selected an exhibition of Irish art (including Tate Adams, Cecil King and others) for the Green Gallery in San Franscisco in 1960, and brought eight Irish artists to the Savage Gallery, London in 1962. When businessman Patrick J. Murphy planned a show of Irish art in Kuala Lumpur in 1970, Hendriks sent work by Middleton and Cooke at his own expense. Close contacts with galleries abroad, notably the Denise René Gallery, Paris, Studio Marconi, Milan, and galleries in London, Los Angeles and Düsseldorf, were also useful in

mention after Hendriks's death in 1983, notwithstanding his outstanding contribution in bringing international art to Ireland (McCrum and Lambert, p. 56). The collector Gordon Lambert remarked how intimidating he had found it to walk into art galleries as a young man (conversation with the author, September 1995). The Hendriks Gallery, however, was visited by penniless

promoting his artists abroad. International activity was balanced by pioneering engagement with organizations at home to show contemporary art outside Dublin. Hendriks collaborated with the Arts Council of Northern Ireland (see 'Arts Councils') and presented exhibitions at the Cork Arts Society, the Ulster Museum, the Wexford Opera Festival and the Kilkenny Arts Festival.

After Hendriks's death, the gallery continued briefly under collector Vincent Ferguson, but its influential days were over. Visits to it by two Presidents of Ireland, Eamon de Valera and Erskine Childers, were a clear indication of the gallery's role in changing the climate for contemporary art, despite the continuing lack of state-funded infrastructure. Robert and Betty Ballagh pointed out that, 'It would be impossible to overestimate the role played by David [Hendriks] in the development and appreciation of contemporary art in Ireland His dedication and vision brought to the Irish public examples of international contemporary art at a time when the public institutions were failing to provide this service.' (McCrum and Lambert, p. 50)

By the 1970s, the climate for contemporary art in Ireland was changing, thanks largely to an improving economy, greater exposure arising from the Rosc exhibitions (qv), the advent of television and greater foreign travel [77]. The Hendriks was joined in the 1970s and '80s by the Oliver Dowling Gallery, run by Oliver Dowling (previously Exhibitions Officer at the Arts Council (AC/ACE)), the Lincoln Gallery, the Caldwell Gallery, and the short-lived Emmet Gallery, run by Walter Cole. Each gallery had its own distinctive identity. The Dowling was associated with Conceptual and Minimal art (see 'Conceptual Art' and 'Minimalism'), especially the ground-breaking presentation of Michael Craig-Martin's *An Oak Tree* (qv); the Lincoln Gallery was described as 'a kind of de facto *Salon des Refusés* of the RHA' (Josephine Kelliher, conversation with the author, 22 September 2011); while the Lad Lane Gallery, later the Solomon, specialized in sculpture. In Belfast, Mary O'Malley's New Gallery in Glengall Street was, according to Deborah Brown, 'an important commercial gallery, and showed a lot of younger artists' (McAvera, op. cit., 72). By the 1980s, the Fenderesky Gallery [78] had become the leading gallery for contemporary art in Belfast, while the Riverrun Gallery in Limerick was another innovative and courageous enterprise. They happily complemented the older established galleries but, despite their willingness to experiment with less saleable artwork, they were still faced with a narrow-minded collecting public. Oliver Dowling recalled pressure to abandon his desire for bare polished floorboards in favour of carpet for his Kildare Street premises in 1974 in case collectors would think it reflected meagre resources (conversation with the author, 28 September 2011).

The galleries benefited from the growth of corporate investment in visual art in the 1970s and '80s (see 'Private and Corporate Art Collecting'). By the early 1990s a new kind of buyer was beginning to appear. As Josephine Kelliher, Director of the Rubicon Gallery, described it, the decade from 1994 to 2004 marked the return to Ireland of 'the first generation who felt entitled to spend their money on anything they chose and a familiarity, from living internationally, with very contemporary art' (conversation with the author, 22 September 2011). While

77. Maria Simonds-Gooding (right) and Betty Parsons at the Betty Parsons Gallery, New York, 28 March 1978

that did not last beyond the demise of the so-called Celtic Tiger economy, these new buyers were far more experimental in their tastes than their predecessors, with a few exceptions such as Gordon Lambert and Basil Goulding. The opening of the Irish Museum of Modern Art (IMMA) in 1991 and the increasing proliferation of regional arts centres (see 'Regional Developments') also helped to increase awareness of contemporary art among the wider public. New galleries, such as the Kerlin [79], Rubicon and Green on Red galleries in Dublin, and the Fenton Gallery, Cork (2000–09), willingly embraced new media, installation (qqv) and performance art (see 'Time-based Art') and took their artists to art fairs from Europe to the Americas and Asia. In return for gallery commissions, they offered their artists catalogues, exhibitions and international promotion while simultaneously wooing audiences to attend regular artists' talks and critical debates. Far from seeing their galleries as shops in which to sell paintings, they envisaged their role as discovering and nurturing artists. Along with Suzanne McDougall of the Solomon Gallery and Kevin Kavanagh of the Jo Rain and, later, Kevin Kavanagh galleries, they formed the Irish Contemporary Galleries Association to lobby the AC/ACE for a greater recognition for their part in aiding the development of Irish art and audiences.

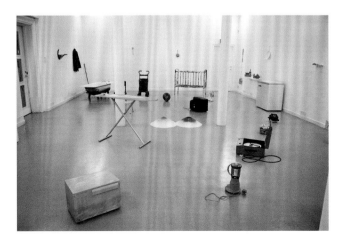

78. *The Beautiful Junk Shop* exhibition which featured forty-seven artists, Fenderesky Gallery, Belfast, September–October 1997

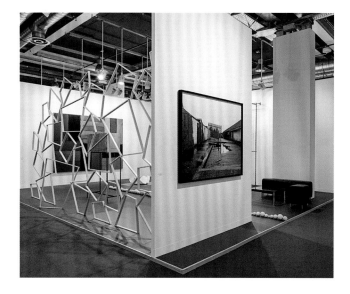

Despite these activities, artists could still complain to Michael Clifford ('The murky side of the canvas', *Sunday Tribune Artlife*, 2 July 2002) that few galleries offered contracts to artists or made any significant effort to promote them in spite of charging fifty per cent commissions and value added tax on sales. Worst of all, many artists still found themselves waiting for payment until the gallery had met other costs. Clifford quoted one artist as saying, 'The galleries give you a spiel about overheads if they give you an exhibition. But they don't supply canvas or paint or anything. Other times they'll buy the painting from you and you'll be damn glad to get some money to keep you going but they go and sell it on for a multiple of what you get.'

The shortage of commercial galleries and the small pool of collectors in Ireland meant that power resided with the galleries, and artists generally were reluctant to voice bad experiences, although those lucky enough to be represented by the main galleries expressed genuine satisfaction with their relationship. The need for leading artists to be represented internationally has led to imaginative partnership arrangements between the leading galleries, their artists and commercial galleries in London, Berlin and New York, which in turn has enabled the Irish galleries to show leading artists from abroad. Reciprocal arrangements between the Kerlin Gallery and Alexander and Bonin in New York in relation to Willie Doherty's (qv) work, or with the Frith Street Gallery in London in relation to Dorothy Cross and Jaki Irvine (qqv) since the 1990s, are a far cry from the breakthrough representation offered by Betty Parsons in New York to Maria Simonds-Gooding (qv) in the 1970s.

Notwithstanding these advances, traces of the old notion that the gallery confers a favour on the artist still lingers. Stella Coffey, author of *A Strategic Review of the Visual Art Market in Ireland* (1999), noted that in Ireland, 'It's New York prices without New York level of services Artists don't have any bargaining power and as a result feel very vulnerable.' (Clifford) Coffey pointed out that artists, generally better educated than the rest of the population, earned significantly less, with two-thirds earning less than £5,000 in 1997. The galleries did not appear to make significant profits either. Clifford revealed that the Kerlin

Gallery, perceived as the most successful of the galleries, declared a profit of no more than £5,928 in 1998. The Arts Council expressed concern about the small numbers of commercial galleries in the 1960s and '70s. To help promote collecting and, by extension, galleries, in Ireland during those decades, the Council made a point of trying to buy artworks at exhibition openings and to signal this by attaching a notice of its purchase to the work. IMMA, too, in its first decade, declared that it would buy only artwork from the artist's gallery or agent in order to support the infrastructure that itself sustained the artist. The Arts Council's response to requests for assistance from the Galleries Association was to give free flights for travel and grants to buy computers, but it was not empowered to subsidize the private sector further. By encouraging members to publish and distribute catalogues for exhibitions, pay their artists on time, and maintain a website, the Association helped to professionalize the sector so that Aidan Dunne, in *Representing Art in Ireland: The Fenton Gallery* (2008), the most important book published by a commercial gallery in Ireland, could rightly point to an 'epochal change' in the Irish art market since the 1980s (Fenton, p. 200). In the same publication, however, James Elkins noted that 'only a few galleries, and usually only in larger cities, escape the allure of repeating the past' (Fenton, p. 217).

Catherine Marshall

SELECTED READING McCrum and Lambert, 1985; S.B. Kennedy, 1991; Isaacs, 1993; Coulter, 2008; Fenton, 2008.

CONCEPTUAL ART. Although Ireland is not a country in which canonical Conceptual art has been developed, Irish artists have been among key practitioners in that mode of art since the 1960s, and a case can be made for regarding Ireland as a seedbed of conceptual attitudes in art generally.

Conceptual art is characterized by a critical stance towards established values and institutions and by the assertion of the primacy of the idea over the art object. It has long been more prominent among Irish artists working overseas, who have retained a subversive interest in the ways in which systems function and ideas manifest themselves. References to Catholic beliefs, where bread and wine are considered to be transformed into the body and blood of Jesus Christ, have been identified as forming part of the intellectual roots of Michael Craig-Martin's (qv) seminal conceptual art work, *An Oak Tree* (1970), where a glass of water is simply stated to be an oak tree. This assertion echoes Samuel Beckett's view that Joyce's *Finnegans Wake* does not represent, but is (Beckett, p. 14). It is in artists' analytical interests in such literary and faith systems that Ireland's claim to having pioneered conceptual practices can be said to originate, notwithstanding Conceptual art's critical stance, which precludes such national pride.

It has been argued that the father of Conceptual art, Marcel Duchamp, could not have attained that title in the 1960s if Joseph Kosuth and Richard Hamilton had not been able to recognize in his work what they had also learned and appreciated in the literary works of Joyce, especially *Finnegans Wake* (Lerm Hayes, pp. 147–48). Samuel Beckett's Joyce-tutored but aesthetically pared-down critique of cultural modes, such as theatre,

character and narrative, is another key reference point for Conceptual art practices internationally. Conceptual art differs from High Modernism (see 'Modernism and Postmodernism') in not defining itself through opposition to literature; instead, it uses language strategically, as indeed is often the case in Irish usage of the English language. In Irish literature, through the use of the dominant language English, the familiar is often rendered strange and political. In the twentieth century, communities of writers were forged around such critical insights. This approach characterizes the conceptual artists' generation, and corresponds to Deleuze and Guattari's concept of the minor, described in terms such as deterritorialization, political immediacy and community (Deleuze and Guattari, *Kafka: Toward a Minor Literature*, London 1986).

Within Ireland, the factors that canonical Conceptual art critiqued elsewhere were, for the most part, not present. The United States of America was where the dominant art market was located, and where the institutionalization of art, the primacy of objects, minimalist formalism, post-War economic boom and the economic and military struggle between capitalism and communism formed part of everyday dialogue. Neither could artists in Ireland rely on being sustained by teaching positions, or the 'politics of publicity', all key features of Conceptual art practice elsewhere. They did not choose the path of central European artists to develop Conceptual art into an oppositional vehicle (Nader and András in Alberro and Buchmann), but did what their colleagues under communism could not do – they emigrated.

With knowledge of both Irish and international culture, and the emigrant's sharpened critical capacity, Craig-Martin settled in England, James Coleman in Italy, Noel Sheridan in Australia, while Brian O'Doherty (qqv), having forgone his medical career, was at home in New York's Conceptual art circles. There, at the movement's outset, he recorded Duchamp's heartbeat on 4 April 1966, thus creating a conceptual 'portrait' [388]. O'Doherty further developed an artistic and philosophical engagement with the eighteenth-century Irish philosopher George Berkeley's conception of the senses in *The Five Senses of the Bishop of Cloyne* (1967/68), as well as compiling *Aspen 5+6* (1967) [49], an exhibition in a box that combined conceptual sources and permutations. As officer with the National Endowment for the Arts in Washington in the 1970s, O'Doherty was the first to introduce a budget line for performance and Conceptual art, thus enabling Conceptual art to be practiced in the USA, which could not be funded through other channels.

With his essay 'Inside the White Cube: The Ideology of the Gallery Space', published in *Artforum* in 1976, O'Doherty generated a seminal institutional critique. His performances and writings formed part of a multi-disciplinary oeuvre that continued to display a conceptual stance. His 1973 performance, *Name Change*, a work created in response to the Bloody Sunday shootings in Derry of the previous year (see 'The Troubles and Irish Art'), resulted in documentation, i.e. an exhibitable artefact, showing the white costume O'Doherty/Ireland wore and that was painted from either end with the colours green and orange (the colours of the Irish flag) and then over-painted until it

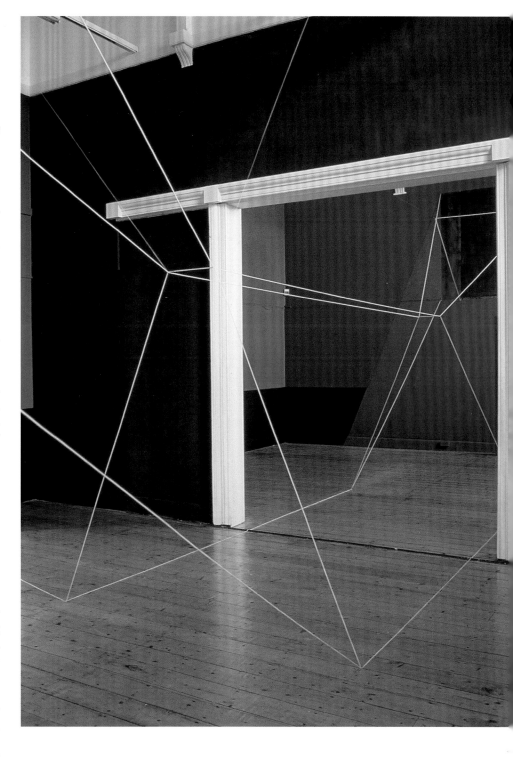

became a brown mess [337, 379]. In other works by the artist, minimalist aesthetics were employed but given a meaningful dimension, particularly through his use of Ogham lettering, a coded alphabet used in Early Christian Ireland.

Michael Craig-Martin's film made in Connemara in 1963, *Film* [89], captured Ireland's material and economic poverty and resulted in a de facto Minimalism (qv). O'Doherty/Ireland counteracted the conventions of the white cube by colouring the gallery walls for his 'Rope Drawings' series [80]. He thus

80. Brian O'Doherty/
Patrick Ireland,
*Borromini's Corridor,
Rope Drawing #103*,
1995, installation, rope,
house paint, Crawford Art
Gallery

81. Kathy Prendergast, *Washington* from the 'City Drawings',1992–96, pencil on paper, 24 x 32 cm, Irish Museum of Modern Art

82. Shane Cullen, *The Agreement* (detail), 2002, 11,500 words of the British-Irish Peace Treaty of 1998, carved into 55 panels, 67 m; work commissioned by Beaconsfield (see fig. 491)

the collective. In these apparent paradoxes surrounding conceptual practices, Ireland conforms to (and perhaps pioneered) the non-binary characteristics that are now identified in the movement, as well as post, neo- and new genre Conceptual art (Alberro and Buchmann).

Conceptual art strategies gained momentum in Ireland only after the conclusion of the canonical, international (western) Conceptual art movement in the mid-1970s, mainly through the Rosc exhibitions (qv), which took place between 1967 and 1988, but also through the work of Declan McGonagale, who organized a series of exhibitions at the Orchard Gallery in Derry (1978–90) and at IMMA in Dublin (1991–2001) which attracted international attention for their rigorous critical stance.

Amongst artists working in Ireland, the sculptor Brian King pursued minimalist and conceptual concerns, e.g. rule-governed, pseudo-scientific uses of colour, or perspex cubes as *Sea Holes* (early 1970s), which make visible the natural phenomenon of the tide. Land art, not widely practiced in Ireland, has been one of the ways in which conceptual artists have highlighted environmental or historical issues. King's *Zurich* (1982) contains earth from James Joyce's grave and thus atoms from his body – a quasi-Eucharistic life cycle that displays conceptual attitudes without being narrowly 'conceptualist'.

Austerity is the aesthetic hallmark of conceptual practices. Conceptual strategies in Ireland display this in early photo-text works by Willie Doherty, as well as in Shane Cullen's (qqv) *The Agreement* (2002) [82, 491]. These works can be regarded as standing at the more austere end, highlighting the frequently more sensual 'Dionysian' and narrative aspects of post- and neo-conceptual art that have been (during the conceptual era) and are more prevalent in Ireland. The fact that sparser work in a neo-conceptual vein and more work forming a conceptual legacy can now be found is partly owing to better international connections and the exponential growth of artists working on the island of Ireland over the last two decades.

International art critics, such as Lucy Lippard, sought in Ireland an art that was untainted by consumerist concerns. The austerity and harshness of life, particularly in the west of Ireland, appealed to conceptual artists such as Beuys, Craig-Martin and O'Doherty, as did the rich literary tradition that contrasted with, and in many ways resulted from, the depressed economy. If the intellectual roots of Conceptual art can be found in the work of Joyce and Beckett, which in many ways are manifested in the work of James Coleman and Craig-Martin, the absurdist inventions of Flann O'Brien also find echoes in the work of O'Doherty. In more recent years, conceptual attitudes have turned towards the narrative in more lavish ways, in works such as Willie Doherty's *Ghost Story* (2009), Gerard Byrne's (qv) elaborate staging of printed conversations, Mark Orange's fictional/analytic strategies, and Seán Lynch's unearthing of histories that often bridge the gap between Irish sources of Conceptualism in Modernist culture and current concerns. Branching out even further, Brian Maguire, Mick O'Kelly (qqv) and Anthony Haughey have occasionally used strategies derived from Conceptual art, although not the first generation's conceptual aesthetics, still clearly readdressing art/life relations in socially engaged ways.

presents a sensual Conceptualism, i.e. an unorthodox, paradoxical one that casts its colourful shadows to younger generations of artists, such as Mark Garry, in post-2000 Ireland.

Indeed, the conceptual strategies employed in Ireland mostly appear to create a balance between the idea and the senses, word and image, intellect and intuition. This may be a legacy of Joseph Beuys's presence in Ireland in 1974 – an atypical Conceptualism, privileging social relations and evocative materials. Kathy Prendergast's (qv) 'City Drawings' (1992–96) [81] use maps, a conceptual hallmark, but are imprecise and emotive; while her work with human hair focuses on generational ties, indicative of a society that is still oriented towards

be established by their authorities for stated purposes and may be powers and functions in respect of all or any part of the island."

iii) the following section shall be added to the Irish text of this Article:

"8. Tig leis an Stát dlínse a fheidhmiú taobh amuigh dá chríoch de réir bhunrialacha gnáth-admhaithe an dlí idirnáisiúnta."

and

iv) the following section

As Ireland's built environment and Modernist interior spaces of the last years of the twentieth century began to approximate the aesthetic, minimalist starting-point of Conceptual art in the 1960s, artists such as Cullen, Doherty, Alastair MacLennan (qv), Sandra Johnston, Aisling O'Beirn, Joanna Karolini, John Beattie, Dan Shipsides and Daniel Jewesbury, and projects such as Art/Not Art, Metropolitan Complex and Factotum can be identified as bringing this together with the 'literary' and conceptual/philosophical roots of conceptual practice already mentioned. One can call them Political/Minimal artists (Klaus Biesenbach (ed.), *Political/Minimal*, exh. cat. Kunst-Werke Berlin, Nuremberg 2008) who reflect these origins in their clear and critical projects, while (again) questioning representability and thus, at times, with-holding images, a characteristic of the conceptual mindset. Coleman is the first Irish artist who has particularly focused on such issues surrounding representability. His slide/narrative presentations are a foundation of much recent work in Ireland and internationally. Among many other things, they encom-pass a paradox of conceptuality: the 'idea' is understood not as something that can exist in reproduction or as language, but something that is experiential and fleeting, a process that hap-pens within the viewers, not 'behind' the works. Indeed, more interesting than definitions of what can rightfully be called conceptual (or even 'Conceptualism') is arguably a considera-tion of what a conceptual attitude can still achieve, in the his-toricized, institutionally co-opted ways in which it can mostly be found today, both in Ireland and elsewhere.

The strength of (Irish) (neo-) conceptual practices lies in their reflexivity and criticality. While little Conceptual art was created in Ireland, a conceptual attitude 'exported' from this island has enhanced the ambitions of art internationally and can be said to have been re-imported to Ireland. A widespread but non-orthodox conceptual attitude has brought about a common currency with international artists, although on differently inflected terms. It has led artists and audiences to 'live in their heads', as the subtitle of Harald Szeemann's 1969 Berne exhibi-tion, *When Attitudes Become Form*, which inaugurated Conceptual art in Europe, had proclaimed, and it has helped to bring about artworks that have sustained a critical attitude and which will sustain enquiry. CHRISTA-MARIA LERM HAYES

SELECTED READING Samuel Beckett, *Our Exagmination round his Factification of Incamination of Work in Progress* (London 1929), pp. 1–22; Lippard, 1973; Kosuth, 1991; Godfrey, 1998; Alberro, 2003; Lerm Hayes, 2004; Alberro and Buchmann, 2006; G. Murphy, 2007; Wilson, 2009.

CONOLLY, THURLOE (b. 1918), painter. The son of an engineer, Conolly spent the first year of his life in Cork, after which time the family moved to Dublin. Over the next six years they moved on to Newbridge, Co. Kildare, and then to Limerick, before returning to Cork where Conolly attended Cork Grammar School. The death of his father when Conolly was just fourteen years old left the family without a means of support, and they again moved to Dublin. After leaving school, Conolly worked as an assistant to Harold Leask, Inspector of National

83. Thurloe Conolly, *Hall's Barn and Dovecote*, 1945, oil on board, 63 x 65 cm, private collection

Monuments, before moving on to the construction industry, where he worked as an assistant engineer, while continuing to write poetry and paint in his spare time. During World War II, encouraged by his friends Elizabeth Rivers, Evie Hone (qqv) and Ralph Cusack, Conolly began to paint full-time. His works from this period include *Untitled (Peasants Dancing)*, a painting inspired by Naomi Mitchison's novel *The Corn King and the Spring Queen* (1931).

In 1942 Conolly, along with Ralph Cusack and Anne Yeats (qv), painted sets for *The House of Cards*, a satirical comedy by Frank Carney, with music composed by Brian Boydell. Conolly collaborated with Boydell on a song cycle, *The Feather of Death*, which premiered in January 1944 at the Shelbourne Hotel. In the same year, Conolly participated in the White Stag *Exhibition of Subjective Art*, organized by Margot Moffett. Around this time, influenced by Paul Klee and the White Stag Group (qv), Conolly began to change his style. His earlier approach, a softer Romantic style, inspired by an exhibition he had seen of John Piper at the Waddington Galleries, Dublin, now began to give way to a more disciplined geometric abstraction (qv).

In 1946 Conolly married Yvonne, the sister of Brian Boydell. The previous year, he had his first one-person show at the Dublin Painters' Gallery on St Stephen's Green. Among the paintings shown were *Spawell House, Templeogue*, a moonlit scene, and *Hall's Barn and Dovecote at Rathfarnham* [83] both painted in 1945. Thanks largely to the support of Victor Waddington, the exhibition was a sell-out and four years later Conolly had a one-person show at the Waddington Gallery on South Anne Street. In the years following, Waddington was both agent and a good friend of the artist, organizing a series of exhibitions in

Boston (Institute for Contemporary Art, 1950), Chicago, Rhode Island and New York (one-person show at the Marion Willard Gallery). Conolly also had a shared exhibition with Alan Davie in London. Walter Gropius and Carola Giedion-Welcker were among collectors who acquired his works. Between 1947 and 1953 (with the exception of 1948), Conolly showed each year at the IELA (qv), while also participating in 1947 and 1948 in exhibitions with Ralph Cusack, Patrick Scott and Phyllis Hayward at the Dublin Painters' Gallery (Kennedy, p. 162). In the 1948 exhibition, he won the Mainie Jellett Scholarship with his painting *Landscape with Reclining Figure*.

In 1953, at the request of Herbert Read, and with support from the Arts Council (qv), Conolly set up a 'Design Unit for Ireland' office in Dublin, along with co-directors Senator Edward McGuire, Dermot O'Regan of Córas Tráchtála (Irish Export Board) and Alan Nolan of the publishers Browne and Nolan. Essentially an Irish branch of the Design Research Unit (DRU), a European design consortium founded by Read, Misha Black and Milner Grey, the Dublin office survived for several years before Conolly moved to London, to work with Read in the central DRU office, where Margot Moffett also worked. In 1967 Conolly moved to France, setting up his own architectural and design practice near Bordeaux, before retiring in 1995 to concentrate full-time on painting. The Haverty Trust purchased some of his paintings during the 1950s, but the bulk of his work remains in private collections. PETER MURRAY

SELECTED READING S.B. Kennedy, 1991; Kennedy and Arnold, 2005; Peter Murray, 'A White Stag in France', *IAR*, XXIV, no. 4 (Winter 2007), 96–101.

84. William Conor, *The Jaunting Car (No. 1)*, oil on canvas, 60 x 75 cm, National Museums Northern Ireland, Collection Ulster Folk and Transport Museum

CONOR, WILLIAM (1881–1968) [84], painter, illustrator. Called the 'People's Painter' in an exhibition of his work under that title (1998, UM), Conor is best remembered for his depictions of everyday life in Belfast over six decades of the twentieth century. While he was not an innovative painter, nor a follower of new trends and ideas, Conor was nonetheless one of the most deservedly popular artists of his day, producing hundreds of mainly small-scale genre pictures of the streets and working people of Belfast. He created a visual record of the social history of a great manufacturing city, documenting the changes wrought by two world wars and by economic and political upheavals. He also had a flourishing portrait practice and in 1932 produced the largest mural painting in Ireland, *Ulster Past and Present*, for the Belfast Museum and Art Gallery.

Son of a Belfast metal worker, Conor studied design at the Belfast College of Art, after which, in 1904, he became an apprentice lithographer, working mainly on poster designs. He carried the influence of this early training with him throughout a long painting career, remaining unaffected either by Impressionism or Modernism (qv), although he spent time in Paris in 1912/13. He was similarly unaffected by American art during a successful mission to New York and Philadelphia to secure commissions and exhibition opportunities in 1926.

Official recognition came slowly. During World War I, Conor was asked to produce a visual record of soldiers and munitions workers. Later, in 1922, with help from his mentor, John Lavery (qv), whom he met in London after the Great War, Conor received a commission to paint King George V and Queen Mary opening the Northern Ireland Parliament in Stormont. Other portrait commissions followed, and Conor, who dropped a second 'n' from his surname to make it more acceptable in art-collecting circles, took his portrait of the Marquess of Londonderry with him to America as a calling card. He showed the portrait at the Babcock Gallery in New York and won many commissions, although Americans were even more attracted by his paintings of children. Among the Irish dignitaries who sat for him were Douglas Hyde, later first President of Ireland, Professor Andrew Fullerton, President of the Royal College of Surgeons in Ireland and St John Ervine.

However, it is for his paintings and drawings of life in Belfast, in both peacetime and in war, that William Conor is cherished today. It was his practice to carry a sketchbook concealed beneath his newspaper, in which he surreptitiously noted every nuance of popular activity as it caught his attention. He sketched and painted children queuing for cinema matinees [15], balloon men at the fairs, mill girls at the end of a working day, fire wardens in wartime, polling on election-day, and Orange drummers during the July and August marching season. No matter how difficult the context, whether he was drawing fire wardens on the backs of Red Cross posters or painting in oils in the comfort of his studio at 1 Wellington Place, Conor always presented the most positive view of the situation. In this, he is the antithesis of his contemporary Jack B. Yeats (qv), who also painted such scenes. Where Yeats emphasized the isolation and heroism of the main figure – a jockey, a performer at the fair, or a boxer in the ring – Conor always affirmed social cohesion, the collective spirit of the

event. His particular contribution lay in his use of the telling detail and his handling of scale, allowing the cheerful mill girls to dominate their harsh industrial surroundings.

It is not surprising then that, despite his innate conservatism, Conor was popular with both the art world and the general public. His CEMA solo exhibition in 1945 attracted record crowds and was the first solo show to tour in Northern Ireland. It was followed by further CEMA shows in 1950 and 1954 and his exhibition of 160 paintings at the Belfast Museum and Art Gallery in 1957 was the largest solo show up to that date in Northern Ireland. Conor was just as successful with the commercial galleries, showing in Dublin with Victor Waddington in 1944 and 1948 and at the Bell Gallery, Belfast in the 1960s. He was one of the first nine academicians elected to the RUA (qv) when it opened in 1930, later acting as its president from 1957 to 1964. Other accolades included an honorary degree from QUB and an OBE in 1952. When he died in 1968 the Prime Minister of Northern Ireland, Captain Terence O'Neill, read the lesson at his funeral, while the Ulster Folk and Transport Museum named a room in his honour.

Apart from paintings, Conor also provided illustrations for books by Lynn Doyle, and costume designs for the theatre which are now in the V&A Museum. His work can be seen in IMMA, UM, the Ulster Folk and Transport Museum, CAG, HL, the Ashmoleon Museum, Oxford, the Brooklyn Museum, New York, and in many regional collections. CATHERINE MARSHALL

SELECTED READING Judith Wilson, *Conor, 1881–1968* (Belfast 1981); Martyn Anglesea, *William Conor: The People's Painter* (Belfast 1999); Catherine Marshall, 'William Conor', in Marshall, 2005.

COOKE, BARRIE (1931–2014), painter. Writing about Barrie Cooke's painting, the poet Seamus Heaney said: 'His oeuvre exhibits that paradoxical combination of spontaneity and almost geological inevitability which is the distinction of the major talent.' (Heaney, p. 33) Heaney's accolade has been echoed by many other Irish writers in tribute to an artist and cultural activist who has made a serious contribution to Irish art.

Cooke was born in Cheshire, England, raised in Jamaica and Bermuda and educated at the Skowhegan School of Art, Maine and at Harvard University, from which he graduated with a degree in History of Art, Biology and Chinese Poetry. He came to Ireland in 1954, settling first in Kilnaboy, Co. Clare and later in rural Kilkenny and Sligo, almost as well known in each place for his love of fishing as for his painting. In the arts community he is recognized for his generous work on behalf of the Butler Gallery, the Kilkenny Arts Festival, the DHG, the Model and Niland Gallery in Sligo and involvement with environmental activities such as the successful campaigns to prevent the building of an interpretative centre at Mullaghmore in County Clare and opposition to uranium mining in County Kilkenny. Brian Fallon suggests that the presence of Barrie Cooke in the Kilkenny area had a lot to do with the success of the Butler Gallery (Fallon, 1994, p. 257), while younger artists such as Paul Mosse and Bernadette Kiely (qqv) acknowledge his constant encouragement.

Success as an artist came early to Cooke. A solo exhibition in Cambridge, Massachusetts in 1953 was followed by another in Dublin two years later. Gregarious by nature, Cooke settled quickly into the art community in Ireland, despite living in remote County Clare and was one of the founding members of the Independent Artists Group. In 1955 he was awarded a scholarship to study with Oskar Kokoschka in Salzburg and he acknowledged a debt to the older artist and also to Willem de Kooning, whose work he had seen in New York. In 1962 he was chosen to represent Ireland at the Paris Biennale, where his painting caught the attention of André Malraux. During the first year of the Independent Artists exhibitions, he and Camille Souter (qv) were chosen by lottery from the membership to have an extended exhibition. Following an introduction from Patrick Collins (qv), the gallerist David Hendriks gave Cooke exhibitions biannually from 1962 until his death in 1983. By then Cooke was a leading figure in Irish art, included in *The Irish Imagination* section of *Rosc '71*, and in *Rosc '84* (qv). Other important exhibitions in Ireland include a ten-year retrospective at the DHG in 1986 which travelled to Belfast, Cork and Limerick, an exhibition curated by Rudi Fuchs at the Haags Geementemusem in the Hague (1992), *Barrie Cooke: A Retrospective* at the RHA (2003) (qv), and *Barrie Cooke Portraits* at the Butler Gallery (2009).

Cooke has always had a tremendous affinity with nature, whether animal, vegetable or human. Heraclitus's summary of the inter-relationships between these three, 'Everything Flows', hung on the wall of his studio in Thomastown, Co. Kilkenny. While his work refers generally to the four elements, earth, air, fire and water, it is the last that most inspires him, echoed in smooth, sparkling washes of paint, whether his subject is water, rocks, the female nude or a highly abstracted combination of these. For a period, in the late 1960s, Cooke expanded on his use of translucent paint with something more earthy and corporeal. Interested not only in the landscape but in its history, he embarked on a series of artworks that reference the ancient Sheela-na-gig [85], symbols of female fertility, carved on the walls of medieval buildings throughout Ireland. The irony of their expression of Dionysian energies in a country where sexuality was highly controlled was not lost on Cooke. His Sheelas, crudely modelled clay figures in three dimensions, appear to evolve from his painted landscape panels. The technical skills behind this extraordinary feat were nurtured by the ceramic artist Sonja Landweer, who, Cooke said, was 'extremely important to my work' (Cooke in Ryan, p. 268).

A further indication of Cooke's willingness to experiment with nature and the mythologies surrounding it was revealed in a series of 'bone boxes' from the late 1960s and early 1970s, in which Cooke presented painted ceramic bones and leaf formations in perspex boxes. This work was influenced by the artist's earlier studies in biology, his interest in the Danish bog bodies, and other history concealed within the landscape [68]. These artworks, resembling specimens in a natural history museum, explore the natural environment from Ireland to the rain forests he visited in Borneo, Mexico and New Zealand. The mixture of the exotic and the domestic is again reflected in his paintings from the 1980s, which alternated between the

85. Barrie Cooke,
Sheela-na-gig II, 1961,
mixed media on canvas
on board, 48 x 43 cm,
private collection

'knot paintings' of vegetable forms isolated from their jungle habitats and reconstructions of the great Irish elk, the skeletal remains of which were unearthed from native bogs.

A less well-known aspect of Cooke's work was his interest in portraiture (qv). He painted his friends, usually writers and fellow artists, giving them the same spontaneous treatment he bestowed on his landscapes and nudes – lightning brushstrokes or pencil marks that refused to flatter but always reveal. Among his sitters are such well-known writers as Seamus Heaney, John McGahern and Ted Hughes, the actress Siobhán McKenna, the artist Dorothy Cross (qv) and an experimental, collaborative portrait with the painter Nick Miller (qv). Tess Gallagher, the American poet, responded to Cooke's portrait of her by writing a poem about him. Given his deep friendships

with Heaney and Hughes it is not surprising that he illustrated books for them. He also executed a number of mural paintings, including one for the BoI, Fifth Avenue, New York (1978), *The Fitzwilliam Murals* for Basil Goulding (1972, now in TCD), and *The Tree of Life* for the St Moling's Chapel, Borris House, Co. Carlow (2005).

Barrie Cooke's work is in most important Irish public and corporate collections and in the Fogg Museum, Boston.
Catherine Marshall

SELECTED READING Seamus Heaney, 'Barrie Cooke', in *Six Artists from Ireland*, 1983, pp. 28–33; Aidan Dunne, Seamus Heaney and Niall McMonagle, *Profile 10 – Barrie Cooke* (Kinsale 1998); Ryan, 2006, pp. 257–92.

COYLE, GARY (b. 1965), multi-media and performance artist. '... Gary Coyle's interiors, exteriors and portraits recall the fantastic imagination of the Symbolist Odilon Redon' (Caroline Hancock in *Into Irish Drawing*, 2009, p. 9). Coyle's work has also been likened to that of the German Surrealist and Expressionist Max Ernst. Coyle, Redon and Ernst share an interest in the fault line between rational, ordered reality and the darker, less explored, instinctual world of desire. Like the earlier artists, Coyle is interested in the Gothic territory of fantasy, danger and obsession, where darker forces on the edges of civil society appear to fester with threatening possibilities. In different bodies of work he has explored urban and rural crime scenes [86], including woodlands and train stations at night, pornographic film settings, and other contexts in which the familiar and everyday are rendered strange by darkness or transgression. *Death in Dun Laoghaire* (2006), a multi-media project, explores the transformation of well-known social spaces into threatening scenarios, in the wake of an unresolved murder in the place of his childhood and adolescence.

Coyle's most recent work continues to explore the local and familiar from a remarkable angle. His photographs, recorded daily, of the well-known Sandycove, formerly 'Men Only', swimming spot, the Forty Foot, disrupt notions of familiarity by being shot from the sea, often through the water. Elements of voyeurism in his work may have prompted Tim Stott's comment that 'Coyle's primary ... insight seems to be that viewing art is tantamount to the pursuit of more "base" pleasures; that, as beholders, we too have certain desires that demand satisfaction, we too seek to play out our hidden fantasies in the aesthetic experience' (Stott, n.p.). Coyle's prize-winning entry for the 2007 RHA (qv) portrait award was a drawing of an anonymous young man, based on a media photograph. His heavily worked image, difficult to read and deliberately retaining the grid lines used to enlarge the source image, continues this impression. The human face has become as inscrutable as the scenarios he explores in his crime scenes.

Coyle was born in Dun Laoghaire, Co. Dublin. After graduating from NCAD (1989), he spent some time in New York before attending the RCA, London, where he obtained an MA in 1996. He was awarded a Henry Moore Fellowship in 1995. His consummate drawing skills secured him Associate membership of the RHA and the RHA annual drawing prize in 1999. However, Coyle's practice has since expanded to embrace photography (qv), film-making, writing and performance.

In 2009 Coyle was elected a member of Aosdána (qv). He has had numerous solo exhibitions in Ireland, and his work is regularly included in curated group exhibitions. Coyle was awarded a residency at IMMA in 1997/98, and was included in the exhibition, *Into Irish Drawing* (2009), which toured venues in Ireland, France and the Netherlands. His work can be seen in the collections of IMMA, AC/ACE and the OPW as well as in many corporate and private collections. CATHERINE MARSHALL

SELECTED READING Tim Stott, 'The Night of the World', in *Circa*, online review of exhibition *The Wild Wild Wood*, Kevin Kavanagh Gallery (Dublin 2004), downloaded 29 November 2010; *Gary Coyle: Death in Dun Laoghaire*, exh. cat. Project Arts Centre (Dublin 2006); Paula Shields, 'Death in Dun Laoghaire', *Irish Examiner* (13 June 2006); D. Maguire, 2007.

CRAIG, JAMES HUMBERT (1877–1944) [87], painter. Craig was born in Belfast, but grew up in Bangor, Co. Down. Mainly self-taught as an artist, he nevertheless spent a term at the Belfast Government School of Art. After that he visited the USA, where he took casual employment, but later returned home to dedicate himself to painting the Irish landscape (qv), and to fishing, for which he had an abiding passion. In the early decades of the twentieth century, Craig several times visited Switzerland (his mother's country), the south of France and northern Spain, but none of these places influenced his work. He was a regular exhibitor at the Belfast Art Society and, from 1915, at the RHA (qv).

Until about 1913, Craig painted mainly around the southern shores of Belfast Lough – Bangor and the nearby Groomsport in particular – but by 1914 he was working on the north Antrim coast and in County Donegal, around Creeslough, Port-na-Blagh and Falcarragh, areas that were to remain favourite haunts for the rest of his career. From the mid-1920s or so, Craig also travelled to Connemara to paint the mountains at Delphi in County Mayo. In 1919 he purchased Tornamona Cottage at Cushendun, Co. Antrim, and thereafter the Glens of Antrim increasingly dominated his subject matter.

Although Craig had contributed regularly to mixed exhibitions, his first ever one-man show took place at the Mills' Hall in Dublin in 1923, reviewing which the *Irish Times* admired his sense of composition and atmospheric lighting. Thenceforth he held many such shows in Dublin and Belfast and was included in group exhibitions of Irish artists in London, New York, Boston and Toronto. Over the years he was regularly praised for his quiet pastoral scenes, the *Irish Times* (*IT*, 12 April 1926), for example, praising his *Owencarra, Co. Donegal* which, it thought, would be 'important in the best of company'; while to George Russell (AE) (qv), writing in the *Irish Statesman* that same year,

86. Gary Coyle, *Scene of the Crime no. 38*, 1988, charcoal on paper, 150 x 150 cm, private collection

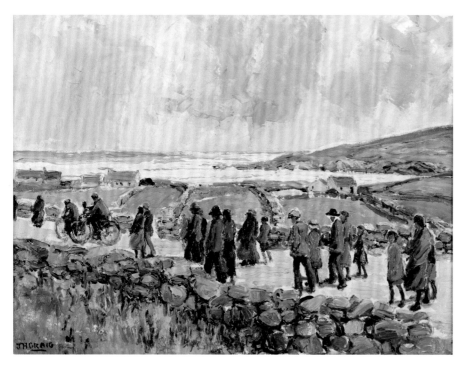

87. James Humbert Craig, *Going to Mass*, c. 1939, oil on board, 37.7 x 50.5 cm, Crawford Art Gallery

CRAIG, MICHAEL (b. 1951), miniaturist, topographical artist and printmaker. Few artists, as highly regarded and successful as Michael Craig is, have nevertheless managed to remain so far removed from the glare of publicity. Craig has never received the critical recognition that most artists depend upon to advance their careers; yet since his first commission, received while still a student at the Cambridge School of Art, he has been in constant demand. Craig's practice is unique because of the scale on which he works. He likes to draw his many commissions for postage stamps, book plates and illustrations to the scale of the tiny finished image, refusing to work, as most illustrators and designers do, on a larger scale which can then be reduced. Referring to his drawings for Irish postage stamps [88], Craig said, 'I tried to draw them four times larger, then two times, but I was only happy when I drew the "Definitives" at the actual stamp size' (*Irish Stamps: Collectors News*, Issue 04/05, Dublin 2005, 5).

Craig's particular vision, in its patient commitment to verisimilitude on a minute scale, calls to mind the small-scale etchings of Albrecht Dürer and the Nuremberg School in the early sixteenth century, and the work of the eighteenth-century English printmaker Thomas Bewick whom Craig admires. In a world busy with images, where most of his contemporaries seek visibility for their work by scaling it up, or using colour, gesture or content in ever more dramatic ways, Craig takes the opposite course. He prefers to work in black and white, and to spend three or four days at a time on a work no bigger than a postage stamp. This approach makes the concept of a solo exhibition almost meaningless because a lifetime's work would not fill the space of a single wall in most commercial galleries. Reproduction of his work also poses challenges because its minute scale tests digital technology and requires highly sensitive photography.

Craig, 'out in all weathers ... delighted in the nature he painted'. 'I have seen Corots hung in important galleries', Russell continued, 'which have no more moving beauty ... he has a real sense of composition' (AE, *Irish Statesman*, 4 December 1926).

There is, however, little development in technique at any stage of Craig's career, which may be divided into three distinct phases: firstly, his early work, when he was establishing a reputation, his subject matter principally landscape and seascapes; secondly, his mid-career, with similar subject matter, but a plethora of commissions which limited his freedom of scope; and, thirdly, the last decade or so of his life when he painted solely to please himself, a time when he developed a deeply penetrating understanding of nature and its moods, especially in his rendering of cattle or other animals grazing by a pool or an isolated farmstead.

Craig worked briskly and reacted directly to the landscape, capturing, in John Hewitt's words, 'the swift notation of the insistent effect, the momentary flicker, the flash of light, the passing shadow' (Hewitt, 1977, p. 83), qualities that are clearly to be seen in, for example, his *Glendun, near Cushendun* (c. 1930–35, Bangor Town Hall), or *The Crolly, Co. Donegal* (c. 1930, private collection), which ably illustrate the subtlety of his brushwork, his feeling for the nature of the landscape, and its ever-changing moods.

The major collection of Craig's work is to be found in the Town Hall, Bangor. He is also represented in the collections of the CAG and the UM. S.B. KENNEDY

SELECTED READING S.B. Kennedy, *With an Angler's Eye: The Art of James Humbert Craig*, exh. cat. UM (Belfast 2001).

88. Michael Craig, postage stamps showing the Casino at Marino from the sixth definitive series (1982–90) (original drawing 3.6 x 2.1 cm) and the High Cross at Ahenny, Co. Kilkenny (original drawing 6.2 x 3.4 cm), 2010, An Post

Instead, Craig relies on the steady stream of commissions that followed a request from the *Reader's Digest* in 1973 for topographical drawings for *The Book of British Towns* and *Hand-picked Tours of Britain*, both of which were published later in that decade. Since then, he has illustrated publications on a variety of subjects which include wine, needlework and self-sufficiency for Dorling Kindersley (1975–77), *A Dictionary of Archaeology* (1977) and *Mrs Cadogan's Cook Book* (1984), both for Macmillan, books on naval warfare for Salamander Books (1978) and on archaeology for Cambridge University Press (1979). In 1989 he executed a set of drawings for *Ireland's Maritime Heritage* (1992) by John de Courcy Ireland, and he wrote and illustrated *Fish out of Water* (1990) in which all the illustrations were scaled up by fifteen per cent, yet some measure no more than a thumbprint.

It is for his architectural drawings that Michael Craig is most well-known. He has drawn buildings for book plates, headed notepaper, fund-raising prints and logos for the Irish Georgian Society, the King's Inns, the Irish Architectural Archive, TCD, the Rotunda Hospital and the OPW. He has made graphic panoramic views of Maidenhall, the former home of the writer Hubert Butler and his wife Peggy Guthrie, and Annaghmakerrig, the multi-disciplinary artists' residence in County Monaghan, run jointly by the Arts Councils (qv) of Ireland and Northern Ireland, and in 1991, during the presidency of Mary Robinson, he was asked to make a drawing of Áras an Uachtaráin for a Christmas card. His most spectacular achievements in this genre can be seen in the illustrations he executed for *The Architecture of Ireland from the Earliest Times to 1880* (1982) by his father, Maurice Craig, the distinguished architectural historian, and their collaborative work *Mausolea Hibernica* (1999).

The most widely distributed, and perhaps the best loved, of all Craig's drawings take the form of postage stamps. He has been responsible for two of the 'definitive' series of stamps published by An Post (the Irish postal service): *Irish Architecture through the Ages* (1982–88) and *Heritage and Treasures* (1990–95). He was also responsible for three of the special 'Commemorative' stamp series: *Post Boxes* (1997), *Round Towers* (2004/05) and *High Crosses* (2010).

Craig was born in Dublin but as a young child he moved with his parents to London where his father was employed as Inspector of Ancient Monuments in the Ministry of Works. He received his art training at Camberwell College (1969) and Cambridge School of Art (1970–73). Craig returned to make his permanent home in Ireland in 1979. CATHERINE MARSHALL

SELECTED READING Michael Craig, *Fish out of Water* (London 1990); Maurice Craig and Michael Craig, *Mausolea Hibernica* (Dublin 1999).

CRAIG-MARTIN, MICHAEL (b. 1941) (qv AAI III), artist. Creating perceptual conundrums, interweaving the verbal and the visual, and confounding the expectations of viewers, Michael Craig-Martin has been credited with bringing Conceptual art (qv) into the mainstream of British and Irish contemporary art. Employing materials such as aluminium, neon light, glass and steel, in works that often incorporate vivid colours, Craig-Martin is perhaps best known for his large wall drawings, but he has also produced sculptures, prints and architectural designs. While proportion, harmony and geometry are evident in his work, along with a high standard of construction and materials, Craig-Martin eschews traditional notions of craft being at the centre of fine art, emphasizing instead the primacy of idea over the materials used to express that idea. However, while his work is intellectual and even austere, Craig-Martin's approach does not exclude the occasional visual pun or joke. His disciplined approach to art, combined with occasional playfulness, echoes that of Marcel Duchamp.

Craig-Martin represents something of a rapprochement between the contemporary art of the Americas and that of Europe, which is echoed in his own life and career. Born in Dublin in 1941, Craig-Martin spent his childhood firstly in London and then in Washington DC, where his father worked for the United Nations Food and Agriculture Organisation. Regular family trips to Ireland maintained a connection with the artist's birthplace. After a short spell at Fordham University in New York, Craig-Martin went on to study at Yale University, where Joseph Albers, formerly a teacher at the Bauhaus, promoted an approach to art that was formalist and geometric involving the use of carefully selected and matched colours. At Yale, Craig-Martin's tutors included Alex Katz, Jack Tworkov and Al Held. Among his fellow students were Brice Marden, Richard Serra, Chuck Close, Jennifer Bartlett and Jonathan Borofsky. The cool, depersonalized approach to art that characterized Yale during those years still permeates Craig-Martin's work.

During the 1960s Craig-Martin travelled to Ireland where he made his first, and only, film. Shot in black-and-white, sixteen millimetre celluloid, *Film* [89] was submitted by the artist as part of his MA degree in fine art for Yale, which was completed in 1966. *Film* represents easily recognizable features of the Connemara landscape, such as stone walls, bogs and lakes, but it focuses also on buildings and churchyard gates, in a way that pays homage to the life and architecture of the west of Ireland, while simultaneously revealing their universality. In 1966 Craig-Martin moved to England and a teaching post at the Bath Academy of Art. His first exhibition was held in 1969 at the Rowan Gallery in London, and was followed two years later by shows at Arnolfini in Bristol and the Demarco Gallery in Edinburgh. In these exhibitions, he used ordinary materials to create works that defy everyday logic, and are instead enigmatic and frustrating. His *Six Foot Balance with Four Pounds of Paper* (1970) explores the unexpected physical relationships between familiar objects, questioning the role of art, the meaning of the art object, and the nature of representation. *Long Box*, originally made in 1969, and recreated for his 1989 exhibition at the Whitechapel Art Gallery in London, defies common sense, in that the box is always open, and always closed. Reflecting the interest in serial art that was at its height in the late 1960s, Craig-Martin's *4 Identical Boxes with Lids Reversed* (1969, Tate) again presents a paradoxical reality. The lid on the first box should be on the fourth box and the lid on the fourth box should be on the first box, and so on.

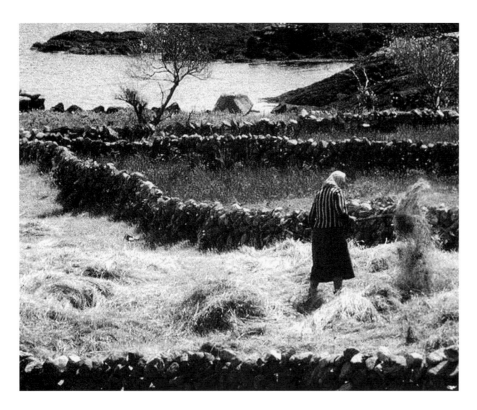

As a teacher at Goldsmiths College from 1974 onwards, Craig-Martin inspired a younger generation of students, among them Julian Opie, Fiona Rae and Damien Hirst. These artists, part of what has been described as the Young British Art movement, were encouraged to step outside the agreed boundaries of what constituted a work of art, resulting in the creation of works that dominated debates about contemporary art through the last decade of the twentieth century. Whether two- or three-dimensional, Craig-Martin's art engages with the world perceived by human beings, but by investigating concepts such as mass, weight and mathematical relationships, they become a quietly eloquent commentary on the nature of perception. In 1973 he created *An Oak Tree*, a deceptively simple work consisting of a glass of water, placed on a shelf, with an accompanying text (NGA). Perhaps Craig-Martin's most famously enigmatic work of art, *An Oak Tree* alludes to the power of art as a transformative discipline, with the artist making the claim that he has transformed this humble household object, a glass of water, into an oak tree. He is more concerned with making the work of art the embodiment of an idea, than symbolizing an idea.

Although an accomplished sculptor and an influential teacher, Craig-Martin is perhaps best known for his large-scale mural outline drawings, made by applying black adhesive tape directly to the wall. Using a pictorial vocabulary, restricted to objects such as stepladders, filing cabinets and globes, Craig-Martin has created his own visual language, one that hovers between a child's ABC book, and the world of semiotics. His drawings are simple linear technical illustrations, while the objects depicted are familiar household items, such as safety pins, buckets and ladders. The title of his 1978 wall drawing *Hammer, Sandal, Sardine Tin* is self-descriptive. Although

Craig-Martin's art is almost completely devoid of nostalgia, his choice of some objects, such as anglepoise lamps and sunglasses, can also be read as an homage to the idealized Modernist world of Josef Albers and the Bauhaus. Many of the objects chosen can also be seen as metaphors for the experiences of modern urban life, representing psychological states such as containment, tension and pressure. However, the important point about his drawings is that by overlaying these linear drawings, and playing with scale, he challenges assumptions about artistic representation.

While Craig-Martin himself is careful not to appear concerned with issues of nationality or identity, in spite of spending most of his life in the USA and Britain, he has maintained a consistent artistic presence in Ireland. Perhaps it is for this reason, unlike other Irish émigré artists who have railed against the narrowness of the Irish art scene, that Craig-Martin's relationship with his native country has never been fraught. Moving easily between the art worlds of London, Dublin and New York, he has shown work regularly on both sides of the Atlantic. In 1979 the Oliver Dowling Gallery in Dublin presented an exhibition of his work, while ten years later, a retrospective at the Whitechapel Art Gallery in London, curated by Lynne Cooke, included contributions from the New York art critic Robert Rosenblum. In 1991 Craig-Martin created a set of wall drawings for the Project Gallery in MoMA, New York, and three years later made two large wall drawings for the mezzanine spaces in the Centre Georges Pompidou in Paris.

Several European museums showed Craig-Martin's work in the 1990s, including the Museé des Beaux-Arts in Le Havre, the Museum Sztuki in Lodz, and at the Kunstvereins of Hanover and Düsseldorf. In 1995 he created site-specific wall drawings for Chicago's Museum of Contemporary Art and for the DHG in Dublin six years later. Depicted in vibrant colours, and set against the artist's favourite background colour of magenta, the objects depicted in the Douglas Hyde included a light bulb, a pitchfork and a bucket, objects perhaps referring to the introduction of electricity in rural Ireland during the artist's childhood. In a second retrospective exhibition, at IMMA in 2006, the artist reacted to the historic building by creating a mural cycle within the arched courtyard of the Royal Hospital Kilmainham (IMMA). His painting *Eye of the Storm* (2003) [90] is in the IMMA collection, as is his earlier conceptual piece *On the Table* (1970). Craig-Martin's architectural design for the Laban Dance Centre in London, completed in 2002, incorporates materials that change colour depending upon the levels of daylight. His wall drawings, whether in simple black and white or in vibrant colours, are international in feeling, and are equally at home in European, American and Australian museums and galleries. Significantly, Craig-Martin has also himself curated exhibitions, notably *Drawing the Line*, at the Whitechapel Art Gallery in 1995, and he served as a Trustee of the Tate, from 1989 to 1999.

While routinely criticized by traditionalists and conservative critics, Craig-Martin is no iconoclast, acknowledging that traditional elements of fine art, such as life drawing or modelling, continue to form an integral part of the world of art. Through his own work, and through his teaching at Goldsmiths

90. Michael Craig-Martin, *Eye of the Storm*, 2003, acrylic on canvas, 335.3 x 279.4 cm, Irish Museum of Modern Art

from 1974 to 1988, Craig-Martin has undoubtedly opened up new possibilities for a generation of artists, in what had become a narrow and somewhat insular British art world. His influence on contemporary art, particularly in Britain, has been profound; his influence on contemporary Irish art has been more limited.
PETER MURRAY

SELECTED READING Simon Field, 'Michael Craig-Martin: An interview', *Art and Artists* (May 1972); Robert Rosenblum, 'A Mid-Atlantic Conversation', in *Michael Craig-Martin: A Retrospective Exhibition 1968–89*, exh. cat. Whitechapel Art Gallery (London 1989); Craig-Martin, 1995; Richard Shone, 'Objects in View', in *Michael Craig-Martin Prints*, exh. cat. Alan Cristea Gallery (London 1997); Rachel Thomas in Richard Cork (ed.), *Michael Craig-Martin: Works 1964–2006*, exh. cat. IMMA (Dublin 2006).

CRILLEY, MARGARET (see Clarke, Margaret)

CRITICAL WRITING AND THE MEDIA. Cultural debate in twentieth-century Ireland focused on a relatively narrow nationalism, and this overshadowed media discussion of visual art. The majority of art critics were conscious of writing in an era of cultural adversity for a readership familiar with the rhetoric of Irish patriotism. Their aim was to convince the general public of the value of art by presenting it within the parameters of this broader cultural context. The purpose of Irish art writing was, therefore, quite different to that of critical writing for a readership with a specific interest in modern art. Similarly,

avant-garde criticism advocating a particular aesthetic ideology has been largely absent from Irish art writing. Irish writers were concerned with the broad agenda of nationalism and with the identification of distinctive Irish characteristics in Irish art.

Until the 1980s, the major forum for art criticism in Ireland was the newspaper, and here the quality of writing varied enormously. Coverage of art is also found in literary periodicals, where it is usually published in a random fashion, indicative of the subsidiary position of visual art in the hierarchy of Irish culture, where literature and theatre are given much closer scrutiny. Exhibition catalogues, less common before the 1970s, occasionally include texts revelatory of contemporary attitudes to art. Despite this rather bleak context, Irish art generated much controversy and interest in the media. Artists, activists and critics used such coverage to promote their own agendas and to undermine those of their opponents. A close examination of writing on art in Ireland reveals that most of it is adversarial and deeply embedded in the cultural politics of the day.

In the years after Independence, Irish art critics hoped that the visual arts could become part of the project of cultural nationalism. However, it was generally agreed that there was little to distinguish painting and sculpture produced in Ireland from that of Britain or continental Europe. Despite these difficulties, critics felt that some sort of distinctively Irish approach to art would evolve after political independence and they encouraged its development in their writing. George Russell (qv), editor and art critic of the *Irish Statesman* from 1923 to 1930, wrote that he could anticipate 'within a few years the emergence of an Irish group with a distinct national character' (*IS*, 19 April 1924, 166). Russell felt that the solution to the stagnation of Irish art, which was dominated by academicism, lay in the exhibition of international art in Ireland. But when he was confronted with Modernist art, his attitude could be contradictory. He described Mainie Jellett (qv) as 'a late victim to cubism in some sub-section of this artistic malaria' when her first abstract paintings (see 'Abstraction') were shown in Dublin (*IS*, 27 October 1923, 206). But Russell recognized that Modernism (see 'Modernism and Postmodernism') offered a vital alternative to academic art, and noted with envy that it was destroying 'the decaying body of the academic' on the Continent.

The *Irish Statesman*, along with the *Dublin Magazine*, offered an alternative view to that propounded in the many Catholic periodicals and newspapers of the 1920s. The demise of the *Irish Statesman* in 1930 marked the end of an important era for the coverage of cultural issues in Ireland. The same year saw the foundation of the *Capuchin Annual*, published by the Franciscan order, and the translation into English of the French Catholic philosopher Jacques Maritain's *Art and Scholasticism*, a key text for Irish artists and critics of the mid-twentieth century. Maritain's influence is evident on writers as diverse as Mairín Allen (d. 1988) (critic of *Father Mathew Record*, 1941–48, *The Standard* and *Furrow*, 1952–55 and *The Leader*, 1956) and Constantine Curran (1880–1972) (contributor to *Studies*, *Irish Ecclesiastical Record*, *Father Mathew Record* and *Capuchin Annual*).

Thomas MacGreevy (1893–1967) returned to Ireland from London in 1940, where he had been chief art critic of *The Studio*.

He was art critic of the *Irish Times* (1941–44) and a regular contributor to the *Capuchin Annual*, which gave extensive coverage to visual art in the 1930s and '40s, making much use of photography and illustration (qqv). In its pages, art was presented alongside politics and religion as an expression of Irish nationalism and Catholicism.

During the Emergency (1939–45) broader ideas of Irish art and culture were expounded. New publications, such as *The Bell* (1940–54) and *Commentary* (1941–46), debated the acceleration of Modernist art in Ireland, sparked off by such events as the Irish Exhibition of Living Art (IELA) (1943 onwards) (qv), the *Exhibition of Subjective Art* (1944) and the *Loan Exhibition of Modern Continental Paintings* (1944). One of the most important controversies of the war years was the rejection of a painting by Georges Rouault [91] by the Art Advisory Committee of Dublin's Municipal Gallery of Modern Art (HL) in 1942. The

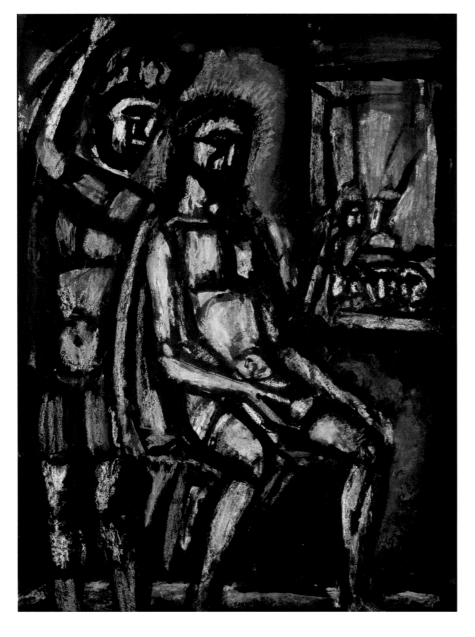

91. Georges Rouault, *Christ and the Soldier*, 1930, mixed media on board, 64 x 48 cm, Dublin City Gallery The Hugh Lane

work had been acquired by the Friends of the National Collections of Ireland (FNCI) and its merits were defended in the newspapers and in various journals. The painting *Christ and the Soldier* (1930) was eventually accepted on loan by St Patrick's Seminary, Maynooth.

Throughout the mid-twentieth century, BBC radio provided Irish listeners with extensive coverage of developments in contemporary art in London and other British cities. Although Eamon de Valera had imposed a tax on foreign newspapers in 1933, the British print media was also readily available in Ireland. Irish literati considered London periodicals such as the *New Statesman*, the *Listener* and the *Spectator* as practically compulsory reading. These weeklies gave a more critical consideration of the development of Modernist art than that found in the Irish media and enabled the Irish art public to become familiar with leading British art critics. However, much of the discussion was not directly relevant to the Irish context.

In its cultivation of leading London critics, the committee of the IELA encouraged a closer connection between British and Irish art circles. In 1945 and 1947 it invited Maurice Collis, critic of the *Observer*, and Herbert Read to lecture at its exhibition. Unfortunately Read's only direct incursion into Irish art, his catalogue essay for the *Exhibition of Subjective Art*, met with mixed results. It demonstrated a lamentable lack of understanding of contemporary Ireland and its cultural make-up because Read implied that the work shown at the exhibition was 'something new in the modern history' of Ireland. He therefore ignored the contribution of such Modernist artists as Mainie Jellett and Mary Swanzy (qv) (Read, 'On Subjective Art', *The Bell*, VII, no. 5, 1944, 424–29).

Clive Bell's notion of significant form was influential on the IELA. The founding statement of the group, which declared that it intended to exhibit 'a comprehensive survey of significant work' clearly echoes Bell's famous doctrine of significant form, in which aesthetic considerations were of paramount concern. Bell's concept of art as autonomous provided a viable alternative to the preoccupation with nationalist content of painting and sculpture of the 1920s and '30s, and allowed art to be considered on its own terms. However, the notion of art for art's sake was mitigated by consideration of the social and national relevance of art in the writings of Irish critics.

James White (1913–2003) became art critic for *The Catholic Standard* in 1938 and subsequently for the *Irish Press* (1950–59) and the *Irish Times* (1959–62). He wielded considerable influence on the general public in the 1950s when he defended Modernist directions in Irish art at the expense of academicism and realism (qv). He advocated the notion of a distinctively Irish version of modern art which was inherently spiritual, in the tradition of Mainie Jellett and Evie Hone (qv). In contrast, Edward Sheehy (1909–56), writing for a more specialized readership as art critic of *Dublin Magazine* (1954–56) and *Envoy* (1949–51), evaluated artworks without any national or religious agenda. In 1953 Sheehy noted how the 'modern painters', who had grown in number since the 1930s, had no common influence and that, like all modern painters, they tended to be international rather than national (*Dublin Magazine*, XXVIII, no. 2, 1953, 49).

Brian O'Doherty (qv), who later emigrated to the United States of America, where he became a distinguished critic, first published criticism in the *Irish Monthly* in 1952 and *Dublin Magazine* (1955–57). Having made a conscious effort to familiarize himself with the craft of art criticism, and systematically reading the works of Read, Bell, Roger Fry and Eric Newton, he advocated a triadic approach which took account of the artwork, the critic and the wider environment, or nature, as he described it. His analysis of artists such as Jack B. Yeats and Patrick Collins (qqv) elevated the level of contemporary art criticism to literary form. Like the older Ernie O'Malley (1897–1957), whose criticism appeared in *Horizon* and *The Bell* in the 1940s, O'Doherty wrote lucidly on the formal and thematic aspects of the artwork, while setting it within a wider national, political and social context. Herbert Read's close examination and analysis of the physical attributes of the artwork was mirrored in O'Doherty's writings, who noted that it was Read's belief in art which enabled him to write with genuine passion and engagement, rather than indulging in 'mere intellectual juggling' (O'Doherty, 'The Vital Cycle', *Dublin Magazine*, XXXI, no. 1, 1956, 56–58). Read's approach contradicted the art for art's sake doctrine of the Bloomsbury critics, making a fundamental connection between art and wider humanistic needs.

The lack of official support for artists and art education (see 'Education in the Visual Arts') in post-war Ireland was highlighted in Thomas Bodkin's *Report on the Arts in Ireland* (1949), which was widely quoted in the press and which led to the founding of the Arts Council (AC/ACE) (qv) in 1951. The media's increasingly sympathetic attitude towards Modernist art was in marked contrast to the reactionary policies of the HL, which rejected an offer of Louis le Brocquy's (qv) painting *A Family* (1951) [71] in 1952, and turned down the donation of a sculpture by Henry Moore in 1954. Debate on the merits and demerits of this work filled the letter pages of the *Irish Times* for weeks. The AC/ACE, under its director Seán Ó Faoláin, came into conflict with Seán Keating and the Royal Hibernian Academy in the press over the refusal of the Council to nominate academic work for its Joint Purchase Scheme in 1959. While the Cultural Relations Committee (CRC) of the Department of Foreign Affairs oversaw Ireland's participation at the Venice Biennale between 1950 and 1962, there was little coverage of the event in journals or newspapers at home. James White pointed out the irony of the fact that Modernist-style work by Irish artists could be seen in such exhibitions abroad but rarely in Ireland (*Studies*, XLIV, 1955, 101–08).

The need to characterize modern Irish art as unique was a feature of the catalogues of exhibitions held by the CRC and the Arts Council during this period. In 1950 the CRC organized a major exhibition of *Contemporary Irish Artists* which toured a number of cities in the USA. Its catalogue emphasized how Irish artists combined Modernist styles with their Irish identity. This suggested that the neglect of international Modernism in the work of Irish artists was a matter of choice and part of a national unwillingness to abandon native concerns, rather than ignorance, or the result of an undeveloped educational and critical art structure in Ireland. The idea that Irish artists' muted engagement with Modernism was a positive attribute was reinforced in the writings of other critics in the 1950s. MacGreevy asserted that, unlike the 'blind alley that modern idioms have turned out to be for many artists of neighbouring countries', in Ireland artists applied an international idiom to the interpretation of Irish subject matter (*Studies*, XL, 1951, 478).

O'Doherty developed this argument in his influential *Irish Imagination 1959–1971* catalogue essay in 1971. This show formed part of the exhibition *Rosc '71*, before travelling to the USA. Identifying the isolation of the Emergency and post-war years as crucial to the subsequent development of Irish art, O'Doherty singled out the work of artists such as Nano Reid and Patrick Collins (qqv) as representative of the 'atmospheric mode', so typical of Irish painting of the mid-twentieth century. Like critics of the 1950s, O'Doherty argued that Irish artists had managed to avoid becoming provincial by selecting characteristics of Modernist art relevant to their 'Irish experience'. He identified a concern with mythical rather than historical time, and an 'evasiveness', which he saw as a reflection of the introspective nature of post-war Irish society but, more importantly, as the result of colonialism.

The influence of O'Doherty's essay is seen in the 1980 exhibition catalogue, *The Delighted Eye*, covering painting and sculpture of the 1970s and shown in London. Here, Irish art is characterized in terms of 'agricultural roots, conservatism, an obsession with the past, and a passion for indirect statement', and the artist presented as intuitive rather than intellectual or academic (Ruane, 1980). Frances Ruane's critical approach in the essay has been described as fulfilling an ambassadorial role for Irish culture abroad (Chris Coppock, *Circa*, no. 14, 1984, 5). This attitude can be contrasted with the writings of the Belfast poet and curator John Hewitt (1907–87) [92]. He recognized the limits of Irish art and placed its development within the contemporary economic context. Thus, in 1944, he noted that the artist, for reasons of economic survival, was unable to develop his interest in aesthetic experimentation, but was forced to 'keep on supplying works of exactly the same style and substance in order to maintain his position' ('Painting in Ulster', in R. Graecen (ed.), *Northern Harvest: An Anthology of Ulster Writing*, Belfast 1944, p. 140). Hewitt's regionalist philosophy allowed for a distinctive Northern Irish culture to exist, independently of Irish nationalism or unionism. This identity, he argued, came from one's surroundings. Thus, Hewitt asserted that being an Ulster artist was not primarily a question of birth or blood, but the result of being immersed in Ulster life and the Irish landscape, and finding there the subject matter of his art. He, therefore, acknowledged that an artist's environment was fundamental to the type of art he produced, but that this was not necessarily linked to national identity or ethnic origin.

Newspaper critics of the 1960s and early 1970s, such as Bruce Arnold, Anthony Butler and Brian Fallon, provided readers with diverse opinions on contemporary art. Patrick Heron's influence is evident, particularly in Fallon's writing. Heron was a critic for the *New Statesman* (1947–53) and later a contributor to *Studio International*. His preference for colour and form, which expressed vitality and spontaneity, rather than work that appeared mechanical, cold and overly concerned

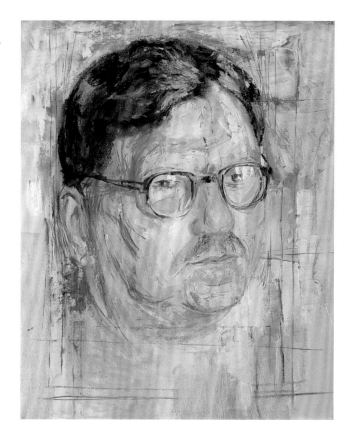

92. Basil Blackshaw, *John Hewitt*, 1984, oil on board, 30.6 x 25 cm, National Museums Northern Ireland, Collection Ulster Museum

James Johnson Sweeney's involvement in the art establishment allowed American influence to have a far greater impact on the discourse surrounding contemporary art than is suggested by the published material. Sweeney was engaged in most of the key exhibitions of Modernist art in Ireland in the 1960s, including *Modern Irish Painting*, the show of American art at the 1963 *IELA*, and most significantly *Rosc '67* and *Rosc '71*. A clear sense of his ideas can be gleaned from his writings in the catalogues for these exhibitions in which he emphasized the autonomy of the artwork and argued that it expressed a universal, poetic language. Sweeney's separation of art from politics coalesced with the need to project a serene image of Irish society, one in which the violence and internal strife of earlier decades and contemporary social discord were absent. This way of viewing visual art also appealed to collectors and dealers since it endowed artworks with abstract rather than literal values. It suited the corporate contexts in which many Irish artworks were now being displayed.

Much of the pro-internationalist discourse took place within the context of professional and personal encounters among members of the establishment, dealers and artists. In written form, it is found primarily in the publications of the Arts Council, including its annual reports and exhibition catalogues. Influential art patrons in Ireland in the 1960s and '70s bypassed the regular art reviews, and educated themselves about avantgarde art through other sources, particularly dealers, and international exhibitions and publications. It was essential for them to develop 'a wider visualization'. Modernism's emphasis on the

with construction, suited an existing partiality amongst Irish critics for expressive art. His staunch defence of British painting in the face of the American Modernist hegemony also put him in high esteem amongst Irish art critics of the 1960s, who sought to make a similar defence of Irish painting.

Their views differed from those of Dorothy Walker (1929–2002) [93], art critic of the current affairs periodical *Hibernia* from 1967, who was vehemently pro-Modernist and scathing of anything that did not adhere to her formalist criteria. Highly critical of the art establishment, to which Walker was closely connected, Arnold, Butler and Fallon drew attention to the government's contradictory attitude to the arts in which it supported major publicity events such as the Rosc exhibitions (qv) and gave tax-free status to artists, but allowed the National College of Art (NCA) to operate in a state of chaos, and turned a blind eye to the elitist operations of the Arts Council. Rosc and the art student protests helped to heighten public awareness of the visual arts during this period which marked a highpoint for media interest in visual art. However, Irish critics were marginalized by the increasing role of Anglo-American forces in the Irish art establishment.

The IELA gave a major platform to Anglo-American critics and curators when it invited some of them to select the Carroll's prize-winners at its exhibitions between 1963 and 1971. This affirmed the idea of a cosmopolitan standard against which Irish art should be measured, while suggesting to the public that Irish art critics were incapable of making objective valuations of Irish art.

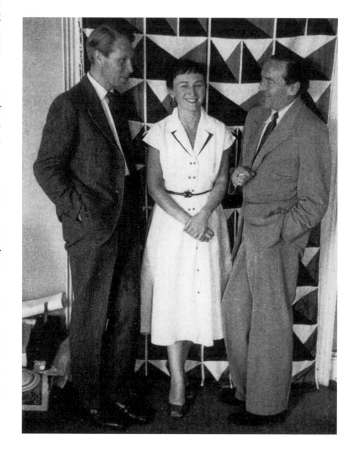

93. Dorothy Walker with Louis le Brocquy (left) and Michael Scott (right), Dublin, 1953

inherent quality of the artwork further encouraged the belief that the viewer's 'propensity to sense' rather than to read enabled one to discern the key criteria of quality, authority and penetration in the artwork (Basil Goulding, *Painting and Sculpture of Today*, Dublin 1965, pp. 6–11).

The Independent Artists occasionally used their annual exhibition catalogues as a vehicle for sounding off against the elitist Irish art establishment centred on the Arts Council. Michael Kane (qv), a prominent member, edited and published the magazine *Structure* (1972–78) [94]. In its pages he outlined what he perceived to be the complicity between the IELA and the Council in creating a canon of Irish art which was 'conciliatory to a commercial society, an art of charm and decorousness, two-dimensional and lacking aggression' (*Structure*, I, no. 3, 1972, 4).

Despite the reform of the Arts Council and the other radical changes in the Irish art world in the 1970s, the promotion of a distinctive Irish art continued in AC/ACE exhibition catalogues. Irish art criticism of the time has been described as obsessed with the megalithic period, Celtic art and James Joyce. Such connections were made by Richard Kearney and Dorothy Walker in *The Crane Bag* (1977–81). As Chris Coppock pointed out, comparisons between Irish artists and writers, both in the actual artwork and in the critical text, perpetuated the notion that Irish art was secondary to Irish writing (Coppock, *Circa*, 1984, 4).

Circa (founded in 1981) challenged the presentation of Irish art as essentially apolitical and linked to a perennial Celtic gene. The journal attempted to set agendas for artists, and challenged existing stereotypical interpretations of Irish

art. Its contributors had been educated in the reformed art colleges of the 1970s and were familiar with critical theory. Many had also experienced the impact of the 'Troubles' at first hand, and were conscious of the role of the artist within the wider political and social arena (see 'Politics in Irish Art' and 'The Troubles and Irish Art'). Regionalism was a leitmotif for *Circa*'s critical direction. This was defined by Kenneth Frampton as mediating 'the impact of universal civilisation with elements derived indirectly from the peculiarities of a particular place' (quoted in John Hutchinson, 'Postmodernism in Ireland', *Circa*, no. 48, 1989, 27). Regionalism gave Irish artists and critics the opportunity to establish more complex ways of interpreting and viewing art to that of the earlier Irishness of Irish art dogma. According to Joan Fowler, it allowed artists to confront local themes in their work, knowing that they would be of relevance on an international, as well as a provincial, level. She further suggested that the concept of regionalism placed the artist within a wider political structure in which art practice could potentially contribute to the formation of cultural democracy (Fowler, 'Regionalism reconsidered', *Circa*, no. 50, 1990, 23–25).

Circa offered other ways of evaluating Irish art. It argued that the separation of the artwork into its own (Celtic) realm could not be continued in the era of Postmodernism. Tom Duddy argued for a 'provincialism of the left', which recognized the wider social, cultural, economic and ideological factors that impinge on the production and reception of Irish art (Duddy, 'Irish Art Criticism: A Provincialism of the Right?', *Circa*, no. 35, 1987, 15; repr. in Cullen, pp. 91–100). Mary Cosgrove, with reference to the ideas of Antonio Gramsci, reminded *Circa* readers that race is an ideological construct, not a fact. A concept of 'Irishness', she asserted, with its associated lack of historical foundations, prevented objective analysis and interpretation of works of art. Her essay, like Duddy's, opened up potential avenues for exploring modern Irish art, which have been scarcely pursued by critics and art historians (Cosgrove, pp. 14–19).

The impact of Postmodernist theory resulted in a much closer integration of critical thinking and art practice, at least in the work of some Irish artists and critics, from the 1980s onwards. It encouraged critics to use wider terms of reference, so that an awareness of the critical context in which the artwork was made and existed is much more prevalent in catalogue essays of the mid-1980s and later. The development of more analytical approaches to criticism can be seen particularly in essays relating to exhibitions of the work of female artists in the late 1980s and 1990s, by writers such as Fowler and Fionna Barber. Work by Alice Maher, Dorothy Cross (qqv) and others encouraged and, one might say, necessitated critical readings that encapsulated a range of approaches, including psychoanalysis, feminism, postcolonialism and a more structured application of art history. One should not, however, exaggerate the impact of Postmodernism on Irish art writing. Media coverage of visual art remained, and still remains, focused on the personality of the artist, or on readings of the work as primarily poetic and passive. This dominant model of Irish art was challenged by a number of major exhibitions mounted by IMMA including *From Beyond*

94. *Structure*, Vol. 1, no. 3, 1972, cover designed and issue edited by Michael Kane

the Pale (1993), *Distant Relations* (1994) and *Irish Art Now: From the Poetic to the Political* (1999).

Currently Ireland, like other countries, is experiencing a vacuum in media interest in the visual arts. Paradoxically, the expansion of galleries and exhibitions over the past twenty-five years has seen a noticeable decline in the regular newspaper coverage of art. This has come about not just because of the growing complexity of Irish art and practice, but is also indicative of a lack of genuine concern for visual art by the media at large. It is a symptom of the international crisis in art criticism in which the application of critical theory, combined with the mechanisms of the art market (qv), has resulted in overly academic or alternatively descriptive accounts of the artwork. The traditional role of the critic as arbiter of public taste has been fundamentally undermined. One of the most prolific critics of the 1990s and early 2000s, Caoimhín Mac Giolla Léith, produces a specialized art criticism that explores critical theory. Apart from his catalogue essays and Aidan Dunne's regular reviews for the *Irish Times*, serious critical activity in the visual arts in Ireland is now confined almost totally to journals and websites produced by, or primarily for, professional artists and curators, such as *Printed Project*, *Circa* and *Source*. The increasing interdependence of art practice and art criticism is reflected in the current emphasis on discursiveness and on the need for artists constantly to renegotiate the terms by which their art is made and considered.

Since the mid-1990s, radio, television and the internet have competed with newspapers and journals as the primary media for accessing information and critical commentary on visual art. While new technology enables greater access, it equally

95. David Crone, *Victim, Tourist and Model*, 1990, oil on canvas, 203 x 244 cm, University of Ulster

ghettoizes art practice and discourages meaningful public debate on the role of visual art in contemporary culture. During the era of the Celtic Tiger, serious discussion of art was largely absent from the Irish media, which continues to present art within conventional gallery or market-led terms. A number of initiatives, such as *Cork Caucus* (2005), have attempted to break down the barriers between artists, art activists and the wider public through critical discussion and related activities (Lucy Cotter, 'Cork Caucus: Where do we go from here?', *Circa*, no. 113, 2005, 56–61). But even the best intentioned of these have made little impact on the general public. Ironically, the increased prosperity of the Celtic Tiger, while funding numerous academic and artist-led initiatives related to criticism, has done little to bridge the gap between public perceptions of visual art and the more complex intentions of artists and curators.

Róisín Kennedy

SELECTED READING O'Doherty, 1971; Cosgrove, 1990; Fowler, 1990a; Cullen, 2000; R. Kennedy, 'Politics of Vision': *Critical Writing on Art in Ireland 1939–1972*, PhD thesis (UCD, Dublin 2006).

CRONE, DAVID (b. 1937) [95], painter. Those familiar with Crone's haunting and elusive paintings might be surprised to learn that he began his art career in 1956 as a student of sculpture at the Belfast College of Art. However, before graduating in 1962, Crone had transferred to a painting course, and it is as a painter that he has made his reputation.

Against a background of civil conflict, which was particularly acute during the 1970s and '80s – his formative years as an artist – Crone developed a form of expression that allowed him to refer to life as lived around his Belfast studio. Through his paintings he reflected the impact of urban disruption and destruction, but always contrived to call attention to the resilience of ordinary people. Crone's focus was not so much on the violence or its effects, as on the ability of people to transcend it. In 1980 *Culture Northern Ireland* quoted him as saying:

> As a source I look at the day-to-day experiences of people about their own business in the streets, in buses, in trains, inside and outside buildings. The environment shows that more violent happenings are taking place. It is patched up and somehow made to work. It is the resulting juxtapositions which I find fascinating. (http://www. culturenorthernireland.org: accessed 20 August 2010)

Crone's paintings make demands on the viewer. He blurs and obfuscates his imagery, rendering it difficult to read, reflecting the complexity and meaninglessness of modern life, yet offering a tantalizing amount of legible information. Thus, details of faces, body parts, buildings and the paraphernalia of life in a war-torn city, such as protective cages and screens, can all be deciphered but are arranged deliberately in unusual combinations and alignments. Crone makes frequent use of grid patterns to segregate elements of his drama, often individual faces, separated from their fellows, because the city outside his studio was also segregated into Catholic and Protestant, unionist and nationalist, male

and female, rich and poor. Crone's technical range is impressive; he develops his pictures in layers, obliterating and overlapping areas with each new accretion, but allowing vestiges of the earlier images to survive, scraping away surfaces and allowing new figurative elements to emerge during the scraping process. He employs this technique to great effect in his *Self-portrait* (1991) in the NSPC in Limerick, where the outline of a hand is scraped out of the underlying pigment to confront the painted face of the artist, who appears to be unaware of it.

After graduating from art college, Crone began to paint landscapes (qv), both rural and urban, but he concentrated on urban environments, especially the destruction of Belfast during the 1970s and '80s, before turning towards people and, increasingly, faces, in the 1990s. He sustained his painting practice by teaching, firstly at his old school, Annadale Grammar School, from 1963 to 1975, during which time he also won a travel scholarship from the ACNI which enabled him to work in Germany, Italy, Belgium and Holland. He taught at the University of Ulster from 1985 to 2001. He has had many solo exhibitions in Belfast and Dublin, notably the inaugural exhibition of the Ormeau Baths Gallery in Belfast in 1995, a retrospective exhibition at the UM to mark the new millennium in 2000 and, outside Ireland, an exhibition at the Academia San Carlo in Mexico City (1995). He has also been selected for inclusion in many of the most important curated group exhibitions of Irish art since the 1980s. Among these were: *The Delighted Eye*, curated by Frances Ruane, which formed part of the bigger Irish cultural project *A Sense of Ireland* in London (1980); *Divisions, Crossroads, Turns of Mind*, curated by the American critic Lucy Lippard, which toured to the USA and Canada (1985–87); *A New Tradition: Irish Art of the Eighties*, which involved a team of curators at the DHG (1990); and *When Time began to Rant and Rage: Figurative Painting from Twentieth-Century Ireland*, curated by James Steward, which was shown in various venues in Britain and the USA (1998/99).

Crone's paintings are represented in the collections of the AC/ACE, ACNI, IMMA, UM, OPW, NSPC in UL, UU and AIB.
CATHERINE MARSHALL

SELECTED READING Seán McCrum, *David Crone*, exh. cat. Arts Council Gallery (Belfast 1984); S.B. Kennedy, *David Crone*, exh. cat. Fenderesky Gallery (Belfast 1991); Steward, 1998, pp. 238, 260.

CRONIN, BRIAN (b. 1958) [96], artist, illustrator. Torn between graphic illustration and fine art, Dubliner Brian Cronin decided to make illustration (qv) his primary focus when his tutor at NCAD, Bill Bolger, showed him the work of the American illustrator Milton Glaser. In 1981 Cronin used the second of two scholarships from KDW to travel to New York to work as an intern in Glaser's studio. Although he went on to found the artists' group '688' with Martin Folan, David Byrne and Jimmy Concagh in Dublin in 1984, and participated with them in a touring exhibition in the same year, Cronin simultaneously worked on illustrations for the *Irish Times* and *In Dublin*, the latter of which inspired his move to New York in 1985.

96. Brian Cronin, *Mother and Child*, 1998, used as a poster in 2001 for the first American production of Edward Albee's *The Play About the Baby*

Within weeks of his arrival, Cronin received commissions from *Rolling Stone* magazine and the *New York Times*. Other commissions flowed in from such well-known international publications and newspapers as *Time* magazine, *Newsweek*, the *Boston Globe*, the *Washington Post*, the *Wall Street Journal*, *GQ* and *Esquire*. Illustrations for Penguin Books included covers for their centenary set of Graham Greene books, while other clients for whom he worked were Microsoft and Virgin Atlantic.

Cronin's commissioned illustrations are joined by artwork of a more personal kind. While this is usually painted on a larger scale and handled more freely than his commercial assignments, they share similar imagery and one can derive from the other. 'A specific commissioned illustration involves a chain of ideas, which in turn can be taken to a new level of form and meaning in my personal work', he remarked (press statement, IMMA, April 1998). Cronin's palette has lightened over the years, without reducing the intensity of his exploration of the idea. Freely acknowledging his interest in the work of a host of historic precedents, ranging from the Russian Constructivists, René Magritte and Andy Warhol to early Japanese advertising, and Mexican and Indian art, Cronin's work is immediately distinctive and dedicated to communication. 'Style is an important tool to bring the viewer into your work, but the idea is always king', he told Declan McGonagle and Brenda McParland on the occasion of his first solo exhibition at IMMA in 1998 (*Brian Cronin*, p. 8). The modernity of Cronin's references might raise expectations

97. Dorothy Cross,
Mantegna/Crucifix, 1996,
cibachrome and black
and white print on MDF,
edn of 3, 76 x 51 cm
each, Frith Street Gallery,
London

about the use of new technologies in the production of his work, but this is misleading. He prefers to draw and paint his images by hand, using a computer only to store them.

Cronin has received Gold awards from the New York Art Directors' Club in 1990 and 1995 (acting as judge of the illustration section at their 1985 annual awards event), and the Society of Publication Designers' annual exhibition (1990, 1997), a silver medal from the Society of Illustrators, New York (1997), the Patrick Nagel Award from the Society of Illustrators of Los Angeles (1997), and a Yellow Pencil Award from Design & Art Direction. In addition to his solo exhibition at IMMA in 1998, Cronin has shown his work in design and illustration exhibitions in London, Los Angeles, Naples, Osaka, Tokyo and Zurich.
CATHERINE MARSHALL

SELECTED READING *Brian Cronin: Fat Face with Fork*, exh. cat. IMMA (Dublin 1998); Paul Buckley (ed.), *Penguin 75: Designers, Authors, Commentary* (London 2010); Jerelle Kraus, *All the Art That's Fit To Print (And Some That Wasn't): Inside the New York Times Op-Ed Page* (New York 2008).

CROSS, DOROTHY (b. 1956) (qv *AAI* III), multi-media artist. One of a generation of contemporary Irish artists who came to the fore in the 1980s, Dorothy Cross is best known for her innovative, and often controversial, work, exploring themes of identity, gender and sexuality, and how these are prescribed within societal constraints. While her point of departure has often been read as a response to personal, local and native Irish situations, ranging from the repressive mores related to class and faith, to the wilful neglect of the surviving remnants of the past in the environs of her home, the issues her work raises have a wider relevance. Consequently, while she is an Irish female, and personal experience informs her work, Cross asserts that she is not a feminist because her explorations are intended to be germane across gender boundaries. She also questions the epithet 'Irish artist', seeing her work as relevant beyond national boundaries (Cross to author, interview, 25 October 2004). Through the methodologies of natural history, anthropology, music (particularly opera), literature and philosophy, Cross considers the parallels across biological, geographical and temporal zones. Throughout her practice to date, her work has confronted subjects or approaches considered to be taboo at the time, often producing imagery that is at once disturbing and humorous. A number of these projects have been undertaken collaboratively with her brother, zoologist Professor Tom Cross, and with actor Fiona Shaw, amongst others. She often performs in her own video and photographic work.

In common with contemporary art practice generally, Cross explores her ideas through a range of media, not only sculpture and installation but photography, video and other technological forms. She has also produced drawings and paintings, though these are less well known. Since the various formats are typically combined in installations, or form an element within a series, Cross is recognized as a multi-media artist (see 'New Media Art') and, consequently, discussion of her work is ideally considered within the context of her broader practice. The works

selected in this essay all comprise or involve technological media.

In an audacious play of ideas on the artist's own name, Cross's *Mantegna/Crucifix* [97] is an early example of work that challenges the dogmas of both the church and of art history. The naked female photographed, foreshortened, from the soles of the feet towards the head, references Mantegna's well-known painting of the dead Christ (Andrea Mantegna, *Lamentation over the Dead Christ*, c. 1480, Pinacoteca di Brera, Milan), the prominence of which rests primarily on its extreme perspectival viewpoint. She provides an alternative body for the one clearly absented from the crucifix in the accompanying image, the imprint of the corpse reminiscent of the missing body from the tomb when Christ was resurrected. The work plays on the oppositional but mutually dependent notions of the sacred and profane body, and of its literal and metaphorical counterparts: the institutional (the church) and the liturgical (the host) bodies; its presence and absence in both contexts; and the respective gender roles within those ambits, paraphrased respectively by the abject and the resurrected.

The work is also about mortality, incorporated to be read literally in Mantegna's and Cross's works, and serving as a *memento mori*, a theme that she returns to in various forms in her work.

The strategy of comparative and mutually dependent opposites recurs also. It emerges in the relative gender roles suggested, inter alia, in one of her best-known works, *Teacup* [98]. This work comprises a still photograph of a genteel domestic porcelain cup and saucer with a three-minute clip from the well-known film *Man of Aran* (1934) [1] by Robert J. Flaherty, showing a four-man currach battling through heavy seas. This scene is embedded in the cup as though to form the liquid surface of the tea. This iconic film, presented as an objective documentary record of life in the Aran Islands, was subsequently criticized for deliberately presenting obsolete activities, particularly the shark hunt, as though still commonly practised, in order to convey an image of pre-modern authenticity. The film remains a classic nonetheless, not least because of the layers of representation and interpretation of cultural, regional and gender identity that it offers – both in terms of the way of life depicted, and the processes involved in the film's production and dissemination. This work, and particularly the selected passage in *Teacup*, represented consequently an ideal forum for the cultural issues of interest to Cross, presenting the alternative spaces of feminine/masculine, indoor/outdoor, culture/nature, domestic/wild, gentry/labouring class, security/danger, containment/freedom and so forth. An element of dark humour and of the surreal is ever present in her work.

98. Dorothy Cross, *Teacup*, 1997, video, 3 min loop, edn of 3, private collections

An underlying motif in Cross's practice has been the consequences of the passage of time, from what she refers to as the 'rot and reality' of organic death, to cultural destruction through what she sees as ill-devised regulations and/or wilful neglect, and to the residues of obsolescence. These are explored in tandem with the processes of loss, recovery and memory. One of her best-known works, *Ghost Ship* (1999) [236], for which she won the Nissan/IMMA Public Art award in 1999, involved enveloping an obsolete lightship in luminous paint. Moored in Dun Laoghaire harbour, after dark the ship glowed in reflected light like a wraith. This pre-existing, 'found' sculptural work was subsequently scrapped as planned, but has a continued existence as an artwork in the form of a video and of photographic prints which in turn function both as documents to the *Ghost Ship* installation and as tangible memorials to a vanishing past.

Cross imaginatively appropriates and re-presents obsolete functional objects, whose reinterpretation incorporates their previous role, as well as the era to which they belonged. For example, *Slab* (1999) makes use of a ceramic mortuary slab, using it as a horizontal 'screen' for projecting video footage of tidal flows. As with many of her works, this example generates conflicting emotions since the inevitable associations of mortality, time and tide are evoked in a work that combines a Duchampian 'found' object and technological imaging. The tidal video in *Slab* is part of the footage gathered at Poll na bPéist (Worm's Hole), a naturally occurring rectangular pool at the foot of the cliffs at Aran Mór. The pool, filled by tides flowing through underground caves and the deposits of high tides, has local folkloric associations, as the title indicates. The shape of the pool is used in the projection of the footage into similarly rectangular spaces – on a small scale in the case of *Slab* and on a grander scale for the spectacular *Chiasm* (1999), where the image of the rectangular pool with the sea flowing into it was projected into each of the two abutting handball alleys. These alleys, once a feature of small towns across Ireland, are disappearing in contemporary Ireland; and double alleys, like the one used for *Chiasm*, are particularly rare. Cross exploited its structure to explore the tidal ebb and flow of relationships. She used the abutting alleys as partitioned spaces for a male and a female opera singer, each separated from the other by the intervening wall. They sang romantic duets selected by the artist, moving spontaneously around their respective spaces, with the possibility of meeting at points on opposite sides of the wall. In the event, they never did meet and the unfulfilled potential could be observed by an audience seated on scaffolding above the alleys.

Such themes of loss, of unfulfilled potential, of wasted opportunity, emerge in various poignant works by Cross in relation to different situations. *Endarken* (2000) represents the artist's frustration at the erosion of remaining fragments of the past, such as the crumbling Famine cottages that are disappearing from the region around her home in Connemara. A video film of a derelict cottage is shown with a tiny black dot growing from the middle of the screen. The dot, suggestive of the black pupil of an eye, enlarges until the image is obscured, a metaphor for the 'blindness' of authorities which fail to protect a disappearing heritage. Cross's objection is not from a position of nostalgic longing, but a practical respect for those predecessors whose marks of survival are still visible in her landscape; her own fields are ridged with lazybeds, and feature also the surviving walls of cottages left roofless by the constraints of building regulations.

The new millennium has been witness to the continued exploratory practices of Dorothy Cross making use of photography (qv) and video as part of multi-dimensional multi-media schemes. The Medusae films of the artist swimming in jellyfish lakes in Australia were used to provide the dramatic backdrop to a production at the English National Opera of Vaughan Williams's opera of Synge's *Riders to the Sea*. With currachs made by Meitheal Mara, in Cork, appropriated for the most dramatic stage designs, and incorporating the tidal pool of Áran Mór, the production represented an extraordinary collaboration of music, art, craftsmanship and theatre connected across time and space.

Dorothy Cross was born in Cork, and attended the Crawford School of Art in Cork, the Leicester Polytechnic and the San Francisco Art Institute, California. She has represented Ireland in numerous travelling exhibitions, as well as at the 1993 Venice Biennale and the Istanbul Biennial in 1997. Her work has appeared in solo and group exhibitions in Ireland and in various locations in Europe, North America, China and Micronesia; a major retrospective of her work was shown at IMMA in 2005. Her work is represented in private and state collections in Ireland, Britain and the USA. Yvonne Scott

SELECTED READING Seán Kissane, *Dorothy Cross*, exh. cat. IMMA (Milan and Dublin 2005); Robin Lydenberg, *GONE: Site Specific Works by Dorothy Cross*, exh. cat. McMullen Museum of Art, Boston College (Boston MA 2005); lecture by Dorothy Cross, TRIARC, TCD (June 2008).

CROZIER, WILLIAM (1930–2011), painter. Combining the colour and verve of the Scottish Colourists with a painterly and instinctive response to landscape, particularly the coastal scenery of west Cork, William Crozier was an artist who defies easy classification. Moving confidently between the Irish and British cultural worlds, he exhibited on many occasions both in London and in Dublin, as well as farther afield. Although born in Scotland, his family roots are in County Antrim, and visits to Ireland were a feature of early family life, setting a pattern of migration that Crozier retained throughout his working career. An Irish citizen, he identified strongly with Ireland as both home and place of work, yet his style and approach was still clearly rooted in the painterly, yet disciplined, tradition he had assimilated in Scotland.

Born in Glasgow, William Crozier grew up in Troon, Ayrshire. At the age of nineteen he enrolled in the Glasgow School of Art, graduating in 1952. His first exhibition was held in 1951 at the Carnegie Library, Ayr, Scotland. After a few months in Paris, where he absorbed the Existentialism prevalent in intellectual circles, Crozier moved to London where he was quickly recognized as one of the leading young painters of the

time. In 1957 he exhibited at the Parton and Drian galleries and at the Institute of Contemporary Art. Over the following twelve years, Crozier had exhibitions at the Drian Gallery no less than eight times, as well as showing work in Milan in 1958, and in Paris, London and Washington the following year. In the mid-1950s, he spent two years in Dublin, becoming friendly with Anthony Cronin and other poets and artists. In addition to his own studio work, Crozier painted sets for the Olympia Theatre and the Theatre Royal. Tiring of the inward-looking Irish art scene, he returned to London, but in 1963 he moved on to southern Spain, where he and Cronin shared a house in Málaga. His paintings from this period are figurative, painterly and full of a sense of energy, qualities retained, but modified and refined, in more recent years.

Many of Crozier's paintings from the 1980s onwards have been inspired by the landscapes around Kilcoe in west Cork, where the artist and his wife, the art historian Katharine Crouan, spent part of each year. The bright colours of fields and hedges are translated, with characteristic brio, into strong, colourful creations. The landscape paintings are distinguished by a high horizon line, the compositions defined by vigorous curving diagonals, depicted in primary reds, yellows, greens and blues, brought together in juxtapositions that are vibrant but not garish. This sense of animated nature is evident in paintings such as *The Ripe Field* [99]. Crozier's signature style sets him apart from most other Irish painters of his generation, with the exception perhaps of Brian Bourke (qv).

In addition to landscapes, Crozier also excelled at still-life painting. Many of his works are begun and completed in one sitting, the concentration of time and energy being important, in terms of creating a work of art that has integrity and cohesive strength. Through his art, Crozier reacted to his environment. He was concerned with meanings that lie beneath the surface, drawing personality from the landscape and investing this with a brooding, mythic quality. While his work can be compared with the Expressionist approach of Robert Colquhoun and Robert McBryde, his response to the landscapes of west Cork has defined a significant part of Irish art.

For many years, Crozier was head of painting at the Winchester School of Art, dividing his time between that city and his house and studio in west Cork. He retired from this post in 1986, to concentrate full-time on his own painting. An exhibition of west Cork landscapes was held at the Angela Flowers Gallery in Rosscarbery, Co. Cork in 1985. In 1991 the CAG and the RHA (qv) presented a retrospective exhibition of Crozier's paintings, and in the years following, his work was shown at the Taylor Galleries in Dublin, and at the William Jackson Gallery and the Bruton Gallery in London. William Crozier was a member of Aosdána (qv), and was elected an honorary member of the RHA in 2000. PETER MURRAY

SELECTED READING Peter Murray and Anthony Cronin, *William Crozier: Paintings 1949–1990*, exh. cat. CAG and RHA (Edinburgh 1991); Yvonne Scott, *William Crozier*, exh. cat. Taylor Galleries (Dublin 2004); Katharine Crouan (ed.), *William Crozier* (Aldershot 2007).

99. William Crozier, *The Ripe Field*, 1989, oil on canvas, 106.6 x 114.3 cm, Crawford Art Gallery

CUBISM. Mainie Jellett (qv) described Cubism as 'the truth which has appeared to us in the midst of the disintegration of our civilization, and what seems to us prophecy of a new and spiritual civilization' (Jellett, 'Modern art and its relation to the past', 1931, in MacCarvill, pp. 81–90).

Cubism offered an alternative to art that was concerned with external appearance and which dominated art practice in early twentieth-century Ireland, especially that shown at the Royal Hibernian Academy (RHA) (qv) exhibitions. Furthermore, of all the art movements in those years, some believed that it was possible to link Cubism directly to the early Christian tradition of art-making in Ireland. According to Jellett, both were concerned with 'the sense of filling and decorating a given space rhythmically and harmoniously' (Jellett, 'A word on Irish art', 1942, in MacCarvill, p. 103). The fascination with Cubism among Anglo-Irish women artists, in particular, may have come from their need to offset the growing isolationism of post-Independence cultural life in Ireland by engaging in avant-garde European art. It is partly owing to this female association with the structured and rigorous style of Cubism that Expressionism (qv) came to be seen as more innately Irish and masculine in character. In the late 1960s and '70s, when Anglo-American models dominated Irish art history, Cubism was understood almost entirely in terms of its early heroic phase when Pablo Picasso and Georges Braque were the main protagonists. Research by Christopher Green, Peter Brookes, Mark

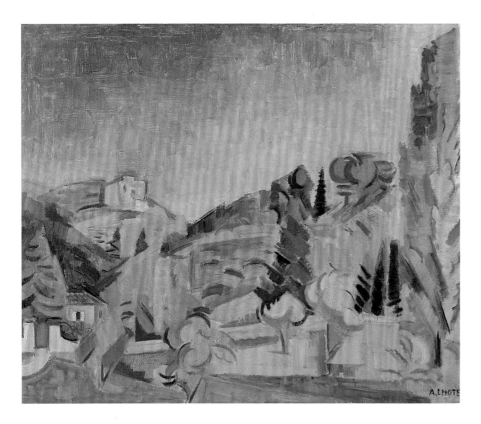

100. André Lhote, *Landscape*, 1935, oil on canvas, 60.4 x 73.4 cm, Dublin City Gallery The Hugh Lane

in conjunction with Jellett and Hone. As described in Gleizes' book *La Peinture et ses Lois* (1923), the artist begins with the basic shape of the support and paints its surface in one colour, proceeding to select colours and shapes which echo the form of the canvas. This is the static element of translation. In rotation, the Cubist element, the artist rotates these basic forms to create a dynamic composition that introduces the idea of time and movement. Gleizes, a devout Catholic, shared with the young Irish artists a reverence for medieval religious art (see 'Religion and Art') and a commitment to an art practice that evoked universal values of space and time while offering a meaningful aesthetic to the wider community.

Jellett's early exhibitions of cubo-abstract paintings at the Society of Dublin Painters (SDP) and the New Irish Salon in the 1920s met with confusion and ridicule [102]. But her embrace of a more representational version of Cubism, focused on demonstrably religious subject matter, made her work palatable to a wide range of critics in the 1930s and '40s. Her Cubist work was selected to feature in Irish pavilions at the Glasgow Exhibition (1938) and at the New York World's Fair (1939). Hone won a gold medal for her Cubist-inspired stained glass *My Four Green Fields* (1938, [465]) at the latter event. In the 1950s, Hone's and Jellett's Cubist versions of religious art were hailed as central to the development of Modern art (see 'Modernism and Postmodernism') in Ireland.

Lhote provided a less theoretical and more pervasive form of Cubism to that of Gleizes. He, like Gleizes, had been associated with Cubism since 1911 when the movement first came to wider public attention. Through the work of his former pupils, Lhote's decorative and colourful approach dominated exhibitions at the SDP in the 1930s and '40s and at the Irish Exhibition of Living Art (IELA) (qv) in its early decades. His Irish students, along with Jellett and Hone, included May Guinness, Norah McGuinness, Grace Henry (qqv) and Jack Hanlon (1913–68).

During the Emergency there was renewed interest in Cubism in Dublin. In 1940 the exhibition *Six Artists from the Académie Lhote* was shown at the Contemporary Picture Galleries, Dublin. The influence of Cubism was evident in work shown at the White Stag (qv) exhibitions, particularly that of Doreen Vanston (1903–88), another of Lhote's students. Works by Picasso and Lhote were included in the group's exhibitions and featured in the 1944 *Loan Exhibition of Continental*

Antliff and others has since highlighted the complex nature of the movement and its continuing development in the post-World War I period, the context in which Irish artists began to engage with it.

Although Cubist works were exhibited in Dublin as early as the 1912 Post-Impressionist exhibition, and artists such as May Guinness and Mary Swanzy (qqv) had seen contemporary Cubist works in Paris before World War I, the movement had no impact on Irish art until the 1920s. Jellett and Evie Hone (qv) began a crucial connection with Cubism when they studied with André Lhote (1885–1962) [100] in 1920/21. Their subsequent collaboration with Albert Gleizes (1881–1953), which began in 1921, resulted in the first exhibition of abstract art (see 'Abstraction') in Ireland in 1923 created in a Cubist aesthetic. Gleizes' method of 'translation – rotation' [101] was developed

101. Diagrams from *La Peinture et ses Lois,* reproduced in *Albert Gleizes: For and Against the Twentieth Century,* P. Brooke (New Haven 2001) pp. 96–97

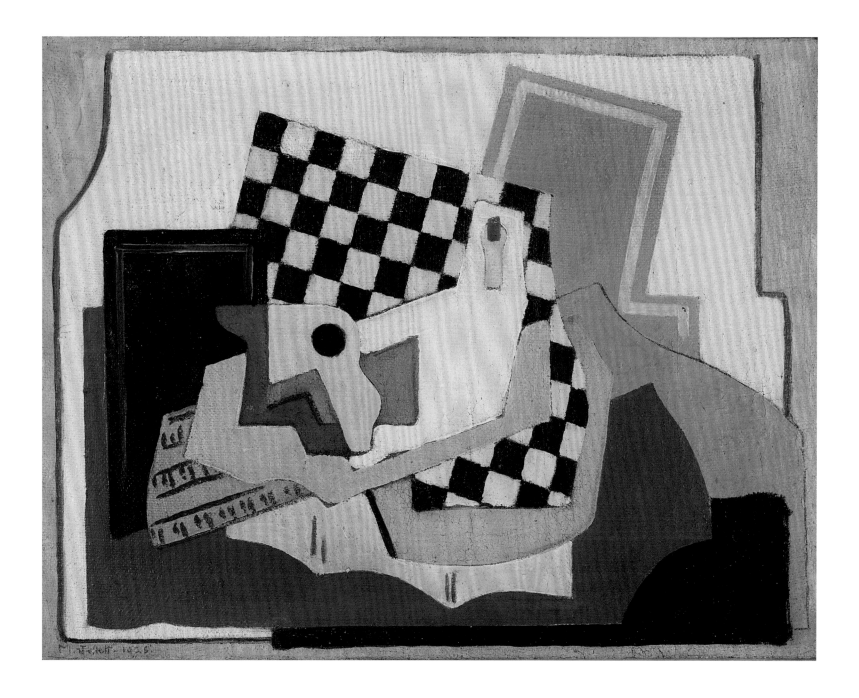

102. Mainie Jellett, *Composition*, 1925, oil on canvas, 51 x 66 cm, private collection

Paintings organized by the Friends of the National Collections of Ireland (FNCI). Louis le Brocquy (qv) absorbed the lessons of Cubism during these years and its influence is manifest in his paintings of the Irish landscape (qv) and tinkers.

In the post-war era, Cubism took on the mantle of liberalism through its association with Picasso and the iconic *Guernica* (1937, Reina Sofía). Le Brocquy's *A Family* (1951) [71] pays direct tribute to this painting and uses the breakdown of space and form to create a powerful image of the disconnection of modern domestic life. Shown at the 1956 Venice Biennale, le Brocquy's work was heralded as signifying a Celtic brand of Cubism. The estranged look of the figures, rather than expressing a universal sense of alienation, marked them out as Irish to an English viewer, according to one critic (Robert Melville, *Louis le Brocquy*, exh. cat. Galerie Lienhard, Zurich 1961, n.p.).

Le Brocquy's continued deployment of Cubism is evident in his fragmented head series of the 1960s onwards which includes his depictions of literary figures such as James Joyce and Samuel Beckett.

Inspired by the School of Paris and especially by the paintings of Marc Chagall (1887–1985), a Cubist aesthetic is evident in the work of Gerard Dillon (qv) [103]. In his paintings of the west of Ireland, the break-up of space lends the subject matter a modern flavour while indicating the artificiality of its theme. Dillon's work develops in an intuitive manner the more theoretical connections between medieval Irish art and Cubism seen in the work of his early mentor, Mainie Jellett. Dillon's fellow northerner, George Campbell (qv), also used Cubism in his paintings of the west of Ireland. He saw work by Picasso and Braque in Paris in 1950 when he met the Russian sculptor Ossip

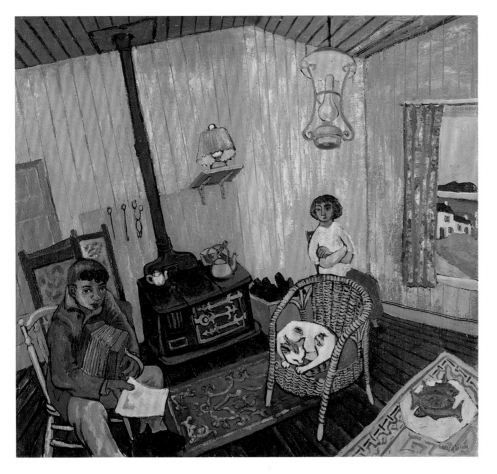

103. Gerard Dillon, *Yellow Bungalow*, 1954, oil on canvas, 76.8 x 81.1 cm, National Museums Northern Ireland, Collection Ulster Museum

draughtsman that he is most critically recognized. Growing up in the relatively undramatic midland landscape of County Longford stimulated Cullen's interest in subtle nuances of light and volume, a quality he shares with the other great draughtsman of his generation, Patrick Graham (qv), from neighbouring County Westmeath.

Cullen won a scholarship to NCA, picking up additional awards, such as the 1916 Commemorative Exhibition Prize and the RDS Taylor Prize. He found the College of Art deeply frustrating during his student years because of the formulaic approach of the teachers. He left for Barcelona during his final year, returning only to claim his teaching diploma, but after a further year in Spain, he returned to teach in the college. In 1973, along with Alice Hanratty, Charles Harper and Paul Funge, he supported student demands for reform and was sacked. A year of unrest followed in which he and his colleagues picketed the college until, in 1975, he was given his job back and the college authorities agreed to improvements. Cullen went on to become Head of the Painting Department, a position he held until 2000.

Cullen was also a member of Group 65 and a founder member of the Project Arts Centre, where he greatly benefited from the multidisciplinary environment that led him, along with artists such as Michael Kane (qv) and John Behan, to collaborate with writers. Despite his activist roles, Cullen is an artist who likes to work away from the public gaze where he can analyze and experiment with the subjects that attract him. His work is always figurative and usually concerned with crowded urban situations, often with an erotic strain reminiscent of the work of the German Expressionist George Grosz.

While he has painted portraits, including a number of self-portraits, it is Cullen's prints and drawings, inspired by James Joyce's *Ulysses*, which are perhaps best-known. One of the finest commentaries on contemporary drawing was inspired by Cullen's work for the exhibition, *NCAD 250 Drawings, 1746–1996*, when Noel Sheridan wrote:

Eye and hand seek out the forms while memories of the appearance of things become fugitive as scale and distance blur. What distinguishes great drawing is the variety of mark making. Marks that open out, wrap around, hang, straddle, split, cantilever, obstruct, contain, grow, glide and dance are all represented in this work of wonderful surprise and great originality. (Sheridan, p. 120)

Cullen was included in such exhibitions as *The Delighted Eye*, Derry and London (1980), *Making Sense*, Project Arts Centre, Dublin (1980), *The Decade Show*, Wyvern Gallery, Dublin (1990), and he had a retrospective at the HL in 1997. His work is included in the collections of the HL, AIB, TCD and AC/ACE. In 2007 Stoney Road Press published *Nighttown*, a boxed set of ten of Cullen's intaglio prints. He is a member of Aosdána (qv). CATHERINE MARSHALL

Zadkine, who encouraged his use of Cubism. Campbell, who divided his time between Spain and Ireland from 1951, transferred the ostensibly metropolitan language of Cubism to the rural contexts of these countries. He used its multiple viewpoints and narrow colour range to emphasize the inherent complexity of local topography and folk life. His work suggests that the Cubist aesthetic, which originated on the margins of cosmopolitan life, is particularly relevant in an Irish context.

By the later 1960s, Cubism was no longer fashionable. Campbell was dropped by the David Hendriks Gallery in favour of more avant-garde artists. Norah McGuinness's continuing deployment of a Cubist style, in conjunction with her long presidency of the IELA, added to the general impression among young artists that the movement was outmoded. In the work of Irish artists, Cubism takes on a distinct, yet diverse, local character. Its radical nature is overshadowed by the frameworks of Irish art, where it was largely used to reconcile tradition with modernity. RÓISÍN KENNEDY

SELECTED READING MacCarvill, 1958; S.B. Kennedy, 1991; Arnold, 1991; *Mainie Jellett, 1897–1944*, exh. cat. IMMA (Dublin 1992); Coulter, 2006; J. O'Donnell, 2009.

104. Charles Cullen, *Interesting Times*, 1984, mixed media on paper, 145 x 111 cm, Dublin City Gallery The Hugh Lane

CULLEN, CHARLES (b. 1939) [104], painter, draughtsman and printmaker. Born in Granard, Co. Longford, Charlie Cullen has described himself in an interview as 'essentially a draughtsman painter' (McAvera, p. 83) and it is for his skills as a

SELECTED READING Sheridan, 1996; Christina Kennedy (ed.), *Charles Cullen: Retrospective*, exh. cat. HL (Dublin 1997); Gallagher, 2006, pp. 86–87; Brian McAvera, 'The Draughtsman Painter', *IAR* (Summer 2009), 80–87.

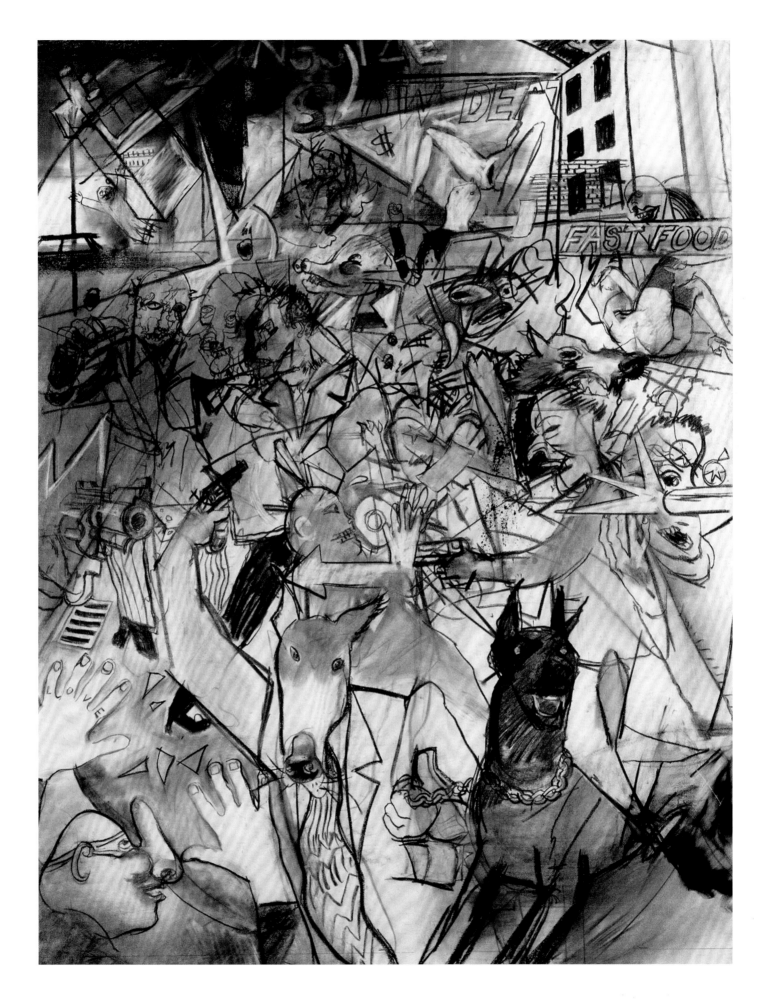

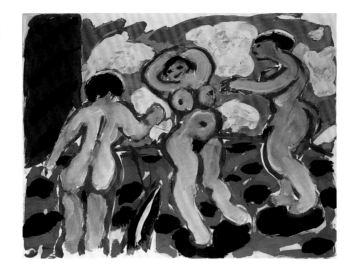

105. Michael Cullen, *Three Graces*, 1983, oil on paper, 27 x 75 cm, Butler Gallery

CULLEN, MICHAEL (b. 1946) [105], painter. Michael Cullen's paintings explore pictorial representation. On the one hand, they appear to conform to Clement Greenberg's formalist theories about the flatness of the painted ground and the qualities and application of the paint, while, on the other, they manage to refer to life outside the frame through his intelligent use of art history. *Painter about to Paint a Picture* (1991/92), one of the handful of paintings purchased by the newly established IMMA from its first acquisition budget, could be read as a sampler of pictorial language, employing gesture, paint application and variations in scale, as well as historical reference to show the range of expression that painting as painting can offer. In it, the hatted van Gogh-like figure of the artist at his easel reminds the viewer of the difficulties that a painter must constantly confront, not least in his own sexual drives, as he tries to paint a nude female model who may be posing or attempting to flee the studio. The exaggeratedly huge hands of the artist remind us that the work of painting requires manual activity, challenging the emphasis on Conceptualism (see 'Conceptual Art'), which dominated the art world in the 1970s and '80s, when Cullen was beginning to establish himself. Colour and texture are emphasized through crudely contrasting striped, spotted and flat areas of paint. Sometimes the paint is almost sculptural, having been squeezed directly from the tube, taking several years to dry out, or scraped back so that the canvas ground is almost visible. All this is pulled together by brushstrokes that alternate between painting and drawing with a brush, in a cartoon-like manner, informed by the work of the American artist Philip Guston, in the 1970s.

Like Clement Greenberg, Cullen thinks of a painting as a 'wall of paint', rejecting the Renaissance idea of it as a window on to another world. 'You see in a medium, not through it', he told Gerry Dukes (Dunne, 211). There is a theatrical element in his work, referenced by the presence of an audience watching the painter/performer as he works, the dramatis personae drawn from great artworks from the past, such as Velázquez's *Las Meninas*, from popular culture (Popeye) and from the animal world, as well as the artist himself and his model.

Born in Kilcooley, Co. Wicklow, Cullen snatched opportunities to study art by working at the Hell Fire Club Gallery, attending part-time classes at NCA (1962) and St Martin's, London, before committing to NCA full-time. In 1973, he went to Spain and Morocco with his classmate from NCA, Michael Mulcahy (qv), returning with a new interest in pattern and colour. Periods of work in Berlin, the south of France, the USA and Mexico, and a residency in the Tyrone Guthrie Centre, Annaghmakerrig, Co. Monaghan, have been interspersed with time spent in his Dublin studio, throughout all of which he has remained committed to figurative painting. The IMMA, HL, TCD and AIB collections contain good examples of his work. He is a member of Aosdána (qv). CATHERINE MARSHALL

SELECTED READING Aidan Dunne, 'A Painter Painting', *IAR Yearbook* (1995), 210–15; Brian Lynch and Brian McAvera, *Profile 27 – Michael Cullen* (Dublin 2009).

CULLEN, SHANE (b. 1957) (qv *AAI* III), artist. Born in Mostrim, Co. Longford, and a graduate of Sligo RTC (1975), Cullen's practice has developed from painting to embrace whatever disciplinary approach is best suited to his conceptual purpose (see 'Conceptual Art'). The most obvious common threads, linking works in sculpture, painting, computer-engraved text, print and installation art (qv), is a commitment to looking at the role of the artist in a world where, he believes, history has been replaced by spectacle. More specifically, his art signals a highly political approach to events and practices that are themselves political, such as the position of the state in relation to the citizen, making politics and bureaucracy visible, or exploring the optics of the documents of officialdom, from political agreements to railway timetables, entrance visas and passports.

Cullen explores what it is to be an artist, to have the right not to be neutral, even when the subject is a highly divisive political one, without, on the other hand, falling into the trap of mythologizing and thence to propaganda. His answer is surprisingly straightforward; it is to make art about events that are overtly

106. Shane Cullen, *Fragmens sur les Institutions Républicaines IV*, 1993–97, painted text, acrylic on 96 styrofoam panels, arranged in 12 blocks of 8 panels, 251 x 480 x 4 cm each block, Irish Museum of Modern Art

political in order to see how that making asserts itself as something different to the politics. A good example of this exploration was to spend nearly five years (1993–97) transposing the secret, smuggled communications from the Hunger Strike prisoners in Long Kesh Maze Prison, in 1981, on to ninety-six large panels, mimicking the typeface and green background of officialdom in Ireland. A key moment for him is the moment of discovery for the viewer when s/he discovers that what appears to be a vast area of mechanically printed text is actually painted, letter by letter, giving the artist a level of intimacy with emotionally disturbing content over a protracted period. The meaning thus revealed was very different to that of the original messages, while each viewer adds more personal nuances. That work, *Fragmens sur les Institutions Républicaines IV* [106], followed other projects using similar strategies of mimicking officialdom, and was in turn succeeded by a further large textual sculpture, *The Agreement*, commissioned by Beaconsfield arts centre, London, in 2000 [82, 491].

The Agreement, spread over fifty-five panels, is a transcription of the document of the multi-party agreement that ended the thirty-year-old conflict in Northern Ireland, put to the people of the island of Ireland in a plebiscite and ratified on Good Friday 1998. Following accidental damage, the work was subsequently remade and amended to include changes to the original agreement which had yet to be implemented five years after Cullen's artwork was first shown in public, in Dublin's Docklands in 2002. Cullen's achievement, on this occasion, was to make visible and monumental material that the populations of Ireland, North and South, had signed up to, that had appeared in their letterboxes like junk mail, but which few had actually read. Using digital technology to create a minimalist, bland wall of text, Cullen raised issues of authority, even-handedness and permanence to something that was still highly contested and which, although signed, was yet to be put into practice. As Cullen explained in a public discussion at the University of Ulster:

> The specific strategy behind the agreement is this idea of a state art that is utterly conformist and almost ceremonial ... this utter conformism, reproducing the document so exactly and then bringing it along to the constituencies that voted for it or indeed against it. It's as if the government has an art department and this is official art ... you have this idea of utter conformity as being the most revolutionary stance an artist can take. (12 May 2006)

Cullen's move away from painting and photography (qv) to text and object was motivated by the effects of over-exposure to holocaust imagery and the falsification of photography in repressive regimes.

Cullen's work has been shown in solo exhibitions in numerous venues in Ireland, Britain and continental Europe, and in North America. In 1995 he was chosen, with Kathy Prendergast (qv), to represent Ireland at the Venice Biennale and has been included in important group exhibitions such as *L'Imaginaire Irlandais* at the École National des Beaux Arts in Paris in 1996. Cullen has been awarded artist residencies in Annaghmakerrig

and IMMA in Ireland, Vassivière, Pontoise and Verdun in France, Budapest, and PS1 in New York. He has worked with Israeli 'refuseniks' who refuse to fight against Palestinians. In 2008 at the Millennium Court Arts Centre, Portadown, he showed sculpted figures modelled on drawings of Irish mercenaries by Albrecht Dürer in Antwerp in 1521. His work can be seen at IMMA and the Irish College, Louvain, Belgium.
Catherine Marshall

SELECTED READING Suchin, 1995; Bewley and Herbert, 2000; Jewesbury, 2002.

CULTURAL POLICY IN IRELAND

Flux: The Irish Revival (1900–21)
Ireland's most renowned period of cultural activity, roughly from 1890 to 1916, occurred under a British government whose overriding policy objective for Ireland was to maintain the union in the face of both radical and moderate nationalist aspirations. Insofar as there was a conscious cultural policy, the aim was to ameliorate nationalist passions – with a broadly indulgent attitude towards them. Thus the nationalist Abbey Theatre was tolerated, even patronized by members of the Anglo-Irish ascendancy, to the point where it has been suggested that during those years it owed as much to 'constructive' unionism as to nationalism (Lionel Pilkington, *Theatre and the State in Twentieth-Century Ireland*, London 2001, p. 2).

Ireland's leading visual artists hailed overwhelmingly from the Anglo-Irish and Protestant middle classes, which were largely unionist in sympathy. The failure of visual artists during the Irish Revival to produce a contribution to the debate on nationalist identity as distinctive as the writers had

107. Patrick Pearse, Rockwood Studios, New York, 1914 , Pearse Museum, Rathfarnham, Dublin

made had implications for the fate of the visual arts in the post-independence era.

Until the Home Rule crisis of 1912, cultural nationalists could distinguish between cultural and political aspirations. Patrick Pearse, [107] whose writings would soon provide a touchstone for advanced nationalism, spent most of his life as a moderate Home Ruler, confident that nationalist cultural goals could be achieved without radical political change. In 1908 he founded the bilingual school St Enda's as a prototype for a radical transformation of Irish education. Through his school, Pearse hoped to produce the template for a balanced curriculum in which arts and sciences were given equal weight in a child-centred educational philosophy. The visual arts figured prominently. Paintings by eminent artists such as Beatrice Glenavy, née Elvery, and Sarah Purser (qqv) (qv *AAI* II) adorned the school, and Pearse's brother Willie – trained as a sculptor at the Dublin Metropolitan School of Art (DMSA) – taught art, while one of the pupils, Patrick Tuohy (qv), went on to become a leading painter and teacher. It could be argued that Pearse's school was the closest Irish education ever came to an educational vision in which the main art forms were accorded their due weight (see 'Education in the Visual Arts').

The descent of St Enda's to the brink of bankruptcy in 1912, however, led Pearse to change from Home Rule supporter to republican, and to postulate a link between an unsympathetic political environment and the failure of his cultural project. He recognized that cultural dreams were constrained by political realities. By the time he published his final reflections on education in January 1916, he was more preoccupied with British educational policy in Ireland than with educational philosophy. Prescriptive about language, he would 'restore Irish as a vernacular to the English speaking six-sevenths of the population, and would establish Irish as the national language of a free Ireland' (Pearse, pp. 18–19). Since Pearse was elevated into a cultural authority in post-independence Ireland, the subordination of detail to rhetoric in his late writings allowed successive governments to validate educational practices that he could hardly have endorsed. A *dirigiste* language revivalism soon became the cultural policy of the Irish Free State [108].

Other writers of the revival had also sensed the narrowing of cultural horizons. At the turn of the century George Russell (AE) (qv), John Eglinton and W.B. Yeats anticipated how the pursuit of national freedom offered two possible outcomes: an introverted provincialism centred on the revival of the Irish language or a Europe-oriented cosmopolitanism based on a wider idea of culture (John Eglinton, W.B. Yeats, George Russell and William Larminie, *Literary Ideals in Ireland*, London and Dublin 1899). Speaking in 1913, Yeats foreshadowed the dilemma thrown up by the native exercise of power in the Free State:

> There is a moment in the history of every nation when it is plastic ... when it is ready to hold for generations the shape that is given to it. Ireland is now plastic, and will be for a few years to come ... if the intellectual movement is defeated, Ireland will for many years become a little huckstering nation, groping for halfpence in a greasy till. It is that or the fulfilment of her better dreams. (*Manchester Guardian*, 15 July 1913)

Polarization (1922–50)

In 1923, in the wake of Civil War, George Russell sensed that cultural life was unlikely to be at the heart of the new government's thinking. 'After a victory brought about by the wreckage of the economic life of the people', he wrote, 'the preoccupation of all with the work of material reconstruction would thrust all spiritual and cultural ideals out of sight.' (Russell, 'Lessons of Revolution', *Studies*, XII, no. 45, March 1923, 3) What Declan Kiberd describes as 'the chastening experience of actual power' quickly impressed itself upon the members of the Free State government (Kiberd, p. 296).

Cultural arteries hardened. At its conference in 1922, the Irish National Teachers Organisation (INTO) recommended that drawing, elementary science, hygiene, nature study and needlework be eliminated as obligatory subjects at primary level. Irish was made an obligatory subject (Coolahan, pp. 39–40). There would be no new education act to give expression to a nationalist educational philosophy. The Ministers and Secretaries Act of 1924 simply rolled over the departmental arrangements for education as inherited from the British, with one significant alteration: the Act transferred responsibility for the national institutions (qv), the Museum, Gallery and Library, along with the DMSA (which became the National College of Art in 1936), to the new Department of Education.

'In 1922 the images of national possibility froze with the country's teachers cast as curators of a post-imperial museum, anxious to ensure that nothing changed very much.' (Kiberd, p. 251). This image of the museum, as a locus of cultural embalmment, could well serve to describe the fate of the national institutions under successive Free State governments. Their institutional origins lay in the mid-nineteenth-century enthusiasm for linking the arts, education and industry as epitomized by the *Great Industrial Exhibition* in Dublin in 1853, which led to the opening of the National Gallery (NGI) in 1864.

From the start, the new Museum of Science and Art in Dublin (1890) promoted a functional link between art, education and the design needs of industry. This utilitarian understanding of the role of museums and art schools in producing designers to support industry had an enduring influence on policies relating to the visual arts. When a new Department of Agriculture and Technical Instruction (DATI) came into operation in April 1900, control of the DMSA shifted from London to the Dublin department, with a new focus on design education. The department made grants to schools on condition that drawing was taught as part of technical education. An impoverished role for art in education inevitably implied a public poorly equipped to appreciate it. T.W. Rolleston commented in 1906 that 'true art needs a public which understands it. The Irish public in all its social classes, from the highest to the lowest, is asleep on the question of art.' (Turpin, p. 207).

The decision to bring all the cultural institutions in the Free State under the Department of Education exacerbated the problems for visual arts education in Ireland. The alignment of both the National Museum and the DMSA with the DATI had been intended to reinforce the relationship between art, design and the needs of industry. That link was now broken. Post-1924, language revivalism became the keystone of cultural policy, with a

National Awakening', *IT*, 19 December 1929). Government neglect of cultural institutions was symptomatic of a deeper polarization. In a self-determining Ireland, an anthropological idea of culture as a 'whole way of life' orchestrated around language, folkways and tradition was displacing the arts in the 'higher' aesthetic sense as defining the relationship between culture and society. In this process, the arts, particularly the visual arts and classical music, were increasingly associated with an 'alien' Anglo-Irish sensibility.

Daniel Corkery, probably the most influential exponent of an exclusive, nativist vision of Irish culture, asserted in *Synge and Anglo-Irish Literature* (1931) the primacy of native culture in Irish over other forms of artistic expression. This excluded not only the entire tradition of Anglo-Irish writing but also the visual artists, many of whom were female, Protestant and Anglo-Irish. In 1925 Seán Keating (qv), one of the few artists to celebrate the achievement of political independence in his work, wrote a memo to the Department of Education complaining that the DMSA had become 'a sort of club for middle-class girls' (Turpin, p. 261).

Ireland Today's art critic, John Dowling, detected an 'absence of character' in the NGI, which he attributed to its history. Founded 'in the heyday of "Anglo-Irish" society', he saw the Gallery as 'doomed to share the sterility of that society' because it 'deliberately maintained an Olympian remoteness, a contemptuous aloofness from our affairs which still contradicts its magniloquent title'. Dowling regarded all the national institutions as similarly tainted, describing them as 'potential enemies ... as alien now as the day we inherited them' (Dowling, 'Art: The National Gallery', *Ireland Today*, 1, no. 6, November 1936, 64–65). Classical music suffered a similar fate. In 1934 Aloys

108. *Saorstát Éireann, Irish Free State Official Handbook*, ed. Bulmer Hobson (Dublin 1932)

corresponding diminution of the links between the arts and industry. Following the Civil War, a reduced scale of industrial activity curtailed the incentive to strengthen the link between design and education (Turpin, p. 233).

Throughout these years, visual artists were left largely to their own devices. Many came from privileged family backgrounds that could facilitate travel and exposure to contemporary European movements in art. The few initiatives to provide an outlet and an income for artists, such as the Society of Dublin Painters (SDP), 1920, the *Irish Exhibition of Living Art* (IELA) (qv), 1943, and a handful of Dublin-based, commercially run galleries, received not a penny of public funding.

In 1929 Thomas Bodkin, Director of the NGI [109], expressed his disillusionment with the state of the visual arts and the neglect of the national cultural institutions. He held up the French system as an example of how Ireland's art and design culture might be revitalized. There, the Department of Fine Arts worked closely with the Ministry of Commerce; 'cultivation of the arts was for the French statesman mainly a business proposition', he advised (Bodkin, 'The Place of Art in Ireland: Need for

109. Seán O'Sullivan, *Thomas Bodkin (1887–1961), Director, National Gallery of Ireland*, 1935, charcoal on paper, 65.1 x 51.2 cm, National Gallery of Ireland

Fleischmann asserted that classical composers like Field, Balfe and Wallace 'belong to a tradition which was completely outside the Irish tradition, and chose foreign material for their work', which makes them 'Irish in the same sense that Swift, Sheridan and Goldsmith are, that is, hardly Irish at all' (Fleischmann, 123–24).

Nevertheless, some nationalists were alert to the insularity that such exclusive ideas of nationality implied. James Devane framed his vision for the arts within a broader idea of culture. In the first of two essays in *Ireland Today* in 1936, he asked: 'Is an Irish Culture Possible?' His answer emphasized Ireland's affinity with 'the great classic tradition and the common European life which she knew so well in her childhood'. His hope was to bypass the taint of British influence and a confining insularity by stressing the organic connections between Ireland's Gaelic traditions and the European culture of Christianity, embodied in the Catholic Church. This led him to a theocratic, elitist and authoritarian idea of culture; he would have it 'subsidized and nurtured from above, from a church, a government, and an aristocracy of tradition and of intellect' (Devane, 'Is an Irish Culture Possible?', *Ireland Today*, I, no. 5, October 1936, 23).

In his second essay, Devane proposed that Ireland should abandon its obsession with literature, which he saw as 'confused by the miasma of the [Irish] language' and concentrate on music and the visual arts, those art forms 'untouched by the written word'. He outlined the rudiments of a public policy based on these art forms. The government should set aside £14,000 a year for commissioning thirty to forty artists to embellish public buildings. Devane was among the first to propose a 'Per Cent for Art' scheme in Ireland, pleading that the government designate 1–2 per cent per year 'for a fund to be used in the adornment of these institutions by work of artistic merit' (Devane, 'Nationality and Culture', *Ireland Today*, I, no. 7, December 1936, 16–17).

But the proposal to rehabilitate the 'high' arts by association with 'high' Catholicism had little influence on the priority afforded Gaelic revivalism. The Irish Manuscripts Commission (1928) was set up to locate, preserve and publish the manuscript sources for Irish civilization, while the Folklore Commission (1935) concentrated on the collection of oral and musical evidence of Irish culture among the rural population of Ireland.

Yet inexorable social and economic forces were threatening the revivalist dream. Writing in *The Bell* magazine on the twenty-fifth anniversary of the 1916 Rising, Seán Ó Faoláin detected a growing cleavage in Irish life between those who 'feel that tradition can explain everything and those who think it can explain nothing'. Those hoping for economic development were making the language revivalists anxious: 'the Revival of Gaelic and the Revival of Industry are not happy bed-mates' and 'the Gaelic Leaguer watches uncomfortably even our development of tourism' (Ó Faoláin, '1916–41: Tradition and Creation', in *The Bell*, II, no. 1, April 1941, 6).

As tourism became central to economic development in the post-war years, the poverty of design in Irish manufactured goods was starkly exposed. Questions about backwardness in visual and design standards opened a door to those few who championed the need for a revitalized visual culture. Bodkin had always insisted that government should overhaul art education in Ireland. In 1929 he wrote to the Department of Education arguing for a revived Ministry of Fine Arts (one had briefly appeared for a few months in 1920 under the Second Dáil). In its reply, the Department focused on what it considered to be the most important issue raised, 'that of improving the position of certain industries by establishing a closer relationship between them and up-to-date instruction in design' (Kennedy, p. 23). Bodkin realized that arousing government interest in the arts depended on this functional connection.

Patronage (1951–70)

As Ireland emerged from World War II, a confluence of factors produced an initiative that would transform the landscape not only for the arts generally, but particularly for the visual arts – the setting up of the first Arts Council of Ireland (AC/ACE) (qv). At least four significant factors can be identified.

Firstly, the failure of the language revival policy was becoming manifest during the 1940s. From 1936 onwards the INTO began increasingly to question the wisdom of the language policy, especially in relation to schools where the home language of the pupils was English (Brown, p. 188). Emigration continued from Irish areas and non-Irish-speaking areas alike. Growing disillusionment created space in which a broader concept of Irish culture, including the cultivation of the arts, could be fostered. Some politicians now saw a link between that language policy and the absence of a broader culture. Erskine Childers felt that there was 'no hope of restoring the Irish language or of maintaining Irish civilisation as a distinct force unless the general culture of the people is enhanced' (Kennedy, pp. 53–55). In this view, the promotion of a broad interest in the arts was a necessary condition for the hoped-for revival of the language.

Secondly, despite the pressure towards cultural introversion, Ireland remained, even through the years of World War II, less isolated from international cultural influences than is often thought. The thousands of Irish people working in support of the war effort in Britain kept Ireland open to contemporary cultural influences from abroad. Popular culture was influenced by British tastes to the extent that 'the twenty-six counties had remained in many respects a social province of the United Kingdom' (Brown, p. 216).

Thirdly, this openness meant that post-war changes in Britain had an impact on Irish culture and politics. The coming to power of a Labour government in 1945 led to the setting up of a welfare state. The founding of the English Arts Council the same year provided a precedent without which an Irish initiative along similar lines only five years later would have been inconceivable. In 1945 P.J. Little began campaigning for a 'Council of National Culture or a Cultural Institute'. A memo he sent to the government in 1950 made clear that the envisaged council would 'undertake work of the kind discharged in Great Britain by the Arts Council' (National Archives, Department of An Taoiseach, s14922A, memorandum to Government, October 1950).

Fourthly, there was a crucial element of personality. When John A. Costello became Taoiseach in 1948, the country had a leader with a personal interest in the arts. As he stated during the debate on the Arts Bill in the Dáil, he had been 'something like

twenty-one years hoping to see this Bill coming into the Irish Parliament' (Dáil Éireann, 125, 24 April 1951, Arts Bill – Second Stage, col. 1344). Costello found an ally in Thomas Bodkin, who understood the issues and was prepared to research and produce the recommendations that would be embodied in legislation. Bodkin's *Report on the Arts in Ireland* (1949), commissioned by Costello's government in 1948, laid the groundwork for the Arts Bill.

An examination of the political circumstances surrounding the Arts Bill shows that there were two key factors governing its successful passage. Firstly, Costello had to convince Dáil deputies of the cultural/economic argument that linked the design needs of industry to raising levels of art appreciation in society. Secondly, he had to reassure the still powerful Irish language lobby that its interests, if not positively promoted, would at least not be hindered by the setting up of an arts council. A memo from the Secretary of the Department of Finance, James McElligott, to the Taoiseach's office warned that:

> ... state subventions to cultural projects in these fields have, in all but a few cases, been restricted to projects for the encouragement of drama and literature in the Irish language. Very strong criticism may be expected of any indication that the State proposes to encourage the development of drama and literature in English by Irishmen. (National Archives, Department of An Taoiseach, s14933A, F.200/42/50)

Three weeks before the Bill was introduced, a deputation from the Gaelic League demanded that only persons actively interested in the revival of the Irish language should be appointed to the proposed Fine Arts Council. Costello replied that because the main focus of the Act would be on the visual arts and design, 'the members of the Council would have to be selected mainly on the basis of their knowledge of and active interest in the visual arts, and he could not give any undertaking that they would be persons who were specially interested in the Irish language' (National Archives, Department of An Taoiseach, s14922B, memo of meeting with the Taoiseach of a delegation from the Gaelic League, 2 April 1951; *Sunday Press*, 15 April 1951: 'Fine Arts Bill now in Danger'). This did not reassure the Irish-Ireland lobby. An editorial in the Irish language paper *Feasta* made it clear that the visual arts were an Anglo-Irish concern, and 'it was under the influence of traditions other than the native ones that these arts were cultivated' (*Feasta*, June 1951, 12).

When introducing the Bill in the Dáil, Costello reinforced his case by tracing a link between the intrinsic and the economic importance of the arts. The Arts Council, he said, would promote '... the visual arts for the spiritual value that can be achieved therefrom; but, in promoting a knowledge and appreciation of the fine arts, you thereby create an environment in which art is adequately admired and displayed, and from that you create the conditions in which artistic craftsmanship can be developed and design in industry brought to a successful conclusion' (ibid.).

In a Catholic country, Costello probably considered it necessary to stress the spirituality of the arts. This would provide a basis of righteous inspiration for the popular appreciation of art, which in turn stimulates people to acquire the skills necessary to produce it, leading ultimately to the *economic* reward of better designed industrial goods. In presenting the case, Costello never lost sight of the line that led from the aesthetic to the utilitarian.

Champions of other art forms were displeased with the Bill's emphasis on the visual arts. Charles Acton alleged that the Bodkin report, on whose conclusions much of the legislation was based, had 'virtually ignored music' (Acton, letter to *IT*, 28 April 1951). Bodkin admitted as much when he subsequently wrote to Costello explaining why he would not be taking up the position of director of the Arts Council that had been offered to him; 'all our conversations, my report and final memorandum to you were principally concerned with the visual arts', he wrote, and the funding limit for the Council's activities specified in the Act (£20,000) would be sufficient to do practical work only if its activities were confined to the visual arts (Bodkin, letter to Costello, 21 February 1951, National Archives, s14922B). This view was shared by P.J. Little, who became the Council's first director. He felt that one of the new Council's virtues was its 'low cost and narrow remit for the visual arts' (Little, memorandum, 8 August 1951, National Archives, s15037A) [110].

The apparent prioritization of the visual arts in the 1951 Act, however, did not translate into a golden age for them in Ireland. The major factor constraining the Arts Council's capacity to make a dramatic impact on the visual arts was the paltriness of its budget, which in its first year of operation was only £10,000 – less than half what Bodkin had considered necessary to do the minimum, and it was only modestly increased over the first decade or so of the Council's life.

A further constraint was the framing of the Act to promote public interest in the arts, rather than the career or professional concerns of artists. Indeed, there is no mention of artists, as such, in the Act. The emphasis was to be, as Acton put it, on stimulating the consumption of the arts rather than 'direct stimulation to the actual producers' (Acton, letter to *IT*, ibid.).

A dilemma facing the Council over the early years was that levels of amateur and community-based activity in the arts of music and drama were more widespread and popular than those in the visual arts, which were more critically dependent on

110. Taoiseach Eamon de Valera with Bay Jellett, Cearbhall O'Dalaigh and Thomas MacGreevy at the opening of the Mainie Jellett retrospective at the Hugh Lane Gallery, 1962

general levels of education – and generally on middle-class income. Seán Ó Faoláin, director of the Council from 1956 to 1959, put the matter succinctly:

> The Council have always been conscious of the fact that their primary function should be the encouragement and promotion of the visual and plastic arts, and that the assistance of music and drama should be secondary functions. It is, however, the case that while the country abounds with musical and dramatic groups which are constantly seeking financial assistance ... there are relatively few groups or institutions active in the fields of painting, sculpture, design in industry and the applied arts. (National Archives, Taoiseach's File, 'Propositions Bearing on the Future of An Chomhairle Ealaíon', January 1959, s15225E)

Initially, the AC/ACE had only a minimal effect on the lives of artists, largely limiting its support to art purchase schemes in which it provided fifty percent of the purchase cost of works, while other public bodies (mainly local authorities) paid the balance. In a country with only a limited art market, these purchases were jealously watched by artists struggling to make a living.

The Joint Purchase Scheme was the flashpoint for open conflict between artists and the Council in 1959. The controversy that flared around the annual RHA exhibition that year crystallizes the deficiencies of the Council's operation and its relations with artists in its first twenty years. Micheál de Búrca, secretary to the RHA, wrote a letter to the *Irish Times* in May 1959 in which he alleged that when the director and the Council member Michael Scott had visited the annual exhibition, they had not deemed a single painting worth recommending for purchase under the scheme. This 'outrageous' act cast a slur on the good name of the artists and painters represented in the exhibition (de Búrca, *IT*, 30 May 1959). In his response, Ó Faoláin defended the 'duty' of the Council to 'act as a public guide in matters of taste' (Ó Faoláin, *IT*, 5 June 1959).

Ó Faoláin's attitude reveals a Council that saw itself not only as patron of the arts, but patronizing the very public it putatively served. This is all the more remarkable because the Arts Act did not give authority to the Council to act as 'a public guide in matters of taste'. The word 'taste' is not used in the Act, and the nearest it comes to defining a role for the Council in this respect is when it directs it to 'assist in improving the standards of the arts'. The word 'assist' implied the kind of collaborative approach to resolving questions of taste for which the RHA was arguing.

But elitist attitudes became even more pronounced under Father Donal O'Sullivan, the longest-serving Council director (1960 to 1973). In the annual report for 1967, he responded to criticisms that his personal passion for abstract art (qv), as represented by the work of certain favoured artists, was too strongly reflected in the purchasing choices of the Council. Defiantly, he insisted that 'no Arts Council in the world regards it as any part of its function to put a premium on mediocrity' ('ACI Chief Replies to Criticism', *IT*, 31 October 1968).

Throughout these years, the Arts Council believed that independence from political direction was best demonstrated by

exercising autonomous judgment on questions of taste in the arts. At the same time, however, it remained conservative and cautious on the other principal role the Act conferred on it: advising the government. Though the Act specified that the Council would advise the government on any arts matter 'on which their advice is requested' (Section 3 (2)), Bodkin was severely critical of the Council for not showing more initiative on this front. In 1956 he wrote an extensive memo criticizing it for its timidity in advising government departments. The Council, he said, should not 'invariably wait for a request from some outside body or individual before making a pronouncement on matters of national importance concerning the fine arts'. He pointed to the Royal Fine Art Commission in Britain, which was consulted by government and private institutions on buildings and 'similar projects involving aesthetic consideration' (Bodkin, memorandum on the Council's third Annual Report, 16 February 1956, Taoiseach's File, National Archives, s15226B).

Bodkin, for instance, thought the Council had demonstrated timidity over a *Bowl of Light* sculpture that was erected on O'Connell Bridge as part of the An Tóstal Festival in 1953, and also over Dublin Corporation's plan to 'tinker' with Nelson's Pillar by replacing Nelson's statue with that of an Irish patriot. In his response, P.J. Little provided an insight into the Council's thinking in relation to its advisory role and also into public attitudes to sculpture in Ireland at the time:

> If a conflict arises between artistic merit and national feeling it is the artistic element that will go by the board. One of the reasons why there is a sullen and unexpressed hostility to cultural activities is due to an ingrained suspicion that art and culture are anti-national and snobbish. Art activities in the past were exclusive of the people, and glorified the British; hence the reserve on the part of the ACI to confine its decision to the column apart from the statue. (Little, memorandum to Taoiseach, 1 May 1956, Taoiseach's File, National Archives, s15226B)

The analogy with the Royal Commission broke down because of the deep suspicion of high culture as anti-nationalist, which caused the Council to be more tentative in championing the arts than it might otherwise have been.

On a wider front, when the fine arts could not be coupled with the promotion of industrial design, successive governments showed an indifference that suggested an ideological suspicion of their 'high' qualities. When James White, curator of the Dublin Municipal Gallery of Modern Art, complained in 1962 that 'not one penny of public funds in any of the galleries or museums was available for the purchase of works by living Irish artists', the Council remained silent on the matter, and the government, which was directly responsible for the national cultural institutions, did little to help (White, *IT*, 29 May 1962).

Professionalism and Democratization (1971–2000)
In 1971 the director of the Project Arts Centre, Colm Ó Briain, criticized the Arts Council for its policy of 'buying paintings rather than providing support and facilities for artists'. Instead of

promoting 'good taste' and 'sponsoring success', he felt the Council should be investing in facilities and outlets for creative artists ('ACI Policy of Buying Criticized', *IT*, 30 November 1971). It was a harbinger of a major change towards an artist-centred arts policy which took place under the Fine Gael/Labour coalition government in 1973. Sculptor John Behan wrote a lengthy letter to the *Irish Times* proposing an eleven-point programme of change for the Arts Council. He made clear that the central policy deficiency was the lack of support for artists (Behan, *IT*, 10 August 1973). This point was taken up by Ruairi Quinn of the Labour Party in a subsequent article. He declared Labour's intention to change arts policy by changing the composition of the Council itself. Labour, he wrote, would cease to appoint 'establishment figures' and would insist that 'working artists or their representatives' made up at least half the Council members (Quinn, 'The Challenge Facing the New Arts Council', *IT*, 26 October 1973). Behan was one of two sculptors (the other being Seamus Murphy) appointed to the new Council in January 1974.

In the first of a series of columns in the *Irish Times*, Anthony Cronin also championed the artist-centred policy. He urged the new Council to devise 'means whereby money can go to artists while other of the council's purposes are served at the same time' (Cronin, 'Viewpoint', *IT*, 8 November 1974).

Colm Ó Briain, appointed director of the Council in February 1974, outlined a number of objectives, which included funding training for artists and helping them with grants for materials. The Council's annual reports began to reflect its new artist-centred approach. In 1977, for example, the chairman Patrick J. Rock identified the need to 'secure for the full-time artist the equivalent of an average wage' as one of the Council's prime objectives ('Higher subsidies needed, says ACI chief', *IT*, 24 November 1974).

In the spring of 1980 Anthony Cronin took up the role of advisor to the Taoiseach, Charles Haughey [111], on cultural and artistic matters. Cronin was a leading influence in the setting up of Aosdána (qv).

Thus a fundamental shift in arts policy was achieved over a short period of years, starting with the Haughey tax concession in the 1969 Finance Bill, and culminating in the establishment of Aosdána in 1981. Having announced Aosdána, Haughey fell from office before he could officiate at its first assembly. That task fell to the new Taoiseach, Garret FitzGerald, who reminded those present that while attending to the muse, they should also concern themselves with 'increasing the accessibility of art to the people and ensuring that the gap does not grow' ('FitzGerald addresses Assembly of Aosdána', *IT*, 15 April 1983). A tension between an artist-centred and citizen-centred approach would become a major issue at the heart of Irish arts policy in the coming years.

In 1984 Peter Sheridan and others founded the Dublin City Workshop, a pioneering community arts project. He pointed out that the Arts Council had no policy in this field. A new policy discourse based on the democratization of the arts was emerging. Growing calls for broader access and participation brought into focus the failures of an education system that remained insensitive to the arts and to visual culture in particular.

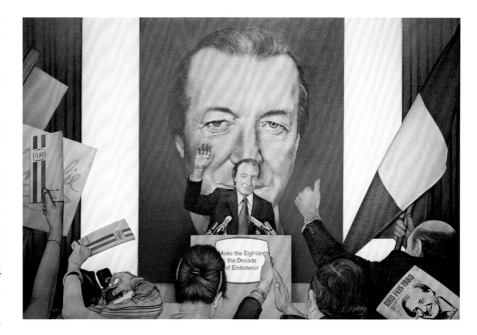

111. Robert Ballagh, *The Decade of Endeavour: Portrait of Charles J. Haughey*, 1980, oil on canvas, 60 x 40 cm, private collection

In 1979 Ciarán Benson, who had been the Council's first education officer, made the crucial connection between investment in arts education and building audiences that would demand inspiring arts experiences. 'Investment in the arts in education means investing in the audiences of the future', he wrote (Benson, 1979, p. 25). Though the Council had no statutory role in relation to education, its main function was, Benson insisted, to stimulate public interest in the arts. This mission required the Council to 'actively concern itself with educational policy, particularly when existing policy works to the disadvantage of the arts in education' (p. 117).

Ten years later, Benson returned to the subject in *Art and the Ordinary*. He was convinced that 'an organization like the Arts Council will only achieve its most coherent impact on Irish society with a proper balance of attention to provisions for the implementation as well as for the making of artworks' (Benson, 1989, p. 24). In an essay entitled 'Reflections on art, non-artists and policy-making in Ireland', he insisted that the champions of community arts were not seeking to displace but to augment existing policies. Benson noted that 'policy-makers such as members of the Arts Council, and the policy-shapers such as the members of Aosdána, will naturally tend to approach questions of art and society from the viewpoint of the artist' because most of them *are* artists. Benson identified an invidious tension between the interests of the artist and society: the shallowness of the funding pool from which both the advocates of community arts and artists drew meant that the ambitions of both could not be met without a dramatic increase in arts funding (p. 26). This friction continued for the remainder of the century, and beyond.

Practising artists found themselves on both sides of this argument. In the year that Aosdána was founded to honour and support individual artists on the basis of their aesthetic accomplishments, and the first artists' retreat, Annaghmakerrig, was opened in County Monaghan, the Arts Council initiated a 'Paint on the Wall' scheme for schools. This represented the first

significant initiative by the Council to involve artists directly in the educational system: the so-called arts-in-education approach. Sixteen artists were recruited to paint thirty-four murals in primary schools around the country (Elgy Gillespie, 'Painting on the Wall', *IT*, 26 September 1981).

When in 1993 Benson became chairman of the Arts Council, and Michael D. Higgins became the first cabinet-ranked Minister for Arts, Culture and the Gaeltacht, a major realignment of arts policies was anticipated. In a letter to the *Irish Times* in March 1994, Martin Drury noted a change in Arts Council pronouncements; 'the location of cultural meaning in people, rather than exclusively in art objects or events', he observed, 'is a reversal of the orthodoxy which has dominated arts policy in Ireland to date' (Drury, *IT*, 24 March 1994). Over the coming years, significant expansion in its budgets allowed the Council to build up its involvement in community arts and arts in education, while simultaneously increasing its commitment to individual artists.

Under Higgins's ministry, the budget for the arts doubled from £10 to £20 million, reaching £28 million in 1999. Thus, the Council's capacity to extend the range of its activities across such a widened field was vitally dependent on the continual expansion of arts budgets. But an underlying problem remained: for all the dynamism of arts policies over these years, they remained decoupled from the crucial field of education policy.

Conclusion

Throughout the period covered by this short study, the change in arts policy that most dramatically affected the visual arts was the shift to an artist-centred policy from 1973 onwards. If, over the same period, there has been a corresponding growth in the wider public appreciation and understanding of the arts, this has perhaps owed as much, if not more, to people's growing exposure to visual culture via media such as television and the internet as to arts education. Indeed, as the twentieth century drew to a close, the unresolved challenge of cultural policy in Ireland remained, despite the persistent rhetorical concern over it, the dysfunctional relation between the arts and education. One decade into the new century, the 'department for culture' (which has changed its name five times) and the Department of Education have so far, between them, failed to provide a synthesis of policies aimed at ensuring that the work of creative artists serves an arts-literate and creative citizenry, broadly and deeply engaged with the arts. PATRICK COOKE

SELECTED READING Pearse, 1916; Aloys Fleischmann, 'The Outlook of Music in Ireland', *Studies*, XXIV, no. 93 (March 1935), 123–24; T. Brown, 1981; B.P. Kennedy, 1990; Turpin, 1995; Kiberd, 1995; Coolahan, 2000.

112. Pauline Cummins, *Celebration: the Beginning of Labour*, detail from a hoarding project in 1984 to mark the 250th anniversary of the founding of the National Maternity Hospital, Holles Street, Dublin

CUMMINS, PAULINE (b. 1949) (qv *AAI* III), artist. A pioneering and prolific artist, Pauline Cummins was born in Dublin. After leaving NCAD, she began her career as a painter, and although she remains loyal to the discipline, it is as an installation and performance artist that she has made her most important contributions to art.

Cummins worked with the Turkana tribe in northern Kenya, directed a ceramics studio in Ashford, Co. Wicklow in the 1970s, and for two years (1979–81) worked alongside the artist Rochelle Rubinstein in Toronto, expanding her understanding of the complexities of cultural stereotyping and the role they play in controlling behaviours and limiting potential. This was compounded by official responses to Cummins's mural painting *Celebration* (IELA, 1984) at the National Maternity Hospital, Dublin, in which her exuberant endorsement of the female body led to calls for the painting's removal. Cummins went on to organize the exhibition *Nine Months and After* at the Grapevine Arts Centre, Dublin (1984) [112], in which she experimented with photographic images and sound. Temporarily abandoning painting, she made a tape/slide installation *Inis t'Oirr/Aran Dance* [44] for the IELA exhibition in 1985. This was widely shown in the exhibition *A New Tradition: Irish Art of the '80s* at the DHG (1990), and with *Unearthed* (1998), another essay in the same medium, in her solo exhibition in Roskilde, Denmark (1989), Munich (1990), and in IMMA.

Always drawn to collaborative practice, Cummins created the installation *Sounding the Depths* (1992, IMMA collection) with Louise Walsh, exhibited in Künstlerhaus in Graz and the Tate, Liverpool (1993) and since then has increasingly concentrated on performance work which she also teaches at NCAD. Working with artists Frances Mezzetti, Dominic Thorpe, Sandra Johnston and others, she continues to explore issues of power and ritual through performances that examine the impact of culturally directed behaviour.

Cummins was the founding chairperson of WAAG (1987–91) and co-ordinated its first exhibition of ninety women artists (Guinness Hop Store, Dublin, 1987).

Cummins's work challenges traditional notions of the artist as an isolated creator and resists collection and the mechanisms of power. Nonetheless, key works by her can be found at IMMA and in private collections in Ireland and abroad.

CATHERINE MARSHALL

SELECTED READING *Sounding the Depths*, exh. cat. collaborative installation by Pauline Cummins and Louise Walsh, IMMA (Dublin 1992); Judith Higgins, 1995; Medb Ruane, 'Installations at the National Maternity Hospital', *Sunday Times* (8 January 1995); Catherine Marshall, 'I'll spin you a yarn, I'll weave you a tale', in *Irish Journal of Feminist Studies* (Spring 2003); Deepwell, 2005.

CURATING (see 'Exhibitions'). The role of the curator has changed almost beyond recognition since 1897 when Louis di Cesnola, director of New York's Metropolitan Museum of Art, could say: 'We do not want, nor will we permit a person who has been digging in a filthy sewer or working among grease and oil to come in here, and, by offensive odours emitted from the dirt on their apparel make the surroundings uncomfortable for others.' (Lawrence W. Levine, *Highbrow/Lowbrow: The Emergence of Cultural Hierarchy in America*, Massachusetts 1988, pp. 185–86) Writing in 1971, in the introduction to a special Museum issue of *Art in America* (July/August 1971, 25), Irish artist and critic Brian O'Doherty (qv) pointed to the fact that 'The Museum age which reached its Augustan apogee with the post-World War II boom … is finally over'. O'Doherty outlined challenges to the museum's historical context arising from social pressures that rendered it irrelevant in the eyes of many by the 1960s. He claimed that museums were suffering a loss of confidence in their history, making them unsure of how to move forward. They faced political problems which their staff and trustees were not trained to resolve, and financial threats from diminishing endowments, increasing operating costs and greater demands from the public; few surveys of conservation had been carried out and the best curatorial talents were going to universities. Curators were 'underpaid, overworked, beleaguered from within and without'. However, the most fundamental issue, as O'Doherty saw it, was that there was little discourse about the function of the museum, although there was constant tension between the requirements of scholarship and conservation on the one hand and education on the other. While these comments were directed to the mainly privately funded American organizations, Irish museums, despite the appointment in 1963 of a new, audience-friendly director at the National Gallery (NGI), James White, were a long way behind in this debate. Instead, while scholarship was nurtured in the museums, farmers were destroying ancient ráths and developers knocking down Georgian Dublin in the name of a different kind of progress.

O'Doherty set out the main issues facing museums. Goals needed to be redefined in the light of a new awareness that art was vulnerable to its context and challenges to the temple status traditionally afforded to museums. Sensitive curatorship could provide for the needs of the artwork without lessening popular educational requirements. 'One of the most valuable and irreplaceable contexts for art is the integrity and sympathy of fine scholarship', he wrote. This would allow for the appropriate placing of work in special exhibitions and new contexts, and would play a vital part in the preservation of the heritage. It would refresh historic work, giving it a new role for another generation, and thereby guarantee its future. O'Doherty described the traditional conflict in museums between the demands of public education and curatorial scholarship, reminding readers that the 'context of art in a museum also includes the public' and noting that a problem facing many museums was that visitor numbers had grown to the point that appropriate access to the artworks was impeded. Whatever other problems Irish museums faced, overcrowding did not become one until the 1990s, and then only rarely. Irish museums were slow to challenge the politics of display. The major problem they faced was economic, with the

113. Beatrice Glenavy (née Elvery), cartoon of the opening of the United Arts Club's new premises, 7 December 1910, with Ellen Duncan seated second from left, United Arts Club

constraint of being almost totally dependent on government funding in a country where private philanthropy is not a given and admission charges are not popular. Few curators felt in a position to spell out the implications of this power structure.

Until the opening of the Irish Museum of Modern Art (IMMA) in 1991, Irish museum curating remained locked into nineteenth-century hierarchical practices. Solo exhibitions, or group survey shows, generally with no particular theme, were the norm. Displays of work from a particular period, such as *The Irish Impressionists* at the NGI, curated by Julian Campbell in 1984, were the exceptions that confirmed this rule. This and other landmark exhibitions from earlier in the century, such as Hugh Lane's *Exhibition of the Work of Irish Painters* in 1904 at the Guildhall in London, the displays of Irish art in Brussels in 1930 and at the Irish Pavilion at the 1939 World's Fair in New York, were assembled without questioning cultures of display or authority. However, it is important to note that the first curator of Hugh Lane's Municipal Gallery (HL) was a woman, Ellen Duncan, and it was Duncan who first introduced the work of Cézanne, Picasso and other avant-garde artists to Ireland in 1911 at the United Arts Club [113].

The reflexivity of O'Doherty and others in relation to the role of the museum and the curator brought change in Ireland in the 1970s, but the impetus for new curatorial practices emerged not so much in museum contexts as from contemporary art projects, rather than the imaginative management of historic collections. Until the mid-1960s few people in Ireland thought of curation beyond its traditional roles of acquisition, caretaking and the classification of the artworks in museum collections. Change came slowly, ushered in by temporary exhibitions of contemporary art, of which Rosc and curated shows at the Hendriks Gallery, Dublin, were the most significant.

The Arrival of the Curator

The first Rosc exhibition (qv) in 1967 was selected by James Johnson Sweeney, director of the Museum of Fine Arts, Houston, Texas, Dr Willem Sandberg, former director of the city museums in Amsterdam, and Professor Jean Leymarie, one of the keepers of the French Museums. The three men had been chosen for this task because of their considerable reputations, their knowledge of international trends in contemporary art, and their contacts in the art world. The word curator was not applied to them and does not appear in the exhibition catalogue. The question of display and arrangement was not left to the selectors and was dictated by the need to use an exhibition space that removed the project from the safe world of the museum or gallery into the industrial space of the Royal Dublin Society's exhibition hall. Patrick Scott (qv), an artist with a background in architecture, rather than a curator, produced an installation plan that proved to be as influential as the artwork, while the non-art site opened up a world of new possibilities in a gallery-starved environment, simultaneously attracting new audiences and offering fresh ways of presenting art. Within the previous year, themed exhibitions of kinetic and Op art, curated by Cyril Barrett, drew crowds to the Hendriks Gallery. These exhibitions, in the view of art historian Anne Crookshank, were as responsible for changing the course of Irish art as the Rosc exhibitions were to be (McCrum and Lambert, 1985, p. 41).

By the middle of the 1970s, arising from the theoretical discourse initiated by Conceptualism (qv) and Brian O'Doherty's influential article 'Inside the White Cube', published in *Artforum* (1976), the noun 'curator' had paved the way for the verb 'to curate'. As the verb implies, the new understanding of curator signified a more proactive and creative role than the traditional caretaker/archivist. O'Doherty himself was one of the first to embody the new concept, with his curation of the exhibition *The Irish Imagination 1959–1971*, a satellite exhibition of *Rosc '71*, at the HL. For this exhibition O'Doherty was responsible for the structure and idea of the show, as well as for the selection of the artworks and the critical catalogue that accompanied it. The actual hanging of this, and the exhibition *Irish Art in the Nineteenth Century*, for Cork *Rosc '71*, curated by Cyril Barrett, was left to the galleries. To maintain this momentum, Frances Ruane was invited by the Arts Council of Ireland (AC/ACE) (see 'Arts Councils') to curate a touring exhibition to promote Irish art abroad. The result, *The Delighted Eye* (1980), was a selection of Irish art that embodied what Ruane believed to be the dominant characteristics in Irish contemporary painting and sculpture – a misty-eyed, dreamy approach to place that owed as much to climatic conditions as it did to a particular reading of history.

This, and other exhibitions, such as Patrick Murphy's Arts Council touring exhibition, *Six Artists* (Cooke, Souter, Collins, O'Malley, le Brocquy, Blackshaw (qqv)), organized by the AC/ACE and the Arts Council of Northern Ireland (ACNI), perpetuated the notion that the exhibition was a transparent process. Although Murphy's and Ruane's shows were very different, the notion of personal taste or vision was not discussed. The exhibitions and their framing literature did not attempt to call public attention to either the curator or the exhibition space as shaping

the meaning of the exhibition in any way. Documents prepared by the AC/ACE in the 1980s, advising regional centres about organizing exhibitions, cover such items as transport, insurance, promotion and catalogue production, and make no mention of a curator (*Information Sheet for Touring Exhibition Scheme*, AC/ACE, Dublin 1984). Nor do they show any awareness of emerging exhibition theory which, since the mid-1970s, had begun to exert a significant influence on curatorial practices in other countries.

Developments

Nonetheless, approaches to curation expanded considerably in the 1980s with the energetic example of Declan McGonagle, who became founding director and curator of the Orchard Gallery in Derry in 1978 and in 1987 one of only two curators to be short-listed for the Turner Prize at the Tate, and with the opening up of EV+A in Limerick to external curators [114]. McGonagle's curatorial strategies to make art relevant to the community beyond the gallery saw him take art out on to the streets of Derry, accommodating the artwork to the context, even if that was a war zone, and engaging the public through proactive programmes. McGonagle invited some of the artists he had worked with at the Institute of Contemporary Art in London to come to Derry. By bringing such internationally recognized artists as Anthony Gormley, Damien Hirst, Leon Golub and Nancy Spero to show alongside local artists like Locky Morris and Willie Doherty (qv), McGonagle showed that a regional centre need not shy away from asking some of the most famous and controversial artists in the world to their place, providing the artists trusted the curator.

This discursive model of curation was reinforced at EV+A in Limerick. Within two years of EV+A's foundation in 1977, it was decided that external curators would bring greater objectivity and a wider vision to the project and facilitate the organizers' ambition to bring the best of contemporary art to audiences in and around Limerick. Starting with Sandy Nairne (Tate) in 1979 and Brian O'Doherty in 1980, all curators have been based outside Ireland with the sole exception of Paul O'Reilly, who was invited to curate in 1998, in recognition of his work behind-the-scenes of EV+A for over a decade. Curators, constrained only by budgets and space, were chosen by the committee, often recommended by those who had filled the role previously. Their task was to select artists for an invited biannual show and to award prizes in the EV+A open submission exhibition held, until 1994, every alternate year. The use of Limerick City Gallery was not a given, although it operated as the main base for the event. Germano Celant, curator in 1991, used the whole city as an exhibition space, and over succeeding years the number of external venues grew. By 1996 the French curator Guy Tortosa (Senior Visual Arts Officer at the French Ministry of Culture) caused a stir in Limerick when one of his selected artists, the Russian Ilya Kabakov, installed a toilet in an open space in the city's docklands, only to have it vandalized by local people who felt it cast a slur on their city. Public engagement was effectively galvanized and affirmed Tortosa's overriding curatorial strategy of allowing art to insinuate itself into the life of the city [115].

114. Declan McGonagle outside the Orchard Gallery in the 1980s

The underlying aim of EV+A, to bring international art to Limerick and to increase awareness of Irish art in the minds of external curators such as Jan Hoet in 1994 (fresh from curating *Documenta* in Germany two years earlier), did much to mitigate geographic isolation. Identifying formal qualities in the artwork and the context for showing it (including such things as history, geology, social climate and even weather) as his criteria for selection, Hoet was interested in three tendencies in his exhibition: those artworks that appear to confront their vulnerabilities in the face of the possible demise of art; those who conceal this; and those who use glamour and kitsch to comment on the consumerism that erodes the values of art (Hoet, 'Art after the Death of God', *EV+A Colloquies*, 1997). Another important initiative in 1993 was the decision by the Cultural Relations Committee of the Department of Foreign Affairs to appoint a commissioning

Missing art loo is spotted in Shannon

By RON KIRWAN

A RUSSIAN art exhibit reported missing from Barrington's Pier on April Fools Day has been spotted in the River Shannon.

Part of the city's Exhibition of Visual + Art, weekend reports have indicated that the wooden structured twin toilet — the work of the internationally renowned Russian artist, Ilya Kabakov — has been spotted in the river by members of Limerick Civil Defence.

Reports suggest that three sightings have been made of the 'priceless' and uninsured twinset.

An EV+A spokesperson

confirmed that the structure has been reported to them as being stuck in an embankment near the 'snuffbox' on the estuary side of the Shannon Bridge.

"We will go down there this afternoon" she said "and see what we can do to restore it to its original site – probably by towing the piece back up the river to Barrington's Pier" she added.

The disappearance of the twin-loo, said to be a 'comtemplative' exhibit went unnoticed until Thursday of last week because EV+A organisors thought the exhibit had been taken away to be repaired.

115. Front page report in the *Limerick Leader* on the hostile response to Ilya Kabakov's *Toilet on the River* at EV+A, 15 April 1996

116. Catalogue of the exhibition *Irish Art Now: From the Poetic to the Political*, curated by Declain McGonagle (IMMA) and Judith Richards (Independent Curators Inc.), 1999–2001

IRISH ART NOW

FROM THE POETIC TO THE POLITICAL

117. *Somebodies*, the catalogue of a touring exhibition curated by teenagers working with the Collection Department, Irish Museum of Modern Art, 1998

curator for Ireland's entries to the Venice and São Paolo Biennials.

A major factor in the development of new curatorial practises in Ireland was the increasing involvement of communities, a trend that came to fruition in the 1990s. As director of IMMA from 1990 to 2001, and with all the experience provided by curating the first Tyne International Exhibition in 1990, serving on the adjudication panel of Tate's Turner Prize and other curatorial projects, Declan McGonagle was committed to this saying, 'This aspect makes the work of curating very real, rather than abstract, and I value that' (Ryan, p. 45). One of his innovative interjections as a director was to impose a curatorial structure in which the head of the Education and Community

Department was tasked with generating exhibitions of similar status to those of the Exhibition and Collections Departments. McGonagle refused to see individual exhibitions within the Museum as isolated presences, preferring to view each one as part of a wider programme, creating a dialogue between them and their surrounding exhibitions, while at the same time engaging with the history of the building and the wider communities beyond the gates [116]. He told Vera Ryan that a personal highlight for him was curating an exhibition of the work of Andy Warhol to sit alongside *Once is Too Much*, an exhibition about domestic violence, generated by women from the local area and curated by Helen O'Donoghue, and a show of the work of American sculptor Kiki Smith, curated by Brenda McParland. The star of pop and consumerism was thus contextualized by being shown with participatory artwork (qv) by artists and women from the community in Inchicore. The context of IMMA, in turn, influenced the shape of this 'blockbuster' show, as McGonagle specifically sought to bring out the European and Roman Catholic influences of Warhol's heritage in his selection of artwork. Guest curators at IMMA, such as Rudi Fuchs (Rijksmuseum, Holland), James Lingwood (Artangel, London) and Michael Tarantino (an American freelance curator based in Europe), readily agreed to participate in this broader interpretation of their work. Tarantino enthusiastically engaged with a proposal to incorporate a showing of traditional work by Irish Travellers from Pavee Point into the exhibition *The Event Horizon*, which he curated for IMMA in 1996, and which included artists such as the film-maker Atom Egoyan, Sigalit Landau and Michelangelo Pistoletto. An imaginative extension of this commitment was the introduction of projects in which the community working with a mentor curator, selected, hung and wrote up their own exhibitions from IMMA's collection, beginning with *Somebodies* (1998) [117].

While institutions and curators are sometimes under pressure from trustees and the media to produce 'blockbuster' exhibitions, their aim of being exhaustive explorations of the subject is impossible to fulfil and risks usurping all the programming resources of an institution. It is hardly surprising then, that there have been few such shows in Ireland, apart from the le Brocquy retrospective (1996), and the Warhol (1997) and Golub (1999) exhibitions at IMMA, the last of which helped to reintroduce Golub to his own country. Blockbuster exhibitions are an American concept, in keeping with the practice of charging for admission to galleries. While such charges have occasionally been implemented in Ireland, it is a practice generally resisted. Funding for showcase exhibitions is always problematic, and curators like Paul O'Reilly were seen as miracle workers in this regard, while Patrick Murphy's ambitious Anselm Kiefer show at the Douglas Hyde Gallery (DHG) in 1990, although critically successful, stretched the gallery's resources and meant restrictions to the programme in its aftermath.

Just as he had employed the city of Derry as the context for artworks, McGonagle and his curators used the history and environment of the Royal Hospital as a frame for the work inside. Irish artists, too, responded to the new concept of the gallery/museum/public space as part of the packaging of the actual work, with Barrie Cooke, Ciarán Lennon (qqv), Barry Flanagan

26 1999 | **Garter Lane Arts Centre, Waterford** October 6–October 30 1999 | **Cavan County Museum** November 16 1999–January 8 2000

118. Jobst Graeve, curator of the exhibition, *In a State*, Kilmainham Gaol, 1991

and others eschewing frames and plinths to relate directly to the public and to the space around them. The emphasis on that space and its specific history became the new frame which curators like John Hutchinson at the DHG since 1991, and Jobst Graeve, guest curator of *In a State*, at Kilmainham Gaol (1991) [118], exploited adroitly. For two decades Hutchinson has used the unique architecture of the gallery to create thoughtfully and precisely presented exhibitions that are carefully conceived to use the physical and social ambience of a university gallery in the heart of the city. His emphasis on the spiritual and meditative qualities of art encourages visitors to linger, in contrast to the manic speed of visits to other galleries. Hutchinson's approach works precisely to counteract the trend that saw artist and curator Philippe Parreno run around the Louvre in nine minutes and forty-three seconds to draw attention to the meagre time the average visitor spends even in such a treasure house (Stuart Jeffries, 'Timing is Everything', *Guardian*, 16 October 2010). Artists increasingly realized the need for someone else to contextualize and present their work. Catalyst Arts, the Belfast-based artist co-operative, instituted a policy of rotating curators from within their own membership to considerable effect. At the other end of the island, the new Glucksman Gallery brought two original and inventive curators, René Zechlin and Matt Packer, to Ireland, in its first decade, bringing a high level of professionalism and ingenuity to the Cork area.

Infrastructural Developments

Concerns about standards around the country led the Arts Council to introduce a bursary in curatorship in the 1990s. Partners in this included the Office of Public Works in 1998 when Róisín Kennedy was awarded the bursary to curate the collection at Dublin Castle. At the same time, increasing opportunities for public art commissions, varying standards in the resulting art, and the need to successfully integrate the commissioned artworks into the communities on which they would

impact, led to the emergence of a number of inventive and sensitive freelance curators such as Clíodhna Shaffrey, Jenny Haughton, Aisling Prior and Sarah Pierce, while the practice of employing visual arts curators to devise the programmes of arts festivals around the country gave opportunities for Hugh Mulholland, Mike Fitzpatrick, Paul Murnahan and others to hone their skills at events such as the Kilkenny and Birr Arts Festivals.

Welcome as this expansion was, curators in regional centres experienced difficulties because of the lack of discourse and resources. An initiative to establish a community of curators around the country, similar to collegial fora in the United States, was spearheaded by Patrick Murphy of the RHA/Gallagher Gallery. Murphy secured funding from the Arts and Heritage councils for a conference in Kilkenny in 2000, but a proposed follow-up event in 2001 failed to take place. Instead a 'troika' of curators – Murphy, Suzanne Woods of the Model Arts and Niland Centre and Mike Fitzpatrick of Limerick City Gallery – agreed to share resources, costs and catalogue production for a William Kentridge exhibition. Sadly the troika, despite a highly successful first project, was discontinued for a variety of reasons, while another Murphy proposal in 2006, to create a Director's Forum, suffered a similar demise.

Training opportunities also began to emerge. During the early 1990s, aspiring curators from Ireland had to go abroad for training, to the Royal College of Art in London (Cliodhna Shaffrey), Bard College, New York (Jenny Haughton) and De Appel in Rotterdam, where Annie Fletcher studied and has gone on to run the curatorial training course. By the end of the 1990s, however, third-level courses in curatorship began to appear in a number of Irish colleges, almost all of which involve internships in museums and galleries. By concentrating on the interaction of writers, artists and curators, the Dun Laoghaire College of Art and Design MA in Visual Studies course offered a significant and more conceptually oriented alternative to the arts administration course at UCD, which in turn has expanded into a Masters course in Arts Administration and Cultural Policy.

New Approaches for a New Millennium

In the 1990s O'Doherty summed up his writing on the concept of the museum as a white cube that detaches the art inside from its external surroundings and pointed to the gallery as used by artists and curators since then, as a gestural space ('The Gallery as a Gesture', in Greenberg et al, pp. 321–40). The gallery's implicit content must be forced to declare itself through gestures that use it to comment on the 'art' within it to which it is contextual and also to the wider co-ordinates – street, city, money, business – that contain it. However no gesture, O'Doherty argues, is any good without theatricals to draw public attention.

A new generation of international curators, nurtured on globalization and the proliferation of international biennales and arts festivals, are more than ready to answer that call. 'Performative curating', that is, curating that 'actively structures and mediates the relationship of art and audience' (Farquarson, 8), is epitomized by Nicolas Bourriaud (France), Hans Ulrich Obrist (Switzerland) and Maria Lind (Sweden) who speed from one venue to another, from biennales to

festivals across all continents. The new curator is frequently hard to distinguish from the artists whose work s/he presents. The exhibition is less an opportunity for the public to see what contemporary artists are doing as much as an event where the curator, as the celebrity at the centre, stage-manages a variety of projects, performances and presentations, which often interact with each other as well as with the audience. The conference *Curating Now* (IMMA, 2004) [119] brought together a number of these increasingly celebrity curators, including Obrist, Iwona Blazwick (UK), James Rondeau and Kevin Power (USA) and others. The remarkable consensus about which emerging artists were worthy of their promotion suggested to Irish audiences that the elitism of the art establishment is being re-enacted under a new order. An example of gestural curation in Ireland, *.all hawaii eNtr*ées/*luNar reGGae*, at IMMA, 2006, curated by guest curator Philippe Parreno (France) and assisted by Rachael Thomas, fused sculpture and text, sound and filmwork. The culmination of such projects in Ireland was the *Dublin Contemporaries Exhibition*, with American curators Jota Castro and Christian Viveros-Fauné in 2011. While such events are often highly dramatic and stimulating, it is sometimes not clear where one artwork ends and another begins, or which is the contribution of the artist and which that of the curator.

A less dramatic approach to 'performative curation' came out of the City Arts Centre in 2002 when Declan McGonagle and Niall O'Baoill interpreted the arts to mean a series of round table discussions on different aspects of art and society, that involved installations and discussion, with invited panellists of artists, curators, academics and members of community organizations to discuss significant art projects and approaches. The *Civil Arts Enquiry* (2001–03), artworks resulting from combined field research, arts projects and public discussion, took the form of a series of publications containing the unedited transcriptions of those panel discussions. Towards the end of the decade, and responding to new pressures on the built environment in the face of economic recession, young independent curators with architectural

training, such as *CultureStruction* and *TransColonia*, are actively using abandoned and disused buildings as a starting point for community development through art.

As a result of all this activity, Luke Gibbons could truthfully assert that 'Curation has taken over from criticism as the new mediator of meaning' (Luke Gibbons, public lecture, 'The Memory of Forms: Image, History and Irish Art', 22 February 2012). However, McGonagle, referring to the generation of itinerant curators, cautions that they 'do not invest in "place" to the degree which I feel makes a difference It is right to professionalize the practice and people should be as good at administration as they can be – but with a purpose beyond themselves or a closed art world. In other words curators in training should be confronted with questions about why as well as how they curate.' (Ryan, p. 53) CATHERINE MARSHALL

SELECTED READING Greenberg, Ferguson and Nairne, 1996; O'Doherty, 2000; Bourriaud, 2002; Alex Farquarson, 'I, you, we curate', *Art Monthly*, no. 269 (September 2003), 8–10; Wade, 2000; Ryan, 2003; O'Donoghue, 2009.

DESIGN AND MATERIAL CULTURE (see also 'Education', 'Book Art', 'Cultural Policy', 'Religion and Spirituality', 'Stained-Glass, Rug and Tapestry Design' and 'Women and the Visual Arts'). This essay has been written in four sections, sections one and three by Lisa Godson, and sections two and four by Linda King.

Section One (1900–39)

Writing about the Aran Islands in the early years of the twentieth century, John Millington Synge commented on the artefacts of daily existence: 'Every article on these islands has an almost personal character, which gives this simple life, where all art is unknown, something of the artistic beauty of medieval life.' (Synge, *The Aran Islands*, Dublin 1907, repr. 1997, p. 2) Synge's romantic account is highly suggestive of the design values that underpinned the, then fashionable, Arts and Crafts movement – the worth of singularity, the beauty to be found in everyday objects, and an idealized sense of the Middle Ages as a time when there was little distinction between craft and art.

For Synge, the 'home-made cradles, churns, and baskets' on the islands were remarkable, 'being made from materials that are common here, yet to some extent peculiar to the island, they seem to exist as a natural link between the people and the world that is about them'. This echoes the Arts and Crafts belief in sensitivity to the specific qualities of materials being used and the significance of place in relation to authenticity.

That Synge believed the material culture of the islanders was organically connected to the place where they lived contrasts with the alienation that so concerned William Morris, the dominant figure of the Arts and Crafts movement in England. His tenet that craft skills and hand-made goods should be preserved, revived and valued was connected with his socialist belief that mass manufacture was inherently alienating for both the worker and the consumer of standardized goods. In Ireland, centuries of colonial rule meant that alienation was also a central concern. One response to this was the championing of the remnants of

119. *Curating Now* conference, Irish Museum of Modern Art, 2004

folk culture, particularly the oral tradition. In its design and craft, the Celtic Revival looked less to vernacular material culture than to the artefacts of ancient and early Christian Ireland, with 'the growing spirit of national consciousness' given substance by archaeological, philological and antiquarian research' (Bowe, p. 175).

Morris was largely concerned with industrialized societies where craft production had been displaced by mass manufacture. In Ireland, only the north-east had experienced an 'industrial revolution', with Belfast undergoing the explosive growth of other Victorian centres of manufacturing, in particular in linen and shipbuilding. The most infamous symbol of that industrial past was the doomed passenger liner *RMS Titanic*, constructed at Harland and Wolf in 1912.

For the rest of the island, the almost moral values ascribed to hand-making were promoted through a number of philanthropic ventures. In 1894 Dermot Bourke, the seventh Earl of Mayo, explained the aims of the nascent Irish Arts and Crafts Society in terms that suggested the uniting of social, moral and aesthetic concerns – notable is the emphasis on the individual 'craftsman' and 'workman':

I. To improve the craftsman and attempt to raise the artistic level of his work.

II. To make the workman less of a machine producing many objects from one pattern (Larmour, p. 56).

The society became a focal point for craft and design in Ireland, organizing lectures and classes, publishing a journal and holding six exhibitions between 1895 and 1925. It was also a vehicle for displaying Irish design to an international audience, as with the *Irish Industrial Exhibition* at the St Louis World's Fair in 1904.

The Dublin Metropolitan School of Art (DMSA) became an important centre from the turn of the century, initially in stained glass and, by 1904, in a wide range of crafts, including enamelled metalwork and leatherwork. These were usually introduced by those who had direct experience of the English Arts and Crafts movement, but working in the stylistic idiom of the Celtic Revival. The Crawford Municipal School of Art in Cork was also significant; here the students of sculptor and furniture designer M.J. McNamara 'distinguished themselves' in various Arts and Crafts exhibitions, particularly in the field of woodcarving (Brian Lalor, 'A Lost Leader: M.J. McNamara and the Arts and Crafts Movement in Cork', *IAR*, XVII, 2001, 37–43, 38). The DMSA's stained-glass studio had been established under the direction of Alfred E. Child, former student of the leading English Arts and Crafts designer Christopher Whall. Child was highly influential in the development of the craft in Ireland and it was stained glass, more than any other aspect of design or craft that won critical acclaim, particularly through the work of An Túr Gloine studio (opened 1903) and associated artists such as Wilhelmina Geddes, Harry Clarke, Evie Hone (qqv) and Michael Healy. Other significant enterprises included the Dun Emer Guild, founded in 1902 by Evelyn Gleeson with Lily and Elizabeth Yeats.

The Yeats sisters left Dun Emer to form Cuala Industries in 1908, Lily overseeing an embroidery workshop and Elizabeth a hand-printing press. Both had been close to Morris's circle in London, but the work of Cuala differed greatly from his Kelmscott Press. Rather than Kelmscott's floriated borders and decorative pages, the productions of the Cuala Press were more specifically typographic, relying on the play of the typesetting and surrounding white page for aesthetic effect. This was characterized by the use of an eighteenth-century Caslon font, close-set small caps and expressive colophons. The press also issued popular series of *Broadsides* illustrated by Maurice MacGonigal, Harry Kernoff and, most frequently, Jack B. Yeats (qqv).

In England, the Arts and Crafts movement was domesticated through middle-class consumption, and while there were some private houses in Ireland decorated and furnished with Arts and Crafts material, in general the greatest patron was the Catholic Church, with Loughrea Cathedral (decorated between 1904 and 1947) and the Honan Chapel, University College Cork (1915–16) becoming showpieces of the movement. One singular project was Sister Concepta Lynch's decoration of the Dominican Oratory in Dun Laoghaire (1919–36). This obsessively detailed interior, almost entirely covered in ornament drawn from early Irish manuscripts, is one of the most intense expressions of the Celtic Revival.

As Claudia Kinmonth has documented, certain vernacular forms of material culture persisted, generally in rural areas. Echoing Synge's description of the economic use of local materials on the Aran Islands, Kinmonth detailed the use of plants, driftwood and shipwrecked timber in coastal areas and pine Irish Creamery 'butter boxes' painted and repurposed as fireside stools. Economy was also inherent in the flexibility of many types of 'country' furniture, such as coop dressers, where space for chickens was built into the base of kitchen dressers, and settle beds [120]. Still in general use until the 1950s, 'numerous'

120. Settle bed, Irish vernacular furniture item that served as a bench-like seat with tall panelled back or bed, this painted wood example dates from the mid-nineteenth century and is from Cross, Co. Limerick, National Museum of Ireland

examples of these high-backed bench seats, which folded down at night for sleeping, have also been found in places of Irish settlement in North America (Kinmonth, pp. 76–90).

The Arts and Crafts movement in Ireland had declined by the final exhibition in 1925, but the values of 'native' craft continued to be promoted. The interplay between philanthropy and the commodification of handcraft for urban consumers can be seen particularly with Muriel Gahan's enterprise 'The Country Shop', opened in Dublin in 1930. This exhibited weaving, basket-making and knitting, sold the resulting goods, and became an important meeting place for those interested in design and craft. It was not the only such outlet in Dublin – the 'Crock of Gold' sold hand-weaving from premises at 18 Dawson Street, Gaeltacht Industries advertised hand-woven tweeds and other textiles from 39 Nassau Street, and, in 1936, 'Cleo' opened, selling sweaters hand-knitted in the much-mythologized Aran Islands; 'Aran' sweaters with intricate raised stitches became particularly popular in the 1950s. Such businesses typically traded not only on the quality but also on the origins of their wares. In 1932 Gaeltacht Industries advertised its shop as selling 'Everything Irish', and an advertisement for Irish lace from Killarney proclaimed 'employment given to many local Girls' (*Saorstát Éireann*, 1932, pp. 148, 126).

Alongside these developments in the making and selling of design and crafts, the revolutionary period of *c*. 1913–22 generated significant objects and symbols that formed a corpus of material culture reworked and cherished by generations of nationalists. These ranged from the striking 'starry plough' banner used by the Irish Citizen Army, to the prison art decorated with Celtic motifs by republicans, to printed material, most potently the *Proclamation of the Republic*. Printed in difficult and dangerous circumstances using damaged and incomplete type on the eve of the 1916 Easter Rising, this document has been described as 'the title deed of Irish republicanism' (Charles Townshend, *1916: The Irish Rebellion*, London 2006, p. 160). As one of the most important artefacts in modern Irish history, it has been reproduced in supposed facsimile numerous times since 1916 and hung in countless homes. Typologist James Mosley has revealed that most of these are inauthentic, using a typeface not invented until the 1930s. (http://typefoundry.blogspot.com/2010/01/image-of-proclamation-of-irish-republic.html). The original *Proclamation*, with its typographic improvisations and peculiarities, more fully expressed the heroic circumstances of its making.

The second Dáil (16 August 1921 – 8 June 1922), the revolutionary government of the Irish Republic proclaimed in 1916, established a Department of Fine Arts. Although in operation a mere nineteen weeks, the Department commissioned cultural expert Thomas Bodkin to advise on 'the functions of a Ministry of Fine Arts'. His response was highly suggestive in indicating the key bodies that were to become important in official design in the Free State. He advised that officers in every ministry would liaise with the Ministry of Fine Arts – for example, the Post Office would oversee the design of stamps and pillar boxes, the Department of Finance the design of coinage, and the Department of Trade, Commerce and Industry industrial design and crafts (B.P. Kennedy, 1990, p. 8).

The Free State government did not follow Bodkin's advice. However, the new leaders displayed a strong understanding of the power of material culture. Famously, one of the first acts of the new government was to paint Irish post boxes green. This covering up of the standard British Post Office red, without removing the 'royal' insignia, was symbolic of the treatment of the objects of governance in the Free State: while Ireland was still within the British Commonwealth, material culture was utilized to assert a separate identity.

And so, while commentators have noted that the fraught conditions attending the birth of the state meant that there was little public celebration of independence, a symbolic break with British rule was proclaimed through the redesign of many important items, including passports, official seals and money. This was coterminous with other acts signalling the change of authority, such as the renaming of streets for nationalist heroes, the removal of certain monuments, and the central position of Catholic ceremony at the inauguration of many of the chief offices of the state.

Changes in official material culture circulated quickly. The letters that were posted in those freshly painted post boxes carried a Saorstát Éireann/Irish Free State mark over the British stamps still in use until the issue of twelve definitive stamps in 1922/23. This over-stamp continued to be used for higher denomination stamps (2/6, 5/-, 10/-) until definitive Irish ones were introduced in 1937. Early stamps were designed by Irish artists using conventional Irish imagery – the Sword of Light, the Celtic Cross, the Arms of the Four Provinces and, most widely, the map of the island of Ireland. This first series remained in circulation for forty-six years. The most widely circulated 'map stamp' was burdened with intricate detail and abrupt jumps in scale, showing Ireland framed by an archway, with further decorative devices of Celtic ornament and shamrocks. There has been commentary on the fact that Ireland is shown without a border, ignoring the controversial partition of Northern Ireland (Paul Caffrey, 'Nationality and Representation', in King and Sisson, p. 78), and the landmark *Design in Ireland* report of 1962 was deeply critical, describing the stamp as 'rather poor ... the arch and ornament ought to have been omitted, being incongruous to the subject' (Córas Trachtála Teoranta, p. 34).

Far more considered was the coinage issued by the Free State. There was no functional reason to issue specifically Irish money as the state was still in monetary union with sterling. But it was another way of expressing identity – Minister for Finance Ernest Blythe explained the rationale to the Dáil in 1926 because 'the natural and logical consequence of the setting up of the Saorstát that we should have here a coinage distinctively our own, bearing the devices of this country' (Dáil Éireann, 14, 27 January 1926). Deciding what those devices would be was entrusted to a 'Coinage Commission' under the chairmanship of poet and senator William Butler Yeats.

Despite advice that the coins should carry recognizably Irish symbols, such as shamrocks and round towers, the commission decided the coins should bear agricultural subjects. Yeats offered a number of reasons: the example of 'the most famous and beautiful' coins, those of the Greek colonies,

especially Sicily; because Ireland was 'the first modern State to design an entire coinage' and so the committee felt the coins should form a coherent set; to please the artists and children who would 'look longer at each coin than anybody else'. The most convincing reason was that the coins would most truly represent the source of Ireland's wealth in agriculture: 'what better symbols could we find for this horse riding, salmon fishing, cattle-raising country?' (W.B. Yeats, 'What we did or tried to do', Irish Free State Committee on Coinage Designs, *Coinage of Saorstát 1928*, Dublin 1929, p. 2) [121].

The animals for the eight coins were carefully selected – for example, a hen for the penny and a sow and litter for the half-penny, since it was believed these were the farmyard animals with which children would have most contact. The committee held a closed competition, inviting seven European artists to submit clay maquettes of their designs. Although the committee voted 'coin by coin' and intended that the final set would include a mix of the work of a number of artists, Yeats wrote that 'one set of designs seemed to far exceed the others as decorations each filling its circular space', that of the English sculptor and medal designer Percy Metcalfe (Yeats, p. 4). The coins resulting from Metcalfe's strong, clear designs varied from the motionless, almost hieratic horse (half-crown) and hare (three pence) to the

animated hen with pecking chicks (penny) and the bull whipping his tail and pawing the ground (shilling). This mix of the dynamic and static was a result of the coins being submitted to the Minister for Agriculture and 'his experts' – the original horse was in motion, but technical advice stilled it and, in Yeats's words, 'we passed from the open country to the show ground' (Yeats, p. 6). The new coins bore direct markers of national identity through Celtic lettering, and the 'Brian Boru' harp on their obverse, adopted as official seal of the Free State government in 1923. Despite protest about their lack of religious content, the coins were put into circulation in 1928. In terms of official material culture, they might be considered the pre-eminent design achievement of the Free State, recognized as 'a visual embodiment of nationhood' (Caffrey, op. cit., pp. 75–88).

A committee was similarly set up to oversee the design of banknotes. As with the coins, the obverse featured a long-established icon – the female figure of Éire, resting on a harp – in larger denominations. This was from a portrait of Hazel Lavery as 'Kathleen ní Houlihan', commissioned by the committee from Sir John Lavery (qv). The reverse of the banknotes featured personifications of the rivers of Ireland, as depicted by the sculptor Edward Smyth on keystones on Dublin's eighteenth-century Custom House.

121. Saorstát Éireann coinage, designed by Percy Metcalfe and issued in 1928

122. *GLORIFICAMUS*,
skywriting over Dublin
during the Eucharistic
Congress, 1932

The lack of an established design profession in Ireland at this time was underscored as artists were given responsibility for the majority of stamps, coinage and paper money. The government was not insensible to the value of design to industrial development – in 1926 the Department of Education suggested the appointment of a Committee of Experts to investigate the DMSA and suggest reforms to ensure 'the improvement of craftsmanship and design as applied to industries' (State Paper Office, CAB, 2/291 item 10, 4 October 1926). Three French 'experts' were subsequently appointed, their 1927 report recommending a deeper commitment to a unique national approach: 'It is an all-important duty for a people to create a tradition of Art and of Crafts.' (TCD Ms 6965/30, 'The Report of the French Delegation on the reforms that are necessary in Artistic and Technical Education in the Free State, and especially in the Dublin Metropolitan School of Art', 8 June 1927; Brian Kennedy, p. 19). Little came of the report.

In regard to other 'official' comments on Irish design, Thomas Bodkin was the most significant figure. In the *Saorstát Éireann Official Handbook* he wrote that 'modern Irish manufactures are, for the most part, mediocre in design' (p. 243). He suggested Sweden as an example of a country where art was successfully applied to industry, citing the model of Orrefors glass as a contrast to the, then struggling, Ringsend bottle factory. A few decades previously, Orrefors had 'manufactured nothing but a small supply of coarse glass bottles' but 'now turn out glassware in enormous quantities, which is eagerly sought for' because of 'the prime importance of good design'. Scandinavia would become a strong reference point for Irish design from the 1960s.

If a strong commitment to developing a strategy for design at governmental level was lacking, one major initiative created a unique record of vernacular material culture – the Irish Folklore Commission. This was established in 1935 to record what was understood to be a dying tradition of folk practices and lore, and its work resulted in one of the largest collections of ethnographic material in the world. The handbook elicited comprehensive information about the making and use of objects. As well as specific craft techniques, informants were asked to 'give a detailed list with local names and a description of the furniture and fittings of houses in your district in former times and at present' followed by categories of 'seating accommodation', beds, tables and so on (Seán Ó Súilleabháin, *A Handbook of Irish Folklore*, Dublin 1942, p. 12).

Beyond the strictly utilitarian, the role and symbolism of objects were researched. So as well as describing seating as 'fireside seats; stone seats; wooden seats; seats made of straw, rushes, heather ...', informants were asked, for example, about the falling of chairs as an omen of death and the placement of the coffin on the morning of funerals: 'Was it usually laid on chairs? Why? Where were these chairs? In what exact position were they fixed? What type of chair was used?' suggesting something of the multiple meanings of objects to the informants (p. 228).

The confessedly Catholic nature of the Free State saw an intensification of public religious displays involving spectacular expressions of devotion and corporate power. The most remarkable were the celebrations of the Centenary of Catholic Emancipation (1929) and the 31st International Eucharistic Congress, held in Dublin in June 1932 [122]. The Congress was a tightly designed event, led by the architect John J. Robinson who created a number of temporary structures, including a triumphal arch, city gates and an impressive white and gold classical 'high altar' around which up to a million 'pilgrims' gathered for high mass on the final day of the week-long event.

The most renowned of all Irish-born designers, Eileen Gray (qv), a pioneering Modernist who lived and worked in France, was at the height of her career in the 1920s and '30s. Her furniture designs in particular are noted for their wit and consideration of the user, as well as for their radical use of industrial materials, such as perforated metal and chromed steel tubing. Her over-stuffed Bibendum chair, for example, contrasts with the taut, reduced outlines of other early Modernist furniture; she wrote how the asymmetrical 'Nonconformist' chair was designed to account for the sitter – 'an armrest was omitted in order to leave the body more freedom in movement and to allow it to bend forward or to turn to the other side unrestricted' (Peter Adam, *Eileen Gray: Architect/Designer*, London 1987, p. 212). [123]

If state bodies were more interested in 'capturing' a fast-disappearing culture, much of the Irish population was encountering contemporary design, particularly in environments associated with modernity. Cinemas revolutionized leisure time and were decorated with modernistic materials and motifs. Film magazines, too, promoted a new style, particularly in dress, enabling a mass readership to partake in the glamour of the cinema. A 'moderne' style was also employed in those enterprises associated with technological progress, as with graphic material related to the Electricity Supply Board (ESB) and in the walnut and chrome interior of the Bord Gáis showrooms on D'Olier Street in Dublin (Robinson & Keefe, 1928). 'Art Deco' motifs similarly found their way into housing in the 1930s through stepped fireplaces or sun motifs on suburban garden gates.

And so, on the brink of the so-called Emergency of World War II, there was scant professional design activity in Ireland beyond that related to architecture and some instances of Expressionist design for theatre. However, much of the population experienced or consumed modern objects, clothing and spaces. LISA GODSON

Section Two: Design professionalization, political economy and educational reform (1940–79)

World War II limited design activity across Europe as combatant countries diverted materials and labour from consumer products into war-related manufacturing. Post-war, the concept of professionalized design practice became part of a broader discourse of reconstruction and economic survival. The Free State experience was somewhat different as emergent design practices continued to be aligned with the material construction of national identity. This included the growth of infrastructural and communications networks begun by state-sponsored companies in the 1920s, including the expansion of the ESB and the founding of Aer Lingus (1936). By the 1940s food, drink, tobacco and textiles dominated the state's manufacturing output, but economic protectionism ensured that most goods were for the home market which, by the early 1950s, was in deep recession.

The growth of the state-sponsored sector laid the foundation for emergent design activity. The Rural Electrification Scheme (1946–73) stimulated demand for new electrical appliances and the ESB invited the Irish Countrywomen's Association to design modern, electrified farmhouse kitchens for promotion at spring shows and through touring exhibitions (1956–58). The 'duty free' concept (1947–) was invented at Shannon Airport and strongly promoted Irish goods to transatlantic passengers, while the Industrial Development Authority (IDA, 1949) provided stimuli to indigenous industry and, eventually, encouraged foreign investment. The establishment of Shannon Airport and the IDA contributed to a wider discourse about future economic development, within which there were many criticisms about the design quality of Irish products and their resultant export competitiveness. The Fianna Fáil governments (1932–48, 1951–54 and 1957–73) placed high tariffs on imports and encouraged

123. Eileen Gray, Non-conformist chair, 1926, steel frame, padded seat in fabric of choice, 79 x 59 x 63 cm, National Museum of Ireland

substitution with goods manufactured in Ireland. Such limited competition directly led to poor standards of design and advertising which became evident when the ubiquitous consumer products promoted through Dublin's annual Industrial Parades (1950–69) were displayed. The availability of luxury craft items grew: in 1947 the dormant company Waterford Glass (1783–1851) was revived by Czech manufacturer Karel Bacik and glass designer Miroslav Havel, renamed Waterford Crystal (1950–2009) and had considerable export success. Arklow Pottery (1935–98) modernized its production methods and by the 1950s was customizing products for hotels, golf clubs and Dublin Airport (Audrey Whitty, 'Arklow Pottery', *IAR*, xx, no. 1, Spring 2003, 124) reflecting the growth in tourism-related and leisure activities.

However, a further intervention by Bodkin, the *Report on the Arts in Ireland* (1949), encapsulated a broader picture and strongly criticized the country's inadequacies in design production. It denounced standards and called for educational reform – of the National College of Art (NCA) specifically – demanded stronger links between art and industry, investigation of European design developments, and better quality print publicity for the tourism industry. Over the next decade and a half, many of its recommendations, including the establishment of the Arts Council of Ireland (1951) (see 'Arts Councils'), were implemented.

Bodkin's specific comments on tourism publicity reflected a growing realization that tourism was central to the country's future economic development and could supplant agriculture as the principal indigenous industry. In the wake of Ireland's receipt of Marshall Aid funding, the subject was frequently discussed by government and led to the publication of the *Synthesis of Reports on Tourism 1950–51* (commonly known as the *Christenberry Report*) by the Department of Industry and Commerce (1951). Collating the observations of Irish and American experts, the report reiterated how substandard advertising and publicity was a barrier to economic development. Influenced by these comments, Dublin-based Sun Advertising (f.1946) began importing graphic design expertise from the publicity department of KLM (Royal Dutch Airlines), to work on the account of its most well-known client, Aer Lingus. This decision indicated that Irish graphic designers (then called commercial artists) lacked the experience required to work on a large, internationally focused account that reflected the airline's ambitious expansionary plans. Guus Melai, Jan de Fouw, Piet Sluis, Gerrit van Gelderen, Ries Hoek and Willem van Velsen were among a steady stream of Dutch expertise enticed into Dublin's advertising agencies throughout the 1950s [124]. A number of these individuals had been trained by Bauhaus graduates and their work synthesized elements of European Modernism (including typographic treatments and the use of grid structures) with brightly coloured, reductionist graphics inspired by contemporary American illustration and animation styles. Highly regarded, they worked for many tourism-related companies, including Bord Fáilte (1952–), CIÉ (1944–) and John Hinde (1957–), in addition to a host of other indigenous companies, including Guinness and RTÉ. Their work was also profiled in the international design press, bringing Irish goods and services to a wider audience (King and Sisson, pp. 166–87).

Graphic design and advertising practices became more professionalized in the 1950s, reflecting developments in Europe and the USA. The first large-scale advertising conference took place in Cork (1952), the Irish Packaging Institute was established in 1958, and the Institute of Creative Advertising (now the Institute of Creative Advertising and Design) that same year. The Institute also published a journal *Campaign* (1959–62) that critiqued contemporary Irish, European and American graphic design.

As *de facto* tourism authority, flag-carrier and transportation agent, Aer Lingus was hugely important in mediating perceptions of Ireland and Irish design. With the exception of its corporate identity systems, which were all designed by London-based companies, the airline became a locus for the promotion of Irish design, making use of indigenous ceramics, glass and textiles for its in-service provision and publicizing Irish goods through the pages of its in-flight magazine *Cara* (1968–). Many Irish manufacturers aligned their products with this potent symbol of infrastructural modernization: Jacob's created the Hostess biscuit, while Friendship Flour took its name from Fokker aircraft. Bord Fáilte's magazine, *Ireland of the Welcomes* (1952–), was another important vehicle for the promotion of Irish goods, and companies, including Waterford Crystal, benefited from advertising in its pages.

The airline's support of Irish design was particularly evident in the 1950s with regard to fashion and textiles. Irene Gilbert, Neilí Mulcahy, Sybil Connolly and Danish-born Ib Jorgensen established influential *haute couture* fashion houses (1951, 1951, 1952 and 1958 respectively) and Gilbert, Mulcahy and Jorgenson designed airhostess uniforms for the company (1958–66, 1962, 1974) [125]. An American gaze was keenly felt in fashion and textiles, in part influenced by an increase in inward tourism after

125. Sybil Connolly coat (modelled by Anne Gunning) on the cover of *Life* magazine, 10 August 1953

economy, and the *Britain Can Make It* (1946) and the *Festival of Britain* (1951) exhibitions proved influential. Belfast hosted part of the *Festival* programme, profiling industrial manufacturing, including shipbuilding and traditional crafts, such as textiles and ceramics. In the Republic, the newly established Arts Council had design promotion as part of its remit. By 1958 the Council could award grants to Irish companies that employed professional designers, although, because of poor standards, this was rarely implemented. More successful was the Council's collaboration with the Design Research Unit of Ireland (DRUI) – a branch of the British Design advocacy body – under the guidance of British industrial designer Misha Black. The DRUI produced modest touring exhibitions for the public and manufacturers of 'art applied to industry', showcasing furniture, household utensils, textiles, ceramics, glass, and industrial and graphic design. Of these, the *International Design Exhibition* (1954) profiled work from North America and Europe, including Italian post-war success, Olivetti, while the *Irish Design Exhibition* (1956) surveyed the 'best' of indigenous design or exemplary work commissioned by indigenous companies. Furniture featured prominently, including Barney Heron's beech or walnut pieces upholstered with nylon cord or Irish tweed, as did design for the tourism sector, including commissions by Aer Lingus and Bord Fáilte.

Irish Design also highlighted the number of architects and fine artists who had moved into design fields in the absence of specialized education or training. These included Patrick Scott and Louis le Brocquy who, along with Thurloe Conolly (qqv), formed Design Consultants (1953, later known as Signa Design Consultants). The studio embraced graphics, textiles, furniture and architecture, and commissions included printed textiles for Dublin's luxury department store Brown Thomas (1953/54) with Nevill Johnson (qv). The establishment of carpet manufacturers Donegal (1954–), Youghal (1954–84) and V'Soske Joyce (1957–) testify to strengths in textile design of the period and Scott would later design carpets for V'Soske Joyce through his work for the Kilkenny Design Workshops. The Dolmen Press (1951), established by former architect Liam Miller, also demonstrates the fluidity of art and design disciplines; the company specialized in high-quality typography and illustration for literary works, of which *The Táin* (1969) would be the most well-known.

The North's linen industry went into decline in the 1950s owing to increasing demand for new synthetic fabrics. Some craft-based design production was modernized, including that of Beleek Pottery, Co. Fermanagh, which introduced electric kilns (1952). The region also saw the expansion of heavy industrial and engineering production: Short Brothers (1936–), the British aerospace company based in Belfast, grew to be the North's largest manufacturer, specializing in the design and manufacturer of RAF aircraft and missiles. Coach building – the design and customization of vehicles – became a specialism on both sides of the border, and large export trade emerged with production of fire engines (Brown's, Lisburn, 1976–), hearses (Byrne, Dundalk, 1972–), ambulances (Pierce, Killarney, 1976–) and military equipment (Timoney Technologies, Co. Meath, 1968–).

the establishment of Aer Lingus's transatlantic route (1958), but also as a consequence of the establishment of Córas Tráchtála Teoranta (CTT, 1952), the export authority, which showcased Irish fashion and textiles in North America. Connolly developed ready-to-wear lines emphasizing indigenous fabrics, including Carrickmacross Lace, Magee Tweed and Moygashel Linen and named these after Irish landmarks and vernacular forms, exploiting a romanticized view of Ireland which proved to be highly lucrative [125]. Connolly's work was particularly popular amongst the elite of American society, as demonstrated by Jacqueline Kennedy's decision to wear one of her designs for her official White House portrait (1970). In 1961 Irish craft and textiles received unexpected media exposure, underlining the power of new media: Irish folk musicians the Clancy Brothers and Tommy Makem appeared on US television's Ed Sullivan Show wearing cream-coloured Aran sweaters, associated with the west of Ireland, and the resultant publicity helped to popularize the garment with tourists and the diaspora (qv). However, this boom period for Irish fashion was short-lived: by the 1960s sales for top quality clothing declined as production costs increased and tastes shifted.

Against a backdrop of high emigration and unemployment which both peaked in 1957, CTT encouraged the design of goods for export with the North American market as a specific focus. One ill-conceived project with this aim was the Shamrock car produced in Castleblaney, Co. Monaghan (1959–60). Financed by Irish-American businessman William K. Curtis, and based on a Ford Thunderbird, only six examples were produced because of fundamental design and manufacturing flaws.

As Irish design activity grew modestly, attempts were made to broaden its public discourse by aligning it to political

By the late 1950s, the Republic had reached a turning point and a shift from insularity to internationalism, accelerated by the publication of T.K. Whitaker's *Programme for Economic Expansion* (1958) supported by Taoiseach Seán Lemass (1959–67). Throughout the 1960s industrial output rose, exports and foreign investment increased and living standards improved. The influence of television expanded with the introduction of two indigenous channels, Ulster Television (1959–) and RTÉ (1961–). These provided new platforms for advertising consumer products, informed by strategies developed in the United States. Günter Wulff's 'Minstrel' ads for Lyons Tea (1962) used the technique of brand characterization, the popularity of which influenced other indigenous companies, including Tayto Crisps and Jacob's Biscuits to introduce Mr Tayto and Jim Figgerty. RTÉ's identity system provided a contrast to these American references; a logo comprising the St Brigid's Cross went through various iterations (1961–95).

With serious deficits in education provision, state intervention into design activity became inevitable as Ireland applied for EEC membership (1961) and sought greater access to international markets. The economic benefits of aligning industrial production to design education concerned government and CTT took over responsibility for 'industrial design' from the Arts Council in 1960 and established a design section within its organization. In 1961, influenced by Nordic successes in adopting traditional craft practices to industrial manufacturing, CTT's William H. Walsh invited a group of Nordic designers, architects and educators to survey Irish design. The invitation reflected earlier observations by Bodkin and the DRUI on the quality of Northern European design and acknowledged an international discourse that Nordic design was intrinsically 'good' because of its emphasis on functionality, aesthetic simplicity and indigenous natural materials. This assessment appeared to resonate with the public as Danish teak furniture became popular in Ireland during the 1950s and '60s, influencing the work of furniture-maker Brendan Dunne during the same period.

The Nordic group – Kaj Franck, Erik Herlow, Gunner Biilmann Petersen, Erik Chr. Sørensen and Åke Huldt (curator of *Irish Design*) – spent two weeks surveying factories, museums, shops and educational facilities. Their observations were published as *Design in Ireland* (1962), commonly known as *The Scandinavian Report*, and included harsh comments on education provision at all levels, poor achievements within design disciplines, low levels of design awareness among the populace, and a tendency by Irish manufacturers to see the designer as a 'frivolous addition' (Córas Trachtála Teoranta, p. 3). They suggested that the government and 'churches' should lead by example and raise design awareness through public and ecclesiastical commissions. By way of balance, they offered that the standard of much craft production (specifically textiles) was high. The report strongly urged radical reform of design education. However, this was slow to materialize and the suggestion of an integrated Irish institute of visual arts for design, art and architecture was never realized. By comparison, Belfast's School of Art developed its design courses, becoming a Faculty of Art and Design within Ulster Polytechnic (1971, now the University of Ulster).

Similar comments on educational reform and patronage were made in the *Report of the Council of Design* (1965). The Council was established (1963) to survey design activities 'carried out with the financial support of the State' and to try and encourage connections between CTT and the NCA (The Stationery Office, *Report of the Council of Design*, 1965, p. 1). Members included Sybil Connolly, Erik Chr. Sørenson and T.J. O'Driscoll (Director General of Bord Fáilte Éireann) and they recommended establishing a National Design Council and a Design Centre to promote and display Irish products and to address the public's 'absence of taste' (p. 3). These initiatives were not realized, and three opposing views emerged as to how the NCA, the principal source of design education in the Republic, should be reformed. Amongst the report's more enlightened comments was that public awareness of good design affected all spheres of Irish life and should not be exclusively aligned to the consideration of exports (pp. 3, 5).

The recommendations of *Design in Ireland* were partly responsible for the establishment of the Kilkenny Design Workshops (KDW) (1963–88) by CTT under Walsh's guidance. It was the single, most important design initiative in the history of the state, the first government-sponsored design agency in the world, and its model was replicated in many developing countries. It specialized in training, retailing, and the modernization and promotion of Irish design, became a benchmark for national standards and developed particular expertise in corporate identity, furniture, household goods and utensils, textiles, ceramics, jewellery, packaging and industrial design. It emphasized the adaptation of traditional craft practices to mass production, evolving a distinct aesthetic that fused Modernist and vernacular forms and patterns, while later emphasis shifted to industrial design. By the mid-1960s, graphic design and textiles were the main source of design employment in Ireland and there was a strong emphasis on these disciplines.

Initially KDW relied on a number of craft designers from Britain (ceramicist David Reeves), the Netherlands (ceramicist Sonja Landweer), Finland (silversmith Bertel Gardberg), Denmark (textile designer Rolf Middelboe), Germany (silversmith Rudolf Heltzel), Sweden, Switzerland and the USA. With echoes of the ideology of the Deutsche Werkbund and Bauhaus, KDW's design teams developed prototypes with the aim of creating sustainable links with Irish manufacturers and, in so doing, trained a new generation of Irish designers intent on marrying creativity and industrial production.

Peter Hiort-Lorenzen's Súgán chair for the Ardee Chair Company (1968); Gerald Tyler's teak dining utensils (1969) and 'Tantulus' glassware for Cavan Crystal (1969); Oisín Kelly's calligraphic textiles (1967); David Reeves's ceramics for Carrigaline Pottery (1966–2002); and Helena Ruuth's textile designs for Terence Conran's Heathrow Airport seating (1966) – manufactured by Birr Fabrics (c. 1966–91) – were typical examples of early production [126]. Collaborations with other indigenous companies included work for Waterford Stanley (1934–) and Greenhill/Lissadell Towels (1969–).

By the 1970s greater emphasis was placed on industrial design, now more clearly defined as product design or design linked to engineering. KDW was now working with a number of international companies, including German companies WMF and Rosenthal (which bought Celtic Ceramics in 1976). Noteworthy designs from this period include Danish designer Holger Strøm's IQ Pendant Light of inter-locking translucent plastic pieces (1972) and his corrugated cardboard furniture

and exhibition cubes manufactured by Smurfit Papers (1971); Gerard Tyler's yellow litter-bins for Irish Aluminium (1973) which became ubiquitous in Irish towns and cities; and Nick Marchant and Raymond Turner's overhead projector for USA-company Bell and Howell (1978). KDW initiated design awards for industry and education and opened a retail outlet in Dublin (1976) which showcased the best of Irish and international design, while in-store concessions in American department stores contributed to export sales (Moran in King and Sisson, pp. 190–207).

KDW had particular successes in poster, packaging and corporate identity design; such specialisms were unusual for the period as 'graphic design' was generally assumed to be 'advertising'. Dutch-trained Damien Harrington established the graphic design department (1968) which provided specialist branding and identity services for state-sponsored companies, echoing the *Design in Ireland* recommendation that government lead by example in ensuring that their external communications were of a high standard. Projects were built around strong, easily identifiable logos, many of which synthesized the abstractions of modern infrastructure with references to Irish heritage. Of these, Harrington's logo for the Office of Public Works (1973/74), referencing the concentric markings found on Irish Neolithic tombs, was a typical example, but by comparison his typographic logo 'P+T' for the Department of Posts and Telegraphs (1968) [127] demonstrates a more internationally inflected, and archetypal Modernist aesthetic. New identity systems for a host

126. Helena Ruuth and Terence Conran, seating for Heathrow Airport, 1966

127. Damien Harrington, logo for the Department of Posts and Telegraphs, 1968

of indigenous companies emerged, reinforcing the communicative importance of clear design strategies. These included the National Dairy Council and Irish Life Building Society (Harrington, 1973, 1979), Éirebus (Elizabeth Fitz-Simon, 1972) and Cospóir, the National Sports Council (Peter Dabinett, 1978). In tandem with numerous posters for cultural events and competitions (Richard Eckersley, Tony O'Hanlon), KDW's graphic design output became part of mass, everyday experiences.

Growth in design awareness increased in the 1970s and two new professional organizations appeared: the Institute of Designers in Ireland (1972) and the Crafts Council of Ireland (CCoI, 1971). By comparison to KDW's evolving emphasis on industrial production, craftspeople working alone or in small groups and producing unique items prevailed. Ceramicists Peter Brennan, Grattan Freyer and John ffrench worked in this vein although ffrench also produced a more commercial line for Arklow Studio Pottery (1962). Successful attempts to commercialize hand-made ceramic tableware during this period include Stephen Pearce's (1973–) 'Shanagarry' and 'Traditional' earthenware ranges – the former conceived by his father Philip – and the spongeware decorated ceramics of Nicholas Mosse (1976–). Similar initiatives occurred in glassware: Orresfors-trained Keith Leadbetter established Jerpoint Glass (1979–) and with Simon Pearce advised NCAD on the establishment of the Republic's only blown-glass department (1975).

Access to popular media, increased foreign travel, greater disposable income, financial support for foreign investment, and membership of the EEC in 1973 broadened consciousness of design issues, and the decade witnessed radical shifts in design education. The NCA was eventually reformed (1971) and its new name – National College of Art and Design (NCAD) – reflected an expanded focus. In partnership with the newly established National Institute of Higher Education, Limerick (1972), NCAD now offered the country's first degrees in industrial design (1976). The College of Marketing and Design, Dublin also expanded its design provision, and former students of the NCA established the first Bauhausian foundation course in Dun Laoghaire (1970), which evolved into the Dun Laoghaire College of Art and Design in 1979 (since 1997 the Institute of Art, Design and Technology). The creation of a network of Regional Technical Colleges (RTCs) in Waterford, Athlone, Galway-Mayo, Sligo, Carlow, Letterkenny and Cork in the early 1970s, led to an increase in design education provision, influencing a boom in design activity in the 1980s. LINDA KING

Section Three: Design specialisms (1980–2000)
In 1980 seven students of the first Industrial Design Degree in Ireland graduated. The nature of their course can be inferred from its status as a joint degree between Engineering at the National Institute of Higher Education, Limerick, and the design faculty at NCAD. While courses in visual communications, fashion and textile design had previous incarnations as craft training, industrial design was different from the start, with its emphasis on mass production. An important implication of this was that manufacturers in Ireland started employing graduates who had a strong understanding of mechanized production, such as machine tooling.

With Ireland in recession, and still relatively under-industrialized, many of the first industrial design graduates emigrated. Those who remained often established design consultancies that worked with companies in Ireland and abroad in furniture design (Omos Ltd.), sports equipment (O'Sullivan Associates), vehicle design (Dolmen Associates) and other specialities.

Alongside its success in graphics, KDW's industrial design division was well established by the early 1980s, with much of its work directed towards the electronics industry, such as the Desktop computer terminals designed for Beehive Ireland in 1982. Although ergonomic principles were strongly considered with such products, there was little innovation in their physical appearance, with the 'beige box' being almost ubiquitous until Apple's landmark 'i-Mac' was launched in 1998.

Until then, the coupling of aesthetic and technical innovation was largely confined to the design of computer peripherals such as mice. This was to be a particular success for one of the earliest Irish industrial design consultancies, Design Partners, founded by David Morgan and Brian Stephens in 1984. Their work for Logitech pushed 'user friendliness' beyond physical ergonomics, to include an expressive legibility, as with the Trackman Marble FX mouse (1997), operated by a large 'marble', the first trackball mouse to employ the use of both thumb and index finger. For this, Design Partners received multiple awards, including the Good Design Award (1999) and the influential 'red dot' (2000).

The closure of KDW in 1988 has been attributed to a number of factors, such as economic recession, their loss-making retail outlet in London, and increasing competition from new design consultancies (Joanna Quinn, 'The Beginning of the End', in Thorpe, 2005, pp. 31–32). Its demise not only affected KDW staff and consumers but the status of design in Ireland. KDW had performed a semi-regulatory role, for example through their 'Design Management Awards' initiative, launched in 1984. Unlike awards given directly to designers, this was for companies who used design effectively. One of the first (1986) was awarded to the new Dublin Area Rapid Transit (DART) system, which, unusually for an Irish business, showed great design coherence in its early years, from the livery of its trains to the form and materials used in its bins, shelters, signage and benches. Generally, however, the lack of a national strategic approach to design management could be seen, particularly in the urban environment of the 1990s, where jumbled signage schemes and ill-judged street furniture marked an incoherent approach to the procurement and management of design.

One graduate of the industrial design degree in NCAD who became acclaimed for expanding the role of the designer beyond the external packaging of consumer products was Anthony Dunne. Through his writings such as *Design Noir*, his work in the design partnership Dunne and Raby, and his position as professor of design interactions at the Royal College of Art, London, Dunne pioneered the field of critical design, creating objects that aimed to offer what he termed 'complicated pleasure' rather than satisfying easily identified needs. Dunne suggested that design can be a way of materializing a critical and speculative perspective, particularly about the role of technology in our lives. Dunne and Raby's work is in the permanent collections of a number of important institutions, such as the Museum of

Modern Art, New York, and the Victoria and Albert Museum, London.

Within Irish furniture design, one approach common from the 1950s was the 'modernizing' of vernacular forms, such as Hiort-Lorenzen's version of the rope-seated 'Súgán' chair, and reworkings of the traditional 'Tuam' chair by a number of craftsmen. This tactic persisted in the later twentieth century, with one version being furniture that emphasized the nature of the materials used in simple, almost minimal forms, such as the work of Tadhg and Simon O'Driscoll. Close attention to materials and traditional processes informed the work of graduates of the furniture college in Letterfrack, Co. Galway, established in 1987.

Alongside this, furniture in a more decidedly modern idiom became a strong element in the work of some Irish industrial designers such as Omos, whose prototype steel and granite benches marked a counterpoint to the pastiche black and gold 'heritage' style street furniture favoured by so many local authorities in the 1990s [128]. Omos later developed a family of hard-edged urban furnishings such as bicycle stands and litter bins that seemed visually coherent with the contemporary spaces constructed during the economic 'boom' years spanning the turn of the twenty-first century.

'Green' issues became a concern of many young designers such as the 'Mash' collective, involving ten graduates of the Dublin Institute of Technology. Their work exhibited a strong self-consciousness of their Irish identity but in more playful ways than their predecessors. The Irish Furniture Design Network (2002–) similarly worked as a co-operative, promoting and exhibiting their work together. This included intriguing furniture designed by Charles O'Toole, such as a range of 're-purposing' tennis balls – a brighter, more spirited approach to design sustainability than had been typical in previous decades.

In fashion design, the 1980s saw a number of initiatives that promoted the industry, such as Irish Fashion Week (from 1982), organized by a group of designers with the collective name Irish Designers' Association. The partly state-funded Irish Design Centre (established in 1984) in Dublin was dedicated to selling the work of Irish fashion designers; it provided them with low-rent retail space and consumers with the opportunity to buy specifically Irish-designed clothes. Just as

significant in connecting designers and mass audiences was the 'Late Late Fashion Awards' (1982–). The dedication to Irish fashion of a special edition of the most-watched programme on Irish television was, according to fashion journalist Robert O'Byrne, 'the biggest boost to the industry during this period' (O'Byrne, *After a Fashion: A History of the Irish Fashion Industry*, Dublin 2000, p. 91).

The Irish Design Centre was part-funded by the International Wool Secretariat. This reflected the use of specific fabrics as a strong aspect of Irish fashion's international identity. Sybil Connolly had described her home in Merrion Square as 'the house that linen built' in the 1950s, and linen again became widely used in Irish fashion in the 1980s, linked to the international impact of Japanese designers (Elizabeth McCrum, *Fabric & Form: Irish Fashion since 1950*, Belfast 1996, p. 55). Although designers drew less explicitly on native costume than Connolly and others had done in the 1950s, Irish identity was still evoked through the use of Irish-produced textiles. Examples included Paul Costelloe's 1984 autumn/winter collection featuring 'Donegal herringbone tweed, crisp Irish linen shirts and Aran-inspired knitwear' (p. 56). More generally, national identity was suggested by many designers through an assertion of the importance of the colours and textures of the Irish landscape. Although many narratives of international fashion point to the inspiration of popular culture and 'street-wear' in the 1980s and '90s, few well-known Irish designers cited such references, instead suggesting the kind of 'timeless', traditionalist and rural values long promoted as quintessentially Irish. Similarly, the tricksiness of 'post-modern' fashion with its eclectic borrowings from different historical periods and cultures was generally eschewed.

The most successful of Irish designers in the late twentieth century tended to be specialists, such as jewellery designer Slim Barrett, milliner Philip Treacy [129] and Orla Kiely. Kiely first came to attention as a bag designer and later extended her repertoire to include clothing and household goods. Treacy has been feted for his work through numerous awards and exhibitions, celebrated for 'fantasy' creations, such as a hat in the form of an eighteenth-century ship (complete with rigging) and helmets mounted by gilded ram's horns.

The 1990s saw the enrolment of fashion designers in creating 'signature' ranges in spheres outside clothing – for example, John Rocha's popular work for Waterford Glass, Paul Costelloe's design range for Newbridge Cutlery, and Louise Kennedy's redesign of the Tipperary GAA's team strip and products for Tipperary Crystal. Such branding might suggest that only *fashion* designers were sufficiently well-known to draw attention to new products, and expresses a faith in the importance of promotion and branding centred on the individual. LISA GODSON

Section Four: Evolving and emergent forms (1980–2000)
The promotion of Irish craft increased prodigiously in the 1980s and became an exemplar of design advocacy. With sponsorship from the Department of Industry and Commerce and the IDA, the CCoI established a headquarters – including gallery and retail space – at Dublin's Powerscourt Townhouse Centre (1986) and business and skills training at Kilworth, Co. Cork (1981–89). The gallery briefly relocated to Temple Bar's Designyard in 1997, before finding permanency as the National Craft Gallery,

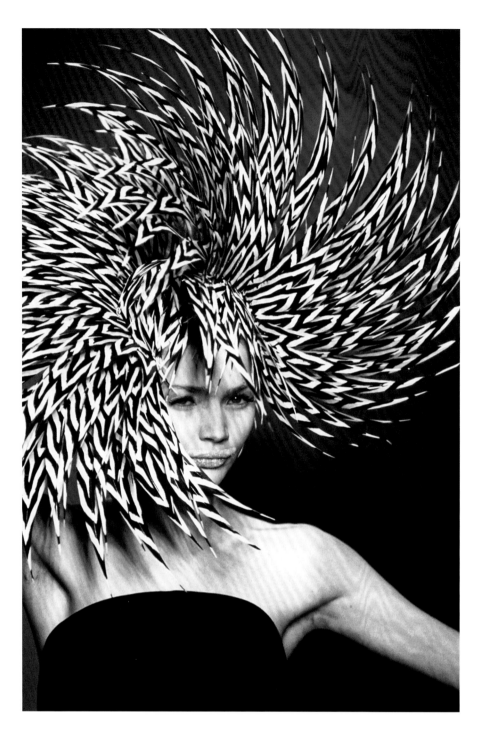

129. Hat from the Philip Treacy haute couture show, Paris, 1998

particularly jewellery, grew. Alan Ardiff developed a popular range with kinetic details, and the use of mixed media – foregrounded by Landweer – influenced Angela O'Kelly's synthesis of fabric and paper which pushed adornment towards sculptural forms. Dutch-born Maria van Kesteren, who worked at KDW, and Liam Flynn were influential in reviving the traditional craft of woodturning; Joe Hogan championed basket-making to produce utilitarian and sculptural objects; while silversmiths Seamus Gill and American-born Kevin O'Dwyer pushed the conventional forms of household objects in unexpected directions. This period was also defined by a decentralization of craft production outside of Dublin and Kilkenny, partly as a result of an increase of education provision with the RTC sector. Crawford College of Art developed strengths in stained glass, and along with Limerick School of Art and Design, specialisms in ceramics. Although there were greater educational opportunities, the pressure of cheap imports from Asia and competition from global retailers, including Habitat led many Irish ceramic firms, including Arklow, to cease production (1998).

Within graphic design practice KDW continued to dominate the 1980s, most notably, with branding and identity projects. When the Department of Post and Telegraphs was split into two entities (1984), Dabinett designed the uncial-inspired interlocking T and E letterforms of the Telecom logo (1981) and O'Hanlon developed the An Post identity (1983/84) originally designed by Della Varilly (1982). Strengths in packaging design included work for Sligo-based Hanson Scales (1980), Tretorn tennis balls, Chef sauces and Stag cider (1983), the ubiquity of which ensured that KDW's work featured in most Irish homes. The closure of KDW left a legacy of professionally trained designers who were absorbed into design industry and education (specifically the RTC sector), while County Kilkenny remained a focus for ceramic, glass and metalwork production.

In 1984 the launch of the Apple Macintosh computer revolutionized the trajectory of graphic design practice worldwide. By giving designers greater access to the means of production, a variety of skills that had previously represented numerous discrete jobs were suddenly made accessible to individuals. This technological shift, combined with an increasing number of graduates emerging from newly established design degrees and diplomas, enabled design companies to emerge independently of the advertising agency system and to evolve distinct specialisms. Of this Dublin-centred generation, Design Factory (1983) and BFK (1989) focused on branding and identity design, while Designworks (1983) moved from packaging and branding to exhibition design, as evident in work for the National Museum of Ireland (1997). In 1980 Steve Averill began a design business around one client, U2. Beginning with album covers, Averill's company (now AMP Visual, 2010–) grew with the popularity of the band to provide a wide range of services to the music industry. An emphasis on illustration was also evident in the 1980s and early 1990s: David Rooney's [130] distinct scraperboard style dominated editorial and advertising illustration and the College of Marketing and Design (part of DIT from 1992) developed courses in this area.

part of the customized CCoI headquarters on the site of the former KDW workshops (2000). The public visibility of these initiatives ensured that the profile of all Irish craft production was greatly increased at both national and international levels.

Craft straddled a broad range of methods and functions as traditional materials and forms were pushed in new directions, or new materials were incorporated into conventional motifs. While there was a strong leaning towards sculptural forms – evident in the work of ceramicists Deirdre McLoughlin and British-born Henry Pim, or glass makers Róisín de Buitléar and Caroline Madden – the demand for utilitarian objects,

Despite such successes, opportunities for employment were limited and many young designers emigrated. Among these was illustrator Brian Cronin (qv) who, after leaving for New York (1985), achieved world recognition for his distinctive editorial illustrations for *Time* magazine. As Irish graduates interned in the design centres of New York, Milan, Paris, Berlin and London, they created opportunities for subsequent graduates to train abroad, some, but not all, of whom would return to Ireland.

Tax breaks for foreign investment lured a number of American animation studios to establish headquarters in Dublin in the 1980s, employing hundreds of young Irish animators. Sullivan Bluth (1985–95) produced *An American Tail* (1986) and *The Land Before Time* (1988) for Steven Spielberg's Amblin Entertainment and helped to establish an animation course at Ballyfermot Senior College, Dublin, while Murakami Wolf Swenson (1989–2000) produced the hugely successful *Teenage Mutant Ninja Turtles* series (1987–96). Ardmore Studios (1958–) also benefited from tax breaks ensuring that many internationally financed films located production to Ireland from the 1960s, stimulating a host of design activities associated with the industry. Josie MacAvin, for example, a pioneer of Irish set design, received Oscar nominations for *Tom Jones* (1963) and the Ardmore production, *The Spy Who Came in from the Cold* (1965), before gaining an Oscar for *Out of Africa* (1985). In the 1990s, design and technology merged to influence another specialism in design for film (qv), concept design, as exemplified by London-based Dermot Power's work on the *Star Wars* franchise (1999) and for Tim Burton (2009–).

The 1990s saw the largest expansion in design activity in the history of the state, bolstered by an economic boom that started mid-decade, a huge increase in education provision, and rapid technological changes. As the network of RTCs became Institutes of Technology and subsumed the regional art schools, and colleges of Further Education also appeared, design education expanded to unprecedented levels and a variety of undergraduate courses in graphics, fashion, textiles, model-making, production design, industrial design and craft production emerged. Many institutes linked design and emergent technologies leading to new specialisms in screen-based media. This synthesis and its importance for economic development was captured in Enterprise Ireland's *Opportunities in Design: Strategies for Growth in the Irish Design Sector* (Dublin 1999), a report that reconsidered the core role of design as framed by developments in emergent media (including web and interface design, animation and gaming) and their links to the music, entertainment and tourism sectors. X Communications (1994– 2012) and Martello Media (1986–) became specialists in merging new technologies with design for the cultural industries, providing interactive components for exhibitions at the new Chester Beatty Library (1998)) – including the *Chogonka Scroll* interactive kiosk and CD-Rom (1998) [131] – and the National Museum of History and Decorative Arts, Collins Barracks (1997). As Irish design became increasingly more aligned to global developments, Havok (1999–) focused on gaming design and developed physics engines for computer games that have been exported world-wide; Frontend (1998–) specialized in interface design;

130. David Rooney, *Druid Murphy*, 2012, black ink on scraperboard digitally coloured

and a number of e-learning companies, including CBT Systems (1984–99), demonstrated the application of technology, animation and design to virtual learning environments. Technological developments also increased the competitiveness of Irish animation companies within global markets: Cartoon Saloon (1999–) and Brown Bag (1994–) were Oscar-nominated and, alongside Kavaleer (1998–), produced cartoons for global entities Disney, the BBC and the Cartoon Network. Strengths in the fields of design and technology influenced the establishment of the Massachusetts Institute of Technology's Media Lab Europe (2000–05) with a remit of applied research.

131. X Communications, Interactive screen providing information about the *Chogonka Scroll*, Chester Beatty Library, Dublin, 1998

By the late twentieth century, a vibrant youth consumer culture had also provided niche platforms for young designers. *D'Side* (1993–2002) – a style and music magazine in the mould of British publications *The Face* and *ID* – reflected the growth of dance clubs and their promotion, and the inclusion of motion graphics within club environments encouraged experimentation with emergent media. The Dublin clothing store Makullas (1993) reflected this demograph and its branding and strategies – art directed by Frank Stanley in collaboration with designer Niall Sweeney – were bold, holistic and ambitious.

In parallel, a second wave of Dublin-centric graphic design studios emerged, including Language (1990–), The Identity Business (1991–2001), RedDog (1993–), Zinc (2000–) and Atelier (2000–), while Carton LeVert (1998–) in Donegal and Copper Reed (1993) in Limerick were among those established outside the capital. Studios now offered design expertise across a variety of platforms and new communication specialisms emerged: the Public Communications Company (1995–2012) offered design for the not-for-profit sector; Dynamo (1992–) concentrated on branding and packaging design; Imagenow (1992–) combined branding and commercial film making; and Webfactory (1995–) was amongst the first companies entirely devoted to design for digital media. In considering the narrative of Irish graphic design activity, from its origins in advertising and printing to its splintering into specialist fields by the turn of the century, the discipline can be seen as emblematic of how Irish design practices have evolved, matured, professionalized and expanded within a relatively short space of time.

LINDA KING

SELECTED READING Córas Trachtála Teoranta, 1962; Marchant and Addis, 1985; Larmour, 1992; Bowe, 1993; Kinmonth, 1993; Lisa Godson, *Stealing Hearts at a Travelling Show: The Graphic Design of U2* (Dublin 2003); Turpin, 2000; King and Sisson, 2011.

132. Jack B. Yeats, *The Emigrant*, 1928, oil on slate board, 23.5 x 36.2 cm, private collection

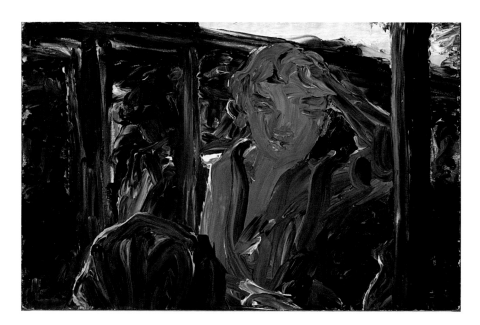

DIASPORA AND THE VISUAL ARTS. In 'From the Land of the Unspoken' the poet Seamus Heaney said: 'We are a dispersed people whose history/is a sensation of opaque fidelity' (*The Haw Lantern*, London 1987).

It was not until the 1990s that the word 'diaspora' began to be applied to Irish emigrants. The word, deriving from the Jewish dispersal from their homeland over two thousand years ago, has a stronger force than 'emigration' since it refers to compulsory exile. Emigration from Ireland over the centuries has encompassed experiences of political exile, flight from famine, poverty, and social repression at home. In addition to those reasons for leaving, Irish artists also felt a need to participate in more stimulating artistic centres abroad. Jack B. Yeats's (qv) painting *The Emigrant* [132] therefore documents a trend that was already a major aspect of Irish life when he painted it in 1928, and the trend was to continue in varying surges throughout the century. People have always left the country but the major exodus began during the Great Famine of 1845–52, when approximately two million departed. By 1900 more Irish people were born in New York than at home in Ireland and there were growing communities in London, Liverpool, Glasgow, Boston, Philadelphia, Melbourne, Sydney and other mainly English-speaking cities, and in rural Argentina, Canada and other far-flung locations.

While emigration was not an easy option, many artists felt they had no choice but to leave. Tony O'Malley (qv), who used the Irish form of his name 'Antoine Ó Máille' to sign his work while living as an emigrant in Britain, told Vera Ryan that he drove to the ferry port of Rosslare several times, only to repeatedly draw back, unable to make the final move. When he finally left, he felt liberated:

In Ireland then the individual didn't count. I so long endured the tribal society after the long period in the san[atorium], I owed myself freedom to paint. It took me a long time to discover how much it would disappoint my own people to follow the path I'd chosen. I had to break to discover, uncover painting. So many people held dogmatic views on work they didn't know. The Ireland I left was a country where everyone had a job and an ambition which was to get married. No friendship with women was possible. You didn't feel the brotherhood of artists. In primordial times the artist did something in the tribe, now he was outside the tribe. We had a measure of freedom, a measure, and we were still trying to discover our own level. (Ryan in Brian Lynch (ed.), *Tony O'Malley*, Berkeley and London 1996, pp. 57–58)

The exodus included artists who followed James Joyce's advice to 'go into exile' or become silent and cunning at home. As a result, as Declan McGonagle has pointed out, 'the Irish diaspora is an important dimension of Irishness and includes those artists living and working outside Ireland who take some responsibility for their Irishness' (McGonagle, 2002, p. 30). This essay is concerned with those artists. Artists of the Irish diaspora include those who are leaving now, as well as the descendants of those who left over generations. While artists such as Francis Bacon (qv) and Bridget Riley in Britain, Georgia O'Keeffe, Mike Kelley

and Paul McCarthy in the United States, and Eileen Gray and Roderic O'Conor (qqv) in France have all pioneered new forms of expression in their chosen fields, they have not all chosen to reflect in their work the responsibility for their Irishness to which McGonagle refers. Others combined engagement with their Irish heritage with forms of expression that seek to avoid closed versions of a past tradition and repetition of ancestral myth.

Artwork directly relating to the immediate and long-term impact of emigration has been made by many Irish artists. Kathy Prendergast (qv) summed up the isolation and grief of those who left in *Lost* [133] and *Empty Atlas* (1999), where she spotlighted the places in the USA with names beginning or ending in the word 'lost'. Patricia McKenna looked at the impoverishment and devastation emigration wreaks on the communities left behind in her installation *The Grey House* [407]. Seán Keating (qv) in *Economic Pressure* (1949) [134] and Belfast artist Brian Kennedy in *Stones in Place* (2003), a recreation from shards of glass of ancient standing stones, express the fragility of native culture in the face of emigration, while Fran Hegarty's (qv) lyrical short film installation *Turas* (Journey)[135] juxtaposes an emigrant mother and daughter, struggling to pass on the mother tongue from one generation to another with the Irish landscape and a centuries-old culture. Hughie O'Donoghue (qv) breaks new ground for painting by fusing it with photography (qv), to explore aspects of his family's migrant paths. 'The Prodigal Son' series [136] draws on found photographs to parallel his Kerry

grandfather's move to Manchester. A compassionate view of the abandonment of the townsland of his mother's homeplace, near Bangor Erris, Co. Mayo, is pursued with greater intimacy in bodies of work such as 'Naming the Fields'. Discussing the painting *Knocknalower* (Hill of the Lepers) from this series, Patrick Murphy says that 'the Christ-like figure that occupies this work … is Jesus at the moment of abandonment, forlorn and discarded, no redemption here, only cruel evidence' (*Hughie O'Donoghue: North Mayo Retrospect*, Ballina Arts Centre, 2011, p. 9). Like O'Donoghue, Geraldine O'Reilly used her own family's archive of letters and photographs from emigrant members to make *Irish Woman Emigrants* and *Bag* [137]. John Ford's film *The Quiet Man* (1952) [173] follows the return of an Irish-American emigrant as he tries to match the romantic view of Ireland, inherited from his mother, with the reality on the ground. His experience is seen through the perspective of the director who himself had absorbed much of the emigrant myth.

Although there are no figures for the number of artists among those who left or those who moved in the opposite direction to settle and work in Ireland, the number from both groups who left their mark on art, both in Ireland and in their new homelands, is important and should be analyzed. The picture of Ireland which they realized is a complex one. The most perceptive analysis of the impact of diaspora on the visual arts in the twentieth century was presented in the form of the book and exhibition *Distant Relations* (1995), shown in venues in Britain, USA, Ireland and Mexico. The curator Trisha Ziff paralleled the

133. Kathy Prendergast, *Lost*, 1999, digital print, edn 4/25, 85 x 132 cm, Tate

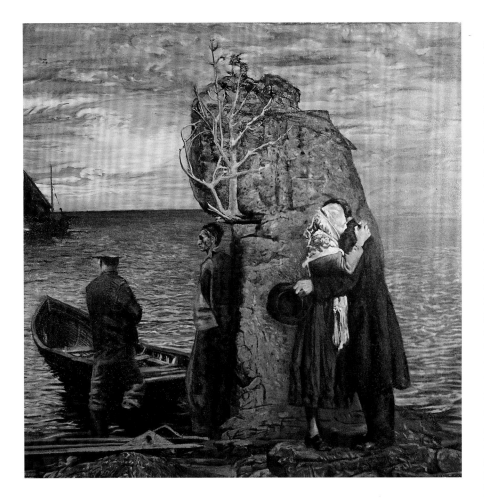

In the same publication, Mary Hickman argued that nations are 'imagined' rather than real communities which require face-to-face contact of the people in them. Dispersed national communities work, instead, to forge commonality, based on remembered and imagined experience. Therefore as emigrants struggle to find new homelands, they inevitably pursue myths of 'nation' in their search for roots, and so the challenge for migrant artists is to either conform to the myth or contradict it. The imagined community of the Irish in Britain, Hickman asserts, is based on a sense of forced emigration. She explains that all migrant groups have to deal with their difference from the dominant, host culture and this process is intensified if the country they migrate to is their former colonizing power. Thus, the experience of the Irish in Britain has been very different to that of the Irish in the USA or Australia. In her analysis, Hickman calls attention to the role of the Catholic Church in Britain through education and social activities, in displacing national identity and working to create a sense of belonging, grounded, instead, in religion. She argues that the Catholic education system which most Irish emigrants experienced worked to denationalize the people and to inculcate a sense of the inferiority of Irishness compared with Englishness. It furthered the colonial concept of 'otherness' rather than simple integration. 'Cultural identities, therefore, are points of identification which are made within discourses of history and culture … not essences but positionings' (Ziff, p. 50). However, Hickman is also quick to point out that cultural identity is not a given; it changes according to circumstances both for the migrant and for the host community. British stereotyping of the Irish in the past centred on working-class catholic emigrants and did not embrace the more affluent or Loyalist protestant emigrants from Northern Ireland. From the 1970s that changed as the 'Troubles' in Northern Ireland intensified and the Prevention of Terrorism Act (1974) was invoked particularly against Irish people. It is changing again to accommodate greater cultural diversity in a more globalized age. Hickman welcomes differentiation and diversity, insisting that 'the greatest danger surely arises from forms of national and cultural identity that attempt to secure their identity by adopting closed versions of culture and community' (p. 55). In the twentieth century over 1.6 million Irish people went to Britain, more than twice the number going to North America. They adopted a low

134. Seán Keating, *Economic Pressure, or a Bold Peasant being Destroyed*, 1949, oil on board, 122 x 122 cm, Crawford Art Gallery

135. Frances Hegarty, *Turas*, 1995, video stills from single screen projection, video/audio cycle 3 min 40 sec

experience of Mexican and Chicano artists with Irish artists at home and in Britain and America. One of the characteristics that emerged among the emigrant communities from both countries was a shared desire to express their continuing Irish or Mexican identity through artwork that often reflected a picture of their ancestral homelands as their parents knew them, while artists who had remained at home were more open to exploration of contemporary international experiments and developments. Speculating on the reasons for this, Ziff wonders if it is 'the erosion of what distinguishes us that makes our desire to place ourselves even more intense' (Ziff, p. 25).

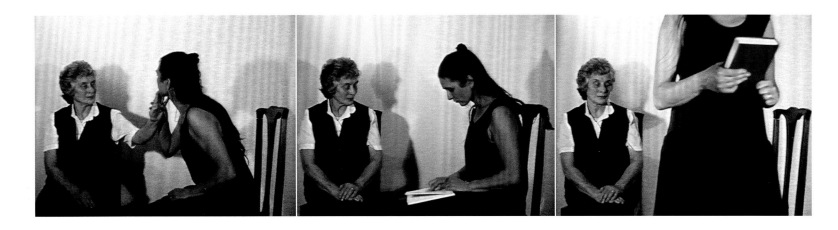

profile, compared to those British migrants to Ireland or Irish emigrants to the USA (pp. 45–55).

Thankfully some artists challenged the stereotypes. Despite Gerard Dillon's (qv) staunch nationalism, he found London a good place to work in, stipulating only that he wanted to be buried in Belfast (*Gerard Dillon: Retrospective*, exh. cat. Belfast 1972). Sean Scully (qv), born in Dublin but brought up from the age of seven in what he described as an Irish catholic ghetto in Croydon, found himself driven in adulthood to make art that celebrated his mother's stand against repressive catholicism in England, despite her own strong spirituality. Peter Lennon's documentary film *The Rocky Road to Dublin* (1967) [174] sought, as the programme notes stated, 'to reconstruct in images the plight of an island community which survived nearly seven hundred years of English occupation and then nearly sank under the weight of its own heroes and clergy'. An Irish Republican, working as a journalist in Paris and London, Lennon realized that liberation from colonial rule had not solved all the country's problems. Post-colonial dislocation is a theme at the centre of much of the work of new media artists Anne Tallentire (qv) and Phil Collins, while Rita Donagh (qv) has made thoughtful conceptual work exploring the impact of the British in Northern Ireland in her work (see 'New Media Art').

The exhibition *0044* (its title derived from the telephone prefix for Britain), curated by Peter Murray (1999, CAG), explored the continuing migration of Irish artists to London in the face of growing prosperity in Ireland in the 1990s. Interviews with the participating artists indicated that poor funding at home, the need to express personal freedoms, and a sense of adventure all motivated Irish artists to move to Britain. Importantly, Claire Schneider noticed: 'They were not isolated from the world at large in a mythical and unchanging place, but neither were they completely divorced from this legacy. They were, instead, endowed from their unique situation in the larger European and international community with a special ability to navigate our changing world.' (Murray, 1999, p. 7) In stressing dislocation as a theme of the exhibition, Murray argued that the relationship between Ireland and England is too often framed only by post-colonial theory. The actual relationship is more complex

than the colonial one, in a world of global interchange. Space and place were important for the artists, however. Liadin Cooke's work incorporated balls of clay from her Kilkenny home. Her blending of the 'here' and 'there' reflected the migrant's sense of insecurity. Mark Francis (qv), Siobhán Hapaska and Daphne Wright create uncertainties about place and time, with Wright admitting, 'I think not accepting things as they seem, believing everything to be deceptive, motivates the work' (p. 11). Maud Cotter and Cecily Brennan (qv), temporary emigrants only, felt liberated by the anonymity of London. Artists from Northern Ireland saw home during the Troubles as a place of insecurity, division and exclusion. London, for them, represented a place that is not Northern Ireland, not Ireland but no longer particularly English either, paradoxically a 'free state'. This attitude was strengthened by the fact that those celebrated as the 'Young British Artists' of the 1990s included people from a wide range of ethnicities. With her usual perspicacity, Kathy Prendergast commented that her mapping projects might appear to represent a search for somewhere to call home but that such identity might be 'most easily found in the search itself' (p. 11).

According to Trisha Ziff, 'The majority of Irish-American artists have through time become absorbed into mainstream American culture, and while individual artists like Mark Alice Durant, Patrick Ireland (Brian O'Doherty) and Michael Tracy reveal through their work a conscious relationship to their Irish heritage, their experience as Irish-Americans today does not place them outside the dominant culture in the way in which Chicano artists have systematically been excluded or Irish artists in Britain have been marginalized.' (Ziff, p. 29) Far from it. Their work has played a considerable part in mainstream

136. Hughie O'Donoghue, *Arise and Go*, from the 'Prodigal Son' series, 2004–06, oil and gampi tissue on panel with photographic component, 72.5 x 62.5 cm, private collection

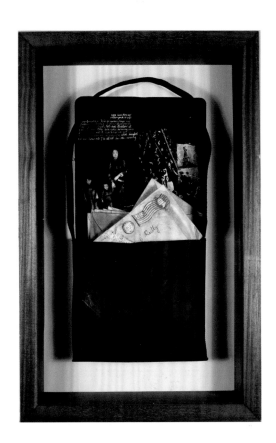

137. Geraldine O'Reilly, *Bag*, 1988, gouache on watercolour paper, 69 x 44 cm, Irish Museum of Modern Art

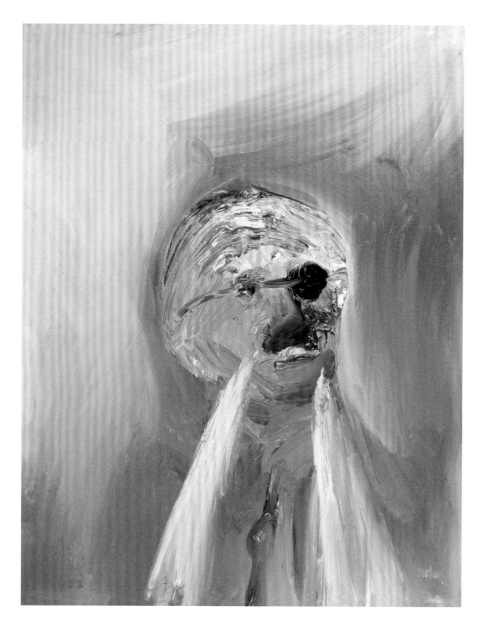

138. Sidney Nolan, *The Wild Geese II*, 1989, oil on canvas, 152.4 x 121.9 cm, Irish Museum of Modern Art

If the Irish in Britain saw themselves as a 'hidden' people (Hickman in Ziff, p. 48), those who went to Canada and Australia wore Irishness as a badge. Luke Gibbons has pointed to the way that Canadian-educated, Irish-American Robert Flaherty's film *Man of Aran* (1934) [1] isolated the daily work of an Aran fisherman and transformed it into a heroic struggle between humanity and nature (Rockett et al, 1987, p. 201). Sidney Nolan, the descendant of Famine emigrants to Australia from Mullaghmore, Co. Clare, explored notions of exile, whether for political or other reasons, in 'The Wild Geese' paintings (1989)[138]. The title refers to the soldiers, known as the Wild Geese, who left Ireland to fight for Jacobite armies in Europe after the Battle of the Boyne in 1691, but the six people represented include a self-portrait of the artist, as one Captain Moses, who was hanged in Dublin in 1720 for recruiting for the armies of England's enemies in Europe, while another portrait is recognizably that of James Joyce. The difficulty of identifying the subjects is itself important. By not providing easily recognizable faces or attributes other than the symbolic wild goose who accompanies each one, the faces become those of every exiled Irishman and woman, painted with brutal Expressionism (qv) to indicate the rawness and harshness of their experience. They connect to Nolan's most famous body of work, his 'Ned Kelly' paintings [238], where the face of the outlaw is always hidden behind the grotesque hand-made armour he wore. Kelly's obscured face, like the burnt and blackened faces of rebelling miners in Ballarat that Nolan also painted, stands as the face of emigration from a regime that makes even lawlessness acceptable. The difference between Nolan's representation, and the nostalgic hankerings for an ancestral past that Hickman describes, is important. Nolan, the Irish-Australian, is interested in the present. He uses the past to forge a distinctive, Modernist art for his birthplace, one that acknowledges its landscape, its indigenous pre-colonial culture, and the contribution of Irish migrants to its development.

Nolan's brother-in-law Arthur Boyd, one of a dynasty of Irish-Australian artists, received the 'Irish Australian of the Year' award in 1988. Later emigrants to Australia continued to make their presence felt. Tate Adams, who exhibited in Dublin and worked with Liam Miller for a year in 1959 before emigrating, founded the Lyre Bird Press in Australia and was named a Member of the Order of Australia in 2009 and Inaugural Honorary Fellow of the Print Council of Australia in 2010, as a reward for his services to printmaking and publishing, while Noel Sheridan (qv) broke ground globally through his appointment as Professor of Conceptual Arts in Sydney in the 1970s, although he later moved to Adelaide. Irish missionaries to Africa in the mid-twentieth century commissioned some of the most avant-garde work by Irish architects for their churches, schools and hospitals.

Other Irish artists chose Europe as their destination. The Hungarian Cubist painter Ferenc Martyn was very conscious of his descent from a landed Catholic family in Galway who felt driven out by the Act of Union in 1801. His gift to the Irish Museum of Modern Art of twenty-four drawings, in response to Joyce's *Ulysses*, in 1991, was an acknowledgement of this. Just as Eileen Gray was highly regarded in France but barely known in

Modernism (qv) and popular culture. This is especially true of Irish-American film-makers. John Ford, whose contribution to American identity, through such 'Westerns' as *The Searchers* and *The Man Who Shot Liberty Vallance*, is seen as one of the most influential names in twentieth-century cinema, and John Huston, who used his status as a Hollywood director to help to establish an Irish Film industry, started a trend by using Ireland as a non-Irish location in *Moby-Dick* (1987), and in *The Dead* (1992) produced the most sensitive visual interpretation to date of James Joyce's writing (see 'Film in Ireland'). Artists like Brian O'Doherty and Les Levine (qqv) could influence the development of Conceptualism in New York while at the same time dealing with explicitly controversial Irish political issues (see 'The Troubles and Irish Art'). In the 1990s Billy Quinn's (qv) experience of repressive attitudes to homosexuality and sexual abuse in Ireland fuelled his activism as an artist involved in Gay Pride and AIDS Awareness campaigns in New York.

Ireland, Patrick Swift (qv) was better known in Portugal for successfully reinvigorating the native ceramic tile-making tradition than he was at home, in Ireland, for his painting.

If the Irish left in large numbers, it is important to acknowledge what those who migrated into the country throughout the century brought to Irish art. The White Stag (qv) artists, two of whom, Rákóczi and Hall (qqv), were themselves descendants of the Irish diaspora, brought valuable new blood into a stagnating artistic pool in the early 1940s. Other migrants who came back to ancestral territory include Charles Brady and Mary Farl Powers (qqv). Like Brady, Barrie Cooke settled in Ireland in the 1960s, joining Camille Souter (qqv), who had lived in the country since early childhood. The English photographer John Hinde had no known connection with Ireland when he settled there in the 1950s but his picture postcards postulated a picturesque Irish identity that attracted tourists for decades to come (see 'Photography'). Campbell Bruce, Jackie Stanley and Rob Smith helped to create a new environment at the National College of Art and Design in the 1970s, and this work was continued by David Godbold (qv) and Kevin Atherton in the final decades of the century. Nigel Rolfe and Alastair MacLennan (qqv) could be described as the founding fathers of performance art (see 'Time-based Art') in the country. Other artists from abroad, such as Derek Hill, Tim Robinson, Nick Miller (qqv) and Stephen Brandes from the UK, and Alexandra Wejchert (Poland), Gerda Frömel (Czechoslovakia) and Varvara Shavrova (Russia) have also contributed in important ways to art in Ireland. Irish design depended very heavily on the work of Scandinavian, Dutch and German artists who were involved in the establishment of the Kilkenny Design Workshops in 1963 and, later, in new technologies (see 'Design and Material Culture'). Book artists Coracle and Franticham moved their publishing enterprises to Ireland in the 1990s, inspiring creative ripples among younger Irish artists (see 'Book Art'). While the influence of artists moving both into and out of the country has been crucial to the development of art in Ireland, perhaps the most directly influential migrations to Ireland have been those of the gallerists Victor Waddington and David Hendriks in Dublin, and Jamshid Fenderesky in Belfast. Without their advocacy and promotion of contemporary artists, many more would have been obliged to leave (see 'Commercial Galleries').

The position of the diaspora in Irish culture is given ample testament in the many exhibitions devoted to aspects of it. While the subject was a sub-theme in *The Irish Imagination*, curated by Brian O'Doherty in 1971, it became more prominent over the following decades. *Selected Images for a Sense of Ireland* (1988), jointly curated by Declan McGonagle and James Coleman (qv), purported to 'present eight artists who deal with resonant images in an exhibition designed to cross boundaries …. Particular ideas/processes are present in the work which link the artists and their activity to a continuum from Armagh to America – beyond expectations of categorization or nationalistic identities.' The artists included were Micky Donnelly, Brian Cronin, Victor Sloan, Alanna O'Kelly (qqv), Vivienne Dick, Joan Fowler and Paul Graham. *The Diaspora Project*, New York (1992–94) was headed up by former Blue Funk (qv) artist Ken Hardy who, himself, emigrated to New York at that time. It looked at the work of Anne Tallentire, Daphne Wright and Seán Taylor. In 1997 another exhibition, *Irish Geographies: Six Contemporary Artists*, brought together work by Pauline Cummins, Fran Hegarty, Kathy Prendergast, Tim Robinson (qqv), Daphne Wright and Chris Wilson. Also in the late 1990s two enterprising Irish-Australian artist/curators, Mark McCaffrey and Annie Mulrooney, curated two exhibitions, *Aerphost* (Airmail) and *Return to Sender*, of artwork that could be sent by post for exhibition in both Dublin and Australia. Ten years later *Migration and Diaspora*, at the Earagail Arts Festival, Co. Donegal, 2007, explored forced or chosen migrations 'across national frontiers or from village to metropolis', and in the same year artists Alanna O'Kelly and Fran Hegarty participated in *Deoraíocht* (Exile) at the Walter and McBean Galleries, San Francisco Art Institute.

Irish emigrants made a stalwart contribution to the countries they moved to. Fintan O'Toole reminds us that despite the migrants' legacy of nostalgia, they also embraced their new cultural surroundings. Francis Bacon, Eileen Gray, Brian O'Doherty, Michael Craig-Martin and Patrick Swift (qqv) feature as prominently in the art histories of their adopted countries as they do at home. American Modernism would not be the same without those with an older Irish ancestry such as Robert Henri and John Ford. Orson Welles spoke for many in American cinema when he said, 'Old masters – by which I mean John Ford, John Ford and John Ford. With Ford at his best, you feel that the movie has lived and breathed in a real world – even though it may have been written by Mother Machree.' (1967 interview, in Joseph McBride and Michael Wilmington, *John Ford*, Cambridge, Massachusetts 1975) Sidney Nolan's role in shaping Australian art has already been discussed. However, Irish emigrants also influenced visual culture at home in Ireland. As O'Toole has pointed out, the clothes parcels the Irish sent home from America carried ideas of modernity and sowed seeds of desire for change at home (McGonagle et al, pp. 20–21). New artistic ideas and energies followed a similar trajectory. It is impossible to calculate the importance of critics and curators of the diaspora, such as James Johnson Sweeney, a former curator at MoMA and director of the Guggenheim Museum, New York, who was a key contributor to the first two Rosc exhibitions (qv), Brian O'Doherty, as critic and head of the National Endowment for the Arts, Thomas McEvilley, as editor of *Artforum* and other influential media, Paula McCarthy Panczenko, through the Ireland-America Art Exchange, Brian P. Kennedy, as Director of the National Gallery in Australia, and Noel Sheridan, as Director of the School of Art in Adelaide, in their advocacy and promotion of Irish art abroad (see 'Curating' and 'Critical Writing'). The diaspora created networks throughout the world of people who welcome Irish art and are open to all its manifestations. Diaspora and globalization have together made notions of cultural centres and margins effectively redundant, making the marginalization that Ireland had traditionally suffered from a thing of the past.

Even as emigrants attempted to preserve what had been left behind and shrouded the nation in a mythical Celtic mist, their own actions were disrupting it. O'Toole said, in 1999, that Ireland is now 'arguably the most globalized society in the world.

Its economy is almost completely dependent on transnational corporations. Its population is a diaspora spread throughout the English-speaking world. Its political institutions are increasingly integrated with Europe.' (McGonagle et al, p. 23) And Lucy Cotter has taken this up, suggesting that 'national structures and processes are now secondary to and cannot be defined in isolation from broader global pressures' (Cotter, 2007). Cotter notes that research needs to be done 'on the racial construction of Irish identity and the relationship between ethnic minority discourses, race and citizenship in the aftermath of Celtic Tiger prosperity'. CATHERINE MARSHALL

SELECTED READING Hardy, 1994; Ziff, 1995; McGonagle, O'Toole and Levin, 1999; Cotter, 2006; Rains, 2007; Nash, 2008.

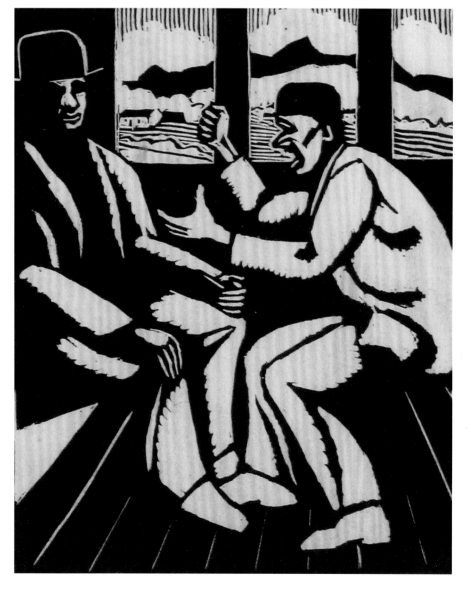

139. E.M. O'Rorke Dickey, *Farmers on the Train*, 1914, wood engraving, 12.5 x 10.6 cm, Dublin City Gallery The Hugh Lane

DICKEY, EDWARD MONTGOMERY O'RORKE (1894–1977), painter. Born in Belfast, Dickey studied at Wellington College, Berkshire and then at Trinity College, Cambridge, where he obtained a Master's degree. He then attended the Westminster School of Art, studying painting under Harold Gilman. His early output included wood engravings, such as *Farmers on the Train* [139], a print showing a heated conversation between two men in a railway carriage. A founder member with Robert Gibbings of the Bewick Club in 1920, Dickey was an original member of the Society of Wood Engravers and illustrated Richard Rowley's book of poems *Workers* (1923). In 1922 he contributed an engraving to *Contemporary English Woodcuts*, produced by Thomas Balston.

After World War I, Dickey lived in County Antrim, painting mainly landscapes and town scenes, and in counties Down and Donegal. In addition to showing at the RA and the NEAC, he exhibited at the *Oireachtas Art Exhibition* in 1920, the Leicester Galleries in 1923, and the Manchester City Art Gallery the following year. He also showed with the Belfast Art Society in the 1920s. In 1921 he was included in the exhibition *Un Groupe de Peintres Anglais Modernes* organized by Robert Bevan and held at the Galerie Drouot in Paris. The exhibition was arranged mainly to promote the artists of the Cumberland Market Group, an offshoot of the Camden Town and London artists' groups that included John Nash, Christopher Nevinson and Edward McKnight Kauffer. Dickey's painting *Soho* (1919, private collection), urban but not avante-garde, is characteristic of the Camden Town Group, as is his *Kentish Town Railway Junction* (1919, Victor Batte-Lay Trust collection, Colchester) where the pattern formed by intersecting railway lines hints at Cubism (qv) while remaining determinedly representational.

Loughislandreavy, Co. Down (1921, private collection), with its strong patterning of trees against mountain and lake, shows Dickey to have been an artist sensitive to landscape (qv), evident also in works such as *Farm in Landscape* (private collection) which recalls the style of Paul Henry (qv). From 1926 to 1931, Dickey was Professor of Fine Art at King Edward VII School of Art, Armstrong College (now part of Newcastle University), close to Gateshead. During this period he painted *The High Level Bridge* (1927), depicting the bridge designed by Robert Stephenson at Gateshead, and the following year he recorded the building of the Tyne Bridge in a finely executed painting now in the Laing Gallery in Newcastle upon Tyne. From 1931 to 1957 Dickey was staff inspector of art for the UK Ministry of Education and from 1939 to 1942 he served as secretary to the War Artists Advisory Committee, which he joined in that latter year. In 1944 he contributed a foreword to *The Irish Scene*, a book of prints by the Belfast painter William Conor (qv).

From 1957 to 1962 Dickey served as first curator of the Minories Art Gallery in Colchester. He painted extensively on the Continent; *In the Volscian Mountains* (CAG) was painted in the mountains south of Rome. Dickey was awarded a CBE in 1952. PETER MURRAY

SELECTED READING Upstone, 2007; Snoddy, 1996.

DILLON, GERARD (1916–71), painter [140, 141]. The independence that characterized Gerard Dillon's paintings was evident from the start of his career, when he abandoned evening classes at the Belfast School of Art, fearing that they might

interfere with his personal artistic vision. The youngest of eight children, Dillon started work as a house painter at the age of fourteen, but pursued a self-directed course as an artist in London and Dublin. In Dublin he was greatly encouraged by Mainie Jellett (qv), who persuaded him to join the SDP and opened his first exhibition at the Country Shop, St Stephen's Green, in 1942. In return, Dillon became an active member of the IELA (qv), serving on its committee for the best part of twenty years.

A year later Dillon showed at the Contemporary Picture Galleries in Dublin with fellow Northerner Daniel O'Neill (qv), with whom he formed a friendship, celebrated later in paintings such as *In the Studio* (undated, private collection). Dillon lived in London from 1934 to 1941 and again from 1945 to 1968, where the house he shared with his sister Molly on Abbey Road was an important meeting place for Irish writers, artists, actors and musicians. While Dillon himself showed considerable facility as a writer and a performer, painting remained his preferred art form. He came back regularly to Ireland, spending the war years there, and with important working interludes in the late 1940s and '50s in the west at Inislacken and Roundstone in County Galway with George Campbell (qv), his wife Madge, and Nano Reid (qv), and in Drogheda and the Boyne Valley, also with Reid. Dillon's serious commitment to his art was carried out against a backdrop of hard manual labour on post-war demolition sites in London and house painting, but none of this interfered with his open approach to experimentation in his art, informed by his instinct for the primitive and by the theatre, to which he was particularly attracted. While his work was highly stylized, and he occasionally flirted with abstraction (qv), as in *Bagdad* (1963, HL), he remained predominantly a figurative painter.

Like Reid, to whom he was close, Dillon was interested in the folklife of Ireland, the rituals of the countryside, and the historical legacies of ancient stone carvings. His work was strongly influenced by the compartmentalization and primitive directness of carvings on early Christian high crosses, by his childhood love of cutting out and rearranging images from newspapers and magazines, and by borrowings from the theatre. Despite the obvious affection for the folklife represented in his work, there is also a strong sense of alienation, which may derive from perceptions of his difference as an artist, and also from his homosexuality in a repressive Roman Catholic environment. Although Dillon's interests in the art of ancient Ireland and the simplicity of rural life were shared by others, including Reid and Louis le Brocquy (qv), that sense of alienation rendered his paintings quite distinctive.

The naïve freshness and spontaneity of Dillon's work and his feeling for texture, rhythm and form made his work exceptional in mid-century Ireland, and earned him recognition in both Ireland and London. This is clear from the number of solo exhibitions he was given: at CEMA in Belfast in 1946 and 1950, at Waddingtons in Dublin in 1950 and 1953, and in London, at the Leicester Galleries (1946), Heal's Mansard Gallery (1948) and Tooth's in 1951. The culmination of this series of exhibitions was solo exhibitions at the Whitechapel, London in 1963, and at the ACNI Gallery in Belfast in 1966. Dillon's work was also shown in

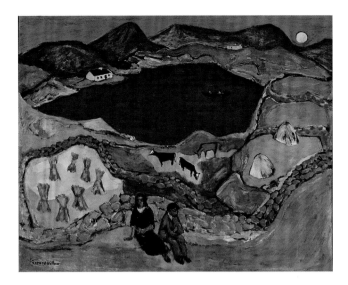

140. Gerard Dillon, *The Black Lake*, c. 1940, oil on board, 56 x 70 cm, Arts Council/An Chomhairle Ealaíon

exhibitions in Paris and Rome, and in the USA, in Boston, Washington, New York and Pittsburgh in 1958 when he represented Ireland (Guggenheim International) and Great Britain (Pittsburgh International Exhibition).

The level of celebrity that this exhibition profile suggests might not seem compatible with work on building sites. What it indicates, however, is the general hardships to which Dillon and other artists from Northern Ireland, such as O'Neill and Colin Middleton (qv) – despite stipends from Victor Waddington – were exposed in the years after World War II. Dillon turned the wide experience he gained from his other activities to good

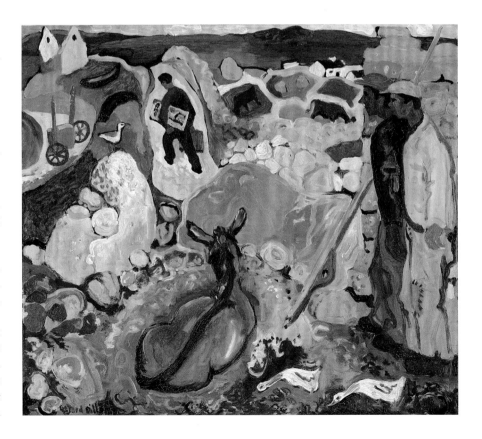

141. Gerard Dillon, *Island People*, c. 1950, oil on board, 58.4 x 68 cm, Crawford Art Gallery

effect, using left-over sand from a building project to add texture to his pigment, and experimenting in his pictures with found materials, such as string, stones, bone, old gloves and fabric. Typically, when he became interested in tapestry (see 'Stained Glass and Tapestry'), he refused to get professional weavers to work to his cartoons as le Brocquy and others did, preferring to learn the rudiments of the craft and then to create his tapestries from concept to finished work himself.

Keenly aware of mortality, Dillon was deeply affected by the deaths, in their early fifties, of his three brothers from heart disease. During the 1960s he created a number of paintings in which the character of a pierrot figure, sometimes masked, can be read as an alter ego, providing him with the means to represent biographical material, but with a level of objectivity. *Space Circus* (undated *c.* 1965, IMMA collection), in which the artist, clearly recognizable in the foreground, points to three figures floating in a vortex around him, is typical of this body of work. Elements of Surrealism (see 'Surrealist Art') in these artworks replace a tendency towards Expressionism (qv), more evident in his earlier west of Ireland paintings, and this is heightened by his use of collage, which facilitated experimentation with composition, and the juxtapositions of things not normally shown together.

Dillon also experimented with designs for the theatre, producing costumes and sets for the Abbey Theatre's 1968 production of Seán O'Casey's *Juno and the Paycock*, in conjunction with Arthur Armstrong and Campbell, and a poster for O'Casey's *Red Roses for Me*. But the highlight of his graphic experience was the classes he attended in 1969 at the recently established Dublin Graphic Studios. His teacher there, the noted printmaker John Kelly (qv), said that Dillon was 'of all the artists I have taught, the most natural' (White, p. 109).

Dillon's activism, which led him to serve on the committee of the IELA (qv) from the 1940s right through to the 1960s, and to become one of the five artists in 'The First Group', founded in London in 1961 to lobby for touring opportunities, was not confined to the artistic milieu. As his biographer and friend James White pointed out, Dillon was a Roman Catholic nationalist. In 1969, following the outbreak of the 'Troubles' (qv) in Northern Ireland, he refused to allow his work to be shown in the Belfast phase of the Living Art exhibition of that year, and petitioned other artists to join with him in this action as a protest against the presence of British soldiers on the island of Ireland.

Dillon died in 1971, at the age of fifty-five, from the heart disease that had caused the deaths of his brothers. A year later a retrospective exhibition of 104 of his artworks in a variety of media was held, at the UM, Belfast and at the HL. Dillon is now recognized as one of the most individual talents of mid-twentieth century Irish art and his work can be seen in the collections of all the major museums and leading corporate collections in the country. Catherine Marshall

SELECTED READING *Gerard Dillon: Retrospective,* exh. cat. UM and HL (Belfast 1972); James White, *Gerard Dillon: An Illustrated Biography* (Dublin 1994); Catherine Marshall, 'Gerard Dillon 1916–1971', in Marshall, 2005, pp. 42–49; Coulter and Ruane, 2009.

DIXON, JAMES (1887–1970), painter. In Peadar O'Donnell's novel *The Big Windows* (1955), Brigid, the girl from Tory Island, remarks to some of the women from the mainland community in which she has come to live that the island people were constantly in touch with the world because of the regular interaction between them and sailors from all over the globe. In some ways it is not surprising, then, that there should have been artists on Tory Island long before Derek Hill (qv) 'discovered' James Dixon, some time around 1957, and no surprise at all that while Dixon was happy to accept the assistance of a mentor from the world beyond the island, he was quick to reject whatever he felt was superfluous to his requirements.

Derek Hill's encounter with Dixon came at a time when there was a growing interest in the art of self-taught artists, or artists from contexts outside the mainstream of art production and display in the western world, combined with an increasing disenchantment with academic training and the preciousness of Modernism (qv). It seems likely that Dixon, already a man in his seventies when he and Hill met, and less involved by then in the professional maritime pursuits from which he had made his living, was prepared to devote more time to painting as a result of the encouragement he got from Hill. According to Hill's account, Dixon rejected the offer of artists' brushes in favour of making his own from donkey hair and opted for paper instead of canvas. In other words, he already knew what he could work with. However, since a lot of his uneven output is undated, it is not clear how much of his work predates his meeting with Hill. He is known to have constructed a ship in a glass case, which he gave to the yachtsman Wallace Clark in 1950, and some years later he gave Clark a painting inscribed *Mr Clark passing Tormore, Tory island in his yacht with a Whole Gale of S.W. Wind and rain with Jill and Others on Board after leaving Greenport with Daylight about the year 1952.*

Dixon was born on Tory Island and lived there for all his eighty-three years, with the exception of a short period as an instructor on a fishing course and occasional visits to the mainland. A boatman, fisherman and small-scale farmer, he was proud of his importance as the captain of the mailboat, which gave him regular contact with the mainland. Dixon was untutored as an artist but, unlike most 'outsider' artists (see 'Outsider and Folk Art in Ireland'), he was neither an obsessive painter nor one who was marginalized by his community. On the contrary, he was the most prominent of a group of Tory Islanders (see 'The Tory Island School') who painted and exhibited with him, including his brother, John Dixon, and James and Patsy Dan Rogers, all of whom were included in *Tory Island Painters,* their first exhibition at the New Gallery, Belfast, in 1968. It is worth noting that, almost coincidentally, the artist Maria Simonds-Gooding (qv) encountered Micheál Ó Gaoithín, also known as *An File* (the Poet), from the Great Blasket Island, off the southwest coast of Ireland, and encouraged his desire to paint his very similar world as he experienced it.

At the age of seventy-nine, in 1966, Dixon was given his first solo show at Belfast's New Gallery when he showed twenty-one oil paintings. A year later he had another solo exhibition at Leo Smith's Dawson Gallery, Dublin, and his paintings were included in an exhibition at the Autodidakt Gallery in Vienna in

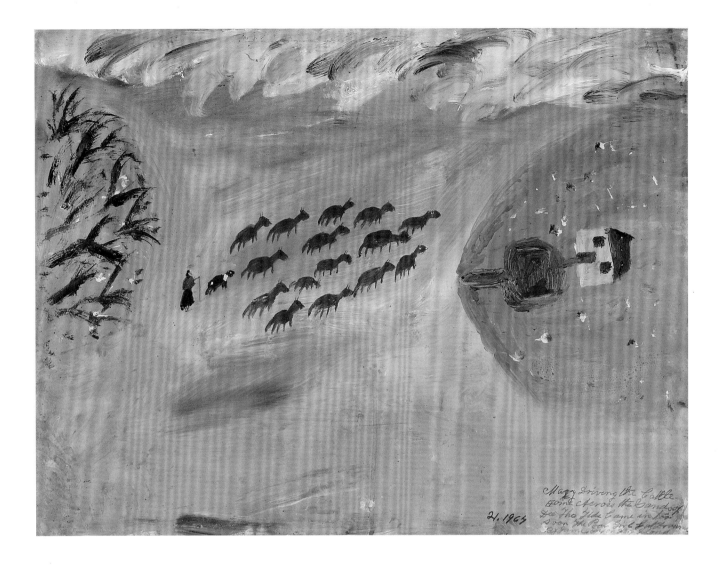

142. James Dixon, *Mary Driving the Cattle Home across the Sands of Dee*, 1967, oil on board, 57 x 71 cm, Arts Council/An Chomhairle Ealaíon

1968, when he also showed in London. By the late 1960s he had achieved considerable recognition, was visited on Tory by the critic John Berger and admired by the jazz musician George Melly, the great promoter of such Outsider artists as Scottie Wilson and Pearl Alcock in Britain. Dixon also had some of his work listed for sale at Sotheby's in London. He was one of the artists included in *Aspects of Landscape*, AC/ACE (1970), *Irish Primitive Painters*, QUB, *Elements of Landscape*, HL (1976), *Irish Art 1943–1973*, at Rosc in Cork (1980), and an Arts Council touring exhibition, *Tory Island Painters* (1983). In 1999/2000, IMMA and Tate St Ives collaborated to present a retrospective exhibition entitled *Two Painters: Works by Alfred Wallis and James Dixon*, in which Dixon was shown alongside Wallis, whose work was highly regarded by the St Ives School of painters.

An important element of Dixon's work was his desire to chronicle significant local events, such as the arrival of the first tractor (NMNI) and motor boat on Tory, or the landing of the first helicopter (1967, Kettle's Yard), as well as significant events, such as *The first Airship that ever passed over Tory Island on her way to America* (1968). His paintings are either imaginative, expressive responses to direct experience, as in *Mary Driving the Cattle Home across the Sands of Dee* [142] or spring entirely from imagination and folk memory, as in *West End Village, Tory* (1964) [483] and *The Gypsy Moth rounding Cape Horn*. He also tried his hand at portraiture (qv) and his work in this genre includes a self-portrait with the Irish flag (1963, private collection), as well as portraits of Queen Elizabeth II and Winston Churchill, to both of whom he sent the finished works.

Dixon also painted the topography of Tory Island, his paintings of West End village revealing his primitive approach to perspective and his ability to render dramatic weather conditions. Paintings of the sea are among his finest works, whether he is recording a shipwreck or a storm, but Derek Hill quoted him as saying, 'there is nothing romantic about little boats, fighting with crashing waves and winds' (Hill, 1993, p. 179). If he refused to romanticize the sea or life on the island, he was, nonetheless, aware of the predilections of his clients, mainly tourists who visited Tory. Dixon's work was avidly collected and can be seen in Kettle's Yard, University of Cambridge, the Scottish National Gallery of Modern Art, AC/ACE, HL, the Glebe Gallery, Co. Donegal, AIB and the Bournemouth Public Gallery.

CATHERINE MARSHALL

SELECTED READING Hill, 1972; Derek Hill, 'James Dixon', *IAR Yearbook*, IX (1993), 179–82; Glennie, 1999; Bruce Arnold, *Derek Hill* (London 2010).

DOHERTY, JOHN (b. 1949), painter. It is the acute observation of detail that gives John Doherty's work its sense of intense realism. Meticulously rendered to show every scuff mark in the painted surface of a rotting door, or the moss clinging to the roof tiles of a defunct village petrol station, Doherty's work presents images of nostalgia with a reserved objectivity.

He is best known for his frontal depictions of the kind of buildings that were typical in Irish towns in the economically depressed years of his childhood, but he has also explored unusual objects and structures for their form, such as the series of harbourside buoys, forming rusting still-life compositions on their quaysides. As with many of his scenes, the series depicting the gleaming upper bodies of whitewashed lighthouses are of actual structures.

Doherty's images have been described in terms of Realism (qv). However, despite the obsessive attention to detail that might suggest literal objectivity, they are also evocative and mysterious. In many, the even light gives little sense of the time of day, and all depict man-made environments devoid of their human occupants. The resolutely closed doors and empty Sunday streets suggest the ennui of places where lives are lived but nothing happens – an in-between existence without extremes. *Five Bells* (2001/02) [143], a typical example, presents an inscrutable exterior whose scruffy door shows five doorbells and as many curtained windows, evincing the separated existences of inhabitants secreted behind a single door. Text appears in some images, promoting commercial products or identifying ships or shops, such as in *McCarthy's Garage* (2002), its function primarily to suggest a literal and photographic objectivity – as though photographs were not as selective and manipulable as painting.

Despite the typical dilapidation of the scenes, they succeed in avoiding pathos or judgment. Some are even playful, particularly when inanimate structures evoke thoughts of human characteristics, as in *The Ballerina* (2004), where an industrial ventilator suggests a dancer's garb.

Most of Doherty's compositions demonstrate abstract qualities, and the frontal buildings, with their reticent stillness and balance, have been related to photographic work by abstract painter Sean Scully (qv).

John Doherty was born in Kilkenny and trained as an architect at Bolton Street College of Technology, Dublin, before turning to art full-time. He was Artist in Residence at the National College of Art, Port Moresby, Papua New Guinea in 1979. He has lived in Australia and Sweden, as well as Ireland.
YVONNE SCOTT

SELECTED READING Hilary Pyle, *John Doherty: Recent Paintings*, exh. cat. Taylor Galleries (Dublin 2005).

DOHERTY, WILLIE (b. 1959) (qv *AAI* III), artist. In the years between 1969 and 2001, the 'Troubles' (see 'The Troubles and Irish Art') made a profound and divisive impact on Irish society. However, the number of Irish artists who have confronted issues raised by the Troubles remains relatively small. The topic was avoided or approached obliquely through a widespread use of symbol and metaphor but, for the most part, artists were uneasy when it came to examining sectarian violence or the world-view of paramilitaries. An exception is Willie Doherty, whose photomontages and videos, made for the most part in Derry throughout the 1980s and 1990s, provide an alert and intelligent commentary on the realities of life in a province wracked by conflict. Born in Derry, Doherty grew up in that city. After studying at the Ulster Polytechnic in Belfast, he returned to Derry where he lives and works. He cites the Orchard Gallery, a small but important art gallery in Derry, as a significant venue, where as a student he encountered the work of artists such as Magdalena Abakanovicz and Richard Hamilton.

From the outset, Doherty avoided those images that became synonymous with the Troubles – scenes of marchers, petrol bombings, armoured vehicles and riot police. He employed, instead, a more distanced approach, using photographs (see 'Photography') of locations such as the city walls of Derry or the Bogside, local settings resonant with political meaning. In these works people rarely feature directly; the urban landscapes are presented as deserted places. Language, the power of words to affirm or denigrate communities and individuals, is also employed, through the use of superimposed texts. In the 1985 diptych, *Fog: Ice/Last Hours of Daylight* (1985), a black-and-white photograph shows countryside seen through fog. The words 'shrouding/pervading' are superimposed over the image, while in the second photograph, images of housing in Derry, with smoking chimneys creating a different sort of fog, are accompanied by the words 'Stifling/surveillance/last hours of daylight'. The words and images are a commentary on efforts by the British army in Northern Ireland to impose civil order by placing large sections of the community under sustained surveillance. *The Walls*, [144] a photographic work made in 1987, features a panoramic view of the Bogside, a nationalist area in Derry, notorious for protests and riots during the 1970s and '80s. The superimposed texts, in green and blue respectively, read 'always/without' and 'within/forever'. Again, the images and

143. John Doherty, *Five Bells*, 2001–02, acrylic on acid-free board, 30 x 45 cm

THE WALLS
WITHIN FOREVER

texts refer to nationalist and unionist points of view, as do the colours of the texts.

Much of the tragedy of Northern Ireland lay in the belief, held firmly on both sides of the religious and social divide, in exclusive ownership of the 'truth'. Doherty's art critiques this notion showing it to be threadbare and ultimately insubstantial. In the slide installation *They're All the Same* [145], a screen presents the face of a man accused of being a member of the Irish Republican Army. Overlaying the image, a soundtrack, a monologue, lists both affirmative and pejorative descriptions routinely applied to members of different communities in Northern Ireland. Such sentiments represent the psychological underpinnings of the Troubles, where stereotyping becomes normal, and, in a self-perpetuating cycle, acting out stereotypes also becomes routine. Doherty's work challenges the easy assumptions that characterized community relations during the worst years of the Troubles. Similarly, in the two-screen slide installation *Same Difference* (1990) [235], an image of a woman's face becomes something else when the viewer learns that the woman had been arrested as a suspected member of the IRA. In the Cibachrome print, *Border Road* (1994), concrete barriers block a quiet country road, an understated but eloquent record of the local impact of partition and guerrilla warfare.

The world depicted in these early works is one in which words with diametrically different meanings can be applied, with conviction, to describe the same event, or person. Doherty appropriates techniques used in advertising and journalism, juxtaposing image and text; but by paring back both images and text to the minimum, he provides little information to explain what is happening, and so leaves it up to the viewer to interpret his work, or to provide a narrative. Since each viewer's interpretation of the works will differ, so Doherty highlights the subjectivity of the artistic experience, while remaining rooted in the world of everyday experience.

A more autobiographical work, *30th January 1972* (1993), a slide installation with two projectors, refers to Bloody Sunday, a massacre of thirteen protesters in Derry. Mixing archival images of marchers with live recordings made during the event, *30th January 1972* differs from other works by Doherty in that it refers to a specific incident. However, the work also analyses how history is created; by combining the reminiscences of those who were present, with those who were not, he emphasizes how memory can be deceptive. Doherty himself witnessed the Bloody Sunday massacre when he was just thirteen years

144. Willie Doherty, *The Walls*, 1987, photograph with text mounted on Masonite, etn unique, 61 x 152.5 cm, Irish Museum of Modern Art

145. Willie Doherty, *They're All the Same*, 1991, slide installation with single projection on to a wooden construction in a darkened space, colour, audio, 3 min

old. A more typical work is *The Outskirts* (1994), a large-scale Cibachrome photograph, showing an anonymous bend in a country road. Tracks of vehicles testify to some activity, but what that was is not revealed. Trees and hedges partly obscure the horizon, where light appears to be fading. Twilight and night are favourite times of day for Doherty, heightening a sense of foreboding, anticipation and mystery. A series of more recent black-and-white photoworks feature a footbridge crossing the Westlink road in Belfast. Although Doherty took the photographs in 1988, some of the work in which they feature was created in 2008.

In Doherty's art, memory and a sense of place are juxtaposed with the everyday experience of life, in such a way as to reduce the certainty of concepts such as truth and objectivity. Growing up in Derry during years in which civil unrest frequently intensified into rioting and open warfare, Doherty was acutely aware that the conflict was grounded in notions of cultural difference. Unlike many of his contemporaries, who moved to London after graduating in order to free themselves from the claustrophobic atmosphere of Northern Ireland, Doherty returned to his native city and chose to remain living and working in what was, in many ways, a frontline city in a war zone. In spite of the immediacy of this environment, he deliberately maintained a distance from the vociferous and emotional world around him, and from the rhetoric that spilled out on the airwaves and on the streets. Instead, his art is characterized by a dispassionate approach, in which experience is carefully filtered and analysed.

Doherty tends to deal with the aftermath of violence, rather than its present. There is a quality of stillness in the work, the silent witnessing of events, many of them disquieting. His video, *Re-Run* (2002), included in the 2003 Turner Prize exhibition, projected images of a man running endlessly across the Craigavon bridge, on to two opposing screens. Spanning the river Foyle in Derry, this bridge can be read as a link between divided communities. In *Drive* (2003), again there are two video images, one of a man driving with his eyes open, the other showing the same man driving with his eyes closed. A sense of mystery pervades these later works, making them even more ominous than the artist's early works. Doherty's protagonists, his images of urban life, share the distanced sense of Edward Hopper's images of people in roadside cafés and hotels. They possess a 'Film Noir' quality, in part inspired by cinema.

Since the signing of the Good Friday Agreement in 1998, and the cessation of violence in Northern Ireland, Doherty has continued to make his characteristic photo-text and video installations (see 'Installation Art'), but they now include images from other cities, such as Berlin. His visual vocabulary continues to incorporate images of steel fencing, antennae, roads and office buildings, imbued with a generalized sense of disquiet and trepidation. Doherty's later photographic works are often in colour, and are larger in scale than the early photo text pieces, while the artist has also, in recent years, incorporated video installations into his practice to a greater degree.

In 1993 Doherty represented Ireland at the Venice Biennale, and the following year was shortlisted for the Turner Prize for the first time. Two exhibitions of his work were held in 1996, at the Kunsthalle in Bern and the Art Gallery of Ontario. In 1998 his work was shown at Tate Liverpool, while the following year an exhibition was held at the Renaissance Society in Chicago. A solo exhibition of Doherty's work was presented at IMMA in 2002/03, and he was again shortlisted for the Turner Prize in 2003. In 2002 Doherty represented Britain at the São Paolo Biennial, while in 1999 he represented Northern Ireland at the Venice Biennale. His work is represented in museums both in Europe and the United States. *Empty*, a 16 mm film transferred to video, was acquired by MoMA in 2007. *The Bridge* (1992) is in the Tate, as are *Remote Control*, a print dating from that same year, and *Re-Run. Ghost Story*, a fifteen-minute film written and directed by the artist, with text narrated by the actor Stephen Rea, was acquired in 2009 by the Dallas Museum of Art. Doherty's work is also represented in the collections of IMMA, CAG, the Albright-Knox Art Gallery in New York, the Carnegie Museum in Pittsburgh, the Kiasma Museum of Contemporary Art in Helsinki and the De Appel art centre in Amsterdam.
PETER MURRAY

SELECTED READING Ben Tufnell, *Turner Prize 2003*, Tate Britain (London 2003); Charles Merewether, *Willie Doherty: Re-Run*, exh. cat. 25th São Paolo Biennial (2002); Carolyn Christov-Bakargiev and Caoimhín Mac Giolla Léith, *Willie Doherty: False Memory,* exh. cat. IMMA (Dublin 2002).

DONAGH, RITA (b. 1939) [146], mixed-media artist. The daughter of an Irish mother and Anglo-Irish father, Rita Donagh was born and raised in the 'Black Country' in the English midlands, but her life and work have been greatly affected by her connection to Ireland, particularly after the outbreak of the 'Troubles' (qv) in Northern Ireland from the late 1960s onwards. Throughout her career, her art, as Michael Bracewell noted, 'maintains a palpable tension between the exploration of technique and the articulation of political events and social identities' (Bracewell, review of Rita Donagh at the Ikon Gallery, *Frieze*, no. 97, March 2006).

After graduating from the University of Durham, Donagh taught variously at the universities of Newcastle upon Tyne and Reading, as well as at the Slade School of Art and Goldsmiths College, London. Her highly conceptual and politically charged artwork has always employed careful draughtsmanship and realistic representation (see 'Conceptual Art' and 'Politics in Irish Art'). In the 1970s, perhaps influenced by her husband Richard Hamilton, she introduced collage to her work and by the mid-1970s was using cartographic methods to call attention to the contested geography of the six counties of Northern Ireland, a political entity created by the Government of Ireland Act 1920. Another body of work involved disturbing aerial views of the H-Blocks in 1979/80 coinciding with the first hunger strike there. Donagh's interest in Northern Ireland continued into the 1990s when she exhibited *Downing Street Declaration* (1993), which included an image of the then Prime Minister, John Major. As Bracewell has also pointed out, her work 'establishes a thematic link between documentary evidence of a situation, its subsequent mediation and its eventual reconstitution, in art, as a form almost of cultural pathology, at once commemorative and diagnostic'.

146. Rita Donagh, *Long Meadow*, 1982, oil on canvas, 152.4 x 152.4 cm, Tate

essentially a contemporary artist, casting a sceptical eye on the world around him.

Born in Belfast, Micky Donnelly studied first at QUB between 1971 and 1973, before enrolling at the University of Ulster in 1976, where he graduated with a BA in Fine Art in 1979. Two years later, he was awarded an MA and in 1985 he received an ACNI scholarship to the British School in Rome. In the years following, Donnelly received several British Council and Arts Council travelling awards, while exhibitions of his work were held at the Fenderesky Gallery in Belfast, the Taylor Galleries in Dublin, and the Orchard Gallery in Derry. In these exhibitions, motifs and symbols were treated lovingly, almost reverentially, but the message conveyed was often sceptical, or even pessimistic. In 1992, at an exhibition at the Orchard Gallery, Donnelly exhibited *Landscape with Donkey's Feet*, a work subtitled 'Henry's Dawn' [147], in which a crippled and neglected donkey was superimposed over Paul Henry's iconic landscape of Killary harbour at dawn.

While Donnelly is perhaps best known for his lily and bowler hat paintings, his approach evolved through the 1990s. At an exhibition held at the Butler Gallery in 1997, he showed paintings made using acrylic and ink, in which the images had been formed by folding the canvas to achieve a mirror image, similar to the Rorschach inkblot technique. In 1981 Donnelly was a founder member of both *Circa* art magazine and the Artists' Collective of Northern Ireland, and of the Queen Street Studios three years later.

In addition to exhibiting throughout Ireland, Donnelly has showed work several times in Germany, in Munich, Kassel, Mainz and Berlin. An exhibition of his paintings was held in 1988 at Glasgow's Third Eye Centre. He has also been included in exhibitions that toured to Mexico, Australia and Canada. In 1993 he was in the *Three Irish Artists* exhibition, held at the Prospectus Gallery in Chicago, and two years later,

While Donagh's work is resolutely political, whether referring to military and police violence in Northern Ireland or gay rights in New York, this interest is always matched by a scientific interest in the process of representation. Her work was shown at the Orchard Gallery in Derry (1989) and at IMMA (1995), and a retrospective exhibition of it covering the period between 1956 and 2005 was held at the Ikon Gallery, Manchester, in 2005. The Tate Collection includes eight of her artworks.

CATHERINE MARSHALL

SELECTED READING Michael Regan (ed.), *Rita Donagh: Paintings and Drawings*, exh. cat. Whitworth Art Gallery (Manchester 1977); Sarat Maharaj, *Rita Donagh 1974, 1984, 1994: Paintings and Drawings*, exh. cat. Cornerhouse Gallery, Manchester; Camden Arts Centre, London; IMMA (Manchester 1994).

DONNELLY, MICKY (b. 1952), painter. In Irish art of the twentieth century, the paintings and prints of Micky Donnelly are instantly recognizable. Using traditional, almost academic techniques, he often depicts isolated objects, such as a hat or a walking stick, against a plain background. These apparently simple images offer a critique both of Irish visual culture, and of those symbols of Irish life and politics which by the mid-century had become established as a national canon. Within this canon, bowler hats were understood to represent unionist beliefs and aspirations, while lilies symbolized the nationalist struggle. However, the ironies and paradoxes inherent in attempts visually to define national identity underlie many of Donnelly's paintings: in the eighteenth century, the lily was also used as a symbol of Ulster Protestantism. The intermingling of past and present is an important element in Donnelly's art, but he is

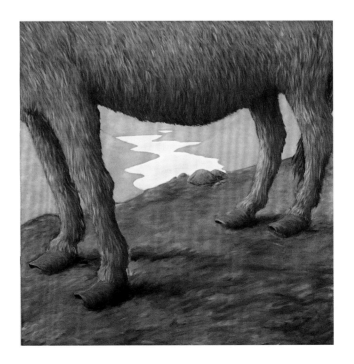

147. Micky Donnelly, *Landscape with Donkey's Feet (Henry's Dawn)*, 1987, oil on canvas, 168 x 168 cm, private collection

the exhibition *Twelve Irish Artists* at the Itami City Museum of Art introduced his work to audiences in Japan. Donnelly is represented in many collections, including IMMA, UM, AIB, the Limerick Contemporary Art Society and the OPW.
PETER MURRAY

SELECTED READING Joan Fowler, *Micky Donnelly: Paintings, Drawings, Prints 1986/87*, exh. cat. ACNI Gallery, Belfast and Orchard Gallery, Derry (Derry 1987); Lewis Biggs, *Cries and Whispers*, British Council touring exhibition of contemporary British paintings, exh. cat. (Manchester 1988); Nuala Haughey, 'Micky Donnelly: Profile', *IT* (7 June 1992).

DRAWING. 'I am all the time drawing', the artist Alice Maher (qv) declared, 'Not with a pencil, or a piece of charcoal, but just drawing in my head It's a feeling-thinking way of understanding time, weight, space.' (Savage, p. 19) As Maher's words indicate, the importance of drawing in an artist's practice cannot be overstated, even for those artists such as Caravaggio or Vermeer, or, in twentieth-century contexts, lens-based artists such as Gerard Byrne or Willie Doherty (qqv), who have left us little or no evidence of their use of it. At the beginning of the twentieth century, Jack B. Yeats (qv), one of the great innovators in Irish art, told Sir John Rothenstein, 'the painter always begins by expressing himself with line – that is by the most obvious means' (Pyle, p. 24).

While agreeing with each other about the centrality of drawing, Yeats's and Maher's comments point to very different attitudes to it in art practice over the years. Those differences may be explained in part by the evolution of drawing, not just in Ireland but in western art, during the intervening period. In Yeats's day, drawing continued to be seen as it had been during the Renaissance, as the servant of painting and sculpture but never their equal. On the positive side, however, drawings, even then, offer a sense of spontaneity that more finished work often lacks, while the opportunity to see the artist working out the early stages of an idea through drawing has always attracted the attention of a small, but discerning, audience.

Michael Craig-Martin (qv), whose innovative use of drawing made him into one of the most highly acclaimed artists at the end of the twentieth century, argues that there is no single form of 'good drawing' and that those who believe there is are overly influenced by the classical western tradition (Savage, p. 10). Penelope Curtis, writing about the differences between the drawings of painters and sculptors, points out that: 'Drawing in general has become more diverse, liberated as it now is from the tradition of drawing from life, or from the Antique, and it may be because of the demise of this shared tradition' that sculptors' and painters' drawings are now quite different from each other (Marshall, 1997, p. 30).

From the life room to revolution
That western classical tradition of drawing from the Antique was still the dominant one when the Dublin Sketching Club, founded in 1874 and exhibiting annually since 1876, began to organize sketching outings. However, although the Club's collective activity centred on drawing, its annual exhibitions took

the form of more 'completed' painting and sculpture. This was also true of the Belfast Ramblers Sketching Club (forerunner of the Royal Ulster Academy (qv)). While both clubs were avant-garde in the 1880s, with the Dublin Club even inviting James McNeill Whistler to participate in its annual exhibition, they were basically conservative.

Drawing from the antique and the life model continued to be the feeding ground for artists such as Sir William Orpen (qv), who trained at the Slade School in London under the legendary Henry Tonks. Orpen's prodigious facility with the pencil won him instant recognition, cementing a belief in a pedagogical approach that later dominated his own teaching at the Dublin Metropolitan Schools (DMSA), and left a lasting influence on his pupils Seán Keating, Margaret Clarke (née Crilly) and Patrick Tuohy (qqv) and, through Keating and Maurice MacGonigal (qv), on Irish students up to the 1970s. Noel Sheridan (qv), himself a rebel against that influence, could, in 1996, describe a drawing by Carey Clarke (qv) as testing Henry Tonks's rules about the power of the boundary line (Sheridan, p. 114). The Tonks regime barely differed from the French *beaux arts* tradition of the eighteenth century. Liam Belton (qv) outlined it briefly as two years of drawing from antique casts, six months of anatomical drawings in the city's hospitals and, finally, entry to the life-drawing class, where the teacher inevitably would pronounce on the quality of the work in proportion to its accord with established tradition (Savage, p. 279). Neither the DMSA nor the National College of Art (NCA; since 1971 NCAD) showed any awareness of new attitudes to drawing emerging from the work of Klee and Kandinsky at the Bauhaus Schools in Germany since the 1920s. Belton recorded the changing context in the 1960s that led students to smash the antique casts in NCA and to demand a more catholic approach to drawing.

Paddy Graham (qv) [148], describing the oppressiveness of the old order, said:

> It was only when I saw [Emil] Nolde [1867–1956, German Expressionist painter] ... that the whole façade began to crumble. I saw this stuff and I was absolutely devastated – I hated it but I knew it was the truth as well. This was the awful thing. I thought it was crude, awful. Yet I thought it was absolutely stunning, such conflict, and that was the beginning of the end. (Marshall, 2010)

An appreciation of the expressive potential of line and mark-making slowly infiltrated Irish art, although, as Alice Maher has pointed out, as late as the 1980s it was still not permitted to present drawings alone for degree examination. That hostility to the drawing as a legitimate end in itself was swept aside by a generation of artists who made it the central focus of their practice in the 1980s and 1990s. The first intimations of this changing attitude were reflected in the teaching of more spontaneous, expressive drawing by John Kelly (qv) in NCAD when he persuaded students to create images to accompany strongly felt news stories; the appointment of Rob Smith to teach drawing; the example of Charlie Cullen (qv); and the controversial acquisition by the Hugh Lane Municipal Gallery from the

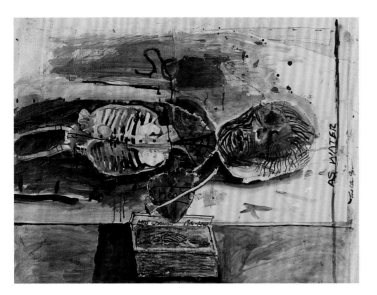

148. Patrick Graham, *As Water*, 1990, mixed media on board, 81 x 112 cm, Private Collection

Drawing as primary practice

The greatest accolade given to drawing by an Irish artist came in 1995 when the Premio Duemila at the Venice Biennale was awarded to Kathy Prendergast (qv) for thirty drawings from a work-in-progress, the 'City Drawings' (IMMA collection) [81]. By 1998 one hundred of these drawings earned Prendergast the Young Artist of the Year award at the Tate and they have since been shown in The Drawing Room in New York, the Sydney Biennale, and other venues from Helsinki to Shanghai. Prendergast exploited the sense of intimacy that drawings convey and, as in earlier work, used the motif of mapping as a means of commenting on the public and the private, colonization, globalization and the position of women in society. 'I would like my work to be seen as some kind of evidence of a private world', Prendergast has said, and her view is echoed by Rob Smith who saw drawing as 'a means of communicating with myself my thoughts about something … a cross-over from internal to external' (Sheridan, pp. 182,

149. Nick Miller, *Corban*, 1996, charcoal and conté on paper, 152.4 x 122 cm, Irish Museum of Modern Art

1980 *Rosc* exhibition of a graphite drawing, *Untitled No. 7*, by Agnes Martin.

Paul Klee had famously exhorted students to 'take a line for a walk'. Irish artists, following this advice, became more experimental in the materials and methodologies they applied to drawing. Far from the pencil or the charcoal stick, drawings now began to incorporate earth and wood (Brian King), ropes (Brian O'Doherty), lines of neon (Felim Egan, qv), concrete (James Concagh) and even wisteria branches (Patricia McKenna), sometimes taking on three-dimensional properties in the process. Furthermore, they could be made by using such varied practices as dipping prepared surfaces in a river and waiting for the water to mark them (Remco de Fouw), allowing nature to guide the hand to produce Helena Gorey's *Windy Drawings* [5], or fixing a pencil and paper in the boot of a car and letting the movement of the car dictate the resulting markings (Joe Stanley). Most radically, Brian O'Doherty (qv) presented cardiographs as a legitimate form of portraiture (qv) [388].

The old order could be said to have been put to rest by 1996 when NCAD marked 250 years of formal art education in Ireland not with a painting or sculpture exhibition, but with drawings alone, personally curated by the director Noel Sheridan. Sheridan had plenty from which to choose. Thanks to a steadily growing audience for drawing, he could happily present pages from the sketchbooks of Michael Healy, Hilary Heron, Rob Smith and Chris Maguire, drawings from the life model, preparatory drawings for paintings or other projects, or studies by Orpen, Keating, Seán O'Sullivan, Tom Ryan, Carey Clarke, Michael Kane and Sarah Purser (qqv), and a widely diverse range of drawings which were conceived as an end in themselves by later artists. Hughie O'Donoghue (qv) raised the profile of the medium by drawing in charcoal on canvas and on a massive scale, challenging painting in each of those aspects. His efforts were marked by the purchase of one of these, *Oxygen*, [340] for the national collection by the Irish Museum of Modern Art (IMMA) in 1997.

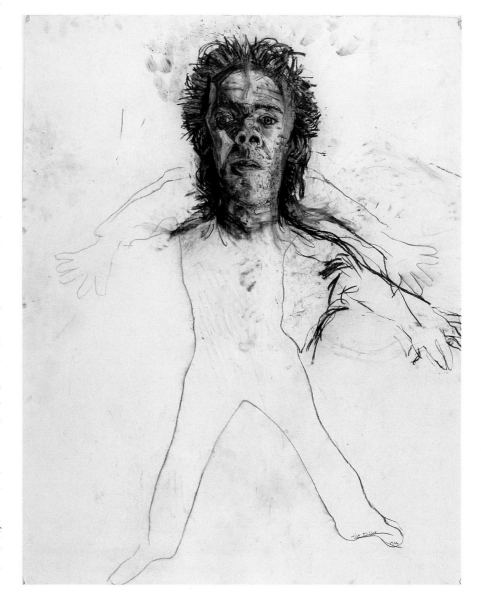

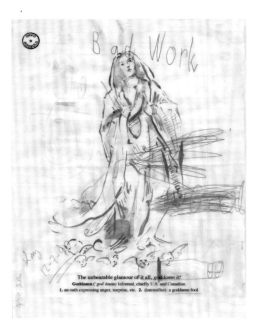

150 (right). David Godbold, *A 'Goddamn' fool (bad work),* 2003, ink and typed computer printout on tracing paper, laid over found drawing, 20 x 16 cm, private collection

151 (below). Tom Molloy, *Oak,* 1 of 96, 1998–99, pencil on paper, each one 25 x 32 cm, Irish Museum of Modern Art

152 (far right). Gerda Teljeur, *Drawing No. 39,* 2007, ink on paper, 80 x 108 cm, private collection

186). That intimacy is also the quality of drawing that most attracts Nick Miller (qv). His drawings of the dead, during a residency at the Royal College of Surgeons, and the strange closeness that entailed, led him to develop a revolutionary method of portrait drawing from, literally, inches above the sitter's head, as the subjects lay on the ground and he hovered over them with the paper on the ground beside them [149]. He pursued this impulse by doing landscape (qv) drawings from nature from the back of a van parked in the heart of woodland and rural settings. Alice Maher has always made drawing a key part of her practice, drawing larger-than-life-sized figures completely covered in hair, in which the depth of the charcoal surface appears to lift and move in a manner close to the hair itself. In *Bestiary* (2007) Maher did a complete exhibition at the Royal Hibernian Academy (qv) comprising charcoal drawings applied on to the gallery walls and paper, and smaller pencil drawings.

Other artists to develop the wall drawing include Paul O'Reilly and David Godbold (qv). Godbold combines manual dexterity, found objects and quotation in witty commentaries on art history and the present, on myth and daily experience, [150] while Eamon O'Kane combines large wall drawings with sculpture. Tom Molloy (qv) questioned his own facility with the pencil by drawing ninety-six oak leaves from life, erasing them and then drawing the series again from memory [151]. Other drawing installations by him include *Dead Texans* (2002) [311] and in 2011 he drew a facsimile text of excerpts from George Orwell's novel *Nineteen Eighty-Four.*

Others who see drawing as their primary medium include Gary Coyle (qv), who combines drawing with a gothic sensibility [86], Róisín Lewis, whose drawings emphasize the delicacy and temporality of the medium, and Gerda Teljeur, who works intuitively, allowing the rhythms of the body to influence the final abstract outcome [152] . David Lilburn's prints retain all the spontaneity of his drawings translated into a more systematic process, and drawing remains central to Anita Groener's (qv) practice even when using a paintbrush.

Digital drawing became an increasingly important element in drawing practice for the generation of artists coming to public notice by the end of the century. It is all the more interesting then that, despite the popularity of this approach with contemporary illustrators, Brian Cronin (qv), an artist with a leading profile in this field, chooses to continue to produce his internationally sought-after designs manually. Vera Klute's drawings with mechanized elements point to new directions for drawing in the twenty-first century.

CATHERINE MARSHALL

SELECTED READING Sheridan, 1996; Marshall, 1997; Maher, 1999; Savage, 2001; Hilary Pyle, 'The Jack B. Yeats Archive', in Yvonne Scott (ed.), *Jack B. Yeats: Old and New Departures* (Dublin 2008); Marshall, 2010.

DUFFY, RITA (b. 1959), painter. Ever since its beginnings, the work of Rita Duffy has been closely involved with the political conflict in Northern Ireland and its consequences (see 'The Troubles and Irish Art'). During the 1980s, years of particularly bitter strife, Duffy's early work (such as *The Marley Funeral*, 1988) used formal distortion and impassioned gesture that recall the work of the German Expressionist artists and the Portuguese painter Paula Rego, to convey the depths of an emotional response to extreme situations, while still retaining an awareness of both the specificities of place and the experience of constructions of gender. Many of these drawings and paintings focus on women in certain working-class communities of Belfast. *Mother Ireland* and her counterpart *Mother Ulster* (1989) [153a, 153b] combine astute critical perception of the everyday with an awareness of Ireland's fractured history in determining present experience.

In the 1990s, Duffy's approach appeared to soften into a more naturalistic handling of figures and scenarios that belied their increasing symbolic value and interrogative power. In the paintings *Banquet* and *Plantation* (1997, QUB), for example, meticulously depicted enclosures based on contemporary military installations open on to a history of colonialism and years of dispossession. Yet Duffy's naturalism also has a humanitarian purpose. The sheer scale of the oversized portraits in *House to House* (2002) restore dignity to the sitters – Belfast women who had suffered domestic violence.

153. Rita Duffy, (a) *Mother Ireland* (b) *Mother Ulster*, both 1989, oil on gesso-primed panel, 121.9 x 91.4 cm, private collections

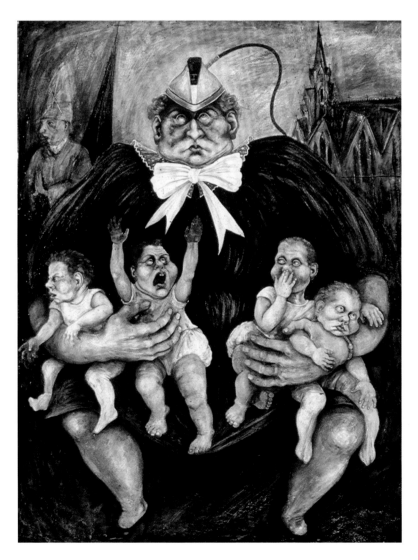

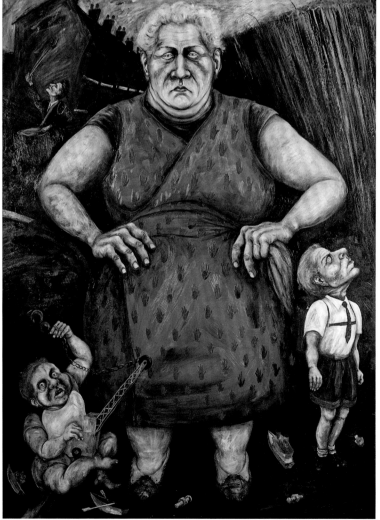

She also began to develop an interest in the depiction of clothing as carrying both personal memories and other meanings interwoven with history and politics, from the knitted Aran sweater in *Geansaí* (1996) to the barrister's robes in *Objection* (2006). Those public references recur in *Cúchulainn Comforted*, a notable collaboration with the poet Paul Muldoon, shown at the Millennium Court Arts Centre in Portadown in 2007, and which also included *Dessert* (2001), a decommissioned paramilitary weapon cast in chocolate to emphasize the seduction of violence.

The Northern peace process also made visible an awareness of deep psychological scarring produced by decades of political turmoil. Although Duffy was initially concerned with the effects on her immediate family, in the *Leadheads* paintings (2003, University of Hertfordshire and artist's collection) the role of trauma within a wider experience of cultural memory surfaced in her work through a preoccupation with the motif of icebergs, their hidden threat a potent metaphor for the difficulties facing a transitional society, as in the painting *Iceberg 1* (2003, artist's collection). For Duffy, such deep concerns are also anchored by history; more specifically, the destruction of the hopes of an earlier generation embodied in the Belfast-built craftsmanship of the *Titanic* in 1912. Yet Rita Duffy's work also embodies a fundamental belief in the ability of humanity to overcome difficulties: icebergs melt, and emotions and dreams locked in the past are themselves set free. FIONNA BARBER

SELECTED READING Fionna Barber, *Rita Duffy*, exh. cat. ACNI Gallery (Belfast 1989); Suzanne O'Shea, *Banquet: Rita Duffy*, exh. cat. Ormeau Baths Gallery, Belfast and HL, Dublin (Belfast 1997); Paul Muldoon, *Cloth: A Visual and Verbal Collaboration*, exh. cat. Millennium Court Arts Centre (Portadown 2007).

EDUCATION IN THE VISUAL ARTS (see *AAI* II and III, 'Education of Sculptors') [154]. For more than half of the twentieth century, education provision in Ireland was influenced by those factors that affect societies in a post-colonial state: provincialism, geographic isolation, civil war, poverty and social conservatism, all of which led, unfortunately, to stagnation in art education. The neutral stance that Ireland took during World War II further isolated it from potential economic and cultural development while the intertwining of Church and State was a conservative factor within the arts (Coolahan, chapters 1–4).

The impact of this was summarized in a specially commissioned report by the Scandinavian Design Group on the state of design in Ireland: 'The Irish school child is visually and artistically among the most under-educated in Europe.' (Córas Tráchtála Teoranta, 1962, p. 49)

This essay looks at art education and the arts in education throughout the century as the country attempted to deal with this legacy.

Art education at primary level
By 1900 every parish and many townlands in Ireland could boast a national school (Coolahan, pp. 7, 8) and almost fifty per cent of all national teachers had been trained – working alongside 'untrained' teachers or 'monitors'. A child-centred

programme, informed by the Belmore Commission (1897) and by the writings of Rousseau, Pestalozzi and Froebel, had added drawing and craft as a central element into the Victorian curriculum, focused until then on the three 'R's, reading, writing and arithmetic. They were to be taught in an integrated manner, in an applied context and teachers offered in-service training.

Unfortunately, this was hampered by the lack of trained teachers but, nonetheless, teachers and children benefited from the provision of more subjects within the curriculum and a more open form of inspection. For the first twenty years, the only visual arts subject offered as a compulsory part of the national school curriculum was 'drawing'. With Independence, even this was dropped to make room for the promotion of Gaelic culture and 'nation-building subjects', including the Irish language.

The Irish Free State established a Department of Education in 1924, which coordinated primary, secondary and technical education but brought few, if any, reforms (Coolahan, pp. 5, 6, 39). The Primary Certificate examination prioritizing the three 'R's and the Irish language was introduced as an option in 1929. This examination initially included five academic subjects, along with needlework for girls. Subsequently Eamon de Valera's administration reduced this to Irish, English and Arithmetic. The examination became compulsory in 1940, and remained in place until its abolition in 1967, but many pupils who entered the sixth standard never sat for the examination. Many Irish children started art school directly following this exam at fourteen years of age.

The emphasis on the Irish language continued until 1971, making curriculum reform difficult. Various attempts by the Irish National Teachers' Organisation and officials from the Department of Education throughout the 1940s and '50s to redress the lack of 'drawing and art' in the curriculum were unsuccessful (Coolahan, pp. 44–45). The Bodkin Report in 1949 revealed a neglect of art education and a lack of trained art teachers, while meagre support from the Department of Education was also a factor (Granville, p. 32). A Council of

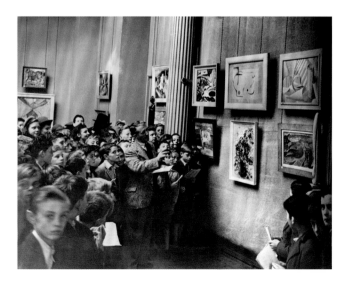

154. Schoolmaster from Scoil Colmcille, Marlborough Street, with his class at the *Irish Exhibition of Living Art*, 1944

Education, established in 1950, produced a report in 1954 urging the reintroduction of drawing at primary level. Although conservative, it confirmed the neglect of art and craft (Granville, p. 33).

It was not until 1971, when a new child-centred curriculum for national schools and a primary teachers' handbook, *Curaclam na Bunscoile*, were introduced, that reform began. Marking an important advance in Irish education, this introduced art and craft and music, emphasizing more open exploration, experimentation and discovery-type learning influencing art teachers training at the National College of Art and Design (Dervil Jordan, 'Initial Teacher Education in Art and Design: The NCAD Experience', MA thesis, NCAD, Dublin 2001, p. 45). Unfortunately a lack of in-service training for teachers meant that the implementation of this curriculum was left to the discretion of individual practitioners, many of whom had neither the knowledge nor the confidence to develop arts-based content in their teaching. Art was viewed as a leisure time pursuit, less important than academic subjects, while failure to coordinate curricula between primary and secondary levels brought other difficulties. However, in the 1980s and '90s many teachers, assisted by Arts Council (AC/ACE) (qv) initiatives, used the summer in-service programmes' structure to develop their knowledge and skills, and make contact with artists and arts organizations.

In 1999 a revised primary school curriculum overhauled visual arts provision and created a support unit of primary schoolteachers to implement its recommendations. Following a more structured approach than its predecessor in 1971, it presented the art syllabus in several strands: drawing, paint and colour, print, clay, construction, and fabric and fibre, alongside looking and responding to artworks and provided in-service training to all teachers. It recognized for the first time that these were vital aspects of a child's visual and aesthetic development, leading to a greater awareness of and participation in educational programmes in arts institutions and museums.

Art education at second level

At the turn of the twentieth century, second-level education was limited to a small, privileged minority. The education offered, mainly in private, religious-run secondary schools, was a general 'grammar-school type, humanistic and intellectual in character' (Coolahan, p. 53). From 1922, technical schools offered boys a range of construction and drawing subjects, while girls were confined to more 'traditional' subjects such as needlework and knitting. The new Department of Education introduced the Intermediate and Leaving Certificate courses in 1924. The Vocational Education Act of 1930 oversaw the development of technical education (which included art) and examinations were reorganized in 1936 and linked to the City and Guilds examinations of the London Institute (Coolahan, p. 100). In 1947 the Group Certificate offered boys art alongside mechanical and academic subjects, while girls were offered domestic economy. Art was still a peripheral subject, with only four per cent of all technical students choosing it (Coolahan, p. 95). Generally there was little commitment to teaching art, with few art teachers being trained or opting to take up posts in art education (Jordan, op. cit., p. 17).

In 1967 free secondary education became available to those who could afford to stay at school. In 1969 a revised Leaving Certificate programme was drawn up. In 1992 the Junior Certificate examination programme in art, craft and design was introduced and was seen as a watershed in Irish art education owing to its greater understanding of the holistic benefits of studying art (Granville in 'A is for Art', p. 12). The approach was project-based, with a broad range of craft choices, including embroidery and print, three-dimensional work as a compulsory component, and recognition for research and critical thinking in the form of support studies. This syllabus was the antithesis of the old Intermediate course, liberating art teachers and their pupils by substituting project work for the earlier examination. The intention was to lay the groundwork for a course on art appreciation and the history of art in the senior cycle, which was still defined by a product-based examination with four components: still life/imaginative composition, design/craft, life drawing and history of art. The history of art component (originally introduced to make art acceptable as a subject for university selection in 1972) is extremely broad and makes no connection between *making* and *receiving* art (Catherine Marshall in 'A is for Art', p. 27).

The Arts in Education: A Curriculum and Examinations Board Discussion Paper (Dublin 1985), the establishment of the National Council for Curriculum and Assessment (NCCA) in 1987, and the Education Act (1998) reiterated the principles of a more open and creative view of child development, but failed to change the Leaving Certificate curriculum. The NCCA produced a draft of a new art syllabus for the Leaving Certificate in 1999 with planned implementation within three years, but this has not happened. Pupils who have studied Junior cycle art revert to a system with a completely different set of assessment criteria. The second-level Transition Year Programme, a major innovation, which was offered in seventy-five per cent of schools by 1999, is particularly amenable to art education, and most schools incorporate arts experience into the programme. The Leaving Certificate Applied is the only national certificate programme that specifies the arts as a required experience for all participating students. By the end of 1999, 33 per cent of Junior cycle pupils took art, craft and design, while art at Leaving Certificate level attracted only 16 per cent. There is a pattern of female predominance in the take-up of art at school and this is replicated at third-level education (Granville in 'A is for Art', p. 12).

Despite dramatic improvements in art education in the latter decades of the century and the recognition of 'creativity' and 'flexibility' as valuable and desirable attributes in the education of young people, written examinations continue to dominate (Granville, p. 36). The new Leaving Certificate syllabus has failed to materialize and Junior Certificate courses are being reviewed following an OECD finding that there is a deficit in literacy and numeracy among Irish schoolchildren. To compensate for deficits in the Leaving Certificate programme, further education colleges have, since the mid-1980s, offered portfolio

preparation courses to help students to meet the criteria for admission to art colleges.

Education of artists and teachers

In 1900 the two main vehicles for art education in Ireland were the Dublin Metropolitan School of Art (DMSA) and the Royal Hibernian Academy (RHA) (qv), while a number of individual institutions contributed to technical education from the mid-nineteenth century. The DMSA, founded in 1749 as the Dublin Society Schools, took on a new life when it came under the aegis of the Kensington Science and Art Department in 1854. Its most famous pupil was probably William Orpen (qv), who joined it at the age of twelve in 1891. Originally the Cork School of Art, the Crawford College of Art and Design was established in the eighteenth century and enlarged several times, while the Athenaeum Society of Limerick established a school of art in 1855. The City of Dublin Technical School in Kevin Street and Pembroke College in Ringsend were opened in 1892 (Coolahan, pp. 85–86).

These institutions all came under the Department of Agriculture and Technical Instruction (DATI) from the nineteenth century, a positive development marred by inadequate financing, the poor education standard of many of the entrants, and a shortage of adequately trained teachers. To redress this situation, from 1901 teachers were offered courses in drawing to help them attain the Teachers' Art Certificate of the Board of Education, and craftsmen qualified for a twenty-week course through a competitive examination (Coolahan, p. 89). The Irish Secondary Teachers' Drawing Certificate continued until 1922 when DATI disbanded its in-service training (Coolahan, p. 102). Under the Irish Free State, responsibility for the DMSA and other technical institutions was transferred to the Department of Agriculture in 1922 and to the Department of Education two years later. In 1936 the DMSA became the National College of Art (NCA). Diploma courses at NCA were established in 1941, the first National Diploma in Design was developed in 1946, and art teachers were trained at the college from 1952, but it was not until 1965 that a diploma was offered in Fine Art, giving its courses official recognition. The Commission of Higher Education was established in 1960 to look into third-level education standards. It invited a report from the Scandinavian Design Group which shocked the government and resulted in important policy initiatives, including the establishment of the Kilkenny Design Workshops and the National Design Council, and paved the way for the incorporation of design into third-level arts education (see 'Design and Material Culture'). The Commission also appointed the Higher Education Authority in 1968 and recommended the creation of a national network of regional colleges, with an emphasis on technology. Regional Technical Colleges were established from the late 1960s, with qualifications awarded by the National Council for Educational Awards from 1972.

In addition to its exhibitions, the RHA conducted a school for the education of professional artists. Over the years the school diminished in importance until the idea was revived in the 1990s by Liam Belton and it was reopened by Mick O'Dea (qqv). In the 1930s the Vocational Education Committees extended earlier initiatives to encourage industrial design and to provide for the education of art teachers at second and third levels. Reflecting the politics of the day, art education became heavily weighted towards the vocational rather than the aesthetic.

The NCA was controlled by a conservative inspectorate aligned to both church and state, which caused frustration and unrest throughout the 1950s and 60s. This was reflected in reports written by many of the professors in NCA, including Seán Keating (professor of painting 1937–54) (qv) who advocated a link to the university sector to raise the professional profile of art education (Turpin, p. 518). Patrick Graham (qv), a student at NCA in the 1960s, felt that he was a part of a

'whole trap of the academy and giftedness, all tied up together in a particular deadly way ... it emphasized art as superficial, as mannerist, all the things you could only do with your hands ... we need to get over the notion that art is simply about technique. It has great potential for transcendence.'
(Graham, in conversation with Catherine Marshall and John Philip Murray, *Connected/Disconnected/Re-connected*, West Cork Arts Centre, 2010, p. 6)

During the 1960s NCA was profoundly affected by the opening up of Irish culture and by international student unrest. Debate centred on the clash between Modernism (qv) and tradition, and anger was expressed at the level of control exercised by the Department of Education. There was pressure for industrial design reform in the face of a new economic future for Ireland pending membership of the EEC. Protests were led by tutors Charles Cullen, Charles Harper (qqv), Alice Hanratty and Paul Funge, and students Brian Maguire, Michael Cullen (qqv), Dympna Cullen, David Kavanagh, Bill Whelan and others [155]. The protests, followed by expulsions and suspensions of staff, led to the re-establishment of NCA as the National College of Art and Design (NCAD) in 1971.

Speaking to Vera Ryan, John Kelly (qv) described the college in the 1970s as a difficult place for artists to teach in, with government-appointed inspectors who had no knowledge of painting, who ignored younger artists, had no concept of current trends in art-making and could not comprehend any style of

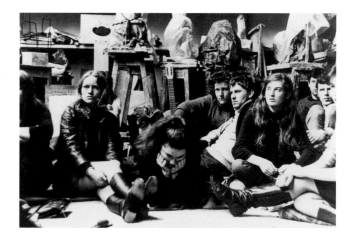

155. Protesting students stage a sit-in in the sculpture studio, National College of Art and Design, 1969

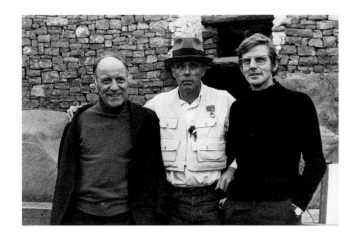

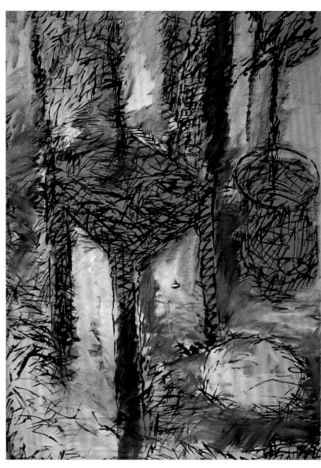

work that was outside their own particular 'ism'. Kelly complained: 'In Ireland we were years working in the darkness, where civil servants known as artists had given up looking at art and went in on Monday and drew *The Discus Thrower*' (Ryan, p. 49).

By 1975 there was a complete restructure at NCAD. Degree courses and new faculties were created: Fine Art, Design, Industrial Design and Education (day and evening courses) with a general one-year foundation, the pre-diploma course. NCAD was the first Irish college to introduce design degrees in studio practice and history and currently is where the majority of students carry out postgraduate work (Lisa Godson, 'Art Education Supplement', *Circa*, no. 89, Autumn 1999, 14). New tutors in Fine Art, influenced by the pedagogies of Joseph Beuys, included Nigel Rolfe (qv) and Rob Smith, under the direction of Campbell Bruce [156, 157].

From the mid-1970s a teachers' diploma course was developed alongside a one-year higher diploma course. It settled into its current four-year graduate structure in 1986. Examinations were set and corrected by the Department of Education until 1988. Freed to run its own affairs without departmental interference, NCAD changed from being a purely traditional academic model to a more experimental and conceptual one, as much shaped by social and political forces as it was inspired by educational philosophy.

The 1980s, under Noel Sheridan (qv) (director 1980–2002), saw NCAD open up to its surrounding community, the development of socially engaged pedagogical practices for artists who wished to work outside the studio, and the introduction of new courses to include new media and postgraduate provision. Artists who led these practices, such as Pauline Cummins, Philip Napier, Alanna O'Kelly, Brian Maguire (qqv), Chris Maguire and Louise Walsh, were employed at the college. This 'repositioning of art in terms of public art and its social element' was further supported with inter-college courses with the Dun Laoghaire Institute of Art, Design and Technology (IADT), Create and New York University, and the subsequent appointment of Colm Ó Briain as director (2003–07).

The college network blossomed in the 1970s with artists of the calibre of Vivien Roche, Eilís O'Connell, Maud Cotter and Dorothy Cross (qv) emerging from the Crawford in Cork, while the Dun Laoghaire College of Art and Design, which became the IADT Dun Laoghaire in 1997, developed strong art and technology courses. Before the 1990s only the University of Ulster (UU) offered postgraduate degrees in fine art. From the mid-1990s, NCAD began to offer Masters courses and followed the lead of the UU by taking on doctoral students in the first decade of the new millennium. New access programmes were piloted in colleges in the 1990s with the introduction of a model at the Dublin Institute of Technology School of Art, when it opened in Portland Row in 1993. This programme was a Women's Art Studies course, designed to facilitate women in Dublin's north inner city. It was run from 1993 to 1996 by Patricia Hurl and Bernadette Burns and was a collaborative programme, facilitated by practising artists. Radically there was no course document, only an open-ended curriculum, loosely based on the theme 'A Woman's Place'. This led to the later development of an outreach degree programme on Sherkin Island, Co. Cork [158]. By the end of the century art colleges across the country were beginning to participate in international programmes, while specialisms were developed in certain colleges, such as Limerick School of Art and Design's association with fine art and fashion, IADT's interface with new technologies, and Ballyfermot College of Further Education's success in animation.

158. Anna Kirsch, *Burden* (detail from an installation presented as part of her BA final examination for the Dublin Institute of Technology), the Pier, Sherkin Island, Co. Cork, 2012

Wider access

Wider access to the arts in education gradually flowed from the establishment of the Arts Council (AC/ACE) in 1951. Attitudes were also influenced by Ireland joining the EEC in 1973, and developing international links with educationalists and arts organizations abroad. Towards the latter decades of the century public institutions began to pay attention to their role as educators alongside schools and colleges, adopting postmodern pedagogies which, according to Melody Milbrandt, celebrate the interconnectedness of knowledge, learning experience, international communities and life-experience and which present 'models of the artist – collaborator rather than the artist's solitary maverick or hero' ('Postmodernism in Art Education: Content for Life', *Studies in Art Education*, LI, no. 6, 1998, 52).

As Brian Fallon has noted, the Rosc exhibitions (qv) and institutions like the Irish Museum of Modern Art (IMMA) powerfully shaped public opinion. 'They were a big break-through. The work was probably familiar to artists, at least in reproduction, but not to the public.' (Ryan, 2003, p. 239) Fallon outlined 'three things that helped Modernist art to emerge here during and after the war. The *Irish Exhibition of Living Art* gave artists a platform. Then there was the lecturing and enthusiasm of James White. And thirdly, there were powerful people like Waddington who sold artists' work.'

James White championed public access to art education. From the early 1960s, as director at the National Gallery of Ireland, he introduced public lectures and children's art programmes. Previously, with Gordon Lambert, he had facilitated special 'Sundays at the Hugh Lane Municipal Gallery' for workers from Jacob's Biscuits and Player Wills Cigarettes factories to encourage the staff to engage with modern art. Rosc, beginning in 1967, gave many Irish people their first opportunity to see work of international artists on a grand scale and continued to do so on five further occasions until 1988. In 1977 EV+A (see 'Exhibitions'), was initiated by artists in Limerick. An education programme was introduced in 1986, Young EV+A, to bring artists and young people together in workshops and satellite exhibitions.

The AC/ACE's advocacy of public participation in the arts led to the commissioning of Ciarán Benson's seminal report *The Place of the Arts in Irish Education* (1979). While critical of formal education provision, this report marked the beginning of a debate between successive government departments charged with the arts and education and led to significant developments with respect to public access to the arts. It led the AC/ACE to appoint an education officer, Adrian Munnelly, and to engage in new initiatives to bring schoolchildren into direct contact with artists. *Paint on the Wall*, the programme of murals-in-schools piloted in 1979/80, operated for five years throughout the country and introduced visual art to children and the communities in which they lived. In that time approximately 300 murals were painted by children in collaboration with artists. In January 1987 the white paper on cultural policy identified the four sectors seen by the Arts Council as critical to the arts: arts education, community arts, regional arts and arts centres. Martin Drury, Munnelly's successor, who implemented wider arts-in-education schemes, including artists' residencies, also produced *The Arts Council and Education, 1979–1989*, stating the Council's commitment to arts education practice in schools.

Moreover, the Council, increasingly aware of the complementary tradition of out-of-school arts education, piloted the experimental three-year Arts Community Education (ACE) project on a joint basis with the Gulbenkian Foundation. This process supported a series of action-research projects with published findings *Arts and the Ordinary* (1989), with an insightful essay 'Reflections on Art, Non-Artists and Policy-making in Ireland' by Ciarán Benson, which explored 'cultural institutions as instruments deliberately crafted for the creation of experiences' (n.p.). Benson distinguishes between policies aimed at making artworks, and policies that aspired to make artworks work. Attacking essentialist ideas about art, Benson argued that a more helpful way of thinking about art is to ask what it does, how it functions, and how, like its human audience, it is always developing. If policy-makers, he argued, attended to the type and quality of the functions of art as well as to the quality of particular types of art, a more appreciative understanding would emerge of what skilled community artists and arts educators strive to do. It would also give directions for ways in which the qualities of this work and its standards could be monitored.

The access approach of IMMA, when it was launched in 1991, was reflective of contemporary arts practice and introduced possibilities for public engagement in a gallery context which have subsequently been taken up and developed by museums, galleries and communities across Ireland. IMMA gave a special focus to gallery education and the interconnectedness of postmodern pedagogies by appointing a Curator of Education and Community Programmes with responsibility for developing models of education provision across all facets of the modern museum and allowed for exhibition-making with community groups. By the end of the 1990s, similar innovative programmes in visual arts were in

place across Ireland, devised and fostered by arts officers and artists in new regional arts centres and other venues (see 'Regional Developments').

The AC/ACE, in the 2003 Arts Act, placed new emphasis on stimulating public interest in and promoting knowledge, appreciation and practice of the arts. By 2004 a framework policy document for Education, Community and Outreach in national cultural institutions (qv) was drawn up by the Council of National Cultural Institutions, setting down for the first time the responsibilities of museums, galleries, theatres, libraries and concert halls in relation to their public education and access role. Two years later *Points of Alignment*, a report of the Department of Education and Science and the AC/ACE, finally picked up the recommendations laid out in the 1979 Benson Report.

Conclusion

More than a decade into the twenty-first century when Ireland has identified the importance of arts education to the development of society as a whole, there is still a reluctance on the part of the responsible government departments (Arts and Education) and policy-makers to work in genuine partnerships to provide a structured and well-thought-out experience for Irish citizens. In spite of reforms, deficits in practice remain and universal provision is uneven; the second-level curriculum is still out of step with newer pedagogical discourse in art college and, while exemplary practices have developed outside the formal sector in communities, galleries and museums, the much desired life-long learning experience is not provided for; art education still remains on the margins of the education system, rather than at its heart.

Much change has taken place since the 1940s and '50s when Taoiseach Eamon de Valera, in a speech in the Dáil, announced,

'I am less interested in the teacher's method of teaching than I am in the results he achieves, and the test I would apply would be the test of an examination' 'I am for cutting off every frill possible to us to make certain that the essentials are properly done' 'What I am afraid of is that teachers are thinking all of the time of making subjects interesting and attractive, and that if they spend all of their time at that sort of thing, the mechanical routine which is necessary to go through a subject as a whole cannot be carried out.'
(Coolahan, p. 43)

Yet, in contrast with the functional pedagogies of de Valera's Ireland, the end of the century has seen radical shifts in education. John Kelly felt that by the end of the 1990s NCAD had been enriched by the introduction of younger women teachers, who, he said, were 'liberating students'. He cites Louise Walsh and Alice Maher (qv) as good models and recalled hearing Maher ask students 'why did you do that?' instead of saying 'that's coming along nicely'. In his day, 'You might open a floodgate of personal fears if you asked "why did you do that?"' (Kelly, in Ryan, 2006, p. 54) HELEN O'DONOGHUE

159. Felim Egan, *Battle of Hercules and Antaeus*, 1984, mixed media on canvas, 253 x 250 cm, Arts Council/An Chomhairle Ealaíon

SELECTED READING Coolahan, 1981; 'A is for Art: A Supplement on Art Education', 1999; Turpin, 1995; Ryan, 2006; Granville, 2012.

EGAN, FELIM (b. 1952), painter. Felim Egan's paintings, and the sculptures he occasionally makes to accompany them, raise questions about purely formalist approaches to art-making. Egan's artworks have been described by Colm Tóibín as 'exercises in pure style' (Steward, p. 28), yet Aidan Dunne wonders if Egan uses his abstracted references to landscape to explore strategies of formalism or to undermine it (Dunne, 1990, 97).

Felim Egan was born in Strabane, Co. Tyrone and studied in Northern Ireland and Portsmouth before going to the Slade School of Art, London to pursue an MA in Painting. The political conflict pursuant on the Civil Rights campaign in Northern Ireland that surrounded him in his formative years does not intrude overtly into his work which, instead, follows an ideal of beauty that is close to music. Egan frequently used the triptych or diptych format to suggest development within the space of the work, a formalist narrative of sorts, and employed marks that have been likened to musical notation. He has also experimented with space, making artworks that relate directly to

160. William Orpen,
*Reflections: China and
Japan*, 1902, oil on
canvas, 41 x 51 cm, exh.
Guildhall, London, 1904,
Dublin City Gallery The
Hugh Lane

their architectural surroundings and using linear statements in neon as well as in paint. In his early work, especially in the work he showed in his first big solo exhibition at the Third Eye Centre in Glasgow and the DHG in Dublin, he employed forms reminiscent of musical patterns, but the pure formalism of his canvases is breached by minimal outline drawings that reference classical myth, and remind the viewer of sexual or heroic battles. It is possible to interpret some of these works, such as *Battle of Hercules and Antaeus* [159], as a reference to the seemingly unending political strife in his native Ulster, but Egan has never made the reference explicit. Indeed, the series of artworks he showed at IMMA in his mid-term retrospective exhibition in 1995/96 seem to draw back from that minimal figurative reference in their emphasis on the formal relationships between large abstract paintings and their companion pieces: bronze sculptures that play on irregular geometric forms. As in his earlier work, proportion and harmony are the key qualities of these works.

During the 1990s Egan's work took on a slightly more explicit level of referencing that seemed to allude to the landscape with vertical forms that might or might not refer to trees, while the landscape format of the images, the notion of a horizon line and the use of sand to add texture to his pigments suggest a new rapport with nature.

Egan enjoyed extraordinary success as a young artist. His particular brand of abstraction (qv) and the scale on which he worked were highly sought after by a new generation of private and corporate collectors, who were drawn by his quiet colour harmonies and subtle textures. In 1979 he was awarded the P.J. Carroll Prize at the IELA (qv) and, in 1981, a GPA emerging artist award. He spent a year at the British School in Rome in 1980, when he also represented Ireland at the Paris Biennale. He represented Ireland again at the São Paolo Biennial in 1985 and at Cagnes-sur-Mer in 1997 where he won the Gold Award. Other successes included the Premier UNESCO Prize for the Arts in Paris, 1993, and a commission from the NGI. In 2005 he was commissioned to make a public sculptural work on Dublin's Cork Street.

Elected to Aosdána (qv) in 1985, Egan is also an accomplished printmaker and has successfully collaborated with the writer Séamus Heaney on the publications *Squarings* (1991) and *Sandymount Strand* (1993).

He has participated in many important exhibitions, including *Irish Art of the Eighties* (DHG, 1990), *The Pursuit of Painting*, curated by the painter Stephen McKenna (qv) (IMMA, 1997) and *Irish Art of the Seventies* (IMMA, CAG, 2006/07). His work can be seen in all the major national and regional public and corporate collections in Ireland and Northern Ireland, and in such international collections as those of the European Parliament, the Stedelijk Museum in Amsterdam and the Metropolitan Museum, New York. CATHERINE MARSHALL

SELECTED READING *Felim Egan*, exh. cat. Kerlin Gallery (Dublin 1991); Brenda McParland (ed.), *Felim Egan*, exh. cat. IMMA (Dublin 1995); Steward, 1998.

ELVERY, BEATRICE (see Glenavy, Beatrice)

EXHIBITIONS (see *AAI* II and III, 'Great Exhibitions'). In the winter of 2010, the Irish Museum of Modern Art (IMMA) anticipated its twentieth anniversary in 2011 by putting together *The Moderns*, the biggest exhibition to date in Ireland, which looked at Irish modern art from 1900 to 1975. The exhibition proved to be a popular one, presenting a broad, if uncritical, view of Modernism (qv) in an Irish context. For the first time, Irish visual achievements were shown to be every bit as energetic, imaginative and nuanced as their literary counterparts, proving that perceptions of visual subordination to the verbal in Irish culture should not go unchallenged. *The Moderns* showed that even with only a modicum of infrastructural support, whether public or private, artists throughout the century had succeeded in making art that was challenging, insightful and as informed by international developments as were the writers. What they lacked were the exhibition opportunities to reveal it.

The twentieth century was bookended by *The Moderns* and Hugh Lane's *Exhibition of the Work of Irish Painters* at the Guildhall in London, in 1904 [160]. In both cases, visitors were surprised by the quality and variety of work displayed. Few artists from the first exhibition were included in the 2010 one, although Lane's show went on to form the basis of Irish collections and to influence the subsequent history of Irish art for at least two generations. Lane clearly stated his intention to encourage the emergence of a specifically Irish school of art and to lobby for an infrastructure to facilitate it. The fact that *The Moderns* was held at Ireland's own national museum of modern art in 2010 demonstrated that the country had finally achieved that infrastructure, and that nationalism was no longer a driving force.

Apart from those two landmark events, the most significant exhibitions were the Rosc exhibitions, held between 1967 and 1988, and the annual Irish Exhibition of Living Art (IELA) (qqv), held between 1944 and 1988. Since they are amply discussed elsewhere, this essay will concentrate on the other

exhibitions that helped to shape Irish art during the same period and the context for them.

Modern art had been shown in Ireland before Hugh Lane's exhibitions. *Modern Painting*, Leinster Hall, Dublin (1899) comprised eighty-eight paintings from France, Britain and the Netherlands and included work by Whistler, Manet, Monet and Degas. Dr Brian Kennedy describes the 1899 exhibition as the biggest exhibition of 'Modern Art' in these islands and said that London had nothing to equal it before 1905 (Kennedy, p. 6). Dublin audiences, it appears, were well disposed to new ideas. 'The whole of Dublin was convulsed' by the work of Whistler and Sargent at the Dublin Sketching Club in 1884, 'and many went ... to see the exhibition who rarely went to see anything of the kind' (Pennell, p. 36).

The motivation underlying the staging of exhibitions in the early years falls under a number of headings: some were didactic, aimed at introducing new ideas from abroad to Irish artists and audiences; many set out to promote a distinctively Irish school of art; and most wished to promote individual artists or groups of artists. Other exhibitions of Irish art were presented outside the country as part of a diplomatic programme under the auspices of the Department of Foreign Affairs (DFA). Before the establishment of the Arts Council (AC/ACE) (qv) in 1951, most government spending on art took the form of exhibitions abroad to Paris, Brussels and New York for the 1939 World's Fair and other North American venues, and while these included some living artists alongside historical work from public collections, their role was to show Ireland as a centre of culture to the rest of the world, rather than to support artists or audiences at home. The Cultural Relations Committee (CRC) of the DFA was established in 1949 'with a view to the enhancement of Ireland's image and reputation abroad, and the promotion of friendly relations and of mutual knowledge and understanding with other countries' (CRC, *50 Years*, 1999, p. 3).

1900–1950

As Róisín Kennedy points out in her essay 'Critical Writing and the Media' (qv), the primary aim of Irish critics in the first half of the twentieth century was, of necessity, to persuade the public of the value of art by presenting it within the parameters of broader cultural contexts in Ireland. Writers and apologists, deeply concerned with nationalism, sought to identify distinctive Irish characteristics in a climate where promotion of the Irish language and the restoration of an older Gaelic culture were prioritized. The annual exhibitions of the Royal Hibernian Academy (RHA) (qv) offered the only official outlet for new artwork. However, although there was never a harsh dividing line between the more progressive artists and the RHA, the Academy was recognized as being staid and unadventurous for most of the twentieth century, with exhibitions that never strayed far from what was acceptable to the conservative majority. What RHA exhibitions did reflect was the increasing emphasis on Irish subjects, the landscape (qv) of the west of Ireland, and lifestyles that could be seen as Irish, especially evident in the work of Jack B. Yeats, Paul Henry, Seán Keating, Charles Lamb, Maurice MacGonigal, Margaret Clarke (née Crilley) (qqv) and others. It was to the RHA and annual Oireachtas exhibitions (organized by the Oireachtas, the arts equivalent of the Gaelic revival movement) that the state looked when promoting Irish art abroad.

The Modernist alternative

Contrary to common perception, Ireland was not especially backward in the early years in showing avant-garde art. Brian Kennedy firmly asserts that until 1912 Ireland was ahead of its time compared to other countries in this regard (Kennedy, p. 17). The legacy of the Dublin Sketching Club's 1884 exhibition and George Russell's (qv) *Modern Painting* show of 1899 were followed by Hugh Lane's 1904 exhibition of pictures presented to the city of Dublin to form the nucleus of a Galley of Modern Art, also pictures lent by the executors to the late Mr J. Staats Forbes and others ('by far the most comprehensive exhibition of modern painting yet seen in Ireland, or for that matter in the British isles', Kennedy, p. 9) and *An Exhibition of Modern Paintings* at the Municipal Gallery, Belfast in 1906. Lane's own interest in contemporary Irish art was aroused by an exhibition of work by Nathaniel Hone and John Butler Yeats, organized by Sarah Purser (qv) in 1901. The opening in 1908 of the Dublin Municipal Gallery of Modern Art (HL) marked the first public gallery dedicated to modern art.

While Lane's collection of modern French paintings was already a generation away from the most current events and ideas in painting, the same could not be said for Ellen Duncan's exhibition *Works by Post-Impressionist Painters*, United Arts Club, Dublin (1911), which was inspired by Roger Fry's exhibition of Post-Impressionists at the Grafton Gallery in London (1910/11). Although the Dublin show was as badly received as Fry's London one had been (Russell said 'not decadent but merely decrepit', Kennedy, p. 15), it did not deter Mrs Duncan from continuing the following year with an even more progressive exhibition, *Modern French Pictures*, again at the United Arts Club, in which Cubist work by Picasso, Gris and van Dongen was shown in Dublin for the first time. Nothing as modern as this was seen again until 1922 when Paul Henry and Arthur Power arranged the exhibition *Pictures by Modern Artists*, which included paintings by Modigliani, Picasso, Matisse, Vlaminck and British artists Vanessa Bell and Paul Nash at Mills Hall during Dublin's Civic Week.

The impetus behind these exhibitions was to spread awareness among Irish artists of the latest trends in art elsewhere. As such, they were the early precursors of the Rosc and EV+A exhibitions in the latter half of the century.

Progressive artists at home

The Society of Dublin Painters (SDP), founded in 1920 by Grace and Paul Henry, Jack B. Yeats and E.M. O'Rorke Dickey (qqv), offered members a group exhibition each spring and autumn and an annual solo show in their small gallery at 7 St Stephen's Green. Against a backdrop of war and its aftermath, the new gallery was seen as a sign of hope by the *Irish Times* (*IT*, 6 August 1920). Initially, membership was limited to ten, with Yeats being the most established of these. Of the founders, Yeats did not show after 1923, while Henry and Dickey, following solo shows in 1921, 1922 and 1923, stopped exhibiting with the SDP in the mid-1920s. Those were the heydays of the SDP when it also

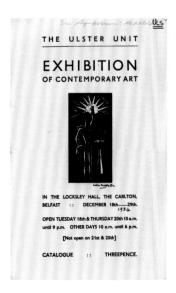

THE ULSTER UNIT

EXHIBITION
OF CONTEMPORARY ART

IN THE LOCKSLEY HALL, THE CARLTON.
BELFAST :: DECEMBER 18th——29th.
1934.

OPEN TUESDAY 18th & THURSDAY 20th 10 a.m.
until 9 p.m. OTHER DAYS 10 a.m. until 6 p.m.

[Not open on 21st & 25th]

CATALOGUE :: THREEPENCE.

provided the venue for showing the first Irish abstract pictures (see 'Abstraction') by Mainie Jellett and Evie Hone, and experimental work by Cecil Salkeld (qqv). Mary Swanzy (qv) had a solo exhibition there in 1922 before leaving Ireland for a decade (Kennedy, pp. 36–37).

From the mid-1920s, the Society became closely associated with less innovative artists like Charles Lamb, Letitia Hamilton (qqv), Eva Hamilton and Harriet Kirkwood. Memberships increased in the 1930s, yet, despite the fresh vigour brought by Nano Reid and Norah McGuinness (qqv), its ethos became more conservative. Nonetheless, the SDP remained important as the only regular alternative to the RHA until 1943 when its work was largely taken over by the IELA. The preponderance of women artists was such that the group show of 1935 was described as 'the first Irish women's exhibition as this show virtually may be taken to be' (Kennedy, p. 48). It was there, in 1944, that Jellett's memorial exhibition was held.

The more politically ambitious, but short-lived, Ulster Unit (1933/34) [161], modelled on Unit One in London, was the first Irish art group dedicated to Modernism, declaring that it symbolized the spirit of the age for them (Kennedy, p. 73). Members included Colin Middleton, John Luke (qqv) and Romeo Toogood. The catalogue to their only exhibition at Locksley Hall, Belfast, in December 1934, carried a polemical essay 'The Art of Picture Buying', which argued that the purpose of art was not to decorate but to 'feed the soul'. John Hewitt, echoing Paul Klee's belief that art should reveal the invisible, wrote that the Ulster Unit was the only body of artists alert to continental influences, not mere imitators of appearance, and aware of the importance of individual experience.

Other departures from the traditional academic exhibitions at the RHA were offered at the New Irish Salon at Mills Hall, Dublin (1923–28). While no mission statement survives, the New Irish Salon may, like the New English Art Club, have hoped to become an alternative to the Academy. Their huge group shows included Henry, Swanzy, Dickey, Kirkwood and, astonishingly, Ossip Zadkine and later, André Lhote and Albert Gleizes. Acrimony was aroused by the 1924 show which seems

to have been the most avant-garde, while works by Seán Keating, John Leech and John Lavery (qqv), were accepted in the 1926 exhibition.

Following in the footsteps of Hugh Lane and Ellen Duncan, Moira Pilkington, under the name Deirdre McDonagh, founded the Contemporary Picture Galleries in 1938 to encourage a Modern Irish School by showing innovative work from outside the country and lobbying for support for contemporary art. Joined in 1939 by Jack Longford, the Contemporary Picture Galleries were described by Kenneth Hall (qv) as 'the only modern gallery that makes any attempt at advanced ideas in Dublin' (Kennedy, p. 81) and operated between 5 and 15 South Leinster Street and 133 Baggot Street (their only venue from 1940). The Contemporary Picture Galleries' solo, group and themed shows presented innovative painting throughout the period of World War II. Among the British artists shown were Edward Ardizzone, Graham and Vanessa Bell, William Coldstream, John Piper and Victor Pasmore, while the *Loan and Cross Section Exhibition of Contemporary Paintings* of 1939 spotlighted European Cubist, Surrealist and Expressionist work alongside native artists. Since war made contact with continental Europe difficult, the galleries staged *Six Artists from L'Académie Lhote* (November 1940), an exhibition of the work of his most prominent Irish supporters, as well as the master himself. *In Theatre Street* (1942) was the first gallery exhibition of theatre design in Dublin and included designs by the painters Jellett, Louis le Brocquy, Basil Rákóczi, Anne Yeats (qqv), Ralph Cusack, Doreen Vanston and Stephen Gilbert, as well as professional theatre designers. The exhibitions of the White Stag Group (qv) provided another stimulating platform for new approaches to painting during the war years.

A new dawn

The initially slow expansion in the disposition and numbers of exhibition venues began to gather pace following the establishment of the Council for the Encouragement of Music and Art (CEMA) (1943), later the Arts Council of Northern Ireland (ACNI), and the AC/ACE (1951). At first the Dublin government, reluctant to fund the arts at home, was more open to the idea of an organization to promote Irish culture abroad. Consequently, a year after the establishment of the CRC in 1949, Nano Reid and Norah McGuinness became the first artists to represent Ireland at the Venice Biennale, and in 1955, Louis le Brocquy carried off the main prize at that event. Procrastination over plans to build an Irish pavilion in Venice, to be designed by Michael Scott, meant there was no representation between 1960 and 1993 when Willie Doherty and Dorothy Cross (qqv) became the first in a more consistent Irish programme there.

Before 1961 the Arts Council had no curatorial staff and, unlike CEMA/ACNI, did not have a gallery, but that did not prevent it backing a proposal from James White to hold a major retrospective of Evie Hone's work in 1959, including stained-glass windows, in the Great Hall of University College Dublin, and to give beneficial support for exhibitions at the HL and other venues. Thanks to Arts Council funds, the IELA was enabled to stage the *Art USA Now* exhibition in 1963 at the HL, which brought the first sight of leading American Abstract

Expressionists such as Robert Motherwell, Willem de Kooning and Philip Guston to Ireland and exercised a profound influence on younger artists. The large catalogue of the Johnson & Johnson Collection, from which the exhibition was drawn, was almost as influential as the exhibition itself. The success of this show prompted the Gallery to hold a Francis Bacon (qv) retrospective the following year.

But it was not until the appointments of Visual Arts Officers Oliver Dowling (1969–75), Paula McCarthy (1975–80), Patrick Murphy (also Exhibitions Officer, 1976–84) and John Hunt (1984–87) that the Council really embarked on a sustained exhibition programme. Lacking an exhibition venue, the Council backed George Dawson's campaign to establish the Douglas Hyde Gallery (DHG) at Trinity College Dublin (TCD) and gave the gallery regular financial support when it opened in 1977. It replaced the TCD Exhibition Hall [162] which was the first university art gallery in Ireland, home to forty exhibitions between 1967 and 1977, including shows of American Banners, Pop art (qv) and works by Karel Appel and Picasso.

AC/ACE exhibitions fell into two main categories – themed group shows and retrospective exhibitions, some of which were staged in conjunction with the ACNI, and from the late 1970s onwards they toured to an increasing number of venues north and south of the border. Shows included landscape and print shows, and solo exhibitions of artists such as Tony O'Malley and John Kelly (qqv), while venues included the Bank of Ireland

162. Picasso exhibition, Exhibition Hall, Berkeley Library, Trinity College Dublin, 1967

Centre and the HL in Dublin, ACNI Gallery in Bedford Street, Belfast, the Crawford Art Gallery and Triskel Arts Centre in Cork, the Butler Gallery, Kilkenny, Limerick City Gallery and the Model Arts Centre, Sligo. Recalling the difficulties these exhibitions posed, Patrick Murphy pointed out that for one year in the early 1980s the AC/ACE was responsible for five shows, each travelling to eight venues, yet there was no supporting infrastructure, and no trained curators, professional art handlers or transporters (Ryan, 2003, p. 74). It is a measure of the professionalism acquired through this process that in 1983 the

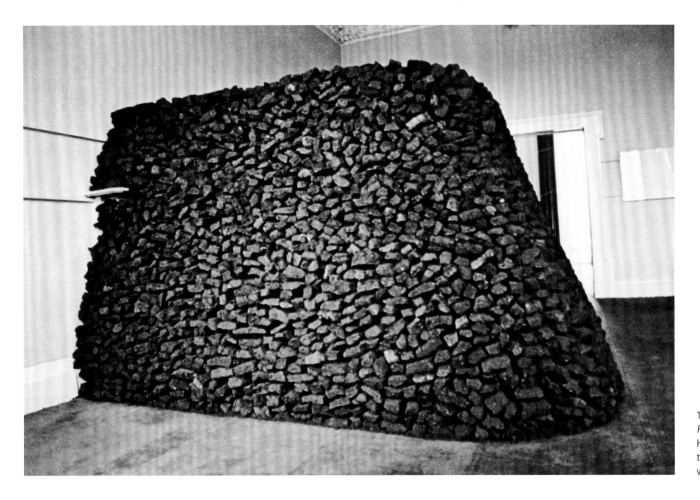

163. Brian O'Doherty, *Rick*, installation at the Hendriks Gallery, 1971, turf sods, dimensions variable

CRC invited Murphy to curate *Six Artists from Ireland*, which toured to eight European venues (CRC Report, 1986, p. 6).

The commercial galleries (qv) made an important contribution to the range and style of exhibitions on offer. Victor Waddington regularly showed his artists, particularly Jack B. Yeats, outside Ireland as well as at his Dublin gallery, but it was not until the arrival of the Hendriks Gallery in Dublin in 1956 that a commercial gallery began to play a semi-public role. Not afraid to show such unsaleable work as Brian O'Doherty/Patrick Ireland's (qv) *Rick* (1971) [163], or sculpture when it was 'notoriously difficult to sell' (Fallon, in McCrum and Lambert, p. 66), the Hendriks Gallery teamed up with the Arts Council for shows in Northern Ireland, and took exhibitions to Cork, Wexford and other regional venues. The sculptor Vivienne Roche spoke of the importance of the gallery's shows in Lavitt's Quay, Cork for her early art education (Ryan, 2003, p. 156).

When the Arts Council rejected the chance to show an exhibition of kinetic art in 1966, curated by Cyril Barrett, 'on the grounds that Ireland was not ready for that kind of art yet', his friend Anne Crookshank rang David Hendriks on his behalf. As she described it: 'It was one thing for an arts council, a municipal gallery or a university to bear the cost of transport and insurance, it is quite another for a private gallery. David took the gamble and won.' (McCrum and Lambert, pp. 36–37) In Crookshank's view, 'it could be argued that the new, more open era of Irish art dates from this show as much as the first *Rosc*, the following year' (p. 41). The gallery went on to show exhibitions of Pop art (qv) and *Arte Povera* in the subsequent years. If Hendriks was the most consistent importer of avant-garde foreign art, he always accorded Irish artists the same level of consideration as he showed the more established foreign ones and could equally accommodate the Expressionist gestures of Barrie Cooke as the pop-inspired portraiture of Robert Ballagh (qv). The gallery's exhibitions were also influential in developing an acceptance of modern visual art in Irish life.

Despite these changes, artists still struggled to showcase their work. The Independent Artists, founded by Barrie Cooke, Charles Brady (qqv) and others in 1960 and run as a co-operative, later more associated with Michael Kane, John Kelly (qqv) and James McKenna, showed their work in the Project Arts Centre and, as Brian Fallon has noted, 'supplied in the '70s and '80s a vehicle for all sorts of mavericks and outsiders, as well as for certain ambitious younger artists' (Fallon, 1994, p. 184). They were joined by Figurative Image, a group founded to counterbalance what it perceived as the dominance of abstract art, especially in the IELA exhibitions.

Growing professionalism: The influence of Rosc
The Rosc exhibitions, created initially with the desire to show artists in Ireland what was happening elsewhere, also fostered professionalism, not least in exhibition design, catalogue production and hanging. The need to find venues for these, essentially, blockbuster exhibitions, since they could not be contained in the handful of gallery spaces available, was a further learning experience for arts administrators, and proved to be attractive to audiences not accustomed to visiting galleries. Because of the public interest they aroused, the Rosc exhibitions achieved a

level of media coverage and critical debate that was unprecedented in Ireland but which established important markers for future activity. Most importantly, by drawing artistic, academic, corporate and government support for an exhibition aimed at domestic audiences, Rosc showed what could be achieved if the right energies were brought together.

More than anything, Rosc showed the importance of audiences. Needing to advance the footfall in the National Gallery of Ireland (NGI), its director Homan Potterton deliberately misappropriated, 'for marketing purposes' (Ryan, 2006, pp. 191–92), the term *Impressionist* for an exhibition, curated by Julian Campbell, of Irish artists who were not Impressionists but who had worked in France and Belgium from 1850 to 1954. The success of the *Irish Impressionists* (1984) exceeded all expectations and marked a new phase in popular attendance at NGI exhibitions from which it never looked back.

In the short term, the main heir to Rosc was EV+A (Exhibition of Visual + Art; artworks that engage more than just the eye), the programme of annual exhibitions that emerged in Limerick from 1977 onwards. Partly in reaction to the Dublin-centred nature of Rosc and its exclusion of Irish artists from the early shows, EV+A aimed to bring the best of Irish and foreign contemporary art to Limerick. By the mid-1990s this had grown to a desire to make Limerick an internationally known venue. Initially selected by the founding committee, the practice of appointing a guest curator who also acted as adjudicator for the EV+A awards began in 1979. From 1986, under the stewardship of Paul O'Reilly, EV+A alternated between invited and open exhibition, with renowned curators such as Germano Celant (Italy), Guy Tortosa (France) and Jan Hoet (Holland) [164]. Artwork was offered for sale and costs were defrayed through a 25 per cent commission charge. In the absence of crowd-pulling but expensive promotion, energy was directed instead to organizing colloquies and evening showings for target groups. Young EV+A, established in 1986, involved younger people in a series of workshops culminating in parallel exhibitions. Working with guest curators and, particularly, facilitating their use of external sites for art installations (qv) offered valuable lessons in curating while also offering local audiences a range of artistic experiences on a scale not found elsewhere in the country.

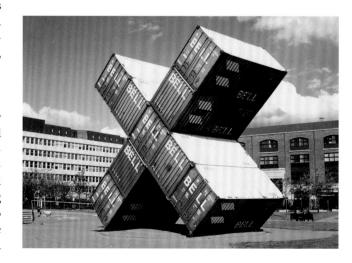

164. Luc Deleu, *Construction X*, nine shipping containers, EV+A, 1994

1980–2000

The pace of exhibition provision and development gained considerable momentum in the 1980s and '90s, especially in the latter decade, fuelled by the arrival of regional art centres and galleries, the growth in arts festivals such as those at Kilkenny, the annual *Claremorris Open Art Exhibition*, Éigse in Carlow and Errigal, Co. Donegal, and a proliferation of commercial galleries (see 'Regional Developments'). Writing in the introduction of *Exposure*, a series of student-led exhibitions in 1980, '81 and '82 to provide opportunities for emerging artists, George Dawson could say with considerable truth that 'the splendid growth of interest in the visual arts in Dublin in the last decade is reflected in the increasing number of galleries. There are now over twenty, more than the number of cinemas.' (*Exposure*, Dublin 1981) Reminding younger artists of the bad old days some years later, Sam Walsh (qv) pointed out that 'It was a seriously big deal to be selected for the Living Art [Exhibition] in 1981, just as it was a big deal to be selected for the Oireachtas or the Independents.' (Walsh, *Circa*, no. 100, Summer 2002, 21)

The year 1980 was marked by a diplomatic mission to show the cultural side of the Irish character in Britain as a counter to the negativity aroused by the 'Troubles' in Northern Ireland and terrorist attacks in Britain. As part of the multidisciplinary arts programme *A Sense of Ireland*, three art exhibitions were presented. These included *The Delighted Eye*, curated by Frances Ruane, a group show which stressed the Celtic and poetic qualities in Irish art; *The International Connection*, curated by Cyril Barrett, with work by Sean Scully, Cecil King, Patrick Scott (qqv) and others; and *Without the Walls: 9 Artists from Ireland*, featuring new media art (qv) by Nigel Rolfe, Alanna O'Kelly, James Coleman, Noel Sheridan, Felim Egan, Ciarán Lennon, (qqv), Brian Hand, Michael O'Sullivan and John Aiken, curated by Dorothy Walker and shown at the Institute of Contemporary Arts, London (ICA). Against the background of this increased activity, the IELA ran out of energy and motivation. In 1982, with no money to stage a conventional exhibition, the IELA invited Declan McGonagle to curate an exhibition which took the form of a book with specially commissioned work by eighty artists. Six years later, facing competition from EV+A and Rosc, and with the prospect of a new museum of modern art, the IELA disbanded.

New concepts of Curation (see 'Curating')
While people were aware of Brian O'Doherty's curation of *The Irish Imagination*, a satellite exhibition of *Rosc '71*, few yet knew of his challenging and influential writing on exhibitions and curation in the USA. His essay 'Inside the White Cube: The Ideology of the Gallery Space', in *Artforum* (1976; repr. New Jersey and West Sussex 2000) brought a new awareness of the gallery as a framework for the art it contained to a generation of curators from New York to Dublin and exerted a significant influence on the first decade of IMMA's existence. *A Sense of Ireland* (1980) introduced Irish artists to broader audiences and new contexts alongside a well-thought-out programme of musical, literary and theatrical events. It also marked the emergence of the curator and the curatorial perspective into exhibitions of Irish art both at home and abroad. Subsequent themed exhibitions in the 1980s, exploring different aspects of Irish art, included the CRC-funded exhibition *Crossroads, Divisions, Turns of Mind*, curated by the American critic Lucy Lippard, under the auspices of the Ireland America Art Exchange, established by Paula McCarthy and Gordon Lambert, and shown in venues in the USA and Canada in 1986; *Directions Out*, curated by Brian McAvera in 1989, which dealt with the Troubles (see 'The Troubles and Irish Art'); and, two years later, *In a State*, an exhibition of site-specific work relating to Kilmainham Gaol and its history, curated by Jobst Graeve.

During the late 1980s, the most challenging curatorial projects happened not in Dublin but in Derry, where Declan McGonagle, newly returned to his native city from the ICA in London to the Orchard Gallery, brought artwork on to the street to actively engage with Derry's contested politics and divided histories. The regular presence of international media to cover the Troubles meant that exhibitions, in which the work of Anthony Gormley, Locky Morris and others were taken out of the gallery and on to the walls of Derry, catching instant press attention, made the radical exhibition programme at the Orchard Gallery a focus of international as well as Irish interest, and led to an invitation to McGonagle to act as guest editor for a special Irish edition of the American journal *Artforum* (1990). Another important first during the 1980s was the staging in three Dublin venues of the *Irish Women Artists* exhibition (1987) at the NGI, DHG and HL. Conceived by Patrick Murphy in response to growing demands from feminist artists, this was the first comprehensive attempt to map the contribution made by women to the visual arts in Ireland (see 'Women and the Visual Arts'), both historically and currently. Recognition that the 1980s was truly a decade of change and that Ireland was at the centre of the postmodern debate was provided in a programme of exhibitions throughout 1990 entitled *A New Tradition: Irish Art of the Eighties*. Under Murphy and his successor as director of the DHG, Medb Ruane, the six exhibitions, *Background*, *Landscape*, *Sexuality*, *Myth*, *Abstraction* and *Politics*, with accompanying essays by Aidan Dunne, John Hutchinson and Joan Fowler, presented a wide-ranging review of the practices and concerns of Irish artists as they headed into the final decade of the century.

The CRC decided to replace the old committee selection system by appointing a curator/commissioner to select and manage Ireland's re-entry to the Venice Biennale in 1993 and the São Paolo Biennial. Having become founding director of IMMA in 1990, Declan McGonagle was entrusted with the task and on that occasion selected the artists Dorothy Cross and Willie Doherty. Two years later, with Peter Murray as commissioner, Kathy Prendergast (qv) went on to win the Premio Duemila at Venice for Ireland. In 1996 the Irish and French governments jointly staged *L'Imaginaire Irlandais: Festival de Culture Irlandaise Contemporaine*, an Irish cultural festival in different parts of France, to be held at intervals throughout the year. McGonagle argued against one definitive exhibition and presented the case for a multiplicity of events and happenings in different centres from Paris and Rouen to Lyon and Poitiers. The event incorporated solo, group and themed exhibitions aimed at different audiences and led the French curator Guy Tortosa to

agree to curate EV+A in Limerick the following year (Paul O'Reilly, 'Notes to the compendium', *EV+A Compendium*, 1998, p. 9).

IMMA was the location for ground-breaking approaches to exhibitions for the remainder of the century, with solo exhibitions that helped to enhance the emerging careers of Stephan Balkenol, Antony Gormley, Juan Muñoz, Olafur Eliasson and Yinka Shonibare, and to enable Irish audiences to become familiar with leading names in international Postmodernism such as Andy Warhol, Ilya Kabakov, Marina Abramovic and Leon Golub. *From Beyond the Pale* (1993/94) was a series of staggered small exhibitions under a bigger umbrella, aimed at encouraging critical dialogue between accepted canons of Modernism and other art practices. Positing notions of exclusion and disempowerment against authority, *From Beyond the Pale* raised awareness of power relations both within the hallowed halls of art history and in the wider world beyond. Questioning assumptions of power and ownership of culture were also motivating factors in other IMMA exhibitions; *Unspoken Truths* (1993) and *Once is Too Much* (1997), led by the museum's education and community department, introduced an entirely new concept of collaborative exhibition-making between artists, local communities and the museum, while exhibitions such as *Somebodies*, in which a group of teenagers was invited to curate a touring exhibition from the museum's collection, provided a model for active involvement with national collections. That process was continued by the institution in 1995 of the IMMA National Programme, through which exhibitions from the collection became widely available in all kinds of venues throughout the country. Challenges to canonical authority were continued in 1998 when IMMA decided to accept and show the Musgrave Kinley Collection of Outsider Art as part of its regular collection, making it the first national cultural institution in the world to show Outsider art (qv) on a par with work from the mainstream.

The century drew to a close with two very different touring exhibitions of Irish art which may be said to sum up the old and the new order. In doing so, they reiterated the biggest issues that confronted Irish art throughout the previous hundred years; in taking its title from a poem by W.B. Yeats and restricting his selection to figurative painting, the curator of *When Time Began to Rant and Rage: Figurative Painting from Twentieth-Century Ireland* (1998/99), James Christen Steward, reconnected to the old literature-dependent, academic tradition in Irish art. *Irish Art Now: From the Poetic to the Political* (1999–2001), curated by Judith Richards and Declan McGonagle, deliberately sought to advance what was significant in new media and new approaches to art-making (see 'New Media Art'), and thereby to assert the political over romantic notions of Celtic poetry.

Since 2000 Irish art has travelled the world, with successful appearances in international biennials, art fairs and intercultural festivals, while opportunities for artists and audiences at home to engage with all kinds of art, never enough to satisfy all needs, are, nonetheless, so numerous that it is difficult to keep track of them all. Catherine Marshall

SELECTED READING Joseph and Elizabeth Robins Pennell, *The Life of James McNeill Whistler*, 2 volumes (London 1908); McCrum and Lambert, 1985; Ryan-Smolin, Mayes and Rogers,

1987; *A New Tradition*, 1990; S.B. Kennedy, 1991; O'Reilly, 1999; Steward, 1998; Ryan, 2003 and 2006.

EXPRESSIONISM AND NEO-EXPRESSIONISM. Expressionism in the twentieth century is considered to have its roots in the Gothic romanticism of the nineteenth century, with reference to the great medieval German artist Grünewald and to other non-classical sources. The movement emerged in Germany with *Die Brücke* and *Der Blaue Reiter* in the early years of the century and gained impetus from the dramatic loss of life and cultural perspectives in World War I. Its immediate precedents can be found in the experimentation with primitive art forms from Africa, which opened a new vein of collision between 'art brut' and Modernism (qv). Ernst Ludwig Kirchner, Max Beckmann, and others in Germany, and the Norwegian Edvard Munch incorporated Freudian speculations of the unconscious with the painterly expression of alienation. That there is a form of Expressionism particular to the island of Ireland, however, is a rather dubious consideration.

Perhaps one of the best-known European Expressionist figurative painters of the mid-twentieth century, Francis Bacon (qv) was born and raised in Ireland, but spent nearly all his working life in London. Bacon's tortured images were uncompromising in their view of a humanity debased by the horrors of World War II. In Ireland, the movement is associated with painters such as Gerard Dillon (qv), who, as a naive painter, embraced aspects of Expressionist form and content, and with the later paintings of Jack B. Yeats (qv), particularly after the death of his wife in 1947 and his own exploration of alienation in his semi-abstract evocations of the other world, such as the wonderful *There is no Night* [165]. Other quasi-Expressionists in Ireland include Belfast painter Colin Middleton (qv), who moved between a surrealistic dialogue, with the subconscious narratives of Max Ernst and Salvador Dali, and a form of Expressionism that may owe something to the Northern Europeans.

But Expressionism's most unequivocal flowering in Ireland came with the Independents Group in the 1960s, especially Charles Cullen, Michael Kane, Brian Bourke, John Kelly (qqv) and the sculptors James McKenna and John Behan, who engaged with the last remnants of European Expressionism and the brand of Realism (qv) then current, in opposition to the new vogue of Modernist abstraction. Michael Kane, in particular, invoked the German angst of the 1930s in his woodcuts for the dynamic socialist magazine *Structure*, which he also edited. His subsequent wood-block prints for the Gallery Press books of poetry were classic re-engagements with the social dynamic of the Weimar Republic. From this they derived a sense of alienation fuelled by his personal disenchantment with the prevailing critical endorsement of international Modernism in Ireland. The raw emotive sketches of Brian Bourke transgressed the obvious nature of their material and managed to induce a sense of delayed disintegration, a mortality, which directly related to some of Grünewald's more harrowing human engagements. Charles Cullen's work appeared deceptively accessible, yet there was a sense of dissociation from the obvious dialectic about his exquisite and detailed drawings. The Independents Group connected directly to German Expressionist painting some fifty years after its original manifestation, as an anarchist disavowal

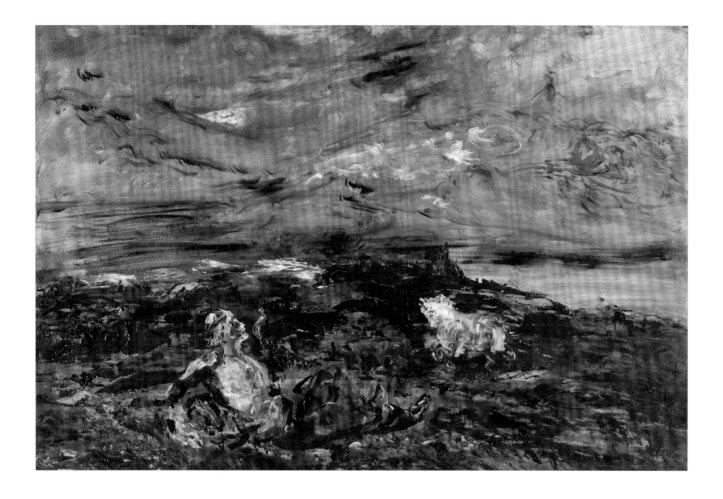

of accepted political and cultural norms in imperial Vienna and Berlin.

The divergence between figurative Expressionism and abstract painting (see 'Abstraction') was an emotive force in mid-century Ireland. When they merged, there is often a brilliant, eclectic moment, separate from the physical and plastic natures of the original sources. This is true of the work of Michael Cullen (qv) in the 1980s, which combines narrative images derived from popular culture with impasto, gestural brushwork and a sense of the absurd. It has the appearance of an expressive moment, informing a personal narrative, as with his Las Vegas wedding series and his pastiche of Velázquez, combined with an internal dialogue linking the genre of cartoons with allusions to the work of Georg Grosz.

Women artists (see 'Women and the Visual Arts'), prominent in the 1980s and '90s, who were influenced by the feminist movement of the 1960s and '70s, such as Eithne Jordan (qv), appear to have an Expressionist sense of angst. This is particularly the case in Jordan's figurative paintings from Berlin in the early 1980s in which alienation and depression are equally present. The paintings and subsequent video work of Cecily Brennan (qv) explore the human despair of existence, while her detailed paintings of skin diseases have a direct emotive and visual connection to Grünewald. Alice Maher's (qv) installations offer a meditation on the parallel between the public spaces of the gallery and the internal spaces of the artwork. Her emotionally

charged work incorporates a tortured physicality with quasi-religious iconography in the service of female rapture.

The eclecticism of the 1960s, the undercurrents of Postmodernism in the 1970s, and the dark shadow of violence emanating from Northern Ireland radicalized some painters, and affected others in a more subtle manner (see 'The Troubles and Irish Art'). The 'Troubles' certainly caused a redeployment of the older motifs of Expressionism in Ireland, but they have not reinvested them with a distinctive character of place and time. In

165. Jack B. Yeats, *There is no Night*, 1949, oil on canvas, 102 x 153 cm, Dublin City Gallery The Hugh Lane

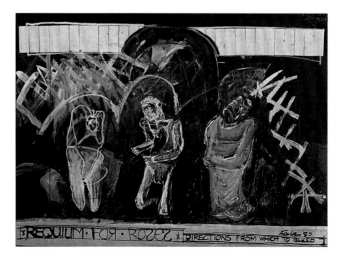

166. Patrick Graham, *Requiem for Roses*, 1985, mixed media on board, 81 x 112 cm, private collection

saying this, in the late seventies and early eighties the Neo-Expressionist movement paralleled a reappraisal of painting as the prime image-making mode in western art, and led to the flowering of three Irish artists whose work transcended social alienation and reinvigorated the subject narrative with all the associative grimace of Munch, Rouault, Nolde, and more recent Neo-Expressionist painters such as Gerhard Richter and Anselm Kiefer in Germany.

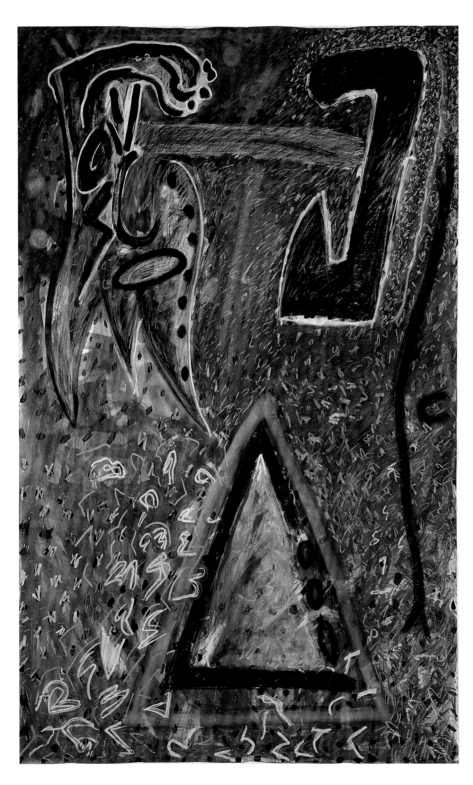

167. Michael Mulcahy, *Untitled*, from the 'Dogon' series, 1988, pastel on paper, 240 x 146 cm, Crawford Art Gallery

To evaluate the Neo-Expressionist achievements of Patrick Graham, Brian Maguire, Patrick Hall, Michael Mulcahy (qqv) and Timothy Hawkesworth, it is necessary to look back to the anti-abstraction, anti-internationalism of the Independents Group. The Independents railed against a kind of cosmopolitan non-figurative art, especially as propounded in *Rosc '67* (see 'Rosc Exhibitions') by Michael Scott and James Johnson Sweeney, and exhibitions of the multinational corporate collections of Johnson & Johnson and Alcan (see 'Exhibitions') and personified by an emerging and successful Irish business class. The group favoured a more politically engaged, indigenous social project, derived from an earlier Modernist tradition of figuration. Many Expressionists still clung to the idea of representation as being the only visual trope for defining the human condition. For instance, Francis Bacon is said to have described abstraction as decoration and Jackson Pollock as 'the lacemaker' (Farson, p. 224).

The founding of the Project Arts Centre in Dublin in 1967, and its political involvement with social and aesthetic programmes, gave the Independents an almost messianic sense of engagement. The group was further radicalized by the 1960s' student movement, and this, together with its own commitment to social change and growing awareness of American Abstract Expressionism, directed the group's work and inclination towards a figurative mode.

Patrick Hall, Patrick Graham, Michael Mulcahy and Brian Maguire, all painters, revelled in the iconoclastic nature of Expressionism. Hall's images, while uncompromisingly bleak, resonate with a spirit of survival against the odds, while Patrick Graham's personal struggles with mental health treatments led him to become an outsider in both the social and artistic senses of the word. The final articulation of this was a series of works called *Notes from a Mental Hospital*, exhibited at the Emmet Gallery in Dublin in 1974. These were a macabre mixture of colour wash and line, of emaciated human beings showering while being observed by white-coated attendants. There was a distinct sense of reference to drawings from prisons and camps during World War II, and to the work of the German artist Käthe Kollwitz. This series aroused the interest of collectors in the USA, where Graham exhibited large deconstructed works, expressions of his internal dialectic during the 1980s. Landscapes of the area around Lough Owel, where Graham grew up, allowed him to incorporate personal and ancient mythology that opened traditional Irish landscape painting (qv) to Expressionist possibilities far beyond anything that had been considered previously [166].

Michael Mulcahy also suffered the wrath of the state mental health care system soon after finishing his studies at the National College of Art and Design (NCAD). He moved to Africa, where he became involved with shamanistic art practices, especially with the Dogon tribe of Mali [167]. His performances with children's tea sets in Dublin's Grafton Street and the use of horoscopes and other ephemera to engage the public in his process as an artist attracted sensational responses. Mulcahy's work has always maintained an animistic awareness of nature and the rituals of art as magic, in keeping with the works of Joseph Beuys, who visited Ireland in the late 1970s and was influential on the

ideas of shamanism and performance in contemporary art here. The 'Dogon' series, exhibited in 1994 at the HL, from a residency at Buddhist monasteries in South Korea, is probably Mulcahy's most succinct statement. These seventeen paintings integrate symbolic iconography and decorative plastic Expressionism with the animism of nature and the sophisticated pictograms of human transmutation.

Brian Maguire's work of the early 1980s references similar themes, articulating the alienation of the artist from society. A change of emphasis occurred following his meeting with the artists Ed and Nancy Kienholz in the USA in 1983. His painting *Holbein's Christ makes it to the Rockies* (1991, private collection) in many ways encapsulates this journey, where his fascination with the figurative aspects of Holbein and the Northern Renaissance combines with his visits to the Kienholzs' studio. Maguire's work is highly political and this is particularly manifested in public art commissions in Northern Ireland, in which both sides of the conflict are presented as human beings lost in a quagmire of violence. Violence and conflict became the theme of his São Paolo Biennial project for the Irish Pavilion in 1998 where he depicted dead prisoners and their ravaged families. His work engages with a politically emotive aspect of the human condition, and shares with Graham and Mulcahy a dynamic and individual approach to the subject as a Neo-Expressionist mode of discourse.

The Expressionist return to figuration since the 1970s has had a significant influence on Irish art-making, particularly with the renewal of painting as a major mode of expression, thus re-engaging with previous generations of painters on the island of Ireland. CIARÁN BENNETT

SELECTED READING Meany, 1983; Henry Sharpe, *Michael Kane: His Life and Art* (Dublin 1983); *A New Tradition*, 1990; Farson, 1993; Dunne, 1994; Steward, 1998.

FARRELL, MICHEAL (1940–2000), painter and printmaker. Farrell was an uncompromising, turbulent and brilliant artist. In his early work, he combined organic motifs from Celtic art with the techniques of geometric hard-edge abstraction (qv), while his later paintings and prints are representational, revealing his skills in life drawing, graphic art and design. Themes of sex, death and politics play an important role in his work, which is often partly autobiographical.

Born in Cookstown House, Kells, Co. Meath, Farrell grew up in a family immersed in the world of sport and fox-hunting. As a child, dyslexia prevented him from achieving academic success, while difficulties in his parents' marriage resulted in his becoming isolated and turning to art at an early age. He attended Ampleforth College in Yorkshire and from there went on to St Martin's School of Art, London where his tutors included Robert McBride and Derrick Greaves. He also studied at Colchester College of Art. In 1960 Farrell graduated with a Diploma in Drawing and Painting from St Martin's. In 1961 he showed with the *Young Contemporaries* at the RBA Galleries, London, and at the age of twenty-three was awarded the Prix de Rome. Shortly afterwards he married Patricia Lamplew.

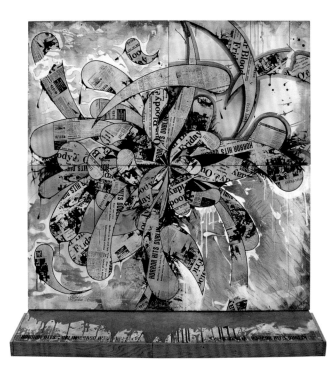

168. Micheal Farrell, *Pressé Politique*, 1972, mixed media on board, 200 x 200 x 30 cm, private collection

Although Pop art (qv) was gaining ground in London, Farrell remained committed to abstract painting. Inspired by the *Book of Kells*, he synthesized geometric art with elements of Celtic interlace, as in the 'Cairn' series, begun in 1964. The same year he went to the British School in Rome, and two years later his first solo exhibition at the Dawson Gallery in Dublin was opened by the poet Patrick Kavanagh. In 1966 also, a Macaulay Fellowship enabled him to go to New York, where a teaching job at the Pratt Institute proved short-lived, owing to his vocal opposition to the Vietnam War. During these years, Farrell was an up and coming star, his work being included in exhibitions in New York, Paris and Dallas. In New York he met Noel Sheridan and Brian O'Doherty (qqv), and was introduced to Mark Rothko, Roy Lichtenstein and Larry Rivers.

However, in 1967 a commission from the National Bank in Dublin induced Farrell to return to Ireland. Working at Ardmore Film Studios, assisted by Robert Ballagh (qv), he completed two canvases, each measuring twenty feet by fourteen feet. Commissions for Bord Fáilte (the Irish Tourist Board) and the Goulding Company followed, while Farrell was also asked to paint sets for films, including *Dracula has Risen from the Grave* (1968), *The Lion in Winter* (1968) and *Country Dance* (1970). In 1967 one of his paintings was purchased by the Musée d'Art Moderne de la Ville de Paris, he was awarded the Carroll Prize at the *Irish Exhibition of Living Art* (qv), and was also considered for inclusion in that year's *Rosc* exhibition (qv), although his work was controversially rejected. Farrell built a studio in his garden in Sandycove, Co. Dublin and embarked on the 'Sandycove' series, in which geometric triangles form part of abstract compositions. These were exhibited in the Axiom Gallery in London in 1969, with Ronald Alley contributing to the catalogue.

At the opening of the 1969 *Living Art* exhibition at the Crawford Gallery, Cork, Farrell, in protest at the deteriorating situation in Northern Ireland, announced his intention of not allowing his work to be shown in the North. This politicizing of his art developed in the years following, in a series of works in which aspects of Irish history are referenced and critiqued (see 'The Troubles and Irish Art'). Farrell moved to Paris in 1971, along with his wife Pat and their three children, and settled in the artists' colony at La Ruche in the south-western outskirts of the city.

A series of shaped canvases, the 'Pressé' paintings, inspired by the French citron *pressé* drink and juice squirting out from two pestles, was shown in 1970 at the Dawson Gallery, Dublin. After the Bloody Sunday massacre in 1972, Farrell produced the 'Pressé Politique' series [168], while his response to the Dublin bombings of 1974 was another series, incorporating newspaper images of the atrocity. An exhibition of cut-out 'Pressé' paintings, held in 1973 at the Galerie de Luxembourg, Paris, was unfavourably reviewed by Dorothy Walker, leading to a rift between her and the artist. However, Farrell's work, including lithographs produced at the atelier of Jacques de Champfleury, Paris, found buyers around Europe, notably at the Galerie Tanit in Munich and the Origrafica Gallery in Malmö.

In 1976, with his marriage in difficulties, Farrell moved to Florence for six months, producing what are perhaps his finest works, the 'Madonna Irlanda' series, based on François Boucher's portrait of the Irish courtesan, *Nude on a Sofa (Marie-Louise O'Murphy)*. In Farrell's paintings the images are wrapped up in puns, innuendoes and a sense of scandal (see 'The Body'). One of the series was acquired, not without controversy, by the HL in 1977 [377]. Returning to La Ruche, Farrell continued working, producing the 'Café Triste' and 'Le serpent al alcool' series, works that document both his struggle with alcoholism and increasing estrangement from his family. The suite of paintings that followed, 'An Incomplete History of Ireland' (1981), are also autobiographical, and depict the recumbent figure of the

artist. If Farrell's political and sexual allegories seem to objectify women, in such nude self-portraits he also lays his male ego bare.

In 1979 a mid-term retrospective of Farrell's work was held at the DHG and two years later he went to Australia to teach, and also to exhibit at the Armidale City Art Gallery in New South Wales and the Rudy Komon Gallery in Sydney. Returning to France, he embarked on a series of paintings based on semi-fictional encounters between Joyce, Picasso, Stravinsky and Nijinsky, said to have taken place in Paris in the early 1920s. Following the break-up of his marriage in 1984, Farrell spent two years in Australia, before returning to France with his new partner, the artist Meg Early. Early accompanied him to Ireland in 1987, where a large tapestry designed by him was woven by V'Soske Joyce, Connemara. After his election to Aosdána (qv) in 1988, Farrell and Meg Early settled in France, in the village of Cardet in Gard. Farrell was treated for cancer at St Luke's Hospital in Dublin, during which time he continued to work, making prints with the Graphic Studio in Dublin (see 'Printmaking'). Despite his illness, Farrell produced a series of works relating to contemporary and historic events [169]. His last work was a lithograph made in response to the Omagh bombing in August 1998, at the same time as his own exhibition *The Wounded Wonder* was opening at the Orchard Gallery in Derry. PETER MURRAY

SELECTED READING Cyril Barrett, *Micheal Farrell* (Dublin 1979); Aidan Dunne and Gerry Walker, *Profile 9 – Micheal Farrell* (Kinsale 1998); David Farrell, *Micheal Farrell: The Life and Work of an Irish Artist* (Dublin 2006).

FERRAN, BRIAN (b. 1940), painter. Born and educated in the city of Derry, Brian Ferran studied from 1959 to 1963 at St Joseph's and St Mary's Colleges of Education in Belfast, where he qualified as an art teacher. He returned to his native Derry and taught in a secondary school there from 1963 to 1966. He won the President Hyde Gold Medal and Arts Council Supplementary Award in 1965, and the Leverhulme European Award in 1969. In 1966 he joined the Fine Art Department of the ACNI. The next year he was commissioned to commemorate the North-West Arts Festival, and his paintings were reproduced in colour on the covers of Éire-Ireland, the quarterly journal of the Irish-American Cultural Institute. The pictures were bought by the Thomas Haverty Trust and the AC/ACE. Also in 1967, he was appointed Exhibitions Officer of the ACNI and later became its chief executive. Two years later he had a two-man exhibition with Colin Middleton (qv) at the Westgate Gallery, Newcastle upon Tyne. In his role as exhibitions officer, Ferran was able to present the work of artists he admired such as Gerard Dillon, William Scott, Colin Middleton, Basil Blackshaw (qqv) and F.E. McWilliam. In 1970/71 he studied at the Brera Academy, Milan. In 1973 he was appointed a committee member of the IELA (qv) and served on the committee of *Rosc '84* (qv). He obtained an honours degree in the history of art from the Courtauld Institute, University of London.

Ferran is essentially a figurative painter. Although he never fully embraced abstraction (qv), he particularly admired the

169. Micheal Farrell, *Black '47*, 1997–98, mixed media on canvas, 300 x 450 cm, Ireland's Great Hunger Museum, Quinnipiac University, Connecticut

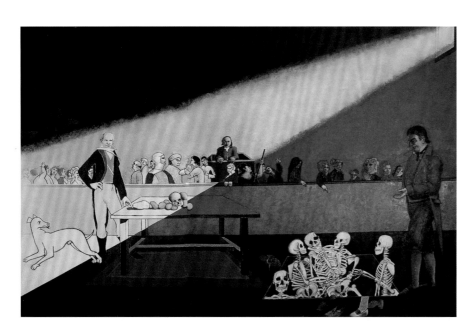

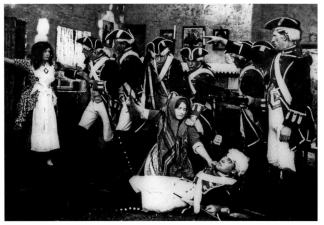

170. Brian Ferran, *Conchobor*, 1971, oil on paper on board, 50.2 x 66.4 cm, National Museums Northern Ireland, Collection Ulster Museum

171. Sydney Olcott, *For Ireland's Sake*, 1914, courtesy of Irish Film Institute

approach to colour of Mark Rothko and Willem de Kooning, the great masters of Abstract Expressionism. His work draws its inspiration from the *Conchobor* [170] and *Táin Bó Cuailnge* legends, and from Thomas Robinson's painting of the *Battle of Ballynahinch* (NGI collection) and its heroine Betsy Gray (Brian Fallon, 'Brian Ferran at Hendriks Gallery', *IT*, 18 October 1977). He was also profoundly influenced by the ancient stone carvings on Boa Island, Co. Fermanagh, and the semi-abstract drolleries in the *Book of Kells* (TCD). The UM has an oil-on-paper, *Conchobor* (1971), and a larger collage, *Pat* (1971), which was exhibited in the Galleria Solferino in Milan in May–June 1971. This latter work was provoked by an incident reported by the BBC European Service: 'While manoeuvering this evening on a narrow Belfast street in the North Queen Street area an army Saracen [a tank] accidentally mounted the pavement and killed a little girl of eight.' It seemed appropriate to Ferran to call the girl Pat, although he later discovered that her name was Denise.

Brian Ferran is married to the artist and teacher Dr Denise Ferran, with whom he formed a formidable team, writing, reviewing and promoting contemporary visual art from Northern Ireland. He retired from the ACNI in 2000. He and his wife live in Malin, Co. Donegal. His work is also represented in the collections of the AC/ACE and IMMA (Gordon Lambert Trust). MARTYN ANGLESEA

SELECTED READING Michael Longley, Denise Ferran and Ciarán MacGonigal, *Brian Ferran: Patterns and Parables*, *Paintings 1966–1996*, exh. cat. RHA (Dublin 1996); *The Lore of Places*, exh. cat. Kenny Gallery (Galway 2008).

FILM IN IRELAND. In the Kalem company's *Rory O'More* (Sidney Olcott, 1911), just as the rebel's sweetheart, Kathleen (Gene Gauntier) rushes to warn Rory (Jack J. Clark) of the edict issued by the English throne against him, the film halts its narrative and inserts an intertitle that reads: 'Learning of the intended capture, Kathleen warns Rory – near the Gap of Dunloe'. Later, the heroic Rory rescues one of his pursuers and a further intertitle informs us that: 'Rory rescues the drowning soldier – Lakes of Killarney'. In the later *For Ireland's Sake* (Sidney Olcott, 1914) [171], produced by the Gene Gauntier Feature Players and also

starring Jack J. Clark and Gene Gauntier, an 'Explanatory Title' precedes the opening of the film's narrative with the information that: 'This entire production was produced in County Kerry, amid the beautiful Killarney District. The Gap of Dunloe, the Black Valley, Muckross Abbey, Sweet Innisfallen and the lakes are shown among many other pretty spots famed in song and story.' Much has already been written about the Kalem films and Olcott's innovative approach to film-making that saw him shoot on location rather than on set. For Irish film historians, these productions have long been a key component of the history of silent-era Irish cinema. For the purpose of this essay, they are mentioned to draw attention to the imagined viewer that these historical melodramas address. Charles Foster tells us that when Olcott returned to New York, he found himself in demand as a speaker: 'The Irish clubs all wanted to hear me. I addressed eleven groups ranging in number from 50 to 1,000 in less than two weeks. As a result, all the films made in Ireland were profitable. It seemed everyone with Irish ancestry wanted to see the old country again.' (Foster, p. 227)

In order for Kalem to be able to make films in Ireland, therefore, the company had to earn its money back in the United States; indeed, we may doubt that Olcott even factored in income from Ireland when compiling his budgetary forecasts. Although he does not mention it here, we may assume that the Irish-American audience warmed to the films' plots – dashing rebels and last-minute escapes to America ('the land of the free', as another intertitle from *For Ireland's Sake* reminds us) – as much as to their locations.

What I would like to consider in this essay is the long history (stretching from the early and silent period of the Kalem productions to the 1970s) of creating films for an imagined non-local viewer. The reasons for this are cultural (deriving from the Irish Catholic Church's suspicion of film-making), economic (the Irish state's reluctance to subsidize a national cinema), and historical (the films that were made in this period were largely created by diasporic film-makers working out of the American/ Hollywood industry who, like Olcott, understood the financial potential of making emigrant-themed films). In this, Irish cinema is distinctive from other national cinemas in comparable territories, such as Scandinavia, where no such cultural or political suspicion of cinema as a symbol of modernity existed and

172. Rex Ingram
(1892–1950), courtesy of
Irish Film Institute

who, by contrast, understood the need to create an indigenous industry or be swamped by films from elsewhere, notably Hollywood. Nor could the same case be made for other Catholic countries such as Spain or Portugal, which enjoyed significant home-produced film-making in the decades that saw Irish screens almost entirely dominated by imported films. Nor did any other European state find itself with such a large and influential diaspora (qv) in the country – America – out of which the dominant cinema of the twentieth century emerged. This specific set of circumstances determined the aesthetics and narrative patterns of Irish film-making for the greater part of the last century, with ramifications that continue to influence current film-making practices. It is this history and these circumstances, then, that are the focus of this essay. For the sake of brevity, I have restricted my discussion to feature-length fiction film-making, although much the same argument could be made for documentary practices in the same period (O'Brien).

Film viewing in Ireland began, as it did in most countries, as a mixture of amateur activity and imported professional productions; in the late nineteenth century and early twentieth century, the latter came primarily from England (notably the Mitchell & Kenyon film company), France, Italy and America. Amateur productions were the terrain of well-heeled enthusiasts, who shot leisure activities and scenes of day-to-day life which could be shown back to their participants on the next or even on the same day. From the beginning, the Irish were keen consumers of the moving image and it was no doubt both the commercial possibilities and the artistic challenge of the new medium that inspired James Joyce to found Dublin's first dedicated cinema, the Volta, in 1909. His opening programme of films contained no Irish titles, nor were most of the other exhibitors of the day, often music hall owners and travelling showmen, able to access Irish-themed films in any significant quantity. The aforementioned Kalem company was the most consistent producer of Irish titles; its first, *The Lad from Old Ireland* (1910), was also the first American film made on location outside the USA. Kalem's success enabled the company to return to Ireland to shoot some seventeen titles, including those

mentioned above. With their intermingling of tourist sights and romantic nationalism, their appeal to the vast Irish emigrant audience was evident.

Ireland could at least lay claim to one successful indigenous company, the Film Company of Ireland, founded, significantly, in 1916. It was responsible for a production slate of comedies and nationalist dramas, notably a version of Charles Kickham's popular novel *Knocknagow* (1917) and *Willy Reilly and his Colleen Bawn* (1920). Other independent producers came and went but, with the establishment of the Irish Free State in 1922, conditions for local film-making drastically deteriorated. As already mentioned, a combination of reasons – official suspicion of cinema as propagating ideas and ideologies foreign to the ethos of the Catholic Church; lack of capital investment, notably state investment; the haemorrhaging of talent through emigration – meant that the creation of images of Ireland in the cinema was to remain, for the moment, largely in the hands of exogenous production companies and directors. This remains true even though Ireland produced a number of notable film-makers in this period who made their careers overseas, including Rex Ingram (1892–1950) [172] and Brian Desmond Hurst (1895–1986); the former never returned to Ireland, the latter made a small number of Irish films, but his best remembered works were in British cinema.

Occasional productions did see the light of day in these years. In 1926 the silent drama *Irish Destiny*, written and produced by Dublin doctor and cinema owner Isaac Eppel and directed by British actor-director George Dewhurst, reproduced a stirring if idealized version of the recent events of the War of Independence. When Kerry-native Tom Cooper made another Independence drama, *The Dawn*, in 1936, casting locals and filming on location in County Kerry, his venture was widely, if mistakenly, heralded as the dawn of Irish cinema. Instead, a series of productions, chiefly from Britain and the USA, filled the world's screens with images of Ireland and the Irish. If we are to distinguish crudely between the productions from the two territories, it is largely the case that the British productions were informed by a residual colonial agenda – to portray the Irish either as incompetent if harmless buffoons or as subversive terrorists, while the American productions followed the trajectory of the Kalem company in combining nationalist sympathies with romantic images of the Irish countryside. Even in the latter productions, the Irish buffoon was never too far removed from the action. On other occasions, the Irish were reduced to secondary characters in dramas that focused on the exhilarating primitiveness of the Irish landscape and seascape. One such production, *Man of Aran* (1934) [fig 1], is the work of another second-generation Irish director, the man credited with founding the documentary film, Irish-Canadian Robert Flaherty. The film notoriously revived long-abandoned practices, such as shark-hunting, to complete its picture of a pre-modern community battling against the elements, and suspicions about its ideological premise have been fuelled by its winning of the Mussolini Cup at the Venice International Film Festival of 1934. Yet its extraordinary cinematography, much of it achieved in conditions of genuine peril, has left a visual inheritance that is impossible to ignore.

A popular theme to emerge from these films was the clash of cultures occasioned by the incursion of modernity (often visually configured as a train and embodied by a stranger to Ireland) into a sleepy, bucolic Irish community. This provided the comic backdrop for one of the most popular Irish-set British films of the 1930s, the Will Hay vehicle *Oh, Mr Porter!*, directed by Marcel Varnel and released in 1937. In this production, the eponymous Mr Porter (Will Hay) is an inept English railway worker who, thanks to family connections, lands a job as stationmaster of Buggleskelly, on the border between Northern Ireland and the Free State. Widely known to be haunted by the ghost of One-Eyed Joe the Miller, the station is also home to two wily Irish hucksters (the British comedians Moore Marriott and Graham Moffatt) who make their living smuggling to supplement their salaries as employees of the railway company. Wild adventures laced with cultural misunderstandings and much local trickery and conniving ensue as all sides become embroiled in a gun-running sub-plot that feeds into the image of the Irish as charming but lawless rogues.

Irish lawlessness and IRA rebellion inform another key British production of this era, Carol Reed's *Odd Man Out* (1947). Shot in *film noir* style by much of the same production team that were later responsible for *The Third Man* (1947), this film envisions an unnamed city in Northern Ireland (identifiably Belfast) as the backdrop to the final hours of a dying and regretful IRA leader, Johnny McQueen, played with romantic intensity by British cinema's leading matinee idol, James Mason. The film's ending and final shootout at the docks pays homage to another tale of doomed love and lawlessness, Julien Duvivier's *Pépé Le Moko* (1937), and reprises much of that film's visual aesthetic – a sense of a city where everyone is under surveillance, where criminality and order play a long-standing game of cat and mouse to rules that only the participants understand. Local colour is achieved by the casting of many of the best-known members of the Abbey Theatre, a strategy also deployed by John Ford in *The Quiet Man* (1952) [173], a production that also serves as a model for this external vision of Ireland. In the opening sequences of Ford's film, as twilight falls over an Irish castle, it is delicately signalled that what follows is a dream. This lyrical moment is abruptly abandoned with the noisy arrival of the Dublin train into Castletown station. The locals who gather to meet it greet the arrival of the American Seán Thornton (John Wayne) as he descends from his carriage with a plethora of advice they evidently reserve for tourists. Playing on expectations of the Irish (lack of) sense of direction, of time and of place, he is warmly sent in all possible directions, with words of encouragement as to the fishing potential of each one. Only when he is rescued by the jarvey, Michaeleen Óg Flynn (Barry Fitzgerald), who most resembles a cunning leprechaun, is he led to Innisfree where he will, in short order, lay eyes on the 'wee humble cottage' (in Michaeleen Óg Flynn's words) where he was born, and the red-haired colleen, Mary Kate (Maureen O'Hara), with whom he will fall swiftly in love. Irish critics were divided in their response to Ford's love story, but its reception in America was unequivocal, with official recognition (two Academy Awards) complemented by box office revenue – the film was the tenth highest-earning film at the US box office in 1952, with

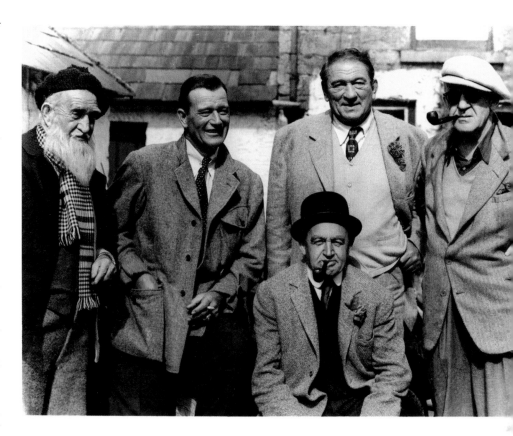

gross income of $3,800m (http://www.boxofficereport.com/database/1952.shtml, accessed 4 March 2011).

Throughout the 1940s and '50s, individual film-makers lobbied the Irish government to provide funding for the creation of a local film industry. Time and again, their entreaties were ignored. However, in other quarters, the educational possibilities of film were being discussed. As a result, the National Film Institute was founded in 1943 under the auspices of Archbishop John Charles McQuaid. Its remit was to produce, distribute and exhibit educational films in both the English and Irish language for use in schools and adult education. (Later, in 1987, the old Quaker Meeting House at 6 Eustace Street was purchased for what is now called the Irish Film Institute. That in turn housed the Irish Film Centre and, from 1992, the Irish Film Archive.)

It was the reputation of the Abbey Theatre and the model of Irishness (or stage Irishness) with which its company of actors had become associated, which eventually provided the selling point needed to strike the deal that led to the first wave of local Irish productions since the establishment of the Film Company of Ireland. The era of the so-called Abbey films was bound up with the founding of Ardmore Studios in County Wicklow in 1958. The company behind the foundation of the studios proposed making, in conjunction with RKO Teleradio Inc. of New York, a series of films based on Abbey plays and performed by Abbey players. As they soon found, to sell an Irish film abroad, Irish actors were only good enough for local colour, not for leading roles. Thus, the pattern established by *Odd Man Out* and *The Quiet Man*, of relying on a combination of local actors and international stars, was repeated in the Abbey productions. Although

173. Francis Ford, John Wayne, Victor McLaglen, John Ford and Barry Fitzgerald (seated), on the set of John Ford's *The Quiet Man*, 1952, courtesy of Irish Film Institute

- Dia's muire dhuit.
- What did you say?
- That's Irish you know. The Irish language. Erse.
- Is it? Would you mind very much speaking English?
- Not at all. Matter of fact, that's the only Irish I know except 'Go raibh mile maith agat'. Thank you.

The point of this comic exchange is that the initial speaker is an Englishman, Crispin Brown (Leslie Phillips) and his addressee, Máire McRoarty (Audrey Dalton) is Irish. A further misunderstanding on Brown's part leads him to believe that Máire McRoarty is English. Leaning forward, he earnestly explains to her that: 'You mustn't be prejudiced …. You may find the Irish hating you. In the past they had every reason to. Always remember, it's your duty not to hate them.' The film will subsequently take Brown into the heart of a bucolic community that is not dissimilar to the one Seán Thornton found himself in only a few cinematic years earlier. Indeed, the story follows a not dissimilar trajectory in many ways, with Brown discovering his Irish origins and proving himself to the village before winning the love of the Irish colleen, Máire.

Of the various Abbey productions of these years, only *Home is the Hero* (J. Fielder Cook, 1959) avoids the whimsicality that has tended to envelop Irish screen characterizations. Adapted from Walter Macken's play of the same name, it is a harsh look at the codification of masculinity and the unglamorous consequences of Ireland's drink culture which other film-makers of all origins strenuously avoided. In this sense, it provides the best link to the breakthrough movement of Irish independent film-making of the 1970s. Before passing on to these, mention should be made of one final production of these years: George Morrison's *Mise Éire* (1959), with its now famed soundtrack by Seán Ó Riada. A magisterial re-interpretation of Irish history as heroic anti-colonial struggle, it became impossible to replicate once Republicanism fell under the scrutiny of Revisionism.

the films now seem dated, and the Abbey acting style often appears at best hammy, works such as *The Big Birthday* (George Pollock, 1959) and *This Other Eden* (Muriel Box, 1959) do reflect not so much a sense of Irish culture of the day as a sense of how Irish cultural production understood itself to be part of a game of give-and-take, whereby the natives play up to the expectations of the foreign viewer while simultaneously acknowledging the ludic nature of the exchange. In common with *The Quiet Man*, such films also suggest that the quest for authenticity (the real Ireland) is an impossible fantasy. To take one such example, in *This Other Eden* an early encounter between the visiting Englishman and the Irish native runs thus:

The works of Cathal Black, Joe Comerford, Peter Lennon, Pat Murphy, Thaddeus O'Sullivan and Bob Quinn form a distinct movement in Irish film-making which stands defiantly outside the mainstream traditions largely established by exogenous film-makers. The first of the new wave of films was Peter Lennon's documentary *The Rocky Road to Dublin* (1967) [174], though the movement gained momentum only with the release of Quinn's *Caoineadh Airt Uí Laoire* (The Lament for Art O'Leary, 1975), the first Irish-language feature made in the country. An experimental work with a complex narrative structure, the film moves between a group of actors who are preparing to stage the eponymous ancient lament and the projection of a film in which they have appeared. The film revolves around a stand-off between two men, the English director (real-life English playwright John Arden) and the actor who plays Art O'Leary (Seán Bán Breathnach). One of the many differences between Quinn's outsider-Englishman and his counterpart in *This Other Eden* is that Arden's character constantly fails to understand the Irish, or to prevent them from undermining him. Nor are the players' taunts alleviated with the good-humoured cynicism of *This Other Eden*; rather they are motivated by intense hostility. In another of Quinn's Irish-language

productions *Poitín* (1977) [175], the character of the poteen-maker Michil (Cyril Cusack) is an unremitting deconstruction of the Stage Irishman. Cusack plays his character as pinched and miserly; his daughter Máire (Mairéad Ní Conghaile) is sexless and unmarried, while the two other central characters, the two poteen agents (played by Niall Toibin and Donal McCann), are socially alienated and emotionally incapacitated. Meanwhile, the countryside of the west of Ireland, unlike that of *Man of Aran* or *The Quiet Man*, is depicted as hemmed in and impoverished. Thus, in film after film of this era, the romanticized version of Ireland was undermined by images of neglect and despair. Dublin, in productions such as *Down the Corner* (Joe Comerford, 1977) and *Pigs* (Cathal Black, 1984), was reimagined as the locus of social disadvantage, whether it be Comerford's new working-class suburbs of Ballyfermot or Black's run-down inner-city Georgian tenements. The kindly priests of *The Quiet Man* and *This Other Eden* became the agents of physical abuse in *Our Boys* (Cathal Black, 1981) and the objects of ridicule in Lennon's *The Rocky Road to Dublin*, while Pat Murphy turned her attention to demythologizing the Irish colleen in *Maeve* (co-directed with John Davies, 1981) [176] and *Anne Devlin* (1984). This intense phase of deconstruction left no cinematic stone unturned in its collective attempt to revision Ireland and claim back Irish film-making for the local eye.

The short life (approximately a decade) of this independent movement of film-makers was facilitated by a number of initiatives (the involvement of the Arts Council in funding film, the establishment of the Irish Film Board in 1981, subsidies from Channel 4 in the UK and the British Film Institute). This permitted Irish film-makers to work in an environment that did not expect films to make a return on the international market. The output approximates to what Colin McArthur, in an advocacy piece, termed 'a poor Celtic cinema' (McArthur, pp. 112–25). This was to be a cinema that was low-budget, cinematically literate, not prescriptive about its aesthetic, and one whose films 'should deal with the *contradictions* of the Celtic past and present' (p. 124, italics in the original). The withdrawal of many funding sources – the Irish Film Board's operations were suspended in 1989 when Taoiseach Charles J. Haughey pronounced it insufficiently profitable, while Channel 4 moved into more commercial ventures and the British Film Institute largely abandoned production – left the majority of pioneering film-makers without the prospect of work other than in overseas' industries, in teaching, or in other art practices. In their place came a new generation of practitioners spearheaded by Neil Jordan and Jim Sheridan. Only Thaddeus O'Sullivan (*December Bride*, 1991; *Nothing Personal*, 1995; *Ordinary Decent Criminal*, 2000; *Stella Days*, 2011) and Pat O'Connor (*The Ballroom of Romance*, 1982; *Cal*, 1984; *Circle of Friends*, 1995; *Dancing at Lughnasa*, 1998) continued to work with any consistency in Irish cinema.

This adjustment – from an avant-garde, arthouse film-making culture to one driven by market forces – provided a new momentum for Irish cinema [177]. In this it was assisted, for the first time, by a commitment from the state to the development of an Irish film industry. The old system of tax breaks (Section 481) was overhauled so as to allow corporations and individuals to write off investment against tax, and in 1993 the Irish Film

Board was re-established and relocated to Galway. The Film Board (Amendment) Act of 1993 increased the limit of funds available to the Board from its earlier limit of £4.1m to £15m. In the years from 1993 to 2004, the Board produced 110 films, an average of nine per annum (*Expenditure Review*, *Irish Film Board/Bord Scannán na héireann*, 2008, p. 18). Many of these have enjoyed significant success; Academy Award recognition for Sheridan and Jordan came quickly with *My Left Foot* (Jim Sheridan, 1989) gaining two Oscars, and *The Crying Game* (Neil Jordan, 1992) gaining one; both received numerous other nominations and awards. Since then, *Once* (John Carney, 2006) won an Academy Award in 2008 for Best Original Song and the animated short film *Give Up Yer Aul Sins* (Cathal Gaffney, 2002) received an Academy Award nomination in the year of its release. Indeed, Irish animation has continued to receive international recognition with the feature-length release *The Secret of Kells* (Tomm Moore, 2009) nominated for an Academy Award

176. Pat Murphy, *Maeve*, 1981, courtesy of Irish Film Institute

177. Mike Newell, *Into the West*, 1992, screenplay by Jim Sheridan, courtesy of Irish Film Institute

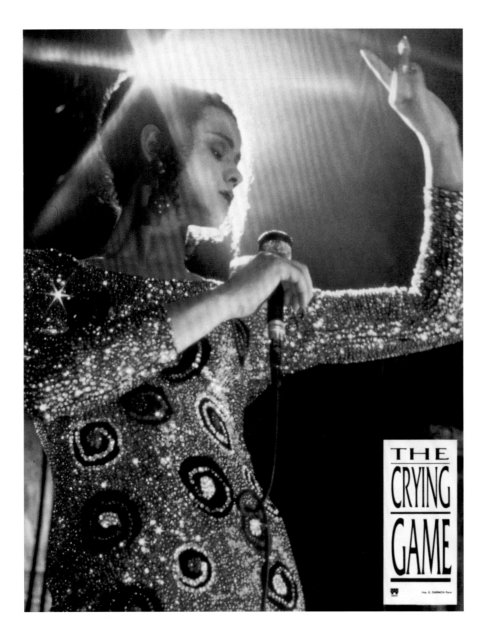

178. Neil Jordan, *The Crying Game*, 1992, courtesy of Irish Film Institute

in 2010, alongside another short animated film *Granny O'Grimm's Sleeping Beauty* (Nicky Phelan, 2008). In 2006 the film *Six Shooter* (Martin McDonagh, 2005) won an Academy Award for Best Live Action Short Film and *The Door* (Juanita Wilson, 2008) was nominated in the same category. Although awards are not the only measure of an industry, such recognition has been a fillip for Irish film-making and is usually seen as vindication for state support for the sector. Another state incentive for Irish cultural production, the Artists' Exemption introduced in 1969, whereby artists could claim tax exemptions on their earnings, subject to certain conditions, saw overseas film-makers, such as John Boorman, make their homes in Ireland.

The Irish Film Board is also charged with overseeing the development of film training. In this case, it has worked closely with Screen Training Ireland to develop a skilled base of practitioners. Many of these individuals have been able to benefit from the experience of working on foreign productions, while others

have come through the various third-level training institutes, notably the National Film School at the Institute of Art, Design and Technology, which was launched in November 2003.

The situation has thus radically changed from the early days of film-making, where images of Ireland were principally created by film-makers from abroad, working out of and financed by Hollywood or other non-Irish production bases. If the history of Irish cinema up to the 1990s was one that responded to an imagined 'outside' viewer, either by reproducing a certain set of images of Ireland or, in the case of the avant-garde films of the 1970s and early 1980s, by subverting that set of images, where does that leave Ireland now, when it has a commercial industry of its own? Has Ireland's change in circumstances – the opportunity to take control of its image-making and to project those images back onto the screens of the world – inspired film-makers to make films that are, in some way or another, identifiably local and Irish? It was this hope that fuelled the work of the first wave of independent Irish film-makers. However, their output was always bracketed as experimental and arthouse and, while many of the films of Pat Murphy, Bob Quinn and that generation of film-makers were highly regarded critically, few found an audience beyond the kind of intellectual circles that consume that model of film-making. Indeed, the best-known 'Irish' film of the 1970s is probably the British director David Lean's *Ryan's Daughter* (1970), a film that is steeped in the romantic legacy of colonialism.

With higher budgets, and decreasing film-making costs (particularly with the introduction of digital technology), the film-makers of the 1990s onwards have had opportunities like no others. The flaw in this argument is that Ireland in the intervening years has embraced globalization with enthusiasm, so that attempting to identify any film as Irish is now open to charges of naivety. Made with international co-production funding, directed by an Englishman and filmed on location on the Isle of Man, is *Waking Ned* (aka *Waking Ned Devine*, Kirk Jones, 1998) an Irish film because it tells an Irish story and its cast is mainly Irish? Or was its relish in foregrounding Irish stereotypes and its unashamed paddywhackery a consequence of the low level of Irish creative input into the production? Many of the key Irish films of this period have been made by British directors – *The Commitments* (1991) and *Angela's Ashes* (1999) are the work of Alan Parker, *The Magdalene Sisters* (2002) of Peter Mullan and *The Wind that Shakes the Barley* (2006) of Ken Loach. All tell Irish stories, most feature Irish actors in the lead roles, and their success has been celebrated as reflecting well on the national industry. Conversely, Neil Jordan is often discussed as a British director and he, Pat O'Connor, Thaddeus O'Sullivan and Jim Sheridan have made a number of films that are clearly Hollywood or British products – *Interview with a Vampire* (Neil Jordan, 1994), *Sweet November* (Pat O'Connor, 2001), *The Heart of Me* (Thaddeus O'Sullivan, 2002) and *Get Rich or Die Tryin'* (Jim Sheridan, 2005).

We now create our own images of Ireland and export them globally, rather than having those images formed for us by film-makers from outside industries. However, only very few Irish films have enjoyed successful overseas releases, especially amongst the coveted audiences of the United States. The

best-performing Irish films in America over the last two decades have been: *My Left Foot* (Jim Sheridan, 1989), *The Crying Game* (Neil Jordan, 1992) [178], *In the Name of the Father* (Jim Sheridan, 1993), *Circle of Friends* (Pat O'Connor, 1995), *Angela's Ashes* (Parker, 1999), *In America* (Jim Sheridan, 2002), *The Magdalene Sisters* (Mullan, 2002), *Veronica Guerin* (Joel Schumacher, 2003), *The Wind that Shakes the Barley* (Loach, 2006) and *Once* (John Carney, 2006). While this is a diverse list, and all these films also performed strongly in the Irish market-place, it does suggest some common factors in ensuring international attention. With the exception of *Once*, high production values attract viewers. Shoestring cinema, which describes most of the current wave of Irish films, needs exceptional content (in the case of *Once*, the romance of peripherality) to succeed. The other common factor shared by many of these titles is that they are concerned with Ireland's troubled past. Only two of these films deal directly with the Northern 'Troubles' (*The Crying Game* and *In the Name of the Father*) but many depict a nation defined by strife and by social deprivation. Aesthetically, these narratives of institutional and social dysfunction (*My Left Foot*, *Circle of Friends*, *Angela's Ashes*, *The Magdalene Sisters*, *The Wind that Shakes the Barley*) summon up an image of Ireland as a country whose history of warfare and poverty guarantees a rubber-stamping of authenticity on universal tales of human suffering. We might easily include *In America* in this list, in so far as its protagonists rehearse the familiar narrative trajectory of abandoning an Ireland associated with death (of their young son) for renewal and rebirth in the USA. Gratifyingly, too, the majority of these filmic narratives also provide their audiences with redemptive conclusions; thus, their singular heroes (several of them female) overcome the atavistic society, which has so restricted their potential for personal fulfilment, and rise above their circumstances to embrace a new future.

While a century has now passed since the release of *Rory O'More*, the visual/narrative drive of Irish film-making has not altered beyond recognition; indeed, the narrative of one of the most successful of all recent releases, *The Wind that Shakes the Barley*, offers many resonances with the Kalem films. It also carefully updates their central premise – that Ireland will always welcome its visitors – while retaining the narrative exploration of freedom fighters versus imperialists. Loach's production opens with a group of young men playing hurling on an emerald green pitch ringed by gorse bushes and surrounded by bare, slightly misty mountains. We then move to Peggy's (Mary Riordan) home, a primitive but tranquil location; her grand-daughter Sinead (Orla Fitzgerald) now appears carrying a basket of turf. The sudden intrusion of the Black and Tans, with their coarse lower-class English voices, is an instant violation of both countryside and homestead. The scene ends with the assassination of Micheál (Laurence Barry), Sinead's brother, after he has refused to give his name in English, and a single female voice carries us into the next sequence where the community 'wakes' the dead man and debates how to respond to the attack. Significantly, it is not this incident that causes Damien's (Cillian Murphy) change of plan (to go to England and practise as a doctor) but the next attack. Standing on the platform, waiting for his train, Damien witnesses the Black and Tans assault the train

driver and the elderly guard when the former, in accordance with union policy, refuses to take British army personnel on board. The set-piece at the train station recalls the symbolic deployment of the train in the mid-century films discussed previously. The celebration of pastoralism that so fuels those earlier films and their narratives of absorbing the stranger into the heart of Irish society is thus rudely shattered, both narratively and visually. In *The Wind that Shakes the Barley*, Loach presents British imperial militarism as a multiple violation – of landscape, of community and of cinematic tradition, placing himself on the side of the colonized rather than the colonizer.

As mentioned above, local audiences have responded well to such films, and their success overseas has been a source of national pride. However, we must recognize that the majority of contemporary Irish films have limited exposure to the overseas market and that their audience is primarily local. Thus a space exists for an alternative image of Ireland, one free of the need to market itself to the overseas' viewer. Recently, such films have tended to relocate the emphasis on rural Ireland that was so much part of the cinematic inheritance to inner-city Dublin. Where the Troubles provided the background to much of the drama of the 1990s, audiences since 2000 seem less responsive to such narratives, which, since the Good Friday Agreement in Northern Ireland, obviously lack topical immediacy. Gangster films have emerged as a particularly popular genre; internationally, the best known of these is John Boorman's *The General* (1998), but releases such as *I Went Down* (Paddy Breathnach, 1997), *Intermission* (John Crowley, 2003) [179], *Perrier's Bounty* (Ian Fitzgibbon, 2009), *Between the Canals* (Mark O'Connor, 2011) and *The Guard* (John Michael McDonagh, 2012) illustrate the appeal of the genre for established and emerging film-makers alike. In the tradition of that genre, these productions allow for an exploration of society's marginalized members while providing (often titillating) representations of violence.

What emerges from the wider picture of Irish film-making in the twenty-first century is the focus on marginalized masculinity. Even the work of director Lenny Abrahamson and writer Mark O'Halloran (*Adam and Paul*, 2004; *Garage*, 2007) [180], whose two feature films and single television series (*Prosperity*, RTÉ,

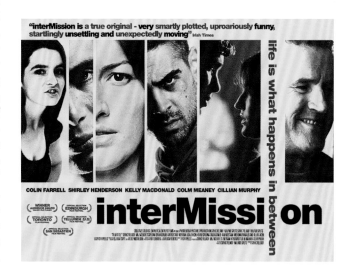

179. John Crowley, *Intermission* poster, 2003, courtesy of Parallel Films

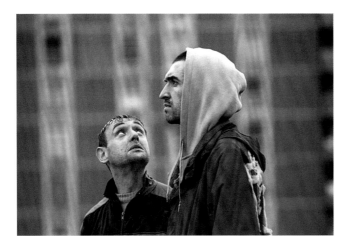

180. Lenny Abrahamson
and Mark O'Halloran,
Adam and Paul, 2004,
courtesy of Irish Film
Institute

compete hard to create a space for itself amongst the prolifera-
tion of images of Ireland already being produced by the global
industry. In this sense, it is still finding its voice or (better)
voices, and there is every sign that this is exactly what it is doing.
RUTH BARTON

SELECTED READING Rockett, Gibbons and Hill, 1987; Slide,
1988; McArthur, 1994; McLoone, 2000; Charles Foster, *Stardust
and Shadows: Canadians in Early Hollywood* (Toronto 2000);
Farley, 2001; Luke Gibbons, *The Quiet Man* (Cork 2002); Barton,
2004; O'Brien, 2005; Condon, 2008; Seán Crosson and Rod
Stoneman (eds), *The Quiet Man ... and Beyond: Reflections on a
Classic Film, John Ford and Ireland* (Dublin 2009).

FITZGERALD, MARY (b. 1956) [181], painter. Born in
Dublin, where she continues to have a studio, Mary FitzGerald
graduated from NCAD in 1977. In 1979 she went to Japan for
two years in search of models of purity and excellence. Her art
practice, on her return to Ireland, was often described in terms
of Japanese mark making, especially in its characteristic mini-
mal essentialism. FitzGerald herself, notwithstanding her
exploitation of such Japanese techniques as the use of black and
gold lacquer in some of her paintings, considered the impact of
Japan on her work as far more nuanced. For her, it was more the
spirit of perfection in Japanese culture, rather than any specific
approaches to art-making, and Japanese attitudes to space that
impressed her.

While her work has always been considered and thoughtful,
the experience of a serious road accident in 1986 and the coinci-
dence of being in Sri Lanka during the tsunami of 2004 have
undoubtedly added to her awareness of mortality. John
Hutchinson has described FitzGerald's work in the 1980s as 'res-
olutely abstract' when it was more fashionable to be figurative
(Hutchinson, 45) and, significantly, FitzGerald was unique for
presenting the only non-figurative self-portrait in the NSPC,
University of Limerick, up to 1989. FitzGerald's work is typically
understated, using a restricted palette and frequently square
canvases. The richness in her work comes from her inventive use
of materials, such as sheets of colourless acrylic laid on to graph-
ite and charcoal drawings, and then marked with paint to create

2007) have been universally lauded as socially engaged and aes-
thetically sophisticated, continue to centre on explorations of
male characters on the periphery of society, as does Abrahamson's
subsequent *What Richard Did* (2012). Although it is tempting to
be critical of much recent Irish film-making, which often seems to
be in thrall to international models, notably the kind of hyper-
bolized violence of the tradition that emerged with Quentin
Tarantino in the USA and transferred to Britain with the work of
Guy Ritchie (*Lock, Stock and Two Smoking Barrels*, 1998), we
should recognize that such film-making is making a play for an
audience that itself primarily consumes globalized genre
film-making. The accenting (literally) of such models, with fre-
quent exchanges that rely on (usually) Dublin humour for their
effect retrieves these films for a local audience.

It would be unduly schematic to conclude that Ireland now
hosts two parallel industries, one aimed outwards at the external
viewer and the other more closely responding to the idea of a
poor Celtic cinema. Indeed, the kind of films that exploit
Ireland's heritage – be it its history or its scenery, or both – have
always held an appeal to the local viewer, who may take as much
pride in the success of the image of Ireland overseas as in the
content of the films themselves. What has changed is the now
active participation of the national industry in these produc-
tions. Even if many are still directed by non-Irish directors, most
gain from financing from the Irish Film Board and avail of
Section 481 tax incentives. So do the small, local productions,
many of which may dream of breaking into the American mar-
ket but few of which do. These productions, not just the gangster
films but other small-scale productions, such as the Traveller
film, *Pavee Lackeen* (Perry Ogden, 2005) and the children-on-
the-run story, *Kisses* (Lance Daly, 2008), address, through more
or less conventional narrative and aesthetic strategies, issues of
inner-city deprivation, criminality, marginality and familial
abuse. With the immediacy of their narratives, and the kind of
urgency and intimacy given to such stories by the use of digital
cameras, these films demonstrate a desire to deal with life in
contemporary Ireland, rather than recycling a view of the coun-
try inspired by a tradition of representation created by outside
film-makers. Within the tradition of Irish art, Irish cinema is
still the newcomer on the scene; as suggested above, it has had to

181. Mary FitzGerald,
Drawing in Five Parts,
1987, acrylic, charcoal
and graphite on 5 panels,
300 x 50 cm each, private
collection

layered images, recording different moments in time and different processes. FitzGerald also uses arrangements of canvases in cruciform and rectangular grids and sequences, sensitively relating to the architectural space. Since her accident, other materials, such as broken glass, steel pins, medical scans and even insects, have been added to her canvases.

FitzGerald won a GPA award in 1983 and represented Ireland in the 1985 São Paolo Biennial. Following a period of slow recovery from her accident, her re-entry to active art-making was signalled in a solo exhibition, *Afterlife*, at the Fenton Gallery, Cork (2009) in which her work took on more figurative elements and included video installation. Mary FitzGerald is a member of Aosdána (qv) and is represented in the collections of IMMA, UCD, TCD, UCC, AC/ACE, ACNI, and most corporate collections in Ireland.

Catherine Marshall

SELECTED READING John Hutchinson, 'Mary FitzGerald', *IAR*, IV, no. 2 (Summer 1987), 45–49; Felicity Woolf, *Works 6 – Mary FitzGerald* (Kinsale 1992); Caoimhín Mac Giolla Léith, *Mary FitzGerald: Afterlife*, exh. cat. Fenton Gallery, Cork (Dublin 2009).

FITZPATRICK, JIM (b. 1948) [182], graphic designer, painter [182]. Because he has not been included in mainstream surveys of Irish art, few people are aware that Jim Fitzpatrick has been responsible for what must be the most widely disseminated image in the history of Irish art in the twentieth century. In May 1968, Fitzpatrick produced a poster bearing a portrait of the Argentinian revolutionary Che Guevara, which, almost overnight, became a symbol of revolution, student protest and anti-establishment activity throughout Europe and the USA, on posters, T-shirts, buttons and badges. In North America in the late 1960s, Fitzpatrick's image became synonymous with anti-Vietnam and Civil Rights protests and was quickly taken up, particularly in Palestine, in North Africa and in South America, where it was adopted as a badge by sympathizers of the Revolutionary Armed Forces of Colombia and the Zapatistas in Mexico.

The original photograph of Che Guevara, taken in 1960 by the Cuban photographer Alberto Korda, and distributed following the discovery of the murdered body of the revolutionary leader in 1967, was used by a number of propagandists, but it was Fitzpatrick's version of the image that caught the attention, not merely of the masses but of the art world. It had a particular resonance for Fitzpatrick because he had actually met Che Guevara, already a hero to him, in 1963, when Guevara stopped off from a flight to Moscow to visit Limerick and Kilkee ('Marking Che Guevara's Limerick Link', *The Limerick Leader*, 4 December 2008). The image created by Fitzpatrick has enjoyed an enduring popularity in the ensuing decades, as testified by the 2007 exhibition, curated by Trisha Ziff, of images of the dead revolutionary leader (Ziff, *Images of Che Guevara*, Barcelona 2007).

Despite the popularity of this work, which subsequently gave rise to artwork by Andy Warhol and a painting of Che Guevara by Gavin Turk (Saatchi Collection, London), Fitzpatrick has never

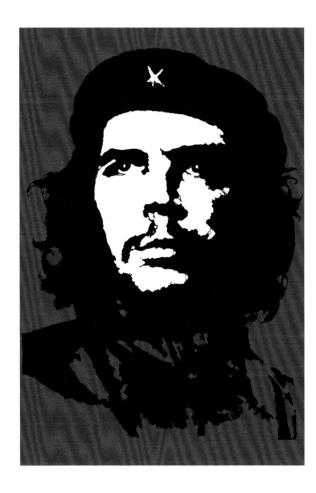

182. Jim Fitzpatrick, *Che Guevara*, 1968, original oil on canvas, later produced as poster art and silkscreen print, private collection

claimed copyright for it. Like Korda, he believed that the political ideals represented by his subject should be disseminated as widely as possible and should not be impeded by copyright restrictions.

Fitzpatrick, born in Dublin and self-taught, with no formal art training, has worked in north County Dublin throughout his career, concentrating on Celtic mythology which he has illustrated in paintings, graphic works and books, spearheading a popularized Celtic style derived from the *Book of Kells* and other ancient manuscripts. This is best illustrated in a stained-glass window, commissioned from the artist for the former Bewley's Restaurant in Mary Street, Dublin.

While Fitzpatrick has never repeated the popularity of his image of Che Guevara, he has maintained his place in youth culture by designing album covers for Led Zeppelin, Sinéad O'Connor, Thin Lizzy and others. He also collaborated with John Lennon. His artwork can be seen in his books, *The Book of Conquests* (1978), *The Silver Arm* (1981) and in his illustrations to *The Children of Lir* by Michael Scott (1992).

Catherine Marshall

SELECTED READING Knowles, 1982.

FLANAGAN, TERENCE PHILIP (1929–2011) [183], painter. Terence Flanagan is one of the most important landscape painters and, arguably, the finest watercolourist of his generation. Born in Enniskillen, Co. Fermanagh, Flanagan first studied art under Kathleen Bridle (1897–1989), and her technique as a watercolourist had a lasting influence on him. In 1949 he entered the Belfast College of Art where his teacher, Romeo C. Toogood (1902–66), who placed great emphasis on drawing and the rendition of forms through tonal relationships within a painting – attributes that remained with Flanagan – also made an impact on him. As a painter, Flanagan always eschewed abstraction (qv), maintaining what he called a 'respect' for nature and a 'human identity', his work being the outcome of meditation rather than recorded observation.

Landscape (qv) was Flanagan's main interest. As a child he spent long periods at Lissadell in County Sligo, where he was fascinated by the mansion (home of the Gore Booth family) and its setting. Thus his early paintings, such as *Back Avenue, Lissadell* (1960s), often depict the estate and form the earliest of the themes that characterize his oeuvre. In the mid-1960s Flanagan became interested in the subtleties of refraction and reflection, exploring the interplay of sky and water, light and luminosity, forms often suspended in a flux of light and merging imperceptibly with one another, as can be seen in his *Winter Lough* (c. 1966, UM).

In 1962 the Dublin gallery owner David Hendriks became Flanagan's agent. His first show with Hendriks, two years later, included paintings of Lissadell and was well received. 'There is real painterliness and delicacy about his work' commented the *Irish Times*, 'for these pictures ... work on you like good music' (*IT*, 21 February 1964).

The often moody Lissadell pictures were succeeded by the 'Gortahork' and 'River through sand' themes, the results of a holiday spent in County Donegal in 1966. These works are simpler in composition and less specific to their place of origin. Flanagan found the north Donegal landscape invigorating and was particularly impressed by the grandeur of Bloody Foreland. Several magisterial compositions resulted from the trip – *A Stream through Sand* (1966), *Boglands (for Seamus Heaney)* (1967) and *Gortahork 2* (1967, UM) amongst them – which are executed in an expressive manner. These pictures, with their strong emphases on the structure of the landscape and atmospherics, represent the maturing of Flanagan's art.

Other works that followed are those that comprise the 'Emigrant Letters' and 'A Rose Wrapped Up' themes. These echo a social conscience and relate obliquely to the 'Troubles' (qv) in Northern Ireland. They have their origin in the tragic story of two postmen, the Rooney brothers, who froze to death on Lough Erne during the severe winter of 1961/62, their boats trapped in ice on the lake. *An Ulster Elegy* (1971, Fermanagh County Museum) was Flanagan's way of paying homage to the Rooneys while also referring to the entrenched, or 'frozen', social attitudes of the Troubles. The 'Emigrant Letters' and 'Rose' pictures are poignant in mood and are executed with great subtlety in light tones, thus suggesting the often fragmentary nature of historical sources, on which they are based, and memory. They are, in the artist's words, pensive, yet 'mute with no urgent communication to make'.

In 1968, Flanagan acquired a cottage at Roughra in southwest County Donegal, an area that became central to his art. There followed a number of pictures, such as *Roughra Hearth* (1972/73) – a potent suggestion of an iconic reliquary – and atmospheric studies of the local landscape, of which the four 'Roughra' paintings in Fermanagh County Museum are typical. Watercolour also assumed a greater importance in his work from this time, the medium permitting, as the artist put it, 'tints of colour of such subtlety as to appear merely glimpsed [and] saturations of a rich depth and luminosity' (T.P. Flanagan, foreword to Carole Froude-Durix, *The Life and Art of Kathleen Bridle*, Dublin 1998, p. 8). Water, too, Flanagan said, ensures that layers of dissolved pigment remain transparent as light is reflected back to the eye from the white paper beneath.

Throughout his career Flanagan returned to his native County Fermanagh for inspiration, as the pictures of his 'Castlecoole' and 'Lough Erne' themes, which he first embarked upon in the early 1970s, illustrate. *The West Pavilion, Castlecoole* (1976) exemplifies the former, of which the house's owner, Lord Belmore, commented that Flanagan's watercolours 'read their subject as if poetry' (Lord Belmore, opening Flanagan's retrospective exhibition at Fermanagh County Museum, 23 May 1995, Belmore Papers). Of the Lough Erne theme, *A Shower Passing* (1971), *Autumn Lough* (1990) and *Dawn, Lower Lough Erne* (2009) are perhaps the most outstanding pictures. There is in them a freshness of palette and a luminosity to which watercolour greatly contributes. The *Autumn Lough* composition also shows the calligraphic brushwork that characterizes much of Flanagan's later painting. S.B. KENNEDY

183. Terence Philip Flanagan, *Two Islands*, c. 1966–67, oil on board, 70 x 89 cm, Crawford Art Gallery

SELECTED READING S.B. Kennedy and Martyn Anglesea, *T.P. Flanagan RHA, PPRUA*, exh. cat. UM, HL and Fermanagh County Museum, Enniskillen (Dublin 1995); Liam Kelly, *Correspondences: Selected Works by T.P. Flanagan*, exh. cat. Ormeau Baths Gallery (Belfast 2010); S.B. Kennedy, *T.P. Flanagan: Painter of Light and Landscape* (London 2013).

FOLAN, ANDREW (b. 1956), printmaker, conceptual artist. Andrew Folan's practice pushes printmaking (qv) to new limits, incorporating photography, sculpture, model making and, most recently, digital technologies, but the core of it remains dedicated to experimenting with this most traditional and democratic of art practices. Born in Donegal, he studied at NCAD and lived in London before taking up a teaching position in the print department of his old college, a position that is informed by his studio work.

Photography (qv) has always been a presence in Folan's work but an early dalliance with it served to remind him of the more sustained opportunities for creativity to be derived from the printing process. The two interests are visible in work such as *Camera Obscura* (1986), which resulted from his chance discovery that the keyhole in his Dublin flat acted like a photographic aperture, revealing inverted images of movement beyond his room. His interest in both science and alchemy, with the rational and the whimsical, is developed in works such as *Release* (1981) and *The Surface Dwelling* (1986 [396]); in the former, chemicals used to slowly destroy an image of a fly, paradoxically cause the release of a real fly from the box in which he is imprisoned. The surreal definition in *Surface Dwelling* derives from Folan's fastidious model making, creating staircases and other items from plaster to lend an air of concrete reality to his fanciful imagery. 'One thing I always held to was that these were actual images, they were not renderings,' he told Patrick Murphy (p. 15).

Most famously, Folan defies perceptions of printmaking as a minor, and thus less valued, art form by combining as many as a hundred prints in single sculptural artworks in his 'Imago' series, *Imago 1* [184]. The stacked-print works offer suggestions of hidden depth but in reality contain the gaze, and challenge conventions of the picture as a window to a world beyond it. They also incorporate a temporal element, gradually revealing the image as each superimposed layer is stripped back.

Since the mid-1990s Folan has gone back to art history as the source of his imagery, creating subversive variations on works by Max Ernst, Goya and Gericault. He has been an inspirational presence in the development and promotion of print as an art form, through his teaching, his work for the Black Church print co-operative and, especially, through his own practice. CATHERINE MARSHALL

SELECTED READING Patrick T. Murphy, *Profile 17 – Andrew Folan* (Kinsale 2002).

FOX, KATHLEEN (1880–1963), painter. Born in Dublin into an aristocratic Roman Catholic family, Kathleen Fox attended the DMSA where she was taught by Oswald Reeves and William Orpen (qv). Her work was considerably influenced by Orpen, for whom she worked as an assistant for several years, and who remained a friend. In 1908 she won the gold medal at the National Competition of Schools of Art, for an enamelled bowl, which was later shown at the V&A Museum in London. Fox was also a skilful woodcarver and a painter of china; she designed costumes and stained glass (qv), but it is for her oil paintings that she is most remembered.

Despite her family's loyalist sympathies and her father's position as a captain in the King's Dragoon Guards, Fox was one of a small number of artists who painted pictures recording events during the War of Independence and the Civil War (see 'Politics in Irish Art'). Her painting *The Arrest* (1916, Sligo Museum) [185] shows the arrest of Constance Markievicz and Michael Mallin at the Royal College of Surgeons in St Stephen's Green, Dublin. Fox's grand-daughter later recalled that her grandmother had kept the painting hidden for many years for fear of official repercussions (Bhreathnach-Lynch, pp. 44, 46–47, and

184. Andrew Folan, *Imago 1*, 1999, stack of 100 etchings, 12 x 26 x 26 cm, Irish Museum of Modern Art

185. Kathleen Fox, *The Arrest*, 1916, oil on canvas, 140 x 182 cm, Sligo County Museum

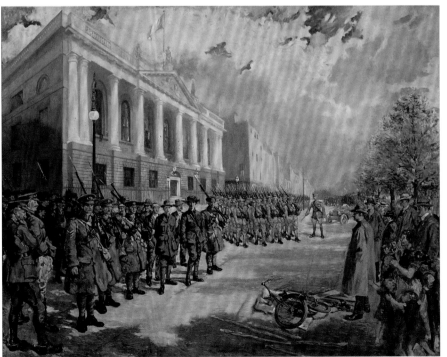

186. Mark Francis,
*Undulation (Indian
Yellow),* 1996, oil on
canvas, 213 x 183 cm,
Irish Museum of Modern
Art

footnotes 18, 19). Paintings of her friend Grace Gifford (widow of the executed signatory of the 1916 Proclamation of the Irish Republic, Joseph Mary Plunkett), and the attack on the Four Courts during the Civil War in 1922, showed her continuing sympathy for the republican position.

Fox lived in London, Paris and Bruges during World War I, marrying Lieutenant Cyril Pym, who was killed in action months before the birth of the couple's only child, Therese. After the war, Fox moved between Nice, London and Dublin and, despite a gap in production in the late 1920s and '30s, exhibited with the New English Art Club, National Portrait Society and RA, and showed some fifty paintings at the RHA (qv). Apart from a portrait of the Irish-Australian prelate Archbishop, later Cardinal, Mannix (1937, HL), and a set of Stations of the Cross for the Jesuit House of Studies in Milltown, Dublin, which she painted in her seventies, Fox's later work was confined to still-life painting.

Her work can be seen in the collections of the HL, UCD and in the Brian Burns collection, Boston College.
CATHERINE MARSHALL

SELECTED READING Ryan-Smolin, Mayes and Rogers, 1987; Dalsimer and Kreilkamp, 1996; Bhreathnach-Lynch, 1998.

FRANCIS, MARK (b. 1962) [186], painter. Employing a fluid and polished oil-painting technique, Mark Francis draws on both the theory and practical application of science as key source material for his art. His paintings can be described as metaphysical, in that they represent a tension between order and chaos, between the natural and the man-made world. While his paintings, often large in scale, may initially appear non-figurative, they are in fact abstractions (see 'Abstraction'), in the sense that while grounded in the visible world, albeit a world discerned mainly through the magnifying lens, oscilloscope or electron microscope, they are also very much paintings, and as such sit comfortably within the history of Modernist and Postmodernist art. Francis's interest in science extends to the study of molecular and cellular structures, the classification of life forms, and the visual recording of phenomena such as wave patterns. As befits this scientific approach, his paintings are often effectively monochromatic. Colour, while used sparingly, is, however, a key element, serving to heighten the work's visual intensity.

Born in Newtownards, Co. Down, Francis studied art at St Martins School of Art in London, graduating in 1985. The following year he was awarded an MA at the Chelsea School of Art. He had solo exhibitions at the Thumb Gallery in 1990, the Jill George Gallery in 1992, and Maureen Paley Interim Art in 1994. Living and working in London, Francis quickly achieved critical and popular attention for his abstract, rhythmic paintings and prints, works of art that were clearly beautiful as objects in their own right. In 1993 he was awarded the Grand Prize at the Tokyo International Print Exhibition. The paintings in his first exhibition at the Kerlin Gallery in Dublin, held in 1995, were based primarily on images of spores, cells and mycology. He was included in the 1996 exhibition, *Absolut Vision: New British Painting in the 1990s*, at the Museum of Modern Art in Oxford, and also the controversial *Sensation* show held at the RA the following year. He has had several shows at the Kerlin, as well as exhibitions in Amsterdam, Darmstadt and Paris. A retrospective exhibition of Francis's work was held at the Milton Keynes Gallery in 2000, which featured not only paintings but also an installation that included anatomical and plant models.

By 2001 Francis's painting had evolved from the early cellular patterns to a point where the original source material was less recognizable. Rhythmic, sinuous lines dominated, serving to dissolve the image. Three years later he had introduced the quintessential Modernist (see 'Modernism and Postmodernism') device of the grid, a decision that anchored his work even more distinctly within a contemporary fine art tradition, and deflected those readings which emphasized the world of science as a source for his art. In 2003 his work was shown at the Michael Kohn Gallery in Los Angeles, and over the next few years he had solo exhibitions at galleries in London, Paris, Helsinki, Berlin, Krems (Austria) and St Gallen (Switzerland). In the 2006 Kerlin exhibition *Pendulum*, his paintings were based upon visual representations of sound waves, while his more recent works have been inspired by particle science and the Large Hadron Collider.

Mark Francis is represented in many public and private collections, notably IMMA, HL, UM, Tate, the Saatchi Collection and the Metropolitan Museum in New York, de Young Museum in San Francisco, the Museum of Modern Art, Miami, Deutsche Bank and American Express. PETER MURRAY

SELECTED READING Stephen Snoddy, Stephen Jay Gould and Andrew Cross, *Mark Francis: Elements*, exh. cat. Milton Keynes Gallery (2000); Richard Dyer, James Peto and Francis McKee, *Mark Francis*, exh. cat. HL (Dublin 2008).

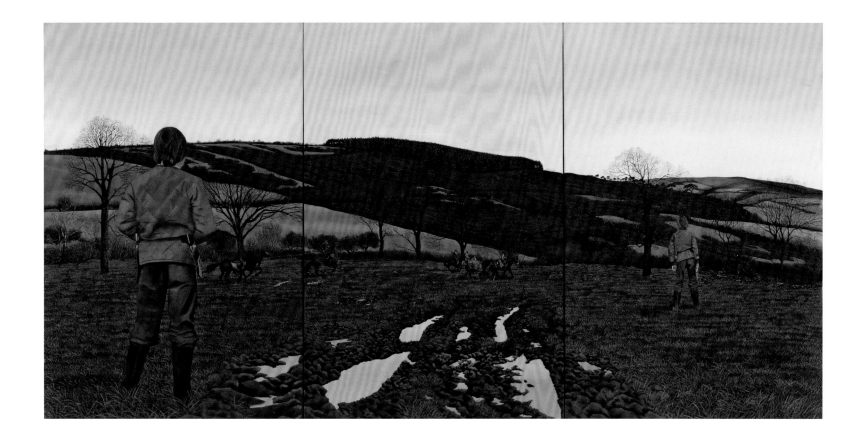

GALE, MARTIN (b. 1949), painter. Born in Worcester, England, Gale's family moved to Ireland where he was educated at Newbridge College, Co. Kildare. He attended NCAD from 1968 to 1973. As in the rest of Europe, this was a time of student revolt and re-evaluation. During Gale's time at NCAD, the traditional *beaux arts* method of teaching was rejected by the students in favour of less structured and innovative approaches. His co-students at the time were Charles Tyrrell, Liam Belton, Brian Maguire, Michael Mulcahy (qqv) and John Devlin, amongst many others who have carved an important place for themselves in contemporary art in Ireland.

Gale's early style was defined as 'photo-realist', referencing the American school of painting that included artists such as Richard Estes and Ralph Goings. These were high gloss urban painters, photographically rendering in oil paint the aluminium, glass and neon confections of the modern American city. However, if Gale did have an influence from the USA it was really from a couple of generations earlier, from the work of Andrew Wyeth and beyond that, from the great nineteenth-century formalists like Thomas Eakins and Winslow Homer.

Gale's paintings from the 1970s and '80s site themselves in the domestic and rural landscape, and, even more emphatically, in the places of personal connection to the artist – the parental home and familial parish. There is an intriguing psychological space being negotiated in these paintings, where the artist probes his own early years and those of his children, and his parents' approaches to child-rearing. The domestic garden and the unkempt countryside just beyond provide the setting for many of his canvases. The large redbrick house with its walled garden and glasshouse repeatedly feature, as do the roads and byways around Mount Kilbride where the artist was raising his young family. *My Heroes have always been Cowboys* (1978) [187], a triptych, shows two young boys, backs turned to the viewer, holstered with their toy guns, witnessing a posse of cowboys galloping across a water-sodden west Wicklow field. In many of the paintings from this period the children have their backs to the viewer, an invitation for them to become 'all children' or the child within us all, mediators between the observed and the observer. Gale never prescribes in his work but rather creates images that offer some, but never all, of a narrative, inviting the viewer to become a contributing reader of the scene.

In the early 1980s, the artist moved his family to just outside Ballymore Eustace, Co. Kildare, to a home he still occupies today. A visit to that area introduces aspects of the landscape that were used by the artist to create his compositions. A nearby white cottage with redbrick trim makes a number of appearances. Gale has a locker of landscape props which he uses to keen affect to create his vignettes.

The year 1992 saw Gale go indoors to develop a series of still-life paintings. There, his attention to detail is rehearsed in the bathe of artificial light. Vegetables, leeks, asparagus, cabbage, lettuce, join with paper bags, pewter mugs and blue vases as subjects in this suite of works. This interior series coincides with the artist's marital break-up and provides a segue for the painting to move further afield throughout the rest of the decade. Ardmore in County Waterford, a childhood holiday spot, County Mayo, the Glens of Antrim and a trip to Israel all provided new arenas for Gale.

187. Martin Gale, *My Heroes have always been Cowboys*, 1978, oil on canvas, 92 x 183 cm, Arts Council/An Chomhairle Ealaíon

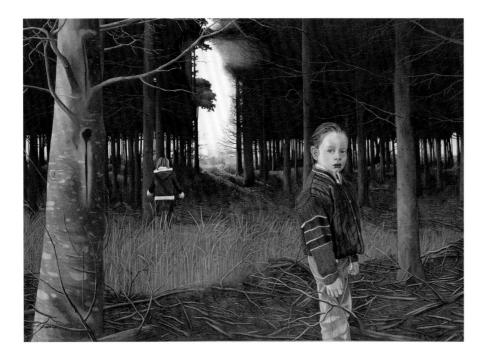

188. Martin Gale, *Waking Up*, 1986, oil on canvas, 122 x 152 cm, AIB Collection

acts of its inhabitants [188]. In that notion of epiphany commentators regularly associate Gale's sensibility with writers of fiction, such as William Trevor and John McGahern. While one can understand this appeal to an oblique ekphrasis, the immediacy of Gale's imagery positions him centrally within his own discipline.

Gale's oeuvre to date has yet to receive the in-depth scholarship its content can adequately support. A wealth of topics and issues remain to be probed – the psychology of childhood, the connection between the natural and the domestic, the changing face of Irish landscape all await their exegesis, the indexing of their metaphorical power as directed by this master image-maker. PATRICK T. MURPHY

SELECTED READING Arnold, 1969; Patrick T. Murphy (ed.), *Martin Gale: Paintings*, RHA and UM (Dublin 2004); Seamus Heaney, Nuala Fenton, Vera Ryan, Aidan Dunne, James Elkins, *Martin Gale: Representing Art in Ireland*, exh. cat. Fenton Gallery (Cork 2008).

GARSTIN, NORMAN (1847–1926) (qv *AAI* II) [189], painter. An Irish painter who became a leading member of the Newlyn School, Garstin combined in his art a muted Impressionism with a Realism (qv) in which social class and occupation are as significant as colour, tone and the handling of paint. His best paintings, such as *A Stranger* (1890, HL), *Overdue* (1889, private collection) and *Among the Pots* (1911, Plymouth City Museum and Art Gallery) are meditative works in which light and shadow play an important role. Perhaps his finest works, however, are atmospheric small panels, such as *Mount's Bay and Tolcarne from Trewiddon Farm Footpath with Alethea and her Mother* (c. 1898, Tate) in which the influence of Whistler combines with an introspective, dark, almost brooding, quality.

Garstin was born in Caherconlish, Co. Limerick, into an Anglo-Irish family. Owing to his mother's illness and the suicide of his father, he was raised by relatives and briefly studied engineering at Queen's College in Cork before being apprenticed to an architect in London. Early in 1871, he became a diamond miner in South Africa, spending two years in Kimberley with Cecil Rhodes. In 1875 he moved to Cape Town and was assistant editor at the *Cape Times* before returning to Ireland where he lived with relatives at Annsgift, near Fethard, Co. Tipperary. Following an accident which left him blind in one eye, he took up painting as a career. In 1880 he enrolled at the Académie Royaume in Antwerp, before moving to Paris, where he became a student of Carolus-Duran. He continued with his journalist work, writing an article on Manet for the April edition of the *Art Journal* (1884).

In 1882 Garstin first exhibited his work, at Southport, and later showed, with mixed success, at the RA, the RHA (qv), the Walker Art Gallery, Liverpool, the NEAC and the RSBA. He also showed with the Belfast Arts Society in 1905. He travelled in Italy and North Africa, painting scenes of Moroccan life that were shown at the Goupil Gallery on New Bond Street. In 1886 he married Louisa Jones and settled in Newlyn, Cornwall. His portrait *The Painter's Wife* (1889, NGI collection, where entitled *Portrait of the Artist's Wife*) is typical of his work of this period,

From the mid-nineties onwards, while maintaining aspects of his implied narrative, Gale's pictures also introduce, as Peter Fallon comments, 'a documentary accuracy matched by a moral concern' (Gale and Murphy, p. 62). Here, the mute beginnings of the Celtic Tiger can be caught in the detail and the background of his paintings. The yellow JCB digger appears, a colourful relief in the tight tonality of the Mayo countryside. But its presence is also portentous of the building boom that introduced strip development along lonely roads and rendered hillside and bogside ripe to receive poured concrete foundations. Interestingly, Fallon also mentions, in relation to this moral concern for the landscape, two other painters who 'engage with the environment in instructive ways' – Nick Miller (Gale's junior) and Barrie Cooke (Gale's senior) (qqv) – and notes that all three of them, though resident in Ireland, are English-born (Murphy, p. 63).

These three artists of distinct generations attempt to depict the Irish landscape as it really is and without the lyrical abstraction that forms a considerable school in post-1950s' Irish landscape painting (qv). And as Seamus Heaney says of Gale's paintings, 'They register injuries to the land and incursions upon it, but they don't insist on these matters as "issues".' (Heaney, p. 86)

The work of the past decade deepens both psychologically and as commentary. Gale, no less rigorous in his capturing of detail and incident, allows himself to create composite landscapes from his own photographic records. Paintings are meticulously planned, watercolour studies are worked up and then gridded and scaled-up onto the canvas to form larger works. Underpainting is applied to heighten or deepen certain areas of colour and then the labour of glaze upon glaze is undertaken. Gale's subject at this point is the Irish midlands, both its accepted banality and its constant redemption into significance by the

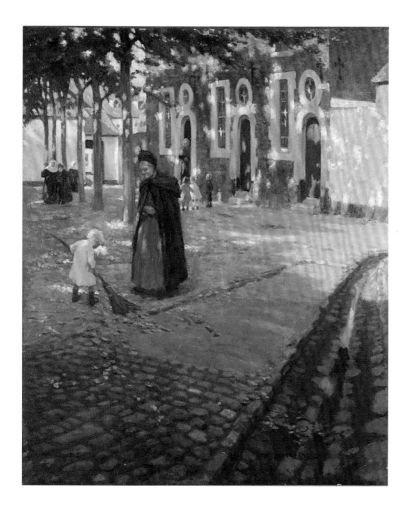

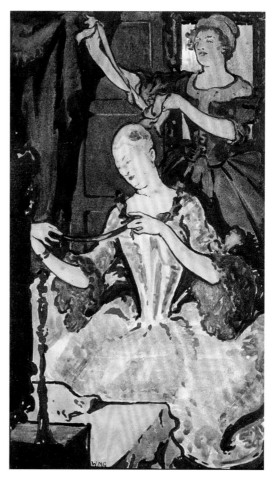

189. Norman Garstin, *Sunshine in the Beguinage, c.* 1908, oil on canvas, 91 x 75.5 cm, Crawford Art Gallery

190. Wilhelmina Geddes, *Cinderella Dressing her Ugly Sister,* 1910, watercolour and ink on paper, 25.7 x 15.3 cm, Dublin City Gallery The Hugh Lane

with the dark figure of Louisa silhouetted against a light background. One of his best-known paintings, *The Rain it Raineth Every Day* (1889, Penlee House Gallery and Museum, Penzance) depicts people huddling under umbrellas against the driving rain on the seafront at Penzance. The Garstins and their three children lived in straitened circumstances in Penzance, dependent on income from Garstin's painting, journalism and teaching. Among his students were Mildred Anne Butler and May Guinness (qv). Garstin suffered periods of depression, struggling to find a saleable style that suited his temperament. He and Louisa organized painting parties to France, and this led to a lightening of his work, which in turn brought increased success. His later works, such as *The Last Furrow* (1915, Glasgow Art Gallery and Museum), are full of feeling and nostalgia for the passing of old ways. In 1924, two years before his death in Penzance, Garstin had a joint show with his daughter Alethea. PETER MURRAY

SELECTED READING Snoddy, 2002; Richard Pryke, *Norman Garstin: Irishman and Newlyn Artist* (Reading 2005).

GEDDES, WILHELMINA (1887–1955), stained-glass artist. When Wilhelmina Geddes died, her obituary in *The Times* claimed her as the greatest stained-glass (qv) artist of our time. Even allowing for the partialities of the individual writer, this is

no small claim in a generation that also produced Harry Clarke and Evie Hone (qqv), and *The Times* was not referring to Irish artists alone. The comment might have arisen from the fact that although born in Drumreilly, Co. Leitrim, and trained in Belfast and Dublin, Geddes moved to London in 1925 and spent most of her mature years as a glass artist in England. Her finest works are to be found in churches at Wallsend-on-Tyne, Laleham in Sussex, and Belfast, while her acclaimed *War Memorial* window, commissioned by the Duke of Connaught, was shown in London in 1919 en route to its final destination in the Church of St Bartholomew, Ottawa, Canada. Her most distinguished commission was to create a rose window in memory of King Albert of the Belgians for St Martin's Cathedral, Ypres, Belgium in 1938.

Geddes was known for her independence of spirit and was one of the few students to withstand the influence of William Orpen (qv) when she arrived from the Belfast School of Art to the DMSA. Her friend Rosamund Praeger, with whom she briefly shared a studio in Belfast, described her as one of the most original and talented artists that Ireland had yet produced (Bowe, 2007, 79). Contemporaries noticed her 'modern' approach and this can be seen at its best in works such as the watercolour drawing *Cinderella Dressing Her Ugly Sister* [190], and in *The Children of Lir* window (UM) where her incisiveness and ability to condense a narrative into a successful composition, simplifying the forms and using only the most telling

gestures, is most evident. Geddes also produced highly distinctive lino and woodcut prints and needlework, as well as book-plates, book jackets, posters and postage stamps.

Wilhelmina Geddes acknowledged a deep debt of gratitude to Sarah Purser (qv) who had invited her to work at An Túr Gloine in 1912. Despite interruptions caused by ill health, Geddes spent nearly twelve years at An Túr Gloine, and from there exhibited in the *Exposition des Arts Décoratifs de Grande Bretagne et d'Irlande* at the Louvre in 1914. She left Ireland for London in 1925 where she joined the stained-glass co-operative the Glass House in Fulham and it was at this location that she gave Evie Hone instruction in translating her drawings into stained glass.

Her *Children of Lir* window was commissioned for the new museum building in Belfast, the Ulster Museum, on the recommendation of Rosamund Praeger, and there are important drawings and cartoons by her in the collections of the HL, NGI, UM and V&A Museum. Stained glass by Geddes can be seen in Achill, Belfast, Dublin, Larne and Monea, Co. Fermanagh. A monograph on Geddes by Nicola Gordon Bowe, the first major study of her work, is scheduled for publication in 2015. CATHERINE MARSHALL

SELECTED READING Nicola Gordon Bowe, 'Wilhelmina Geddes', *IAR*, IV, no. 3 (1984–87), 53–59; Snoddy, 2002, pp. 181–83; Nicola Gordon Bowe, 'A Forgotten Masterpiece: The Fate of the Children of Lir', *IAR* (Spring 2007), 77–85.

GERRARD, JOHN (b. 1974) [191], artist. Born in Dublin, Gerrard studied at the Ruskin School of Drawing and Fine Art in Oxford and in 2000 received his MFA from the Art Institute of Chicago. He returned to Dublin in that year to complete an MSc in New Media at TCD.

Gerrard works in the digital medium of Realtime 3D. This software is mostly employed in video gaming, an entertainment that we associate with simulated war games or martial arts

191. John Gerrard, *Double Portrait*, 1997, two computer-generated prints, 34 x 44 cm each, Butler Gallery

adventures. Its fast and furious imagery attempts to outpace the player and engulf him or her in a deluge of information. During a residency at the Ars Electronica Futurelab in Linz, Austria, Gerrard grasped its potential for a very opposite application to its commercial use. His sophisticated approach has exploited the ability of this digital medium to increase the presence in a work of art of the fourth dimension – time. Gerrard reduces the imagery to singular subjects and limits the movement to three-dimensional panoramas, and, by adding location and time, creates contemplative icons for the twenty-first century. The intense labour expended in creating the data to form these images requires the artist to maintain a studio of three to four technicians.

Double Portrait (2003), a digital update of his earlier *Double portrait* (1997), comprises two vertically mounted flat-screen monitors. The computer-generated image is of the upper torso and head of a young woman. Quite believable as actual portraits, the screens can be turned through 180 degrees so that the head can be examined in the round. However, *Double Portrait* contains another layer of complexity: its attention to its physical location on the earth, for eyes of sitter in the left-hand image open and her gaze follows the arc of the sun from rising to setting, while the right-hand image is aligned to the orbit of the moon. A GPS system is wired into the hardware of the work to locate its point of presentation and to plot the celestial paths, but this technical innovation is of less interest than the effect it achieves. For the viewer of the work, the mystery of this primordial witnessing of days passing is a telling reminder of time and mortality.

As much as Gerrard is a reductivist in the paring down of the image he presents us, so too is a minimalist aesthetic co-opted into its presentation. When using flat-screen presentation, all screens, cabling and hard drives are concealed within white Corian cases that are exquisitely finished and sculptural in their own right.

Gerrard's *1000 Year Sunrise* (2004) amplifies the subject of mortality since the programming extends for many generations beyond the lifetime of the viewer. A figure stands on the beach gazing at the distant horizon. The sky grows yellow with the promise of the rising sun, but the programme dictates that the orb will not free itself of the ground until 3004; when it does, the spectator will leave the beach. And, reflexively, most of us viewing the beach will have left this life in the meantime.

If these earlier works dealt with human mortality, Gerrard's later pieces extend to encompass the mortality of the planet itself. And, in the main, these grander ambitions have found their expression through cinematic-style projections. This artist is passionate about our abuse of oil and its derivatives, such as petrol and nitrates. A body of work, conceived over the past four years, thoughtfully raises consciousness about our dependence on oil for energy and agricultural production.

Grow Finish Unit (Eva, Oklahoma) (2008) shows a number of industrial sheds that house computer-controlled fattening units for pigs. At the rear, a large lake of effluent from the units glistens in the sun which rises and sets in unison with Oklahoma time. This automated environment is predicated on oil: oil provides the electricity, nitrates force-grow the corn feed, and

gasoline enables them to be sited in isolated areas where young pigs can be shipped in, the same vehicles being used to collect the finished animals. Gerrard's detailed study of this eerie architecture is elegiac, the scene devoid of the tarnish and wear of industrial use. It is as if it is already a memory, an evocation of a former age when the last great exploitation of the planet began. John Gerrard's work combines the most mutable of today's technology with the most pressing problem of our age. His minimalistic images are charged with dense content and are as pristinely beautiful as they are darkly portentous.

Since his successful presentation *Animated Scene* as an official collaborative event at the Venice Biennale in 2009, Gerrard has subsequently shown substantial work at the Hirshhorn Museum in Washington DC and at the Scottish Museum of Modern Art in Edinburgh. He was commissioned to create a large installation in the ticket hall of Canary Wharf, London, as part of the London Underground Jubilee Line celebrations in 2010. PATRICK T. MURPHY

SELECTED READING *John Gerrard*, exh. cat. Ivorypress (Madrid 2011).

GINGLES, GRAHAM (b. 1943) (qv *AAI* III) [192], artist. Born in Larne, Co. Antrim, Gingles attended the Belfast College of Art during the mid-1960s when Neil Shawcross, Basil Blackshaw and John Luke (qqv) were among the tutors there. He was impressed by the painted sculptures of Anthony Caro, which he first encountered during a year at Hornsey College of Art in 1967. In 1968 he returned to Belfast where he has continued to work, firstly as a painter and, later on, with mixed media constructions, many of which have a distinctly Surrealist (see 'Surrealist Art') feel through their use of shifting scale and covert sexuality. A feature of his work is his refusal to be categorized as either a painter or a sculptor, or, in political terms, as a loyalist or nationalist. Although brought up in a stalwart unionist, Protestant tradition, he does not ignore his Catholic ancestry. While Gingles's work may not conform to any political ideology, his art has been undeniably shaped by the Northern 'Troubles'. 'If there hadn't been the Troubles, my work would have been completely different. Probably I would only be doing paintings. I have been disturbed by the quality of politics in Northern Ireland, so the work had to be discreet in its presentation – how it would be read by one grouping or another.' (McAvera, 100)

The Troubles (qv) led to a deliberate obscuring of meaning in works such as the series 'Scenes of Crime' (1970s). Gingles's highly personalized iconography draws on the circus and other sites of theatre, such as the Catholic rituals he observed while on an ACNI fellowship in Rome in 1980/81. That iconography is further enriched by the use of materials from the real world that connect to family history, such as items gathered by his grandfather when he served as an air warden during the war, or real flies and animal blood as signifiers of mortality, a direction in which he anticipated the more sensational work of Damien Hirst in the 1990s. These materials are assembled in glazed, compartmentalized boxes, with connotations of the tomb, museum and laboratory specimen boxes and

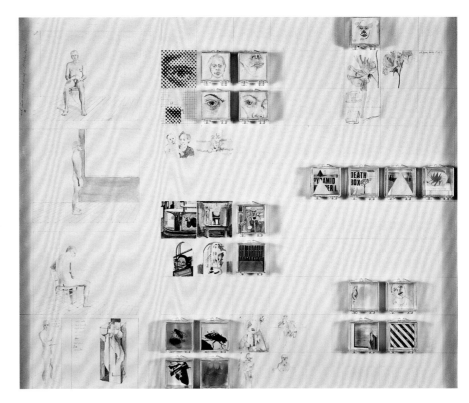

192. Graham Gingles, *Symbol for a Year (Time, Place, Situation),* 1979–80, watercolour and pencil on paper with mixed media, 45.8 x 45.9 cm, Irish Museum of Modern Art

the theatre, the precise craftsmanship of which derives from his painter and decorator father, rather than from the artist Joseph Cornell, to whom he has often, he believes inaccurately, been compared (McAvera, 96).

Gingles won the ACNI Art in Context prize for *Concrete Trees* in 1972 (Brook Road, Armagh), the painting prize at *EV+A* (1977), the George Campbell travel award (1989), and the gold medal at the RUA (qv) exhibition in 1988. While Gingles turned to his constructions as a response to the Troubles, he has resumed painting in the decade since 2000. He has served on the selection committee for the RUA annual exhibition, and in 2008 succeeded Rita Duffy (qv) as president. His work is included in the collections of the Gordon Lambert Trust at IMMA, the NSPC at the UL, and the UM, and featured in such exhibitions as *In a State* at Kilmainham Gaol (1991), and *Irish Art of the Seventies*, IMMA and CAG (2006/07). CATHERINE MARSHALL

SELECTED READING *In a State*, exh. cat. Kilmainham Gaol (Dublin 1991); Brian McAvera, 'Cabinet Curiosa', *IAR* (Winter 2005), 92–101; Gallagher, 2006.

GLENAVY (NÉE ELVERY), BEATRICE (1883–1970), painter, multidisciplinary artist. Born in Dublin, Beatrice Glenavy was a painter of Surrealist and decorative scenes, much in the style of Rex Whistler, although she was also a sculptor, stained-glass artist, theatre-set painter and illustrator of children's books (see 'Surrealist Art', 'Stained Glass and Tapestry' and 'Illustrations and Cartoons'). The Elvery household was steeped in the arts and crafts aesthetic; both her mother, Theresa Moss, and her mother's sister Phoebe Traquair, had attended the

DMSA, and in turn, Glenavy, aged just thirteen, and her sister Dorothy, enrolled in that same institution. Initially studying sculpture under John Hughes, she remained at the Metropolitan for eight years, during which time her fellow student William Orpen (qv) graduated, and returned as her teacher. She, herself, taught at the school after 1904. Glenavy did not persevere as a sculptor, although she was a gifted modeller in clay.

Between 1901 and 1903 Beatrice Elvery won three Taylor Scholarships, using the funds to support a short term at the South Kensington Schools, and at Colarossi's studio in Paris. In 1904, through Richard Caulfield Orpen, brother of William, she was commissioned to make a bronze lectern and other furnishings for Tullow Church in Carrickmines, Co. Dublin, and later to sculpt *Mourning Victory* (1908), a bronze sculpture for the War Memorial at Clonmel barracks in County Tipperary. In 1903 Glenavy joined An Túr Gloine (The Tower of Glass) and two years later windows made by her were installed in the Convent of Mercy in Enniskillen, Co. Fermanagh. She

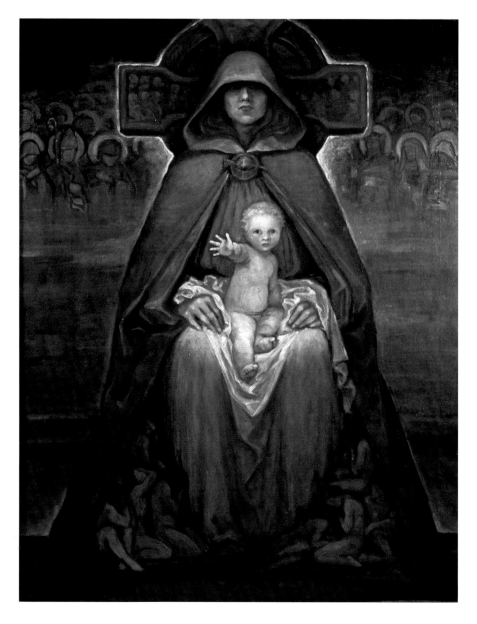

193. Beatrice Glenavy, *Éire* [or *Virgin and Child*], 1907, oil on canvas, 91 x 71 cm, private collection

continued to produce stained-glass windows, but came eventually to dislike the medium. Her oil painting *Éire* [193], an allegorical portrait based on Maud Gonne playing the role of Cathleen Ní Houlihan in W.B. Yeats's play, was presented by Gonne to St Enda's, the Irish-speaking school set up by Patrick Pearse. Glenavy subsequently illustrated stories written by Pearse, and produced quasi-religious paintings for St Enda's.

In 1910 Glenavy moved to London where she enrolled at the Slade School. Two years later she married Charles Gordon Campbell (later Lord Glenavy), a literary-minded barrister who had shared rooms with D.H. Lawrence and was a friend of Kathleen Mansfield and Mark Gertler. In 1913 she returned to Dublin for the birth of her first son Patrick, who himself later became a writer and broadcaster. Thereafter, Glenavy combined her work as an artist with raising three children.

In the 1920s, after the disruption caused by the Civil War, she gravitated to the world of theatre. Her later easel paintings, depicting ceramic figures, flowers and keepsakes, can be compared with the work of her friend Mark Gertler. She also designed prints for the Cuala Press. An active member of the RHA (qv), to which she was elected as an associate member in 1932, and a full member two years later, Glenavy showed over 200 works at the Academy in her lifetime. She died in Dublin in 1970. PETER MURRAY

SELECTED READING Ryan-Smolin, Mayes and Rogers, 1987; Nicola Gordon Bowe, 'The art of Beatrice Elvery, Lady Glenavy (1883–1970)', *IAR Yearbook*, XI (1995).

GODBOLD, DAVID (b. 1961), conceptual artist. Born in Norfolk, England, in 1961 and educated at Norwich School of Art and Goldsmiths College, London, Godbold first came to public attention in the mid-1980s as part of a collaborative duo, Godbold & Wood. He had a successful first solo exhibition, *The Fall Guy*, at the Photographers' Gallery, London, in 1988, after which he went to Australia. He arrived in Dublin in the early 1990s where he quickly became one of the most influential teachers in NCAD, and an important contributor to critical debate on the visual arts. He has had residencies in New York at MoMA PS1, in Ireland at IMMA, in Rome at the British School, and has exhibited widely in Ireland (Orchard, DHG, Butler), Australia, Britain, Belgium, France, Germany, Italy and the USA. He continues to live and work in Ireland.

Godbold's first solo exhibition in Dublin, which toured to the Oriel Mostyn Gallery in Wales and the Orchard Gallery in Derry, gave an unequivocal indication of what could be expected in the future. His witty and iconoclastic artwork, drawing on Pop art (qv), critiques the role of visual imagery in contemporary culture, from the moment of production through distribution to completion by the viewer. High Renaissance icons and hallowed religious images are alike treated to Godbold's sceptical exploration. Out of deference to the plurality of the audiences for imagery now, Godbold uses recognizable visual material from all kinds of sources – from opticians' standard test sheets, discarded tickets and bill heads, road signage and corporate logos, to figures from Disney films and merchandise, wickedly fusing them with references to

Picasso, Leonardo da Vinci, Poussin and the stars of classical art history. This can be seen in *Madonna and Child with Onlookers* [194] which appropriates elements of a fresco by Masaccio, a face by Picasso and an Abstract Expressionist background, and combines them using both drawing and painting.

Walter Benjamin aspired to write a novel entirely composed of quotations from earlier writing. Similarly, Godbold's finished paintings, digitally enhanced prints, drawings and installations (qv) appropriate such a wealth of visual references, from 'high' and 'low' culture, that their meaning becomes obscured, making it difficult for viewers to comprehend their full range and, like Benjamin, challenging perceptions of originality and appropriation. Communication in contemporary life is possible only, if at all, he suggests, if we engage with all the languages available to us, without privileging any group.

Godbold's satire is directed at myth, superstition and other vehicles of social control. Even if art is powerless to change these control mechanisms in a post-modern world, he believes that it should at least reveal them. Underneath the mockery and the humour in his work, there is an almost puritanical sense of outrage at wrong-doing and injustice. In his perceptive essay in the catalogue to Godbold's DHG show in 1994, Caoimhín Mac Giolla Léith wrote, 'The passions ... which animate all human relationships ... are still what animate Godbold's work. That they are all but silenced by the raucous cacophony of the images through which they are necessarily mediated is, in the end, the endlessly frustrated message of this mediation.' (Mac Giolla Léith, p. 52) It is also the problem of the new communications age.

A serious issue for artists like Godbold is how to critique imagery that promotes superstition and injustice without actually adding to it. Godbold's solution is to make work that requires participative scrutiny to comprehend it. As theorists, like Declan McGonagle, have argued, the act of engagement, while empowering the viewer, changes him/her from a passive consumer into an active participant in the work (McGonagle, 'From Community Arts to Civil Culture and Back Again' in S. Fitzgerald (ed.), *An Outburst of Frankness*, Dublin 2004, pp. 50–55). That act of participation and engagement compromises the viewer, obliging him/her to adopt their own position in relation to the work.

Godbold's work can be seen in Ireland in the collections of IMMA, TCD and the AC/ACE, and in numerous private and corporate collections all over the globe. In 2005 a series of commissioned drawings for the House of Commons, London, provoked some controversy. In 2010 he was shortlisted for the Sovereign European Art Prize for his work, *It Gets Darker Every Day*. CATHERINE MARSHALL

SELECTED READING Edward Colless, *Songs, Divine and Moral*, exh. cat. Chameleon Contemporary Art Space, Hobart, Australia (Hobart 1989); Caoimhín Mac Giolla Léith, 'An Intimate Relationship', in *David Godbold: Selected Works, 1988–92*, exh. cat. DHG (Dublin 1994); Booth-Clibborn, 2005.

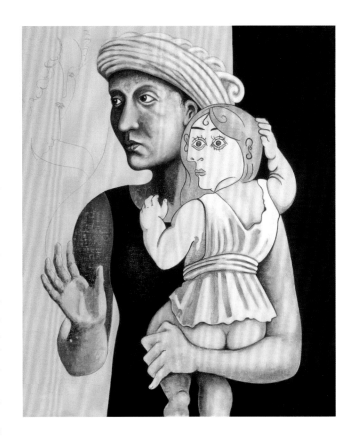

194. David Godbold, *Madonna and Child with Onlookers*, 1992, acrylic and sepia ink on canvas, 70 x 58 cm, Irish Museum of Modern Art

GORMAN, RICHARD (b. 1946) [195], painter. One of Ireland's leading contemporary painters, Gorman is best known for his abstract and minimalist canvases (see 'Abstraction' and 'Minimalism'). Often large in scale, these paintings are characterized by a sense of discipline and order, and a carefully controlled use of colour. Working within a Modernist tradition (see 'Modernism'), Gorman's work is infused with a Japanese aesthetic, particularly the art of the haiku, a literary form where deliberately few words are chosen to convey a sense of profound feeling, often a response to a transient natural occurrence, such as a shower or a gust of wind. In like manner, his abstract compositions are often based on something the artist has seen, such as an everyday object, the essential shape of which then forms the basis of a painting or a series of paintings. His approach to oil painting is methodical and traditional. He makes his own canvases, stretching linen onto wooden panels and preparing it with coats of gesso.

The notion of series, or sequences, is critical to Gorman's art; for example, he might set out to paint nine canvases, each measuring nine foot by nine foot. Occasionally he uses shaped canvases, adding an architectural quality. The paintings are built up in layers, the artist avoiding the impulse to incorporate narrative or subject matter and consciously working to make artworks that are, as he puts it, 'clear in their thought processes and non-rhetorical' (Tóibín, introduction essay, n.p.). The quality of the paintings also depends on an uneasy equilibrium established between line and surface. In his 2000 exhibition, *Made in Japan*, at the Ormeau Baths Gallery, Belfast, and the Limerick City Gallery of Art, Gorman showed works on hand-made Japanese washi paper, made in the Iwano Heizaburo workshop in Japan,

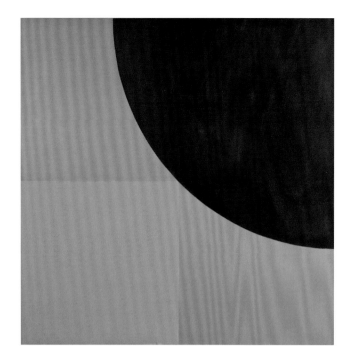

where the colour was incorporated as the artist made the paper from pulp.

Born in Dublin, Gorman studied at TCD and initially worked in the family business before deciding, with the encouragement of Patrick Scott (qv), to pursue a career as an artist. A seminal influence was the exhibition of the George Costakis collection of Russian Constructivist art, shown at *Rosc '88*, while the paintings of Willem de Kooning and Abstract Expressionism were also important formative sources. Graduating from the DLCAD in 1980, Gorman moved to Paris three years later, where he set up a studio and studied lithography with Jacques Champfleury. He has lived in Milan since 1984, apart from frequent trips to Japan. As Caoimhín Mac Giolla Léith has noted, while Gorman's earlier paintings bore titles derived from James Joyce's *Finnegans Wake*, such as *Muddlecrass*, *Publin* and *Foodbrawler*, his later paintings are untitled and freed from any literary association, no matter how tangential. The visual impact of the work is strengthened by the juxtaposing of unusual colours, while the treatment of surfaces and edges helps to reveal the history of how the painting was made. His work is characterized by poise, balance and simplicity.

Gorman was elected an RHA (qv) in 2005. A member of Aosdána (qv), he received a Pollock-Krasner Award in 1996. His work is in the collections of IMMA, CAG and the HL.
PETER MURRAY

SELECTED READING Aidan Dunne, *Richard Gorman: Paintings 1988–90*, exh. cat. Barbican Centre and Rhodes Gallery (London 1990); Caoimhín Mac Giolla Léith, *Richard Gorman*, exh. cat. Kerlin Gallery, Dublin; Orchard Gallery, Derry; Butler Gallery, Kilkenny (Derry 1995); Walker, 1997; Colm Tóibín, *Paintings: Richard Gorman*, exh. cat. Civic Theatre Gallery (Dublin 2005).

GRAHAM, PATRICK (b. 1943) [196], painter. Although he himself does not like the description, Patrick Graham is one of the finest Neo-Expressionist painters that Ireland has produced (see 'Expressionism and Neo-Expressionism'). A member of the Independent Artists and Group 65, a more radical group that emerged from within the Independents he was born in Mullingar, Co. Westmeath. Precociously talented as a draughtsman, he won a scholarship to NCA at the age of sixteen, and won the RDS's prize for drawing a year later. Early recognition, with the expectations it brought with it, proved burdensome as he increasingly recognized the need for a blunter form of expression than anything fostered by his art education. Work in advertising and art teaching led to a period of depression and alcohol abuse for which he sought treatment in a psychiatric hospital. As he described it: 'Very soon too, I moved to that hallowed ground in Dublin of the mythical failure, a has-been before I ever actually was anything. A blazing history to zero in a few short years. I stopped even attempting to make art a few years later.' (Graham, n.p.)

The Graham who re-emerged a few years later produced artwork that burned with raw emotion and social commentary. Suppressing the more obvious expression of his drawing skills, he painted, collaged and scrawled politically loaded text on to canvases that were ripped, sewn or left hanging in pouches from their stretchers, in a manner somewhat reminiscent of the German painter Anselm Kiefer. Few aspects of Irish life were left unchallenged, from nationalist politics and religion to sexuality and censorship (see 'Politics in Irish Art', 'Religion and Spirituality' and 'The Body').

His art practice in the 1970s and 1980s was dominated initially by censorship in cultural matters and the 'Troubles' (qv) in Northern Ireland, especially conflict inspired by sectarianism, and later by the power of the Catholic Church in Ireland and the inequality and poverty that forced large numbers of Irish people to emigrate. A measure of the outrage Graham experienced can be seen in paintings such as *Ire/land III* (1982, HL), in which a shamrock separates crude portraits of religious figures from icons of nationalist history, to form a decorative frieze across the front of a funeral bier. Scrawled like graffiti across the base of the bier are the words: 'Ah Sweet Jesus This Is Another Way To Love … And I Understand'. Graham leaves the viewer to decide whether the figure on the bier died for love of his God or his country, both of which are symbolized by the shamrock, since, while often used to represent Ireland, legend tells us that St Patrick used it as a motif to explain the Trinity. However we resolve Graham's ambiguity here, the possibility of death for sectarian reasons remains a distinct one. Another painting, from the same year, *My Darkish Rosaleen (Ireland as a Young Whore)* [42], draws on a more Joycean form of iconoclasm, but where Joyce used humour to temper his fury with Irish ideologies, Graham offers no such emotional safety valve. The title of the painting derives from the eighteenth-century aisling poems, in which the virginal princess, Ireland, seeks a hero to rescue her from her colonisers. In independent Ireland she is replaced by a predatory whore, still pulled between old civil war political parties, and the pickings she can extort from Irish immigrants in America or Britain. While the twin Irish obsessions of religion and

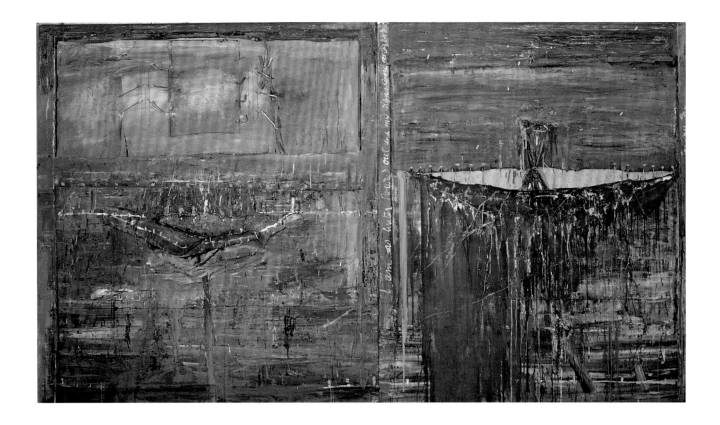

nationalism figure prominently in his work, Graham could also draw very effectively on popular culture from other places (such as the American cowboy hero Hopalong Cassidy), to explore more personal issues.

Graham's work was recognized through solo exhibitions such as his 1974 show, *Notes from a Mental Hospital*, at the Emmet Gallery, Dublin, and later shows at the Lincoln Gallery, but his real breakthrough came when he was invited to exhibit with Jack Rutberg Fine Arts in Los Angeles where he has had at least six solo shows between 1987 and 2002. He was elected to Aosdána (qv) in 1986 and was awarded prizes by the Independent Artists (1981), the Baghdad International Festival of Art (1988), and the Oireachtas Exhibition (Gold Medal, 1991). Graham was invited to serve as artist-in-residence in Pasadena Community College, California, in the 1980s.

Those who hankered after Graham's early promise were relieved by two exhibitions in the early 1990s, *The Lark in the Morning* (DHG, CAG, 1994), and *Plain Nude Drawings/Studies for the Blackbird Suite*, Galway Arts Festival, which revealed a more lyrical side to his practice. His love of nature and his exquisite line drawing came to the fore again in these bodies of work, proving that no matter how much time was given over to painting, his drawing had not suffered. In 2008, in order to concentrate on his own painting, he resigned after many years of teaching at the School of Art, Design and Printing at the DIT where he had played a considerable role in shaping a vibrant and dynamic studio programme.

Looking back over his career, Graham concluded that:

All of one's learning about art, all of the knowing that it is possible to squeeze from the history of art is necessary until one knows what the God of art is, and where every mark is a plea for the affirmation and consent both from history and from the critic. The great paradox is that this knowledge itself tells one that to go on one must free oneself from its harness and suffocating weight. (Graham, n.p.)

These words sum up the conflict that has shaped Patrick Graham's career, poised between a religious and cultural inheritance and the existential task of self-construction. Graham endorses the Lacanian view that the self is not only constituted for the other but also by the other.

Graham's work is included in the collections of IMMA, CAG, HL, AC/ACE and the OPW. CATHERINE MARSHALL

SELECTED READING John Hutchinson, *Patrick Graham*, exh. cat. Jack Rutberg Fine Arts Gallery (Los Angeles 1989); 'I Am of Water', *Portfolio 1: Patrick Graham* (Kinsale 1991); Jack Rutberg, *Works 5 – Patrick Graham* (Dublin 1992); Peter Murray, Donald Kuspit and John Hutchinson, *Patrick Graham: The Lark in the Morning*, exh. cat. DHG and CAG (Dublin and Cork 1994); Patrick Graham, *Leaves and Papers: No. 2* (Dublin 2008).

GRAY, EILEEN (1878–1976), artist, designer and architect. Despite reclusive habits and a reluctance to sign her work, Eileen Gray is widely acknowledged to have been one of the most influential designers of the early twentieth century. Shane O'Toole has described her as 'the only Irish person wholly immersed in the pioneering work of the modern movement' (*Sunday Times*, 17 March 2002) and Dorothy Walker declared her to be 'one of the most remarkable Irish women and one of the most remarkable artists of the century' (Walker, 119). A contemporary of the

196. Patrick Graham, *Ark of Dreaming*, 1990, mixed media on canvas, 180 x 316 cm, Irish Museum of Modern Art

painter William Orpen (qv), Gray, like him, studied art at the Slade School in London (1901), then dominated by the great Victorian academician Henry Tonks, who influenced Orpen and, through him, generations of Irish artists. Gray's independent spirit, however, enabled her to evade this influence. In 1902 she moved to Paris, attending the École Colarossi and, later, the Académie Julian. Although she continued to paint and draw throughout her life, declaring that 'painting is a life-long business', this was not her primary field of creative activity (Adam, p. 31). Gray's major contribution to the history of art lies in her achievements as a designer of furniture, wall coverings, rugs, lighting and of one of the most influential buildings of the twentieth century.

Gray's background was privileged; she grew up in County Wexford, in Brownswood near Enniscorthy, the child of an aristocratic mother and an artist father, who gave her her first lessons in painting. Gray was alienated from Brownswood when her brother-in-law, following her father's death and with her mother's permission, transformed their old Georgian house into a pastiche Gothic mansion. She left Ireland for good in 1902 and after a period in London, decided to settle permanently in Paris in 1906. At the age of twenty-nine she moved into an apartment on rue Bonaparte, her home for the rest of her life.

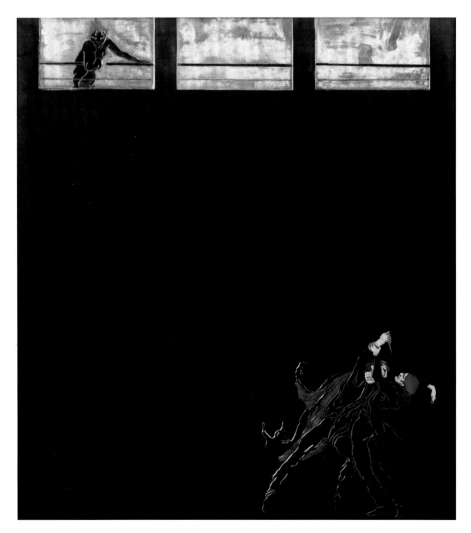

197. Eileen Gray, *The Murder*, c. 1914, lacquer panel, National Museum of Ireland

Gray's London years were not wasted however. It was there that she received rudimentary training in the techniques of lacquer work from Mr Charles, a Chinese lacquer worker, who allowed her to assist him in his practice. In Paris, spurred by classes with the Japanese craftsman Seizo Sugawara, who was to work for her for the next twenty-five years, '... she mastered the medium to a perfection that assures her a place as one of the great lacquer artists in history' (Adam, p. 50). She introduced the technique to Swiss artist Jean Dunand, who, more of a publicist than Gray, went on to become the most famous lacquer artist of the 1920s.

For Gray, lacquer was not an end in itself. She perfected its slow techniques – which require a minimum of twenty-two layers of lacquer with drying time in between – initially to make objects for her own apartment, telling her biographer Peter Adam that the small lacquer objects she made for her private use '... were an attempt to simplify the figurative with almost geometrical designs and to replace those ghastly drapes and curves of Tiffany and Art Nouveau' (Adam, p. 54) [197]. Through this, and even more through the rugs she designed from 1910 onwards, Gray was to be a leading pioneer of the Art Deco movement. She succeeded, after much experiment, in introducing blue into the familiar black-dominated medium of lacquer and in 1913, following an invitation to show at the 8th Salon de la Société des Artistes Décorateurs, began to make the large lacquer screens that first established her name. Positive coverage in such trend-setting magazines as *Vogue* and *Harper's Bazaar* led the famous fashion designer Jacques Doucet to buy several important examples of her work, including one of her most famous screens *Le Destin*, a four-panel screen, abstract on one side and with an image of two youths, one carrying an old man, on the reverse. The August 1917 issue of *Vogue* described her as 'An artist in Lacquer' (p. 19) and showed her first large multi-panel screen, *The Milky Way*, made for her friend Florence Gardiner.

By the early 1920s, Gray was highly regarded as a designer in the new Art Deco style. Doucet bought her Egyptian-influenced *Lotus* desk, preceding the craze for Egyptian art that followed the discovery of Tutankhamun's tomb by nearly a decade. Articles about her in *Vogue, Harper's Bazaar, The Times*, the *New York Herald* and the *Chicago Tribune* spread images of her work around two continents, leading to purchases by such people as the Maharaja of Indore in central India. Thus, her design of the furnishings and wall coverings of the Paris apartment for another fashionista, Mme Mathieu-Levy, in 1919 became world famous, especially the wall panels of black and silver leaf lacquer, while the *Pirogue* sofa – a canoe-shaped day bed, made of lacquer and tortoise shell – introduced an entirely new concept into furniture history. Walker claims that Gray's free-standing lacquer screens are the first example of Postmodernist deconstruction, enabling her to break up the architecture of the space and challenge the integrity of the wall (Walker, 121).

In 1922 Gray opened a shop under the name Galerie Jean Desert, on the fashionable Faubourg Saint-Honoré. With her characteristic reticence, she did not use her own name, although cards announced that furniture, lacquer and rugs by Eileen Gray would be on sale there and the shop's headed notepaper carried

the names Jean Desert and Eileen Gray. Among the pioneers of Modernism (qv), whose work she showed in Jean Desert, was the Russian sculptor Ossip Zadkine. Although Gray rarely exhibited, when she was persuaded to show at the 1922 Salon d'Automne, fellow exhibitors included Le Corbusier. Asked to design an entire room at the 14th Salon des Artistes and Décorateurs, she produced the acclaimed *Monte Carlo* room, which was especially admired by Dutch designers of the De Stijl movement, while Gray herself was interested in their social policy. Even her most luxurious chairs, such as the *Transat* and *Bibendum* chairs, were designed to be mass-producible, in accordance with her belief that good design should improve the lot of the common people [198, 123]. The Dutch art magazine *Wendingen* devoted a special issue to her in 1924, with articles by Jan Wils and the young Romanian architect Jean Badovici.

Gray and Badovici became close, and it was Badovici who encouraged her to pursue her latent interest in architecture. At the age of forty-six, with no training, but with Badovici's support, Gray designed her first house *E1027* (1924–29) [309], the title conjoining their two names: E for Eileen, while the numbers 10, 2 and 7 represented the numerical place of the initials J, B and G in the alphabet. The house, near Rocquebrune in the south of France, is now a French National Monument. It embodies many of Le Corbusier's ideas about architecture and he, in turn, was obsessed with it. In an honour previously accorded only to Le Corbusier, the house was the subject of a special edition of the architectural periodical *L'Architecture Vivante*, of which Badovici was editor. The Irish architect Robin Walker, who worked with Le Corbusier

in 1947/48, said that the only item in the architect's private office, apart from his drawing board, was a model of *E1027* (Walker, 125, ft. 6). Le Corbusier appears to have been unable to free himself from the spell of *E1027*, even painting murals on its walls, which Gray considered an act of vandalism. The building itself, a landmark in the history of European architecture, and the later house *Tempe à Pailla* (1932), which Gray designed for herself when she moved out of *E1027*, embodied her design philosophy.

Gray rejected the cerebral approach of the avant-garde as overly mechanized and lacking in heart. Convenience, simplicity and comfort were her hallmarks, matched by a profound understanding of the relationship of the building to the sun, such that prize-winning architects Shelley McNamara and Yvonne O'Farrell could describe *E1027* as an architectural sundial (lecture, Wexford Arts Centre, 17 October 2010). Lighting and fenestration could be controlled from central switches, and in *Tempe à Pailla*, anticipating the artwork of James Turrell, a circular roof light, allowing sunlight and moonlight to enter, could be controlled from the bed by a disc-shaped cover. Each room has a measure of separation from its surroundings so that occupants should be able to enjoy solitude when required, no matter how small the overall space. For this reason, every cubic metre, even in the ceilings and the steps of the stairs, contained hidden storage, and in order to promote comfort and ease, light tubular steel tables and chairs, fitted with adjustable shelves and handles to carry them by, were shaped to save space, and could be used externally as well as internally.

Notwithstanding her fame abroad, Gray was little known at home in Ireland. In 1973 that began to change when an exhibition of her work *Eileen Gray: Pioneer of Design* was lent to Dublin by the RIBA. The RIAI marked the occasion by awarding her an honorary fellowship and in 2000 the National Museum acquired the contents of her apartment. Other collections to include her work are those of the Pompidou Centre, Paris and the V&A, London. In 2009 Gray's *Dragon's Chair* was sold at the auction of the collection of the couturier Yves Saint Laurent and his partner Pierre Bergé for almost €22 million, shattering existing sales records for twentieth-century furniture.

Gray's niece, Prunella Clough (1919–99), was also a distinguished artist. CATHERINE MARSHALL

SELECTED READING Peter Adam, *Eileen Gray: Architect Designer* (London 1987); Dorothy Walker, 'L'Art de Vivre: The Designs of Eileen Gray (1878–1976)', *IAR Yearbook* (1999), 118–25; *Eileen Gray – Invitation to a Voyage*, documentary film, written and directed by Jörg Bundschuh, RTÉ, AVRO (2006).

GROENER, ANITA (b. 1958) [199], painter. Anita Groener was born in Veldhoven in the Netherlands. She holds a Master's degree from the Hogeschool voor de Kunsten Arnheim and a BA degree from the Moller Institute, Tilburg. Groener moved to Ireland in the early 1980s and by the end of the decade had established herself as an important painter within her generation, which included artists such as Cecily Brennan and Eithne Jordan, and in a wider context, Brian Maguire and Paddy Graham (qqv). All were painting in an *art sauvage* style

198. Eileen Gray, dressing table, rosewood, pine, zebrawood, steel frame, 1925–29, zebrano veneer, 1971, National Museum of Ireland

– aggressive paintings with hostile images. The 1990s were to see Groener abandon the *Sturm* and *Drang* of Expressionism (qv) and opt for a more reflective and complex imagery that dealt with immigration, exile and definitions of home. Her palette grew lighter and more tonally tight, while black-painted line became her method of creating images.

On to the painted surface, Groener applied fragments of actual letters she had received from her mother, and the literary association was further amplified by painting script into the picture. It was a highly personal and critical exploration of her exile from Holland and her ambivalence about her adopted home. Work from this time was pivotal in the artist's development because subsequently she was able to diminish the specificity of her subject matter and develop a more generous metaphorical language.

Crossing, a solo show at the RHA (qv) in 2006, embraced the artist's mature style – brush drawings with oil paint on canvas and paper – taking the language of road signage and demarcation into a dance of pattern and movement. Here the road becomes the place of occupancy and no longer the means to an end. Since 2006, Groener has moved this sense of dislocated/location on to a new level. In *Gilgamesh* (2009), installed at the Rubicon Gallery, Dublin, she made two immense wall drawings from short rapid brushstrokes, featuring the forest of Caspar David Friedrich and Grimm's *Fairytales* alongside a less defined, more ambiguous representation of space. Seán Kissane, in his essay on this installation, says: 'By means of its sheer mutability, it communicates numerous sensations and polarities: figuration vs. abstraction, narrative vs. formalism, esoteric vs. exoteric. It is this mutability that can be seen as Groener's focus in her search for visual narratives without a story.' (Kissane, n.p.)

Groener's work is included in the collections of IMMA, AC/ACE, DIT and many corporate collections. PATRICK T. MURPHY

199. Anita Groener, *Heartlands*, 1999, oil on canvas, 360 x 240 cm (6 panels) private collection

200. May Guinness, *Still life with Poppies, c.* 1930, pastel on paper, 142.9 x 76.8 cm, Dublin City Gallery The Hugh Lane

SELECTED READING Seán Kissane, 'Gilgamesh and the Uncanny', in *Tipping Point*, exh. cat. Rubicon Gallery (Dublin 2010).

GUINNESS, MAY (1863–1955) [200], painter. Born in Rathfarnham, Dublin, Mary Catherine Guinness was one of a number of Irish women who studied Modernism (qv) in Paris in the early twentieth century. However, although in Paris at the same time as Mary Swanzy and Mainie Jellett (qqv), she belonged to the older generation of Mildred Butler, with whom she had studied briefly in the Cornish fishing village of Newlyn, along with Norman Garstin (qv), in 1894. Perhaps because of parental opposition, Guinness was unable to study in Paris until 1907.

She studied at the Académie de la Grande Chaumière. Her works of this period, such as *Paris Scene* (private collection, exhibited Irish Impressionists, catalogue no. 114), are in a *plein*

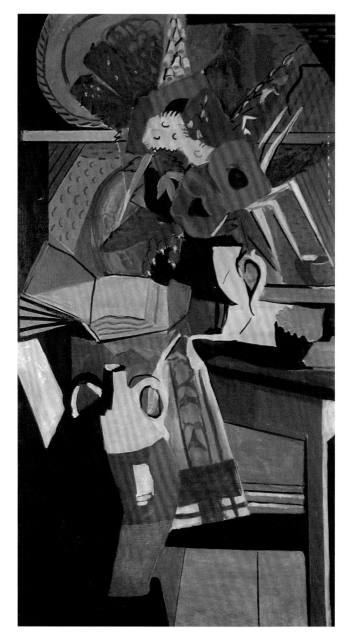

air style. Like many painters, she spent time in Brittany, visiting there in 1909.

Guinness's growing interest in modern developments is reflected in her choice of teachers. In 1910 she studied under the Symbolist painter Hermenegildo Anglada de Camarasa, an associate of Picasso's from Barcelona. However, 'desiring to paint in a broader and more decorative manner', she subsequently attended the class of the Dutch painter Kees van Dongen ('A versatile Irish Artist', *IT*, 19 October 1912). His expressive use of colour was something with which she could identify, strong colour being always a feature of her work. A review in the *Irish Times* refers to 'mauve nude women on a bright green and yellow background' (artist's scrapbook, unidentified review of her exhibition at the Eldar Gallery, London, 1920).

Guinness's career was interrupted by World War I, but she remained in France, nursing at the front, for which service she was awarded the Croix de Guerre in 1917. She stayed in Paris after the war, where she held a number of solo exhibitions, and also exhibited in London. Like many Irish artists, she studied with André Lhote, from 1922 to 1925, producing a number of works based on his highly formalized Cubism (qv), such as *Procession à Joscelyn* (1922, NGI collection) and *Golden Wedding in Belgium*. However, in later years she returned to an expressive, loose manner of working. She travelled widely, visiting Palestine and Greece and produced pastels of her journeys. In her later years she returned to Rathfarnham where her chief subjects were flowers and informal portraits.

Guinness has been largely overlooked in views of Irish Modernism – perhaps because she appears to have sold few works in her lifetime.

She had a collection of European art, including work by Picasso, Rouault and Bonnard (*Boy with Cherries*, now in the NGI), and her regular soirées at her Rathfarnham home offered an opportunity for younger artists to view these works.
DAIRE O'CONNELL

SELECTED READING Daire O'Connell, 'May Guinness, 1863–1955', MA thesis (NCAD, Dublin 1994).

HALL, KENNETH (1913–46) [201], painter. Born in Surrey, Charles Kenneth Hall came from a middle-class family with Irish connections; his mother was originally from Cork. After attending Lancing College, Hall moved to London in 1931, where he studied furniture design. Four years later, he began to attend meetings of the 'Society for Creative Psychology' in Fitzroy Street, and became close friends with the Society's founder, Basil Rákóczi (qv). In 1935 Hall took a studio at Fitzroy Street, where he began to make paintings based on psychoanalysis, and to exhibit with the White Stag Group (qv), which Rákóczi had also founded. Although Hall received some art lessons from the architect and designer Juan Stoll, a fellow-member of the Society, he was otherwise self-taught as an artist.

In 1936, accompanying Rákóczi, Hall made a painting trip to Spain. The resulting paintings, mainly landscapes, were shown at the Wertheim Gallery in London. Over the following two years, he and Rákóczi continued travelling, on the Continent and in Ireland, with Hall exhibiting works in London and

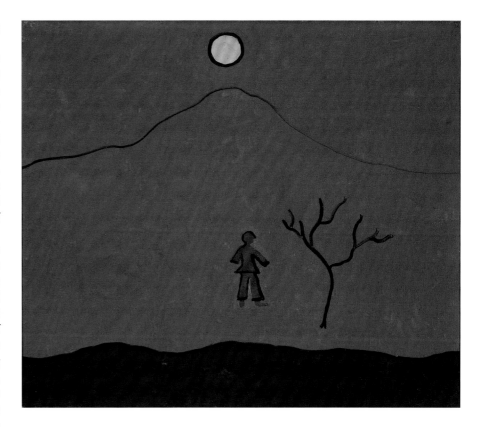

Manchester. In 1938 they travelled to Glyfada in Greece, where Rákóczi rented the Villa les Fauvettes. Here they were joined by the psychiatrist Herbrand Ingouville-Williams, another member of the Society for Creative Psychology. During this period, Hall's journal reveals his acute depression, partly owing to Rákóczi's bad treatment of him. In June 1939, when Britain declared war on Germany, Hall and Rákóczi sought refuge in Ireland. Initially they rented a cottage in Connemara, but the following March they moved to Dublin. In a letter to Lucy Wertheim, Hall was clearly struggling to overcome depression: 'the sadness and mystery of the Irish landscape are so overpowering one sinks into a quite passive state of mind where nothing seems really to matter' (Kennedy, p. 4). The first Irish showing of paintings by the White Stag Group took place that year, 1940, at 6 Lower Baggot Street, the exhibition also including works by Picasso and Rouault. Hall painted mainly landscapes during this period, his style being characterized by the use of flat areas of colour outlined in black. His later work is characterized by the scraping back of paint.

Although Mainie Jellett, Evie Hone (qqv) and others exhibited with the White Stag Group, essentially the group consisted of just three people, Hall, Rákóczi and Ingouville-Williams. In his introduction to the book *Three Painters*, published in 1945 to accompany an exhibition of work by Hall, Rákóczi and the young Irish painter Patrick Scott (qv), Ingouville-Williams quoted Hall's views on art: 'I am interested in creating Subjective paintings. In a painting, or indeed in any work of art, there is an objective and a subjective element, which are collected into the mind and personality of the artist and fused into the one form

201. Kenneth Hall, *Red Man Yellow Moon*, 1936, oil on canvas, 51 x 61 cm, private collection

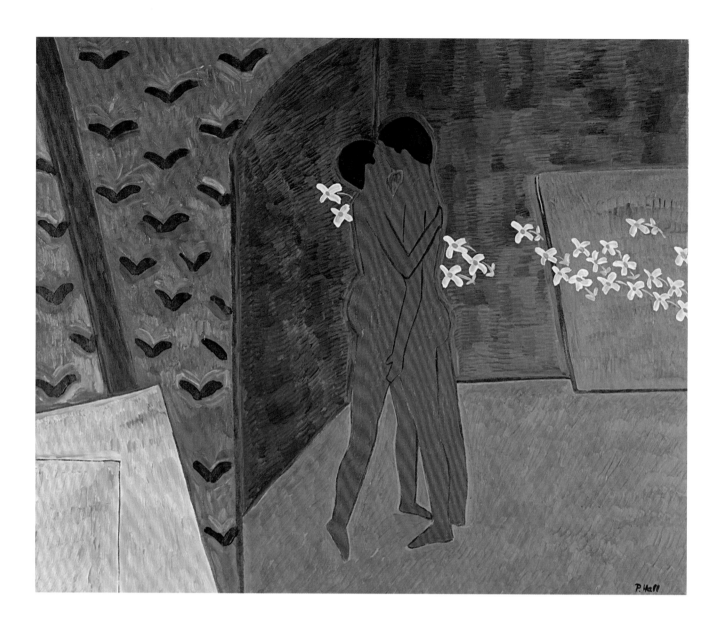

202. Patrick Hall, *The Kiss*, 1978, oil on canvas, 76 x 91 cm, Arts Council/ An Chomhairle Ealaíon

that they bear in the finished picture.' (Ingouville-Williams, p. 23) Hall held that the 'Subjective' came from within the artist's consciousness, while the 'Objective' was based upon the external world. During these years, 1944 and 1945, Hall lived at 18 Upper Fitzwilliam Street, and showed work at the RHA (qv). Pursuing the theory of the 'Subjective' in art, he began to introduce symbolic elements into his work. An exhibition, *Paintings of Birds and Fishes by Kenneth Hall*, was held in Dublin in January 1945. However, Hall's success in Ireland was limited, and after the war ended, he returned to London, where he exhibited at the Redfern Gallery. He was also included in the exhibition *Young Irish Painters* held at the Arcade Gallery. In July 1946, unable to readjust to life in post-war Britain, and suffering from severe depression, Hall took his own life aged just thirty-three. PETER MURRAY

SELECTED READING Ingouville-Williams, 1945; S.B. Kennedy, *Kenneth Hall, 1913–1946: A Retrospective Exhibition*, exh. cat. European Modern Art (Dublin 1991); Kennedy and Arnold, 2005.

HALL, PATRICK (b. 1935) [202], painter. Hall's paintings explore what it means to be, to exist, in the world. That exploration has taken very different forms over the years. In the 1980s his work was angry, challenging and tormented, reflecting the heroic suffering of mythical figures such as Marsyas and Faust, both of whom Hall made the subject of a series of large Expressionist paintings. Over the following decades the work has become calmer, though no less informed by the difficulties of existence. However, as John Hutchinson describes it, his painting remains 'haunted by the unknowable, the indescribable and the wrong turn. This anxiety helps to account for a certain awkwardness in his work; it stutters in a way that reflects a lack of coherence, a dislocation between different aspects of its being.' (Hutchinson, *Patrick Hall: Clouds*, exh. cat. Green on Red Gallery, Dublin and Butler Gallery, Kilkenny, 2003) The important constant in his practice is that sense of not ever knowing the ultimate answers in this existential quest and to find the courage to continue to reveal it, rather than to attempt to find comforting solutions. 'Everything that matters on the human journey is beyond knowing. It's a process of unknowing, of discovery, of

surprise.' (Karen Sweeney, *Patrick Hall: Drawings*, exh. cat. IMMA, Dublin 2007, n.p.)

Hall's existential meditations oscillate between the Freudian opposites of Eros and Thanatos, the life force and the death wish, the tensions between the two erupting into work that is masochistic and self-destructive in *The Flaying of Marsyas* or *The Cry of Faust* (1983, IMMA collection), or lyrical and even gently comic in his paintings of *Jacob's Dream* (2002) [431] and *Jacob's Ladder* (2002). 'We are creative in order to be human', he told the members of Sligo's youth programme Young Model (video interview, 29 June 2011, accessed on the internet, 23 May 2012), but that creativity comes at a price. As he went on to explain to his interviewer, 'Art investigates the cracks in your own personality and those are your strengths Investigating your weakness when you are painting, that's your ally.' For him, that has meant an intuitive, rather than rational, engagement with the other, with everything that is external to him, although it may have shaped him: his family background, the wider cultural history, the landscape that surrounds him, even the wind and clouds, frequently using mythical or biblical motifs to embody that separation of self from surroundings. Acceptance of that alienation is central to Hall's work. He told Karen Sweeney that the 'sense of aloneness appeals to me aesthetically. Even if I do a "bad" drawing, if I get that sense of aloneness in the drawing, that's what I'm captivated by – that's what I aim for.'

Hall is reticent about his personal life. In his Young Model interview he revealed that he became aware when he was twenty-two that he wanted to be an artist but, when pressed about what might have prompted this, he simply said 'it just came to me out of circumstances'. He was born in County Tipperary, into a mixed Catholic and Protestant family and studied at the Chelsea School of Art and Central Saint Martins College of Art and Design in London. He became involved with the Independent Artists Group in the early 1960s, attracted by their common leaning towards Expressionism (qv), though not by their political concerns. In 1966 he travelled to Spain, where he encountered the work of Velázquez, Goya, Titian and Bosch, describing that experience as his university. Hall rejoined the Independents on his return to Ireland in 1974. He became a member of Aosdána (qv) in 1982 and has been a practising Buddhist since the early 1990s.

Hall has had solo exhibitions in London, Liverpool, Cambridge, Los Angeles, Boston, Belfast, Dublin, Sligo, Limerick, Kilkenny and Galway, and has been included in important group exhibitions such as *The Quick and the Dead*, HL (2009), *Fifty Years of Painting*, Limerick City Gallery (2007), *In a State*, Kilmainham Gaol (1991), *A New Tradition: Irish Art of the Eighties*, DHG (1990), *Four Irish Expressionist Painters*, Northeastern University and Boston College (1986) and *Making Sense: Ten Painters, 1963–83*, Project Arts Centre, Dublin.

Hall's work is represented in the collections of IMMA, AC/ACE, ACNI, TCD, HL, NSPC and many other private and corporate collections. CATHERINE MARSHALL

SELECTED READING Patrick Hall, 'Notes on Painting', *Arena*, no. 1 (Spring 1963); Hutchinson, 1990a; John Hutchinson, *Patrick Hall – Works 12* (Dublin 1993).

HAMILTON, LETITIA MARION (1878–1964) [203], painter. Letitia Hamilton, whose style reveals the influence of French artists of the 1930s and of Raoul Dufy in particular, was one of a generation of Irish women from relatively privileged backgrounds who turned to art as a profession. Her paintings are bright and breezy, combining the light palette of Impressionism with an essentially nineteenth-century approach to subject matter. Her depictions of equestrian events, such as point-to-point meetings, are among her best works, evoking the everyday life of the Irish countryside, while her landscapes of Connemara capture the windswept terrain of the west of Ireland. Together with her sister, Eva Henrietta (1876–1960), (they were known as the Hamwood Ladies), Letitia spent her life painting, travelling and exhibiting.

The daughter of Charles Robert Hamilton and Louise Brooke, and the great-grand-daughter of the accomplished artist Caroline Hamilton (1771–1861), Letitia Hamilton was born into a family of ten at Hamwood House, Co. Meath. After attending Alexandra College, Dublin, during which time she probably took painting lessons with John Butler Yeats, she began exhibiting with the WCSI. Her early watercolours, exhibited at the WCSI in 1902 and 1904, depict the gardens at Hamwood House. Academic in style, they reveal the influence of her cousin Rose Barton. In 1907, at the relatively late age of twenty-nine, Letitia became a student at the DMSA, studying under William Orpen (qv), with Eva shortly afterwards also enrolling there. The sisters then moved to London, where Hamilton studied for a time under Anne St John Partridge at the Chelsea Polytechnic and

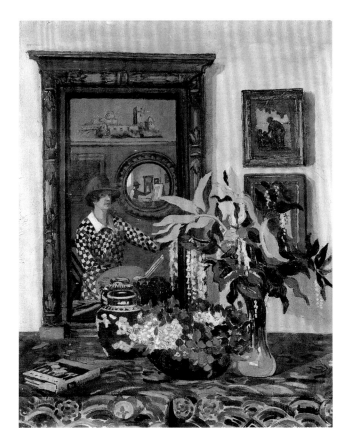

203. Letitia Marion Hamilton, *Self-portrait*, 1922, oil on canvas, 58.5 x 48 cm, private collection

also under Frank Brangwyn. She first showed at the RHA (qv) in 1909, submitting a view of her local village, Dunboyne, and thereafter exhibited regularly at the Academy, eventually being elected a member in 1943.

After the death of their father in 1913, the family lived at its Dublin townhouse, 40 Lower Dominick Street, but three years later moved to Monasterevin, Co. Kildare. By 1920, when Letitia was one of the founder members of the SDP, the family was living at Font Hill in Palmerstown, close to Dublin.

Hamilton spent time in Sligo painting west of Ireland landscapes, but she also travelled extensively on the Continent, particularly in Italy and Yugoslavia. In 1924, at the invitation of Ada Longfield, the two sisters spent a year in Venice, the first of several visits. Letitia's paintings reveal her exhilaration with the sun-filled Italian light, while her technique changed and she began to paint using a palette knife. She exhibited at the Paris Salon in 1925, and also in London, at the Goupil, Walker and French galleries, as well as showing with the RA, the RBA and the Fine Art Society. Remarkably, she won a bronze medal at the 1948 Olympic Games in London, for her painting of a Meath Hunt point-to-point race, and the following year her *Castlepollard Fair* (Brian Burns collection) was reproduced as a calendar.

Letitia Hamilton is represented in the collections of the HL, NGI, LCGA and CAG. Peter Murray

SELECTED READING Pyle, 1975; Hilary Pyle, 'The Hamwood Ladies: Letitia and Eva Hamilton', *IAR*, XIII (1997), 123–34.

HANLEY, JAMES (b. 1965) [204], painter. Primarily a portrait painter (see 'Portraiture'), Dublin-based James Hanley also paints other subjects which, since 1992, have been exhibited in several solo and group shows. A strong historical underpinning of his work can be traced to his degree in History of Art and English (UCD, 1987) and to the intensive art historical study incorporated into his subsequent Fine Art degree (NCAD, 1991). A technical master of his craft and having an exceptional ability to capture a likeness, Hanley has been commissioned to paint well-known figures from politics, sports, the church, academia and entertainment, becoming the most sought-after Irish portraitist of his generation. Paintings of An Taoiseach Bertie Ahern and President Mary McAleese are among his state commissions. His work is not flattering or in soft focus: it emphasizes creases and wrinkles so that the face takes on a sculptural quality. His portraits are marked by a stark, uncompromising honesty, their gravitas reinforced by their clarity and austerity. Flat unadorned backgrounds are a foil for beautifully rendered textural elements. However, the intensity of these portraits is largely attributable to their restraint.

Hanley has a quirkier side to his work which is most evident in his paintings intended for exhibition. A portrait of actress and comedienne Maureen Potter (1999) commissioned for the Gaiety Theatre, Dublin has a sense of playfulness and theatricality more associated with his non-commissioned paintings. Reflected in a mirror suggesting a proscenium arch, Potter is painted behind curved rows of theatre seats enclosing her in a niche. The composition nods to traditional religious art, a chandelier acting as a halo. Hanley appropriates elements from the

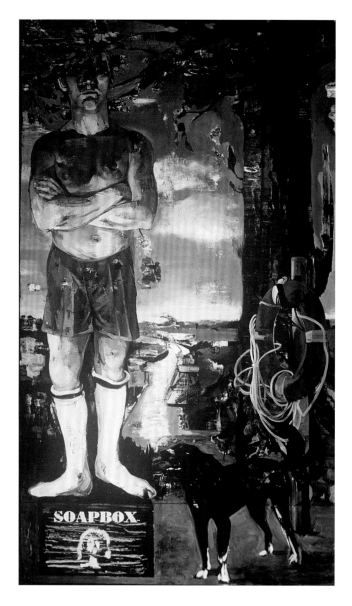

past and turns them inside-out, in this case creating a witty homage.

Hanley's less formal pieces have a playful humour and love of incongruity that borders on the surreal. Convincingly depicted, the narratives in these paintings are fictional, Hanley deliberately creating an unsettling mismatch between the real and the imagined. He draws on history as well as on contemporary popular culture for a range of intriguing themes.

Hanley was commissioned by An Post to design several series of commemorative stamps, their simplicity and graphic quality working successfully on a small scale. A member of the RHA (qv), Hanley has been active in reinvigorating their Life Room, where he has painted studies of nudes which are characterized by a spontaneity not associated with his more formal work. He was elected to Aosdána (qv) in 2008. Frances Ruane

SELECTED READING Brian P. Kennedy, *James Hanley: Grand Tourists*, exh. cat. Hallward Gallery (Dublin 1997); Órla Dukes, *James Hanley – A Decade of Works on Paper*, exh. cat. RHA

(Dublin 2005); Cristín Leach, 'Nude Awakenings', *Sunday Times Culture* magazine (6 March 2011).

HARPER, CHARLES (b. 1943) [205], painter. Born on Valentia Island, Co. Kerry, Charles Harper studied film animation at the Fischer-Kösen Film Studios, in Bonn, in 1960, before returning to Ireland to study painting at the Limerick School of Art and at NCA. He received his diploma in Principles of Teaching from NCA in 1968 and worked briefly both in the Graphic Studios, Dublin, and NCA. He then moved to Limerick where he taught at the Limerick School of Art, becoming head of the Fine Art faculty in 1975. While Harper's contribution to art education is important, he is perhaps best regarded in Limerick for his part in the founding of EV+A, the annual exhibition of national and international contemporary art which put Limerick on the visual arts map (see 'Exhibitions').As a painter, Harper's work is distinctive. Drawing on the grid as a structural motif, he explores aspects of life as revealed by the human body, particularly the head, as it engages in solo or group activities such as boat racing and rowing. His use of the grid, often accompanied by obvious references to how modern images are constructed and distributed – almost certainly derived from his experience in animation and film, can be read as a vehicle for his obsession with particular motifs, as well as a desire to both frustrate and communicate a narrative. His pictorial references include collaged images from Hollywood movies or popular culture, colour charts, and imposed scraps of text, all of which aim to help the viewer to pursue meanings that might not be otherwise obvious to non art-trained audiences.

Harper won an Oireachtas Painting award in 1974 for his painting of the Irish legendary hero Goll mac Morna which reveals the influence of Francis Bacon (qv). He was given a mid-term retrospective by the Butler Gallery in 1980 and was a founding member of Aosdána (qv) the following year. A major change for him came in 1995 when, inspired by an artist's residency in Claremorris, Co. Mayo, he overcame a long-held resistance to landscape painting (qv) and began to use it as a new challenge in his work in which avoiding the sentimentality often associated with it is his primary goal.

Harper's work is included in the collections of IMMA, CAG, NSPC in the UL, AC/ACE, HL, UM, Limerick City Gallery and the San Francisco Museum of Modern Art.

CATHERINE MARSHALL

SELECTED READING Gerry Walker and Aidan Dunne, *Profile 7 – Charles Harper* (Kinsale 1998); O'Byrne, 2010, pp. 160–61.

HARRIS, PAT (b. 1953), painter. 'With what mark do I make a piece of fruit visible and how can I make time tangible?': that is the question that Pat Harris attempts to answer through his paintings (Harris in conversation with Hans Theys, *The Loose Box*, p. 9). How does an artist make the subject in its particular timeframe visible with the limited tools of pigment, oil and canvas?

Born in Dublin and a graduate of NCAD, Pat Harris began his career with paintings and drawings of the nude, portraits, landscapes and still lifes, the conventional themes that have concerned artists since the Renaissance. Yet his question, especially when its receiver is simultaneously confronting one of Harris's paintings, assumes a weight that is rarely reflected in a more detailed exploration of those same motifs in the hands of other artists. He has the courage, as William Gallagher put it in 2008, to 'risk looking simple' (Gallagher, p. 94).

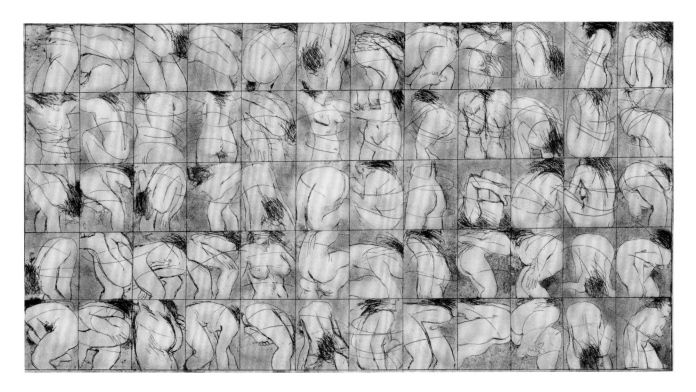

205. Charles Harper, *Figure Stress*, 1995, etching, edn 1/5, 54.5 x 73.5 cm, Arts Council/An Chomhairle Ealaíon

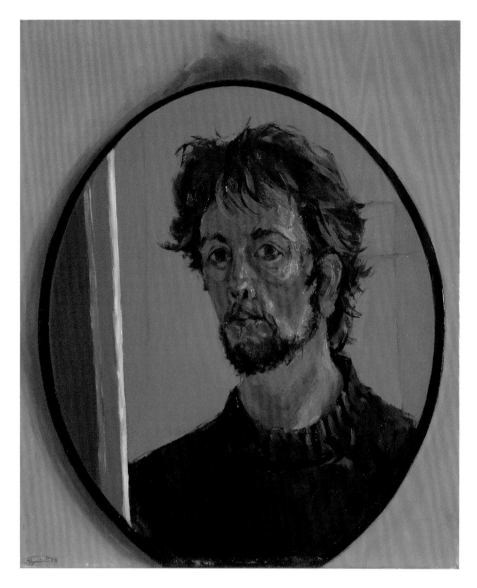

206. Pat Harris, *Self-portrait*, 1978, oil on linen, 60 x 50 cm

various elements across the surface of the canvas' (*The Loose Box*, p. 6). The spaces between the scattered elements and paint surfaces created by layering and scraping, not with a knife but with an aggressive brush, carry the weight of their history. Because of the brutality of the brushwork that evokes his delicate results, Harris paints onto canvas stretched across wooden boards in order to protect it. He then removes the finished painting from the board, re-stretching the canvas on to normal stretchers. The struggle that has taken place on its surface is visible only to the most carefully observant; visibility itself has become the core of the work. Explaining his process and his intention, Harris said: 'I wanted to make the marks more visible and the only way I found was to take the paint away. The mark arose as a trace in the remaining paint.' (*The Loose Box*, p. 6)

Structural lines and pencil marks have blended, over the years, with the tactile qualities of paint into a more integrated kind of expression, where the pigment, traces of the brush – even, on occasion, blown charcoal dust – are combined, creating figurative motifs that appear independent of the elements from which they are formed. *Spring Self-portrait* (1989, NSPC), painted in the colours of the landscape, reveals not just the individuality of the artist but the indissoluble link between man and his temporal and spatial coordinates.

Pat Harris is professor of painting at the Royal Academy of Fine Art, Antwerp. His work can be seen in the collections of IMMA, CAG, AC/ACE and the OPW. CATHERINE MARSHALL

SELECTED READING *Pat Harris: Where the Horses Walk*, exh. cat. Taylor Galleries (Dublin 2001); *Pat Harris: The Loose Box*, exh. cat. Purdy Hicks Gallery (London 2008); William Gallagher, 'Pat Harris', in Fenton (ed.), 2008, pp. 94–97.

HEGARTY, FRANCES (b. 1946) (qv *AAI* III), artist. A great deal of Fran Hegarty's work is concerned with emigration, and the alienation, cultural accommodations and dislocation it brings. She uses her body, and her personal and family history as the vehicle for much of her exploration of this experience, whether in performance, site-specific installations, photography (qv) or video film, while consciously critiquing traditional modes of representation.

A native Irish speaker from Teelin, Co. Donegal, Hegarty moved with her family, as a child, first to Scotland and then to the English midlands, pursuing her art education at Leeds and Manchester Art Colleges, and later becoming professor of fine art at Sheffield Hallam University.

Since the 1970s Hegarty has been an important figure in the development of performance and time-based art (qv) in Britain and Ireland. Informed by 1980s' feminist theory, she uses her own body to deconstruct traditional notions of the woman as subject of the traditionally male artist's gaze, claiming a level of objectivity in the making of the work that subsumes her subjective role: '... if one were to accept the notion of femininity as masquerade, then there is no self-image other than a masquerade image. Even the biological skin is a masquerade skin', she told Shirley McWilliam (Murray, p. 81). Thus, the dress or the skin becomes the adopted costume of

Harris's work, shown in Dublin since the 1990s, represents a significant shift from his early pencil and watercolour triptych of Gordon Lambert (1980); yet even then Harris was exploring the medium, his subjects and their spatial and temporal context. A year in Madrid and undergraduate studies from 1978 to 1981 at the Higher Institute for Fine Arts in Antwerp, where Harris now lives, served to deepen this exploration, although his work has changed from the linear, Giacometti-like qualities it displayed in the mid-1980s. Harris explores his bigger existential question in paintings dealing with a limited range of motifs, including the self-portrait [206], still lifes of skinned rabbits and pools in the landscape. Pools of still water now occupy the craters aggressively excavated from the fields of Belgium by wartime artillery fire, and fragile poppies glow out of the hollows created by gun shells; the painter's task is to make their opposing energies, and the time in which they unfolded, visible. Initially, Harris concentrated on the single object at the centre of the canvas, 'but now I've succeeded in spreading

masquerade in her work, a device for both concealment and revelation. Hegarty uses it in this dual way to explore the burden of Irish migrant experience in Victorian Britain in a performance/video work *Seemingly So Evidently Not Apparently Then* (1997) [482], recorded on cctv cameras as she walked through Sheffield Midland Railway Station and boarded a train, in a costume that was both transparent and opaque, ghostly and exaggeratedly present. *Turas* (Journey) (1995) [135] and *Voice Over* (1995) look at the impact of the loss of the mother tongue, first on the artist herself and her mother, and secondly on women who were displaced and abused in the 1990s' Serbo-Croatian conflict. While this work is deeply serious, Hegarty, in collaboration with the English artist Andrew Stones, extrapolated both humorous and political comments from the work of another Irish emigrant, James Joyce, in a series of nine neon text pieces, *For Dublin* (1997), with which they won the first Nissan Public Art Project run by IMMA in that year.

An important sub-theme in much of Hegarty's work has been the self-portrait. *Turas*, inspired by Whistler's famous profile portrait of his mother, *Harmony in Grey and Green*, can be viewed both as a double portrait and as a commentary on youth and age. Since 2000 Hegarty's series of 'Auto Portraits' [207] calls attention to the ageing process and the perceived invisibility that attends this for women.

Hegarty has been included in most of the defining group exhibitions of Irish art since the early 1990s. These include *From Beyond the Pale*, IMMA (1994), *L'Imaginaire Irlandais*, Paris (1996), *Distant Relations*, Birmingham, London, Dublin, Santa Monica, Mexico City (1995–97), *0044 – Irish Artists in Britain*, New York, Buffalo, Belfast, Cork (1999/2000), *For the Sake of Appearance*, Brazil (2000) and *Something Else: Irish Contemporary Art*, Helsinki, Oulu and Joensuu (2002/03). In 2001, with Andrew Stones, she presented *Overnight Sensation* in St George's Market Hall, Belfast, while, since 2000, other collaborations with Stones have been exhibited in Carlow and in Glydegate Square, Bradford. Hegarty was one of the artists selected by the Public Art Development Trust to create an installation (qv) for Pier 4A at Heathrow Airport's Terminal 1, and in 2004 the Model and Niland Gallery in Sligo presented a retrospective exhibition of her work from 1970 to 2004. CATHERINE MARSHALL

SELECTED READING Ziff, 1995; Murray, 1999, pp. 80–87; Koskinen, Connor and McGonagle, 2002, pp. 78–81; Monica Ross and Sharon Kivland (eds), *Frances Hegarty: Selected Works 1974–2004* (Kinsale 2004).

HENNESSY, PATRICK (1915–80), painter. Along with Edward Maguire, Martin Gale and John Doherty (qqv), Patrick Hennessy is one of a relatively small number of twentieth-century Irish artists who can be described as photo realist (see 'Realism'). His canvases are generally medium-sized and depict landscapes (qv) with figures or interiors, the latter often including memorabilia referring to the artist, his friends and his interests. However, while Hennessy's paintings are worked up from photographs, the introduction

207. Frances Hegarty, installation shot of *Auto Portrait #2*, Peri Gallery, Turku, Finland, 1999, National Self Portrait Collection, Limerick and Turku Art Museum, Finland

of Surrealist elements make him difficult to categorize as an artist. He used oil paint in a meticulous and precise way, blending images captured by the camera lens into compositions that combine elements of Surrealism (qv), magic realism, and, occasionally, *trompe l'oeil*. His paintings often evoke a chilly, almost eerie, sensibility. He had a preference for windswept coastal landscapes, enlivened by male figures or horses. In contrast to the larger Surrealist canvases, he also painted many smaller still lifes of roses and other flowers. These latter works found a ready market, compared with the larger paintings that sometimes remained unsold, in some measure because of their coolness and resistance to any emotional engagement with the viewer.

The son of an army officer, Hennessy was born in Cork. Because of the military situation in Ireland, he was taken to Scotland to be raised by relatives. In 1933 he won a scholarship to Duncan of Jordanstone College of Art and Design in Dundee, where he was taught by James McIntosh Patrick and met Harry Robertson Craig, a fellow student who was to become a life-long friend and companion. After travelling, also on a scholarship, to Rome and Paris, Hennessy returned to Arbroath, Angus, where he completed further studies at Hospitalfield Art School. In 1939 he exhibited at the Royal Scottish Academy for the first time. At the outbreak of World War II, while Craig enlisted in the British army and served in the intelligence service, Hennessy returned to Ireland.

208. Patrick Hennessy, *Exiles*, 1943, oil on canvas, 99 x 60 cm, Dublin City Gallery The Hugh Lane

Magazine commented on Hennesy's 'morbid pessimism which sees flesh as something very much less healthy than grass', the writer identifying a sense of doom in the paintings *De Profundis* (1944/45, private collection), which depicted part of the façade of TCD, and *Miserere* (*c.* 1944) with its 'mouldering classical statues against an infinitely dreary stretch of marshland' (Edward Sheehy, 'Art Notes: Living and Partly Living', *Dublin Magazine*, xx, no. 1, 1945, 39–42). With only three exceptions, Hennessy exhibited annually at the RHA in Dublin from 1941 to 1971, and also showed at the RSA and the RA. In 1947, by which time Craig had joined Hennessy in Ireland, he was living at Crosshaven, Co. Cork, and two years later, when elected a member of the RHA, he gave his address as 3 Upper Park, Cobh.

Hennessy and Craig also lived for a time at Kinsale, Co. Cork where they were friendly with Major Stephen and Lady Ursula Vernon. The Vernons were patrons of the two artists; their house, Fairyfield, contained a dining room decorated with murals of roses painted by Craig, along with several paintings by both Craig and Hennessy, including the latter's portrait of *Elizabeth Bowen at Bowenscourt* (1957, CAG) [387]. The novelist Elizabeth Bowen, of Bowenscourt, near Kildorrery, Co. Cork, was another close friend, and Hennessy painted several works depicting the interior of her house, before its demolition in 1960. His painting *Sunlight on the Floor: Interior at Bowenscourt* (private collection) depicts two carved figures, based on medieval statues of saints, missing their forearms and hands, standing side by side in the ballroom. Hennessy often painted series of works, basing them on classical or medieval sculptures or buildings. *A Dialogue of Angels* was shown at the RHA in 1943 and relates to a series of similar compositions, including *The Guardians of Nôtre Dame* (exhibited RHA, 1957), *The Angel of the Annunciation* (exhibited RHA, 1953 and 1958) and *The Dance of the Blessed Spirits* (exhibited RHA, 1959).

A retrospective of Hennessy's work was held at the Dublin Painters Gallery in 1951 and five years later he had his first solo show in London, at Agnew's Gallery on Old Bond Street. In the 1960s and '70s several exhibitions of his paintings were held in Chicago, at the Guildhall Galleries on South Michigan Avenue. He also had several one-person shows in Dublin and in later years, by which time he and Craig were living at Raglan Road in Dublin, was represented by the Ritchie Hendriks Gallery. A painting dating from 1963, *Farewell to Ireland* (private collection), depicts President John F. Kennedy ascending the steps of the aeroplane that was to take him back to the USA after his historic visit to Ireland.

Hennessy and Craig travelled extensively on the Continent, and from 1968 onwards they spent most winters in North Africa, in Tangiers, returning to Ireland in the summer months to work in the west and in Cork. They finally settled in Portugal where, in December 1980, Hennessy fell ill, dying in London later that month. A tribute exhibition was held at the Cork Arts Society the following year.

Hennessy's work can be found in the CAG, HL, NGI, UCG, UCC and IMMA. PETER MURRAY

In Dublin, he was commissioned to paint portraits of the family of Eduard Hempel, German (minister) ambassador to Ireland. Hennessy first exhibited at the RHA (qv) in 1941 and also became a member of the SDP. His *Exiles* [208], shown at the RHA in 1943 and subsequently purchased by the Haverty Trust for the HL, depicts a man dressed only in ragged trousers, seen from the back, standing in a bleak coastal landscape. The *Dublin*

SELECTED READING Pyle, 1975; 'Unusual Origins for Patrick Hennessy's Still Life', in *IAR* (Autumn 2006), 52.

HENRY, NÉE MITCHELL, GRACE (1868–1953), painter. Emily Grace Henry, a distant relative of the poet Lord Byron, was born in Aberdeen, Scotland, into a well-to-do family. Educated at home and at a London finishing school, she studied art in Brussels and Paris, where she attended classes, possibly those given by James McNeill Whistler, famous for his espousal of colour and harmony over literary or representational concerns. It was in Paris that she met the Belfast painter Paul Henry (qv), who was studying with Whistler, and whom she married in 1903. The couple lived in London until in 1910, on the recommendation of their friend Robert Lynd, they decided to travel to Achill Island for a short holiday. They were to remain on Achill for nearly ten years, finding the place and its people inspiring in different ways; he was hugely influenced by the landscape, while she was more moved by the lives of the people. They exhibited together in Belfast in 1913. In 1920 the couple came to live in Merrion Row in Dublin, where they were the prime movers in the establishment of the SDP, with the aim of providing an alternative exhibition forum to the RHA (qv). Perhaps on advice from friends and fellow members of the SDP, Grace Henry went back to Paris to study under André Lhote.

In 1930, following the breakdown of her marriage, Grace Henry went to the Continent, where she painted landscapes of the French and Italian Riviera, as well as still-life subjects. She exhibited in Brussels and London in 1930 and London in 1939, when she returned to live in Dublin and exhibited annually at the RHA until 1952. In 1940, in a period of extensive and innovative work by women artists in Ireland, she was the only woman to be included in an exhibition of twelve Irish artists in the Waddington Gallery, Dublin, for which Thomas Bodkin wrote an introductory essay.

S.B. Kennedy, author of the definitive monograph on Paul Henry, summed up Grace Henry's career as having been spent largely in the shadow of her husband: 'while she never equalled the best of his paintings, she was in many ways the more experimental and subtle painter of the two, always in search of something new' (Kennedy, p. 24). The accuracy of Kennedy's comment is indisputable. The couple were married for twenty-seven years, during which they exhibited together successfully on a number of occasions and were jointly involved in the foundation and running of the SDP; nevertheless, she is effectively written out of her husband's account of his life throughout his two books of autobiography. Surprisingly, he describes his visit to Achill, on which he was to make his career, without a single reference to her.

Grace Henry's work shows a willingness to experiment, a quality not easy to find in her husband's work, which, however, popular, is also highly formulaic. Her work is generally small in scale and very varied in style and palette, but it is always signalled by a loose painterly approach. She loved to paint people, particularly evident in her pictures of the folk life of Achill and the Mediterranean towns she visited later, and in her picaresque figures of musicians and entertainers. Her greatest work, however, *Girl in White* [209], shows nothing of this folksiness. Instead, the antecedents for this sensitive white-on-white painting are to be found in the works of Whistler and Ingres, whose

work she would have seen while studying in Paris. Grace Henry also deserves to be remembered for her drawings, which are less well known but are finely observed, intimate and often enhanced by a sense of humour. She was made an HRHA in 1949, just four years before her death.

Her work can be seen in the collections of the HL, IMMA, UM, LCGA and AIB. In 2010 she was given a non-commercial retrospective at the Jorgensen Fine Art Gallery, Dublin.
CATHERINE MARSHALL

SELECTED READING Ryan-Smolin, Mayes and Rogers, 1987; S.B. Kennedy, 1991; Steward, 1998.

HENRY, PAUL (1876–1958), painter. In 1940 Victor Waddington published *Twelve Irish Artists*, a book which its author Thomas Bodkin, former director of the NGI, hoped would cement the reputations of a group of artists he saw as constituting a 'national school' of Irish painting. While these twelve artists, eleven men and one woman, held some things in common, they were really a disparate group. William Conor, Harry

209. Grace Henry, *Girl in White*, before 1908, oil on canvas, 61 x 51 cm, Dublin City Gallery The Hugh Lane

Kernoff and Seán Keating (qqv) were best known for their depictions of urban and rural working people, Seán O'Sullivan and Leo Whelan (qqv) were accomplished academic portrait painters, while James Humbert Craig and Frank McKelvey (qqv) specialized in landscapes of Donegal, Antrim and other Ulster counties.

Further underlining the lack of cohesion in Bodkin's group, two of the artists, Grace Henry (qv) and Paul Henry, were barely on speaking terms and held quite opposed views on art. Grace, the more innovative of the two, was sympathetic to Modernist theories, which emphasized formal values and the importance of the picture plane, while Paul Henry remained loyal to a more traditional view of painting as a 'window' through which the viewer would see a landscape represented as it might appear in reality. This lack of cohesion between the Henrys was complicated by personal factors: after meeting in 1900 in Paris as art students, Paul and Grace had married, and over the ensuing quarter of a century they worked closely as a couple, showing paintings together in many exhibitions. Indeed, the joint exhibitions by Paul and Grace Henry, held annually in Belfast, became something of a fixture in the Irish art calendar. They also regularly exhibited in Dublin and London. An apogee was reached in

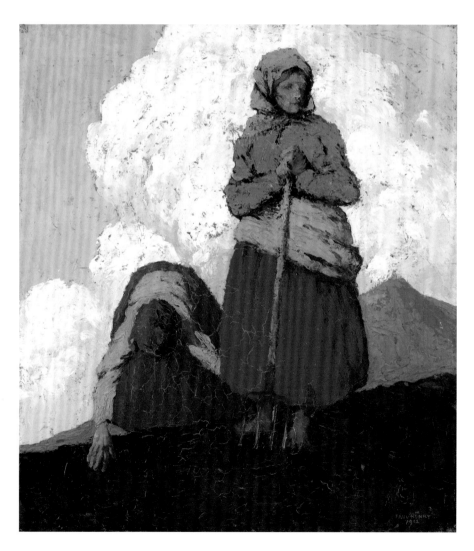

210. Paul Henry, *The Potato Diggers*, 1912, oil on canvas, 51 x 46 cm, National Gallery of Ireland

1925 when Paul Henry's landscape painting *In Connemara* (1921, private collection) was used as a poster for the London, Midland and Scottish Railway, advertising holidays in the west of Ireland. However, by the time Bodkin's book was published, Paul and Grace's marriage had broken up irretrievably, and while a solo exhibition of Paul Henry's work, held in 1940 at Combridge's Gallery in Dublin, was well received, some critics were now beginning to view his landscapes, with their thatched cottages, hayricks and piles of hand-won turf, as old-fashioned and irrelevant to modern Ireland (Kennedy, p. 79).

The 1940 exhibition was notable also in that it included a number of views of towns such as Kinsale, New Ross and Kilkenny, urban scenes that were out of the ordinary for Henry, who for years had focused almost entirely on landscapes of Mayo and Connemara. Painted for a book by Sean Ó Faoláin, entitled *An Irish Journey*, these townscapes, with their strong compositions and vertical format, highlighted the degree to which he had lapsed, for the most part, into a rather monotonous diet of turf stacks, cottages and mountains. They revealed also the degree to which Henry had come full circle, emerging from a conservative background, then becoming an avant-garde artist fired with a zeal to paint 'the very soul of Ireland', but ending up, in middle age, painting stereotyped views of Connemara landscapes. Henry's early concern with social conditions, inspired in part by his father's missionary efforts, but also by the life and work of Vincent van Gogh, had dissipated, giving way to idealized landscapes devoid of inhabitants. There is no doubt that Henry's greatest works, paintings such as *The Watcher*, *Incoming Tide*, *The Potato Diggers* [210] and *Grace O'Malley's Castle*, almost all date from the years before 1920. By the time Bodkin's *Twelve Irish Artists* was published, his work, both in painting and in writing, had become increasingly introspective and repetitive.

Born in Belfast, Henry was the son of the Reverend Robert Mitchell Henry, a Presbyterian minister who later converted to the Plymouth Brethren, and Kate Anne Berry, of the Anderson family in Sligo. After attending the Belfast Academical Institution and receiving drawing classes from Thomas Bond Walker, Henry was taken on as an apprentice at the Broadway Damask Company, a firm specializing in patterned linen fabrics. Graduating to the company's design studios, he discovered an aptitude for art and decided to study at the Government School of Art in Belfast, where he won prizes in 1897 and 1898. In 1898 Henry travelled to Paris, where he spent two years studying, initially at the Académie Julien and then at James MacNeill Whistler's short-lived Académie Carmen, where one of the teachers was Alphonse Mucha. His dignified and rather staid charcoal portrait of *James Wilder*, a prominent member of the Boy Scout movement in the USA, is characteristic of the artist's student years in the French capital (Kennedy, p. 124). In company with fellow students Stephen Haweis and Francis Cadell, Henry went on sketching tours around Paris, and in 1900 they rented a cottage at St Léger-en-Yvelines, in the forest of Rambouillet. Around this time, Henry met Emily Grace Mitchell, the daughter of a clergyman from Aberdeen, who was probably also a student at the Académie Carmen. While Henry had started out in Paris admiring the Realist paintings of Millet, and then moved on to absorb the purity of Whistler's art, in the

end he came to admire most of all the Post-Impressionist paintings of Cézanne, Gauguin and van Gogh.

In December 1900 Henry moved to London. He shared a flat in Kensington with the Northern Ireland writer Robert Lynd, and earned a living by working as an illustrator and teaching art. Influenced by the graphic style of Whistler, a series of early charcoal portraits (1902–04) are characterized by a highly sensitive, but rather cheerless, quality. The portraits – of actors, clerics and politicians – were for the most part commissioned for *To-day* magazine. In 1906 Henry produced twelve charcoal illustrations for *The Mantle of the Emperor*, a story written by his friends Robert Lynd and Ladbroke Black.

In 1903 Paul and Grace were married in London, and four years later they held the first of many joint exhibitions of their work, at the Ulster Arts Club in Belfast. In 1910, at the invitation of Dermod O'Brien, Paul showed at the RHA (qv). That year he exhibited also, for the first and only time, at the RA in London. That same year, the couple travelled to Achill Island where Paul was so impressed that, by his own account, he tore up his return railway ticket and decided to remain (Kennedy, p. 31). Achill in 1910 was poverty-stricken and many of the inhabitants were dependent upon funds from emigrants in the USA, or some other form of subsidy. Henry took a job with the Congested Districts Board, enabling him to remain on the island, painting and sketching, for the next nine years [211]. While Grace missed the society and comforts of city life, Henry admitted that he was drawn to the bogs of Achill Island by 'some deep buried ancestral feeling' (Paul Henry in *An Irish Portrait*, quoted in Kennedy, p. 126).

Much of the irony of Henry's career as a painter lies in the response to his first exhibition, held in Belfast in 1911. Reviewers singled out for praise paintings similar to the later work *The Potato Diggers*, a starkly Realist work, reminiscent of Daumier's washerwomen or Millet's gleaners. They noted that Henry had eschewed the stereotypical tourist view of Ireland, creating instead works that depicted hardship and toil, an everyday part of life in the west of Ireland. The success of the exhibition resulted in Henry being elected a member of the Ulster Arts Club, and also to his being invited, along with Grace, to exhibit in Dublin at an exhibition at Leinster Hall in Molesworth Street. The exhibition was organized by George Russell 'AE' (qv). Henry showed thirty-nine paintings, including *A Prayer for the Departed* (1910/11, UM) and *Old People Watching a Dance* (1910/11, private collection). Although the venture was not a commercial success and the Henrys continued to exhibit in Dublin, the main support for their work over the following twenty years came from loyal buyers in Belfast and London. Inevitably, dividing their time between London and Achill placed a strain on both their marriage and the couple's precarious finances. Grace grew to dislike the isolation and harsh climate of Achill, preferring instead the camaraderie of artistic circles in Dublin, where she spent an increasing amount of time. In 1919 she and Henry moved to Dublin where they were founder members of the SDP. He organized an exhibition in Dublin in 1922 which included works by Picasso, Matisse and Vlaminck, as well as British artists such as Harold Gilman and Spencer

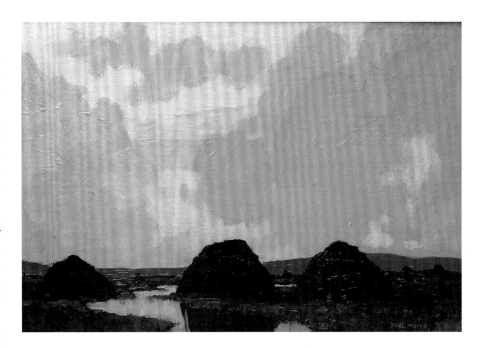

Gore. Henry exhibited regularly at the RHA and was elected a member of the Academy in 1929. Two years later he and Grace separated, and Henry met Mabel Florence Young, who would be his companion for the rest of his life.

During the 1930s, exhibitions of Henry's paintings were held in New York, Toronto, Dublin and London. A radio talk that he scripted and presented for the BBC became the basis of his autobiographical *An Irish Portrait*. In the mid-1940s, ill health resulted in the partial loss of eyesight and in 1950 he and Mabel moved from Carrigoona Cottage, near Kilmacanogue, Co. Wicklow, where they had lived for twenty years, to Sidmonton Square in Bray. With the publication of *An Irish Portrait* in 1951, Sean Ó Faoláin interviewed Henry for *Eye and Image*, a BBC radio arts programme. After the death of Grace in 1953, Henry and Mabel Young were married. Paul Henry died at his home in Bray aged eighty-two. A second autobiographical volume, *Further Reminiscences*, was published posthumously.
PETER MURRAY

SELECTED READING Paul Henry, *Further Reminiscences* (Belfast 1973); Paul Henry, *An Irish Portrait* (London 1988); S.B. Kennedy, *Paul Henry: Paintings, Drawings, Illustrations* (New Haven and London 2007).

HICKEY, PATRICK (1927–98) [212], printmaker, painter, designer and architect. Described by John Kelly (qv) as the 'founder and only teacher' of the Graphic Studios in Dublin (John Kelly interviewed by Vera Ryan, p. 68), the artist and printmaker Patrick Hickey was born on the Northwest Frontier in India (now Pakistan). After attending public school in England, he served in the British Army, before moving to Ireland in 1948. Hickey studied architecture at UCD and worked in the offices of Scott Tallon Walker from the mid-1950s to the early 1960s. In 1957 an Italian government travel scholarship enabled

211. Paul Henry, *Turfstacks on the Bog*, c. 1920, oil on canvas, 33 x 49 cm, O'Malley Collection, Irish American Cultural Institute, University of Limerick

him to study etching and lithography for a year at La Scuola del Libro, Urbino. Although he exhibited paintings at the IELA (qv) from the 1950s to the 1970s, and held a solo exhibition of paintings in Dublin in 1961, when Elizabeth Rivers (qv) noted his 'original and convincing use of colour', it was as a graphic artist that Hickey excelled (Rivers, *Studies*, Summer 1961). According to Kelly, Hickey had a 'natural feeling for lithography' (Ryan, p. 82). He revolutionized printmaking in Ireland and his commitment to the new studio meant that no task was beneath him. As his friend from his teenage years, Patrick Scott (qv), said, 'he started the Graphic Studio [1960]; he did it on his own, we had only a few stones, they took hours to clean. They'd been thrown out as paving stones...' (Ryan, p. 121). These valuable lithographic stones, used by the Ordnance Survey to print maps of Ireland in the nineteenth century, had been salvaged and rehabilitated by the Graphic Studio.

Hickey's contribution to the advancement of printmaking and design in Ireland is difficult to overstate, but it is for his own achievements in the medium that he is justly remembered. Always a figurative artist, he was interested in natural forms; he took advantage of a commission to illustrate work by W.B. Yeats in 1968 to highlight Yeats's 'the silver apples of the moon, the golden apples of the sun' by incorporating the leaf metals into the prints, and continued this innovation to good effect in his later work [394]. In 1965 he came second in an international competition sponsored by the Italian government to mark Dante's 700th anniversary, with illustrations for the *Divine Comedy*. Hickey did eighteen etchings for *The Inferno* which are now in the National Archives, Paris. His work is informed by his deep knowledge of Japanese art and ceramics, particularly evident in his treatment of flowers and the landscape of County Wicklow.

212. Patrick Hickey, *The Edge of the Bog, Co. Meath*, 1985, oil on paper, 56 x 76 cm, private collection

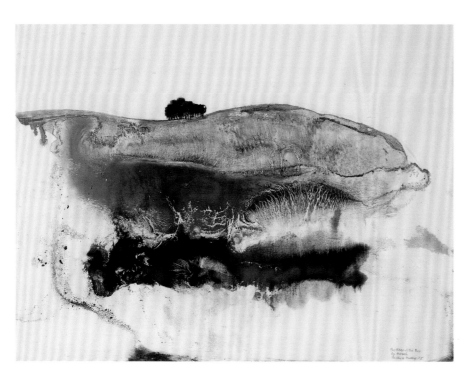

Hickey participated in international print biennials and exhibitions, representing Ireland at the first International Biennial of Contemporary Prints in Liège, Belgium, and later in Tokyo, Pistoia, Salzburg, São Paolo and Cracow. Deeply involved with all aspects of design in Ireland, Hickey combined designing postage stamps and banknotes for the Irish government, teaching part-time in the School of Architecture at UCD, sitting on the Boards of the KDW and NCAD, and also serving on the CRC of the Department of Foreign Affairs. In 1986, despite having been diagnosed with Parkinson's disease thirteen years earlier, he was offered, and accepted, the position of head of painting at NCAD. He held this post until 1990, at the same time exhibiting new paintings and graphic works. His only concession to his debilitating illness was his decision to limit all editions of his work from 1974 onwards, which he personally printed, to twenty.

Hickey's paintings and prints were shown in solo exhibitions in Dublin and Belfast, mainly at the Dawson, Caldwell and Taylor galleries. A retrospective exhibition of his work was held at the Royal Institute of Architects of Ireland in 1994 while a year later, the Graphic Studio Gallery showed twenty-seven new prints by him. Hickey was included in *The Irish Imagination 1959–71* exhibition as part of *Rosc '71* (qv), for which event he also curated an exhibition of Irish eighteenth-century blue and white delftware, at Castletown, Co. Kilkenny.

There are fine examples of Hickey's work in the AC/ACE, HL, LCG, UL, TCD, CAG, OPW, Gordon Lambert Trust, IMMA, National Archives, Paris, and in several corporate and institutional collections in Ireland. A founding member of Aosdána (qv) in 1981, Hickey was honoured by an RTÉ documentary, *Patrick Hickey Artist*, in 1996. CATHERINE MARSHALL

SELECTED READING Patrick Hickey, 'The Japanese minor arts of Netsuke and Inro', *IAR* (Spring 1987), 37–40; *Patrick Hickey New Prints*, exh. cat. Graphic Studio Gallery (Dublin 1995); Ryan, 2006; Lalor, 2011, pp. 57–64.

HILL, DEREK (1916–2000) [213], painter, collector and promoter of art. To these activities, through which the English artist Arthur Derek Hill became known in Ireland, may be added theatre designer, art curator, writer, traveller, photographer, gardener, aesthete and social lion. For some, this diversity of interests hampered his advancement as a painter; for others, it was the essence of his achievement.

Hill's background in Southampton was comfortable. He left Marlborough College at sixteen to pursue art, though steered by his father towards the more 'secure' world of theatre. He worked briefly with Oliver Messel and then went to Munich to study stage design, where he saw Kurt Schwitters addressing his class ('Hill at 82', *IT*, 17 September 1998) and the newly empowered Hitler in cafés. He worked under Paul Colin and with Marie Laurencin in Paris and, in Vienna, studied with Joseph Gregor, completing sets for a production of *Agamemnon*. With an introduction to Tairov of the Kamerny Theatre, he studied in Moscow, visiting Leningrad, Kiev and, against opposition, Novgorod, before crossing Siberia to Japan, China, Bali and Vietnam.

Returning home, he designed the set and costumes for Frederick Ashton's 1937 production of the ballet *The Lord of Burleigh* at Sadler's Wells. In 1938 the couturier Edward Molyneux advised him to become a painter, and gave him access to his outstanding collection, where Hill's real art education began.

Throughout World War II, Hill was a conscientious objector, painting and exhibiting when possible, developing friendships with artists including Victor Pasmore and Cecil Beaton. He organized exhibitions such as *Constable to Cézanne* and *Since Impressionism* at the Wildenstein Gallery, New York, and later curated substantial surveys of Degas (1952, Edinburgh Festival and Tate Gallery) and Landseer (1961, RA). From 1949 he spent part of each year in Italy, basing himself near Florence at Villa I Tatti, home of the art historian Bernard Berenson; in 1953 he became art director at the British School in Rome. Meanwhile, in 1954, he bought a house in County Donegal, while continuing travels in the Middle East and North Africa. His photographic surveys of Islamic architecture were published in 1964 and 1976.

Thus an extensive career preceded Hill's move to Ireland and St Columb's, the house in Churchill, Co. Donegal he came to describe as his home. His contributions to cultural life in his adoptive country were diverse – an early patron of the Wexford Opera Festival, he also championed one of Ireland's remotest locations, Tory Island, campaigning for its continued habitation.

From 1956 he stayed in a disused hut on Tory Island, each summer painting and encouraging the self-taught artist James Dixon (qv), whose narrative-filled pictures presented a rival view to Hill's own focus on isolated grandeur. Hill was equally supportive of other islanders, showing their work at home and abroad (see 'The Tory Island School' and 'Outsider and Folk Art'). He supported contemporary painters such as Basil Blackshaw (qv), Antonio Music and John Bratby. Irish women artists featured strongly in his collection (Norah McGuinness, Camille Souter (qqv)). Stressing a painter's response to what attracted him, his collecting embraced the 'aesthetic' – Islamic and Wemyss ceramics, William Morris textiles, Chinese prints – while avoiding conceptual, political or Pop art (qqv). The wilfully eclectic character of his collecting, and his decoration of St Columb's, contrasted with the museum-standard taste of his friend Henry McIlhenny, in nearby Glenveagh Castle. In 1975 the OPW took on the management of Hill's house and collection, which he generously gifted to the nation in 1981. It opened as the Glebe House and Gallery in 1984. Hill bequeathed the art collection from his London home to the National Trust.

A traditionalist painter, Derek Hill concentrated on portraits and landscapes. Earlier landscapes reflect an interest in modernist formal values (*The Pamir at Wapping*, *c.* 1949, private collection). By the 1950s his growing technical facility led towards greater fluidity, naturalism and sense of place. While

213. Derek Hill, *Tory Island from Tor More*, 1958–59, oil on canvas, 71.3 x 122.3 cm, National Museums Northern Ireland, Collection Ulster Museum

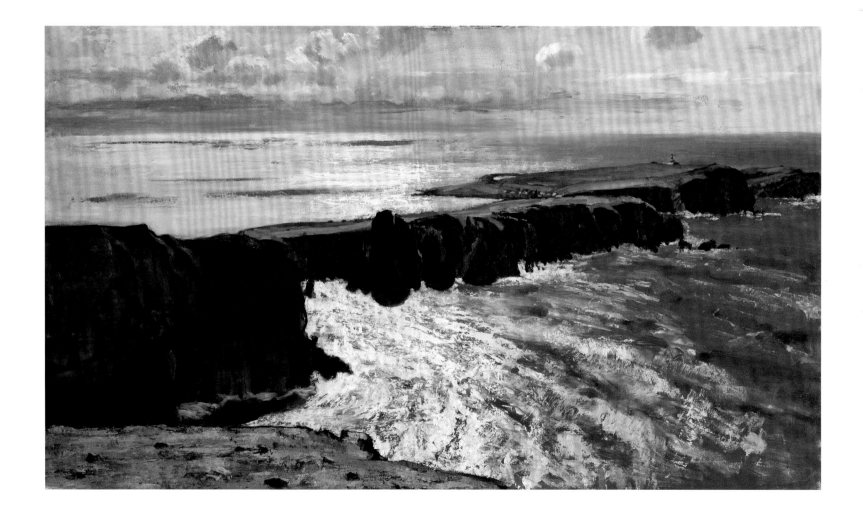

his collecting embraced aspects of Modernism (qv), his exposure to Bauhaus ideas really influenced only his gardening. His painting suggests a nineteenth-century aesthetic, grounded in an admiration for Corot, Courbet and Degas. His landscapes are notably distinct from the Irish academic tradition and its cultural touchstones, but equally from the contemporary mythic quests of Collins or O'Malley (qqv). He regarded his art as essentially realist (see 'Realism') without the imposition of 'issues'. Able to master a commanding likeness while a sitter talked, his best portraits have a spontaneity rare in official portraiture (qv). Commissioned to portray such well-known figures as Archbishop McQuaid, Tony O'Reilly, Mariga Guinness and Prince Charles (whom he mentored in painting), he recorded equally well his friends or Donegal neighbours. Even rejections of Hill's portraits might confer cachet: having burned a portrait sketch at a party, Nancy Mitford communicated the deed in a letter signed 'Love from Savonarola'. Certainly, Hill's independent income and participation in an international social elite were factors in the shaping of his career.

For his contributions to Irish life, Hill was awarded honorary Irish citizenship in 1999. His reputation as an artist is divided. Among younger, conceptually trained artists, his work is barely known, yet he remains an iconic figure for an older, establishment world, Lord Gowrie describing him as 'the most important painter of Irish landscape since Jack Yeats' (Gowrie, 1987). WILLIAM GALLAGHER

SELECTED READING Bryan Robertson, *Derek Hill: A Retrospective Exhibition*, exh. cat. Whitechapel Art Gallery (London 1961); Derek Hill and Oleg Grabar, *Islamic Architecture and its Decoration AD 800–1500* (London 1964); Grey Gowrie, *Derek Hill: An Appreciation* (London 1987); Bruce Arnold, *Derek Hill* (London 2010).

214. Seán Hillen, *A Marine Commando and two older men on a bench, Twelfth of July, Sugar Island, Newry, Co. Down, c. 1985*

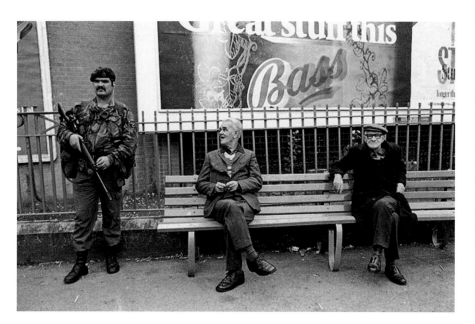

HILLEN, SEÁN (b. 1961) [214], artist. Providing a wry and often humorous commentary on the construction of national identity through imagery, Seán Martin Hillen's photomontages, or more correctly photo-collages, often combine familiar and reassuring scenes, with images of destruction and danger. Reminiscent of the photomontages of Weimar artist John Heartfield, Hillen's work also contains a mordant critique of contemporary politics and society. Having initially specialized in documentary photography, Hillen focused on the 'Troubles' in Northern Ireland (see 'Photography' and 'The Troubles and Irish Art'), before moving on to create images that juxtaposed Irish scenes from tourist brochures with unlikely and 'exotic' interpolations, such as Egyptian pyramids or dinosaurs. In his more recent work, he addresses wider concerns regarding the effects of terrorism on society.

Born in Newry, Co. Down, Hillen studied at the Ulster Polytechnic where he received a Foundation Art Certificate in 1980. The following year he enrolled at the London School of Printing, graduating with a BA in Photography, Film and Television in 1983. That same year, the first exhibition of his work was held at the Newry Arts Centre. In 1984 he was awarded a Diploma in Fine Art at the Slade School in London, where he won the Prankerd-Jones Memorial Prize twice. A second exhibition at the Newry Arts Centre followed in 1985, as did Hillen's first solo exhibition in London, held at the Brent Irish Cultural Centre. In 1991 he was awarded a prize at the South Bank Photo Show, and two years later moved to Dublin, where he embarked on a series of photomontages entitled *Irelantis*, in which he created a Surrealist world, combining found imagery of the landscape and people of Ireland with visual references to new technologies and ancient civilisations. In Dublin, the Gallery of Photography presented an exhibition of Hillen's work in 1993, and the following year he showed at the Anya von Gosseln Gallery. He has also designed stage sets, notably for Gerry Stembridge's 1999 production of Lennox Robinson's *The White-Headed Boy*. In 2004 Hillen's work was shown at the Imperial War Museum in London, and at the Centre Culturel Irlandais in Paris. The following year, a picture-researcher friend of Hillen's was killed when the No. 30 bus was blown up by extremists in the '7/7' bombings in London. This incident prompted Hillen to create a new body of work, examining aspects of modern counter-terrorist tactics such as 'False-flag operations'. These works were shown at the Gallery of Photography in Dublin in 2007. Hillen has also recently been commissioned to create a sculptural memorial to the victims of the Omagh bombing atrocity of 2001.

Hillen's work is in many public and private collections, including the Imperial War Museum, London, and Newry and Mourne District Council. His photomontages have appeared in magazines and journals, notably *Time Out*, *Aperture*, *Circa*, *France Soir* and *Art Actuel*, and also in the *Irish Times*, the *Sunday Independent* and the *Evening Standard*. In 1999 Quarto Books published *Irelantis*, a book featuring Hillen's work. PETER MURRAY

SELECTED READING Seán Hillen, *Irelantis* (London 1999); Abrams, 1999; Seán Hillen, *Seán Hillen Photomontages 1983–1993*, exh. cat. Gallery of Photography (Dublin 2004).

HISTORY OF ART: THE ACADEMIC DISCIPLINE

(see *AAI* I, 'Historiography'). This essay is concerned with the evolution of the discipline of art history in Ireland in the twentieth century. It focuses on its institutional framework, rather than on art historiography per se. However, since the one cannot be wholly separated from the other, in addition to those who contributed significantly to the establishment of the discipline formally, the work of a number of scholars which underpins its development stands out and will be referenced here.

In 1913, the Registrar (later acting director) of the National Gallery of Ireland (NGI), Walter Strickland produced his two-volume *A Dictionary of Irish Artists* (Dublin and London 1913), the first systematic study of the lives and work of Ireland's historical painters, engravers and sculptors, and the first work of the twentieth century to establish a database line for the discipline in Ireland.

In the NGI, Strickland was followed *inter alia* by Walter Armstrong, Thomas Bodkin, Thomas McGreevey and James White. Alongside Assistant Director Michael Wynne and subsequent curators, these functioned as the art historians of Ireland, before the establishment of art history as a university level, academic subject from the mid-1960s onwards.

Hugh Lane's efforts to establish a modern art gallery in Dublin in the early years of the twentieth century also had a pedagogic dimension. Hence, the history of art was provided, albeit on a modest and elitist scale, to adult audiences by the NGI, and the then Municipal Gallery of Modern Art in Dublin (HL). In turn, these institutions developed education departments that broadened delivery, starting with the NGI from the mid-1970s. Subsequently, Homan Potterton (director, 1980–88) nurtured the scholarship that led to such work as Hilary Pyle's *Jack B. Yeats: A Catalogue Raisonné of the Oil Paintings*, three volumes (London 1992) and Róisín Kennedy's *Jack B. Yeats: Masquerade & Spectacle – The Circus and the Travelling Fair in the Work of Jack B. Yeats* (Dublin 2007).

In 1932 Professor Roger Chaviré invited the archaeologist and art historian Françoise Henry [215] to lecture in French in University College Dublin (UCD), inspiring Dennis J. Coffey, President of the University, to establish a series of lectures on the history of art, which Henry delivered. In 1934 the Purser Griffith scholarship and diploma was initiated in Trinity College Dublin (TCD), and three years later offered also at UCD. The intention was to educate young people in the history of art 'to become scientifically grounded as historical critics' and form 'an enlightened public opinion'; the course was open to all, not just to students of the universities (*IT*, 30 November 1934). As honorary professor of fine arts in 1934/35, Thomas Bodkin, recently retired as Director of the NGI, delivered twelve lectures in TCD, demonstrating his intellectual bravery thus: 'Those of you who have never been fettered by the restrictions which entangle a civil servant can scarcely imagine how galling it may be to feel deeply and think seriously upon a subject of real public moment and be precluded from utterance. I have at last "the liberty to know, to utter, and to argue freely according to conscience, above all liberties"… for at a great price I bought this freedom.' Bodkin went on to describe how, as director of the NGI, when he had delivered a public lecture on *The Condition of Art in Ireland*,

215. Françoise Henry, founder of the History of Art Department, University College Dublin, outside an An Óige hostel in the 1930s

he 'received a stern reprimand' prompting him to declare: 'If the Arts are not practiced or honoured in modern Ireland to-day the blame must be laid on our various Governments.' ('With the muzzle off', *IT*, 25 June 1935) The later stalwarts of the Purser Griffith Diploma were Anne Crookshank (TCD) and Eileen Kane (a specialist in ecclesiastical art and architecture, who studied with Françoise Henry in UCD in the 1960s).

In 1948 Henry moved from French to archaeology, and from there, in 1965, to the new History of European Painting department, as director of studies, until her retirement in 1974. Thus, the first History of Art Department was directed by a scholar of international repute with an impressive bibliography in the early and medieval art and archaeology of France and Ireland. Henry, the granddaughter of the philospher and historian Charles Clément, biographer of Théodore Géricault, friend of Charles Gleyre and Jean-François Millet, had studied with the great art historians of the early-twentieth century Abbé Breuil and Henri Focillon, in the École du Louvre and the Sorbonne. Her first visit to Ireland resulted in *La Chapelle de Cormac à Cashel* (Paris 1928). Henry's scholarship showed the world that 'a civilization had existed which was until then completely unknown except to specialists'; indeed, James White added, her work constitutes the 'pillars on which this whole edifice of learning has been constructed' (White, 'Françoise Henry', *Studies*, LXIV, Winter 1975, 307). Over some fifty years, Henry published extensively in both French and English, culminating in her influential three-volume *L'Art Irlandais* (Saint-Léger-Vauban 1965, and subsequent editions, published up to 1970). She also contributed to the wider development of the discipline in Ireland, as a member of the Board of Governors and Guardians of the NGI.

Henry's students were trained in the European method, rigorous, historical and mono-disciplined: the iconographic

emphasis of Aby Warburg and Erwin Panofsky, rather than the social history of Arnold Hauser and Michael Baxandall. She understood history of art as on a continuum with the study of archaeology; her focus favoured historical antecedents rather than lateral connections. Her methodlgy was more postgraduate than undergraduate, and resulted in a high level of professional engagement in her graduate and postgraduate students. The publication, of which this essay is part, came from this department, postulated by Paula Murphy and Nicola Figgis. Murphy's *Nineteenth-Century Irish Sculpture: Native Genius Reaffirmed* (London 2010), and Figgis's (with Brendan Rooney) *Irish Paintings in the National Gallery of Ireland* (Dublin 2001), are examples of scholarly Irish art history also emanating from this School.

In UCD, Henry was succeeded by Alistair Rowan, who became the first chair of the department. Rowan broadened the discipline to include the study of architecture; he was engaged in the expansion to Ireland of the great Nikolaus Pevsner's forty-six-volume *The Buildings of England* project. His own *North-West Ulster: The Counties of Londonderry, Donegal, Fermanagh and Tyrone* was published in 1979, and he went on to collaborate with Christine Casey on further publications. When Rowan was appointed principal of Edinburgh College of Art, Michael McCarthy, author of *The Origins of the Gothic Revival* (1987), succeeded him at UCD. McCarthy's doctoral thesis at the Courtauld Institute had been supervised by Pevsner. Under McCarthy's professorship, the MA in Cultural Policy and Arts Management, directed by Anne Kelly, was integrated into the History of Art Department, known since 2006 as the School of Art History and Cultural Policy. Kathleen James-Chakraborty succeeded McCarthy. Previously Professor of Architecture at the University of California, Berkeley, James-Chakraborty's publications include *German Architecture for a Mass Audience* (London 2000), further consolidating the association of architectural history with UCD.

The establishment of the Department of History of Art in TCD followed shortly after that of UCD. George Dawson, Professor of Genetics – in an early form of interdisciplinary collaboration across the university – initiated a picture-hire scheme in 1959 for staff and students, and was a prime mover in the establishment of the College's Douglas Hyde Gallery (DHG) in 1978 (Giltrap, 2010). Dawson was a powerful lobbyist for the establishment of a full department dedicated to the history of art, which he achieved in 1966.

Anne Crookshank, graduate of TCD and the Courtauld Institute of Art, London, and Keeper of Art in the Ulster Museum from 1957, was appointed lecturer in what was then called the Department of Visual Arts in 1966, subsequently becoming its first professor. Although Crookshank's academic interests were predominantly concerned with eighteenth-century Irish art, previously she had worked in the Tate Gallery, London, accounting for her enthusiastic interest in international Modernism, and evidenced by her contribution to the modern collection at the Ulster Museum and her founding involvement in Rosc (qv). This background accounts for the support she gave for the growing collection of contemporary art, and the establishment of the DHG in TCD.

The research and writing undertaken by Anne Crookshank and Desmond FitzGerald, the Knight of Glin (1937–2011) (ex-deputy keeper, Victoria and Albert Museum, London, president of the Irish Georgian Society, and Irish representative of Christie's) over some thirty years, is in many respects on a continuum from Strickland's work early in the century. Their work, spanning over 300 years of art, culminated in *The Painters of Ireland c. 1660–1920* (London 1978) [216], the first illustrated history of Irish art, updated as *Ireland's Painters 1600–1940* (New Haven and London 2002), and *The Watercolours of Ireland: Works on Paper in Pencil, Pastel and Paint, c. 1600–1914* (London 1994). Their approach was highly connoisseurial (Crookshank had studied with Anthony Blunt at the Courtauld), and their finest achievement was the identification of artwork that could be attributed to artists hitherto known only through documentary sources. Their exhaustive searches of neglected country house collections, combined with their knowledge of written material gleaned from libraries across the western world, enabled them to add artists of the calibre of James Latham to the pantheon of Irish art. Their research was lodged in the TCD art history library, augmenting earlier donations of books by Walter Armstrong and Norah McGuinness (qv). Undeniably, their research formed the canon of Irish art history, the foundation on which much subsequent research has been built.

The four-year degree in TCD, and the limited numbers of students in each year, have ensured a high standard of scholarship in the department, as evidenced by the research of faculty members, and undergraduate and postgraduate students, the exemplary work of Jane Fenlon, on painters, patrons and inventories of the seventeenth and eighteenth centuries in Ireland, being a notable example. Notwithstanding the scholarship of Crookshank and Glin, their work gave rise to a style of art history where an umbilical connection was promulgated between high art and the Protestant Ascendency, a legacy of the Anglo-Irish tradition. In this regard, Crookshank's influence on the expansion of the collection of the NGI along ideological lines is striking. This gave rise to a conservative form of art history in which art, revelatory of political aspects of national identity (with but a few exceptions), tends to have been obliterated. It has taken the more recent scholarship of art historians, adept at situating Irish art within its social, political, economic and religious contexts, as diverse as Catherine Marshall, Fintan Cullen [217] and Claudia Kinmonth and Yvonne Scott, to counteract this style of scholarship.

From the 1980s, design history grew along similiar connoisseurial lines (concerned largely with the artefacts of 'the big house'), but, beginning with Nicola Gordon Bowe's [218] work in this field, a newer branch of the discipline, which engages with the methodologies of material culture, has emerged at the hands of Linda King, Anna Moran, Lisa Godson and Mary Ann Bolger, for example, who are producing work of a critical order.

At the end of the twentieth century, Thomas McEvilley declared that 'the most important novelist, poet and playwright of twentieth-century literature in English are all Irish' – meaning Joyce, Yeats and Beckett (McEvilley, *From Beyond the Pale: Art and Artists on the Edge of Consensus*, Dublin 1994, p. 16). In Irish anglophone literature, Ireland's reach extends way beyond its shores, but not in the visual arts. Is it that the Irish are an oral and literary people rather than a visual race? Or is it because Irish painters, sculptors and architects migrated, were trained in London, and put their work to the service of the colonizer? And, has the canon dictated our cultural memory and values?

It is striking to see a recently post-colonized country creating its own canon along hegemonic lines. The type of art history that emerged in Ireland from the 1970s tended to air-brush out more overtly 'Irish' works. As Fintan Cullen puts it, Ireland is treated as 'a locus of constant colonial indoctrination' (Cullen, 'The Visual Arts in Ireland', in Joe Cleary and Claire Connolly (eds), *The Cambridge Companion to Modern Irish Culture*, Cambridge 2005, p. 309). McEvilley describes how previously colonized cultures recover their cultural identity: first they 'pick up the pieces of their heritages and try to reconstruct identities long ravaged by the imperial mode of representation'; then, 'overwhelmed by mental colonization, the colonized [is] lured into a deliberate imitation of Western canons in an attempt to take on a Western, supposedly universal identity'; penultimately, in the post-independence period, 'the colonized reverses the hierarchy', insisting on its own identity, and, finally, a hybrid identity is arrived at (McEvilley,

217. Fintan Cullen with Barbara Dawson of the Hugh Lane Gallery at the launch of his book *Ireland on Show: Art, Union and Nationhood*, 2012

218. Nicola Gordon Bowe launching Gloine, the ongoing database documenting stained glass in Ireland, 2009

op cit, pp. 12–13). In art history in Ireland, however, there is a time-lag evident in this evolution.

Crookshank and Glin's book on Irish watercolours begins, 'it must be made quite clear, this book is not a study solely of masterpieces, there is no Irish J.R. Cozens, Girtin or Turner, but there are many visual delights … ', thereby relegating Irish art to a low canonical status (Crookshank and Glin, 1994, p. 9). In a sense, this legacy dogs the discipline that continues to privilege high art, with its established canon, over other visual manifestations. Equally, the association of late nineteenth-century Irish artists who went to France with the Impressionists, as evidenced in the exhibition in the NGI, *The Irish Impressionists: Irish Artists in France and Belgium, 1850–1914* (Dublin 1984), while involving significant research, may also suggest a form of identity insecurity.

Nevertheless, credit must be given for Crookshank and Glin's research – a long and arduous process of retrieving long-forgotten artists, who rank across the spectrum. However, they argue conservatively in favour of the survey method, rather than what was called the 'New Art History', 'because we do not think this type of analysis can be attempted until a reasonable foundation of knowledge has been assembled' (Crookshank and Glin, 2002, p. 1). To describe an art history

that takes cognizance of other disciplines as 'new', thirty years after the innovative work of John Berger, for example – disassociating the subject from the interdisciplinary fields of sociology, psychoanalysis, gender studies and cultural and literary theory – set parameters that, arguably, continue to inhibit the development of the discipline in Ireland today. The potential for theory to underpin methodology, or cross-disciplinary research to enrich the study of art histories and practices, remains an underdeveloped feature of Irish art history. Moreover, the underlying assumption that a survey of a subject is inherently neutral is highly problematic, as the failure to deal adequately, if at all, with a number of artists who might be described as nationalist, or whole swathes of art produced by women, for example, attest. Such perceptions gave rise to utterances, such as Cyril Barrett's: 'There was no nationalistic art in Ireland ... or if there was it was of a very gentle kind By *nationalistic* art, I mean works which are either (a) designed to arouse or (b) capable of arousing national sentiment.' (Barrett, 1975, 408) While the absence of Irish art (by which is meant an Irish or, in this context, even nationalist subject matter) was not absolute, as some art historians would have us believe, nor was it pervasive – the real issues lie with the state of the discipline.

Eschewing what he calls 'the provincialism of the right (nationalism) and a provincialism of the left (modernism)', Brian O'Doherty (qv) seductively shifted the debate from one concerning historical dependency on the imperial centre, to a romanticized inward gaze, with a plumbline to the Celtic past (O'Doherty, 'The Native Heritage', 1971, p. 20).

Barrett, however, provoked Jeanne Sheehy [219] to take on the Celtic Revival in art and architecture. Although Sheehy's work is predominantly empirical, in so far as it pursues the

relationship between art and national identity, it frees 'the study of Irish art in the nineteenth century from the iron grip of the artist monograph', as Cullen puts it, which is the legacy of Crookshank and Glin's surveys of Irish art (L.M. Geary and M. Kelleher (eds), *Nineteenth-Century Ireland: A Guide to Recent Research*, Dublin 2005, p. 155). Nevertheless, if Françoise Henry can be credited with the establishment of the discipline of art history in Ireland, the important work of retrieval undertaken by Crookshank and Glin resulted in the creation of the discipline of the history of *Irish* art in Ireland.

The study of Irish architecture was also pursued at TCD. Following on from the pioneering work of Maurice Craig, and substantiated by the work of the Irish Architectural Archive, Roger Stalley, the second Professor of Art History at TCD, specializes in medieval art, especially the architecture and sculpture of Britain and Ireland. He has published extensively, including *The Cistercian Monasteries of Ireland*, for which he was awarded the Alice Davis Hitchcock medallion in 1988, and a volume in the Oxford History of Art series, *Early Medieval Architecture* (1999). In parallel, Edward McParland, prolific author of, notably, *Public Architecture in Ireland 1680–1760* (New Haven 2001), is an important scholarly contributor to the historiography of architecture in Ireland.

The development of other history of art departments and courses, in Queen's University Belfast, University College Cork (UCC), University of Limerick and the National University of Maynooth, and in colleges of art and design and institutes of technology, such as the National College of Art and Design (NCAD), the University of Ulster, the Dun Laoghaire Institute of Art, Design and Technology, the Dublin Institute of Technology, the Crawford College of Art, and the Galway-Mayo Institute of Technology followed the lead laid down by UCD and TCD, substantially tempered by the new art history, emanating, since the 1960s, from British art colleges and polytechnics.

The admission of modern and contemporary art as appropriate fields of scholarship, alongside the development of the discipline of design history, and the use of new methodologies in expanding these fields, rests largely with NCAD. In 1974 the Faculty of History of Art and Design and Complementary Studies, with John Turpin as its first chair, was set up and became the model emulated by other art colleges throughout Ireland.

Turpin himself researches national institutions, such as the Royal Hibernian Academy (qv), and the variously named schools of art in Ireland, providing an infrastructure for the understanding of aspects of Ireland's visual history and culture. In NCAD, important work in uncovering a history of design in Ireland (see 'Design and Material Culture') was initiated by Nicola Gordon Bowe, whose book *The Life and Work of Harry Clarke* (Dublin 1989) provided a model for the academic integration of art, architecture and design. Also from NCAD, Frances Ruane's *The Delighted Eye: Irish Painting and Sculpture of the Seventies* (exh. cat. touring exhibition, Arts Councils of Ireland, Dublin 1980) was one of the first scholarly essays on contemporary art in Ireland, and parallels the challenging work published by *Circa* art magazine, founded in 1981, and spanning thirty years (which included, for example, the critical work of Joan Fowler, David Brett and Fionna Barber).

In 2006, in recognition of the changing landscape of intellectual debate on historical, contemporary and theoretical issues in art, design, material culture and film (qv), NCAD appointed the first Professor of Visual Culture in Ireland (this writer), marking a paradigmatic shift in content and methodology. As an art college, NCAD was less hidebound by tradition as the ongoing practices and needs of art and design students, and the pressure to make art history relevant, broke the boundaries of the connoisseurial style of much Irish art history.

Historical and critical studies are fundamental to the formation of artists and designers, and given that they clarify their civic and professional selves, and become reflective practitioners through engagement with visual culture, the emphasis in NCAD shifted from traditional art history to the education of visually literate, expressive and articulate students, who can critique objects, processes, institutions and concepts related to their own art and design, and that of others. This has conferred NCAD with a leadership role amongst art and design colleges, and is central to its influential position as an art school with university status.

So what of the state of art history more than a decade into the twentieth century? The emergent academic field of visual culture is, according to W.J.T. Mitchell, 'a site of convergence across disciplinary lines' (Mitchell, 'Interdisciplinarity and Visual Culture', *Art Bulletin*, LXXVI, no. 4, 440–41). If once 'visual culture used to be seen as a distraction from the serious business of text and history', it is now 'the locus of cultural and historical change' (Nicholas Mirzoeff, *An Introduction to Visual Culture*, London 1999, p. 31).

Notwithstanding the shift from a connoisseurial-type survey of art history to a more critical discourse of visual culture in recent decades, James Elkins, the first head of History of Art in UCC (2003–06), is highly critical of the state of the discipline in Ireland. From his arrival to his departure, Elkins maintained a polemic in *Circa* in which he called for a greater range of critical methodologies, the prioritization of non-Western art in curricula, more contemporary art, a greater understanding of the relationship between theory and practice, and more co-operation between universities and art colleges. His *envoi*, written with the collaboration of six Irish academics who refused to be named (for fear of reprisal, they said), declared art history in Ireland as more akin to art history in Lithuania, Venezuela and Chile than that in Sweden, the Netherlands and Switzerland. His call for art history to 'up its game' – exhorting Irish scholars of visual culture to move, analogously, from a simple reliance on the stethoscope, to include the X-ray, the MRI and CAT scans in their visual arsenal – caused great indignation among Irish art historians (James Elkins, 'The State of Art History in Ireland', *Circa*, no. 116, Summer 2006). In the early twenty-first century, however, the dominant criticisms – insularity, discipline protectionism, lack of critical reflexivity and methodological conservatism – are becoming less matters of concern, although more remains to be done.

From *The Capuchin Annual* (1930–77) and *The Bell* (1940–54), for example, to later periodicals wholly devoted to the visual arts, such as *Circa* art magazine (1981–2011) and the *Irish Arts Review* (1984–), Ireland's art historians

have been circumscribed by the number, range and quality of outlets available to them to present their research. The expansion of the Irish Studies movement, which produces interdisciplinary journals such as *Éire-Ireland* (1966–) and *New Hibernia Review* (1997–), has provided new opportunities for publishing work of a comparable standard to research in other disciplines, such as literature and history.

Towards the end of the twentieth century, scholarship and intellectual innovation shifted back towards the museum, as exemplified in the work of S.B. Kennedy (formerly Head of Fine and Applied Art at the Ulster Museum, Belfast); Declan McGonagle (Drector, IMMA), Catherine Marshall (Head of Collections, IMMA) and Helen O'Donoghue (Head of Education and Community, IMMA); Christina Kennedy (HL and IMMA); and Peter Murray (Crawford Art Gallery, Cork), for example, who have variously reorientated art history away from the poetic, towards the critical, in its many guises. These curators were responsible for commissioning new research in the form of exhibition catalogues that contribute significantly to the field.

In addition to the output in Ireland, a small number of Irish art historians work(ed) in British universities, but continue(d) to produce publications that address aspects of Irish art history and visual culture: Jeanne Sheehy's study of cultural nationalism at the turn of the century, *The Rediscovery of Ireland's Past: The Celtic Revival, 1830–1930* (London 1980) was written while the author was at Oxford Brookes University; Kenneth McConkey, University of Northumbria, has written, amongst others, *Memory and Desire: Painting in Britain and Ireland at the Turn of the Twentieth Century* (Farnham 2002); Fintan Cullen, University of Nottingham, publishes extensively on representations of Ireland's colonial past, as in *Visual Politics: The Representation of Ireland 1750–1930* (Cork 1997) and *Sources in Irish Art: A Reader* (Cork 2000) for instance; while Alyce Mahon, Cambridge University, is one of the few Irish art historians to have made a name abroad, publishing on international art, her *Surrealism and the Politics of Eros, 1938–1968* (London 2005) being a case in point.

Scholars from other disciplines who have made vital contributions to art history, expanding its depth and breadth, include Professor Luke Gibbons, who, in addition to his work on James Barry and Edmund Burke, has made a number of important interdisciplinary contributions to the discourse of visual culture. Equally, the work of other institutions, such as the Open University, which ran a module in Irish art in the 1990s, has been influential in broadening and enriching the discipline.

While historians should learn from art history if they are to move on from the use of visual imagery as the mere backdrop to history, art historians need to open wider the gilded cage of their own construction and learn from other disciplines. They also must take cognizance of the wider field. In this regard, Vera Ryan's *Movers and Shakers* trilogy (Cork 2003, 2006, 2011) is an interesting exercise in oral art history, a compilation of interviews with politicians, curators, artists and arts administrators. There have been various attempts since the 1990s to produce meaningful cross-fertilization: Síghle Bhreathnach-Lynch, *Ireland's Art, Ireland's History* (New York

2007), Brian P. Kennedy and Raymond Gillespie (eds), *Ireland: Art into History* (Dublin 1994), and Adele Dalsimer (ed.), *Visualizing Ireland* (Boston and London 1993), for example, may have promised more than they could deliver, but their contributions have led on to the work of art historians who are increasingly informed by the methodologies of literature, gender studies, psychoanalysis and anthropology. Contemporary visual culture specialists, such as Gavin Murphy, Mick Wilson, Francis Halsall and Declan Long, in the early years of the twenty-first century, are now taking the discipline in new directions.

Since the formation of the Research Council for the Humanities and Social Sciences in 2000, strides in new scholarship in art history and criticism in the early twenty-first century are taking place (see 'Critical Writing and the Media'). Róisín Kennedy's 'Politics of Vision: Critical Writing on Art in Ireland, 1939–1972' (unpublished PhD thesis, UCD 2006) is a good example. With the current emphasis on postgraduate research, an important development occurred in 2003 when the Trinity Irish Art Research Centre (TRIARC) was established under the directorship of Yvonne Scott to promote research into Irish visual culture, but this is beyond the scope of this volume. Niamh O'Sullivan

HISTORY AND NARRATIVE PAINTING (see 'Narrative and Anti-Narrative'). History or narrative painting, as it evolved from the Renaissance to the late nineteenth century, was concerned with the important myths, histories and stories of western culture, usually presented on a large-scale with many figures in an academic style, and generally commissioned for public places. The genre had to translate a time-based process (beginning, middle and end) into a spatial one, and artists overcame this in a number of ways: by allowing the viewer to fill in the connecting parts for themselves in the case of well-known stories, or to use strategies, such as multiple 'scenes', within a single frame, often with unforeseen effects on the linearity of the narrative. Memory, prejudice and selectivity in the choice of episodes represented also influence its meaning. Such paintings were a rarity in Ireland where Vincent Waldré's paintings on the ceiling of St Patrick's Hall in Dublin Castle (1778) were the most significant and best-known examples before the twentieth century. James Barry's decorative scheme for the Royal Academy in London is as much about Irish as British history but it was little known in his native country. There was nothing in Ireland to equal the drive that prompted the Comte d'Angiviller, Director of State Buildings in France in 1774, to commission history paintings and sculptures for the Louvre to 'inspire virtue and patriotic sentiments' (J. Locquin, *La Peinture d'Histoire en France de 1747 à 1785*, Paris 1912). Waldré's paintings depicted the union of Britain and Ireland, a narrative that was to dominate Irish history far into the future. Since that particular history was increasingly contested by nationalists, and because the money to commission grand decorative schemes was scarce, Irish art has had only occasional glimpses of the genre.

The absence of visual representation of Irish history was felt as a loss by many during the lead up to, and following, the establishment of the Irish Free State (1922), and although history

220. James Ward, *Irishmen oppose the Landing of the Viking Fleet AD 841*, 1914–19, mural for the Rotunda of City Hall, Dublin, Dublin City Council

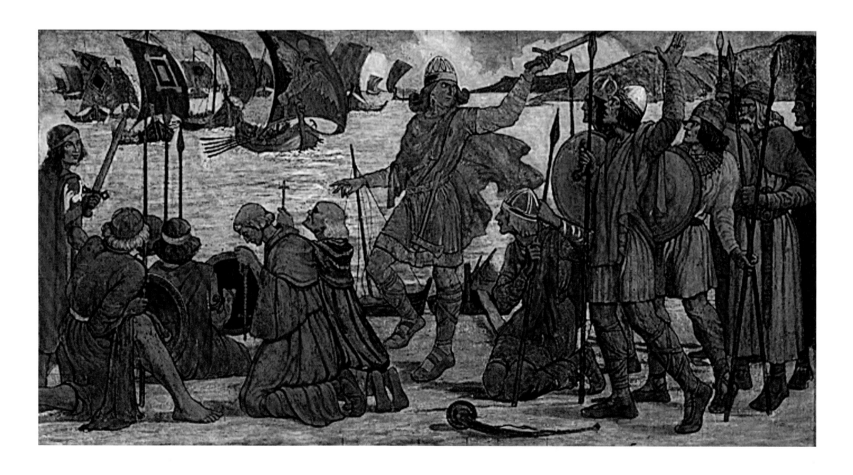

painting was no longer as popular as it once had been in the rest of Europe, it is important to look at its development in twentieth-century Ireland.

Notwithstanding the examples of James Barry and Daniel Maclise, both Irish and both acclaimed in their time as leading painters of history and allegorical subjects in Britain and Ireland, there are relatively few Irish history paintings. Thomas Davis, in the 1840s, called on Irish artists to make up for this loss, even listing appropriate subject matter. His call was echoed in the early years of the twentieth century when James Ward, headmaster of the Dublin Metropolitan School of Art, introduced a course in history painting into the school's curriculum, and inaugurated a prize for the best painting of a subject from Irish history, legend or romance appropriate for public buildings. To give students experience, Ward proposed to Dublin Corporation in 1913 that he and his pupils (among whom was Harry Clarke (qv)) would execute a scheme of the Corporation's choice of subject, free of charge. The resulting work, in eight panels, recessed into the wall below the Rotunda in City Hall [220], was devoted to scenes from Irish and mainly Dublin history, ranging from the baptism of the King of Dublin by Saint Patrick, to Brian Boru praying for victory against the Vikings in 1014. The scheme was devised by Alderman Thomas Kelly, a Sinn Féin member of the Corporation. As Daniel Maclise had done with his *Marriage of Strongbow and Aoife* (1854, NGI collection), it avoided upsetting unionists and nationalists by focusing solely on ancient and medieval history which, nonetheless, conveyed a sense of Irish religious fervour and independence. Ward's scheme was completed in 1919 but failed to ignite a taste for such projects. The only other important mural scheme was John Luke's (qv) *The Life and History of Belfast* (1952) [221] for the tympanum of the dome of Belfast City Hall. Even an establishment favourite, Sir John Lavery (qv) saw his painting *High Treason, Court of Criminal Appeal: The Trial of Roger Casement* (1916–29) [222] sidelined, because although suggested by the presiding appeal judge, Sir Charles Darling, it was considered in bad taste and likely to incite hostility to the British government if publicly displayed. It remained in Lavery's studio until his death, was offered to the National Portrait Gallery in London but was rejected and eventually given to the King's Inns, Dublin, in 1950 on indefinite loan, which meant, according to the Lord Chancellor, 'we can forget to ask for its return' (John McGuigan, *IAR Yearbook*, 1999, p. 159).

Emerging Modernism (qv) across Europe and the experience of World War I effectively challenged old attitudes to heroism and patriotism. There are no heroes and no victors in Picasso's *Guernica* (1937), yet the reality it presents seems more credible than the idealizing spectacles of the nineteenth century. Modernism also questioned the language of painting and its dependence on literature. It demanded that artists should be able to communicate powerful emotions and events without resorting to outmoded forms of representation or dependence on literary sources. Free State Ireland, seeking a visual history, trod a narrow path between the desire to celebrate its new status and the need for tact and restraint in its expressions of this following a divisive civil war and continued legislative ties with Britain. From an aesthetic perspective, it was also caught between Modernism, on the one hand, and an ongoing

academic tradition on the other. While artists like William Orpen, Margaret Clarke (née Crilly) and Seán Keating (qqv) opted for a traditional approach, Jack B. Yeats (qv), openly sympathetic to the republican cause, and at one time considered by Eamon de Valera as the right person to head up a Ministry of the Arts, refused to be drawn into the narratives of officialdom. His characters, representing the displaced rather than conquering heroes, are unnamed sailors, boxers, poachers and circus performers, romantic but never idealized.

Orpen's allegorical painting *The Holy Well* (1916) [40] posed challenges for catholic nationalism while simultaneously idealizing the figure of the revolutionary who defiantly ignores religious ritual. Margaret Clarke produced a number of symbolic paintings, notably *Strindbergian* (1927) [63] and *Mary and Brigid* (1917, Mount Saint Vincent University, Nova Scotia, Canada), but by far the most acceptable and least ambiguous history paintings for Free State Ireland came from the brush of Seán Keating. Clarke later came to see Orpen's academic approach to painting as restrictive (Hilary Pyle, 'Darling Margaret: A Look at Orpen's Favourite Pupil', *IAR*, 24, Spring 2007, 91) but this was certainly not the case with Thomas Ryan (qv), who saw it as his mission to compensate for the absence of history painting in the 1960s. Ryan showed *The Flight of Sir Hugh O'Neill, Earl of Tyrone* at the Oireachtas Exhibition in 1965 and *The GPO 1916* [223] at the special commemorative exhibition, *Cuimhneachán 1916*, but the taste for such traditional painting was no longer there. The paintings were not well received.

In 1945 the government broke a long record of inactivity and supported an *Exhibition of Pictures of Irish Historical Interest*, held at the National College of Art in 1946. Astonishingly, in the centenary year of the outbreak of the Great Famine, the greatest disaster from which Ireland ever suffered and which was to permanently alter the course of Irish social, cultural and political life, the government stipulated that the exhibition should commemorate Thomas Davis and the Young Ireland revolutionary movement. In its choice of emphasis, de Valera's administration was clearly keen to celebrate nationalist heroes and to overlook death, poverty, emigration and the devastation of communities on a national scale. Seventy-eight artworks were submitted for exhibition, of which forty-seven were selected; of these, eight

221. John Luke, *The Life and History of Belfast*, 1952, mural for the tympanum of the dome, Belfast City Hall

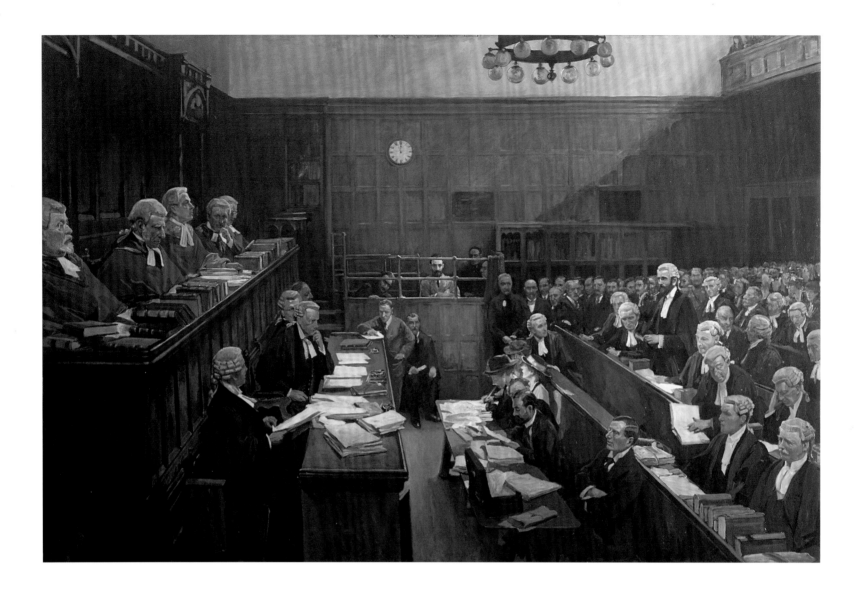

222. John Lavery, *High Treason, Court of Criminal Appeal: The Trial of Roger Casement*, 1916–29, oil on canvas, 194.5 x 302.5 cm, Government Art Collection, London

related to the history of the Famine, but the overwhelming majority told of nationalist and revolutionary activity. The emphasis is not hard to explain. Emigration and poverty continued to cause serious concern in 1946. While a government was unlikely to want to remind the voting public of its inability to deal with such problems, it is also timely to note that within two years de Valera would declare the Irish Republic breaking, once and for all, a legislative link with Britain.

Contrary to patterns elsewhere, twentieth-century Ireland's most successful visual depiction of a major history cycle was presented, not in large-scale canvases or monumental sculpture, but in the pages of a book. Louis le Brocquy's (qv) illustrations to Thomas Kinsella's translation of the Cú Chulainn legend, *The Táin* (1969, Dolmen Press, Dublin) [230], successfully incorporated a semi-abstract Modernist form of figuration showing that it was possible to represent history while using a present-day language. The widespread positive critical and popular reactions to this publication made it possible for le Brocquy to scale up this imagery in the form of monumental tapestries, giving the country a sustained visual narrative without reneging on his Modernism.

Ironically le Brocquy's work was far more effectively transmittable to the public at large than schemes like those of James Ward.

Jean-François Lyotard, who coined the term 'grand narrative', believed that they are always mechanisms of class authority, not tenable in a Postmodern society (Lyotard, *The Postmodern Condition: A Report on Knowledge*, Québec 1979). History painting, as it was known and understood in the past, could function only in a social system that accepted notions of authority and its supporting narratives without question. Postmodern and post-colonial situations, by contesting the old histories, posited different knowledge and alternative representational forms. Irish-Australian artist Sidney Nolan (see 'Diaspora') was as inspired by Aboriginal art as by European tradition in his painted narratives of the anti-hero, fellow Irish-Australian Ned Kelly. In Ireland, Gerard Dillon, Robert Ballagh and Micheal Farrell (qqv) mocked the grand tradition by appropriating its imagery and bending it to the cause of subversion rather than passive acceptance.

Some of the most powerful images of Irish history have been painted by artists from outside the country. Richard Hamilton,

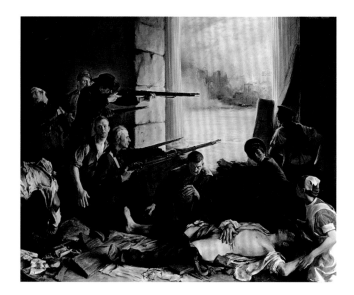

often considered to be the founder of British Pop art, painted *The Citizen* (1982/83) and *The Subject* (1988–90) as a comment on the Republican and Orange positions in the Northern Ireland 'Troubles'. Hamilton upset establishment representations of hunger strikers in the Maze Prison in 1981 by transforming them from IRA thugs to Christian martyrs in *The Citizen* and using a photograph of Raymond Pius McCartney, a prisoner, as the source of his image. Hamilton used it again for *Finn MacCool* (1983) in his forty-five year project to illustrate Joyce's *Ulysses*. Terry Atkinson, a founder member of the group Art and Language (1968–74), and one of the most influential figures in modern British art, represents the human figure by implication rather than actualization in his series 'The Bunker Drawings' (1980s, IMMA collection), evoking the dehumanization, isolation and fear of life in a military dugout in Northern Ireland and, as a further act of defiance towards the genre, used the medium of drawing instead of the customary painting.

Dermot Seymour and Rita Duffy (qqv) blended surreal and Expressionist styles, motifs and practices, as well as black humour, in their paintings of life in Northern Ireland during the Troubles (see 'The Troubles and Irish Art'), while Alice Maher (qv) ranges from drawing, photography, installation (qqv) and sculpture in her exploration of folk culture and fairy tales in the modern world. The act of painting, on the other hand, is fundamental to Shane Cullen's (qv) ninety-six panels of text, based on messages smuggled in and out of the Maze Prison (Long Kesh) during the Hunger Strikes [106]. If Modernism frowned on history painting's overdependence on literature, Cullen lovingly painted every letter and punctuation mark in this entirely textual work, challenging alike the orthodoxies of Modernism and the academic tradition. Cullen's work could be said to round the circle by returning history painting to narrative in the most graphic manner possible. Hughie O'Donoghue (qv) clearly upholds the values of painting on a grand scale, drawing openly on the lessons of Titian and Rubens. In doing so, however, he celebrates a newer and far more democratic narrative focus – that of the ordinary soldier/worker/family member

participating in great events but either anonymously or, most tellingly of all, so individualized through the use of personal letters and photographs that they portray real people, and deny historical mythologizing.

By the late 1970s and '80s artists like James Coleman and Alanna O'Kelly (qqv) had rejected history painting and its rituals in favour of multi-vocal interpretations of, hitherto, neglected or unchallenged narratives. In electing, in the early 1990s, to explore the unrepresented history of the Famine, O'Kelly prompted a spate of less successful representations of this subject. Coleman and O'Kelly's chosen media were no longer painting but performance, mixed media, installation and film (qv) which, as Joan Fowler has pointed out, 'has largely supplanted the plastic arts as the popular, artistic, and intellectual medium for visual narrative, while story-telling in film remains indebted to the literary arts and to music'.
CATHERINE MARSHALL

SELECTED READING Cullen, 1997; Steward, 1998.

HONE, EVIE (1894–1955) [224], painter, stained-glass artist. Eva Sydney (Evie) Hone was born in Dublin, into perhaps the most established visual arts family in Ireland. Her mother died two days after her birth and, following an attack of polio at the age of eleven, which caused a lifelong disability, Hone was educated by a governess. By the age of twenty, however, she was in London, studying art at the Byam Shaw School of Art, later the Central School of Arts and Crafts, under Bernard Meninsky, and at the Westminister School under Walter Sickert, where she met Mainie Jellett (qv). The two Dubliners travelled to France in 1920 to work under the Cubist artists André Lhote and Albert Gleizes. Gleizes later claimed that he learned as much from his two Irish students as they did from him (Bruce Arnold in Ryan-Smolin et al, p. 32). Although Hone and Jellett spent a

223. Thomas Ryan, *The GPO 1916*, 1966, oil on canvas, 134 x 160 cm, artist's collection

224. Evie Hone, *St Rémy de Provence*, c. 1921, watercolour on paper, 38.2 x 51 cm, Crawford Art Gallery

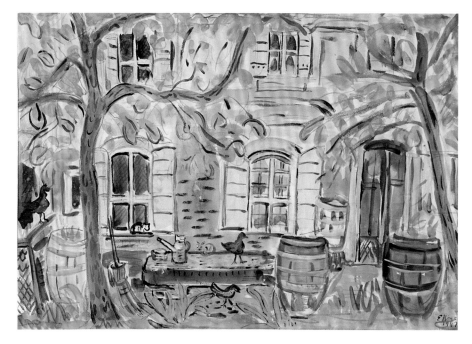

part of every year throughout the 1920s in Gleizes's studio, they were also active in Dublin, becoming early members of the SDP and causing a minor controversy in 1924 with their joint exhibition of abstract paintings. It is often said, as Brian Kennedy does, that their work in those years was virtually indistinguishable, although Kennedy quotes an *Irish Statesman* review of the 1924 exhibition saying that Hone was 'the purer artist' (Kennedy in Ryan-Smolin et al, p. 37). She and Jellett were members of the Abstraction-Creation group in Paris and had their work reproduced in its journal. They also showed at the Paris Salon des Indépendants, the Salon des Surindépendants and Salon d'Automne in the 1920s. They continued their loyalty to the avant-garde in Ireland as founding members of the IELA and exhibiting with the White Stag Group (qqv).

Bruce Arnold argued that Hone did not fully understand the principles of abstraction (qv) and that she was dependent on Jellett to elucidate them for her (Arnold in Ryan-Smolin et al, p. 30). It is certainly true that Hone's real interests lay elsewhere. In 1925 she spent a year in an Anglican convent in Cornwall, converting to Catholicism twelve years later. She had a strong religious inclination and this may have led her art away from abstraction. By the late 1920s she had moved from painting towards figurative stained glass (qv), which was to be her main activity from then on.

Despite ill health, Hone learned the craft of stained glass from A.E. Child, Wilhelmina Geddes (qv) and, in Holland, from Roland Holst, looking to medieval stained glass in Chartres Cathedral and the contemporary painting of Georges Rouault for inspiration. Hone worked initially at An Túr Gloine with Michael Healy, completing an important commission for Clongowes Wood College after his death. On the death of Sarah Purser (qv) and the closure of An Túr Gloine, Hone established her own stained-glass workshop in Rathfarnham where she was helped by a number of apprentices, notably Elizabeth Rivers and Hilda van Stockum (qqv), while another artist Harriet Kirkwood and her husband commissioned her to do a commemorative window in the Church of St Naithi, Dundrum, Dublin.

Following Harry Clarke's (qv) death, Hone became the most important stained-glass artist in Ireland. The critic Dorothy Walker, while praising Clarke for his 'remarkable virtuosity', felt that his work lacked a spiritual quality, 'whereas Evie Hone's work actually announces her faith in Christianity and in the reality of the spirit by means of a noble simple art' (Walker, 1980, 108). She received over fifty commissions for stained glass from Irish and foreign patrons, the most distinguished of which were the commission for a window for the Irish Pavilion at the New York World's Fair in 1939 and the request to replace the East Window of Eton College Chapel (1949) which had been bombed during the war. *My Four Green Fields* [465], for the World's Fair, probably the largest secular window in Ireland at over six metres high, won first prize for stained glass and was installed in the renovated Government Buildings, Merrion Street, in the late 1980s, but the Eton Window, which took three years to complete, is regarded as Hone's masterpiece.

At her death, she bequeathed artworks by Picasso, Gris and Gleizes to the NGI. Memorial exhibitions were held at the IELA (1955), the Dawson Gallery, Dublin (1957), QUB (1968), and a retrospective, curated by James White, for which some of her large windows were especially reinstalled, was held at UCD in 1958. The exhibition attracted 22,000 visitors and broke new ground by being the most expensive exhibition to have been mounted in Ireland to date. It later travelled to the Tate and to the Arts Council Gallery, London.

In 1969 a stamp showing the Eton College window was issued and in 2005/06 a small exhibition of her work was presented at the NGI to mark the fiftieth anniversary of Hone's death. Her work can be seen in the collections of the NGI, HL, CAG and UM and in churches throughout Ireland and Britain. CATHERINE MARSHALL

SELECTED READING James White, *Evie Hone 1894–1955*, exh. cat. UCD (Dublin 1958); Ryan-Smolin, Mayes and Rogers, 1987; Wynne, 1977; Hilary Pyle, 'Iron in the Soul, Evie Hone', *IAR* (Winter 2005), 126–31.

HUGHES, RONNIE (b. 1965), artist. Hughes prefaced a catalogue of an exhibition of his work with a poem by Roberto Juarroz, containing the lines 'The word is full of voice/ though no one speaks it' (*Manifest*, frontispiece). The lines are especially apt because Hughes's work concerns the possible meanings encapsulated in the most banal manifestations of our world, and the hints of what are obscured by what is actually presented. Thus, the abstruse shapes in his paintings may allude to familiar, but often forgotten, things that lie dormant in our mental landscapes, only to leap into life when the allusion becomes clear. *Expresso Mundo*'s (1996, IMMA collection) [225] lozenge-shaped forms, possibly referencing anything from boiled sweets to planetary systems, or simply what you see when you stick your finger in your eye, call attention to the image's potential to carry meaning in ways that are scientific and humorous as well as aesthetic. While he might be considered a painter in the formalist, abstract tradition, Hughes is one of those artists who are opposed to the oppositional and hierarchical interpretations of the terms 'representation' and 'abstraction'.

Born in Belfast and educated at the University of Ulster, Hughes lives in Sligo and teaches at the Institute of Technology there. He has been a regular exhibitor at EV+A since 1990. His work appeared to change dramatically in the mid-1990s, but there is a clear trajectory from an early three-dimensional work, the installation *Consummation* (1992), comprising a large armchair made up of crates of empty beer bottles and shelves of bottles each carrying a label with a tourist image of Ireland, to his paintings of immigrant workers in the People's Collection in Sligo, and his more abstract work from the mid-1990s (see 'Abstraction'). *Keepsakes* (2000, Sligo), referencing the destruction of the Spanish Armada off the Sligo coast, could be described as a physical embodiment of his use of form to encapsulate multiple meanings as glass 'cannonballs', each containing objects selected from the local community, were placed along the beach, only to be scattered by the tides.

Hughes has executed public art projects, notably *Keepsakes*, and has taken up residencies in Ireland, Canada and the USA. His work is in the collections of the British Council, the Josef & Anni Albers Foundation, and in Ireland in the AC/ACE, ACNI, IMMA, UU, CIAS and other collections. CATHERINE MARSHALL

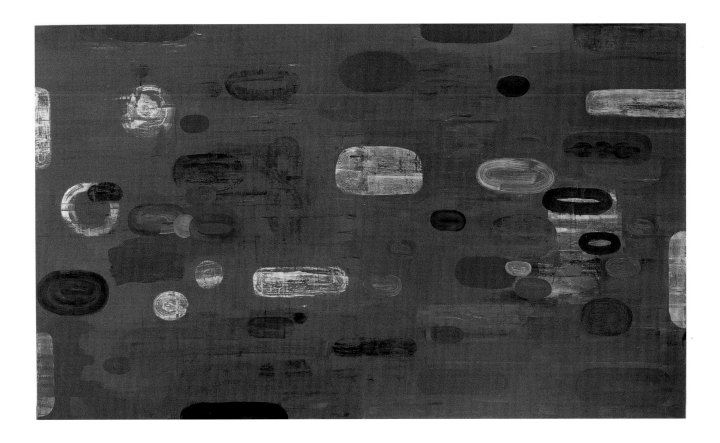

SELECTED READING G. Murphy, 2000; Aidan Dunne, 'The Language of Forms', in *Ronnie Hughes: Selected Works 1999–2001*, exh. cat. Rubicon Gallery (Dublin 2001); *Manifest*, exh. cat. Millennium Court Arts Centre (Portadown 2008).

IDENTITY IN IRISH ART: MODERNISM AND THE POLITICS OF FORM (see *AAI* III, 'Celtic Cross').

'For history's a twisted root/with art its small, translucent fruit ...' (Paul Muldoon, '7, Middagh Street' from *Meeting the British*, 1987).

'In Ireland, where the tide of life is rising', wrote W.B. Yeats in 1904, 'we turn not to picture-making, but to the imagination of personality – to drama, gesture.' (Yeats, 'First Principles', *Samhain*, 1904, in *Explorations*, New York 1973, p. 163) In Yeats's statement, it is possible to see why language and performance took precedence over the image in Irish culture: the institutional basis of 'picture-making' did not lend itself to a national revival, and it was left to literature to project Ireland onto the world stage. But in the decades since the founding of the state, Irish writers continued to enjoy the limelight, and win literary accolades, whereas Irish artists remained in the wings. Certain individuals achieved international recognition: Jack B. Yeats, Eileen Gray, Harry Clarke, Francis Bacon, Louis le Brocquy (qqv) and Kevin Roche feature in accounts of their respective visual media, as do leading contemporary artists such as Brian O'Doherty, Les Levine, James Coleman and Sean Scully (qqv). In the past two decades, Willie Doherty, Dorothy Cross, Alice Maher, Brian Maguire, Gerard Byrne (qqv) and others have exhibited at the highest international level. But in Ireland, as Fintan Cullen and John Morrison have remarked, 'the visual arts have too often been seen as a poor relation to the literary tradition' (Cullen and Morrison (eds), *A Shared Legacy: Essays on Irish and Scottish Art and Visual Culture*, Aldershot 2005, p. 5).

Backlit by a powerful literary tradition, Irish writers stand to gain in international prestige, but the same cannot be said of visual artists. It may be that the rejection of representation and the tendency towards abstraction (qv) in twentieth-century art made the particularities of place and location even more problematic, however much this was in keeping with the emergence of cosmopolitan style under global modernity. It does not follow, however, that a work of art is any less marked by its historical moment for seeking definition in style, or even abstraction: as we shall see, cultural specificity or location may be articulated through form, by indirection and obliquity, as much as through overt professions of identity.

The nationality of art is often misunderstood in programmatic terms as a self-conscious identification with the nation, or the representation of overtly national themes. Much of the groundwork for advancing the debate beyond literal depictions of Irish culture was laid by W.B. Yeats during the literary revival, particularly in his insistence that patriotism or promoting the national idea did not set the limits on distinctive Irish contributions to literature. Stressing the importance of literary value, Yeats sought to shift national literature from propaganda or 'rhetoric' to an aesthetic imperative, whose contribution to national freedom lay in the freedom of the imagination itself. A distinctive culture found its voice in style, not just in readily identifiable subject matter. Yeats noted that much self-proclaimed Irish writing dealt with the affairs of the nation but the *manner* was derivative: Irish novelists imitated Scott, Thomas

225. Ronnie Hughes, *Espresso Mundo*, 1996, copolymer on canvas, 198 x 335 cm, Irish Museum of Modern Art

Davis borrowed from Macaulay, and John Mitchel took his bearings from Carlyle. Foreign influence itself was not the issue, but rather the availability of indigenous forms to give them a local habitation. It was for this reason, according to Yeats, that great national literatures like those of England or France could take 'their subjects from foreign lands' while yet speaking in their own voice: 'Shakespeare observed his Roman crowds in London, and saw, one doubts not, somewhere in his own Stratford, the old man that gave Cleopatra the asp.' (W.B. Yeats, 'Irish Dramatic Movement', *Explorations*, p. 160) It was the mastery of form that enabled a culture to speak not only to itself but also to the world at large. Writing in 1895 of the canonical status of Robert Burns and Sir Walter Scott, Yeats conceded that Irish literature had not yet attained this capacity to convert national themes to distinctive qualities of feeling:

> The time has not yet come for Irishmen, as it has for Scotsmen, to carry about them *a subtle national feeling, no matter when, or of what they write*, because that feeling has yet to be perfectly elaborated and expounded by men of genius with minds as full of Irish history, scenery, and character as the minds of Burns and Scott were full of Scottish history, scenery, and character. (Yeats, 'Irish National Literature, IV: A List of the Best Irish Books', 1895, in John P. Frayne and Madeleine Marchaterre (eds), *Collected Works of W.B. Yeats*, Vol. IX: *Early Articles and Reviews*, New York 2004, p. 290)

Burns and Scott had raised literature above local horizons to what Raymond Williams was later to call 'structures of feeling', a process whereby content acquired formal idioms that manifested themselves in new constellations of narrative, genre and style. Williams later glossed the term: 'It was a structure in the sense that you could perceive it operating in one work after another that weren't otherwise connected – people weren't learning it from each other; yet it was one of feeling much more than of thought – a pattern of impulses, restraints, tones.' (Williams, *Politics and Letters: Interviews with New Left Review*, London 1979, p. 159)

Irish Modernisms
In 1942 the Royal Hibernian Academy (RHA) (qv) rejected two paintings by Louis le Brocquy (qv) for exhibition, a critical turning point in Irish art that led to the founding of the Irish Exhibition of Living Art (IELA) (qv), chaired by the leading Irish Modernist painter Mainie Jellett (qv). In a key statement of her artistic principles, Jellett followed Yeats in asserting that a national culture found its highest articulation in form, as against work driven by content that merely reproduced what was already there. Inspecting the academic realism (qv) on show at the RHA, Jellett commented that 'with the exception of Jack B. Yeats and an odd work here and there', the paintings 'resulted in a coloured photograph void of any creative element of colour or form'. She proceeded to apply herself to questions of national style:

> Then one looks for some sign of nationality, something that would tell the onlooker that these pictures were by Irish men and women. The only artist who could stand this test was Jack B. Yeats …. This quality of nationality is something lacking in Irish art as a whole. It is a quality that cannot be studied and self-consciously looked for; it will only show if we artists are working creatively with our whole capacity of body and soul, and not if we continue to paint complacent coloured photographs of cottages and rural scenery, without delving into the inner consciousness of our country and the natural rhythm of life. (Jellett, p. 116)

Jellett's difficulty with the photographic image was not only its imitation of surface truth but also the failure to register movement, rhythm and process – precisely the elements invoked by Cézanne and Cubism (qv) in their challenges to naturalism. Jellett had no objections to international movements – she and other Irish Modernists such as Evie Hone, May Guinness and Norah McGuiness (qqv) had trained with André Lhote and Albert Gleizes in France – but influences ceased to be derivative when they were recast by the host culture; 'if the particular country which adopts or absorbs them has any creative capacity worthy of the name, they can be re-born and bear the stamp of the country and nation of their re-birth' (Jellett, 'Modern Art and its Relation to the Past', 1941, cited in Arnold, 1991, p. 180). This presupposes that the host-culture had a tradition in visual form 'worthy of the name', and it was in this context that Jellett looked to early Christian art as an indigenous precursor to the abstraction of Cubism. In a note appended to a draft of a lecture, she wrote:

> I will try to point out the similarity of ideals between the art of the modern movement (headquarters Paris) and the ideals inspiring Celtic art, and try and show if we could only open our eyes to the truth behind Celtic art and the treasure we have in this country in what it has left us, we might become conscious of a reality that would give our art a national character. (ibid., p. 181)

Hence the spirit of innovation with which artists such as Jellett and Evie Hone evolved a style of 'Celtic Cubism', inflecting the angularity and three-dimensionality of Cubism within the contours of ancient Celtic and medieval art. Although the shift from content to form marked a considerable advance on appeals to subject matter and representation in national art, the recourse to a 'Celtic consciousness', transcending time and place, still relied on fixed conceptions of national character. (For the persistence of such thinking into the contemporary period, see Robert O'Driscoll (ed), *The Celtic Consciousness*, New York 1982.) Elements of Celticism also informed the early Rosc exhibitions (qv) in Ireland, as will be noted below. Versions of this critical approach, associated with Heinrich Wölfflin, Alois Riegl and the heyday of Formalism in art criticism, led to the tracing of different national sensibilities in the lineaments of form: Renaissance as 'linear', Italian; 'Baroque' as 'painterly', Northern. In Ireland, the relation of modern abstraction to the timeless or spiritual qualities of 'Celticism' served to further insulate art against the incursions of actual history, and the political instabilities of the early decades of the newly established state.

Jellett exempted Jack B. Yeats from her withering critique of contemporary Irish art, and that Yeats's negotiations of form were not exempt from the pressures of actual history was the tenor of Ernie O'Malley's [226] acute critical reappraisals of the relation between art and national life. O'Malley himself was no stranger to the front-line of history, having earned a reputation as one of the most formidable IRA leaders during the War of Independence and the Civil War. Leaving Ireland in 1924 to recover from the effects of prolonged imprisonment and multiple wounds sustained during the conflict, O'Malley visited the United States, spending an extended period at the artists' colony in Taos, New Mexico, and in Mexico. He struck up friendships with Hart Crane, Paul Strand and Dorothy Brett, and met Georgia O'Keefe, Edward Weston, and during a long sojourn in Mexico, Sergei Eisenstein. Contrasting the divergent paths taken by the visual arts in the colonial conditions of Mexico and Ireland, O'Malley noted that in Mexico the importation of Spanish styles in painting led originally to slavish imitation for 'no native tradition [was] sufficiently strong to correct the imitation of removed European standards' (O'Malley, 'Background to the Arts in Mexico', *The Bell*, XIV, no. 5, reprinted in O'Malley and Allen, p. 429). O'Malley pointed out that it was only in architecture that a native style developed: 'Baroque and Churrigueresque [a Spanish form of Baroque] became almost indigenous, and created a number of buildings which surpass anything to be seen in Europe in this manner.' Likewise in Ireland there was no possibility (contrary to myths of a lasting Celtic temperament) of an unbroken visual tradition: 'the plastic arts were not even a dim memory' owing to conquest. Unlike visual culture, however, literature retained a clandestine existence in the margins: 'Literature was a survival of the tongue, history was kept alive by folklore memory alone. Criticism in the creative sense had neither material to work on nor educated people to work with.' This allowed tradition to live on but often in an uncritical sense, as a kind of national mystique: 'In Ireland history is used as a compensation for a vanished past for which there has been no critical understanding as a result of the lack of continuity in the tradition of scholarship; or else it is a source of undue pride in superficial knowledge.' (p. 430) It is for this reason that O'Malley took issue with the primacy of representation in art, warning of the tendency to construe the image in narrative or literary terms: 'In Ireland the visual sense is not strongly developed in terms of creative painting Due to the destruction of the arts by conquest there is but one continuous tradition, the literary tradition; we are inclined to see paint in a literary way as if the implied title should continue as a story on the canvas.' (O'Malley, 'Introduction,' in *Jack B. Yeats National Loan Exhibition Catalogue*, 1945, repr. in O'Malley and Allen, p. 395.)

In these circumstances, it is not surprising that O'Malley looks to form rather than content for the outlines of a national style, drawing on the strong visual awareness of everyday life in Ireland:

There is a fine feeling for colour, well expressed in small towns where white-wash is mixed with paint powder to give house fronts a fascinating texture of tender pastel shades. Irish atmosphere softens and blends the clash that might

have ensued from the individuality of the wonders in selection of colour. There is, as well, a peculiar unliterary affection of landscape, but the manner of looking at paint is too often determined, not by this corrective, based as it is on evasive colour and the inherent structural sense of line and form in bare mountain, but by thinking of other paintings. (ibid., p. 69)

The emphasis on colour, light, atmosphere and line suggests that the deepest engagement with history is effected through the materiality of paint, and the distinctive repertoires of expression available to the artist ('thinking of other paintings'): 'Memory must play its part The sense of man is present in enclosures of light-filigreed stone walls which map land hunger, or in unobtrusive cottages, dwarfed by mountain and hill to an almost tragic insignificance.' (pp. 392–93)

Thus, when a shift towards form takes place in Jack B. Yeats's painting from a linear to a painterly style in his mid-career, O'Malley notes that the increasing 'subjective' approach is no less culturally produced and immersed in the contingencies of time and place (p. 394). In 1925 Yeats executed a hurried sketch with scribbled notations of a crowded scene at Kingsbridge (now Heuston) Station, Dublin in which two women walk into a small clearing in space. This formed the basis of *Going to Wolfe Tone's Grave* (1929) [227], a sombre painting that can be seen as marking a key transition in the dominance of colour over line in

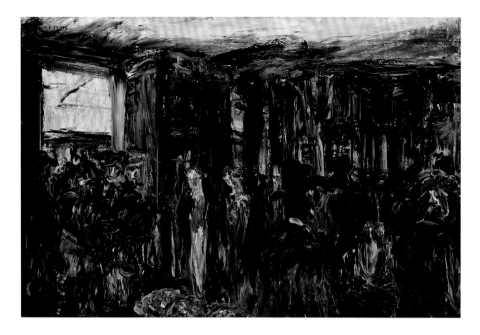

227. Jack B. Yeats, *Going to Wolfe Tone's Grave*, 1929, oil on canvas, 61 x 91.4 cm, private collection

Yeats's later work. The air of mourning absent in the sketch is registered in the dark tonalities and application of paint, and it is this heavy impasto that some critics have taken to signify the 'introversion' of the work, and its reversion to memory at one remove from politics: '[B]y invoking the memory of a great Irish martyr, it speaks of Irish heroism and the politics of republicanism while distancing itself from the latter's overt political manifestation. Politics here reside in memory rather than in present-day violence.' ('Jack Yeats and Mid-Century', in Steward, 1998, http://www.nyu.edu/greyart/exhibits/irish/irish2/text3/text3.html, accessed 12 February 2012) Yet the fact that the two women left of centre in the painting are leading Republican activists, Maud Gonne and Charlotte Despard, must surely raise doubts about the memory of the dead, any more than the memory embedded in stone walls on the landscape, being laid to rest. The motif of two isolated figures recurs in Yeats's later work but it is here configured as part of a crowd whose solidarity contrasts with the sepulchral tone of the vertical station walls. Notwithstanding the gloom, there is, according to Kenneth McConkey, a 'surface ripple of light and shade' that anticipates 'the preoccupation with form in the Abstract Expressionism of De Kooning' (McConkey, *A Free Spirit: Irish Art 1860–1960*, London 1990, p. 183). The source of illumination is a window of light in the top left-hand corner, whose brief flashes are picked up in the face and dress of Gonne and Despard, and by other sequin-like points on the canvas.

Yeats's use of light was seized upon by Samuel Beckett to establish his internationalism: 'He is with the great of our time, Kandinsky and Klee, Ballmer and Bram van Velde, Rouault and Braque, because he brings light, as only the great dare to bring light, to the issueless predicament of existence, reduces the dark where there might have been, mathematically at least, a door.' (Beckett, 'MacGreevy on Yeats', in Roger McHugh (ed), *Jack B. Yeats: A Centenary Gathering*, Dublin 1971, p. 73) It may be that the mathematical door or window also opens up Irish

Republicanism onto a wider world: Maud Gonne and Charlotte Despard were both internationalists, and were leading lights in the founding of the Irish-Indian Independence League. The Bodenstown Commemorations at the grave of Wolfe Tone likewise broke the mould of 'introverted' Irish Republicanism, with the controversial attendance of a Belfast Protestant socialist delegation in 1934. That none of these themes is overtly signalled in the work is precisely what is meant by the mediation of form, as O'Malley observed: 'It is hard to explain a change in direction [in the painting of Jack B. Yeats], but one of the factors may have been the heightened sensibility, which could result from the tension of life during the struggle for freedom in Ireland then, and the new note of intensity felt by a sensitive observer.' (O'Malley and Allen, pp. 393–94)

For all the use of paint as 'an end in itself', O'Malley concludes, 'In Jack Yeats we have a painter who is as much concerned with what he has to say in paint as with his manner of saying it.'

Abstract historicism

At stake here is an idea of the aesthetic elaborated by Marxism and psychoanalysis: what is repressed as content returns as form. As formulated by Theodor Adorno, history, though erased from representation, remains 'sedimented' in form: 'What is specific to artworks – their form – can never, as the sedimentation of content [,] fully disown its origin. Aesthetic success is essentially measured by whether the formed object is able to awake the content sedimented in the form.' (Theodor W. Adorno, *Aesthetic Theory*, trans. Robert Hullut-Kentor, New York 2004, p. 184) Adorno later describes the 'substantive elements' buried in form: 'In works where forms seem to have divested themselves of any content, they generate an expression and a content of their own …. As they grow outdated, contents which are sedimented in form suddenly wake up, as it were.' (p. 407) Hence it is in the materiality of style, technique and medium that culture leaves its most important, if often elliptical, traces, even in work addressed to the specificity of the medium or the aesthetics of form, as is evident in the work of a leading contemporary artist such as James Coleman. Introducing her critical reflections on the 'projected images' of Coleman, Rosalind Krauss relates that on her first meeting with Coleman, she informed him that she had 'decided not to go down the road of the Irish Question in writing about his work':

> It's not that I feel incompetent (which I do) to speak with any authority or subtlety about Irish history and culture or the Literary Revival, mounted by Synge and Yeats, to all of which there are obvious references in his work. It's rather that the issue of the medium as I've begun to think it in relation to his art is not a matter restricted to one country or another, but is generalizable across the whole field of the avant-garde. (Rosalind Krauss, '… And Then Turn Away', in Baker, p. 161)

Krauss observes that Coleman's radical engagement with the notion of a 'medium' in art may derive from 'a certain distrust in the internationalist scope of conceptualism's practice' in his

work, but there is an equal suspicion of any recourse to national essence as an answer to abstract internationalism: 'The blanket condemnation of the avant garde's belief in transnationalism as just another cover for the imperialist ambitions of international capital, and the idea that the only source for unalienated, authentic meanings is to be found in the specificity of national tradition, seems a dangerous embrace of the archaic to me.' (p. 161)

Krauss's rendering of Coleman is accurate and to the point. There is a continual probing of the limits of the transnational avant-garde, but there is also no 'embrace of the archaic', still less a search for 'unalienated, authentic meanings' grounded in the consolations of place. Krauss points out that 'the two major ingredients for Coleman's medium – the slide tape and the *foto-romanzo* [or photo-novel] – have nothing particularly Irish about them', and that to ignore such transnational impulses would be to turn one's back 'on the long history of modernism' and its powerful 'idea of a tradition against which to test the meaningfulness of forms' (p. 162). But what if testing 'the meaningfulness of forms' has itself a provenance in Ireland, deriving precisely, as noted in relation to W.B. Yeats above, from the pressures placed on a colonial culture by an encounter with received forms, structures and styles? Notwithstanding the avant-garde's radical break with the past, not the least of the ironies of 'the long history of modernism' is that many of its disruptive energies derive from the periphery rather than from the metropolitan centre. As Fredric Jameson notes: 'How was it that aesthetic modernism was less developed in England than in Scotland, let alone Britain's "other island" whose extraordinary modernisms mark a sharp contrast with the commonsense empirical life of London or Cambridge?' (Jameson, p. 103) That James Joyce, moreover, 'was evidently still in Ireland throughout his "exile" ' provides an insight into how Modernist innovation and cosmopolitanism carry their submerged histories into the innermost recesses of form.

A disruptive play on the materiality of the medium – whether in advertising practices, media technologies and photo-novels – is to be found in Joyce's *Ulysses* and *Dubliners*, but the issue extends beyond the heart of the Hibernian metropolis. It is true that as Modernism (qv) moved away from representation and figuration, art ceased to reflect society in a mimetic fashion, but even at its most abstract it was no less implicated in the moment of its own production. The work of James Coleman does, indeed, belong to the international stage but is no less situated for this, as can be seen if we look at art in its most assertive, ahistorical form, the reflexive world of Abstract Expressionism. American post-World War II art, as theorized by Clement Greenberg and Michael Fried, was taken to represent the final vindication of form over history, but its very aloofness belied its manifold roles in the cultural politics of the Cold War. As if aware of these anxieties, Willem de Kooning exclaimed: 'It is a certain burden, this American-ness I feel somehow an American artist must feel like a baseball player or something – a member of team writing American history.' (Pam Meecham and Julie Sheldon, *Modern Art: A Critical Introduction*, 2nd edition, London 2005, p. 189) It is not surprising in these circumstances that artists should declare their independence from national culture (with the often unacknowledged rider that in such

claims to 'universality' lay precisely America's role on the world stage). As critics such as Adorno argued, the legacies of both the death camps and nuclear disaster following World War II induced a crisis in representation that could seek refuge only in form. Clyfford Still's determination to break free from what he termed 'those gas-chamber white walls' of the gallery is a case in point, for, as his language showed, the shadow of the camps even fell across the surface of paint (James Demetrion (ed.), *Clyfford Still: Paintings 1944–1960*, New Haven and London 2001, p. 149).

Barnett Newman was perhaps overstating the revolutionary potential of abstraction to challenge the instrumental reason of American corporate culture, but whether being appropriated by, or contesting, Cold War ideology, Abstract Expressionism was inextricably bound up with the politics of its time. The restless energies of Jackson Pollock's abstractions can be seen as both re-enacting and disputing (through its Native American sympathies) the expansionist aesthetic of the American sublime. As T.J. Clark notes, such is 'the nature of the history Pollock encounters that it is experienced as a general (abstract) condition of fate', but tangled up in paint on the canvas, may 'be understood at the same time as contingent and deceptive – garbling the history it tries to speak precisely, exalting the condition it suffers, repeating the lie of the culture at the same time as it rails against it' (Clark, 'Jackson Pollock's Abstraction', in Serge Guilbaut (ed.), *Reconstructing Modernism: Art in New York, Paris and Montreal 1945–1964*, Cambridge, Massachusetts 1992, p. 230). It is by virtue of their abstraction that such appropriations never exhaust the undecidability of the paintings themselves, their unsettling of the boundaries that enclose them. Pollock's work 'turns back to the roots conditions of its own abstractions, and tries to give them form: the form it chooses is the refusal of aesthetic closure; cutting out, interruption ...' (Clark, *Farewell to an Idea*, New Haven and London 1999, p. 366).

To locate the coordinates of Abstract Expressionism in a specific cultural moment is not to diminish its complexity, but may help to explain why aspirations to universalism, and the disavowal of location, come more easily to some societies than others. The contrast between the valorization of art in the advanced metropolitan centre and the perceived cultural deficit of the periphery is evident in the 'exoticization' of cultural difference – that is, when it features in the circuits of the international art world at all. In the extended controversy that surrounded the *'Primitivism' in 20th Century Art: Affinity of the Tribal and Modern* show at the Museum of Modern Art, New York (MoMA), in the early 1980s, Hal Foster pointed to the measured ahistoricism of the term 'affinity' in the title of the exhibition. As if to escape actual history, relations between centre and periphery were considered not in terms of interaction, or unequal cultural crossings, but as formal resemblances between the work of High Modernism, and the excluded 'others' of (primitive) history. Cultural artefacts were removed like primary raw materials from their original settings, and refined through abstraction to take their place alongside masterworks of the west: 'This presentation was typical of the abstractive operation of the show, premised as it was on the belief that "modernist primitivism depends on the autonomous force of objects" and that its

228. James Coleman, *Box (ahhareturnabout)*, 1977, 8 mm film transferred to 16 mm, black and white, audio (see [325])

complexities can be revealed in purely visual terms, simply by juxtaposition of knowingly selected works of art.' (Foster, 'The "Primitive" Unconscious of Modern Art, or White Skin in Black Masks', in *Recodings: Art, Spectacle, Cultural Politics*, Seattle 1987, pp. 182–83) In keeping with the 'autonomy' of western art, 'the primitive/tribal is [also] set adrift from specific referents and coordinates – which then makes it possible to define in wholly western terms' (p. 187). Emptying both art and artefact of their particular histories, a hollowed-out sacred past was invested with the secular aura of the modern art gallery.

Mediations of the modern
Elements of the thinking that informed the MoMA show were prefigured in the first four Rosc exhibitions in Ireland from 1967 to 1980, which set out to bring Irish art – belatedly – into contact with the energies of post World War II Modernism. Masterworks from Abstract Expressionism, Colour Field painting, and Conceptual art were exhibited alongside 'treasures' from antiquity, whether drawing on 'Celtic' heritage (prehistoric and medieval) in *Rosc '67*, Viking culture in *Rosc '71*, 'Animal Art' in *Rosc '77*, or ancient Chinese civilization in *Rosc '80*. In the spirit of Mainie Jellett's earlier 'Celtic Cubism', James Johnson Sweeney's introduction to the original 1967 exhibition stressed the rejection of representation in both ancient Irish historical artefacts and contemporary art, an elective affinity, in Dorothy Walker's phrase, that discovered 'the modern aesthetic of the ancient gold' (James Johnson Sweeney, 'Foreword', in *Rosc '67: The Poetry of Vision*, Dublin 1967, pp. 14–15; Walker, 1997, p. 113). It is worth noting in passing that some of the principles informing the MoMA Primitive/Modern Art exhibition in the 1980s

were traced by Hal Foster to James Johnson Sweeney's publication *African Negro Art*, accompanying the show by the same name at MoMA (1935), following the *American Sources of Modern Art* exhibition in 1933.

The key question raised by Foster's critique of the MoMA show is if setting works 'adrift from specific referents and coordinates', thus making 'it possible to define [them] in wholly western terms', is part of the same aesthetic ideology that also suppresses the particular cultural coordinates of *contemporary* art. The re-staging of the ancient past in the early Rosc exhibitions was consistent with the idea that contemporary Irish art was of no value – perhaps on account of its ostensible 'Irishness'. Hence the exclusion of contemporary Irish artists (Francis Bacon (qv), symptomatically, not being considered Irish) in the early shows, a policy that was not redressed until *Rosc'77* when two Irish artists, James Coleman and Brian O'Doherty/Patrick Ireland, were included in the main exhibition, Coleman's *Box (ahhareturnabout)* [228, 325] and O'Doherty/Ireland's *Yellow Rectangle* and *Rope Drawing # 34* featuring in the Hugh Lane Municipal Gallery of Art. It is striking that O'Doherty's second exhibit, a performance relating to his name-change to 'Patrick Ireland' in protest against the murder of unarmed civilians in Derry in 1972, was not considered suitable for the actual exhibition.

Coleman's work, based on the famous return bout between Gene Tunney and Jack Dempsey for the world heavyweight boxing championship in 1927, also examined mediations of history, albeit in a more circuitous ('*ahareturn-about*') manner. Taking the form of an audio-visual installation of a looped film with voice-over, it confronted the spectator with a series of jarring reflections not only on violence, suffering and the 'fighting Irish', but also on the enigma of the hero in an age of mechanical reproduction. Both Dempsey and Tunney were Irish-Americans, and central to the celebrated struggle of the famous boxing match was the contrast between Tunney's image as a cool, fighting intelligence and the 'brute-Irish' stereotype exemplified by Dempsey (known as the 'Manassa Mauler'). The continuous loop-film, punctuated by blackouts, carries a fragmented voice-over of Tunney's inner speech ('the refs … a clock … a circular …'), heightened by the pulsating rhythms of his heartbeat and blows to, and from, his body. The 'stream of consciousness' is closer to raw sensation and, for all Tunney's 'intelligence', it never succeeds in freeing itself from the punished body to escape to a psychic realm, in keeping with the body politic that produced Joyce, Beckett and Francis Bacon. That time weighs heavily on the hero raises questions about the role of the epic in a modern age – a concern not unfamiliar to Irish Modernism (see Jean Fisher, 'The Enigma of the Hero in the Work of James Coleman', in Baker, pp. 41–42). The 'replaying' of the return bout on the new medium of film brought history itself into the realm of spectacle, a recurrent concern in the explorations of the 'medium', and media effects, in Coleman's work.

Tunney's Daedalus-like cunning was shown to controversial effect in the famous 'long count' in which, having suffered a knockdown, he exploited Dempsey's failure to return to his corner to remain on his knees longer than the mandatory count to ten. It is as if the historical specificity of *Box* turns in on itself, the

different rhythms of the enclosed ring and gallery space marking disjunctions, as Dorothea van Hantelmann puts it, between 'those of *experienced* time and *historical* time': 'This particular aesthetic structure makes the historical appear in a unique way: history is not represented but rather evoked in and as a present experience. *Box* produces an image of the historical, which takes place in a space beyond all pictorial representation.' (van Hantelmann, 'Presence, Experience and Historicity in the Works of James Coleman', in *How to Do Things with Art*, Zurich 2010, p. 38) What is not represented is all the more present for being offstage, out of time. The notion of extended time – what happens between frames, intervals and units of measurement – is a central concern of Coleman's work but acquires a new intensity when linked to suffering. The injuries of time are marked ('Do it – again, again – stop, s-t-o-p – return') in a cyclical form, in a ring, that is equally applicable to Irish history. As in Jack B. Yeats, there is also a measure of triumph in endurance, and living to fight again ('the liver … an evergreen … soul …'), sentiments akin to those of the Irish hunger-striker Terence MacSwiney, who died in 1920: 'It is not those who can inflict the most, but those who can suffer the most who will conquer.' (Francis J. Costello, *Enduring the Most: The Life and Death of Terence MacSwiney*, Dingle 1995, p. 115) The symbolic force of the hunger-strike appears in Coleman's later allegory, *guaiRE,* (1984) [229], where it comes across as an overt *restaging* of history, rather than a timeless legacy of an ancient Celtic past. (For these aspects of *guaiRe* see Luke Gibbons, 'Narratives of No Return: James Coleman's *guaiRE*', in Baker, pp. 73–82).

The point of historically situating Mainie Jellett's abstraction, Jack B. Yeats's 'expressionism' or James Coleman's avant-garde installations (qv) is not to add local colour or a few anecdotes of Irish interest, but to show how images, no less than words, draw on the signifying practices of a culture. For Benjamin H.D. Buchloh, Coleman's *Box*, like much of his work, undertakes a 'general project of reconstituting a historically specific body to the universal abstraction of phenomenology'. 'Coleman insists on a sociopolitically specific body, structured by the discourse on national identity (in this case by presenting the Irish [sic] fighter Gene Tunney as the struggling protagonist who tries to save his boxing championship as much as his sociopolitical identity as an Irishman).' (Buchloh, 'Memory Lessons and Historical Tableaux: James Coleman's Archaeology of Spectacle', in Baker, p. 99) It is in this sense that the location of art has little to do with representing national essences but with the grounds of representation in the first place, the 'sociopolitically specific' conditions of art. (The case for a greater emphasis on materialist readings in Irish art criticism was proposed by Tom Duddy in his influential essay 'Irish Art Criticism – A Provincialism of the Right', *Circa*, no. 35, July/August 1987). One of the paradoxes of the 'self-sufficiency of form' (in Hal Foster's phrase) is that by rendering works placeless, there is no elsewhere, and the autonomy of art reverts into aesthetic solipsism. Writing of Jasper Johns's 1963 exhibition in New York, Michael Fried declared it 'one of the handsomest shows in New York this season', but with a reservation: 'The paintings are undercut by an awareness of their relation to a particular historical state of affairs; and one's own doubts

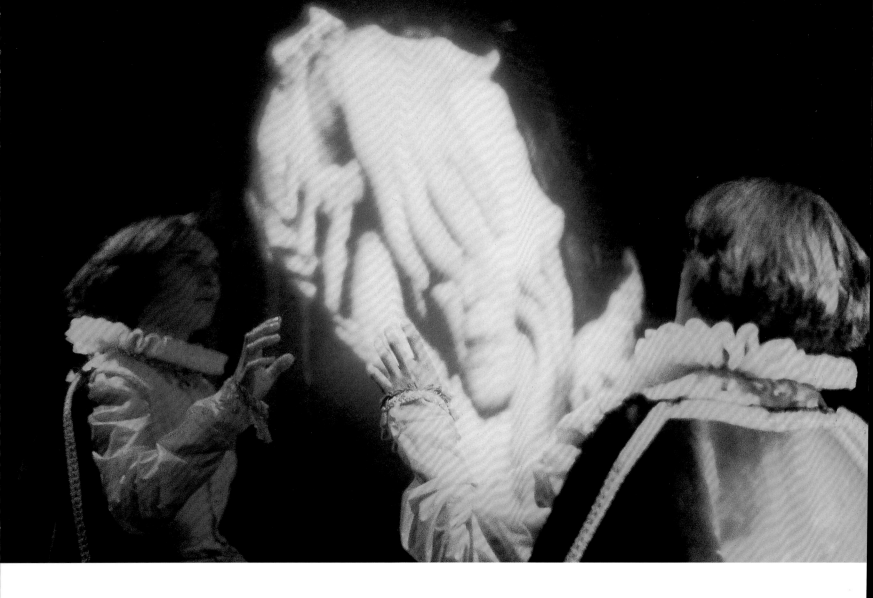

229. James Coleman, *guaiRE: An Allegory*, 1985, performed work, Dún Guaire Castle, Kinvara, performed by Olwen Fouéré

about the relevance of such an awareness to final judgments of quality chiefly serves to complicate things further.' (Fried, 'New York Letter: Johns (February 25, 1963)', in *Art and Objecthood: Essays and Reviews*, Chicago 1998, p. 293). It is noteworthy that Fried's strictures are directed at the self-conscious appropriations of history: what is left open is the formal engagement of a work with its historical circumstances, regardless of overt 'intentions'. One contemporary response to Jack B. Yeats's *Going to Wolfe Tone's Grave* demurred that were it not for the title, one would not even know it referred to a particular event: in this, it could be argued, lies the most profound relation of a work to the history of its time. LUKE GIBBONS

SELECTED READING Mainie Jellett, 'The RHA and Youth', *Commentary*, May, 1942, cited in S.B. Kennedy, 1991; Fredric Jameson, *A Singular Modernity: Essays on the Ontology of the Present* (London 2002); George Baker (ed.), *James Coleman: October Files 5* (Cambridge, MA and London 2003); O'Malley and Allen, 2011.

ILLUSTRATIONS AND CARTOONS. 'What is the use of a book ... without pictures or conversation?' Alice asks in the opening sentence of *Alice's Adventures in Wonderland* (Lewis Carroll, London 1865, p. 1). Perhaps because the written word has had such a prominent place in Irish culture, illustration has been a fruitful field of opportunity for Irish artists. Its importance in the public mind can be understood from Bulmer Hobson's solution to the attendance deficit at meetings of the Dungannon Club in 1905. He simply invited Jack Morrow, of the celebrated Belfast family of illustrators, to give a lantern slide presentation of his cartoons.

While artists have produced artists' books (see 'Book Art'), for the purposes of this essay illustration will be taken to mean works in which the illustrations play a supporting rather than an equal role in publications ranging from books to illuminated addresses, cartoons, caricatures and digitally generated illustrations and animations. Some types of literature – fairy tales for example – lend themselves to the drawn image rather than the photograph, and illustration is an optional, although increasingly demanded addition in others; but in some cases, such as

anatomical and botanical books and catalogues, they are essential. At the start of the twentieth century, photography (qv) was more expensive and less portable than it was to become, so drawn or painted illustrations bore the brunt of the non-verbal impact of most publications.

Illustration

Although declining in interest in the first half of the century, illuminated addresses were made by Michael Holland (1855–1950), Mercy Hunter (1910–89), Sister Concepta Lynch (1874–1939) and the Gilbert Brothers in Cork, largely related to the Early Christian traditions of manuscript illumination. Several commercial illustrating companies flourished in Dublin and Belfast, such as Marcus Ward and Co. (Belfast), the Dublin Illustrating Company, and a number of design and printing houses, such as Colm O'Lochlann's Three Candles Press, known for cards, programmes and books of Irish interest, and Gayfield Press, all mainly Dublin-based, while the Dun Emer, later Cuala, and the Dolmen presses saw themselves as specialist art presses. The Dublin Metropolitan Schools offered classes in illustration, and many of the most respected artists have been associated with the discipline; yet the role of the illustrator, positioned between craft and fine art, has rarely received the recognition it deserves in Irish art. While some artists specialized in illustrating other people's writing, subordinating their drawings and paintings to the needs of another creative intelligence, others, such as Jack Butler Yeats (qv), Rose Barton, Robert Gibbings and Micheál Mac Liammóir married their own texts and images, often in broadsheets or newspaper columns, to reach a wider audience than that offered by the galleries, although both Yeats and Gibbings also exhibited their illustrations. Audiences for illustration may have been greater, but they were generally less visually literate than gallery-goers, and were obliged to experience the image as a more intimate and less independent phenomenon. Mindful of its subservience to the written work, many artists resorted to illustration out of financial expediency. Thus Yeats, Paul Henry and Norah McGuinness worked for a variety of publishing outlets to augment their earnings from fine art, while Louis le Brocquy (qqv) illustrated cookery books and a children's version of Irish legends during the economic recession of the 1950s.

Artists specializing in natural history and archaeological illustration included Lady Edith Blake (1845–1926), who did 196 watercolours of Jamaican Lepidoptera and plants (1889–98, Natural History Museum, London), and Alice Jacob (1862–1921), who in 1908 succeeded Lydia Shackleton (1828–1914) as painter of the orchid collection at the National Botanic Gardens, although she was not allowed to be paid more than £3 per year (Snoddy, p. 283). Eileen Barnes (*fl.* 1921–32) drew archaeological and natural history specimens for the National Museum of Ireland, including both faces of the Tara Brooch (qv *AAI* I). Barnes also executed fine drawings for two monographs by Robert Lloyd Praeger, published by the Royal Horticultural Society in 1921 and 1922. Of her drawings for his sempervivum group, Praeger declared, 'I owe special obligation to Miss Eileen Barnes ... Her patience and skill in portraying the plants and making analysis of the flowers have resulted in drawings which

add greatly to whatever value the present account possesses.' (Snoddy, p. 26)

Irish illustrators were among the best in the business. Self-taught, Hugh Thomson (1860–1920) moved from Marcus Ward and Co. in Belfast to London, pioneered new photomechanical reproduction methods and went on to develop his 'Cranford style', gentle rustic images which were first revealed in his illustrations for Mrs Gaskell's novels. Thomson's interpretation of Jane Austen's novels is generally taken as the classic one. Yeats and Harry Clarke (qv) produced very different illustrations. Yeats's graphic simplifications of folk life, to accompany Synge's articles on the Congested Districts Board in the *Manchester Guardian*, 1905 and *Aran Islands*, 1907 presented a positive and influential view of the west of Ireland, while Clarke, following successful commissions for Coleridge's *The Rhyme of the Ancient Mariner* and Hans Andersen's *Fairy Tales* was increasingly able to choose his material for illustration [61], most notably Edgar Allan Poe's *Tales of Mystery and Imagination*. So successful was Clarke that in the autumn of 1914, when *Studio* produced a special issue *Modern Illustrators and their Work*, to cover the work of Aubrey Beardsley, Edward Burne-Jones, Arthur Rackham, Kate Greenaway, Hugh Thomson and others, Clarke was one of only two artists whose work was reproduced. As a youth, Harry Furniss (1854–1925) had produced the *Schoolboys' Punch* and contributed to *Zozimus*, the Dublin equivalent of *Punch*. By 1910 he had created 1,200 illustrations for the novels of Charles Dickens, followed in 1911 by illustrations for books by William Thackeray.

Corkman Robert Gibbings (1889–1958), having illustrated in 1923 Samuel Butler's *Erewhon* (1872), took over the Golden Cockerel Press in 1924. During his nine years with the press, he produced seventy-two books, many with wood engravings by himself and with subjects ranging from travel books to Helen Waddell's *Beasts and Saints* and *Glory of Life* by Llewelyn Powys. Gibbings lectured in typography and book production at the University of Reading and worked as an art editor for the Penguin Books' series 'Illustrated Classics' (1938). His 'river-books', with almost 500 wood engravings, include *Sweet Thames Run Softly* and *Lovely is the Lee*.

Like Gibbings, Yeats was closely connected to a printing house. The Cuala Press, run by Yeats's sisters, Lily and Lolly, in 1908 not only published his illustrated Broadsides and Broadsheets and the poems of their brother William, but gained a reputation for high production values and respect for typography. Among the artists they employed were Hilda Roberts, Beatrice Glenavy, Harry Kernoff (qqv) and Beatrice Salkeld (1925–93) who went on to work for her father's Gayfield Press. The Dolmen Press (1951–87), founded and run by Liam Miller, specialized in poetry and was responsible for the most famous illustrated book to come out of Ireland in the twentieth century, *The Táin* [230], with text by Thomas Kinsella and a radical reinterpretation of the human figure in Louis le Brocquy's imagery.

A number of almost entirely male illustrators, including Seán O'Sullivan (qv), were given regular employment in periodicals such as the *Capuchin Annual*, *Our Boys* and *Ireland's Own* but some women artists excelled in the discipline; of these, Rose Barton, Rosamund Praeger and Hilda van Stockum (qv) began

230. *The Táin*, translated by Thomas Kinsella and illustrated by Louis le Brocquy (Dublin 1969, pp. 92–93)

231. John Kelly, poster for *The Invincibles* at the Abbey Theatre, 1967

the artist Ruth Brandt, while other illustrators included Gerard Dillon, John Kelly [231] (qqv) and James McKenna. Since the 1980s, P.J. Lynch has won prestigious awards for his children's book illustrations, but he has also produced highly detailed and imaginative posters for the theatre.

In the mid-1980s, Brian Cronin (qv), fresh from Milton Glaser's Studio in New York, contacted the *Irish Times*, recommending that they needed an illustrator as well as cartoonists. The result was a weekly commission. In 1986 Cronin emigrated to New York where he speedily won recognition as one of the leading illustrators working for such international publishing houses as Time, Newsweek and Penguin. Although Cronin does not use digital technology, preferring to hand-draw his images, the arrival of personal computers and foreign animation companies, and an explosion of courses in art colleges around the country in the 1980s, have led to unimaginable developments in the field of illustration. David Rooney has been influential in the field of advertising, while Sullivan Bluth's animations for Steven Spielberg's films *An American Tale* (1986) and *The Land Before Time* (1988), and Murakami Wolf Swenson's *Teenage Mutant Ninja Turtles* (1989–2000) provided successful local models for young Irish illustrators.

Cartoons and caricatures
Modern Irish cartoonists drew inspiration from the satirical print, usually of a political nature, a popular genre in the country since the seventeenth century. The cartoon can exist more

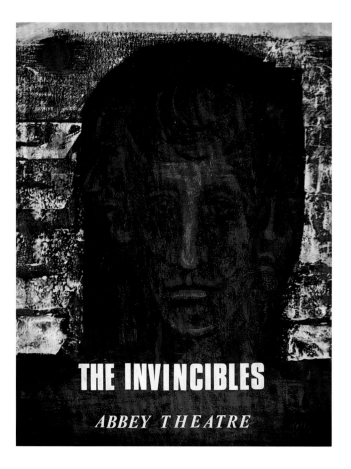

by illustrating the work of other people before going on to write and illustrate their own books. Elinor Darwin (née Monsell) (1871–1954) designed the Dun Emer pressmark in 1907 and contributed to *The Shanachie*. W.B. Yeats praised her work, saying: 'it is full of abundance and severity, a rare mixture' (Snoddy, p. 127). Her 1904 programme cover of Queen Maeve with her wolfhound, commissioned by Yeats, was famously adopted by the Abbey theatre for its stationery. Norah McGuinness was W.B. Yeats's personal choice as illustrator for his poem 'Red Hanrahan and the Secret Rose', but that did not pre-empt her acceptance of commissions from *The Bystander*, *Vogue* and *Harper's Bazaar*. Beatrice Glenavy (née Elvery) worked on children's books and provided cartoons for *Dublin Opinion* and the United Arts Club. Elizabeth Rivers (qv), described as 'the most graphic of all illustrators in Ireland' (Donlon, p. 91), wrote and illustrated *Stranger in Aran* in 1946, and went on to supply wood engravings for books by Ethel Mannin, Seán Doran, Patricia Lynch and, in 1956, *Out of Bedlam* by the poet Christopher Smart for Dolmen Press.

Rivers was joined in the 1940s by Nano Reid (qv), who illustrated Eileen O'Faoláin's *King of the Cats* (1941) and Pamela Hutchins's *Ivan and His Wonderful Coat* (1944). Sadly, poor quality paper and cheap ink in the former undermine the quality of the drawings. The books proved popular in wartime Ireland where children's publishing was minimal and Reid went on to show her ability to adapt to different writers' voices, with vigorous linocuts for Máirtín Ó Direáin's *Rogha Dánta*, and more free-flowing illustrations for Elizabeth Hickey's *I send my love along the Boyne*. Another landmark publication marrying images with creative writing was *Structure* [94], founded by Michael Kane (qv) in 1972. In its ten issues, audiences were introduced to the robust block prints of Kane and his first wife,

independently of text than an illustration but it must always embody an idea. Dennis Kennedy, former assistant editor of the *Irish Times*, speaking of Martyn Turner's work for that newspaper, said: 'He adds greatly to the individuality of the paper ... He should upset half the people as well as amusing half the people and he does that.' (Kathy Sheridan, '40 years a-cartooning', *IT*, *Weekend Review*, 11 June 2011)

Most newspapers took cartoons seriously, with the best artists moving freely between the *Irish Times*, *Belfast Telegraph*, *Irish Press* and *Irish Independent*. Irish artists were prominent contributors to *Punch* and other satirical publications in Britain, such as the *London Opinion* and the *Daily Sketch*. Nonetheless, the founding of the *Dublin Opinion* by Arthur Booth, Charles E. Kelly [232] and Thomas Collins in 1922, against a background of civil war, marked a significant opportunity for practitioners and replaced *The Leprecaun*, which had flourished between 1905 and 1919. Published monthly until 1968, the *Dublin Opinion* sold 60,000 copies per issue at its peak and employed most of the leading cartoonists of the day, including the founders W.H. Beckett, W.H. Conn and Matt Sandford, who together invented the character Larry O'Hooligan for *Ireland's Saturday Night*, and Rowel Friers (1920–98), Grace Gifford (1888–1955) and Bill Glenn (1904–74), who published his first cartoon at the age of sixteen and was responsible for the scraperboard cartoon *Ballyscullion*. *Dublin Opinion* has been credited with taking the bitterness out of post civil-war Ireland through its gentle humour and its even-handed treatment of civil war

233. Martyn Turner, *Éire's Ark*, pencil, brush and ink, 14 x 34 cm, *Irish Times*, 6 August 1997, p. 14

protagonists. Aside from the *Dublin Opinion* and *Ireland's Saturday Night*, the *Capuchin Annual* (1930–77) provided a regular outlet for cartoons and illustration. The drolleries by Father Gerald (Joseph McCann) over a period of fourteen years were an important feature of the publication, while artists such as Richard King and Patrick Pye (qv) illustrated essays and stories.

Friers's cartoons wove a careful line between opposing factions during the difficult years of the 'Troubles' in Northern Ireland (see 'The Troubles and Irish Art'). Like many cartoonists, he began to publish as a schoolboy but he also studied at the Belfast College of Art for four years. Best known for his work for the *Belfast Telegraph*, for which he produced full-feature cartoons, he also contributed to *London Opinion*, *Punch*, the *Irish Times*, *Irish Independent* and the *Radio Times*, moving easily between pen-and-ink, paintbrush or mezzotint for his highly detailed images. Friers achieved a rare level of recognition among illustrators and cartoonists, being elected president of the Royal Ulster Academy (qv) in 1994. His caricatures of Gerry Fitt, Ian Paisley and Enoch Powell are now in the collection of the National Portrait Collection in London.

Martyn Turner [233] came to Ireland from England as a student. From the 1970s Turner has been supplying up to five cartoons a week for the *Irish Times*, claiming that he thinks in words rather than images and that he is 'not trying to get people to fall over laughing ... but I am trying to get them to look at something in a different way' (Sheridan, op cit.). His popularity can be deduced from the fact that Dublin's Shelbourne Hotel has a room dedicated to his sharp depictions of political life over a forty-year period. He is joined at the *Irish Times* by Tom Mathews, creator of the weekly slot *Artoon*.

Moving away from the political and the local, Cartoon Saloon (1999) in Kilkenny, and Brown Bag (1994) and Kavaleer (1998) in Dublin, produce cartoons for a world market, including BBC and Disney. With a growing global emphasis on youth culture and digital technologies, cartoons and illustrations have vibrant times ahead. CATHERINE MARSHALL

SELECTED READING Friers, 1994; Pat Donlon, 'Drawing a Fine Line: Irish Women Artists as Illustrators', *IAR Yearbook*, XVIII (2002), 80–92; Snoddy, 2002.

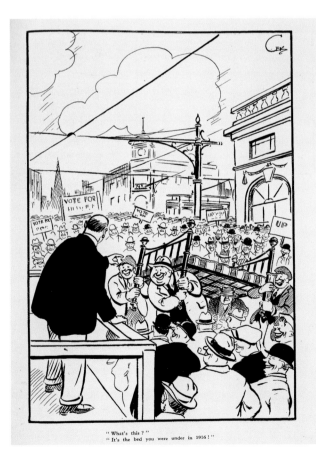

"What's this?"
"It's the bed you were under in 1916!"

232. Charles E. Kelly, 'What's this? It's the bed you were under in 1916!' *Fifteen Years of Dublin Opinion*, eds C.E. Kelly and T.J. Collins (Dublin 1937, p. 19)

INSTALLATION ART (see *AAI* III). It is often argued that installation art is the default setting of contemporary art. Defined by Claire Bishop as a 'type of art into which the viewer physically enters, and which is often described as "theatrical", "immersive" or "experiential"', this is a now-dominant modality of practice that is flexible enough to involve processes that might otherwise be understood as purely curatorial. 'The word "installation" has now expanded to describe any arrangement of objects in any given space, to the point where it can happily be applied even to a conventional display of paintings on a wall.' (Bishop, p. 6) The ubiquity of the installation mode thus contributes, as Boris Groys has argued, to the current condition wherein 'contemporary art can be understood primarily as an exhibition practice', and as a result it has become 'increasingly difficult to differentiate between the two main figures of the contemporary art world: the artist and the curator' (Groys, p. 51).

Installation is a demonstrably Postmodern art form, a product of the decline of the authority of medium as the primary framework for understanding the progress of art and a corollary of the interrogation of space and site undertaken by Minimal and Conceptual art (qqv). In this regard it is a distinctly 'impure' approach to art: eclectic mixtures of media and heterogeneous situations of display and encounter are fundamental to its potential. This is an art 'form' forged in the era of modern art's radical deformation: the 'end-of-art' period that is for Hal Foster a 'paradigm-of-no-paradigm' (Foster, *Design and Crime (and other Diatribes)*, London 2002, p. 128) – a historical moment of plurality and radical eclecticism in which, as Arthur Danto says, 'there is no special way works of art have to be' (Danto, *After the End of Art: Contemporary Art and the Pale of History*, New Jersey 1997, p. 35). Such plurality may be understood as a liberating break from the strictures of Modernist hierarchies, or it can be viewed as the terminal subsuming of art's criticality by the art market – a flattening of all possibilities for determining meaning and differentiating value beneath one overarching system. As Rosalind Krauss has argued, a problematic relativism might be implied by installation art: for within the diverse environments of this 'expanded' art form, 'every material support, including the site itself [is] now levelled, reduced to a system of pure equivalency by the homogenizing principle of commodification' (Krauss, p. 15).

In Ireland, many emergent signs of these potentially problematic or progressive shifts from Modernist medium specificity to Postmodern plurality were present in the Rosc exhibitions (qv) which so dramatically internationalized and energized Irish art practice during the 1960s, '70s and '80s, and significant in this regard were many nascent versions of installation art. Rosc was inaugurated in 1967 with a celebration of major highlights of the High-Modern, bringing to Ireland a stellar selection of works by central figures in the canon of mid-twentieth-century art. But it also became an exhibition project in which new forms of art, such as installation, were supported often despite the pressures imposed within the predominantly conservative cultural context. On several occasions, Rosc introduced Irish audiences to artists experimenting with the creation of unconventional art environments – artists such as Daniel Buren and Jochen Gerz, for instance, whose work proposed idiosyncratic forms of architectural interruption and invention; or important presences within performance art such as Laurie Anderson or Marina Abramović and Ulay, who staged situations to be entered into by viewers and that involved, respectively, multi-media sensory distraction or intensely visceral 'live' human drama. Though all very different, aspects of each of these important Rosc presentations correspond in distinct ways to installation art's variously emphasized attention to the 'theatrical', 'immersive' or 'experiential'.

If showcasing the most ambitious international art was a characteristic of Rosc, two of the most notable presences included were in fact the pioneering Irish artists Brian O'Doherty/Patrick Ireland (qv) [234] and James Coleman (qqv), leading figures with respect to the development of installation art in general, even if neither artist would necessarily embrace the term. Both Coleman and O'Doherty had built major reputations outside Ireland and each had cultivated art practices that were engaged with tackling the limits of visual representation: O'Doherty working within the milieu of conceptual and minimal art, and Coleman leading the post-conceptual interrogation of technologies of sound and vision. In both cases, theirs was an art that extended beyond the medium of representation, to take account of contexts of display and conditions of spectatorship. (It is also worth noting here that O'Doherty's theoretical analysis of the 'ideology of the gallery space', *Inside the White Cube*, has become an essential set-text for artists and critics concerned with contesting the underlying conventions of viewing in the wake of Modernism.)

It is certainly arguable that the visibility of works by O'Doherty and Coleman in Dublin was empowering for a subsequent generation of artists who would later conceive of path-breaking, and often powerfully politicized, versions of

234. Brian O'Doherty/ Patrick Ireland, *The Purgatory of Humphrey Chimpden Earwicker, Homunculus*, Rope Drawing #73, 1985, installation, rope, house paint, Douglas Hyde Gallery

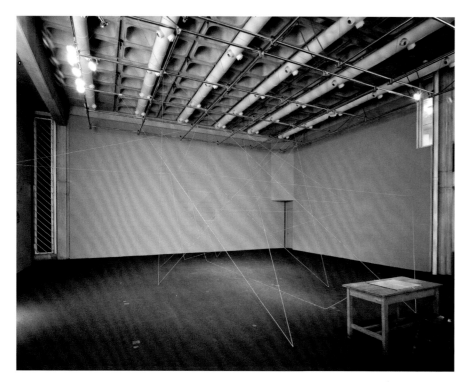

installation art during dramatic and troubled periods in the development of (post) modern Ireland. In Claire Bishop's view, a key effect of installation artists' interest in establishing unique *situations* – in addition to creating unorthodox arrangements of images and objects – is to accentuate the importance of the 'literal presence of the viewer' in a gallery or other chosen site. As such, possibilities of 'embodied viewing' and even 'activated spectatorship' become central. This manner of thinking gained particular urgency for many artists in Ireland who began to employ varieties of installation art as they contemplated conditions within a society that was not only undergoing accelerated 'modernizing' transformations, but that also remained enduringly unsettled by traumatic post-colonial legacies and constrained by the forces of church-led patriarchy. As Fintan O'Toole has suggested, Ireland experienced 'a rapid shift from the pre-modern to the post-modern with only a half-finished project of modernity in between (O'Toole, 'Ireland', in *Irish Art Now*, 1998, p. 23). For a number of the Irish artists whose work emerged in the 1980s and '90s – the timeframe in which installation art begins to become established as a primary form within the international art world – the capacity of such spatial and situational practices to create circumstances of defamiliarization and destabilization in opposition to normative situations of cultural consumption and spectatorship was tested in artistically daring ways.

Northern Ireland during the 'Troubles' was one particularly turbulent setting for such innovations. Artists associated with Art and Research Exchange (ARE) in Belfast (including performance artist Alastair MacLennan (qv) confronted the conservative loftiness of the local art world by developing 'issue-based' works that often employed the experiential anxieties of installation art to powerful effect. ARE originated as a part of the Belfast-based manifestation of Joseph Beuys and Heinrich Böll's Free International University and its members were therefore motivated by the Beuysian concept of 'social sculpture': a mode of practice important to the broader development of politically engaged installation art. One of the most critically lauded reflections on the fractured society of the North, however, has been the practice of the Derry-based artist Willie Doherty (qv) [235] – a key figure in any assessment of the art of the Northern Ireland conflict (see 'The Troubles and Irish Art'), but also one relevant to any account of how artists in the closing decades of the twentieth century sought to interrogate received situations of viewing. Following his widely acclaimed photo-text series of the 1980s, Doherty extended his practice in the early 1990s by developing a number of tense slide and video installations. The multiple-screen environments of these projected-image works – often featuring visual material alluding to contemporary news media in Northern Ireland – were designed to stimulate heightened, 'activated' awareness of the 'position' from which viewing takes place. As such, Doherty's work is of considerable importance to the emergence of installation practice in Ireland. Related shifts in how the Troubles became 'mediated' in contemporary art were also achieved in the work of significant artists such as Philip Napier (qv), Locky Morris and Una Walker; each of whom – in quite distinct ways – took account of the unsettling gap between the public mediation of the conflict and the private experience of individual citizens (or subjective art viewers).

Political strife north of the border demanded not just, as Seamus Heaney proposed for poetry, 'images and symbols adequate to our predicament' (Heaney, *Preoccupations, Selected Prose, 1968–1978*, London 1980, p. 56) but new systems, processes and experiences of art. In the Irish Republic, social and cultural orthodoxies were also sufficiently oppressive to prompt artists to seek options to the categories of art more widely accepted by establishment institutions. Recognized forms of expressive articulation or abstract composition – arguments for which had frequently been grounded in essentialist notions of a uniquely 'Irish' art, corresponding to specific attributes of the island's landscape or the national 'character' – were subjected to strenuous critical interrogation by a younger generation of artists. (It might be added that installation art's emergence also coincides with a renewed focus on 'critique' in art, and in art education, resulting from the increasing influence of post-structuralist theory.) Among the various artists who sought fresh options within the emergent field of installation-based practice, those committed to a feminist analysis of art and society had a marked impact. Artists such as Alanna O'Kelly and Pauline Cummins (qqv) pursued, as Medb Ruane has written, forms of 'specifically feminist practice [that] quickly thrived on the use of what were still considered alternative media', offering 'challenges to nationalist and modernist dogmas … [and] parodying what were seen as traditional female concerns' (*Shifting Ground: Selected Works of Irish Art 1950–2000*, exh. cat. IMMA, 2000, pp. 47–48). Questions of gender, along with intertwined issues of class and nationality, were also critical to the experimental activities of the artist-collective Blue Funk (qv), a group formed in the late 1980s with the explicit aims of making 'flexible and innovative use of live performance, assemblage and installation work' in order to explore the 'interface between art and politics' (http://www.theartistledarchive.com/Blue%20Funk.html, accessed 28 August 2012). In so doing, these artists helped to bring new media-based installation art to greater prominence within Irish art. Blue Funk itself existed only until 1993, but core members, such as Brian Hand, Valerie Connor and Jaki Irvine (qv) have independently continued to foster ambitious forms of art practice in Ireland through teaching, curatorship and art practice – and Irvine in particular has succeeded in gaining international recognition for her work in the field of film and video installation.

In the 1990s installation art gradually secured institutional acceptability in Ireland, in accordance with its prominent status as an established progressive medium (or 'post-medium' practice) within global contemporary art. The exhibition programme at Dublin's Douglas Hyde Gallery, for instance, featured at this time several international artists who had been pivotal in the development of installation art – among these were Félix González Torres, Annette Messager, Christian Boltanski and Bill Viola, whose dramatic installations variously stimulated an intensified sense of 'embodied viewing'. The opening of the Irish Museum of Modern Art (IMMA) at the Royal Hospital Kilmainham in 1991 created further opportunities for the display of ambitious contemporary art from Ireland and abroad, and though many of the building's seventeenth-century spaces were not always appropriate for the staging of large-scale

235. Willie Doherty, *Same Difference*, 1990, slide installation with four projections on to two diagonally opposite corner walls, black and white, Arts Council England

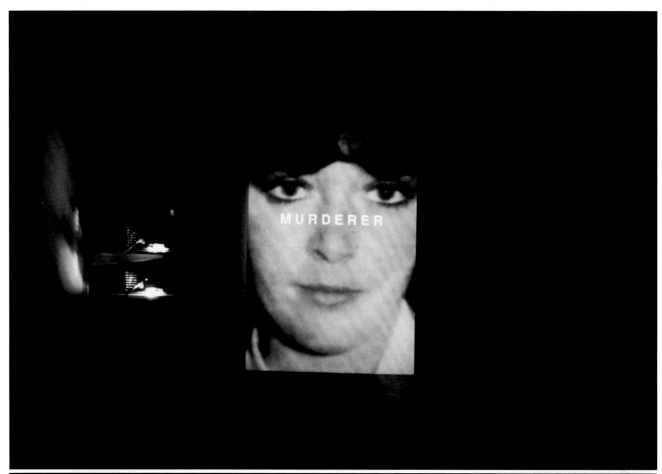

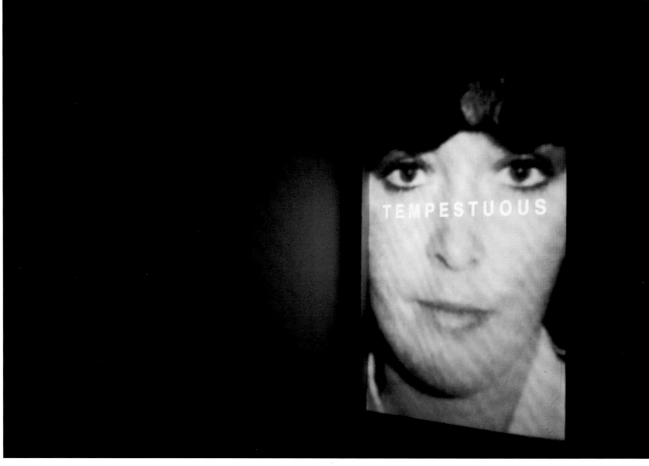

installation works, there were occasions when such grand projects were impressively facilitated. One such achievement was Vong Phaophanit's post-Minimalist intervention *Neon Rice Field* (1993), an interior landscape made from parallel rows of piled-up rice, each separated by elongated strips of lurid electric lighting (a reflection on the influence of East Asian societies on western culture). Under its first director, Declan McGonagle, IMMA also made efforts to engage with *exterior* landscapes, not least through its stewardship of the Nissan Art Project, a series of specially commissioned large-scale, temporary, public artworks. These too can be understood as variations on the installation mode, though, as it relates to experiments in site-specificity and strategies of social engagement. Dorothy Cross's (qv) extraordinary *Ghost Ship* (1999) [236] was arguably the most memorable episode in this acclaimed series of public 'installation' projects. The main 'material' of this work was a decommissioned ship that Cross brought briefly back into service, coating it in luminous paint so that it would glow spectrally in the distance as it sailed across Dun Laoghaire harbour at nightfall – turning the resonant coastal scene into an expanded, atmospheric art environment, creating a new 'imaginative landscape' by fleetingly transforming the topographical characteristics of a particular place.

Notably, both Dorothy Cross and Jaki Irvine also represented Ireland at the Venice Biennale during the 1990s. Indeed, it is surely telling that following Ireland's return to the Biennale in 1993 (after a thirty-three year hiatus), a recurring characteristic of the national pavilion selections at this vital gathering of the global art world was an emphasis on installation-type projects. Venice exhibitions by Shane Cullen (qv), Anne Tallentire and Grace Weir (qqv) in the 1990s – and later by artists such as Katie Holten and Gerard Byrne (qv) – were diverse, well-received variations on the installation mode. Such selections demonstrated the deserved prominence of installation within recent Irish art practice, while also hinting at the overwhelming dominance of this mode of practice and presentation within international art at the end of the twentieth century. DECLAN LONG

SELECTED READING Rosalind Krauss, *A Voyage on the North Sea: Art in the Age of the Post-Medium Condition* (London 2000); Claire Bishop, *Installation Art: A Critical History* (London 2005); Boris Groys, *Going Public* (Berlin 2010), pp. 50–69.

INTERNATIONAL ARTISTS AND CURATORS IN IRELAND (see *AAI* II, 'Visiting Artists'). Throughout the twentieth century, while the arts in Ireland were continually revitalized by influences from overseas, local artists tended to pursue their own career paths and there are practically no instances of a 'school' or group of followers developing as a result of well-known international artists or curators settling in Ireland. However, such influence was often important as a catalyst for change. By and large, artists settling in Ireland tended to retain their connections abroad and to exhibit primarily with galleries in their home countries, generally in Britain, the Continent or the United States. Some exhibited in Irish galleries and museums, but this was essentially a matter of personal preference, with no significant patterns of influence emerging as a

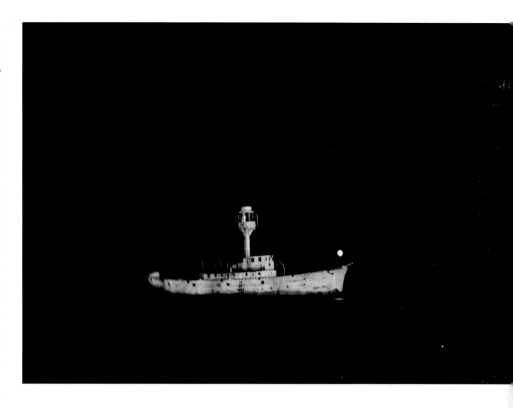

result. While the paintings of Charles Brady (qv), an American who settled in Dublin in the 1950s, are instantly recognizable, his style was not emulated by any Irish artist of significance; similarly, the paintings of William Crozier, Barrie Cooke (qqv) and Gottfried Helnwein remain stylistically unique to these artists. Although the Franco-German artist Tomi Ungerer settled in west Cork in 1976, he made few contacts with Irish artists, focusing instead on the development of a museum of his work in his native Strasbourg. Parallels can be drawn between the colourful paintings of Michael Cullen (qv) and the work of A.R. Penck (Ralf Winkler), but if Cullen was influenced by the legendary German artist, this happened in Berlin in the 1970s, decades before Penck established a studio in Dublin. Slight connections can be detected here and there: the influence of the American Robert Henri [237], who worked on Achill Island in the early twentieth century, can be discerned in the portraits of Hilda Roberts (qv) who worked there some years later, while the influence of Belgian artist Marie Howet, who also worked on Achill, can be seen in the work of Nano Reid (qv). Throughout the century, touring exhibitions of international art and visits by curators were important, and became more so with the setting up of galleries and museums devoted to contemporary art in the later decades of the century. The presence in the Dublin City Gallery The Hugh Lane of a collection of works by Roger Fry and Duncan Grant shows the importance of the Bloomsbury Group in the earlier part of the twentieth century; indeed, Fry gave lectures in Dublin while collaborating with Ellen Duncan in presenting two exhibitions of Post-Impressionist art at the United Arts Club, Dublin, in 1911 and 1912. There would be nothing to equal the influence of these exhibitions in Irish art until half a century later, when, at

236. Dorothy Cross, *Ghost Ship*, 1999, documentation of installation, Scotsman's Bay, Dun Laoghaire, comprising two lightship models, phosphorescent paint, UV lights, video, 10 min, Irish Museum of Modern Art

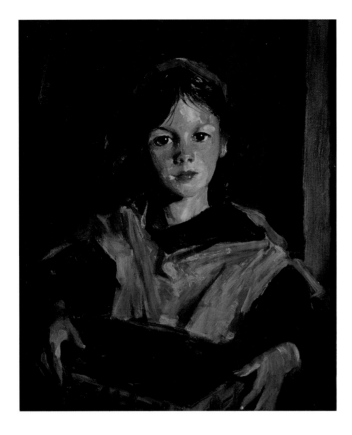

237. Robert Henri, *Mary Ann with her Basket*, 1926, oil on canvas, 61 x 48.3 cm, Currier Museum of Art, New Hampshire

twentieth-century movements such as Pop art, Minimalism and Conceptual art (qqv) were also absorbed into the mainstream of Irish contemporary art.

While artists and curators were drawn to Ireland for many reasons, several factors are of particular significance: quality of life, an unspoiled landscape, family connections and, from the 1980s onwards, exemption from income tax. Irish music, literature and a vibrant social culture have long been valued by overseas visitors. The dramatic landscapes of the west of Ireland have also attracted and inspired many artists. To cite just three examples: paintings made by Rockwell Kent on a 1926 trip to Glencolmcille, Co. Donegal, are in the Plattsburgh State Art Museum, State University of Plattsburgh, New York, while a series of works by David Ireland, another artist from the United States, made after a visit to Sceilg Mhichíl, were shown in 1994 at the Ansel Adams Center in San Francisco. Six years later, the British painter Norman Ackroyd produced a series of freely worked etchings inspired by different locales on the west coast of Ireland.

Identification with Irish ancestry was important for some artists, notably the Australian Sidney Nolan [238] who, in 1986, announced his intention to donate fifty new paintings to the Irish government, a gift only partly realized on his death six years later. Although the Irish ancestral connections of American-born James Turrell are slighter, he forged strong links with Irish artists in the 1990s, creating key works at Lissard in Co. Cork and Kilfane, Co. Kilkenny. The powerful dark canvases of Hughie O'Donoghue (qv), who was born in Britain, about suffering and redemption are often based on particular locales linked with his family roots in County Mayo. While there was clearly an attraction for artists of Irish ancestry to return to their roots, the introduction by the Irish government of tax-free status for artists in 1969 helped to entice overseas talent. Much media attention focused on this scheme, and by the end of the century just over 1,000 visual artists, both Irish and international, had qualified for exemption.

Influences and opportunities came to Ireland through artists, and also through visiting collectors and patrons of the arts. At the beginning of the century, the Irish-American lawyer John Quinn, promoter of the Armory Show in New York in 1913, sponsored the Abbey Theatre and its writers while also supporting John B. Yeats and Jack B. Yeats (qv). Quinn was a close friend of Lady Gregory, whose nephew Sir Hugh Lane (1875–1915) brought his protégé, the Italian portrait-painter Antonio Mancini, to Dublin, installing him in the Harcourt Street house that became a temporary home to the Municipal Gallery in 1908. While in Dublin, Mancini painted portraits of Lady Gregory, Hugh Lane and Lane's sister Ruth Shine. The tradition of American patronage Quinn established continued throughout the twentieth century, sustained by collectors such as Helen Hooker O'Malley, William and Joan Roth and Fred Krehbiel (see 'Patronage and Awards').

As the century advanced, there were periods when an influx of new artists made a strong impact on the Irish art world. In the mid-1930s Elizabeth Rivers (qv) settled for a number of years on the Aran Islands, exhibited at the Royal Hibernian Academy (RHA) (qv) and produced illustrations for books, including her

238. Sidney Nolan, *Glenrowan*, 1946, enamel on composition board, 90.9 x 121.2 cm, National Gallery of Australia

approximately four-yearly intervals, between 1967 and 1988, under the title of Rosc (qv), a series of large exhibitions of international contemporary art was held in Dublin. In much the same way that Impressionism, Fauvism and Cubism (qv) had their offshoots in Ireland, Rosc ensured that later

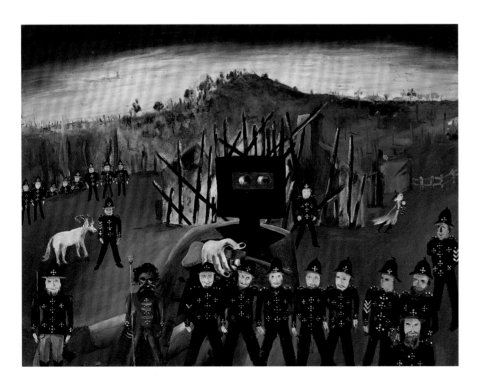

own homage to the islands, *Stranger in Aran* (1946) (see 'Illustrations and Cartoons'). Fleeing from Vienna to Northern Ireland in 1938, the abstract painter Alice Berger Hammerschlag lived and worked in Belfast for the next three decades, designing sets for the Lyric Theatre, running the New Gallery that opened on Grosvenor Road in 1963, and bequeathing money for an important art award after her death. The French artist Yvonne Jammet (née Auger), who moved to Dublin in the 1920s, exhibited at the Waddington Galleries in 1944. The restaurant she and her husband ran became an important meeting place for artists, architects and theatre people. During World War II, a group of refugee artists, mainly from Britain but with Central European connections, settled in Dublin and County Wicklow. Of these, Basil Rákóczi (qv) was of mixed Irish and Hungarian parentage. In 1935 Rákóczi had founded, along with Kenneth Hall, the White Stag Group (qqv). Four years later they moved to Ireland and held their first exhibition in Dublin in 1940. A substantial *Exhibition of Subjective Art*, selected by Hall and Rákóczi and organized by Margot Moffett, was held in 1944 at 6 Lower Baggot Street. The British art critic Herbert Read contributed an essay to the catalogue and was invited to Dublin to lecture. Rákóczi and Hall left Ireland soon after the end of the war. Their influence on the development of Modernism (qv) in Irish art was not insubstantial and through their lectures and exhibitions they assisted in making Dublin a centre for artistic creativity during World War II.

In reviewing the exhibition *Art from the Continent*, organized in 1944 by the Friends of the National Collections and including works by Cézanne, Matisse and Picasso, Thomas MacGreevy noted that it was over thirty years since Ellen Duncan's exhibition of Post-Impressionist paintings had transfixed the Dublin art world (MacGreevy, *IT*, 11 August 1944). Clearly there was an increased interest in Modernist art during the war years, and galleries such as the Victor Waddington flourished, providing a showcase for moderately progressive artists. Born in London, Waddington opened his Dublin gallery in 1925, creating a model of excellence for other galleries to follow. He showed work by Jack Yeats, Thurloe Conolly, Colin Middleton (qqv) and others, but also, and particularly in the 1940s, international artists, including John Piper, Felix Topolski, Georges Mirianon, Georgette Rondel and Geza Szobel. In the mid-1950s, Waddington closed his gallery in Dublin and transferred the business to London (see 'Commercial Galleries').

After the war, while many Irish artists still regarded emigration as the only means to pursue a career, a number of them moved to Ireland under the GI Bill, a scholarship available to former members of the US armed services. The writer J.P. Donleavy, who was studying painting when he arrived in Ireland, enrolled in 1946 as a student at Trinity College Dublin. His first exhibition was held at the Stephen's Green Gallery in 1948. Eight years later Charles Brady, another former US Navy serviceman, also settled in Dublin becoming a founder member, along with Barrie Cooke and Camille Souter (qqv), of the Independent Artists Group.

In spite of the economic doldrums of the 1950s, Ireland had a suprisingly active cultural life. Attracted by the atmosphere of the Irish capital city, Lucian Freud was a frequent visitor to Dublin in the early 1950s, sharing a studio on Leeson Street with Patrick Swift (qv), where they produced paintings that are almost indistinguishable. In 1954 Dorothea Lange [239] travelled through Ireland on assignment for *Life* magazine, the photographs she took emphasizing the poverty and backwardness of Irish rural society (*Dorothea Lange's Ireland*, London 1996). Other visiting photographers who recorded Ireland through the camera lens included Henri Cartier-Bresson, Jill Uris, Eve Arnold and Martin Parr. Artists settling in Ireland included Mary Farl Powers (qv), an American printmaker who studied at the Dun Laoghaire School of Art and later became an influential director of the Dublin Graphic Studio; the Minimalist artist Jo Baer (b. 1929) who moved to Ireland in 1975; and Nancy Wynne-Jones (qv), a member of the St Ives School, who settled along with her husband, the sculptor Conor Fallon, in Kinsale, Co. Cork in 1972. Geometric abstraction was the driving force behind the work of Erik Adriaan van der Grijn [240], a Dutch artist who came to Ireland in 1964. Through exhibiting regularly at the Irish Exhibition of Living Art (IELA) (qv), and designing the Europa postage stamp for Ireland in 1977, van der Grijn did much to promote appreciation of non-representational art before leaving Ireland for the Americas in the 1980s. Although primarily a graphic designer, another graduate of the Royal College of Art in the Hague who settled in Ireland, Jan de Fouw also promoted a Modernist aesthetic through poster and print design. To appease nationalist sentiment, however, de Fouw's designs for government-sponsored publications were often deliberately uncredited, as was also the case with Guus Melai, who designed the logo for the cultural festival 'An Tostal' (Eric G.E. Zuelow, *Making Ireland Irish: Tourism and National Identity since the Irish Civil War*, New York 2009, p. 94).

Both van der Grijn and de Fouw were part of a movement to introduce new European art and design into Ireland (see 'Design

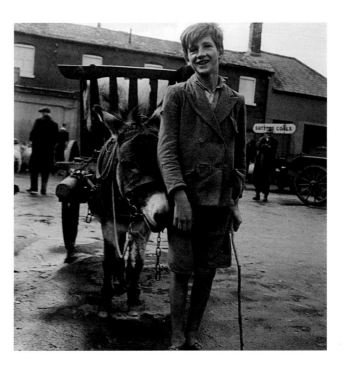

239. Dorothea Lange, *Fairs and Markets*, Co. Clare, c. 1954

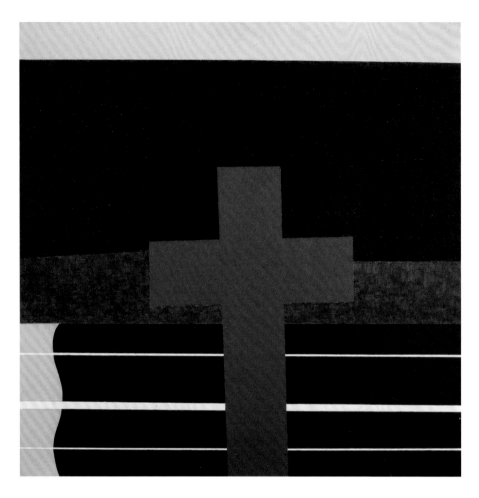

240. Erik van der Grijn,
Oakport Demesne, 1976,
oil on canvas, 76 x 76 cm,
Butler Gallery

of James Joyce, particularly *Ulysses*, which inspired a cycle of drawings begun in 1958. Böll, who had a cottage on Achill Island, was one of the founding members of the Committee for a Free University. Although the proposed university was never realized, Beuys's ideas, many of them tied in with the Fluxus movement, have had an enduring influence, one manifestation being the 2005 Cork Caucus, a series of open seminars and discussions led by Charles Esche and Annie Fletcher. Contemporary artists Seán Lynch and Gary Coyle (qv) have created works that reference Beuys's 1974 visit, while the German art historian Christa-Maria Lerm Hayes, who settled in Ireland in the 1990s, curated a 1999 exhibition at the RHA that documented the influence of James Joyce on Beuys.

Curators and gallerists visiting or settling in Ireland were a significant factor in internationalizing the Irish art world. Born in Jamaica in 1924, David Williams came to Ireland to study at TCD. In 1956, having adopted his mother's maiden name Hendriks, he founded the Ritchie Hendriks Gallery at St Stephen's Green that showed Irish and international art. Later known as the David Hendriks Gallery, it introduced Irish audiences to movements such as kinetic and Op art, and to such artists as Josef Albers, Shusaku Arakawa, Adolph Gottlieb and Victor Vasarely. In Belfast, the Iranian gallerist Jamshid Mirfenderesky has provided an equally important platform for contemporary art at the gallery he founded in 1984. Among artists represented by the Fenderesky Gallery is the printmaker Alfonso López Monreal, who, since 1981, has divided his time between Belfast and Zacatecas in Mexico. In 1985 in Rosscarbery, Co. Cork, Angela Flowers inaugurated her Downeen Gallery with an exhibition of paintings by William Crozier. Flowers's subsequent annual exhibition programme included John Kirby, Philip King, Nicola Hicks and Patrick Hughes. Ian Breakwell, who also showed with Angela Flowers, in 1998 exhibited at Temple Bar Galleries in Dublin. In 1992 two gallerists and curators from Philadelphia, Margo Dolan and Peter Maxwell, set up the Ballinglen Arts Foundation in Ballycastle, Co. Mayo, providing residencies for both Irish and international artists, while Anya von Gosseln from Hamburg, who settled in County Wexford, forged a career as an independent curator. In the 1990s Margaret Warren, from Boston, sponsored annual exhibitions at the Warren Boathouse Gallery in Castletownshend, Co. Cork showing artists such as Martin Gale, Dermot Seymour (qqv), Graham Crowley and Seán Stanley.

Colleges of art were important in attracting international artists to Ireland (see 'Education in the Visual Arts'). Following a precedent established in the early twentieth century, when A.E. Child moved to Dublin to teach stained glass, many graduates of art colleges in England came to Ireland to teach. At the Crawford College of Art and Design in Cork, Marshall Hutson, Alan Robb, Jill Dennis and Ron Melling among others, made a lasting contribution. In the Belfast College of Art, the Scottish artist Alastair MacLennan (qv) promoted performance as a contemporary art discipline (see 'Time-based Art'). In Dublin, Steve Barraclough, another artist represented by the Angela Flowers Gallery, became head of printmaking at the National College of Art and

and Material Culture'), one that had been advocated by Herbert Read in his essay for the *International Design Exhibition*, held in Dublin in 1954 (John Turpin, 'The Irish Design Reform Movement of the 1960s' in Dennis P. Doordan (ed.), *Design History: An Anthology*, Cambridge, Massachusetts 2000, p. 254). This movement saw the setting up, eleven years later, of the Kilkenny Design Workshops. KDW designers and craftsworkers such as Bertel Gardberg, Rolf Middelhoe, Rudolf Heltzel, Sonia Landweer and Peter Hiort-Lorenzen transformed the public's appreciation of applied arts, while painters such as Anne Madden and Stephen McKenna (qqv), both born in London, also helped to direct the public gaze away from stereotypical Irish scenery. McKenna lived in Belgium, Italy and Germany before settling in Ireland; though inspired by artists ranging from de Chirico to Poussin, his paintings are nonetheless contemporary in spirit and feeling.

In 1974 the artist Joseph Beuys (1921–86) was invited to Ireland to show a series of drawings entitled 'A Secret Block for a Secret Person in Ireland' (Hamburger Bahnhof collection, Berlin). At the same time, Caroline Tisdall promoted the idea of basing Beuys's proposed new art college, the Free International University for Creativity and Interdisciplinary Research, in Ireland. Beuys's interest in Ireland had been sparked by Heinrich Böll's 1957 book *Irisches Tagebuch* (Irish Journal), but he was also strongly influenced by the writings

Design (NCAD). A graduate of the Royal College of Art (RCA), Jacqueline Stanley also taught at NCAD, where her quasi-abstract approach influenced young Irish artists of the 1980s. The painter Campbell Bruce, another RCA graduate, was appointed head of painting at NCAD in the mid-1970s. In the years that followed, other artists from Britain, such as printmaker Tim Mara (qv), were invited to Dublin as visiting lecturers and tutors. Mara, like Sean Scully and Michael Craig-Martin (qv), was originally born in Ireland, but was raised and trained abroad. While in some ways their exhibiting and working in Ireland could be regarded as a 'homecoming', the artistic output of these individuals betrays little or nothing of this sentimental idea. Born on the Isle of Wight, the performance artist Nigel Rolfe (qv) trained at Bath Academy of Art before moving to Ireland in 1975, where he also taught at NCAD. An innovative artist, inspired by Joseph Beuys and working in a wide variety of media including sound, photography (qv) and video, Rolfe's contribution to contemporary art in Ireland is substantial (see 'Time-based Art' and 'The Body').

In the absence of a permanent museum of modern art, the Rosc exhibitions served in some ways as a transitory museum, with exhibitions being shown successively at different venues in Dublin. The chairman and one of the founders of Rosc, architect Michael Scott, invited James Johnson Sweeney [241] to curate the original exhibition, held in Dublin in 1967. The initial success and notoriety of Rosc was diluted in the 1980s as the Orchard Gallery in Derry and the Douglas Hyde Gallery in Dublin increasingly focused on international artists. In 1985, at the behest of the Ireland America Arts Exchange and the Williams College Museum of Art, Massachusetts, curator and critic Lucy R. Lippard visited Ireland, selecting a number of young artists for *Divisions, Crossroads, Turns of the Mind*, an exhibition that subsequently toured to several venues in the United States (see 'Exhibitions'). The Irish-American critic Tom McEvilley sustained this interest in Irish art when he became a contributing editor at *Artforum* and editor at *Contemporanea* (art periodicals). A growing interest in contemporary art was aided by the founding, in 1991, of the Irish Museum of Modern Art (IMMA) where the programme included artists such as Lee Jaffe, Richard Long and Joseph Kosuth. In the 1990s David Walter McDermott and Peter Thomas McGough were among a growing number of international artists who became partly resident in Ireland, both for creative and for tax purposes. In Limerick, the annual EV+A exhibition, an early curator of which was Paul O'Reilly, an artist from New Mexico who settled in Ireland in the 1970s, provided an important counterbalance to a growing preponderance of museums and galleries in Dublin. Uniquely in regional Ireland, in the late 1970s EV+A developed a policy of inviting international curators to select the exhibition; among these guest curators have been Jeanne Greenberg Rohatyn, Guy Tortosa, María de Corral, Jan Hoet, Lars Nittve, Germano Celant, Rudi Fuchs, Pierre Restany and Sandy Nairne. EV+A benefited young Irish artists whose work was seen by international curators, leading to invitations to participate in exhibitions abroad. This was also the case with 'Eigse', the annual arts festival in Carlow, where curator Fumio Nanjo saw the installations of Clare Langan (qv), and subsequently invited her to participate in a number of exhibitions in Asia.

While opportunities for artists to travel increased exponentially in the last decade of the twentieth century, some of the individual enterprises that characterized the Dublin art world in the 1970s appeared to ebb, edged aside by corporate, civic and state-funded initiatives. While visits by artists such as Joseph Beuys, Christo, Abramović and Kosuth had created palpable ripples of excitement and commentary in the 1970s, by the year 2000 a cooler attitude had become prevalent in the Irish art world, which now took for granted an ease of travel and access to museums, galleries and studios around the world which would have been unthinkable even three decades before. With the proliferation of websites, video streaming, inexpensive air travel and access to fine art education facilities and information, the attempt to track specific pathways of influence becomes less meaningful, as the Irish art world in the twenty-first century melds into a pan-European and worldwide cultural environment. PETER MURRAY

SELECTED READING Moore-McCann, 2002; Coulter, 2003; Brian Fallon, 'The White Stags', *IAR*, XXII, no. 2 (Summer 2005), 68–73; Giltrap, 2011.

IRELAND, PATRICK (see O'Doherty, Brian)

THE IRISH EXHIBITION OF LIVING ART (1943–87) (see also 'Exhibitions'). Established by a committee of artists, including Mainie Jellett, Louis le Brocquy and Norah McGuinness (qqv), the annual Irish Exhibition of Living Art (IELA) played a crucial role in the consolidation of Modernism (see 'Modernism and Postmodernism') in Ireland and was for many years the principal forum for the display of non-academic art.

The primary catalyst for the exhibition was the conservatism of the Royal Hibernian Academy (RHA) (qv). In 1942 Mainie Jellett published a damning indictment of the Academy, accusing it of 'a miasma of vulgarity and self-satisfaction' ('The RHA and Youth', *Commentary*, May 1942). Later that year the

241. James Johnson Sweeney (centre) with fellow selectors, Willem Sandberg and Jean Leymarie, at *Rosc '67*, with a painting by Roy Lichtenstein in the background

Academy rejected Louis le Brocquy's paintings *The Spanish Shawl* [242] and *Image of Chaos* and in 1943 it excluded Modernist work entirely. Although they had reason to rebel, the founders of the IELA did not wish to establish a Salon des Refusés. Instead, they chose to embrace both the avant-garde and the academic and create an institution best described as pluralistic. The minutes of the committee's inaugural meeting record that the function of the exhibition was to 'make available to a large public a comprehensive survey of significant work, irrespective of School or manner, by living Irish artists' (12 May 1943, IELA Minute Book). Jellett was elected chairman, Ralph Cusack, Evie Hone (qv) and the Academicians Laurence Campbell and Margaret Clarke (qv) were invited to join, and the National College of Art (NCA) was identified as the most suitable venue.

Undoubtedly, the IELA's promotion of pluralism was partly pragmatic: it needed the RHA-dominated NCA and the patronage of establishment figures, including Dermot O'Brien, president of the RHA. Aiming for a comprehensive survey of Irish art, the IELA invited some artists to submit recent examples of their work, and considered submissions from others. By August, 500 works had been received, only 168 of which would be shown. From 16 September to 9 October, the IELA attracted over 5,000 visitors and raised £289 from sales. The *Irish Times* heralded 'the most vital and distinguished exhibition of work by Irish artists that has ever been held', and noted that Academicians 'chivalrously' joined in by sending work to be judged by the Moderns (16 September 1943). Inevitably, there was also criticism of the Modernist works. The *Irish Press* complained of the

inclusion of 'persons who claim the title artist without the ideas or capacity', but also conceded that 'the exhibition is a very revealing symposium of the virtues and defects of the Irish artistic world of 1943' (17 September 1943).

If there was debate over the IELA's definition of 'significant', most critics agreed that the work was well displayed. Others recognized that audience was a major concern of the Living Art, as the IELA was called, and that it aimed to answer a public need. If the founding of the IELA is considered as primarily a didactic mission, many of the committee's decisions become clear. Pluralism was essential to create a survey of Irish art, selection was required to maintain standards, and official backing was desirable to placate those suspicious of Modernism. In order to ensure that they attracted and educated the public, the committee organized a programme of tours and lectures, including free tours for all primary school children in Dublin. The press clamoured to cover these visits and, undoubtedly, such publicity helped to challenge the public perception of art as elitist.

The IELA's attempts to be democratic and didactic can be partly attributed to the influence of Mainie Jellett [243]. Although she died in February 1944, Jellett's determination to create a Modernist Irish art continued to influence the IELA for many years. Norah McGuinness succeeded Jellett as chairman, ensuring that the IELA remained under the guidance of a Paris-educated Modernist for the next twenty years [244].

The 1944 exhibition included a memorial to Jellett and, at the request of the Department of Education, school visits were repeated. The most significant change from 1943 was the inclusion of non-Irish artists. Foreign artists living in Ireland, many of whom were associated with the White Stag Group (qv), were eligible to submit their work. Despite wartime transport restrictions, the committee managed to borrow works by English artists, including Ben Nicholson, Graham Sutherland and Henry Moore. Inevitably the exhibition of English art led to national comparisons and most critics concluded that Irish art could easily stand up to that of its former colonizer. Comparisons between Irish and foreign art continued to be a feature of the response to the Living Art. While some critics accused the Modernists of derivation and branded their work as alien, others realized that the exhibition of foreign art at the IELA aided the development of a unique Irish art that could hold its own internationally.

In 1945 the committee wanted to borrow examples of Belgian or French art. However, the war continued to hamper their efforts, and in the end they exhibited pre-war works by artists, including André Lhote and Jean Lurçat, from the collection of the French provisional government in exile, and British works from Kenneth Clark and Edward Sackville-West. The foreign work was seen as both an essential post-war reintroduction to European art, and once again a measuring stick against which Irish art could be judged.

In 1946 the gallery at the NCA was not available for the exhibition. Senator E.A. McGuire offered the gallery at Brown Thomas's Department Store as an alternative, but the committee expressed concerns about the cost of making the premises fit for the show. In the end a dock strike that threatened attempts to import foreign work, and the expense of refitting Brown Thomas, forced the committee to cancel the exhibition.

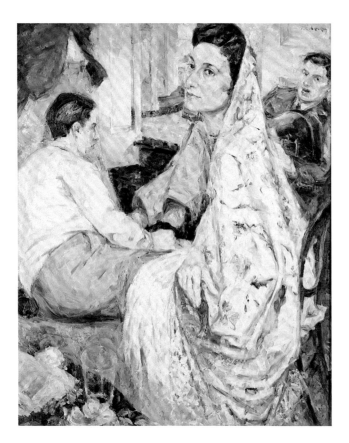

242. Louis le Brocquy, *The Spanish Shawl*, 1941, oil on shantung silk laid on board, 97.5 x 79.5 cm, private collection

A few months later the committee started to work on securing continental and British paintings for the 1947 exhibition. The resulting show, held at NCA, included works by Julian Trevelyan, Robert McBryde, Robert Colquhoun and Jankel Adler, and also featured a public lecture by Herbert Read on contemporary European art. Responses to the exhibition were generally positive. However, some reviews provoked Norah McGuinness to write to the *Irish Times* clarifying that the IELA was not at war with the Academy and re-emphasizing its policy of pluralism.

In 1948 work from the Bomford Collection, including paintings by Picasso, Modigliani and Matisse, were well received, and in 1949 a selection of work by contemporary French painters, including Pierre Tal-Coat and Edouard Pignon, was exhibited. In both years critics confidently praised the Irish art on show and argued that it compared well to the international work. However, while some commentators were celebrating the IELA, others argued that it was becoming too academic. In February 1949, Louis le Brocquy wrote to the chairman advocating the withdrawal of all painters from the organizing committee. The committee rejected his recommendation on the grounds that the IELA was not yet well enough established, although it acknowledged the need to invite new members on to the committee. This was the first of many calls for reform which would lead to the reorganization and eventual demise of the IELA.

In 1950 the committee asked the Irish-American curator James Johnson Sweeney to source twelve paintings by American artists. These efforts failed but the exhibition did include works by British artists such as Prunella Clough, Keith Vaughan, John Minton and Ivon Hitchens, alongside Irish painting, sculpture and stained glass (see 'Stained Glass and Tapestry'). Despite this diversity, a critic in the *Irish Times* accused the IELA of fostering a new academicism and questioned their selection process (17 August 1950). Responding in a letter dated 18 August, McGuinness defended the committee's decisions and once more challenged the presumption that the IELA was established as a Salon des Refusés.

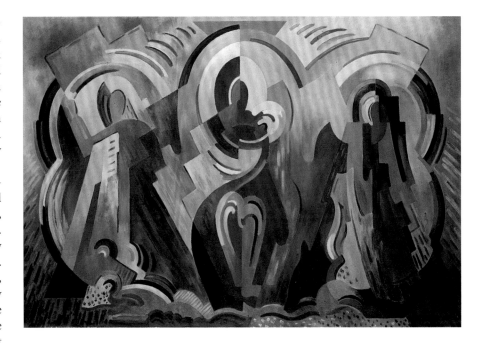

To answer their criticism, the committee invited the English critic Eric Newton to select the 1951 exhibition. Newton's selection was not markedly different from the show of 1950. While some welcomed him, Thomas MacGreevy, Director of the National Gallery of Ireland (NGI), objected to his involvement. Whether MacGreevy disapproved of Newton's choice, or resented the importation of a British judge, is not clear. In either case, in 1952 the committee chose the exhibits. Nevertheless, issues of selection continued to plague their deliberations.

In June 1952 the committee received a memo from Ralph Cusack lamenting the low standard of the RHA and expressing chagrin that members of the Living Art exhibited there. Discussing Cusack's complaint, the committee unanimously decided that open hostility to the RHA was against its policy. Nevertheless, the members did agree to enforce a more ruthless rejection process. These changes appear to have been implemented immediately and the 1952 IELA, which included work by Picasso, Miró, Max Ernst and Giorgio de Chirico, was marked by a scarcity of Academicians.

In 1953 the committee decided to exhibit a selection of paintings from abroad and that one third of the IELA should be devoted to new work. It also proposed to ask the recently formed Arts Council (AC/ACE) (see 'The Arts Councils') for funds to tour the show around Ireland. The resulting exhibition included works by Rouault, Matisse and Marino Marini but it was shown only in Dublin. James White judged it 'easily the best of the exhibitions' and concluded that 'one can see the possibility of a uniquely Irish style emerging' (*Sunday Press*, 16 August 1953).

The debate between those who felt that the IELA was fostering a unique Irish art and those who saw it as a quasi-academy in decline, continued throughout the 1950s. A review of the 1954 exhibition – which included work by contemporary Dutch and German artists and Henry Moore's *Reclining Figure* – stressed the significance of newcomers, including Anne Madden and

243. Mainie Jellett, *The Virgin of Éire*, 1943, oil on canvas, 64 x 92 cm, National Gallery of Ireland

244. Reception committee at the Irish Exhibition of Living Art, with (from left to right) Louis le Brocquy, Margaret Clarke, Norah McGuinness and Ralph Cusack, 17 September 1943

Barbara Warren (qqv), and argued that the original contributors were beginning to look conservative in the face of contemporary art (*Sunday Independent*, 2 August 1954). Although the committee was responsive to criticism, in light of the post-war shift of the international art world from Paris to New York, their reliance on French strains of Modernism was outdated.

In 1955 and 1956 attempts to secure contemporary work from Italy and Belgium failed, resulting in almost exclusively Irish exhibitions. These shows toured to Limerick and Belfast where they introduced regional audiences to contemporary art. A selection of films on artists was shown in 1956 on artists including Cézanne, Gauguin, Grandma Moses and Matisse. Education and access were consistent concerns of the IELA. Building on the successful school tours, a policy of late opening was implemented to facilitate access for workers, and the programme of lectures and art films was expanded throughout the 1940s and '50s. This emphasis on education was particularly important owing to the grim state of arts education in Ireland (see 'Education in the Visual Arts'), as outlined in 1949 by Thomas Bodkin's *Report on the Arts in Ireland.*

In 1957 the Belgian pictures sought for 1956 were secured, but in 1958, the committee failed to source examples of American action painting. Instead they borrowed work from the Commonwealth Artists Association exhibition in London. These artists, including Sidney Nolan from Australia, Canadian Paul-Émile Borduas and F.N. Souza from India, were the first non-Europeans to exhibit at the IELA. In 1959 concerns over the availability of the NCA retarded the committee's attempts to borrow contemporary British work and the resulting exhibition included only a few British and French works loaned from Irish collections. Among the Irish artists who received attention was Patrick Collins (qv) who had represented Ireland in the 1958 Guggenheim International Award in New York. The IELA applied for affiliation with the Guggenheim Institute in 1956, the same year that Ireland was first represented at the Venice Biennale. Participation in these international events suggests that by the late 1950s both the AC/ACE and the IELA were actively promoting Irish art abroad.

In the mid-fifties a new generation of artists emerged who would dominate Irish art for several decades. Noel Sheridan, Barrie Cooke, Charles Brady, Michael Kane (qqv) and John Behan all exhibited at the IELA for the first time between 1958 and 1960, where they joined other young artists, including Basil Blackshaw, Camille Souter and Cecil King (qqv), who were already making a name for themselves. Some of these artists were dissatisfied with the opportunities available for them and in May 1960 they formed the Independent Artists Group. The Independents were opposed to two aspects of the IELA: the submission fee and the restricted number of entries. However, most of the Independents exhibited in the IELA of 1960 suggesting that theirs was an additional, rather than an alternative, exhibition. Over the next decade the Independents became just one of the bodies challenging the IELA.

In the IELA of 1960 there was an impressive selection of work by artists working in Britain, including Ben Nicholson, Francis Bacon (qv), Elizabeth Frink and F.E. McWilliam. For arguably the first time, the exhibition contained a selection of

avant-garde work by non-Irish artists. While previously foreign works had acted as a comparison against which to judge the progress of Irish Modernism, in 1960 the exhibition of the best of contemporary British art signalled that the IELA had finally outgrown its national roots and was becoming an international exhibition.

Despite general critical acclaim for the international work, in a letter to the *Irish Times* Michael Kane vehemently opposed internationalism. Applauding the IELA committee for bringing to Dublin a large and representative selection of British art, Kane wrote that at least now Irish artists could see the 'uncontrolled, uninventive, tasteless, shapeless, boneless and fleshless vacuity which passes for the Art of Our Time, not only in Britain – where it is only to be expected – but in the international sphere' (17 August 1960). An Expressionist (see 'Expressionism') involved with the Independent Artists, Kane would continue to be an outspoken figure throughout the 1960s and '70s, yet in 1961 and in 1963 he exhibited at the IELA alongside contemporary international work suggesting that, despite his hostility, there was still no alternative to the IELA [245].

The foundation of the Independents was an attempt to create an alternative, or additional, exhibition to the IELA but the strongest challenges to the institution came from within. At a committee meeting on 14 February 1964, Michael Scott and Patrick Scott (qv) argued that, owing to the increase in exhibiting venues, the Living Art was no longer necessary. Instead, they suggested a national show with external judges and valuable prizes. Both Anne Yeats (qv) and Leslie MacWeeney disagreed and pointed out that if the IELA ceased to exist, the next generation would not have the chances they had had. While these defences were valid, they were also largely retrospective and the principles and structure of the IELA were rapidly becoming out of touch with both the international art world and the needs of young Irish artists.

Undoubtedly part of the reason for the IELA's increasing inability to adapt to contemporary circumstances was the committee's insistence on sticking to its original principles. Although the committee of 1964 differed significantly from the original group, more than half of its members had been appointed before 1950 and Norah McGuinness had occupied the chair for twenty years. Arguably too dependent on the continental traditions that had moulded them, the older artists resisted re-examination of the founding principles. While they were still keen to encourage young artists, after two decades their once progressive views on art had become outdated, and their tendency towards pluralism had occasionally sacrificed quality.

Despite rejecting calls to disband, the IELA did accept some of the criticisms and, from 1964, the annual Carroll Prize was judged by international critics and curators. In 1967, both Scotts were instrumental in the foundation of Rosc (qv), the exhibition that supplanted the IELA as Ireland's most significant contemporary show. Taking place once every four years and initially showing only international art, Rosc did not so much make the Living Art redundant as expose it as old-fashioned.

During the 1970s, an increase in exhibiting venues and private galleries also reduced the need for the IELA. In 1972, aware

that they were no longer in touch with recent developments, the IELA committee handed over to a younger group of artists led by the sculptor Brian King. The new committee sought to revitalize the organization and bring it up to date with developments including Conceptualism, Minimalism and installation art (qqv). Despite its best efforts, however, the new committee ultimately failed to save the aged institution.

In 1982 the lack of a suitable venue resulted in the exhibition being produced in book form. There was no IELA the following year and in 1984 another new committee was elected. Chaired by Aileen McKeogh, it decided to focus on particular art forms and to tighten up the selection process. This approach bore results in 1987 when the exhibition, held at the Guinness Hop Store, focused on small sculptures and drawing. This attempt to rejuvenate the IELA also failed, however, and the 1987 exhibition was the last. It was clear that other institutions, including the Independent Artists, Oireachtas and EV+A, as well as private gallery shows, had made the IELA redundant and underlined that it had outlived its usefulness.

Yet from 1943 to 1967 the IELA was undoubtedly the most influential institution for the promotion of non-academic art in Ireland. Through its engagement with the debates over the nature of Irish art, the Living Art effectively inherited Mainie Jellett's role as mediator between international Modernism and the conservative conception of national art endorsed by the RHA. Uniting exhibitors from north and south of the border, with domiciled foreigners and examples of international art, the IELA not only created the sole forum where the nature of Irish art could be assessed, it also helped to forge a concept of Irish art in the minds of critics, artists and, most significantly, the public it had set out to serve. RIANN COULTER

SELECTED READING *IELA Minute Books*, Anne Yeats Archive, NIVAL, NCAD; Marianne Hartigan, 1987; S.B. Kennedy, 1991, pp. 115–46; Coulter, 2003.

IRVINE, JAKI (b. 1966) (qv *AAI* III), new media artist. Dublin-born artist Jaki Irvine graduated from NCAD with a BA in 1989, and from Goldsmiths College in London, where she secured an MA in 1994. She was a prominent founder member of the influential Dublin group Blue Funk (qv) in the early 1990s. In 1993, while still a student at Goldsmiths, she held her first solo exhibition at the Riverside Studios, London. Three years later she was shortlisted for the IMMA/Glen Dimplex Artists Award, and represented both Britain and Ireland at the Venice Biennale, in 1995 and 1997 respectively. Refusing to be tied to a single place, she has lived and worked in Ireland, England, Italy and Mexico, and her work practice includes curating, art writing, and acting as an artist advisor at the Rijksakademie, Amsterdam, as well as making her own art.

From the start of her career, Irvine's chosen art form has been film and slide projection. Often using a Super 8 camera, especially in such early works as *Star*, *Eyelashes* and *Sweet Tooth*, she creates 'knowingly awkward' and disjointed narratives, mismatching sound and imagery, which frustrate by offering fragmented clues and differing viewpoints that can be read in a variety of ways (see 'Narrative and Anti-Narrative'). Her work challenges the notion of a single coherent meaning. While this has led one critic to say that her art treads a fine line between 'the ludicrous and the lyrical' (Mac Giolla Léith, 52), it is the latter which generally triumphs. The strength of the work derives from Irvine's staunch refusal to foreclose on possible outcomes, to insist that we don't always know what motivates us or others around us. 'In my case it is usually something that I don't know or understand that plays on my mind and sparks off my interest in making a piece of work', she told Katy Deepwell in 2005. 'The process of making the work then turns into some way of trying to focus on or think about that thing. The finished piece is often then a kind of framing of, or gesturing towards that unknown, rather than an explanation of it.' (Deepwell, p. 71)

Irvine is attracted to Super 8 as a medium because the discipline imposed by the three-minute cartridges that the camera takes forces a concentration on the preciousness of time. Inevitably this influences how the artist looks and the level of intensity she brings to the project. Films such as *Margaret Again* [246] and *Ivana's Answers* were shot on video, however, and later work uses DVD, the choice of media being dictated by whichever technology is best suited to the nature of her exploration (see 'New Media Art').

Irvine's work draws on romantic fiction and psychological case studies and is informed by discourses on film and photography (qqv). Their interrupted narratives are played out in scenarios involving the natural world, particularly animals and the built environment. They use multiple projections, placed and scaled so that the viewer has to adapt to each one physically as well as emotionally.

I've been thinking about the limits of a certain visibility that attaches itself to living privately in public... about those points where what at first seems most available to understanding, slowly turns opaque, revealing itself as misleading or meaningless. If this then opens out a sense of untold distances

between things and people, it also brings with it a desire for the reverse, gesturing towards impossibly compensatory intimacies between ourselves and the world…towards a belief in the transparency and agreement of things – of gestures, smiles, meanings, chance remarks and strangers. (Artist's statement, Glen Dimplex Artists Award exhibition, 1996)

A feature common to many of Irvine's film works is a dreamlike melancholy. *The Silver Bridge* (2003, IMMA collection) loosely refers to the nineteenth-century gothic writing of Joseph Sheridan Le Fanu and was filmed in Dublin Zoo and the Phoenix Park. Other films have been shot in Italy and Mexico.

Fans of Irvine's film works were both surprised and pleased to see the quality of her drawings (qv) when she was selected for a group exhibition of drawings, *Way Marks* (2009, Droichead Arts Centre, Drogheda), curated by Ruairí Ó Cuiv. In 2011 she produced a series of five video films on the process of printmaking (qv) at the Graphic Studio in Dublin.

Irvine has been a contributing curator at IMMA and for Double Agents, Central Saint Martins, London. In 2000 she curated the group exhibition *Somewhere Near Vada*, which

marked the reopening of the Project Arts Centre of which she has been a board member. She has had solo exhibitions in Amsterdam, Baden-Baden, Dublin, Leeds, London and Sligo. Group exhibitions, other than those mentioned above, in which she participated include *The Dublin Contemporaries* (2011), *A Century of Artists' Film in Britain*, Tate Britain (2003), *Shifting Ground: Selected Works of Irish Art, 1950–2000*, IMMA (2000), Venice Biennale, (2001, 2007), *Intelligence*, Tate Britain (2000), *White Noise*, Kunsthalle, Bern (1998) and *NoWhere*, Louisiana Museum of Modern Art, Denmark (1996).

Jaki Irvine is represented in the collections of Tate, London, the British Council, IMMA, Moderna Museet, Stockholm, the Butler Gallery, Kilkenny, the HL and in numerous other collections, both public and private. She has served as a member of the Arts Council and is a member of Aosdána (qqv).

CATHERINE MARSHALL

SELECTED READING Caoimhín Mac Giolla Léith, 'Jaki Irvine', *Circa*, no. 77 (June 1996); Deepwell, 2005, pp. 68–79; Glennie, Irvine and Newman, 2008.

ITEN, HANS (1874–1930) [247], landscape and flower painter. Hans, also known as John, Iten was born in Zurich and educated at the School of Art in St Gall before coming to Ireland to work as a damask designer for the flourishing linen industry in Belfast in 1904. He brought with him an interest in Impressionism, gleaned from a period in Paris, and very quickly became active in art circles in Belfast. By 1906 he had become vice-president of the Belfast Art Society (from 1930 the Ulster Academy of Arts, and from 1950 the RUA, qv) and two years later showed the first of almost fifty paintings that he was to exhibit at the RHA (qv) until his early death.

Although Iten painted a number of portraits, he specialized in landscape (qv) and flower painting, confining his landscapes to the areas of counties Antrim and Down, but interspersing these with paintings of his native country, which he continued to visit annually. However, it was for flower paintings that he was to become best known. Alfred McGuigan of the Rodman Gallery in Belfast said of Iten that, 'There was no one to touch him anywhere in Ireland as a flower painter' (Snoddy, p. 280). In addition to the RHA and the Belfast Art Society, Iten's work was also accepted at the RA, the Royal Glasgow Institute of the Fine Arts, the Society of French Artists and the Paris Salon, where he got an 'honourable mention' in 1926.

In the year of his death, he was one of the original nine artists elected to the Ulster Academy of Arts and in that same year shared an exhibition in Dublin with the sculptor and illustrator Rosamund Praeger, and was included in the *Exhibition of Irish Art* in Brussels.

Iten was given a retrospective exhibition at the Arts Council Gallery, Belfast in 1971, followed by another, smaller, retrospective in 1999 at the UM. His work can be seen in a number of important collections, including the UM, the HL, and in such private collections as the George and Maura McClelland Collection, through which it was lent to IMMA. One of Iten's important, though rarely acknowledged, legacies to Irish art was that he was the earliest teacher of the painter Colin Middleton

(qv), whose father Charles was, like Iten, a damask designer and an expatriate. CATHERINE MARSHALL

SELECTED READING Martyn Anglesea, *A Continental Touch: Hans Iten 1974–1930* (Belfast 1999); Snoddy, 2002, pp. 279–81.

JANZ, ROBERT (b. 1932), artist. Although born in Belfast, Robert Janz has lived in many places around the world, especially in the USA, but he has always maintained contact with Ireland, exhibiting regularly in both solo and group shows and participating in residencies in Cork and Dublin. Following completion of a Masters degree in Fine Art at the Maryland School of Art in 1962, a graduate fellowship at the Rinehart School of Sculpture, Baltimore in 1963, and a Fulbright Fellowship in Spain in 1964, he founded an organization for kinetic artists, Continuum, in Spain and later in London.

Janz's art has always been concerned with the ephemeral and the long-term effects of human activity on the environment, but he has also responded to other political situations. A DAAD fellowship to Berlin in 1980 saw him draw a fist clenching and unclenching, which was then erased and redrawn daily on the Berlin Wall for twenty days.

Janz has taught film (qv) and performance in London, where he was a founder member of The Ting: Theatre of Mistakes in 1978, and his practice has been marked by public performances of painting and drawing, using a variety of impermanent media, such as chalk, on city roadways, and water on rocks and sandy beaches, as well as comic-strip drawings on the internet. For an exhibition in the DHG in 1985, he studied the changes in a single flower (*Southern Rose: 10 Days*) [248] from bud to blossom to seed over ten days, in five panels, with a sixth one to record the total process. Drawing and erasure, either by the artist himself or by processes in the world around him, is a feature of his practice. Films made to record this activity include Tiernan MacBride's film *Patricia's Lily*, Dublin (1990), a record of twelve days of drawing and redrawing; *Takes Time*, drawing adjusted as the clock changed, the Hamptons, New York, by LIPA TV (1986); and *Waves between Waves*, on Venice beach, California (1979), made under the auspices of LA Louver.

Janz works with twigs and discarded wood to make what Aidan Dunne described as 'exceptionally nuanced, spirit-like animal and human figures ... glimpses of transience and fragility' (Dunne, *Wall and Plinth*, Dublin 2007, p. 3).

Robert Janz was awarded a prize for sculpture at the RUA (qv) in 2007 and his work can be seen in many collections, including those of the HL, AIB and the NSPC in the UL. He has had solo exhibitions in Belfast, Berlin, Cork, Dublin, London, Melbourne, Montreal, New York and San Francisco and is a frequent exhibitor at EV+A, Limerick. CATHERINE MARSHALL

SELECTED READING Robert Janz, *Trek Elk*, exh. cat. Peppercanister Gallery (Dublin 2007); O'Byrne, 2010.

247. Hans Iten, *Still life with Oysters*, before 1904, oil on canvas, 64 x 80.5 cm, National Museums Northern Ireland, Collection Ulster Museum

248. Robert Janz,
Southern Rose: 10 Days,
1985, acrylic on canvas, 6
panels, 61 x 61 cm each,
AIB Collection

JELLETT, MAINIE (1897–1944) [249], painter, designer and educator. Born in Dublin, into a family of Huguenot descent, Mary Harriet (Mainie) Jellett was the first Irish artist to exhibit Modernist abstract art in Dublin and was an outspoken advocate for progressive art.

Jellett's artistic education began with watercolour classes given by Elizabeth Yeats, followed by lessons from Sarah Cecilia Harrison and May Manning. She entered the DMSA in 1914 in an era when William Orpen (qv) reigned over the school. Although he left Dublin a year later, Orpen's influence remained strong and can be seen in Jellett's early figurative work. After

three years, Jellett moved to London where she attended the Westminster Art School and came under the influence of Walter Sickert. She later described this period as her first artistic revolution, the moment when 'drawing and composition came alive to me and I began to understand the work of the Old Masters' (MacCarvill, p. 43). It was at Westminster that Jellett met fellow Dubliner Evie Hone (qv), who became a life-long friend and collaborator.

Returning to Ireland, Jellett won the Taylor Scholarship in 1920 and, the following year, travelled with Hone to Paris, where they studied with André Lhote. Lhote's love of history painting, combined with a dedication to the innovations of Cézanne, created a form of Cubism (qv) which favoured representation over abstraction (qv). With Lhote, Jellett experienced her second artistic revolution and later wrote, 'I learnt how to use natural forms as a starting point towards the creation of form for its own sake; to use colour with the knowledge of its great potential force, and to produce work based on a knowledge of rhythmical form and organic colour.' (MacCarvill, p. 43)

Jellett and Hone studied with Lhote for ten months before their desire to explore abstraction further led them to Albert Gleizes. Gleizes did not take students, but the two artists persuaded him to teach them. They soon graduated from pupils to collaborators, and even after they returned to Ireland they continued to contribute to Gleizes' research towards abstract Cubism.

By 1923 Jellett was ready to unleash onto the Irish public the abstract aesthetic she had developed in Paris. In the SDP she exhibited *Decoration* (1923, NGI collection). One of the first modern abstract paintings to be seen in Ireland, *Decoration* [7] and its creator became a target for the forces that railed against Modernism (qv). George Russell (qv), utilizing language reminiscent of Continental attacks on Modernism, described Jellett as 'a late victim to Cubism in some sub-section of this artistic malaria' and concluded 'what Miss Jellett says in one of her decorations she says in the other and that is nothing' (Russell, *Irish Statesman*, 27 October 1923). Contrary to Russell's assessment, *Decoration* did have something to say. Based on the principles of abstraction that Jellett had learnt from Gleizes, *Decoration* was a devotional painting. Composed in a pentagonal format, the arrangement of forms has affinities with traditional images of the Madonna and Child. The iconic references are emphasized through the use of gold leaf and tempera on panel, in colours relating to the fifteenth-century paintings of Fra Angelico, whose influence Jellett later acknowledged. That these references were lost in a religious society suggests the degree to which abstraction was incomprehensible to Irish audiences.

Despite criticism, Jellett continued to exhibit abstract compositions and defend Modernism. By 1927 her art was no longer condemned unconditionally. In reviews of that year, she is described both as an artist whom 'the average man will ... find it difficult to understand' and as 'the only serious exponent in this country of the ultra-modernist school of painting' ('Modern Painting: Miss M.H. Jellett's work', *IT*, 8 January 1927; 'A Plea for Pictures, Miss Jellett's Lecture', *IT*, 3 February 1927). Yet it was not until the exhibition of *Homage to Fra Angelico* (private collection) in 1928 that critics praised her work in specific terms.

Inspired by Fra Angelico's *Coronation of the Virgin*, this painting marks the beginning of Jellett's return to figuration. Detecting a 'marked advance' in her work, the *Irish Times* approved of the painting's 'mystic fascination' of colour and subject ('The Cubist School: Miss M.H. Jellett's Painting', *IT*, 12 June 1928). In the *Irish Statesman*, Hylda Boyd praised Jellett for creating a painting 'which while based on and retaining the religious significance and colour beauty of the Angelico evinces the simplicity of form and absence of representation which are the essence of modern decorative art' ('Exhibition of Painting by Miss Jellett', *Irish Statesman*, 16 June 1928). Through her return to figuration, her use of Christian iconography and her reference to art history, Jellett had created an image that was modern and expressed spirituality in terms comprehensible to the Irish public.

Although Jellett continued to produce abstract work, her practice was becoming increasingly diverse. In 1935 a visit to the *International Exhibition of Chinese Art* at the RA in London and a trip to Achill, Co. Mayo inspired a new approach to landscape painting (qv) through which she connected the west of Ireland landscape and the rhythms of Chinese art. This approach was tested in 1939 when she represented Ireland at the New York World's Fair. There, *Achill Horses* (1939, NGI collection) [504] hung in the Irish pavilion designed by Michael Scott. While the State's commissioning of Modernists in New York, along with the choice of Jellett to represent Ireland in the Glasgow World Fair of 1938, suggests an acceptance of Modernism, arguably she was chosen less for her innovations than for her ability to represent Irish subjects in a modern manner. In New York the Irish

Modernism that gained official endorsement was neither autonomous nor avant-garde. Irish imagery, rendered in a mildly Modernist aesthetic, conveyed to an international audience the impression of a modern nation.

The combination of a Modernist style and an Irish subject represented in *Achill Horses* brought Jellett a wider audience, but did not fulfil her vision of Modern Irish art. Spirituality had been usurped by nationalism. An alternative was needed that was Modernist, Irish and spiritual. It was through the familiar iconography of religion that Jellett achieved a reconciliation between Modernism and Ireland (see 'Religion and Spirituality').

The expression of spirituality through art was a vital aspect of Jellett's Modernism. Just as Ireland challenged her to re-examine her abstract aesthetic, it forced her to reconsider her universal ideas of spirituality in a staunchly Catholic society, preoccupied with issues of national identity and largely oblivious of developments in modern art. Jellett found the Free State government oppressive and wrote to Gleizes in October 1932: 'times here are very bad ... de Valera clothing us all with his mad nationalism and narrow-minded men' (Arnold, p. 136). Yet Jellett chose to remain in Ireland and, by exchanging spiritual abstraction for Christian imagery, finally found acceptance. Just as Chinese painting had informed her return to landscape, Celtic art pointed the way towards a modern Irish religious art.

Jellett's interest in Celtic art was nurtured by Gleizes. For him, Celticism was a form of primitivism that represented a return to origins in the art of the Celtic world. In Ireland, Celtic art was the ideal primitive, indigenous and familiar through illuminated manuscripts, metalwork and architecture. Finding Ireland unprepared for her modern aesthetic, Jellett invoked the art of the past to authenticate her own work.

The influence of Celtic art is discernible in *Virgin and Child* (c. 1936, private collection) where the framing devices are reminiscent of the Virgin from the *Book of Kells*. Yet the implications of Jellett's use of Celtic art reached beyond technique. Stressing the common ideals between Celtic and contemporary abstraction, she claimed that 'if an Irish artist of the eighth or ninth century were to meet a present-day Cubist or non-representational painter they would understand each other' (MacCarvill, pp. 103–05). By declaring Cubism the legitimate descendant of Celtic art, Jellett pointed the way towards a modern Irish art.

In November 1941, Jellett was described by the *Irish Independent* as 'one of our leading artists' who 'charges her pictures, especially her religious ones, with intense emotion' ('Academy of Christian Art', *I Ind*, 21 November 1941; 'Paintings by Miss Mainie Jellett', *I Ind*, 22 November 1941, signed H.S.K). In the same month she exhibited in the Academy of Christian Art, an institution founded to 'promote the intellectual commonplaces of Catholic life' (Count Plunkett, 'President's Address', *Journal of the Academy of Christian Art*, I, 1937, 7). Finally, critics who had lambasted her abstraction embraced her 'deeply religious expression in cubist form' ('Dublin Painter's Exhibition', *I Ind*, 19 February 1944). In an overwhelmingly conservative and Catholic country, art was obliged to express spirituality in popular and intelligible terms.

From 1923 to her death in 1944, Mainie Jellett engaged with discourses of landscape and religion, drawing on formal motifs familiar from those traditions to make Modernism palatable to Ireland. Although she did not live to see the consolidation of Modernism in Ireland, Jellett's appointment as the first Chairman of the IELA in 1943 acknowledged her pioneering role in exposing the Irish public to modern art and her attempts to create an authentic Irish Modernism.

Fine examples of Jellet's work can be seen in the collections of the NGI, HL, CAG, and regional collections throughout Ireland. RIANN COULTER

SELECTED READING MacCarvill, 1958; Arnold, 1991; Anne Crookshank, James White, Bruce Arnold, Peter Brooke, Paula Murphy, Daire O'Connell, *Mainie Jellett, 1897–1944*, exh. cat. IMMA (Dublin 1991); Coulter, 2006.

250. Nevill Johnson, *Children, Masterson's Lane*, 1952–53, selenium-toned gelatin silver print, 14/20, 34 x 27 cm, Irish Museum of Modern Art

JOHNSON, NEVILL (1911–99) [250], painter, photographer. An enigmatic but important figure in twentieth-century Irish art, Johnson is best known as a painter of Surrealist and quasi-abstract interiors, still lifes and portraits. However, he was also a talented photographer, who recorded the streets of Dublin in the early 1950s with a sympathetic and sensitive eye (see 'Photography'). Never part of a group, Johnson embarked on his chosen career without conventional art education. His early style was Surrealist (see 'Surrealism'), influenced by Salvador Dali, Giorgio de Chirico and Yves Tanguy; he then moved on to develop a Cubist (see 'Cubism') abstract idiom, echoing the work of Braque and Picasso. Although he continued to paint into the early 1990s, Johnson's earlier works are his best: clear, formal, geometric and reflecting in their dislocated imagery a world haunted by the threat of nuclear annihilation. While unreliable in some details, his autobiography *The Other Side of Six*, published in 1983, reveals also a literary talent, while giving an insight into the Irish art world of the mid-twentieth century.

Johnson was born in Buxton, Derbyshire. His years at Sedbergh School were followed by employment with the Ferodo motor parts company, which brought him in 1934 to Belfast. Like others who worked in industry in Belfast during this period, he was drawn to art as a means of self-expression, within a repressed and divided society. In Johnson's case, this interest was prompted also by a rejection of religion and his adoption of an Existentialist world view. He formed friendships with John Hewitt and Louis MacNeice, and throughout his life preferred the fellowship of writers rather than visual artists. In the late 1930s, influenced and partly tutored by John Luke (qv), Johnson embarked on a series of tempera paintings that reflect a bleak and austere world view. In 1936 he and Luke travelled to Paris, where they saw works by Picasso, Tanguy and Dali. The paintings that followed this trip, including *Kilkeel Shipyard* (1943, Down County Museum), *Byrne's Pub* (1942, private collection) and *Linenscape* (1945, private collection) are stark and Surrealist, the latter work depicting monumental bobbins and shuttles set in a coastal landscape draped in cloth.

By the time of his first exhibition at the Waddington Gallery in 1947, where he showed Surrealist paintings inspired by driftwood, Johnson had settled in Dublin, was separated from his wife Noelle Biehlman and their two children, and was pursuing a full-time career as an artist. He remained in Dublin throughout the 1950s and in the early years of that decade, accompanied by Anne Yeats (qv), explored the inner city, taking photographs of street scenes. He was included in *Four Ulster Painters* (with George Campbell, Daniel O'Neill and Gerard Dillon (qqv)) which toured from Waddington's to the Mansard Gallery at Heal's, London. In 1949 he showed *Crucifixion* (1946, private collection) at the IELA (qv), and in 1950 a second Waddington exhibition confirmed his rising reputation as a painter, when the HL purchased his *Landscape, Rock Pool* [471]. In 1951 Johnson's *Crucifixion* was included in an exhibition held at the Rhode Island School of Design and the Institute of Contemporary Art in Boston which also included Thurloe Conolly and Louis le Brocquy (qqv). In 1956 he showed at the IELA an oil painting entitled *Dark Head*.

Around 1957, when he had a solo exhibition in Washington DC, Johnson decided to move back to England. He settled in Notting Hill, sharing lodgings with the artists Robert Colquhoun and Robert MacBryde. Dissatisfied with his work and his lack of success, Johnson destroyed a good deal of the art he had produced up to that time. He does not seem to have painted much, or at all, from then until 1962, by which time he had moved to Suffolk. In the late 1960s Johnson and his second wife, Margaret, moved back to London. Although living in England, he continued to send work to the IELA; in 1966 he showed *Machine for Saying Goodbye*, *Red Landscape* and *Morning Figure*. Johnson's first solo exhibition in many years took place in the Collectors Gallery in Notting Hill in 1970, and in that year he received a grant from the RA. During this decade his work became more lyrical and painterly; he experimented with collage, etchings, monoprints and photography, but still painted, producing mainly quasi-abstract figures in landscapes, or abstract compositions. In 1978 *Summer Solstice* was purchased by the UM from an exhibition at the Tom Caldwell Gallery, Belfast, his first one-person show in Ireland in twenty years. In 1980 Johnson's paintings were acquired by the AIB, OPW and the AC/ACE and in 1981 his book of photographs *Dublin: The People's City* was published. Over the following decade, he began a series of interpretations of well-known paintings such as Manet's *Déjeuner sur l'herbe* and Velázquez's *Las Meninas*.

In the last years of his life, in failing health, he concentrated on ink drawings and on completing literary works, such as the unpublished *Tractatus Pudicus*, a wry philosophical look at his own life and at the human condition. PETER MURRAY

SELECTED READING Nevill Johnson, *Dublin, The People's City: The Photographs of Nevill Johnson 1952–53* (Dublin 1981); Nevill Johnson, *The Other Side of Six: An Autobiography* (Dublin 1983); Dickon Hall and Eoin O'Brien, *Nevill Johnson: Paint the Smell of Grass*, exh. cat. Ava Gallery (Bangor 2008).

JOHNSTON, ROY (b. 1936) [251, 305], painter. Born in Pomeroy, Co. Tyrone and educated at Stranmillis College (QUB) and the Belfast School of Art, and later at TCD, Roy Johnston has distinguished himself both as an art historian and an artist. His introduction to art practice was auspicious, winning a travel scholarship from the ACNI in 1966 and the Carroll's Prize for painting at the IELA (qqv) in 1973, in which year he was also commissioned to design a tapestry for the NUI, Galway. Following a number of teaching roles at the Belfast College, the Ulster Polytechnic and the University of Ulster between 1964 and 1987, he went to the USA where he held the role of Professor of Art in Skidmore College, Saratoga Springs, New York and later at Eastern Michigan University. He has remained in America since his retirement in 2004, but throughout his career has continued to exhibit and lecture on both sides of the Atlantic.

Committed to abstraction (qv), Johnston has a fondness for wall-mounted grid structures in which each element is subtly arranged to exploit surface variation and rotation, with a strong emphasis on three-dimensional qualities. But he has produced

251. Roy Johnston, *Sixteen Rotated Forms* (1 of 4), 1975, acrylic on cotton duck, 100 x 100 cm each unit (202.4 x 202.4 cm assembled), Irish Museum of Modern Art

free-standing pieces, and reliefs using wood, or welded steel. His leanings towards a mathematical and analytical form of abstraction, already fully present in his work for the *Young Irish Artists* satellite exhibition of *Rosc '71* (see 'Rosc Exhibitions'), was supported by attendance at a systems workshop at the London Polytechnic in 1974. Johnston has represented Ireland at the International Festival of Painting at Cagnes-sur-Mer, and featured in such group shows of Irish art as *Irish Directions of the 1970s*, shown in Dublin, Belfast and in nine venues in the USA (1975), and *The Irish Imagination* (1972) which travelled to Boston, Philadelphia and Washington. When four young artists were asked to curate an exhibition *Four Now* (2005, Glucksman Gallery, UCC), based on work by four older artists who inspired them, Johnston was one of those selected. He is an authority on the work of the artist Roderic O'Conor (qv), on whom he has published and lectured, in addition to curating several exhibitions of the earlier artist's paintings and prints. Johnston has had residencies at the Tyrone Guthrie Centre, Annaghmakerrig, and L'Atelier d'Artiste de la Grande Vigne, Dinan, and has twice been awarded the International Artist-in-Residence slot at the Musée des Beaux Arts de Pont-Aven, Brittany.

A retrospective exhibition of his work was held at the Arts Council Gallery, Belfast and the HL in 1985, and he has had numerous solo exhibitions in the USA, Ireland and Britain. His work can be seen in the collections of the Arts Councils of Ireland, Northern Ireland and Britain, IMMA, HL, UM, UU, TCD, BoI and AIB. CATHERINE MARSHALL

SELECTED READING Knowles, 1982; Roy Johnston, Christina Kennedy and Daire O'Connell, *Roderic O'Conor: Vision and Expression*, exh. cat. HL (Dublin 1996); Murray, 2007b.

JORDAN, EITHNE (b. 1954) [252], painter. Eithne Jordan studied at the Dun Laoghaire School of Art and was a founder member of the Visual Arts Centre, Dublin. She has lived and worked in London, Berlin and the South of France, as well as in her native Dublin. Jordan received early recognition as an artist, with early solo exhibitions in Dublin's Project Arts Centre and David Hendriks Gallery, winning a *Deutscher Akademischer Austausch Dienst* scholarship of an artist's residency in Berlin in 1984 and a GPA award in 1986.

Initially interested in highly abstracted landscape paintings, she introduced the figure into her work in the early 1980s in a series entitled 'Swimmers' in which the figure and the water appeared to blend into a common, organic rhythm. Her residency in Berlin led to more emotive work, the 'Beauty and the Beast' paintings, which explore relationships between women and men, the latter presented either as adults or children. Further emotionally charged paintings, in which the female face, sometimes split and expanded to fill large, dark canvases, continued to emerge until the early 1990s. The Expressionist nature of Jordan's work in this period means that she is often associated with the Irish Neo-Expressionists Brian Maguire, Patrick Graham, Patrick Hall and Michael Cullen (qqv), the only woman artist to be so named. During the 1990s Jordan scaled down her work, focusing initially on the domestic sphere: the restoration of a house, the bright colour of a Provençal garden and on small non-contentious urban scenes that, nevertheless, seem weighed down with meaning.

Though she has been described as a Feminist and a Neo-Expressionist (see 'Expressionism and Neo-Expressionism'), neither of these descriptions define Jordan's work, which is primarily about painting and her lived experience. It is also informed by her admiration for older masters such as van Gogh and Picasso, balanced by the more rational work of Poussin and Cézanne. More than other Irish artists, she has also been able to assimilate the influence of Jack B. Yeats (qv), so that *Figure in a Poppy Field* (1993, IMMA collection) acknowledges his work from the 1940s but is undeniably her own.

Jordan has had residencies in Annghamakerrig and IMMA. Elected to Aosdána (qv) in 1990, she was awarded the EV+A prize for painting in 1994. She has had solo exhibitions in Cork, Dublin, Kilkenny, Letterkenny, Limerick, Sligo and Waterford and was included in seminal group exhibitions of Irish art such as *A New Tradition: Irish Art of the Eighties*, DHG (1990), *Re/Dressing Cathleen*, Boston (1997) and *When Time began to Rant and Rage*, Los Angeles, New York, London and Liverpool (1998). Her work is included in the collections of IMMA, AC/ACE, CIAS, AIB, BoI, GPA, and in numerous private collections. CATHERINE MARSHALL

SELECTED READING *A New Tradition*, 1990; Conley and Grinnell, 1997; Catherine Marshall, *Eithne Jordan, 1992–1998*, exh. cat. Rubicon Gallery (Dublin 1998); Steward, 1998.

KANE, MICHAEL (b. 1935) [253], painter, printmaker. Michael Kane has played a very visible role in the arts in Ireland since the 1960s, both as an artist and as a critic of those in positions of power in the arts establishment.

Born in Dublin, Kane grew up in County Wicklow and spent two years (1956–58) at NCA before going to Spain and Italy in search of Modernism (qv). Having rejected the vogue for Modernist abstraction, he returned to Ireland in 1959 and worked in John Skelton's advertising agency. His first exhibition, at Dublin's Hendriks Gallery in 1960, was a critical success.

Keenly interested in graphic art, Kane had an exhibition of monoprints in 1963 at the RHA's (qv) small gallery and worked for a time (1961–63) in the Graphic Studio Dublin, under Patrick Hickey (qv), who taught him etching. But the woodcut was to be his favourite print medium (see 'Printmaking').

Kane has worked in Spain, Britain and in Switzerland, where he was granted a residency by the Swiss Federal Cultural Foundation, and was introduced to an alternative kind of Modernism from Central Europe. His travels in Europe gave him a first-hand education in art history, enabling him to reject the Old Masters, so dear to his teachers in NCA, in favour of the geometry of Cézanne and the gestural figuration of Kandinsky and Kirchner. For most of his life, however, Kane has lived and worked in Dublin, using his knowledge from abroad in the service of his (almost exclusively) Dublin subject matter. Notwithstanding his rural background, his work can be read as a polemic in favour of the city, a subject seriously neglected in Irish visual art until he emphasized it in his painting.

Despite his outspoken critique of the AC/ACE, he was a founder member in 1980 of Aosdána (qqv), for which he also served as Toscaire (1982–86). Although not a founding member of the Independent Artists group (1960), as is often suggested, Kane was co-opted to the group within a year, along with Brian Bourke and John Kelly (qqv), and John Behan, and almost immediately became its most outspoken voice. The Independents made insistent demands for alternative exhibition opportunities, and their ability to attract public attention opened up debate. To keep pressure on the establishment,

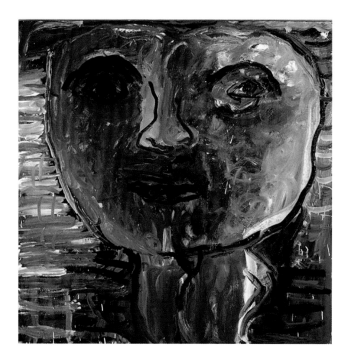

252. Eithne Jordan, *Split Face 1*, 1988, oil on canvas, 150 x 150 cm, Irish Museum of Modern Art

especially the AC/ACE, Kane and his friend James McKenna founded the more radical but short-lived Group 65, which held two exhibitions, in 1965 and 1966, at the Irish Times Gallery in Westmoreland Street, Dublin. When the Project Arts Centre opened in 1967 under the directorship of Colm O'Briain, influenced by the multidisciplinary aspirations of Jim Fitzgerald, and with Kane and McKenna as founding members, Group 65 was disbanded. Kane, McKenna and Behan continued their critique of the AC/ACE for what they perceived to be its neglect of Irish artists and Irish subjects in favour of bland international abstraction. They were joined in their campaign for reform of the Council by critics Bruce Arnold and Tony Butler, who called attention to the Council's failure to support emerging artists while buying multiple copies of work by a handful of established figures.

Kane and the artist Ruth Brandt (1936–89) were married in 1961, and in 1972 he founded the magazine *Structure* [94] of which he was also editor. *Structure* ran from 1972 to 1978, through ten editions, and combined art, literature and thought in one magazine. As Kane said, 'I found that most art magazines were pretentious rubbish and most literary magazines were written by people who were blind.' (Sharpe, p. 54) Kane, as editor, was forthright in his critique of Irish tendencies to favour the rural at the expense of the city and to denigrate intellectual discussion, saying that 'the majority of artists in Ireland are afraid to be intelligent'. An outstanding feature of the magazine was the woodcuts, many of them by Kane and Brandt, contained in every issue, while other contributors included McKenna, Anthony Cronin, Alice Hanratty and, retrospectively, Gerard Dillon (qv). Kane's poem 'Boglandia' proffered a blistering attack on the Irish art elite, and especially on the institutions of the AC/ACE and the RHA. That combined interest in poetry and graphic imagery has been sustained throughout his career, and was a feature of the 2006 publication *Michael Kane: If it is True, 1-XX* and his many fine book covers for the Gallery Press.

Never one to compromise his views, Kane resigned from the committee of *Rosc '84* (see 'Rosc Exhibitions') following a disagreement with Michael Scott over the selection of Irish artists. He later served as a member of the board of IMMA (2001–03), a position from which he also resigned. A 1996 retrospective at the RHA coincided with a solo exhibition at IMMA.

Kane's paintings and graphic works are characterized by a primitive, honest quality, and by a robust sense of defiance, something that was obvious in his first solo exhibition when he sought to express the spirituality of atheism, and in paintings such as *The Funeral of Harry Kane* (the artist's father). Executed in 1966, the painting shows a coffin carried in a child's pram and flanked by four Union Jack flags, a particularly challenging combination of elements in the year of the fiftieth anniversary of the Easter Rising. Later bodies of work, predominantly paintings and woodcuts, explore the underbelly of the city, sparing nothing of the seamier but vital aspects of modern urban life. While there is always a political edge to his work, Kane has said, 'I abhor issue-based art' (interview with Kissane, p. 22).

Among the public collections to include his work are IMMA, HL, RHA, CIAS, TCD, OPW, the Abbey Theatre and

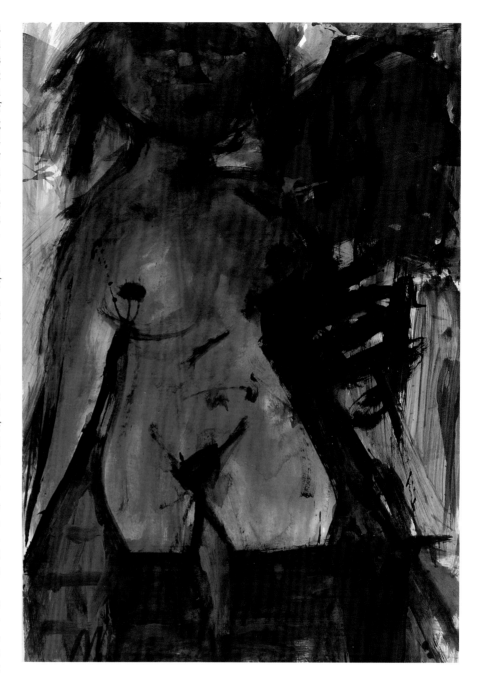

the Gulbenkian Foundation, Lisbon. Kane is married to the prize-winning architect Shelley McNamara.

CATHERINE MARSHALL

253. Michael Kane, *The Blue Nymph*, 1991, acrylic on paper, 113.5 x 79 cm, Butler Gallery

SELECTED READING Henry Sharpe, *Michael Kane: His Life and Art* (Dublin 1983); Brian McAvera, 'A Robust Grace', *IAR*, XXI (Winter 2004), 72–79; Iseult Dunne and Josephine Kelliher (eds), *Michael Kane – A Monograph*, exh. cat. Rubicon Gallery (Dublin 2008); Michael Kane, *Life Story* (Kinsale 2011).

KEATING, SEÁN (1889–1977), painter. By the time Seán Keating died in 1977, he had become one of the best-known and most controversial artists of twentieth-century Ireland. Strong-minded, opinionated and unashamedly outspoken, Keating became known as the 'official' artist to the Irish Free State, owing to a series of politically nationalist paintings made between 1915 and 1924 (see 'Politics in Irish Art'), and for his visualization of the Shannon Scheme at Ardnacrusha between 1924 and 1929. His initial focus on the west of Ireland in general, and the Aran Islands in particular, was profoundly influenced by Thomas Davis, Douglas Hyde, John Millington Synge and his own belief in the necessity to establish a national identity (qv) for Ireland. Early works, such as *An Aran Fisherman and his Wife* and *Men of the West* (both painted in 1915 and in the HL), serve to locate both his vision of the west of Ireland and his adherence to violent separatist nationalism before the Civil War. But his idealism changed after 1923. As his frustration with his perceived failure of the promise of the War of Independence worsened over the years, Keating began to recast his formerly idealized vision of the west of Ireland to create socio-political critiques of the contemporary situation, clearly evident in, for example, *Ulysses in Connemara* (1947, private collection) and its pendant *Economic Pressure (or a bold peasant being destroyed)* (1949) [134]. Paintings of Aran fishermen sitting with their backs to the sea, or on the quayside, signal the economic reality associated with the collapse of the mackerel market in the 1930s.

Keating was born in Limerick city, the eldest of eleven children, seven of whom survived into adulthood. His father, Joseph, was a clerk and a 'religious sceptic' who did not 'fit into the local ecclesiastical structure' (Andy Bielenburg, *Limerick Leader*, 26 February 1972). Unsurprisingly, Keating was similarly sceptical of the religious and political classes, and this is acutely evident in several paintings, including the well-known *An Allegory* (1924, NGI collection) and the lesser known but extraordinarily disturbing image *Homo-Sapiens, an allegory of democracy* (1930, whereabouts unknown). While he had an innate facility for literature and languages, and became fluent in

254. Seán Keating, *Men of the South*, 1921–22, oil on canvas, 127 x 203.4 cm, Crawford Art Gallery

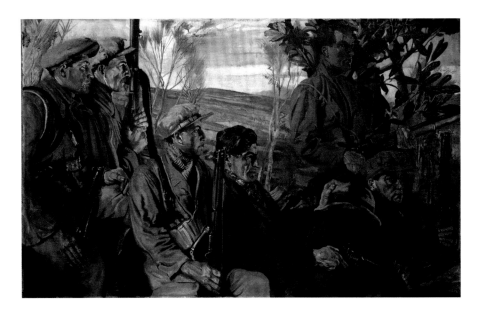

Latin, Irish and French, he left school, aged fifteen, in 1904. After three years idling, drawing and hunting, he enrolled with the Limerick Technical School of Science and Art to train as an artist and art teacher. *Early Self Portrait I* (1907–11, private collection), a technically naive oil study on canvas, is a rare example of Keating's work at this time which offers a clear indication of the aptitude for portraiture (qv) which was to blossom later. He won several awards while in Limerick, one of which offered him the opportunity for tuition at the DMSA during the summer of 1910. It was at this point that Keating met William Orpen (qv). The following year, possibly encouraged by Orpen, Keating successfully gained a scholarship to complete his training as an artist and art teacher at the DMSA.

Keating was taught by several well-respected members of staff at the DMSA. He received the first of numerous awards and commendations in 1912 for *The Dance* (1912, private collection), the only enamelled copper plaque he ever made, executed under the supervision of arts and crafts artist Oswald Reeves (1870–1967). The following year he made a stained-glass window under the guidance of Harry Clarke (qv). Keating was also taught mural painting by James Ward (1851–1924), a skill that was to prove vital to his economic survival: between 1931 and 1960 he received several important, but ephemeral, large-scale mural commissions, including schemes for the Irish Hospital Sweepstakes (1933/34), Michael Scott's architecturally Modernist but emblematically Irish 'Shamrock Pavilion' (World's Fair, New York, 1939), sets for Synge productions at the Abbey Theatre (1940–52), and a large-scale mural on the development of Irish industry for the International Labour Office in Geneva, now the World Trade Organization office, which is still *in situ* (1960).

Keating's best-known teacher was Orpen. Under his guidance, the young artist won the RDS Taylor Award in 1914 for *The Reconciliation* (private collection), a well-composed painting for which his siblings Mary Frances, Paul and Vera modelled. The prize money gave Keating the opportunity to move to London in 1915 to work for a year as studio assistant to Orpen, who had resigned from the DMSA and the RHA (qv) in 1914. Keating took up a part-time teaching position at the DMSA in 1919, and remained there until 1958. He taught in the manner of Orpen, for which he has been both damned and praised. His teaching methods were dictated by economic conditions: the school was seriously under-resourced, and, with no entrance examination until 1937 (when, as a result of the French Report, it became the NCA), it was seriously overcrowded. After 1937, frustrated by the continuing lack of resources at the NCA and the absence of governmental support for artists, Keating concentrated his attention on those who had talent; he had little time for those whom he felt did not. His persistent reliance on Orpen's artistic legacy has proven problematic and has ultimately complicated the assessment of his own work by critics and art historians.

Despite popular casting as the 'official' artist of the Irish Free State, Keating continually challenged this role and many, if not most, of his non-commissioned post-Civil War images can be read as allegorical critiques of various contemporary issues. On his return to Dublin from London in early 1916, he began a

series of paintings that illustrate both heroic idealism, evident in *Men of the South* [254], and the alienating reality of warfare, seen in *Ar a gCoimead* (1919, Bray Public Library) and *On the Run, War of Independence* (*c.* 1924, AIB). Similarly, while most of his work on the Shannon Scheme project demonstrates Keating's hope in the future of post-Civil War Ireland, paintings such as *Der Uberman* (1930, ESB) and *Bunkhouse at Ardnacrusha* (*c.* 1927, ESB) illustrate the harsher and more realistic side of life on the site. Continually sympathetic to nationalism and the Treaty of 1922, Keating's *An Allegory* (1924, NGI collection) was the point at which he visually declared his abhorrence of violence after the bloodshed of the Civil War. Yet he always maintained faith in the ordinary people of Ireland. Several paintings advertise his vision of the valiant types whom he believed could run the country, evident in images such as *Race of the Gael* (1927, private collection) and *The Tipperary Hurler* (1927, HL), and he preferred to use models whose identity contributed to the allegorical meanings in certain of his paintings.

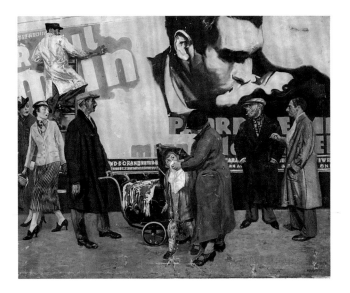

255. Seán Keating, *Sacred and Profane Love*, 1937, oil on canvas, 121 x 148.5 cm, private collection

Although largely self-censored, Keating was a socialist, and during a series of published articles (1924–71) and broadcasts with 2RN (later Radio Éireann) in the early 1930s he publicly berated the Irish government for failing to realize that artists were essential to society. He also castigated cultural 'elaborators' whom, he believed, were responsible for creating an 'artificial antithesis' between art and modern art, when it seemed to him that 'art was always modern in the sense that sincere artists were always experimenting' (Keating, 17–18). An admirer of Sergey Eisenstein, Keating's interest in the socio-political and intellectual possibilities offered by film was apparent in several broadcasts, yet the theme of *Sacred and Profane Love* (1937, private collection) [255] signalled his concern about the negative effects of consumerism and commercialism.

Keating's election as President of the RHA in March 1950 coincided with the formation of the CRC (1949) and the Arts Council (AC/ACE) (1951) (qv). The role put him in both an unenviable and invidious position of authority, which he did not relish. But, given his pragmatic and opinionated demeanour, Keating was the obvious choice to protect academic principles against government and AC/ACE support of abstract Modernism, although his reputation suffered terribly as a consequence. While he continually and controversially privileged academic art, [256] Keating was acutely aware of the shortcomings of the academic system in general and the RHA in particular. He was publicly critical of all institutions, including academies of art, which were founded as incubators of young talent. He firmly believed that they should be 'abolished after twenty-five years' so that they would not, instead, 'become refrigerators' (O'Connor, pp. 82–86).

Keating resigned as PRHA in 1962 in order to complete a major mural commission for the International Labour Office. It was acknowledged at the time of his death that he had been an 'outspoken advocate of a better position for the artist in Irish Society' (Kealy, p. 4). His career spanned seventy politically turbulent years which coincided with the birth and adolescence of the Irish Free State. For his ability to mirror and critique social and political issues and contemporary realism in all its fragmented manifestations, Keating was a painter of the modern.

His often contentious contribution to Irish cultural life epitomized the essential tension between tradition and modernity which was crucial to the development of a national post-colonial identity in the twentieth century.

Keating's work can be seen in the collections of the NGI, CAG, NMI, UCD, UM, LCGA, the Burns Library, Boston College, Glasgow Gallery of Art, the Irish College, Rome, and Oldham Gallery and Museum, UK. ÉIMEAR O'CONNOR

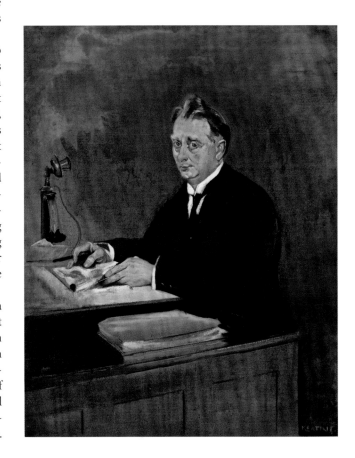

256. Seán Keating, *Portrait of President Cosgrave*, 1923, oil on canvas, 120 x 100 cm, private collection

257. John Kelly, *Drawing from the Heart Ward 2*, 2003, pencil on paper, 29.5 x 21 cm, private collection

SELECTED READING Seán Keating, 'Painting in Ireland Today', *The Bell* (December 1950), 17–18; Willie Kealy, 'Work and personality evoke many tributes – Keating – a portrait of the artist', *Irish Press* (22 December 1977); Andy Bielenberg, *The Shannon Scheme: The Electrification of the Irish Free State* (Dublin 2002); Éimear O'Connor (ed.), *Seán Keating in Context: Responses to Culture and Politics in Post-Civil War Ireland* (Dublin 2009).

KELLY, JOHN (1932–2006), painter, printmaker. John Kelly's was a forthright and courageous voice in the endeavour to change restrictive art practices in the 1960s and '70s, a period of great change in Irish art. His importance as an activist, teacher and facilitator for fellow and future artists equals that of his artwork. Born in Mountjoy Square, Dublin and educated at the Central Model School in Marlborough Street, Bolton Street College of Technology and NCA, he spent most of his working career, apart from one short period abroad, within a three-mile radius of his birthplace. Nevertheless, his contribution to Irish art was never limited by his geographic boundaries.

While his artwork secured him prizes at the Oireachtas, Cagnes-sur-Mer and the IELA (qv) (1980), and although he was one of the first artists to be given a solo exhibition at the recently established Hendriks Gallery in 1957, Kelly is at least as well remembered for his teaching at NCAD from 1977 until his retirement in 1997, for his work at Graphic Studio, Dublin where he served as a director for ten years, and for his role in the establishment of the Black Church Print Studio. In the 1960s, Kelly was a member of Group 65 and the Independent Artists. He was one of four artists, along with Michael Kane, Charles Cullen (qqv) and John Behan, to be invited by Colm Ó Briain and Jim Fitzgerald to show their work in the Gate Theatre in 1966, thus opening up new opportunities for collaborative rapport between writers and artists. One eventful outcome of this was the staging of the *Project Art Exhibition* in Abbey Street in 1967 and the establishment of the Project Arts Centre, the first such venue in Ireland. Kelly was an active player in these events, going on to serve on the board of the Project as well as that of the HL. In 1977 he was invited, with Barrie Cooke (qv) and Brian King, to select the work for the first EV+A exhibition in Limerick, since then a landmark in the Irish art calendar.

Kelly's artwork, influenced to some degree by the work of the American Abstract Expressionists which he saw at the *Johnson and Johnson Collection Exhibition* at the HL in 1964, reflects a deep spiritual connection to society. His early themes, as he described them, 'were rather hackneyed religious images' (Ryan, p. 62), but following a visit to Spain, where he shared accommodation with the singer Ronnie Drew, his vision changed and expanded. Subsequent bodies of work encompass the 'Troubles' (qv) in Northern Ireland and republicanism, to mark the bicentenary of the French Revolution at an exhibition at the Kerlin Gallery in 1989, and Joycean-inspired explorations of his native city. One of his final subjects – drawings completed while seriously ill in the intensive care unit in Dublin's Mater Hospital – was a series of self-portraits, courageously using his own imminent death as the subject [257]. He frequently combined text with visual imagery, hardly surprising since he had a

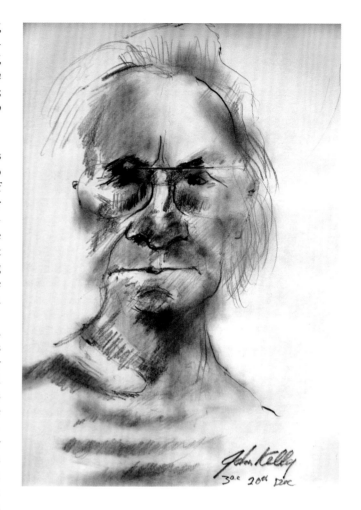

successful play, *The Third Day*, presented at the Gate Theatre in 1961, for which he also designed the sets.

Kelly was commissioned to design a number of stained-glass windows in County Cavan and Northern Ireland, and he also designed sets for the Abbey, Gaiety and Gate theatres. His work can be seen in the collections of IMMA, OPW, NSPC in the UL, and in many private collections. In 1985 Kelly was given an Arts Council (qv) touring exhibition and was elected to the RHA (qv) in 1991 and to Aosdána (qv) five years later.
CATHERINE MARSHALL

SELECTED READING Gerry Walker, *John Kelly RHA*, exh. cat. Hallward Gallery (Dublin 1996); Ryan, 2006, pp. 46–88; Lalor, 2011, pp. 113–16.

KERNOFF, HARRY (1900–74) [258], painter. A dedicated and sympathetic chronicler of working-class life in Dublin, Kernoff enjoyed popular success in the 1920s and '30s; however, in the post-war years his strongly held socialist ideals resulted in him gradually becoming marginalized in the Irish art world. After his death there was a revival of interest in his work. Kernoff's depictions of street scenes and pubs are, in many ways, equivalent to the work of L.S. Lowry. However, his street scenes are livelier than those of Lowry; they bustle

with animated and cheerful pedestrians, while his pub interiors record famous literary haunts.

Born in London, into a Jewish family from Belarus, Harry Aaron Kernoff was one of five children of cabinet-maker Isaac Kernoff (or Kournoff) and his wife Katherine. In April 1914 the Kernoffs moved from Stepney to Dublin, where Isaac joined the firm of Louis Gurevich, also from Belarus, who had a business at 101 Capel Street (Milligan, 2010, p. 2). The family settled in 13 Stamer Street, in Dublin's Jewish quarter, where Kernoff would live and work for the rest of his life. While serving apprenticeships with their father, Kernoff and his brother Hyman enrolled in evening classes at the DMSA in 1919. Four years later, a Taylor Scholarship worth £50 enabled him to visit Paris and become a full-time student at the DMSA, where his tutors included Seán Keating, Patrick Tuohy and Harry Clarke (qqv). Kernoff's first exhibition was held at 7 St Stephen's Green, in April 1926, and over the following two decades he showed frequently, both in one-person exhibitions in Dublin and London, and also at the RHA (qv). He exhibited with the SDP in 1930, 1932 and 1934, with the WSI during the same period, and at the Oireachtas exhibitions of 1932 and 1944.

A member of the Friends of Soviet Russia, Kernoff remained deeply interested in political developments in his parents' homeland. Folios of drawings he made during a Friends' visit to the USSR in 1930 are preserved in the NGI, while his diaries of his travels are in the NLI. During the trip, he visited a workers' club in Moscow where artists of the Association of the Artists of the Revolution (AKhR) were painting a mural. On his return to Ireland, seven of Kernoff's works, including a view of a Labour Party meeting, were reproduced in the November 1930 issue of *Iskusstvo v massy* (Art to the Masses), the journal of the AKhR. In Dublin, through the Radical Club of which he was a member, Kernoff organized an exhibition of Soviet posters, which was held at the Daniel Egan Gallery. An account of his visit to the Soviet Union was published in the Labour Party newspaper, *The Watchword*.

In Dublin, Kernoff's socialist principles found expression in paintings and drawings documenting poverty and deprivation, as in his pastel *Misery Hill* (1936, private collection). In

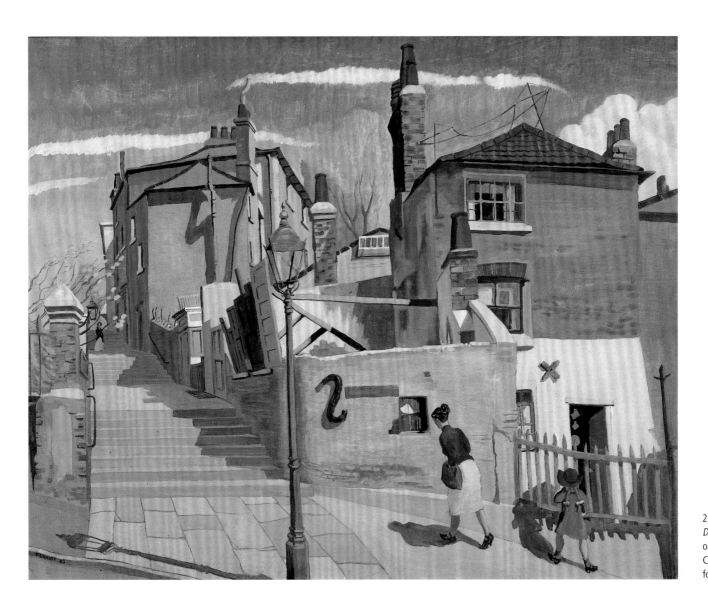

258. Harry Kernoff, *Sunny Day, Dublin*, 1943, oil on board, 60 x 75 cm, Crawford Art Gallery, formerly AIB Collection

1939 he travelled to New York with Maurice MacGonigal (qv) to paint a mural for the Irish Pavilion at the New York World's Fair. During this trip he painted *Yonah Shimmel's Knish Bakery* (private collection), a Jewish bakery that still survives on Houston Street, New York. Kernoff's paintings of Dublin include *Winetavern Street* (1936, HL), *The Forty Foot, Sandycove* (1940, CAG) and *Forbes Street, On the Dublin Quays* (1945, a sketch for which is in the NGI collection), a dockland view that again underlines his interest in working-class Dublin. This is reflected also in works such as *Labour Meeting* (1954) and *James Larkin addressing a crowd at Bolands Mill, Dublin* (date unknown).

While Kernoff made painting trips to the west of Ireland, the majority of his work depicts the city and suburbs of Dublin. He had two exhibitions at the Victor Waddington Gallery, in 1936 and 1937. Elected a member of the RHA in 1935, he submitted works almost annually to the Academy for the rest of his life. Three books featuring his woodcut prints were published, the first appearing in 1942 followed by *12 Woodcuts* in 1944 and *36 Woodcuts* in 1951. However, with sales of his work intermittent, Kernoff struggled to make a living, designing sets and costumes for Dublin theatre productions and selling woodcuts individually. He lobbied for improvements in art education in Ireland, and for increased state support for practicing artists, but these efforts, while appreciated by radical politicians such as Seán Moylan, were largely ignored. Among his most popular paintings are those evoking Dublin's literary pub life, such as *In Davy's Back Snug* (1936, private collection), *Davy Byrne's Pub, from the Bailey* (1941, NGI collection), *A Bird Never Flew on One Wing* (1947, private collection) and *The Twins (There's Only a Few of Us Left)* (c. 1935, private collection). As Kathryn Milligan has pointed out, these paintings consciously evoke the literary world of Joyce's *Ulysses*. Kernoff's portrait of the poet and labour supporter F.R. Higgins (1928, CAG) depicts a fellow habitué of the Palace Bar in Fleet Street.

A retrospective exhibition of Kernoff's work was held at the HL in 1976. His work can be found in the collections of the NGI, HL and CAG. PETER MURRAY

SELECTED READING Kathryn Milligan, 'Irish, mostly': A Thematic Exploration into the Art of Harry Kernoff RHA (1900–1974), MPhil thesis (TRIARC, TCD, Dublin 2010); Kathryn Milligan, 'Dear Dirty Dublin: Representations of the City in the Art of Harry Kernoff RHA (1900–1974)', *Artefact*, no. 5 (2011); Elaine Sisson, 'Experimentalism and the Irish Stage', in King and Sisson, 2011, pp. 39–58; Kevin O'Connor, Harry Kernoff, *The Little Genius* (Dublin 2012).

KIELY, BERNADETTE (b. 1958) [259], painter. Bernadette Kiely studied graphic design at the Waterford School of Art and received no formal training as a painter, but was greatly encouraged, informally, by her one-time neighbour in Thomastown, Co. Kilkenny, the painter Barrie Cooke (qv). Born in Clonmel, and reared in Carrick-on-Suir, Co. Tipperary, Kiely has always lived and worked in rural Ireland, and is fascinated by the ecology of the country, usually the relatively settled area around her home, but also the wilder, less habitable landscape of County Mayo where she has spent a number of artist's residencies.

Kiely draws and paints the landscape (qv), spanning the whole range of painterly technique from impasto paint, sometimes with wax ironed into it, to more delicate application with the paint almost poured on in thin washes, pushing charcoal dust in its wake to great effect.

Where other artists are concerned with topography and place, Kiely is more interested in the forces at work in nature, particularly the four essential elements earth, air, fire, and water and their interaction. As she said: 'I've read books about weather and understood what I was reading at the time, but then I look at the sky and I can't grasp the science any longer.' (conversation with the author, January 2000)

Changes in the landscape over time, as evidenced, for example, in the geology of the Céide Fields and other areas of the Mayo coast, feature in her work, as do the more immediate environmental changes resulting from global warming. While these reveal themselves more obviously in relation to earth and water, she has also painted a field of straw bales on fire, capturing the incredible drama with speed and replicating the fire's implacable energy. Although rooted in figuration, her paintings, especially her *Moon River Sky* paintings (1999/2000), could almost be read as abstract.

Bernadette Kiely's paintings are to be found in the collections of the Arts Council (qv), OPW, AIB and CIAS and are eagerly sought after by private collectors. She is a member of Aosdána (qv) and has been a regular exhibitor at the RHA (qv). CATHERINE MARSHALL

SELECTED READING Catherine Marshall, *Moon River Sky*, exh. cat. Taylor Galleries (Dublin 2000); Aidan Dunne, *Profile 15 – Bernadette Kiely* (Kinsale 2002); Kevin Whelan, 'Layers in the Landscape', in *The Pollen Record*, exh. cat. Claremorris Gallery (Mayo 2008).

259. Bernadette Kiely, *Haystacks Burning – Marina's Field*, 1999–2000, oil, feather and metal on canvas, 100 x 120 cm, Office of Public Works

KINDNESS, JOHN (b. 1951) (qv *AAI* III), artist. Kindness was the son of a 'driller' in the shipyards of his native Belfast. His sympathy with working-class cultures, and his interest in social issues, were thrown into sharp focus by the 'Troubles' (qv). This led him to question the education he had received in the Belfast College of Art, and the social role of art. Keenly aware from the outset of the divisiveness inherent in the presentation of art in museums and galleries, Kindness set out to develop forms of practice that could engage across social barriers. As he remarked in 1994, 'Social change required a more immediate art form I became interested in print media ...' (Ziff, p. 71). After graduation in 1974, Kindness worked in a graphic design studio and, along with other cartoonists, became involved with *The People's Comic*. Throughout the 1970s and '80s, he produced artwork in a variety of media and, more importantly, strove to make it distributable to publics beyond the gallery. His newsprint series, commenting on everything from capitalism to Irish attitudes to unmarried motherhood, was made up of posters based on newspaper headlines. Spread over a period of fourteen days, the posters were distributed in newspaper outlets, and thus, like Kindness's billboard art in Dublin and Belfast, sidestepped the usual channels for visual art, going straight to the wider public domain. Mosaics and frescoes offered him another way of creating artwork in public spaces that were at once popular, historically validated and which offered more longevity than newsprint.

Since the 1980s, Kindness has raised issues of identity, sectarianism, globalization and destruction of the environment through painting, etching, mosaic, fresco and sculpture. Perhaps his most well-known venture into sculpture and etching has been his use of discarded bodywork from New York taxis, on to which he etched images of contemporary life, parodying the arcadian dreams represented on ancient Greek vases (1991) [260]. Other witty but unusual practices include creating an Irish harp out of toy turtles to make a *Ninja Turtle Harp* (1991), and his *Sectarian Armour* of 1995, now in the Imperial War Museum, London, in which a metal jacket is etched with images to represent the Catholic, nationalist tradition on one side and the Protestant, loyalist one on the other. Common elements in all these projects are his combining an older, 'fine art' tradition with popular culture, along with his personal wit and sophistication. Since 2000, Kindness has completed a public artwork at Ballymun, Dublin, entitled *Sisters*, in which Renaissance portraiture is sifted through the filter of popular fashion. He has also collaborated on an opera in Belfast with writer Wendy Steiner and animator Joshua Mosley.

Kindness has been awarded residencies at PS1 in New York (1989/90), and in the British School in Rome (2001). As well as showing his work in solo exhibitions, he has been included in a number of group exhibitions of contemporary Irish art, notably *Divisions, Crossroads, Turns of Mind*, curated by the American critic Lucy Lippard, which toured in the USA and Canada in 1985/86, *Directions Out*, curated by Brian McAvera and shown at the DHG in 1987, *Irish Art of the Eighties*, at the same gallery three years later, *In a State*, curated by Jobst Graeve and shown at Kilmainham Gaol in 1991, and *Distant Relations*, curated by Trisha Ziff, which toured to Birmingham, London, Dublin,

260. John Kindness, *Dulce et Decorum est...*, 1990, taxi cab fragment, etched painted steel, 153 x 163 cm, Irish Museum of Modern Art

California and Mexico in 1995–97. Kindness was also represented in the exhibition, *Views from an Island*, curated by Catherine Marshall and Richard Wakely, shown at museums in Beijing and Shanghai in 2004.

His work is in the collections of the Victoria and Albert Museum and the Imperial War Museum in London, the Museum of Fine Art, Boston, the British Council, IMMA, UM and the UL. CATHERINE MARSHALL

SELECTED READING John Carson, *John Kindness*, exh. cat. DHG (Dublin 1990); Ziff, 1995; Marianne O'Kane, 'John Kindness: Rewriting Art History', *IAR* (Autumn 2006), 58–59.

KING, CECIL (1921–86), painter. Born in Rathdrum, Co. Wicklow, Cecil King attended the Church of Ireland Ranelagh School in Athlone, and Mountjoy School in Dublin. In common with other Irish artists of his generation, such as Thurloe Conolly, Louis le Brocquy (qqv) and Brian Boydell, King grew up during the depressed years of the 1930s, and was obliged to become something of a polymath, combining earning a living with pursuing his extensive cultural interests. Also, like Conolly, le Brocquy and Boydell, King was largely self-taught as an artist, acquiring his training through reading, discussions and visits to museums and galleries, rather than attending art college. On leaving school, King worked for W & S Magowan in Dundalk, a printing firm, of which he later became a director. In his spare time he was involved in theatre, art and other cultural activities, and was a pioneer of youth hostelling. King was thirty-three years old before he decided to take up painting seriously.

Having received some training and encouragement from Barbara Warren and Nevill Johnson (qqv), his work was shown at the IELA (qv) from 1956 onwards. In 1957 King painted *Ringsend Morning* (private collection) and *Evening Ringsend*, the earliest works to be included in a retrospective exhibition, held a quarter of a century later at the HL. His first solo show at the

261. Cecil King, *Berlin Suite I*, 1970, 3-colour screenprint on paper, 1/6, 54 x 41 cm, Dublin City Gallery The Hugh Lane

Hendriks Gallery, Dublin was held in 1959, and included paintings of nocturnal scenes and figures shrouded in mist. Two years later, he designed stage sets for the Irish National Ballet Company's production of *Les Sylphides* at the Abbey Theatre. It was not until 1964 that King felt confident enough to retire from his career in commercial printing and become a full-time artist. A founder member of the Rosc committee in 1966, he remained involved in the organization of Rosc exhibitions (qv) over the following two decades.

Throughout the 1970s and '80s, King's paintings and prints were shown in a wide variety of exhibitions in Ireland and Europe. Beginning in 1979, a number of books of poetry illustrated with his paintings were published by Editions Monica Beck. These included editions of Seamus Heaney, published in 1979, and of Micheal O'Siadhail and Thomas Kinsella, published two years later. Original silkscreen prints by King were also produced by Editions Alecto of London. His retrospective exhibition at the HL in 1981 included over eighty paintings, pastel drawings, tapestries and prints.

From the late 1960s onwards, King rarely deviated from a visual vocabulary of subdued colours and precise, formal compositions based on obtuse angles frequently employing a geometric 'U'-shaped motif. This motif varies slightly from one work to the next, in much the same way as composers create variations on a theme. King generally worked in sequences, or series, of paintings and prints. His *Berlin Suite I* (1970) [261] is a characteristically austere formalist work, while *Easter* (1974, IMMA collection) is more colourful, with a red rectangle surrounded by a geometric band of red, on a dark background. *Link* (1976, IMMA collection) resembles a diagram showing a beam of light passing through a lens. Unlike Micheal Farrell, Patrick Scott (qqv) and Eric van der Grijn, King's artworks are generally modest in scale, although his tapestry at the NUI Galway, *Untitled* (1974), measuring over four by two metres, is a confident essay in geometric abstraction. More than any other Irish painter of the mid-twentieth century, King's approach to art evokes the high-minded austerity of Albers, Piet Mondrian and other artists associated with movements such as the Bauhaus and De Stijl that flourished in the 1920s. The geometric rigor of Albers, his formalist paintings employing a language of squares within squares, is echoed in King's elegant compositions, as is Albers' almost scientific exploration of colour theory.

Although apparently simple, King's abstract paintings and prints (see 'Abstraction') are disciplined formalist exercises in which elements such as colour are allocated a primary role, and there is no attempt to create any sort of emotional narrative. This, however, does not result in paintings that are cold or lacking in humanity; King clearly revelled in working within a finely tuned aesthetic environment, using the language of colour, shape and line with confidence and skill. His paintings and silkscreen prints may employ a restricted vocabulary, but with the availability of the full chromatic range, employed within a framework of Euclidian geometry, he had ample means to make formalist explorations that reflect the discipline of experimental sciences as much as they do developments in art in the twentieth century. Much of King's quasi scientific interest in colour sprang from his twenty or so years spent with the printing firm in Dundalk, where he was in daily contact with the technology of printing inks and dyes. If there is a spiritual quality to King's art, this was not emphasized by the artist himself, and yet the rigour with which he approached painting and printmaking (qv) suggests a philosophical neo-platonic underpinning, such as that provided to Piet Mondrian by the writer M.H.J. Schoenmaeker. However, notwithstanding his considerable achievements as an artist, there is also no escaping the fact that while Mondrian and Albers in the 1920s had been creating art of the future, by the time King came to take up painting full-time in 1964, he could not be considered to be an avant-garde artist, but instead was refining and perfecting a minimalist approach that had been developed almost half a century before. PETER MURRAY

SELECTED READING *Cecil King Retrospective*, exh. cat. HL (Dublin 1981); Seán Kissane, Medh Ruane and Richard Demarco, *Cecil King: A Legacy of Painting*, exh. cat. IMMA (Dublin 2008).

LAMB, CHARLES (1893–1964), painter, illustrator. Charles Vincent Lamb was born in Portadown, Co. Armagh, and worked with his father, John Lamb, a painter and decorator. He showed an aptitude for art at Portadown Technical College, and in 1913 won the Decorator's Guild gold medal for best apprentice house-painter. He attended evening classes at Belfast School of Art.

In 1917 he was awarded a scholarship to the DMSA, where he won several medals and his Art Teachers Certificate in 1922. Lamb focused on work, while fellow students and teachers got involved in the political ferment of the War of Independence. Teachers James Sleator, Margaret Clarke, Patrick Tuohy and Seán Keating (qqv) transmitted to him the academic Realism (qv) of William Orpen (qv). *Country People at Prayer* (1919, LCGA) is an early academic work that illustrates Lamb's interest in rural lifestyles. The poet Padraic Ó Conaire encouraged Lamb to paint the landscape (qv) of Connemara.

Lamb exhibited at the RHA (qv) regularly from 1919 to 1964. In 1923 he became an ARHA and a full RHA member in 1939. His growing skill at portraiture is evident in *A Lough Neagh Fisherman* (1920, UM), demonstrating the reflected light

that was characteristic of Orpen. His masterpiece, *Dancing at a Northern Crossroads* (1920, private collection), shows the artist's understanding of complex figurative groups, combined with his grasp of western rural customs. In 1923 he exhibited at the Dublin Painters' Gallery where he met Katharine Madox Heuffer, daughter of the writer Ford Madox Ford, whom he married in 1928. In 1926/27, following the pattern of other Irish artists, Lamb visited Brittany, where he painted landscapes and subject pictures before settling in the Irish-speaking district of Carraroe, in Connemara.

Lamb spent a winter in Germany just before World War II and travelled around Ireland in a caravan sketching. From 1936, he held an annual exhibition and summer school at his house and studio in Carraroe.

Lamb's early promise was sustained notably in *The Quaint Couple* [262], which showed a poor but dignified couple from the Gaeltacht in a form of heroic portraiture at which Lamb excelled. In 1934, commissioned by the Haverty Trust to paint *A Pattern Day in Connemara*, for the NUI Galway, he used the large canvas to express an abstracted view of ancient local

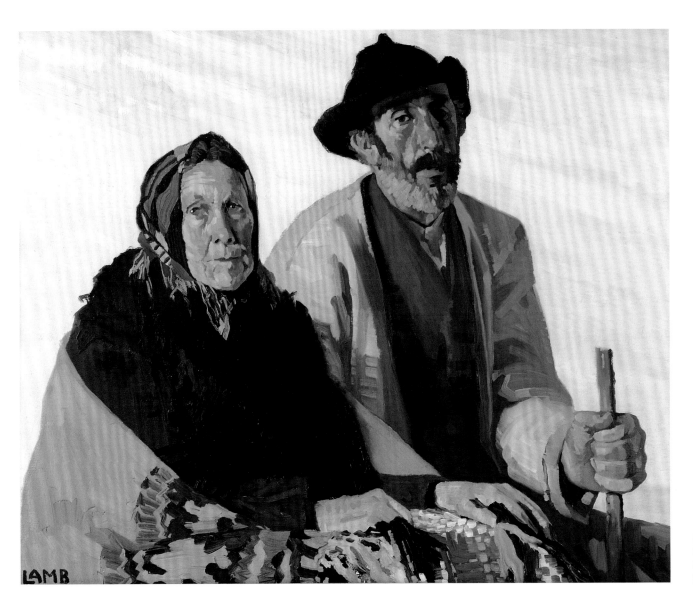

262. Charles Lamb, *The Quaint Couple*, 1930, oil on canvas, 61 x 73 cm, Crawford Art Gallery

rituals, simplifying forms to convey the immediacy of the moment. Another genre work, *Gathering Seaweed* (1944, HL), is a typical quayside scene. His painting *A Connemara Woman Knitting* was exhibited at the RA, London (1936). As Lamb's reputation increased, his work was shown in Ireland, Belgium, Britain and the USA.

Lamb was a prolific painter of modest-scale landscapes and subject pictures, but he avoided large figurative work because there was no market for it, especially during World War II. He exhibited at all the major venues in Ireland and won the Tailteann silver medal in 1924. His skill as an illustrator was used by writers such as Mairtín Ó Cadhain in *Cré na Cille* (1949) and Sean Ó Coisdealbha in *An Tincéra Buí* (1962).

Lamb's observations of Connemara and its people have become a valuable record of a changing world. He was not interested in Modernism (qv), spending the majority of his career painting and teaching in Carraroe. His finest work is considered to be from the early part of his career, although his mature landscapes remain popular.

Charles Lamb was one of a group of Irish artists – Paul Henry, Seán Keating, Maurice MacGonigal and Gerard Dillon (qqv) – who found their inspiration in the west of Ireland. He died in 1964 and was buried at Barr an Doire, Carraroe, Co. Galway. In 1969 a retrospective exhibition of his work was held at the HL in Dublin. MARIE BOURKE

SELECTED READING *Charles Lamb Memorial Exhibition*, exh. cat. HL (Dublin 1969); Maire Bourke, 'Charles Lamb and National Identity', *History Ireland*, VIII, no. 1 (2000), 30–34; Maire Bourke, 'A Growing Sense of National Identity in the Visual Arts in the Early Twentieth Century', in Garnham and Jeffrey, 2005; Rooney, 2006.

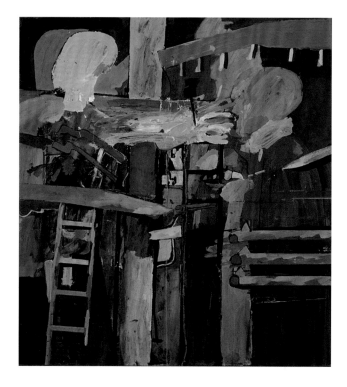

263. Gene Lambert, *Figures 1, c.* 1981, mixed media, 86 x 80 cm, Arts Council/An Chomhairle Ealaíon

LAMBERT, GENE (b. 1952) [263], painter. Gene Lambert was born into a family of famed puppeteers. His studies at NCAD coincided with a student revolt there in the early 1970s against the *beaux arts* method of teaching. He became known as a painter and printmaker, winning prizes at the Claremorris National Art Exhibition in 1979 and the Carroll's Award at the IELA (qv) in 1981.

In 1982 Lambert was seriously injured by a car, while walking along a footpath. He was to spend months in hospital and was left with a dependency on walking aids. He embarked upon a series of paintings based on his time in hospital. Bed ends, traction devices and the geometry of the ward were rendered in a tight tonal range with a chalky surface. These tough paintings, offering little redemption, were shown under the title *Work from a Ward* at the Lincoln Gallery, Dublin in the late 1980s (an important venue for expressive figurative work).

The experience of disability greatly affected Lambert's work and stimulated his political and organizational skills. He also began to educate himself in photography (qv), creating crisp black and white portraits. A suite of works entitled *Work from a Dark Room* (1985, IMMA collection) comprised portraits of people with disabilities and included those born with deformities caused by thalidomide, suffering from mental illness, or disabled through social marginalization. The work evoked the great spirit of dignity that the nineteenth-century photographer Edward S. Curtis brought to his portraits of Native Americans. The exhibition was shown at the DHG and Lambert used that platform to highlight the lack of facilities in public places for disabled people. That same year, Lambert received the *Sunday Tribune* Visual Artist of the Year award.

In the late 1980s, he brought his powers of persuasion and operational skills to bear on a mammoth project, *The Great Book of Ireland* [35, 46], inspired by illustrated manuscripts such as the Book of Durrow and the *Book of Kells*. With Theo Dorgan, who acted as his co-editor, Lambert wanted to create a contemporary chronicle exploiting the translucent qualities and historic associations of velum. Writers were invited to make a handwritten contribution on one side of the page to accompany a visual artwork on the other. It is a tribute to both Lambert and Dorgan that many of the most recognized Irish writers and artists were involved in the project. The book was launched in 1991 and has been widely shown in Ireland.

There is a consistently biographical strand running through Lambert's work. His solo exhibition at the RHA Gallagher Gallery in the late 1990s, *Playtime*, was a visual rumination on childhood, also reflected in his paintings for the artist's book *In the Land of Punt* in which he collaborated with the poet Paul Durcan.

Over the past decade Lambert has continued to paint, though confining his output to a few works a year. His brushwork is ridged and flowing, defining crowds or individuals loosely and in an unmistakable muted tonality. He is a full member of the RHA (qv) and exhibits annually at the *Summer Exhibition*. He is a member of Aosdána (qv) and in 1999 was appointed to the National Disability Authority. His work is in the collections of IMMA and the HL. PATRICK T. MURPHY

SELECTED READING Gene Lambert, *Work from a Dark Room*, exh. cat. DHG (Dublin 1985).

LANDSCAPE (see *AAI* II, Irish Landscape).

Imaging Irish landscape: motivation and meaning

'In the popular mind, painting equals landscape.' (Sarah Browne, 'Suburban Landscapes', *Circa*, no. 109, 2004, 33–37, 33) Introducing her article on the type of art to be found on the walls of suburban domestic homes, this comment by artist Sarah Browne indicates something of the choice of image that dominates popular taste. Her observation bears out David Brett's proposal in a seminal text on landscape painting in Ireland: 'it is a fair bet that of ten commercial reproductions sold, eight will be of "scenes" ' (Brett, 'The Land and Landscape', *Circa*, no. 43, 1989, 14–18, 14). This subject preference holds true in many institutional collections also; it has been identified, for example, that landscape is the predominant theme in the art collection of the Office of Public Works (OPW) which is dedicated to work by Irish artists (Y. Scott, 2006, pp. vii–xiv, xi).

The representation of landscape is significant in many, if not most, cultures and is certainly the case in Ireland. This focus might be expected given the nature of the country's history and geography: its island status, unsettled climate and varying topography; its much vaunted aesthetic appeal and consequent relative dependence on tourism; its traditionally agricultural economy and rural society; the dramatic history of catastrophic crop failure; its colonization, subsequent independence and contested border, and the shifting migration patterns within and beyond its boundaries. These have collectively conspired to focus attention on the physical external environment, on the land and landscape, and man's interaction with it, providing a significant range of thematic issues for representation within the genre. These have been availed of to a greater or lesser extent, and with shifting emphases, throughout the twentieth century.

Landscape's popularity in these contexts can be explained also in aesthetic and practical terms because, as a general rule, most landscape imagery tends to be, at least superficially, relatively pleasing and accessible, if often somewhat anodyne. However, the benign reputation of landscape imagery generally may belie, first, some of the starker realities underlying the history and cultural geography of the land it represents, and second, the body of work that confronts those elements that are less decorative and seductive. It is notable that most artists in Ireland have painted the landscape at some point, including those with a reputation for the most challenging and uncompromising imagery. In any case, it is argued here, all landscape representation, however seemingly bland and unassuming, embodies an agenda whose origins or motivations may be at odds with the seductive nature of the image.

While Irish landscape is particularly loaded with its own iconographic and semiotic import, exacerbated by the established tradition of dwelling on its history, it has to be acknowledged that the example of other cultures in landscape representation has been a significant factor in certain respects. The idea of painting images of the landscape was, after all, initially imported and, while adapted to incorporate local tastes and interests as these changed over time, it has often been with an eye on practices elsewhere, including in the context of imagery intended to be, and interpreted as, quintessentially Irish. Cottage landscapes, for example, feature prominently in western art from the nineteenth century, not only in Ireland.

The meaning and the role of landscape as a general concept, and in visual art, has changed radically in the last hundred years. Commonly defined as an expanse of scenery that can be observed in a single view, the genre typically refers to outdoor scenes incorporating an established array of obvious elements – trees, mountains, rivers, sky and so forth. While commonly associated with nature, landscape imagery in practice incorporates man-made elements too. Patrick Duffy makes this point in his introduction to his cultural geography of Irish landscape: 'In the strict meaning of the word, landscape is the natural environment, acted upon and fashioned by the economic, cultural and social practices of humanity in the past.' (Duffy, p. 15) The twentieth century introduced challenges and ambiguities that have upset the established notions of what landscape can mean, and towards the end of the century new terms, like 'space and place', came into play which recognize the impact of fields of enquiry that facilitate interpretation in social and philosophical terms, and such transitions across the century form the basis of this essay. It is through such associations that landscape plays a crucial role in, for example, the formation of identity and the associated issues of politicization.

Landscape and identity

Perceptions of Irish landscape have been coloured by a colonial history, and while this by no means provides the only set of motivations, it captured the imaginations of artists, particularly in the first half of the twentieth century. 'Identity politics' is based in a sense of belonging either to an identifiable group of people or to a place. It is on such terms of blood or soil that nationality and, consequently, national identity are assigned, and similar relationships of belonging occur at local and regional levels. The politics of landscape refer on one level to issues of entitlement, a term that encompasses the range from personal ownership of tracts of land to sovereignty with respect to an entire state. Entitlement – and the associated power it wields – confers rights of access. It has been widely recognized also that depiction of landscape has often been at the behest of those with control over it, in order to reinforce claims to entitlement. This has been the tradition in the past both of landowners (hence the popularity of 'portraits' of great houses and demesnes) and of those seeking to assert claims to, or to maintain, territorial sovereignty (giving rise to a nationalistic stereotyping of landscape).

For such reasons, imagery involving boundaries as well as cartographic idioms, whose functions include defining the fields and borders of possession, have played a role in the interpretation of landscape. Access to land is, obviously, vital for the basic essentials of sustenance and shelter. While the work of Maria Simonds-Gooding (qv) [264] belongs to the latter half of the twentieth century, and therefore late in art historical chronology of the genre, its themes and methods of expression, it is relevant as a point of departure. Bordering on abstraction (qv), Simonds-Gooding's spare, restrained aesthetic has been prompted by the

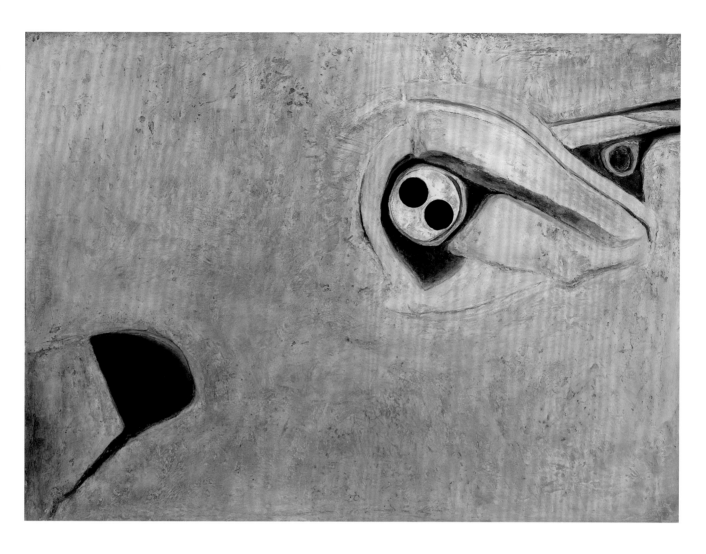

264. Maria Simonds-Gooding, *Habitation*, 1970, plaster, collage, oil, 106.7 x 147.3 cm, Irish Museum of Modern Art

challenging environments she witnessed in parts of India, Africa and the west of Ireland. She has observed that in such places, even the basic units of agricultural production – fields – have to be painstakingly made to garner and protect the thin soil needed to grow crops. The simple shelters and the vital waterholes, together with their protective and excluding fences, are indicated in her work in a few calligraphic lines inscribed in the undulating plaster surfaces that typify her work. The symbolic forms of her representations imply the resilience and determination that accompany the existences to which she alludes, but they also incorporate protective and excluding boundaries that represent the most basic level of border politics: the defence of the homestead. While Simonds-Gooding does not see herself as a political artist, and her work is not generally included in such analyses, the essentials of survival that she inscribes, and the consequences of their denial, resonate significantly both within and beyond traditions of Irish history and culture, and the experiences are shared across time and place.

Such boundaries provide the structural logic of Gerard Dillon's (qv) *The Little Green Fields* [265]. A faux naïve work that incorporates icons of Irishness – including Celtic crosses and thatched cottages – within a network of fields, it alludes to the landscape of the Aran Islands where Dillon lived for a while, on Inis Oírr. The ubiquitous dry-stone walls depicted were constructed as a means of clearing the land of stones as well as providing field demarcations. Quaint though it appears, with the barefoot boy engaged in the basic labours of cottage farming and a young man planting seed potatoes, the image references one of the factors dogging Irish agriculture in the past – the prevalence of small-holdings whose viability was constantly in question, and where few crops and livestock could thrive. As elsewhere across Europe, such a subsistence lifestyle was projected in romanticized, nationalistic terms as typifying the 'real' Ireland, at least until mid-century, promoting an image connecting the people to the landscape, and exploited in the tourist literature of the time.

Access to land was projected also at an emotional level for the sense of community and identity. It is primarily at this level that those images more commonly referred to in political terms emerged – by artists like Paul Henry, Jack B. Yeats, Charles Lamb, Seán Keating (qqv) and others, mainly during the first half of the century. While artists often treat landscape as a background to human activities, and subordinate to them, as in the case of Yeats and Keating, Henry communicated primarily through the image of the land itself. However, his work is not about the landscape for its own sake, or about nature, but

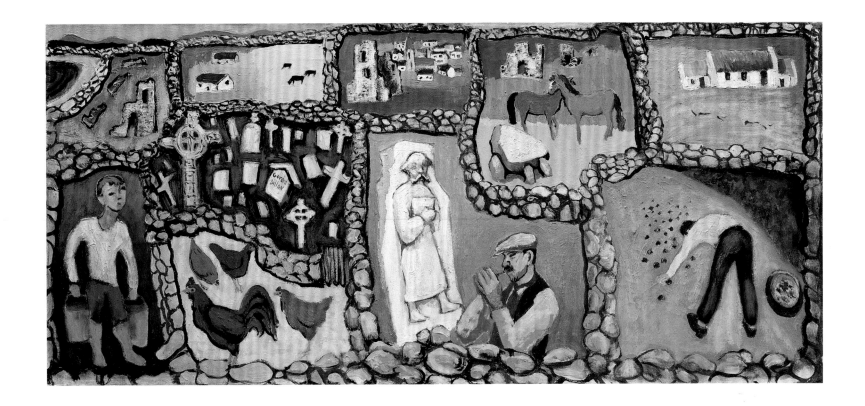

fundamentally about the social interaction with an environment intended to be read as identifiably Irish. While, by the 1920s, Henry's stoical, monumental peasants had been removed from the scenery, evidence of their presence remained in the omnipresent cottages and turf stacks. In such works, aesthetic politics come into play and Henry was arguably the most significant in establishing a style of landscape with which a concept of nation could be identified, notwithstanding the ambiguity of his position on nationalism (Paul Henry, *Further Reminiscences*, Belfast 1973, p. 63). It is noteworthy, though, that at this time the western seaboard landscape was projected to characterize Ireland generally: not the west *of* Ireland so much as the west *as* Ireland. Henry's imagery was used more than any others to project Irishness in state and state-sponsored publications and publicity during the first half of the century, from the frontispiece for *Saorstát Eireann, Irish Free State Official Handbook* [266] to tourist board and airline posters, as well as to illustrate copious literature written for the armchair tourist. While the aims of nationalism and of tourism may be intended to serve different ends, their imaging is at times remarkably similar where both are dependent on a notion of an identifiable type that is distinct from elsewhere.

While Jack B. Yeats has similarly been celebrated as key in the construction and projection of Irish identity in art, he rarely presented landscapes independently from figures (human or animal) and, from the late 1920s onwards, as an Expressionist idiom increasingly predominated in his late work, the figures and their landscape environment were often indistinguishable, as in *He Seeks His Fortune* (1947). Such works suggest two things: first that Yeats saw identity in terms of the relationship of environment and people, and second, that the relationship is generalized rather than specific. The rooted sense of place that underpins Henry's work translates into placelessness in Yeats's, and it has been noted that the latter's work became increasingly populated by peripatetic outsiders (Yvonne Scott (ed.), *Jack B. Yeats: Old and New* Departures, Dublin 2008, pp. 84–99). In wandering the land, Yeats's protagonists have access to all, if ownership of none, suggesting sovereign entitlement rather than legal title. The idiom of dissolution in such late works by Yeats, with its deliberate evasion of clear markers, is the polar opposite of the cartographic aesthetic described above. A similar ethic to Yeats's is suggested by Patrick Collins (qv), most

265. Gerard Dillon, *The Little Green Fields*, 1945, oil on canvas, 40.5 x 89 cm, National Gallery of Ireland

266. Paul Henry, frontispiece for *Saorstát Éireann, Irish Free State Official Handbook*, 1932

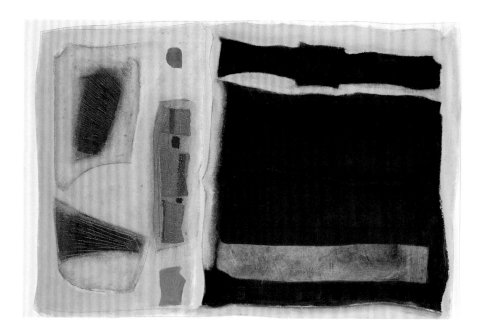

267. Tony O'Malley, *Old Place, Callan*, 1978, oil on board, 61 x 90 cm, Crawford Art Gallery, formerly AIB Collection

Landscape politics, and related concepts of identity, extend to issues of gender. While landscape generally has been feminized for its fertility and subservience to control and exploitation, geo-political allegories of nation states differ in how they are gendered. While some are configured as fatherlands or projected as male (as in John Bull), Ireland has long been allegorized as female in art and literature, and was caricatured in the nineteenth and early twentieth centuries as in need of a male protector. Analysis of more recent history has proposed a gendering of the landscape, in terms that include its 'curvaceous outlines' (Breathnach-Lynch, p. 78) in the work of artists like Paul Henry and James Humbert Craig (qv). Among contemporary artists, Kathy Prendergast has drawn analogies between the control of the landscape and the female body in her geomorphological series 'Enclosed Worlds in Open Spaces' (1990) where the body is mapped out and cross-sectioned to reveal superimposed mechanisms on bodily organs (see 'The Body'). Dorothy Cross (qv) refers gender stereotypes to location, specifically the heroicized male assigned to challenging outdoor environments in contrast with the 'refined' female, relegated to an indoor, genteel environment. The video piece *Teacup* (1997) [98], as with much of Cross's work of the time, requisitions family heirlooms of crockery and linen from their 'bottom drawer', to violate their sacred place in genealogical ritual, and to challenge gender roles. In this work Cross draws on imagery of Aran fishermen in a currach tossed on heaving seas in the legendary if contested documentary film by Robert Flaherty, *Man of Aran* (released 1934) [1], transmitted in the artwork within the rim of the photographed ceramic cup.

If personifying the country of Ireland as an allegory of exploited subservience on the one hand, or as a curvaceous and fecund land on the other, the gendering of landscape by artists and cultural theorists references the traditional consignment of women to a passive role at the disposal of the active male. In a rare reversal of roles, Pauline Cummins's (qv) slide installation *Inis t'Oirr/Aran Dance* (1985) [44] overlays an Aran jumper on a naked male torso, displayed as an object of female desire. She thereby conflates the body with a symbol of a specific cultural landscape, unexpectedly in an environment associated with religious repression. A criticism of some gender-oriented interpretations, however, is that they are more readily categorized thematically as genre, rather than landscape, for their interpretation depends typically on a reading of body language and dress. While this is undoubtedly true, the landscape associations can be vital in determining the nature and context of meaning.

notably in his *Travelling Tinkers* (1968) [356], which describes a nomadic, rather than a fixed, relationship with the landscape. This is essentially a romantic view that denies the centres of power, and the consequences of an outsider existence that are implied in Brett's understated truism 'The land has not ceased to be owned' (op. cit., p. 14).

The notions of nomadism and migration, so fundamental to concepts of Irishness internationally, present the binary opposite of the concept of 'home' as fixed to place, particularly involving generational and ancestral associations. Tony O'Malley's (qv) ideas of home and homing, in the sense of returning, are embodied in works like *Old Place, Callan* [267], an abstracted, bird's eye view of a scarred and frozen landscape surface, of dark earth whose puddles reflect winter skies of a landscape that has been associated with his family for generations. Seán McSweeney's (qv) work, in a similar viewpoint, returns constantly to the abstracted forms of the cut-out bogs of his Sligo roots which, from the late 1990s, are commonly shown directly from above. The fixity of 'home' is signified by a view that eliminates that symbol of alternatives, of either space or time – the horizon. Specific human relationships with place are evoked *inter alia* through toponymy. Hughie O'Donoghue (qv) created a body of work that references both the narratives and the archaeology of engagement with the landscapes of his ancestors, named for people and events otherwise forgotten, like *Gortmelia (Melia's Field)* (2001). Kathy Prendergast's (qv) 'emotional cartography' series comprises digital maps she has commissioned, adjusted at her request to include only those place-names with selected words like 'lost' or 'love'. In contrast to O'Donoghue's work cited above, these invoke the narratives of migration and toponymic associations, while similarly referencing past conditions and events that leave their imprint on contemporary charts of places. Prendergast's series focuses particularly on the United States, which she sees as inscribed with the trajectories of Irish migrant journeys and settlements (*Lost*, 1999) [133].

Nature versus culture: from wilderness to worked landscape
Varieties of landscape, as defined by theorists like Yi-Fu Tuan (*Topophilia: A Study of Environmental Perception, Attitudes and Values*, Columbia University Press, 1974) and as suggested in Duffy's comments, exist at some point between the polarities of nature and culture, between total wilderness on one hand, and megalopolis on the other. While for much of the last millennium prevailing western culture viewed wilderness as there to be tamed, and its existence expressed a less than flattering lack of cultivation, this perception began to change in

the nineteenth century when the wilderness movement in the United States led to the rehabilitation of such environments in the public mind. Consequently, while Ireland's landscape has long been recognized as being relatively benign and safe (at least, once its forests had been exterminated in Elizabethan times), Ireland's projection as 'wild', particularly along the western seaboard, had the double value of distinction from the sophistication associated with colonial values, and the exoticism of touristic attraction. The work of Henry and Yeats was interpreted in such terms, and the rolling boglands – devoid, interestingly, of the demarcations of the strictures of ownership, and implications of subjection to law – became a staple of the iconography of Irishness. The right of 'the people' in general (not just entitled individuals) to such landscapes, to avail of their bounty, remained a contentious issue into the twenty-first century over issues such as turf-cutting rights.

The open unfettered landscapes were compatible with, rather than contradictory to, the stone-walled smallholdings depicted by Dillon, Maurice MacGonigal (qv) and others; each style of environment contributed to a concept of modest demands and equal access, in contrast to the once inflammatory image of the 'big house'. Expansive scenery is a characteristic associated with the sublime, a concept developed and theorized in social and aesthetic terms by Edmund Burke in the eighteenth century. While Burke drew on prevailing ideas, and presented a treatise to justify the status quo of land ownership and control, the imagery conjured by his imaginative language enthralled an international audience and it continues to resonate with artists. The sublime is manifest in the idea of wilderness in the awe and terror that it is intended to evoke. Among the characteristics of the sublime are those infinitely open spaces and the stark, uninterrupted extent of bogland referred to above. Such spaces, where they exist, are largely thanks to their unsuitability for most forms of agriculture and architecture. Brian O'Doherty's (qv) uncompromising *Shannon* (1949) presents such a vista, though intended primarily to counter the cosy myth of traditional 'bland nationalist' landscape painting in the 1940s and '50s. It indicates instead the relentless hardship and cheerless climate that he felt prevailed at the time, thereby evading both the romanticism normally associated with the term 'sublime' as well as the enticing nostalgia of nationalistic imagery.

By contrast, fifty years later Mary Lohan's (qv) sublime seascapes, while certainly not nationalistic or nostalgic, betray a romantic desire to escape to, as opposed to from, a western environment. Rather, however, than invoking a land-bound expanse, her view is from the liminal edge of coastline and out to sea towards the element that least retains visible residues of human activity, whatever about the ecological reality. In addition, her perspective eliminates all locating points of reference; the dissolution of the horizon through climatic effects, and the merging of sea and sky, ensure that anthropocentric space and time cannot be defined, and water provides no secure foundation on which to establish the specifics of identity. While such scenes, devoid of anything but seemingly 'natural' elements, suggest purest 'wilderness', Lohan acknowledges that her city origins and a desire to escape provide the impetus for her work

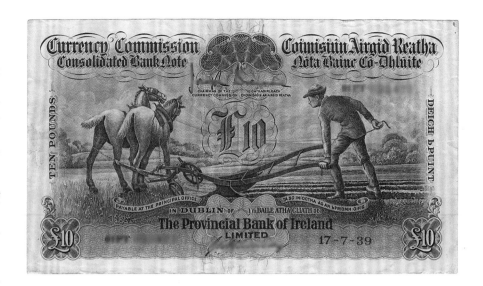

268. Dermod O'Brien, Irish banknote depicting the ploughman, 1929–41

that essentially reflects the effect of culture. In this, she represents a contemporary link in a long chain.

A return to nature, at the level of the sublime, underpins Nick Miller's (qv) landscapes of County Roscommon; while the rough fields of his views appear unaffected by artistic licence to improve and compose, the terrain itself is as subject to modification as any agricultural land in Ireland. Some images are close encounters with tangled shrubs and forestry that have connotations of the malevolence of fairytales (Catherine Marshall, 'The Well Field', in *Nick Miller: Figure to Ground*, Dublin 2003), of uncontrollable nature, despite efforts at civilization. A defining feature of this series is the 'framing' of the view by the outer edges of the doorway of the artist's mobile studio, a van converted for the purpose of carrying him and his equipment around the countryside, and providing shelter. Since the mobile studio is the locus of art, and the exterior is the site of the object, the culture/nature dichotomy collides at the margin of the opening.

The insertion of culture into the actual landscape is fundamentally through its development for subsistence at one end of the spectrum and exploitation for gain at the other. The activity of modification through farming work is surprisingly uncommon in art in the Irish context. In a country traditionally noted for its agriculture, and the consequent valorization of its rurality, representations of such work have the potential to project a persuasive image of Ireland, one that might appeal both at home and to Irish emigrant communities. A major exception is Dermod O'Brien's (qv) seminal image of the ploughman, which featured on Irish banknotes produced between 1929 and 1941 [268]. Here a lone farmer is shown with a traditional horse-drawn plough against an open landscape, lit by the stylized rays of a, presumably rising, sun – not unlike similar images exploited extensively by totalitarian states to valorize the folk and a nationalist connection with the soil. The plough does not feature often in Irish art, however, perhaps because of its political associations with socialism. Despite the huge significance of hay in Irish agriculture, only very occasionally is the

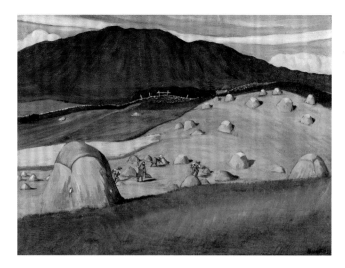

269. Harry Kernoff, *Making Hay at Renvyle, Connemara*, 1936, oil on board, 36.5 x 49.5 cm, private collection

saving and stacking of the crop depicted, as in Harry Kernoff's (qv) arcadian *Making Hay at Renvyle* [269]. Much more popular themes, where they exist, are of cutting turf, an opportunity once again to locate the people within the western Irish landscape. Similarly, the work of local fishermen provided the opportunity to paint coastlines and seascapes, along with the ubiquitous currach, again alluding to tradition and the western seaboard and all that it implied. Examples occur in the work of Henry, Yeats, MacGonigal, Kernoff, Lamb and Keating and while, collectively, they may give the impression that the landscape as an economic resource is adequately represented, such images seriously skew the reality of the shifting patterns of agricultural dependence on the land during the twentieth century.

A further rare exception, later in the century, is found in the work of James Dixon (qv), who presents the everyday nature of work on the land in images that function like pages from a diary; the titles are lengthy and descriptive, and the relationship between work and landscape, if simplified, is entirely pragmatic. *Mary Driving the Cattle Home across the Sands of Dee* (1964) [142] is a compelling but anachronistic example of 'outsider' art (qv) in an era when elsewhere artists were experimenting with Pop, Minimalism and Conceptual art (qqv), in the context of rising consumerism and expanding globalization. Some urban landscapes deal with the work of the city, such as Joan Jameson's *Unloading Turf Barge* (1943), and it can be inferred in MacGonigal's *Dockers* [283] (who stand heroically, rather than engage in their labours), but these are even less common than the rural counterparts.

The wilderness, with its image of effortless bounty and pastoral lifestyle, has long been posed as the opposite of the settled, worked landscape, and its destruction from pollution underpins much of the work of Barrie Cooke (qv), a keen fisherman dismayed at the devastating impact of algal infestation of freshwater lakes. He was among the first artists in Ireland to deal with environmental concerns, a theme of global relevance and of fundamental significance in the depiction of landscape after the turn of the millennium.

The dichotomy of urban and rural landscape

Artists in Northern Ireland have been prepared to address the urban throughout the twentieth century, from William Conor's genre scenes of the urban poor in a backdrop of treeless streetscapes, John Luke's stylized industrial landscapes, and Colin Middleton's (qqv) surreal suburbs, to more recent uncompromising scenes related to the 'Troubles' (qv) by Willie Doherty, Paul Seawright (qqv) and others. South of the border, by contrast, urban landscape has been conspicuously absent until late in the twentieth century. Notwithstanding exceptions, by Harry Kernoff, Jack Yeats, Norah McGuinness and Cecil Salkeld (qqv), these have been far outweighed by the sheer quantity of rural subjects. While it might be argued that this trend reflected the predominantly rural economy in the Republic until the 1960s, it has been proposed as an ideological desire for distance from industrialized and urbanized Britain, the home of Ireland's erstwhile colonizers, posited in contrast to its supposed Irish opposite. While that might have explained the situation in the past, the far greater popularity of rural imagery across the island at the end of the century ignores the distribution of the population between the city and the country, the increasing proportion who live in large towns and cities, and the progressive dissolution of the contrast between the two in the light of suburban development and the communications revolution. The prominence of the rural is arguably less about projecting the truth of society than of desire or perhaps, more accurately, to recognize that imagery of non-urban landscapes is a construction, or concoction, for urban tastes; thus, an urban/rural designation on the basis of the scene depicted is arguably misleading.

The city has traditionally been demonized in both literature and art for centuries as refined but also opportunist and decadent, and it has long been represented as the opposite of the more naive, but principled, rural; the notion of wilful corruption versus innocent integrity in these binary opposite sites explains something of the implied projection of British colonial power, in contrast to that of Irishness. Yeats's professed ambivalence to the urban is evinced particularly in *Morning in the City* (1936) which suggests something of the traditionally demonized nature of an environment represented here as oppressive and isolating. More than ten years earlier, the city provided for Yeats the somewhat more optimistic imagery of *A Westerly Wind* (1921), where the traditional horse and cart operates alongside the modernity of tramlines, or the *Liffey Swim* (1923) [511], where an annual event, drawing on the resources of the city environment, provides a unifying focus for its audience, and where the perspective, designed to draw the gaze of the viewer along the sightline of the crowd, is created by the structure of the city quayside.

Apart from such examples, the general avoidance of the urban contrasts significantly with the willingness of writers, notably James Joyce and, later, Seán O'Casey, to locate their work in the city, though Fintan O'Toole has described O'Casey's environments as essentially rural in their social constructs, and the same argument could be made for various of the urban images (O'Toole, 654–58). Kernoff's Dublin is essentially a series of villages, rather than a metropolis, and McGuinness's scenes of the Liffey often depict family outings and neighbourly encounters. Patrick Collins was also, on occasion, drawn to the city river but

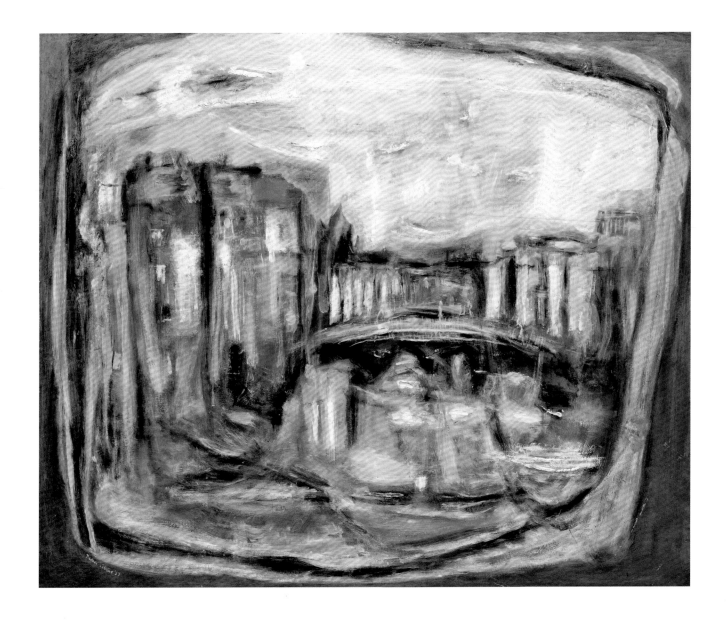

his *Liffey Quaysides* [270] is presented as mirage-like, and almost as imaginary and ephemeral as his rendition of the mythical island of Hy Brasil. Thus, while set in a city, specifically urban issues are avoided.

However, as Ireland became increasingly urbanized, eventually, in the 1960s and '70s, the predominance of rural romantic nationalism as a valid image to represent Ireland was challenged by artists like Michael Kane and Jonathan Wade (qqv). Wade's stark environments, comprising a mass of steel tubing beneath unreachable concrete flyovers, presented an unsympathetic interpretation of a man-made world, suggesting a less seductive reality than heretofore. Kane, however, was attracted by the city as representing cultural freedom as opposed to the strictures of rural disapproval and morality which he, and others, had encountered as artists in the mid-century. He was concerned about the consequences of the continuing avoidance of the urban in art given its vital role in the development of Modernism (qv), and vociferous in these concerns (Kane, 'A Light at the End of the Old Bog Road', in *Structure*, I, no. 1, 1971, 3).

The post-modern era has been more ambiguous, both in the demarcation of the urban/rural space, and in its depiction in art. As villages and towns expand and interconnect in networks of physical and technological highways, and cities are punctuated by sprawling parklands and amenities, the distinction is less evident and relevant, and related distinctions regarding ignorance, innocence or edification are increasingly blurred. Oliver Comerford's (qv) 'rural' scenes are observed as though through the windscreen of a car; his misty distances generated by the enveloping smog of effluent, rather than the romantic climatics which they imply, *inter alia*, raising ecological concerns (see *Line In*, 1998). The ambiguous space between actuality and the dubious reality of popular journalism, as well as the fiction of cinema and conventions of cinematography, are played out in the work of various artists, such as Mark O'Kelly. *Car* (2001), a bird's eye view of a vehicle stopped in an intermediate area, a roadway between destinations whose verge is marked by shrubbery, and with a door lying ominously open, sparks imaginative reconstructions of the sinister possibilities that such locations proffer.

270. Patrick Collins, *Liffey Quaysides*, 1957–58, oil on board, 107 x 129.5 cm, National Gallery of Ireland

Equally suggestive and disturbing are Brian Maguire's (qv) Postmodern arenas: harbours of violence, isolation or suicide, as in his *Divis Flats* and *Liffey Suicides* [421, 295] (both 1986), and the more recent work set in the favelas of South America.

The urban environment as a site of nationalistic political conflict related more often to the South in the early part of the century, in a handful of narrative images such as those by Kathleen Fox (qv), while in the latter part of the century it has tended to focus on the North, as examples by Willie Doherty, Paul Seawright (qv) and others convey. These later images incorporate, but ultimately go beyond, the more obvious interpretations of religious division, and reflect related, inherent social inequalities that have given rise to disaffection and the eruption of frustrated or opportunist violence. Doherty's *Strategy Isolate* (1989) is an uncompromising photographic image with a view into a perspectively constructed space, where the viewer is drawn in through the orthogonals of a pedestrian bridge, caged in to prevent the hurling of missiles onto passersby beneath – a feature associated with deprivation around the world. While the route here is visually blocked, we see the bleak geometry of the social housing beyond, isolated from any sense of hope by the imperatives of history and of those in a position of control. The view through the lens, presented here as dispassionately objective, also implies the selectivity and potential for digital adjustment, as well as the biases inherent in some forms of reportage. Doherty's later work will exploit cinematic conventions to evoke atmospheres of suspense and threat in the representation not only of urban, but also of rural environments.

So ingrained is the perception of nature as positive that its presence or absence in landscape imagery defines markedly how we interpret an image. Communities can and do exist in areas devoid of trees, and terrible things are perpetrated in leafy environments. Darkness can be safely enveloping and stark daylight witness unspeakable atrocities; consequently, the iconography of urban and rural, and of dark and light, has become deliberately ambiguous, playing on, but also questioning stereotypes of representation. YVONNE SCOTT

SELECTED READING P. F. Lewis, 'Axioms for reading the landscape', in D.W. Meinig (ed.), *The Interpretation of Ordinary Landscapes* (Oxford and New York 1979); Fintan O'Toole, 'Going West: The Country Versus the City in Irish Writing', in *The Field Day Anthology of Irish Writing*, III (Derry 1991); Síghle Bhreathnach-Lynch, 2000; Scott, 2005; Patrick J. Duffy, 2007.

LANGAN, CLARE (b. 1967), artist. Clare Langan graduated from NCAD in 1989 and received a Fulbright Scholarship three years later which enabled her to take the Intensive Film Workshop course at New York University. By 1993 she was already showing her work at the City Arts Centre, Dublin, and as far afield as Berlin and Vienna. By the end of the 1990s IMMA had acquired her film *Forty Below* [271], and she rounded off the decade by being shortlisted for the Glen Dimplex Artists award at IMMA in 2000.

Langan's mature style can be plotted from *A Film Trilogy*, which commenced in 1999 with *Forty Below*. This work introduces some of the major themes she has explored since then. Shot in Iceland, *Forty Below* features a dark, shadowy world. No frame is fully rectangular; all are softened by dark areas that create irregular apertures throughout the film. And this is film, shot on 16 mm and later transferred to DVD for presentation. The film is saturated in blues and greens. Effects seem to come from the sophisticated realm of post-production technology as favoured in commercial cinema; however, all Langan's effects are

271. Clare Langan, *Forty Below*, 1999, 16 mm Bolex transferred to DVD, with surround sound, Irish Museum of Modern Art

achieved by manipulating the lens during filming. Using hand-painted lenses and prisms, Langan creates an eerie world at once unsettling and attractive.

Forty Below (1999), *Too dark for night* (2001) and *Glass Hour* (2002) feature ice/water, sand/desert, and magma/fire respectively. In each, a lone protagonist leads us through the scenes. More cipher than character, this individual does not alter or influence what we are shown. S/he is like a spectral witness to a catastrophe that has already happened, to a post-apocalyptic world where sites of domesticity and industry have been invaded by the active agents of the natural world: water, sand and fire. Nature here has asserted her rank through the activity of some of her most awesome constituents. The Gaia principle of the planet, compensating and reorganizing itself to remain healthy, underpins the philosophical basis of this work. The moral sense here is tacit; mankind is not so much chastised for its transgressions as eliminated in the process of renewing a natural order.

I Gaer (2007) seems to site the struggle for existence within the essential quality of cinema itself – light. The heightening of the contrast between heaving breakers and the rocky coastline transmutes the analogous facts into an abstract struggle for the survival of the image. Both the white of the waves and the blackness of the rock threaten to dissolve the image into mono-tonal singularity. This work also saw the artist's first use of a high-speed digital camera which facilitates the slowing down of motion more than the conventional celluloid camera. In *The ice above, the fire below* (2008), this formal play becomes even more pronounced in the form of a triptych. As Langan has said: 'The pace and slow movement does touch on the act of painting itself along with the formal element of the triptych' (in conversation with the author, autumn 2009). It is interesting, then, that her reconnection with painting takes the form of reducing colour to its bookended elements of almost black and almost white.

It is compelling to see Langan's progress from the cinematic referencing of the first trilogy, with its characterizing colour, her rigorous redefining of the language of the moving image and profound themes, move through technical innovation to a stark filmic exploration of the picture plane and the formal qualities of painting and drawing.

Langan's work has been shown in Australia, Austria, Brazil, China, France, Germany, Israel, Italy, Japan, the Netherlands and the USA. She has represented Ireland in Biennales in São Paolo, Shanghai, Liverpool, Tel Aviv and Sydney, and her work can be found in the collection of IMMA. PATRICK T. MURPHY

SELECTED READING Christoph Grunenberg, *Apoclaypse Now, Clare Langan – Too dark for night* (Liverpool 2002); Aidan Dunne, 'No Place to Stay', in Patrick T. Murphy (ed.), *Clare Langan: A Film Trilogy*, exh. cat. RHA; Mia Sundberg Galleri, Stockholm; Galleri Salvador Diaz, Madrid; Fenton Gallery, Cork (Dublin 2003).

LAVERY, JOHN (1856–1941) (qv *AAI* II), painter. Lavery was born in Belfast and orphaned in his infancy. His early career was marked by poverty and hardship. By the beginning of the twentieth century, however, he had already achieved considerable recognition, although his major achievements were still to come. His picaresque early life included a childhood on the farm of an uncle in County Down, a spell as a young teenager with another relative in a pawnshop in Glasgow, from which he ran away, and a return to drudgery on his uncle's farm, where he managed to teach himself to draw.

Lavery touched up photographs for J.B. McNair in Glasgow to pay for art classes at the Haldane Academy and in 1879

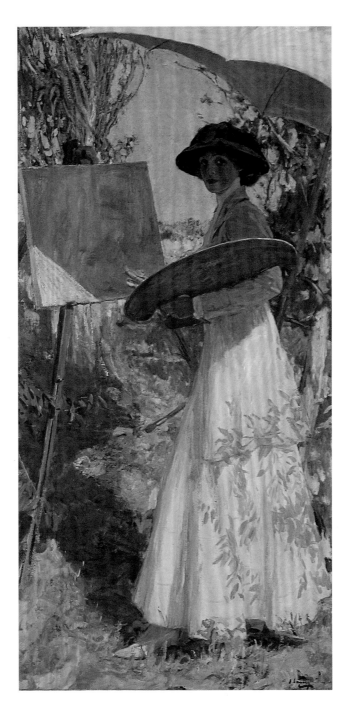

272. John Lavery, *Mrs Lavery Sketching*, 1910, oil on canvas, 203.2 x 99 cm, Dublin City Gallery The Hugh Lane

exhibited his first picture. A £300 insurance payment, following a fire at his first studio, enabled him to go to London to study at Heatherley's Academy, and later the Académie Julian in Paris. Critical recognition began with a number of paintings of Grez-sur-Loing, near Fontainebleau, where he became part of the cosmopolitan artists' colony. His major work of the 1880s, *Played!* (1885), was bought by the Bavarian government. Back in Glasgow, he met and married his first wife, Kathleen MacDermott, like himself a runaway, who, sadly, died just two months after giving birth to his daughter, Eileen. In 1888 he was fortunate to receive a commission to record the visit of Queen Victoria to the Society of Artists exhibition in the city. The Queen and 250 other prominent members of Glasgow society, who attended the exhibition on that occasion, sat for him. The painting, one of the most important ceremonial group portraits of Victoria's reign, together with the financial remuneration that accompanied it, established Lavery as a portrait artist of the first order (see 'Portraiture').

For the next decade Lavery alternated between Morocco, Germany, where he painted portraits, and London, where he became actively involved in the International Congress for contemporary artists (1897). The Congress evolved into the International Society of Sculptors, Painters and Gravers, with James McNeill Whistler as its first president, and Lavery as vice-president. Although Lavery is frequently referred to as one of 'the Glasgow Boys', a group of innovative young Scottish artists active between 1880 and about 1895, he considered himself Irish. When he bought his London house he described himself as doing it 'in a fit of Irish recklessness' (Lavery, p. 46).

In 1904 Lavery met Hazel Martyn and six years later, following the death of her husband, Edward Trudeau, he married her. Hazel, and her daughter Alice, joined Lavery and his daughter at his house on London's Cromwell Place. The combination of Lavery's skill as a portrait painter and Hazel's personality and beauty made them an impressive double act in the London social milieu. Lavery painted over 400 portraits of his wife, some, such as *The Yellow Bed* (whereabouts unknown), caused a stir because the setting for the portrait was considered risqué in Edwardian London, but mostly, because Hazel's glamour, her innate sense of style and her almost professional skills as an artist's model meant that the portraits epitomized all that was attractive in the genre [272]. Lavery constantly acknowledged his debt to his wife, a trained artist herself, who frequently sat and conversed with his sitters, showing the social skills that enabled the couple to mix as equals with their patrons and the celebrities of the day. Hazel soon became a celebrity in her own right, photographed by leading photographers from Emil Otto Hoppé to Cecil Beaton, participating in *Tableaux Vivants* in which society beauties performed roles from famous artworks as a contribution to the war effort and even taking part in a short film. An unidentified newspaper cutting in the Lavery archive reveals a journalist saying: 'Circumstances, too, have dealt unkindly with the Provosts, Professors and Politicians, in giving Mr Lavery a wife who offers a perpetual invitation to portraiture that is not masculine.' (McCoole, p. 48) Their fame seemed unlimited. In 1910 Lavery was given a solo exhibition at the Venice Biennale, where he showed fifty-three pictures to considerable acclaim, one reviewer noting that 'the daily crowd of Italians who filled the Lavery gallery was the talk of Venice' (McCoole, p. 22). Just three years later, Lavery was invited to Buckingham Palace to paint the Royal Family (NPG, London), given the White Drawing Room as his studio while working on it, and claimed to have given George V a paintbrush to block in part of the picture.

The frivolous but rewarding side of society portraiture did not entirely occupy Lavery. In 1916 he controversially followed the encouragement of the presiding judge, Chief Justice Darling, to paint the appeal trial of Roger Casement, who had been convicted of treason for his part in gun-running for the Irish insurgents in the Easter Rising of that year (*High Treason, Court of Criminal Appeal: The Trial of Roger Casement*, 1916) [222]. This decision, at the height of World War I when even to paint a perceived traitor was itself seen as a challenge to establishment values, reveals a different side of Lavery's character. For the next fifteen years, alongside his role as an official war artist for which he received a knighthood in 1918, he painted most of the leading figures involved in the treaty discussions that ended the War of Independence, leaders of the Irish Free State and Government of Northern Ireland, as well as public figures of all political and religious persuasions (see 'Politics in Irish Art'). While the Laverys, husband and wife, were heavily involved in the Treaty negotiations, and Hazel Lavery appears to have had a personal fascination for Michael Collins, they contributed to a political settlement by making their home available to all the participants as a neutral space where delegates, from Winston Churchill, on the one hand, and Collins and Arthur Griffith, on the other, could meet in a social and domestic context. Oliver St John Gogarty remarked that, 'The Laverys did more to bring about a settlement than all the weary officials and overlooked weeks at Hans Place [the official venue for the Treaty discussions]' (McCoole, p. 80). Despite aspirations toward neutrality in the portraits of sitters from opposing sides, it is said that Sir Edward Carson, a leading unionist, remarked of his portrait, painted at the artist's request, as a pendant to a similar portrait of the Irish nationalist leader, John Redmond (1914), 'It's easy to see which side you're on' (McCoole, p. 63). Carson would have been fully aware that Lavery was a Belfast Catholic and therefore likely to support the nationalist cause. The portrait presents Carson as a haughty and arrogant man, while Redmond's features are significantly quieter and less revealing. Whatever Carson may have felt about this picture, he sat for Lavery for a second portrait in 1922.

One of Lavery's most famous legacies to his countrymen can be seen in yet another portrait of Hazel, this time as an Irish colleen, Kathleen Ní Houlihan [273], when, in 1927, in response to a commission from the Irish government, he designed the first Irish banknotes, using the image to personify Ireland. Since the commission, contrary to Lavery's wishes, was not opened to competition from other artists, the resulting banknotes were viewed negatively in some quarters, but the fact that they remained in use for some fifty years, and the portrait was retained as a watermark in the Irish banknotes until the introduction of the euro in 2002, testify to the popularity they acquired over the years.

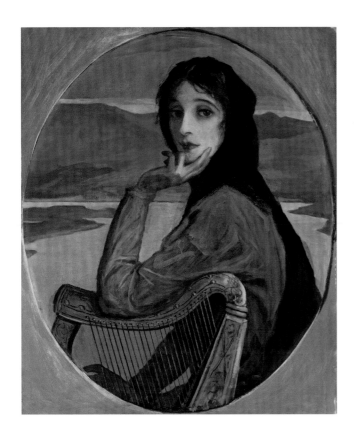

LE BROCQUY, LOUIS (1916–2012), painter. At the 1956 Venice Biennale, Ireland was represented by Louis le Brocquy, who showed a series of paintings based on the theme of the family. Although the theme suggests images of comfort and reassurance, le Brocquy's paintings were stark, Cubist-inspired works, depicting people trapped in angular claustrophobic interiors. Devoid of colour, the paintings reflected a barren and grey postwar Europe, characterized by displaced populations rebuilding lives shattered by conflict. The theme, and its treatment, resulted in le Brocquy's *A Family* (1951) [71] being awarded a prize by the Biennale jury. Although *A Family* is representative of le Brocquy's 'grey' period, his art during these years also included works in which colour plays an important role, notably in tapestry designs such as *Garlanded Goat*, produced by Aubusson Tapestries between 1949 and 1950. In works such as this, le Brocquy had begun to reflect a more optimistic view of the world, one that the artist sustained throughout the following decades.

Born in Dublin, the eldest child of Albert le Brocquy and Sybil Staunton, Louis le Brocquy grew up in an affluent, cultured home. His paternal grandfather had come to Ireland from Brussels in the late nineteenth century and set up a small oil refinery. Although trained as a chemist and with a career assured in the family firm, le Brocquy's real interest lay in art and in 1938 he decided to become a full-time painter. He was encouraged by his mother, who was active in Dublin's cultural world. Leaving Ireland to study art directly from paintings in European museums, le Brocquy's travels took him through London and Paris to Switzerland, and then on to the south of France, where he and his first wife, Jean Stoney, settled in Menton, a seaside town popular with artists. In Geneva, le Brocquy had the good fortune to be able to study paintings by Goya, Velázquez and El Greco, transferred from the Prado to Switzerland for safe keeping during the Spanish Civil War. *Las Meninas* (Velázquez, 1656), in particular, made a strong impression, while the influence of Titian's *The Worship of Venus* and *Bacchanal of the Andrians*, paintings celebrating pagan ritual, is evident in his later works (le Brocquy, letter to John Russell, 24 September 1990, quoted in Madden, p. 37).

Forced to leave France during World War II, le Brocquy returned to Ireland. His paintings from this period include *A Picnic* [274], *Girl in White* (1941, UM) and *The Spanish Shawl* (Private collection, 1941) [242]. The influence of Japanese woodblock prints and the paintings of Manet and Whistler are evident in these works, but they also resonate with a sense of alienation. *The Spanish Shawl* was rejected by the RHA (qv) in 1942, prompting the artist's mother to take a lead role in setting up the IELA (qv). Le Brocquy, meanwhile, continued his artistic training by studying colour theory and attending lectures given by Erwin Schrödinger, who also spent the war years in Ireland. By 1947, when le Brocquy had moved to London, he had left behind this academic, Whistler-inspired phase and the influence of Cubism (qv) was beginning to predominate, as seen in *Tinker Woman with Newspaper* (1947) [16] and *Irish Tinkers* [275].

In the decades after World War II, le Brocquy's paintings were inspired by a small number of themes, nearly all based on

273. John Lavery, *Lady Lavery as Kathleen Ní Houlihan*, 1927, oil on canvas, 75.5 x 62.5 cm, National Gallery of Ireland

While Lavery is mainly remembered for his portraits, he speaks in his autobiography of his desire to record his country's history. In addition to the Roger Casement painting, he painted singular events, such as the funeral of Terence MacSwiney, the republican Lord Mayor of Cork who died on hunger strike, the *Blessing of the Colours* (1922, HL), the funeral of Michael Collins in *Pro-Cathedral, Dublin, 1922 (Michael Collins)* (HL) and *The Ratification of the Irish Treaty in the English House of Lords* (1921, NGI collection). Typically, when Lavery painted the rituals of Ulster protestants in *The 12th July in Portadown* (1928, UM), he matched it by painting the more Catholic *Saint Patrick's Purgatory* (1930, HL). No other artist has left such a complete visual record of the history of the War of Independence. Such was the Free State's appreciation of this that Lavery's name was put forward as a possible Governor General of Ireland on two occasions, yet he continued to enjoy the esteem of the establishment in Britain. He was an active supporter of the return of Hugh Lane's modern art collection to Ireland, and donated substantial holdings of his work to the UM, as well as thirty-four paintings to the Dublin Municipal Gallery of Modern Art (HL) in memory of his wife, Hazel, who predeceased him. CATHERINE MARSHALL

SELECTED READING John Lavery, *The Life of a Painter* (London 1940); Kenneth McConkey, *Sir John Lavery: A Painter and his World* (Edinburgh 2010); Sinéad McCoole (ed.), *Passion and Politics, Sir John Lavery: The Salon Revisited*, exh. cat. HL (Dublin 2010).

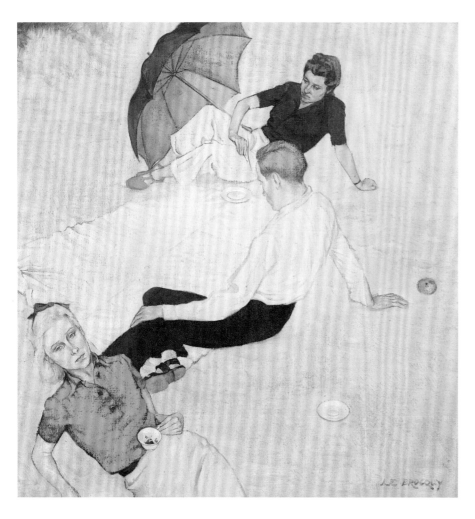

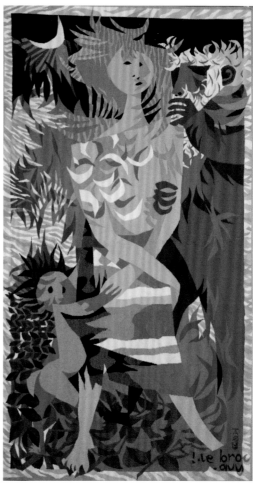

274. Louis le Brocquy, *A Picnic*, 1940, wax-resin medium on canvas mounted on board, 40 x 40 cm, on loan from the Beecher Collection to Irish Museum of Modern Art

275. Louis le Brocquy, *Irish Tinkers* [*Travellers*], 1948, Aubusson tapestry, edn of 9, 182 x 105 cm, Crawford Art Gallery, formerly AIB Collection

the human figure. The earliest was travelling people and this was followed by the family, 'Procession', 'Children in a Wood', the 'Presence' paintings and 'Ancestral Heads'. In 1964 he began work on a series of portraits of deceased writers based on photographs and his own imagination. In post-war London, when le Brocquy first began to show at the Gimpel Fils Gallery, abstract painting (see 'Abstraction') had become the dominant art form and figurative artists such as Lucian Freud, Francis Bacon (qv) and le Brocquy were regarded as being out of step. While not disregarding the achievements of abstract painters, le Brocquy looked to sources such as Cézanne's *Les Grandes Baigneuses* (*c.* 1894–1905, NGL collection) and Poussin's Bacchanals as sources for his 'Children in a Wood' series, while in his 'Procession' paintings, the figures are depicted as though they are low-relief sculptures on an antique sarcophagus.

The seventeenth-century painting *Boys Playing with a Goat* (thought to be by Nicholaes Maes when shown at the Matthiesen Gallery, London, in 1953 but more recently attributed to Cornelis Bisschop) intrigued le Brocquy, who used it in 1954 as the basis for a large canvas *Children in a Wood*. John Berger described the work: 'This painting has a Poussin-like formality to it. Each figure has its appointed niche in the landscape. Each movement is received by another …. The sharp angular drawing

gives the whole picture a lean, nervous energy. It has the quality of a ritual dance, staged and yet intense.' (*New Statesman*, February 1955.) *Children in a Wood* brings together memories of the artist's childhood, much of which was spent at his maternal grandmother's house in County Roscommon. Le Brocquy posits that the painting has 'something to do with the "game of life" ' noting that 'the arms of the central figure inevitably suggest the opposing tragedy of the crucifixion in the midst of a bacchanate playground!' (le Brocquy in a letter to the author, 11 September 2003).

Thirty years later, he revisited the theme with *Children in a Wood I* (1988, IMMA collection). In this work the sense of anxiety, evident in the earlier work, has been dispelled. What started as an allegory of existence has become a cheerful romp, full of energy. In *Children in a Wood II* (1989, DCU) the romp advances a step further, perhaps presaging a loss of innocence. This progression towards a greater sensuality continues in *Children in a Wood IV* (1992), the last in the series. However, in the midst of the confusion of limbs and faces, a knife held aloft echoes that reading of le Brocquy's art proposed by Herbert Read forty years before, when he referred to the artist's ability to reconcile opposing principles, innocence and experience, or 'Eros and Thanatos' (Read, *A Letter to a Young Painter*, 1962, quoted in Madden, p. 61).

In 1956 le Brocquy embarked on a series of non-figurative 'Presence' paintings. In these works, suggestions of individual human forms emerge from white backgrounds, while flashes of red suggest blood and the inner workings of the body. In a catalogue preface, written for an exhibition held at the Gimpel Fils Gallery in 1961, Herbert Read explored le Brocquy's depiction of the human figure, 'recorded so discreetly that the full force of the erotic imagery is only revealed to quiet contemplation' (Read, n.p.).

Three years later, le Brocquy embarked on a new series of works based on Polynesian human skulls in the Musée de l'Homme in Paris. These rekindled his interest in the Celtic tradition of the head image. An early work in this series was the 1967 *Reconstructed Head of an Irish Martyr*. The series then evolved into images of Irish writers, such as Joyce, Beckett and Yeats, the last's recurring image of the mask, as in the poem 'A Vision', also influencing the artist. In 1975 le Brocquy began a series of portraits of Yeats when the Galerie Börjeson in Malmö, Sweden, commissioned him to produce an image of an Irish Nobel prize-winner. An exhibition of charcoal sketches, watercolours and oil paintings of Yeats was held at the Musée d'Art Moderne de la Ville de Paris the following year. Le Brocquy continued this series throughout the 1990s, creating images, both in paint and in graphic media such as charcoal, of Seamus Heaney and John Montague, but also including European cultural figures such as Shakespeare, Lorca and Picasso.

In technique, le Brocquy's method of painting was precise and measured. While he often favoured predominantly white backgrounds, he also emphasized the three-dimensionality of forms through the use of warm 'advancing' and cool 'receding' colours, while his graphic skill, working in pure black and white, was seen at its best in a series of magnificent brush and ink illustrations for Thomas Kinsella's translation of the ancient Irish epic poem *The Táin* (1969, Dolmen Press, Dublin) [230].

Although le Brocquy's second marriage to painter Anne Madden in 1958 resulted in a lightening of mood, his images are often of a bleak world, haunted by anxiety. Dark clouds hover over his protagonists; their time on earth seems short and unsettled. But, as in Beckett's work, the figures in his paintings seem also to have an inner strength; they stride forward, making do with their lot.

Louis le Brocquy's work can be seen in all Irish major collections. PETER MURRAY

SELECTED READING Herbert Read, *Louis le Brocquy*, exh. cat. Gimpel Fils Gallery (London 1961); Anne Crookshank and Jacques Dupin, *Louis le Brocquy: A Retrospective Selection of Oil Paintings*, exh. cat. HL and UM (Dublin 1966); Jacques Lassaigne, *Louis le Brocquy: À la Recherché de W.B. Yeats*, exh. cat. Musée d'Art Moderne (Paris 1976); Dorothy Walker, *Louis le Brocquy* (Dublin 1981); Anne Madden le Brocquy, *Louis le Brocquy: A Painter, Seeing his Way* (Dublin 1994); Pierre le Brocquy (ed.), *Louis le Brocquy: The Head Image* (Kinsale 1996).

LEECH, WILLIAM JOHN (1881–1968) [276], painter. Although by the end of his long working life as an artist, William Leech was painting in an Impressionist style that was almost half a century out of date, his paintings have a timeless quality and sense of atmosphere that appeal to successive generations. Much of this enduring popularity derives from the artist's sensitive and inspired use of colour, and his aspiration to represent beauty in nature. While Leech's paintings may lack the flash of the canvases of John Lavery (qv) or John Singer Sargent, their quiet harmonies, enlivened by an occasional brave use of colour, reveal an artist who painted with sincerity and feeling.

Born in Dublin, Leech was the son of Henry Brougham Leech, a distinguished professor of law at TCD. The family was well-off, and, in addition to attending St Columba's School, William also spent some of his childhood in Switzerland. In 1898 he became a student at the DMSA, but not long afterwards, dissatisfied with the standard of teaching, he transferred to the RHA Schools, where Walter Osborne was a tutor. Even as a student, Leech's talents were recognized, and he won the Taylor Prize no less than four times.

In 1901, following in the footsteps of many other Irish and British painters, Leech moved to Paris and enrolled at the Académie Julian. While in France, the nineteen-year-old continued to send paintings to Dublin where they were well received and shown at the RHA (qv). Two years later, as was almost customary for students at the Académie Julian, he moved to Brittany, arriving around the same time as his compatriot, the painter Roderic O'Conor (qv), was leaving. Accompanied by a friend, a painter from New Zealand named Sydney Thompson,

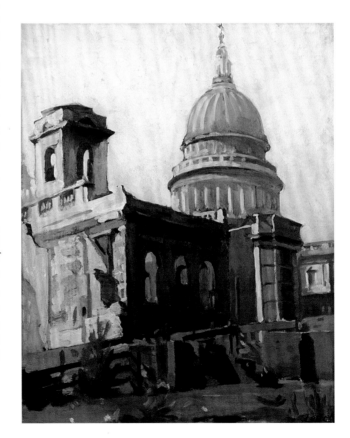

276. William John Leech, *St Paul's*, 1945, oil on canvas, 45 x 37 cm, Highlanes Gallery, Drogheda

Leech set down to work in the seaport of Concarneau. In addition to producing large, highly finished compositions, he also followed the Impressionist *plein air* tradition, sketching out of doors, working quickly so as to capture effects of sunlight and shadow from a direct observation of nature. Aware of the experiments being made by Post-Impressionist artists such as Matisse and Bonnard, Leech began around this time to move towards a purer and more vibrant use of colour. His painting *A Convent Garden, Brittany* (*c.* 1911, NGI collection) is an accomplished work, containing references also to his own personal life. The figure of the young woman in a Breton wedding dress, holding a prayer book, is a portrait of Elizabeth Kerlin (née Lane). Shortly after the painting was completed, Elizabeth, an American-born painter, divorced her husband, and in 1912 she and Leech were married in London.

In spite of the high regard in which his work was held, as an artist Leech was never commercially successful. He showed at Leinster Hall in 1907, along with two fellow students from the Académie Julian, Constance Gore-Booth and Casimir Dunin Markievicz, but sales were barely sufficient to cover their costs. The following year, Leech's father retired from his professorship in Dublin and the family moved to London. In the years following their marriage, Elizabeth and William eked out a living, spending part of the year in France and the rest in England, where they stayed with Leech's parents. Elizabeth inspired some of Leech's finest paintings in these years, including *The Sunshade* [355] (*c.* 1913), but the marriage was not a happy one, and matters were not helped by their remaining in Brittany during the early years of World War I, where opportunities for selling paintings were few. In 1917 Leech travelled to the South of France, again following the lead of other British and Irish painters, in search of the bright sunlit landscapes of Provence and the Riviera coastline. The influence of the Fauves, of André Derain and Raoul Dufy, is clear in his work at this time. Many of Leech's finest paintings are of flowers, gardens and rural scenes, although works such as *Interior of a Barber's Shop* (1909, CAG) are equally atmospheric and painterly.

Shortly after the war, Leech, suffering from depression, returned to London. His marriage to Elizabeth was failing and he had stopped painting. His brother Cecil, a former Artillery officer, who had fought in the war and spent years in a German prisoner-of-war camp, was working in London with a volunteer, May Botterell, who had set up a centre to assist repatriated prisoners of war. Having been introduced to May's family, Leech was commissioned by her husband Percy Botterell to paint portraits of May and their three children, James, Guy and Suzanne. May and William fell in love during this time, and she remained a loyal friend and muse throughout the rest of his life. Setting up a studio in Surrey, Leech continued to paint quietly, regularly submitting works to the RHA's annual exhibition. He also exhibited, between 1945 and 1953, at the Dawson Gallery in Dublin. In 1953, just twelve years before her death, May Botterell and William Leech were finally married, after the death two years previously of May's first husband, Percy Botterell. Leech's wife Elizabeth had died in 1950. Leech survived his wife May by only three years; in 1968 he was fatally injured after falling from a railway bridge in Surrey.

While Leech's early paintings are dark in tone, not unlike the early Antwerp scenes of Osborne, his later Impressionist-style works, influenced by studies and travels in France, are characterized by sensitivity and a delicate sense of colour. Leech's skill at depicting reflections on the surface of water drew him to paint scenes on the Brittany coast, and later, when living in England, he delighted in depicting scenes in Regent's Park and on the banks of the river Stour. He was also drawn to the tranquillity of churchyards and cemeteries, which appear in several of his paintings. Never a self-confident or sociable artist, Leech succeeded nonetheless in creating a number of paintings that are among the most popular with visitors to museums and galleries in Ireland. PETER MURRAY

SELECTED READING Alan Denson, *An Irish Artist, W.J. Leech, RHA 1881–1968*, II: *His Life Work – A Catalogue*, Part 1 (Merseyside 1969); Campbell, 1984; Denise Ferran, *William John Leech: An Irish Painter Abroad* (Dublin 1996).

LENNON, CIARÁN (b. 1947), painter. Lennon is one of those artists sometimes ambiguously referred to as 'a painter's painter'. The term can be interpreted in many different ways but in Lennon's case it means that he is dedicated to the discipline of painting, and to investigating all aspects of its process and context, even at the expense of his own advancement. The critic Dorothy Walker, who compared Lennon to Sean Scully and James Coleman (qqv), said his paintings 'borrow no support from popular iconography. They rely on the integrity of the painted surface and its capacity to communicate the intention of the artist ... it is up to the spectator to look quietly for long enough to apprehend these emanations.' (Walker, 1987, 66) Lennon constantly alludes to the ethics of painting and the meaning of vision, and it is these philosophical fields that he seeks to understand through an analysis of the physicality of the art work as a particular kind of object in space.

A Dubliner, Lennon owes as much to the influences of his childhood on the edge of the city as to his art education (NCA, 1963–67) and the influence of artists he admires: in the early days, Francis Bacon (qv), Jackson Pollock, Jasper Johns, Brice Marden and Frank Stella, and, as he got older, such historical figures as Giotto, Poussin and Cézanne. It was the impact of the work of Bacon and Stella that led him to definitively reject the illusionistic figuration that his early talent for drawing led him towards, and which is still evident in his entry, in the form of a comic-strip cartoon, to the 1982 IELA exhibition (qv) which, in that year, took the form of a book.

Ever since his first solo exhibition at the Project Arts Centre in 1972, Lennon has sought to 'make a painting with detail, interest and figuration and not allow it to be a geometric or biomorphic illusion' (*Ciarán Lennon, May 27 – June 27*, exh. cat. DHG, Dublin 1987, n.p.). Instead he developed a practice in which folded and unfolded stretcher-less canvases, raw, stained, painted, and often bearing scratches and incisions into the paint layers, reveal the unseen and inexpressible; forces hidden from us but of which we are aware. Lennon frequently speaks of his childhood experience of seeing the world around him but being

unable to see himself. Self-knowledge comes in a different way. At first the sense of the invisible was transmitted through the folded, unstretched canvases, which later gave way to more sculptural paintings where the physicality of the work was emphasized and the canvas stretched over thick box-like structures to make large-scale triptychs such as *1/3/92B* (1992) [277] or shaft-like forms such as *Breathe* (both IMMA collection). The meaning of centre and edge is undermined by turning the canvas in on itself or applying the paint in triangular brushstrokes that refuse entry to illusionistic space. As in most of Lennon's previous work and like later bodies of work such as *Scotoma* (1987), *L'Entre* (1995) and *Hapax* (2002), the palette employed in these paintings is limited. It is a measure of his austerity and integrity that he will not allow colour to distract attention from the challenge of presenting the unseen or barely visible. These groups of paintings formed installations that the artist refused to break down into their component parts, even though this decision seriously reduced their sale potential, since that compromised the intention of the work.

A change came in the early years of the new century as the artist experimented with paintings and gouache drawings on a smaller scale, some of which were linked to the idea of the container. An exhibition of smaller abstract (see 'Abstraction') colour sketches, allied to photographs of the stimuli that inspired them, were shown in book form in *Books, Boxes and Bronze*, at the Chester Beatty Library in 2002; the bronze containers, which were part of the artworks, were minimalist reinterpretations of Irish Early Christian book shrines.

The latest phase of his work, arising from the gouaches, comprises paintings such as the *Arbitrary Colour Collection*, in which Lennon makes a break with the muted austerity of his past to present a more sentient side of his artistic personality. He has described the relationship between the dark, folded works and his colourful gouaches as the relationship between sleeping and waking states. The emphasis on the physical remains, as the pigment sits on a ground that is champfered at the bottom to reveal where the brush stroke ends. Increasingly that ground can be aluminium or brass as well as canvas. No room is allowed for mystery or romantic illusion. The key to much of this work lies once again in Lennon's childhood experience of the gaze. In relation to the *Arbitrary Colour Collection*, he has spoken of his mother giving him a brush and a bucket of water to 'paint' the wall of their house and of his delighting in the effect of the light on the wet areas of wall, or looking through openings in the bridge over the Poddle river at the water below, frequently coloured with dyes from the local paper mill (conversations with the artist, IMMA, September 2000).

Both bodies of work are subject to the same aesthetic. 'Being a formalist artist as I am, is all about creating limits and obeying rules, and creating what's an honest exchange between us', Lennon told Emily Mark-Fitzgerald in 2007, adding that 'Only formal art can underpin the rule of law and democracy' (Mark-Fitzgerald, p. 101).

Ciarán Lennon is also an accomplished printmaker (see 'Printmaking'). He represented Ireland at the São Paolo Biennial in 1993, is a member of Aosdána (qv), recipient of the Pollock Krasner artist award, and has had solo exhibitions in the DHG, IMMA, NGI, Limerick City Gallery, Chester Beatty Library and RHA (qv) in Ireland, and in Arken Museum, Copenhagen, and the Centre Culturel Irlandais, Paris. He was one of the artists represented in *L'Imaginaire Irlandais* in Paris in 1996 and in *Irish Art Now: From the Poetic to the Political* (USA, Canada and Ireland) 1999/2000. His work has been collected by IMMA, NGI, AC/ACE, the Fogg Museum of Fine Art, Harvard University and many private collections. CATHERINE MARSHALL

SELECTED READING *Irish Exhibition of Living Art*, 1982, p. 41; Dorothy Walker, 'Ciarán Lennon', *IAR*, IV, no. 2 (1987), 66–67; Dorothy Walker, *The Scotoma Group Paintings 1992–93*, exh. cat. DHG (Dublin 1992); Marian Lovett and Declan McGonagle, *Ciarán Lennon: L'Entre*, exh. cat. IMMA (Dublin 1996); Emily Mark-Fitzgerald, 'Awake! Absolutely Awake', in Mark-Fitzgerald, 2008, pp. 92–107.

LEVINE, LES (b. 1935), conceptual artist. Les Levine was born in Dublin and educated in Dublin, London and Toronto, but his considerable reputation as a conceptual artist is based almost entirely on work carried out in the United States, Canada and elsewhere, rather than in Ireland. He was firmly embedded within the emerging Conceptual art (qv) movement in the 1950s and '60s, as Brian O'Doherty (qv), writing about the radical sensory transformations of sixties' culture, noted: 'In the galleries

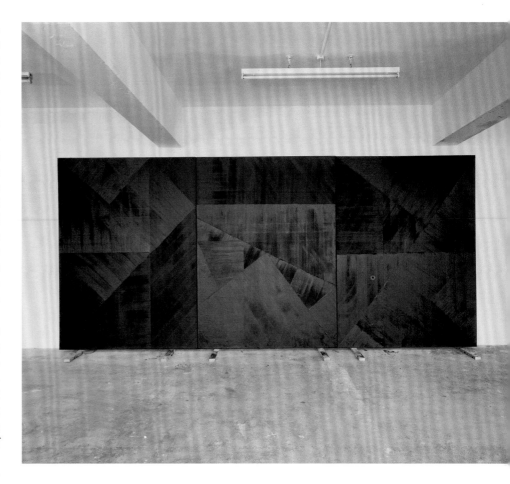

277. Ciarán Lennon, *1/3/92B*, 1992, oil on canvas, 244 x 488 x 10 cm, Irish Museum of Modern Art

its most cogent expression was in Les Levine's *White Sight* at the Fischbach Gallery in January 1969.' (O'Doherty, 'The Gallery as Gesture', in R. Greenberg, B. W. Ferguson and S. Nairne (eds), *Thinking about Exhibitions*, London 1996, p. 332) *White Sight* effectively rendered the audience sightless, through the use of high intensity lighting, effectively turning the audience itself into the artefact. In pursuing this line of enquiry, Levine and like-minded contemporaries sought to re-evaluate the relationship between art and its social context. Another art project, *Levine's Restaurant*, a restaurant on New York's 232 Street, Park Avenue South, was described by *The New Yorker* as an 'autobiographical culinary experience' (7 April 1969). Here, the presence of television cameras and monitors trained on the clientele underlined the notion that people dine out as much to be seen as to eat. Levine's use of new media (qv) went on to influence Gary Hill and Dan Graham.

But Levine had other ways of reaching audiences. *Media Mass* (1985) displayed words such as 'kill', 'rape', 'race', and 'lie', over Times Square, taking their place regularly between advertising slogans on the Spectacolor lightboard. The billboard series 'Blame God' [278, 430], for which he is probably best known in Ireland and the UK, again highlighted the relationship between words and images and their potential to impinge in diverse ways on audiences. The work's subsequent history, when shown in Derry, and in London at the height of the 'Troubles' (qv), and again in Dublin in 1993, clearly indicated that meaning resided with the spectator. The work was variously interpreted as a comment on the sectarian violence underlying the Troubles in the 1980s, while in Dublin eight years later, those who had won a legal injunction to ban its public display, cited blasphemy, in a context of discourse about divorce and abortion.

An exhibition, *Mindful Media: Three Works from the 1970s*, at IMMA (2011) allowed Irish audiences to reacquaint themselves with Levine's work from the 1970s, when he led artistic experimentation with new media. It also enabled Irish audiences to enjoy a major donation of Levine's artwork to the country. This included work made in response to the Troubles to which Levine was deeply attentive, although he was living abroad at that time. Another part of his donation, *Using the Camera as a Club* (1979), was included in *The Moderns* (IMMA, 2010), an exhibition about Irish modernity. Speaking of *The Troubles: An Artist's Document of Ulster*, a group of 80 cibachrome photographs and 18 photo-etchings (1972–79), Levine said:

It deals with every aspect of the situation. It goes into Catholic homes, Protestant homes, churches, funerals, explosions… My approach was to take it from the human point of view, not the political. So in all cases I tried to show the people involved and to evoke some state of mind that they were representing in the photo. I avoided taking sides or showing bias. I think the photos tell their own extraordinary story…

He went on to outline his thoughts on media art:

I am interested in using media to effect change and understanding of our environment. I want to consider media as a natural resource and to mould media the way others would mould matter. In the case of *The Troubles* I was forced to ask myself, are the political problems of a society a valid concern for art? The answer was 'Yes, of course.' (Kennedy, n.p.)

CATHERINE MARSHALL

SELECTED READING Thomas McEvilley and Declan McGonagle, *Les Levine – Blame God: Billboard Projects*, exh. cat. ICA, London; Orchard Gallery, Derry; DHG (London 1985); Christina Kennedy, *Les Levine: Mindful Media*, exh. cat. IMMA (Dublin 2011).

278. Les Levine, *Attack God*, 1985, 'Blame God' series, billboard project (see 430)

LOHAN, MARY (b. 1954), painter. While Mary Lohan's paintings generally refer to the landscape of the west of Ireland, they are conditioned also by her urban location and, in particular, by the associated desire for retreat. In marked contrast to her Dublin studio environment within the throng of city life, her work is notable for the absence of any traces of human activity.

She developed her recognizable method of representation in the 1990s, making polyptychs comprising multiple canvases arranged as a series of views along a single panorama. Her technique involves painting the abutting canvases in thick impasto as a single image, then separating them as they dry, so that the paint is dragged at the sides to indicate both their connection and separation. The viewpoint of her landscapes is invariably out to sea, towards the element where the traces of human activity are most mutable and least visible.

Lohan provides no markers to indicate scale or distance, blurring the distinction between land, sea and sky as though by saturated climatic conditions. While romanticized, these are not self-indulgent works, suggesting the consolation rather than the pathos of isolation, evoking the sublime rather than the nostalgic. As the horizon – symbol of aspiration and progress – is dissolved, time and space lose all shape. In negating traditional landscape anthropometrics, the invitation is less to the body than to the spirit. *Donegal Bay* [279] is a typical example.

While Lohan's work borders on the abstract, she counters the potential metaphysics with her play on the physicality of the paint. Thickly impastoed, her paintings function almost as sculptures, excavating to the lower deposits of pigment to exhume veins of unexpected colour. While the work of the 1990s and early 2000s imply immateriality, later paintings suggest the tangible textures of sand and sea and their characteristic flux.

Lohan's imagery confirms the assertion that Irish art at the turn of the millennium continues to manifest a romantic leaning. While this is sometimes levelled as a criticism, suggesting a dependence on tradition, in her case it is presented as a necessary antidote to the pressures of contemporary life.

Born in Dublin, Lohan attended NCAD and is a member of Aosdána (qv). She has been included in numerous group shows representing contemporary Irish art in Ireland and abroad, including *Re/Dressing Kathleen* (Boston, 1997), *Something Else: Irish Contemporary Art from Ireland* (Turku, Helsinki, Oulu and Joensuu, 2002), *Re-Imagining Ireland* (Virginia, USA, 2003), *Views from an Island*, Chinese-Irish Cultural Festival (Beijing and Shanghai, 2004), and *10,000 to 50: Contemporary Art from the Members of Business2Arts* (IMMA, 2008). Her work appeared in a documentary film entitled *Soul of Ireland: The Landscape Painter*, directed by Seán Ó Mordha (RTÉ Arts Lives series, Araby Films, 2007). Lohan is represented in various state and institutional collections in Ireland. YVONNE SCOTT

SELECTED READING Aidan Dunne and Noel Sheridan, *Profile 5 – Mary Lohan* (Kinsale 1997); Yvonne Scott, 'Refreshing the Landscape', *IAR* (Spring 2004), 60–61.

279. Mary Lohan, *Donegal Bay*, 1997, oil on canvas on 2 panels, 61 x 61 cm each, Irish Museum of Modern Art

LUKE, JOHN (1906–75), painter. Born in Belfast to a working-class family, John Luke's first job was in the shipyards in his native city. It was only after an accident led to a change of jobs that he turned to art, attended part-time classes at the Belfast School of Art and, in 1927, won the Taylor and Dunville Prizes, the latter of which enabled him to study at the Slade School in London from 1928 to 1930, sharing a studio there with fellow northerner F.E. McWilliam.

Highlighting Luke's enigmatic position in the traditions of Irish art, where his work did not fit into any recognizable context, Dickon Hall said that the artist's 'own disinclination to discuss meaning in his work, as well as an overemphasis on his fascination with technique, has clouded appreciation of his achievement' (Hall, 101). James White, later to become director of the NGI, who encountered Luke's work in 1946, was sufficiently impressed to write about his purity of colour, technical mastery and textural values, which he described as being 'of a quality unequalled by any painter of the past three centuries whose work I know' (Snoddy, p. 353). It is certainly true that Luke's painstaking exploitation of the laborious tempera techniques of the Renaissance made his work unusual at a time when oil pigments dominated western painting. That technique undoubtedly affected Luke's level of production, which was not prolific; but it is the magical and mysterious qualities of the paintings for which Luke is remembered, which are only, in part, attributable to their technical brilliance.

There is an element of the surreal in Luke's work, which may derive more from the formal stylization it embodies, than to any natural sympathy with the aims of the Surrealists. Luke was an admirer of Renaissance art and of the work of Cézanne and Seurat, and it is to them that his formal and idealized compositions should be linked. This is most clearly evident in works such as the early painting *The Bathers* (1929), *The Dancer and the Bubble* (1947, private collection) and *The Three Dancers* [280]. He executed twelve of the fifteen panels of a frieze to represent Ulster at the *Glasgow Empire Exhibition* (1938), and again represented Northern Ireland at the New York World's Fair of 1939.

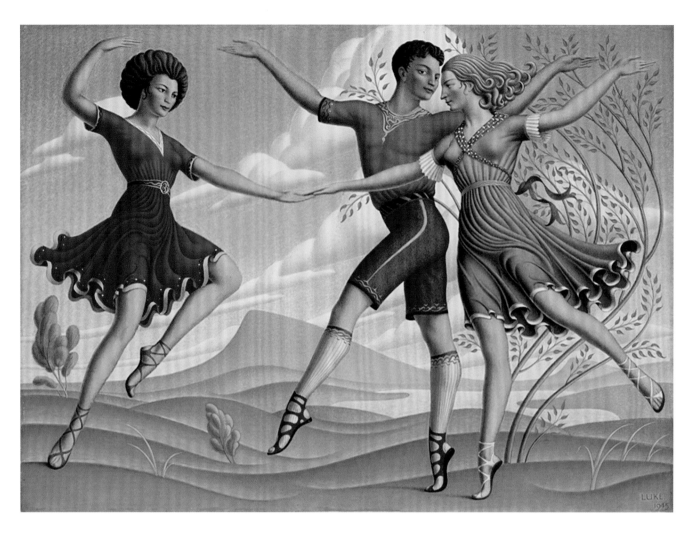

280. John Luke, *The Three Dancers*, 1945, oil and tempera on canvas on board, 30.7 x 43 cm, National Museums Northern Ireland, Collection Ulster Museum

Luke abandoned painting for sculpture for a time during World War II, but returned to painting in 1943 and had his first solo exhibition three years later at the Belfast Museum and Gallery. While he is acclaimed for his theatrical, jewel-like paintings, he could also work on a grand scale, as is shown in his mural on *The Life and History of Belfast* [221] for the tympanum of the inner dome of Belfast City Hall, where he covered an area 4.6 m by 9.5 m (1951/52). He was later commissioned to paint *King Solomon building the Temple* for the Provincial Masonic Hall, Rosemary Street, Belfast, and in 1959 to carve a plaque in stone for the Governor of Northern Ireland, Lord Wakehurst. In 1953 he became a part-time lecturer at the Belfast College of Art, although his teaching work is best remembered for his informal tutoring in the 1930s of the artist Nevill Johnson (qv). Luke's work can be seen in the collections of the UM and the NGI.
CATHERINE MARSHALL

SELECTED READING John Hewitt, *John Luke Retrospective*, exh. cat. UM and DHG (Belfast 1978); Snoddy, 2002, pp. 351–54; Dickon Hall, 'Unlocking John Luke', *IAR* (December 2011 – February 2012), 100–03.

MCALEER, CLEMENT (b. 1949), painter. The landscape painter Clement McAleer was born in Coalisland, Co. Tyrone, and worked in a factory for several years before studying art in Belfast, Canterbury College of Art and the RCA in London. Landscape (qv) could be described as the default position for many Irish artists, but from the outset McAleer's landscapes were distinctive because of their panoramic viewpoint, their large scale, and his geometric, structured approach to composition. In this McAleer clearly looked back to the proto-Cubism of Cézanne and the contemporary reinterpretation of it by the American painter Richard Diebenkorn, rather than to the romantic Irish tradition, laid down by Jack B. Yeats, Paul Henry and Patrick Collins (qqv). In stubbornly resisting what Frances Ruane has described as 'the Celtic imagination' (Ruane, n.p.), McAleer presents a modern reality between the edges of the city and the country, placing an emphasis on form that is more sculptural and architectural than painterly. There is no human presence in these landscapes, although it is clear that man has played a significant part in shaping them. This is very much in evidence in paintings such as *Telemachus* [281] from the 'Ulysses' series, painted for the Douglas Hyde memorial exhibition in 1982. It is present again in a more sombre fashion in *Seafront at Night* from the Vincent Ferguson collection (n.d.,

'My paintings are about the magic of what at first seem to be very ordinary places, often deserted or undergoing transformation with traces and signs of human activity left behind, the mysterious atmosphere with which they are imbued, the quality of light.' (Knowles, p. 223)

McAleer's work is included in the collections of IMMA, UM and the AIB. CATHERINE MARSHALL

SELECTED READING F. Ruane, 1981; Knowles, 1982; Brian McAvera, 'Memory and Invention', *IAR* (Spring 2006), 86–93.

MCCARTHY, CAROLINE (b. 1971) [282], conceptual artist. In 1998, when invited to participate in the exhibition *Irish Art Now: From the Poetic to the Political*, an international touring exhibition jointly organized by IMMA and Independent Curators Inc., Caroline McCarthy offered a video piece entitled *Journey through the Longest Escalator in the World*, which features an empty plastic bottle caught in perpetual motion along a subway escalator. In typical McCarthy fashion, something worthless and generally beneath our attention becomes a metaphor for human life, endlessly and pointlessly carried through space in the hope of arriving at a destination that the viewer knows is fruitless. Notwithstanding the seriousness of her intention, or the forum in which it was presented on that occasion, the comic aspect of her imagery is also important. McCarthy's concerns are to re-examine mundane events and objects, even the detritus of our lives, to see what they reveal about the human condition, and particularly practices to do with food consumption and consumerism.

281. Clement McAleer, *Telemachus, The Martello Tower, Sandycove* from the 'Ulysses' series, 1982, oil on canvas, 152 x 152 cm, AIB Collection

282. Caroline McCarthy, *Greetings*, 1996, video installation, 2 monitors on 2 plinths, Irish Museum of Modern Art

IMMA), where the weight and gravity of the landscape is increased by the brooding darkness that is about to engulf it. This is as close as McAleer gets to expressing the difficulties of life in Northern Ireland during the 'Troubles' (qv). Instead, he seeks something more lasting in the landscape. Paintings such as *Glass House*, also from the Ferguson collection at IMMA (n.d.), show a considerably lighter palette but continue to embody the fragility of human intervention.

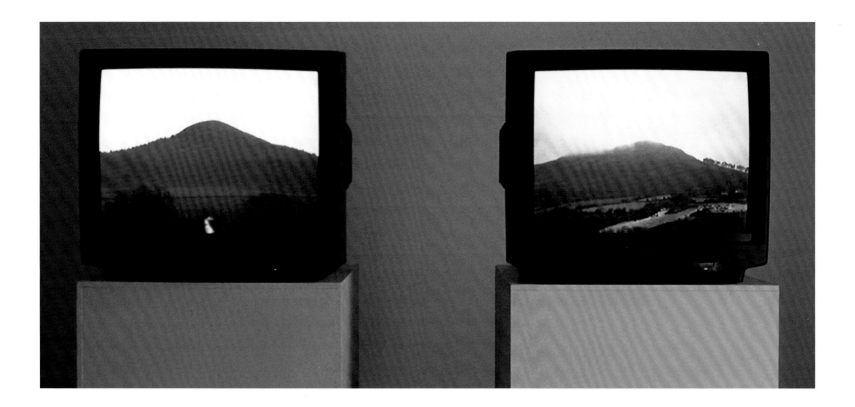

A body of photographs of luscious arrangements of food, serving as a vehicle for the examination of the traditional genre of the still life, aspects of sculpture, consumption, waste and ultimately human vanity, won her the AIB Art Prize in 2001. The still-life genre's traditional association with *memento mori* and human vanity becomes more pointed in this work since the sculpted food is entirely moulded from wet toilet paper, perhaps the most universally discarded of all materials. It also serves to deconstruct the status of the genre within 'high' culture by bringing it closer to vulgar 'toilet' comedy.

McCarthy was born in Dublin, raised in Dundalk and educated at NCAD and Goldsmiths College, London. Her career path has been meteoric. In 1996 her work was selected by the renowned Italian curator Guy Tortosa for the EV+A Open Award and purchased for IMMA. A residency at IMMA in 1997 was followed by others in Eindhoven, Paris and Reykjavik, at Parker's Box in New York, and Biz-Art in Shanghai, while she has had solo exhibitions in Dublin, Ghent, London, Düsseldorf,

New York and other centres. She has been included in group shows all over Ireland and in Albania, Australia, Britain, Canada, China, Denmark, Finland, France, Germany, Greece, Iceland, Japan, the Netherlands and the USA. Among the awards she has already accumulated are bursaries from the AC/ACE and the British Council, two Open Awards at EV+A, the AIB Art Prize, and the Culture Ireland Award in 2006. Caroline McCarthy has been commissioned to execute art projects for Blanchardstown, Letterkenny, Dundalk, the De La Warr Pavilion, Bexhill, East Sussex and King's College, London.
CATHERINE MARSHALL

SELECTED READING Mark Hutchinson, 'An Art of Escape', in *Escape: Caroline McCarthy*, exh. cat. Temple Bar Gallery (Dublin 2002); *Caroline McCarthy*, exh. cat. Gasworks Gallery (London 2003); Chris Townsend, *New Art from London* (London 2006).

MACGONIGAL, MAURICE (1900–79), painter. Born in Dublin, MacGonigal followed his father, Frank, into employment in the stained-glass division of Joshua Clarke and Sons, the firm established by his uncle Joshua, father of Harry Clarke (qv), when he was sixteen. MacGonigal, however, was more drawn to nationalist politics (see 'Politics in Irish Art') than to stained glass and having joined Na Fianna Éireann in 1916, and later the IRA, he took part in revolutionary activities, which included the attack on Viceroy Lord French, and was interned at Ballykinlar Camp, Co. Down in 1920. Although he resigned from the IRA on release, MacGonigal's nationalism remained a potent force throughout his life; Katharine Crouan claims that he was the only painter to become actively involved in the armed struggle for independence (Crouan, p. 8). MacGonigal's patriotism re-emerged during the Emergency of World War II when he enlisted in the Defence Forces and manned an anti-aircraft battery at Booterstown, near his home. From an artistic/political perspective, MacGonigal shared with Patrick Tuohy and Seán Keating (qqv) a sense that it was his duty to foster the emergence of an Irish school of painting. 'There was an attempt ... to be aware of the contribution the artist should make to Ireland but I don't know that people pay much attention to that now. In my time we did think that we were doing something to create a new Ireland' (MacGonigal interviewed by Tom McGurk, RTÉ, *c.* 1972)

Following his release from internment, MacGonigal returned to the Clarke studios but soon left again, this time to pursue a scholarship at the DMSA where the academic legacy of Orpen (qv) was strong, especially among those whom MacGonigal admired. Another powerful influence on him was the landscape and life of the people of the west of Ireland. Like his cousin Harry Clarke (qv), he went to the Aran Islands where he perfected his spoken Irish and befriended the writer Máirtín Ó Direáin. Throughout his life, MacGonigal escaped from Dublin annually to Carraroe, An Spidéal, Achill, Blacksod Bay and Roundstone, painting a world that he perceived as the real Ireland. Significantly he was less interested in the Celtic Twilight atmospheric painting of the west as depicted by Paul Henry (qv) or the religiosity that is sometimes a feature of Keating's work, than in the lifestyles and

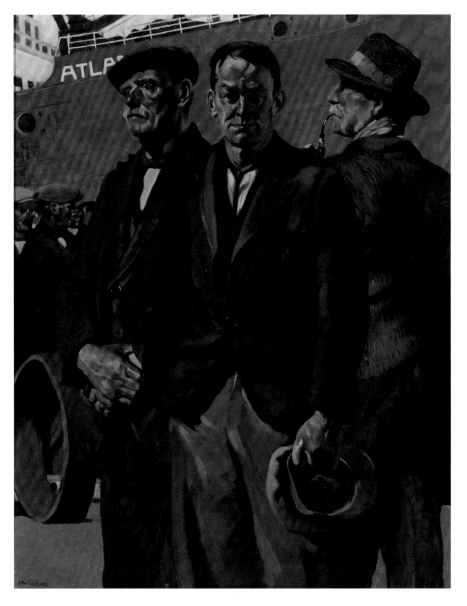

283. Maurice MacGonigal, *Dockers*, 1934, oil on canvas, 125 x 100 cm, Dublin City Gallery The Hugh Lane

social values of the people. This was especially evident in his first large commission, nine wall panels for Runnymede House, Shrewsbury Road, Dublin (sadly now dispersed), and is seen at its best in his images of women from the west of Ireland, for which his wife, Aida, was generally the model. These paintings, such as *Mathair agus Naoidheanán* (*Mother and Child*) (1942) [375], from the late 1930s and '40s, gave credence to Eamon de Valera's dream of an Ireland where traditional values were dispensed by dignified and devoted mothers, but ignored the reality of woefully inadequate maternity services in rural areas, a situation remedied only in the 1950s after a hard-fought battle.

From the outset, MacGonigal was a successful artist, winning medals for landscape and drawing (qqv) at the Aonach Tailteann in 1924 (while still a student), 1928 and 1929, and securing a commission to make thirty-three images of the west of Ireland for the *Free State Handbook*; these formed the subject of his first solo show at the Stephen's Green Gallery, held that same year, 1932. In 1939 he was commissioned to paint a twelve-metre-high painting of famous Irishmen in American history for the Irish Pavilion in the New York World's Fair. Another monumental piece of public pageantry, a mythological backdrop for the Irish Sweepstakes Draw in 1932, big enough to frame 224 figures in costume and the huge lottery drum, requiring a team of assistants and delivery in twenty-four days, confirmed his organizational skills and his ability to devise images on a grand scale. He repeated this feat again in another temporary art project, the sets for the 1936 Abbey Theatre production of Seán O'Casey's *The Silver Tassie*.

In 1934 MacGonigal became Keeper of the RHA School and, three years later, was appointed to a teaching job at NCA. Teaching was essential for survival for most Irish artists during this period, but MacGonigal actively enjoyed it. His approach was surprisingly liberal for someone who was to become president of the RHA (qv) in 1962, as well as Professor of Painting (1954–69) in the notoriously conservative NCA. 'Every kind of art expression should be encouraged in Ireland. There is little enough of it', he told the *Sunday Independent* (28 May 1967).

Highly political, MacGonigal's best work reflects the lives of Irish workers – the industrial workers of the city as well as the small farmers and fishing families of the west. One of his most powerful paintings, *Dockers* [283], is reminiscent of Soviet Socialist Realism in its treatment of the dignified disillusionment of three men who have failed to get themselves hired for the day. Part of the strength of this image arises from MacGonigal's use of a striking primary red on the hull of the ship which forms a backdrop to the men's situation, and reflects the influence of van Gogh.

Unlike fellow traditionalists, such as Keating, MacGonigal was deeply excited by the work of van Gogh which he saw on a visit to Holland in 1927 when he stayed with the family of Hilda van Stockum (qv). Although he felt obliged to paint generally in a conventional manner, van Gogh's influence surfaced throughout his career, occasionally unbalancing it, but often giving it an expressive force, most evident in pictures such as *Roundstone: Desmond Stephenson ARHA coming home in Connemara* (1953, private collection) or *Man with Hay* (1972, Norma Smurfit collection).

In 1969, having served as professor of painting at the NCA for thirty-two years, MacGonigal resigned following student demands for change, and nine years later he also resigned his presidency of the RHA. He exhibited at the Academy every year from 1924 until the year before his death. A retrospective exhibition of his work was held in the HL in 1991.

MacGonigal's work is included in most of the national and many of the regional collections. CATHERINE MARSHALL

SELECTED READING Turpin, 1988; Katharine Crouan, *Maurice MacGonigal RHA, 1900–1979*, exh. cat. HL (Dublin 1991); Sinéad Crofts, 'Maurice MacGonigal, PRHA (1900–1979) and his western paintings', *IAR Yearbook* (1997), 135–42.

MCGUINNESS, NORAH (1901–80) [284, 285], painter. Norah McGuinness was born in Derry, Northern Ireland, and attended life-drawing classes there as a schoolgirl. In 1921 she enrolled at the DMSA, where she was taught by the academic painters Patrick Tuohy (qv) and Oswald Reeves. However, the teacher from whom she benefited most was Harry Clarke (qv) whose drawing style and ability as an illustrator particularly appealed to her. McGuinness also studied at the Chelsea Polytechnic, London, in 1923/24. She married Geoffrey Phibbs (the poet Geoffrey Taylor) in 1925, although the marriage broke up four years later. In 1927 she met Mainie Jellett and Evie Hone (qqv), and, like them, briefly attended André Lhote's classes in Paris. While there she was impressed by Cubism (qv) and admired the work of Braques, Dufy and Lurçat, but was not overwhelmed by it. She spent most of the 1930s in London, apart from a five-month visit to India in 1931, and had her first solo show there in 1933.

On foot of recommendations from Harry Clarke and William Butler Yeats, she received her first commissions to do book illustrations (qv). She illustrated Laurence Sterne's *A Sentimental Journey* in 1926, and a year later Yeats's *Stories of Red Hanrahan: The Secret Rose* for the London publisher Macmillan. Yeats liked the 'powerful simplicity' of her illustrations and thought them 'amusing and vivid'. He declared that she had 'done me a great service' and dedicated his poem 'Sailing to Byzantium' to her, which he included in the book at her suggestion (Brown, pp. 107–08). She went on to illustrate books by the Irish writers Maria Edgeworth, Elizabeth Bowen and Elizabeth Hamilton. An energetic all-rounder, McGuinness was involved in the theatrical life of Dublin, designing sets and costumes for such plays as Yeats's *Deirdre*, and Oscar Wilde's *The Importance of Being Earnest,* for the Abbey and Peacock theatres. No task that might provide a living for an artist was beneath her. Having seen artists design shop-window displays in America, she described how, on her return home to Ireland, she 'went to Brown Thomas with the idea; they accepted, and I did a display for the Spring. Nothing like that had ever been done before and it literally stopped traffic.' (*IT*, 25 July 1968) She was to continue this work for three decades.

McGuinness is one of the artists dismissed by the critic Brian Fallon as 'Lhote's Wives' (Kennedy, p.168), although other writers, Anne Crookshank for instance, thought that the

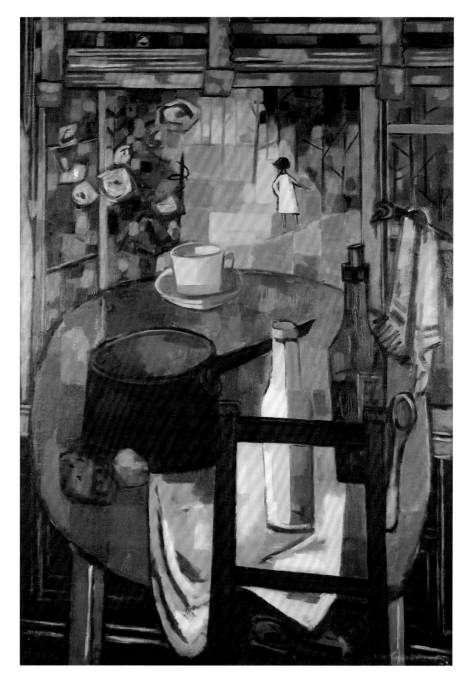

reason she was not influenced by Lhote was because she was already an established artist before they met (S.B. Kennedy, p. 54; Crookshank, n.p.). McGuinness saw Cubism (qv) as a means to an end rather than an overarching aesthetic, saying: 'Cubism gets rid of things that are not essential. It is a great simplifying aid and I think in that way its influence is apparent in my work as part of an overall simplification process.' (Brown, p. 110) She is generally remembered for her popular landscape (qv) and still-life paintings, in which a mild influence of Cubism is easily absorbed, and which reflect her strong sense of design, but it could be argued that her design work is her most important legacy.

McGuinness showed at the RHA (qv) for the first time in 1940, and three years later was one of the founding committee members of the IELA (qv). Following the death of Mainie Jellett, she became president in 1944, a post she continued to occupy with considerable energy until 1970. Brian Fallon described her as having an 'acute social sense and firm opinions about virtually everything', and that she was 'another masterful woman in the Irish Protestant mould, and a useful person to lead the official opposition to Keating [qv] and the RHA' (Fallon, p. 169). The highlight of her career came in 1950 when she and Nano Reid (qv) were chosen as the first artists to officially represent Ireland at the Venice Biennale. She was elected HRHA in 1957 and at the age of sixty-five was given a retrospective exhibition in TCD, for which Anne Crookshank wrote the catalogue introduction. In 1973 she was honoured with a DLitt from TCD.

Her work can be seen in the collections of IMMA, HL, CAG, TCD, and in most of the big corporate collections.

Norah McGuinness is remembered with great fondness by the many younger artists, such as Patrick Scott (qv), to whom she acted as a mentor when she was President of the IELA. Like Sarah Purser (qv), she is respected as much for her work on behalf of fellow artists, and for the promotion of art in Ireland, as for her painting. Catherine Marshall

SELECTED READING Anne Crookshank (ed.), *Norah McGuinness: Retrospective Exhibition*, exh. cat. TCD (Dublin 1968); Fallon, 1994; Karen E. Brown, 'Norah McGuinness, W.B. Yeats and the illustrated book', in Brown, 2008, pp. 101–16; S.B. Kennedy, 1991; Róisín Kennedy, 'Lhote's Wives,' in O'Connor, 2010, pp. 168–78.

MCGUIRE, EDWARD (1932–86), painter. Edward McGuire, son of a wealthy businessman, member of Seanad Éireann and successful amateur artist, may have found privilege more of a burden for his artistic vision than a gift. Following private education in Dublin and later at Downside in England, he studied Renaissance art in Italy and worked for a short time in the studio of Pietro Annigoni, a successful portrait painter who had painted the young Queen Elizabeth II. A short stint as a trainee manager in his father's company, Brown Thomas and Co., convinced McGuire that painting was the career for him. He enrolled at the Slade School in London for a year where he was taught by Lucian Freud and John Minton, and on his return, via a stay on the Aran Islands, he settled in Dublin and began a serious career as a painter.

284. Norah McGuinness, *Garden Green*, 1962, oil on canvas, 102 x 71 cm, Dublin City Gallery The Hugh Lane

285. Norah McGuinness, *The Last of the Trees*, 1972, oil on canvas, 71 x 101 cm, Arts Council/An Chomhairle Ealaíon

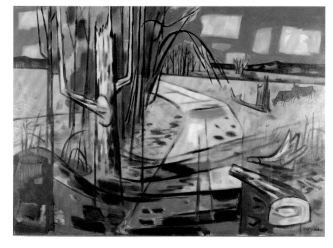

Under the name Edward Augustine, he showed a self-portrait at the IELA (qv) in 1953 where the critic Edward Sheehy commented on a 'curiously tense and nervous quality in his work' and expressed a desire to see more of it (Murphy, p. 39). Encouraged by this and the steady support of artist friends, such as Patrick Swift (qv) and Patrick Pollen, he began to exhibit under the name Edward McGuire, showing at the RHA (qv) from 1962 onwards. Shy and insecure as an artist, with a very small output of about five pictures a year, often destroying his work, McGuire avoided solo exhibitions, yet such was his reputation as a portrait painter (see 'Portraiture') in the 1960s and '70s that Brian Fallon could say later: 'There are greater painters than Edward, but he is the only important Irish portrait painter since John Yeats. He is to the culture of his age what the elder Yeats is to the Literary Revival.' (Ryan, 2003, p. 243) Theo Snoddy records that when McGuire's painting *The Four Snipe* (1969) was shown at the Dawson Gallery, it was the first time a Dublin gallery had held a full-scale exhibition of a single work.

Because of this reticence, McGuire was at his best painting still lifes and portraits of his friends, many of whom were writers and fellow artists. But commissions were necessary for his survival, and the first of these came in 1966 for a portrait of Wanda Ryan, whose father, the artist and writer John Ryan, McGuire had also painted (Dublin Writers Museum collection). A year later he painted a delightfully *faux naïf* painting of Rossenara House, Co. Kilkenny, home of the writer Richard Condon and former home of John Lavery (qv). Other commissions followed; the UM commissioned a portrait of Seamus Heaney [385] in 1974, a head study of which was purchased by the NGI. Charles Haughey, who viewed McGuire as having the calibre of an Old Master (Ryan, 2003, p. 89), commissioned an equestrian portrait of himself in front of his house at Abbeyville, like an eighteenth-century ascendancy grandee. Other commissions included portraits of Sir Alfred and Lady Beit, William Whitelaw, Mrs Doreen Mullen, the social columnist Terry Keane, and a host of portraits of academics, but it was with portraits of writers and artists such as Anthony Cronin, Patrick Kavanagh, Pearse Hutchinson, Sean Ó Faoláin [286], Eilís Dillon, Patrick Collins (qv) and the Guinness heir and promoter of the arts, Garech Browne, that McGuire excelled. The portraits and his still-life images reflect an obsessive control and his elaborate analytical approach to his subjects.

His vision, influenced to some degree by early Lucian Freud, and more so by René Magritte, was unique. He posed his sitters in his studio, generally under artificial light conditions, surrounding them with stuffed birds, artificial foliage and eccentrically chosen objects which appear random but often have a symbolic function. Brian Fallon observed that McGuire was not a natural craftsman, yet his almost scientific approach to the business of painting is one of the distinctive features of his work. The artist described to his friend Hayden Murphy how he created a 'stepped palette, filled with colours, carefully mixed and allowed to stand, before selecting a handful for further use', going on to explain that '... Every colour has its own private purpose, its own tonal purpose' (Murphy, p. 47). McGuire's unique process was put on display along with his artwork in a retrospective exhibition at

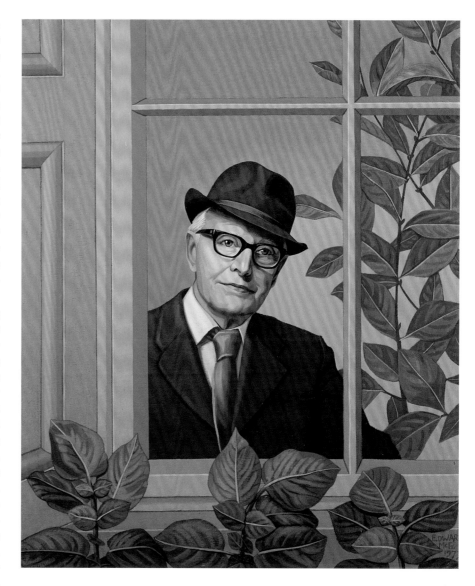

the RHA Gallagher Gallery in 1991, five years after his premature death at the age of fifty-four. His studio is now at IMMA.

Maguire was included in such important group shows of Irish art as *The Irish Imagination*, *Rosc '71* (see 'Rosc Exhibitions'), *The Delighted Eye* (1980) and *Ireland's Literary Renaissance: 20th Century Portraits*, Marshall Field's, Chicago. He was a founding member of Aosdána (qv) and his work is included in the collections of the NGI, IMMA, HL, UM, CAG, TCD, UCC, UCD, UL and Leinster House.

CATHERINE MARSHALL

286. Edward McGuire, *Sean Ó Faoláin*, 1977, oil on canvas, National Gallery of Ireland

SELECTED READING Hayden Murphy, 'Edward Maguire [*sic*], a profile', *The Arts in Ireland*, II, no. 4 (1974), 38–48; Dorothy Walker, 'Sailing to Byzantium: The Portraits of Edward McGuire', *IAR*, IV, no. 4 (Winter 1987), 21–29; *Edward McGuire, RHA, 1932–1986*, exh. cat. RHA (Dublin 1991).

MCKELVEY, FRANK (1895–1974), painter [287]. Belfast painter Frank McKelvey was described by Crookshank and Glin in *Ireland's Painters* as 'virtually self-taught' (Crookshank and Glin, 2002, p. 290). McKelvey had, however, following a period working with the advertising firm of David Allen and Sons, studied at the Belfast School of Art, where he won prizes for drawing in 1912 and 1914. He went on to win a bronze medal at the Taylor Art Competition in 1917. He exhibited at the RHA (qv) annually from 1918 until 1973. In 1930 he became a founding member of the RUA (qv) and, five years later, was elected to full membership of the RHA. Outside Ireland, McKelvey showed his work at the Royal Glasgow Institute of the Fine Arts and was represented by the Hackett Galleries in New York in the 1930s. He was included in the *Irish Exhibition* in Brussels in 1930 and had his first solo shows in Dublin at the Victor Waddington Galleries in 1937 and 1939.

Best known as a painter of landscapes (qv) of the north and north-west of Ireland, McKelvey was also a portrait painter (see 'Landscape' and 'Portraiture'). His first big opportunity came when the businessman Thomas McGowan commissioned him to paint pictures of Belfast (UM collection) and later supported him to do portrait drawings of thirteen American Presidents who claimed Ulster connections. Other portraits include paintings of senior academics for QUB, and the Duke of Abercorn, first Governor of Northern Ireland (1946). His 1933 painting of the Lord Mayor of London, Sir Percy Greenaway, arriving in Londonderry to open the new Craigavon Bridge may have been destroyed in the 1972 bombing of London's Guildhall by the IRA.

S.B. Kennedy believed that McKelvey helped to create a distinctive Irish school of painting (Kennedy, 1991, p. 176), but Crookshank and Glin considered his work merely competent and sometimes slick (op. cit.). McKelvey's reputation has been

287. Frank McKelvey, *On the way to Muckish, Co. Donegal, c.* 1940, oil on canvas, 50.7 x 59.8 cm, Crawford Art Gallery

overshadowed over time by the more dramatic work of fellow northerners Paul Henry and James Humbert Craig (qqv). Three of his landscapes were presented as a wedding gift to Queen Juliana of the Netherlands by Irish-based Dutch citizens in 1936. He provided drawings for Margaret Holland's *My Winter of Content under Indian Skies* (Belfast, 1926).

McKelvey's work is in the collections of the UM, the National Maritime Museum, London, the Belfast City Hall and Harbour Office, and in private collections. CATHERINE MARSHALL

SELECTED READING Bodkin, 1940; S.B. Kennedy, 1991; S.B. Kennedy, *Frank McKelvey RHA, RUA: A Painter in His Time* (Dublin 1993).

MCKENNA, STEPHEN (b. 1939), painter [288]. 'The classical humanism which steeps his work stretches back over the centuries in its references, but it is developed through a contemporary vocabulary and sensibility.' (Brian Fallon, *Stephen McKenna: Arrangements and Distances*, Dublin 1990)

Born in London, McKenna is a peripatetic artist who has lived and worked in various countries, most notably Germany, Belgium and Italy, later dividing his time between Italy and Ireland; more recently, while continuing to travel, he is based in Bagenalstown, Co. Carlow. Travel is central to the understanding of his work as it initially opened his eyes to nineteenth-century French, German and Italian painting and also to classical mythology and architecture. McKenna was drawn to the allegorical narratives of Swiss symbolist Arnold Böcklin's work, and also to the classical Italian architecture and shafts of bright Mediterranean light and shadow found in the work of Giorgio de Chirico. However, perhaps more akin to McKenna's emerging sensibility were the modest still-life paintings of Giorgio Morandi, who bathed his subtly coloured images in a unifying light, imbuing the most banal objects with a startling presence. This quality is also evident in McKenna's painting, albeit with a richer palette.

McKenna gained considerable international attention in the 1980s, with his references to classical antiquity coinciding with the vogue for Postmodernism (see 'Modernism and Postmodernism'). He had solo exhibitions at the Museum of Modern Art, Oxford (1983), Stedelijk van Abbemuseum, Eindhoven (1984) and Städtische Kunsthalle, Düsseldorf (1986), as well as participating in *Documenta 7* (1982) and exhibiting in major shows at San Francisco Museum of Modern Art (1986), Hayward Gallery, London (1986) and Los Angeles County Museum of Modern Art (1987).

Gradually McKenna's overt classical themes gave way to still-life, interior and landscape painting (qv), all marked by a controlled, coolly elegant approach. He paints the observed world and manages to combine a sense of visual accuracy with his own imposed order.

After McKenna finished his studies at the Slade School of Fine Art in 1964, he painted in a geometric abstract style and, although this was short-lived, his later representational work continues to retain a strong internal abstract order and geometry (see 'Abstraction'). Shapes are subtly echoed in several parts of each composition so that a visual dialogue ensues. The

disorganized clutter of a large interior is pared down, with emphasis on a softly rhythmic repetition of similar shapes. In a way that recalls Matisse, McKenna creates tension between real observed space and the artificially constructed two-dimensional space of the painted image. The panoramic vista of a busy port in Lisbon or the rooftops of Naples all seem topographically true, yet strangely independent of the initial subject. McKenna's versions are more unified and self-contained than their counterparts in the real world. His interiors often have pictures within pictures, landscape fragments framed by windows, and glimpses of adjacent rooms. McKenna meets the challenge of tying together multiple perspectives in a seamlessly integrated composition. And underpinning each composition is a taut linear framework. There is the sense that every aspect of the painting holds together, that McKenna has never lost sight of the work in its entirety. Colours are restrained, pulled tightly into a smaller, calmer range than one finds in the real world. Pigment is applied carefully, with subtle modulations rather than showy brushwork. McKenna's later classicism is not based on motifs but is characterized by the spirit of antiquity.

McKenna's travels have also influenced his use of light, which is one of the most distinctive aspects of his work. The Umbrian paintings are suffused with golden tones, with interiors marked by strong geometric shafts of sunlight. The Neapolitan cityscapes suggest a quivering heat, while the Irish landscapes have that eerily diffused half-light of sun obscured by cloud. By 2007 light had become the focus of several works, McKenna painting subjects at dawn and dusk, in rain, fog, sunlight and at night, often with light reflecting off water. But, as in his earlier work, he remains an artist who uses observation of the real world as his starting point. Technical control and virtuosity are put to use in creating a parallel painted world with its own internal rhythms and harmonies so that the familiar is made new.

McKenna was elected an RHA in 2001 and is a member of Aosdána (qv). Since the 1980s he has had important one-man shows, most notably in IMMA (Dublin, 1993), the Hans und Sophie Taeuber-Arp Foundation (Bonn, 2000), DHG (Dublin,

2003), as well as galleries in London, Milan, New York, Ljubljana and Derry. His work is in the collections of IMMA, Tate, Berlinische Galerie and in many other public, corporate and private collections worldwide. FRANCES RUANE

SELECTED READING Ian Jeffrey and Declan McGonagle, *Stephen McKenna: Paintings 1985–1993*, exh. cat. IMMA (Dublin 1993); Liam Kelly (ed.), *Stephen McKenna: Paintings 1992–1995*, exh. cat. Orchard Gallery (Derry 1996); Stephen McKenna (ed.), *The Pursuit of Painting*, exh. cat. IMMA (Dublin 1997); Patrick T. Murphy, *Stephen McKenna: Paintings, Drawings, Watercolours: A Selection, 1969–2004* (Dublin 2005), pp. 9–71.

MCKEOWN, WILLIAM (1962–2011) [289], painter. On first encounter, McKeown's modestly scaled, monochromatic paintings could be read as abstract (see 'Abstraction'). He intended them, however, to represent segments of sea or sky. While they are *of* nature, they are not so much *about* nature itself, but what such spaces imply. It would be misleading, therefore, to analyse them simply as depictions of the objective, tangible world. Painted in thin washes, McKeown's strikingly understated methods first came to critical attention during the mid-1990s and have provided the central focus of his practice. His imagery is compelling for its translucent purity, and for the

288. Stephen McKenna, *The Yellow Window*, 1990, oil on canvas, 120 x 160 x 3.5 cm, Irish Museum of Modern Art

289. Willie McKeown, *The Lane*, 2008, oil on linen, 182 x 168 cm, Dublin City Gallery The Hugh Lane

technical expertise that renders it either perfectly even, devoid of intonation or brushstroke, or gradually modulated to suggest infusions of light, spatial depth and aerial density.

Since these paintings could be interpreted within the remit of landscape (qv) imagery, McKeown expressed a concern with two key principles: first, he proposed that art addressing nature should represent it as it actually exists, rather than as 'improved' and idealized in the manner of Claude Lorraine; and second, he responded to aspects of nature that are essentially open and free. He interpreted the sky in particular as resistant to boundaries and private ownership. The rectangular canvas suggested for him the view through the panes of a Georgian window; implying elegance, culture, privilege and status, while the boundless space of the sky beyond the frame, represents the natural opposite, free of the restraints of social conditioning. The artist explained: 'The thing that I love about the sky is that it is the same for everybody ... and the sky also is for me a kind of metaphor for a new emerging culture in the West which doesn't have a hierarchy according to identity or gender or sexuality.' (McKeown, interview by the author, 31 January 2003)

McKeown responded to techniques that reflect such conditions. His training in design drew him to study weaving, attracted to its lateral structure where warp and weft carry equal status, and where the colour is within the fabric rather than on top of it. Similarly, he intended his works to challenge traditional painting which 'was very male ... there was a kind of hierarchy between ... the paint and the canvas; the canvas was only there to hold the paint, and the paint was all about the expression of the master, of the specialist, of the gesture – all the sorts of thing that I was not interested in'. His paint is typically applied thinly, appearing to integrate with the support, and lending itself to an abstract reading of 'the moment where surface dissolves, where the appearance of what is seen encounters the invisibility of what is sensed' (Glen Dimplex catalogue, 1997). McKeown's titles for works and exhibitions reveal a romantic sensibility, with an essentially positive outlook, as demonstrated by the 'Morning' and the 'Hope' series.

Others are indicative of the relationship to the landscape: for example, *The Lane*, *The Field* and *The Meadow* (all 2008). The intimate scale of his work is deliberately opposite to the muscularity of large-scale 'corporate' art, with its implications of power and persuasion. Later, he introduced delicate line drawings of single wild flowers. Rather than culled horticultural specimens, these are shown emerging from the base of the image, as though extending beyond the frame, still rooted to the ground, continuing to grow – nature in progress.

McKeown developed installations (qv) involving intimate enclosed spaces, paraphrasing the body, and drawing on childhood memories of encounters with nature. From 2005 until his death in 2011, he carried out a series of installations in small, contemplative rooms, under the general theme of 'Waiting Room'.

William McKeown studied at Central Saint Martins College of Art and Design, London, was awarded an MA in Design at the Glasgow School of Art (1987), and an MFA at the University of Ulster (1994). He has had solo shows at the Ormeau Baths Gallery, Belfast, IMMA, DHG and HL, and participated in numerous group exhibitions in Britain and Ireland. He was shortlisted for the IMMA/Glen Dimplex Artist Award (1997), and represented Northern Ireland at the 51st Venice Biennale in 2005.

McKeown's work is included in numerous public and private collections, including IMMA and the AC/ACE. He was elected a member of Aosdána (qv) in 2008. YVONNE SCOTT

SELECTED READING Isabel Nolan, *The Sky Begins at our Feet*, exh. cat. Ormeau Baths Gallery (Belfast 2002); Enrique Juncosa, *William McKeown* (Milan 2009).

MACLENNAN, ALASTAIR (b. 1943) (qv *AAI* III), performance artist. Born in Blair Atholl, Perthshire, MacLennan could fairly be called the father of Irish performance art (see 'Time-based Art'). Since his arrival in Belfast from his native Scotland in 1975, he has worked almost exclusively in this field, and has had a profound impact on the artists he taught at the Belfast College of Art, or who have been influenced by his dedication, commitment and his ability to surrender himself fully to the experience of the performance in hand. MacLennan studied at Jordanstone College of Art and Design, Dundee (1960–65) and at the Art Institute of Chicago (1966–68) and worked in Canada before settling in Belfast. He began his career as a painter but turned to performance art as early as 1970, in order to communicate directly with audiences in real time, obviating the necessity for intermediaries, and to avoid the traditional link between painting and the commercialism of the gallery system.

Although performance art was little known in Ireland before the mid-1970s, when MacLennan and Nigel Rolfe (qv) staged the earliest events, the former won a Carroll's Prize at the IELA (qv) in 1979. The critic Hilary Pyle wrote vividly about the impact MacLennan's *Performance, with Twelve Rotten Fish*, at the Triskel Arts Centre, Cork in 1981, made on her and on other spectators [290]. Like her, they were unfamiliar with art of this kind, initially recording bewilderment, even revulsion, but returning again and again over the eight-hour duration of the artwork, only to be increasingly won over by the effectiveness of MacLennan's use of colour, symbolism and, above all, his acceptance of the realities of the process. In that instance this entailed a ritual walk between two pillars with eight dead and decaying fish hanging over his naked body and two on each of the pillars. Neither the smell of decomposing fish, his own exhaustion, nor audience reactions interrupted the performance. Speaking about *Twelve Rotten Fish*, MacLennan remarked that it was easier to 'make something beautiful from that which is already accepted as beautiful, than it is to try to make something which eventually has a kind of beauty, maybe a beauty of authenticity, from elements which in some way are viewed or thought of as being negative' (Knowles, p. 198).

Relating his performance to more traditional approaches to art-making, MacLennan said: 'I tend to think of the activity very much as I would think of organizing elements on the surface, very much like drawing on the flat and using myself as a mark-making device creating strokes in space.' (*Living Art*,

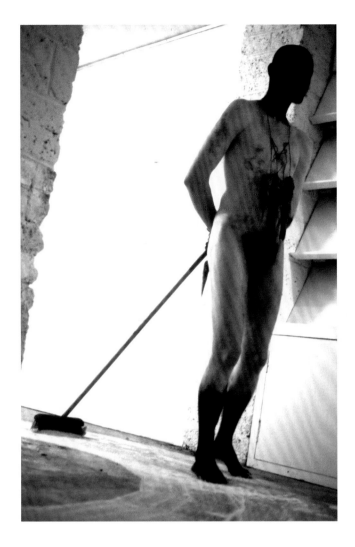

He represented Ireland in the 1997 Venice Biennale and is now Professor of Fine Art at the University of Ulster. He has made performances in North America, Australia and Europe. *Work with what has been spoiled*, using images and text and made with David Brett, was published in the winter issue of *Circa* in 1995, and MacLennan was among thirteen artists specially commissioned to produce an artwork for the celebratory centennial issue of the journal in 2002. CATHERINE MARSHALL

SELECTED READING Knowles, 1982, pp. 195–98; Slavka Sverakova, 'Performance Art in Ireland 1975–1998', in Martel, 2001, pp. 412–24; *Alastair MacLennan: Knot Naught*, exh. cat. Ormeau Baths Gallery (Belfast 2003).

MCSWEENEY, SEÁN (b. 1935) [291], painter. In attempting to answer the question 'what is Irish art?' the Belfast gallery owner Jamshid Mirfenderesky identified the painter Seán McSweeney as the only person he knew who had come close to the definition of an 'Irish artist'. Mirfenderkesy explained: 'He was born in Ireland, his subject matter is specifically about the Irish landscape, boglands, pools etc., and his painting technique could be traced back to some of the paintings of Jack B. Yeats.' (Ryan, 2006, p. 334)

On the surface it might appear as if McSweeney has had a fairly uneventful career. Unlike the widely travelled Barrie Cooke (qv) or predecessors in Sligo, such as Jack B. Yeats and Patrick Collins (qqv), who seemed to attract constant attention, McSweeney has lived his life quietly between Dublin where he was born, west County Wicklow where he lived for a couple of decades following his marriage, and rural County Sligo to which he moved in the mid-1980s and where he now lives and works.

290. Alastair MacLennan, *Performance; with Twelve Rotten Fish*, Triskel Arts Centre, Cork, 1981, durational performance

291. Seán McSweeney, *Sligo Landscape*, 1986, oil on canvas, 81 x 99 cm, Arts Council/An Chomhairle Ealaíon

catalogue, 1985, n.p.) Space is a vital element for performance artists and MacLennan shows a preference for unmediated spaces, such as the public street. In *Target*, Belfast 1977, he walked, clad from head to foot in black with a dartboard attached to his head, from his home to the College of Art, to call attention to the vulnerability of ordinary citizens in a city torn apart by extremist violence.

MacLennan is frequently likened to a shaman and there is a healing element in his confrontation with the positive and negative realities in life, with the whole truth rather than the more palatable aspects of it. He draws on Christian and pre-Christian symbolism but rejects the narrow Christian practices of Northern Ireland in favour of Zen Buddhism. His performances or 'actuations', as he terms them, are concerned with issues of mortality, politics and society, as well as with aesthetics. Having lived through some of the worst years of the 'Troubles' (qv) in Northern Ireland, his work has not shied away from that history, although he is emphatic that he is 'committed to art which uses the particular to manifest the general and vice versa' (*IELA*, exh. cat., Dublin 1985, n.p.).

MacLennan was involved in the establishment of Art and Research Exchange in Belfast in 1977 and joined Black Market International, the European performance organization in 1989.

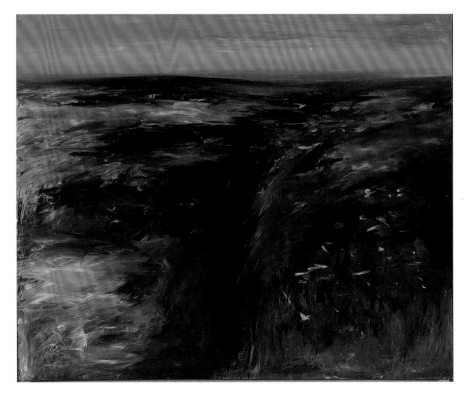

Although self-taught as an artist, McSweeney gleaned useful skills from his father who was a painter and decorator and a competent amateur artist. On his mother's side McSweeney has connections with Sligo, the area which had so inspired his artistic mentors Yeats and Collins. Even in terms of subject matter, McSweeney has stayed within limited boundaries throughout his career, painting only landscapes (qv), almost invariably remote and rural, rarely including signs of human occupation beyond the occasional glimpse of a grey house wall or a clothes line blowing in the wind. He rarely, if ever, allows a human figure to stray into his field of vision and never offers a hint of the urban environment into which he was born.

Nevertheless, there is great drama in even the smallest of his paintings. This is all the more interesting since McSweeney rarely exploits the theatrical potential of stormy Atlantic waves, so much a feature of the area in which he paints, but concentrates on quieter contemplative responses to the seashore and interior boglands of Sligo. His art concentrates on inner tensions, for which the loneliness of the landscape provides a metaphor. Brian Fallon has referred to him as 'a poet-painter, not a prose one, like Keating or Charles Lamb [qqv]', noting that his works 'are born out of his inner vision as much as his outer perceptions' (Fallon in Emer McGarry, p. 8). Fallon also distinguishes between artists of the dominant, tonalist tradition in Irish landscape, such as Patrick Collins and Tony O'Malley (qv), and McSweeney, who Fallon claims, like Jack Yeats, is not afraid to seize the power of contrasting colours (op. cit.). McSweeney's rich contrasting palette, from which much of the drama in his work derives, is applied with the vigorous brushstrokes of the international Abstract Expressionist movement. His paintings connect to the English colourist Howard Hodgkin, whose work can be likened to McSweeney's, not just in their love of colour, but in their similar use of painted framing devices.

Patrick J. Murphy recalled that McSweeney's first solo exhibition at the Dawson Gallery was so popular that one collector is said to have bought nineteen paintings (Ryan, 2003, p. 106). Inevitably that level of support was unsustainable in the short term, but McSweeney has always been critically acclaimed. He showed at the IELA (qv) during the 1960s and he has had many successful solo exhibitions in Dublin, Belfast and Galway and, in 2007, a retrospective exhibition that toured from Sligo to Cork

and Navan. His work has been shown outside Ireland in Australia, Britain, Germany and Switzerland.

With his wife Sheila, McSweeney has played an important part in raising the profile of the Model Arts Centre gallery in Sligo. Largely as a result of their selfless commitment, the former Model Arts Centre was reconstituted as the Model Arts and Niland Gallery and is now one of the most important regional arts centres in Ireland. In 1994 Mc Sweeney was the subject of an RTÉ documentary directed by Seán Ó Mordha.

TCD chose McSweeney's painting *Deserted Holding* (1988, TCD) to illustrate the cover of the first full catalogue of the college's Modern Art Collection (David Scott, Dublin, 1989). There are artworks by him also in the collections of the Model Arts and Niland Gallery, IMMA, AC/ACE, OPW, the Butler Gallery, LCGA, and in most of the major corporate collections.
CATHERINE MARSHALL

SELECTED READING Brian Fallon, 'The Passionate Lyricism of Seán McSweeney', in *Seán McSweeney: Family Collection*, exh. cat. The Gallery, Civic Theatre, Dublin (Kinsale 2003); Y. Scott, 2005; Emer McGarry (ed.), *Seán McSweeney: Retrospective*, exh. cat. Model Arts and Niland Gallery, Sligo; Triskal Arts Centre, Cork; Solstice Arts Centre, Navan (Sligo 2007).

MACWILLIAM, SUSAN (b. 1969), artist. Working also as a teacher, the Belfast artist Susan MacWilliam has packed an extraordinary amount of activity into her career to date, with exhibitions and artist's residencies in a variety of venues throughout Ireland, Britain, Europe, the USA and Canada. She has represented Northern Ireland at the Venice Biennale (2009) and has won several prizes at EV+A, to which she has been a regular contributor since 1994. She has also been a multiple recipient of awards from the Arts Councils (qv) of Northern Ireland and the Republic, and was short-listed for the 1999 IMMA/Glen Dimplex Artists Award.

MacWilliam studied painting at Manchester Polytechnic from 1988 to 1991. From the outset her work moved painting and art-making into original directions, marked by her informed awareness of the ways in which meaning is generated around the artwork. Her first solo exhibitions, *Liptych* (Lisburn, 1994) and *Liptych II* (Belfast, 1995), which took the

292. Susan MacWilliam, *Experiment M*, 1999, installation with 2 videos, black and white, silent, 5 min 43 sec

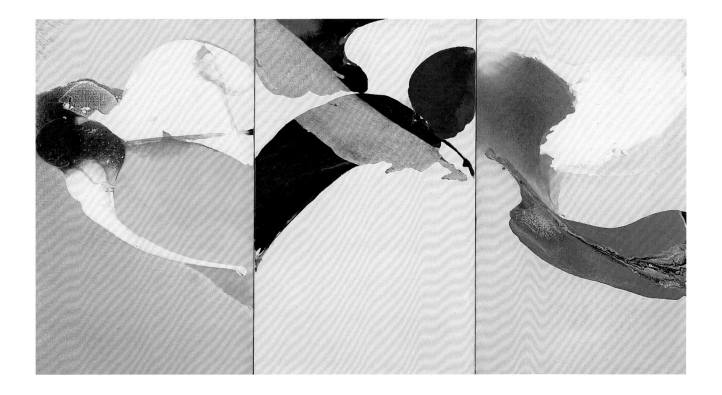

form of paintings arranged on the floor of the gallery or propped against its walls, explored different materials and surfaces, including live and blemished skin, as well as practices of display and their meaning. Developing this line of investigation at the Project Arts Centre, Dublin, in 1997 with 'Curtains', a series of large canvases where, instead of paint, plasticine is used to mimic the folds and drapes of curtains, MacWilliam simultaneously evoked historical traditions of illusionism and Modernism's (qv) critique of it. Since then, working with installation, still photography (qv), slide projection and video, MacWilliam's work has explored notions of visual credibility, drawing on her research into the history of psychology, paranormal and psychic behaviours, and perceptual phenomena, including eyeless vision, or dermo optics. This research led her to spend a number of years working with the Parapsychology Foundation in New York and a period observing the work of Madame Duplessis, director of the Centre d'Information de la Couleur, Paris, and to explore séances, ectoplasmic materializations and fingertip vision. The results have been revealed in works such as *F-L-A-M-M-A-R-I-O-N, Experiment M* [292], *Explaining Magic to Mercer, Dermo Optics* and *Eileen*, an installation at the Gimpel Fils Gallery, London in 2008 which includes filmed interviews with the daughter of the famous, Irish-born medium Eileen Garrett (1893–1970).

In 2000 MacWilliam was commissioned to design coffee cups for the illy Café MoMA PS1 Collection. Her work can be found in the collections of the British Library, London and the ACNI. Catherine Marshall

SELECTED READING Michael Wilson, 'Susan MacWilliam, Project Arts Centre, Dublin', *Circa*, no. 81 (Autumn 1997), 52–53; Deepwell, 2005, pp. 115–26; Karen Downey (ed.), *Remote Viewing: Susan MacWilliam* (London 2009).

MADDEN, ANNE (b. 1932), painter [293, 378]. Born in London, to Anglo-Chilean parents, Anne Madden had a peripatetic childhood, moving between Chile, England and Ireland. Perhaps as a result of this, and of early tragedies in her life in which her brother, sister and father died, she came to identify closely with the bleak and austere, but beautiful, limestone landscapes of the Burren in County Clare, where she lived for some years. A keen horsewoman who excelled at show jumping, Madden explored the Burren on foot and on horseback, experiences that had a lasting influence on her art.

After studying at the Chelsea School of Art, in 1958 she married the painter Louis le Brocquy (qv), settling at Carros in Provence. However, while remaining alive to the influence of the Mediterranean, Madden continued to draw on the Burren in her paintings, which became increasingly abstract (see 'Abstraction'). Accident and intention increasingly interlinked in her work in the 1960s, where paint was poured and sand and other materials added, to create paintings of considerable beauty. In a series of works in the 1970s inspired by Irish megalithic tombs, where she employed this free use of media along with masked edges, the artist explored the creation of pictorial space using the device of a portal or window. These works were shown at the Taylor Galleries in Dublin in 1979.

Over the following decade she concentrated more on drawings, producing a series of large works in graphic and oil paper entitled 'Openings', shown in 1983 at La Fondation Maeght, and

293. Anne Madden, *Clareland*, 1967, oil on canvas, 114 x 229 cm, Arts Council/An Chomhairle Ealaíon

in Rosc (qv) the following year. In the 1990s the colours of the Mediterranean influenced Madden's 'Odyssey' and 'Icarus' series of paintings, in which small figurative elements are set into large expanses of almost pure colour. These successive series of works reveal the influence of Abstract Expressionism (see 'Expressionism'), Minimalism (qv) and Colour Field painting on the artist, but in each case, Madden adapted these international approaches to create works that remain personal and rooted in her own aesthetic appreciation of sky, sea and rock. Her paintings reveal a poetic imagination, and can be accurately described as mythic, in their conscious evocation of the world of prehistoric Irish society or the brilliant colours of ancient Greece, as described by Homer.

Madden represented Ireland at the Paris Biennale in 1965. In 1990 her paintings were exhibited at an Arts Council-sponsored retrospective at the RHA (qv) in Dublin. In 1993 her memoir of life in France, *Louis le Brocquy: Seeing His Way*, was published. An exhibition of her work was held at the HL in 1997 and a large retrospective at IMMA in 2007.

Madden's work is in the collections of the HL, CAG and IMMA and she is a member of Aosdána (qv). PETER MURRAY

SELECTED READING Aidan Dunne, *Profile 16 – Anne Madden* (Kinsale 2003); Aidan Dunne, *Anne Madden*, exh. cat. HL (Dublin 1997); Enrique Juncosa, Derek Mahon and Marcelin Pleynet, *Anne Madden: A Retrospective*, exh. cat. IMMA (London and Dublin 2007).

294. Elizabeth Magill, *Blue Constrictor*, 2006, oil on canvas, 153 x 183 cm, Crawford Art Gallery

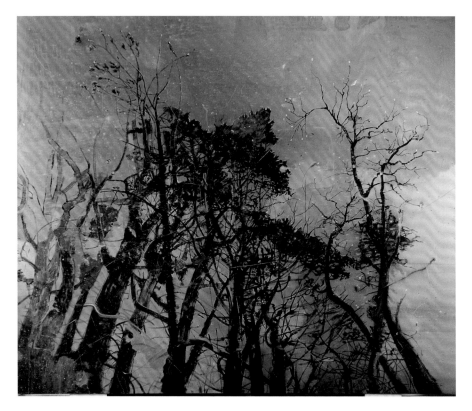

MAGILL, ELIZABETH (b. 1959) [294], painter. Reminiscent of early nineteenth-century Romanticism, and in particular the work of Caspar David Friedrich and J.M.W. Turner, the landscape (qv) paintings of Elizabeth Magill, pensive, elegant and mysterious, are firmly rooted in late twentieth-century art practice. While at first glance her paintings appear to be pure landscapes, in fact they contain very little in the way of visual cues, such as detailed depictions of trees or rocks. More abstract than representational, often created by using oil colours laid on in thin washes, her paintings depend upon the viewer's imagination to reconstruct, or interpret, areas of paint as sky, forest or lake, rather than depicting in any conventional way these elements of landscape. Magill's art is more about exploring the relationship between the thing perceived, and the viewer's perception, than about representing a particular scene or place. She is interested in the relationship between people and nature, the way in which identity and meaning have become social constructs, mediated by a wide range of historical and contemporary influences. Her sparsely peopled landscapes combine beauty and alienation in a way that is unsettling, rather than reassuring. Her paintings evoke also the other-worldliness of the Symbolist movement, as well as the cascading night skies of James MacNeill Whistler.

Although born in Ontario, Canada, Magill was raised in rural County Antrim, her parents having moved back to Ireland when she was three years old. She studied art at the Belfast College of Art, before moving to London in 1984 to continue her studies, where she was awarded a postgraduate degree at the Slade School of Art in 1986. Living and working in central London, Magill has also occasionally taught at art schools, such as the Byam Shaw Academy. In 1994 she received a Momart Fellowship, awarded by Tate Liverpool. A very independent artist, she avoids Arts Council (qv) support, preferring instead to live and work independently, her paintings finding a ready market in galleries such as the Kerlin in Dublin, and Anthony Wilkinson in London. In 1999 an exhibition of Magill's work was held at Southampton City Gallery, and that same year she was included in the exhibition *0044*, shown at PS1 in New York City, the Albright-Knox Museum in Buffalo, and the CAG in Cork.

While inspired by Romantic landscape painting, Magill's work is in no way nostalgic. In the early 1990s she developed a series of paintings, entitled 'Belongings', which were based on the X-ray photographs of people's personal belongings, displayed in airport security checkpoints. A later series of paintings were based on the printed lyrics of popular songs. Although photographs are often used as the starting point of her compositions, she cannot be described as a photo-realist. Her paintings evolve slowly, and a group of canvases will be worked on over a period of months, rather than one being started and finished in a short space of time. Magill describes her approach to painting as a 'cautious activity'. Although her paintings explore notions of representation, she has no interest in being classified as a conceptual artist, describing her approach instead as an 'accumulation' of experience and intuition, commenting 'I'm more interested in what works in painting, rather than why it works' (in conversation with the

author, 1999). Her paintings often feature figures standing in the foreground, placed as if observing the landscape around them. She will sometimes stick paper cut-outs on to the canvas, in order to gauge the effect of the placement of figures within the composition. When she is satisfied with the effect, the figures will be painted in. The placement of these elements, often silhouettes of figures, against the 'ground' of her paintings, introduces a narrative element. While the figures are precisely delineated, the background is often built up in thin layers, the paint being allowed to flow and spread across the surface of the canvas.

There is little doubt that Magill's art derives from deeply felt, personal experience, in which childhood memories of the vast untamed landscapes of Canada contrast with the more intensively cultivated landscapes of Britain or Ireland. This sensibility is made explicit in a series of paintings, dating from 1996/97, entitled 'Way out West' in which shadowy horsemen traverse a prairie landscape. The concept of beauty is important in Magill's work, and there is also an atmosphere of stillness, evident in paintings such as *Blue Constrictor* [294], in which a deep blue background is used to accentuate a sense of mystery. Although she declines to admit to being influenced by philosophy, Magill's paintings clearly explore the way in which images are constructed as much through human knowledge and experience as through sensory apprehension. The title of her painting *Scenic Route 3* (1997) highlights the way in which she addresses notions of beauty in nature, and the often uneasy relationship between mankind and an increasingly fragmented and fragile natural world.

Magill's work is represented in many public and private collections, including IMMA, CAG and Tate. PETER MURRAY

SELECTED READING Murray, 1999; Christina Kennedy and Caoimhín Mac Giolla Léith, *Elizabeth Magill: New Work*, exh. guide, HL (Dublin 2003).

MAGUIRE, BRIAN (b. 1951), painter. Born in Bray, Co. Wicklow, Maguire was educated at Dun Laoghaire Technical School and later NCAD, from which he graduated in 1975. As a student, Maguire was involved with Marxist politics, especially with Official Sinn Féin, which later metamorphosed into the Workers' Party, and ultimately, the Labour Party, of which he continues to be a member. He points to the fact that since NCAD was sited in buildings attached to the Dáil in his student days, when students protested, the army, and not just the police, were involved in keeping control. As Maguire has said, 'The context for us was political' (Ryan, p. 296), but the strong sense of social justice and engagement in his work stems from deeper childhood experience.

In an interview with Vera Ryan, Maguire speculated that his painting may have come from seeing newsreel footage of Nazi atrocities as a twelve-year old at his local cinema. Having defied the 'over eighteens' age restriction and mitched from school to see the newsreel meant that he couldn't talk about what he had seen and so the impact of this imagery was all the greater. He became interested in victims of aggression and injustice, but his inherent humanism obliged him to try to

understand the perpetrators too, asserting that 'Nobody does anything others are not capable of' (p. 296). It is this humanist sensibility that permeates Maguire's work, and what drove him to become a lead artist in the pilot programme of the 'Artist in Prison' scheme in 1987 rolled out by Medb Ruane of the AC/ACE (qv), Noel Sheridan (qv), Director of NCAD and Kevin Warner of the Department of Justice. It was this force that led him to work to reposition art in terms of its public role and its social elements when he became professor of fine art in NCAD in 2001.

Maguire is often linked to the Neo-Expressionist (see 'Expressionism and Neo-Expressionism') trend in Irish

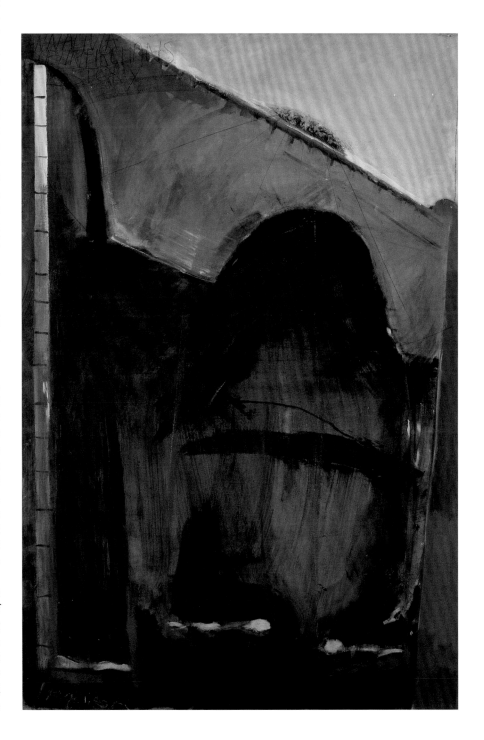

295. Brian Maguire, *Liffey Suicides*, 1986, acrylic on canvas, 152 x 101.6 cm, Irish Museum of Modern Art

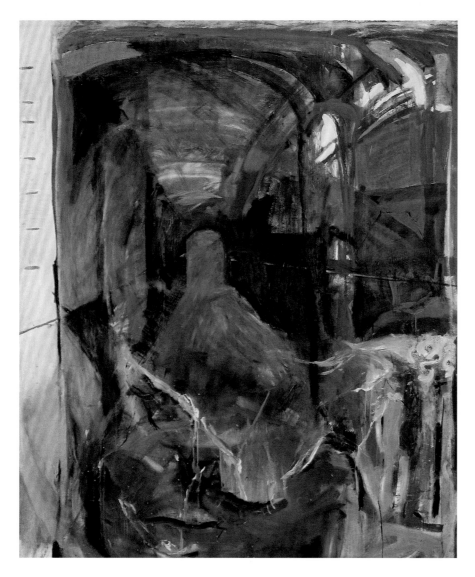

296. Brian Maguire, *The Foundation Stones (Mental Home)*, 1990, oil on canvas, 202 x 170 cm, Dublin City Gallery The Hugh Lane

acclaim from such critics as the American art critic Donald Kuspit when some of them were shown at his solo exhibition at the DHG and at the Orchard Gallery, Derry in 1988. Maguire points out that much of his art of the 1980s was self-critical and concerned with people as either victims or perpetrators of injustice. His later work, however, turned the spotlight increasingly on institutions rather than individuals. Prisons, psychiatric hospitals, bad government, and the institutions of the art world became the subject of his work and influenced his approach to practice.

Maguire's solo exhibition of artworks from 1989 to 1993, at the DHG, introduced work derived from his engagement with prisoners in Portlaoise Prison and with the psychiatric services. *The Foundation Stones (Mental Home)* [296] shows him working with layers of washes in place of the opaque, aggressive paint applications of the previous decade, to produce a more elegiac yet sombre exposé of the impact of incarceration, for whatever reason, on the individual. In these works Maguire merged his identity as a painter with those of patients in a psychiatric hospital, and he took this radically further in his *Inside/Out* exhibition at the HL in 2000, when he showed his work alongside the work of inmates from the institutions he had been working with. In doing so, he was also critiquing the normal, elitist practices of the art world, by not separating his work from theirs.

Maguire also undermined the exclusiveness attached to collecting (see 'Collecting Art'). In work with Irish Travellers and in São Paolo, where he represented Ireland in the 1998 Biennial, he did portrait paintings (see 'Portraiture') and sketches, gifting the sketches to the people who posed for them, and photographing the paintings installed in their homes, whether that was a Travellers' halting site or a favela. He later exhibited similar sketches in the sanitized surroundings of the art gallery. It was at São Paolo too that he showed *Memorial* (1998) [4], his searing response to prison massacre in Argentina. Although he has also recorded Irish historical events, such as the Stardust Ballroom fire tragedy, he prefers to work on historical political material retrospectively or distanced by its foreignness, finding that the filters of memory and cultural translation give him an essential measure of distance from immediate pain. Discussing the relationship between art and politics, Maguire says simply:

I see the role of the artist to be an individual witness. It's both your freedom and your limitation. As an individual you are not threatening, this gives you access. It enabled me to make a relationship with the UDA in Belfast while simultaneously working with Republicans in the late '90s. These men's beliefs are opposite. Because you are an artist and only represent yourself you have freedom. It has a downside; you don't get to do much. (Ryan, pp. 306–07)

Maguire has served on the boards of directors of the Project Arts Centre and IMMA (1995–2000), and is a member of Aosdána (qv). He has held prison residencies in Limerick, Portlaoise, Spike Island and Matsqui Prison in Vancouver. He won the 1990 O'Malley Award from the Irish American Cultural Institute and has had solo exhibitions throughout Ireland, in Europe and in

painting in the 1980s. The support of Michael Kane (qv) and the Independent Artists group, and the American duo Ed and Nancy Reddin Kienholz, who bought about twenty of Maguire's paintings, was important to him. His first big breakthrough came when he was included in the exhibition *Making Sense: Ten Irish Artists, 1963–83*, at the Project Arts Centre, Dublin. Maguire struggled to find ways as a painter to show that there were more important things in life than the concentration on aesthetics that dominated art discourse in the twentieth century. In early paintings, such as *Child looking for 6 grains of rice in Uganda* (1982, Nancy Reddin Kienholz collection, Idaho), the emotional power comes from the flattened perspective, hot colours and Expressionist application of pigment, but in order to make the subject fully legible, he included the title as painted text in the picture. Within the next couple of years he had arrived at a pictorial language that could function independently of the written word without sacrificing communicability. The images in paintings such as *Divis Flats* (1986) [421], *Liffey Suicides* [295] and *Homage to 1984* (1995), from the collection of IMMA, speak for themselves and won

North and South America. Maguire participated in such group exhibitions as *Irish Art of the Eighties* (1990), *In a State: Kilmainham Gaol* (1991), *Inheritance and Transformation* (1991), *Images and Insights* (1993), *Poetic Land, Political Territory* (1995), *A Century of Modern Painting* (1997), *When Time Began to Rant and Rage* (1998), *Irish Art Now: From the Poetic to the Political* (1999) and *Something Else* (2002).

Maguire is represented in the public collections of the Houston Museum of Fine Art, Wolverhampton Art Gallery, Gemeentemuseum, The Hague, Jyväskylän Taidemuseo and Alver Aalto Museum, both in Finland, in Ireland in IMMA, HL, TCD, UCD and CAG, among others, and in numerous private collections in Europe and the USA. CATHERINE MARSHALL

SELECTED READING Donald Kuspit and Michael Casey, *Brian Maguire: Paintings 90/93*, exh. cat. Orchard Gallery, Derry and Kerlin Gallery, Dublin (Derry and Dublin 1993); Thomas McEvilley, *Casa da Cultura* (Dublin 1998); Ryan, 2006, interview with Brian Maguire, pp. 293–316.

MAHER, ALICE (b. 1956) (qv *AAI* III), multi-media artist. Never static, always evolving, over the years the work of Alice Maher has taken on a multiplicity of forms: hybrid bodies and indeterminate objects shift and reconverge across an ever-expanding range of media, painting, drawing, printmaking (qqv), sculpture and installation. Maher's works often defy easy categorization, as in *Mnemosyne* (2002, artist's collection), a bed made entirely of ice, or her short animated films ('film-drawings') made with the composer Trevor Knight, that develop the polymorphous concerns of the drawings of *The Night Garden* (2007, private collection).

Although Maher's work is recognized as undermining conventional expectations of female identity, it also incorporates an oblique questioning of fundamental aspects of Irish culture (see 'Women and the Visual Arts', 'The Body' and 'Identity in Irish Art'). Her practice is situated within a context of major changes in both the status of women and also in deeply held views of nationhood in Ireland in the last decades of the twentieth century. Early influences and experiences were formative of a range of concerns developed through her work, although the artist's preoccupations are certainly not restricted by her background.

Born near Cahir, Co. Tipperary, she attended the Crawford School of Art between 1981 and 1985, followed by a year studying for an MA at the University of Ulster. This led in turn to a Fulbright Scholarship to the San Francisco Art Institute in 1986/87. In 1994 she represented Ireland at the São Paolo Biennial and in 1996 was both elected to Aosdána (qv) and shortlisted for the Glen Dimplex Award. Since then, she has exhibited widely, not only in Ireland but on an international scale.

Maher lived in Belfast during a period when the art of many of her male contemporaries took the form of a Neo-Expressionist response to the ongoing political conflict (see 'Expressionism and Neo-Expressionism'). Although her own work of the time conveyed a sense of pain and violence, this was also profoundly connected to the struggles of women throughout Ireland, concerning such issues as divorce,

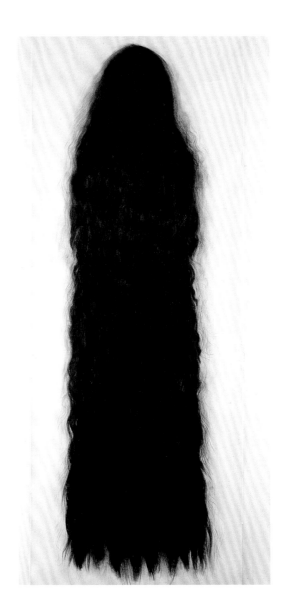

297. Alice Maher, *Ombre V*, 1997, charcoal on paper, 397 x 152 cm, Irish Museum of Modern Art

abortion and sexuality, in the face of continuing antipathy of both church and state. Maher's collaged drawing *Icon* (1987, private collection) depicts the Virgin Mary – not only pregnant but monstrous, a grotesque subversion of the religious iconography of idealized femininity. The references to Piero della Francesca in this image were also indicative of other concerns which included a life-long engagement with European art history (see 'History Painting'), although this was later to become more focused on the pre-modern, the medieval. The culture of the medieval also became the setting for an interrogation of mythological representation as formative in discourses of femininity: the French city of Poitiers was the location for Maher's *Les Filles d'Ouranos* (1997, artist's collection), the effigies of swimmers emerging from the river suggesting not just one Venus rising from the waters but a multiplicity of female identities. Yet these interests also led back to Ireland's history through deep preoccupations with the Hiberno-Norman past. At a time when the founding narratives of nationalism, privileging myths of a Celtic arcadia, were themselves being

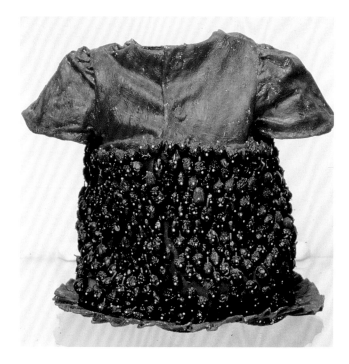

298. Alice Maher, *Berry Dress*, 1994, rosehips, cotton, paint, sewing pins, 16 x 20 x 30 cm, Irish Museum of Modern Art

SELECTED READING Fionna Barber, 'Unfamiliar Distillations', in *Familiar: Alice Maher*, exh. cat. DHG, Dublin and Orchard Gallery, Derry (Dublin 1995), pp. 11–18; Medb Ruane, *Alice Maher* (Dublin 1997); Alston Conley, 'An Interview with Alice Maher', *Éire-Ireland* (Spring 1999), 198–211; Siobhán Kilfeather, 'Alice Maher's Materials', *Field Day Review*, no. 2 (2006), 3–17; Gill Perry, 'Tales, Trails and Transformations: The Work of Alice Maher' in *Alice Maher: Natural Artifice*, exh. cat. Brighton Museum and Art Gallery (Brighton 2007); Seán Kissane, Penelope Curtis, Anne Enright, Ed Krčma, David Lloyd, Catherine Morris, *Alice Maher: Becoming*, exh. cat. IMMA (Dublin 2012).

MARA, TIM (1948–97), printmaker. Throughout his short but brilliant career, Tim Mara showed himself to have been one of the most experimental printmakers of his generation (see 'Printmaking'). His death, at the age of forty-nine, robbed Britain (where he lived and worked) and Ireland (where he was born and with which he maintained close links) of one of their most innovative and skilful printmakers and teachers. Educated at Epsom and Ewell College of Art, Wolverhampton Polytechnic and the RCA, London, he later taught at Chelsea School of Art where he was appointed Head of the Printmaking Department in 1981. He was a visiting lecturer at NCAD from 1976 to 1977, and in 1990 he accepted the post of professor of printmaking at the RCA.

Even as an undergraduate student, Mara won prizes: the Stowells trophy in both 1972 and 1973, when he also won the British Airways award, and, in the following year, a travelling scholarship to the USA. Prizes at the British International Print Biennale followed, while Mara showed at the International Biennale of Graphic Art in Ljubljana, and represented Britain at the Vienna and Miami Graphics Biennales. He secured his first solo exhibition in Birmingham Laboratory at the age of twenty-six, and a second one two years later, at the London Institute of Contemporary Art.

Although Mara was admired for his extraordinary technical ability, and wrote a book on screen printing, he saw technique and craftsmanship as tools of expression, not ends in themselves, saying '... in the hierarchy of fine art, printmaking is usually associated with craft skills – with technique. My work was always about the ideas, more than the medium' (Frayling, n.p.). Yet if the idea is primary, Mara pursued perfection unstintingly, using up to sixty colour separations in a single print and prepared to give several months to its making. One of his innovations was the range of different print techniques he could combine to make a single image, such as relief printing, screen printing, collage and etching. *Danish Blue* (1978, Gordon Lambert Trust, IMMA collection) goes a stage further than this by incorporating copper wire into an etching that unites photographic and relief printing.

Perhaps influenced by a year in the advertising industry, Mara used the new language of Pop art (qv) and technology to reiterate classical concerns. *Power Cuts Imminent* [299], one of his best-known, prize-winning screen prints recalls Velázquez's famous painting *Las Meninas*, not only because of the presence of other figures in the studio, but also because of its concern with

questioned in Ireland, her focus on a period characterized by its cultural hybridity struck particular resonances.

Maher's interests also keep company with other twentieth-century women artists who explored the irrational and the marvellous, most notably Louise Bourgeois (Perry, p. 11). In Maher's work the hidden and the unexpected actively contribute to her working processes. The drawings from *The Thicket* (1990, private collection) scratch and rub at a heavily worked surface, to offer a partial glimpse of an unexpected reality beneath, suggestive also of the rich inner life of the girls she depicts. Even the more reflective Classicism of Maher's work of the 1990s suggested, through her materials, not stasis but an ongoing fluidity of meaning. The stark verticality of the installation *Keep* (1992), made entirely from ropes of human hair, evokes the perilous status of female mythological heroines such as Rapunzel. Echoes of this ambivalence between fascination and danger resurface in later drawings of hair which include both *Coma Berenice* (1999, IMMA collection) and *Ombre V* [297]; indeed, all Maher's practice is linked, sinuously, by drawing as a common thread.

An experience of the rural also pervades Maher's art. The vertiginous disjunctures of scale that plummet from the gigantic to the miniature image of a tiny woman in paintings from the series 'Familiar' (1994), for example, connect with an awareness of the diminutive presence of the human figure in the vastness of landscape. The natural world has often provided many of the artist's materials whose meanings emerge in the small but menacing *Berry Dress* [298] or the bloodied lambs' hearts in the photographic self-portrait *Collar* (2003) [472]. This is work that not only challenges the viewer's expectations, but consistently renews itself in the process of its own making. FIONNA BARBER

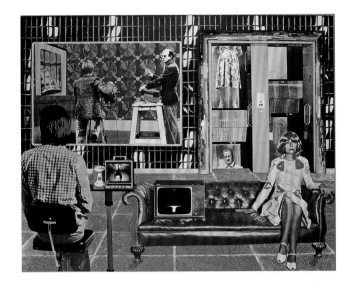

299. Tim Mara, *Power Cuts Imminent*, 1975, screenprint, 77 x 97 cm, Irish Museum of Modern Art

the Oliver Dowling Gallery, Dublin in 1990. As his painting career developed, Martin attended the New York Studio School of Drawing, Painting and Sculpture and in 1998 was given a solo show at the Project Arts Centre, Dublin.

His practice moves between abstract-minimalist painting and sculpture and, in collaboration with the photographer Anthony Hobbs, he has made a number of artworks with a figurative element, for which he himself posed. It is clear, however, that, even in these collaborative works, it is the aesthetic concepts rather than a figurative narrative with which Martin is concerned.

It has been argued that Martin's work should not be categorized as geometric abstraction (Dawson, p. 9); however, while his paintings and sculptures would never be confused with the work of such masters of this genre as Robert Morris, Ellsworth Kelly or Donald Judd, they nevertheless share an avoidance of gestural expression and a love of simple, geometric shapes. What distinguishes them is Martin's insistence on a human dimension even if only an implied one. This can take the form of the brushstrokes in his paintings, visible only after careful scrutiny and under raking light: the understated allusion to the human presence in the positioning of the sculptures and occasional placement of paintings at waist height or on the floor, and the figurative element in the photoworks. Even when the human figure is overtly present, however, as in *Frieze* (with Anthony Hobbs [300], it is subordinated to a careful interplay of spatial and lighting considerations. All the works, in their self-containment, carry an element of mystery, as if the work is withholding meaning from the viewer. Martin's public sculpture *Steel*, commissioned for the entrance gates of IMMA in 2008, almost disappears into reflected images of sky and surrounding trees, teasing the passersby to examine it further.

In addition to other solo exhibitions at Le Confort Moderne, Poitiers, as part of *L'Imaginaire Irlandais* (1996), the HL, Butler Gallery and Triskel Arts Centre, Cork, Martin's work has been included in *Comharsana Beal Dorais*, St John's, Newfoundland, *Four Now* at the Glucksman Gallery, Cork (2005), *Painting by Other Means*, Oriel Mostyn Gallery, Llandudno, North Wales (2005/06) and *A Measured Quietude*, Berkeley Art Museum, University of California; the Drawing Center, New York; and David Winton Bell Gallery, Brown University, Providence,

modes of representation and contextualization. Typically, it calls attention to the ways in which imagery is used and presented, but it is also typical in its modern interpretation of the *memento mori*.

Following his untimely death, an Honorary Doctor of Arts degree was conferred posthumously on Mara by the University of Wolverhampton, and retrospective exhibitions were held at the University of Alberta, Edmonton, Canada, RCA, IMMA, UM and CAG. There are examples of his work in the collections of the Tate, IMMA, RCA, V&A Museum, London, Manchester City Art Gallery, Whitworth Art Gallery, Brooklyn Museum, New York, the National Gallery of New Zealand, and in many other public collections. CATHERINE MARSHALL

SELECTED READING Mara, 1979; Christopher Frayling, *Tim Mara*, exh. cat. Flowers East Gallery (London 1996); *Tim Mara – The Complete Prints*, exh. cat. RCA (London 1998).

MARTIN, FERGUS (b. 1955), artist. Fergus Martin was born in Cork and attended the Dun Laoghaire School of Art, Co. Dublin from 1972 to 1976. Following a decade as a lecturer in the English language at the University of Milan, he returned to Ireland and to painting in 1988. His first solo exhibition was at

300. Fergus Martin and Anthony Hobbs, *Frieze*, 2003, pigment print (an inkjet on watercolour paper), edn 1/3, 222 x 975 cm, Irish Museum of Modern Art

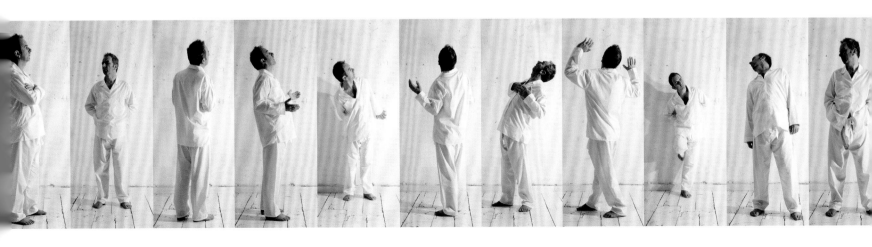

Rhode Island (1999/2000). His work has been widely shown in Europe.

The winner of two Pollock-Krasner awards and the Marten Toonder Prize, Martin was elected to Aosdána (qv) in 2001. His work is in most Irish public, and in many private, collections.
CATHERINE MARSHALL

SELECTED READING O'Molloy, 2005; Barbara Dawson, David Godbold and Andreas Pinczewski, *Fergus Martin*, exh. cat. HL (Dublin 2009).

MIDDLETON, COLIN (1910–83) [301, 470], painter. Described as a 'problem' artist, even if 'without doubt the most brilliant of our younger group' ('Variety keynote at one-man art show', *Northern Whig and Belfast Post*, 8 September 1943), Colin Middleton made the task of Irish art critics difficult by working in a variety of different, and sometimes conflicting, styles. The same critic identified as problematic Middleton's use of symbolism which, 'despite certain obvious affinities to modern psychoanalytical formulae, is over-laden with historical, literary, and geographical significances which are not commonly intelligible'. Other critics, while equally aware of Middleton's outstanding qualities, all comment to a greater or lesser degree on his frequent use of different styles, which made it difficult immediately to identify his hand. Aware of this critique, Middleton stoutly insisted on his right to experiment, citing Picasso and Paul Klee as precedents for his own approach to art. Refusing to be ruled by market dictates, he told his friend the poet Michael Longley: 'The dealer is depending on you to supply him with commodities that he can establish as So-and-So's If you depart from that you cut your own throat, and most artists keep to the straight and narrow'. ('Talking to Colin Middleton', *IT*, 7 April 1967, reprinted in Eastwood, pp. 14–18) His reasons for moving between styles were deep-seated: 'This is one of the most complex periods that the species has ever been through psychologically. And it is why we are getting this unbelievable diversity in styles and so on.' (ibid., p. 17) Continuity in his work derives from his constant exploration of the links between nature and man and his use of the female archetype to symbolize these connections.

Born in 1910 in Belfast, Middleton left school in 1927 and, reluctantly abandoning his ambition to study art, went into his father's damask design business. His formal art education was limited to part-time attendance at the Belfast College of Art, especially Newton Penprase's design classes. Visits to London (1928) and Belgium (1931) introduced him to the work of Vincent van Gogh, James Ensor, and fifteenth-century Flemish painting, with which he felt an immediate spiritual affinity. Apart from those visits, a brief interlude in England in the 1940s and trips to Australia and Spain within the last years of his life, Middleton worked all his life in Northern Ireland. Lack of art education and increasing demands from the business, owing to his father's failing health, did not prevent Middleton from winning the Taylor prize at the RDS in 1932, or joining the Ulster Unit, Belfast's response to the Surrealist Unit One group in London. Pressure grew following his father's death in 1935, when he became his mother's sole support, and his marriage to Maye McLain, who was to die tragically four years later. The bombing of Belfast in 1941 was also traumatic for Middleton, yet despite these difficulties, when invited by John Hewitt to hold the first solo exhibition in the re-opened Museum and Art Gallery at Stranmillis, his unremitting work ethic was such that he was able to show 115 paintings, a remarkable figure, considering the highly detailed and ordered nature of his work.

Middleton was given another exhibition in 1945, this time under the auspices of CEMA. In that year too, he married the poet Kate Giddens, and set up home for her, her two children, and the two children they were to have together. Financial demands were heavy. In 1947, following his mother's death, he abandoned the business and moved with his family to John Middleton Murry's Community Farm in Suffolk, hoping to combine less stressful work with painting. Returning to Belfast in 1948, he was rescued from poverty by Victor Waddington, who became his agent until 1955, paying him a stipend of £40 a month in return for paintings of the same value. Waddington opened up opportunities in Dublin and London and Middleton's career began to prosper, although the break-up of the relationship, when Waddington moved to London, brought a return to hardship. Middleton was forced to accept teaching jobs in the Belfast College of Art, Coleraine Technical College, and the Friends' School, Lisburn, from 1955 to 1970. Honours eventu-

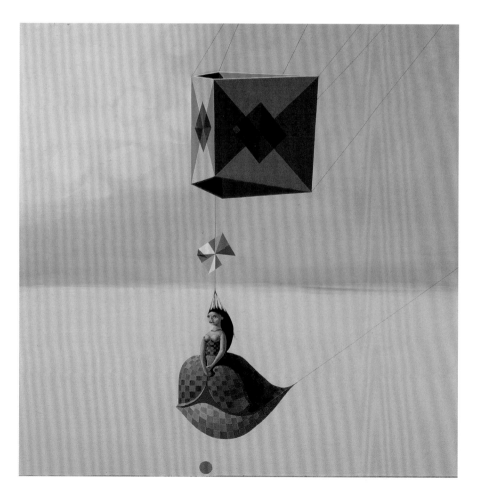

301. Colin Middleton, *Bon Voyage, c.* 1976, oil on panel, 62 x 62 cm, Irish Museum of Modern Art

ally began to flow in, including an MBE in 1969, membership of the RHA (qv), and an Honorary MA from QUB in 1972. That same year, a bursary from the ACNI, and an arrangement with McClelland Galleries International, Belfast, enabled him to give up teaching and travel to Australia and Barcelona. The 'Wilderness' series of paintings, exhibited at McClelland Galleries on his return, are viewed by many people as his finest work.

The different styles that baffled critics can be seen in the contrast between the precise draughtsmanship and solid structure employed in his Surrealist works, and the emotional charge of his Expressionist and Cubist-style paintings (see 'Surrealist Art', 'Expressionism' and 'Cubism'). Middleton's work as a textile designer probably contributed to his meticulous craftsmanship; it also clearly influenced his sense of structure and pattern. To this he added his very personal interest in symbolism and archetype, prompted by the Bible, James Joyce's *Ulysses*, and the work of Carl Gustav Jung, which led him to conflate the female body with the landscape.

Riann Coulter has argued that Middleton was not accorded due recognition within the Irish art canon because he avoided the nationalist and west of Ireland imagery particularly valued by critics in the Republic. Middleton never blindly followed models set down by other Irish artists, telling Michael Longley with typical bluntness, 'There is no Irish painter I would put among my household gods' (Eastwood, p. 15). He was closer to the poets, especially Hewitt, Longley and Seamus Heaney, who were among his most discerning admirers. There are paintings by Colin Middleton in all the major Irish public collections.
CATHERINE MARSHALL

SELECTED READING Carlo Eastwood (ed.), *Colin Middleton: A Millennium Appreciation*, exh. cat. Eastwood Gallery (Belfast 2000); Dickon Hall, *Colin Middleton: A Study* (Belfast 2001); Catherine Marshall, *Colin Middleton: Paintings and Drawings from the McClelland Collection* (Dublin 2001); Riann Coulter, '"An Amazing Anthology of Modern Art": Place, Archetype and Identity in the Art of Colin Middleton', *Visual Culture in Britain*, IX, no. 1 (June 2008), 1–25.

MILLER, NICK (b. 1962) [302], painter. Born in England, where he obtained a degree in Development Studies from the University of East Anglia, Nick Miller began painting full-time following his arrival in Ireland in 1984. Largely self-taught as an artist, his work is rooted in the history of Northern European painting; however, his focus on understanding direct observational encounters with a subject has opened his practice to many influences. Philosophers such as Martin Buber, as well as Taoism and Eastern thinkers, who address 'attention' in the 'present moment', have all affected his painting. Usually subliminal, these influences occasionally become evident, as in the 'Innocence' series (1998–2000), executed immediately after Tai Chi sessions when his normal critical faculties were deactivated but energy and concentration levels were most finely tuned.

A visit to South Africa in 1990 led to artworks based on an attempt to observe memory, shown at IMMA in 1994. But the power of remembered experience was displaced by his growing

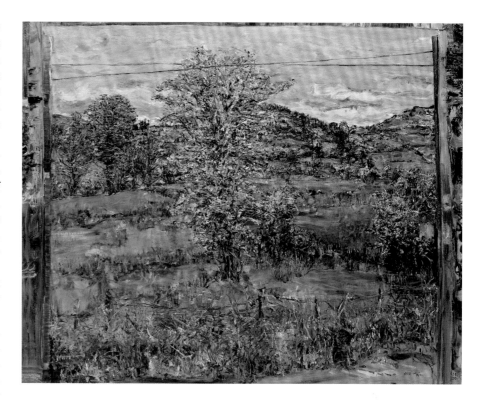

desire to work directly from the subject without any conscious censorship. This was fuelled by closely observed drawings of animals and cadavers in Dublin Zoo, and the Royal College of Surgeons in Dublin (1988–94).

In 1993 Miller began what he calls the 'Closer Drawings', portrait drawings of friends and family members, in which he worked at such close range to his sitters that an overview is impossible, but the intensity of the details and the rawness of the portraits, especially in *Corban* [149], a portrait of the artist Corban Walker (1996), places them among the most powerful drawings of the decade (see 'Portraiture'). Miller has gone on to execute similar closely observed paintings of still-life objects and of the rural landscape in Counties Leitrim and Sligo. To facilitate this, he uses a mobile studio, a truck, through the open doors of which he paints nature as it thrusts itself upon his field of vision. The cramped space of this makeshift studio and the immediacy of the natural world outside it give these paintings and drawings an extraordinary degree of intimacy, energy and strangeness. His landscapes (qv), generally of the west of Ireland, reject the picturesque nationalism of earlier west-of-Ireland landscapes in favour of a kind of gothic awe at the implacable renewal of nature itself. As he told Patrick Murphy: 'I see Nature as disinterested in human matters. It is a relentless continuum of energy that I am only beginning to appreciate.' (Murphy, p. 31)

Patrick T. Murphy has also drawn attention to the performative qualities in Miller's work, citing Jackson Pollock as the producer of similarly enlivened and dense surfaces; but despite similarities, Miller's emphasis on the subject places him in a different category to the earlier artist (op. cit.).

His subjects, whether still-life objects, portraits, landscape or the nude, all of which have been subjected to the

302. Nick Miller, *Whitethorn, fading blossom*, 1999–2001, oil on linen, 122 x 152.5 cm, private collection

303. John Minihan,
*Samuel Beckett at the
Petit Café, Boulevard St
Jacques, Paris*, December
1985, hand-printed
photograph, 60 x 40 cm,
Crawford Art Gallery

same fierce concentration, are alike in their emphasis on a primal closeness, immediate detail blocking more rational overviews. Miller points to time spent with the Chinese artist and calligrapher Chen ZhongSen, with whom he shared an exhibition in Sligo (2002) and, for a particularly intense period of work, to Tai Chi as the means to his heightened focus and his ability to record the infinite in nature. They helped build the 'necessary concentration to face the impossibly intense detail of the visible natural world as I find it outside the truck, without simplifying or consciously abstracting in the face of nature' (Marshall, p. 10).

Miller is a member of Aosdána (qv) and has been the recipient of several awards and bursaries from the AC/ACE. He has had solo exhibitions in Amsterdam, Atlanta, Belfast, Dublin, Kilkenny, Limerick, London, Paris, Sligo, New York and other venues. He has been included in group exhibitions in Europe, North America and China. His work can be found in the collections of the AC/ACE, IMMA, the OPW and the National Drawing Collection in the LCGA. Miller has painted portraits of the painters Patrick Hall (1994, IMMA collection), Barrie Cooke (1997), and of the writer John McGahern (1998, Model and Niland Collection, Sligo). CATHERINE MARSHALL

SELECTED READING Catherine Marshall and Patrick T. Murphy, *Nick Miller: Figure to Ground*, exh. cat. RHA (Dublin 2003); Peter Plagens, *Truckscapes: Drawings from a Mobile Studio, 1998–2007*, exh. cat. Rubicon Gallery, Dublin; LCGA; Centre Culturel Irlandais (Dublin 2007); David Cohen, *Truckscapes: Paintings*, exh. cat. New York Studio School (New York 2008).

MINIHAN, JOHN (b. 1946), photographer. Born in Dublin, Minihan spent his childhood in Athy, Co. Kildare, before moving to London with his family. In 1967, at the age of twenty-one, he became the youngest person to be appointed staff photographer to the *Evening Standard*. He deliberately describes himself as a photographer rather than an artist (see 'Photography'). The journalistic aspect of his practice reached its zenith when he secured a particularly newsworthy photograph of the teenage Lady Diana Spencer, after the public announcement of her engagement to the Prince of Wales.

Minihan's considerable artistic reputation rests on his commitment to recording the changing face of provincial life in Athy, which he has documented annually since 1967, and his portrait photographs of figures from art and literature, such as Beckett, William Burroughs and Francis Bacon (qv).

Minihan's ability to secure defining images of personalities like Samuel Beckett arises from his willingness to build up bonds of trust over a period of years, as much as from his expertise with a camera. Initially reluctant to be photographed, Beckett was won over to Minihan's work after seeing photographs of the wake and funeral of Katy Tyrrell, filmed over forty-eight hours in Athy in 1977. His subsequent trust in Minihan led to some of the most celebrated images of the writer [303]. Minihan's friendship with Francis Bacon enabled him to take photographs of the artist over two decades, commencing in 1971 when he photographed him outside a

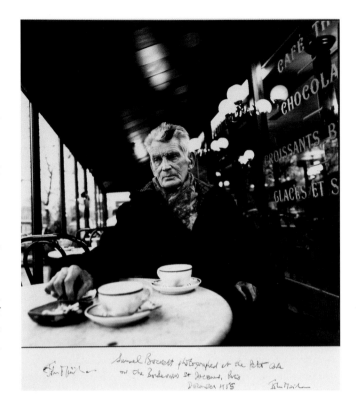

London court following his acquittal from drugs' charges. Bacon, whose reverence for photography made a deep impression on Minihan, invited him to film the openings of his exhibitions at the Claude Bernard Gallery, Paris, in 1977 and his celebrated Tate Gallery exhibition in 1985. Four years later, Minihan's exhibition *Beckett, Bacon and Burroughs*, at the October Gallery, London, was attended by Bacon and Burroughs.

Minihan has been the recipient of many awards and was the subject of an 'Arts Lives' documentary by RTÉ (2006). His photographs can be seen in the collections of the Museum of Modern Art in Rio de Janeiro, the Georges Pompidou Centre, Paris and the NPG, London. CATHERINE MARSHALL

SELECTED READING *Samuel Beckett: Photographs by John Minihan* (London 1995); John Minihan, *Shadows from the Pale: Portrait of an Irish Town* (London 1996); John Minihan, *An Unweaving of Rainbows: Images of Irish Writers* (London 1998); *Samuel Beckett: Centenary Shadows*, photographs by John Minihan (London 2006).

MINIMALISM. Generally associated with artworks characterized by an austere, geometric appearance and a deliberate lack of expressive content, Minimalism is an aesthetic that relies on specific conceptual attributes for artistic meaning. The term emerged in the 1960s to describe the work of a group of artists based in New York which included Frank Stella, Donald Judd, Carl Andre, Robert Morris and Sol LeWitt. While they never exhibited together, their work advocated a similar set of principles that stemmed from the idea of the 'Specific Object' and

related to concepts, including non-relational composition, objecthood and perception.

In opposition to Abstract Expressionism (see 'Abstraction' and 'Expressionism and Neo-Expressionism'), the Minimalists eliminated gesture and relational harmony initially through the use of repetition and the design of symmetrical compositions. This was further emphasized in sculpture by the use of serial components, such as in Andre's controversial work *Equivalent VIII*. This highly rational approach to art-making removed any opportunity for subjective expression and symbolic interpretation, while the frequent use of plain and industrially produced materials pointed towards the production of objects. Judd believed that this brought forth a new type of artwork, which he termed the 'Specific Object'. In his seminal essay, 'Art and Objecthood', Michael Fried argued that the Specific Object stressed the 'theatrical quality' of the artwork by revealing the literal space of the object and the phenomenological experience of the viewer. This implicated the viewer and their individual perception within a given space as a primary source of meaning in minimal art.

During the 1960s a number of Irish artists began to look towards American art for aesthetic inspiration. A small number, including Patrick Scott (qv), exhibited in New York. This coincided with a highpoint in Abstract Expressionism, which Scott later recalled 'overwhelmed everyone' (Ryan, 2006, p. 113). Scott and Cecil King (qv), among others, soon began to produce work in a more hard-edged geometric idiom. This demonstrated their interest in the physicality of the artwork. However, suggestions of metaphor and meaning remained an important element of even their most austere compositions.

Minimalism was essentially an American aesthetic and its conceptual origins were fundamentally connected with the culture and polemics of the period. However, the publication of Gregory Battcock's *Minimal Art: A Critical Anthology* in 1968 launched the minimal debate into wider circulation, reinforcing its significance and affirming its status in the development of western art. The impact of the aesthetic on new American and European art became considerably apparent. In 1971 the critic Robert Pincus-Witten coined the term Post-Minimalism to describe an expanding field of visual practices, including process art, Conceptual art (qv), Land art and systems art, all of which developed on the key principles of the aesthetic.

Irish artists experienced the aesthetic first-hand at *Rosc '71* (see 'Rosc Exhibitions') when artworks by Stella and Judd were selected for display. Around this time, Irish painters, including Evin Nolan, Michael Coleman (qqv), Erik van der Grijn and Deborah Brown, who stressed that 'form is everything', began to demonstrate some awareness of minimal values. The most public manifestations of the aesthetic to emerge in Ireland were the large outdoor sculptures that appeared throughout the country in the early 1970s. These reflected the current trend in public sculpture in the United States of America, whereby Minimalists such as Judd, Andre and Richard Serra were commissioned by architects to create works for specific public and architectural spaces. Often rigorously formal, these sculptures relied for aesthetic effect on the relationship between the work, its site and the public's presence. This dynamic was explored by Irish sculptors

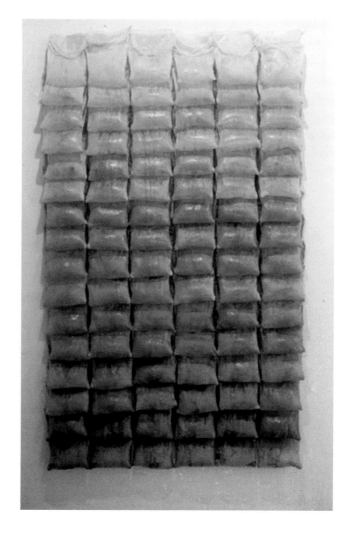

304. Helen Comerford, *96 Bag Piece II*, 1980, relief-assemblage, fabric, fibreglass, 96 x 158 x 7 cm, Irish Museum of Modern Art

such as John Burke, Brian King and Michael Bulfin. Bulfin's large geometric sculpture, *Reflections* (1978), references the architecture of the Bank of Ireland's head office, Lower Baggot Street, while at the same time altering the viewer's experience of the plaza for which it was commissioned. King's understanding of this relationship led him to explore the idiom of Land art. An extension of Minimalism, Land art emphasized natural materials and the temporal nature of the artwork, as demonstrated in King's two earthworks, *Sea Holes* and *Burning Spiral* (1976).

In 1968 Robert Morris proposed that a consideration for materials and processes should be prioritized over the finished object. He recommended the reassessment of methods of production, drawing attention to their effects on the perception of the Specific Object. The influential artist Eva Hesse experimented with a range of unorthodox materials, developing a highly personal idiom that elaborated on the conceptual, social and metaphorical implications of Minimalism. Along with Agnes Martin, Anne Truitt and Judy Chicago, Hesse subverted the rigidity of the aesthetic by inviting metaphorical interpretations of her artworks. By the late 1970s, Irish artist Helen Comerford [304] had begun to work in fibreglass, creating large modular wall reliefs that incorporated dozens of small, water-filled, organic-looking

shapes. Their arrangement suggested the serial aesthetic of Minimalism, while their hemispherical shape and the relatively domestic processes involved in their production conferred a distinctly female presence.

Sol LeWitt recognized the conceptual underpinnings of Minimalism and in the late 1960s he pioneered a move towards a purely conceptual application of the idiom. This appealed to Brian O'Doherty (qv), who, as an artist and critic based in New York, was an active contributor to minimal discourse. In 1967, he guest-edited a double issue of *Aspen* magazine (5 and 6). Known as the Minimalism issue, its plain white design drew attention to the unorthodox box format of the periodical which included contributions by Roland Barthes, Samuel Beckett and John Cage. During the 1970s, O'Doherty produced a series of works that employed the linguistic model of the Ogham alphabet as a conceptual framework for the production of art. His investigations into perception, language and systems informed his influential series of essays 'Inside the White Cube: The Ideology of the Gallery Space', first published

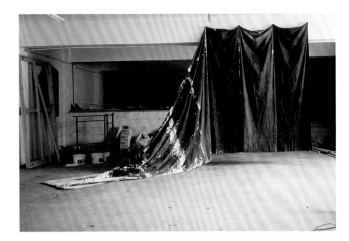

in *Artforum* in 1976. This conceptual approach to art practice gained currency among a number of Irish artists later in the decade. Roy Johnston (qv) [305] employed various geometric systems as a form of visual description, and his modular sculptures, such as *Square to cube transformation (series I)*, emphasized an equality of parts that was comparable to the Minimalists' approach to construction.

The interpretation of processes through the application of social, political and conceptual metaphor brought about a significant reconsideration of Minimalism. Interpretations of the Specific Object became focused on the artists' materials and concepts. The level to which such developments made an impact on the Irish visual arts was evident by *Rosc '80*, at which Minimalism was strongly represented by the work of Agnes Martin and Robert Mangold. Carl Andre, Sol LeWitt and the French artist Daniel Buren were also invited to make temporary, site-specific installations (qv). However, the level of antagonism with which the Irish public responded to Dublin City Council's acquisition of Martin's painting *Untitled No.7* was indicative of the negative perception and misunderstanding of the aesthetic in general.

In many ways, the progress of Minimalism signalled the end of the autonomous artwork, a transformation particularly apparent in painting, which had become grounded in the physical world. Sean Scully (qv), who emigrated to the USA in 1975, participated in the trend of post-minimal painting and produced austere, 'literal' canvases, such as his series of black paintings (late 1970s). He subsequently observed that 'process' now justified art, asserting that his later emotionally charged canvases 'could not have been made before Minimalism' (Scully, lecture at NGI, 13 March 2008). The late 1980s and early '90s saw a major resurgence in subjective painting in Ireland, yet a handful of painters, including Ciarán Lennon [306], Seán Shanahan and Fergus Martin (qqv), continued to pursue a process-based practice, advancing the visual and conceptual strategies associated with the Specific Object. Lennon's rational approach to painting evokes the work of Stella. His large monochrome canvases, as Aidan Dunne observes, 'convince us of their materiality, their ... physical presence and identity ..., like the

305. Roy Johnston, *Beneath 27/B*, 1972, acrylic on cotton duck, 214 x 212.6 cm, Irish Museum of Modern Art

306. Ciarán Lennon, *Folded/Unfolded*, 1972, Project Arts Centre installation, acrylic paint in/on linen, 274.3 x 548.6 cm

prototypical minimalist art object' (Dunne, *IT*, undated press clipping, Ciarán Lennon file, NIVAL).

The subversion, homage, deconstruction and reinvention of Minimalism remain a critical feature of the work of many young Irish artists working today. Reflecting an international trend of post-modern art practice, artists including Gerard Byrne, Mark Francis (qqv), Fergus Feehily, Sarah Iremonger, Corban Walker, Liam O'Callaghan, Karl Burke, David Timmons and David Beattie all draw upon the iconography and principles of the aesthetic as a vehicle for expression and content. While each artist explores his or her own specific arguments across a range of media, these ultimately are subsidiary to the simple perceptual reality of the object. DONAL MAGUIRE

SELECTED READING Judd, 1965; Fried, 1967; Morris, 1968; Battcock, 1995; Meyer, 2000; *Gerard Byrne: Tuxedo Junction, 1960*, exh. cat. Lismore Castle Arts (Waterford 2010).

MODERNISM AND POSTMODERNISM IN IRISH VISUAL ART.

While there are many famous examples from the fields of literature and theatre and a few notable exceptions (such as the architect and designer Eileen Gray (qv)), Irish Modernism in the visual arts is not well known outside of Ireland and specialists in the field. This is partly explained by it often being measured against a dominant paradigm of Modernism, which is defined through a group of styles that are assumed to be international yet which, paradoxically, valorize a set of practices clustered around established centres in the north of the continents of Europe and America (such as Paris and Berlin) and canonical collections like the Museum of Modern Art in New York. This dominant definition is generally accepted as a canon of fine art practices in Western Europe and North America and spans the hundred years from the mid-nineteenth to the mid-twentieth century. It is characterized by a developmental process of self-reflexive, self-referential and autonomous practices. It is generally associated with avant-garde attitudes that styled themselves as both radical and challenging of accepted tastes and authority. Hence it tended to celebrate newness over tradition. It was also associated with a move to Formalism – that is, an emphasis on the non-representational elements of the work, such as form and colour – and, ultimately, abstraction (qv).

Such hegemonic definitions of international Modernism not only tend to marginalize those cultural activities that exist on the periphery but are also frequently underwritten by problematic assumptions about such concerns as a spirit of the times or generalized traits of national character. Even in 1968 the hugely influential art critic and pope of high Modernist painting, Clement Greenberg, could use a lukewarm review of the *Rosc '67* exhibition (see 'Rosc Exhibitions') of 'modern painting and ancient Celtic art' to resort to the national stereotype that the Irish are not a visual people. He claimed to respond to local debates in Ireland which disavowed claims of a national 'visual sense' by claiming that there had been 'little in the way of significant art' in Ireland since the Middle Ages and whatever 'modest' innovations there were were mostly 'imported' (Greenberg, 1993, pp. 282–83). Considered in these

terms, the Ulster painter Colin Middleton (qv) exemplifies an attempt to synthesize a variety of European influences (such as Cubism and Surrealism), leading to a body of work that might be dismissed as derivative.

It is clear that in the century following Manet's *Le déjeuner sur l'herbe* (1863), during which Modernist art reached an apogee, Irish artists, critics and audiences were somewhat reluctant to adopt avant-garde practices in the visual arts. But what is also clear is that this coincided with the tumultuous, bloody birth pains of a nation that witnessed uprisings and civil war before an independent Irish Free State was tentatively established in the twentieth century and the Republic finally declared in 1949. Hence, cultural activities in Ireland were positioned between two poles. On the one hand there was a deep distrust (born from the experience of colonization) of external influence, and in particular from Britain, although there was more willingness to look to Scandinavia, Germany and France. On the other, there were politicized attempts to establish a national identity (see 'Identity in Irish Art') through appeals to either an indigenous Celtic ancestry or a (potentially international) religious collectivity predicated on Catholicism.

Thus, even artists working in recognizably Modernist idioms, such as Jack B. Yeats's (qv) use of Expressionism (qv) and Paul Henry's (qv) Post-Impressionism, did so while attending to indigenous themes and subject matters. This led to a focus on rural landscapes (often the west coast) and local traditions and activities in a manner similar to Gauguin in Brittany and Tahiti, yet in a way that sought to value national identity.

In summary, there are three clear reasons why the emergence of Modernism in visual arts practices was stifled in Ireland. Firstly, location: Ireland is geographically remote from mainland Europe and this led to a certain distance, geographical and cultural, from dominant avant-garde practices. The island's modest size, population, resources and position on the edge of Europe have often provided natural limits on any cultural, political or sporting ambitions.

Secondly, economics: the consequence of colonization was famine, emigration, political rebellion and the tentative birth of a politically independent nation in the nineteenth and early twentieth centuries. This provided social and economic impediments to the emergence of an internationally validated scene of visual Modernism and an attendant critical discourse. During this time an affluent and independent middle class did not flourish in Ireland, as it did in Britain, northern Europe and North America. Further, where a middle class was present, this was predominantly associated with an Anglo-Irish identity. The radical self-reflexive practices of avant-garde art and its discourse require financial nourishment from a bourgeoisie to which they are always tied, in Clement Greenberg's terms, with an 'umbilical cord of gold' (Greenberg, 'Avant Garde and Kitsch', in *The Partisan Review*, VI, no. 5, 1939, 34–49). It was only relatively late – in the second half of the twentieth century – that the financial and attendant cultural confidence emerged to support such practices.

Thirdly, nationalism: owing to the coupling of avant-garde practices with bourgeois concepts of Modernism, the visual arts were particularly associated with a small coterie of patrons and

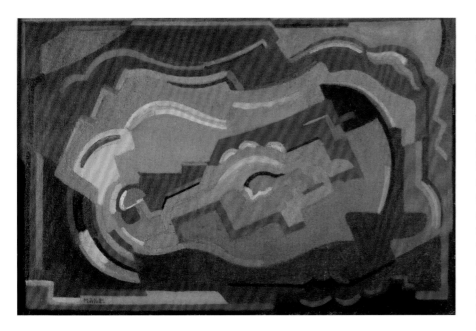

307. Mainie Jellett, *Untitled, c.* 1930, oil on canvas, 61 x 91 cm, O'Malley Collection, Irish American Cultural Institute, University of Limerick

Thus, the history of Modernist art and culture in Ireland is the history of a resistance to newness and external influence, played out as a complex dialectic between, on the one hand, tradition and indigenous, Celtic and religious identities and, on the other, modernity and imported cultural forms.

But, contrary to accounts that compare Irish Modernist art to canonical examples and dismiss it for a lack of originality or genius, the iterations of Modernism in Ireland show that, from a global perspective there is no monolithic or fixed Modernism in the visual arts or any other cultural activity. To take this view means accepting that Modernism is not a particular style but rather a variety of different practices that are the symbolic expression of the historical (technological, economic and material) conditions of modernity no matter where they emerge or what forms those expressions take. This account means, on the one hand, that other expressions and experiences of modernity are made manifest in different Modernisms and, on the other, that dominant forms of Modernism are those forms that have been institutionally framed and validated in hegemonic institutions and histories.

It would be absurd to suggest that there were no experiences of modernity in an Irish context. The central role that Irish writers such as James Joyce [308], Flann O'Brien and Samuel Beckett played in Modernism in literature and the theatre is so well known that it need not be repeated here. What does seem clear,

artists of Anglo-Irish and/or Protestant identity (like Mainie Jellett [307], Evie Hone and Norah McGuiness (qqv)). Thus, the notion of Modernism in the visual arts was as contested as the Anglo-Irish identity with which it was most frequently associated. Such a conflicted identity is made more complex against the backdrop of already anxious and contested ideas of national character.

Until the second half of the century, Modernism in the visual arts was viewed with a certain suspicion from catholic and nationalist perspectives as either a colonial (specifically English) ideology that was imposed externally in the name of modernization or as something that was not Irish (an issue that even those who embraced Modernism, such as the architects Michael Scott and Ronnie Tallon in the 1930s, had to deal with). It was seen to challenge religious, national or Celtic identities which, by contrast, emphasized the relationship between the Celtic Revival and nationalism. For example, the flourish of cultural activity between 1890 and 1916 (exemplified by the opening of the Abbey Theatre in 1904), although involving people with an Anglo-Irish heritage, such as Lady Gregory, Edward Martyn and W.B. Yeats, was predicated on reviving the Irish language and Celtic identity, in opposition to British influence.

In education, too, an emphasis was placed on Irish identity in general and language in particular through the continued influence of political activist and educationalist Patrick Pearse (1879–1916). In 1922 the Irish National Teachers' Organisation recommended the removal of drawing and needlework as compulsory subjects for primary level students while making Irish a required subject. Subsequently, an emphasis on Gaelic language and culture became a core principle of education policy after independence (see 'Education in the Visual Arts'). It was inevitable that this created an environment in which at least indifference, if not outright hostility, towards the modern was fostered.

308. James Joyce as a young man, Dublin, *c.* 1904

however, is that experiences of modernity were mediated in specific ways. These were: in the fields of literature and theatre; through the violent reconfiguration of the social sphere (particularly in the twentieth century when Ireland, like much of continental Europe in the nineteenth century, experienced revolution); or in exile and the experience of migration. But, in Ireland, modernity was rarely manifest in predominantly visual art practices.

In turn, this lack of an expression of modernity predicated on visuality had a negative effect on the emergence of a critical discourse grounded in aesthetics but radiating into politics. Indeed, Luke Gibbons has pointed to the lack of the Irish equivalents of 'Adorno, Barthes or de Beauvoir, or, for that matter, Marx, Wollstonecraft or Weber' (Gibbons, 'Towards a Postcolonial Enlightenment: The United Irishmen, Cultural Diversity and the Public Sphere,' in Carroll and King, pp. 81–92).

All the details of a dialectic of Irish modernity and Modernism are too complex to be fully explored here. On the one hand, it has been suggested that modernity arrived too late in Ireland, and that even by the middle of the twentieth century social conditions (indexed by literacy and infant mortality) did not compare favourably with mainland Europe. On the other hand, Ireland experienced the shock, disintegration and fragmentation of modernity well before the twentieth century because such experiences were thoroughly inscribed within the colonial condition.

However, in relation to fine art, it seems clear that western European Modernism was not taken up by artists in Ireland in the nineteenth and early twentieth centuries. Modernist art was either practiced in exile, as in the case of Norman Garstin (qv) who painted in realist (see 'Realism') and Impressionist idioms first in Brittany and then in Cornwall, or adopted somewhat unconvincingly. For example, there was no prominent Impressionist working in Ireland at the end of the nineteenth century and those who did paint in recognizably Impressionist and Post-Impressionist styles, like Roderic O'Conor (qv) and Walter Osborne, followed European models and received little in the way of international recognition or influence.

Avant-garde practices in the visual arts fared little better in the twentieth century. A notable exception was the collector Hugh Lane, who established the first modern art gallery in the world, the Municipal Gallery of Modern Art (now the Dublin City Gallery The Hugh Lane (HL)) in Dublin in 1908, and who brought European Impressionism to Ireland with the express intention of establishing Modernism in Irish painting.

However, following this, from the 1930s onwards, there was what Terence Brown calls 'an almost Stalinist antagonism' to Modernism, which was coupled with cultural conservatism and respect for tradition (Brown, p. 147). This led to a general climate in which even those artists attempting a European style of painting (such as the Cubist-inflected experiments of Jellett and Hone, or the expressive abstraction of Louis le Brocquy (qv)), had no audience for their work outside of a very small community of committed artists, collectors and curators. Even as late as the 1960s, any contemporary art being exhibited in Ireland could still be convincingly dismissed as a 'kind of tame

309. *E1027* by Eileen Gray, assisted by Jean Badovici, Roquebrune-Cap-Martin, France, 1924–29

second-generation modernism' (Brian Fallon in Ryan, 2003, p. 240) or, what Brian O'Doherty (qv) witheringly called both 'rural' and 'tasteful'. O'Doherty went on to explain:

With the decline of modernism local art looks better…In Ireland one is spared this doppelgänger provincialism (The Irish Warhol, The Irish Rauschenberg) so prevalent in more visually sophisticated cities. Dublin still preserves a somewhat rural mentality within its urban pale. A jeering suspicion makes short work of modernism's more exotic hybrids. Both the artist and his audience discourage formal impoliteness or radical gestures. Modernism is kept as a distance by what modernism eventually rid itself of – taste. Most Irish art since 1959 is very tasteful. (O'Doherty, pp. 10–11, 20)

Of those artists in the twentieth century who did explore European styles, particular attention should go to the role of women practitioners, who are well represented in the development of Modernist art in Ireland. There is an argument to be made, that without the presence of grand masters of the male-dominated European avant-garde (Manet or Picasso, for example) female practitioners in Ireland were somewhat freer to practice alongside their male compatriots. Both Hone and Jellet had studied with second generation Cubists on the Continent and brought these lessons and styles back with them, while Camille Souter and Nano Reid (qqv) were key figures in exploring Expressionist idioms. In addition, the rediscovery of Eileen Gray, in the 1990s, as an internationally significant designer (of furniture and carpets) and architect of the paradigmatic work of

international style architecture, *E1027* (1924–29) [309] has rescued her reputation as one not subordinate to her collaborators, like Le Corbusier, but an innovator in synthesizing design and art in her own right.

Still, in the 1960s Modernism in the visual arts did begin to gain a tentative academic and public profile. This began to happen when art and artists moved both in and out of the country. Between 1967 and 1988 the six Rosc exhibitions brought contemporary avant-garde art (and art world figures such as James Johnson Sweeney, Willem Sandberg and Clement Greenberg in 1967) to Ireland from abroad and, following from a big exhibition of American Abstract Expressionism at the HL in 1964, was the first introduction of a recognizably Modernist art to the general public on a grand scale; while from 1972 the Irish Exhibition of Living Art (IELA), which had been showing contemporary art, such as the White Stag Group (qv), from 1943 continued to embrace international Modernism under the new chairmanship of Brian King. Likewise, Ireland's first representation at the Venice Biennale came at the twenty-fifth show in 1950 (Fionna Barber, 'Excavating Room 50: Irish Painting and the Cold War at the 1950 Venice Biennale', in Cullen and Morrison (eds), 2005, pp. 207–24), followed by le Brocquy winning the Premio Prealpina at Venice in 1956, and Patrick Scott (qv) the Guggenheim Award in 1958. It is no coincidence that these dates loosely coincide with the establishment of art history departments in Trinity College Dublin and University College Dublin, for while these departments were dedicated to traditional art history (with a strong focus on medieval scholarship), they represent an increased interest in the visual arts in general that led to a growing awareness of contemporary practices.

Postmodernism in the visual arts is, by definition, the art which came after, and in response to, Modernism. Generally this is understood to be a range of practices grounded in a return to, and critique of, representation; a use of irony; and a turn to popular culture and the mass market. This can be seen as a reaction to the perceived preoccupation in canonical Modernism with abstraction, sincerity and elitism. Often the figure of Marcel Duchamp was invoked as an influence, and in particular his statements on anti-art and the Readymade. This reached a high watermark in the 1980s and coincided with the ascendency of the globalized, de-regulated free-market economic policies of Ronald Reagan, Helmut Kohl and Margaret Thatcher and a boom in international art sales. In such a context, the notion of a national identity in visual arts was questioned in the global context of unfettered capitalism, in which multinational companies spread across borders and continents, and art practices and the art market burgeoned internationally. The very idea that there could be a specifically national style of Postmodern art became unfashionable.

That said, for the latter part of the twentieth century, the lack of a well-established or canonical Modernism in fine art did set some conditions for Postmodern and contemporary practice in an Irish context. In short, without a dominant Modernism in the visual arts there was no context for anti-Modernist gestures from which Postmodernism emerged. Neo-Dada at the end of the 1950s was predicated on a rejection of high Modernist painting, such as American Abstract Expressionism, while the critique of the institutions of art at the end of the 1960s saw artists like Hans Haacke and Marcel Broodthaers use site-specific gestures to undermine the hegemony of the modern art museum. In Ireland, without such hegemony, there was less at stake in such gestures and, subsequently, less occurred.

This seems to have had two main consequences. On the one hand, many artists, such as Sean Scully (qv) or John Burke, either continued an interrogation of Modernist styles and attitudes in contemporary contexts, or, like Robert Ballagh (qv), playfully revisited instances from the history of art through a pop sensibility and an attempt to recoup techniques and 'skills'.

310. Willie Doherty, *The Only Good One is a Dead One*, 1993, video installation with projection on two walls, colour, audio, 30 min, on loan from Weltkunst Foundation to Irish Museum of Modern Art

On the other hand practices that can be recognized as Postmodern did appear as ones that were predicated on either interrogating or rendering uncertain fixed notions of identity. In fact, an argument could be made that the essentially divisive experience of being colonized, such as living with two cultures and languages simultaneously, was already similar to what theorists of Postmodernism like Fredric Jameson identified as the inherently schizophrenic experiences of late capitalism, and the feelings of transnational dislocation brought about by globalization. Brian O'Doherty/Patrick Ireland, for example, made the performative gesture of adopting a second identity as part of his Conceptual Art (qv) practice; and his work consistently interrogated the framing of both identity and aesthetic experiences within institutional frames, such as what he famously described as the 'white cube' of the gallery. Similarly, Dorothy Cross's (qv) sculptures unsettle any fixed distinctions between male/female and human/animal identities. James Coleman's (qv) installations use multiple media and multiple approaches to the senses of the viewer to create ambiguous narratives that consistently confound easy readings or meanings. In his work, identity is interrogated through staged gestures and texts.

Today artists, curators and critics working in an Irish context have a confidence and freedom in part born from the increasing irrelevance of national identity in contemporary practice, that is, in the main, inherently international in its ambitions, scope and audience. For example, artists like Willie Doherty [310] and Gerard Byrne (qqv) make complex installation and film work which invoke aspects of Irish identity and history while acknowledging the place of these identities in global contexts. Budget airlines, including well-known Irish firms, have led to cheap air fares and increased mobility such that there is increasing freedom in where one might study, live, work and socialize. Contemporary artists are as likely to have studied and be based in Berlin, London, Glasgow, Dublin or elsewhere; and while in such cities they might find themselves freer to work without the constraints of troubled histories and traditions. FRANCIS HALSALL

SELECTED READING O'Doherty, 1971; Terence Brown, *Ireland: A Social and Cultural History 1922–79* (London 1981); Graham, 2001; Carroll and King, 2003; Cullen and Morrison, 2005; Long, 2008.

MOLLOY, TOM (b. 1964), conceptual artist. Born in Waterford, Tom Molloy has embraced a variety of practices since his graduation from NCAD with a Master's degree in 1992. Since then, his work has evolved through painting and drawing (qv) to encompass installation and sculpture, although much of his output is an interesting amalgam of these, in a conceptual framework that investigates the artistic context and locates both artist and human individual within a wider social and political arena (see 'Conceptual Art').

The earliest body of work for which Molloy became known during the 1990s was a series of paintings which replicated in minute detail the covers of *Time* magazine. While the paintings demanded attention for their technical bravura, the artist's

311. Tom Molloy, *Dead Texans*, 2002, fifty small drawings, pencil on paper, 14 x 14 cm each, Irish Museum of Modern Art

intention was far more complex. In presenting an internationally distributed mass-media product, with an obvious if unstated imperialist agenda, reproduced through the traditional but devalued dexterity of an individual human hand, Molloy was confronting issues of the individual in relation to the global. This has been the leitmotif of his work ever since, although his next significant project, the drawing from life and redrawing from memory of one hundred oak leaves did not at first sight appear to have the same global dimensions. What it shared with the *Time* magazine work, and was to share with all his subsequent output, was an interest in the individual and the universal: the single oak leaf that is unique, yet also representative of the species. The *Time* magazine paintings were overtly political in their interest in current affairs, highlighting the way in which the item of world news on the painted front cover was clearly paid for by the advertisements for multinational corporations on the back cover.

Other projects, such as *Dead Texans* (2002, IMMA collection) [311], invited speculation about the process of imaging, since the artist drew thumbnail portraits from photographs of those sentenced to death in Texan prisons under the authority of the State governor George W. Bush. Although based on conventional prison portrait mugshots, sourced on the internet, the meaning of Molloy's drawings differs from that of the original photographs, which are given another layer of mediation as they are presented globally on the internet. Molloy added an additional element to the theme by presenting them in tandem with drawings of his own skull, captured by X-ray photography, forcing us to contemplate mortality and our communal fate in a wider context.

Since the American invasion of Iraq in 2003, Molloy has concentrated his attention on the pervasiveness of American culture which insinuates itself into every corner of the world, no matter how remote. In a group exhibition at the Burren College, Co. Clare in 2003, he presented a single image, very small in relation to the whole room in which it was shown, but with a message all the more powerful owing to this contrast in scale. Molloy's image was a map of the world cut out of a US dollar bill (1999, Rubicon Gallery), the reverse of which, like all United

States currency, bears the inscription *e pluribus unum* (out of many comes one). Other work, sculptures made from cut-out paper dolls in sinister hoods, referring to the Abu Ghraib prison tortures in Iraq (*Crown*, 2005), or individually drawn replicas of embroidered stars cut from an American flag to represent the individual states that make up the federation of United States (*Allegiance*, 2004), or photographs and pencil drawings of photographs draw attention to the all-enveloping nature of global imperialism and the tragedy it brings in its wake. Money and the logo go everywhere, their destructiveness symbolized by a wall of attacking paper planes made from folded dollar bills in *Swarm* (2008, installation, Solstice Arts Centre, Navan).

Unlike many conceptual artists, Molloy's obsessive attention to every drawn line or minute cut-out shape re-establishes academic respect for the manufacture of the artwork, while simultaneously exploring the meaning of each medium. His social commitment can take other forms; a public art project in his native Waterford in 1997 led to the mysterious discovery of lottery tickets in books in the County Library. The ensuing surge in library borrowings led to national news coverage, and may have had some impact in the community's rediscovery of its services,

but the fact that it was an art project devised by Molloy did not emerge for some years, when the book documenting the process, and quietly placed among the shelves, was discovered.

Molloy had a mid-career retrospective at the LCGA in 2005, and a similar one, *Tom Molloy, Subplot* at the Solstice Art Centre in 2008. He has had solo exhibitions in Dublin, Geneva, Austin (Texas) and a major exhibition at the Aldrich Museum of Contemporary Art, Ridgefield, Connecticut (2010), and has shown in group shows in Ireland, Britain and continental Europe. He was shortlisted for the AIB awards in 2005, and in 2008 he was given an Arts Council (qv) multi-annual bursary.

Molloy's work can be seen in the collections of IMMA, the AC/ACE, the Zabludowicz Collection, London, Fondazione Spinola Banna per l'Arte, Turin, Fondo Regionale Arte Contemporanea, Piemonte and Princeton University Art Museum. CATHERINE MARSHALL

SELECTED READING Katerina Gregos, 'The Politics of Seeing', in *Tom Molloy: Subplot*, exh. cat. Solstice Arts Centre (Navan 2008); Joe Wolin, *Molloy*, exh. cat. Aldrich Contemporary Art Museum (Connecticut 2010).

312. Paul Mosse, *Untitled No. 47*, 1994, papers and acrylic on board, 81 x 101 cm

MOSSE, PAUL (b. 1946) [312], painter. Paul Mosse's art practice makes a mockery of conventional definitions of painting through his use of constructions, made from wood, acrylic resins, glass and other materials, and the incorporation of colour drawn from found objects. Apart from a decade in London, and regular trips to exhibitions elsewhere in the world, Mosse has spent his entire life in County Kilkenny where he was born and where his family have been key figures in the development of such organizations as the CIAS, the Kilkenny Art Gallery Society and the Butler Gallery. In 1968, while still a student at Chelsea School of Art, he won the Carroll's Prize at the IELA (qv) and a scholarship to the British School in Rome two years later. He seemed destined for a career in the spotlight. Instead, Mosse chose to work in relative seclusion in Kilkenny, soon abandoning the hard-edge abstraction that represented progressive art in the sixties and early seventies, in favour of a total commitment to the representation of nature in contemporary life.

Encouraged by the artist Barrie Cooke (qv), Mosse followed a personal, instinctive vision, while part-time teaching prompted an analytical approach. Describing himself as just a 'rough scraper and hewer and digger tunnelling away crudely', Mosse's concern is with the totality of nature, the inner workings and relationships as well as its external elements (O'Drisceoil and Russell, n.p.). Although his early work in London remained close to the formalist aesthetic dominant in the Chelsea Art School, his return to Kilkenny in the 1970s led him to analyse all the totalities of a rural environment. 'I think being within my forms, not just an onlooker, is important I love being in rivers, mud, undergrowth, caves – I love photos of inside the body.' (*Leaves and Papers*, p. 3)

Mosse is absorbed by thoughts of the infinite and of the endless variety and continuities in nature; this is reflected in drawings where the detail is so closely observed and recorded that the totality of the thing represented has to be rediscovered. The microcosm becomes the vehicle for the macrocosm, often leading to extraordinary and mysterious images of familiar phenomena. In his series *Through to the Kitchen* (1978/79), familiar domestic spaces become dense accumulations of tiny molecules, and later, more abstract works, constructed from thousands of minutely folded paper 'cells', replicate the build-up of natural organisms. Since the 1980s the work has become increasingly more sculptural. Drawings give way to intricate cut-away shapes in wood, paper and other materials, applied in layers so that the works seem to grow like weighty honeycombs from the walls on which they hang. Mosse fills and stuffs some of the overlapping voids with nails, glue, pigment and found matter to create an environment as revealing as an archaeological excavation. Perhaps no other Irish artist produces such extraordinarily textured work, and Mosse's comments on the subject are revealing: 'I'm very aware of the dangers of texture and "decoration" as seductive elements in painting. I think texture should come into work not as a primary concern, or an effort to bring it in – but more as a by-product. Then it seems to appear more fresh and true.' (*Leaves and Papers*, p. 4) If the world emerged from chaos, in Mosse's work it appears to return to it, albeit following a powerful internal logic that is honestly transmitted by the artist.

Mosse has had solo exhibitions at the Hendriks Gallery (1987), Garter Lane Gallery, Waterford (1994), the DHG (1997), and a retrospective at the Butler Gallery, which subsequently toured to Limerick, Sligo, Monaghan, Portlaoise and Dublin, in 1991, and a Butler Gallery exhibition in 2013.

Mosse's work has been acquired by IMMA, AC/ACE, OPW, AIB and TCD. CATHERINE MARSHALL

SELECTED READING Seán McCrum, *Paul Mosse: Works*, exh. cat. Butler Gallery (Kilkenny 1991); Aidan Dunne, 'In the Labyrinth: The Work of Paul Mosse', in *Partial*, exh. cat. DHG (Dublin 1997); *Paul Mosse: Leaves and Papers, No. 5* (Dublin 2008); Jerome O'Drisceoil and Ian Russell, *Chronoscope*, exh. cat. Newman House (Dublin 2008).

MULCAHY, MICHAEL (b. 1952), painter. Mulcahy's reputation as a painter of powerful, energetic canvases pulsating with shamanistic mystery was won at the expense of his suppression of an earlier career as a street performer. His behaviour in those early years was often wildly disruptive and out-of-control. Writing a decade after Mulcahy had tamed his demons, about the strength of will involved in that transition, Aidan Dunne was prompted to say, 'His paintings are paintings of crisis, all-or-nothing works that set out to decisively redeem the primacy of the imagination' (Dunne, p. 3). What each of Mulcahy's modes of being has in common is a belief that primitive is best and that western culture and lifestyles have lost touch with their true selves. This belief is augmented by his extraordinary facility with colour and form. He is frequently discussed in the context of Neo-Expressionism (see 'Expressionism') and, while it is legitimate to relate his work to this movement, it is distinctive from that of the other Irish Neo-Expressionists of the 1980s. The concern with the minutiae of social injustice and political and religious repression central to the work of many Expressionists does not manifest itself in his painting, which although no less concerned, is dedicated to more mythic and heroic struggle.

313. Michael Mulcahy, *The Navigator*, 1982, oil on canvas, 157.5 x 165 cm, Irish Museum of Modern Art

Mulcahy's history has been a peripatetic one, travelling from Ireland to Berlin, Australia, Papua New Guinea, India, Korea and Mali, to Innisheer in the Aran Islands, in search of spiritual fulfilment. His own restlessness has led him to identify with other travellers and explorers such as the Irish saint Brendan the Navigator, who is said to have discovered America in the sixth century, but Mulcahy's best work has come from living for significant periods of time with tribal communities – the Aboriginals in Australia and the Dogon people of Mali [167]. His work is raw, often strident in its blatant sexuality, and sizzles with intensity, whether that evokes the heat of the desert, the depth of the night sky or the human spirit trying to find its proper place in the cosmos. Although Mulchahy's work has taken him to very specific places, what his paintings reflect is the spirit of the landscape and its occupants, human and animal, rather than any recognizable autobiographical or geographical features, the archetypal rather than the personal. That said, it is possible to relate the womb-like caves of darkness through which the traveller moves in *The Navigator* (1982) [313] to the artist's psychological journey from wild man to controlled and mature painter.

In 1990 'The Betrayal', a book of poems by Michael D. Higgins (President of Ireland since 2011) with drawings by Mulcahy, was published by Salmon Press, Galway. Since 2000, Mulcahy's work has centred on quieter but no less imaginative subjects, paintings and drawings, inspired by, rather than illustrative of, archetypal stories such as Hans Christian Andersen's *Fairy Tales*.

Born in Cork and brought up in Dungarvan, Co. Waterford, Mulcahy was educated at the Crawford College of Art (1969) and NCAD (1970–73), and at a Buddhist monastery in South Korea where he studied calligraphy. Mulcahy's work has been widely shown in Ireland and in important group exhibitions such as *Irish Art of the Eighties* (DHG, 1990). He represented Ireland at the 5th Sydney Biennale in 1984, and at the 19th Festival of International Painters, Cagnes-sur-Mer, 1987. He was elected to Aosdána (qv) in 1986 and his work can be seen in numerous collections, among them the NGA, the Arts Councils of Ireland and Northern Ireland, IMMA, HL, CAG, UM, TCD, CIAS and many corporate and private collections. CATHERINE MARSHALL

SELECTED READING Dorothy Walker, 'The Art of Michael Mulcahy', *IAR*, II, no. 4 (1985); Aidan Dunne, 'The Limits of Desire' in *Michael Mulcahy*, exh. cat. DHG (Dublin 1989); D. Scott, 1991/92; Mairéad Byrne, *Works 17 – Michael Mulcahy* (Kinsale 1995).

NAPIER, PHILIP (b. 1965) (qv *AAI* III) [314], installation (qv) artist. Born in Belfast, Napier studied at the Falmouth School of Art between 1984 and 1987, and then at the University of Ulster where he was awarded an MA in Fine Art in 1989. From the outset, his work has been characterized by an interest in social and political issues. In 1991 Napier was represented in the *Shifting Ground* exhibition in Belfast, while his installation/performance, *Eating the Day*, was held at the Orpheus Gallery. The following year he was awarded a fellowship at the British School in Rome. In 1994, along with Alice Maher and Ciarán Lennon (qqv), Napier represented the Republic of Ireland at the São Paolo Biennial, while the following year he represented the UK at the Gwangju Biennale in South Korea. In 1993 he was included in a group exhibition at the Grey Art Gallery, New York. In the mid-1990s, Napier worked on commissions relating to Heathrow airport and the Portlaoise by-pass, and subsequently worked as arts co-ordinator for the Royal Victoria Hospital in Belfast.

In 1997 Napier's *Gauge* was installed at two locations in Derry, Glenfada Park and the Orchard Gallery. Glenfada Park was the area where fourteen unarmed protestors were shot by British army troops in January 1972, during a civil rights march on what came to be known as Bloody Sunday. For the best part of four decades, there was no government apology for this action; indeed, it was maintained, incorrectly, that the marchers had had weapons and that the killings were justified. Napier's *Gauge* was a darkened room, with fourteen loudspeakers suspended from wires, each with a weighing scale gauge. The soundtrack consisted of variations on the theme of apology, and the work proved to be prescient in the wider political dimension, when the British Prime Minister, David Cameron, in 2010 issued an unreserved public apology in relation to Bloody Sunday. Other political work of Napier's includes *Ballad No. 1* [390, 488], an installation at IMMA as part of the exhibition *From Beyond the Pale*, in 1994, which referenced the death on hunger strike of Bobby Sands, who was elected to the House of Commons while dying in prison in 1981; the colonial history of the Royal Hospital Kilmainham and its post-colonial reinvention as IMMA; and the installation *Apparatus V* (1995), which formed part of the exhibition *Distant Relations* in 1995 (see 'The Troubles and Irish Art' and 'Politics in Irish Art').

In 2010 Napier was appointed head of Fine Art at NCAD. He has exhibited in Ireland, the USA, Britain, Italy, France, South Korea and Brazil. PETER MURRAY

SELECTED READING Ziff, 1995.

314. Philip Napier, *William*, 1998–99, digital print, reconstructed fireplaces, soot, table legs, audio

NARRATIVE AND ANTI-NARRATIVE (see 'History Painting and Narrative Painting'). In the early twentieth century, Seán Keating chronicled the struggle for independence and the birth of the Irish state in a narrative involving people and landscape, occasionally using symbol to signify 'Ireland'. While Keating looked backwards to history painting for inspiration, he may have recognized that the grand scale and heroic themes of the genre were no longer appropriate for the purposes of patriotic representation. Despite Keating's desire for a truly Irish art, he remained caught between tradition and modernity, and after the 1920s his paintings are academic in style and outlook. At the end of the twentieth century, Irish art may be characterized as often concerned with the local, but without the aspiration to represent the nation. Where Keating is sometimes described as a 'romantic realist', the term may be also applied to contemporary figurative painters such as Brian Maguire and Patrick Graham (qqv), where the symbolic is displaced by more particular subject matter. By contrast, various forms of narrative abound in the allegoric and idyllic paintings of artists as diverse in their ideas about art and society as Patrick Hall, David Godbold and Alice Maher (qqv). It is also possible to read the distancing techniques employed in the photographs of Willie Doherty or Hannah Starkey (qqv) in terms of narrative: their photographs are constructed as a frame in time with indexical links to a possible incident or passage of time. The terms of reference for Irish art of the late twentieth century are considerably less insular than hitherto; it is much more in synch with the international art world.

It is in this context that film (qv) has largely supplanted the plastic arts as the popular, artistic and intellectual medium for visual narrative, while story-telling in film remains indebted to the literary arts and to music. The challenge of film is central to debate in art and art theory over the past century, and this essay will concentrate on art at the turn of the twenty-first century where film is the preferred medium. In general terms, 'narrative' is here understood as the representation of temporalities (time and space). A concern in such art is the subjectivities involved by the lack of stability or constancy in our relations with others and with the world, as distinct from the fixed, stable subject of narrative forms directed at the mass market. 'Moving image' is a term employed to signify use of film in visual art within which artists can explore or examine experience in more experimental and reflective ways than may appear in commercial cinema. The Irish art under discussion is located in the contemporary global context after post-colonialism and, further, may be situated as post-national. It is exemplified by the two artists whose work in moving image in the gallery space will be examined in some detail, Jaki Irvine (b. 1966) and Gerard Byrne (b. 1969) (qqv).

When asked in interview if she positions her films as deconstructionist over anti-narrative (i.e. Jacques Derrida's post-structuralism or avant-garde film), Jaki Irvine responded by speaking to the qualities she seeks. In this, she coupled words: unease and discontent, pleasures and anxieties. Perhaps taking her cue from Irvine's focus on the affects the work itself might produce, rather than on the grand schemes of art history or cultural theory, the interviewer turns to a further category in art discourse by asking Irvine about her use of romantic idioms and how these might be read. It may be presumed that the question identifies, for example, the artist's incorporation of wistful snippets of classical music and 'poetic' voiceover as sound to her short, montaged films. Also, Irvine's early films seemingly signify classic narratives in cinema, yet employ a fleeting, 'left field' use of the camera where a definite story-line is denied. The installation context situates the work (to resort to category again) outside Film, even though the techniques and allusions of film are fashioned idiosyncratically. This then is 'moving image', though the term fails to acknowledge sound and installation (qv) as important elements. Irvine's response to the question about romanticism begins thus: 'It seems obvious that a kind of conflict or tension can easily arise between the banality of the lives we live and the tendency to resort to romanticism as a way to deal with this.' (Katy Deepwell, 'Interview with Jaki Irvine' in Deepwell, 2005, pp. 68–79, p. 70). The statement seems a carefully worded means of identifying not just Irvine's concerns as an artist but, broadly, those of contemporary art. If the prevailing subject of contemporary art is contemporary life, the problem is one of representation. While the Romantics of the nineteenth century privileged the qualities of feeling and experience, this was achievable within the established sphere of High Art where the nobler aspirations of Man could be explored. Such a lofty position for fine art can be no longer assumed. Moreover, feelings and experiences are now not only the stuff of commercial cinema, but are on endless public display in TV reality shows.

In a series of articles, *Frieze* art magazine asked artists to write on their formative influences in film. Gerard Byrne may have deliberately confused accuracy with intent by beginning his disclosure with *Live and Let Die* (seen when he was four years of age) followed by *Star Wars* (at eight years old) ('Life in Film: Gerard Byrne', *Frieze*, no. 123, May 2009, 30–31). But the immersive spectacle of such movies is quickly set aside for more challenging discoveries in art-house cinema and television. Byrne identifies several Irish subjects and cites his fascination with the distinction between what is seen on film and what is heard on sound in the dubbing of the voices of Sinn Féin representatives on news programmes by actors. This was introduced in the late 1980s in British and Northern Irish television and radio as the broadcasters' response to a United Kingdom government-imposed ban on direct interview with groups deemed to have terrorist connections. However, Byrne's contribution to the *Frieze* series revolves around the feature-length documentary *Rocky Road to Dublin* (1968) [174], which was immediately banned in the Irish Republic and was generally accessible only after its release on DVD in 2005. A curiosity of Byrne's discussion is the lack of disclosure as to when he actually first saw it. *Rocky Road* was made by an Irish journalist based in Paris and a French cameraman who had worked in New Wave Cinema in France. The resulting documentary critiques a repressive Irish society of the late 1960s, a society dominated by male hierarchies, especially that of the Catholic Church.

The genealogy set up by Byrne in this article is on the one hand the lure of a near global popular culture as experienced through Hollywood movies and, on the other, social and cultural analysis and how such analysis is constructed through the contemporary mediums of film or video. Byrne notes that 'luckily' the writer of *Rocky Road to Dublin*, Peter Lennon, 'knew

nothing about film-making', while it has been said of camera-man Raoul Coutard that he did not speak any English which, one may imagine, made for interesting documentary making. Whether or not this is myth, it suggests that Byrne's enthusiasm is to be seen in terms of how *Rocky Road* was made, at least as much as for what it had to say, and this is hardly surprising as the Republic's isolation in the immediate post-World War II decades was subsequently well documented. It is the way *Rocky Road* pursued its critique that gives it its edge. Yet this does not explain why Byrne should choose this documentary to serve in a talismanic way. It may be that he was playfully Freudian with the *Frieze* brief about formative influences. The facts are that his international reputation was initiated during his years as a graduate student in the United States, since which time his work makes only slight or incidental reference to Ireland in his occasional use of Irish actors and locations and a referencing of Samuel Beckett, the latter being part of a larger project.

A similar genealogy may be applied to Jaki Irvine, though with different emphasis. As with Byrne, Irvine's most sustained study of a specifically political subject was during her undergraduate years in Dublin in, for example, her dissertation (1989) on the film *Maeve* (1981) [176]. *Maeve* is a feature-length fiction film set in Belfast in Northern Ireland and is an exploration of the role of women in, or rather on the margins of, the male-dominated Republican movement during the height of the 'Troubles' (qv). The co-directors, Pat Murphy and John Davis, had made a film that was conversant with feminist analyses of society as well as avant-garde critiques of the conventional narratives of Hollywood cinema. Irvine's later participation in the artists' collective Blue Funk (qv) in the early 1990s also addressed Irish issues but, at the break-up of the group in the mid-1990s, Irvine travelled to London for graduate study, after which she embarked on a solo career with work that eludes definition in terms of time and place. The gulf between the Ireland represented in 1968 by *Rocky Road to Dublin* and the questions regarding the marginal role of women as articulated around 1980 through *Maeve* can hardly be over-estimated. If these years

traverse the childhoods of Irvine and Byrne, this is less at issue than why it is that Ireland assumed some significance to both artists during the latter 1980s and why this subsided in the mid-1990s. Thereafter, this discussion will consider their mature work by employing a second counter-point.

If these films play a formative role for the two artists, text and theory are of equal importance. Throughout his career, Gerard Byrne has made frequent reference to the importance of Michael Fried's seminal essay, 'Art and Objecthood' (1967), which culminated in his large multi-channel installation *A thing is a hole in a thing it is not* (2010) [315]. Alternately, the writer and academic Michael Newman has stayed in touch with Jaki Irvine and her work since her days in London. In his essay 'Moving Image in the Gallery since the 1990s' (2009), Newman uses the term 'moving image' as a general description in an account of art, including Irvine's, that may be seen as a challenge to Fried's negative understanding of 'theatrical' work, or installation work which engages with the actuality of the gallery and the viewer's activation, in time, of that space. In establishing these reference points, the work of Irvine and Byrne is, for the purposes of this analysis, framed by two films and two essays.

Under the banner of Postmodernism (see 'Modernism and Postmodernism'), Irish art of the 1980s rejected Modernist abstraction in three pertinent respects. Time-based work (qv) was almost in itself a statement against traditional art forms. Art and theory became more embedded, and with regard to the latter, post-structuralism was prevalent. Also, there was a new emphasis on art's relationship to society. The Troubles in Northern Ireland weighed heavily in the politics of the Republic and, in the 1980s, it was also a substantive issue in intellectual and cultural circles. There was revived interest in the principles and the practices of the Irish Republic, and whether and how it might accommodate those of the other tradition in the North, who saw themselves as British. In short, identity issues prevailed, and art was inflected by these discourses which included not just nationhood, but also gender and sexuality. However, identity politics had subsided by the Good Friday Agreement of 1998, which formally ended the conflict between the main Republican force, represented politically by Sinn Féin, and several groups which supported continued British rule in Northern Ireland. In truth, given the protracted lead-up to the agreement, the Irish Question had ceased to engage artists by the early 1990s. More significantly, there were also wider shifts in art and culture. The concentration on nationhood during the previous decade was in retrospect still bound up with exceptionalism – the belief in unique features about Ireland – a feature of nationalism which carries over to post-colonial analysis. This was less credible in the 1990s, while the feminist movement also lost impetus. While a considerable element of Irish art of the 1980s was culturally specific, identitarian issues and politics regarding Ireland were of less interest by the end of century. In effect, after the 1980s, Irish art has struggled to redefine itself in respect to the emergence of the globalized cultural network. Irvine and Byrne may be linked to these latter developments and, since the mid-1990s they have taken different courses as regards their philosophic and ideological concerns.

315. Gerard Byrne, installation shot of *A thing is a hole in a thing it is not*, 2010, 5-channel HD video projection, custom projection shutters, audio, Green on Red Gallery

In interview in 2010, Byrne explained his attitude to stage drama in the early 1990s: 'Being a post-structuralist (as I was at the time) I couldn't countenance all those associations with "the human condition" ' (Lytle Shaw, 'Interview with Gerard Byrne', *Printed Project*, no. 14, 2010, 78–87, 80–81). If that is how he locates his interest in the literary arts at the beginning of his career, how then does he see his later work? We may observe that Byrne's responses in this interview are carefully calculated, and what emerges is how he draws his ideas from an extended field, for example, drama and drama theory, architecture and architecture theory, history, popular culture, as well as art and art history. The interviewer persists in trying to draw Byrne on his attitude to literature, though his interviewee insists on including popular magazines within this field. His answers are only to state that art is distinct. If this belief is indebted to the core argument of Fried's 'Art and Objecthood', this is a Fried modified into accommodation with installation art, and it is more multi-dimensional in form and content than Fried could have imagined in 1967. In sum, Byrne's responses identify a spread of various domains of knowledge rather than a subject-centred view of the world.

How then are these various domains used by Byrne and in what combinations? And why? He has identified popular magazines as a sort of popular paradigm of recent culture. Four of his large-scale installation projects are based in interviews on contemporary issues as found in *Playboy*, *Le Nouvelle Observateur* and *National Geographic*, which he then re-stages through actors and film. The ostensibly 'serious' subjects of the interviews were originally intended for general consumption as avant-garde pursuits, such as 'new' sexual mores or gender roles; but when these are returned into a temporal mode by Byrne, the flaunted fashions and values expressed in them are seen as outmoded, yet somehow still connected to the contemporary context. Such disjunctions are crucial to how Byrne wants his work to be viewed. These four 'magazine works', as he has referred to such projects, are sourced from the immediate past (1963 to 1980), a time when magazines still enjoyed mass circulations and assumed a role in the production of the public imaginary. For Byrne, his reworkings are attempts to test relationships generated between a mainstream, as constructed by the mass media, and 'recent history, shoddy dramatic realisation, and collective memory'. His hope is that the works 'manage to confront their viewers within the present, with a dissonant recent present, countering prevailing narratives of contemporaneity' (Shaw, op. cit., p. 81). The actual time involved in dramatization and film aren't simply Byrne's preferred mediums: the magazine works highlight dominant representations of contemporary life that are flat, lacking in substance, while the temporalities that are the experience of contemporaneity need to be brought to subjective awareness and conditions analysed.

Byrne has referenced Berthold Brecht more directly in other work, incorporating the playwright's ideas of epic theatre and alienation. His interest in theatre and its techniques has extended to Harold Pinter and, more pertinently here, to Samuel Beckett. One of Byrne's on-going series using still, colour photography (qv) is 'A country road. A tree. Evening.' (2006) [316]. The title is Beckett's opening stage direction in *Waiting for*

Godot, and for his project, Byrne photographs locales in both Ireland and France where Beckett may have actually experienced such scenes during his walks in the countryside. While Byrne's photographs reference an actual scene of a road, tree, and evening, as underpinned by the detailed description of the location in each of the titles in the series, the potential for the picturesque is obliterated by harsh theatre lights beaming onto the subject so that the subject is suffused in an unnatural colour. An earlier project involved the photographing of stage sets for the same play. Points of View in 'Waiting for Godot', (2002/03) is a series of photographs which show the sparse props – a tree, a stone, a suitcase, boots – but the expansive emptiness of the stage that surrounds these props is included in the frame, to emphasize a significant absence which is the play itself. Byrne is interested in the spatial construct over the human presence. Man-made environments in isolation from the human interaction they are made to service display much about what we think we are. He is well aware of the iconic status of *Waiting for Godot*, and even a highly stylized fabrication of a stone as sole content in a photograph has loaded meaning in this context. But the 'stone' also serves a basic function as prop without which the play cannot operate. This concentration on a thing leads towards *A thing is a hole in a thing it is not*.

As with several of Byrne's works, *A thing is a hole in a thing it is not* is a reflection on art of the recent past. Specifically, the installation includes five films projected on large screens: a reconstruction of Robert Morris's performance *Column*, in which the artist struggled with a large prop, the column without a sculpture; vignettes on Minimalist artworks and how they have undergone 'museumification', which include a critic's interpretation and photographic 'documentation' which also interprets; a reconstruction of a round table discussion exemplifying

316. Gerard Byrne, *'A country road. A tree. Evening.' (The turn in the road at Pine Valley, on the way up to Glencullen)*, 2006

317. Jaki Irvine,
Installation shot of *In a
world like this*, 2006–07,
Frith Street Gallery,
London

how Minimalism (qv) was originally articulated by four of its key practitioners; and a reconstruction of artist Tony Smith's recall of his experience of driving on an as yet unopened stretch of highway, an iconic account in American Modernism. In the installation only one projection can be experienced at a time, but not without the interference of another nearby, and Byrne has emphasized his use of 'shutters' where the digital projections are programmed to variously stop for minutes at a time, returning the gallery space to darkness. This environment is intended to underpin 'dissonance'. For Byrne, the work is to be distinguished from drama or documentary, thereby affirming a

specifically art discourse which could expose him to the charge that his project is ontological. However, his intent is identified by the title: *A thing is a hole in a thing it is not*. It is a formulation attributed to Carl Andre as his way of stating that sculpture was not so much about carving into material as about cuts in space formed by materials. The 'thing', then, is particular to art-making as temporal phenomenon, but it is also at the root of our reality – it is to do with matter, not metaphysics. For Byrne, his installations are an engagement with the problem of the relations between film, real time and space, containing material drawn from various fields that describe contemporaneity.

A thing is a hole as installation contains segments on the representation of 'pure' experience, original and not-so-original discourse on art, art's ultimate destiny as museum object, and other elements that make up the art field. The exhibition catalogue adds another dimension. Titled after a Donald Judd work, *Tuxedo Junction, 1960: Gerard Byrne*, the catalogue includes essays and an interview by curators along with documentation of other Byrne works exhibited with *A thing is a hole*. But it also includes an unrelated essay by Alex Potts selected by Byrne, the subject of which is the point of view of photographed Minimalist artworks and how photography influences the reading of the works themselves. Uniquely, each of the texts in the catalogue has been printed as photographs, i.e. we read the texts as texts, but clearly visible beyond the margins is the wood veneer on which the texts were photographed. The texts have become the object of the camera, if only for the millisecond of the operation of the shutter, which indicates that they too will become part of the process of consumption. Yet, enveloping the catalogue is a folded dust cover which, when opened out, reveals a photographic reproduction of Michael Fried's essay 'Art and Objecthood' as originally printed in *Artforum* in 1967.

In 2000 Jaki Irvine published a small book in conjunction with an exhibition of work by British artist Mike Nelson. With

318. Jaki Irvine,
Installation shot of *Seven
Folds in Time*, 2009, video,
Frith Street Gallery,
London

the apocalyptic title *Extinction Beckons*, it is loosely based on Nelson's work but may be described as fiction. In the text Irvine writes: 'In an old silent black-and-white version of *Planet of the Apes* released on Super-8 film, Taylor realises that all the humans have lost their power of speech. He runs out into the fields and silently shouts "They're all mute!" This appears in subtitles beneath him. How could he know that in this version he is too?' (Irvine and Nelson, *Mike Nelson: Extinction Beckons*, p. 14). Irvine's text could be considered a double reflection on language: both a divergence from the conventional artist's catalogue with explanatory or interpretive text by critics and curators and, generally, in contra-distinction to the directional role of language in film and in art. In this she echoes Byrne in his questioning of language through his affirmation of the 'thing'. There is then a scepticism about language by two of its most assured exponents in Irish art. The extract above, based on *Planet of the Apes*, is as much about Irvine's visual work as Nelson's. Her early work employed the already redundant medium of Super-8 film lending her short films their languid aura. Since then she has used 16 mm, before transferring work to DVD, and to using digital camera. More significantly, since the mid-1990s, non-human aspects and worlds have featured in many of her works. This includes tigers in the zoo in *Another Difficult Sunset* (1996); the dog in *The Hottest Sun, The Darkest Hour* (1998); or, deer and birds in *The Silver Bridge* (2003). If the vagaries of human relationships or the impossibility of pure intimacy are at the core of Irvine's early work, it could be argued that, in later work, strangeness occurs with the appearance of animals and most particularly of birds. The latter is in part related to Irvine's use of Gothic novels where birds often serve a symbolic role. Irvine's later films reckon with the knowledge that birds communicate in a sonic range beyond that of humans. Where the early films appropriated waltzes and tangos for use in conjunction with visual imagery, sound later becomes more integral to the imagery as language recedes.

Speaking of the emergence of video art in the late 1960s and '70s, Michael Newman argues: 'The temporality of video – the possibility of a continuous recording of the present which may appear simultaneously with itself – distinguishes it from cinema.' (Newman, 'Moving Image in the Gallery since the 1990s', in Stuart Comer (ed.), *Film and Video Art*, 2009, pp. 86–121, 98). This feature continues to be critical to moving image work even after, as Newman elaborates, a return to story-telling in the 1990s. Narrative is now inflected by the anti-narrative practices of artists of Fried's generation, and by subsequent developments in technology and by theory. In all of this, the actual relation, between work and viewer is an important and contingent factor in installation. This is, of course, antithetical to Fried's 'Art and Objecthood', but may be also seen as co-extensive with Byrne's work which involves what the artist calls 'media-reflexive practices'. This is less explicit in Irvine's art, but the elusiveness of presence, as post-structuralism demonstrated, may be addressed in other ways. *In a world like this* (2006/07) [317] is based on film of wild birds in a raptor centre in County Sligo. In so far as the 'world' of wild birds necessarily invites a conceptual relation to our human world, the work could be interpreted

as Romantic since the birds assume a symbolic function in their 'otherness'. But, the 'this' of the title also suggests that all we can do in regard to this world is point – we are reduced to witnessing instances of things we do not understand. A return to the world of the human is significant in *Seven Folds in Time* (2009) [318], a collaborative work that presents itself through space across several TV screens. While the gallery space is relatively large, the films are shown on the intimate scale of television sets. A sequence of music is produced by two musicians and their instruments, differentiated only by various points of view in filming and the time settings of the presentation. Iteration is therefore subsumed as this music has no beginning or end, something which is reinforced by the movement of the viewer/listener as she moves from screen to screen. Time folds back on itself as there is no inside or outside to the installation; there is simultaneity between subject and object in that there is no hidden meaning underlying the production of sound and vision in time and space. Music has helped Irvine to think this work as an event.

The foregoing has looked at narrative in Irish art largely through the moving image in the gallery space. Other investigations of narrative are of course possible. For example, at the other extreme one might cite Sean Scully's abstract art (see 'Abstraction') as exemplifying the narrative of modernity. Nor can narrative be restricted to medium. However, work that engages with actual time and space is specific to modern art and is bound up with the problem of the representation of the present. Where it can be argued that, historically, Modernism was imported into Ireland, by the late twentieth century Irish art is fashioned simultaneously with international trends. If this sounds something of a truism given the contemporary communications, it indicates that, by virtue of the fluid condition, 'Irish art' as a category, has less meaning today than in the past. In the recent past, Irish art has been subject to interpretation in terms of nationhood (i.e. how was the movement towards nationhood reflected in art?), and in terms of poetics (i.e. how is Irish art inflected by landscape or literature as major determinants of Ireland or Irishness?). Such narratives of Irish art are based in a prior notion of what constitutes 'Ireland', and at least some of these fall into an essentialism that is limited by identifications that fail to stand up to rigorous scrutiny. By the late twentieth century, the global art economy was a determining factor and it is perhaps now necessary to further develop narratives of Irish art which address and challenge this larger context. JOAN FOWLER

SELECTED READING Michael Fried, 'Art and Objecthood', in Battcock, 1968, pp. 116–47; Nicolaus Schafhausen and George Baker, *Gerard Byrne: Books, Magazines and Newspapers* (New York and Berlin 2003); Sarah Pierce and Claire Coombes (eds), *The Present Tense Through the Ages: On the Recent Work of Gerard Byrne* (London 2007); Newman, Glennie and Irvine, 2008; Penelope Curtis, Alex Potts and Mike Fitzpatrick, *Tuxedo Junction, 1960: Gerard Byrne*, exh. cat. Lismore Castle Arts (Waterford 2010); Pablo Lafuente (ed.), *Images or Shadows: Gerard Byrne*, exh. cat. IMMA (Dublin 2011).

The fate of a Harry Clarke (qv) window [365], commissioned by the Irish government for the International Labour Organization in Geneva in 1930, but later rejected for no clearly defined reason, is a classic example of artistic expression being suppressed because of official insecurities regarding the cultural representation of the nation. Its rejection resulted in one of Ireland's most celebrated art works being irredeemably lost to the country. Many of those insecurities remain.

According to Chantal Mouffe, democracy acknowledges the contingent character of the political and economic influences that determine the specificities of a society at a given moment (Mouffe, 'Artistic Activism and Agonistic Spaces', *Art & Research: A Journal of Ideas, Contexts and Methods*, 1, no. 2, Summer 2007, 3). Mouffe's theories of the relationship of combative approaches to (re)configurations of the public space (agonism) are gaining popularity among western-based arts researchers in a climate of financial unsettlement and disenchantment with centralized structures of support. Mouffe believes that binary oppositions are not limitations but can offer sets of useful adversarial relations. Her propositions provide a helpful baseline from which to reflect upon the contextual histories and current state of the main national institutions of visual culture in Ireland. The perspective of recent policy developments in the light of older ones; the question of national identity in the face of localized affiliation; the collapsing space between private and public property; as well as a number of connective organizations and supportive groups are all contributing elements to the present-day status of those institutions.

This essay focuses on the role played by that group of state-funded entities defined by their membership of the Council of National Cultural Institutions (CNCI) which have responsibility for the visual arts. CNCI members include the National Gallery of Ireland (NGI), the Irish Museum of Modern Art (IMMA), the Chester Beatty Library (CBL) and the Crawford Art Gallery (CAG). The Arts Council (AC/ACE) (see 'Arts Councils'), Culture Ireland and the Heritage Council (HC) are also members of the Council, as are the National Archives of Ireland (NAI), the National Museum of Ireland (NMI), the National Library of Ireland (NLI), the National Concert Hall and the Abbey Theatre, the latter organizations having a lesser role in promoting the visual arts. In Northern Ireland, the Ulster Museum (UM) and Arts Council of Northern Ireland (ACNI) are the main national cultural institutions concerned with the visual arts.

Founded in 1998 and established as a statutory body in 2001, the aims of the CNCI are 'to facilitate the pooling together of talent, experience and vision of the Directors of the National Cultural Institutions in furtherance of the national cultural interest and to make recommendations to the Minister … on proposed acquisitions using the Heritage Fund Act, 2001' (http://cnci.ie/?page_id=32, downloaded 25 October 2012). Membership of the CNCI in 2012 was thirteen, the member institutions all being funded directly by the government, through the Department of Arts, Heritage and the Gaeltacht. The DAHG website summarizes the relationship of the CNCI institutions to government: 'Issues relating to the day-to-day

management of the individual National Cultural Institutions are dealt with directly by the institutions themselves; matters relating to the general policy under which they operate and the provision of financial resources are matters for this department.' (http://www.ahg.gov.ie/en/Culture/ downloaded 25 October 2012). Member institutions provide a wide range of services to the public.

The word 'national' is open to question, since it can be used legally in Ireland with impunity. The University of Limerick initiated the National Self-Portrait Collection (inspired by the Uffizi portrait collection) in 1977 with the purchase of fifteen artists' self-portraits commissioned by John Kneafsey. The Limerick City Gallery of Art (1948) has named within its collection the National Collection of Contemporary Drawing. The use of the prefix 'Irish', denoting national representation, can similarly be self-elective. This laissez-faire approach can result in confusion. The title Irish Museum of Contemporary Art belongs to an artist-led, self-funded initiative begun in 2007 which is centred on programming exhibitions and residencies, and exists, despite the use of the word 'museum', determinedly without a collection. The Irish Film Institute, initiated in 1943 as the National Film Institute, to act as a moral guardian to the cinema-going public under the watch of Archbishop McQuaid and the Roman Catholic Church rather than the state, has pioneered an invaluable documentation of Irish society and has increasingly reflected the breadth of excellence and experimentation in national and international film. Private guardian organizations, such as the Irish Georgian Society and An Taisce, the Irish Heritage Trust, fulfil important national remits reflective of members' concerns. None of these organizations are included in the government's official listing of national cultural bodies and do not receive regular or guaranteed state funding.

Membership of the CNCI can also present certain anomalies. Although not listed among its members, the Office of Public Works (OPW) is the state organization responsible for the oldest art collection in the country, with significant spending power in relation to the visual arts. Established in 1831 and known originally as the Board of Works, the OPW maintains one of the largest collections in the state, comprising over 7,000 works of art. It also has an active acquisitions policy, purchasing art for state buildings at home and abroad. Since 1978, when it introduced a Per Cent for Art Scheme, the OPW has played a key role in commissioning works by contemporary Irish artists to enhance new courthouses and government offices. Outside of its touring exhibitions, displays at venues such as Farmleigh House and Kilkenny Castle, and intermittent catalogues, often with historically useful essays, this collection is largely hidden from public view, accessible only to a limited audience and with a restricted media focus.

National institutions in context: history and policies in twentieth-century Ireland
Established in 1951, the Arts Council's founding aim for the visual arts was to improve the standard of national design and to promote Irish art internationally. It organized touring exhibitions: the *International Design Exhibition* (1954) and the *Irish Design Exhibition* (1956) and, during the 1960s and '70s, a series

of retrospective exhibitions of Irish artists held under the joint auspices of the AC/ACE and the ACNI. In the 1960s the Council decided to set up the Permanent Collection, the first national collection of contemporary art. It now has well over 1,000 artworks, from the 1950s to the present, with over 80 per cent of them on loan to public institutions nationwide. From 1954 to 2004 the Arts Council also sponsored a Joint Purchase Scheme, through which public bodies and hotels could buy approved art at half-price, while the Council paid the balance, subsequently retaining co-ownership of the purchased work. The OPW and many local authorities availed of this scheme.

The Heritage Council is responsible for allocating grants, mainly to protect and safeguard aspects of the natural and built environment. Its role in the visual arts is limited, although the Museum Standards Programme of Ireland, administered and staffed by the HC, is a key factor in introducing a higher level of standards and professionalism in museums throughout Ireland, both large and small. Culture Ireland, drawn under the control of an interdepartmental advisory board in 2012, evolved from an earlier agency, the Cultural Relations Committee, administered by the Department of Foreign Affairs and similarly dedicated to the promotion of Irish culture overseas. As a quasi-autonomous organization, Culture Ireland has distinguished itself as a successful mechanism for promoting Irish arts worldwide.

It is difficult to make a clear distinction between privately owned art, on the one hand, and what comes to be considered as national property, or public heritage, on the other. During the twentieth century, critical links were established between such private philanthropic groups as the Friends of the National Collections (FNCI) of Ireland (1924), the Thomas Haverty Trust (1930), the Contemporary Irish Art Society (CIAS) (1962), Business to Arts (1988, formerly Cothú) and the national visual arts institutions. This marked a change from the early part of the century, when there was little comparison with international trends, and fine arts 'were regarded as a luxury, a needless expense and relics of the landed gentry' (Breathnach-Lynch, 2000, p. 1). The Free State's growing art collection, held by the NGI and the OPW, derived largely from donations and loans from those private philanthropic organizations and from official commissions. The latter comprised predominantly heroic portraiture (qv) and symbolic sculpture with nationalistic reference, two examples being the cenotaph in the form of a High Cross outside Leinster House by George Atkinson (1920s), and Oliver Sheppard's *Cú Chulainn* (1911) installed at the General Post Office, Dublin, in 1935.

Advocacy by Sir Hugh Lane, Sarah Purser (qv) and others, from as early as 1904, led to the opening of the Dublin Municipal Gallery of Modern Art in 1908. Renamed Dublin City Gallery The Hugh Lane (HL) and later housed in Charlemont House, Parnell Square, the gallery has a singular identity in Irish culture. Municipal rather than national, its historic role as a forerunner to IMMA ensured its place in the evolution of the national collections.

In 1924 the Free State transferred responsibility for cultural institutions from the former British Department of Agriculture and Technical Instruction to the new Department of Education

– not an unusual alliance because public museums and galleries had been seen as centres of enlightenment and informal education since the nineteenth century. Internationally, as the twentieth century progressed, education and outreach programmes extended the horizon of museums as sites of learning, with the introduction of educational strategies to attract communities not typically engaged with museums (see 'Education in the Visual Arts'). An overt social role for museum practice and policies emerged on the international stage. In Ireland, however, revolution and civil war, two world wars and economic depression in the 1950s took their toll on the cultural sector. It was not until the 1960s that provision for visual cultural in Ireland gradually became analogous to developments elsewhere.

This was influenced by the Irish Exhibition of Living Art (IELA) (qv), the first being held in 1943, the establishment of the Arts Councils and the Rosc exhibitions (qv), which started in 1967. By the 1970s Ireland entered a new phase of public understanding of the visual arts, but the country still lacked a national centre for Modernist and contemporary art (see 'Modernism and Postmodernism'). While belying the state of visual culture in Ireland, this situation reflected the struggle for the visual arts to achieve adequate recognition in the public sphere.

By the early 1990s the founding of IMMA (1991) and urban regeneration in central Dublin hugely aided the visibility of the visual arts. Following the setting up of a number of studios and galleries in Temple Bar, the Irish Film Institute moved to Eustace Street in 1992, joined in 1995 by the relocated Gallery of Photography (founded 1978), which opened nearby in purpose-built accommodation, and the NLI's Photographic Archive, which opened in new premises in Meeting House Square in 1998. In 1993 the first ministry with dedicated responsibility for arts was launched under the title Arts, Culture and the Gaeltacht, later reconfigured a number of times, notably into the Department of Arts, Sports and Tourism (2002) and subsequently realigned again into Arts, Heritage and the Gaeltacht (2011). While these regroupings may betray unstable government attitudes, the Cultural Institutions Act (1997) indicated serious appreciation of Ireland's cultural organizations and movable heritage, providing indemnity for loans and promoting a national register and an over-arching framework for responsibility for institutional structures.

National art museums
The National Gallery of Ireland, opened in 1864, focuses on its collection which has developed through purchases and donations. According to its mission statement: 'As the treasure house of an irreplaceable national and international cultural resource, the National Gallery of Ireland is in a prime position to display, conserve, manage, interpret and develop the national collection, enhance enjoyment and appreciation of the visual arts and enrich the cultural, artistic and intellectual life of present and future generations.' (http://www.nationalgallery.ie/aboutus/Reports_and_Policies/Statement_of_Strategy.aspx, downloaded 1 September 2012). The NGI is a national cultural institution in a way quite unlike IMMA or the Crawford Gallery. The NGI director is answerable to Dáil Éireann, from which the gallery receives its funding [319].

319. Seán O'Sullivan, *Thomas MacGreevy (1893–1967), Director of the National Gallery of Ireland*, 1942, graphite on paper, National Gallery of Ireland

to be offered in the 1950s and children's workshops in the 1960s. During the 1960s the NGI director, James White, initiated a regular lecture programme, but it was 1974 before Frances Ruane was appointed as the NGI's first Education Officer. While collection exhibits were largely static, by the 1940s the gallery had caught up with international practice by hanging paintings in a single line at eye level. Loans to other museums were encouraged from the 1960s, raising the gallery's international profile and setting the scene for incoming loans in later years, although loans around the country were not favoured and copies of artworks were used for regional exhibitions. Temporary exhibitions began in earnest in the 1970s and continued throughout the 1980s and '90s (especially under the directorship of Homan Potterton), as well as intermittent international loan exhibitions, albeit with admission charges. Some included loans to complement the NGI's collection, such as the popular *Love Letters: Dutch Genre Painting in the Age of Vermeer* (2003). The historicization of Irish art was central to the exhibition programme and enlivened a previously lagging culture of publication on Irish art history. New exhibition spaces in the Millennium Wing enabled the NGI to borrow valuable artworks and stage touring exhibitions – typically with entrance fees – and move towards international practices of blockbuster-type shows, such as the popularly received *Monet, Renoir and the Impressionist Landscape* (2002).

The NGI's collection of 14,500 works of European and Irish art has grown from 112 works, including thirty loans from the National Gallery in London in 1864. Gifts and bequests followed, some necessitating building extensions (see 'Patronage'). The donation of over 200 works by the Countess of Milltown required the construction of a new wing in 1901; a 1968 extension, later named to mark the donation from Sir Alfred and Lady Beit of Russborough House, Co. Wicklow, and its contents in 1987, included a restaurant, shop, lecture theatre, library and twelve galleries and led to an increase in visitor numbers (Bourke, pp. 376–77). Other gifts included the Turner watercolour collection, bequeathed in 1900 by Henry Vaughan; Chester Beatty's French collection, donated in 1978; and, in 1987, Marie MacNeill Sweeney bequeathed some early twentieth-century art. Hugh Lane left artworks and gave financial assistance to the gallery and George Bernard Shaw bequeathed a third of his royalties, from which the NGI will continue to benefit until 2020. By the turn of the century, annual attendance figures were at 800,000 and future plans included improved facilities for conservation, documentary photography and education programming. The Millennium Wing, designed by Benson & Forsyth in 2002, provided a vertiginous, cathedral-like new entrance and additional exhibition spaces.

Throughout the twentieth century the NGI slowly echoed international developments in changing attitudes towards public access. As early as 1914 it was recommended that private days (closed days when art students could copy the works on display uninterrupted) be reduced and public hours increased. By the 1930s school visits were encouraged; free public lectures began

320. Crowds attend the opening day of the Irish Museum of Modern Art, 26 May 1991

By the end of the century the NGI had become a centre for research into Irish art, with special archives and research facilities. These include the Yeats Archive, begun in 1996 with Anne Yeats's (qv) donation of a trove of Yeats family material, inspiring later archival donations, the Prints and Drawings Study Room and the Electricity Supply Board Centre for the Study of Irish Art. Scholarship associated with these resources has bolstered artist-focused NGI shows, such as *Evie Hone: A Pioneering Artist* (2005/06), and thematically developed projects, such as *A Time and a Place: Two Centuries of Irish Social Life* (2006).

The opening of IMMA [320] was influenced by the promise of the donation of a major private collection. Gordon Lambert's gift, and his long advocacy of a modern art museum, was memorialized in the dedication of the Gordon Lambert Galleries there in 1998. While IMMA was clear that it did not intend to be a traditional collection-led museum, minimal state funding for acquisitions in the 1990s meant that the collection drew on private donations and temporary loans. These included the Weltkunst Collection and the Musgrave-Kinley Outsider Art Collection, while key works from the Bank of Ireland, the Ferguson and other collections were given under new taxation exemption laws. In addition to donations of historic work, such as the Madden-Arnholz Old Master print collection (2,000 prints and books), the permanent collection now contains approximately 1,500 post-1940 artworks (http://www.imma.ie/en/nav_9.htm, downloaded 27 December 2012). Undeterred by lack of financial power, IMMA asserted the centrality of exhibition, education and community programming, with outreach a defining aspect, from the outset. In the early years, IMMA's programming developed two distinct strands, distinguishing it significantly from more conventional collection-based museums such as the NGI. There was a focus on exhibitions using national and international loans, such as *From Beyond the Pale* (1994/95), and projects to share ownership of the collection nationally through the museum's active National Programme, with projects and exhibitions from the collection. Exhibitions of major international artists, such as Andy Warhol (1998) and Marina Abramović (1997), introduced Irish viewers to contemporary art practices from abroad, successfully circumventing restrictive expectations of collection-led programming. Such exhibitions have sustained an international dimension and the Artists' Residency Programme has continuously bolstered the museum's reputation among artists.

As with some other national institutions, continued habitation of a historic building has presented challenges. The decision, in 1990, to house IMMA in the seventeenth-century Royal Hospital Kilmainham, facilitated by the then Taoiseach Charles J. Haughey, provoked ardent public debate about an alternative location in the Dublin Docklands. While it has generated the need for refurbishment to ensure appropriate environmental conditions for a range of art media, the location's historic identity was, however, seen by the founding director, Declan McGonagle, as an important contextual foil for current use. IMMA's subsequent programming took a fluid approach, defined through curated projects, international collaborations, sponsored-artist awards (Glen Dimplex Artists Awards, 1994–2001) and the commissioning of innovative public art

projects (Nissan Art Project, 1997–2000). The museum accommodated a demand for increased displays of Irish art in its amplified programming of the collection, while simultaneously co-curating touring and thematic group exhibitions of Irish art at home and abroad. New media, installation works (qqv) and performance (see 'Time-based Art') were continuously promoted in its first two decades, alongside large-scale retrospectives of such artists as Mainie Jellett and Louis le Brocquy (qqv), as IMMA stepped jauntily into a representational vacuum in Irish visual culture.

The Crawford Art Gallery has a permanent collection of over 2,500 Irish and European artworks, dating from the eighteenth century. The collection is housed in an eighteenth-century building with an 1884 extension funded by William Crawford, after whom the institution is named. European Regional Development funding of €1.8 million permitted the opening of a new exhibition wing in 2000. Initially established as a municipal gallery, in 2006 the CAG was designated a national cultural institution. Founded when the Canova Cast collection (copies of Graeco-Roman sculptures) was presented to the Cork Society of Arts in 1819, the CAG collection was augmented over the years, notably with the Joseph Stafford Gibson Bequest (1919). Acquisitions facilitated by Gibson's generosity included twenty-three illustrations by Harry Clarke. The collection holds strong representations of the painters James Barry and Daniel Maclise, modern artists Elizabeth Rivers and Nano Reid (qqv), and contemporary artists Willie Doherty, Dorothy Cross and Elizabeth Magill (qqv).

The CAG has availed of the AC/ACE's Joint Purchase Scheme since the 1960s and has also benefited from its Friends of the CAG (1987). The 2012 announcement that the gallery would receive thirty-nine works from the Allied Irish Bank's art collection reflects recognition of its position as a national institution. By the end of the twentieth century, touring exhibitions of works from the collection to the USA (*Irish Art 1770–1990: History and Society*, 1995), along with thematic shows (*Onlookers in France*, 1993) and incoming loan and temporary projects of international art and culture defined the gallery's growing national and international profile, while continued historical and contemporary exhibitions, and educational programmes on Irish art, has enlarged the regional relevance of the Crawford.

In Northern Ireland, the Ulster Museum's [321] wide-spanning collections include the applied arts along with collections of historical artefacts, archaeology and science. Its fine arts collection has northern and southern Irish and international artists, and since the 1960s, has focused acquisitions on post-war art. Turbulent times in Northern Ireland from the 1960s to the 1990s had a negative effect on the museum, while the post-conflict era is apparent in the UM's expansion and identity. Extensions in 1972 and 2009 provided a new entrance atrium, educational facilities and media-specific gallery spaces. The state-of-the-art refurbishment demonstrates the museum's focus on visitor experience, with displays now developed around 'zones' of art, history and nature. The thematic organization of displays and content claims priority over chronologies or discipline specificities.

321. The Ulster Museum following re-opening after refurbishment, October 2009

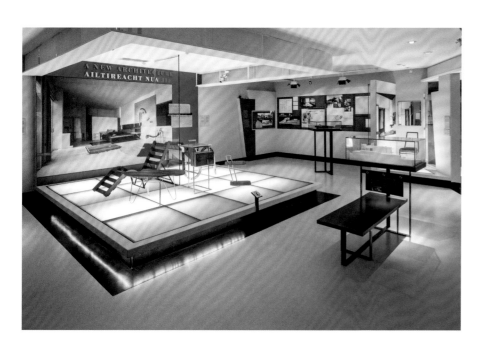

322. Furniture and designs by Eileen Gray, on display at the National Museum of Ireland

Alongside the NGI, IMMA, the Crawford and the UM, other key institutions pertaining to visual culture include the National Museum of Ireland and the Chester Beatty Library, both of which are generic museums rather than art institutions. In the absence of a design museum in Ireland, the NMI holds the only, although limited, national representation of design, with furniture, ceramics, glass, jewellery, lace and costume collections spanning wide time-frames and eclectic sources, reflective of

the evolution of the NMI's historic collections. A Modernist focus is represented with works by Eileen Gray (qv) [322] and a minor contemporary interest is evident in some aspects of the furniture and glass collections. The CBL, originally the private collection of American industrialist Alfred Chester Beatty, houses manuscripts, prints, drawings, art and textiles mainly from Asia, dating from as early as the third millennium BC. It opened as a library on Shrewsbury Road in 1953 and moved to Dublin Castle in 2000.

Across the globe, as Susan Sontag noted, '[o]nce a repository for conserving and displaying the fine arts of the past [the contemporary public museum], has become a vast educational institution-cum-emporium, one of whose functions is the exhibition of art. The primary function is entertainment and education in various mixes, and the marketing of experiences, tastes and simulacra.' (Sontag, *Regarding the Pain of Others*, London 2003, p. 109) Notions of a museum as a treasure house, defined by a canon of history as a coherent narrative and of collective identity as inclusive, are contested by recent theories of the instability of collective representation and individual demands for knowledge, entertainment and cultural enlightenment. In Ireland, the various emphases between the main institutions of visual culture bear witness to the breadth of experience and ideas that influence policies around collecting (see 'Collecting Art'), access and public exhibition programmes.

A new century

Early in the twenty-first century, state proposals to save money threatened to deny the usefully agonistic distinctions between the identities of these institutions. Auxiliary groups, such as the Heritage Council and Culture Ireland, and professional bodies, such as Visual Artists Ireland (1980) and the Irish Museums Association (1977), essential to the health and variegated character of visual culture in Ireland and its expanding international profile, have advanced the work of Irish artists and collecting institutions. All require recognition as effective sites of dissent and public self-representation before they are subsumed by a politics of anodyne consensus in the face of economic uncertainty.

The National Campaign for the Arts was established in September 2009, in response to the 2009 McCarthy Report. The report was produced by the Special Group on Public Service Numbers and Expenditure Programmes, led by economist Colm McCarthy, and included a rationalization of the provision of cultural services, while omitting recourse to impact studies on the functions that maintain the visual and material heritage of Ireland. Another report followed in 2011: along with cutbacks in public funding, it proposed an amalgamation of the NGI, IMMA and the Crawford [323, 324], and the merging of the NLI and NAI with the NMI. Historian Diarmaid Ferriter resigned from the NLI's board, citing the 'irony' that in a decade of commemorations of the founding of the Irish Free State, government policy was 'intent on doing untold damage to the very institutions which are custodians of so much of that history' (*IT*, 24 May 2012). Cultural commentator Fintan O'Toole suggested the 'so-called reforms [...] arise from ignorance, philistinism and a deep contempt for the value of cultural institutions' (*IT*, 3

While the Tax Incentive S1003 (Consolidation Taxes Act 1997) may have served to benefit public collections in the Republic, with donations made more attractive for donors, a creeping culture of the promotion of philanthropy in lieu of consistent state support may lead to a situation where Ireland's cultural institutions are blatantly promoted as sites of capital endorsement. A pilot scheme announced by the Minister for Arts, Heritage and the Gaeltacht in October 2012 outlined that eight selected arts bodies are expected to seek ten million euro in private funds to offset public funding cutbacks (*IT*, 18 October 2012). Not recognized as a national cultural institution, the Irish Film Institute's self-definition as an arts organization has left it open, along with the RHA and the Model Arts Centre in Sligo, to be selected for this policy experiment. In this context, the National Campaign for the Arts can be seen as an alert cultural watchdog and, more urgently, as a social necessity safeguarding a useful form of dissent in the absence of reasonable state policy to preserve the public ownership of visual culture.

Cumulatively, recent state attitudes to cultural institutions risk undermining the public heritage and the subtlety of cultural expression. This was hard-won over more than a century in Ireland, in a postcolonial context that was painfully slow to accept the full potential of visual culture.

Elsewhere, prolonged wrangles over ownership of the so-called Elgin Marbles, at the British Museum London, show how important visual heritage actually is. NIAMH ANN KELLY

SELECTED READING McGonagle, 1991; Bhreathnach-Lynch, 2000a; Bourke, 2011.

NEW MEDIA ART IN IRELAND. Debate concerning new media commonly focuses on the impact of new technologies upon social and cultural change. An optimistic response claims that new communication technologies may bring into being new forms of consciousness or new forms of democratic accountability on a level comparable to the historical influence of the printing press. Art will have no small part to play in this process. A more reserved response claims that technological innovation has merely been shaped by commercial and corporate state interests. New media function within existing structures of power set to uphold the status quo. Such a perspective recognizes visual art's estranged relationship with the mass media and, at best, views it as a minor critical supplement to an ever-shifting behemoth.

Histories of new media *art* draw upon these debates while emphasizing the medium or media through which the artist works. New media art is commonly contrasted with older, established forms of practice, such as painting and sculpture, and their associated ways of seeing. It is characterized as a shift away from the static, self-contained and medium specific art object towards new, dynamic, interdisciplinary forms, real time events and interactive experiences. Its roots can be found in the counter cultures of 1960s' Europe and the United States. Alternative spaces were opened in reaction to the limited opportunities afforded to more experimental forms of art by established commercial galleries (qv) and museum culture. This is not to suggest

December 2011). Unbelievably, the CNCI was omitted from consultation in the proposed rationalization. By October 2012 this proposal was modified; the government announced the retention of separate governance for the NGI, CAG and IMMA, although the National Museum and National Library will be brought under a new combined Advisory Council. There will be an emphasis on shared services and the re-structuring of existing governing boards at the NGI, IMMA and CAG, all of which will be incorporated into a new National Cultural Institutions Act.

323. National Gallery of Ireland, Millennium Wing with Louis le Brocquy tapestry, *The Triumph of Cúchulainn*, 2002

324. John Bowen, Chair of the Crawford Art Gallery and Minister Jimmy Deenihan, T.D., with Cork artists Irene Murphy and Mick O'Shea, at a launch at the Gallery in 2012

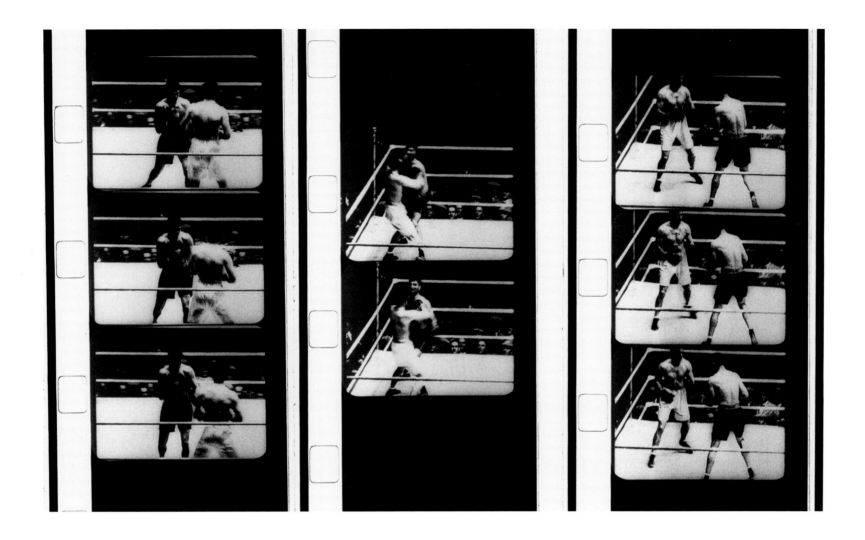

325. James Coleman, *Box (ahhareturnabout)*, 1977, 8 mm black and white film transferred to 16 mm, audio (see 228)

a coherent, focused revolt; rather, it is to recognize the plurality of voices and interests that characterize what now falls under the term new media art. Today, the definition of new media art, while retaining an instability in the face of emerging technologies, commonly settles around performance, installation, digital art, and various lens-based practices (see 'Time-based Art', 'Installation Art' and 'Film'). This is testament to the establishment and institutionalization of such practices.

The historical reception of this art in Ireland is similarly characterized by tensions between the driving forces of new media art and the shifting state-funded cultural infrastructure that comes to support them. In addition, the idea of new media art in Ireland posits the nation state and competing views of Irishness as a filter through which art is strained. This is not without its tensions.

The response of Brian Fallon, the then critic of the *Irish Times*, to the choice to (eventually) include Irish artists James Coleman and Patrick Ireland (Brian O'Doherty) (qqv) among the 'best' of international contemporary art in *Rosc '77* (see 'Rosc Exhibitions') is telling in this regard: 'The two Irish entries were mild and harmless gimmicks such as we have got comfortably inured to, and were also untypical of Irish art – if, indeed, they were ever intended to be so.' (Fallon, 'Last thoughts on the Rosc show', *IT*, 4 November 1977)

Fallon harks back to the painterly visions of Jack B. Yeats (qv) and Nathanial Hone. He attacks a younger generation and their institutional backers for merely mimicking international trends towards new media since Coleman and 'Ireland' were seen to have been selected on the basis of their existing international credentials. That well-established figures holding office in the Arts Council/An Chomhairle Ealaíon (qv), such as Michael Scott and Sir Basil Goulding, would defend such artworks is significant. For the emergence and consolidation of new media art in Ireland is not simply a story of battling old ways of seeing which are deeply rooted in the visual arts infrastructure. Rather, it is caught up in the grander debate of which form of art best represents a vision of a new modern Ireland and the subsequent support such work might receive.

Coleman exhibited *Box (ahhareturnabout)* [325, 228] for *Rosc '77*. The short looped film extract is of the return fight between the defending champion, Irish-American Gene Tunney, and Jack Dempsey in 1927. The fractured dialogue, grunts and gasps over the rhythmic pulse creates an interior scape. Since the film footage is looped, the figure is suspended in a realm of indeterminacy, forever defending his status and forever performing as spectacle. One is struck by the thin line between the performer in the boxing ring and artistic struggle in an equally contested arena.

Patrick Ireland exhibited one of his 'Rope Drawings'. A network of coloured, taut ropes is installed and interacts with painted forms on the gallery walls. Ireland's work focuses on the viewer's spatial interaction and the relationship between things. The name change from Brian O'Doherty to Patrick Ireland, sparked by his reaction to Bloody Sunday, would also be a source of contention (see 'The Troubles and Irish Art'). Some local commentators found it politically naïve and O'Doherty's reaction is telling: 'In Ireland that may not seem like anything much, but in America it counts for a lot.' The reception of O'Doherty's work is very much marked by tensions between local and international demands.

A concern for the local as a point of resistance to wider, more powerful state and global agendas characterized new media art in Ireland from the 1980s to the mid-1990s. The emergence of *Circa* magazine provided a crucial platform for this negotiation. Writing in *Circa*, Christopher Coppock reacted to how the 1980 London Festival of Irish Art, *A Sense of Ireland*, was used by the state as a vehicle to project *its* sense of Ireland. Artists such as Alanna O'Kelly, Nigel Rolfe and Noel Sheridan (qqv), participating in *Without the Walls* at the Institute of Contemporary Art, were promoted as evidence of Ireland's 'new cosmopolitan sophistication,' despite what Coppock saw as the artists' indifference to such aspirations. Declan McGonagle's curatorial roles in the Orchard Gallery, Derry, and the Irish Museum of Modern Art (IMMA) also typified a politics of place. The challenge was not merely a matter of identity politics, but involved questioning the hierarchies underpinning the canon of art itself. Subsequently, forms of art with an inherent sensitivity towards the relations of medium, context and power received valuable support and international exposure.

Willie Doherty's (qv) slide installation *Same Difference* (1990–92) [235] appropriates an image of Donna Maguire, an IRA member at the centre of various extradition orders and trials at the time. It is a media mugshot image – cropped, pixelated with a rough, heightened contrast. The figure is implicated by its very mediation. The image is cast onto two opposing walls. A sequence of words articulating competing discourses (MURDERER ... /VOLUNTEER ...) is projected on to each image. The viewer is physically set amidst this terrain and so confronts a structural bind of pressure and resistance which dominates an understanding of political conflict in Northern Ireland.

Sanctuary/Wasteland (1994) [326] is a projected installation by Alanna O'Kelly. It centres on a negative photographic image of Teampall Dumhach Mhór (the Church of Great Sandbank), a famine burial ground that has lain at the foot of Mweelrea, the mountain on the Mayo coast. The work slowly draws to light a rich, shifting history of the site – from an early monastic settlement, to its naming as 'The Sanctuary' by seventeenth-century mapmakers and 'The Wastelands' by locals in the nineteenth century. The naming or mapping of an area is as much an act of remembrance as a cold imposition of a proprietary right. It is a work enmeshed in colonial discourse where resistance emerges from visualizing an organic, feminized space born of tragic loss and historical circumstance.

326. Alanna O'Kelly, *Sanctuary/Wasteland*, 1994, DVD projected installation, Irish Museum of Modern Art

By the mid-1990s, new media art was comfortably established in the local visual arts. It is a key signifier of Ireland's modernity on an international stage since new media art very much typifies what is contemporary on a global art circuit. Artists such as Gerard Byrne, Jaki Irvine, Alastair MacLennan, Anne Tallentire and Grace Weir (qqv) have all been chosen to represent Ireland at the Venice Biennale. Indeed, the work of many of these artists can be positioned amidst the drift from a concern with a place-bound politics of cultural difference towards more globalized and homogeneous forms of subjectivity and identity.

A major element of Gerard Byrne's *New Sexual Lifestyles* [57, 327] is a filmwork restaging a series of panel discussions around aspects of the sexual revolution published in *Playboy* magazines from the late 1960s. A sense of dislocation colours the work. It is re-enacted by actors set in a Modernist pad (with its utopian

327. Gerard Byrne, *New Sexual Lifestyles*, 2003, 3-channel DVD, 54 min, 7 photographs, dimensions variable (see 57)

328. Paddy Jolley, Rebecca Trost and Inger Lise Hansen, *Hereafter*, 2004, black and white film transferred from 16 mm/Super 8 to DVD, Irish Museum of Modern Art

First, there is a danger that the unrealized potential and disappointments of numerous ventures will be overlooked. Paul O'Brien has consistently drawn attention to the development of the *Ars Electronica* project in Linz, Austria from the mid-1980s by regular coverage of its annual festival. The festival focuses on the productive crossovers linking art, technology and new social developments. The establishment of an Ars Electronica Centre and Futurelab, with major state and corporate investment, has furthered a commitment to an open, interdisciplinary engagement with the potentials of the digital revolution. O'Brien's writing has purposely advocated this model before its very absence in an Irish context. Arthouse's fraught history and handling of its artistic programme, having been established in 1990 by Temple Bar Properties with public funds to provide multimedia facilities for artists, is a good case in point; as indeed is the collapse of Media Lab Europe, having been set up in the Guinness Hop Store in 2000. Despite ambitious promises to fuse art and technology, ultimately short-term commercial interests ruled the day. If such episodes reinforce a sense of the marginalized status of new media art beyond the visual arts infrastructure in Ireland, they also point to a merit in the relative autonomy of the existing infrastructure.

This leads to the second point: that those practices that have risen to the surface have all, at some point, been reliant upon the local grassroots support and initiatives that energize the visual arts in Ireland. One could trace the subsequent paths of members of the Blue Funk (qv) collective to get a sense of how their initial efforts to develop structures and opportunities for new media practices would bear fruit in their prolonged commitment to the visual arts in various artistic, curatorial, educational and administrative capacities. Indeed, one senses that it is from the setting up and subsequent backing of artist-led organizations, such as Catalyst Arts (Belfast) and G126 (Galway), that new experimental forms of art will continue to emerge in all their wildness and potential. Creating a record of this chaotic network of ideas from the ground up is crucial for a history of new media art and its stories of what is to come [328]. GAVIN MURPHY

associations) in County Wicklow in the early 2000s. There is the additional disjunction where the topic for consideration in the gallery space finds its origins in an American magazine associated with more immediate bodily gratification. The work thrives on opening these temporal, geographical and cultural fissures in an effort to posit new kinds of subjective orientation that are estranged from the historically contingent forms of desire outlined.

Jaki Irvine's *The Silver Bridge* also explores tensions between subjectivity, place and history. It consists of eight projections of differing scales and intensity spread across a number of rooms. The video footage is taken from the Phoenix Park, Dublin Zoo and the Natural History Museum. The scenes of bats, a flock of starlings and deer grazing create an eerie and pensive mood. The viewer confronts a world of heightened perception and instinct inhabited by ghostly characters from the past and the present. The work dwells on how these civic spaces of nineteenth-century Dublin haunt their contemporary realm in a manner that is enigmatic and fragmented.

In an era where accessibility and accountability to the greater public prevail, the esoteric nature of material presented confirms a level of commitment to the demands of high art. The work also anticipates a viewer well grounded in the complexities of contemporary critical thought. No doubt such efforts are encouraged by the consolidation of James Coleman's legacy in the contemporary canon of art and IMMA's successful bid in 2005 to purchase a number of Coleman's major works.

This brings us full circle to earlier struggles new media art faced in order to be validated in an Irish context. Yet one should be wary of an affirmative sense of closure in an account that primarily focuses on the apex of a slowly shifting hierarchy. By doing so, two points become clear.

SELECTED READING McCabe and Wilson, 1994; Paul O'Brien, 'Leaving Reality Behind or Re-Playing Art Historical Realities?', *Circa*, no. 78 (Winter 1996), 20–23; MacWilliam, 2002; Megs Morley, 'The Irish Artist-Led Archive', 2006–08, http://www.theartistledarchive.com/home.html.

NIETSCHE, PAUL (1885–1950) [329] painter. Paul Nietsche was a cosmopolitan figure in Belfast before, during and after World War II. Born in Kiev, Ukraine, he studied art in Odessa and Munich and worked in both Paris and Berlin before coming to Belfast in 1926 at the invitation of his friend Dr Michael O'Brien, a lecturer in Celtic Studies at QUB. He retained a studio in Berlin during his early years in Belfast and continued to travel regularly, seeking different places to paint, such as St Austell in Cornwall, Dubrovnik, the south of France and Switzerland, but always returning to Belfast, where his first-hand knowledge of artists and his familiarity with bohemian lifestyles made him an exotic presence. This

reputation was enhanced by his fluency in French, Russian, German and English and his skills as a poet and short-story writer. A friend of the sculptor Rodin, he showed at the Paris Salon of 1912, but, although he has been described as an Impressionist and he was a good colourist, his emphasis on sculpture and drawing (qv) reveal him to be closer to Cézanne and Post-Impressionism than to Monet and Pissarro.

Nietsche painted still-life compositions, portraits and landscapes. Dr Brian Kennedy has correctly identified his talent for the intimate rather than the panoramic, making him more successful with the first two of these than with landscape (Kennedy, 1991, p. 82). His portrait sitters included fellow artist James Humbert Craig (qv) (UM collection), fellow expatriate and art collector Zoltan Lewinter-Frankl, the actors J.G. Devlin and R.H. McCandless, the novelist F.L. Green (UM collection), author of *Odd Man Out*, and the Russian singer Feodor Chaliapin, who was a personal friend.

Nietsche showed work at the Ulster Arts Club, Belfast, the RHA (qv), and the United Arts Club, Dublin, and in London and Montreal. His first solo exhibition in Ireland was at the home of his friend Michael O'Brien, but other exhibitions followed at the Magee Gallery, Belfast and a CEMA-sponsored exhibition at Tyrone House, Belfast in 1945. A retrospective exhibition of his work was held at the Arts Council Gallery in Belfast in 1984.

Nietsche's work can be seen in the NSPC at the University of Limerick, and the Ulster Museum. CATHERINE MARSHALL

SELECTED READING S.B. Kennedy, *Paul Nietsche, 1885–1950*, exh. cat. Arts Council Gallery (Belfast 1984); S.B. Kennedy, 1991; Snoddy, 2002, pp. 454–55.

NOLAN, EVIN (b. 1930) (qv *AAI* III) [330], painter, sculptor. Evin Nolan was born at the Curragh, Co. Kildare. He worked as a cartoonist in England and Ireland in the 1950s before going to work with *Dublin Opinion* and the *Sunday Review* in Dublin. Largely self-taught as an artist, Nolan began his career as a watercolourist in the 1950s, painting landscapes (qv), but it is arguable that the time he spent working as a textile cutter had a greater influence on his work than either his proficiency as a watercolourist or his experience as a cartoonist. By the 1970s Nolan's name was linked with those of Cecil King, Roy Johnston, Anne Madden (qqv) and Theo McNab for their shared espousal of an international abstract idiom, as opposed to a very conscious expression of Irishness found in the work of Micheal Farrell and Robert Ballagh (qqv).

Nolan's distinctive contribution to Irish art took the form of canvases in unusual geometric shapes, or cut and rearranged to create colourful sculptural shapes and multi-media constructions made from layered and interwoven, brightly coloured paper. Such work blurred the distinction between painting and sculpture and can be seen to greatest advantage in two large canvases commissioned for the P.J. Carroll & Company headquarters in Dundalk, Co. Louth. The geometric shapes of Nolan's canvases, and his hard-edged style were particularly appropriate as an accompaniment to Modernist architecture. He won first prize in the Arts Council's (qv) *Art in Context* exhibition in Belfast in 1975 and another prize at the Claremorris Open in 1985. A gentler, less hard-edged, but still sculptural, painting, *Liffey Whispers* (1979), is included in the collection of the BoI.

Nolan was briefly employed as a lecturer at DLIAT and served as a committee member of the Project Arts Centre, Dublin (1968–77) where he had solo exhibitions in 1971, 1975 and 1976. The ACNI honoured him with a solo show in 1980 and in 1999 the RHA Gallagher Gallery showed a retrospective exhibition of his work from 1984.

Nolan's self-portrait in the NSPC at the UL is surprisingly modest and quiet in tone by comparison with his very

329. Paul Nietsche, *Self-portrait*, 1947, gouache on cardboard, 61 x 51 cm, National Self Portrait Collection of Ireland, Limerick

330. Evin Nolan, *Green Touch, c.* 1974, acrylic on canvas on board, 121.9 x 132.1 cm, Irish Museum of Modern Art

331. Paul Nugent,
Portrait of a woman,
1997, oil and acrylic on
board, 50 x 32 cm, private
collection

assertive and assured abstract works (see 'Abstraction'). His work can be seen in the collections of UCD, UCG, TCD, in the Gordon Lambert Trust and Carroll's collections now at IMMA, and in such corporate collections as those of the AIB and BoI. CATHERINE MARSHALL

SELECTED READING *Evin Nolan: Works 1994–1999*, exh. cat. RHA (Dublin 1999); Gallagher, 2006; Murray, 2007a.

NUGENT, PAUL (b. 1964) [331], painter. Paul Nugent is a Dublin artist and graduate of NCAD. Using the twin tools of the paintbrush and the camera, his principal concern in his painting has been to investigate the archiving of history, from personal memory to such forms of documentation as portraiture and photography (qqv). Taking archetypal personae and locations from the past, imbued with ritual and symbol, he explores the veracity and creativity of memory. Like the Belgian artist Luc Tuymans, Nugent is interested in the concept of the 'authentic forgery', which posits the impossibility of originality.

Nugent first achieved prominence in 1997 when he showed the 'Cardinal' paintings in Dublin. Two of the six paintings in that particular series are now in the collection of IMMA, through which they have been widely exhibited. His paintings appear at first sight to be abstract (see 'Abstraction'), colour-field paintings, but, on closer viewing, they reveal figurative presences. Quietly, but inexorably, they erode ideas of past and present, positive and negative, absence and presence, abstraction and figuration. The 'Cardinal' pictures evoke impressions of earlier portraits of cardinals by Raphael and Velázquez, of which they at first sight appear to be faint recreations. The series, like other Nugent paintings, recalls the originals, only to have that impression subtly subverted.

His paintings are based on memories of an original, often seen only in photographic reproduction and then constructed and painted in the studio to form a new artwork. The personal memory, the ultimate source for the final painting, inevitably leads to deviation from the original image, so questions about authenticity remain. Churches and religious buildings, such as hospitals and orphanages, religious statuary and symbols also feature in his work. Paintings based on photographs and memories of the Chapel and Hospital of Pitié-Salpêtrière in Paris invite questions not merely about the veracity of the artist's memory, but also about the truthfulness of the celebrated photographs of so-called 'hysterics' on which the nineteenth-century French neurologist Charcot based his theories of hysteria. Charcot's photographs were presented as evidence of pathological behaviour, but since they were created in far from 'normal' conditions, the abnormalities they appear to depict are open to question. It is such tantalizing links between the real and the perceived that Nugent's work investigates.

As in the 'Cardinal' series (1997), the 'Carmelite Nun' series (1999), the 'Franciscan' series (2002), and later works inspired

by Flemish fifteenth-century paintings by Jan van Eyck, the overall monochrome tonalities of the pictures suggest a surface opaqueness that is challenged by barely perceptible references to the original image. The paintings thus represent a powerful dialogue between the surface impression, the 'face' of the picture, and its 'soul', the illusion of something from the past, residing beneath that surface.

Nugent's work has been shown in solo exhibitions in Dublin, Paris, Kerava, Finland, and in group exhibitions at the RHA (qv), and IMMA in Ireland, and in China, the USA, Canada, Spain and Finland. He has been the recipient of a three-year bursary from the Arts Council (qv) and a residency at the Centre Culturel Irlandais, Paris (2004). CATHERINE MARSHALL

SELECTED READING Marshall, 2004; O'Molloy, 2005.

O'BRIEN, ABIGAIL (b. 1957), artist. Born and educated in Dublin, Abigail O'Brien holds a Master's degree in sculpture from NCAD. Her work revolves around the place of ritual in daily life, particularly as it impacts on the lives of women, and this has been expressed most effectively through a series of installations (qv) that use religion as their narrative and archetypal framework (see 'Religion and Spirituality').

Working over a ten-year period (1995–2004), O'Brien drew on the rituals employed, particularly, though not exclusively, in Ireland in the Roman Catholic liturgies of the Seven Sacraments. Catholicism and other religions are referenced as a means of universalizing and re-presenting the local historical moment. O'Brien's initial examination of the role of ritual in social initiation, *The Last Supper* [332], which she developed during her final undergraduate year at NCAD, explored the Sacrament of

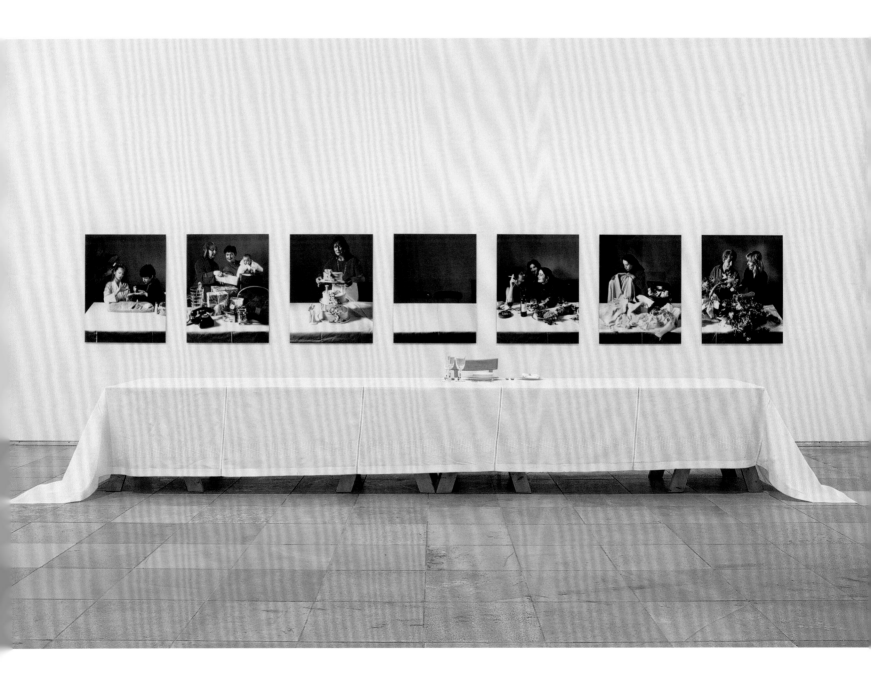

332. Abigail O'Brien, *The Last Supper*, 1995, 7 cibachrome photographs, table, chair, embroidered tablecloth, dinner set, Irish Museum of Modern Art

Matrimony. Within a year the work had been shown at *EV+A* in Limerick and acquired by IMMA. This, and the subsequent installations in the series, draw on a variety of art practices, from embroidery and cast-making to photography, video and sound art. While all are informed by such historic precedents as Poussin's two 'Seven Sacraments' series and by Dutch and Renaissance painting, they break decisively with history by placing women at the centre of each sacrament, involving men by implication only. As Medb Ruane pointed out, her works are not about religion but about initiation into social formation (*Baptism*, 1996) although there are moments when ambivalence towards Catholic teaching is suggested. O'Brien has, for example, described her stitching of *mea culpa* on to the slip habitually worn underneath the baby's christening robe in *Baptism* 'as a kind of subversive act. I made *Baby's Slip* [429] in order to represent the contradiction between the innocence of a child and the sin imposed on it by the Church' (*The Seven Sacraments*, p. 106).

O'Brien's exploration of rites of passage moments, from birth to death, in a woman's life, undermines one of the most potent structures of patriarchal authority, the Sacraments of the Roman Catholic religion, while exploiting the richness of their structures in the interests of narrative. But survivals of pagan practices (as in the 'Rag Tree' photographs) also provide inspiration for her deconstruction of archetypes. Masterfully she manages to do that while retaining a level of ambiguity and irony around each time-honoured ritual, clothing them simultaneously in a veil of middle-class comfort and sterility which manages to be both attractive and off-putting. Her focus on women is multi-layered, drawing on practices long associated with women's work but disrupting cosy assumptions about sewing circles through a visceral handling of flesh in work like *How to Butterfly a Leg of Lamb* (1999), which she made in collaboration with the artist Mary Kelly. The women in *Martha's Cloth* (2001–04, *Confirmation*, the final one of the 'Seven Sacraments' series) represent different ways of being in the world, active and contemplative; unlike Christ in the Gospel version, the artist resolutely refuses to favour either one.

The function of art, its responsibility as Paul Klee described it, not to imitate reality but, instead, to make it visible, is realized in O'Brien's work through a transformation of ordinary realities into something glossy and thought-provoking. This is evident again in *Temperance*, a public Per Cent for Art project she completed in Letterkenny, Co. Donegal in 2009. The work comprised a series of photographs of candy manufacture, revealing the level of physicality, sensuality, indulgence and balance it involves from both male and female workers.

O'Brien has had solo exhibitions at the Haus der Kunst in Munich, the RHA Gallagher Gallery, Rubicon Gallery and Temple Bar Gallery in Dublin, Galerie Bugdahn und Kaimer in Düsseldorf, Galerie Stadtpark in Krems (Austria), and the Letterkenny Arts Centre. She has been included in such group exhibitions as *Irish Art Now: From the Poetic to the Political* (Boston, Pittsburgh, Halifax, Chicago and Dublin), *The Monocular Glance* (Kunstverein, Lingen, Germany), *Inter Space* (Berlin) and *Photography as a Dimension of Painting* (Heidenheim and Saarbrücken). Her work is included in the collection of IMMA and in many corporate collections. Catherine Marshall

SELECTED READING Medb Ruane, *Abigail O'Brien: Baptism*, exh. cat. Temple Bar Gallery (Dublin 1996); Stephanie Rosenthal, Ciarán Benson and Friedhelm Mennekes, *The Seven Sacraments and The Ritualized Daily Life*, exh. cat. Haus der Kunst (Munich 2004); John Cunningham and David Galloway, *Oatfield-Temperance: Abigail O'Brien*, exh. cat. Letterkenny Arts Centre (Donegal 2009).

O'BRIEN, DERMOD (1865–1945) (qv *AAI* II), painter. Born at Mount Trenchard, near Foynes, Co. Limerick, grandson of the Young Ireland leader William Smith O'Brien, Dermod O'Brien traced his descent from Brian Boru, the eleventh-century High King of Ireland. His father, Edward O'Brien, ran the family estate, Cahermoyle, near Ardagh, Co. Limerick. O'Brien was educated at Harrow and Trinity College, Cambridge, before studying the techniques of the old masters in the great public art collections in Rome, Florence and Paris. In 1887 he entered the Académie des Beaux Arts, Antwerp, to study under Charles Verlat, and remained there until 1891. Thereafter, he spent brief spells at the Académie Julien in Paris and at the Slade School of Art, London. He spent much of the 1890s in London working as a portraitist and landscapist.

By 1901, however, O'Brien had settled in Dublin where, with the Literary Renaissance at its height, he became a central figure in the worlds of the visual arts and music. Despite an innate preference for landscape (qv), O'Brien set up as a portrait painter – 'One's livelihood is the first thing to be considered and that means portraiture', he wrote at the time (letter to Julia O'Brien, 1 May 1890, O'Brien Papers, NLI) – and for almost three decades thereafter, and particularly when he became president of the RHA (qv) in 1910, he was one of the leading portraitists in Dublin. On his appointment, the *Studio* noted 'he is full of zeal on behalf of all progressive movements for the furtherance of art in Ireland' (*Studio*, no. 51, 1910/11, 63). From the mid-1920s, however, he diverted his attention to landscape painting, the genre for which he is now most remembered.

Much of O'Brien's portraiture (qv) is stiff and formal in manner, as his *Alderman W.F. Cotton* (*c*. 1895, HL) shows. Others, like *The Jewel* (1903, NGI collection), an O'Brien family scene, evoke a feeling of reserve, while his less formal studies, such as that of *Lennox Robinson* (1918, UM), have more fluency. Of his early landscapes, *Sheep Shearing* (*c*. 1901, HL) and *The Sand Pit* (1908) are good examples, but they too have a 'set piece' formality. From the 1920s, however, his canvases become smaller in size and have an increasing spontaneity of execution.

From the mid-1920s, O'Brien worked a good deal around Powerscourt in County Wicklow and in the valley of the River Liffey. *The Deer Park, Powerscourt* [333] typifies his work at the time and shows his delight in the countryside – the River Dargle tumbling through the wooded and rich pastoral land, the image set down spontaneously *en plein air* and with less concern for detail than in his earlier landscapes. Also during the 1920s he paid several visits to Picardy, so that French subjects – *Place de l'Eglise, Montreuil* (1925, CAG) is typical – begin to occur in his

oeuvre while, from the late 1920s until the outbreak of war in 1939, O'Brien regularly painted at Cassis in the south of France. *Olives, Cap d'Ail* (1938, Waterford Art Gallery), a scene of olive trees and cliffs bathed in warm sunshine, shows the exuberance of his mood and sureness of touch at the time, and is typical of his Provençal pictures in general. In these works, perhaps more than in any others, he reached an easy confidence in himself.

Of O'Brien's Irish landscapes of the 1930s, *Evening at Feltrim* (1937) and *The Bridge at Baltray* (*c.* 1938, Waterford Art Gallery) are good examples. Reviewing the 1937 RHA exhibition, in which the former picture was exhibited, Lynn Doyle (*IT*, 19 April 1937) thought the 'veteran President' was 'painting better than ever'. His *Feltrim*, he said, 'is a little masterpiece in a worthy tradition'. These late pictures are distinctly freer in execution than anything he did earlier and the bright palette of the *Baltray* composition shows the influence of his visits to the Mediterranean.

Besides portraits and landscapes, O'Brien painted flowers and still lifes. In compositions such as *My Birthday Presents* (1923, Waterford Art Gallery) or *Arrangement* (late 1920s, CAG), his academicism, which underpins all his work, is perfectly suited to the subject and recalls the seventeenth-century Dutch painters who influenced him as a student.

Yet as an artist O'Brien seems not to have realized his full potential; he was perhaps overeager in his exertions. Probably, too, his work suffered because of the time he devoted to the RHA, of which he was president for thirty-five years; the Irish Agricultural Organisation Society, where he worked closely with Horace Plunkett and George Russell (AE) (qv); the Irish Academy of Music, of which he was a governor; as well as his general gregariousness, for he always tried to help other, especially young, artists, painters, musicians and actors. S. B. KENNEDY

SELECTED READING Lennox Robinson, *Palette and Plough: A Pen-and-Ink Drawing of Dermod O'Brien PRHA* (Dublin 1948); S.B. Kennedy and Anne Stewart, 'Dermod O'Brien: Abroad and at Home', *IAR* (Autumn 2007), 74–79.

O'CONOR, RODERIC (1860–1940) (qv *AAI* II), painter. Roderic O'Conor was an important figure in the history of twentieth-century Irish art, although he is known to have paid his native country only one visit after 1893 when his father died, and the work for which he was known in Ireland for most of the century was limited to a small number of paintings. Despite his history before 1900 being covered in Volume II, it is important to briefly sketch it again here.

Born into a well-to-do family from County Roscommon, O'Conor studied art at the DMSA and the RHA Schools before going to the Académie Royale des Beaux Arts, Antwerp with his classmate from Dublin, R.T. Moynan, and later to the studio of Carolus-Duran in Paris. His real education, however, was gleaned from contact with a cosmopolitan group of artists who worked near Grez-sur-Loing and later in Brittany, particularly the area around Pont Aven. O'Conor was quick to reject the conservatism of his teachers. Work from the late 1880s revealed an interest in Impressionism and, according to Alden Brooks, son of an American artist friend of O'Conor's, he visited van Gogh's studio in Paris (Snoddy, 2002, p. 474). In 1894 he met and befriended the artist Paul Gauguin, who invited O'Conor to accompany him to the South Seas. Although he did not accept the invitation, O'Conor did execute a portrait etching of Gauguin in the same year. Throughout the 1890s, O'Conor painted the people and the landscape of Brittany, exhibiting at the Paris Salon and the Salon des Indépendants [334]. He exhibited at the first ever Salon d'Automne in 1903 (where he continued to show regularly until 1935), and within the year returned to settle in Paris.

O'Conor's most radical years were undoubtedly the early 1890s, especially 1892–94, when he invented a style of painting in parallel stripes of pure colour that is similar to, but differs

333. Dermod O'Brien, *The Deer Park, Powerscourt*, 1925, oil on canvas, 64 x 75 cm, National Gallery of Ireland

334. Roderic O'Conor, *La Ferme de Lezaven, Finistère*, 1894, oil on canvas, 72 x 93 cm, National Gallery of Ireland

335. Roderic O'Conor, *A Young Breton Girl*, 1903, oil on canvas, 91.5 x 73.6 cm, Dublin City Gallery The Hugh Lane

from, the pointillism of Seurat. He also made a number of etchings during the 1890s, instructed in the practice by his friend Armand Séquin at Le Pouldou. Together they perfected a cheap process for making prints by using zinc from builders' suppliers, instead of the usual, and more expensive, copper (see 'Printmaking'). O'Conor's contact with the French avant-garde can be judged by the fact that he was invited to participate on the jury for the Salon d'Automne in 1907. Following his return to Paris, O'Conor's subject matter changed to more intimate interiors, nudes and still-life paintings, apart from an occasional subject picture and a group of landscapes painted at Cassis around 1913. While this work can be considered to be less innovative, it is nonetheless distinctive and informed by the art of very avant-garde contemporaries such as Bonnard and the Fauvist painters, while *Romeo and Juliet* (n.d., private collection) recalls the work of Edvard Munch. Yet despite his close knowledge of new developments in French art and slight nods in the direction of van Gogh, Seurat and Bonnard, O'Conor's work remains quite separate and distinguishable from his famous contemporaries. His biographer, Jonathan Benington, thought him too independent to be easily influenced by anyone else.

O'Conor was closely linked to French painting. As his friend Clive Bell pointed out, he thought O'Conor knew 'most of the more interesting French painters of his generation – the Nabis for instance' (Crookshank and Glin, 2002, p. 264) and he owned paintings and prints by many of the leading figures, some from as early as 1904 (Gauguin, Bonnard, Rouault, Segonzac, Derain and Vlaminck, and prints by Cézanne and van Gogh). Nonetheless, he joined the London Group in 1925. Since Roger Fry was also a member of this group, it is clear that O'Conor, for all his famed reclusiveness, was close to innovation throughout his career. His inclusion in such exhibitions as *La Libre Esthétique*, Brussels, and the Allied Artists Association, London, offers further evidence of his connection to avant-garde art in Europe.

Thanks to a private income, O'Conor was financially secure and repudiated the idea of painting for sale. He did not choose to have solo exhibitions, agreeing to only one during his lifetime, at the Galerie Bonaparte, Paris in 1937. Instead, he lived an increasingly secluded life until his marriage in 1934 to his model, the painter Renée Honta. For this reason his work was known only to a few informed friends, such as the critic Clive Bell, and the artist and writer Roger Fry who bought a painting, *Still Life with Bowl of Fruit by a Window* (1924), which he later donated to the Courtauld Institute of Art, London.

O'Conor's considerable importance in Irish art history in the twentieth century rests largely on the impact his work made on Hugh Lane. Lane included O'Conor's paintings in the exhibition of international Modernists (see 'Modernism and Postmodernism') that he curated from the Staats Forbes Collection in Dublin in 1902, and his painting *A Young Breton Girl* [335] formed part of the exhibition of Irish art which Lane presented at the Guildhall in London in 1904, the first exhibition of Irish contemporary art outside Ireland. The importance of that exhibition in shaping the subsequent history of Irish art, especially its role in the founding of the Municipal Gallery of Modern Art (HL) in 1908, to which O'Conor donated the

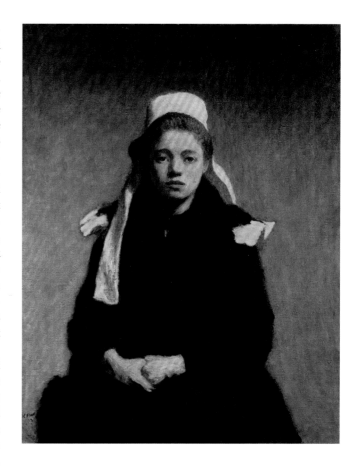

painting, cannot be overestimated. From an Irish point of view, the presence of work by someone Crookshank and Glin describe as 'unique among his Irish colleagues as the only Irishman who became an artist in the international scene and was associated with the Post-Impressionists' offered proof when it was most needed that Irish artists, too, could consort with the leaders (Crookshank and Glin, 2002, p. 263). O'Conor was one of the artists chosen to represent Ireland at the *Exposition d'Art Irlandais*, Musée d'Art Ancien, Brussels, in 1930.

O'Conor died at his home in Nueil-sur-Layon, Maine-et-Loire in 1940. His true achievements as an artist became known to a wider audience at the studio sale only in 1955, following the death of his wife the previous year. Over the next three decades a number of retrospective exhibitions were arranged. The first exhibition of his work in England, along with Matthew Smith whom O'Conor had known since 1918, was staged in London in 1956; a retrospective at the Musée des Beaux Arts de Pont-Aven, curated by the artist Roy Johnston (qv) and Catherine Puget, took place in 1984; and a major retrospective of 128 paintings at the Barbican in London, the UM in Belfast, the NGI, and the Whitworth Art Gallery in Manchester, also curated by Roy Johnston, was presented in 1985. An exhibition of O'Conor's prints was held at the NGI in 2001.

Roderic O'Conor's work is now eagerly collected and, while much of it is in private hands, it can be seen in such public collections as the HL, NGI, UM, the Hunt Museum, Limerick and

the Glebe Gallery, Co. Donegal, in Ireland, and in the Courtauld Institute, Tate Gallery and Victoria & Albert Museum, London, the Musée d'Orsay, Paris, MoMA, New York, and in other collections in the USA, Australia, Switzerland and New Zealand. CATHERINE MARSHALL

SELECTED READING Bell, 1956; Roy Johnston, *Roderic O'Conor*, exh. cat. Barbican, London; UM; NGI; Whitworth Art Gallery, Manchester (London 1985); Jonathan Benington, *Roderic O'Conor* (Dublin 1992).

O'DEA, MICHAEL (b. 1958), painter. Specializing in portraiture (qv), O'Dea is one of those contemporary artists who have managed to bridge the gap between working within the time-honoured tradition of European portraiture, while also maintaining an intellectual stance that respects its recent critiques. In O'Dea's work, the relationship between artist and subject is an important part of the creative process. Although primarily a skilled painter and draughtsman, whose ability to capture likenesses is evident, he is also an artist conversant with the role of portraiture in society and in the history of art. O'Dea has painted Édáin O'Donnell, Gerard Stembridge, Michael Harding, Micheal O'Siadhail and Eamon Delaney. When working from life, O'Dea is direct and spontaneous, whereas when he works from photographs, his paintings interrogate and reference the qualities of that medium, through, for example, using charcoal or colour tints to evoke vintage photographs.

In recent years he has produced works depicting scenes from the Irish War of Independence. Reminiscent of the work of Seán Keating, these paintings reference both Irish history and the history of painting. However, it is in portraits of individuals that O'Dea excels. His *Portrait of Brian Friel* [336] conveys accurately Friel's presence and appearance, while also hinting at the preservation of a private individuality behind a famous public persona.

O'Dea was born and raised in Ennis, Co. Clare, and enrolled at NCAD in 1976, where his tutors included Carey Clarke, Charles Cullen (qqv) and John Kelly senior. He then studied at the University of Massachusetts, graduating in 1981. Returning to Ireland, in the early 1980s he taught art at the Grapevine Arts Centre, Dublin and in secondary schools. In 1982/83 he was a tutor at the DLCAD, between 1983 and 1996 he taught at NCAD, and he was a visiting lecturer at other colleges in Britain and Ireland. For several years O'Dea participated in the 'Artists in Prisons' scheme run by the Arts Council (qv) and the Department of Justice. His portrait of Brian Meehan, a criminal convicted of the murder of journalist Veronica Guerin, was painted in Portlaoise prison and shown at the RHA (qv) in 2003. In 1993 O'Dea was elected an Associate of the RHA, and a full member three years later.

Beginning with his participation in a student exhibition at the Grapevine Arts Centre in 1978, O'Dea has participated in scores of exhibitions, including the Oireachtas, Independent Artists, IELA (qv), GPA Emerging Artists, and SADE at the Crawford Art Gallery, Cork. In 1985 he won the first of four awards at the Arnotts Portrait Awards. In 1997 he spent a year studying in Winchester and Barcelona, and was awarded an MA

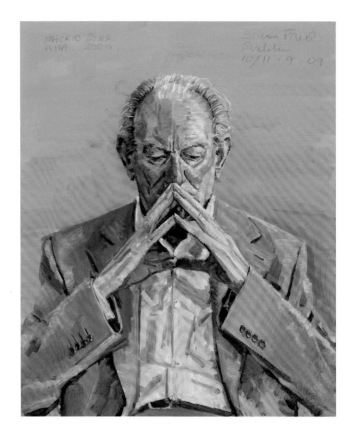

336. Mick O'Dea, *Brian Friel (b. 1929)* 2009, oil on canvas, 60.5 x 50.5 cm, National Gallery of Ireland

in Fine Art by the Winchester School of Art. In 2006, in collaboration with the Kevin Kavanagh Gallery, Dublin, he showed 'Un Salon par Mick O'Dea', a series of portraits, at the Centre Culturel Irlandais in Paris.

O'Dea's work can be found in the collections of CAG, HL, IMMA and UL. PETER MURRAY

SELECTED READING Catherine Foley, Eamon Delaney and Kevin Kavanagh, *Mick O'Dea: Audience*, exh. cat. Kevin Kavanagh Gallery (Dublin 2004); Helen Carey and Aidan Dunne, *Un Salon par Mick O'Dea*, exh. cat. Centre Culturel Irlandais (Paris 2006).

O'DOHERTY, BRIAN/IRELAND, PATRICK (b. 1928) (qv *AAI* III), artist. Brian O'Doherty is arguably one of the most fascinating artists on the Irish and international art scene in recent decades. Although born in Ballaghadereen, Co. Roscommon, he has lived and worked in America since the late 1950s as an artist, critic, writer, teacher and arts administrator. The ability to work successfully in many fields simultaneously is rare, but what is most striking is the range and depth of art he has produced as two distinct artistic personae, Brian O'Doherty and Patrick Ireland. Historically the first performance artwork in Ireland, *Name Change* [337, 379] marked the 'birth' of Patrick Ireland in 1972 when O'Doherty was forty-four years old (see 'Time-based Art'). The gesture was conceived as an exile's protest against the killing that year of civil rights marchers on Bloody Sunday in Derry, Northern Ireland (see 'The Troubles and Irish Art').

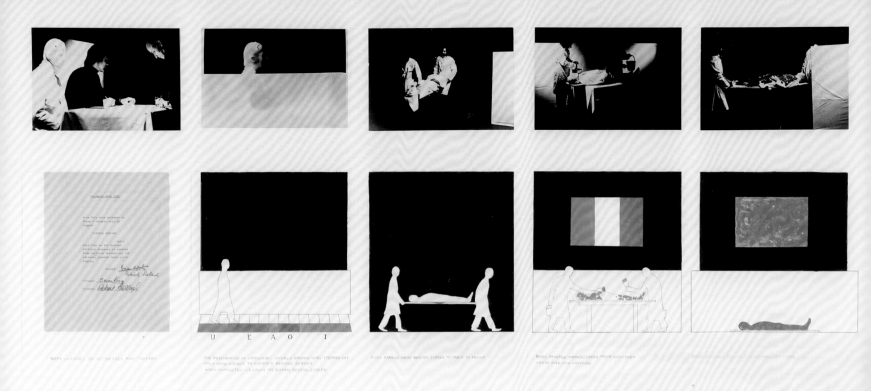

Simultaneously it complicated artistic reputation and challenged Greenbergian formalism by becoming a unique memorial through use of a name contingent upon history. The gesture remained open-ended for thirty-six years until the advent of peace and a power-sharing government in Northern Ireland made the name change redundant. In a formal ritual of burial in May 2008, an effigy of Patrick Ireland, with a face-mask of the artist by Charles Simonds, was laid to rest in IMMA, marked by a simple gravestone. As the 'reborn' Brian O'Doherty, the artist continues to practice.

In addition to his major contribution to art critical discourse, Brian O'Doherty became a pioneering conceptual artist (see 'Conceptual Art') during the 1960s and, as Patrick Ireland, an installation (qv) artist from the early 1970s. His artwork is frequently presented, not as a physical object, but as a negotiation about the changing historical significance of images, language, the self and institutions of art. His work thus links art to the everyday world of the social, economic and political (see 'Politics in Irish Art'). In spite of operating within the 'institution' of the museum or gallery, his artworks successfully encourage critical reflection upon a range of cultural issues, including the role of the institution itself.

Although based in New York, O'Doherty/Ireland's art from the beginning of the conceptual period moved beyond specifically American concerns to engage with European intellectual ideas and the cultural legacy of his native Ireland. His work implies that the conditions of art, language, and the self are not 'natural' entities but rather, socially and historically constituted, and thereby mutable. His art eminently fulfils the criteria for the critical evaluation of Conceptual art outlined by Thomas Crow:

that it be living and available to lay audiences, and that it has the capacity to refer to the world beyond the traditionally esoteric one of the arts (Crow, pp. 212–42).

O'Doherty's multiple talents became evident as early as his training as a medical doctor in Dublin when he regularly exhibited, published poetry, and wrote critical essays about such artists as Jack B. Yeats and Mainie Jellett (qqv). Following qualification, he studied perception at Cambridge University and obtained a Masters degree in Public Health at Harvard University before abandoning medicine altogether in the late 1950s. Initially he worked in television and as art critic for *The New York Times* and *Newsweek* (see 'Critical Writing and the Media'), returning to art making in the early 1960s in the milieu of Post-Minimal, Conceptual art with such colleagues as Sol Le Witt, Dan Graham, Mel Bochner, Peter Hutchinson, Eve Hesse and Robert Smithson. As a critic, he made a major contribution to the debate about exhibition spaces with the seminal 'Inside the White Cube: The Ideology of the Gallery Space' (1976), essays first published in *Artforum*. The ubiquitous term 'white cube' to describe the Modernist gallery, was first coined in these essays (see 'Modernism and Postmodernism'). Contemporaneously, O'Doherty taught film at Columbia University and acted as part-time Director of the National Endowment for the Arts in the USA, positions held for over thirty years. In the 1980s he became an award-winning film-maker with *Hopper's Silence*, and novelist in the following decade with *The Strange Case of Mademoiselle P*.

The deliberate creation of alternative personae throughout O'Doherty's art, more commonly found in literature than visual art, signalled a central theme: identity, specifically that of the

Romantic artist. This meta-artistic device also applied to some of O'Doherty's critical and fictional writings. As 'Mary Josephson', for example, he wrote articles on Andy Warhol and Jimi Hendrix for *Art in America* when O'Doherty was editor in the early 1970s; 'William Maginn' was an alternative narrator in O'Doherty's novel *The Deposition of Father McGreevy* (1999); 'Sigmund Bode' provided the fictitious 'editorial text' for *Aspen 5+6* [49], an early conceptual exhibition devised by O'Doherty himself (1967).

While O'Doherty/Ireland's mature art evolved within the context of New York, it was inflected by re-conceptualized elements from Irish culture like the linear Ogham script in use from the second/third century AD until the fifth/seventh century, and a labyrinth based on the pre-Christian St Bridget's Cross. He maintained his link with Ireland as external examiner at NCAD and as a member of the inaugural Board of IMMA in 1991. Twenty years earlier, in 1971, O'Doherty had curated and written catalogue essays for *The Irish Imagination: Irish Art 1959–1971*. Part of the 1971 *Rosc* exhibition, these essays became landmarks of Irish criticism as one of the first attempts to position Irish modern art within historical and international contexts. In a departure from catalogues at the time, the volume included a poem by W.B. Yeats and contributions from literary as well as art critics.

As an artist based in a major art centre abroad, O'Doherty introduced international ideas and forms to a small, relatively isolated, Irish art world. In 1977 he, with James Coleman (qv) (then based in Milan), became the first Irish artists admitted to the international Rosc exhibitions (qv). Both formally introduced post-modern art forms to Ireland. Coleman submitted a video *Box (ahhareturnabout)* (1977) [228, 325] while Ireland offered the documentation of his earlier 1972 *Name Change* gesture together with an installation *Rope Drawing #34*. The jury controversially rejected the former.

O'Doherty/Ireland's art is conceptually rich, multi-layered and visually appealing. It has always maintained its distinct vision through a dazzling array of subjects, themes and sub-themes. Through a repertoire of drawings, sculptures, gestures and installations, O'Doherty/Ireland probes the contradictions and complexities of self and other, language and silence, seeing and not seeing. Drawing (qv) and the consistent use of his own hand distinguished his work from most other Conceptualists, as well as his use of an archaic linguistic medium. Key works of the conceptual period were the introduction of the labyrinth (1967), one of the earliest non-gallery exhibitions, *Aspen 5+6* (1967), and the Duchamp portrait (1966/67) [388], which challenged aspects of Duchamp's legacy. Duchamp has often been cited as the chief source of O'Doherty/Ireland's work. Closer examination reveals many sources, in particular the literature of Flann O'Brien and James Joyce (Moore-McCann, pp. 18–20).

'Joycean' works appeared in different media over the decades: *In the Wake (of)* (1963), a box sculpture where viewers can make their own 'Wake' text; a drawing using ropes, *Purgatory* (1985), the first full-room installation in Ireland in the DHG; and *HCE (Redux)* (2004), another such drawing for the centenary of Bloomsday at the RHA Gallagher Gallery.

The centrality of drawing in the oeuvre is fully underlined by the name Patrick Ireland gave to his installations, 'Rope Drawings' [80, 234]. Ireland's contribution to installation art frames the viewer *inside* the drawing, creating integration of figure and ground, form and content. For over thirty-six years, these installations sculpted interior space from floor to ceiling. Inside and outside become blurred as one moves through prepared spatial volumes while 'doors and windows' painted on surrounding walls seem to invite exploration of spaces beyond existing physical boundaries. At certain points on the odyssey, rope lines frame painted motifs and colours appear to move forward or recede, depending on the colour employed. As far removed as possible from the white cube described in O'Doherty's essays, the 'Rope Drawings' coax active participation and a sense of discovery. With an acute awareness of looking that lingers in the memory, the 'Rope Drawings' multiple layers of reference to architecture (Borromini, Bramante), cinema (*Citizen Kane*), literature (Sartre, Rimbaud), science (Newton), dance (Fred Astaire), art (Tatlin, Hopper), music (Morton Feldman), and history (Northern Ireland, Vietnam, Berlin), become powerful conductors of energy that provoke thought. They stand as major contributions to contemporary art that also successfully avoid the lure of the marketplace.

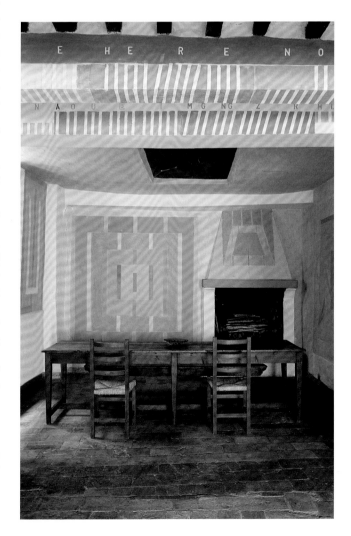

338. Brian O'Doherty/ Patrick Ireland, *Ogham Alphabet and One, Here, Now* (Irish, English, Italian), 2005–06, water-based house paint, Casa Dipinta, Todi, Italy

Drawing has been a constant preoccupation for both O'Doherty and Ireland. Ireland restricted himself initially to wall painting [338] and 'Rope Drawings'. Bridging a gap of over thirty years, he returned to easel painting in the 1990s, allowing further exploration of abiding concerns. This development coincided with the move into fiction with his first novel *The Strange Case of Mademoiselle P*, receiving a prize from the British Society of Authors. His second novel, *The Deposition of Father McGreevy* (1999), was shortlisted for the Booker Prize in 2000.

His work is included in the collections of the Metropolitan Museum in New York, the Hirshhorn Museum & Sculpture Garden, the National Museum of American Art and the National Gallery of Art, all in Washington DC, IMMA, HL and NGI in Ireland, and Centre Georges Pompidou, Paris. BRENDA MOORE-MCCANN

SELECTED READING Thomas Crow, 'Unwritten Histories of Conceptual Art,' in *Modern Art in the Common Culture* (New Haven and London 1996); Alberro and Stimson, 1999; McEvilley, 2005; Brian O'Doherty/Patrick Ireland, *Beyond the White Cube: A Retrospective of Brian O'Doherty/Patrick Ireland*, exh. cat. HL (Dublin 2006); Brenda Moore-McCann, *Brian O'Doherty/Patrick Ireland: Between Categories* (Farnham 2009).

O'DONOGHUE, HUGHIE (b. 1953) [339, 340], painter. '… he is one of the relatively few contemporary artists to convincingly attempt history painting in the grand sense of the term' (Aidan Dunne, *IT, Weekend Review*, 29 May 2010).

Born in Manchester to Irish parents and educated both there and in London (the Royal College, and Goldsmiths College, University of London), O'Donoghue speaks of the formative influence of the Manchester City Gallery. Childhood holidays were spent at his maternal grandparents' home near Erris, Co. Mayo.

Although O'Donoghue's early work, especially during the course of his MA studies, explored the abstract formalism that dominated Western art at that time, he quickly abandoned it in favour of an art practice more directly referencing external reality. The pervasive theme running through his painting since the 1980s has been the vulnerability and endurance of the human body, particularly the male body, which he has traced from the dawn of history through paintings of Danish bog bodies, to European myths of the heroic, to his own family's more recent and intimate memories (see 'History Painting'). A residency at the NGL in 1984, and a year in Italy, cemented his regard for Italian Renaissance painting, particularly the work of Titian and Michelangelo. His most important commission, from the American collector Craig Baker in 1986, inspired by their mutual admiration for historic religious paintings, was to explore the possibilities of a contemporary equivalent of Old Master depictions of the Passion of Christ. The resulting body of paintings – monumental charcoal drawings and prints – executed over an extended period of some fifteen years, epitomizes O'Donoghue's attempts to reconcile his interest in the human body with abstraction (qv) and the language and activity of painting. In this series of artworks, the Christian story of the Passion is universalized through the suppression of detail, allowing an ill-defined but suffering body to emerge from an Expressionist colour field.

O'Donoghue works and reworks his paintings, so that time itself becomes an element, along with the massiveness of the canvas panels and the weight of his pigments. The execution of *Blue Crucifixion* (part of the original Craig Baker commission and now in the collection of IMMA), one of his largest paintings, spanned the ten years from 1993 to 2003, during which

339. Hughie O'Donoghue, *Crossing the Rapido*, 1998, graphite wash on canvas, 325 x 686 cm, Irish Museum of Modern Art

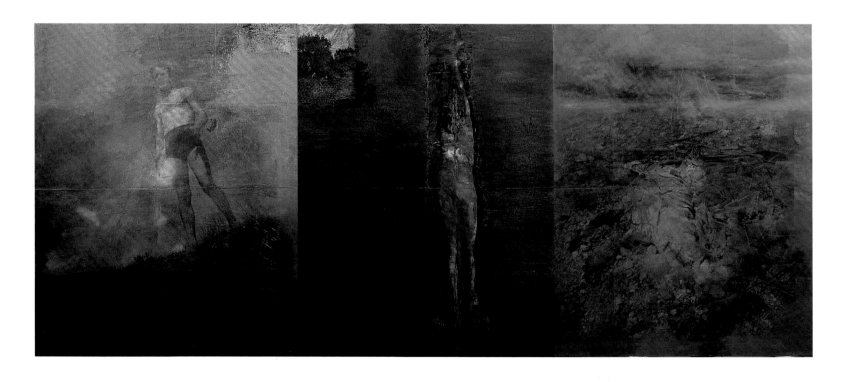

O'Donoghue moved with his family from England to County Kilkenny.

He accepted a residency at IMMA in 1995, while continuing to work on the Passion series, 'Via Crucis'. The opportunity unleashed an examination of individual history in the context of wider narratives of conflict, struggle and survival, embracing modern and ancient wars, and opened up new possibilities for the imaging of history. Sorting through papers of his recently deceased father, O'Donoghue discovered letters and photographs from his father to his mother, documenting his experiences during the evacuation of Dunkirk, the battle for Monte Cassino and other scenes of conflict during World War II. The result was the fusion of this very personal narrative with the public history of that war. It also led to a new and innovative form of history painting, in which enormously enlarged details from the photographs, sometimes with text from the letters, are combined with pigment to make paintings as monumental as those of the great Renaissance painters, but with a new concentration on ordinary figures who are, nonetheless, heroic. In this, O'Donoghue could be said to combine the achievements of Titian and Michelangelo with those of Picasso and van Gogh, the last of whom is overtly referenced in a body of paintings called *The Yellow Man* (2008).

O'Donoghue challenges the authority of history and associated ideas of scale and monumentality in the installation *Anabasis* (2003, IMMA collection) in which he uses a pre-war edition of the *Encyclopaedia Britannica* into which photographs from his parents' war-time lives are superimposed, along with text from Xenophon's account of the retreat of 10,000 Greek mercenaries from Persia. Instead of the physically monumental, it is the optimistic ambition of the encyclopaedic project to represent the sum of all history and knowledge that the work examines, its shortcomings revealed by the intimacy of the personal photographs.

Subsequent bodies of work, fusing photography, charcoal and paint, focus more on personal memories than on public history. O'Donoghue's heritage of poverty and emigration, resulting from famine and rural hardship in Ireland, provides the basis for individualized images of universal diaspora, especially when combined with archetypal stories such as the biblical story of the Prodigal Son (see 'Diaspora and the Visual Arts'). The emotional charge of these images becomes all the more powerful, the artist believes, because they derive from memory rather than from history. 'Although it [memory] is not always accurate, it is always true; it tries to present the truth as it is felt' (O'Donoghue, *Naming the Fields*, Dublin 2001, p. 6).

Although primarily a painter, O'Donoghue executed a major stained-glass project for the Chapel of the Bons Secours Hospital, Galway in 2005, developing a new technique that enabled him to work on curved glass without the interruption of traditional stained-glass armature. His solution was to sandwich painted layers of high resolution photographic images on translucent film between huge sheets of curved glass, which can be read effectively from both inside the building during the day and from outside at night, when the chapel is illuminated. His literary collaborations include working with the poet Seamus Heaney in 2004 to illustrate *The Testament of Cresseid*, Heaney's

modern version of the Chaucerian story of Troilus and Cressida, as translated by Robert Henryson.

O'Donoghue has exhibited widely in solo shows throughout Europe, and in group exhibitions as far afield as China and the USA. IMMA has a particularly strong collection of his work. In addition to a number of purchases, the museum received a donation of thirty-nine artworks from Craig Baker's collection, gifted through the American Ireland fund. O'Donoghue's work can also be seen in the AC/ACE, HL and CAG in Ireland, the Arts Council of Great Britain, the NGL, the Imperial War Museum, the British Museum and the Yale Centre for British Art in New Haven, and in important regional and university collections in Ireland, Britain and Australia. CATHERINE MARSHALL

SELECTED READING Christoph Vitali, *Hughie O'Donoghue: Via Crucis*, exh. cat. Haus der Kunst (Munich 1997); Craig Baker, *O'Donoghue: Episodes from the Passion*, exh. cat. RHA Gallagher Gallery (Dublin 1999); James Hamilton, *Hughie O'Donoghue: Painting, Memory, Myth* (London and New York 2004); Seamus Heaney and Hughie O'Donoghue, *The Testament of Cresseid* (London 2004); Maeve Butler (ed.), *Hughie O'Donoghue* (Dublin 2009).

340. Hughie O'Donoghue, *Oxygen*, 1993, charcoal and dry pigment on cotton duck prepared with gesso, 267 x 236 cm, Irish Museum of Modern Art

O'DOWD, GWEN (b. 1957) [341], painter. From the date of her first solo show at the Project Arts Centre in Dublin in 1984, O'Dowd has maintained a reputation as one of Ireland's foremost contemporary artists, who carries forward a tradition developed in the 1950s by Nano Reid, Patrick Collins and Camille Souter (qqv). Her paintings use abstract elements of landscape (qv) as the basis for compositions, the artist adding layers of oil paint, mixed with materials such as wax, to create complex weathered surfaces that are rich in colour and depth. Writing in 1989, Julian Campbell emphasized the importance of the scratched and striated surfaces of O'Dowd's paintings: 'In spite of their abstraction, there is a gritty "down to earthness" about them – a sense that they are somehow involved with her real experiences and natural environment.' (Campbell, p. 3) Campbell also pointed out another essential element in O'Dowd's work, a sense of mystery, an inclination towards the sublime, heightened by the artist's preference for dark, intense colours and her focus on aspects of the landscape, such as cliffs, caves and rock pools. In more recent years, however, O'Dowd's paintings have become freer, more expressive and even lyrical.

After graduating from NCAD in 1980, O'Dowd was one of the founder members of the VAC in Great Strand Street, Dublin. In 1984 she used the George Campbell (qv) travelling scholarship to travel to Spain for several months. Over the following years, she produced paintings that are meditative, sombre and intensely felt. A journey to Wales in 1986 resulted in paintings that form a visual diary, recording the ascent of Snowdonia. Explorations of the Dublin coastline resulted in another series evoking sea and shore. Works inspired by a visit to the Grand Canyon were shown at the Kerlin Gallery in 1995; other paintings were inspired by the Burren in the west of Ireland and the frozen landscape of Alberta. Always conscious of damage inflicted by mankind, one series of O'Dowd's work was inspired by the 1991 Gulf War. As well as solo exhibitions

341. Gwen O'Dowd, *Ice Fields*, 1990, oil on paper, 18 x 26 cm

at the Hillsboro, Kerlin and Vangard galleries, she has shown at the Butler Gallery, Kilkenny (1989), the West Cork Arts Centre, Skibbereen (1989) and the RHA's (qv) Ashford Gallery in 2000. She has also participated in many group shows, including the IELA (qv), Independent Artists, the *Parable Island* exhibition at the Bluecoat Gallery in Liverpool in 1991, *Re/Dressing Cathleen* at the McMullen Museum at Boston College in 1997, and *Éire Land*, held ten years later, also at the McMullen Museum.

O'Dowd is a member of Aosdána (qv) and her work can be found in the collections of the AC/ACE, ACNI, AIB, IMMA and CAG. PETER MURRAY

SELECTED READING Julian Campbell, *Gwen O'Dowd: Paintings*, exh. cat. Butler Gallery (Kilkenny 1989); Rosemarie Mulcahy, *Works 13 – Gwen O'Dowd* (Dublin 1994), pp. 12–25; Brian McAvera, 'Composing the Elements', *IAR* (Spring 2004) 77–84.

O'KELLY, ALANNA (b. 1955) (qv *AAI* III), performance, multi-media artist. Alanna O'Kelly's work is inspired by a deep and intuitive sympathy with humanity and nature. Roderic Knowles cites the critic Dorothy Walker as saying: 'Her work is the most rigorous in the pursuit of its own ends' in reference to O'Kelly's early career when she made artworks from organic materials, often sited in natural habitats, and using archetypal forms that refer to such things as boats and shelters, to tap into universal, as well as Irish, folk knowledge (Knowles, p. 211). As Walker went on to point out, that work had a lightness of touch that defied conventions about monuments, but it made a powerful impact for that reason when brought indoors at the *Without the Walls* exhibition at London's ICA in 1980. Towards the late 1980s O'Kelly's work moved increasingly in the direction of performance, fusing this with a radical and experimental use of new technologies, especially video, sound and slide projection or combinations of these (see 'Time-based Art' and 'New Media Art'). Since 2000, her practice has been devoted to performance art which she also teaches.

The destructive politics of the race for nuclear armaments provoked the first important video and performance work, *Chant Down Greenham* (1984), in which O'Kelly added traditional Irish keening or lamenting to images of the human chain that was attempting to preserve Greenham Common in England from the establishment of a Cruise Missile base there. Other work, using tape/slide technology included *Dancing with my Shadow*, shown at the DHG's important *Irish Art of the Eighties* exhibition in 1990, and *Echoes II* [342]. But it was for her work in commemorating the Great Famine of the mid-nineteenth century that she became widely known.

Like all O'Kelly's work, the three Famine-related installations, collectively entitled *The Country Blooms, A Garden and a Grave* [3, 326], that won her the first IMMA/Glen Dimplex Artists Award in 1994, and *Á Beathú*, the work that she subsequently showed when she represented Ireland at the São Paolo Biennial in 1996, had a long gestation, being developed, shaped and reshaped from performances and photomontages since 1990, as the artist refused to hurry her composition. Fed by a sense of the guilt, humiliation and anger that Irish people have

342. Alanna O'Kelly, *Echoes II*, performance with Trish Haugh, Douglas Hyde Gallery, 1983

discomfort with the commodification of artwork as a 'thing to be bought and owned', means that little of O'Kelly's work is saleable and therefore acquirable by public collections. As Medb Ruane said of her: 'You're not known as an artist who's an opportunist' (Ruane, 1996).

In 1996 IMMA acquired *Sanctuary/Wasteland* [326], one of the three installations that made up *The Country Blooms, A Garden and a Grave* and photographic montages with text by her can be seen in the collection of the Crawford Gallery, Cork. *No Colouring can Deepen the Darkness of Truth* (1992–95, ed. 1 of 3), another work from her IMMA/Glen Dimplex trilogy, was installed in the Workhouse Famine Museum in Carrick-on-Shannon in 2008, making it the only work by this influential artist to be placed on permanent display. It has also been acquired by Ireland's Great Hunger Museum, University of Quinnipiac.

Born in Gorey, Co. Wexford, O'Kelly studied at NCAD and the Slade School of Art in London. She has worked and performed in venues in Europe and in North and South America, and in many different environments from Lapland – where she designed and built a snow house in which she lived for some time – to the United States, where she participated in the 1987 Women's Caucus of the Arts in Boston.

O'Kelly's work has been shown in such exhibitions as *Without the Walls*, during the *Sense of Ireland Festival* in London in 1980, *Irish Women Artists*, NGI and HL (1987), *Irish Art of the Eighties*, DHG (1990), *IMMA/Glen Dimplex Artists Award Show* (1994), *L'Imaginaire Irlandais*, Beaux Arts, Paris (1996), *Representations of the Famine*, Dublin, Cork, Belfast and Castlebar (1998/99), *Irish Art Now*, Boston, Philadelphia, Halifax, Chicago and Dublin (1998–2000) and *Views from an Island*, Beijing and Shanghai (2003). CATHERINE MARSHALL

SELECTED READING Knowles, 1982; M. Ruane, 1996; Jean Fisher, *Alanna O'Kelly* (Dublin 1996).

internalized ever since the Famine, by her personal experience of living in Britain in the 1980s, which inspired thoughts about earlier emigrations from Ireland, and by her awareness of starvation around the world, O'Kelly understood what official attempts to commemorate the Famine a few years later did not; that no amount of bronze monuments could ever assuage those emotions until the nation had first acknowledged the scale of the trauma and had mourned its dead, and the damage to its culture.

That is what O'Kelly set out to do, through performances and installation art (qv) that involved sound and photographic imagery. By pulling together the sounds of keening, breathing, panting, praying, singing, incorporating the Irish language (the first language of many of the victims of the Famine), images of nature with its traces of the old potato growing patterns, and signs of rebirth, O'Kelly was able to lead viewers through a complex cycle of powerful and cathartic emotions. Subtle references to contemporary Africa and Asia force viewers to question their own complicity in supporting systems that enable the continuation of similar tragedies in the world today.

An important factor for performance artists is the immediacy of the experience in real time which cannot be mediated by anyone other than the viewer and the performer. This, and a

O'KELLY, MICK (b. 1954) [343], artist. Mick O'Kelly's work foregrounds issues of social need over aesthetics, or to put it differently, his work questions traditional aesthetic values, the role of art and the gallery system in the face of marginality, exploitation and imbalances of power. It asks how an artwork that consciously ignores those realities can be beautiful.

Educated at the College of Technology, Dublin, NCAD, the California Institute of the Arts and holding a practice-based PhD from the University of Ulster, O'Kelly began his art practice with photography (qv), but his training in technology and construction empower him to work comfortably with large three-dimensional projects, and to teach sculpture at NCAD.

Almost immediately after his graduation, O'Kelly's work was selected by Lucy Lippard for inclusion in *Divisions, Crossroads, Turns of Mind*, which travelled to venues in the USA in 1985. Three photographic works with overlaid text, from his series 'Allegories of Geography' (1987), shown in the Politics section of *A New Tradition: Irish Art of the Eighties* at the DHG in 1990, cemented the association of his art with social issues. This was furthered by his work for the Irish Congress of Trade Unions and residencies at the Semperit Tyre Factory, Ballyfermot

343. Mick O'Kelly, *Nomadic Kitchen*, 2005–07, a participatory art event in the Vila Nova Favela, São Miguel, São Paolo

(1991–95) and at Wheatfield Prison, Clondalkin, Dublin (1991). If that early activity revolved around place and the ownership of it, later work deals with homelessness, identity, racial prejudice and sustainability, often in more practical ways. Examples of this include a van, kitted out to feed the homeless, which he installed in TBG+S in 2005 for his solo exhibition, and *Nomadic Kitchen* at Vila Nova, São Miguel, São Paolo in 2006. His contribution to *Breaking Ground*, the art project devised as part of the Ballymun Regeneration programme, was to make working beehives from models of the demolished tower blocks.

O'Kelly has had solo exhibitions in Dublin, especially at the Gallery of Photography, where he was included in the inaugural exhibition at the new gallery in 1996, at Lahti in Finland, Frankfurt, London and Santa Monica in California. He was commissioned by the Public Art Development Trust to make artwork for Pier 4A at Heathrow Airport, and for *An Leabhar Mór/ The Great Book of Gaelic* (2002), and he was one of the artists included in *L'Imaginaire Irlandais* in Paris in 1996.

O'Kelly's work is in the collection of the Arts Council (qv) and in many private collections. CATHERINE MARSHALL

SELECTED READING *A New Tradition*, 1990; Paul McAree (ed.), *Breaking Gound, 2001–2009* (Dublin 2009).

O'MALLEY, TONY (1913–2003) (qv *AAI* III) [267, 344], painter. Tony O'Malley was born in Callan, Co. Kilkenny. His father, a native of Clare Island, Co. Mayo, moved to Callan where he and his wife raised a family of four children. From a young age, O'Malley drew and painted, but for his generation and background a career as an artist was not an option. He joined the Munster and Leinster Bank as a clerk in 1934. During this time he received various postings in the provinces and used his spare time to continue his passion for drawing and painting. There are a number of extant works on paper from this period.

In the early 1940s, O'Malley was diagnosed with tuberculosis and spent the next decade alternating between periods of convalescence, during which he painted full-time, and periods of employment, dictating a return to a part-time approach to art. O'Malley received no formal art education but the influence of

Cézanne and van Gogh, known mainly through reproduction, can be seen in work of this period.

In 1955 O'Malley visited St Ives in Cornwall for the first time. St Ives was known then as a vibrant centre for post-war British abstraction. Ben Nicholson and Barbara Hepworth had settled in the town, as had artists like Bryan Winter, Patrick Heron and Terry Frost. O'Malley attended the St Ives' Loft School, run by the painter Peter Lanyon, to whom he became very close. He returned to St Ives again in 1956 and 1957 and, in 1958, left his bank job on health grounds to apply himself fully to painting. In St Ives, O'Malley had discovered abstraction (qv) – not the formal abstraction of the surrounding British School, but a sense of abstract geometry and structure within the landscape itself. He was close in sensibility to Lanyon, a native of Cornwall, and O'Malley spoke of a Celtic spiritual bond in their work (he frequently signed his work using the Irish form of his name, Antoine Ó Máille) [2].

O'Malley became increasingly frustrated by rigid, conservative perceptions of the visual arts in Ireland which, in the 1950s, were still dominated by Dublin and warring Modernist and academic factions.

In 1960 O'Malley moved permanently to St Ives, for him the perfect base from which to build a practice and maintain his health. In 1961 he suffered a heart attack and spent the initial phase of his recovery with his friends, the Redgraves, well-known for their support for artists in the area, although later, at the insistence of Patrick Heron, he joined him at Heron's house, Eagles Nest. He was to finish his recuperation at Trevaylor House, the home of Nancy Wynne Jones (qv). He knew Wynne Jones through her partner, Conor Fallon, the sculptor and son of the poet Padraic Fallon, whom O'Malley knew from Wexford when he was employed in the bank there.

O'Malley moved easily from representational to abstract forms, seeing them both simply as a different emphasis to suit what was being pursued in the subject. His work practice established itself very quickly in St Ives, with daily sessions of observational drawing and studio painting. His style in that period involved flattening the subject, whether person or landscape, and his palette was in the sombre range, composed of browns, greys and blacks. O'Malley generally worked his oils on board (hardboard in the main); the hard surface offered resistance to the brush and carried the struggle of its making. In 1964 Peter Lanyon tragically died at the age of forty-six in a gliding accident; O'Malley was deeply affected by the loss. That year O'Malley made a painting on Good Friday. Each year, thereafter, he would make an elegiac painting on that day, which for him carried associations of pagan Ireland as well as more modern Christian history.

In 1969 the Arts Council of England offered O'Malley a subsidized studio and cottage in St Ives; as a result, Seal Cottage became his home for the next twenty years. The studio was in a large old sail loft above Porthmeor beach. So dedicated was his practice that in 1981 he was painting in the corner in a space the size of a generous kitchen table, surrounded by his output of over a decade.

In 1973 Tony O'Malley married the younger Canadian painter Jane Harris and they worked productively alongside

344. Tony O'Malley, *Inagua Bahamas*, 1983, acrylic on canvas, 122 x 152.4 cm, private collection

each other, although never collaboratively, for the remainder of his life. Yearly, they would travel to the nearby Isles of Scilly and later, farther afield, to spend lengthy periods of the winter sketching and painting. The light of the Scilly Isles and perhaps Jane Harris's palette saw a widening of the spectrum of colour O'Malley employed. These Scilly works were mainly painted in gouache with free-flowing flips, from figurative studies of his wife to abstract renderings of swarms of birds in flight, and even more abstract representations of bird song. In the mid-1970s, the O'Malleys began to travel annually to the Bahamas to visit Jane's family. If the light of Scilly was to open the door of colour, the experience of the Bahamas was to take it off its hinges.

There is a breath to O'Malley's oeuvre that is unique in twentieth-century Irish art. Pencil, watercolour, gouache and oil were further widened in their application to paper, canvas and board and were joined by found objects in the three-dimensional constructions that form in themselves a separate body of work. His art was as challenging in figuration as it was in abstraction, crumbling the barriers of Modernist progression to which his generation was so attached.

O'Malley's subjects equalled the range of his style. The historical aspect delved into the implements and the labour of the farmed field, and back into the reaches of Celtic myth and Norman settlement. He was profoundly interested in music, both the heritage of Irish folk music and the music of bird song. Similarly, landscape (qv), figure, still life and Christian imagery

(see 'Religion and Spirituality') all came under his purview. He worked the surfaces of his paintings in a variety of ways, particularly using a scalpel to score the surface of his hardboard ground to create a ridged and active picture plane.

In 1981, in one of the first acts of official recognition of his work, the AC/ACE (qv) invited O'Malley to form an exhibition. Entitled *Miles Apart* and containing twenty works, the show contrasted ten works from his native Kilkenny with ten works executed in the Bahamas, and travelled to five venues throughout Ireland. In 1978/79 his work was championed by the artist, agent and collector George McClelland, and O'Malley established a relationship with the Taylor Galleries, with whom he was to exhibit regularly from then on. The mid-1980s saw the consolidation of his reputation, with an AC/ACE retrospective exhibition shown in the UM, DHG and CAG. A documentary on O'Malley's life, *Places Apart*, directed by Muiris Mac Conghail, was produced and broadcast by RTÉ in 1982.

The O'Malleys returned to live in Callan, close to his birthplace, in 1990. Though now in his late seventies, there was no let up in his production. In 1993 he was elected a *Saoi* of Aosdána (qv), the highest award that could be bestowed by his fellow artists. Other awards included an honorary doctorate from TCD (1994) and the IMMA/Glen Dimplex Award for sustained contribution to the visual arts in Ireland (1999).

Tony O'Malley died in his ninetieth year, while working on one of the largest canvases he ever attempted. His work was

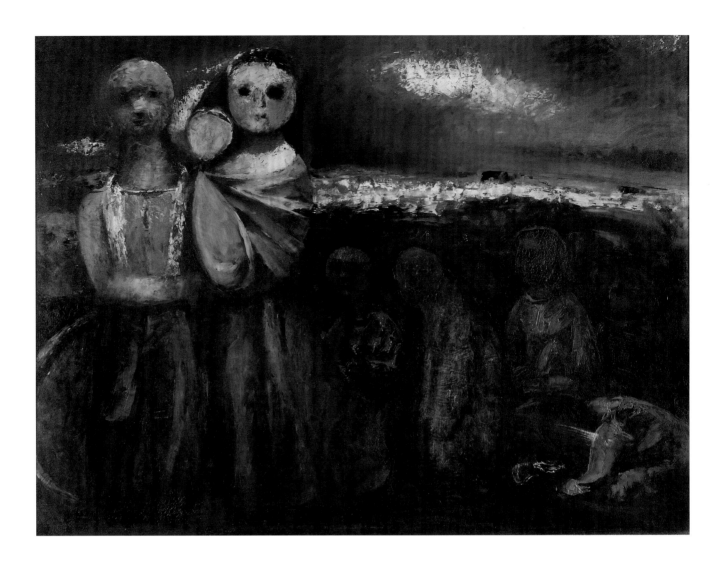

345. Daniel O'Neill,
Family, 1970, oil on
board, 45 x 60 cm,
Crawford Art Gallery

posthumously celebrated in a retrospective exhibition at IMMA in 2005, curated by Caoimhín Mac Giolla Léith. O'Malley's work is in all the major public collections in Ireland and in the collections of the AIB and BoI. A gallery devoted to his work will form part of the new premises to which the Butler Gallery, Kilkenny, plans to move in the near future. PATRICK T. MURPHY

SELECTED READING Brian Lynch (ed.), *Tony O'Malley* (Berkeley and London 1996; repr. Dublin 2004); Peter Murray, *An Irish Vision: Works by Tony O'Malley*, exh. cat. Kennedy Center, Phillips Collection (Washington DC and Kinsale 2000); Caoimhín Mac Giolla Léith, Catherine Marshall and Brian Fallon, *Tony O'Malley: Retrospective*, exh. cat. IMMA (Dublin 2005).

O'NEILL, DANIEL (1920–74), painter. Born in Belfast, O'Neill was the son of an electrician. When he left school at the age of fourteen, he too trained as an apprentice electrician, working in the Belfast shipyards and as a housepainter on building sites. An early interest in art led O'Neill to take life-drawing classes at the Belfast College of Art, where he befriended the painter Gerard Dillon (qv). He also worked

for a time in the studio of fellow Belfast artist Sidney Smith. After the 1941 air raids on Belfast, O'Neill salvaged wood from the destroyed buildings and experimented with wood carving. His first exhibition, a group show, was held that year at the Mol Gallery in Belfast. In 1943 he had a joint exhibition with Dillon at the Contemporary Picture Galleries in Dublin, and the following year he moved to London, painting and, once again, working on building sites. In 1945 O'Neill was taken on by the Victor Waddington Gallery in Dublin, which showed his first solo exhibition in 1946. The gallery provided him with an income that allowed him to paint full-time for a number of years. Three years later he visited Paris, where he saw the work of older contemporary painters such as Vlaminck and Utrillo.

In his foreword to the CEMA *Loan Exhibition of Paintings 1944–52*, the poet John Hewitt wrote:

It is easy enough to recognize Daniel O'Neill's individual quality, but a much more difficult matter to define it. The critic may call him an out and out romantic; he may assert that O'Neill's vision is narrow but deep; that his colour range is restricted but subtle; that he treats his pigments

with affection … that his work has both a sensory and a sensual quality; that, though his subjects have, above all, a lonely poetry, he handles with most confidence the great common-places of being: birth, death, love, belief, wonder.

O'Neill's painting *Family* (part of the Great Southern Collection at CAG) [345] depicts two women – one holding a child – leading a group of people along a dark road. As with most of O'Neill's paintings, the date, location or identity of the people is not specified. At one level, it can be read as depicting a family in the west of Ireland making its way home at dusk along an unlit road. The painting can also be read perhaps as evoking the plight of refugees, fleeing from a conflict. His painting *Birth* dates from 1952 and is filled with that same characteristic sense of morbidity and foreboding. In 1950 an exhibition of new Irish painting was shown at the Institute for Contemporary Art in Boston. Selected by the director of the Institute, the exhibition included works by O'Neill, Gerard Dillon, Louis le Brocquy, Nevill Johnson and Colin Middleton (qqv).

O'Neill returned to Ireland in the early 1950s, where along with Gerard Dillon and George Campbell (qv), he became a member of the Ulster Contemporary Group. He settled with his wife and child in the village of Conlig, Co. Down, where Campbell and Dillon were also living and working. However, O'Neill's restless nature did not allow him to settle for more than a few years in any one place. In 1958, the year he represented Ireland at the Guggenheim International, he moved again to London, and travelled also on the Continent. In 1968 he was in Dublin, designing sets and costumes for Seán O'Casey's *Juno and the Paycock*. Although an exhibition of his work at the McClelland Gallery in 1970, his first one-person show in eighteen years, was a commercial and critical success, the closure of that gallery the following year as a result of the 'Troubles' affected the artist badly. He died in Belfast four years later, at the age of fifty-four. PETER MURRAY

SELECTED READING Anne Marie Keaveney, 'Daniel O'Neill', in Marshall, 2005, pp. 50–58.

O'NEILL, TIMOTHY (b. 1947), calligraphic artist. O'Neill is such an important figure, as advocate, artist, teacher and lecturer on calligraphy and its history, that it is difficult to conceive of the practice in modern Ireland independently of him.

A member of the De La Salle brothers for a number of years, O'Neill taught art at the order's school, Saint Benildus College, Kilmacud, Dublin where his teaching nurtured pupils such as Denis Brown, one of the most distinguished of the next generation of Irish calligraphers. Monastic life and historical research (MA in Medieval History, NUI, 1979) complemented his attraction to the manuscript work of early and medieval Ireland. Speaking at an IRCHSS workshop at the School of Humanities, UCD on 12 March 2012 (published as an internet video by Mick Liffable, 25 March 2012), O'Neill acknowledged the influence on his own work of page design in the books of Kells and Durrow. He went on to discuss the challenges facing a present-day calligrapher, one of which was adapting historical scripts for contemporary use and reconciling script styles

associated with different languages in the text of a modern manuscript.

O'Neill's self-taught mastery of this and other aspects of calligraphy, and his association with Liam Miller of the Dolmen Press, led to important commissions, such as the design and illumination of an altar missal to mark the centenary of the Cistercian Abbey at Roscrea (1978), and a Gospel Book in memory of Cardinal Tomás Ó Fiaich for St Patrick's College, Maynooth (1994). Shorter but equally distinguished projects included addresses to Pope John Paul II (1979, 1988, 1997), from the Irish government to President Bill Clinton (1995), from Offaly County Council to President Barak Obama (2011), and many collaborative works with Seamus Heaney, one of which was commissioned by the poet as a gift to the RIA and later became a limited edition.

Although most of O'Neill's work can be described as calligraphy, there is an important conceptual element in it. An early example of this can be seen in *Prelude* (1980) [346], his manuscript version of a poem by J.M. Synge, in which the words 'Wicklow' and 'Glens', in the insular style, are not drawn but cut from Ordnance Survey maps which reference all the mountains, glens and youth hostels frequented by the artist and owners over a designated period. This aspect of his work is again evident in his interlace design for British Airways which formed part of their World Images series in the 1990s. O'Neill's image, named 'Dove' for St Columcille, was widely used by the company and was seen worldwide on the tailfins of twenty-four planes (1997). A temporary public art project, *Sea Angels*, was installed around the village of Derrynane, Co. Kerry (2001) and O'Neill designed two postage stamps to commemorate the Plantation of Ulster (2009). Informed by his thorough knowledge of early medieval manuscripts, in 2010 O'Neill reconstructed, for the NMI, several pages of the eighth-century *Faddan More Psalter*, found in a bog near Birr, Co. Offaly. A contributor to *A New History of Ireland* (Oxford 1987) and to *An Leabhar Mór/ The Great Book of Gaelic* (2002), O'Neill also featured in *Art in Ink: Contemporary Irish Calligraphy* (Chester Beatty Library, 2007).

O'Neill has designed medals for An Garda Síochána and has worked for TCD and the NLI. He was the Burns Scholar at Boston College in 1995 and was awarded the Clans of Ireland

346. Tim O'Neill, *Prelude by J.M. Synge*, 1980, handmade paper with pieces of Ordnance Survey maps, 30 x 90 cm, private collection

347. William Orpen, *The Artist's Parents*, n.d., oil on canvas, 169 x 138 cm, National Gallery of Ireland

Order of Merit in 2011. O'Neill's work can be found in the Vatican Library, the White House in Washington, the collection of the Emperor of Japan, Boston College, Notre Dame University, the NMI, NLI, RIA and OPW. CATHERINE MARSHALL

SELECTED READING Timothy O'Neill, *The Irish Hand* (Dublin 1984); Timothy O'Neill, *Airy Plumeflights* (Dublin 1994); T. O'Neill, 2012.

ORPEN, WILLIAM (1878–1931) [347], painter. The complex figure of William Newenham Montague Orpen dominated Irish art and art education (qv) for much of the twentieth century. Yet he has rarely received the level of appreciation his talent and his prodigious output merited in his native country. There are several reasons for this: the role he played as a cosmopolitan figure in touch with changing times, yet resolutely traditional in his own practice; the dogmatic reverence accorded to his teaching by artists who themselves went on to dominate officialdom in Irish art, through the institutions of the RHA (qv) and the DMSA/NCA; his identification with Britain during the Great War, which made him less welcome in Free State Ireland; and his absence from Ireland for most of the final decades of his life. Nonetheless, Orpen's achievements as a painter, his part in Hugh Lane's project to bring modern art to Ireland, his energetic presence in the DMSA, and his stature as a role model for younger artists made him an outstanding figure in Irish art in his time.

Waldemar Januszczak, describing Orpen as an Anglo-Irish protestant, believed that meant that he had a 'background and angers similar to those of Francis Bacon [qv], Anglo-Irish respectfulness on the one hand and the Irish immigrant's need to feign tameness when painting rich English people in London' ('Portrait of the Artist in search of himself', *Sunday Times, Culture Supplement*, 13 February 2005). However, there is no evidence of the kind of anger Januszczak refers to in Orpen's career or work, any more than there is any indication of 'feigned tameness' in the work of either artist.

Born and raised in Blackrock, Co. Dublin in a well-established bourgeois household, Orpen had a meteoric progression through the DMSA, which he entered at the age of twelve in 1891. As a second-year pupil in 1892/93, he won one of only twenty scholarships for the whole of the British Isles, going on to win four of five Queen's prizes that came to Ireland in his fifth year, two of which (anatomy and drawing from the antique) were also first prizes in the British Isles. The gold medal for drawing followed in his final year. An illustrious period at the Slade School in London ensued where he was taught by Alphonse Legros and Henry Tonks and where he and fellow student Augustus John quickly established themselves as the leading new talents. Orpen's painting *The Play Scene from Hamlet* won the Slade Summer prize in 1899 and that same year he showed his first two pictures at the NEAC, seen as the challenging alternative to the RA. Two years later his portrait of the collector James Staats Forbes and a subject picture, *A Mere Fracture*, were well received at the same venue.

Orpen married Grace Newstub in 1901 in London and, from then until 1915, lived between London and Dublin. Both places were exciting for a young artist. In Dublin, where he taught

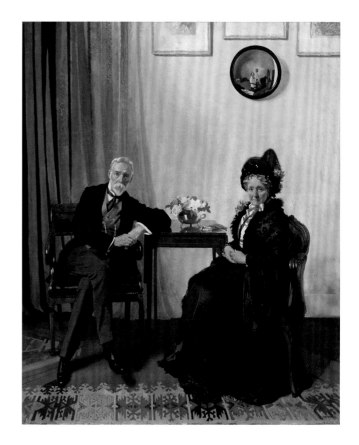

part-time at the DMSA from 1902 until 1914, he became part of the circle around George Moore and the Irish Literary Revival, helping Hugh Lane to organize the Guildhall exhibition of Irish art in 1904, travelling with him to look at painting in France and Spain, and acting as an adviser and supporter of Lane's efforts to establish a modern gallery in the city. In London the milieu he inhabited included Augustus John, William Rothenstein, who was married to Orpen's sister-in-law, and Walter Sickert, darling of the NEAC.

Orpen's early propensity for figure drawing led him towards subject pictures and inevitably, to portraiture (qv), then the most lucrative of art practices. Orpen excelled at this form of painting on both sides of the Irish Sea, to the point that John Butler Yeats, one of the most regarded of older Dublin portraitists, could write to his son William in 1906: 'At present my object is to paint better than Orpen – that is the only path of salvation. I have set myself to do it. I can already beat him in power of getting a likeness.' (Arnold, p. 140) Whatever Yeats may have thought, it was Orpen who completed seven of the twelve Irish portraits that Hugh Lane commissioned from Yeats. In London, he was seen as the rival to John Singer Sargent, then the leading society painter in Britain. Notable sitters included Lane, John Pentland Mahaffy, Orpen's lover Mrs Evelyn St George, her daughter Gardenia, George Moore and Anna Pavlova in Ireland, and Lady Rocksavage, Augustus John, the artist William Nicholson and his family, and Field Marshal Sir Douglas Haig in London. Winston Churchill said of Orpen's 1916 portrait of him: 'It is not the picture of a man. It is the picture of a man's soul.' (Carroll Carstairs, *Postscript to Criticism*, n.d., c. 1934, p.

43) *Homage to Manet* (1909, Manchester City Art Gallery) is a group portrait of Irish and English artists and critics, with the collector Hugh Lane, in front of Manet's portrait of Eva Gonzalès which Lane owned. Perhaps because of the constraints that are incumbent on society portrait painters, Orpen frequently painted and drew his own portrait, often in a comic fashion, or like his hero Rembrandt, posing in costume. The self-portraits form an important gloss on his life, full of the direct emotion and tension not acceptable in portraits of society sitters, and reveal a more expressive side of his personality.

If portraits paid the bills, it was subject pictures that really attracted Orpen. These ranged from dramatic literary and historical scenes (see 'History Painting') to an Irish typology which includes *The Knacker's Yard* (1909, NGI collection) and *Old John's Cottage, Connemara* (1908), interior pictures such as *The Mirror* (1900, Tate), *The Wash House* (1905, NGI collection), paintings of nudes such as *Sunlight* (c. 1925, NGI collection), and a number of airy outdoor scenes of his wife and his daughters which include *On the Beach, Howth* (c. 1910) and *A Breezy Day, Howth* [348]. In some ways the most interesting, though not the most successful, of these are three allegorical paintings executed by the artist between 1913 and 1916, experimenting with a new tempera-like paint medium that had a flattening effect on his work. The pictures *Sowing the Seed*, *The Western Wedding* and *The Holy Well* [40] depict different aspects of Irish life. They are highly stylized when compared to Orpen's more realistic manner, their use of nudity angered Irish viewers, and their allegorical meanings were not understood by contemporary audiences. What is clear is that the paintings were unequivocally critical of entrenched ideas about art, culture and religion.

Orpen joined the army as a war artist in 1917, remaining in the role as official painter of the ensuing peace process. Unlike most of his contemporaries, Orpen sought to record the horrors of trench warfare and the stoicism of the ordinary soldiers, rather than portraits of their leaders. An exhibition of 125 of his war works at Agnew's, London, in 1918, also shown in Manchester before it travelled to the USA, was visited by Queen Mary, and attracted very favourable attention. Orpen was knighted for his war work and subsequently gave 138 paintings and drawings to London's Imperial War Museum, although his painting *To the Unknown British Soldier in France*, voted picture of the year at the RA in 1923, was nonetheless rejected by the museum. Following alterations to remove depictions of two semi-nude soldiers, the picture was finally accepted in 1928. In addition to portraits of the main signatories, Orpen produced one of the most telling images of the Peace Conference of Versailles. The painting *The Signing of Peace in the Hall of Mirrors, Versailles, 28th June, 1919* [349], in its use of fractured reflections and the scale of the diminution of the signatories by the architecture, is portentous of the troubled history of the treaty itself.

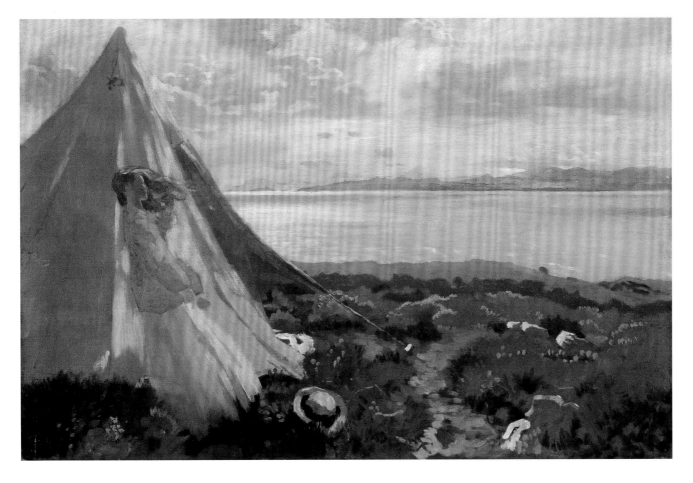

348. William Orpen, *A Breezy Day, Howth*, 1909, oil on panel, 40 x 61 cm, Dublin City Gallery The Hugh Lane

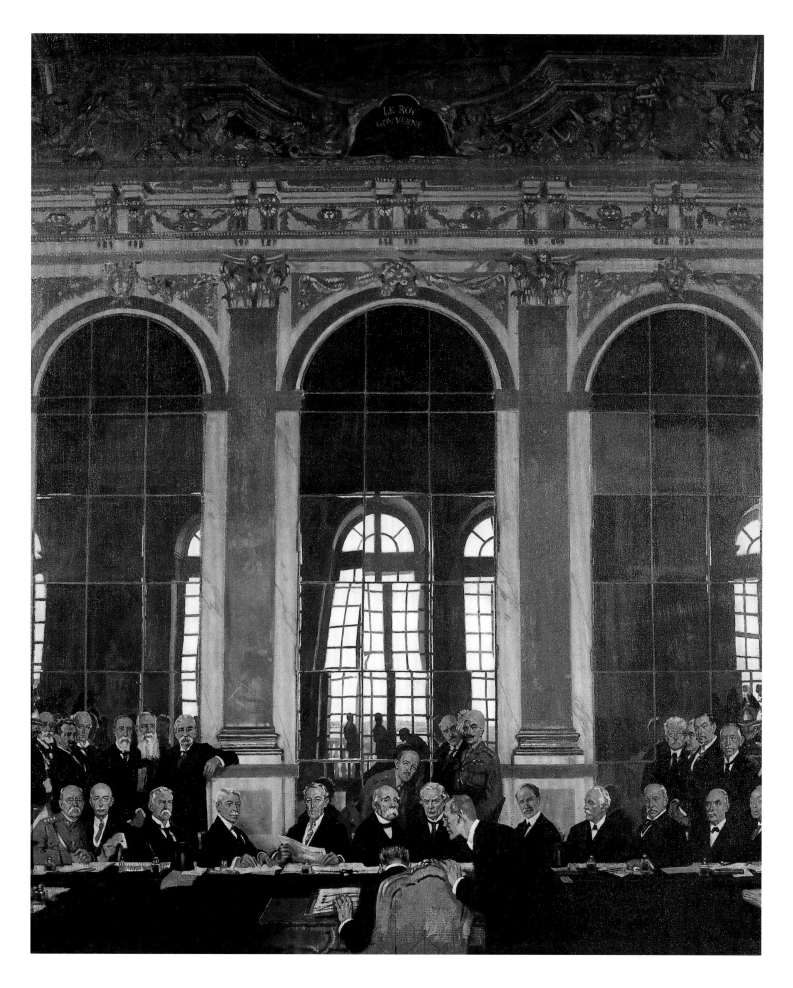

338

Orpen's attitudes to war and hierarchy are also given free expression in his book *An Onlooker in France* (1921). He subsequently published *Stories of Old Ireland and Myself* (1924) and in 1923 edited *The Outline of Art* (London 1923). Although *Stories of Old Ireland and Myself* reveals a fondness for his native country, Orpen never lived there after 1915. He had, however, revolutionized the life-drawing class at the DMSA by introducing professional models, and inspired an almost dog-like devotion among the most talented of his students. Of these, Seán Keating was the most prominent, but other students included Beatrice Glenavy (née Elvery), Leo Whelan, Harry and Margaret Clarke (née Crilly) and James Sleator (qqv). While the most emphatic impact of his teaching was his endorsement of the *beaux arts* tradition of figure drawing, Orpen's presence as a role model for Irish artists should be appreciated. His rise to fame from the child in the DMSA in 1891 to an artist commanding international accolades and earnings of approximately £40,000 a year at the time of his early death gave great hope to his successors.

Orpen's work can be seen in national collections in Ireland, Britain, Italy, Canada, Australia and the USA, and in many institutional collections around the world. CATHERINE MARSHALL

SELECTED READING Frank Rutter, 'Orpen's Self-Portraits', *The Studio*, LXXX, no. 18 (1932), 268–77; James White (ed.), *William Orpen 1878–1931: A Centenary Exhibition*, NGI (Dublin 1978); Arnold, 1981.

O'SULLIVAN, SEÁN (1906–64) [350], painter. Seán O'Sullivan's many portraits of leading figures from the world of Irish arts and politics are instantly recognizable for their conservative academic style and technical brilliancy. Not as fluid as the drawings of Augustus John, O'Sullivan's pencil portraits are nevertheless consistent, confident and assured. From an early age, O'Sullivan received commissions from people who recognized his considerable talents as a portraitist (see 'Portraiture'). After taking courses at the DMSA, he went on to study lithography at the Central School in London, and in 1926, moved to Paris, where he attended Colarossi's studio and the Académie de la Grande Chaumière. In Paris he was friendly with James Joyce, Samuel Beckett and Georges Rouault. His studio in Montparnasse was in the same building as Antoine Bourdelle's. In 1928 O'Sullivan was elected an associate of the RHA (qv) and became a full member three years later. He exhibited regularly at the Academy, showing an average of six works per year up to his death.

Unfortunately, while O'Sullivan attracted patronage and commissions without difficulty, his creativity was never encouraged, and ultimately his portraits attract admiration and praise for their skill and fidelity to their subjects, but not for a great deal more. A series of drawings in the NGI, commissioned by the Dublin solicitor John Burke in the 1940s, records the faces of those who shaped the Irish Free State in its infancy, but are otherwise of limited interest. O'Sullivan worked both in oils and in pencil, but seems only on a few occasions to have put his early training as a lithographer to good use, through producing limited-edition prints of his portraits. In 1955 he tried to establish

himself as a portrait painter in Philadelphia and New York, but without much success.

Born in Dublin, the son of a carpenter, O'Sullivan was taught by the Christian Brothers at Synge Street. During the Depression, he was employed by the Vincent family as a gamekeeper on their Muckross estate in County Kerry. Throughout his career, O'Sullivan was adept in using his contacts to attract commissions, but he seems to have taken what work came his way, rather than searching for commissions in a more focused way. He painted murals for a bar in Tullamore and a hospital in Drogheda and designed stamps for the postal service. An engaging conversationalist and raconteur, O'Sullivan was one of many artists and writers in Dublin in the 1950s who became dependent upon alcohol, a dependency which contributed to his early death, following a stroke, aged fifty-eight. O'Sullivan's portrait of Bulmer Hobson is in the NGI, while his portrait of William Butler Yeats is one of several by the artist in the collection of the Abbey Theatre, Dublin. PETER MURRAY

SELECTED READING Seán O'Sullivan, 'What is a Portrait?' in *Irish Art: A Volume of Articles and Illustrations* (Dublin 1944), p. 11; *Irish Literary Calendar, 1983: Seán O'Sullivan edition* (Mullingar 1982); S.B. Kennedy, 1991, pp. 168–69.

OUTSIDER AND FOLK ART IN IRELAND. Most definitions of Outsider artists include the following cluster of descriptions: they are self-taught; they work away from the mainstream art world of galleries, critics and dealers; they are not influenced by art history; they work obsessively to satisfy

349. William Orpen, *The Signing of Peace in the Hall of Mirrors, Versailles, 28th June 1919*, 1919, oil on canvas, 152.4 x 127 cm, Imperial War Museum, London

350. Seán O'Sullivan, *Ernie O'Malley, c.* 1942, charcoal on paper, 58 x 43 cm, National Gallery of Ireland

351. The Musgrave-
Kinley Collection of
Outsider Art on show
at the Irish Museum
of Modern Art, 1998

352. Dusan Kusmic,
*Portrait of Padraig Ó
Faoláin, c.* 1980, builders'
plaster, house paint, Irish
Museum of Modern Art

their inner needs, rather than to meet the expectations of either the art world or the wider community. What all this suggests is an art that is very pure in its adherence to the artist's personal vision, one that has not been diluted by exposure to art education or the dictates of society. Not everyone thought to be an Outsider artist will embody all these criteria, but they will generally incorporate several. Since a very impressive grouping of the leading names in Irish art over the past hundred years, such as Louis le Brocquy, Gerard Dillon and Tony O'Malley (qqv), have been self-taught, and the Irish art world generally was thought to be underdeveloped relative to its nearest neighbours, it might be assumed that there should be a considerable number of Outsider artists in Ireland.

While it is immediately clear that the artists named above, although self-taught, were highly conscious of art history and familiar with, and able to negotiate, the world of galleries and exhibitions, and so were not Outsiders, evidence to date does not support the idea that there are many others who were. It is important, however, to realize that the concept 'Outsider art', or *Art Brut* as the French innovator in this field, the artist Jean Dubuffet, termed it, is a relatively young one internationally and younger still in Ireland. Dubuffet first coined the term in the late 1940s but it was not until 1979 that the first Outsider exhibition was held in Britain, at London's Hayward Gallery, and not until 1998 that the Musgrave Kinley Collection of Outsider Art was lent to the Irish Museum of Modern Art (IMMA) [351] where the first Outsider exhibition in Ireland, *Art Unsolved: Outsider Art from the Musgrave Kinley Collection*, was held. That exhibition prompted wide discussion in Ireland about the nature of Outsider art and led to a new awareness of art practices that were not supported by the mainstream.

The Musgrave Kinley Collection, created by Victor Musgrave, a London gallery owner and film-maker, and his partner Monika Kinley, threw a spotlight on the work of Dusan Kusmic, a Yugoslavian who had been brought to Ireland as a post-World War II refugee in 1950 and who, before his arrival, had begun to make art in response to the trauma of war and its aftermath. Kusmic was befriended by a number of Irish artists, notably Brian Maguire (qv), Padraic Ó Faoláin [352] and Terry O'Farrell, who all played a part in bringing his highly idiosyncratic but imaginative work to the attention of the public. Working mainly in the Mountjoy Square area of Dublin, where he shared Padraic Ó Faoláin's studio, Kusmic made conceptual art objects from the most unlikely materials, including recycled food tins and shells, generally painting them with house paints and cheap felt tip pens. Other artists with an Irish connection in the Musgrave Kinley Collection include Damien le Bas, English-born son of an Irish Traveller family, and Seán Molloy, while Victor Musgrave believed that the anonymous artist who called himself Michael the Cartographer was also Irish.

IMMA offered the Musgrave Kinley Collection a home when it became clear, in the mid-1990s, that it could not find adequate public accommodation in England. The offer was made because the Outsider collection, with its emphasis on the artwork rather than the celebrity status of its authors, was a perfect vehicle to encourage debate at IMMA about canons of art collecting and for a post-modern museum to challenge

the authority of museums and galleries. As a result, IMMA became the only national institution in the world to incorporate Outsiders into its mainstream art collection. The policy at IMMA of seamlessly integrating the two collections was an innovative one, which earned the museum considerable attention from abroad. The collection remained on loan to IMMA, with the offer that it could be acquired outright until 2010, when storage issues led to its removal. It has been donated to the Whitworth Museum in Manchester, to which it had previously travelled as a loan exhibition from IMMA.

The presence of this collection at IMMA and the great public interest expressed in the work, as it was shown in many exhibitions both at the museum and in other places, led to discussion of other Outsider artists in Ireland. Cork Community Artsquad brought the work of John the Painter [353] to the attention of the museum in 1998 and an exhibition of his work was held in 2003 to coincide with the donation of a piece of his work, probably the largest work on paper in the country, *Jet Plane, Blue, Red, Yellow, Green Boxes, Arrows on Grand Parade, Chinese Version* (1997). It was also the first occasion in the country when an Outsider artist was given a solo exhibition at a national institution. Other artists who pursue their highly developed individual practices, oblivious of the mainstream, include Joe Bell, a resident in the Cheeverstown Home near Tallaght, Co. Dublin, while the KCAT collective at Callan, Co. Kilkenny provides support and studio facilities for such inventive artists as George McCutcheon, Sinéad Fahey, Andrew Pike and Thomas Barron [354].

Another outcome of the Outsider collection in Ireland was the research visit of Scottish artist Peter Haining, who travelled around Northern Ireland by bicycle in 1999, seeking out folk and Outsider art not hitherto recorded or documented. Encouraged by his preliminary visit, he applied for, and was given, an artist's residency at IMMA in 2000 with the specific purpose of researching Irish Outsider art. Haining's researches are contained in his Archive of Contemporary Irish Folk and Outsider Art, now lodged with the Attic Archive in Dundee, Scotland. Among the artists that Peter Haining encountered in the course of his research was Joe McKinley (1931–2003) from Carnlough, near Ballymena, Co. Antrim, known colloquially as 'Moscow Joe' because of his several visits to Russia. McKinley, a graduate of Queen's University, Belfast, was a true eccentric who alienated those immediately around him through his obsessive collecting of what other people termed rubbish, in the course of turning his home and its surroundings into an Outsider 'environment', which was destroyed after his death. Only a small number of topographical paintings remain, along with Peter Haining's documentation. Another artist to surface through Haining's research was John Bourke from Kilmallock, Co. Limerick, who lived in a care home for most of his adult life but painted animals and birds and his native village with a freshness of vision not often present in the work of those who encounter them daily.

Folk and Outsider artists are alike in that they benefit little from the mainstream apparatus of galleries and the art market

353. Installation of John the Painter's *Jet Plane, Blue, Red, Yellow, Green, Boxes, Arrows on Grand Parade, Chinese Version*, 1997, gouache on paper, 214 x 511 cm, at the Irish Museum of Modern Art, 2003

354. Thomas Barron, *Cook and Waiter in Kitchen*, 2003, marker on paper, 35 x 23 cm, Kilkenny Collective for Arts Talent

(qv). They differ from each other in their intensity and singularity of vision. Outsiders are frequently people who exist at the margins of society and who work alone. Because their creativity is unsupported by a tradition, it is often fiercely individualistic and uncompromising. The folk artist, on the other hand, is supported by a traditional way of working and a community, which understands and respects what s/he does, and the resulting artwork emerges from a shared vision. It is to this group of artists that James Dixon (qv), the Tory Island painters (see 'The Tory Island Group') and Mícheál Ó Gaoithín, *An File* (The Poet) from the Great Blasket Island off the coast of Kerry, belong. Their subject matter and iconography are strongly connected to their communities and, in the case of Mícheál Ó Gaoithín, son of the legendary folk writer Peig Sayers, there was already a profound respect for creativity, at least in relation to literature in his part of the world, long before he was encouraged to paint by the artist Maria Simonds-Gooding (qv).

It is to Simonds-Gooding that we owe the survival of a body of textile works by the Traveller artist Ella Coffey. Based in the Bullring in Tralee, Co. Kerry, Coffey designed and embroidered clothing, soft furnishings and dolls with great versatility and panache. Her work was clearly informed by an older Traveller tradition. It is to folk art too that the work of Finola Leane from Listowel belongs. Although untrained as an artist, Leane borrows from the earlier folk tradition of scraffito decoration on north Kerry architecture to embellish her unique interpretations of life in her town, especially the magical teaching of the town's great schoolteacher and writer Bryan MacMahon.

Since this is a new field of art historical research in Ireland, it is likely that much more material will emerge in the future to flesh out this brief introduction. This is not a universal view, however. Alannah Hopkin, curator of *Irish Outsider Art* at the Crawford Art Gallery (2003), has quoted Peter Haining as saying that folk and Outsider art have a very low profile in Ireland. Instead of recognizing such art as radical and subversive, it is seen as a cultural embarrassment, a result, Haining believes, of an Irish tendency to deny working-class culture.

Exhibitions of Outsider and folk art in Ireland include: *The Tory Island Painters*, AC/ACE touring exhibition (1983), *Art Unsolved*, Roscrea (1999), *Nine Outsider Artists*, IMMA (2000), *Inside Out*, Catalyst, Belfast (2002), *The Tail that Wags the Dog*, shown in tandem with an exhibition of Cobra art, IMMA (2003), *Irish Outsider Art*, CAG (2003), *Inner Worlds Outside*, IMMA (2006) and *Beyond the Mainstream*, Abhann Rí Festival, Callan, Co. Kilkenny (2010). The presence of the Musgrave Kinley Collection at IMMA inspired a considerable body of research into the area by art and art history students. CATHERINE MARSHALL

SELECTED READING Marshall, 1998; Peter Haining, 'Outsider Art in Ireland', *Circa*, no. 105 (Autumn 2003), 88–90; Marshall, 2003.

PAINTING. The New York Armory Show in 1913 provides a snapshot of the watershed moment in twentieth-century painting. The collision of styles shown, from both the avant-garde and the realists, from Europe and North America, illustrates the unruly beginnings of a youthful movement in opposition to the academic principles of the past.

The changes were unprecedented. Painting evolved from being a tool with which to depict public events and personalities, to becoming a mode of self-directed invention not easily understood by the public. John Butler Yeats and his son Jack (qv) provide a link between the two cultures. The former was a visitor to the show, the latter an exhibitor. Though not by any means a bohemian, and yet to display the painterly freedom of his mature work, Jack B. Yeats recognized that 'The great good these Post-Impressionists and futurists will do will be that they will knock the handcuffs off all painters.' The imperative of John B. Yeats, to 'try, try, try and try again – to understand the Cubists', reveals the position of a generation out of step with the fast-moving currents of Modernism (qv) (Betsy Fahlman in Declan J. Foley (ed.), *The Only Art of Jack B. Yeats*, Dublin 2009, pp. 96–97).

While Braque and Picasso in France experimented with collage, sand, Ripolin paint and tradesmen's tools to reinvent pictorial space, in Ireland the older traditions of fine art held sway. This was partly because of the conservative nature of Irish society and the lack of patrons to support innovation, and partly a result of William Orpen's (qv) teaching at the Dublin Metropolitan School of Art (DMSA) from 1906 to 1914. Orpen emphasized academic values and, importantly, introduced life drawing to the school. Accomplished nude studies by Patrick Tuohy and Margaret Clarke (qqv) are a direct consequence of this training. Roderic O'Conor (qv), although too early to have been influenced by Orpen, had also studied at the DMSA. His vividly coloured, experimental Post-Impressionist landscapes were exceptional among Irish artists *c.* 1900, but since he emigrated to France and was wealthy enough not to have to sell his work, his influence in Ireland was negligible. Only O'Conor and (later) Yeats employed the 'constructionist' brushstroke and colour experimentation that characterized Cézanne's revolutionary break with the seamless finish of the Paris Salon. Orpen's influence endured through his pupil and successor at the DMSA, Seán Keating (qv). Keating's work, especially his 'Shannon Scheme' series (1924–27), harmonized with the state's vision of a national art. Many Irish artists travelled to further their education; John Lavery, Paul Henry, Mainie Jellett, Evie Hone and Mary Swanzy (qqv) were among those whose artistic horizons were enlarged by study in France, while Stella Steyn, Cecil Salkeld and Francis Bacon (qqv) went from Ireland to Germany – the twin centres of artistic innovation at that time. New ideas circulated when artists returned home to exhibit in Dublin.

Despite Jellett's and Hone's importation of contemporary developments from Europe, social realism (see 'Realism') endured at the DMSA with the teaching of Keating and Maurice MacGonigal (qv). The position they represented was copper-fastened when they became consecutive presidents of the Royal Hibernian Academy (RHA) (qv), between 1949 and 1962 and 1962 and 1977 respectively.

No one did more to advance Modernism in Ireland than Mainie Jellett. Early Cubist (see 'Cubism') works like *Composition* (1925) [102] stand comparison with Picasso's *Still Life with a Mandolin* (1924) and *Pierrot* (1921) by Juan Gris in the National Gallery of Ireland. When Jellett showed two Cubist paintings at the Society of Dublin Painters (SDP) in 1923 – the first Irish abstract paintings to be exhibited in Ireland – the response was hostile. Earlier, Stephen Gwynn wrote of Mary Swanzy's work, also at the SDP, 'I can neither recognize shape or colour of nature in them, nor can I see any beauty in this vision of hers', pinpointing the gulf between academic art and Modernism (Snoddy, 2002, p. 638). Modern painting was not confined to the 'shape or colour of nature' and colour was used for emotional effect. Modernists rejected illusionistic space and the need to 'mirror' reality; instead, space was flattened, and figurative forms, if used at all, were often exaggerated or simplified [355]. Jellett recognized that without informed commentary, critical response could descend to ridicule. When the Irish Exhibition of Living Art (IELA) (qv) opened in 1943, she arranged for lectures and tours to demystify the Moderns' departure from academic art (Coulter, 2003, 82). It was not easy. Patrick Collins (qv) [356] was quoted as saying, 'It's the business of a painter to be ahead of public taste' (Dunne, 92). The monopoly of the RHA was dismantled with the foundation of the IELA, although in time this came to be viewed as biased in favour of abstraction (qv). The Independent Artists group (see 'Artists' Support Groups') was formed in 1960 to counteract this and in 1972 Figurative Image was formed to offer another platform for representation (Brian Fallon, 1994, p. 184).

Landscape and portraiture (qqv) were the most popular genres in Ireland before Modernism and, crucially, the best source of income for artists with limited opportunities for commissions. Orpen and Lavery had access to wealthy patrons in Britain and were the exception to the norm in Ireland. In the last years of his life, Orpen, who died in 1931, earned £45,000 per annum, a significant income for those years (Crookshank and Glin, p. 280) but many other artists simply subsisted. What were described as 'character studies' in Lavery's time, came to be seen as powerful psychological studies in Louis le Brocquy's (qv) portrait heads. The Modernist's impulse to reduce rather than expand is seen in the flat colour and thin, sketchy paint techniques of Bacon and le Brocquy. If le Brocquy's 'studies' were well-received, the very different portraits of Edward McGuire (qv) were even more popular. His sitters are of his time, but little in his style would surprise a Renaissance painter. Nonetheless, his pictures evoke a sense of disquiet that is Modernist in sensibility, while the predominance of leafy plants in the background sometimes threatens to engulf the sitters. Modernism's concern with abstract concepts where painting took on 'the aspect of a thing made rather than a scene represented' (Meyer Schapiro, *Modern Art*, New York 1979, p. 141) meant that traditionally recognized genres gradually fell from favour or were subverted, as in such works as Camille Souter's (qv) witty *Cod's Head, Self-Portrait* (1994) [462]. Hughie O'Donoghue (qv) has made the genre of history painting relevant for the late twentieth century, bringing a Titian-like painterliness to large series such as 'Episodes from the Passion' (1991–98) and 'Parable of the

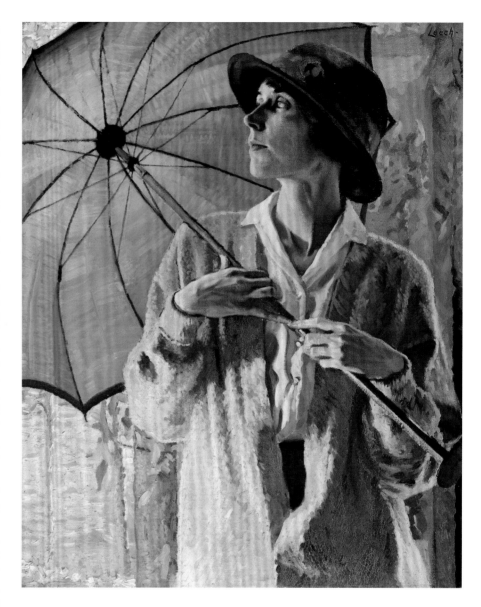

Prodigal Son' (2005) [136]. Radically, O'Donoghue uses photography (qv) in his paintings. Where earlier artists used it as an *aide-mémoire*, in O'Donoghue's work photography is both source material and an intrinsic element.

The success of Hugh Lane's ambition to bring into being a distinctively Irish school of painting is still debated. Brian Fallon argues that an identifiably Irish style can be detected in Paul Henry's (qv) landscapes before the 1930s (Fallon, pp. 237–38) and Jack Yeats depicted many essentially Irish rural and urban scenes, but does this constitute a signature Irish style? Both Patrick Collins and Tony O'Malley (qv) developed their own distinctive landscape motifs, which they believed were inspired by the atmospheric conditions and history of their native country. In opposition to the internationalism of Modern art, Collins called for Irish painters to look for their own native style (Dunne, 89). Others argue that while later painters such as Michael Kane and Brian Maguire (qqv) represented Irish subjects, the painterly techniques they employed were universal.

355. William John Leech, *The Sunshade*, c. 1913, oil on canvas, 81 x 65 cm, National Gallery of Ireland

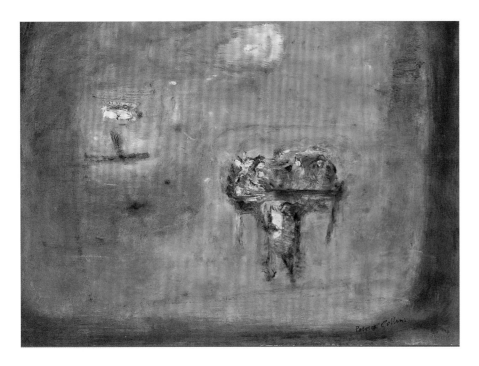

Private patronage and supportive galleries (see 'Patronage and Awards' and 'Commercial Galleries') were especially important because sponsorship from both the state and the churches was limited. With some notable exceptions, such as Zoltan Lewinter-Frankl in Belfast, Ernie O'Malley in Dublin, John Quinn in New York and, in the latter half of the twentieth century, Basil Goulding and Gordon Lambert in Dublin, collectors were largely conservative in taste. Dublin was fortunate in having a gallerist like Victor Waddington, who showed such avant-garde artists as Kokoschka, Soutine and Matisse in the 1930s. Pragmatically, he also displayed academic work. The gallery's most successful artist was Jack B. Yeats, whose work consistently sold out (Clark, p. 105). Yeats was a unique case, however, and Waddington left for London in 1957 claiming losses of £80 a week in Dublin. His experience illustrates how limited the market actually was (Clark, pp. 36–37). Gallerist David Hendriks played a pivotal role in the reception of the next wave of painting, showing artists such as Robert Ballagh, Barrie Cooke, Cecil King and Ciarán Lennon (qqv). Like Waddington, he showed both academic and experimental work (McCrum and Lambert, 1985, p. 14). Many art students recall that their first contact with contemporary international styles, such as kinetic art and Op art was at the Hendriks Gallery in the 1960s.

The first Rosc exhibition (qv), in 1967, was influential too. The hanging arrangements by Patrick Scott (qv) gave the paintings a sculptural effect. The blurring of boundaries between sculpture and painting and the use of multi-media gained currency as the century progressed. Deborah Brown [442] extended the boundaries of the canvas into three-dimensional space by literally slicing through it. Brown had been influenced by Lucio Fontana who initiated this practice in order to overcome painting's flatness and also to protest about its 'over-weighted tradition' (Jon Thompson, *How to Read a Modern Painting*, New York

2006, p. 258). The tendency to combine a number of media is seen in Robert Ballagh's playful Pop art (qv) *Portrait of Gordon Lambert* (1972) [400] which combines photography, screen-printing, sculpture and painting. Painting overlaps with sculpture in Barrie Cooke's 'Sheela-na-gig' [85] series where a moulded female nude stands proud of the mixed-media panel. Likewise, Maria Simonds-Gooding (qv) began her investigative approach into the landscape genre with *Habitation* (1970) [264], executed in plaster, collage and oil. Modernism's irreverent attitude to materials surfaced in techniques developed by Patrick Scott and Charles Tyrrell (qv): soaking unprimed canvas to produce suffused forms in *Orange Device* (1962, Scott) and *Brief Instant* (1974, Tyrrell) (Walker, p. 59). Ciarán Lennon's use of folded, painted canvas pinned to the wall in the 1972 IELA was a forthright rejection of Clement Greenberg's insistence on the flatness of the picture plane (Brian McAvera, 'Ciarán Lennon', *IAR*, Summer 2012, 71).

Large atria and double-height spaces in Modernist buildings such as the Carroll's factory in Dundalk and the Bank of Ireland and RTÉ headquarters in Dublin made new demands on artists. Robert Ballagh's modular approach in the 'Figures Looking at ...' series was one way of tackling the scale of these new spaces. Artists who exploited scale, like Deborah Brown and William Crozier (qv), often had links with the theatre. Large corporate spaces inspired artists to expand the scale of their paintings, while the new interest in colour-field abstraction enhanced the architecture, and posed no threat to corporate concerns.

A multiplicity of factors contributed to student protest at the National College of Art (NCA) from 1969 to 1971. Martin Gale (qv), a student at the time, recalls awareness of a similar situation at Hornsey College of Art, London. Undoubtedly, expectations were raised by the Rosc (qv) exhibitions. Pointing to government neglect of NCA and dissatisfied with the academic system, students demanded an independent governing body. It was not until 1974 that new teaching methods were introduced. A new Head of Fine Art, Campbell Bruce from Britain, and tutors such as Charles Brady (qv), were welcomed as a step towards a more liberal environment. No student had dared to submit exclusively non-representational painting until Charles Tyrrell did so for his final year assessment in 1974 (email communication Charles Tyrrell, 26 March 2012). He credits the presence of minimalists Patrick Scott and William Scott (qv), as influential, for getting this work through (see 'Minimalism').

Shifting societal mores brought a backlash against painting during the 1970s. A liberalizing climate encouraged a new respect for diversity, while many feminists shunned painting as a male-dominated practice. The position of women moved from a highly visible role, within the IELA, to one much reduced in representation (Walker, p. 89) (see 'Women and the Visual Arts'). Yet, unperturbed by these currents, many women painters such as Mary FitzGerald, Eithne Jordan and Gwen O'Dowd (qqv) continued to produce critically acclaimed work.

Patrick Graham (qv), who taught at the Dublin Institute of Technology in the 1980s and 1990s, noticed that a career in art had suddenly become sought-after, attracting large numbers of students, rather than passionate neophytes. The ensuing diversification in the curriculum meant that there was less emphasis on

skill and a suspicion that those who chose to paint were elitist. Drawing (qv) and painting became maginalized (Graham in Marshall, 2010, p. 2). The contemporary rise in new art forms, such as installation (qv), may also have contributed to this mind-set.

Large-scale abstract paintings, such as those by Tyrrell and Sean Scully (qv), highlight the changing relationship between viewer and painting or figure and ground, which was an important consequence of scale. Paintings executed on a vast scale include the viewer in an encompassing sensory experience, a view espoused by Mark Rothko: 'I want to be very intimate and human. To paint a small picture is to place yourself outside experience However you paint the larger picture, you are in it. It isn't something you command.' (Rothko, 1951, cited in Nikos Stangos (ed.), *Concepts of Modern Art*, London 1994, p. 196) Yet Bacon voiced a recurring criticism of abstract painting: 'It seems to me that abstraction basically reduces painting to something purely decorative.' (Clark, p. 27)

While Modernism dominated Irish art of the 1970s, painting remained overwhelmingly figurative, with many of Ireland's leading artists negotiating a path between abstraction and Expressionism/figuration (see 'Expressionism and Neo-Expressionism'). Post-painterly, Minimalist, Colour-Field and Expressionist are distinctions best considered with latitude since artists experimented freely across a range of options. Through a variety of interpretations, artists like Sean Scully, Camille Souter [357], Patrick Graham, Richard Gorman [358], Mark Joyce and John Shinnors have reinforced a belief in painting.

Despite assertions that the medium is irrelevant, paintings continue to be bought and sold at higher values and in larger quantities than any other medium in Ireland (see 'The Art Market'). Since the mid-nineties, individual Irish paintings, such as le Brocquy's 1947 *Travelling Woman with Newspaper* (2000) [16], have fetched in excess of £1 million, and in 2007 Francis Bacon's 1956 *Study for a Portrait II* brought in £14 million. The acquisition of artworks by significant artists, described in the art economy as positional goods, places the buyer and the artwork in an exclusive stratum of society (McAndrew, 2007, p. 38). Painting remains their preferred art form, with sculpture accounting for only 2–5 per cent of the total sales for Ireland's largest auctioneers.

Irish representation at the Venice Biennale, still considered the most important international showcase for art, was dominated by painting until the 1990s. In 1950 Norah McGuinness and Nano Reid (qqv) were selected, followed by le Brocquy and sculptor Hilary Heron. Patrick Scott followed (1960), but a dispute over an exhibition venue for Yeats's paintings interrupted the showing of Irish art until 1993 (Walker, p. 35). Since then, installation and film-based work have overtaken painting. Yet Stephen McKenna curating an exhibition about painting at the end of the 20th century, argued confidently that 'the invention of photography did not make painting superfluous – it made it indispensable' (*The Pursuit of Painting*, exh. cat. IMMA, 1997, p. 15). SUSAN KEATING

SELECTED READING Dunne, 1981; Walker, 1997; B. Fallon, 1999; Crookshank and Glin, 2002; Clark, 2010.

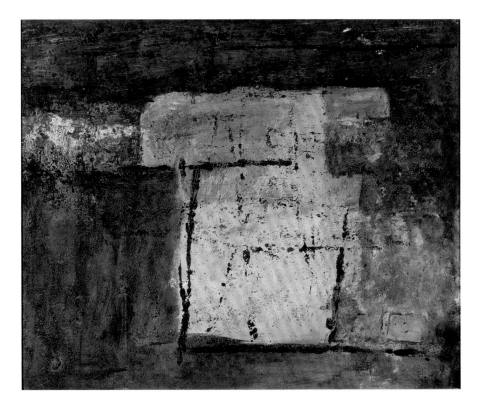

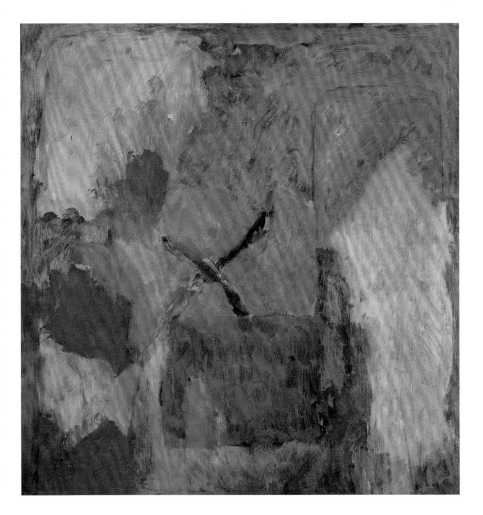

PAKENHAM, JACK (b. 1938) [359], painter. Although born in Dublin, Pakenham has lived most of his working life in Belfast. He studied French, Spanish and philosophy at QUB in 1959 and worked as a teacher of English from 1960 to 1990, since when he has been working full-time as an artist. He is largely self-taught as a painter.

His early paintings were landscapes in which he explored the formal and textural elements in the terrain with a hint of the surreal, and reflected his travels in Italy and Spain and the influence of Antoni Tapies. He flirted briefly with Pop art (qv) as in *Bikini Girl* (1967, private collection). It is, however, his figurative and dramatic urban narratives related to the political troubles in Northern Ireland for which he is well known (see 'The Troubles and Irish Art'). From the 1970s onwards, he has explored themes related to manipulation, intimidation, innocence, idealism and corruption. Many of his protagonists or 'actors' work from within their own sense of alienation. The 'stage', once a street corner or an enclosed room, later became a multi-faceted series of interconnecting scenarios, with an increasing number of characters, worked out on larger format canvases.

In many works Pakenham adopted a ventriloquist's doll as the artist's alter ego and surrogate victim, perhaps risking sentimentality and over-exposure. His sense of disgust at the callousness with which people were targeted during the 'Troubles', or at planned acts of terror, may be seen in *Your Move* (1976). The painting is pivotal in allowing Pakenham to comment upon, rather than merely illustrate, a situation. *Now Listen Carefully Son* (1975, private collection) condemns bigotry as often passed from father to son and hence from generation to generation.

Another much-deployed theatrical prop is Pakenham's use of the mask, symbolizing dishonesty and moral cowardice, as in *Picking the Masks* (1986, artist's collection). In allegorical paintings like these, the artist has created a carnival of horrors with no rationing of disguises. His work has been influenced by Grosz and Beckmann, offering despairing urban encounters with stereotypical Ulster characters. More recent works have related to the Northern Ireland Peace Process – for instance, *Peace Walk* and *Peace Juggler* (both 2000–08, artist's collection) and also a

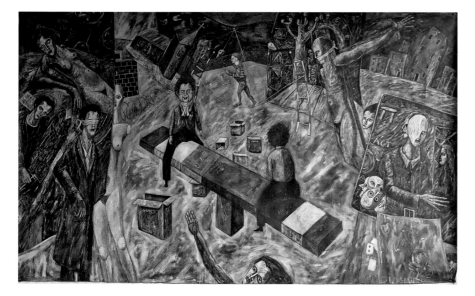

359. Jack Pakenham, *Ulster Playground*, 1989–90, acrylic on canvas, 213.4 x 365.6 cm, Office of Public Works

return to landscape painting emanating from his travels in Spain.

Pakenham's work is represented in private and public collections, including the ACNI, ACE and IMMA. LIAM KELLY

SELECTED READING Catto, 1977; Jack Pakenham, *A Broken Sky: Poems and Paintings* (Derry 1995); Kelly, 1996; Brian McAvera, 'Reflections on a Troubled Canvas', *IAR*, xxv, no. 4 (2008).

PARTICIPATORY ARTS (see *AAI* III, 'Community Arts'). Throughout the twentieth century, artists in Ireland have worked creatively both outside and inside the studio as teachers, tutors, facilitators and, especially in the later decades, in art practices that have come to be described as 'socially engaged', 'participatory' and/or 'community arts'. These practices all involve levels of participation and collaboration by both audience and artist. The underlying motivation of artists who wish to engage outside of the hierarchical structures of a hegemonic art world led them to adopt strategies that were inclusive of others in their arts practice, to question the notion of the single 'authorial voice', decisions about who gets to participate in the production and distribution of artwork, and strategies about how this should be done. Influenced by postmodern theoretical positions, Irish artists have tested the parameters of arts practice in creating direct contact with their audiences.

The multi-faceted practices that artists engage in outside of the traditional studio environment in Ireland have their roots in late 1960s' counter culture and the Hippy rebellion through which they linked to world-wide movements such as the Cuban Revolution, the Black Panther Movement, anti-Vietnam war agitation and global student protests. Working-class activists in post-industrial Britain, who saw this as a predominantly middle-class phenomenon that further marginalized them, led their own revolt. By the late 1970s this expressed itself as a community arts movement (Fitzgerald, p. 65). In Ireland, pockets of similar activity were also emerging in the circus and in street theatre. Neighbourhood Open Workshops (NOW) in 1978 in Northern Ireland and, in the Republic, local circumstance and idealism led to the creation by the late 1970s of such organizations as the Grapevine Arts Centre and Moving Theatre in Dublin. The Cornmarket, later the Wexford Arts Centre, founded in 1974 (influenced by Joseph Beuys's aspiration to found a Free International University in Ireland), the Gorey Arts Centre, initiated by Paul Funge, who had been prominently involved in staff/student protests at the National College of Art and Design (NCAD), the Galway Arts Festival and Waterford Arts for All were other important independent developments outside the capital city (see 'Regional Developments' and 'Education in the Visual Arts').

In the 1980s, artists from third-level colleges led movements across a range of art forms and made insertions into wider cultural production, harnessing their desire to engage with local communities outside the walls of the academy and to build on initiatives from the previous decade. These included City Vision Productions (film and video), City Workshop (theatre), Co-Motion Theatre Company, Women's

Community Press, Pintsize Puppet Theatre, Alternative Entertainments and Wet Paint Arts, which was specifically dedicated to Youth Arts development in Dublin.

Patricia Hurl, in the project she initiated, *A Woman's Place*, worked with women to highlight feminist issues. This project involved artists Beth Lazroe Ridgell, Pauline Flynn, Hanna Melly, Marie McDonald, Jackie Duignan, Annabel Konig, Laura Averill, Kate Hipwell, Mary McCaugherty, Mary O'Rourke, Beth Royds, Gráinne Dowling, Ger Draper and Mary Ehmicke, working across eight communities in Dublin. It culminated in a week-long event in 1991 to celebrate Dublin women's contribution to the European City of Culture and was given public affirmation when the newly elected President of Ireland, Mary Robinson, opened a large group show of the work in the City Arts Centre, Dublin. Hurl went on to initiate the first formal Arts Access programme for women in Dublin's north inner city in the Dublin Institute of Technology, Portland Row (DIT) [360]. The programme, which ran for four years (1993–96), influenced the development of the Sherkin Island BA in Visual Arts led by Bernadette Burns, Hurl's colleague at DIT.

Many artists have responded to specific local circumstances where they live, such as Martin Folan in St Mary's Island, Limerick, Chris Maguire, who works in collaboration with the Rialto community development group and has documented life there through photography for over thirty years, and Joe Lee, artist and film-maker, who has developed a series of film projects with communities throughout the city, including *Dreams in the Dark* (1999) and *Out of Place* (1999–2001). A significant development was the foundation of the Fire Station Artists' Studios through a collaboration with the North City Centre Community Action Project (a community development organization which developed a wide range of arts events) and artist Robbie McDonald from the Triskel Arts Centre in Cork, acting on behalf of the Arts Council (AC/ACE) (qv). This collaboration was further developed under Tony Sheehan's directorship of the Fire Station, with the 1997 project 'Inner Art'. This included many Irish and international artists, Pauline Cummins and Shane Cullen (qqv) amongst others, testing their belief in the potential of 'art and marginalized communities'. The Fire Station Artists' Studios also supported a programme of residencies whereby artists engaged with the surrounding communities. This began in 1997 when John Langan created *Con Sume – A Flavour* and continues to date with a programme dedicated to social/collaborative arts practices.

Official recognition of community practice

The Arts Council, under the directorship of Colm Ó Briain, began to shift its policy emphasis to reflect ideas of cultural democracy (Paula Clancy, 'Rhetoric and Reality' in Fitzgerald, p. 86). During the 1980s the Council increasingly recognized the need for broader access to the arts. Pilot projects were developed with Regional Development Organizations (RDO) as community arts schemes with visual artists, in counties Galway and Mayo in 1983 (Helen O'Donoghue) and with Geraldine O'Reilly in 1985. Marian Fitzgibbon, arts development officer in the mid-west region, developed a community arts programme in Ennistymon, Co. Clare in 1984, which included artists Liz

360. A workshop at Garter Lane Arts Centre, Waterford in which women respond to Patricia Hurl's *The Living Room, Myths and Legends,* International Women's Day, 1999

McMahon, Fiona Woods and Deirdre O'Mahony. Arts festivals spawned community theatre events such as Spraoi in Waterford and, later, Buí Bolg in Wexford. Official responses to this growth were captured in a three-year Arts Council initiative in collaboration with the Gulbenkian Foundation to fund and monitor an Arts, Community and Education Project (ACE), which was launched in 1987. ACE included visual artists working with City Vision productions and The Big Game, from which Macnas street theatre grew and which involved Tom Conroy and other artists associated with the Galway Arts Festival. The final report and policy recommendations, *Art and the Ordinary*, were published in 1989. Ciarán Benson's cogent arguments on access to art for all challenged the beliefs of the then Taoiseach's cultural adviser, Anthony Cronin, who held a more conventional attitude to the definition of an artist (Fitzgerald, p. 90). As a result of the Benson report's recommendations, the AC/ACE established funding for community arts under its multidisciplinary arts budget in its successive arts plans. The Council uses the term 'arts and communities' to encompass arts practices and activities which bring artists together with specific groups of people in a mutually beneficial engagement that respects different creative ideas, experiences and skills.

Two new representative organizations emerged to serve community arts; Creative Activity for Everyone (CAFE) in 1984, renamed CREATE in 2001, was founded as the umbrella group in the Republic, and the Community Arts Forum (CAF) in 1993 in Northern Ireland. An important feature of CAFE was the introduction, in 1984, of a 'community arts worker' training course, while City Arts Centre emerged from the Grapevine Arts Centre five years later. In 1990 Arts Squads, founded by the Artists Association of Ireland and Sculptors' Society, funded by FÁS, at that time the State's vocational training agency, enabled another strand of arts engagement.

In the last decade of the twentieth century, a new wave of development in both arts practice and critical reflection made its presence felt. A significant event in this was the opening of the Irish Museum of Modern Art (IMMA) in 1991. The new

museum prioritized access to the arts and artists and committed itself to testing the philosophy of community arts and access policies in its own practice as a national cultural institution. Through IMMA's National Programme, a series of experimental projects was put in place where artists worked in collaboration with a range of communities in the immediate proximity of the museum in Kilmainham and later, from 1995, throughout the country. Arts programming initiatives centered on participation were developed, the outcomes exhibited, and their findings evaluated and disseminated through publications and public conferences. The exhibition *Unspoken Truths* [361], at IMMA in 1992, marked a new highpoint in community arts engagement, since it was located in a national institution, backed up by the supporting frameworks of the museum and community development organizations, and given significant recognition when it was formally launched by Mary Robinson, President of Ireland. The exhibition toured widely throughout Ireland until 1996.

Simultaneously public art programming strands, associated with the Per Cent for Art Scheme (see 'Public Art'), were opening up access by adopting participatory arts practices. This was informed by both Arts Council policies, freelance practitioners such as Jenny Haughton and Aisling Prior, and arts officers and others who commissioned artists to engage in new ways with the public. A notable example of this was the collaboration between Clíodhna Shaffrey as commissioning arts officer, Patricia McKenna as artist, and the local community in Belturbet, Co. Cavan, 1993/94, which led to the installation *The Grey House* [407] in which an abandoned house became the temporary repository for a community's shared experience of emigration. Mary McAuliffe, appointed arts officer in County Sligo in 1997, integrated Per Cent for Art schemes, public education and aesthetic innovation in six projects for a pilot Public Art Programme in Sligo from 1998 to 2001. Her aim was to examine and develop models for active public ownership of artworks commissioned on behalf of Sligo County Council and to evaluate both process and achievements.

The development of an infrastructure through the appointment of arts officers in almost every county in the country enabled support for ground-level community arts practices. As arts centres were built across Ireland, they, too, adopted access policies that were more 'participant-centred' in their education/community/outreach strategies, supporting artists to engage through their programming with the communities they served. Many of these programmes were aimed directly at the inclusion of people who were not thought to have availed of cultural provision in the past. The resulting projects were both challenging at the time and far-reaching in their influence, such as the Waterford Arts Office's interaction with the Allied Irish Banks art collection in 1997. In this project Mary McAuliffe, then arts officer in Waterford city, requested the help of the Head of Collections at IMMA to mentor a group of Waterford teenagers to select and present an exhibition, *Blah, Blah, Blah, AIB Art on Tour* (Waterford City Hall, 1997), from the bank's significant art collection. The success of the project led to IMMA's touring exhibition of Young Curators, *Somebodies* (1998) [117], in conjunction with Garter Lane Arts Centre, Waterford, and a subsequent series of community curatorial projects both at IMMA and around the country through the museum's National Programme. In Dublin, the city arts officer, Jack Gilligan, expanded the reach of the Arts Office in the 1990s by placing area-based arts officers throughout the city and county, and creating a matrix of connections across art forms and community groups. South Dublin County Council responded to the challenge of expanding the scope of public art programming with a series of distinctive commissions, *In Context*, the first phase of which ran from 1997–99, and involved artists such as Patricia McKenna and Louise Walsh.

Arts festivals form a major catalyst in the infrastructure supporting community and participatory arts. While many of the leading events in the major festivals at Galway and Waterford combine street theatre and the visual arts, some of the smaller rural festivals, such as the Iniscealtra Arts Festival in Mountshannon, Co. Clare, the Bealtaine Festival in Dingle, Co. Kerry, and the national festival of creativity in older people, also called Bealtaine, have enabled particularly well thought out projects of engagement. Nicola Henley in Mountshannon developed a team of artists in the area to develop workshops and exhibitions in response to artworks from the IMMA collection, a process that is repeated in Dingle, with the additional assistance of Ealaín na Gaeltachta. The integration of artists in residencies across all sectors of community life has been consistent in County Mayo, initiated by John Coll in the 1990s, and continued and developed by Anne McCarthy, who has supported artists such as Deirdre Walsh, Tom Meskell and Margaret Morrison to work in health care settings.

New definitions of work practice emerged as artists engaged in international debates. Suzanne Lacey, the Californian artist whose installations, video and large-scale performances on social themes and urban issues were widely known, came to Ireland in the early 1990s to meet and discuss participatory practices with Irish artists. American curator Mary Jane Jacobs invited Maurice O'Connell (IMMA, *From Beyond the Pale*, 1994/95, and Wet Paint, IMMA's community project for young people) to participate in 'Conversations in the Castle', the Arts Festival of Atlanta in 1996, devoted to the theme of changing

361. President Mary Robinson at the launch of *Unspoken Truths* at the Irish Museum of Modern Art, November 1992

audiences for contemporary art. The ideas of Grant Kester, introduced to Irish artists through the 1998 event *Littoral* held in the Dun Laoghaire Institute of Art, Design and Technology, provided a theoretical basis for the examination of participatory practice. This symposium linked Irish artists to the international network of artists, critics and educators interested in new approaches to contemporary arts practice, research and pedagogy.

A number of artists whose practice has been significant in arts and community development have emerged through these decades. An influential and leading pioneer of participatory practice is Brian Maguire (qv), who tackles the official judicial system and its impact on individuals and communities through the representation of, and often in collaboration with, prisoners in Ireland and elsewhere. Ailbhe Murphy, who first came to public attention with *Unspoken Truths* in 1992, in collaboration with the Family Resource Centre, St Michael's Estate, Inchicore and the Lourdes Youth and Community Services, Sean McDermott Street, Dublin, and IMMA, has developed a sustained practice informed by Kester's international 'Dialogical Aesthetics'. Simultaneously, Aileen Barr, Marie Barrett and Lisa Spillane-Doherty formed Artlink in County Donegal in 1992, a locally based community arts practice that interchanged with all sectors of the population in the north-west. In the early 1990s, Monica de Bath reinvigorated a dying tradition of spinning and weaving through the creation of Taipéis Gael, a contemporary arts/local industry initiative in Glencolmcille, Co. Donegal. Canadian artist Rochelle Rubinstein, introduced to Ireland by Pauline Cummins, spent three consecutive residencies at IMMA, where she worked on a major collaboration involving artists (Joe Lee, Ailbhe Murphy and Rhona Henderson) and local women from the St Michael's Estate Family Resource Centre in Inchicore, to develop the exhibition *Once is Too Much* [362, 506]. The collaborative artwork *Open Season*, made by the women and Joe Lee for this exhibition, was acquired for IMMA's collection, making it the first participatory artwork in a national collection.

William Frodé de la Forêt and Cork Community Artlink have worked since the early 1990s to counteract the effects of institutional care on individuals. KCAT, the Kilkenny Centre for Arts Talent, emerged from a desire to expand creative opportunities for George McCutcheon of the Camphill community at Ballytobin, near Callan, Co. Kilkenny. An art school and studio complex was founded in Callan in 1998 which offers validated courses in visual arts and theatre studies, as well as studio accommodation for artists with and without disabilities. Dublin-based Scottish artist Rhona Henderson, who straddled both practice and theoretical positioning in the context of international trends and worked on many community programmes, emerged as one of a group of NCAD graduates in the mid-1990s. Henderson, Michelle Deignan and Cliona Harmey, who developed their practices in IMMA and in Holles Street, Dublin (inaugural arts programme), were amongst the first wave of young practitioners who tutored in access courses in art colleges such as Hurl's course in the DIT.

Many artists have specialized in working with children and young people and these include Liz McMahon (IMMA,

362. Ailbhe Murphy and women from the Family Resource Centre, St Michael's Estate, Inchicore with the Education and Community Department, Irish Museum of Modern Art, *Once is too Much*, 1998, glass shelving, fresh lilies, text

363. John Ahern, in association with Una Keeley, creating plaster and acrylic paint casts of boys from the Christian Brothers School, Francis Street, Dublin, 1994

Creativity in the Classroom), Kieran McNulty (Sparkling Seven, IMMA and Rialto Arts Programmes, Dublin), Una Keeley (who also worked actively with IMMA in the 1990s and went on to develop a collaborative public art practice with Daniel Cullen in the following decade) [363], Niamh Lawlor (Púca Puppets), John Langan, Julie Merriman, Leanne Mullen, Sally Noelle, Martin Yelverton and Terry O'Farrell. O'Farrell, who has worked at IMMA and at The Ark, the Children's Culture Centre, Dublin, has also worked with older people, especially through her involvement with *Wise Ways*, in tandem with the Iniscealtra Arts Festival, since 2002 [364]. Louise Walsh's public art projects prioritize the community's right to engagement in the conceptualization and realization of the artworks in the communal spaces they inhabit. Her first public project, *Women of Belfast*, 1993, contained indications of a consultative process that has matured into such public artworks as *Sweets and Snails* (1999, Lucan) in which local children devised road safety signage and attended

art workshops as an intrinsic aspect of the artwork, and *Love Seat*, for the Luas tramway stop at St James's Hospital, Dublin (1999–2007).

A significant informant to the discourse in the last decades of the twentieth century and into the next has been the development in urban areas of major regeneration programmes with integrated public art schemes. Two of note in Dublin are *Breaking Ground*, Ballymun and *Fatima*, Rialto. Both neighbourhoods have had extensive community engagement with arts practice, and in the latter a new model of participatory/collaborative practice with young people, initiated by artist Fiona Whelan, is developing. The impact of modernization in rural environments has simultaneously been the focus of artists such as Aileen Lambert and Deirdre O'Mahony. This discourse complemented practice and created the impetus for art colleges to provide (following the lead laid down by Hurl at DIT) critical reflection on broadly termed, socially engaged practices, both in dedicated courses and as modules in Fine Art faculties. O'Mahony's research in County Clare, where she reopened the obsolete post office in Kilnaboy as a centre for rural development through arts and culture, *X-PO* [408] has influenced the Galway-Mayo Institute of Technology to institute a new course in this area of practice. Similarly, the Limerick School of Art has a new postgraduate course led by artist Seán Taylor, who has extensive experience in this field. These courses sit alongside that offered in NCAD, providing a matrix of new opportunities and practices for students.

By the end of the twentieth century, a complex understanding of terms such as 'participatory' and 'community' art practices had emerged in the form of artists working in interdisciplinary ways across organizations and institutions. This can be seen in collaborations with community development, health and environmental programmes, and the communities themselves, and in a new pedagogical framework across a broad range of contexts. As contemporary arts' practices have expanded their forms of production and dissemination across all aspects of life, artists continue to question the notion of who gets to participate, finding challenging ways to articulate this.
HELEN O'DONOGHUE and CATHERINE MARSHALL

SELECTED READING Benson, 1989; Grant Kester, 'Dialogical Aesthetics: A Critical Framework for Littoral Art', presented at the conference *Critical Sites: Issues in Critical Art Practice and Pedagogy* at DLIADT (Dublin 1998); Jacob and Brenson, 1998; *Placing Art: The Pilot Public Art Programme* (Sligo 2000); Kester, 2004; Fitzgerald, 2004; Brian Hand, 'A Struggle at the Roots of the Mind', in Moran and Byrne, 2010.

PATRONAGE AND AWARDS (see *AAI* II, 'Patronage' and *AAI* III). The romantic picture of the Renaissance patron and artist had declined by the nineteenth century as support through museum, private collecting and corporate commissions established themselves as the dominant paradigms of the patron/artist relationship. If that model worked in other countries, there was little evidence of it in Ireland for the greater part of the twentieth century. There was no national museum for the acquisition of contemporary art in the Republic before 1991, and only limited scope for it at the Ulster Museum in Northern Ireland. Although museums, such as the Dublin Municipal Gallery of Modern Art and the Crawford Art Gallery, Cork, were encouraged to buy art, they received little or no public money to help them do so before the 1960s. In 1939 the annual subvention to the National Gallery of Ireland (NGI) was the same as what it had been under the British administration of the 1860s. Not only did the state not help artists, the perception was that it hindered them; as Ernie O'Malley pointed out in a letter in 1946 to James Johnson Sweeney, Curator at the Museum of Modern Art, New York, 'One is not allowed to charge for admission or, I believe, even to sell a catalogue of an exhibition without special legislation.' (O'Malley and Allen, 2011, p. 234)

O'Malley was warning Sweeney of the difficulties he would encounter if he went ahead with a plan to bring an exhibition of American art to Ireland. In the same letter he described the only potential sources of support as he saw them:

There are two groups here: 'The Friends of the National Collections' who have bought some contemporary paintings, mostly French, and have presented them to the Municipal Gallery here. The Rouault [French Expressionist painter] was refused by the Gallery and was the[n] sent on loan to Maynooth College [91]. The Friends, to me, have a faint hang-over air of patronage ... but also they have a few good workers. The other group, 'The Living Art Committee' [see 'The Irish Exhibition of Living Art'], is all workers.

They have succeeded for the past three years in putting on a show of representational and abstract work which would have been turned down by the Academy [see 'Royal Hibernian Academy']. French and English painters now contribute yearly.

The situation O'Malley described was a highly restricted one, with only a handful of voluntary support organizations for contemporary art and artists and little help from the state. O'Malley's letter predates the establishment of the Arts Council/An Chomhairle Ealaíon (AC/ACE) (see 'Arts Councils') in 1951 and the Cultural Relations Committee (CRC) of the Department of Foreign Affairs in 1949, both of which provided patronage of a formal, if limited, kind from mid-century onwards. Before 1950 the state offered virtually nothing by way of support. The churches, so central to European art history, were, with some significant exceptions, more interested in quantity than quality, preferring to import mass-produced art from abroad than to commission artists at home. For much of the twentieth century it was left to a small number of devoted individuals to give artists the vital assistance on which their continued creative achievements depended.

Official commissions were generally restricted to commemorative monuments. But before the establishment of the Free State, as Sir Thomas Grattan Esmonde pointed out in 1898, those monuments did not satisfy the needs of the majority and were seen at best as colonial impositions rather than as public art (qv). As he laid the foundation stone for the Wexford 1798 monument Esmonde said. 'Our towns are studded with memorials of English kings, of English Lords Lieutenant [but] we have nothing to show.' (John Turpin, 'Oliver Sheppard's 1798 Memorials', *IAR Yearbook*, 1990/91, 71) The governing establishment was better received in its patronage of the Arts and Crafts movement, with Lady Aberdeen, wife of the Lord Lieutenant of Ireland (1886, 1905–15), setting up the Irish Lace Depot in Dublin and the Irish Industries Association, and Lord and Lady Mayo actively involved in the establishment of the Irish Arts and Crafts Society (1894) and the Royal School of Irish Needlework (1894). However, their efforts were not sustained following the War of Independence and, as Thomas Bodkin pointed out in his 1949 *Report on the Arts in Ireland*, they 'died out, largely because of lack of public or State support' (p. 39). Where the Free State did commission artworks, other issues could arise. Harry Clarke's (qv) so-called *Geneva Window* [365], a stained-glass window devoted to illustrations of significant passages from Irish literature, commissioned as Ireland's gift to the League of Nations, Geneva, was rejected, apparently on the grounds of indecency; it was not paid for until after the artist's death and was later sold out of the country.

The Free State's neglect is at odds with the ambitions of some of its founding fathers. In *Leaves from a Prison Journal*, Michael Davitt declared that providing for economic well-being was only as important as the need to bring the arts to everyone. The realities of government, however, soon turned political attention towards more expedient issues and the arts were left to go it alone. A series of reports – Bodkin's (1949), *Design in Ireland* (1962) (see 'Design and Material Culture'), the 'Richards Report',

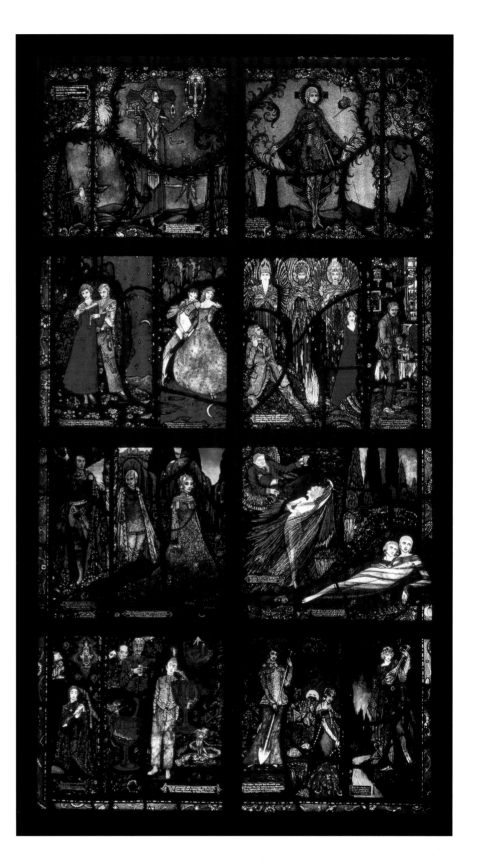

365. Harry Clarke, *The Geneva Window*, 1930, stained glass, Wolfsonian-Florida International University, Miami

Provision for the Arts (1976), and an Irish Marketing Survey report (1980) repeatedly called for state action. Identifying fifty years of neglect, Bodkin criticized the NGI and National Museum for poor standards of public education and

scholarship, and lambasted the Tourist Association for the poverty of its publications. His report, and a memorandum written in 1945 by P.J. Little, led to the founding of the Arts Council in 1951 and the Kilkenny Design Workshops in 1963, the two most important political gestures towards the arts and design in the century. However, as the 'Richards Report', jointly commissioned and published by the Arts Council and the Gulbenkian Foundation to look at funding of arts organizations, showed, despite improvements during the Council's first twenty-five years, there was still a huge gap to fill. The report called on the Council to make support for individual artists a priority and to create a structure for regional development. Immediate responses to this were the expansion of an existing scheme for writers, the Ciste Cholmcille, to musicians and visual artists, and support for the establishment of the Mid-West Arts Association, with Paul Funge as arts officer. Supports for festivals and touring exhibitions, and a new national association for film (qv), were also put in place.

These initiatives indicated that state patronage was now an active process and this was greatly assisted by increases in the money allocated to the arts under the Minister for Finance, Charles J. Haughey. As Haughey later told Vera Ryan

> The State must, through appropriate agencies, act as an impartial, objective patron, supporting and facilitating creativity but not attempting to intervene or to influence or restrict artistic freedom. Given the circumstances in which democratic governments must perform and the need at all times for public accountability, this is not always very easy. (Ryan, p. 81)

Haughey raised funding for the arts from £40,000 to £60,000 in his first budget in 1967 and two years later introduced tax exemptions for creative artists, the first direct acknowledgement by the state of these individuals' contribution to society and the need to sustain it. The gesture was significant for several reasons: it asserted the importance of the role of the artist in the state; controversially, it encouraged well-established artists from abroad to come to Ireland to avoid paying tax at home, although their presence here benefited the profile of the arts generally; and it helped a handful of highly successful artists and writers. For the majority, however, the tax exemption was more beneficial psychologically than practically. Very few artists earned enough money to pay tax and it did nothing to promote patronage.

Greater funding for the Council and increased activity led to an ever-growing list of client organizations. Unfortunately, it stimulated demands that it still could not meet, leading a more professionalized Council to commission a report on artists' living conditions. This report, by Irish Marketing Surveys (1980), pointed out that 75 per cent of artists had to secure other work in order to survive. Nearly 70 per cent had no pension provision, incomes were generally unstable, and 23 per cent of artists received no income for at least a month of each year. Fifty per cent of the money spent on art went to the top 18 per cent of artists. Few benefited from the tax exemption. While most artists looked favourably on the Council, they felt that its grants were inadequate and led to too much competition.

In *Art and the Majority*, an address to Harvard Summer School Institute of Arts Administration (abbreviated version, *IT*, 13/14 July 1972), Haughey articulated what was to be the official view of state patronage for the next three decades. Referring to his tax exemption scheme of 1969, he declared:

> And as I believe that in cultural affairs the only valid role for a government to play is that of an impartial patron, I stipulated when bringing in this provision that there must not be an attempt to pick and choose, that it must be universal in its application and that the benefit of the doubt should be given to the artist in any case where it arose.' Haughey went on to argue that, 'where there is a conflict between the demands and necessities of society and those of the artist, there is certainly a sense in which those of the artist are more important.

Not all politicians agreed with this view.

Haughey drew attention to the conflicting needs to support art-making and provision for audiences. One could argue, he pointed out, that money for performances, events and exhibitions is subsidizing people who should pay for the experience of the artwork and that support for the art-loving public should not be at the expense of the creators. Haughey was aware of the temptation for politicians to provide for audiences, and the need to make contemporary art acceptable to the masses whose taxes paid for it, rather than to assist individual artists, but he argued that it was important to support the artist even if he or she never manages to produce the work. He referred to the link between patronage and wealth and its use to disempower the poor, stressing instead the role of the arts in promoting national self-esteem. In conclusion, Haughey expressed a hope, reiterated in post-Celtic Tiger Ireland by Arts Ministers Hanafin and Deenihan, that an Ireland lacking substantial material resources could, nonetheless, make a significant contribution to international culture.

The need to develop a deeper appreciation of the arts among the wider public was articulated by Patrick Rock, chairman of the Arts Council, in his introduction to the annual report of 1975: 'we have an obligation to both artists and public to see that adequate facilities exist; especially at regional level, to enable all to participate meaningfully in the arts' (p. 5). In a flurry of activity under Colm Ó Briain, its first full-time director, the Council embarked, from 1975 onwards, on a period of development which saw the introduction of an honours scheme for artists, Aosdána (qv), the establishment of the first artists' residential retreat with the Arts Council of Northern Ireland (see 'Artists' Studios and Residencies') at Annaghmakerrig, a programme of touring exhibitions, and, with growing support from local authorities, a programme to develop arts centres and appoint arts officers around the country which was completed in 2007 (see 'Regional Developments'). Cork Corporation, Dundalk Urban District Council and Sligo Corporation were the first local authorities to budget specifically for the arts. While the Arts Council in the early decades had felt that patronage by purchase was the most effective way to support artists, policy in the 1970s moved towards direct assistance to individual artists

through commissions, bursary and scholarship schemes, and this trend was strengthened in 1980 when the budget for this increased to £150,000. Steady growth in this programme since then means that the Arts Council is now by far the most important direct supporter of the individual artist.

Direct commissions from the state were few until the 1960s when a desire to commemorate the 1916 Rising, on the occasion of its fiftieth anniversary, led the Office of Public Works (OPW) to commission a number of large-scale sculptural works, including the *Wolfe Tone* monument in St Stephen's Green by Edward Delaney and *The Children of Lir* by Oisín Kelly at the Garden of Remembrance, Parnell Square. It was the start of a patronage process that slowly grew until the 1990s when increased prosperity and the introduction of a Per Cent for Art Scheme by the Arts Council and government enabled a proliferation of artworks in public buildings. The OPW also began to buy artworks for embassies abroad and state buildings domestically. In describing how he advised the OPW, businessman and gallerist Patrick J. Murphy noted, 'They have about 6,000 works. Recently we bought for the Dáil; we had €100,000 to spend. The State is now a big patron.' (Ryan, p. 98)

Another vehicle for state patronage was the Cultural Relations Committee of the Department of Foreign Affairs. Against a background of caution about provision for the arts at home, lest they should be too subversive, the CRC grew out of Taoiseach Eamon de Valera's recognition of the value of the arts in promoting the country abroad. With an initial grant of £10,000, the CRC initiated a programme of cultural propaganda, confining its activities to funding exhibitions and events outside the country. One of its early contributions to the visual arts was to send two artists, Nano Reid and Norah McGuinness (qqv), to represent Ireland at the 1950 Venice Biennale. Other foreign exhibitions followed, together with the introduction of travel bursaries for artists and support for exhibitions into Ireland from abroad. Lampooned by *The Bell*, initially, for its pretentiousness and elitism when creativity got so little assistance at home, the CRC went on to acquit itself well on behalf of Irish artists, and to work positively with the Arts Council. By the late 1990s the CRC was reformed as Culture Ireland and brought under the direct control of the ministry for the Arts. State support was also channelled through Bord Fáilte (the Irish Tourist Board), when its emphasis was to stress marketable images of Ireland rather than aesthetics. Division of funding among the AC/ACE, OPW, CRC and Bord Fáilte, and the Departments of the Taoiseach and Finance caused tensions that were only partially resolved, with the establishment of the first Department of Arts, Culture and the Gaeltacht, under Michael D. Higgins, in 1993. Although the ministry has gone through several name changes and role modifications since then, it remains the main overseeing body for state patronage.

Looking back on the state's record, it is fair to say that there were no long-term policies for patronage for most of the twentieth century. Instead, a series of once-off gestures were offered while a few dedicated individuals struggled to keep the Arts at centre stage. Brian P. Kennedy cites a senior official in the Department of Finance in the 1970s as saying: 'The Department of Finance did not care a fig about cultural bodies . . . I, like everyone else in the Department, I should think, had little respect for the Arts Council.' (B.P. Kennedy, p. 167)

Kennedy's anonymous spokesman was opposed to the Arts Council because he felt that, 'They established a coterie or clique around themselves.' This perception was shared by others in the early decades of the Council. It was felt that certain members of the Arts Council used public funds to indulge private taste, especially in relation to the artwork bought to embellish the Council's offices and to support artists, that they were too middle-class and too concerned with reputation (Bruce Arnold), that they lacked policy (Charles Acton), and that their spending was too concentrated in the Dublin area, at the expense of the rest of the country (B.P. Kennedy, pp. 156–57). In response to a question about arts funding in twelve counties in 1961/62, the Department of the Taoiseach was forced to admit that five counties had received nothing. This number had gone up to seven when the question was repeated in 1965/66. Artists complained about the bias towards internationalism which saw the Council give £17,000 to Rosc (qv) in a single year, 1971, while its total grant to the Project Arts Centre between 1969 and 1973 was only £3,000. Nationalists were outraged when an exhibition catalogue essay by T.G. Rosenthal referred to the period of the War of Independence as a 'senseless war' and was not spotted by the editors (op. cit., p. 160). Nonetheless, increased pressure on the Council's services shows how important it was becoming to the arts community.

Although patronage by the Roman Catholic Church was one of the most powerful forces in the history of European Art, it is not surprising that that model was not replicated in Ireland, where it began to emerge from political repression only in the early nineteenth century. For better or worse, it was still the most important patron of the arts in the 1920s and '30s, although much of this related to events, such as the centennial anniversary of Catholic Emancipation in 1929 and the 1932 Eucharistic Congress [366]. More quietly, but with a more enduring effect, the Church was responsible for the architecture and decoration of two of the finest art projects in the century, the Honan Chapel (1915–17), University College Cork (UCC), and Loughrea Cathedral (1897–1947), where some of the finest artists from all

366. Main altar, Eucharistic Congress, Phoenix Park, Dublin, 1932, Dublin Diocesan Archive

367. Francisco Goya's *Doña Antonia Zárate*, gifted to the Irish State by Sir Alfred and Lady Beit, in its previous location in the drawing room at Russborough House, Co. Wicklow

religious denominations came together to provide a fully integrated decorative scheme. Loughrea and UCC are the exceptions that underline the rule, however. On the whole, the Church in Ireland was stolidly conservative in its patronage, despite huge expansion in the mid-century which saw 26 new parishes, 34 new churches and 67 new secondary schools established in Dublin alone, under the archbishopric of John Charles McQuaid. Although important commissions were given to artists such as Patrick Pye (qv), Richard King and Imogen Stuart in the second half of the century, a preference for cheap, imported blandness predominated. Nevertheless, the Church helped to develop wider appreciation of the visual arts through articles, and commissioned illustrations in journals such as the *Capuchin Annual*, *Studies* and *The Word*. Conservatism and lack of imagination at home was offset by innovative architectural projects by missionaries in Africa. While other churches were less overt in their patronage, there was widespread support from them all for Irish stained glass by Sarah Purser, Evie Hone, Harry Clarke (qqv), Michael Healy, Catherine O'Brien and Richard King (see 'Religion and Spirituality' and 'Stained-Glass, Rug and Tapestry Design').

As the century developed, sponsorship became the new patronage, directed generally to museums and mass events such as performances and exhibitions (qv). S.B. Kennedy identified an upsurge in private patronage in the 1920s and '30s as individuals stepped in to assuage the meagre budgets of publicly funded galleries (S.B. Kennedy, p. 84). The role of Hugh Lane in Dublin between 1903 and 1915, and Joseph Stafford Gibson in Cork in 1919, as the major benefactors respectively of the Hugh Lane and Crawford galleries, and the Friends of the National Collections of Ireland (FNCI), the Haverty Trust, Michael Scott, Alfred Chester Beatty, John and Gertrude Hunt, Sir Alfred and Lady Beit [367], Gordon Lambert, Basil Goulding, the Contemporary Irish Art Society (CIAS) and others has been related in essays on collecting (see 'Collecting Art', and 'Publicly Funded Collections'), but Gibson's sponsorship of a scholarship to enable Munster artists to study abroad for up to one year is less well known. The influence of Sarah Purser's An Túr Gloine (Tower of Glass), which she founded to train stained-glass artists, was immeasurable (see 'Women and

the Visual Arts'), as was the impact of the contemporary British paintings bought for the Ulster Museum in Belfast with monies from the Lloyd Patterson bequest. Without Bea Orpen and her husband Terry Trench, the Drogheda Municipal collection would not have succeeded as it has. Of the contribution of patrons who were not noted collectors, the most important is undoubtedly George Bernard Shaw. By bequeathing one-third of his residual estate, hugely boosted by proceeds from *My Fair Lady*, the film version of his play *Pygmalion*, Shaw became a major benefactor to the NGI.

But despite the importance of these individual acts of patronage, it is from corporate collecting and sponsorships that the greatest gains have been made (see 'Private and Corporate Art Collecting'). The process was begun by the Electricity Supply Board in the 1920s, when the company commissioned Seán Keating (qv) to record the creation of the first power station at Ardnacrusha. Brian Fallon has described Alexandra Wejchert's *Freedom*, commissioned for the Allied Irish Banks (AIB) Group headquarters at Ballsbridge in Dublin, as the best piece of abstract public sculpture in Ireland (Ryan, p. 248). Its closest rival is Gerda Frömel's *Sails* at the former P.J. Carroll and Co. offices in Dundalk, while other forms of corporate sponsorship included the use of the Bank of Ireland's Baggot Street headquarters as an exhibition venue. Patronage did not stop at collecting as corporations heeded the words of Arts Council director, Father Donal O'Sullivan, 'the advertising returns from art patronage would be far more prestigious and far more durable eventually' (John Armstrong, 'Art Patronage and Irish Industry', *IT*, 8 September 1971).

By mid-century, corporate sponsorship of the arts was already underway with the inauguration of the Carroll's Art Awards, and sponsorship of *Rosc '67* [436] by W.R. Grace and Company, and Bord Fáilte. The P.J. Carroll Awards revitalized a flagging IELA in 1964 and sustained a generation of Modernist artists until that role was taken over by Guinness Peat Aviation. GPA first signalled its interest in contemporary art by agreeing to sponsor Rosc in the 1980s, and, starting in 1981, ran an emerging artists award that continued into the next decade. Dorothy Walker, a former selector and judge of the award, claimed that it was really important for young artists and that, 'It was through GPA that Willie Doherty (qv) became known.' (Ryan, p. 212) GPA and, later, the Glen Dimplex Artists Award (1994–2000), the Nissan Public Art Award (1997–2000) [368] and the AIB Art Prize for emerging artists, inaugurated in 2000, were significant events, involving exhibition opportunities in prestigious venues, the chance to have artwork seen by internationally renowned jurors, as well as significant cash awards. Collectively they did a great deal to arouse attention for challenging new art and the artists who made it, as well as the promotion it gave to the sponsors themselves. The year 1988 saw the establishment of Cothú, the Business Council for the Arts and Heritage, now called Business2Arts, which brokers relationships between business and the arts.

The scale of corporate awards and the exhibitions that accompany them should not overshadow the solid contribution of individual awards, such as the Royal Dublin Society's (RDS) Taylor Scholarship. This, the longest-running art award in the

368. Declan McGonagle (IMMA) and Gerard O'Toole (Nissan) with artists Frances Hegarty and Andrew Stones at the launch of the Nissan/IMMA Public Art Award in 1997

state, was instituted by Captain George Archibald Taylor in 1860 and is administered by the RDS. Recipients include many important figures from Irish art, among them William Orpen, Beatrice Glenavy (née Elvery), Harry Clarke, Mainie Jellett, Seán Keating, Louis le Brocquy, Norah McGuinness, Colin Middleton, Charles Cullen, Andrew Folan and Dorothy Cross (qqv). A prize for students, its benefits were pointed out by Ronnie Hughes (qv), winner in 1989: 'More important than the money at that tender age of my practice was the confidence it engendered – the sense that what I did was of some value to someone other than myself. That feeling should not be under-estimated, especially at the beginning of a career.' (*Dearc: Celebrating 150 Years of the Taylor Art Award*, 2011, p. 52) Other awards, such as the Alice Berger Hammerschlag Award, the Thomas Damann Award, the Macaulay Fellowship, the PS1 (now Location One) scholarship offered by the Arts Council, the Purser-Griffith Travelling Scholarship, and the Arts Council's comprehensive Travel and Training Award, encourage foreign travel and study at different career points. Prizes were also a feature of events and exhibitions such as the Aonach Tailteann (Tailteann Games) in the 1920s, the annual Oireachtas prizes, and the RHA and Royal Ulster Academy exhibitions, where the prize is often directed towards a particular form of practice, such as the *Irish Arts Review* Portraiture Award at the RHA. Since 1991 an important Irish-American award is the O'Malley Award, in memory of Ernie and Helen Hooker O'Malley, while Irish artists from Louis le Brocquy and Patrick Scott to Kathy Prendergast (qqv) have benefited from the international attention that Venice Biennale or Guggenheim awards confer. Since the 1990s a new trend is the number of local authorities that have also instituted art prizes.

When asked about the role of the state and wealthy patrons, Noel Sheridan (qv), conceptual artist (see 'Conceptual Art') and former director of NCAD, gave an artist's response:

One thing, I think about it is that it doesn't matter what I think With the death of Modernism [qv] it may be that we are going back to an earlier model where the State rather than the Church is patron and corporations or wealthy individuals, in competition for status art, set the agenda.

Great artists in the past have made great art in what might be called barbarous conditions. I think in many ways it's becoming more like the Renaissance now than Modernism. It's very complex and I'm interested in how artists deal with it. Art is no longer underground. It is hugely popular, so old strategies no longer apply. Art's got to make itself up again. If I knew how I'd tell you ... it must come from the bottom up – from artists. (Ryan, p. 23)

CATHERINE MARSHALL

SELECTED READING S.B. Kennedy, 1991; B.P. Kennedy, 1998; Ryan, 2003.

PHOTOGRAPHY IN IRELAND (see *AAI* II, 'Photography in Nineteenth-Century Ireland').

In the international art world, photography is accepted as one of the most important art forms. It's fair to say that in Ireland we have been much slower to come around to this idea, though that is changing, with an increase in the number of photographic exhibitions, and indeed galleries devoted to photography, and photographic degree and MA courses. (Aidan Dunne, 'Moving Pictures', *IT Magazine*, 26 June 2010)

That Ireland was outside the European norm in this is clear from the remark of the German artist Wolfgang Tillmans: 'When I was growing up all the art that touched me was lens-generated.' (*Guardian Review*, 26 June 2010) Before the 1970s, when conceptual artists influenced new attitudes to photography, the absence of education, exhibition and collection structures meant that its main practitioners in Ireland were press photographers, studio portraitists (see 'Portraiture') or those who developed tourist images for picture postcards.

The lack of recognition for photography is especially disappointing given that early Irish photographers were considerably more experimental than their painting colleagues. J.M. Synge's photographs of Aran Islanders (1898–1905) presented compelling photographic images of a vernacular life style in the west of Ireland years before Paul and Grace Henry (qqv) put the region on the map through their paintings. David Davison emphasizes the contributions made in the nineteenth century by such figures as Francis Stewart Beatty – the first person in the English-speaking world to record making a daguerreotype, an achievement he published by sending a sample to the *Belfast Telegraph* on 20 September 1839, only five weeks after Louis Daguerre first announced his discovery in France.

Lucien (George) Bull (1876–1972) was appointed director of the Marey Institute in Paris in 1916 for his contribution to rapid photography. As early as 1902 Bull had managed to record 500 images per second, increasing this to a million over the next fifty years. The importance of this can be understood when we realize that early photography was so slow that sitters posing for studio photographs were frequently required to wear a neck brace to maintain their pose. Yet Frederick A. Bligh (1861–1915), from County Meath, captured high-speed sports events, including a man on a toboggan soaring at an estimated speed of 100 mph,

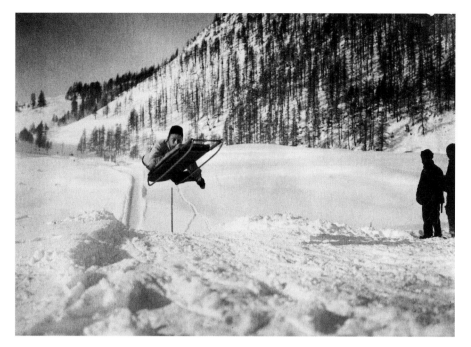

above the Cresta Run at St Moritz *c.* 1896 [369], without sacrificing the principles of composition. For all his technical accomplishments, Bligh adhered to the aesthetic ideas of the Pictorialist movement, which was dedicated to making photographs for purely artistic purposes (Davison). George Bernard Shaw, an enthusiastic member of the Royal Photographic Society, claimed to be a failed artist more interested in making pictures than in writing. Having acquired his first camera in 1898, Shaw valued the roles of photographer and subject equally, as can be seen in his involvement in photographs *of* as well as *by* himself, including a series of nudes for which he happily modelled. A 1910 photograph of an interior, in which he is portrayed warming his hands before a simulated fire, reveals an interest in mixing visual fact with fiction. Although opposed to manipulation of the image after the photograph was taken, Shaw delighted in playing with perceptions of truth in relation to the camera. *Interior beside Sigismund de Strobl bust, shaking head* [370] offers a wry comment on the nature of sculptural and photographic portraiture.

Photography became popular in Ireland between 1870 and 1920, the period of the Land Wars and the War of Independence. Photographic collections grew up around the houses of the gentry. While many of those collections were lost, as some Great Houses burnt down during that period of unrest, enough remain to testify to both the quality and the range of subjects photographers embraced. Roger Casement's photographs of life in the Congo and South America formed important accompaniments to his writing about colonial cruelty (National Photographic Archive (NPA)). Photographers at home in Ireland ranged from celebrations of life in the Great House by the owners, such as the Clonbrook Collection (NPA), to photographs by Patrick Kenrick, an employee at Grove House, Fethard, Co. Tipperary (National Museum of Ireland). Kenrick never owned a camera but used one given to him by his employer between 1900 and

1910, teaching himself to develop and print his own images of cricket parties and elegant visitors, with an intuitive but unerring understanding of composition. The Poole, Lawrence, Keogh and Hogan collections (NPA) contain important visual records of the day-to-day history of Waterford and Dublin through very stirring times, including the 1916 Rising and the Civil War, while the landscape of the Irish coast was recorded by the Irish Lights Commissioners and their photographer, Sir Robert Ball, during inspection tours of lighthouses (NPA).

The most well-known Irish photographer of the first half of the twentieth century was Father Francis Browne, whose images of the ill-fated Titanic on which he had sailed from Belfast to Cobh, won him instant fame, rekindled when he published photographs of his experience as a chaplain to the Irish Guards in World War I. But although he went on to take nearly 42,000 photographs recording his travels to Australia and South Africa, and the places he visited en route, as well as life back home in Ireland, his work as a priest took precedence. When, in 1985, twenty-five years after his death, a colleague rediscovered the negatives and took them to the Sunday Times in London, the features editor described the find as 'the photographic equivalent to the discovery of the Dead Sea Scrolls' (O'Donnell, p. 118).

Topography and lifestyle

Synge's photographs of the folk life of the Aran Islands were complemented by the topographical photographs commissioned by the Congested Districts Board between 1891 and 1923 to record housing conditions in the poorer parts of the country. Of these, the photographs taken by Robert J. Welch, around 1900, are exceptional for their documentary rigour, on the one hand, and the beauty of the images on the other. Fifty years later Nevill Johnson (qv) captured the mixture of decayed Georgian grandeur and poverty that was the Dublin of the 1950s, and the streetscapes of Dublin were recorded again in the 1960s and

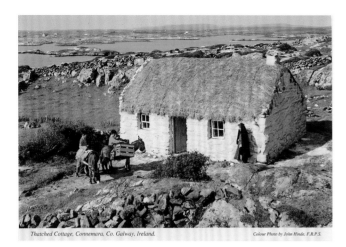

Thatched Cottage, Connemara, Co. Galway, Ireland. Colour Photo by John Hinde, F.R.P.S.

early '70s by Elinor Wiltshire, who, with her husband Reginald, established the Green Gallery on St Stephen's Green. Wiltshire's photographs encompassed the utopian dream of social housing represented by the new tower blocks in Ballymun and the destruction of inner city communities as York Street was cleared. What these photographers shared was a reverence for the Pictorialist tradition, later taken into more psychologically penetrating directions in Tony O'Shea's *Dubliners*.

Of the commercial photographers interested in topographical imagery, the Eason, Cardall and John Hinde viewcard collections were the most popular and important. The images used to promote Ireland, either in the form of postcards or calendar illustrations, blended reality with fantasy and romance. This is especially true of the postcard photographs produced by John Hinde (1916–97) [371] and his studio. Hinde, from Somerset, came to Ireland in the 1950s to work in a circus, but turned, instead, to professional photography. Unable to get his images printed in colour, he set up his own company, John Hinde Ltd, in Dalkey, Co. Dublin in 1957, to produce and market Irish view cards. His team experimented with colour intensity and subject matter to present a view of Ireland that was often more constructed than real, and always romanticized. Where earlier, more realistic views of Ireland appealed to generations of emigrants, Hinde's cards attracted a new generation of tourists who had no Irish connections, attracted by the romance of thatched cottages and fishermen carrying currachs, even if Hinde had cunningly imposed rhododendron bushes to provide colour and to guide the eye, or dressed the fishermen to conform to a more picturesque view of the country. The success of John Hinde Ltd was due to the company's identification and shaping of aspects of Ireland that suited the needs of the tourism industry, as a retrospective exhibition, *Hindesight*, at the Irish Museum of Modern Art (IMMA) in 1993 revealed. In many ways the photomontages of Seán Hillen (qv) in the 1980s and '90s can be read as a critique of the clichéd nostalgia of Hinde's pictures. Photographers such as Colman Doyle (staff photographer with the *Irish Press* since 1951 and photographer of Irish subjects for *Paris Match* for forty years) and Bill Doyle opted for less constructed views of the west of Ireland. Bill Doyle's colour photographs *Island Funeral, Inis Oirr* (1964) challenge the

artificiality of Hinde's postcards. Like Fergus Bourke [372] and Bob Quinn in Connemara, Padraig and Joan Kennelly in Kerry and John Minihan (qv) in Athy, they photographed the people and the landscapes they inhabit, documenting the ordinary in an extraordinary environment.

The exotic nature of Irish life attracted photographers from abroad. Henri Cartier-Bresson photographed horse racing at Thurles, while Martin Parr, whose experimentation with new colour documentary photography was to influence a generation of Irish practitioners, published the activities of a fair day in Ireland in 1984. Other visiting photographers included Dorothea Lange, Josef Koudelka, Eve Arnold, Don McCullin and Candida Höfer.

Socially engaged photography
A number of socially engaged photographers, such as Derek Speirs, Mick O'Kelly (qv), Tony Murray, Tony O'Shea, Leo Regan and Anthony Haughey [373], concentrated on realist photographs of life along the border during the 'Troubles' (see 'The Troubles and Irish Art'), in Traveller communities, and areas of social stress and disadvantage. Derek Speirs used his camera to highlight working conditions, social inequality and injustice from Dublin to Africa and Cambodia. The realities of daily life in poorer areas of Belfast during the Troubles were explored through *Belfast Exposed*. Developed, initially, in 1983 as a community project, led by Danny Burke, which enabled amateur photographers to document and exhibit local life, *Belfast Exposed* is now a successful gallery with an important

371. John Hinde,
*Thatched Cottage,
Connemara, Co. Galway*,
picture postcard,
1966–69

372. Fergus Bourke,
*Famine Burial Ground,
Flight 105 to Boston*,
c. 1999, limited edn of 30,
61 x 81.3 cm

373. Anthony Haughey, *Red Coffins, Glogjani, Kosovo*, from the Disputed Territory series, 2006, chromogenic print, 101.6 x 101.6 cm

visual archive of life recorded by the communities themselves. Hinde's romantic views of Ireland give way, in Anthony Haughey's images of the Blasket Islands, to the realities of emigration and depopulation, while Padraig Murphy's photographs of Newport in Wales draw attention to transience. Much of this work is monochrome, although Haughey went on to use colour to great effect in a body of work entitled 'Disputed Territory' from Bosnia, between 1998 and 2005, and in 'Settlement' [517], his work documenting the ghost estates of Celtic Tiger Ireland. Martin Cregg, Noel Bowler and Eoin O'Connell also negotiate and visualize the shifts and changes in the Irish social and cultural landscape in their photographs.

There is a level of social engagement, too, in the work of Donovan Wylie, the only Irish photographer, and the youngest ever, to be invited to join Magnum Photos, the international photographer's co-operative, established by Cartier-Bresson. Wylie brought his camera inside the decommissioned Maze prison in 2003 and flew by helicopter around army surveillance towers to reveal the disconcerting aesthetics of military architecture.

The influence of conceptualism (see 'Conceptual Art')
In 'The Photographic Fix', Tanya Kiang points to the ubiquitous nature of the medium, asserting that 'Photographic languages form the vernacular of modern visual culture' (Kiang, 18–23). Yet the tendency to think of photographs primarily as evidence

remains strong in Ireland despite awareness of photomontage, trick photography, and newer forms of image manipulation. The idea of the photograph as a record of reality forecloses other more imaginative interpretations of them. The use of photography by conceptual artists forces a reappraisal of that innocent reading on audiences made sceptical by advertising and digital technologies. While painters like Robert Ballagh and Hughie O'Donoghue (qqv) have blurred the distinction between painting and photography, the real changes came from within sculpture departments in the art colleges. Since the 1980s, artists like Willie Doherty, Gerard Byrne, Paul Seawright (qqv), Ronan McCrea and Mary McIntyre, inspired by the example of James Coleman (qv), used photography and film (qv) as the primary vehicle of their fine art practices. As early as the 1970s, Coleman pioneered the use of photographic stills, in tape/slide and multi-media installations (see 'New Media Art' and 'Installation Art') that disrupt assumptions about history and identity. Since then, a generation of younger Irish artists have experimented with the sculptural possibilities of photography, most notably Willie Doherty and Gerard Byrne (who represented Northern Ireland and Ireland respectively at the 2007 Venice Biennale), Jaki Irvine, Clare Langan, Hannah Starkey (qqv) and Paddy Jolley.

Growing up within Northern Ireland during the Troubles, Doherty reacted against the manipulation of the viewer in news photography and media representation. The American critic Lucy Lippard quotes Doherty as saying that his photographs 'do not propose any evidence of truth Their job is to be there. They occupy space in an uncertain present, a past which is in the process of being denied and a future without history.' (Lippard in Ziff, 1995, p. 20). As Lippard also remarks: 'For Irish artists, the camera becomes witness and surveillant, a contradictory double-symbol of internal liberation and external oppression.' (p. 22) Like Coleman, Doherty combined documentation with Conceptualist strategies from fine art. Where Coleman used the voice-over, Doherty created a dialectic between superimposed text and the image or sequences of images and texts and went on to critique the politics of vision through his exploration of colour in relation to nationalist sentiment, the vantage-point from which the photograph is taken (the view of the colonizer, victim, terrorist, patriot, Catholic, Protestant) and the context for the image (images with words in the art gallery instead of the newspaper or the advertising hoarding). The outcome is a new questioning of identity and context.

Paul Seawright, another Northern artist, used photography to search for and reveal what is hidden from the camera. Through his fondness for occluded views of subjects such as gatherings of Orangemen and police barracks, he draws attention to zones of activity that create a sense of unease, or point to brutalization without explicit reference. When the Imperial Wartime Museum, London, invited him to go to Afghanistan in 2002, Seawright sought to counter dramatic embedded press images of war, emphasizing instead the purity and innocence of the landscape, until closer scrutiny reveals pervasive traces of conflict. Victor Sloan (qv) manipulates his negatives during the printing process to create images of communities and tradition in flux in Northern Ireland which erode distinctions between photography and painting.

Positioning photography

Kiang quotes John Tagg as saying: 'Photography as such has no identity. Its status as a technology varies with the power relations which invest it. Its nature as a practice depends on the institutions and agents which define it and set it to work.' (Kiang, 22) Writing about photography in the UK, Emma Dexter points to the absence of an institutional framework to support it, collect it, and establish its connection to Modernism (qv) (Dexter, pp. 221–22). She calls attention to the situation in New York where MoMA has had a dedicated photography department since the 1930s. The first British museum to house a photography department was the Victoria and Albert Museum in 1976 and, even then, the impetus for its establishment was driven by fashion and design rather than by fine art. It was only after the advent of Conceptualists like Victor Burgin and Richard Long that the medium began to arouse serious attention in Britain, and it was not until the 1990s that the Tate Gallery started to collect photography.

The situation in Ireland was little different. Thanks, however, to the achievements of lens-based Conceptualists like Coleman and Doherty in deconstructing the language of photography, thus placing it firmly within a Postmodernist discourse, and regular lobbying for the medium by Fergus Bourke and others, the profile of Irish photography grew incrementally during the 1970s and '80s. The Arts Council (qv), which gave Nevill Johnson a grant to buy his Leica camera as early as 1952, publicly acknowledged the practice by giving a bursary to Tony Murray for his photographic work in 1978, including Fergus Bourke among the founding members of Aosdána (qv), and, above all, helping to fund the Gallery of Photography when it opened in Dublin in 1978. Apart from the sterling work of this gallery which succeeded, despite meagre resources, in providing talks, workshops and exhibitions, among them *Belfast Exposed* in Belfast from 1983 onwards and *Contemporary Irish Photography* at the Guinness Hop Store in 1987, opportunities to exhibit photography were limited until the 1990s. Following its opening in 1991, IMMA held solo exhibitions of some of the most celebrated photographers internationally such as Bernd and Hilla Becher, Craigie Horsfield, John Heartfield and Thomas Ruff, and collected work by Horsfield, Ruff, Doherty, Gene Lambert (qv), Langan, Seawright, Starkey, Amelia Stein and others in its first decade.

The Gallery of Photography moved, in 1995, to Dublin's Temple Bar, to a purpose-built space, designed by the architectural firm O'Donnell + Tuomey to reference the ubiquitous box camera. Over the years it has built up a reputation for showing first-class photography by Irish artists and solo shows of some of the most legendary names from abroad, initiated an active forum for discussion, provided dark room, digital and workshop facilities, and promoted Irish photography at home and abroad. It provides a regular focus for the medium for both audiences and practitioners and, with the Dublin Institute of Technology (DIT) School of Photography, and the NPA, forms the National Photography Centre. In 2010 the Gallery initiated the *Photo Ireland Festival*, in which some thirty photographic events were staged in venues throughout Dublin and which it hopes to turn into an annual event. *Source Magazine*, formerly *Photoworks North*, the Belfast-based photography periodical, offers another medium for contact, information-sharing and critical writing.

On an educational front, the first full-time, nationally accredited diploma course in photography was co-ordinated by Daniel de Chenu at the Dun Laoghaire Institute of Art, Design and Technology during the 1990s. It has now become an honours BA course and is joined by similar courses at NCAD, DIT and the University of Ulster.

In the course of the twentieth century Irish photography moved from the Great House to the city centre, and on to the national stage. Photography has proved itself as a suitable recipient for public art projects, as shown by Paul Seawright's work for *In-Context*, Tallaght, 1999 and Amelia Stein's successful completion of a Per Cent for Art project at the Royal Hibernian Academy (qv). Having documented all the Academicians in their studios, Stein was herself elected to membership of the Academy, the first photographer to achieve this recognition. When, in 2006, IMMA presented the exhibition *Magnum Ireland*, which brought together photographs of Ireland, from 1950 to 2000, by a host of foreign photographers including Cartier-Bresson, Arnold, Koudelka and others, it proved to be one of the most popular exhibitions of the decade. It was not surprising, then, that when IMMA offered an overview of Irish art from 1900 to 1970, *The Moderns* (2010), it collaborated with the Gallery of Photography to curate a display of Irish photography that surprised many with its scope and quality. The publication in 2011 of the first substantial engagement with the formation of photographic culture in Ireland, *Photography and Ireland* by Justin Carville, marked another landmark in this history. CATHERINE MARSHALL

SELECTED READING Cameron, 1993; Kiang, 1995; E.E. O'Donnell, 1994; Durden and Stathatos, 2003; Lardinois and Williams, 2005; Davison, 2006; Emma Dexter, 'Bringing to Light: Photography in the UK 1980–2007', in Stephens, 2008; C. Kennedy, 2011.

POLITICS IN IRISH ART 1900–2000 (see *AAI* II, 'Politics in Irish Painting 1700–1900'). Notwithstanding the multiplicity of meanings associated with the word politics, this essay sets out to map in a straightforward way the interaction between artist and state, from the Celtic Revival of the early 1900s through to the turbulent years of the Celtic Tiger economy a century later. Focusing on the relationship between the individual and the state, politics provides one matrix within which the impact of the visual arts on society can be assessed. Movements such as Feminism, civil rights and gay rights are included in the search for representation of marginalized groups, with art providing visual evidence of their endeavour, and the creation of new identities. The relationship between art and the 'Troubles' is covered in a separate essay (see 'The Troubles and Irish Art'). In the twentieth century, art was mainly viewed by politicians within a narrow framework, primarily as a means to commemorate significant events and personalities. However, this forms only a small part of a larger picture in which the visual arts play a surprisingly active role.

The artist Brian Maguire (qv) tells of a class he gave in the early 1990s to Republican prisoners in Portlaoise jail. He described a public art project he was working on – a billboard depicting urban deprivation. In the ensuing discussion, one of the prisoners suggested displaying the billboard in a shopping centre, where it might make middle-class shoppers feel guilty. Maguire explained that if the billboard were displayed in one of the poorest areas of Dublin's inner city, it might make local people angry and they might then do something about their situation. One of the group was startled at the idea. 'I never thought art could be like this', he said; 'this is like a bombing meeting.' (conversation with the author, 1995)

An advocate of social justice for many years, Maguire is one of a generation which came of age in the late 1960s, a decade after Michael Kane, Brian Bourke (qqv) and James McKenna, all of whom looked to art, rather than violence, to effect political change. Up to this point, painting and sculpture in Ireland had been steadily sapped of much of the vitality that had characterized the first three decades of the twentieth century. Visual aesthetics had become distanced from politics, with art seen as an autonomous activity rather than as a prime mover of social change. Painting in its various forms was celebrated for an ability to convey likenesses and impressions, while non-representational art, notwithstanding its being championed by the Arts Council (qv), was generally considered to be elitist and remote from popular concerns. These attitudes were linked to earlier developments in Irish politics and society. The partitioning of the country in 1922 into the six counties of Northern Ireland, which remained within the United Kingdom, and the twenty-six counties of the South, that were now self-governing, led to a myriad of changes, at both local and national level. In the Irish Free State, representatives of large sections of a previously marginalized community now occupied positions in government. Conversely, a minority, who had enjoyed political power and privilege, began to feel excluded. In Northern Ireland, the status quo did not change markedly, although Catholics were a minority in the new political arrangement. While the Free State remained a dominion of the British Empire until 1949, the effective end of British rule in the South brought with it a desire to create a new and distinct identity for the Irish nation, but there was no consensus as to what this identity should be (see 'Identity in Irish Art' and 'Cultural Policy in Ireland'). Official attitudes were informed by outdated ideas, and were frequently contradictory or irrational. While there were efforts in the 1920s and 1930s to establish the Hiberno-Romanesque style of architecture as the new 'national' style, these did not flourish, nor did attempts to promote Celtic art. The Irish Free State was classically post-colonial, as evidenced, on the one hand, by the destruction of Georgian buildings, largely because of their perceived association with British rule; while, on the other hand, much of the art world remained rooted in colonial experience and resistant to change. London retained its status as a major cultural centre, and many Irish art schools, galleries and museums continued almost as though they were regional institutions within the United Kingdom.

There is no single art form that can be tied in with the revolutionary period in twentieth-century Irish history, but Realism, in its various forms, held sway, with occasional forays into Modernism (qqv). Debate regarding art and politics concerned what was depicted, rather than the forms employed in such depictions. Art historians and social commentators alike tended to focus on portraits, street scenes, landscapes and allegorical works, overlooking the political dimension of non-figurative art. Artists were not impervious to this critical environment. From the nineteenth century onwards, Irish politics had been largely defined by nationalist idealism, in which the land and its inhabitants were seen as inseparable. Unionist aspirations were to a considerable extent also based on territory. Reinforcing this viewpoint, landscape painting (qv) emerged at the beginning of the century as both the most dominant and the most distinctly politicized genre. Just as the Irish language had survived in Gaeltacht (Irish-speaking) areas in the west, so it was felt that Irish identity was embedded in those same landscapes, particularly in Connemara, as exemplified in paintings by the nineteenth-century artists Frederick William Burton and Augustus Burke. This view of an 'authentic' Ireland was promulgated by many artists, notably Aloysius O'Kelly, whose *Mass in a Connemara Cottage* (c. 1880, on loan, NGI) is an unsentimental and realistic, but also a heroic, painting, one that shows the strength of Roman Catholicism in Ireland at a time when Catholic merchant and professional classes were beginning to dominate local government within Ireland.

The fact is that most land in the west of Ireland was in large estates, owned by more or less absentee landlords and administered by often ruthless agents, who regarded the eviction of tenants as a necessary economic strategy. However, with the passing of the Wyndham Land Act of 1903, followed by the Birrell Act six years later, there was a seismic shift in land ownership, with tenant farmers now able to acquire their holdings outright. At the same time, the Local Government Act of 1898 had transferred control of local affairs from mainly Anglo-Irish Protestant landlords to the newly emergent Catholic middle-class. The artistic gaze, associated as it had been with the landed class, now sought out less contentious territories. Opting out of a romanticized, or Gaelicized, view of the landscape, Irish artists such as Norman Garstin, John Lavery (qqv), Nathaniel Hone and Walter Osborne gravitated to Antwerp and Paris, where, untroubled by the politics of property ownership, they could study continental trends in painting. Although they learned to honour the heroic, sturdy peasants of Brittany and Normandy, as typified in Roderic O'Conor's (qv) *A Young Breton Girl* (1903, HL) [335], any idealized view of pre-industrial society they adhered to gradually evaporated as Europe was gripped by strikes, war and all-too-real revolutions of the proletariat. These artists, for the most part, quietly closed the door on politics, as their familiar, privileged world began to change. An extreme instance was the murder, by nationalists, of Permanent Undersecretary Thomas Henry Burke in the Phoenix Park, Dublin, in 1882, an atrocity that resulted in his brother, the artist Augustus Burke, quitting his post as professor of painting at the Royal Hibernian Academy (RHA) (qv) and moving to England.

Exposure to radical and socialist political theories in France did influence some Irish artists. Paul Henry's (qv) early paintings, inspired by Honoré Daumier and Vincent van Gogh

during Henry's studies in Paris, depict the harsh struggle for existence in the west of Ireland, with painful realism. However, in later years, as Henry continued to produce views of Irish cottages and mountains, that intensity of purpose, so evident in his earlier work largely disappeared. The country people tilling the soil, are not to be seen in later paintings such as *Lough Altan, Co. Donegal* (1930, CAG, AIB collection). For the most part, the task of representing the peoples of rural Ireland, and particularly the west of Ireland, fell not to artists who had studied abroad, but to graduates of the Dublin Metropolitan School of Art (DMSA), where the influence of William Orpen (qv) remained paramount. In 1912 Patrick Tuohy painted *The Mayo Peasant Boy* (HL) [492], and three years later Seán Keating (qqv) exhibited *Men of the West* (HL). In much Irish art, the poor remain unseen, invisible or sentimentalized, but the unflinching gaze of Tuohy's peasant boy, a child representative of an underclass considered dangerous by the authorities in Dublin Castle, transforms this painting into a political statement.

A latent sense of Irish nationhood had been encouraged in the late nineteenth century by artworks celebrating political heroes such as Daniel O'Connell and Charles Stewart Parnell. A similar impulse led Hugh Lane, in 1903, to commission John Butler Yeats to paint a series of portraits of political and cultural leaders, including Douglas Hyde, George Moore, Roger Casement, John Millington Synge, Lady Gregory and William Butler Yeats. This pantheon was to form the centrepiece of a museum of modern art that Lane worked to establish in Dublin. While the series was composed mainly of Anglo-Irish subjects, many seem to have qualified for inclusion through their espousal of the cause of Home Rule. Included also were the veteran Fenian John O'Leary, the Young Ireland leader Michael Davitt, and George Wyndham, who, although a Conservative, had steered reforms of land ownership through parliament. Lane's vision was supported by artists and writers, notably Sarah Cecilia Harrison and W.B. Yeats, as well as by public representatives such as the Sinn Féin Alderman Thomas Kelly (Logan Sisley, 'Portraits of National Interest', in *Revolutionary States: Home Rule and Modern Ireland*, exh. cat. HL, Dublin 2012, p. 55).

A palpable shift in loyalties, a key element in the politics and art of early twentieth-century Ireland, is encapsulated in the life of several women, including Alice Milligan, a friend of John O'Leary. Born into an Ulster unionist family, Milligan, while still a teenager, embarked on a series of cultural initiatives, including participating in touring theatrical tableaux that rejected the colonial history of Ireland and promoted instead a resurgent Gaelic culture. Another woman who rebelled against her background was Constance Gore-Booth, whose family lived in the stately home Lissadell in County Sligo. Gore-Booth first became an artist, then a left-wing republican rebel. After studying art in Paris, where she met her future husband, the Polish Count Markievicz, Gore-Booth fought in the 1916 Easter Rising and was only spared execution because of her womanhood. The artists Aebhgréine de Ceabhasa and Sadhbh Trinseach changed their names respectively from the Anglo-Irish Chevasse and Trench, reflecting a similar shift in political sympathies. While some of these artists are relatively minor figures, their transfer of

loyalties shows that parts of Anglo-Irish society were beginning to identify their future with Irish nationalism rather than with British imperialism. Other women artists were more neutral, overtly at least, in their response to changing political conditions. Credited with introducing Modernism to Ireland, Mainie Jellett (qv) came from a unionist family, as did Edith Somerville, yet both artists contrived to survive and even prosper within the new world in which they found themselves.

While many Irish nationalists enlisted in the British army in World War I, they often did so on the basis that Home Rule would be granted after the conflict. Others had reservations about joining up, and in late 1915 Seán Keating, a studio assistant to Orpen in London, returned to Ireland to avoid conscription. By 1918 he was teaching at the DMSA, and the following year he was elected a member of the RHA, an indication that the loyalties of the Academicians were also beginning to shift towards a more nationalist position. Keating's own change in outlook had been prompted by a visit in 1913, to the Aran Islands with Harry Clarke (qv). Over the following years, Keating produced many paintings depicting the islanders and their lives. Before his election to the RHA, few of its members, or indeed the members of other artists' organizations, would have been overtly nationalist or republican in outlook. Although Keating produced several works recording the War of Independence in heroic images, he came to renounce violence as a means of advancing political ideals. During the first decades

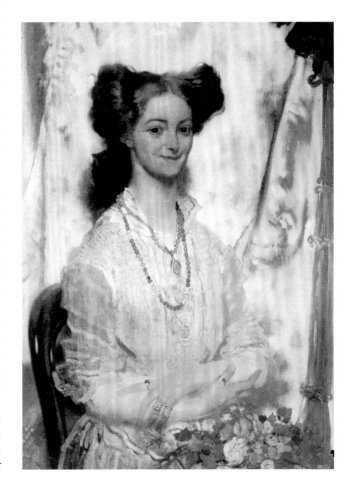

374. William Orpen, *Young Ireland: Grace Gifford*, 1907, oil on canvas, 89 x 63.5 cm, private collection

of the twentieth century, artists who actively promoted nationalist ideals often did so in oblique or symbolic ways – for instance, by representing the nation in the guise of a woman, as in Beatrice Glenavy's (qv) *Éire*, Orpen's portrait of a fellow-artist as *Young Ireland: Grace Gifford* (1907) [374], Keating's *An Allegory* (1924, NGI collection) and Maurice MacGonigal's (qv) *Mathair agus Naoidheanán* (1942) [375]. It is significant that, apart from Maud Gonne, the model for *Éire*, all the women chosen to represent Ireland in this way were revolutionary socialists: Grace Gifford, involved in nationalist and suffragists groups, married Joseph Plunkett shortly before his execution in 1916; May Keating was a member of the Friends of Soviet Russia (an organization suppressed by the government in 1932), while Aida Kelly raised funds for left-wing fighters in the Spanish Civil War.

Although there were many writers and poets among the leaders of the Easter Rising of 1916, few artists took a direct part in the events of that key week in Irish politics. Patrick Tuohy was involved in the fighting at the GPO, but shortly afterwards his parents sent him to study art in Spain, while the students and staff at the DMSA were for the most part neutral or undecided. Maurice MacGonigal, who would have been just sixteen at the time of the Rising, was one of the few to take an active part in the War of Independence that followed, as a member of the 4th Battalion of the IRA, and was later interned in Ballykinlar Camp, Co. Down. From 1916 onwards, Orpen remained in London and never returned to Ireland. Coming home to Dublin in 1916, after four years of study at art school in Paris, Kathleen Fox (qv) was shocked to find her friend Countess Markievicz amongst the Irish Volunteer insurgents who had briefly taken over the city centre. Fox recorded the surrender of Markievicz to British troops, outside the Royal College of Surgeons, in *The Arrest* (1916, Niland Collection, Sligo) [185]. Fox worked on this painting in secret, and when it was completed, sent it to a friend in New York, fearful that it would be confiscated by the British army, who were raiding houses in Ireland, seeking evidence against Republicans and rebels (Bhreathnach-Lynch, 1998, p. 44). During the Civil War of 1922/23 the painter Estella Solomons (qv) allowed her studio to be used by Republicans on the run. She painted portraits of leading political figures, including Sinn Féin activists Darrell Figgis, Frank Aiken, Seán Milroy and Father Michael O'Flanagan. Another portrait was of Frank Gallagher, contributor to the *Irish Bulletin*, the newspaper of the Irish government during the War of Independence.

Given the importance of trade unionism, the 1916 Rising and the War of Independence, it is surprising that there are so few paintings depicting scenes from these intense periods of unrest. However, this is more understandable when one considers that Solomons destroyed portraits she had painted, lest they be used as incriminating evidence. While works by Jack B. Yeats (qv), such as *The Funeral of Harry Boland* (1922, Niland Collection, The Model, Sligo) and *Communicating with Prisoners* (*c*. 1924, The Model, Sligo), can be related to particular events, Yeats was always careful to avoid direct political comment (see Róisín Kennedy, 'Divorcing Jack … from Irish politics', in Yvonne Scott (ed.), *Jack B. Yeats: Old and New Departures*, Dublin 2008, pp. 33–46). The realist paintings and woodcut prints of Harry Kernoff (qv), depicting everyday scenes in Dublin streets, stand out as rare examples of social realism during this period. He painted crowds at a socialist political rally, Liberty Hall, headquarters of the Irish Transport and General Workers Union, and portraits of James Connolly, leader of the Labour movement. Throughout his life, Kernoff was an avowed Communist, a risky stance for an artist in a predominantly Catholic country.

No less than the Easter Rising, the 1913 Lockout, a bitter dispute between employers and trade unions in Dublin, remains unrecorded in any major work of art. However, a large canvas from that same year, *Sowing New Seed in the Department of Agriculture and Technical Instruction*, painted by William Orpen (1913, Mildura Arts Centre collection, Victoria, Australia), is certainly a political allegory, albeit a bizarre one. The Department of Agriculture was responsible for administering art education in Ireland, including the DMSA, where Orpen had enrolled as a student at the age of thirteen, and where he subsequently taught. The following year, Orpen painted *A Western Wedding* (no longer extant), a painting that satirized rural Irish Catholic society. Painted in 1916, Orpen's *The Holy Well* [40], perhaps the oddest of all his political allegories, simultaneously celebrates and satirizes Irish nationalist cultural aspirations. In these works, Orpen stumbled in his attempt to make a reasoned response to Modernism. His greatest works of art are undoubtedly his harrowing depictions of trench warfare in France, made when he was serving as an official war artist during World War I. In addition to depicting ordinary soldiers, in 1919 Orpen painted a group portrait of the signing of the Peace Treaty at Versailles [349], in which the centrepiece is not Lloyd George or Woodrow Wilson seated at the table, but the distorted reflections in the Hall of Mirrors, with shadowy figures silhouetted against the light, fractured images expressing not only the artist's disillusionment with politicians, but perhaps also with his own conflicted sense of identity. Like Jack Yeats, Orpen's appreciation of Irish politics was perceptive, and, also like Yeats, he instinctively championed the underdog – he had been an admirer of the Dublin socialist leader Jim Larkin. However, the reality of having accepted a commission in the British army alienated him from his native country.

With Orpen achieving success as a society painter in London, it was his former pupil, Keating, who set out to create a series of images that celebrated both traditional Irish life and the revolutionary ardour that had brought the Irish Free State into being. His *Men of the West* (1915, HL) is legendary. His *Men of the South* (1922) [254] depicts an IRA flying column in County Cork. Absorbing Orpen's allegorical spirit, Keating created works of art that, more than any other, celebrate the revolutionary nationalists who fought in the War of Independence. However, he was disillusioned at the outcome of the Civil War that followed, and was not slow to satirize the more pretentious elements of the new Free State.

John Lavery had also served as a semi-official war artist, before returning to Ireland, where he painted portraits (see 'Portraiture'), including one of John Redmond, leader of the Parliamentary Party (1916, HL). Encouraged by his American wife Hazel, Lavery also painted portraits of the delegation sent to London in 1921 to negotiate the Anglo-Irish Treaty. The

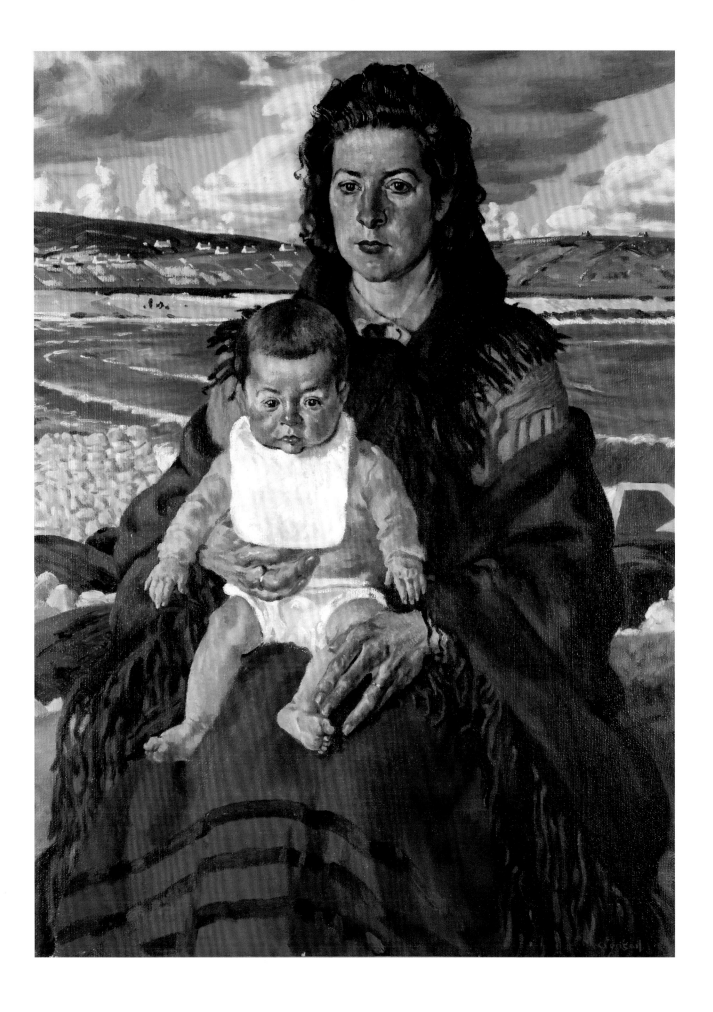

376. John Lavery,
Michael Collins (*Love
of Ireland*), 1922, oil on
canvas, 63.8 x 76.8 cm,
Dublin City Gallery The
Hugh Lane

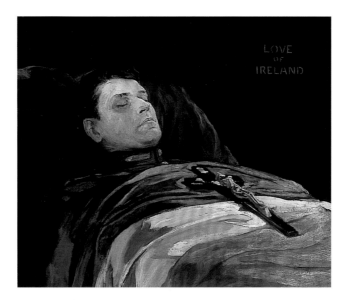

previous year, the Government of Ireland Act had allowed for the establishment of two parliaments – one in Belfast, the other in Dublin – and so effectively introduced partition. Lavery painted the signing of the Treaty in the House of Lords, and in 1922, following the assassination of Michael Collins, depicted the lying-in state in the Pro-Cathedral [376] and the subsequent funeral. In 1928, in recognition of their assistance in the early years of the Irish Free State, Lavery's portrait of his wife in the guise of Cathleen ní Houlihan, or Éire, arm resting on a harp, was incorporated into the design for the Irish bank note.

A revealing example of government arts patronage, the 1932 *Saorstát Éireann: Official Handbook* [108], edited by Bulmer Hobson (a Quaker and leading Republican), shows how the state portrayed even technologically pioneering works, such as the Shannon hydroelectric scheme, in visually conservative ways. The artists in this publication included Paul Henry, Maurice MacGonigal and Seán O'Sullivan, while the Celtic interlace cover was designed by Art O'Murnaghan. Conceived in the high-minded atmosphere of the 1920s, by the time the *Handbook* appeared Ireland had entered a more regressive cultural phase, dominated by a conservative business and political vision. The realities of self-government, coupled with a worldwide economic depression, combined to drain away much of the poetic inspiration that had sustained the Irish Free State in the first decade of its existence. Explorations of individual liberties and of new ideas were not encouraged by either Protestant or Catholic churches, with the latter perceiving its remit as extending to policing all aspects of cultural life in the state. Fear of such control had been a key element in Protestant fears of an independent Ireland, particularly as southern Protestants were now a small minority. State censorship and lack of patronage (qv) stifled creativity in the visual arts and drove many out of Ireland. One of the most celebrated instances of censorship came in 1930, when a stained-glass window by Harry Clarke, commissioned by the Irish government for the International Labour Organization in Geneva [365], was mothballed, on the grounds that some of

the imagery was inappropriate to represent a nation (Andrew J. Haggerty, 'Stained Glass and Censorship: The Suppression of Harry Clarke's Geneva Window, 1931', in *New Hibernia Review*, III, no. 4, Winter 1999, 98–117). By 1931 Samuel Beckett had concluded that pursuing a career in Ireland would be a 'grotesque comedy', and departed for the Continent (James Knowlson, *Damned to Fame: The Life of Samuel Beckett*, New York 1996, p. 126). In his essay 'Censorship and the Saorstát', Beckett observed that the Irish government of the 1930s promoted 'sterilization of the mind' (Ruby Cohn (ed.), *Disjecta: Miscellaneous Writings and a Dramatic Fragment*, Berkeley 1984, p. 87). It was not only that intellectuals such as Louis le Brocquy, Francis Bacon, Brian O'Doherty (qqv) and Beckett had left Ireland over the following decades to pursue careers abroad (see 'Diaspora and the Visual Arts'), within Ireland, a wall of silence built up, protecting state and religious institutions from critical oversight or democratic accountability. There were some opportunities, however, and Ireland's participation in the 1939/40 New York World's Fair took the form of a Modernist pavilion designed by Michael Scott which echoed perfectly the Fair's theme of looking to the future. Modernist works by Mainie Jellett and Evie Hone were displayed within the pavilion, alongside more traditional paintings, including a large mural by Seán Keating. However, the success of the Fair was overshadowed by the outbreak of World War II.

Throughout the war years, while the Free State remained neutral and therefore isolated from the world, Northern Ireland, being a part of the United Kingdom, was an active participant in the conflict. In the Free State, the government maintained a strong grip on security. More than 500 IRA members who had refused to accept the Free State were interned without trial, and some died on hunger strike. In contrast with Lavery's depiction two decades previously of the funeral of an earlier hunger striker, Terence MacSwiney, almost no reference to these events appeared in the visual arts, while the 1939 Offences against the State Act aroused little comment from the artistic world. Most of those involved in the visual arts, even if they did not fully trust Eamon de Valera, respected his leadership of a state that could easily have begun to slide into political disarray. Ireland remained divided into two political entities, North and South, and while there were some artistic interactions, in practical terms, the North had begun to go its own way.

Dublin's intellectual and artistic life was enlivened by the arrival of refugees from the Continent and conscientious objectors from Britain. Members of the White Stag Group (qv) became active in Dublin artistic circles, while members of the German diplomatic corps were also made welcome, with Patrick Hennessy (qv) painting portraits of the family of Eduard Hempel, the Nazi envoy to Ireland. Ireland's ambivalent neutrality during World War II, which encompassed covert support being extended to the Allies, left a curious aftertaste in the postwar period. The Irish expatriate artist Francis Bacon continued to work mainly in London, where in 1946 he completed *Painting*, the first of a series of tortured images that would catch the attention of the art world. William Crozier (qv) was equally influenced by Expressionism (qv) and a series of his paintings, inspired by the horrors of Nazi concentration camps, featured

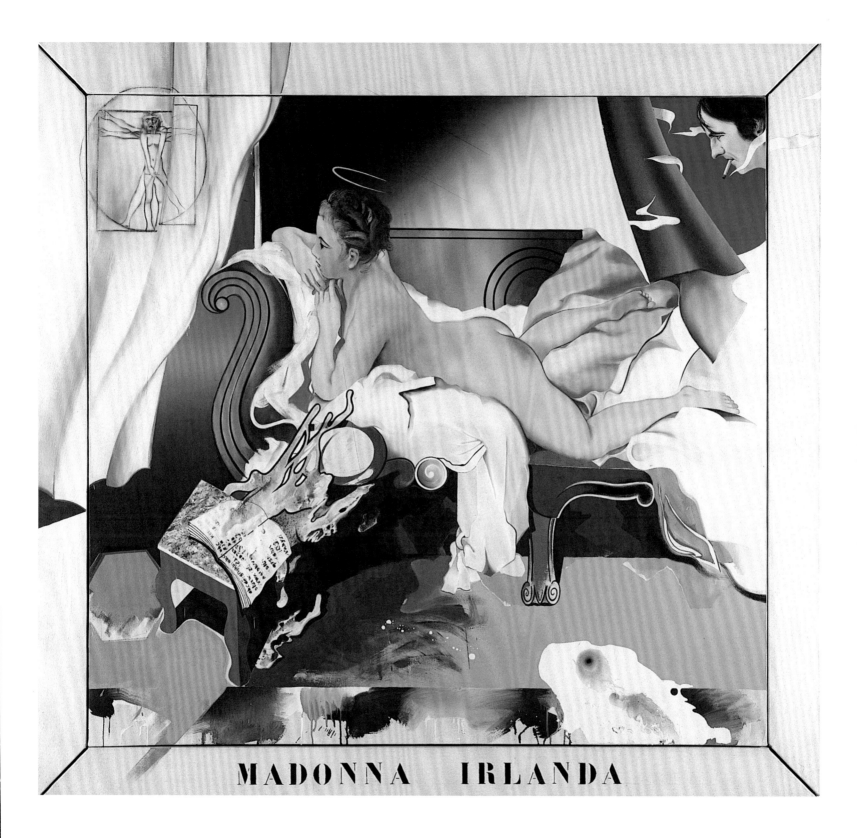

MADONNA IRLANDA

skeletal figures. Living in France, Louis le Brocquy painted *A Family* (1951) [71], an almost monochrome, fragmented image that captures the generalized feeling of post-war angst and political alienation that pervaded a Europe full of refugees and displaced citizens with chronic food shortages. In Ireland, although the economy was in the doldrums, food and drink were relatively plentiful. However, a sense of existential despair, and a claustrophobic atmosphere, permeated cultural life in Ireland during the 1950s with many artists, such as Tony O'Malley, Patrick Swift, Micheal Farrell, Patrick Collins and George Campbell (qqv) deciding either to emigrate or spend considerable periods living and working abroad, in such countries as Britain, France and Spain. In popular parlance, they were voting with their feet.

377. Micheal Farrell, *Madonna Irlanda or The Very First Real Irish Political Picture*, 1977, acrylic on canvas, 174 x 186 cm, Dublin City Gallery The Hugh Lane

While Realism flourished in the post-war period, Modernism in Ireland was more problematic. To an educated middle-class audience, concentrated for the most part in Dublin, Modernism was attractive, not least because it represented a window on to Europe and the wider world. However, as introduced largely through the work of Mainie Jellett, Evie Hone, Patrick Scott and Cecil King (qqv), Irish Modernism tended not to embody political radicalism, but more a conservative social idealism. This was underpinned by the architectural firm of Scott Tallon Walker, with Michael Scott taking a lead role in promoting progressive ideas, as well as designing several key buildings based on the style of Mies van der Rohe. Traditional political aspirations continued to be expressed largely through realist paintings, although by the 1960s depictions of the west of Ireland by Henry, MacGonigal and Keating had become clichéd, and were associated less with political ideals than with the marketing of Ireland as a tourist destination. After the 1960s, such images came to be avoided, for the most part, by younger artists such as Micheal Farrell [377] and Robert Ballagh (qv), who, while remaining acutely aware of Modernist trends, reinvested realist painting with much of the urgency and commitment evident in the early twentieth century.

The general avoidance of political themes in Irish art of the mid-twentieth century was widespread, and one looks in vain for direct political references in the work of such painters as Nano Reid, Norah McGuinness, Tony O'Malley, Patrick Collins, Edward McGuire, Patrick Scott, Charles Tyrrell and Barrie Cooke (qqv). However, there are plenty of oblique, or emblematic references. The abstract landscapes of Collins and O'Malley have been widely interpreted as attempting to evoke the 'soul' of pre-colonial Ireland, while Barrie Cooke's paintings of ancient Irish giant deer similarly refer to an 'authentic' prehistoric situation. Women artists have been often more courageous in directly engaging with political subject matter (see 'Women and the Visual Arts'), with, for example, in the 1970s Anne Madden (qv) referencing the events of Bloody Sunday in her abstract painting *Menhir (Bloody Sunday)* [378]. Over the course of the twentieth

century, depictions of violence in Irish art are comparatively rare, but the after-effects of conflict form the background or subject matter in many works of art, such as Robert Ballagh's 1972 installation at the Project Arts Centre, where he drew the outlines of dead marchers from the Bloody Sunday massacre, an event that also prompted an artwork performance by Brian O'Doherty [337, 379].

Beginning in the 1970s, performances and actions that had a direct political intention began to take place, mainly in Belfast and Dublin, and artists Robert Ballagh, Mick O'Dea (qv) and Brian Maguire consciously set out to champion individuals who had been silenced by the state, either through incarceration or being institutionalized [380]. As the 1980s unfolded, artists increasingly critiqued state institutions and society, and Expressionism provided an apt visual style for their message. Patrick Graham's helpless individual oppressed by state and religious institutions, and Maguire's portraits of prisoners and victims of extra-judicial killings in South America in the 1990s, are powerful political statements. These artists adopted a consciously urban standpoint, distancing themselves from the romanticized view of Ireland as a rural, homely and picturesque country. Ballagh's *The History Lesson* (1989) [381], a self-portrait of the artist between Patrick Pearse and James Connolly, reflects Ballagh's political stance, while his photo-realist portrait of Charles Haughey [111], the Fianna Fáil leader who had set down the seeds for the 'Celtic Tiger', but whose corruption led to his political downfall, is a poignant reminder of the fickleness of public opinion. During his years in power, Haughey was held in

378. Anne Madden, *Menhir*, 1979, acrylic on canvas, 195 x 342 cm, Arts Council/An Chomhairle Ealaíon

379. Brian O'Doherty/ Patrick Ireland, signed and witnessed agreement forming a part of *Name Change*, 1972 (see 337)

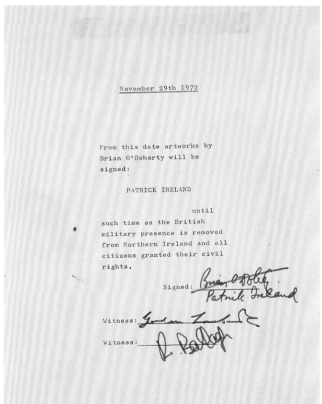

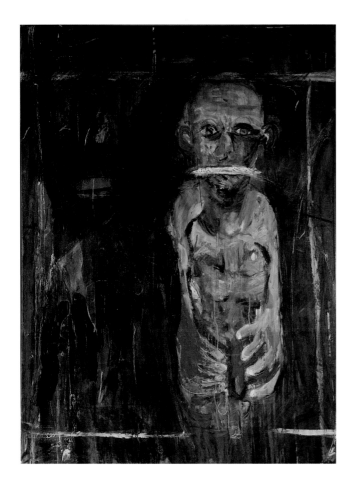

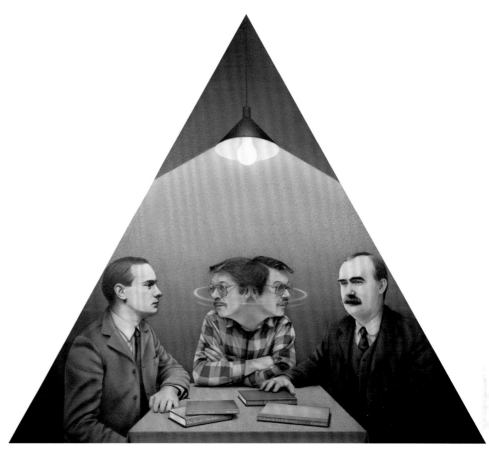

high regard, not least for his introduction of tax-free status for creative artists. After his death he was vilified.

In the 1970s and '80s, artists Nigel Rolfe, Alastair MacLennan (qqv) and Danny McCarthy continued to pioneer an art that was performative and politicized. Using text and performance, Gerard Mannix Flynn, who had been educated at one of the infamous 'industrial schools', brought a new level of protest and rejection of the culture of silence that characterized the Irish establishment. Other artists worked directly with different groups and communities, by-passing conventional politics, but creating art that was nonetheless clearly political. Pauline Cummins (qv) was the first visual artist to work with prisoners in Mountjoy's Women's Prison. She also participated in the *In a State* exhibition held in Kilmainham Gaol in 1991, in which artists reflected on the history of the building where the leaders of the 1916 Rising had been executed. Personal politics, and the quest for identity of self, dominated much of the art produced between 1980 and 2000. By looking at the way maps of cities and countries are created, and making her own maps of the human body or of cities, Kathy Prendergast (qv) highlighted the emotional responses of people to landscape. Prendergast and other artists, notably Alice Maher (qv), revisited the visual art tradition of assigning meaning to the female body (see 'The Body'), but did so from a critical point of view, deconstructing nationalist ideals through focusing on aspects of life such as individual identity, trauma and healing. Shane Cullen (qv) deals with

aspects of Irish history as recorded in monuments, memorials and commemorative art; his work has a universal significance in terms of the creation of the image of the state by governments in many countries. Working in a variety of media, often basing his paintings and sculptures on texts and legal documents as well as corporate images and logos, Cullen represented Ireland at the Venice Biennale (1995) with an uncompleted work, composed entirely of texts, *Fragments sur les Institutions Républicaines IV* [106]. This work, first shown at the Douglas Hyde Gallery, Dublin, is based on republican prisoners' writings during the hunger strikes of 1981. While at first glance these monumental panels appear to be machine-made, in fact they are hand-painted, a slow laborious process that reflects and echoes the prisoner's experience of time.

During the 1980s, encouraged by changes in the Arts Council's policies and the rapid development of community arts as a discipline, artists began to highlight the poverty and marginalization of inner city communities. The status of Travellers, the disabled, of refugees and economic migrants also motivated artists to work in programmes initiated by organizations such as CAFE (Creative Activity for Everyone), the Grapevine Arts Centre and the City Arts Centre. The exploration of socially engaged art practice and critical theory was led by a small number of art college tutors, notably Joan Fowler, who inspired a group of seven graduates of the National College of Art and Design, in 1989, to found Blue Funk (qv), champions of new

380. Brian Maguire, *Figure Silenced*, 1991, acrylic on canvas, 174 x 128 cm, Crawford Art Gallery

381. Robert Ballagh, *The History Lesson*, 1989, oil on canvas, 48 x 48 x 48 cm, private collection

media, live performance and installation art (see 'New Media Art', 'Time-based Art' and 'Installation Art'). Notwithstanding the diversity of work created by Blue Funk and other groups emerging around the same time, landscape and portraiture persisted as metaphors for political issues, albeit often in video and lens-based artworks, rather than conventional paintings. As the century drew to a close, the depiction of people, along with urban and rural settings, continued to be a potent source of imagery for creative artists. However, while the human experiences presented by Alanna O'Kelly (qv) in her video works documenting the Irish Famine may have been particular to Ireland, they are also universal.

In the area of gender politics, Jaki Irvine, Billy Quinn (qqv) and Mick Wilson identified sexuality as a social construct and sought to create artworks that looked beyond superficialities, to an exploration of shared aspects of human existence and identity. By the end of the century, increasing affluence and an overriding sense of confidence, both in the institutions of the state and also in the economic development of the European Union, characterized Ireland's culture and politics. Generous funding for artists' projects in inner-city areas began to appear, with government agencies and the Arts Council increasingly looking to artists to highlight social cohesion and quality of life. Hidden tensions within Irish society at the end of the century can be discerned in the work of several artists, notably Daphne Wright, Jaki Irvine, Dorothy Cross, Alice Maher, Abigail O'Brien and Amanda Coogan, but while they delved beneath the surface of a new-found sense of national self-confidence, exposing its often shaky underpinnings, there were few who predicted the impending national debt crisis that would shatter this confidence, before the first decade of the twenty-first century had elapsed. PETER MURRAY

SELECTED READING *Saorstát Éireann*, 1932; Barrett, 1975; Sheehy, 1980, chapter 10; Fowler, 1984; McAvera, 1989; B.P. Kennedy, 'The Irish Free State 1922–49: A Visual Perspective', in Gillespie and Kennedy, 1994; McGonagle, O'Toole and Levin, 1999; Foster, 2005.

POP ART. An important movement in art between the 1950s and 1970s, Pop art was a reaction to the elitism of 'high' culture. In attacking accepted notions of what art is and refusing to acknowledge a qualitative distinction between high and low culture, artists such as Richard Hamilton and David Hockney in London, and Andy Warhol, Roy Lichtenstein and Jim Dine in New York, posited a new field of opportunity for art-makers and consumers, which was dizzyingly democratic, iconoclastic and free from the weight of tradition. Their revolution was dynamic, embracing a language and content drawn from advertising, comic books, film (qv), television and even packaging, incorporating new media (see 'New Media Art') and techniques, such as screen printing and photography (qv), which were mass reproducible and not easily controlled by the power brokers in art galleries and museums.

Perhaps not surprisingly, Pop art did not establish a significant presence in Ireland until its international heyday was already on the wane. The reasons for this are obvious and

manifold. In general, Irish artists and audiences for contemporary art were only beginning to emerge from the spell of William Orpen's (qv) 'Grand Manner' in painting and sculpture as transmitted through the National College of Art (NCA) and the Royal Hibernian Academy (RHA) (qv), and they were still feeling the effects of isolation following Irish neutrality in World War II. Importantly, too, the awareness of art history that led to revolution among the young in Britain and America in the 1950s was limited to a handful of people in Ireland until art history was introduced in schools and universities in the mid-1960s and '70s. The four-yearly Rosc exhibitions (qv), so important as a catalyst for innovative thinking in Irish art, did not commence until 1967. *Rosc '67* [436] showed work by some of the most important international Pop artists at the time, in the persons of Jim Dine, Robert Indiana, Roy Lichtenstein and Robert Rauschenberg, while four years later they were joined in the second Rosc by the sculptors Jasper Johns and Claes Oldenburg. The influence of these exhibitions on younger Irish artists at the time cannot be easily quantified and *Rosc '67*, however late in the international history of Pop culture, marked an important moment in the development of a Pop language in visual art in Ireland. The example of the works shown and the reception they received paved the way for the first Irish Pop art, then, and in the following year.

The ingredients for revolution in London and New York did not begin to mature in Ireland until well into the 1960s. The main factors included slowly improving economic conditions, the introduction of free trade with Britain, the hope of joining a more united European economic forum, the advent of Irish television, the introduction of a level of free education, and the influence of Elvis Presley, the Beatles and pirate radio stations. Irish musicians were quick to get involved in Pop culture and it should probably not come as a surprise that the first Irish visual artist to adopt the new practices was one who had already begun his professional life as a musician in a show band, Robert Ballagh, while his contemporary Jim Fitzpatrick (qqv) was to collaborate with Phil Lynott of the band Thin Lizzy in his later work. The need to assert their difference, as a generation brought up in urban environments, was also a factor for Ballagh and his friends. 'By the end of the 1960s, Robert Ballagh was making Pop Art in an Irish idiom [382], celebrating the brash vulgarity of an emergent consumer culture in hard-edged, stylized images. The implication that the enjoyment of material things was not necessarily bad was almost shocking.' (Dunne, p. 23)

Jim Fitzpatrick never went to art college but worked as the manager of a small graphic studio, where he developed the technical skills required to produce one of the most potent images of the 1960s. Influenced by Andy Warhol's silkscreen portraits of pop idols, such as Marilyn Monroe and Jackie Kennedy, Fitzpatrick produced an iconic image of the Cuban revolutionary Che Guevara in 1968 [182], just days before his murdered body was found in Bolivia. Fitzpatrick's portrait, from a photograph by Alexander Korda, was screen printed (see 'Printmaking') on to posters, T-shirts, and other merchandise, which were highly sought after by a generation of students from Berlin to Baghdad, who were sickened by war, conscription in the United States and by injustice everywhere. This artwork gave

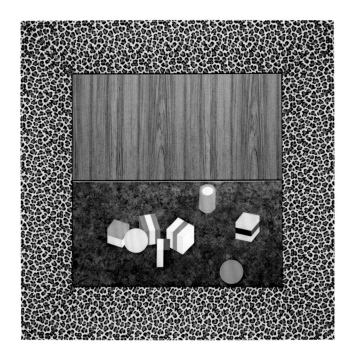

them precisely the image by which they sought to express their sympathy with revolution, and offered them a hero from their own time in a graphic form that was instantly identifiable. The contradiction in practice between the capitalist commodification of Che Guevara's image and its meaning as a symbol of communist revolt and democracy might cause discomfort to fellow revolutionaries, but it epitomized an aspect of Pop art of which founding fathers, such as Andy Warhol, were keenly conscious and ready to exploit. The immediate success of this image cemented Fitzpatrick's place in popular culture internationally but while he has continued to produce popular imagery, he has never courted, nor been courted by, the Irish art establishment. Fitzpatrick's refusal to claim copyright ownership of his work distinguishes it from the blatant consumerist philosophy of Andy Warhol's brand of Pop.

Pop art made it possible for Robert Ballagh, another artist who managed to avoid art school, to become an artist of some distinction almost overnight. Since the movement was not only irreverently unimpressed by the highly developed drawing and painting skills that academic art demanded, but was able to provide an alternative borrowed from advertising in the form of the camera and the screen print, it made it possible for Ballagh and others to enter an otherwise closed world. Ballagh's first exhibited works drew on these technical developments. In 1966, the same year in which he decided to abandon music as a career, he sent his first 'pop' artworks to the Irish Exhibition of Living Art (IELA) (qv). The IELA rejected him on that occasion, but a year later his pinball construction, now destroyed, and an erotic torso constructed from aluminium were not only accepted but attracted favourable critical commentary. Invited to participate in the inaugural exhibition at the Brown Thomas Gallery in 1968, Ballagh showed large paintings of a matchbox, an ice-cream carton and a razor blade, which were again favourably reviewed. When the Arts Council (qv) decided to spend £130 on

Blade, however, the decision proved controversial. The Contemporary Irish Arts Society bought *Iced Cream Caramels* (1970–71) for the Dublin Municipal Gallery of Modern Art, and other pop artworks by Ballagh found their way into emerging new corporate collections (see 'Private and Corporate Art Collecting'). Even Ballagh's early portrait commissions owed a debt to Pop art practices. Although his first Pop works were constructions, Ballagh turned to painting almost immediately, looking to the technical approaches of Pop to help him to circumvent his lack of training in drawing and painting the human figure. Since he did not distinguish between the work he was increasingly offered as a graphic designer, and so-called 'high' art, it seemed appropriate to call on the skills he was familiar with when offered a commission to paint the portrait of the art collector Gordon Lambert [400]. Ballagh looked to advertising to help him tackle this challenge, photographing the sitter, screen printing the photograph on to canvas, adding three-dimensional hands cast from the sitter's by the sculptor Brian King, and even allowing the convention of the advertising cut-out to decide the format of the finished portrait. Lambert, an advertising aficionado, was delighted with this innovative work and went on to give Ballagh a number of other commissions. As Aidan Dunne has pointed out, however, Ballagh's early espousal of Pop art should not define him 'as an apostle of materialism per se; he has proved to be a critical observer of Irish society' (Dunne, p. 23).

If these young men were more or less self-taught, Tim Mara (qv) [383], creator of highly sophisticated and technically accomplished artworks in the language of Pop, was not only the product of some of the most esteemed art education on offer in the 1960s and '70s but he went on to become an establishment figure himself. Yet in his commitment to new media, especially a range of silkscreen and print techniques, and in his love of quotidian contemporary references, the vivid colours of advertising

382. Robert Ballagh, *Dolly Mixtures*, 1971, acrylic on canvas, velvet, 152 x 152 cm, private collection

383. Tim Mara, *Picture Window*, 1980, multicolour screenprint 20/40, 76.3 x 107.3 cm

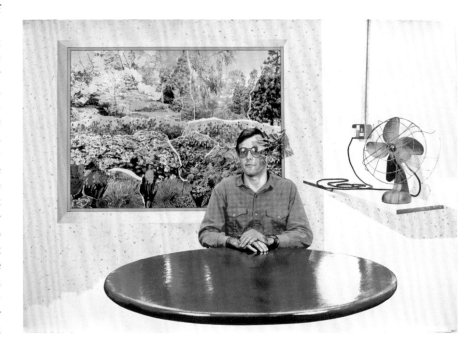

384. Evin Nolan, *Orange Expansion*, 1974, acrylic on canvas, 123.2 x 348 cm, Irish Museum of Modern Art

and his absorption of the achievements of Richard Hamilton, he showed himself to be a true son of Pop. *Power Cuts Imminent* (1975) [299] successfully fuses a variety of images, reminiscent of Hamilton's collages, into a single screen print, to comment on the vulnerability of modern life.

Other artists in Ireland affected by Pop in the 1960s and '70s include the sculptor Alexandra Wejchert, whose large constructions made of plastic recalled the kinetic work of Alexander Calder. In doing so, she turned a cheap 'pop' material into something that both challenged the preciousness of conventional bronze and carved marble, and caused people to reconsider a material more commonly associated with packaging and disposable furniture. The painter and sculptor Evin Nolan (qv), who had previously worked as a cartoonist, also used plastic to create an alternative form of painting, using folded sheets of laminated paper in almost luminous colours to make abstract pictures, and, like Ballagh, he adopted the shapes of advertising cut-outs and billboards in works such as *Orange Expansion* [384]. Jonathan Wade (qv), self-taught like so many of the artists discussed in this context, combined the simple, communicable language of advertising with serious social commentary. By 1982 almost one-third of the artworks included in the catalogue of the IELA, which for reasons to do with unavailability of venues, that year acted as the exhibition itself, show marked features of Pop. From a join-the-dots work (Christopher Coppock, cat. no. 13), to graphic instructions for knotting a tie (*One to Ten and Tighten* by Sandra Hudson, cat. no. 27), to a punning *Bar Code* (Mike O'Neill, cat. no. 67) and the use of comic-strip imagery, all the familiar techniques and many of the concepts embraced by Pop found expression in the show. The exhibition's aim, as described in the introduction, 'rather than invite the public to this exhibition in one place, we bring the exhibition to the public – in the form you now hold in your hands', could itself be read as a piece of Pop art (IELA, Dublin 1982).

Pop art could not have had the place it did in Irish art were it not for influential collectors such as George Dawson, founder of the College Gallery in Trinity College Dublin, Basil Goulding, Gordon Lambert, Don Carroll, and the architects Peter and Mary Doyle. By the late 1960s and throughout the '70s, they collected artwork by such international leaders of the movement as Enrico Baj, Valerio Adami, Oyvind Fahlstrom,

James Rosenquist, Robert Rauschenberg and Jim Dine, making their collections available to young artists and actively promoting the new work through loans to exhibitions and purchases of work by the Irish artists who practised Pop art. Basil Goulding commissioned Ballagh to paint murals for the new headquarters of his company, Fitzwilton, and was delighted with the results: a series of abstract paintings, the shape of which were as random as inkblots while the colours were decided by the throw of a dice. Don Carroll, advised by the architect Ronnie Tallon, included work by Ballagh, Nolan and Wejchert in the new Carroll's building in Dundalk, Co. Louth, and as chairman of Bank of Ireland oversaw their acquisition into its corporate collection, where they were seen as the backdrop to a new kind of Ireland.

The influence of Pop in Ireland is more pervasive than is often recognized. It is not possible to conceive of Michael Craig-Martin's (qv) (qv *AAI* III) enormous wall paintings of everyday objects in the hard-edged colours of commercial art without it. The use of text over images, such a powerful aspect of Willie Doherty's (qv) early photoworks, ultimately is a feature he shares with Pop art. Ciarán Lennon (qv), one of the most important gestural Abstract Expressionists (see 'Abstraction' and 'Expressionism') in Ireland, submitted a comic-strip narrative to the IELA in 1982 (*Living Clay*, cat. no. 41). Even the romantic, abstract painter Felim Egan (qv) had a dalliance with Pop, using the cast neon lighting strips of shop signs and advertising as a linear element in his work in the late 1970s. But the golden age of Pop was already over by then, and while its influence was to prove important for artists such as John Kindness, Seán Hillen (qqv), Francis Tansey and particularly to printmakers such as Terence Gravett and Andrew Folan (qv), it is with groups such as Blue Funk (qv) that the full political implications of Pop are most revealed to a new generation. Where earlier artists in Ireland had drawn on the language of Pop to open up new possibilities for their own work, Blue Funk brought the focus back to the elitist division in the art world between fine art and popular visual culture. Catherine Marshall

SELECTED READING Lippard, 1966; *Irish Exhibition of Living Art '82*, exh. cat. (Dublin 1982); Knowles, 1982; Walker, 1997; Dunne, 2006.

PORTRAITURE (see *AAI* II, 'Portraiture' and *AAI* III, 'Portrait Sculpture'). The tensions between the portrait's role as 'the use of accidents of the human face to reveal inner life ...' (Kenneth Clark, *Civilisation*, London 1972, p. 104) and the desire for it to reflect status, lineage and wealth were as active in Irish portraiture of the twentieth century as they have been anywhere since the High Renaissance. Any overview of the subject must bear this point in mind. While the concept of portraiture has also been used to refer to explorations of the face, using fictive or anonymous faces to comment on the human condition, its discussion here will be restricted to depictions of specific individuals or groups of individuals as themselves in their private or social roles, rather than as models for other subjects. In a century of flux, the portrait, here as elsewhere, has changed more than any other genre, thanks to the advent of new and reproducible media and the spread of democracy.

The artist and the genre

When commissioning a portrait, artists are generally chosen more for their skill in representing a likeness than for creativity or expressiveness, with willingness to flatter an unstated accompaniment. The Irishmen John Lavery (qv) and William Orpen (qqv), who dominated portraiture in London in the early twentieth century, excelled at pleasing the patron without compromising pictorial values. They were also stalwarts of the academic approach to representation. A century later, John Kelly (qv) was pleased to talk of his former teachers Seán Keating and Maurice MacGonigal (qqv), for all their innate academicism, in somewhat different terms:

> Mac was commissioned to do the occasional portrait, but was never the academic type portraitist. Nor was Keating. His painting was crude; he didn't smooth on the paint like cream. If the hands were expressionless, like pounds of Denny's sausages, if the nose was red, he'd lay on the paint as he saw it. The RHA were flatterers, usually. George Collie did those wonderful fashionable portraits, very well painted, smooth as glass, as lifeless as waxworks. (Ryan, p. 50)

Since many portraits look like reflective masks rather than representations of the individual, the English artist Lucian Freud spoke about the importance of talking to his sitters. 'In order to grasp the topography of a face, the artist needs to see it moving, speaking, reacting. Hence the need to talk.' (Francis Spalding, 'Portrait of the Critic', *Guardian Review*, 25 September 2010). Noting that Francis Bacon (qv), too, would talk to his sitters, Kelly remarked: 'With academic-painters you get the feeling there's no real conversation going on. The last thing the painter wants is to talk to the sitter.' (Ryan, p. 51)

Much of Lavery's success as a portraitist, as he constantly acknowledged, stemmed from his wife's rapport with his sitters. Her beauty and her skills as a model were such that it was said that none of his institutional portraits could compete with his portraits of her (McCoole, p. 48). Hazel Lavery also sat for others, most notably the photographers Emil Otto Hoppé and Baron de Meyer, whose photographic images of her helped to earn him the title 'founder of fashion photography' (McCoole, p. 50). A close relationship with a personable sitter was an asset; it enabled Lavery to experiment with the genre, so that his portrait of his wife in her bed, *The Yellow Bed*, shown at the RA in 1911, caused London tongues to wag and led one commentator to note, 'John Lavery's portrait of his wife in bed may have started a new style in portraiture' (McCoole, p. 48). Orpen's most dazzling portraits were of his mistress, Mrs Evelyn St George, and his parents [347].

Hazel Lavery claimed that her husband's 400 portraits of her stemmed from her availability rather than her beauty. She joked that he would say 'off with her head and on with yours' if the need for a portrait of a different sitter arose at short notice (McCoole, p. 48). Whatever the reason for painting them, Lavery's portraits of his wife launched him as one of the most sought-after painters of his day. No other Irish portraitist had such a relationship with a sitter. It was not until the second half of the century, when Louis le Brocquy (qv) painted multiple images of W.B. Yeats, James Joyce and others that a portraitist became so closely linked to a subject, albeit, in le Brocquy's case, with their death masks rather than with the living sitter.

The portrait market

Henry Doyle, Director of the National Gallery of Ireland (NGI) from 1869 to 1892, attempted to create an Irish portrait gallery, only to receive a contemptuous rebuff from the civil service that Irish portraits are of 'local interest not national – let alone Imperial' (Cullen, p. 209). However, there was a growing portrait collection in the first decade of the century largely owing to the work of W.G. Strickland (Duncan, p. 6). The National Portrait Collection forms a sub-section of the collection of the NGI. While it does not purchase the work of living artists, it occasionally commissions portraits. Other important publicly owned portraits are to be found in Dáil Eireann, the collection of the Office of Public Works (OPW), Áras an Uachtaráin, the Arts Council (AC/ACE) (qv), the Abbey Theatre and the bigger regional collections. The Ulster Museum (UM) has, since the 1970s, consistently commissioned and collected portraits of notable figures in public life by leading artists, such as the portrait of Seamus Heaney by Edward McGuire (qv) (1974) [385]. Important institutional collections were also developed by the universities, the main churches, and by public and private corporations (see 'Collecting Art' and 'Private and Corporate Art Collecting').

The market for portraiture in Ireland was never a large one, although artists such as Sarah Purser (qv) managed to make a respectable living from it, while Sir Hugh Lane's first act of philanthropy towards his native country was to commission twelve portraits of leading Irishmen from John Butler Yeats. Lavery and Orpen made their reputations and their fortunes from portrait painting in London, but there was also a steady, if conservative, demand for institutional portraits from academic artists such as James Sleator, Leo Whelan, Keating, MacGonigal (qqv) and George Collie.

The genre became less prominent from the mid-century as abstraction and photography (qqv) took over from academic representation, making the continued presence of portraiture the distinguishing feature of Royal Hibernian Academy (qv) exhibitions. Even the NGI was obliged to resort to corporate sponsorship for its portraits of Mary Robinson, first female President of Ireland, and her husband Nick, by Mark Shields, as well as for the portrait of the rock-star Bono by Louis le Brocquy.

The National Self-Portrait Collection (NSPC) at the University of Limerick (UL), begun from a donation of some fifteen images in 1981, has been growing ever since. Not surprisingly, while it remains quite traditional, it is more experimental than other portrait collections.

The political portrait (1900–60) (see 'Politics in Irish Art')

'Representations of the Irish in court, prison portraits and accounts of speeches from the dock had by the late 1880s and the Parnell Commission become potent visual symbols of Anglo-Irish relations and would continue as such well into the twentieth century.' (Cullen, p. 205) Following the War of Independence, the image of the figure in the dock began to give way to the death

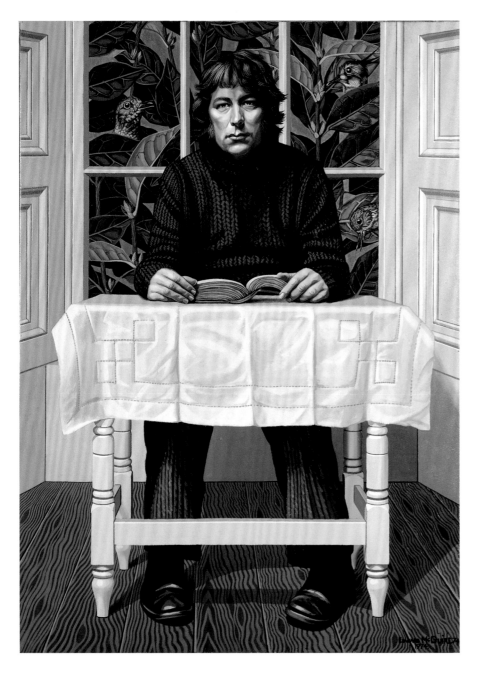

painted a group portrait of the staff of the IRA's general headquarters in 1922 [386]. For the most part, however, political portraits were of single figures, almost exclusively male, generally in formal dark suits, against a sombre background from which distracting detail is ruthlessly obliterated, although in the case of several of the Northern figures, artists exploited the opportunity to introduce colour by painting them wearing the colourful sashes of the Orange Order or other institutional regalia. The most impressive female political portrait from the early period is Sarah Purser's charcoal and pastel sketch of Maud Gonne (1898) [414]. As Townsend-Gault has pointed out, institutional portraits prioritize eloquence and authority over individual expression and avoid rippling the 'static calm of the institution' (Townsend-Gault, p. 513). The same could be said for portraits of Irish presidents and leading politicians, although Derek Hill and Robert Ballagh (qqv) challenged this later in the century with Hill's portrait of Erskine Childers driving a tractor and Ballagh's portraits of C.J. Haughey [111] and Noel Browne (1985) [389].

The blandness of political portraiture must be understood in the context of political life itself. The fate of the finished work, irrespective of the status of the artist responsible for it, could be uncertain. While Lavery's painting *High Treason, Court of Criminal Appeal: the Trial of Roger Casement* [222] in 1916 included portraits of many of the legal brains of the day in both London and Dublin, as well as Casement and his supporters, it was not acquired by Lord Justice Darling who had encouraged him to paint it. Two years later, however, when Lavery received a knighthood, Darling wrote to him suggesting that such an indication of government approval meant that he could now complete the picture. Nonetheless, when the canvas was offered to the Government Art Collection, the Lord Chancellor's office advised against public exhibition, fearing 'undesirable demonstrations by people who considered Casement a martyr' (Cullen, p. 208). When Casement's remains were brought to Ireland for burial fifty years later, the OPW invited Oisín Kelly to make a bronze portrait for his new burial place in Glasnevin cemetery. Once again politics intervened. The outbreak of the 'Troubles' in the late 1960s aroused fears of Loyalist reprisals if the installation went ahead. In the end, the sculpture was installed in a park near Banna Strand, Co. Kerry, as remote from audiences as from trouble.

385. Edward McGuire, *Seamus Heaney*, 1974, oil on canvas, 142 x 112.1 cm, National Museums Northern Ireland, Collection Ulster Museum

386. Leo Whelan, *General Headquarters Staff, IRA, 1922*, 1922, oil on canvas, 178 x 274 cm, National Museum of Ireland

mask or the lying-in-state picture as epitomized in *Love of Ireland*, Lavery's portrait of Michael Collins on his funeral bier [376]. The twinning of religion and nationalism, represented by the crucifix and the tricolour in this portrait of a young man shot down at the height of his powers shaped Irish hero iconography. The model was to be used repeatedly by Republican groups throughout the twentieth century, although these were mainly photographic.

Lavery volunteered to paint key figures from each side of the political spectrum in Ireland and Britain before the 1916 Rising and the establishment of the Free State and the Government of Northern Ireland. They included John Redmond, Edward Carson and most of the signatories of the Treaty in 1922. Following the example of Lavery and Orpen, Leo Whelan

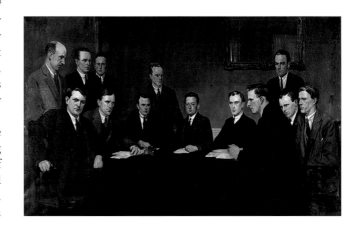

Celebrity portraits

The society portrait flourished up to the 1920s in the hands of Orpen, Lavery, Purser and John Butler Yeats. Orpen, less sought after than Lavery, was nevertheless painting portraits of the most exclusive circles within London society by 1914, a marked improvement on the previous decade, when he had written: 'I'm painting profs and judges till I'm nearly off my chump' (Arnold, 1981, p. 285). Amid increasing competition from photography, the leading portraitists in Ireland, Leo Whelan, Estella Solomons, Patrick Tuohy, Seán O'Sullivan (qqv), especially in his portrait drawings, and James Sleator (qv) after his return from London in the 1940s, pursued the Orpen model. While the best of them could be formulaic, Whelan's portrait of Lord Dunraven was described as 'arguably the finest portrait painted in Ireland during our period [1880–1950]' (Kennedy, p. 167). It is rivalled in intensity by Patrick Hennessy's (qv) portrait of *Elizabeth Bowen at Bowenscourt* [387]. None of these artists proved to be as experimental as Christopher Campbell, whose retiring nature, however, kept him out of the public eye.

The Irish portrait in the age of mass media

Important developments in the portrait emerged in the second half of the century. They were all, with the exception of the surreal portraits of Edward McGuire, and the psychologically penetrating portraits of Patrick Swift (qv), influenced to a marked degree by the advent of photography. Francis Bacon and Louis le Brocquy drew on photographic stills in their reinvention of the face. From the late 1960s, le Brocquy painted an extensive series of portrait studies towards an interpretation of a single face. Since the faces he chose frequently belonged to dead celebrities such as W.B. Yeats, James Joyce, and even the seventeenth-century philosopher Descartes, le Brocquy worked from photographs and death masks.

The introduction of photography and their own leanings towards Expressionism (qv) meant that the portraits of Tony O'Malley, Basil Blackshaw, Barrie Cooke, Brian Bourke and Nick Miller (qqv) were liberated from any need to satisfy mere retinal accuracy. Cooke's portrait of *Siobhan McKenna* (1964, AC/ACE collection) and Bourke's picaresque self-portraits eschew all existing formulae, and bring an entirely new level of spontaneity to the Irish portrait. Nick Miller, on the other hand, opts for unparalleled physical closeness as the tool to unlock some of the most intense drawings and paintings of the human face. Robert Ballagh's overt use of photographs, sometimes screen printed on to canvas and over-painted, as in his portraits of Gordon Lambert [400] and Bernadette Greevy (1972, 1978, IMMA collection), allowed him to reinvent the society portrait. Examples of conceptual (qv) portraits are less common in Ireland. Brian O'Doherty's (qv) images of Marcel Duchamp [388], where the subject is depicted in a series of recorded heartbeats, offer an outstanding example of what is possible.

Photography, with all the benefits it offers of spontaneity, accuracy, reproducibility and cost-effectiveness, almost caused the demise of the traditional portrait, although artists such as Carey Clarke and James Hanley (qqv) continue to respond to its timelessness. John Minihan (qv), Amelia Stein and Fergus

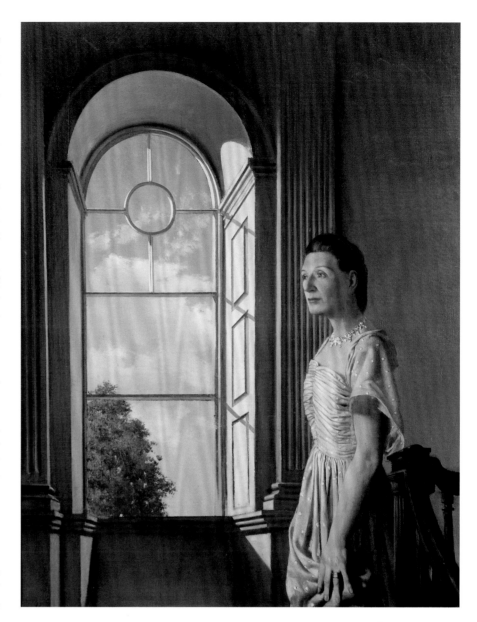

387. Patrick Hennessy, *Elizabeth Bowen at Bowenscourt*, 1957, oil on canvas, 91 x 71 cm, Crawford Art Gallery

388. Brian O'Doherty, *Portrait of Marcel Duchamp*, 1966–67, mixed media (wood, heartbeat monitor), 43 x 43 x 10 cm, artist's collection

Bourke are among the photographic artists who have specialized in the portrait, producing series of images of actors for the Abbey Theatre (Bourke), celebrity writers and artists such as Francis Bacon and Samuel Beckett (Minihan), and fellow artists in their studios (Stein).

The political portrait in the age of mass media

The use of new and mass media is nowhere more influential than in the political portrait. Perhaps the most reproduced work of portraiture in the twentieth century has been Jim Fitzpatrick's (qv) screen-printed image of Che Guevara [182]. Released initially as a poster, the portrait has been reproduced as an icon of political protest all over the world. Ballagh's portrait of Charles J.

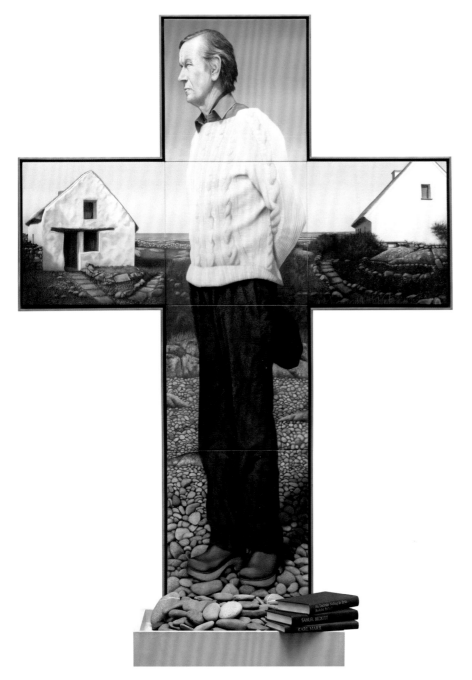

389. Robert Ballagh, *Portrait of Noel Browne* (1915–97), 1985, oil on canvas, mixed media, 183 x 137 cm, National Gallery of Ireland

Haughey, *The Decade of Endeavour* (private collection) [111], did not get as much exposure, but it revealed the same awareness of the potential of photography. The painting shows Haughey, recently returned to power after a period in the political doldrums, addressing his party colleagues. Behind him is an enormous photograph of his own face, allowing the viewer to speculate on the role of the media in transforming the individual into a Titan. Ballagh's *Portrait of Noel Browne* [389], Minister for Health from 1948 to 1951, who resigned rather than yield to Catholic Church pressure to withdraw his controversial Mother and Child Scheme, eschews displays of power. Browne is shown alone, at ease with himself and the Connemara landscape in which he stands, while the portrait's cruciform shape suggests personal sacrifice for public good. Brian Maguire's (qv) series of drawings 'Diario Popolare', based on newspaper photographs, records the faces of those who disappeared during one month, March 1997, in São Paolo. Representing Ireland at the Biennial exhibition in that year, Maguire made their shocking disappearance an international event. Tom Molloy (qv) also looked outward from Ireland in another series of drawings *Dead Texans* (2002) [311]. These small-scale drawings, based on internet thumbnail photographs in prison records, call attention to the humanity of the men executed during George W. Bush's governorship of Texas. By showing these photographs alongside a self-portrait drawing, based on an X-ray photograph of his own skull, Molloy offers a post-modernist interpretation of the portrait as *vanitas*.

During the late 1980s and '90s Willie Doherty (qv) combined text and photographic portraits to disrupt perceptions about individual and cultural identity, and to question media representation of the political situation in Northern Ireland. In the context of the Troubles (see 'The Troubles and Irish Art'), the portrait was made problematic; as Doherty perceived it, 'Irishness is criminalized once someone's face appears in the newspaper' (Cameron, 1993, n.p.). In Doherty's 1990 installation *Same Difference* [235], a news photograph of Donna Maguire, arrested on IRA terrorist charges, is projected on a large scale on to two adjacent screens, superimposed with polarized word sequences about her, drawn from the unionist and nationalist media, words such as 'Murderer… Pitiless… Murderer… Misguided…' on one, and 'Volunteer… Defiant… Volunteer… Honourable…' on the other. Doherty used a similar approach to news photographs of specific individuals in *They are all the Same* [145] and *Six Irishmen* (1991). This use of photographs of recognizable people served to give both a face and a voice to organizations rendered voiceless by the British Broadcasting Act of 1988 which allowed for the censorship of proscribed organizations such as the IRA and loyalist paramilitaries. The photograph of imprisoned hunger-striker Bobby Sands [390], used as his election poster during the campaign to elect him to Westminster, was re-used to extraordinary effect by Philip Napier (qv), another northern artist at IMMA in 1993. Napier attached a bellows to the photograph, installed on a balcony of the Royal Hospital Kilmainham, former home of the British Army in Ireland and, since 1991, location of IMMA. The wind, intermittently inflating the bellows, created gasping breaths that animated the whole courtyard and spoke

390. Philip Napier, *Ballad No. 1 (View of Bobby Sands)*, detail, 1992–94, relief image, National Museums Northern Ireland (see fig. 488)

The self-portrait

'The conception of the self-portrait as a privileged insight into an authentic truth has, like all interpretation, been opened up to more demanding and nuanced scrutiny.' (Gallagher, p. 11) Some Irish artists – Ballagh, Bourke, O'Malley among them – have used the self-portrait to explore truths that the relationship between the patron and the artist in traditional portraiture does not encourage. Nonetheless, the NSPC does not claim to represent Irish art and is generally conservative, with an obvious leaning towards figuration. The artist Samuel Walsh (qv) criticized it for failing to acknowledge the changes that have taken place in the visual arts since its inception in 1981 (*Circa*, Autumn 2000, 54) and Hugh Maxton (*Circa*, no. 49, January/February 1990, 16–19) considered it something of a fraud but identified a number of good works within it. Among the most illuminating explorations of the self it contains are portraits by Kathy Prendergast, Dorothy Cross, Leo Whelan, Gerard Dillon and Brian Bourke (qqv), which at the same time manage to embrace traditional approaches to painting, sculpture and drawing, as well as performance and cartography.

Conclusion

By the end of the century new developments had taken place at all levels of the portrait. Hugh Maxton worried that while bourgeois liberal economics made individualism possible, this has been disrupted by mass communication and globalization, with a consequent effect on portraiture. He cites the imposition, for commercial purposes, of bronze portraits of well-known figures, such as that of James Joyce in Dublin's North Earl Street, as masking the revolutionary nature of their work. Calling for a redefinition of the genre in the multi-media age, Fintan Cullen says that the oil portrait is no longer a *sine qua non* of public life, but a luxury (*Circa*, 1990, 227). Redefinition is already under way in the hands of the artists themselves. In 2008 Cathy Henderson executed a series of portraits of Dublin Corporation workers, but, instead of the usual hierarchical boardroom pictures, she produced a set of portraits representing the full range of worker activity from street cleaners to the city manager. John Byrne unveiled the first equestrian statue in Ireland in modern times (*Misneach*, 2010, Ballymun); in true post-modern fashion, it represents local teenager Toni Marie Shields from Ballymun, rather than an Imperial general. And when Gerard Mannix Flynn spoke at the launch of his self-portrait at the University of Limerick, he pointed out that his 'self-portrait', composed of a number of institutional representations of himself, could be more accurately described as a portrait of the nation as child abuser, than an insight into the person at its centre (14 October 2010, NSPC, UL). CATHERINE MARSHALL

SELECTED READING Duncan, 1907; Charlotte Townsend-Gault, 'Symbolic Façades: Official Portraits in British Institutions since 1920', *Art History*, XI, no. 4 (December 1988), 511–26; S.B. Kennedy, 1991; Cullen, 2004; Gallagher, 2006; Ryan, 2006; McCoole, 2010.

simultaneously to the military history and the current use of the space, while powerfully evoking Sands' ordeal and death.

The diaspora (qv)

Emigration and, since the last decades of the twentieth century, immigration have also impacted on the development of portraiture. The Irish-Australian artist Sidney Nolan created an unforgettable post-colonial narrative of the life of the Irish Australian outlaw Ned Kelly. The outlaw is shown hidden from head to toe by an outlandish homemade suit of armour, which became his signifier. Nolan showed his identification with Ireland and the historic plight of so many of its inhabitants again in a series of portraits called *The Wild Geese* (1989) [138]. The six portraits, not all of which have been identified definitively, represent Nolan himself, as one of the original Wild Geese, who fled Ireland after the Williamite victory at the battle of the Boyne, and James Joyce, a self-styled exile for his art, while others appear to represent the explorer Ernest Shackleton and George Bernard Shaw.

Fran Hegarty (qv), a native Irish speaker from Donegal, emigrated to England as a child. Decades later, having forgotten the language and her birthplace, she explores her heritage in an installation *Turas* (1996) [135]. By combining her mother's face and voice with images of the landscape of the Foyle estuary and the *Book of Kells* she is able to reclaim her Irish identity.

POWERS, MARY FARL (1948–92) [391, 395], printmaker. Mary Farl Powers was one of the most important printmakers in Ireland in the second half of the twentieth century (see 'Printmaking'). Born in Minnesota, into a fourth-generation American family with Irish and German ancestry, she came to Ireland in 1951 with her family. Although the family moved back and forth a number of times before finally settling again in America, Powers chose to remain in Ireland from 1975 until her untimely death from cancer.

Powers attended the DLCAD and won the Navan Carpets scholarship to NCAD, where she studied for four years. She joined the Graphic Studio in Mount Street in 1973, soon becoming its third director. Her greatest legacy, apart from her considerable and innovative artwork, was her organization of the Graphic Studio. She wrote happily to her sister Katherine that she was called 'Mrs Thatcher' because of the notices she put up insisting that users of the studios should observe the rules governing the use of the equipment, hygiene and safety, but her colleagues were particularly grateful for her professionalism in the establishment and management of the Graphic Studio Gallery, the first institution for this purpose in Ireland. Painters who wandered into the Graphic Studio hoping to capture some of their ideas in print, such as Maria Simonds-Gooding (qv), found Powers endlessly generous and helpful as well as inspirational. She was a tireless advocate of the professionalization of printmaking, evident in her catalogue essay to the first exhibition of the National Council for Educational Awards Printmaking Competition (1991), for which she was the adjudicator.

391. Mary Farl Powers, *Waterfall*, 1977, colour etching, edn 22/45, 48 x 40 cm, Irish Museum of Modern Art

Primarily an etcher, she also made lithographs, woodblock prints and cast-paper works, good examples of which were donated to IMMA by her family following a major retrospective of her work there in 1995. In 1980 she was invited to become Printmaker-in-Residence with the ACNI in Belfast, and in the following year she became a founding member of Aosdána (qv), later acting as one of its Toscairí. Her artwork was informed by her feminism, and her prints, especially those she made for a group exhibition *The Male Nude*, a rare theme for Ireland in 1975, are both playful and satiric. Other work was more serious in tone, such as her art made in relation to pregnancy, in an Ireland where women's right to birth control was hotly contested and anti-abortion legislation was written into the Constitution (see 'Women and the Visual Arts').

John Kelly (qv), whom she succeeded as director of the Graphic Studio, said 'Mary Farl Powers never took an ordinary image. She always had a fantastic reason for making an image and the image gained from her intelligent approach. It set her aside. You'd see a real character behind the image. She had a very high technique, very high finish.' (Ryan, p. 71) Much of her later work had to do with the cycles of life, birth and decay, the erosion of materiality, graphically expressed through her medium. Powers's facility was not confined to printmaking. She produced highly innovative free-standing sculptures made from cast paper.

Her work was exhibited widely in solo shows in Ireland and in print shows in China, Europe, India, Mexico and the USA, winning the Gold Medal at the Listowel Graphics Exhibition in 1975. The Arts Council (qv) commemorates Mary Farl Powers through a biennial award in her name to a practising printmaker.

Powers's work can be seen in the AC/ACE, the OPW, in schools, hospitals and public buildings all over Ireland, as well as in IMMA, which has some fifty of her prints and cast-paper sculptures. CATHERINE MARSHALL

SELECTED READING Muldoon, 1994; Aidan Dunne and Katherine A. Powers, *Mary Farl Powers*, exh. cat. IMMA (Dublin 1995); Katherine A. Powers, 'Mary Farl Powers (1948–1992): American Person, Irish Artist', in Kreilkamp and Curtin, 1999; Ryan, 2006; Lalor, 2011.

PRENDERGAST, KATHY (b. 1958) (qv *AAI* III), artist. Addressing themes that are profound and deeply rooted in human experience, much of Kathy Prendergast's work continues the long-established European tradition of *memento mori*, a meditation on life and death. Using materials such as chalk, hair, fabric and maps, in which are embedded both personal lives and collective histories, Prendergast's art, whether in watercolour, pencil or mixed media, is generally spare and attenuated. She avoids the rich chromatic scale of oil paint; almost all her paintings are done in watercolour, lightly tinted, or almost monochrome, while her best-known work to date, the 'City Drawings' [81], are created with the simplest of materials, pencil on paper. However, there is also a rare quality of beauty in Prendergast's art, expressed in fine draughtsmanship and craftsmanship that has a universal appeal.

Born in Dublin, Kathy Prendergast studied art at NCAD between 1976 and 1980 obtaining a Diploma in Fine Art. She then trained as a video cameraman with RTÉ, the Irish state broadcasting service, for a year and a half, before returning to NCAD where she was awarded a degree in 1983. That same year, Prendergast moved to London, enrolling in an MA course in sculpture at the RCA, from which she graduated in 1986. Even as a student, Prendergast was recognized as an artist of exceptional talent. Her degree show at NCAD, comprising a series of eleven drawings, 'Body Maps' [43, 392], was shown at Temple Bar Galleries and acquired by art collector Vincent Ferguson, who later donated it to IMMA. While clearly inspired by the frequent association of women and the land in Irish literature, 'Body Maps' challenges Romantic treatments of the nude in the landscape, combining as it does elements of engineering diagrams, admiralty charts, and detailed drawings of the female body (see 'The Body'). Associated with the drawings, a life-size painted sculpture of a woman on a bed, *Seabed* (1980), was painted with the contour lines and colours used in Ordnance Survey map-making. Since mapping is frequently linked to military conquest and individual maps in the series contain words such as 'alter' and 'control', 'Body Maps' can be read as a reference to the dual colonization of the body and the landscape. From the outset, the style of Prendergast's drawings has been characterized by a precise, meticulous finish and an avoidance of sentimentality. However, these characteristics are of secondary importance in works such as 'Body

Maps', where her achievement is to examine concepts of sexuality, identity, and the exploitative relationship of mankind and the earth.

Shortly after graduating, Prendergast was selected to represent Ireland at the 1985 Paris Biennale. The work shown in France consisted of large plaster columns, inscribed with symbols, and inspired by Egyptian architecture. Another early sculpture, *Waiting* (1980, HL), made of translucent fibre-glass resin, parquet flooring and dress-making patterns, represented women in 1950s' ball-gowns seated at a dance. Confirming the artist's growing reputation, by winning her an IELA Carroll's Award in 1980, this work was acquired by the HL while the artist was still a student. With its sense of incompleteness and memorializing, *Waiting* shows the direction in which Prendergast's work would evolve. Rooted in family history and everyday experience, with the human presence suggested by clothing, while the people themselves are only partially portrayed, the theme is one to which Prendergast has returned in more recent years.

Prendergast's work has often involved the creation of sets, or series, of detailed drawings and watercolours. She also makes individual three-dimensional sculptures, a pattern of working that has continued through her career. Her use of cloth or hair, materials that have strong personal associations, imbues her art with meaning and an emotional range that is intense and captivating. Dramatic contrasts in scale, where a human hand is depicted in a two-metre-high drawing (*Hand Drawing*, 1989, CAG), or an entire city mapped in a drawing barely thirty

392. Kathy Prendergast, *Enclosed Worlds*, 2/11 and *To alter a landscape*, 6/11 from the 'Body Maps' series, 1983, both watercolour and ink on paper, 76 x 57 cm, Irish Museum of Modern Art (see [43])

centimetres high, enhance this sense of 'otherness'. Prendergast's approach to making art has been consistent, with the theme of map-making reappearing in different bodies of work, extending over three decades. In 1990 she made *Land*, a large tent-like sculpture of canvas, on which she painted the contour lines of an Ordnance Survey map. This led to the 'City Drawings', begun in 1992, in which she set out to chart the capital cities of the world in a series of austere drawings that pared down streets and an urban infrastructure to an attenuated skeletal framework. These drawings (qv), executed with pencil on plain white A4 sheets of paper, started out as maps, but during the course of their making became transmuted, so as to resemble illustrations from a textbook on anatomy, or microscopic life forms. Devoid of notation, text or marks of identification, they present an overview of human society across the globe that is quasi anthropological. However, it is clear that the task Prendergast set herself, of mapping every capital city in the world, was, and is, unattainable, as new nations emerge, and political centres are subsumed within shifting boundaries. Part of the meaning of the work, its conceptual basis, lies in the acceptance that there can be no successful conclusion to the task.

In 1995 Prendergast was selected to represent Ireland at the 46th Venice Biennale of Contemporary Art. Among the works shown at the Nuova Icona Gallery on the Guidecca, which served as the Irish national pavilion, were the first seventy drawings of the 'City Drawings' series, along with *Two Hundred Words for Lonely* (1992, private collection), a faded child's pillow inscribed with the word 'lonely', translated into two hundred languages. Simple in concept, and straightforward in its use of everyday materials, *Two Hundred Words for Lonely* has nonetheless an extraordinary power as a work of art. At Venice, Prendergast was awarded the Premio Duemila, the prize for the most outstanding young artist at the Biennale. In 1995 the drawings were acquired for the IMMA collection in an arrangement whereby the museum accepted batches of the drawings as the artist completed them. One hundred of the 'City Drawings' drawings were exhibited at the Tate Gallery, London in 1997, and another group of them at the Drawing Center in New York two years later. Also shown at Venice was *Grave Blanket (Version 1)* (1995), a child's blanket interwoven with the small white marble chips used to decorate graves. Later related works, such as *The End and the Beginning I* (1997), in which wisps of human hair had been patiently threaded into a baby's bonnet, and *Prayer Gloves* (1998), gloves that can be worn only when the wearer's hands are joined together, suggest long timeframes and the repetition of human rituals.

In contrast to Prendergast's unmistakeable autograph presence in the 'City Drawings', her next project was researched and produced using a computer and printer. In 1999 she produced a new series of maps, plotted and drafted digitally, then colour-printed, using iris laser printers, on to large sheets of paper. In these works, entitled *Lost* [133], Prendergast created a map of North America, in which only those places that had the name 'Lost', such as Lost Canyon, or Lost Creek, were marked. The frequency with which such names occur is remarkable, with the pattern of distribution reflecting the pathways of settlers spreading across the continent. In a related work, *From Abandon to Worry, an Emotional Gazetteer of North America* (2003), the artist collated thousands of names that carry a similar import, while in *Between Love and Paradise I* (2002), a more optimistic view of the world is revealed in selecting place-names of North America in which the word 'love' and 'paradise' appear.

More recent works by Prendergast include a series of painted or enamelled bronze sculptures, that continue the theme of extracting from everyday domestic items a sense of finality and of human fragility and fragmentation based on old family photographs and the residues of familial celebration.

Through her art, Prendergast emphasizes truths that can be learned from an intense examination of how human societies create images of self. Her works, charged with emotional intensity, are reflective meditations on life and death and on the importance of families. Prendergast is a member of Aosdána (qv) and her work is in the collections of the Albright-Knox Art Gallery in Buffalo, the Cheekwood Museum of Art Collection, Nashville, Tennessee, the Contemporary Museum, Honolulu, the Tate Gallery, London, IMMA, HL and CAG. She was the artist selected by IMMA for a one-person exhibition, *The End and the Beginning*, to mark the end of the old and the launch of the new millennium in 1999. However, in spite of international recognition, Prendergast refuses to respond to pressure to produce work in large quantities or more speedily. Her output therefore, has not been substantial in quantitative terms. After a gap of some years between 2007 and 2009, in two exhibitions entitled *The Grey Before Dawn*, she showed new work at the Kerlin Gallery in Dublin. PETER MURRAY

SELECTED READING O'Regan, 1991; Conor Joyce, *Kathy Prendergast*, exh. cat. DHG (Dublin 1990); John McBratney, 'Something More Exciting than Ordinary Living', *IAR Yearbook*, XIII (1997), 180–87; Brenda McParland and Francis McKee, *Kathy Prendergast: The End and the Beginning*, exh. cat. IMMA (Dublin 1999); Sherlock, 2001.

PRINTMAKING (see *AAI* II, 'The Print'). A small number of artists dominate the history of fine art printmaking in the first half of the twentieth century in Ireland. In contrast to international experience, it is not possible to identify any specific group promoting and supporting printmaking in Ireland until the foundation of the Graphic Studio in Dublin in 1960. Apart from a small number of artists who collaborated as illustrators with the Cuala and Dolmen presses, for the majority of Irish artists, printmaking was not a primary means of expression. As a result, it has tended to be a postscript in the history of Irish art.

The second half of the nineteenth century saw the emergence in Britain and continental Europe of the Etching Revival, a specific movement to promote the art of the painter engraver and the creative possibilities of intaglio processes. In 1880 William Booth Pearsall (1845–1913), a keen amateur artist, was the first in Ireland to produce etchings following the principles of the Etching Revival, by working directly from nature on to the etching plate. Other Irish artists began to make prints after training and living on the Continent, including Joseph Malachy Kavanagh (1856–1918), who produced etchings of Belgian and French subjects in a realist manner (see 'Realism'). Roderic

O'Conor (qv) created etchings and lithographs in a Post-Impressionist style in the 1890s, recording his experience of nature in a subjective way through the creation of bold, simplified and stylized forms.

By 1900 a number of Irish artists, who had trained and worked in England, became members and associates of the Royal Society of Painter-Etchers and Engravers, which was set up to promote original fine art printmaking. Irish affiliates of the Society included Robert Goff (1837–1922), Francis S. Walker (1848–1916), Edward Millington Synge (1860–1913) and Myra Hughes (1877–1918). Other printmakers who gained a reputation for their work were Edward L. Lawrenson (1868–1940) and Percy Gethin (1874–1916). All these artists exhibited their prints in Dublin, and Hughes and Lawrenson were part of a relatively small number of internationally known printmakers who experimented with colour printing.

In the 1910s, a group of artists working at home in Ireland began to produce prints. The leading figures among them were Estella Solomons (qv), Mary Duncan (1885–1964) and Dorothy Fitzgerald (1888–1979). Until the 1930s, Solomons was the most prolific, principally producing etchings of Dublin, its people and environs. In 1914 the Dublin Metropolitan School of Art appointed George Atkinson (1880–1941) to its staff. Atkinson, a native of Cork, attended the Royal College of Art in London where he learned various printmaking techniques, and his arrival marked the beginning of a modest etching movement in Dublin. As a printmaker, among his greatest achievements were his series of etchings based on the Shannon Scheme Excavations at Ardnacrusha, Co. Limerick, of the late 1920s. Atkinson's most accomplished students were Stella Steyn and Seán O'Sullivan (qqv). Steyn, who also trained in lithography at La Grande Chaumière in Paris, had moved on from the Etching Revival principles of working directly from nature, and looked instead to European Modernist movements, including Cubism (qv). Steyn spent time at the Bauhaus in 1931, producing a series of collage relief prints which incorporated type. Later in the 1930s, Steyn married and settled in England, devoting herself exclusively to painting. From this period, her contribution to Modernist printmaking in Ireland was almost negligible.

Seán O'Sullivan, with the encouragement of Atkinson, studied lithography at the Central School of Art in London. When in London, he was elected a member of the Senefelder Club, which was founded in 1908 to promote the artistic merits of lithography. From the 1920s to the early 1930s, O'Sullivan produced a series of portrait drypoints, which were promoted by the Victor Waddington Gallery in Dublin. Norah McGuinness (qv) worked in the field of lithography from the 1930s, a process she may have learned when studying in Paris in the previous decade.

The introduction of hand-printed, illustrated texts, inspired by William Morris, was advanced in Ireland by the Dun Emer and Cuala presses (see 'Book Art'). The Cuala Press was operated by Elizabeth Corbet Yeats (1868–1940), who from 1908 to 1915 published a series of limited edition, hand-coloured, illustrated broadsheets for her brother Jack B. Yeats (qv), entitled *A Broadside* [47]. These publications are rightly celebrated as examples of 'fine art publishing'. However, unlike practices at Morris's Kelmscott Press, Jack Yeats never produced hand-cut

393. Robert Gibbings, *Scraps*, 1921, wood engraving on paper, 9/12, 26.8 x 20.6 cm, Dublin City Gallery The Hugh Lane

woodblocks. The *Broadside* images were printed from photo-engraved blocks made after Yeats's original drawings, often with the stylistic traits of woodcut.

Cork-born Robert Gibbings (1889–1958) and Edward Montgomery O'Rorke Dickey (qv) from Belfast, with Noel Rooke, Eric Gill and Paul Nash, were among the founding figures of the Society of Wood Engravers, in London in 1920. Gibbings [393] became director of the Golden Cockerel Press from 1923 to 1933, where he produced a number of illustrated texts using artists' wood engravings. His style evolved from that of reduced silhouetted forms, to decorative, stylized images based on nature. Dickey and fellow Northern Irish artist Lady Mabel Annesley (1881–1959) produced highly individualized woodcuts influenced by European Expressionism. Other Irish artists who produced relief prints included Elinor Monsell (1879–1954), who designed and cut the decorative wood-engraved Abbey Theatre emblem, of Maeve, ancient Queen of Connacht, with an Irish wolfhound. The stained-glass artist Wilhelmina Geddes (qv) exhibited a number of figurative wood and linocuts in Dublin, before her permanent move to London in 1925. An artist who followed Geddes by producing a series of linocuts in the late 1920s was Dorothy Blackham (1896–1975). Cecil ffrench Salkeld (qv), who in 1921 travelled to Kassel in Germany to study art, looked to the Modernist German movement 'Neue Sachlichkeit', or 'New Objectivity', for direction in his etchings and woodcuts of cosmopolitan themes.

In the 1940s and '50s a number of artists continued to produce relief prints, many for publication in Ireland. Harry Kernoff (qv) executed a series of woodcuts of urban and rural themes along with portraits of leading political and cultural figures. He exhibited and sold his prints as individual art works and in three limited-edition volumes in 1942, 1944 and 1951, a unique venture in Ireland. All were critically well received. A *Times Literary Supplement* review of woodcuts (1942) acknowledged Kernoff's

As the director of the Dolmen Press, Miller was responsible for some of the finest illustrated publications in Ireland from the 1950s to the 1980s. His illustrated volumes, where possible, were printed from the artists' original hand-cut blocks. Among the printmakers employed over the history of the press were Tate Adams, Michael Biggs, Ruth Brandt, Jack Coughlin, Stanley Hayter, Robert Gibbings, Louis le Brocquy (qv), Michael Morrow, Elizabeth Rivers and Anne Yeats. Patrick Hickey [212, 394], director of the GSD in the 1960s, had trained as an architect but in 1957 he travelled to Urbino in Italy, where he studied etching and lithography. From its inception, the GSD provided training in printmaking techniques, from etching to lithography to relief processes. The studio had the support of the Arts Council (AC/ACE) (qv) and to further boost its income initiated, from 1962 to the early 1980s, a sponsors' print portfolio. Today, these portfolios provide a valuable archive of the work produced by the studio in its first decades. Among the first 'graduates' of the GSD were Brian Bourke, Charles Cullen, Michael Kane, John Kelly (qqv), John Behan, Chris Reid and Alice Hanratty. Kelly became an important figure in the studio's history as a tutor, technician and director in the 1970s. He later became the head of Ireland's first Fine Art Printmaking Department in NCAD.

In the late 1970s the Arts Council encouraged the expansion of the facilities at the GSD. By then, NCAD was issuing awards in printmaking; therefore the focus of the studio as a training facility was no longer necessary. Disagreements over the process

talents and noted his commercial 'sacrifice' in choosing to print from woodblocks rather than from photo-engraved blocks. Stylistically, Kernoff's woodcuts are quite idiosyncratic; figures are distorted and stylized, with a strong emphasis on pattern.

One of the most important printmakers in the 1950s and '60s to work in Ireland was the London-born artist Elizabeth Rivers (qv), who travelled to the Aran Islands in the 1930s and began a productive and mutually beneficial relationship with Ireland, eventually settling in the country in 1955. Rivers is mostly associated with the relief medium of wood engraving. She was employed to illustrate a number of publications, including *Out of Bedlam* in 1956. Her stylized engravings are taut and refined, with a strong linear emphasis. In 1946 Nano Reid (qv) produced a series of linocuts to illustrate *Rogha Dánta* by Mairtín Ó Direáin. Other artists producing woodcuts from this time include Fergus O'Ryan (1911–89), who taught printmaking at the National College of Art (later NCAD) until the 1970s, and Doreen Vanston (1903–88), an associate of the White Stag Group (qv), whose members produced woodcuts from the 1930s until the 1970s.

There is no evidence in Ireland of the continental European atelier system, which provided printmakers with specialist equipment and technical support. During and after World War II, print studios appeared in other cities, including New York and London. At this time, William Scott (qv) was among a new generation of artists experimenting with print. Developments in modern art, including the Pop art (qv) movement, saw a new generation of artists move away from traditional fine-art media. Their experiments with screen printing and photo printing techniques led to a renewed interest in all forms of printmaking. In this atmosphere, the Graphic Studio Dublin (GSD) was founded in 1960 by the publisher Liam Miller (1924–87) and artists Patrick Hickey, Elizabeth Rivers, Anne Yeats (qqv) and Leslie MacWeeney (b. 1936).

of the proposed expansion led to the establishment of a second print studio in Dublin in 1982, the Black Church Print Studio. It was headed up by former GSD members John Kelly, Sara Horgan, Jan de Fouw, Michael Byrne and Liam Ó Broin and attracted a new generation of printmakers which included Andrew Folan (qv), Gráinne Cuffe, James McCreary and Michael O'Sullivan.

In 1977 three young artists, Joe Hanly, Daniel Courtney and Brian Maguire (qv), set up a studio specifically for the production of screen print. Throughout the 1980s, the Screenprint Workshop, as it was named, attracted artists such as Michael Cullen, Eithne Jordan, Michael Mulcahy (qqv) and Gerald Davis.

At this time an American-born artist Mary Farl Powers (qv) [391, 395] heralded the changes at the GSD. Powers chose to express herself almost exclusively through the medium of print, bringing a new professionalism and dedication to the process. In the 1980s she became director of the studio and was a prime mover in the foundation of the Graphic Studio Gallery in 1988, the first exhibition space in Dublin dedicated to selling prints. To encourage a greater awareness of print among artists, the GSD introduced its Visiting Artists Programme in 1980, where artists with some or no experience of printmaking were invited to create prints, with the assistance of studio technicians. Artists who were included in the scheme included Charles Brady, Michael Mulcahy, Michael Cullen, Brian Maguire, Cecily Brennan, William Crozier, Patrick Scott and Tony O'Malley (qqv). The programme was instrumental in creating a renewed public interest in Irish printmaking.

Of vital importance to the promotion of printmaking in Ireland was its recognition by national institutions and commercial galleries (qv). From the 1920s and into the 1930s, the New Irish Salon, the Society of Dublin Painters, the Daniel Egan Gallery and the Victor Waddington Gallery provided venues for printmakers to sell their work. Furthermore, these galleries displayed the work of international printmakers, promoting a new awareness for graphic art among Dublin audiences. In the early 1940s, the White Stag Group (qv) organized a number of exhibitions of twentieth-century art, including graphic art, in Dublin. Exhibitions (qv) that allowed Irish artists to display their prints in the 1950s, '60s and '70s included the Irish Exhibition of Living Art (qv) and the Independent Artists. The Dublin City Gallery of Municipal Art, the Ulster Museum and the Arts Council of Northern Ireland (ACNI) Gallery in Belfast exhibited the work of national and international printmakers from the 1960s. David Hendriks's commercial gallery showcased international graphics from the 1950s, beginning with an exhibition of Picasso's *Vollard Suite*, and later he and Leo Smith of the Dawson Gallery exhibited the work of Irish printmakers. Collectors such as George Dawson, Gordon Lambert and national organizations, including the AC/ACE and the ACNI, helped to sustain the development of printmaking through sponsorship of print workshops and the acquisition of prints. From the late 1960s, artists such as Micheal Farrell, Robert Ballagh, Cecil King, Louis le Brocquy (qqv) and GSD printmakers received international recognition through their participation in numerous international print biennale including Berlin, Bradford, Ljubljana, São

396. Andrew Folan, *Surface Dwelling*, 1986, etching and aquatint, 86.5 x 46.3 cm

Paolo, Salzburg, Segovia and Tokyo. The internationally renowned painter Sean Scully (qv) had begun to make prints in the late 1960s, and throughout his career has worked in a variety of processes from intaglio to relief to monotype. During the 1970s and early '80s, Listowel, Co. Kerry, in conjunction with the Writers' Week festival, hosted a series of international graphic exhibitions, showcasing the prints of Irish artists such as Maria Simonds-Gooding, Anne Madden and Richard Gorman (qqv).

In 1991 the Black Church Print Studio held an exhibition, *European Large Format Printing*, in Dublin. This exhibition, administered by Andrew Folan [184, 396], marked a new confidence in Irish printmaking. The scale of the prints challenged conventional perceptions of print as being an intimate and individual art form and placed it on a par with painting and sculpture. It provided an important platform for Ireland's leading

397. Diarmuid Delargy, *From an Abandoned Work V*, 1996, aquatint, mezzotint, engraving and etching, 56 x 75 cm, private collection

Maher (qqv) are making an important contribution to the development of print in Ireland.

At the turn of the twenty-first century, alongside the GSD and the Black Church Print Studio, there are a number of successful print studios in operation throughout the country, including the Belfast Print Workshop, which was spearheaded by Jim Allen in the 1970s, Cork Printmakers (1991), the Leinster Printmaking Studio (1998) and Limerick Printmakers Studio (1999).

Each of these organizations faces new challenges, including the implementation of greener methods of printmaking. In the 1990s, Seacourt Print Workshop, Bangor, Co. Down, was the first on the island of Ireland to use a technique known as 'The Edinburgh Etch', a process first developed in the Edinburgh Printmakers Workshop, which uses ferric chloride, a process that, unlike traditional methods, does not give off toxic vapours. Seacourt Print Workshop has been to the fore in researching and providing training in non-toxic print methods. The Leinster Printmaking Studio, in collaboration with the Seacourt Workshop and Cork Printmakers, introduced these new methods in the Republic of Ireland in the late 1990s, and in recent years the Black Church Print Studio is running numerous courses in green printmaking.

The newest debates among printmakers centre on the role of computer-aided imagery and digital printing. For some, fine art printmaking is defined by the use of time-honoured methods; for others, technology such as inkjet printing allows for greater collaboration between different media, photographic, digital and film. However, the editioning of such imagery as fine art prints is questioned by traditionalists and, as new media (qv) are introduced, questions are raised as to the relevance of categorizing works as 'fine art print'. Those who work with digital technologies argue that print cannot be simply defined by its method of production, and through the continuous evolution of process, print remains relevant to developments in contemporary art.
ANGELA GRIFFITH

SELECTED READING *Graphic Studio Dublin*, 1976; Liam Miller, 1976; Folan and Fay, 2007; Angela Griffith, *Making their Mark: Irish Printmaking in Context c. 1880–1930*, PhD thesis (TCD, Dublin 2009); Lalor, 2011.

printmakers, including Diarmuid Delargy [397], Micheal Farrell, Andrew Folan, Alice Hanratty, Sara Horgan, Michael Kane, Stephen Lawlor, Aidan Linehan, Tim Mara (qv) and Mary Farl Powers.

Other leading printmakers to emerge in the 1990s include Brian Kennedy [398], John Graham and Cliona Doyle who, along with artists who primarily work in other media, such as Ciarán Lennon, Richard Gorman, Gwen O'Dowd and Alice

398. Brian Kennedy, *Untitled*, 1997, monoprint, 30 x 25.5 cm, Crawford Art Gallery

PRIVATE AND CORPORATE ART COLLECTING (see *AAI* III, 'Collecting Sculpture: Private'). Institutional art collecting grew out of the belief that the great private collections of the past were signs of a culture which reflected the superiority of their owners. If such collections were made available to the rest of society, the benefits, it was believed, would be widespread. The situation for American collectors which Kathleen D. McCarthy described, that 'art patronage provided a point of access to institutional power, the trappings of gentility, and favourable publicity ...' , was echoed in Ireland (McCarthy, p. 153). The relationship between collector and artist has always been acknowledged, with a consensus that, without the great patrons of the past, we would not have the great art we have. The English critic Richard Cork only partially challenged this assumption when he pointed out that although artists need

patrons who will support the making of new work, artists do not want their masterpieces hidden away from the public eye, in the castles and luxury homes of those wealthy enough to pay for the privilege (Cork, *The Social Role of Art: Essays in Criticism for a Newspaper Public*, London 1979). In Ireland, where state patronage (see 'Patronage and Awards') was practically unheard of, the private collector was, and remains, especially important.

That the public institutions lagged behind the private in buying power is easily proved; Lord Iveagh, then a member of the Board of the National Gallery (NGI), bought 250 works in four years in the 1880s, more than Henry Doyle, its Director, managed to acquire for the gallery, between purchases and donations in his entire twenty-three-year tenure (Hodge, 97). Incredibly, the purchasing budget for the NGI, fixed at £1,000 in 1866, remained at this level until 1937 when it was doubled, only for it to be re-instated two years later (Hodge, 95). Following international patterns, the stage for public collecting in Ireland was set by private collectors who frequently occupied influential positions on the management boards and acquisition committees of those public institutions. Lady Milltown wielded extraordinary authority over the board and director of the NGI in return for her donation of the Milltown Collection in 1902 (Potterton, p. xxiv). It was a private collection, that of James Staats Forbes, the collector behind William Orpen's (qv) first portrait commission, which aroused Hugh Lane's interest in modern French painting, and when it was offered for sale at a knockdown price if bought by a public collection in 1906, public disgust at the failure of the authorities to do so led Lane and friends to campaign outright for a gallery of modern art.

In the absence of resourced public collections, an understanding of private collecting is central to an understanding of art collecting in Ireland at all levels. There are certain times when such collections are far more than the sum of their many parts, and this is especially true of the collections of two Irishmen at either end of the twentieth century, those of Hugh Lane at the beginning of the century and Gordon Lambert, whose collection was to be important at its close.

The Lane Collection provided the stimulus that brought about the creation of the Dublin Municipal Gallery of Modern Art (HL), the first institution for the collection and display of modern art in the country (see 'Collecting Art in Twentieth-Century Ireland'). Furthermore, when Lane died in 1915, the disputes surrounding his intentions for his collection fed debate around art and its importance that was to last for generations, involving sections of the Irish population which had not hitherto displayed any interest in this field of activity. The recurring failure to resolve differences between the Irish and English governments in relation to the Lane collection influenced the environment in which offers of new collections were received throughout the century. It predisposed the relevant authorities to show an enthusiasm and circumspection that was lacking at official level in that case and helped to ensure the successful gifting of Sir Alfred Chester Beatty's Oriental Collection following his death in 1968, and the Beit Collection in the 1990s. When, following his death in the 1970s, the collection of Sir Basil Goulding was broken up and sold, some of it outside the country, the raw wound of the Lane Collection was reopened.

Awareness of Gordon Lambert's intention to offer his international collection of modern and post-modern art to the state if a suitable home could be found for it became an important factor that led to the foundation of the Irish Museum of Modern Art (IMMA) in 1991. Repetition of the Lane and Goulding debacles was unthinkable.

Despite a depressed art market (qv), there was always a small number of educated people who bought art. George Furlong, Director of the NGI (1935–50), often complained about the lack of culture in Ireland, but noted 'Visitors to private houses are frequently surprised at the number of small collections of the leading French painters of today they find hanging side by side with their Irish contemporaries' (Furlong, *The Contemporary Art World*, 1939). It was these collectors, such as Lord and Lady Dunsany, who bought at the annual Royal Hibernian Academy (RHA) (qv) exhibitions and from the Society of Dublin Painters (SDP) in the 1920s and '30s. While their tastes were generally conservative, they did buy the work of Paul Henry and Jack B. Yeats (qqv) and liked to be seen in the right social circles. Thus, Mrs Bodkin, wife of Thomas Bodkin, Director of the NGI (1927–35), noted, following a tea party at their house in Wilton Terrace in the 1920s, 'I remember ... Cosgrave [President, Executive Council, Irish Free State 1922–32] complaining fractious-facetious-like that he could never get a full meeting of the cabinet together except in our house' (Somerville-Large, p. 319).

Following the establishment of the Irish Exhibition of Living Art (IELA) in 1943, and the White Stag Group's (qqv) sojourn in Ireland, taste gradually expanded, with a small proportion of the buying public opting for experimental artwork. S.B. Kennedy has noted a considerable upsurge in art-buying during the war years, and speculated that the absence of other consumer items may have created an opportunity that did not survive the war years (Kennedy, p. 147). One such buyer was Zoltan Lewinter-Frankl, a Hungarian businessman who set up a knitwear factory in Newtownards, Co. Down in 1939. His extensive collection of mainly Irish contemporary art, which included portraits of him by both Paul Nietsche and Basil Blackshaw (qqv), was exhibited in the canteen of his factory and also at the Belfast Museum and Art Gallery. Following the end of World War II, Sir Alfred Chester Beatty [399], anxious to avoid new taxes imposed by the Labour government in Britain, indicated a wish to come to Ireland. In discussion with the Irish government about his plan, he offered to give ninety-three important French paintings by nineteenth-century Barbizon painters, such as Theodore Rousseau, Corot, Daubigny and others, and leading Orientalists, such as Eugene Fromentin and Jean Léon Gérôme, to the NGI. While Chester Beatty is now better known in Ireland for his significantly larger gift of his magnificent library of oriental manuscripts, scrolls and other artefacts, his comments about modern art are revealing. 'I cannot help feeling more and more that some of the eccentric painters like Picasso and that group will not live', he said, 'and although the Barbizon School ... will never retain its old position ... they were the only great artists who existed in the Nineteenth Century' (Somerville-Large, p. 362).

Chester Beatty's wife collected French Impressionist painting. When her husband decided to donate these to the NGI, he showed a degree of humility not often encountered among

major collectors. 'I want to do everything I can to build up the gallery and if I offer anything which is not of proper quality I hope you will be perfectly frank and turn it down immediately' (NGI archives, CB file, 6 January 1954). A loan exhibition of these pictures was held but sadly the promised gift did not materialize, perhaps because the exhibition was very poorly attended. Following Beatty's wife's death, the pictures, including van Gogh's *Wheatfield*, were sold to pay British death duties.

John and Gertrude Hunt, successful antique dealers and collectors in London, also came to Ireland in the 1940s. Their collection, which they continued to amass after their arrival, is an eclectic one, with sculptural objects from Ancient Egypt and South America sitting alongside medieval Irish artefacts and eighteenth-century ceramics. The Hunts were conservative in their collecting practices: apart from a couple of drawings by Henry Moore, they did not favour contemporary art.

The most important collection of historic painting to be gifted to the state is the collection of Sir Alfred and Lady Beit. This magnificent collection, including paintings by Vermeer, Velázquez, Goya and Rubens, was given to the NGI, together with their County Wicklow home, Russborough House, which, fittingly, had been the residence of one of the NGI's earlier benefactors, the Duchess of Milltown. Their donation was being discussed just as another more nationalist-inspired donation was presented to the Royal Hospital, Kilmainham, now IMMA. The Madden Arnholz Collection of nearly 2,000 old master prints, including some by Dürer, Rembrandt, Hogarth and Daumier, was collected by a survivor of the Jewish Holocaust, Dr Friedrich Arnholz, and donated by his mother-in-law, Clare Madden, on the advice of the writer John Banville and his wife, Janet.

George Dawson, founding Professor of the Genetics Department of Trinity College Dublin (TCD) in 1958, came to appreciate pre-Renaissance art through his passionate love of contemporary art. Making his collection of tribal and contemporary art available to the university, Dawson's enthusiasm for international Modernism led him to set up the College Gallery through which students and staff could rent quality artwork for a nominal sum each year to hang in their campus accommodation. By enabling students to select and live with avant-garde artwork, Dawson did much to stimulate a new audience for contemporary art. With the student committee he set up to run the College Gallery, he went on to lobby successfully for the establishment of the Douglas Hyde Gallery, Dublin (DHG).

The most important private art collector in Ireland in the second half of the twentieth century was undoubtedly Gordon Lambert [400], not because his collection was bigger or necessarily better than others, so much as its international spread, his creative use of it and the crusading zeal which he, as a collector, shared with Hugh Lane and George Dawson made it influential. The knowledge that he planned to gift it to the state was an influencing factor in the creation of IMMA (1991) and was followed within a year by a preliminary gift of 212 artworks from it. His collection, partly inspired by his friendship with the gallerist David Hendriks, was built up, not only through purchase, but through active commissioning. It was his request for a series of portraits of such figures as the singer Bernadette Greevy, David Hendriks and himself that led Robert Ballagh (qv) to develop

one of the most successful portrait practices in Ireland. Lambert's ready understanding of Ballagh's Pop art (qv), arising from his own knowledge of advertising, made him unique in the Ireland of the 1970s. He used his considerable promotional skills to find new ways of advancing contemporary art. He lent his collection for an Arts Council-aided touring exhibition, gave artworks to such public venues as the Firkin Crane Dance Centre in Cork, the Wexford Opera Festival, the Irish Management Institute, the NGI and the Ulster Museum (UM), and hung works from his personal collection in the headquarters of Jacob's Biscuit factory. In an effort to showcase Irish art, Lambert introduced the couturier Sybil Connolly to Ted Hickey of the Ulster Museum, with a plan to show artworks alongside new creations on the catwalk in both Ireland and New York. While that particular plan did not materialize, the relationship with Sybil Connolly led to an invitation to Lambert to join the International Council of MoMA in New York. Typically, Lambert exploited this opportunity, introducing reports from Ireland at each international meeting, and showing video tapes of the first two Rosc exhibitions (qv). He invited fellow council members to visit Ireland, used their presence here as leverage to secure government support for a new gallery for contemporary art, and failed to secure a thank-you gift of a painting by Mark Rothko from his visitors, only because there was no suitable public gallery in Ireland to house it. Again, typically, Lambert used this as further fuel in his campaign for a modern gallery, using the goodwill of his friends at MoMA to help to get exhibitions by Roy Lichtenstein and Philip Guston for the DHG instead. On the domestic front, he joined fellow collector Basil Goulding and the artists Cecil King and Patrick Scott (qqv) and others in founding the Contemporary Irish Art Society (CIAS) in 1962 to promote the collection of contemporary art, and to assist the HL to develop its collection in the absence of a purchasing grant. Avoiding the preciousness of many donors Lambert recommended the de-acquisition of some artworks from his collection, if such action was considered in the better interest of IMMA.

As a collector of important international Modernism, Gordon Lambert was equalled only by Dr John O'Driscoll, whose collection included works by Kees van Dongen, Paul Signac, Alexander Calder, Roy Lichtenstein, Alberto Giacometti, William Turnbull and Patrick Heron, as well as tapestries, painting and sculpture by leading Irish artists. Where Gordon Lambert's eye was influenced by David Hendriks, John O'Driscoll's education as a collector can be deduced from his personal notebooks [401], which record an almost scientific analysis of the works of well-known paintings by Cézanne and others, along with his line and colour studies of certain aspects of their artworks. Other important private collectors during the latter half of the century are Joe and Marie Donnelly, Maurice Foley, who introduced the Guinness Peat Aviation (GPA) awards in the 1980s and part of whose collection was given to IMMA in 2002, the Reihill family, who donated three Francis Bacon (qv) works to the HL, Carmel Naughton, Chairman of the Board of the NGI (1996–2002) and her husband Martin, donors of a le Brocquy tapestry (see 'Stained-Glass, Rug and Tapestry Design') to the NGI in 2000, businessman Lochlann Quinn,

401. Pages from a notebook of the art collector Dr John O'Driscoll, undated, private collection

Chairman of the Board of the NGI since 2002, George and Maura McClelland, former gallery owners in Belfast whose collection was partially gifted to IMMA by Noel Smyth, himself a major collector of Irish art, Patrick J. Murphy, Chairman of the Arts Council (2000–03) and his wife Antoinette, who also ran the Peppercanister Gallery, the Goulandris O'Reilly family, Tony Ryan and Michael Smurfit, horse breeders and trainers J.P. McManus and John Magnier. They have been joined since the 1990s by the Irish-American couple Fred and Kay Krehbiel, said by *Apollo* magazine to have 'perhaps the most representative collection of Irish paintings in private hands' (Burns, p. 51).

An important contribution to Irish art was also made by a number of expatriate collectors, by far the most important of whom, in terms of their active participation in the history of Irish art, were the revolutionary leader Ernie O'Malley and his American wife, Helen Hooker. A noted art critic, O'Malley abandoned medical studies following the War of Independence and travelled to Paris and the United States of America where he met his wife, herself an artist of considerable ability. Together they built up a collection of contemporary Irish art, including Yeats, Jellett, Hone, Dillon, Hennessy (qqv) and others, to which Helen Hooker added her large collection of European, Asian and American folk and classical art. The Hooker-O'Malleys divided their time between Ireland and the USA but always retained an active role in Irish cultural affairs. They assisted Patrick Tuohy (qv) in putting on an exhibition at the Hackett Gallery in New York in 1930, donated a large part of their collection to the Irish American Cultural Institute in 1990 with the intention that it be given on 'permanent' loan to Ireland, and established the O'Malley art award in 1989. Their friend Máire MacNeill, married to the Boston art professor John L. Sweeney,

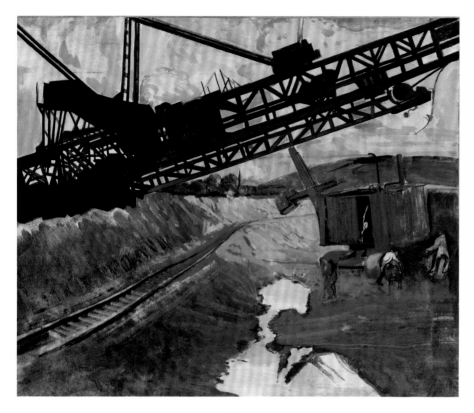

402. Seán Keating,
*Upstream of Power House
with Drilling Gang and
Wagon Train*, c. 1927–29,
oil on canvas, 77 x 92 cm,
Electricity Supply Board

new building that created a need for appropriate artworks. The main inspiration for a generation of corporate collecting came from Michael Scott and Ronnie Tallon of the architectural firm Scott Tallon Walker. Michael Scott persuaded P.J. Carroll and Co. to become major sponsors of the IELA, and Ronnie Tallon, with Don Carroll, who was also chairman of the Bank of Ireland (BoI), went on to commission major works by Gerda Fromel, Michael Bulfin, John Burke and Louis le Brocquy (qv) for a number of new bank and Carroll & Co. buildings [403]. Ronnie Tallon maintained this practice throughout his busy and successful career and, following his example, significant art collections began to emerge in Allied Irish Banks (AIB), GPA (now dispersed), BoI (some of which has been gifted to IMMA), Corás Iompar Éireann (CIÉ), Aer Lingus and other big corporations. Tallon believed that corporate collecting increased awareness of contemporary art and gave confidence to private buyers. The process accelerated; following Ireland's entry to the EEC in 1972, collections of Modernist painting and sculpture, on a scale and in a style sympathetic to the new architecture, found their way into insurance companies and hotels all over the country. Some collections stagnated following oil shortages and an economic slowdown in the 1980s only to re-emerge with renewed vigour in the 1990s.

While the bulk of this collecting was of Modernist art, AIB employed a highly qualified professional adviser, Dr Frances Ruane, to build up a substantial collection of Irish art designed to reflect its full range, from the late nineteenth century to the present day. Prior to the establishment of IMMA in 1991, it was to this collection that students and scholars went to get a clear overview of Irish art from 1890 to 1990 since it had resources far beyond the aspirations of the Arts Council (AC/ACE) and its closest publicly funded peer in the 1970s and '80s, the HL. Initially, AIB confined its collecting, which began in 1980, to those works that could sit comfortably within the rarefied world of corporate banking, but since the mid-1990s, the collection has embraced artworks less obviously compatible with the bank's worldview. Installation art (qv) still poses problems for corporate collectors, as do some forms of political and Conceptual art (qv). The collection of the Smurfit Group, despite paying record prices for works by Jack B. Yeats, did not manage to equal the quality or range of the AIB collection. Like AIB, Smurfits bought mainly Irish art, but through their multi-national partnerships they tapped into vast holdings of international art. When the Group acquired Cartón y Papel de México in 1999, it marked the occasion by donating some 150 works on paper from all over Latin America to IMMA. Since the 1990s, the supremacy of the AIB was challenged by IMMA, which although unable to match the bank's resources, could acquire work that did not sit comfortably within its corporate ethos. During the economic recession of the following decade many corporate collections were sold, while those of the two main banks were partially dispersed through a number of state collections.

In the early years of the twentieth century there was little encouragement to buy art in Ireland, almost no public models to guide aspiring buyers, and a limited critical environment, although poet John Hewitt urged people to buy pictures to 'feed the soul' (Hewitt, in *Notes on the Art of Picture Buying*, Ulster Unit exh. cat., 1935). Nonetheless, a small number of art lovers

left a Picasso and other works to the NGI in 1980. Their collections are small by comparison to more recent collections of Irish art by Irish-Americans such as Brian Burns. Burns's collection was lent to Boston College in the 1990s and partly shown in Dublin in 1995. These collections, while representative, are largely conservative, unlike the Wolverhampton Gallery's collection of Irish Art of the 'Troubles', which was begun in the 1990s in England, and embraces art in all practices relating to the Troubles in Northern Ireland (see 'The Troubles and Irish Art').

Following a lead established by the Electricity Supply Board in the 1920s [402], corporate collecting really emerged in Ireland in the 1960s, encouraged by an economic upturn that followed the 1959 Anglo-Irish Trade Agreement and a spate of

403. Carroll's Factory,
Dundalk with tapestry
by Louis le Brocquy,
commissioned 1969

continued to purchase modestly. Thoughts of future profit are unlikely to have influenced them in the slightest, since there was little indication then that this might be a possibility. Collectors like Gordon Lambert, Maurice Foley, Patrick J. Murphy and Lochlann Quinn bought art for the love of it. Lambert saw the arts as a unifying force in a divided Ireland and was proud to give his collection to IMMA unconditionally (Marshall). One of the early aims of the island's two Arts Councils (qv) was to promote collecting. The Joint Purchase Scheme of the AC/ACE aimed to promote buying and showing contemporary Irish art in state-sponsored companies, schools, hotels and public buildings. The scheme was influential in the establishment of art collections which remain in the joint-ownership of the buyer and the Council, although following changes in the status of the purchasing partners, some of the collections have been dispersed or, as in the case of the Great Southern Hotels, returned to the state. The scheme flourished throughout the 1960s, '70s and '80s, but fell into abeyance in the 1990s when prices rose on the art market and a different breed of collectors emerged.

Voluntary organizations established by private individuals, such as the Friends of the National Collections of Ireland (FNCI) and the Haverty Trust, the Gibson Trust at the Crawford Gallery in Cork (CAG), and the CIAS aimed to assist badly under-resourced public collections. In the case of the CIAS and the FNCI, an important outcome of their activities was the mutually supportive network they offered to fellow collectors. Over the years they did much to promote collecting by both individuals and corporations. A small number of corporations paid professional buyers and advisers to buy for them, but the supply of Modernist artworks appropriate for their new self-image was limited. In an interview with Vera Ryan, Ronnie Tallon complained that when he was given a budget by Don Carroll to buy art in the 1960s, he could not spend it all without lowering the standard, so he had to return it to the fund (Murray, 2007a, p. 46). Frances Ruane says that a measure of the success of AIB's collection was the bank's resistance to pressure to cover walls quickly; instead, it focused on collecting Irish art from the birth of Modernism (qv) in the 1880s onwards and waited for the best. In the 1990s AIB began to tour its large collection, and, since 1995, reflected its increasingly global presence by including Polish art. In 1999 and again in 2008, BoI gave part of its collection to IMMA in return for a government tax break, using the money saved to purchase more contemporary work. It has been claimed that recent collections have been led more by their investment potential than any thought of their historic or aesthetic significance (Burns).

Apart from an enlightened few, the buying public needed leadership. The NGI's dithering over purchases of Impressionists in the 1930s led Brian Fallon to suggest that 'modern art did not occur in Ireland' (Fallon, p. 110). This means that very little Impressionist painting was brought to Ireland, even though the Irish writer George Moore had been one of its leading advocates. That conservatism continued. When Basil Goulding's collection came up for sale, Brian Coyle of James Adams Auctioneers advised a private sale because there were no Irish buyers for abstraction. 'All the international works

were offered to London dealers and went out of the country for low prices...It was the outstanding private collection in Ireland, but it was too early. People weren't tuned in.' (Burns, p. 57) Among collectors of contemporary art, only Goulding, Lambert, O'Driscoll and the Donnellys bought international art. While Gordon Lambert was limited by his relatively modest resources and domestic arrangements, he managed to buy artworks by leading artists from twenty-seven different countries. Bruce Arnold's accusation that Lambert was a cautious buyer because he didn't buy Jack Yeats had more to do with price than with caution, since he bought early work by the then unproven and far more experimental James Coleman, Dorothy Cross (qqv) and others (Marshall). For the most part, other collectors focused on the national and the figurative, with Irish abstraction (qv) as evidence of their experimentation. Reviewing the market for Irish art in recent years, Clare McAndrew distinguishes two periods: one dedicated to patronage and one to the market (McAndrew, 2007, p. 17). Buyers from the second one, in the 1990s, may have bought more for investment than for the love that inspired the founding fathers, but most compete with one another within a narrow band of nineteenth and twentieth-century Irish art, headed by Yeats, Orpen, Lavery, Henry and le Brocquy, all now validated by public collections (see 'Publicly Funded Collections'). This pattern reflects the paradigms of old and new collecting across the western world. 'In the old regime possession by nobility conferred cachet upon the work; in the bourgeois world it was the other way around.' (Saisselin, p. 30)

'It was through Lane and his immense energy that the work of converting a suspicious Irish audience to an interest in painting was begun.' (Crookshank and Glin, p. 275) While Lane certainly aroused interest in art collecting generally in Ireland, it is harder to measure the influence that collectors such as Gordon Lambert had on contemporary art. However, few would deny the very considerable influence of architects like Ronnie Tallon and the corporate collectors who followed his lead, on the emergence of large-scale abstract artworks, while the vital support given by some private collectors kept artists afloat in an otherwise difficult environment. CATHERINE MARSHALL

SELECTED READING Potterton, 1981; Rémy Saisselin, *The Bourgeois and the Bibelot* (Rutgers University Press 1984); Kathleen McCarthy, *Women's Culture: American Philanthropy and Art, 1830–1930* (Chicago 1991); S.B. Kennedy, 1991; Fallon, 1994; Marshall, 1999; Crookshank and Glin, 2002; Somerville-Large, 2006; Hodge, 2007; Burns, 2009.

PUBLIC ART (see *AAI* III, 'Public Sculpture') [404]. The term 'public art' is a contested one. Outside of those professionally involved in the arts, it is often thought to mean artworks sited in public spaces and funded with public money, especially historic sculptural monuments. Since the 1960s, however, the term has come to be associated with artworks representing a variety of art disciplines and approaches not limited to sculpture, outside the familiar domain of the gallery or museum, and increasingly as best practice recommends, with a high degree of community involvement and participation (see 'Participatory Art'). Implicit

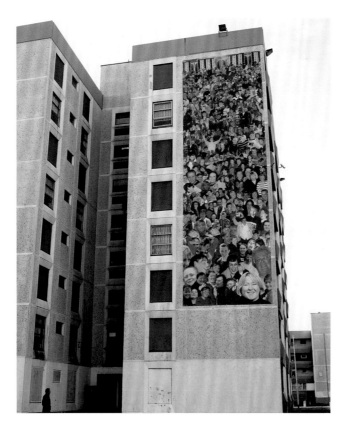

404. Joe Lee, Rhona Henderson and the Family Resource Centre, *The Laughing Wall*, 2001, banner erected from Block 4, St Michael's Estate, Inchicore in 2003

in good public art, are a sense of public ownership, accessibility and site specificity. Controversy has arisen historically from a tendency to see the public as a single homogenous mass that fails to account for cultural divergence and from the colonizing of public spaces with propagandistic artwork.

While the embellishment of classical, Gothic and Romanesque architecture, such as churches with sculpture, painting and decorative ironwork, can certainly be described as public art, its functional role in those contexts means that it is often thought of more as an accompaniment to the architecture or the civic purpose than as art. Before the establishment of the Irish Free State in 1922, the colonial history of the country means that much of the art in public places, even if paid for by the public purse, was not generally felt to be owned by the Irish public. In 1898 the speech made by Sir Thomas Grattan Esmonde at the unveiling of the 1798 commemorative sculpture of a rebel with a pike in Wexford town made this very clear: 'While there are monuments in plenty to the alien representatives of English misrule in Ireland, the monuments commemorative of great Irishmen, of great events in Irish history, are few and far between.' (John Turpin, 'Oliver Sheppard's 1798 Memorials', *IAR Yearbook*, 1990/91, 71)

The lack of a sense of ownership of those 'alien representatives of English misrule' was graphically revealed in recurring acts of vandalism sustained over more than three centuries by equestrian monuments of such prominent figures as Kings George II and William of Orange, the Gough Memorial in the Phoenix Park, and, most blatantly, the blowing up of the Nelson Monument in Dublin's O'Connell Street in 1966 by the IRA

[405]. These sculptures may have been publicly sited and publicly paid for but they did not feel publicly owned.

Following the establishment of the Free State, nationalist authorities on the whole did not prioritize the commissioning of public artwork and therefore did little to balance this picture, while the brutalist purity of Modernist architecture did not invite embellishment of any kind, although a notable exception is Patrick Scott's (qv) mosaic work in Busáras, Dublin. As a result, there were few opportunities for public art in Ireland for the first three-quarters of the twentieth century and little awareness of the shifts in thinking about art in public places that were emerging with Richard Serra, Richard Long and others abroad. The fiftieth anniversary of the 1916 Rising in 1966 allowed for a small number of significant public art commissions, such as the Garden of Remembrance in Dublin by architect Dáithí Hanly and sculptor Oisín Kelly and Edward Delaney's statue of Wolfe Tone in St Stephen's Green. These projects were mainly confined to sculpture and architecture and were imposed on the public by a benign authority rather than planned to convey a sense of real public ownership.

As early as 1936, James Devane argued vainly that 1–2 per cent of spending on public buildings should go to artwork ('Nationality and Culture', *Ireland Today*, 1, no. 7, December 1936, 16–17). In the 1970s John Behan put the case afresh and the Office of Public Works (OPW) introduced a version of this in 1978 for its own use. Following a paper by Medb Ruane, Visual Arts Officer at the Arts Council (qv), the Department of the Environment (DOE) established a similar Per Cent for Art Scheme (PCAS) in 1986. A review of these schemes, the *Public Art Research Project: Steering Group Report to Government* (PART Report) in 1997, led to their revision and extension to all government departments with construction budgets and encouraged new approaches to commissioning. The PCAS allows for a maximum of one per cent of monies from all government-funded capital projects up to a fixed limit (in 2012 this was €64,000) to be spent on new artwork. Between 1986 and 2002 the DOE spent €5 million on over 300 art projects, and local authorities increasingly matched this. The review

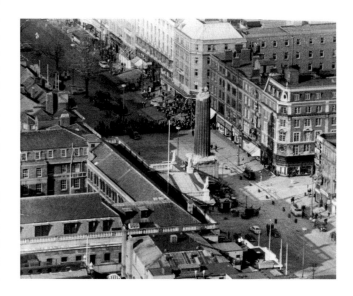

405. Press photograph following the bombing of Nelson's Pillar, *Irish Times*, 8 March 1966

recommended the establishment of the Public Art Co-ordination Group under the auspices of the Department of Arts, Heritage, Gaeltacht and the Islands. The objective of this group was to develop a national approach to public art with detailed guidance on procedure, management and documentation. Crucially, it allowed for funds from several capital projects to be combined and for co-funding where available. The local authorities were given responsibility for commissions and for selecting the location and type of project. In both 2004 and 2009 the Co-ordination Group issued General National Guidelines covering the scheme, and a new public art website http://www.publicart.ie was established with Cliodhna Shaffrey and Sarah Searson as first editors.

An early indication of a more sensitive approach to the placement of public art came in Northern Ireland with the commissioning of two significant artworks by Irish artists for Derry's new hospital, Altnagelvin, during the period 1956 to 1962, when the painter William Scott (qv) and the sculptor F.E. McWilliam were invited to provide artwork to soften the perceived harshness of the architecture. The brief from the architects to McWilliam was that 'the artwork should as far as possible retain its own integrity while establishing a link between a new hospital for a major city and the fact that it is to be situated in Ireland' (Roy Wilkinson and Fionna Barber, 'The Place of the Public in Public Sculpture', *Circa*, no. 45, 29–31). McWilliam sought to meet the brief by creating a statue of a mythical Irish warrior woman, the Princess Macha, known also for her healing abilities. The nationalist press in Derry, familiar with Catholic imagery of the Virgin and Child transposed to become a symbol of Irish motherhood, expressed irritation that the work did not conform to that traditional imagery, while unionist commentators failed to find anything meaningful in the work. Restricted budgets meant that the work was not located on the mound planned by the artist but was placed unsympathetically against the architecture, ruling out the anticipated aesthetic harmony and integrity desired by both architects and artist. In questioning notions of 'public' in relation to this, Wilkinson and Barber concluded, 'Ultimately the question comes down to whether a particular art object can actually be seen as possessing meaning within a given culture' (ibid., 29). Róisín Kennedy has documented parallel issues in relation to Scott's painting ('Art for the Public', *IAR Yearbook*, XVIII, 2002, 53–57).

A more systematic approach to public art in Northern Ireland was initiated in 1986 when Tony Hill of the University of Ulster (UU) and Mansil Miller, principal landscape architect with the Department of the Environment, Northern Ireland (DOENI), jointly began working on what later came to be entitled *Art in Public Places* (1989). Hill travelled around Britain in 1987, where he met with John Carson of Artangel and Paul Bradley (leading advocates of public art), and continental Europe, where he visited the Münster Sculpture Project in Germany, the Kröller-Müller Museum at Otterloo in the Netherlands, and Amsterdam, which was European city of culture in 1987. On his return, an executive group comprising Hill, Miller and Declan McGonagle, Director of the Orchard Gallery in Derry, was established to develop an archive of existing projects, to identify potential sites and look for sponsorship for

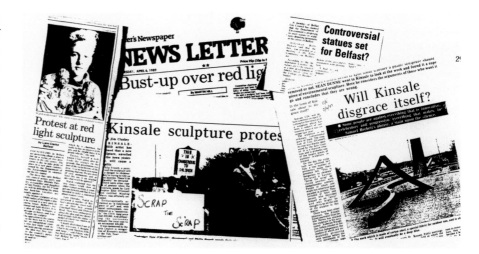

406. Montage of press reports relating to the public art debate, J. Odling-Smee and K. Walsh, 'Putting Public Art on the Agenda', *Circa* (July/August 1989) p. 29

public art. A new research post was established at the University of Ulster, and Charlotte Jones, its first incumbent, began to research and document developments in July 1988. The group chose Blackstaff Square in Belfast as the site for a public art test case. Confused communication among the client, the Belfast Development Office of the DOENI and the research team led to a controversial outcome involving artists Louise Walsh, Locky Morris and John Kindness (qv).

Controversy also followed the Arts Council's commissioning of Eilís O'Connell's *Great Wall of Kinsale*, the largest piece of public sculpture in Britain or Ireland, when unveiled in 1988. An arched, curving wall of corten steel, 179 ft long, the piece was offered to Kinsale, Co. Cork by the Council as a reward for its commitment to the Tidy Towns' competition. Although accepted by the majority of the inhabitants, public dissatisfaction among a small but vociferous group led to calls for its removal, forcing a modification of the work and increased expenses.

The debate surrounding these works [406], a new interest in public art as a tool of urban re-generation and an outlet for patronage for sculpture, and greater opportunities owing to the introduction of the PCAS led to a more analytical and sensitive approach to the issues of ownership and appropriateness of the selected work for the locations. There was widespread agreement that mediation between local communities, funders and artists was essential if public art was to be successful in the future.

Ten public sculptures placed around Dublin to celebrate the city's millennium in 1988 aroused considerable attention. Of particular interest was the attempt by the English sculptor Peter Fink to engage the local community for a project in Pimlico in Dublin's Liberties. Fink's Modernist sculpture referenced both the Irish flag and the history of weaving in the area but the project proved to be problematic because of community hostility to the funders, Dublin Corporation and Allied Irish Banks, over neglect of the area and the failure of the organizers to provide effective outreach programmes around the sculpture.

The public art debate was facilitated in the pages of *Circa* throughout the late 1980s and '90s, with David Brett insisting that: 'It is a central issue of modern culture – a problem that will not go away since it has a bearing on how we perceive and

407. Patricia McKenna, *The Grey House*, Belturbet, Co. Cavan, 1993–94, mixed media materials gathered from the local community

comprehend the societies we live in, and how we understand our own individualities' (*Circa* May/June 1989, no. 45, 14). From the 1990s onwards, a number of conferences in the UK, under the auspices of Public Art Forum and the Public Art Development Trust, and in the Netherlands, the widespread debate about controversial installations in the USA, and sculpture symposia in Dublin, Kilkenny and Sligo, run by the Sculptors' Society of Ireland, the National Sculpture Factory, Cork, and Sligo County Council's Placing Public Art programme, led to a new professionalism in relation to the identification of locations, the selection of artists and mediation with communities. Greater mobility of artists and curators (see 'Curating'), common concerns about the PCAS, and a determination to move art away from architectural adornment contributed to new thinking. A number of principles began to emerge: it was generally agreed that public art should confer a sense of place and involve the people who use that place, drawing on a deep knowledge of local communities and physical and historical factors; furthermore, that it could be a powerful strategy in urban regeneration, should improve the environment and should be stimulating. It also quickly became clear that public art should not be limited to sculptural projects and did not have to be permanent. The performance work and street theatre of Macnas, founded in Galway in 1986, showed that this was a very direct way of engaging local communities in all aspects of the art process (see 'Time-based Art'). Patricia McKenna's installation *The Grey House* [407] involved filling a derelict house near Belturbet, Co. Cavan with

objects and envelopes from emigrants from the area, donated by the local community. Such was its impact nationally, as well as locally, that the installation, intended as ephemeral, was maintained for over a year. Pauline Cummins's mural on a temporary hoarding outside Holles Street Hospital (1984), and billboard art by John Kindness and Les Levine (qqv), proved that public art in two dimensions was possible outside the gallery and continued to ensure that it could be controversial.

Professional organizations and dedicated public art curators began to emerge, of which Artworking, founded by Jenny Haughton, was the best-known example, and the OPW and Arts Council created advisory committees or posts to provide policy and procurement guidelines. Influenced by the 1997 report, Sligo County Council and Urban District Council, having appointed Mary McAuliffe as the Arts Officer in 1997, set up a Public Art Working Group that same year. Under the direction of McAuliffe and the working group, a three-year pilot programme of public art was initiated, aimed at encouraging experiment, dialogue and critique, to inform a viable future public art policy, and to expand the place of art in the lives of the people. Using monies acquired under the PCAS, the pilot concentrated on six modest projects, each of which was documented and evaluated, and a public art co-ordinator, Mary McDonagh, was appointed to mediate the projects and to assess how best the artist's vision could be melded with the needs of the community. A pool of artists was drawn from an open submission process, and projects were selected on the basis of quality, appropriateness and the range of practices they offered for engagement with local communities. They included a collaborative project led by artist Ronnie Hughes (qv), based on Sligo's history of the Spanish Armada and contemporary memory; entrusting a small community group with money to purchase artwork by an artist from the designated pool to start a people's collection; a performance involving the local community and artist Imelda Peppard; a film by Laura Gannon; a site-specific sculptural and sound work by Ron van der Noll; and sculptural installations by Pauline O'Connell, Martina Coyle and Hilary Gilligan in a local park (see 'Installation Art'). Dr Gavin Murphy's positive evaluation of this pilot, published in 2000, was to prove influential on later public art programmes, notably Ground Up, Co. Clare and Breaking Ground, Ballymun, Dublin, while simultaneously In-Context, under the auspices of South Dublin County Council, was responsible for a series of innovative and locally engaged artist-led projects. As evidence of the successful mediation of a public art project, South Dublin County Council and the communities of Kill and Saggart even agreed to the installation of an artwork by artist Maurice O'Connell, which took the form of a time capsule containing statements from households throughout both communities; it was buried in 1998 and will not be opened until 2098.

Of course not all art in public places is owned by the public. While the controversy surrounding Louise Walsh's work in Belfast and Eilís O'Connell's in Kinsale was the accidental outcome of a process that was not fully thought out, artists seized the opportunity to make political statements beyond the exclusive domain of the gallery, albeit sometimes with its support. A strong tradition of political mural painting had existed in Northern

Ireland throughout the century. Initially, this followed very rigid formulae and came almost entirely from the unionist tradition, but following the outbreak of the 'Troubles' (see 'The Troubles and Irish Art') in 1969, new murals, informed by film and by revolutionary art from abroad, were introduced on the nationalist side. Les Levine's 'media campaigns', as he termed his work on billboards and television, well-known in North America, were represented on this side of the Atlantic in his billboard project 'Blame God' [278, 430] in various sites in London (1985) and Dublin, as part of the *From Beyond the Pale* exhibition at the Irish Museum of Modern Art (IMMA) in 1994. As gallery projects, rather than publicly owned art, they could be both overtly political (see 'Politics in Irish Art') and deliberately provocative. Public procurement processes can be both unwieldy and time-consuming. When the Nissan Public Art Award was initiated in conjunction with IMMA in 1997, it was immediately clear that temporary projects would offer the greatest opportunity for experimental work. The award was short-lived but during its lifetime it produced some of the most memorable projects the country has ever seen in Dorothy Cross's installation *Ghost Ship* [236] in Scotsman's Bay, Dun Laoghaire (1999) and *For Dublin* (1997) by Fran Hegarty (qqv) and Andrew Stones.

Conclusion

The emergence of some outstanding examples of public art in Ireland in the 1990s should not prevent recognition that a great deal of art was installed in public spaces all over the country without proper consultation, regard for quality or imagination, and little consideration for its long-term maintenance. In some situations, identifying the community of a place can be difficult, where the main users of a place are transient or have special needs, such as the very different requirements of staff and patients in hospitals. But public art has fulfilled and continues to fulfil many important roles. It can break down the separation of the artist and community, raise a level of critical awareness and an engagement of audiences with art outside the gallery, and provide an important source of patronage (see 'Patronage and Awards'). It can improve the environment and act as a comforting landmark, as do *Perpetual Motion* by Remco de Fouw and Rachel Joynt at the junction of the N7 and the Naas by-pass, and Maurice Harron's *Indian Chief* on the hill overlooking Lough Allen. Gavin Murphy has pointed out how the Sligo Public Art Pilot projects challenged notions of the West of Ireland as a mythic domain beyond modernity, proving that the periphery, too, can be a site of innovation (Murphy, p. 18). Since 2000 this has been borne out in projects such as *X-PO* (2007 ongoing) [408], the reinstatement of a closed rural post office as a centre for community development and renewal by the artist Deirdre O'Mahony, and work in north Wexford and Mayo by Aileen Lambert. While those projects are rural, Seamus Nolan's transformation of the top floor of a tower block scheduled for demolition in Ballymun in 2008 and work by Seán Lynch in Limerick are not just artistically innovative; they mark significant moments in the regeneration of urban areas. The appointment of public art managers by local authorities and the allocation of real time for mediation in the same period are important stages in the development of public art for the future.

By 2000 there was a veritable rash of public artworks all over the country but, as Andrew Brighton has argued in relation to Britain, a boom in this aspect of arts patronage can often be hostile to serious art (Brighton, pp. 42–43). Public art defines the relationship between the artist, the public and power, yet the negotiation with community that this implies conflicts with the still prevalent notion of the artist as genius. This may explain the anguished comment in a 2008 interview by the artist Anish Kapoor, while he was busy working on the largest piece of public sculpture in Britain to date: 'I think we've gone totally public-sculpture mad. I hate public sculpture Oh god, even the phrase makes me feel tired' ('A life in Art', interview by Charlotte Higgins, *Guardian Review*, 8 November 2008). CATHERINE MARSHALL

SELECTED READING Roundtable discussion, 'Sculpture, Admin and Money', *Circa*, no. 42 (October/November 1988), 30–37; James Odling-Smee and Kieran Walsh, 'Putting Public Art on the Agenda', *Circa*, no. 46 (July/August 1989); Peter Fink, 'Another Dublin, Another People', *Art Monthly* (July/August 1989); Miles, 1989; *Public Art Research Project*, 1992; Brighton, 1993; G. Murphy, 2000, pp. 15–24; Con Power, 'The Per Cent for Art Scheme', *IAR* (Summer 2002), 66–69; Shaffrey, 2010.

PUBLICLY FUNDED COLLECTIONS (see 'Arts Councils', 'Collecting Art in Twentieth-Century Ireland' and 'Private and Corporate Art Collecting'). The most important collections supported by the public purse in Ireland are the national collections; that is to say, those of the National Gallery of Ireland (NGI), the Irish Museum of Modern Art (IMMA), the Arts Council (AC/ACE) and the Office of Public Works (OPW) in the south, and the collections of the Ulster Museum (UM) and the Arts Council of Northern Ireland (ACNI) in Northern Ireland. Each one is uniquely shaped by its history and the policies that drive it. Unquestionably the most important of these in its size and time span is that of the NGI, although it is relatively young compared to its older sister, the collection of the OPW. The challenging newcomer to this field is IMMA which did not open until 1991, but which has succeeded in amassing a considerable collection in the two decades since then. Smaller

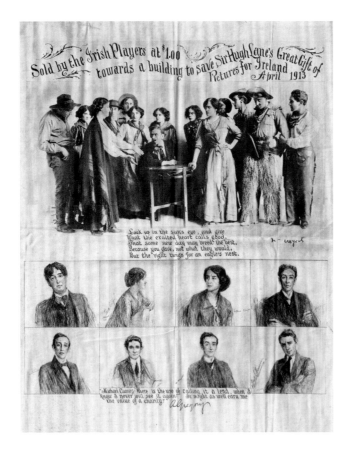

409. Linen handkerchief sold to raise funds to save Hugh Lane's paintings, eight Abbey players by John Butler Yeats, 1911–12, private collection

collections have always existed – in situations where determined individuals successfully lobbied for them, and in organizations such as hospitals and universities where collections evolved with the minimum of public funding. The twentieth century brought major changes in the number of public collections, public expectation of them, their professional management and new critical and theoretical attitudes.

The NGI (1864–) is the pre-eminent collection of visual art on the island, with a mixed collection of European and Irish art dating from the Middle Ages to the middle of the twentieth century. Housed in a purpose-built gallery from the 1860s, the collection is largely made up of paintings, prints and drawings, with a small selection of sculptures. Never well resourced by international standards, it nonetheless boasts a particularly fine collection of seventeenth-century paintings by such masters as Rembrandt, Vermeer, Velázquez, Murillo, Caravaggio, Guercino, Lanfranco, Poussin and Rubens, as well as a solid cohort of lesser-known but important artists from that period. In addition, the collection of eighteenth-century British and nineteenth-century French works should be mentioned, while other highlights include two wonderful Goyas and some good paintings from the Renaissance. As with all other historic collections, this one owes a great deal to generous benefactors, notably the Milltown family, Sir Hugh Lane, Sir Alfred Chester Beatty, Sir Alfred and Lady Beit, Sir Denis Mahon, whose gift was partly in recognition of the fact that the gallery did not charge for public access, Máire McNeill Sweeney, and artists like Evie Hone (qv), who donated her Picasso. Until the 1990s, the gallery

collected only artwork from before the 1930s, but that has since been altered to 1950, with a proviso that no work by living artists should be hung. This restriction was increasingly seen as burdensome as pressure mounted for a truly representative collection of modern, especially modern Irish, art.

The issue is as old as the century itself. It was in response to this perceived need that Sir Hugh Lane successfully campaigned for a gallery of modern art for Dublin [409], the Municipal Gallery of Modern Art (later the Hugh Lane Municipal Gallery of Modern Art and since 2000, Dublin City Gallery, The Hugh Lane (HL)), which opened in 1908 in temporary premises and later transferred to its permanent home in Charlemont House. However, notwithstanding Lane's generosity and the indefatigable efforts of his supporters in this endeavour, the new gallery was given no money to develop a collection. Furthermore, as a municipal gallery it answered to a different authority and did not have a national remit. It took nearly a century of further lobbying to establish IMMA in 1991, leaving the HL, in the interim, struggling to cope with public demand for a national collection of modern art. Nationalist outrage at the perceived mishandling of the Lane Bequest did not bring about the provision of a budget to honour Lane's ambitions for his gallery, and were it not for the assistance of voluntary organizations, the gallery might never have acquired a collection. The Friends of the National Collections of Ireland (FNCI) was founded by Sarah Purser (qv) [410] in 1924 on the lines of the Contemporary Art Society in London with the aim of obtaining 'works of art and objects of historic interest or importance, for the national or public collections of Ireland, by purchase, gift or bequest, and to further their interests in other analogous or incidental ways' (Kennedy, 1991,

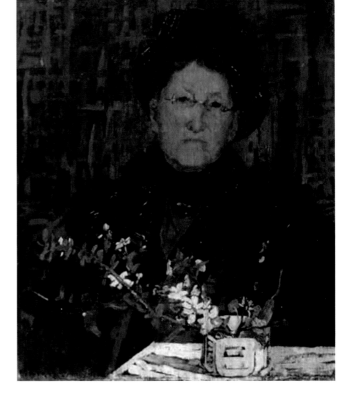

410. Mary Swanzy, *Sarah Purser*, oil on canvas, 58.5 x 49.5 cm, Dublin City Gallery The Hugh Lane

p. 86). One hundred and twelve people joined in the first year and the association has been growing ever since. The FNCI devoted itself initially to the HL and, to complement the Haverty Trust (established in 1930 to purchase Irish art), bought non-Irish, as well as Irish art as the opportunity presented. The HL collection was enlarged in the 1960s when the Contemporary Irish Art Society (CIAS) was established in 1962 by a group of Dublin art lovers led by Cecil King, the artist Patrick Scott (qqv), Basil Goulding, Stanley Mosse and Robert Figgis with the express purpose of assisting the gallery. Their membership subscriptions, combined with assistance from the Art Council's recently established Joint Purchase Scheme, enabled the gallery to acquire works by William Scott, Patrick Scott [411], Barrie Cooke (qqv) and others, and in 1969 Dublin Corporation finally granted a small but regular acquisition budget. By 1990 the HL could boast a good founding collection of Irish and European works from Lane's opening exhibition in 1908, enriched by gifts from the FNCI and Haverty Trusts (Maurice MacGonigal, Patrick Hennessy (qqv), Bonnard, Vlaminck, Rouault, Moore), and a small number of high-quality artworks purchased directly during the 1980s and '90s (Nikki de Saint Phalle, Agnes Martin, Kathy Prendergast (qv). However, lack of resources to staff the gallery and to develop the collection continued to be a problem until the end of the century.

Under the guidance of Arthur Deane, the Belfast Museum and Art Gallery, which was later absorbed into the UM, used monies from the sale of a bequest from Sir Robert Lloyd Patterson to purchase a collection of British art from 1900 to 1937. A more conservative and provincial direction was pursued in the 1940s and '50s. But the gallery got a lease of energy with the appointment of Anne Crookshank, Keeper of Art from 1957 to 1965. In the words of Louis le Brocquy, 'the Ulster Museum, under her inspired initiative, was widely known to have the most exciting policy and practice of any gallery outside London' (Jane Fenlon, Nicola Figgis and Catherine Marshall (eds), *New Perspectives in Art History in honour of Anne Crookshank*, Dublin 1987, p. 18). Crookshank shamelessly exploited local patriotism to secure better acquisition funding and to buy good modern art, including paintings by William Scott who was brought up in County Fermanagh and early work by Francis Bacon (qv), Jean Dubuffet, Victor Vasarely, Karel Appel, and the American artists Helen Frankenthaler and Morris Louis. The example set by the UM under Crookshank's leadership was, however, not copied by public institutions in the Republic.

The Arts Councils, both north and south, made some attempts to meet demands from artists and the public for collections of Irish contemporary work by initiating their own. Northern Ireland led by example, from 1943, through the activities of the Council for the Encouragement of Music and Art (CEMA), superseded by the ACNI (1949). CEMA began collecting in 1944 and from the outset included the work of contemporaries from Britain and the Republic, although the collection was weighted towards artists with a Northern Irish connection. While the earliest purchases were relatively avant-garde, the collection quickly oriented itself around traditional painting, with little interest in conceptualist practices as they

emerged, concentrating on paintings and prints and a small collection of domestically scaled sculptural works. For some years the ACNI also ran a small gallery in which the collection and other art work were shown.

In the south, the AC/ACE made its first purchases in the 1950s, aimed at building up a collection 'to be hung in the council's premises and possibly at a future date to be sent on tour ... the support of artists, the building up of a body of material for prestige exhibitions in other countries and the showing of the entire collection in Dublin and the provinces and finally the donation on permanent loan to Irish galleries of any or all of the works' (AC/ACE Annual Report, 1967). The Council never envisaged permanent public display, and the aim of supporting artists through purchase, laudable and necessary as it was, was not designed to guarantee a representative collection of excellence. Irish painting and small sculptures are well represented in the collection, but the lack of exhibition space meant that it was difficult to accommodate larger work, and work representing newer practices, such as performance (see 'Time-based Art') and installation art (qv), although these, and new media works (see 'New Media Art'), have been increasingly purchased since the late 1990s. As Aidan Dunne summed it up, 'Though it has no exhibition space, and though it is not of uniformly high quality, it is a strong collection with a significant core of fine work and could be a valuable national asset – if there was somewhere to see it.' (Murphy, p. 5) In 1999 the Arts Councils, both north and south, commissioned a joint study of their collections with a view to future changes. In the light of this review, the ACNI decided to focus its collecting on work relating to Northern Ireland, made within the decade of purchase, and with possible de-accessioning of artwork after five to eight years to other publicly funded organizations.

Opened in 1991, IMMA has quickly established itself as the location of the most important collection of modern and contemporary art in Ireland. Resisting pressure to be a museum of Irish art, IMMA boldly embarked on a policy of collecting both Irish and international contemporary artworks. Acquisition budgets have always been small, relative to similar institutions internationally, but significant when compared to other collecting organizations at home. Apart from purchasing funds, the museum also has considerable exhibition spaces, a curatorial team and the technical expertise to mount touring shows. Consequently, in addition to purchases, the museum's collection attracts significant donations, such as the Gordon Lambert Trust collection of over 300 artworks from some twenty-seven countries. In 2008 artworks owned outright by the museum numbered approximately 1,600 (Harry Magee, *IT*, 4 August 2008), a figure that is augmented by 2,000 Old Master prints donated by Clare Madden, and major long-term loans, such as the Weltkunst Collection of British Sculpture and Sculptors' Drawings. IMMA's founding policy was to purchase artworks in all media by living artists and to accept loans and donations of artwork from as early as the 1940s to provide a historical context for contemporary activities. Although storage difficulties and staffing levels remain a challenge, the IMMA collection is now acknowledged as the country's primary collection of Irish and international modern and contemporary art. The collection is

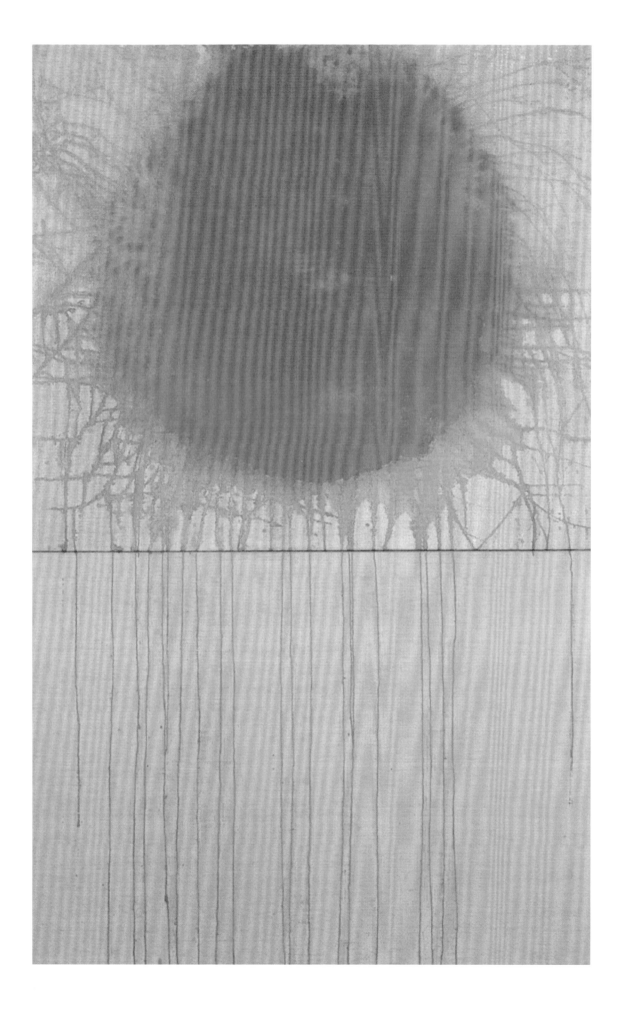

widely exhibited: at the museum itself in regularly rotating displays, throughout Ireland through its active National Programme, and internationally via its touring exhibitions, which to date have taken it to Canada, China, the United States of America, and various European venues.

The OPW collection, begun in 1831, is the oldest public art collection in state control in Ireland. Responsible for all state buildings, the OPW inherited a small number of historic artworks, but the bulk of the collection was acquired since the late 1980s to decorate public offices and institutions. The OPW is assisted in this by the Arts Council which lends artworks for the same purpose. Recent purchases and commissions are almost entirely Irish, but since its 4,600 artworks decorate working offices and buildings, it does not attempt to set itself up as a definitive national collection. Composed mainly of modern paintings and prints, some of which are duplicated around different offices, but with historic works from Dublin Castle, the Royal Hospital, Iveagh House and other older buildings, it has been described as a 'heterogeneous collection ... acquired in an unsystematic way' (Turpin and de Chenu, p. 7). Noel de Chenu points to proactive moments in its history such as the decision in 1922 to commission portraits for Áras an Uachtarán and Dáil Éireann (pp. 9–10). A spate of Per Cent for Art projects, gaining in momentum since the 1990s, whereby one per cent of monies associated with government building programmes is dedicated to an artwork, is another significant development. The collection is looked after by a dedicated arts management team and holds regular exhibitions.

> National art institutions typically attempt to piece together a history of the unfolding developments of art over time, with representative examples of the work of major artists and movements, and the inclusion of particularly iconic examples. They will also, or alternatively, assemble a body of work that has thematic coherence designed to reflect the society in which it was produced, to reflect its interests and/ or to challenge its norms. (Scott, p. vii)

As Yvonne Scott points out, in reference to the OPW, the collection of a national institution may be driven by considerations other than the most obvious one – the piecing together of the history of the country to which it belongs. There is a perception that national galleries, however, should collect in a systematic way that reflects national identity and aspiration. That this was not always the case in Ireland is evident from the history of the NGI, which, up to the appointment of Henry Doyle (Director, 1869–92), purchased copies of Old Masters. It was only under Doyle's direction that original classics and Irish art became the focus of the collection (Hodge, p. 95). As it grew in the twentieth century, the collection was driven by opportunism, however inspired, rather than by any clearly mapped-out strategy, with directors making purchases as chance and their limited resources allowed. The gallery's grant in aid from the British government in 1921/22 was £5,145.00. Twelve years later the Free State government could allocate only £3,875.00. Resources were so limited that directors had to be part-time and could afford to take office only if they had other means of support.

Thus, Thomas Bodkin (Director, 1927–35) openly boasted about his private dealing that 'with the sale of one picture, I once ... earned fifteen times my annual salary' (Somerville-Large, p. 30). Conflict of interest was not considered problematic, but the implicit link between art and social class was a hard one to overcome. The purchasing grant for the NGI doubled in 1937 from £1,000 to £2,000, the first increase since 1866, only to be reduced to the original figure just three years later. Gifts were welcomed, subject to the approval of the board, although some of these came at a price. The gallery felt obliged to yield when Lady Milltown insisted in 1906 that the top floor of the gallery should be cleared to accommodate some 200 items, in addition to her original gift, even though the director considered them 'undesirable' (Potterton, 1981, p. xxiv). Emily Drummond gifted two paintings on condition that if Ireland ever separated from the British Empire, the canvases should be given to Scotland instead. More controversially, the gift of a painting *Jupiter and Ganymede* by Nicolaes van Helt Stockade was finally accepted in 1940, although its homoeroticism had caused its rejection, two years previously (Somerville-Large, p. 338). Nationalism was also a factor, especially in the early half of the century, with the board refusing to extend a loan of a painting by William Orpen (qv) to the British Council on the grounds that the Council was anti-Irish (p. 342).

James White, the NGI's first full-time director (1964–80) and, thanks to the George Bernard Shaw bequest, the first to have disposable funds that had not come from the public purse, called for licence to continue to buy affordable artworks to fill a list of 'gaps' in the art historical canon, as he interpreted it, whenever they became available (White, 'Buying for the Nation', *Hibernia*, 21 June 1974, 24). 'It is most difficult to sit down and explain buying policy in a gallery, since the exercise is purely speculative and however much one desires a painting there is no way of knowing if it will ever become available', he wrote. Where Bodkin used the monetary value of a painting in order to emphasize its desirability, White stressed the related importance of rarity and quality. White argued that it was more appropriate to buy a painting by Jacques Louis David for a quarter of a million pounds, than a possibly more attractive portrait by Baron Gerard for a more affordable £40,000, on the grounds that it was rarer, and that both the Louvre and the Metropolitan Museum in New York wanted to purchase it. By opting for the rarer work, White clearly signalled his intention to raise the gallery's international profile, rather than to continue to build a collection that was interesting only in an insular context. In the same vein, White identified, in consultation with Anne Crookshank, then Professor of Art History at Trinity College Dublin (TCD), the artists whose work he believed should be acquired. No Irish artists appear on this list or elsewhere in his article, perhaps because he felt that was so obvious as to be unnecessary. The board clearly endorsed the speculative nature of White's art purchasing. His successor, Homan Potterton (Director, 1980–88), was allowed to spend up to a quarter of a million pounds at auction, without the prior approval of the board of the NGI in the 1980s, a figure that exceeded the entire acquisition budget for IMMA in its first two years. The gallery now collects Irish art, produced before 1950, and has permitted exceptions to the 'no living artist

411. Patrick Scott, *Large Solar Device*, 1964, tempera on unprimed canvas, 234 x 153 cm, Dublin City Gallery The Hugh Lane

rule'. The collection has been augmented by some spectacular donations and long-term loans, and, through a series of temporary exhibitions inaugurated by Homan Potterton, has greatly increased its visitor numbers.

IMMA, under its founding director, Declan McGonagle (1991–2000) pursued a rather different approach. Claiming that it bought art not artists, IMMA pursued art practices and art works that are new and challenging, irrespective of established reputations. Refusing to be limited by nationality, gender or media quotas the museum sought instead to reflect its commitment to inclusion, by seeking to make the collection representative of what contemporary artists do. Recognizing the NGI ban on the work of living artists, IMMA decided to buy only recent work by living artists but to accept gifts and loans of artwork from the 1940s when the foundation of the IELA (qv) and World War II brought changes nationally and internationally. Stating further that the museum's commitment was to *showing* rather than *owning* art, IMMA embarked in 1996 on a National Programme, designed to promote a sense of ownership of the collection throughout Ireland by working collaboratively with local communities to curate exhibitions from it. An important founding policy for the collection was the decision to purchase work by international artists from exhibitions of their work at IMMA. This led, in many cases, to the acquisition of artworks that were made specifically with the physical, historical and/or social context of the museum in mind. More radically, IMMA accepted a long-term loan of an important private collection of Outsider art (qv) – the Musgrave-Kinley Collection – in 1997, as a signal of its commitment to inclusion. By subsequently showing the Outsiders as a fully integrated part of the collection, IMMA sent out an important message to the art community internationally. This reinforced the decision taken a year earlier to purchase *Open Season* [506], a collaborative work, made by women from the Saint Michael's Estate, Inchicore, and artist Joe Lee. These activities questioned the traditional role of the museum as arbiter of an implied artistic canon. In 2001, in response to confusion about the appropriate designation for certain gifts offered to IMMA and the NGI in lieu of tax exemptions, the two institutions agreed that, for the purposes of such gifts, work made before 1950 should be given to the NGI, while later work was to go to IMMA [412].

The Arts Council's collection was built up at a time when there was little state involvement in art collecting in Ireland and it has grown to over 1,040 artworks since its inception in 1959, and formalization in 1962. The early aims of decorating Arts Council offices, encouraging collecting and touring art were speedily expanded to include, by the 1970s and '80s, a growing response to two different needs: to support artists, and to meet public demand for a national collection of excellence. In 1984 the Visual Arts Sub-Committee stated that '... a permanent core collection should be identified, the ultimate objective being the building up of the nucleus of a national collection of modern art' (Minutes, 1967 and 11 December 1984, AC/ACE file 6150/1977/1). A discussion paper, presented to Council, pointed to other means of support for artists, and recommended concentration on '... rebuilding the most important collection of contemporary Irish art in the country' (Patrick T.

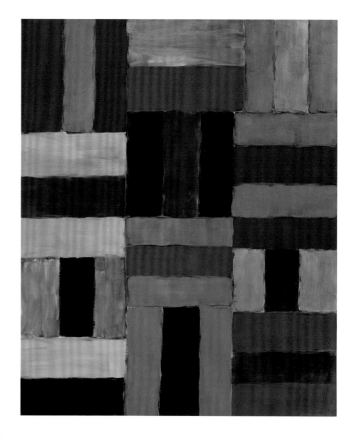

Murphy, discussion paper, 8 October 1984, AC/ACE file 6150/1977/1). The committee called for gaps in the existing collection to be identified, and allowed for the commissioning of new work (Minutes, 4 March 1983, AC/ACE file 6150/1977/1). In 1990 the Arts Council ceded responsibility for a national collection to IMMA which was scheduled to open within the year (AC/ACE file 6150/1989/1), and support for artists became the primary collecting aim (AC/ACE press statement, 25 January 2007). The Council identified those needing support differently from time to time, but the focus has generally been on younger artists or artists working in fields such as new media and performance, which are less easily marketed. As other effective ways of supporting artists were put in place, the role of the collection has been questioned, since although 80 per cent of it is on loan to public offices, schools and other institutions, it is not generally known or recognized. A part-time manager was appointed in 1987 but this post does not allow for proactive programming or publication. 'As the national agency for the arts, the Council's responsibility for its collection and the need for it to set high standards of care cannot be overestimated. Despite the Council's long tradition as a collector, systems of curating have not kept pace.' (Mebh Ruane, February 1983, AC/ACE file 6150/1977/1) Since the mid-1990s, consultant curators have been brought in but the deficit in proactive curatorship of this unique collection remains. De-acquisition has been considered many times, especially since the ACNI, following the joint report in 1999, has taken that route. Since 1995 the Arts Council has not had a fixed budget for collection, and there is no comprehensive publicly available catalogue of it.

For the greater part of the twentieth century, the collections of the Arts Councils, both north and south, were the only publicly funded collections of contemporary art in Ireland with a national remit, although both were easily outpaced by the end of the century by IMMA and the UM, while the municipal collections in Cork and Dublin, especially following the allocation of regular purchasing budgets, were also growing apace. Each had different strengths: the HL with its outstanding collection of work from the early years, the Councils in mid-century, the UM's more cosmopolitan collection of art from the 1950s and '60s, and IMMA with its collection ranging from the very contemporary back to the 1940s. However, the history of Irish art would be greatly diminished without the small but highly focused collections of some local authorities.

Collecting around the country happened in a fairly haphazard way, spurred on by private citizens who brought pressure to bear on their local authorities. The oldest public art collection in the country is the Cork Municipal Collection, housed in the Crawford Art Gallery. An offshoot of the Crawford School of Art, the collection has been growing since the early nineteenth century when it was the custom to acquire work by the leading students in the college. During the twentieth century, aided by donations such as the Gibson Bequest, the Crawford has been able to continue building a representative collection of Irish art, including good examples of all the major developments. In 2005 the Gallery was given 'national collection status' to make it eligible for donations in lieu of taxation, and in 2009 the government announced plans to amalgamate the Crawford with the NGI although these were later set aside.

The Waterford Municipal Collection emerged in the 1930s, built up through the energy and enthusiasm of local artists and patrons, with occasional grants from the local authority and the Waterford Vocational Educational Committee [413]. The Kilkenny Art Gallery collection was privately begun by a similar local group, which also agitated successfully for the establishment of the Butler Gallery, where it is housed. Other collections, developed in response to private donations, in counties such as Limerick, Louth and Meath, are now supported by their local authorities. By far the most significant of these, the Niland Collection in Sligo, began on a tiny scale in the late 1940s and includes important works by Jack B. Yeats (qv) who had spent his boyhood in the town. The collection, now widened to include art with a connection to the area, is called after Nora Niland, a local librarian who, with a group of like-minded residents, strategically lobbied, raised funds and judiciously used the Arts Council Joint Purchase Scheme to set it up. In Northern Ireland, the collections of Armagh and Fermanagh county museums have good collections of artwork by mainly local artists, including such local celebrities as Sir John Lavery, George Russell, Paul Henry and William Scott (qqv). They were joined in 2009 by the F.E. McWilliam Gallery and Studio, in the artist's native town, Banbridge, which has a considerable collection of his work.

While the main bulk of material in these collections is Irish or by artists working in Ireland, almost all accept donations of non-Irish work, while the Cork, Limerick and Kilkenny collections actively seek the work of international artists as their resources and opportunities permit. A noticeable breakthrough,

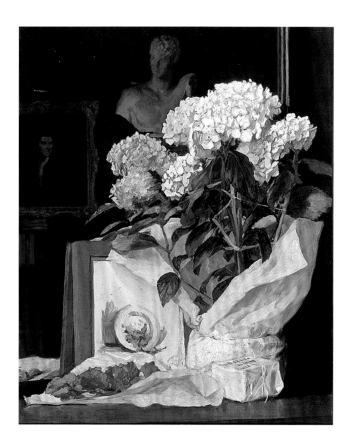

413. Dermod O'Brien, *My Birthday Presents,* 1923, oil on canvas, 51 x 39 cm, Waterford Municipal Art Collection

especially in the course of the last decade, is the number of local authority collections that are now emerging in almost every county in the country. Public art schemes developing from the Per Cent for Art Scheme, initiated in 1989, have been a significant spur for this activity (see 'Public Art'). Some galleries, notably the Butler Gallery, the Model and Niland Gallery, Limerick City Gallery and the Glucksman Gallery in Cork have been brought into the Heritage Council's Museum Standards Programme in recent years. Their policy statements, publications, exhibition programmes and storage facilities are now equivalent to good international practice. All have been assisted by the Arts Council, both to collect, via the Joint Purchase Scheme, and to function as they do.

Some hospitals, universities and colleges have also built up significant collections of contemporary art, most of it Irish. The process was initiated by TCD which already had an interesting historic collection. Its contemporary collection of national and international art is largely a result of the vision of George Dawson, founding Professor of Genetics in the 1960s. Similar collections are being developed in University College Dublin, and the University of Limerick (UL). The UL's National Self-Portrait Collection (NSPC) grew out of the purchase of a small private collection of artists' self-portraits which the university has continued to develop. Although uneven in quality, this collection boasts some highly imaginative representations of the self by artists in all media. Art collecting in hospitals is seen at its best in the collection of the Waterford Healing Arts Trust, which not only buys, but also commissions, artwork for the Waterford Regional Hospital. Following its example, arts' officers have

been appointed to a number of other hospitals that have growing collections. Despite other financial pressures, several of these organizations have published catalogues and designated curators.

The century has seen a growth in the number, size and prestige of public collections, both national and local. This has been accompanied by increasing professionalism in their care and management, especially since the introduction of the Museums

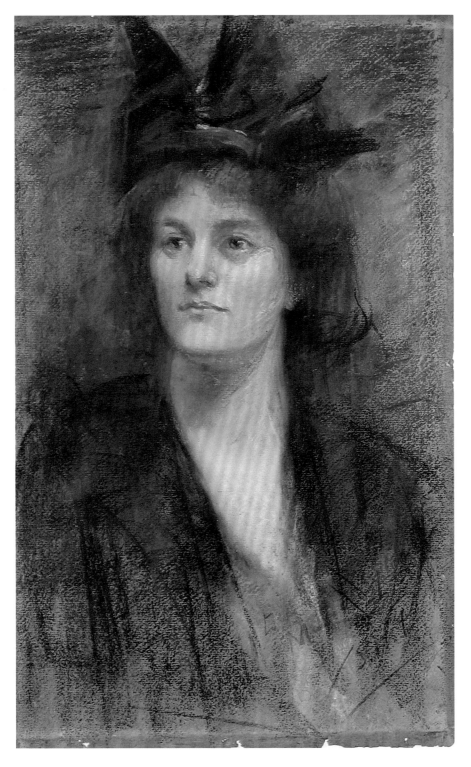

414. Sarah Purser, *Miss Maud Gonne*, 1898, pastel on paper, 43 × 27 cm, Dublin City Gallery The Hugh Lane

Registration and Accreditation Scheme by the Heritage Council during the 1990s. Visitor numbers and the number of interactive education programmes have also grown exponentially. However, without the vision and generosity of private individuals such as Hugh Lane, George Dawson, Norah Niland, Gordon Lambert and others, the story of Irish art collecting would be a very different one. CATHERINE MARSHALL

SELECTED READING Potterton, 1981; S.B. Kennedy, 1982; S.B. Kennedy, 1991; Mayes and Murphy, 1993; Turpin and de Chenu, 1995; T. Murphy, 2001; Y. Scott, 2005; O'Molloy, 2005; Hodge, 2007; Somerville-Large, 2008.

PURSER, SARAH (1848–1943) (qv *AAI* II), painter, illustrator and designer of stained glass. Ireland's first really successful woman portrait painter, Sarah Purser could, with equal accuracy, be regarded as the first woman activist in Irish art, in which role, during the twentieth century, she was matched only by the collector Hugh Lane (see 'Women and the Visual Arts').

Following the conventional childhood and education befitting the daughter of a wealthy businessman in the nineteenth century, Purser attended the DMSA and later the Académie Julien in Paris (1878/79). Her brief six months in Paris was enough to introduce her to Berthe Morisot, who became a friend, and to the paintings of the Impressionists, whose influence is evident in her work. When her father's business failed in 1873, Purser decided to make a living from painting. Although she was drawn to landscape and 'figure pictures', she focused on portraiture (qv) as the most lucrative genre, and completed a considerable number of highly prized portraits of such well-known figures in Irish life as Maud Gonne [414], Roger Casement, Sir Samuel Ferguson (RIA collection), John Kells Ingram (RIA collection) and a number of her siblings and cousins, several of whom occupied high positions in academic and public life. Her pastel portrait of Maud Gonne is one of her finest interpretations of a strong character, somewhat similar to her own. Her biographer John O'Grady noted that: 'By the 1880s she was Ireland's most popular artist in that field and over the next fifteen years her commissioned portraits at annual RHA exhibitions outnumbered those of every rival.' (O'Grady, 2006, n.p.). She was elected to full membership of the RHA (qv) in 1924, becoming the first woman to receive this honour.

Having proven her worth as a portraitist, Purser, like George Russell (qv), Lady Gregory, Edward Martyn and W.B. Yeats, turned her considerable resources to promoting the idea of an Irish school of visual art. This led her to organize a retrospective exhibition of the work of John Butler Yeats and Nathaniel Hone in 1901, which attracted Hugh Lane, then visiting Dublin, to become involved in promoting Irish art. Purser speedily became one of Lane's most energetic supporters in his struggle to secure a gallery for modern art in Dublin. Following Lane's death in 1915, Purser was a founding member of the FNCI, set up initially to lobby for the return to Ireland of the paintings Lane had left to the NGL, in his penultimate will (see 'Collecting Art'). Purser's portrait practice financed An Túr Gloine, which she set up in 1903, at the request of Edward Martyn, to train Irish artists in the making of stained glass

(qv). Among her most accomplished recruits were Wilhelmina Geddes, Evie Hone (qqv), Michael Healy and Catherine O'Brien, while a further achievement was to lure A.E. Child, later a teacher of Harry Clarke (qv), from England to be its manager. She directed An Túr Gloine herself, retiring only in 1940 when she was ninety-two.

In 1910 Purser was a founding member of the Irish Artists Guild, just as she had earlier been a founder of the Dublin Art Club in 1886, and a member of the organizing committee of the first *Oireachtas Art Exhibition* in 1906. A final act of philanthropy was her joint endowment, with her cousin Sir John Purser Griffith, of the Purser Griffith scholarship to enable students of history of art in UCD and TCD to travel abroad.

William Orpen (qv) attributed his interest in Irish art to her (Bruce Arnold, *Orpen: Mirror to an Age*, London 1981, p. 36) and both Mary Swanzy and Jack B. Yeats (qqv) painted portraits of her (HL and LCGA collections).

Purser showed at the RHA regularly throughout her life and had work shown at the RA and the Grosvenor Gallery in London, the Walker Art Gallery in Liverpool, and the Galeries Barbazanges in Paris. She participated in Hugh Lane's *Exhibition of the Work of Irish Painters* at the Guildhall, London, in 1904 and four years later was included in the Irish artists' section in the exhibition of Franco-British art, London. In 1923 a retrospective exhibition of her work was held at the Institution of Civil Engineers of Ireland, Dawson Street, Dublin.

Purser's soirées, held on the second Tuesday of every month at her Mespil Road house, were nearly as important in the promotion of Irish art as her direct involvement. They provided a meeting point for artists, writers, academics, politicians and potential patrons, attended as they were by such colourful and influential figures as the Yeats brothers, George Bernard Shaw, Maud Gonne and G.K. Chesterton. The playwright Lennox Robinson described her Mespil soirées as 'the Mecca of every distinguished visitor to Dublin' (Brennan-Holohan, p. 35).

Paintings by Sarah Purser can be found in the collections of the NGI, HL, UM, TCD and RIA, while there are examples of her stained-glass work in St Brendan's Cathedral, Loughrea, and St Columba's College, Dublin. CATHERINE MARSHALL

SELECTED READING Mary Brennan-Holohan, *A Portrait of Sarah Purser* (Dublin 1996); John O'Grady, *The Life and Work of Sarah Purser* (Dublin 1996); John O'Grady, 'A Collection of Works by Sarah H. Purser HRHA (1848–1943)', in *The Sarah Purser Sale*, sale catalogue, Adam's (Dublin 2006).

PYE, PATRICK (b. 1929) [415], painter, stained-glass artist and printmaker. Patrick Pye has pursued a highly creative but increasingly isolated course in Irish art. Although he was born in Winchester, Hampshire, Pye came to Ireland with his mother when he was three years old. He attended St Columba's College, Rathfarnham, where he was taught by the sculptor Oisín Kelly (qv *AAI* III), and NCA (1950–53). In 1957 he was awarded the Mainie Jellett Scholarship which enabled him to study the art of stained glass (qv) with Albert Troost in Holland. Exposed to a strong evangelical Protestant tradition, he converted to Roman Catholicism in his early thirties,

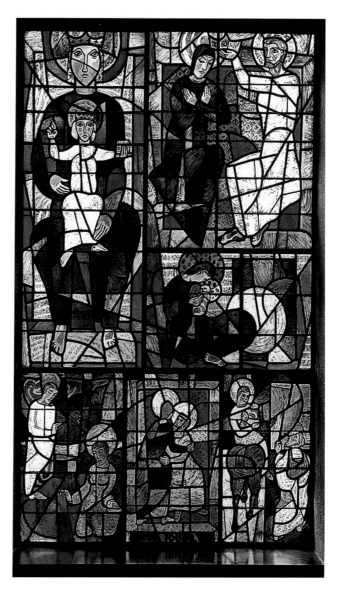

415. Patrick Pye, *Life of Mary Window*, 1961, leaded stained-glass window, Convent of Mercy Chapel, Cookstown, Co. Tyrone

becoming one of the most dedicated painters of religious subjects in the country since the 1950s, and an automatic choice for ecclesiastical commissions.

Pye's most important patron (see 'Patronage and Awards') has been the Roman Catholic Church, either directly through commissions for altarpieces, stations of the cross, wall hangings and stained glass, or indirectly through opportunities to create prints and illustrations for religious publications such as the *Capuchin Annual*. Romanesque and Catalan sculptures, in their use of gesture and non-rational space, and the elongated, stylized figuration of El Greco and Pontormo are important influences in his work. Pye works intuitively, painting in tempera, which enables him to build his colours in glazes and avoid naturalism, and in oil, on both linen and copper. 'With oil on copper, the copper forces me into a richer palette, a stronger tone and colour' (McAvera, 73). Although sacred themes dominate his work, Pye has also painted mannered still lifes and landscapes (qv) which, like earlier English visionaries William Blake and Samuel Palmer, he sees as extensions of the sacred.

Pye is highly polemical and has produced a number of publications: *Has Art Any Meaning?* (1962), *Apples and Angels* (1980) and *The Time Gatherer: El Greco and the Sacred Theme* (1991).

The RHA (qv) exhibited *Triptychs and Icons*, a retrospective of his work, in 1997, and in 2005 Pye received an honorary doctorate from the NUI Maynooth. A member of the Graphic Studio Dublin, the RHA and Aosdána (qv), his work can be seen in churches throughout Ireland: Glenstal Abbey, Co. Limerick; Church of the Resurrection, Belfast; the North Cathedral, Cork; Our Lady of Lourdes Church, Drogheda; Fossa Chapel, Killarney; and St Brendan's Cathedral, Loughrea. Other religious establishments that include his work are the Convent of Mercy, Cookstown, Co. Tyrone; St Michael's School, Ailesbury Road, Dublin; and St Mary's Oratory at NUI Maynooth. The collections of the NGI, CAG and the Centre of Catholic Studies, University of St Thomas in Saint Paul, Minnesota, also have examples of his artwork. CATHERINE MARSHALL

SELECTED READING Knowles, 1982; Brian McAvera, 'Vocation and Vision', *IAR* (Spring 2009), 68–75.

QUINN, BILLY (b. 1954), conceptual artist. Born in Dublin, Billy Quinn's practice embraces painting, photography,

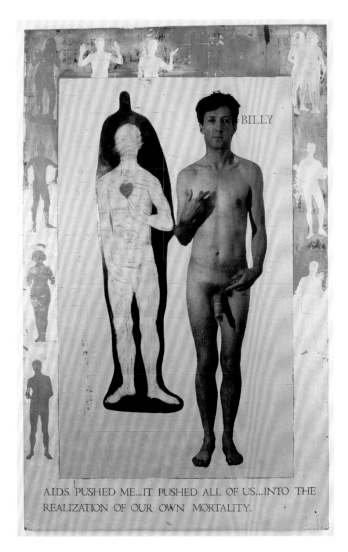

416. Billy Quinn, *Billy*, 1991, laser prints, gold and silver, acrylic on wood, 244 x 152 cm, Irish Museum of Modern Art

installation (qqv) and performance (see 'Time-based Art'). The work is informed by his Catholic upbringing in Ireland, his experience of child abuse, and his homosexuality. It is also influenced by his extensive reading of philosophy and literature. He attended NCAD but moved to Liverpool and London where he completed his formal art education. He became an activist in the AIDS Awareness campaigns of the 1980s and 1990s, and in March 1987 was a founder member of Act-Up, a New York-based organization dedicated to combating the AIDS crisis. One important outcome of this period was the 'Icon' series of artworks [416], comprising large-scale portraits of friends, some of whom were HIV positive, each one naked but accompanied by an attribute of their choice. Photographic images were blown up to life size, and mounted in gold, then framed in silver leaf, to resemble saints in Renaissance altarpieces (see 'The Body'). The sexual explicitness of Quinn's 'Icons', combined with their inherent critique of Catholic hero imagery, made them unique in Irish art. As Alyce Mahon has argued, this work is not in any way parochial (Mahon, p. 241).

In 1995 Quinn came back to Ireland to take up a residency at IMMA, returning to London some years later, where he completed the first doctoral degree in Fine Arts Practice at the University of East London. Quinn is one of those Irish artists whose vision has never been limited by the constraints of life on a small island. From bases in New York, London, Berlin and Amsterdam, his art encompasses artistic, political and religious events in locations as diverse as Iran, China, Ireland and Italy. He makes work digitally also, disseminating it through the internet, using this medium to comment on outmoded traditions of art-making, elitism and privilege in the art world.

While his work has been primarily concerned to expose the suffering caused by sexual abuse and discrimination, particularly by institutions and fundamentalist religions, he is also inspired by Marcel Duchamp, whose irreverence in relation to the icons of art history parallels his own satirical gaze. This is particularly evident in his digital work made under the pseudonyms Doublevelvet, Bottom-Feeder, and others, and published on the internet site Flickr. His socially engaged art practice draws on an extensive knowledge of art history, literature and philosophy to provide the conceptual underpinnings of his work. His refusal to copyright his work on Flickr, as much as its content, expresses his disdain for the traditional connections between art-collecting, power and social exclusion.

Quinn has taught at NCAD and DLIADT and has shown his work in solo exhibitions in Temple Bar Gallery and Studios, IMMA, and in group exhibitions in Ireland, Britain, Finland, USA and Canada. It is included in the collection of IMMA. CATHERINE MARSHALL

SELECTED READING Robert Baker, *The Art of Aids: From Stigma to Conscience* (New York 1995); Mahon, 2005; O'Molloy, 2005.

RÁKÓCZI, BASIL (1908–79) [417], painter, designer and illustrator. Along with his friend Kenneth Hall (qv), Basil Rákóczi was one of the founders of the White Stag Group (qv), established in London in 1935 and reconstituted in Ireland during World War II, when he and Hall, both pacifists and both half-Irish, relocated there to avoid conscription. The son of a Hungarian musician and an Irish mother, Rákóczi was born in Chelsea, London. His art education was a cosmopolitan one, divided between England (Worthing and Brighton) and France (Académie de la Grande Chaumière, Paris) and private study with the Russian sculptor Ossip Zadkine. An interest in psychology and Surrealism (qv) drew him to the Society for Creative Psychology, London, in 1935. The artwork inspired by this society was exhibited under the name, White Stag Group, and Rákóczi showed initially under the name Basil Beaumont, after his stepfather. Rákóczi travelled around Europe painting with Hall, exhibiting in London at the Lucy Wertheim Gallery and the RA in the late 1930s. He also exhibited with Hall at 8 Fitzroy Street.

Rákóczi came to Ireland in 1939, spending the war years near Delphi in Connemara, Achill and Dublin. Having established the Society for Creative Subjectivity in Dublin, he and Hall held up to ten exhibitions in Dublin between 1940 and 1946 under the banner of the White Stag Group. However, during this period Rákóczi exhibited also with the RHA, IELA (qqv), WCSI, DSC and held solo exhibitions of his landscape and flower pictures. His flamboyant personality enabled him to integrate easily into Irish avant-garde artistic and literary circles, and attracted attention to the new group, which was welcomed by the small band of Modernists (see 'Modernism') led by Mainie Jellett (qv). Their exhibitions, supported by the well-known English critic Herbert Read, and Herbrand Ingouville-Williams, did much to advance modern ideas in Dublin art circles. The lecture programme of the White Stag Group, to which Rákóczi contributed, also played an important role in the dissemination of new thinking about art in Ireland.

When the war ended, Rákóczi left Ireland for England, but settled in Paris in 1946, continuing to send pictures occasionally to the RHA, IELA, WCSI and DSC. He died in London. Rákóczi designed sets for the Gate Theatre and for dance events in Paris, as well as making prints and illustrating poetry and other writing, notably his own books, *The Painted Caravan* (1954) and *The Caged and the Free* (1955). The Galerie Arches et Toiles, Paris, presented an exhibition of his costume designs and theatrical sets in 1990. The Gorry Gallery in Dublin staged a retrospective exhibition of his work in 1996.

Rákóczi's work is included in collections in Australia, Britain, Israel, New Zealand and in Ireland in the UM, TCD, Butler Gallery and UL. A copy of *The Painted Caravan: A Penetration into the Secrets of the Tarot Cards*, with illustrations by the author, was presented to IMMA in 2006 by the FNCI.
CATHERINE MARSHALL

SELECTED READING Ingouville-Williams, 1945; S.B. Kennedy, *Basil Ivan Rákóczi (1908–1979): A Symbolist and Expressionist Painter with Irish Connections* (Dublin 1996); Kennedy and Arnold, 2005.

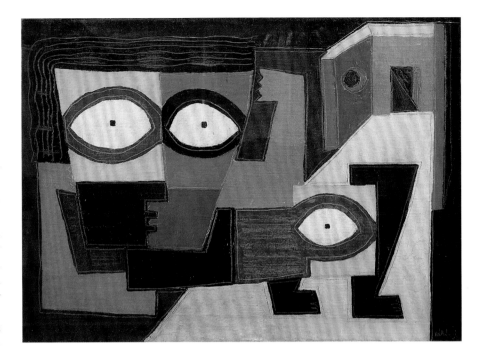

417. Basil Rákóczi, *The Prisoner*, 1944, oil on canvas, 52 x 73 cm, private collection

REALISM. 'For me realism is an attempt to capture appearance with all the sensations which that particular appearance has suggested to me' (Francis Bacon in Peppiatt, 379).

The term 'realism' in visual representation is generally used in two distinct ways: first, in the approach to subject matter, where it seeks to address the actualities of life; and second, the method or style of representation, where objects are rendered illusionistically. These two elements are not necessarily operated in tandem; a realistic appearance may be adopted to convince of the feasibility of an unlikely or impossible scene.

Realism as a movement emerged in nineteenth-century French art, presented as the impartial obervation of contemporaneous everyday life, particularly of those at the lower end of the social ladder. It mainly comprises genre scenes of peasants and the urban poor. Realism, in this case, was intended to challenge the formal idealism of academic art, and drew on the example of earlier Dutch and Flemish imagery. Consequently, Realism as an art-historical term, relating to a particular period and method, is rarely applied to images of the privileged in society, perhaps because their lives were seen as exceptional rather than the norm. Therefore, the term 'realism' is usually used in relation to the population at large. Similarly, realism tends to be associated with scenes of hard work, privation, dissolution or tragedy. Realism was usually adopted either to make a moral point, to elicit sympathy, to challenge inequities in society, or to entertain the viewer.

The second meaning of realism refers to mimetic techniques of representation, involving the impression of objectively recording the appearance of things, in a way that was popularly associated with photography before the advent of digital enhancement. It is paradoxical that such methods in painting are necessarily *illusionistic*, a term that is generally understood as the opposite of *reality*. At its extreme, realist techniques in

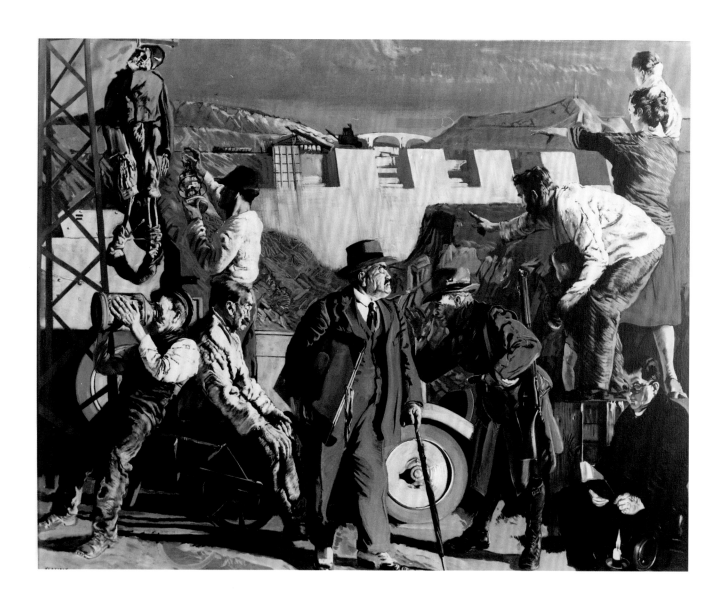

painting are referred to as *trompe l'oeil* (deceives the eye). The motivation of realism as a technique, however, is the depiction of the actual *appearance* of the world. While contradictory in some respects, the common denominator between these two ideas of realism, in content and in style, is the objectivity of observation that it implies.

The phrase 'academic realism' refers to the technical training in academies of art devoted to methods of illusionistic representation to a specified standard. Artists were typically taught an understanding of anatomy, and skills of drawing directly from the posed figure, in order to convincingly represent the human body. However, with physical perfection as the ideal, the chosen exemplars were drawn from classical sculpture, and classicizing painting from the High Renaissance to the Neoclassical. Thus, while naturalism was projected as an aim, the idealized figure was the accepted standard.

Seán Keating (qv), who became a professor of painting at the Dublin Metropolitan School of Art, and eventually president of the Royal Hibernian Academy (qv), provides a significant example of academic realism in the Irish context. While his convictions

changed over time, he was consistent in his devotion to academic standards. Keating's brand of realism relates both to certain of the themes he adopted, which included groups of men, from rebels to fishermen awaiting action beside the tools of their particular calling, and also to the individualized characters in his many studies, as well as in allegorical works like *Night's Candles are Burnt Out* [418]. Some of his figures border on the stereotypes of caricature, which in turn is recognized as a type of realism in its identification of common or typical features, albeit generally exaggerated and humorous. Early work by Jack B. Yeats (qv) is associated with both caricature and realism in such terms. *The Circus Dwarf* (1913) is a relevant example of Yeats's frank and sympathetic interpretation of the peripatetic outsider in society.

Aspects of Keating's work have been associated with Social Realism, in their recognition of the economic realities of Ireland in the 1930s and '40s. *Economic Pressure* (1949) [134], for example, depicts the painful partings endured by family members where economic necessity forced the separation of emigration. Such a representation contrasts substantially with the more nationalistic renderings of typical, local activity in the hands of

Paul Henry, Jack Yeats, and Charles Lamb (qqv). Keating's alleged sympathies with the politics of the (then) USSR has prompted his connection with Socialist Realism which, in turn, depended superficially on so-called academic realism. Maurice MacGonigal's stirring image of *Dockers* [283] could also be related to Social Realism, while Harry Kernoff in Dublin and John Luke (qqv) in Belfast dealt with urban hardship in less emotive ways (see 'Politics in Irish Art').

A student of Keating, Carey Clarke (qv), joined the staff of NCA just before the protests of 1968 introduced radical changes that all but obliterated traditional methods and values. He remained as an isolated torchbearer, producing works of meticulous and faithful detail. Clarke is significant for communicating to generations of younger artists academic techniques that were exploited to question the very traditions from which they came. Geraldine O'Neill paraphrases Old Master still lifes as she conscripts the paraphernalia of domesticity and parenthood to explore issues of mortality and obsolescence at the turn of the millennium. Sheila Pomeroy, Stephen Loughman and Margaret Corcoran have similarly exploited their technical facility and draughtmanship as a means rather than an end.

It is difficult to conceive of any cultural artefact that is entirely, objectively, realistic because perspectives may differ and choices are invariably involved. It is tempting to view Paul Henry's work as realist, and the locations of many of his scenes have been identified from his topography. This is evident from S.B. Kennedy's exhaustive research which has identified the locations of many of the depicted scenes (Kennedy, *Paul Henry: Paintings, Drawings, Illustrations*, New Haven and London 2007. However, as an anthropological representation of Ireland in the first half of the twentieth century, his imagery is highly selective, with crucial dimensions avoided or eliminated. For example, with only one exception found by this author, none of the cottages depicted is devoid of its thatched roof, a situation divergent from the reality of abandoned, decaying homesteads that dotted the countryside of the rural west. As Fintan O'Toole has argued, 'the notion of the peasant and of the country which the peasant embodied was not a reflection of Irish reality but an artificial literary creation, largely made in Dublin, for Dubliners' (O'Toole, 'Going West: The Country versus the City in Irish Writing', *The Crane Bag*, IX, no. 2, 1985, 111–16).

Realism of technique was a defining characteristic of Surrealist art (qv). Illustionistic means made objects and juxtapositions that are literally impossible seem believable, but with a psychologically charged, dream-like quality. In Ireland, Colin Middleton was arguably the leading exponent, while Patrick Hennessy (qqv) produced notable examples. Although the devotion to Surrealism was selective – as tends to be the case generally with Irish adherents of Modernism (see 'Modernism and Postmodernism') – categorization has tended to depend on the appearance of the work more than anything else. Middleton's *Bon Voyage* (1974) [301] suggests the genre of magic realism in representing the fantastical within a convincingly natural context. Supported by his reading of the writings of Carl G. Jung, Middleton made liberal use of archetypal symbols as bridges between the conscious

419. Patrick Hennessy, *The Studio Cat*, 1978, oil on canvas, 63 x 88 cm, Arts Council/An Chomhairle Ealaíon

and unconscious mind, and between the respective faculties of reason and instinct (Catherine Marshall, 'Colin Middleton', in O'Molloy, 2005, p. 124). Thus, what is represented as unreal in literal terms arguably relates to a deeper, psychological reality.

While Hennessy's work tends towards a more naturalistic approach, his obsessive detail is a common feature of realist painting [419]. Ironically, since this strategy runs counter to the mechanics of optics – where, for example, peripheral vision is, in fact, less sharp than the area of direct focus – the effect of giving equal clarity to all elements across the spectrum of the canvas can be consequently disconcerting. This explains Hennessy's occasional categorization as a Surrealist.

Francis Bacon's independent methods originated in Surrealism, reflected *inter alia* in an interest in the creative possibilities of the subconscious, and his work reflects psychological conditions drawing on his own experience and his reading on the subject. Bacon was an admirer of Vincent van Gogh, and his prodigious collection of books included the collected letters to Vincent's brother, Theo. Bacon paraphrased the artist in an interview, while referring to his own practice: ' "What I do may be a lie," he said, "but it conveys reality more accurately." That's a very complex thing. After all, it's not the so-called "realist" painters who manage to convey reality best' (Peppiatt, xx).

Bacon's exploration of the reality of the human condition focuses on the body as receptacle, conduit and communicator of a dark, often tortured, physical and psychological range, and portraiture is consequently central to his practice. Portraiture (qv) is among the most realist of genres, in the sense that it purports to convey a likeness at some level of a living person. Patrick Tuohy, Edward Maguire, Carey Clarke, Robert Ballagh and James Hanley (qqv) are among those working in a visually realist idiom across the century. Ballagh's examples are of particular interest to the subject of realism for their incorporation of relevant objects – such as a heap of actual stones apparently extending from the fictive ones in his portrait of Noel Browne (1985) [389], and the inclusion of a voice recording as part of the portrait of mezzo-soprano Bernadette Greevy (1978, IMMA, Gordon Lambert Trust).

420. Dermot Seymour, *The Russians will water their horses on the Shores of Lough Neagh*, 1984, oil on board, 77 x 107 cm, private collection

Pop artists (see 'Pop Art'), like Ballagh, challenged the status of high art through an exploration of the ethics and aesthetics of consumerism and celebrity, using realist methods in keeping with the genre. He liberally quoted from the pantheon of art history, using illusionistic, poster-like methods in the rendering of great master works, thereby subtly undermining the notions of originality and singularity. In painting a 'copy', Ballagh references Plato's opposition to art, and its role as copyist of nature. Nature, as the true original in Plato's philosophy, is the ultimate reality, whereas art, in its mimetic role, is no more than a copy and therefore false and suspect. The more convincing the illusion, the greater the travesty, and the more extensive the departure from true realism (Plato, *The Republic*, Book x, 601b). Ballagh places himself at a yet further remove in painting a copy of a painting. However, in challenging high art, the epitome of Plato's 'imitator', he deals with a contemporary reality which gives value to the commercial object and mass production. One of Ballagh's best-known works of the interior of his home paraphrases Richard Hamilton's iconic challenge to consumer society, *Just what is it that makes today's homes so different, so appealing?* (1956, Kunsthalle Tübingen collection).

Like Ballagh, Micheal Farrell (qv) borrowed from art history to make political points and his most celebrated work proclaims itself – appropriately for this discussion – *Madonna Irlanda or the Very First Real Irish Political Picture* (1977) [377]. He appropriates from François Boucher's famous painting of a courtesan of Irish descent to propose that belief in the hallowed tenet of Ireland as independent in any real sense was as much a matter of blind faith as her image of sanctity.

421. Brian Maguire, *Divis Flats*, 1986, acrylic on canvas, 180.4 x 124.5 cm, Irish Museum of Modern Art

Evidently then, realist strategies are fundamental to Postmodernism, and many artists demonstrate their technical skill with mimesis as a language for exploring the experience of contemporary life, including, in various ways, Martin Gale, Dermot Seymour (qqv) [420] and Mark O'Kelly. By contrast, Michael Kane, Patrick Graham, Brian Maguire [421] and Patrick Hall (qqv) adopted a looser, Neo-Expressionist idiom as a means of examining abstract inner realities.

The advent of photography (qv) in the nineteenth century was a catalyst for the release of painting from the constraints of illusionism, enabling artists to experiment with Modernist methods of expression. Contemporary artists, however, now respond to the opportunities and challenges of digital technology and the range of issues presented by the lens, from the distorting layers of media interjected between the viewer and the object, to concerns about surveillance and interrogation as a means of eliciting 'truth'. Willie Doherty (qv) and Paul Seawright are among those at the forefront of such investigations, particularly in relation to the political realities in conflict zones, while Tom Molloy (qqv) has emulated the relentless seriality, and inhumanity of 'mugshot' photographs in his intentionally disconcerting, obsessive drawings. By such means, the notion that 'the camera cannot lie' has been decisively displaced by recognition of its capacity to mislead through distortion, selectivity and digital 'enhancement'. Artists exploit illusionism to paraphrase the characteristics of the lens-based image, with its pixelation and 'blur', while digital imagery has been instrumental in the conception and realization of a visual culture more interested in debunking than in emulating an illusion of reality. YVONNE SCOTT

SELECTED READING Michael Peppiatt, 'Francis Bacon: Reality Conveyed by a Lie', *Art International*, 1987; S.B. Kennedy, 1991; Steward, 1998.

REGIONAL DEVELOPMENTS (see 'Arts Councils'). The first half of the twentieth century was characterized by poor levels of provision for the visual arts outside of Dublin. Access to exhibitions and collections featuring established artists was limited to a number of key venues in cities, such as the Crawford Art Gallery, Cork, Limerick City Gallery and, in Northern Ireland, the Ulster Museum, Belfast. Policies to promote greater access were effectively non-existent, although, in the 1940s, the Minister for Finance, Seán MacEntee, had raised the need for dedicated buildings for the provision of cultural activities, modelling a programme on the library network. MacEntee favoured the establishment of village halls as part of his scheme, giving statutory powers to local parish councils. His idealistic proposal, presented in a memorandum to the government was, however, rejected. The Department of Finance advised that if every parish pleaded for its own village hall, the financial implications for the government might be 'horrendous' (Kennedy, p. 39).

While arts policy at regional level was not always a priority, arts activities around the country were developed with increasing momentum following the establishment of the Arts Council (AC/ACE) in 1951. Since then, partnership structures between the state, local government and local communities with regard to the visual arts have evolved as a jigsaw of positions and strategies. These involved the provision of new venues and facilities for the visual arts and the creation of regional centres. In rural halls and award-winning arts centres, and through activities ranging from the expansion of touring exhibitions and fund-raising to the growth of arts organizations and the professionalization of the sector, attempts have been made to balance the relationship between centre and periphery.

This essay seeks to explore this development and the extent to which a sustainable partnership had been established on an all-island basis by the year 2000. It also questions issues from equality of access to recognition and reward for regional activities. It looks at such factors for change as examining infrastructural deficit in arts venues, regional access to touring exhibitions, the professionalization of the arts sector, the availability of sustainable funding, and collaboration between arts organizations, local authorities and communities.

The first director of the Arts Council, Patrick J. Little, was in favour of regional institutions, proposing arts centres in Cork, Limerick, Galway and Waterford in the early 1950s. His proposed programme for cultural development was shelved in favour of further support for festivals. Recognition of the need for appropriate and accessible space for the visual arts throughout the country was acknowledged in the AC/ACE annual report of 1953/54:

> There is no field of culture where the need and scope for developing public interest is so great as in the visual arts As in the case of music and drama in the past, this interest is only just awakening and asserting itself against an attitude of indifference ... [there] is a great need here of a realisation of the value to the Nation of our galleries, public monuments and institutions.

The Council, at this early stage, was clearly aware of what was required: 'There remains the very serious need of proper premises for exhibition and other cultural purposes, and throughout the country the need for properly maintained halls is fairly widespread.' (AC/ACE Annual Report of 1953/54) The expressed desire for a regional development programme targeting the visual arts did not, in fact, lead to any material results during this period.

Local festivals often acted as catalysts for the provision of a more physical and infrastructural presence for the visual arts locally and regionally. Arts centres followed, as did more consistent touring programmes. From the mid-1980s arts officers were supported by their local authorities and nationally by the Arts Council and later by the Irish Museum of Modern Art's (IMMA) National Programme. While the Arts Council has been a leading shaper of policies aimed at a broad and balanced provision of the arts throughout the country, before the 1970s the main driving force for change came from the impetus and energy of the regions themselves, predominantly through arts festivals. During the late 1960s and 1970s, a groundswell of interest among committed individuals led to the promotion of active participation and an increase in public awareness of the

422. Wexford Arts Centre with *Big Drawing 9* and *Big Drawing 6* by Gerda Teljeur and ceramics by Jane Jermyn, 2007

visual arts on a local level. Successful early arts festivals included those of Kilkenny (1974), Galway (1976) and Clifden (1977). The visual arts were represented to varying degrees in these multi art-form gatherings.

This work, often through organic, community-based projects and festivals, coupled with the potential witnessed by the establishment of the Project Arts Centre in Dublin (1967) allowed for the demonstration and articulation of new and exciting models of participation. Arising from a three-week arts festival at the Gate Theatre, Dublin, the Project Arts Centre presented a model venue where art forms and artists could interact, where the local public could enjoy access and engage actively, and where flexibility and dynamism would be the key to success.

Involvement in the late 1960s with the Project Arts Centre encouraged Paul Funge to establish an arts centre in his hometown of Gorey, Co. Wexford. Like its prototype, the Gorey Arts Centre was initially established as a temporary, multidisciplinary arts festival in Funge's own garden in 1968. When at Gorey's ninth annual season, Michael Scott, then a member of the Arts Council, launched an exhibition of work by Charles Harper (qv) and a selection of prints on loan from the Dutch government. Scott lamented the lack of support nationally for the visual arts and called for the establishment of more local centres where works from the extensive stores of the National Gallery (NGI) could be displayed. The Gorey Arts Centre was soon followed by the foundation of the Wexford Arts Centre [422] and Siamsa Tíre Teo, Tralee, both opening in 1974. While Siamsa focused on dance, introducing the visual arts to its programme in 1991 with a dedicated gallery space in its new purpose-built building, the gallery provided the main impetus for the Wexford Arts Centre, which also incorporated a theatre.

Influenced by the successful Wexford Opera Festival begun in 1961, the NGI director James White had suggested that if the assembly rooms of the Wexford Town Hall were made available, he would consider lending works from the gallery occasionally for exhibition. A proposal and architectural plans for an arts centre, arising from this, were submitted to the Arts Council centred

on the exhibition space and the requirements of the NGI. Special attention was given to climate control and security (*Proposed Art Centre Report and Recommendations*, Niall Montgomery, 27 Merrion Square, Dublin, 13 June 1972). This proposal demonstrates the emergence of a new partnership approach to planning for the regions, involving key local and national actors. While material outcomes were slow to emerge, in 1977, encouraged by a forty per cent increase in funding from the Arts Council, the arts centre plan continued on an ambitious scale. By 1979 the Wexford Arts Centre (WAC) was seen by the Council as the 'only centre with adequate and secure premises, a factor which has made a considerable contribution to its success' (AC/ACE Annual Report, 1979). The presence of the centre allowed for programming with a focus on contemporary Irish art, as well as an ability to engage with key local issues. In 1979 *Irish Mythology in Contemporary Sculpture*, an AC/ACE exhibition which included artists such as John Behan, Oisín Kelly and James McKenna, was opened at the launch of WAC's fourth annual Tradisiún Festival. The closing of the festival saw a discussion on the implications of nuclear power in Ireland and a commissioned performance by artist Nigel Rolfe (qv) entitled *A Nuclear Ireland*.

In June 1978 the Arts Council approved a grant towards the renovation and programming of the Triskel Arts Centre in Cork under the direction of Pat McQuaid. In a challenging funding environment, and with no formalized infrastructural support policy for the regions, Triskel temporally closed in May 1979, citing inadequate support from Cork Corporation and the Arts Council. At this stage, only £20,000 of the Council's £2 million annual budget was allocated to arts centres in regional areas. Triskel received a mere £2,000 for 1979, while the Project in Dublin was granted £62,000.

Despite this difficult situation, a sample of Triskel's exhibitions for 1980 shows a commitment to producing a significant programme. Exhibitions of established artists, such as Cecil King, Ciarán Lennon and Patrick Pye (qqv), were shown, but Triskel did not shy away from more challenging art forms, such as performance art, including the artists Nigel Rolfe, Alastair MacLennan (qqv), Danny McCarthy and Margaret Gillan.

Festivals and arts centres developed a shared, synergetic relationship in the 1970s and '80s. The festivals provided an annual focus whereby innovative programming was to the fore, while the development of new centres allowed for greater access to a wider range of local and internationally established artists. A critical example of this evolving relationship between annual event and venue is EV+A, the Limerick exhibition of visual art, and the Limerick City Gallery. Since 1977 EV+A has become a major Irish platform for innovation and interaction between artists, a city topography and curation.

The Orchard Gallery in Derry opened in 1978 and, under the directorship of Declan McGonagle, adopted a challenging and controversial programme, especially given the political situation in Northern Ireland (see 'The Troubles and Irish Art'), quickly achieving international recognition far beyond any other visual arts' venues in the country. Programming included McGonagle's 1987 commission to Antony Gormley for *Sculpture for Derry Walls*, a three-part sculpture in three particular locations on the contested Derry Walls. In the same year McGonagle

became the first curator to receive a nomination for the Turner Prize. The Orchard Gallery's advanced programme prompted John Hutchinson to say that 'While peripheral to the Arts Centres of Belfast and Dublin it [the Orchard Gallery] is closest to the "advanced" thinking of London or New York.' (Hutchinson, 'Sense, Direction and Selected Images: Irish Art in the 1980s', *Circa*, March/April 1990, 34–35)

The arts infrastructure of Derry was further enhanced with the opening of the Context Gallery in 1992. Initiated by Hugh Mulholland, the gallery focused mainly on the promotion of emerging Northern Irish artists. Both galleries included established national and international artists in their exhibition programmes, which aimed to inspire the public and to encourage and influence younger Irish artists. For example, Terry Atkinson's 1983 exhibition may have influenced younger artists such as Willie Doherty (qv).

In 1975 the Butler Gallery, which grew out of the Kilkenny Art Gallery Society (1943), was finally accommodated in Kilkenny Castle. From its inception, the gallery developed a consistently strong and balanced programme of exhibitions. As well as showing such Irish artists as Sean Scully (1994) (qv) and Amelia Stein (1990), the gallery facilitated access to international artists, including M.C. Escher (1979), Richard Hamilton (1988), Antoni Tapies (1992), Bill Woodrow (1997) and Tony Cragg (2000).

By the early 1980s, the new and exciting regional models in Wexford, Cork, Derry and Kilkenny, and other emerging centres and galleries, seemed to be gaining ground. However, Paddy Woodworth raised a pertinent question regarding further development and sustainability in 1981:

> Why have arts centres sprung up and expanded until they consume a considerable portion of central and local government arts budgets? Are they getting too much money on the whims and fads of oddball minorities, or are they getting too little to do an important job properly? (Woodworth, 'Arts Centres – Poor Platforms for Political Antics', *Irish Press*, 28 April 1981)

In asking whether or not the model for collaboration across the disciplines had worked ('the exotic marriages between theatre, painting, film and music'), Woodworth suggested that after 'some exciting success and many pretentious failures, the actors have mainly returned to the theatres and the painters to the galleries'.

The manner in which these concerns were addressed by local authorities, the Arts Council and an emerging professional and decentralized arts sector is central to any analysis of development in infrastructure in the final decades of the century. Access to secure funding, the promotion of challenging programmes, and the need for appropriate venues for the visual arts have informed regional attempts to articulate a local discourse.

A building programme for the regions emerged in the 1980s. By 1986 the AC/ACE funded twenty-three buildings throughout Ireland, fifteen of which were outside the capital. Of these, four galleries, four theatres and seven multidisciplinary arts

centres were established. Two other arts centres had been set up but did not yet receive funding: Castleisland Arts Centre (1982) and the West Cork Arts Centre, Skibbereen (1985). The Arts Council stated that it was 'determined that every significant centre of population should have an arts centre. Such a facility in a town would represent the appropriate equivalent of other leisure resources, such as parks, forest walks, sports complexes or local libraries' (*Art Matters*, no. 2, September 1986). In looking to existing facilities, the Council appealed to the library service, in particular, to consider sharing facilities, especially in smaller towns. Where this took place, the role of curator was often undertaken by local librarians.

By the late 1980s, arts centres had been planned for Ballymun, Blanchardstown, Tallaght, Bray, Donegal, Monaghan, Westmeath and Galway. While the Dublin bias was at odds with the AC/ACE's proclaimed commitment to the regions, the Council justified it, declaring: 'it is perhaps time to consider the greater Dublin area as a densely populated region much in the need of a developed arts infrastructure independent of the established venues in the city centre'. As the building programme intensified throughout the 1980s and '90s, the vision of the AC/ACE and the Arts Council of Northern Ireland (ACNI) for regional access to the arts seemed to be materializing as Ireland witnessed a dramatic development of arts centres: Belltable, Limerick (1981), Waterford (1983), West Cork (1985), South Tipperary, Clonmel (1986), Garter Lane, Galway (1988), Sirius, Cobh, Co Cork (1988), Clotworthy, Antrim (1993), Letterkenny, Co. Donegal (1995), Tinahely Courthouse, Co. Wicklow (1996), Golden Thread Gallery, Belfast (1998), Mullingar, Co. Westmeath (1998), and Dunamaise, Portlaoise (1999) [423].

The rise of arts centres also saw a substantial increase in Arts Council funding. In 1980 it allocated €153,890 to arts centres with €7,500 of this allocated to the regional galleries

423. Adrian Munnelly, Director of the Arts Council/An Chomhairle Ealaíon, 1983–96

424. Terry O'Farrell working with older people in Kilnaboy, Co. Clare, 2008

(AC/ACE Annual Report, 1980). Twenty years later the Council allocated €4,233,931 to arts centres, with €604,688 of the total allocated to the regional galleries (AC/ACE Annual Report, 2000). This was supplemented in the 1990s by funding from the Arts and Culture Capital Enhancement Support Scheme, a complementary pool of money available to local and national government. In 2000 the Council gave €2.8 million to fifty-eight events and festivals throughout Ireland, providing an opportunity for people to experience the arts in cities, towns and rural communities from Earagail in Co. Donegal to Cape Clear in Co. Cork and from Iniscealtra [424] in Clare to Boyle in Roscommon, and assisted Counties Cavan, Kerry, Kildare, Limerick and Meath to develop visual arts strategy plans (2000).

During the last decades of the century, such funding resulted in a dramatic growth in the provision of space for the arts in the regions, albeit from a negligible base. Nonetheless, gallery space for the visual arts in the majority of arts centres was secondary to theatre provision and often not suitable for the desired display of artwork. The multidisciplinary approach of the original vision had somehow managed to physically sideline the visual arts.

Despite an expansive building programme, the regional centres continued to lack trained curatorial staff. The design and layout of the buildings often led to major obstacles in the facilitation of exhibitions because architects and planners sometimes failed to fully understand the basic requirements for a gallery space, resulting in 'galleries' in the corridor area towards the theatre. Curved walls, excessive glass, poor lighting, lack of storage, uneven access and unsuitable wall surfaces are common curatorial complaints within the network of arts centres. Furthermore, in many cases the director of the centre was employed only when the building was near completion and thus too late to remedy many of these mistakes.

The need for venues for touring exhibitions, the most direct and accessible promotion of the visual arts for much of the century, was the main incentive for the development of the centres. The Arts Council's first touring exhibition was of the Haverty Trust collection. Artist Thomas Haverty had left a substantial sum of money for the purchase of artwork by Irish artists for display throughout the country. In 1955 the Trust's secretary applied to the Council for a grant to assist an exhibition at the Municipal Gallery Dublin, which in turn led to the suggestion of an Arts Council touring exhibition. The exhibition was shown in the Christian Brothers School, Enniscorthy, Co. Wexford, and then travelled to twenty-one other towns throughout 1955/56, from Wexford to Donegal. It included many of the established artists of the time, such as Colin Middleton and Norah McGuinness (qqv). The Council took responsibility for the insurance, transport and art-handling. James White, then director of Dublin's Municipal Gallery, compiled the catalogue and was available to provide a lecture at each venue. The local community, in return, had to find a suitable space, handle publicity and invigilate the exhibition. The appointment of Oliver Dowling as the Council's organizer and exhibitions officer in 1967 signalled a further development in the promotion of regional access.

A collaborative project with the ACNI led to a series of retrospective solo exhibitions of artists such as John Luke, Louis le Brocquy, Patrick Scott and William Scott (qqv). These exhibitions were fully curated and supported by the two councils and ran biannually. The package now included curation and publication as well as transport, insurance, and art handling, and exhibitions toured to the larger venues such as the Crawford Art Gallery, Cork and Limerick City Gallery.

However the Arts Council did not confine itself to the promotion of established artists but proved a welcome support to younger artists through the Bursary and Schools exhibitions. From the early 1980s, the Bursary Show allowed for promotion of, and access to, younger emerging artists, such as Cecily Brennan, Samuel Walsh and Kathy Prendergast (qqv). These exhibitions travelled to such places as the Butler Gallery, Kilkenny; the Mayo Education Centre, Castlebar; the Belltable Arts Centre, Limerick; the Triskel Arts Centre, Cork; Tuam Art Gallery, Co. Galway; the De Valera Library, Ennis; South Tipperary County Museum, Clonmel; and the Basement Gallery, Dundalk.

Regional arts policies were further embedded in a clearly articulated national and local policy framework under the directorship of Colm Ó Briain, a co-founder of the Project Arts Centre, and visual arts officer Paula McCarthy and subsequently Patrick T. Murphy. The Council intensified its touring exhibition programme between 1980 and 1984, with such shows as *Out of the Shadows* (1980), *Drawing Towards* (1982), *Paint on the Wall*, *Patrick Collins* (1982) and *Tony O'Malley: Painter in Exile* (1984). Venues were encouraged to assume the role of curator and to initiate their own exhibitions. A number of important ventures, such as the touring scheme, the exhibition hire subsidy and the catalogue research scheme, were put in place. Each contributed significantly to the professionalization of the visual arts sector. The AC/ACE 1986 Annual Report noted that 'both the Transport and Hire-Subsidy schemes were utilised more than ever before during 1986 This was particularly welcome in a year when it was imperative to make the maximum use of limited resources.'

These programmes relieved the Arts Council staff of the burden of curating exhibitions, but also challenged the centres to develop their own curatorial expertize. The Council assisted further professionalization of the visual arts with a number of publications: *Handle with Care* by John Hunt (1991), *Organising an Exhibition* by Siobhán Barry (1991) and *A Guide to Visual Arts Venues in Ireland* by Sarah Finlay (1992). They were important tools for arts officers and regional centres.

As the 1980s progressed, a shift towards more direct funding to individual artists via assistance schemes moved the emphasis away from touring exhibitions. The touring exhibitions that continued during the late 1980s and into the 1990s were primarily the Schools shows. These exhibitions aimed to introduce the work of contemporary Irish artists to second-level students:

The exhibitions provide second-level students, who do not have ready access to exhibition venues, with an opportunity to experience and interact with original, high-quality work by contemporary visual artists and architects ... each exhibition is designed so that it can be shown with ease in virtually any space. It is accompanied by a comprehensive

catalogue to aid the teaching staff. (Dermot McLaughlin, 'Introduction', *A Room of One's Own*, AC/ACE and the architects, Kinsale 2000)

The initial exhibition in 1986 invited twenty artists, including Michael Cullen, Eithne Jordan and Patrick Graham (qqv), to respond to the theme 'School'. *The School Show* was followed by others: *Prints in Schools* (1986), *Irish Artists: Portraits by Muiris Moynihan* (1987), *Heroes* (1997), *Heads* (1988), *A Special Place* (1988), *Tokens* (1993), *Inside Out* (1993), *Altered States* (1995), *What is a Print?* (1995) and *A Room of One's Own* (2000).

While regional access to the visual arts was primarily determined by the availability of suitable venues and touring exhibitions, during the 1970s and '80s local festivals and communities began to take on more ambitious exhibition programmes. These complemented new curatorial interests in diverse arts practice, often outside the gallery environment. This locally driven approach represented an important development in audience engagement with visual art.

The next critical step was a collaboration between the Arts Council and local government bodies in the development of a national network of arts officers. As early as 1976, *Provision for the Arts in the Republic of Ireland*, by J.M. Richards, published by the AC/ACE, had outlined a plan for regionalization through the appointment of regional arts officers within the Regional Development Organization (RDO) areas countrywide. This policy can be seen in part as a response to local arts initiatives and festivals, such as those at Galway, Kilkenny and Clifden, and the consequent need for suitable professionally run venues.

The AC/ACE partnered local authorities in the appointment of arts officer posts, with appointees being directly responsible to the RDOs. The mid-west region covering Limerick, Clare and Tipperary (North Riding) was the first to make an appointment, and it was followed in mid-1979 by Galway and Mayo. By the end of 1979 a number of RDOs – Donegal, the South-East (Wexford, Waterford, Carlow, Kilkenny and Tipperary (South Riding)), and the South-West (Cork and Kerry) – agreed to appoint regional arts officers. However, it was the appointment of the first county arts officer in County Clare (1985) that further integrated the posts within the local authority structure. This strengthened the commitment by local authorities with the salary jointly funded by the local authority and the Arts Council. By 2000 thirty arts officers were employed throughout the country.

From its establishment in 1991, IMMA adopted a set of policies and practices that acted as a further impetus for more widespread access to the visual arts. Recognizing the expert role of the arts officers in promoting regional access and development, Catherine Marshall, the newly appointed head of collections, invited them to meet in 1995 to examine the manner in which the museum could act as a resource and genuinely fulfil the institution's national remit. In response to this gathering, Carol Gleeson approached IMMA in 1996 requesting the loan of an exhibition for the County Museum, Dundalk. Marshall curated an exhibition entitled *Literary Themes*, followed closely by *Figuration* in 1997 at the Dublin South County Council Offices, Tallaght.

A number of innovative curatorial projects ensued, involving arts officers and enabling IMMA to work in partnership with interested parties on an all-island basis. This model was formalized as the IMMA National Programme in 1997 [425] with the financial support of the Paul Hamlyn Fund, and directed successively by Carissa Farrell and Johanne Mullan. The National Programme promoted the widest possible involvement with the museum's collection and education programmes encouraging participation, understanding and public ownership of the collection. IMMA also acted as a resource in the promotion of professional art-handling and curation. Conservator Maighread McParland (NGI and the Institute for Conservation of Historic Artworks in Ireland) and the IMMA technical staff hosted professional art-handling seminars for regional staff/volunteers charged with the installation of exhibitions. The museum endeavoured not to 'parachute ready-made exhibitions' into venues, offering instead models of curatorship between the venues and IMMA staff, with the venue taking responsibility for insurance, transport and exhibition costs.

While the National Programme continued to promote access to the developing IMMA collection, the dynamic programming of galleries allowed for greater access to a wider range of artists. This was particularly the case in Northern Ireland. The Octagon Gallery (Belfast, 1972–89) exhibited artists, such as Jack Pakenham (qv), Northern Ireland (1984), Per Barclay, Norway (1992) and David Mach, Scotland (1992). Galleries, such as the Orchard and the Context, regularly showed international artists as well as those from the Republic. In 1993 the ACNI announced a plan to relocate its gallery on the Dublin Road, Belfast to the former Ormeau Baths public bath house, transformed between 1990 and 1996 into the Ormeau Baths Gallery. The gallery was billed as the leading contemporary gallery in Belfast and was jointly funded by the ACNI and Belfast City Council. The gallery's mission was to introduce the public

425. Children at West Cork Arts Centre taking part in the IMMA National Programme (with a work by Beverley Semmes in the foreground)

to the best of contemporary art through the display of local and international work.

Other national and local organizations provided a further layer of support. In order to develop the contemporary arts in the Gaeltacht regions, Údarás na Gaeltachta, in partnership with the AC/ACE, co-funded Ealaíon na Gaeltachta Teo, in 1997, employing three arts officers.

Despite these advances, core challenges of under-resourcing of the sector remain. Reviews of arts' funding by the end of the 1990s pointed to the low levels of discretionary spending by local authorities. According to an Arts Council survey, in 1997 Irish local authorities spent little more than IR£1 per head of population, as compared with IR£7.67 in England and Wales and more than IR£15.08 in Finland.

The Arts Council continues to be the critical source of financial support for regional arts activities:

> We provided more than €1.3m in direct funding towards the arts programmes of 31 local authority areas, and welcomed the preparation of local strategies for the arts by Counties Clare, Laois, Wexford, Sligo and Donegal. In an initiative to promote better provision for the visual arts, we helped Counties Kerry, Cavan, Limerick, Kildare and Meath to develop visual arts strategy plans.
> (AC/ACE Annual Report, 2000)

The network of art centres and spaces had sought to present work of a professional standard, and to provide the public with the opportunity to experience the best of local, national and international art. However, the expectation that ground-breaking artwork would be supported continues to be balanced against the financial demands of maintaining and developing the sector.

JOHANNE MULLAN

SELECTED READING B.P. Kennedy, 1990; Finlay, 1992; Everitt, 2000.

REID, NANO (1900–81) [426], painter. Respected for forging a style that, while influenced by Modernism (qv), remained personal and individual, Anne Margaret (Nano) Reid was born in Drogheda, Co. Louth. Reid attended the Sienna Convent, and after winning a scholarship in 1920 to the DMSA, where she studied under Seán Keating and Harry Clarke (qqv), she moved to Paris where she attended La Grande Chaumière, along with the older artist, Kathleen Fox (qv). She then went to the London Central School where she studied under Bernard Meninsky. After these travels, Reid remained for the greater part of her life in Drogheda. Most of her paintings relate to her immediate surroundings in and around the town, some thirty miles north of Dublin.

Reid exhibited first at the RHA (qv) in 1925, and thereafter showed regularly there. Her first one-person show was held in 1934 at the Dublin Painters' Gallery, and she was represented later by both the Dawson and Waddington galleries. A prolific artist, Reid showed seventy-six watercolours and oil paintings in her second exhibition held at the Egan Gallery, Dublin, and also in Drogheda. Reid was included in an exhibition, organized by

the Dublin Painters, held in 1939 at the Architectural Association in London. In 1941 she was one of a handful of forward-looking Irish artists who joined the White Stag Group and later the IELA (qqv). Along with Norah McGuinness (qv), Reid represented Ireland at the 1950 Venice Biennale, the first Irish artists to be so honoured since the founding of the state.

Reid used paint intuitively, employing a limited colour range, tending towards browns, greens and ochres, but applying the paint with a carefully controlled spontaneity in which painterly abstraction (qv) is combined with figuration. Her interest in mythology and in the vernacular inspired paintings that are in many ways emblematic of Ireland during the 1940s and '50s. She painted still lifes, interiors and landscapes, gypsy encampments and genre scenes, as well as portraits and depictions of birds and animals. Her painting *The Bottling Store*, shown at the Dawson Gallery in 1959, is based on the cellar of her family's public house in Drogheda. She visited the west of Ireland with her friends Gerard Dillon and George Campbell (qqv), travelling to Inislacken, an island off the coast of Mayo. A series of pastel drawings of Connemara were included in her 1941 exhibition at the Dublin Painters' Gallery. She and Dillon also together explored and painted the megalithic monuments of the Boyne Valley.

Reid held trenchant views on the church and the influence of commerce on life in Ireland. The art historian Riann Coulter argues that Reid had to struggle against the tide of a male-dominated art world in Ireland, and that her art was undervalued by the public as a result, although critics recognized her importance. Her commitment to painting is clear, not only as a form of cultural expression, but as a medium to advance political and social causes. In 1946, along with Frances Kelly, Reid painted murals depicting the history of the trade union movement in the 'Four Seasons' ballroom, part of a building owned by the Bakers Union and the Allied Workers Union. While living in Pembroke Street in the late 1940s, Reid had been very supportive of Patrick Swift (qv) when he was establishing himself as an artist. In 1950 Swift wrote an article on Reid in the magazine *Envoy*, in which he emphasized the importance of the imagination and of painting from memory.

What made Reid's art appealing, even to those opposed to Modernism, was the strong vein of poetic feeling that infused her work. Her watercolour *The Thrush* (*c.* 1959, CAG) is an evocation of birdsong, rendered in visual terms, while *River Edge* (*c.* 1960, CAG), also a watercolour, is a composition in which the simplified outlines of birds are subsidiary to the free and expressive mark making, used by the artist to evoke the abundance of life and energy in the landscape. The recurring motifs in Reid's art are presented with a sense of humour and lack of pretentiousness which is honest and appealing. She occasionally painted portraits, often of fellow artists, including *Patrick Swift*, exhibited at the Dawson Gallery in 1950, and *Patrick Hennessy*, now in the NGI. Her painting *Tinkers at Slieve Breagh* is in the AC/ACE (qv) collection. A retrospective exhibition, organized by the Arts Council, was shown in Dublin and Belfast in 1974, while the Taylor Galleries held a retrospective exhibition of her work in 1991.

PETER MURRAY

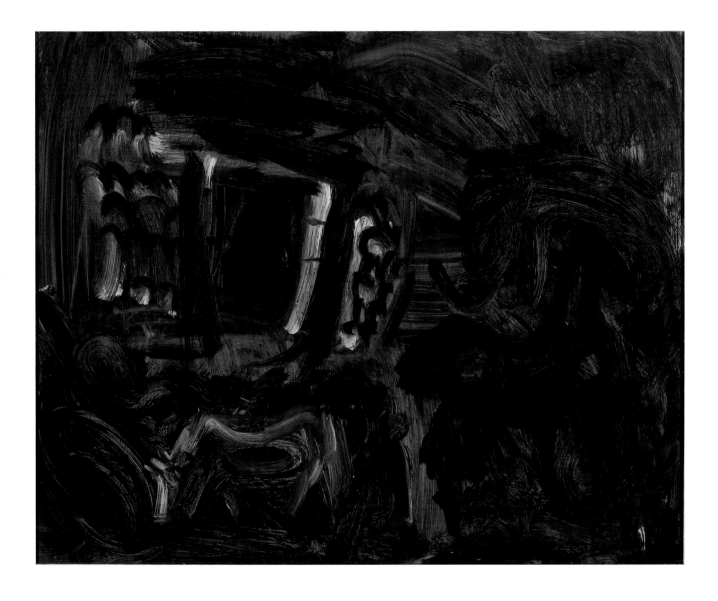

SELECTED READING Pearse Hutchinson, 'Nano Reid', in *The Irish Imagination*, 1971; Declan Mallon, *Nano Reid, 1900–1981* (Drogheda 1994); Riann Coulter, 'Nano Reid: From the Boyne to Bohemia', in O'Connor, 2010.

RELIGION AND SPIRITUALITY IN IRISH ART (see

AAI III, 'Ecclesiastical Sculpture'). Religion and spirituality are terms that are often, albeit erroneously, used interchangeably. For the purposes of this essay, therefore, their definitions as set out in the *Concise Oxford Dictionary* will be used throughout. Religion is defined as: 'belief in a superhuman, controlling power, esp. in a personal God or gods, entitled to obedience and worship; expression of this in worship; a particular system of faith and worship'. Spirituality is defined as: 'of, or concerning the spirit as opposed to matter; concerned with sacred or religious things; (of the mind, etc.), refined, sensitive, not concerned with the material'.

Religion is often connected to identity because people feel defined by a particular religious faith, community or set of practices. It is also connected to morality and, most commonly of all, to spirituality, with the latter often used nowadays in contexts where the term 'religion' was used in the past. Since much art, even when represented by a material object or set of actions, is itself concerned with the non-material, there is a need to distinguish between religion, spirituality and art. In *The Arts without Mystery*, the Irish literary critic Denis Donoghue distinguishes between art and religion, saying:

> Even in a world mostly secular, the arts can make a space for our intuition of mystery, which isn't at all the same thing as saying that the arts are a substitute for religion. There is nothing in art or in our sense of art which corresponds to my belief in God. In religion, our faith and love are directed beyond ourselves. In art, faith doesn't arise. It's enough that the arts have a special care for those feelings and intuitions which otherwise are crowded out in our works and days. With the arts, people can make a space for themselves and fill it with intimations of freedom and presence. (Reith Lectures, 1982, p. 129)

The writer John McGahern stressed that the most important remnant of his very Catholic upbringing in mid-century Ireland

426. Nano Reid, *Cave of Firbolg*, 1973, oil on board, 59 x 74 cm, Arts Council/An Chomhairle Ealaíon

was gratitude for the spiritual elements of that heritage, which he described as 'a sense of our origins beyond the bounds of sense, and awareness of mystery and wonderment, grace and sacrament, and the absolute equality of all women and men' ('The Church and its Spire', in *Love of the World: Essays*, London 2009, p. 133). Critiquing the Catholic Church's over-identification of religion with morality and its obsession with sexual morality at the expense of the spiritual, McGahern posited instead that 'Religion is our relationship with our total environment; morals, our relationship with others' ('Autobiography, Society, History', ibid., p. 146).

Religion and religious divisions have been prominent features of Irish history. The old power systems of the dominant Churches – the Roman Catholic and Hiberno-Anglican (Church of Ireland) – altered greatly during the nineteenth century, but their impact continued to be significant all over the island for most of the twentieth century. While 86.6 per cent of the population in the Republic of Ireland still professed to be Roman Catholic in 2011, with 4 per cent representing Church of Ireland and other Protestant denominations, there was a different demographic in Northern Ireland, with the population fairly equally divided between Catholics, on the one hand, and a number of Protestant faiths, especially Presbyterian, on the other. Other religions collectively came to approximately 3 per cent of the population of the whole island, as immigrants representing various global religions settled in Ireland, especially towards the end of the century, establishing newer places and forms of worship. Since churches and religious orders have been, historically, sites of important patronage of the arts, their impact on Irish art in this period must be examined. While attempts have been made to associate particular styles of art with national identity and Catholicism, it should be noted that Protestant denominations in Ireland, usually associated with loyalism, represent a wide spectrum of beliefs and attitudes and this is reflected in their embrace of a range of architectural styles. All the main Christian churches happily employed artists, irrespective of their religious persuasion, although the Protestant churches generally avoided figurative ornament. This essay will look at clerical influence on the wider culture out of which art was created, the responses of artists to this, and direct church influence on the visual arts in the form of patronage (qv). It will also look at a number of artists who are keenly aware of art-making as a spiritual activity, whether this is inspired by the dominant religions or in opposition to that influence.

Impact of the churches on the wider culture
Church disestablishment in 1867 relieved the majority Roman Catholic population from the frustrating burden of having to support a church, the Church of Ireland, to which they did not belong. By the early 1900s an increasingly ebullient Catholic Church asserted a growing control of schools, hospitals and orphanages. The establishment of the Free State in 1922 and the publication of an Irish Constitution in 1937, drafted in consultation with Archbishop John Charles McQuaid [427], controversially confirmed the 'special position' of the Catholic Church as guardian of the faith of the majority and protected a patriarchal interpretation of the family. There was a significant

decline in the Protestant population in the Free State, as many, correctly fearing the imposition of a Catholic state, left the jurisdiction. The Catholic Church was given considerable influence over education, healthcare, social welfare, and, by extension, over communications and culture. Ecclesiastical influence enabled film censorship (1923), a ban on divorce (1925), the censorship of publications (1929) and prevented the importation of contraceptives. Through *Our Boys*, the only indigenous children's magazine in the country, the Christian Brothers advocated a Catholic, nationalist martyrology, and in its editorials laid down clear but repressive guidelines that had a particular bearing on the visual arts. In August 1928 the editor, Father Craven, wrote:

> Preachers may preach, teachers may instruct, parents may advise, but cinema pictures are more than a match for them all. Pictures leave an impression which can never be forgotten. They are a more powerful source of inspiration than all the other sources combined. The dances, the dresses, the pictures showing bathers in scanty costume, added to the picture house scenes are quite sufficient to degrade, to demoralize and bring spiritual ruin on the holy families of our island (*Our Boys*, XIV, 895).

Even the holding of public dances was curtailed. Catholic bishops caused the collapse of a progressive social welfare scheme, the Mother and Child Scheme (1947–51), and insisted on denominational segregation in education. When offered control

of the Abbey Theatre in 1924, the government accepted provided that a Catholic be appointed to the board. Their choice, a surprised economics professor at University College Dublin, George O'Brien, admitted, 'I possessed no obvious qualification, beyond being a Catholic which was apparently considered desirable' (Kennedy, p. 12). Formal attempts at Church control of the Arts Council (qv) and RTÉ were resisted, although indirect interventions were occasionally more successful. A move towards a more ecumenical environment followed the Second Vatican Council from 1962 to 1965. Church influence declined from the 1970s when a ban by the bishops on Catholic students attending Trinity College Dublin was lifted (1970), a successful legal challenge was raised against the ban on contraceptives (1973), divorce was permitted (1995), and the Church's special constitutional position was revoked, following the Belfast Agreement of 1998. Revelations of clerical sexual abuse in the 1990s added to a general decline in ecclesiastical authority.

Patronage

Not surprisingly, the Roman Catholic Church's patronage (qv) of visual art prioritized the liturgical over the aesthetic. The position was summarized by the Jesuit priest Father P.J. Gannon, who wrote: 'Art and literature are delightful things ... so far and so long as they fulfil their lofty function of rejoicing, refreshing, elevating the soul of man and affording it noble ground for noble emotion ... they are not art or literature at all ... if they fail to do this.' (Kennedy, p. 14) Despite that attitude, the Catholic Church was the biggest promoter of visual art in the early decades of the century. It was supported in this by the Academy for Christian Art (1929–46), established by Count George Plunkett, 'To improve the quality of Church art and to promote the study of Christian art in all its various branches: architecture, painting, sculpture, illumination, iconography, sacred archaeology, music, literature and drama'. Father E.J. Cullen, Principal of St Patrick's Training College, told the Academy:

It is the Church that offers opportunities for architectural genius to display itself, it is also the Church that offers the greatest sphere for just and proper decoration. And as the Church is the object that most people see, and see often, where the Fine Arts are called in ... to good advantage in the building and embellishment of a church, the edifice, besides discharging its sacred and proper mission, becomes unconsciously a source of education and arts culture for the people who frequent it. (Kennedy, p. 33)

While the most important public celebrations in the history of the Free State were those for the 1929 centenary of Catholic Emancipation and the 1932 Eucharistic Congress (when a million people converged on Dublin to witness pageantry designed by leading artists, with the Army as a prominent player), and some fine churches were built and decorated, the face of Catholic patronage in Ireland continued to be dominated, as in the previous century, by cheap, mass-produced, Italian imagery. There were important exceptions. The Honan Chapel at University College Cork, a modern interpretation of St Cronan's, Roscrea, consecrated in 1916, with stained glass by Harry Clarke (qv) and artists from An Túr Gloine, and

tabernacle enamels by Oswald Reeves, was a virtual showpiece for the Arts and Crafts Movement in Ireland (see 'Stained-Glass, Rug and Tapestry Design'). The project also helped to revive silver and textile work in the Cork area, and benefited local builders. St Brendan's Cathedral, Loughrea (1897–1947) was described as having 'in its interior decoration the most comprehensively beautiful expression in terms of art of the religion of the people of modern Ireland' (Thomas MacGreevy, *Capuchin Annual*, 1946/47, pp. 353–73). It has statuary by John Hughes, capitals by Michael Shortall, stained glass by Sarah Purser, Evie Hone (qqv) and Michael Healy, including Healy's three-light *Ascension* window (1936) [428], a later window by Patrick Pye (qv), and banners designed by Jack B. Yeats (qv) and his wife Mary Cottenham Yeats.

428. Michael Healy, *Ascension*, 1936, 3-light window, Loughrea Cathedral, Co. Galway

429. Abigail O'Brien, *Baptism: Baby's Slip* (detail), 1996, white linen christening undergarment, hand sewn and hand embroidered, Kunsthal, Rotterdam

Rapidly growing new suburbs led to a huge expansion of the Catholic Church in Dublin in mid-century under the direction of Archbishop McQuaid, enabling the creation of 26 new parishes with 34 new churches and 67 secondary schools. Similar expansion, with opportunities for patronage, happened all over the country. While a number of developments provided models of the highest artistic achievement, the vast majority of building projects and decorative schemes were at best uninspired. Nothing in the Dublin area matched the boldness of the Church of Christ the King, Cork (1931) by Barry Byrne and J.R. Boyd Barrett. Other major, if on the whole conservative, projects included Galway Cathedral (consecrated 1965). Built with a budget of £600,000, excluding furnishings and decoration, this was probably the biggest piece of religious patronage of the century. Sheathed internally with expensive marbles and built on an enormous scale, the cathedral represents a triumphalist moment for the Catholic Church in Ireland. This is hardly surprising since Bishop Michael Browne rejected his predecessor's proposed site, following advice that it would not facilitate a building any larger than the rival cathedral at Mullingar (*Galway Cathedral: A Visitor's Guide*, 2002). Decoration includes windows by Patrick Pollen, George Campbell (qv) and, since 2000, by James Scanlon and others, and sculpture by Imogen Stuart, Gabriel Hayes and Domhnall Ó Murchadha. Mosaic heads of John Fitzgerald Kennedy and Patrick Pearse flanking the altar in the Mortuary Chapel remind the visitor of the continuing link between politics and Catholicism in Ireland.

In comparison, the Church of the Holy Rosary, Limerick by McCormick and Corr bristles with modernity. Built in the 1950s and partially rebuilt and extended following a fire in the 1970s, the dominant aesthetic is a pared-down Modernism (qv), in which richness resides in its architectural simplicity and in the decorative details, which include a wonderful baptistry window by Evie Hone, a tabernacle by Brother Benedict Tutty, paintings by Father Jack Hanlon, and sculpture by Oisín Kelly, Bríd Rynne, Yvonne Jammet and Imogen Stuart, the last of which has sadly been lost. From here, Liam McCormick went on to design a series of more radical, centrally planned parish churches, modest in scale if not in aesthetic ambition, but these and others, such as the parish church in Newtown,

Kilcock, Co. Kildare, are the exceptions that show up the banality of much Church patronage.

The painter John Kelly (qv), deeply interested in the spirituality of religion and art, could not hide his disappointment:

> You couldn't say there was any member of the hierarchy who had any feeling for art. Some of the architects did try to wake up and show the Church what churches could be Richard Hurley and Liam McCormick were a few of them, trying to drag the hierarchy protesting and screaming into the twentieth century. They were still buying church art from Italy, still using female models for Christ, and putting on the little beard. Every Catholic house in Ireland had an oilograph [oleograph] from Italy with a figure with a female face, and beautiful long curly hair. Christ had a pinkish face, and beautiful long tapering fingers and long curly hair. The clergy referred to the place in Italy that made the Sacred Heart images as the Chamber of Horrors. There was not the slightest effort to bring in any serious art of religious images. (Ryan, 2006, p. 52)

Artists such as Richard King were favoured, although a critic dismissed his 1948 Waddington's exhibition for its 'sweetly decorative style which appears to be the occupational disease of modern religious art' (Snoddy, 2002, p. 322). Andrew O'Connor was less successful. Snoddy cited clerical obscurantism for the rejection of O'Connor's 1931 *Christ the King* sculpture, commissioned for Dun Laoghaire, until it was erected, following public subscription, in Haigh Terrace in 1978 (Snoddy, p. 486).

Writing about the work of Abigail O'Brien (qv), Ciarán Benson has pointed to the 'limited iconography in Irish churches and religious educational texts' and identified the Catechism of Catholic Doctrine (1951) as the core control system of Irish Catholic pedagogy, and 'quite literally a defining cultural instrument'. He sees O'Brien's *Seven Sacrament* works as informed by a position of respectful secularism. O'Brien's art examines participation in a dominant faith community from a feminist point of view. There is a level of subversion in her work that is particularly evident in *Baptism*, where the *Baby's Slip* [429] symbolizes the chasm between the baby's natural state of innocence and the 'original sin' imposed on it by the Catholic Church. Les Levine (qv) is also interested in faith communities. His controversial 'Billboard' series, 'Blame God' [278, 430] shown in London and Dublin at the height of the 'Troubles' in Northern Ireland focused attention on the crimes that are committed in the name of religion, rather than at religion itself (see 'The Troubles and Irish Art').

Both art and religion claim to pursue spiritual ends. But dogma and institutionalism do not sit happily with the kind of soul-searching that characterizes real artistic endeavour. Even those artists who directly address religious belief systems or rituals in their work have found it necessary to look beyond them in search of something more relevant. Francis Bacon's (qv) paintings of the Pope strip away status, power and belief, to reveal the human individual beneath the costume. Hughie O'Donoghue (qv), often thought of in terms of religious art because of paintings such as *Episodes from the Passion*, is adamant that his work is not about religion, even if one of the

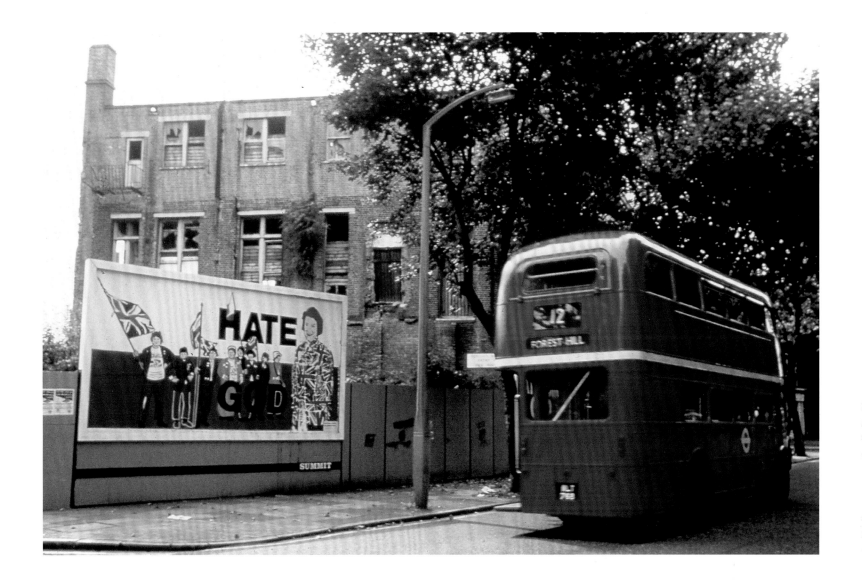

430. Les Levine, *Hate God*, 1985, 'Blame God' series, billboard project (see fig. 278)

myths that it springs from is the Christian one. In Ireland, where there was no equivalent of Malevich's Suprematist exploration of spirituality, representation of the non-objective world has been largely faith-driven. However, artists have worked to provide other choices. Mainie Jellet (qv) argued that the more geometric and less realistic an artwork is, the more spiritual it is. And this is echoed by Sean Scully, who described abstraction (qqv) as 'a non-denominational religious art ... the spiritual art of our time' (Judith Higgins, 'Sean Scully and the metamorphosis of the stripe', *Artnews*, November 1985, 106). Similarly, Felim Egan (qv) claims, 'It's easier to find that type of reality [spirituality] through abstraction than through something more figurative' (interview with Sebastian Smee, *The Art Newspaper,* May 2002, p. 30). Tony O'Malley (qv), however, warns against overly simple approaches to abstraction. 'In a world where there is complete and total disbelief, there is a worship of the abstract for its own sake – it's like a kind of false god – and then it's mannerism.' (Thiessen, p. 91) Patrick Scott (qv), who, despite his own atheism, has received many church commissions, says, 'I have always found religions a bit disturbing because they seem to generate hate so often. But I have found Zen the most ...

meditative religion that I've come across.' (Thiessen, p. 102) Visionary artists Patrick Hall (qv) [431] and Paki Smith, similarly interested in art as a meditative rather than logical practice, have never abandoned figuration.

Patrick Graham's (qv) view that religion should be experienced as a question rather than as a dogma is reflected in his painting. In 'Art after the Death of God?' (*EV+A, Compendium*, 1999, pp. 106–07) Jan Hoet argues that the form of spirituality that is turned into dogma and imposed from above has long since been rejected in art. He asserts the need to experience God, if at all now, through matter, through the body, the earth, through art. The artist no longer sees himself as a Michelangelo, sharing in God's creativity, but rather as a questioner, courageously accepting that it is only through doubt that we can uncover the reality of existence. Hoet argues that it is only through an appreciation of difference, fuelled by doubt that spirituality can surface. For art and spirituality alike, then, the presence of minority faiths, such as the Jewish faith, which has been a constant throughout the century, and the newer religions that have come into being in Ireland from the 1980s onwards, manifested most emphatically through the Mosque building in Clonskeagh, Dublin, is to be valued.

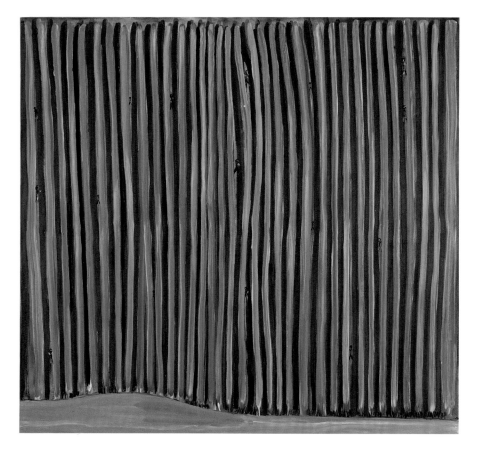

Dream, a children's book *The Very Thing*, by Ffrida Wolfe, and was also commissioned by Maurice Gorham of the BBC to produce woodcut illustrations for the *Radio Times*. Although highly regarded as a wood engraver and illustrator (see 'Printmaking' and 'Illustrations'), Rivers saw herself primarily as a painter (*Memorial Exhibition*, p. 11).

By the time Rivers paid her first visit to the Aran Islands in 1935, she had been praised in *The Studio* for her technical ability, and had had a solo exhibition at the Wertheim Gallery in Manchester. Returning to Inishmore in 1943, she supported herself by running a small cottage as a hotel for some months before returning to war-time London to work as a fire warden. After the war, she settled permanently in Ireland, but visited Israel in 1951, drawn by admiration for the way in which the Jewish people had created 'their own myth in this modern age' (White, p. 7). Following the death of her friend Evie Hone (qv), she lived for a time in Cornwall.

The Irish Countrywomen's Association commissioned Rivers to paint pictures of everyday life in the west for the Country Shop on St Stephen's Green, Dublin, a popular meeting place for artists and writers. She also received a commission from Guinness's for mural paintings for the Zetland Hotel in Connemara. Following the war, her paintings became more biblical in theme, perhaps influenced by her experiences during the war, and by close contact with Hone, whom Rivers assisted in transferring to large-scale, drawings for such stained-glass projects as the window for the Chapel in Eton College. Rivers' most successful religious works are a series of paintings of Noah's Ark [432], executed in the late 1940s, to mark the end of war.

The most accomplished wood engraver in Ireland during her lifetime, Rivers' work appeared in books such as *This Man* (London, 1939); *Stranger in Aran* (Dublin 1946) which she both wrote and illustrated; *Out of Bedlam* (Dublin 1956), illustrating the poems of Christopher Smart; *Out of Bondage* (London, 1957), referring to recent Jewish history; and a 1952 portfolio of images of the Aran Islands, published by Victor Waddington. Waddington and the Department of Post and Telegraphs also commissioned Rivers to design Christmas cards. A small number of accomplished sculptures, depicting

431. Patrick Hall, *Jacob's Dream*, 2002, oil on canvas, 183 x 198 cm, Irish Museum of Modern Art

Perhaps in that more questioning understanding of art and spirituality, Eamon de Valera's words in relation to the 1951 Arts Act will come to mean more than a distraction from poverty: 'My own view is that if we are to have any place in the world we will get it only through the intellectual and, for want of a better word, the spiritual line. It is in that realm we can hope to have some pre-eminence, and everything that is proposed here to make us more outstanding along that line should get support from the House' (*Dáil Debates*, 125, 24 April 1951, col. 1341). CATHERINE MARSHALL

SELECTED READING Mainie Jellett, 'Art as a Spiritual Force', in Eileen MacCarvill, 1958; de Breffny and Mott, 1976; B.P. Kennedy, 1990; Thiessen, 1999; Enda McDonagh, *Theology in Winter Light* (Dublin 2010); Alain de Botton, *Religion for Atheists* (London 2012).

RIVERS, ELIZABETH (1903–64), painter, printmaker and illustrator. Described by Basil Rákóczi (qv) as 'a genius mislaid' (letter to Kenneth Hall (qv), cited in Kennedy and Arnold, 2005, p. 26), the artist Elizabeth Rivers came to Ireland from Sawbridgeworth, Hertfordshire, in 1935. Having studied at Goldsmiths College in London, and the RA under Walter Sickert, Rivers then moved on to Paris, where she continued her studies under André Lhote and Gino Severini. While still a student, her talents as an illustrator were recognized, securing her commissions to create woodcuts for C.A. Caverley's translation of Theocritus. She went on to illustrate Tennyson's *The Day

432. Elizabeth Rivers, *Noah's Ark*, 1948, oil on canvas, 30 x 40 cm, O'Malley Collection, Irish American Cultural Institute, University of Limerick

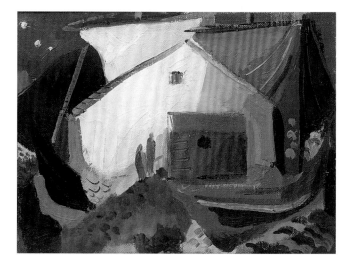

proverbs, such as *Hear no Evil, See no Evil, Speak no Evil* were also produced by her towards the end of her career. Rivers was given a retrospective exhibition at the Dawson Gallery in 1960 and a *Memorial Exhibition* at the HL two years after her death in 1964.

Rivers' work can be seen in the UM, HL, IMMA, UL, NLI and the British Museum. CATHERINE MARSHALL

SELECTED READING James White, Patrick Pye and Marian Fitzgerald, *Elizabeth Rivers Memorial Exhibition*, exh. cat. HL (Dublin 1966); S.B. Kennedy, *Elizabeth Rivers 1903–64: A Retrospective View*, Gorry Gallery (Dublin 1989); Lalor, 2011.

ROBERTS, HILDA (1901–82), painter, illustrator. Born into a prosperous Dublin Quaker family, while still in her teens Hilda Roberts was commissioned to illustrate a book of Persian folk tales, translated by David and Emily Lorimer. Published by Macmillan, the sixteen colour and eight black-and-white illustrations (qv) in *Persian Tales* are elegant and sophisticated. In 1919 Roberts enrolled at the DMSA, where she studied under Patrick Tuohy and Seán Keating (qqv) until 1921. She excelled at figure drawing and portraiture, her figures being angular, expressive and slightly attenuated, with a strong sense of the underlying skeletal structure. Roberts spent a further two years in England, studying anatomy, life drawing and illustration at the London Polytechnic.

She exhibited for the first time at the RHA (qv), in 1922, submitting a painting entitled *A Ghost Story*. After two years in London, Roberts returned to Dublin to study sculpture under Oliver Sheppard. After winning two Taylor scholarships, she was awarded the RDS California Prize in 1925, and spent the following year in Paris. In the late 1920s Roberts produced illustrations for a number of guidebooks published by Dublin Corporation and in 1929 and 1931 two exhibitions of her work, mainly portraits of friends, among them people from Achill Island in Mayo, were held at the Dublin Painters Gallery. The patronizing attitude often shown towards women artists is evident in a 1931 *Daily Express* review, where Roberts is described as a 'clever young Dublin portrait painter' whose 'great charm is that she is entirely without any affectations or tiresome theories' (Daily Express, 12 June 1931). Roberts's most famous portrait, of George Russell (qv) [433], was shown at the New York gallery of Helen Byrne Hackett in 1930. During this period, Roberts stayed with Elizabeth Rivers (qv) in her cottage on the Aran Islands.

In 1932 Roberts married the historian Arnold Marsh, headmaster of Newtown School, Waterford, and thereafter her painting career was largely set aside as she raised her daughter and taught art at the school. However, she continued exhibiting at the RHA almost annually, until 1942, and thereafter intermittently. A retrospective exhibition of her work was held at the Taylor Galleries in 1979, and another retrospective, organized to coincide with the centenary of Newtown School, was held at the Crawford Art Gallery in 1998. PETER MURRAY

SELECTED READING Joan Johnson and Peter Murray, *Hilda Roberts*, exh. cat. CAG (Cork 1998); Snoddy, 1996.

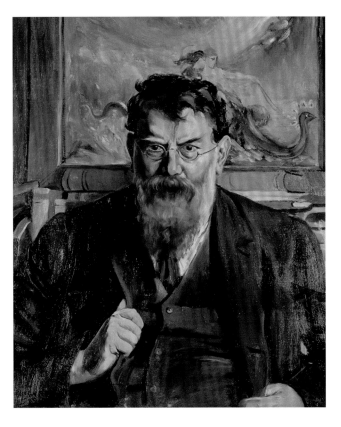

433. Hilda Roberts, *Portrait of George Russell (Æ)*, c. 1929, oil on canvas, 76.2 x 63.8 cm, National Museums Northern Ireland, Collection Ulster Museum

ROBINSON, TIM (b. 1935) [434], writer, artist. Timothy Drever Robinson was born near Ilkley Moor in Yorkshire. He studied mathematics at Cambridge, serviced RAF planes in Malaysia in fulfilment of his national service obligations, and taught in Turkey before beginning a career as a visual artist in Vienna and London, under the name Timothy Drever. Although recognized by the arch-advocate of Modernism (qv), Clement Greenberg, who selected him for the John Moores Biennial in

434. Tim Robinson, installation shot of his exhibition *The Decision* with *Winged Victories, I–VIII*, c. 1963, *To the Centre*, 1972, *Autobiography*, 1972, *Inchworm 35*, 1972, *Staircase 19*, 1973, *Maps of the Aran Islands, the Burren and Connemara*, 1980, Dublin City Gallery The Hugh Lane, 2011–12

Liverpool, Drever, with his colleague Peter Joseph, found himself to the fore in the challenge to Modernism posed by environmental and participatory art (qv). Drever and Joseph outlined their concerns about the commodification of art and the elitism of the gallery and private collection systems in *Studio International* (June 1969), and staged two outdoor exhibitions in the grounds of London's Kenwood House in which Drever's abstract forms were simply laid on the ground for the public to place.

By combining environmental art or site-specific installations (qv) with a participatory element, Drever anticipated the work to which he was to dedicate himself from 1972 onwards. In that year, he and his wife Mairead came to visit the Aran Islands, inspired by Robert Flaherty's 1930's film, *Man of Aran*. Using the name Robinson, to distinguish his writing from his artwork, he began the Folding Landscape Project, incorporating writing and map making, that draws intimately on the folklore, mythology, local history, geography and topography of the Aran Islands, the Burren and Connemara and particularly the Irish language in which he is fluent. This project won a Ford European Conservation Award for Ireland in 1987 and work on it has continued ever since.

Robinson lived on the Aran Islands until 1983 when he and his wife moved to Roundstone, Connemara, and from there published many of the books about the area for which he is now best-known. While map making is not seen primarily as an artistic process, it is one very close to the heart of Conceptualism (qv), and Robinson's work in this regard blurs the distinctions between the visual and the literary arts. When he was invited by Hans Ulbrich Obrist to submit an artwork for an exhibition *Map Marathon* for London's Serpentine Gallery (2010), which included such artists as Louise Bourgeois and Ai Weiwei, Robinson/Drever combined his early installation strategies with his cartography and produced a huge vinyl print of his Aran Islands' map on which visitors to the gallery could walk or dance as they thought fit. In 1996 Timothy Drever was included in the exhibition *The Event Horizon*, curated by Michael Tarantino at IMMA, and a year later Coracle published *The View from the Horizon*, constructions by Timothy Drever, texts and maps by Tim Robinson (1975–96), his first overt attempt to link the works of the artist with those of the writer.

In 2010 Tim Robinson was elected a member of the Royal Irish Academy; the following year he was elected to the RHA (qv) and an exhibition of his visual art was presented at the HL. As 2010/11 Parnell Fellow in Irish Studies at Magdalene College, Cambridge, he delivered the annual Parnell Lecture there in February 2011, posing the question: 'What makes a place out of a locality?' CATHERINE MARSHALL

SELECTED READING Timothy Drever and Tim Robinson, *The View from the Horizon* (London 1997); Tim Robinson, 'A Career in Art', in *My Time in Space* (Dublin 2001); Jos Smith, 'The Good Step West from Timothy Drever to Tim Robinson', paper delivered at the conference *Regional Literary Culture after Modernism*, University of Nottingham website, accessed 20 September 2011.

ROLFE, NIGEL (b. 1950) (qv *AAI* III), artist. As a student at Bath Academy in the early 1970s, Nigel Rolfe attended some of Joseph Beuys's ground-breaking lectures in Düsseldorf. In 1974 he came to Ireland from England to teach at NCAD. The appointment was a propitious one. The college was undergoing major changes following student and staff protests over the previous years and students welcomed Rolfe as a direct connection to the most dynamic art pedagogy of the twentieth century. Rolfe's firm endorsement of Beuys's teaching principles and his own practice as an artist confirmed his importance in Irish art for a generation of students and he has continued to make Dublin his home and working base ever since, despite moving his teaching work from NCAD to the Royal College in London, where he later became visiting professor of Fine Art. Rolfe has also worked as visual arts director at the Project Arts Centre, Dublin (1977–79).

However, it is as an artist that Rolfe has made his biggest contribution. From the outset his practice opposed tradition. In *Challenge* (1978), a text-based artwork, he articulated aims that he has sought to fulfil ever since: to challenge how public space is used to present art, how art galleries have developed, the notion of the art object as saleable, and the effect of journalism on the presentation of the artwork. In the same forum he expressed a desire that the audiences would engage practically with the experience of the work. With Alastair MacLennan (qv), Rolfe pioneered performance art in Ireland, using his own body as an un-saleable, sculptural medium and, initially, evoking Beuysian ideas of transformation and shamanism (see 'Time-based Art' and 'The Body'). Deconstructing the classical sculptural tradition, Rolfe shocked conservative Irish audiences at the Project Arts Centre and on the popular television programme the *Late Late Show* by performing naked, but transforming his body into living, moving sculpture or 'ground etchings' by lying on a ground covered in coloured dust or dipping himself in substances such as red clay and white plaster. At the Centre Georges Pompidou, Paris (1980) he painted his body with blue pigment powder in reference to the French artist Yves Klein. Titles for his work, such as *Cast* (1980, ICA, London) and *Red Sculpture* (IMMA collection), which was used as a cover for a record album by the pop band Therapy, further cement the subversion of traditional sculptural practices and extend its appeal to very different publics.

By the end of the 1970s Rolfe increasingly used photography, installation, drawing (qqv), video, mixed media, tape/slide and audio media (see 'New Media Art') as vehicles for his work in addition to performance. However, as Declan McGonagle has pointed out, he successfully avoids trapping his practice in one medium (Rolfe, introduction). Occasionally he has also collaborated with musicians.

Fully conscious of his identity as an Englishman (born on the Isle of Wight) in an Ireland that was riven by the Northern Irish 'Troubles', his work in the 1980s increasingly reflected that reality (see 'The Troubles and Irish Art'). In her essay 'Locating the Context: Art and Politics in the Eighties' in *A New Tradition: Irish Art of the Eighties*, Joan Fowler discerned the influence of postmodern theory that moved Rolfe's performances towards more 'located representation of the relationship between

England as colonial oppressor and Ireland as politically and culturally oppressed' (p. 120). Notions of capture, containment and smothering recur in work from the 1980s as Rolfe continued to use Beuysian ritualized ordeal and real time acts of physical stress to engage with wider issues: the politics of colonization, conflict, poverty, climate change, feminism and social discrimination. Rolfe himself reveals how the discovery of a ball of oiled sisal taken from a house in County Leitrim, abandoned because of economic stagnation and emigration, led to the making of his performance *The Rope that Binds Us Makes Them Free* (1983–84) (Rolfe, n.p.). Other performances and their photographic residues, such as *Blood of the Beast*, a photographic triptych (1990) [435], challenge assumptions about loyalism, nationalism and violence. 'I see each work as a cycle with a deliberate and balanced construction stage and a violent and primitive climax', he has said (Gallagher, p. 324).

Rolfe was elected to membership of Aosdána (qv) in 2000. A member of the performance group Black Market International, he has taken part in events staged by them in Europe, North and South America and Japan. There are artworks by Nigel Rolfe in the collections of IMMA, HL, NSPC, and in collections in Europe, North America and Japan. Major solo shows include *Nigel Rolfe Videos, 1983–96*, a retrospective exhibition at the Musée d'Art Moderne de la Ville de Paris (1996), *Archive* at IMMA (1994), and *Resonator* at the DHG (1992). His video works have been shown at Gwangju, South Korea (1997), at the São Paolo Biennial (1998), and at the Centre for Photography at the University of Salamanca (2001), while more recent work has been presented at the Galerie Polaris, Paris, and at the Butler Gallery, Kilkenny (both in 2002). Rolfe participated in *Rosc '80* and was also represented in such important group exhibitions of Irish art as *A New Tradition: Irish Art of the Eighties*, DHG (1990), *Something Else: Contemporary Art from Ireland*, Turku, Helsinki, Oulu and Joensuu (2002), and *Views from an Island: Contemporary Irish Art from the IMMA Collection*, Beijing and Shanghai (2004). CATHERINE MARSHALL

SELECTED READING *A New Tradition*, 1990; *Nigel Rolfe: Archive*, exh. cat. IMMA (Dublin 1994); Marshall, 2004; Gallagher, 2006.

THE ROSC EXHIBITIONS [436, 437, 438]. The Roscs were a series of ground-breaking international art exhibitions in Ireland between 1967 and 1988. Their enormous impact upon Irish artists, critics and the public was such that it is now possible to speak historically of Irish art before and after Rosc. Although international art had previously been shown at the annual Irish Exhibition of Living Art (IELA) (qv) exhibitions, James Johnson Sweeney's *Art USA Now* (1964, HL), Cyril Barrett's *Kinetic Art* and *Arte Povera* exhibitions (1967, Hendriks Gallery), and George Dawson's *Pop Art Banners* (1967, TCD), the scale of the Roscs made them the first 'blockbuster' exhibitions to be seen in Ireland. For the first time visual art attracted a wide international audience of artists and critics to Ireland, although paradoxically, not for Irish art.

'Rosc', an Irish word, generally translated as 'poetry of vision', was suggested by Father Francis Shaw for the exhibitions, which were held in 1967, 1971, 1977, 1980, 1984 and 1988. Because of financial constraints, the 1975 Rosc was deferred; only a satellite exhibition, *Irish Art 1900–1950*, curated by Hilary Pyle, was presented that year at the Crawford Art Gallery, Cork. The modern

435. Nigel Rolfe, *Blood of the Beast*, 1990, cibachrome photographs on 3 panels, 150 x 100 cm each, Irish Museum of Modern Art

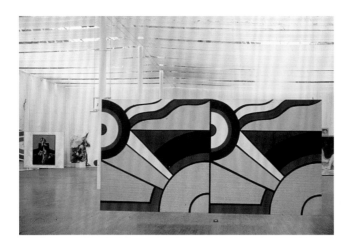

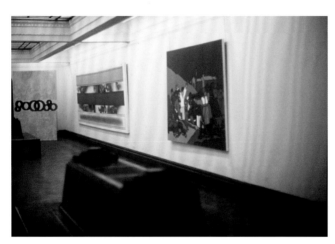

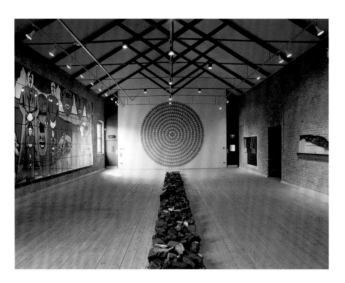

436. *Rosc '67*, installation shot with diptych by Roy Lichtenstein

437. *Rosc '71, The Irish Imagination*, installation shot with paintings by Micheal Farrell and Robert Ballagh on the right

438. *Rosc '84*, installation shot with works by Richard Long and Gilbert & George

be seen on a regular basis. The Dublin Municipal Gallery of Modern Art (HL) had no money to build on its Modernist collection, in spite of the best efforts of Ethna Waldron, curator from 1965 to 1990. Michael Scott, the Modernist architect, developed the idea of importing exhibitions showing international trends in art to Ireland. He was supported in this by James Johnson Sweeney (1900–86), the Irish-American director of the Museum of Fine Arts, Houston, Texas, from 1961 to 1967, a frequent visitor with a holiday home in the west of Ireland. Sweeney had been director of Painting and Sculpture at MoMA, New York (1945/46), director of the Guggenheim (1952–59), and had written several books on artists, including Joan Miró, Alexander Calder, Henry Moore and Alberto Burri, and a book on African art. His international prestige had a significant bearing on the agenda and practical realization of Scott's ambitious project.

The Arts Council of Ireland (AC/ACE) (qv), with Scott and Sweeney as members and directed by Father Donal O'Sullivan, fully supported the initiative. The first Rosc was also backed by Anne Crookshank, Professor of Art History, Trinity College Dublin (TCD), critic Dorothy Walker (1929–2007) and artist Cecil King (qv), as well as Minister for Finance Charles Haughey (1925–2006). The enthusiasm and support of a government minister was vital to the success of the project, not least in attracting corporate financial support that continued in succeeding exhibitions, and firmly established business support for the arts in Ireland (W.R. Grace & Co., Aer Lingus, CIÉ, Bord Fáilte, RTÉ, Guinness Peat Aviation).

Unusually for such international exhibitions, each Rosc presented a parallel ancient section, possibly Sweeney's idea since he had written about early Irish art and exhibited ancient and modern art together in Houston. This section aimed 'to demonstrate that the art of the past can share both the spirit and appearance with the art of the present' (Walker, p. 113). These parallel sections of ancient art included: *Celtic Art* (1967), comprising Neolithic, Bronze Age and early Christian art from Ireland, with an introductory essay, edited by John Hunt; *Viking Age Art* (1971), compiled by Sweeney, with a catalogue essay by David M. Wilson; *Early Animal Art in Europe to AD 800* (1977), selected and catalogued by Máire de Paor; and an exhibition of Chinese painting from the Sackler Collection at the Metropolitan Museum, New York (1980), curated by Marilyn and Shen Fu. Departing from the original Rosc criteria of 'ancient', in 1984 the nineteenth-century Guinness Hop Store, venue for the modern section, was itself cast as representative of the ancient section, while the older section of the 1988 Rosc comprised the Costakis Collection of the Russian Avant-Garde, displayed in the Royal Hospital Kilmainham, with catalogue essays by Angelica Zander Rudenstine.

The catalogue covers of the first four Roscs were designed by the artist Patrick Scott (qv) [447] and gave a clear indication of the revolutionary nature of the exhibitions for Irish audiences, with the remaining two designed by Raymond Kyne Design. Unlike the ancient sections, there was no introductory essay to the modern exhibitions (with the exception of *The Irish Imagination* exhibition in 1971), although catalogue information was supplied by Anne Crookshank and Cecil King (1967) and Rosemarie Mulcahy (1984, 1988). The 1984 and 1988 Rosc

section of the first three Roscs was selected by an international jury and comprised three to five works from the preceding three to four years by fifty international living artists. From 1980 a local jury, assisted by an international panel, made the selection.

The primary stimulus for Rosc was the lack of a national museum of modern art in Ireland where international art could

catalogues, as well as some colour plates, had essays on the international and Irish artists by William Packer and Dorothy Walker (1984) and by Olle Granath (director, Moderna Museet) and critic Aidan Dunne (1988).

The Roscs took place at a time of immense change which affected art theory and practice. Internationally, the formalist model of Modernist painting was giving way to the eclecticism of Postmodernist genres of sculpture, video, installation (qv), land and performance art (see 'Time-based Art') from the late 1960s and early '70s. Contemporaneously, Ireland was slowly evolving from a predominantly rural, relatively isolated country into a more open, urban, secular and wealthier society with an emerging business class. These shifts had a bearing not only on the international art selected for the Roscs, but also on conflicts within the small Irish art world, specifically on the policies of the Arts Council.

Council membership had remained virtually static during the 1960s, with control of visual art resting mainly with O'Sullivan and Scott (Kennedy, chapters 7, 8). The Council's marked preference for abstract art (see 'Abstraction') during the 1950s and '60s fostered resentment from such groups as the Independent Artists (1960) and those associated with the first artist-led cooperative arts centre, the Project Arts Centre (1967), which were pressing for change in the structures of art patronage (see 'Patronage and Awards'). Ciarán Benson characterized the clash of cultural ideologies between the early Arts Councils of the 1960s and '70s and this group of artists, as a struggle between the 'cultural democratic viewpoint' and a perceived 'lowering of artistic standards and debasement of "Art"' (Benson, p. 28). This struggle was also being played out on the international stage, although with different circumstances and preoccupations (P. Wollen, 'Global Conceptualism and North American Conceptual Art', in *Global Conceptualism: Points of Origin, 1950s–1980s*, exh. cat. Queens Museum of Art, New York 1999, pp. 73–85). The Rosc jury's exclusion of Irish artists gave the struggle a further impetus. Although Walker stated that there was no explicit exclusion policy for Irish artists, it appears that problems over which Irish artists to choose was a factor (Walker, p. 111). The agreement of the Arts Council and the local Rosc committee to this strategy seems clear, because even artists patronized by the Council were not put forward for selection. Oliver Dowling confirmed that the decision to create an international exhibition only was made to 'avoid any difficulties over which Irish artists to include, and which to exclude, in Rosc ...' (email to the author, 31 May 2010). Critics like Bruce Arnold and Tony Butler, and Independent Artists Michael Kane (qv), James McKenna and John Behan, saw the 'establishment attitude' of the Arts Council as allied to its stance of 'promoting outside art in Ireland without doing anything to promote Irish art abroad' (Kane, *I Ind*, 11 October 1967). The jury's decision, under Sweeney's chairmanship, to include in the ancient section 'masterworks from the great ages of Irish art' implied that contemporary Irish art was of an inferior quality. The 'ban' was all the more intriguing given that some Irish artists favoured by the Council, such as Patrick Scott, had already been included in such international arenas as the collection of the MoMA in New York. Micheal Farrell (qv), although initially chosen to be one of the fifty internationally recognized artists for *Rosc '67*, was later dropped.

The key to the 'ban' may be the educational impetus behind Rosc of bringing to the Irish public 'a faithful record of what is happening in the artworld', to which Irish art had not yet contributed significantly (Cyril Barrett, *IT*, letter to the Editor, December 1977). This position was maintained for another decade, although an exhibition, *The Irish Imagination* (one of a series of parallel exhibitions to the main one), was admitted in 1971. It is likely that international acceptance of Postmodernist pluralism since the early 1970s, allied to persistent local criticism, led the 1977 Rosc jury to select the first Irish artists. Ronald Alley (Tate Gallery, London), a juror at the IELA who was familiar with Irish art, was jury chairman when James Coleman and Patrick Ireland (a.k.a. Brian O'Doherty) (qqv) were selected. Both were conceptual artists (see 'Conceptual Art') who had exhibited at the Hendriks Gallery and the IELA. In spite of this, however, their selection caused another row since the vice-chairman of the Arts Advisory Committee of the HL, Gerald Davis, considered them to be 'outsiders' (*Irish Press* and *IT*, 30 September 1977). Critic Brian Fallon remarked that neither was particularly distinguished and that 'The insult is surely to the far more distinguished Irish artists who were not included' (*IT*, 13 December 1977).

Unlike large-scale exhibitions internationally, the Roscs, with one exception, took place in 'alternative sites'. This term, coined by Brian O'Doherty, was used to describe the use of non-gallery, non-museum spaces for exhibition, as part of a growing critique of art institutions internationally. In Ireland, such a critique was less relevant than elsewhere, since there was a dearth of appropriate institutions in the first place. Thus, the main contemporary exhibitions of the first Roscs (1967 and 1971) were located in the industrial space of the Royal Dublin Society (RDS); University College Dublin (UCD) hosted the 1980 Rosc; and the Guinness Hop Store accommodated the last two in 1984 and 1988. The only Rosc sited, for financial reasons, in an art space was the 1977 exhibition at the smaller HL.

The Rosc exhibitions can be seen as barometers of a paradigmatic shift in art from Modernism to Postmodernism (qv) between the 1960s and '80s. Transition was gradual so that, although the era of Postmodernism had been launched internationally from the mid-1950s to the mid-1960s, Modernism continued to be a force until the end of the 1960s. This was reflected in the predominantly Modernist preferences of the juries of the 1967 and 1971 Roscs under Sweeney's chairmanship. It was not until a decade after their inauguration that Postmodernist art was gradually included. By the last Rosc of 1988, in tandem with international trends, Postmodernist art was given less prominence as the art market promoted a resurgence of painting.

The first two Roscs achieved the most impact nationally and internationally. The Modernist preferences of the juries of 1967 and 1971 can be gleaned from the implied criteria of transcendental excellence, formal quality and visual poetry mentioned in their catalogues, but without any more precise definition. As critic Aidan Dunne noted, Rosc's notions of excellence 'make sense only within the validating framework of a centralized conception of Modernism' (Dunne, pp. 21–27). The term 'Rosc', he

argued, derived as it was from poetry, reinforced the primacy of Ireland's literature over its visual tradition, which Rosc was trying to overcome.

A public furore over the ancient section was such that, paradoxically, the 1967 Rosc became a topic of discussion all over the country even before the first exhibition opened. While TCD agreed to loan Rosc the precious *Books of Kells, Durrow and Armagh*, local resistance to the movement of stone monuments like the High Cross in Carndonagh and the Turoe Stone was so great that the original idea of showing the abstract qualities of ancient and modern art together was thwarted.

The 1967 Rosc showed 150 modern artworks. Although large for Dublin, compared to international exhibitions it was modest. The jury of museum directors, chaired by Sweeney, comprised Willem Sandberg (Israel Museum) and Jean Leymarie (Louvre). They conceived the exhibition as a recent survey of Cubism (qv), Abstract Expressionism and Surrealism (see 'Expressionism' and 'Surrealist Art') by canonical European and American artists such as Pablo Picasso, Francis Bacon (qv), Willem de Kooning and Joan Miró. Pop (qv), Dada and Assemblage were represented by a younger generation such as Robert Rauschenberg, Jim Dine, John Latham and Robert Indiana. Surprisingly, in view of Rosc's educational remit, the catalogue, by Anne Crookshank and Cecil King, did little to contextualize these different art movements to a non-specialist audience. Unlike the ancient section, there was no introduction beyond biographical notes and the materials and dimensions of works, perhaps owing to financial constraints, the volunteer status of the Rosc committee, and the absence of a full-time secretariat. These problems, and the lack of a dedicated venue, persisted throughout the Roscs.

Of the fifty-one artists, all were male except for two sculptors, Mary Martin and Lee Bontecou, reflecting the international gender imbalance. Experimental 'cutting edge' practices, already on the international scene by the late 1960s, were absent. Minimal and conceptual work by artists such as Ad Rheinhardt, Donald Judd, Sol LeWitt and Joseph Kosuth, or proto-conceptual artists like Yves Klein, Joseph Beuys and Piero Manzoni, for example, were not included, possibly reflecting establishment resistance to art practices that eschewed the traditional art object in favour of concepts, processes and the ephemeral, and methods of display that directly challenged the museum system. The fact that the jurors were all powerful museum directors cannot have been without relevance, given the international dominance of American Abstract Expressionism as the 'official' style of art. James Johnson Sweeney, through his association with MoMA and membership of the American Committee for Cultural Freedom, had been a driving force in the promotion of Abstract Expressionism as a propaganda weapon during the Cold War (S. Guilbaut, *How New York Stole the Idea of Modern Art: Abstract Expressionism, Freedom, and the Cold War*, Chicago 1983).

The lack of a dedicated exhibition space led to the unusual treatment of the industrial RDS building that received almost unanimous praise from critics and the public. Designed by Patrick Scott, the ceiling and walls were draped with white cotton and muslin. The space was further enhanced by Sweeney's hanging of paintings back to back from the ceiling, allowing for the free movement of the viewer which anticipated installation art. It is likely that this method, used by Frederick Keisler in the 1940s at Peggy Guggenheim's Art of this Century Gallery, was seen there by Sweeney, when he acted as a juror for American art.

Response to *Rosc '67* was on a scale never seen before in Irish art history. While critical and public reaction locally was not always favourable, the event, nevertheless, attracted the largest ever attendances at the RDS (50,100), and at the ancient section in the National Museum (29,000) (M. Scott, Report on *Rosc '67*). Scott suggested that if an epidemic of foot-and-mouth disease had not restricted travel, the numbers would have been higher. Children were given a half-day from school to attend, and the *Irish Times* initiated a Rosc essay competition for schools. 'Press, radio and television coverage was at front-page level for three or four weeks', Scott reported. The show attracted a large contingent of international critics, as well as artists like Barnett Newman, Pierre Soulages and John Latham. The majority were enthusiastic. Yet Clement Greenberg, commenting that Rosc contained 'a great deal of information about the present state of painting even for someone familiar with the New York scene', also had reservations: '*Rosc 1967* could have been so much better chosen ... the failed fifties, not the still living fifties ...' (Greenberg, pp. 282–88). Greenberg's assessment may have been inaccurate with regard to the dating of paintings, but accurate in relation to styles that by the late 1960s were no longer cutting edge. At the same time, his personal resistance to Postmodern art was also reflected in his patronizing opinion that it was probably just as well that Ireland's first introduction to contemporary art included so much of the 'fatigue of the fifties ... [since] all the novelty and razzmatazz of the sixties might have been too bewildering'. Scott commissioned George Morrison to make a film of *Rosc '67*, but there was no money for editing (email from Ciarín Scott, May 2006). Another film by Brian Cleese of RTÉ won the Prix Italia in 1968.

Rosc '71, again at the RDS, was also chaired by J.J. Sweeney, joined on this occasion, by jurors Pontus Hulten, Director of the Moderna Museet, Stockholm, and Werner Schmalenbach, Director of the Nordrhein-Westfalen Museum, Düsseldorf. The opening night was disrupted by protesting students from NCAD. Following official speeches, the platform was given to the students in front of an audience of 2,000, to make their case about delayed reforms in the college, and the lack of art education in Irish schools (see 'Education in the Visual Arts'). This Rosc maintained a similar concentration of canonical names, such as Max Ernst, Mark Rothko, Joseph Albers, Jasper Johns, René Magritte, Bridget Riley and Cy Twombly. It also gave a better indication of the diversity and eclecticism of art practice internationally by including minimal and conceptual work by Robert Morris, Donald Judd, Michelangelo Pistoletto and Shusaku Arakawa. There was an increased representation of sculpture, compared with the 1967 Rosc, with such diverse artists as Jean Dubuffet, Claes Oldenberg, Alexander Calder, Baldaccini César and Julio Le Parc. Both local and international critics agreed that *Rosc '71* was an exhibition that conveyed, more accurately, international trends in art than its predecessor.

A number of films by Ciarín Scott and Jack Dowling of RTÉ, recorded the 1971 Rosc. They included Colm Ó Briain's interview with the artist Seán Keating (qv). Often regarded as the anti-Modernist *par excellence*, recent historians claim that Keating's attitude was directed towards the elitism surrounding Modernism, rather than towards the art itself (R. Kennedy, review of Éimear O'Connor's 'Seán Keating in Context: Responses to Culture and Politics in Post-Civil War Ireland', in *Artefact*, no. 3, 2009, 95–98).

Some sense of the dichotomy between Modernist and Postmodernist art was evident in the jurors' remarks in the 1971 catalogue foreword; Sweeney emphasized the basic Modernist thesis of Rosc, noting that the fundamental quality of a work could be recognized by the 'fullness of its realization of order, form, and sensuous appeal in the materials employed'. Werner Schmalenbach acknowledged that art had developed into directions that a conventional exhibition, like Rosc, was unable to display adequately owing to the growth of processes and concepts instead of objects that maintained the principle of quality. His attitude to this new art was clear: 'Our exhibition displays little of these *acute threats* [author's italics]. It retains the traditional idea of the created art piece – though at present endangered by a severe crisis – and it is certainly based on considerations of quality' Pontus Hulten expressed a view more attuned to Postmodernist thinking: 'We stand in the midst of a phenomenal explosion of technological means. At present these means are mainly concentrated on producing goods that are bought and sold. There is no doubt that if we are not to become the victims of what we ourselves produce, we must quickly attain a society based on other values than buying and selling.'

Clement Greenberg had a different attitude:

It makes no difference that this Rosc is even worse in terms of art *qua* art than the first Rosc. The present Rosc is more up-to-date, but the bad in it, which preponderates even more this time, tends to be uselessly, boringly bad That's the way bad conspicuous art on the international scene has been since the latter '60s, and to this extent *Rosc '71* is no worse than that scene, reports that scene faithfully, and brings the Irish abreast of it. It's not the art that shocks but the state of mind of those who let themselves choose this art. (Greenberg, 'Rosc '71', *Art International*, XVI, no. 2, February 1972, 12–17)

Greenberg's comment exemplifies an American establishment viewpoint as described by Hal Foster in *The Return of the Real*, 'The Crux of Minimalism' (Massachusetts, 1996, pp. 35–68).

In response to persistent resistance to the exclusion of Irish art, the 1971 jury agreed to inaugurate an exhibition devoted exclusively to Irish Modernist and contemporary art. *The Irish Imagination 1959–1971* did not, however, take place alongside the main exhibition but at the HL. There was a precedent for this; other forms of mainly Irish art – nineteenth-century art, silver, glass and ceramics, and an exhibition of Jack B. Yeats (qv) and his family – were displayed in satellite exhibitions around the country. *Modern Graphics and Multiples* in Waterford included such artists as Josef Albers, Antoni Tapies, Jim Dine, Hans Hartung and Ben Nicholson. *Young Irish Artists* in Galway, which subsequently travelled to the Demarco Gallery, Edinburgh, included Robert Ballagh, James Coleman (qqv) and Jack Donovan.

The Irish Imagination was curated by Brian O'Doherty, an internationally recognized critic and artist and editor of *Art in America*, assisted by Oliver Dowling and Ethna Waldron. It was an important breakthrough not only because the Rosc committee accepted contemporary Irish art for the first time, albeit in a satellite exhibition, but also because its catalogue, which O'Doherty wrote and designed, was the first attempt to critically evaluate contemporary Irish art (see 'Critical Writing and the Media'). O'Doherty adopted the curatorial device of dividing work into the categories of *The Irish Imagination*, *The Native Heritage*, *The Puritan Nude* and *The Literary Influence and the Visual Response*. In a novel departure, writers and critics contributed to the last category in the catalogue. In the series of introductory essays to each of the categories, O'Doherty noted that there was little Pop, Op, Hard Edge, Minimalism (qv) or Conceptualism in Irish art in the period 1959–71, suggesting that this reflected a country that was until recently, predominantly rural and agricultural. Alongside older artists working in abstract, figurative and landscape modes, he selected a younger generation representing subjects that reflected a new era in Ireland. Some local critics criticized the curatorial structure as artificial, others the omission of the Independents and the relative absence of the favoured subject of Irish art, landscape (qv). O'Doherty defined the older generation's work as a 'poetic' genre suffused with atmospheric light and an evasiveness marked by 'an uneasy and restless fix on the unimportant'. This characterization was adopted by Irish critics for many decades, notably by Frances Ruane in *The Delighted Eye* exhibition of 1980. The younger artists who breached this romantic mode included Robert Ballagh, Micheal Farrell, Michael Bulfin, Brian King and Brian Henderson making energetic, abstract or political work, often with new materials such as acrylic and fibreglass. In spite of the criticisms, the critic Desmond McAvock concluded that O'Doherty's achievement was to show that, compared 'with the grand opera at Ballsbridge', there was a distinctive native expression in Irish visual culture (McAvock, *IT*, 25 October 1971). The exhibition provided an international platform for Irish artists when a smaller version of *The Irish Imagination* travelled to Boston, Philadelphia and Washington DC in 1972, while the title of the exhibition was reused in the 1996 Paris exhibition, *L'Imaginaire Irlandais*.

The 1977 Rosc was distinguished from its predecessors by the decision to admit Irish artists, Patrick Ireland (Brian O'Doherty) and James Coleman and, for financial reasons, to limit the selection to European artists, at the smaller venue, the HL. Concentrating on new developments, it included Conceptual art, installation, photo-realism and photography (qv) as well as abstract, kinetic, and Pop art from seventeen countries, showing artists like Daniel Spoerri, Richard Hamilton, Jan Dibbets, Mario Ceroli, R.B. Kitaj, Josef Beuys, Richard Long, David Hockney and Christo. The Irish selection, inevitably, led to a row, but Ronald Alley, on behalf of the

adjudicators, argued that the work of Ireland and Coleman, working respectively at the major art centres of New York and Milan, particularly suited an exhibition dedicated to new types of art and media (see 'New Media Art') not shown in previous Roscs. Conceptual art was ushered into Ireland at *Rosc '77* with Coleman's 16 mm black-and-white film piece with audio, *Box (ahhareturnabout)* [228, 325] and Patrick Ireland's installation *Yellow Rectangle, Rope Drawing # 34*. Indicative of current political tensions relating to Northern Ireland was the jury's refusal to admit Ireland's second piece, the documentation of his *Name Change* [337, 379] performance of 1972, citing it as offensive to the 'art community in Northern Ireland' (Walker, p. 126). On his threat of withdrawal, supported by fellow artists, a compromise was reached, and the event and statement were documented in the catalogue (see 'The Troubles and Irish Art').

The response to *Rosc '77* was mixed, with the limitations of the venue and the diversity and conceptual nature of the art felt by some to lack the excitement of its predecessors. But Ciarín Scott combined footage from the Roscs of 1967, 1971 and 1977 to make a much-praised film which won prizes in Houston, Paris and New York.

The Rosc of 1980 was distinguished from earlier Roscs by having the first definitive Irish representation, with artists like Louis le Brocquy, William Scott, Robert Ballagh, Nigel Rolfe, Cecil King and Patrick Scott (qqv). The complement of Irish artists for the remaining two Roscs continued to grow, so that by the last one in 1988 ten were included. By that time, Irish art had diversified beyond its traditional *and* Modernist boundaries to reflect international trends as Postmodernist discourse filtered into art education and artists not only adopted postmodern practices but also addressed concerns such as the political strife in Northern Ireland, feminism, gay rights and other social issues.

Rosc '80 was for the first time chosen without an international jury but by a committee chaired by Dorothy Walker and Michael Scott, assisted by an international panel. It included the first *in situ* installations and performances from artists such as Sol LeWitt, Daniel Buren, Dennis Oppenheim, Marina Abramovich and Ulay, Charles Simonds and Walter de Maria, alongside minimal art, happenings and oils on canvas. The venue, more spacious than that of 1977, was UCD and many of the performances were planned to coincide with the International Art Critics Congress being held in Dublin at the same time. The sponsor's (Guinness Peat Aviation) announcement of a Rosc Foundation to cope with the chronic shortage of funding unfortunately came to nothing. In spite of controversy and public bewilderment, *Rosc '80* was critically seen as a more representative and energetic show than *Rosc '77*.

By the 1980s, there was a sense, internationally, that 'order' had been restored, with the re-emergence of painting and sculpture alongside more experimental art forms. The selectors for the 1984 Rosc were collectors, Patrick J. Murphy (chairman), Count Panza di Biumo and Fritz Becht. Becht withdrew and most of the international artists were selected by the chairman, while the contentious Irish selection was by the architect and collector Ronald Tallon. Tallon's catalogue remarks reiterated

his formalist tastes in a selection based on 'a knowledge of medium and a respect for quality' (foreword, *Rosc '84* catalogue, p. 16). They included Felim Egan, Anne Madden, Cecil King, Barrie Cooke, Sean Scully (qqv), Eilís O'Connell and Michael Warren. Controversy erupted once more when Irish painters working in an Expressionist way, many associated with the Independents, were not selected to show with such artists as Anselm Kiefer, Georg Baselitz, Francesco Clemente, Sandro Chia and Enzo Cucchi.

The venue for the final Rosc in 1988 was, once again, the Guinness Hop Store and the partially restored Royal Hospital Kilmainham. The exhibition included work by Jennie Holzer, Richard Deacon, Wolfgang Laib, Jean-Michel Basquiat, Luciano Fabro, Gilberto Zorio and Anthony Gormley, as well as James Coleman, Cecil King, Kathy Prendergast, Tony O'Malley, Brian Bourke, Basil Blackshaw (qqv) and Francis Tansey. By 1988, many felt that the Rosc exhibitions had run their course, especially when, in 1991, the Irish Museum of Modern Art (IMMA) opened at the Royal Hospital.

The legacy of the Rosc exhibitions has been far-reaching in its impact on artists and the public owing to the breath, scale and diversity of work. They achieved their original objective of introducing international art practices to Ireland over a sustained period of twenty years before the establishment of IMMA. In this sense, they fostered the internationalization of Irish art. That they were organized against a background of constant economic and political strife, without a permanent secretariat or museum, was a remarkable achievement. However, the four-yearly retrospective structure proved problematical given the rapid pace of change and thinking over the same period. The various divisions made visible and provoked by the Rosc exhibitions, with local inflections, mirrored those also being played out on the international scene. These related to the break with Modernism in the 1960s which was connected to other ruptures in the social, political and theoretical spheres. The early Roscs were very certain about what art was; by the late 1970s, there was more uncertainty; by the 1980s, there was a drive to reassert earlier certainties. The Rosc exhibitions became a symptom of these tensions. Yet they succeeded in putting visual art centre stage in an unprecedented way in Ireland. They encouraged art critical discourse, institutional structures, and fostered international contacts between artists, collectors, critics and curators, the growth of an internal market and exposure for Irish art that led to the vibrant environment of the early twenty-first century. BRENDA MOORE-MCCANN

SELECTED READING B.P. Kennedy, 1990; Dunne, 1990a; Benson, 1992, 28; C. Greenberg, 1993; Walker, 1997.

THE ROYAL HIBERNIAN ACADEMY OF ARTS. Founded in 1823, the Royal Hibernian Academy (RHA) operated under its second royal charter of 1861. It was a body of thirty members and ten associates, all elected by the General Assembly of the members at its October meeting. These elections, and the annual elections of officers and honorary professors, were subject to the approval of the Lord Lieutenant, who was the Academy's vice-patron (*ex officio*), representing the

monarch. An elected Council managed the business of the Academy, which worked under its bylaws, as updated by a revision of 1903 approved by the Lord Lieutenant. On the appointment of the Lord Lieutenant, and later of the Governor General, the Academy presented him with an address of welcome which set out its current concerns.

The Academy had two main functions: to hold an annual exhibition of the work of living artists open to public submission, and to conduct a school for the education of the professional artist. The state, since 1832, gave an annual grant of £300, which remained unchanged and was mainly intended for the upkeep of the school. Academy House, Lower Abbey Street, Dublin, had two top-lit exhibition galleries and a studio for the school. The keeper who managed the building and the school had a free apartment in the house. Academy House also contained a council room with portraits of past presidents and an art library with a collection of books, catalogues, manuscripts, drawings and engravings. The Academy published an annual report which included its financial accounts and statistical returns for the exhibition and the school. These reports allowed the Treasury, and later the Department of Finance, to monitor its spending. Throughout the twentieth century, the Academy nominated two members of the Governors and Guardians of the National Gallery of Ireland (NGI), as it had done since the gallery's foundation.

Academy House was located at a distance from the fashionable museum area that had developed in Dublin in the nineteenth century. The Academy believed that its location made its exhibitions less attractive to visitors and collectors, and from the 1880s had expressed a desire to move to a new site near the museums, south of the Liffey. In the early twentieth century, attendance at exhibitions was declining, as were commissions from sales. The institution could survive only on the voluntary efforts of its officers and teachers, who worked for low payments. Under the terms of its lease, Academy House could not be used for commercial fund-raising. The only other important annual exhibition was that of the Watercolour Society of Ireland where the members exhibiting were mainly women amateurs, although some Academicians also showed there. The Academy's crowded displays, mixing watercolours with oils in heavy frames, did not show watercolours to their best advantage.

Thomas Drew (president 1900–10) campaigned tirelessly for a move to a site near the museums, and for greater support of the Academy school, but without success. The official report of Sir William de Abney (1901) accepted the need to move the Academy but also recommended that the life school be amalgamated with the Dublin Metropolitan School of Art (DMSA) on the grounds of economy. Following a parliamentary initiative, the Windsor Report (1906) into the affairs of the RHA and DMSA resulted in a majority report that was critical of the teaching in the Academy school and the quality of its exhibitions. It did not support a move to a new site and recommended that the school be amalgamated with the DMSA. A dissenting minority report argued for the maintenance of the Academy school and stressed its value as providing an education for artists by artists. Public opinion, articulated in the press, supported the minority report, and as a result no official action was taken.

The Academy had run the School of the Living Model and the School of the Antique since 1832 in a top-lit studio in Academy House, with plaster casts of the antique. To gain admission to the school, applicants had to submit a drawing of the antique or a drawing or painting from life for evaluation by the Council. Most students had already studied the rudiments of drawing at the DMSA. In the twentieth century most of its students were women. Male students did not welcome the advent of women students and preferred to remain at the DMSA where, in the early twentieth century, William Orpen (qv) was to have a dominant influence as teacher in the life school. No fees were charged and the students were admitted initially as probationers. There was no limit to the length of stay at the Academy School. The programme consisted of antique drawing, as well as life drawing and painting, including the portrait head. Every year a series of prizes was offered, drawn from the Albert prize fund, including one for a composition on a set subject done in the students' own time. The Academy appointed three judges to examine the students' work and to award prizes. Students also competed for the Taylor Art Scholarship, offered annually at the Royal Dublin Society (RDS) to which the Academy nominated one of the three judges. The school year was generally from the beginning of October to the end of May. The life school was open for five half-days and the painting school on a similar arrangement but for fewer weeks. The teaching was by four visitors (tutors) elected annually, who were paid a small fee. The work of the students was subject to inspection by a nominee of the Treasury, which approved the grant.

The annual exhibition took place in March and April, although dates could fluctuate. The openings were important social events attended by the Lord Lieutenant, members of the nobility, gentry and the professions. After the establishment of the Irish Free State in 1922, the political and professional leaders of the new Ireland attended. The number of artists exhibiting in the first two decades of the twentieth century was around 200 annually, with female entrants comprising about a third of that number. As in the nineteenth century, the Academy paid for the carriage from London and Edinburgh of work by non-resident artists, several of whom were Irish. The work shown in the annual exhibitions was mainly portrait, landscape, still-life and genre paintings. The exhibitions throughout the twentieth century were reviewed in the national press and by some periodicals. News photographs of the guests and the exhibits also appeared. The opening was a major date in the Dublin social calendar.

The Academy supported the efforts of Hugh Lane to promote the arts. It co-operated with him by giving its gallery for the loan exhibition of the English and French schools in 1902. The Academy also loaned its gallery for Lane's seminal exhibition of French modern painting in 1904, which was accompanied by a programme of lectures as well as by private parties, hosted by society ladies. In addition to Lane's exhibitions, the Academy held retrospective exhibitions of the deceased Academicians, Walter Osborne (1903) and Patrick V. Duffy (1910). Dermod O'Brien (qv), president from 1910 to 1945, organized an old master print exhibition in 1910.

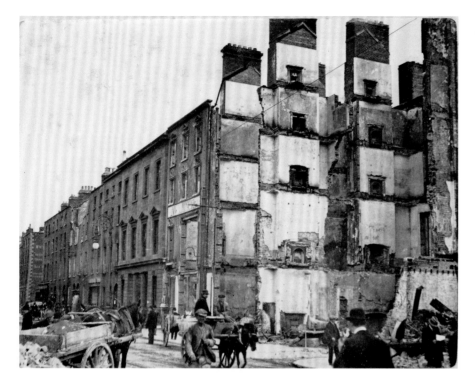

The Academy's annual exhibition was hanging when Academy House was burnt out on 24 April 1916, as a result of fighting during the Easter Rising [439]. All the exhibits, the Academy's art collection and its library were destroyed. Not only were the minute books of the Council and the General Assembly lost but also a collection of artists' letters and portrait photographs of artists. Only the president's chain of office was saved. After the fire, the re-establishment of the Academy and the search for new premises were the challenges for the decades ahead.

For its annual exhibitions from 1917, the Academy had the use of the top-lit gallery of the DMSA, which became the National College of Art (NCA) in 1936, and the National College of Art and Design (NCAD) in 1971. This gave the annual exhibitions a location in the museum area of Dublin. Owing to the Civil War in 1922/23, the Academy was not permitted to exhibit at the DMSA and had to use the Industries Hall of the RDS during Horse Show week in August. It employed Daniel Egan, the art dealer, to install and take down exhibitions. Initially in 1917, perhaps because of the 1916 Rising and World War I, there was a spectacular drop in the exhibitors from Britain, but non-resident exhibitors had recovered by the 1930s, only to be severely reduced again by World War II. Numbers of exhibitors varied from around 110 to 170 in the 1920s and '30s, with the percentage of women artists around a third of that number (for example, in 1943 there were fifty-five women out of 168 exhibitors). Attendance in that period grew steadily, as did sales. Commissions on sales rose from £10 in 1917 to £144 in 1943. However, costs also rose so that the Academy had to subsidize its exhibitions from investment income until the 1940s when profits returned. A major cost was the transport of work from Britain. One of the results of the regular use of the DMSA's gallery was that the two institutions grew closer, especially since several artists were prominent in both. In 1928, at a special banquet to mark the opening of the annual exhibition, W.T. Cosgrave, President of the Executive Council of the Free State, spoke in favour of the Academy and its role. The Academy supported the revival of Aonach Tailteann, the ancient Irish sporting and cultural festival, by donating a prize medal for its art exhibitions in 1928 and 1932.

The Academy school reopened, following the fire in November 1916, in rented premises in Lincoln Place. By 1920 the life school had moved to a studio at 6 St Stephen's Green, a building with other artist occupants. No antique drawing was provided owing to the lack of a cast collection, although students could draw from the casts at the DMSA. When the Academy bought 15 Ely Place, the school moved there in 1939. Annual advertisements were published in the press announcing the start of classes during the 1920s and '30s and teaching followed the pattern that had prevailed up to 1916 [440]. The arrangements for admission by an examination of drawings, tuition by the visitors and annual examination for prizes also continued as before. Most of the students continued to be middle-class women, perhaps attracted by the genteel atmosphere of the Academy's studio and the absence of fees. The classes in the 1920s consisted of life drawing for two hours in the mornings over five days, and a painting class for two hours on three afternoons. In addition to the Albert prize, the Judith Wilson prize fund was established in 1931. The running costs of the school by the late 1930s were twice the annual grant of £300 and it finally closed in 1942 after a period of uncertainty over its future.

Following the Anglo-Irish Treaty and the Irish Free State Constitution of 1922, the Academy sent the results of elections for approval to the Governor General. Under the 1937 constitution, such elections were submitted to the Taoiseach. The original procedures of the royal charter were modernized by the government passing the Adaptation of Charter Order in 1940. The Academy drafted new bylaws which the Taoiseach approved. The Academy maintained its existing connections with the NGI and the Taylor Bequest. It was also invited to nominate members

to the boards of the Gibson and the Haverty Bequests. Outside Ireland it maintained its links with the British School at Rome and the British Institution Scholarship Fund, administered by the Royal Academy (RA). The RHA elected the Presidents of the RA and Royal Scottish Academy as honorary members (*ex officio*) and this was reciprocated. Although women had been exhibitors since the Academy's foundation and honorary members since the late-nineteenth century, it was not until 1919 that the Council decided to admit women as constituent members, leading to the election of Sarah Purser (qv) as an associate in 1923 and as a member a year later. Other women followed, initially as associates.

After 1916 the search for a building for exhibitions, school and offices led the president to petition the British government and thereafter the Free State governments for funds but without success. The Academy was awarded compensation for the destruction of Academy House, but this was insufficient to acquire a site and to build. Although pressed by the Dublin city authorities to rebuild in Lower Abbey Street, the Academy refused to do so. The majority view in the Academy was that the site was unsuitable for modern requirements and it was sold in 1929. The Academy sought unsuccessfully to be given a government site in Kildare Street. The government offered 88 Merrion Square (next to the NGI), with the possibility of the Academy building a gallery in the garden to the rear and in that of its neighbour. The Academy was unable to accept this offer because it could not afford the high commercial rent and retain the funds to build a gallery. Finally, from its own funds in 1938 it bought 15 Ely Place and its adjoining garden from Dr Oliver St John Gogarty, the RHA's Professor of Anatomy. Lucius O'Callaghan, the Academy's Professor of Architecture, provided plans for a gallery with studios beneath to be built in the garden, but this never happened.

During the presidencies of James Sleator (1945–50) [441] and Seán Keating (1950–62) (qqv) the Academy had to face the loss of its unique position as the only major exhibiting organization following the foundation of the Irish Exhibition of Living Art (IELA) (qv) in 1943. However, cordial relationships were maintained between the two bodies and several members of the Academy exhibited in both. The venue for both exhibitions was the gallery of NCA. The Academy concentrated on the exhibition of traditional representational art, but its members became increasingly defensive in the face of the rise of Modernism (qv), especially in the 1950s and '60s. The Arts Council (qv), in its purchasing policy in the 1960s, favoured Modernist artists and this put the Academy members at a disadvantage.

In 1946 the Academy set up a committee to revive plans to build galleries and to accommodate the school at Ely Place, but once again the Department of Finance rebuffed its appeal for funding and the issue lay in abeyance until the 1960s. The Academy did, however, create its own small gallery for solo shows in its Ely Place premises. Since its annual exhibitions were often not profitable in the 1960s and '70s, the Arts Council helped by offering a guarantee against loss.

When student revolution broke out at NCA in 1969, not only was the Academy's informal link to the NCA life class broken, but it could no longer hold its exhibitions there. They moved,

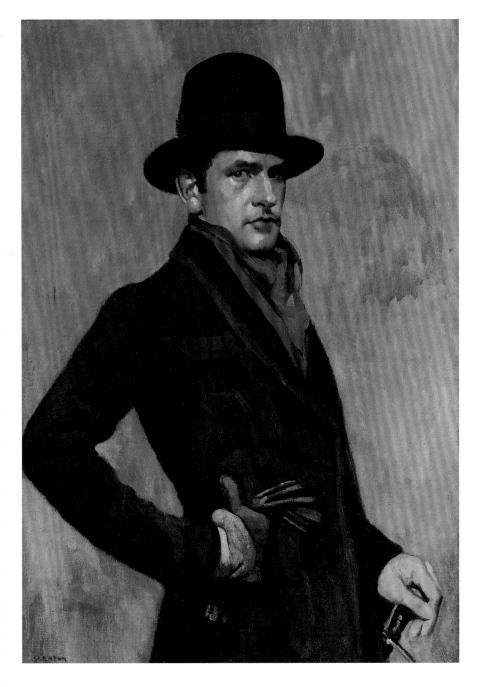

441. James Sinton Sleator, *Self-portrait*, c. 1915, oil on canvas, 89.5 x 63.5 cm, National Gallery of Ireland

instead, to the NGI in 1969, to the State Apartments of Dublin Castle in 1970, and then back to the NGI until 1984. Members who wanted to see change in the Academy voted for a new secretary in 1971 to replace Micheál de Burca, who had served as secretary since 1949.

Dublin Corporation sought to compulsorily acquire the Academy's garden site in Ely Place for public car parking during the 1960s but Maurice MacGonigal (president 1962–77) (qv), argued the case publicly for financial assistance towards the building of galleries. In January 1970, Matthew Gallagher, Director of the Gallagher Group, announced his intention to provide such a gallery. The design was a Modernist one by Raymond McGrath, former principal architect of the Board of

Works and Academy president (1977). This gallery, apart from its use by the Academy, was to be made available to groups of Irish artists and to visiting loan exhibitions. Three large interconnected galleries occupied the first floor; a sculpture gallery and rooms for the Academy occupied the ground floor with a capacious basement beneath; the front courtyard led to the keeper's house, and on the roof were to be six studios for the school. Work started in June 1971 with the demolition of the existing headquarters. Although Charles Gallagher maintained support for the project following the death of Matt Gallagher on 7 January 1973, work had ceased by early 1975. Maurice MacGonigal met the Taoiseach in 1974 to explore the issue of state funding for the rebuilding of the Academy.

The building remained a bare concrete shell during the presidency of David Hone (1977–82). The next president, Thomas Ryan (1982–92), restarted the momentum to finish the building by looking for government and private funding. The Academy received the support of Charles Haughey, Minister for Finance, and money came from the Suitors' Fund (a fund of dormant accounts attached to the law courts, into which fines had been paid) and other sources. The Arts Council also became involved with the project. The first exhibition in the unfinished gallery was the Guinness Peat Aviation exhibition of Emerging Artists in 1984. It was followed the next year by the annual Academy exhibition which was the first occasion since 1916 that the Academy had held its exhibition in its own gallery. Ted Nealon, Minister of State for the Arts at the Taoiseach's office, was a key figure in maintaining official support. He set up a board of trustees, made up of sympathetic business figures, to complete and run the RHA Gallagher Gallery. In order to raise a loan, the trustees sold the keeper's house, despite some resistance from within the Academy. There was tension between the trustees and the Academy over their respective authority. The exhibition galleries were completed by October 1991 and the Academy held its meetings in the staircase atrium. The Academy council room and offices were completed by November 1993. The trustees of the Gallagher Gallery were appointed to serve for ten years from the completion of the building. They divided into a finance committee dealing with funding, on which government nominees were in a majority, and an exhibitions committee, on which the Academy was dominant. The Arts Council and the Electricity Supply Board were prominent among several financial supporters for the work of the trustees.

The repositioning of the Academy in relation to contemporary art was led by Arthur Gibney (president 1996–2005), and by the Secretary, Conor Fallon from 1989. Gibney took over the architectural development with a master plan in 1994. To administer the gallery, the post of director was established in 1990. The growth of the administration was greater than ever before in the Academy's history, while the aims were broadened to establish the gallery internationally. In November 1990 the president and keeper represented the Academy as guests of the Spanish Academy at a meeting of European academies in Spain.

When the period of service by the trustees ended in 1999, the accumulated debts were paid off from Academy funds. Members met for a seminar to plan the future of the Academy at Hunter's Hotel in County Wicklow in June 1999. Henceforth,

the Council of the RHA, elected by the General Assembly, was responsible for all aspects of the Academy, including the building. It would be advised by a foundation board on capital development and a programme board to deal with exhibitions. As a third advisory element, the Academy established an honorary council of its honorary members. In order to increase constituent membership beyond thirty, as laid down in the 1861 charter, the Academy, following the model of the RA, introduced in 2001 the category of Senior Academician for those over sixty-five. Members could opt for this and thus leave vacancies for new members drawn from the Associates. Academy possessions, paintings and furniture, stored at the NGI since 1971, were reclaimed. A diploma collection of members' work was initiated in 1983.

Under Carey Clarke (president 1992–96) (qv), a greatly expanded exhibitions programme took place. Christmas shows by the Academicians, retrospective and thematic exhibitions, including the degree show of the final year students at NCAD, took place there during the 1990s. The most important of these exhibitions was the series of Banquet exhibitions, held annually, where the selection process invited artists, hitherto detached from the Academy, to exhibit. Collectively, the exhibition programme was significant in broadening the range of work shown and it increased engagement with the wider art community which hitherto had perceived the Academy as a venue restricted to a conservative realist art (see 'Realism'). The Banquet exhibitions, and also special invitations to exhibit at the annual exhibitions, were designed to show that the Academy was open to a wide range of contemporary art and artists. The Ashford Gallery, a small, distinct space, separately managed, was established in 1997 to show the work of Academicians and other artists not normally represented by a commercial gallery. This enabled the work of emerging artists to be shown in a professional context. In an effort to increase revenue, the premises were let out for occasional commercial events such as art auctions and fashion shows.

The Friends of the RHA was set up in 1997, comprising patrons and other supporters of the Academy. Lectures and visits to Academicians' studios, an educational programme of lectures, and other events were organized and a regular newsletter on Academy affairs was published. During the 1990s, a number of bequests led to the establishment of a series of prizes awarded at the annual exhibitions. The Elizabeth Fitzpatrick Bursary and the Academy's gold medal for distinguished service to art were among the most important. The Academy continued its involvement with outside bodies such as the NGI and the Taylor Art Award, and was asked to send a representative to the board of the National Self-Portrait Collection at the University of Limerick.

The idea of reopening the Academy School had been part of the Academy's policy since McGrath's design of the new building. In 1990 Academy officers visited the RA to learn what was being provided in its school. There was occasional use of a large life studio that was part of the building as it stood in the 1990s. In it, from 1995, life classes were started and a committee began to develop policy for the school aimed at artists who had already begun their careers. The building was sensitively remodelled in

2007/08 to improve the circulation of space and to include an additional suite of studios and a library, intended for the school. A School's Board was established to plan for its future.

The Academy's annual exhibition was the main venue in which Irish artists could show their work up to the 1940s. These exhibitions, especially from 1922 onwards, reflected the ideals of the new Ireland in landscape, figure and portrait subjects. Exhibitions (qv) were well supported by the public. From the 1940s, with the growth of the IELA, private galleries and other exhibiting spaces, the context of exhibiting contemporary art in the country became increasingly diverse, with a consequent lessening of the impact of the Academy's annual exhibitions. As Modernism gained momentum, the Academy became more and more identified with traditional realist art, thus narrowing its appeal for many contemporary artists and many Academicians suffered a loss of confidence. However, with the advent of its own exhibition gallery and with the growing pluralism of the art world, the Academy rose to the challenge. This resulted in an enormous growth of its operations in the 1990s. The Academy reached out to a wide spectrum of artists and public in a large and varied exhibition programme, expanded its membership to elect members from a broad range of contemporary art practice, and renewed its commitment to teaching life drawing and painting, which had lapsed since 1942. Thus, it faced the twenty-first century in better circumstances than ever before. JOHN TURPIN

442. Deborah Brown, *Blue and White Form on Ochre*, 1972, fibreglass on canvas, 92 x 122 cm

SELECTED READING De Courcy, 1985, XI–XIX; Royal Hibernian Academy Special Issue, *Martello Arts Review* (1991); Turpin, 1991/92; C. Fallon, 2000/01; Turpin, 2002, pp. 24–29; Minutes of the RHA Council, Minutes of the General Assembly (mss and typescript), RHA Archive; Annual Reports of the RHA (printed).

THE ROYAL ULSTER ACADEMY OF ARTS [442]. The Royal Ulster Academy (RUA), the largest artists' collective in Northern Ireland, originated as the Belfast Ramblers' Sketching Club (1879–90), grew into the Belfast Art Society (1890–1930), following which it became the Ulster Academy of Arts (1930–50), and in 1950 the RUA. Unlike the Royal Academy (RA) and the Royal Hibernian Academy (RHA) (qv), the RUA does not have a charter. The 'Royal' prefix was added in 1950, following receipt of a letter of permission from King George VI. Although the Belfast Ramblers' Sketching Club, founded by John Vinycomb, adopted a predominantly Impressionist style, it was guided by academic-style rules. Comprised of sixteen male members, the stated purpose of the club was to 'encourage sketching directly from nature and to develop original composition' (Ferran, p. 17). By 1885, when drawing classes and lectures commenced, women were admitted as members to the club and, over the ensuing years, their number rose steadily. Despite these early classes, the organization has never had an associated formal school or operated as a centre of learning in the way that the RA in London or the RHA in Dublin have.

Throughout Europe, academic art has undergone a somewhat tumultuous history. It is at once respected and criticized as largely representing tradition and convention, while often aspiring towards innovation. Closely associated with patronage and art education, it is considered the art of the Establishment, yet challengers have come and gone, and even its principal opposition, the so-called avant-garde, has become a cliché. In Britain and Ireland, the annual exhibitions, which quickly became an integral part of academy practice, attracted much public interest and support.

Among the founding Academicians of the Ulster Academy of Arts were the painters William Conor, Frank McKelvey and Charles Lamb (qqv) and Mildred Anne Butler. As the organization evolved into the RUA, other prominent artists who became members include Cecil Maguire, Maurice C. Wilks, the sculptors Deborah Brown and Sophia Rosamund Praeger, and the painters James Humbert Craig, Tom Carr, John Luke, T.P. Flanagan, Colin Middleton, Paul Henry, Basil Blackshaw and Neil Shawcross (qqv). Presidents of the RUA include John Lavery, William Conor (qqv), Rosamund Praeger, Richard Croft, Joe McWilliams, Carol Graham and Julian Friers.

Like all artist-led organizations, the RUA has experienced difficulties over the years in securing adequate funding and staffing. Remarkably, its first full-time member of staff was not employed until 2008. According to past president Rita Duffy (PRUA, 2008) (qv), the organization has never received revenue funding from the Arts Council of Northern Ireland or from any government source. In the first decade of the twenty-first century the education programme of the RUA was underwritten through sponsorship by the accountancy firm KPMG, which has also facilitated the annual exhibition, with its accompanying catalogue.

The RUA Annual Exhibition includes work by members of the Academy, invited artists and artists selected through open submission. Since 2006 it has involved an external adjudicator,

an important development that has seen Hughie O'Donoghue (qv), Catherine Marshall, Riann Coulter and Patrick T. Murphy invited to fill this role. According to RUA president Julian Friers, the temporary closure in 2007 of the Ulster Museum 'turned out to be a kind of catalyst for change, and a group was set up to investigate the perceived status of the RUA and how it could be improved. That group recommended many changes – all of which are being implemented now.' (Friers, interview with the author, 5 November 2010) Numbers attending the annual exhibition increased, partly owing to the diversity of host venues. The 2008 annual exhibition, held in the refurbished Titanic Drawing Offices, witnessed visitor numbers rise from 3,500 to 14,500, with an attendant increase in public perception of the value of the Academy. Friers believes that the RUA is important 'for the same reasons that visual art is important. There may be a subjective element to that but, nevertheless, it defines who we are both as humans generally but also culturally. We would like to be seen as the authoritative collective of the visual arts in Northern Ireland.' (Friers interview, op. cit.)

The principal asset of the RUA is its Diploma Collection. In 1930 a rule was established requiring that 'each academician, within a period of one year from the date of appointment, shall present a representative Diploma Work to the Academy' (RUA catalogue, 2009). In a practice that has been sustained over an eighty-year period, the collection now consists of over one hundred artworks. However, the RUA continues to exist without a permanent home and Denise Ferran contends that: 'What the Royal Ulster Academy now needs is an archangel patron like Matthew Gallagher who funded the core building for the RHA in 1971 on the site of the former home of Oliver St John Gogarty, which had been bought by the RHA in 1939.' (Ferran, p. 19)

Throughout the twentieth century, the RUA in many ways demonstrated what Mike Catto described as a subordination

443. George Russell (Æ)
The Stone Carriers,
c. 1912, oil on panel,
45.7 x 61 cm, Dublin City
Gallery The Hugh Lane

of international influences owing to a conservative reticence on the part of most Ulster artists (Catto, p. 42). With some exceptions, the RUA continues to promote a predominantly traditional, yet also largely representative, survey of Northern Irish art. There have been some concessions to innovation, such as the recent inclusion of photography (qv). However, Conceptual art and installation work (qqv) remain largely absent, perhaps understandably so because of the survey nature of the exhibition and the limitations of conventional hanging. MARIANNE O'KANE BOAL

SELECTED READING Hewitt, 1977; Catto, 1977; Anglesea, 1981; Denise Ferran, 'The RUA is on the Move', in the 128th annual *Royal Ulster Academy* exh. cat. Northern Bank (Belfast 2009).

RUSSELL, GEORGE (AE) (1867–1935) (qv *AAI* II) [443], painter. One of the leading artists and intellectuals of the Irish Literary Revival, George William Russell (known as 'AE' from his pen-name Æ) is remembered today mainly as a writer and editor, although he produced many oil paintings depicting sprites and fairies, in landscapes that are quasi-mystical and imagined, but also recognizably Irish. Influenced by the Symbolist movement and by artists such as Gustave Moreau and Puvis de Chavannes, Russell was interested in mysticism and esoteric religions. He believed in the existence of a spirit world, peopled by ethereal beings, and so his paintings are less a stylistic exercise than a sincere attempt to depict this otherworld.

Born in Lurgan, Co. Armagh, Russell moved to Dublin with his family when he was eleven years old. Educated at Rathmines School and at the DMSA, he worked for a time with Pim's drapers. In 1887 he became banks organizer for the Irish Agricultural Organisation Society (IAOS) and was mainly responsible for establishing co-operative banks. Between 1905 and 1923 he edited the Society's newspaper, the *Irish Homestead*, which then merged with *The Irish Statesman*, with Russell continuing as editor until the journal folded in 1930.

Russell was a leading figure in the Dublin Theosophical Society from 1888 to 1908, when he formed the Hermetic Society. In 1902 he became vice-president of the Irish National Theatre Society (later the Abbey Theatre Company). In addition to being a painter, he wrote on mysticism, most notably in his book *The Candle of Vision* (1918), which he later developed in *Song and Its Fountains* (1932). He also wrote on agricultural policy in *The Building up of a Rural Civilisation* (1910), and on political theory, in both *The National Being* (1916) and a futurist fantasy *The Avatars* (1933). His 'Open Letter to the Masters of Dublin' appeared in the *Irish Times* in 1913 and was critical of the employers' stance during the Dublin Lock-out. Although a nationalist, Russell generally kept his politics in the background, apart from his involvement in the Irish Convention of 1917/18, when he spoke out against John Redmond's stance on Home Rule. A respected poet and playwright, Russell's first book of poetry, *Homeward: Songs by the Way* (1894), was followed by *Collected Poems* (1913). His plays include *Deirdre*, published in 1902.

In his lifetime he was highly regarded as an artist and two of his paintings were loaned to the 1913 Armory Show in New

York by the lawyer John Quinn. In collaboration with W.B. Yeats, he painted murals at 3 Upper Ely Place, the Dublin headquarters of the Theosophical Society. Another set of murals, in the IAOS offices in Merrion Square, was later transferred to the NGI. He also painted portraits, of W.B. Yeats, Lady Gregory and others. His home, at 17 Rathgar Avenue, was a meeting place for artists and writers. Although a prolific writer, Russell's contribution to art criticism is not significant; he had no liking for abstract art and famously referred to Mainie Jellett (qv) as 'a late victim to Cubism in some sub-section of this artistic malaria' (*The Irish Statesman*, 27 October 1923, 207, 208).

Russell is represented in the collections of the HL, CAG and the NGI. Peter Murray

SELECTED READING Henry Summerfield, *That Myriad-Minded Man: A Biography of G.W. Russell, 'A.E.'* (Gerrards Cross 1975); S.B. Kennedy, 1991.

RYAN, THOMAS (b. 1929) [444], painter. An outspoken critic of Modernism (qv), Tom Ryan is proud to be an academic painter. Following in the footsteps of fellow Limerick artist Seán Keating (qv), Ryan graduated from the Limerick School of Art to NCAD (where he was taught by Keating and Maurice MacGonigal (qv)), going on not only to paint in the academic manner and subject matter of his predecessor, but, like Keating, to become president of the RHA (1982–92) (qv) where he used his considerable skills as a polemicist to secure the RHA's move to Ely Place.

Patrick T. Murphy has described Ryan as a member of 'the neglected generation of Irish art, the Academy ... one of an entire generation of Irish artists who never had a public gallery exhibition in their lives' (Vera Ryan, p. 72).

It is surprising, then, that Ryan's first solo exhibition, in 1958, was at the Ritchie Hendriks Gallery, soon to be associated with the most avant-garde art projects in the country. However, in that same year, Ryan offered to the RHA *The Flight of Hugh O'Neill, Earl of Tyrone*, the first of a number of history paintings that were a continuous thread connecting his whole career, only to have it rejected. While the painting was later hung, following intervention from Keating, it was an indication of things to come. Ryan's later ventures into academic history painting (qv), notably his *The GPO* (1966) [223], painted for the fiftieth anniversary of the Easter Rising, did not find favour with the art establishment and this was to be true of other paintings, such as *The First Dáil* (OPW collection, Leinster House). Ryan believed strongly that his marginalization in Irish art was due to the pro-Modernist bias of the Arts Council (qv).

However, Ryan has always won loyal collectors, wooed by his sensitive handling of colour and light across a range of media, from oil paint to watercolour and pastel, and of such diverse subjects as portraits, flowers and landscapes (qv). It is in these intimate subjects that he excels, unlike his history paintings, which, some critics feel, are marred by theatricality and lack conviction. Proving that his confidence is undiminished by the critics, he told Philip McEvansoneya, 'I can take on the Impressionists at their own game' (McEvansoneya, 169). Ryan is an excellent cartoonist and caricaturist and has

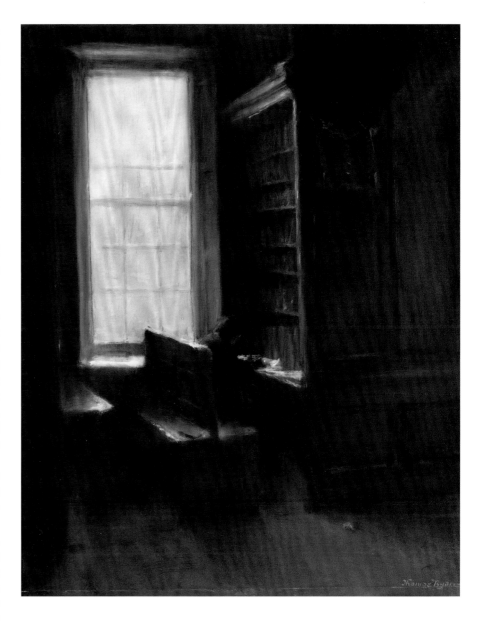

designed stamps and coinage. His work can be seen in the collections of the NGI, OPW, Limerick City Gallery, UCD, St Patrick's College, Maynooth, and in many corporate collections. Catherine Marshall

SELECTED READING Philip McEvansoneya, 'Insider on the Outside: Thomas Ryan PPRHA', *IAR Yearbook*, XIII (1997), 169–79; Vera Ryan, 2003; Thomas Ryan, *Thomas Ryan: Oil Paintings* (Dublin 2009).

444. Thomas Ryan, *Marsh's Library with a reader*, 1997, oil on canvas on board, 50.8 x 40.6 cm, artist's collection

SALKELD, CECIL FFRENCH (1904–69) [445], painter. The son of an Irish mother and an English father, Cecil Salkeld was born in Karimganj, India. His mother, Florence ffrench (née Mullen), widowed at the age of twenty-eight, returned to Ireland with two young sons, and in 1908, under the name Blánaid Salkeld, embarked on a career as an actress and author. As a child, Salkeld attended summer schools on the Aran Islands. Although briefly imprisoned in Mountjoy Jail (McKeon, 3), he was not involved in the War of Independence.

After studying under Seán Keating (qv) at the DMSA, in 1921 Salkeld travelled to Germany where he enrolled in the Akademie für Kunst in Kassel. Taught by Ewald Dülberg and influenced by *Neue Sachlichkeit* art, he learned printmaking (qv), cutting wood blocks for books and pamphlets. He exhibited at the first *Internationale Kunstausstellung* in Düsseldorf, along with Léger, Matisse and other Modernists. Salkeld married Irma Taesler and moved to Ireland in 1924 with their daughters, Beatrice (who later married Brendan Behan) and Celia. In Dublin, he won the 1926 Taylor Scholarship with his painting *The Builders*. He painted murals in Davy Byrne's bar in Duke Street and a *Portrait of F.J. McCormick* (Abbey Theatre collection). He was active in Dublin's literary world, co-editing, with Francis Stuart, the magazine *To-Morrow*. In 1937 Salkeld set up the Gayfield Press, hand-printing the pamphlet series *Dublin Poets and Artists* that matched original prints with poems.

Elected ARHA in 1946, Salkeld wrote and broadcast arts' programmes on Radio Éireann in the early 1950s, as well as working on the cultural festival *An Tostal*. Conversant in several

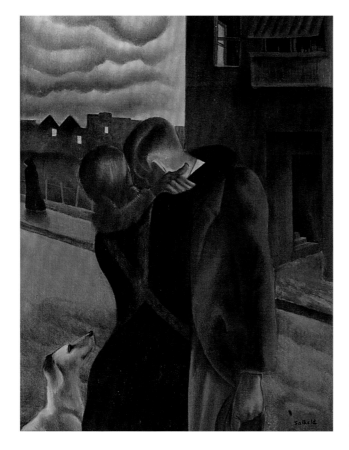

445. Cecil ffrench Salkeld, *The Soldier's Farewell, c.* 1946, oil on canvas, 48.3 x 38 cm, O'Malley Collection, Irish American Cultural Institute, University of Limerick

languages, he translated plays from German for Irish radio. His play *Berlin Dusk* was produced in 1953 by the New Theatre Group. Salkeld wrote for *The Bell* and *Envoy* magazines and became the first director of the Irish National Ballet. His paintings, generally undated, vary between a Realism (qv) inspired by the *Neue Sachlichkeit*, and a slightly sinister, Surrealist approach (see 'Surrealist Art'), evident in such pictures as *Leda and the Swan* (1943–48, private collection).

The inspiration for the character Michael Byrne in Flann O'Brien's 1939 novel, *At Swim-Two-Birds*, Salkeld has been described as a polymath and a genius. However, a more objective assessment of his career cannot avoid noting the disappointments and frustrations encountered by an artist, described by the critic Brian Fallon as 'over-cultured', in the Dublin of the 1940s and '50s, a city marked by economic stagnation, cultural pessimism and a generation of disappointed intellectuals, writers and artists (Fallon, review of Salkeld exhibition at Godolphin Gallery, *IT*, 12 February 1980). PETER MURRAY

SELECTED READING Cyril McKeon, 'Cecil ffrench Salkeld, 1904–1969', *Martello Arts Review* (Winter 1992).

SCOTT, PATRICK (1921–2014) [446], artist. Among his contributions to Modernism (qv), Patrick Scott's major achievement was to be the first artist to embrace minimalist abstraction in Ireland, which he did with his 'Goldpainting' series, initiated in 1964. Minimalism (qv) had emerged first in the USA during the 1950s, and represented a critique of what were seen as the excesses of the prevailing, dominant style of Abstract Expressionism. In contrast to an art form that was identified as painterly, emotional and individualist, Minimalism sought to be restrained and anonymous in its adherence to a democratic machine aesthetic. Since painterly art carried the signature of identifiable brushwork, providing the basis for connoisseurial judgment and evaluation, and therefore played a major role in setting the commercial value of art, Minimalism sought to eradicate such tell-tale evidence and thereby challenge the alleged elitism of art associated with the museum and the market. Furthermore, the philosophy of Minimalism opposed the representational nature of all existing art which invariably addressed an extrinsic subject. Minimalism's major objective, in theory, was to eradicate from art all reference to anything other than its own existence as an object, just as a plate or a tyre or a pen are not apparently *about* anything but, according to this line of argument, exist simply as intrinsic objects.

Scott's response was to produce a unique form of art that drew selectively on this strict ethic. On a base of raw, unprimed canvas, he left areas unpainted, adding pale fields of tempera and bands of gold leaf (or, occasionally silver-coloured palladium leaf) to create an abstract, geometric arrangement limited to those three subtly textured surfaces. The gold leaf was generally applied in strips of abutting squares in a modular format. Occasionally, Scott applied the gold leaf to form a disc, sometimes with rays, suggestive of the symbolism of the sun. Such motifs, as well as the crafted element in the gold leaf, was a diversion from the strictures of

pure Minimalism and indicates his independent interpretation of its principles. While the majority of these works were not mimetic, they have an intentionally contemplative, almost spiritual, character.

It is not certain how Scott came to Minimalism, but it has been argued that it was prompted by his exposure to the work of Ad Reinhardt in the *Art USA Now* show at the HL in 1964, the same year that Scott made his transition to pure abstraction (qv) (Scott, pp. 33–56). Reinhardt is acknowledged as a key influence on the emergence of Minimalism in the USA, not only for the format of his works, but also for the accompanying philosophical commentaries (Weller, p. 270). Scott's adherence to the movement, however, appears mainly as a resolution of his previous explorations and experiments. The rational geometries of his mature work are heralded in his earliest imagery in the 1940s – deceptively naive drawings made by etching with the pointed end of the paintbrush into a dark ground of paint on board (*Evening Landscape*, 1944, private collection). These works were made during Scott's involvement with the White Stag Group (qv) during the Emergency, and while they remain at a remove from the theories of Subjective art explored by some of the group's adherents, Scott's paintings nonetheless reflect some sympathy with their interest in the psychology of children's art, and the example of Paul Klee (*Exhibition of Subjective Art*, exh. cat. Lr Baggot St, Dublin 1944).

Self-taught as an artist, Scott's early ventures were carried out while he was studying architecture, and something of an associated structured aesthetic is evident in his work of the 1940s, and especially into the 1950s during the fifteen or so years he worked with the architectural firm Scott Tallon Walker. *Building Operations Sundown* (1956, Patrick Scott collection), for example, was prompted during a working visit to New York, inspired by the reflection of sun on the rectangular window of a skyscraper covered in scaffolding.

In the early 1960s, Scott temporarily ventured into a softer painterly aesthetic, when his travels across Ireland by train exposed him to rain-sodden landscapes, resulting in the 'Bogland' series, such as *Quiet Morning* (1962, Ronnie and Nora Tallon collection). The wet-on-wet technique provided a sympathetic method of conveying something of the physical atmosphere of such environments, a kind of visual onomatopoeia.

While Scott generally avoided politicizing his work, an exception was the 'Device' series developed as a protest to the H-bomb tests in the early 1960s. In common with many artists of the time, the potential for human destruction caused serious alarm and prompted a strong reaction. As a development from the staining techniques he had been exploring, the 'Device' series also allowed trickles of paint to trail down the tilted canvases or flare out from 'explosive' cores, exploiting the relevant conditions of unpredictability and limited control (*Large Solar Device*, 1964) [411]. While the techniques he developed bear resemblance to similar methods practiced in the USA, among artists like Morris Louis and Helen Frankenthaler from the late 1950s, Scott asserted his independence in his working methods of the time. The transition to Minimalism in 1964, while reflecting his earlier interests, comes as a significant contrast to the softer 'Bogland' and 'Device' series

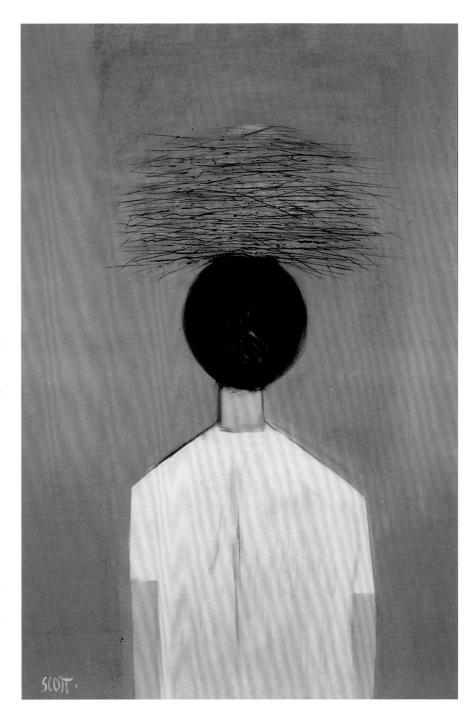

that were prompted by his experience of environments and concern for contemporary events.

The 'Goldpainting' series, from the start, involved a limited range of materials, initially making use of a store of gold leaf in Scott's possession at a time when he was looking for ideas. Scott took advice from experts on how to apply it, developing a method of adhesion that seems to be remarkably durable (Scott was known to use a hose to clean some of his artworks). The earliest of the series are highly reductive, gradually becoming more complex in form over time, as in *Cross (Polyptych)* (1973, private collection). Comprised of

446. Patrick Scott, *Woman Carrying Grasses*, 1958, oil on canvas, 183 x 122 cm, private collection

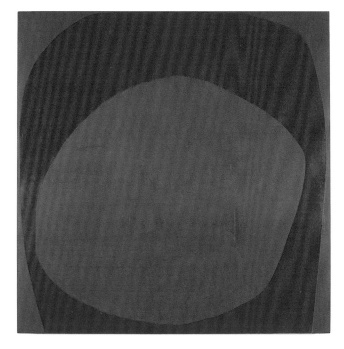

447. Patrick Scott, *Small Rosc Symbol*, 1967, oil on panel, 152.4 x 152.4 cm, Irish Museum of Modern Art

Born in Kilbrittain, Co. Cork, Patrick Scott spent his working life in Ireland at a time when other innovative artists felt the pressure to leave for more sympathetic environments for their explorations. His early work drew strong criticism from the more conservative commentators. However, Scott's potential was acknowledged in his selection to represent Ireland at the *Guggenheim International Exhibition* in 1958 in New York, when one of his exhibits, *Woman Carrying Grasses* (1958), was shown at MoMA, New York. He represented Ireland again in 1960, securing the National Award. He was also selected to represent Ireland at the 30th Venice Biennale in the same year, with a solo show, and these successes led him to give up architecture to concentrate full-time on his artwork. A founding member of Aosdána (qv), Patrick Scott was conferred with the office of Saoi in 2007. His work is included in national, municipal and institutional collections in Ireland (IMMA, HL, CAG, CIAS, TCD), in most important corporate collections and in many collections abroad. A significant survey of his work took place in the DHG, Trinity College in 1981, and a major retrospective was held at the HL in 2002. His work is widely collected in Ireland. Yvonne Scott

SELECTED READING Nordness and Weller, 1962, p. 270; Dorothy Walker, *Patrick Scott* (Dublin 1981); Yvonne Scott, Christina Kennedy, Raymund Ryan, Dorothy Walker, Michael Wilson, *Patrick Scott: A Retrospective*, exh. cat. HL (Dublin 2002), pp. 89–95; Aidan Dunne, *Patrick Scott* (Dublin 2008).

four identical panels, the work can be rearranged to make new forms, thereby engaging involvement by curators and collectors, people other than the artist and bringing the work into the field of Postmodernism (see 'Modernism and Postmodernism'). Since their inception, the 'Goldpaintings' have represented the single most dominant format in Scott's work for the proceeding four or five decades.

Patrick Scott's career as an architect, as well as involvement with the design company Signa, informed various other aspects of his work, from mosaics for the Busárus building, to tapestries intended to work collaboratively with contemporary architecture, as with the monumental *Blaze* (1972) [467], commissioned by Scott Tallon Walker for the Bank of Ireland building in Baggot Street, Dublin. The tapestries were carried out, to Scott's instructions, by V'Soske Joyce, carpet hand looms at Oughterard, Co. Galway, and by Atelier Tabard Frères & Soeurs at Aubusson (Kennedy, 2002, pp. 89–95).

Scott is credited also with the design of the hang of the first Rosc exhibition (qv) at the RDS in 1967, and the cover of the exhibition catalogue which featured his purpose-designed painting [447]. While, controversially at the time, none of the artists whose work was included in that first Rosc were Irish, the catalogue cover with Scott's painting met with critical acclaim. Drawing on the meaning of the Irish word 'rosc' (translated, both as 'a battle cry' and 'eye of vision'), Scott brilliantly conceived an abstracted form that could suggest either/both the aperture of mouth or eye, opened to its fullest. Informed by his interest in Zen philosophy, and by his interpretation of Japanese aesthetics, Scott combined his art and design capacities in a series of screens, in the late 1970s, and of elegantly folding tables in the early 1990s, intended to extend the combined reach of art and meditation to daily living.

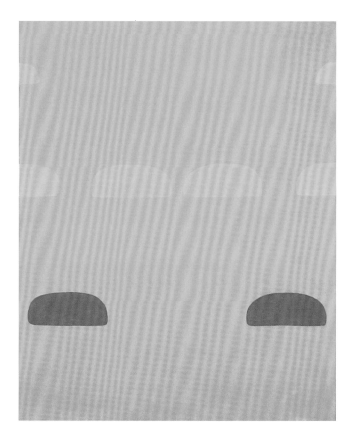

448. William Scott, *Parallel forms, Orange*, 1971, oil on canvas, 254 x 203.2 cm, Irish Museum of Modern Art

SCOTT, WILLIAM (1913–89) [448, 449], painter. Born in Greenock, Scotland, of Irish and Scottish parentage, William Scott moved to Ireland in 1924, when his father, a house painter and sign writer, returned to his hometown of Enniskillen, Co. Fermanagh. Three years later, Scott's father was tragically killed, while helping to put out a fire. From an early age, Scott's artistic talents had been recognized, and his parents had employed Kathleen Bridle, a teacher at the Enniskillen Technical College, to give him private art lessons. A graduate of the RCA, Bridle introduced Scott to the writings of Roger Fry and Clive Bell, and to the work of French Post-Impressionists such as Bonnard and Cézanne. Aged fifteen, assisted by a scholarship provided by the town council of Enniskillen, Scott enrolled at the Belfast College of Art. However, when compared with the tuition he had received from Bridle, he found the teaching there old-fashioned. In 1931 Scott moved to London, enrolling as a sculpture student at the RA Schools. The following year, for the first time, he saw at first-hand the works of Cézanne and other Post-Impressionists, at an exhibition of French art at the RA. Although awarded a silver medal for sculpture in 1933, Scott transferred the following year to the painting school.

During his student years, Scott formed a friendship with F.E. McWilliam who had enrolled at the Slade School of Art three years previously. Scott shared a flat with Alfred Janes and Mervyn Levy, also with Dylan Thomas, which led to a lasting friendship. Over the years he also formed friendships with Terry Frost, Patrick Heron, Bryan Winter and Roger Hilton.

Leaving his RA course unfinished, Scott spent time in Cornwall, then London, painting landscapes inspired by Cézanne. He and a former fellow-student, Mary Lucas, married in 1937, after which they travelled to Italy for six months, visiting Florence, Venice and Rome. The following year, the couple moved to Brittany, where, along with former Slade student Geoffrey Nelson, they ran the Pont-Aven School of Painting. On the outbreak of World War II, the Scotts moved initially to the safety of Dublin, where their son Robert was born in 1940, but soon afterwards they moved to London. During the Blitz, they left London and bought a house at Hallatrow, in Somerset, where Scott started a market garden. A second son, James, was born during this period. Scott enlisted in the Royal Army Ordnance Corps and was sent to Wales, where designers with the Corps worked on the production of maps. Although Kenneth Clark, chairman of the War Artists Advisory Committee, was aware of his talents, Scott was not appointed a war artist. Here he learned lithography, using this new skill to produce a series of lithographic prints in 1945, to accompany an anthology of war poems entitled *Soldiers' Verse*. While serving with the Engineers, Scott exhibited at the Leger Gallery in 1942, showing mainly figure studies, with his wife Mary acting as model.

After the war ended, Scott visited Pont-Aven, hoping to recover the art materials he had been forced to leave behind, also wishing to resume artistically from where he had left off before the war. He worked on paintings of Breton women and other figure studies. Back home in Somerset, his paintings became increasingly abstract, often based on cooking utensils, objects which provided a link with his childhood in Scotland and Northern Ireland. These still lifes – of iron frying pans, eggs,

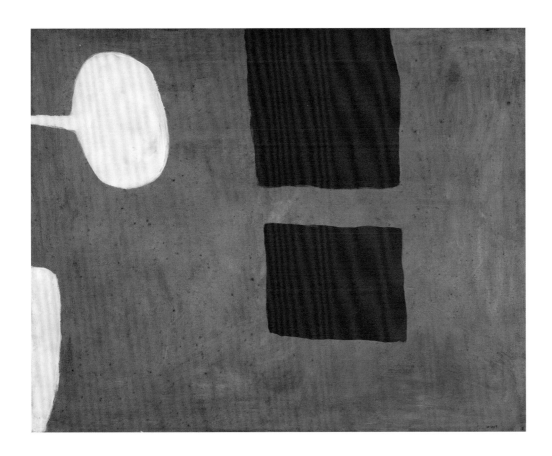

449. William Scott, *Two and Two 1*, 1963, oil on canvas, 100 x 125 cm, Dublin City Gallery The Hugh Lane

bottles and wooden spoons – became the principal subject of Scott's art from 1947 onwards, although he continued also to produce figure studies. His interest in kitchen objects was prompted by their everyday quality, by the fact that he believed simple plates, pans and utensils lacked associations that would lead the viewer of the artwork to create meaning or narratives in the work. This austerity of vision linked with Scott's early childhood, can also be associated with post-war rationing. However, there is a deliberate erotic quality in these simple abstractions, and in the choice of pots and pans, pears and plates, which can convey an elemental sense of sex, and also an underlying duality between male and female (Balfour-Oatts, p. 6).

Scott taught at the Bath Academy of Art for a decade from 1946, when he was appointed Senior Painting Master and where his students included Howard Hodgkin. Scott's interest in lithography, encouraged by a fellow-teacher, printmaker Henry Cliffe, resulted in his first print based on a landscape, *Cornish Harbour* (1951), which also incorporated a still life of fish on a tabletop. Over the following decades, Scott translated some of his most successful paintings into lithographs or screenprints.

In 1952 Scott visited an exhibition of works by Nicholas de Stael, held at the Matthiesen Gallery, New Bond Street, London. De Stael's thick impastoed paint, applied with a palette knife, inspired Scott to work in a more painterly sensuous way. The following year, after teaching at the Banff Summer School in Canada, he visited New York, where Martha Jackson (at whose New York gallery he had several exhibitions) introduced him to Jackson Pollock, Franz Kline and Mark Rothko. Three years later, Scott resigned from his teaching post at the Bath Academy to concentrate on studio work. In 1958 he represented Britain at the Venice Biennale, where his importance was recognized internationally. Four of his paintings were acquired by European museums, while *Blue Painting* (1957) was acquired privately by the curator William S. Lieberman and bequeathed by him to the Metropolitan Museum of Art, New York. The twenty paintings by Scott shown at Venice were subsequently sent on tour to Zurich and other cities, which led to invitations to show at Freiburg, Dortmund and Munich. Anton Tapies, who represented Spain at the 1958 Venice Biennale, and who also showed at the Martha Jackson Gallery, became a long-time friend.

In the following decade, Scott's painting became increasingly abstract, and he developed an idiosyncratic and instantly recognizable style, in which the still-life elements of his previous work were reduced to essentials of form and shape on the surface of the canvas. These still lifes, a genre Scott returned to throughout his life, are essays in the pure tactile and visceral qualities of paint. Skirting warily around the domains of abstraction (qv) and representational art, he remained, in his own words, 'an individualist'. Along with Lanyon, Heron, Wynter and Hilton, he became part of a group of British artists identified as 'the Middle Generation', who all, while adopting varying degrees of abstraction and non-figurative art, retained at the core of their art a sense of the figure, or the still-life motif. By the late 1950s, however, Scott was moving towards an almost completely non-figurative approach, his work characterized by an interest in texture, in the physical scratching of paint, where contrasting thick and thin lines emphasized the direct elemental quality in his work. Works from this time, such as *White, Sand and Ochre* (1960–61, Tate), were inspired by the cave paintings of Lascaux in France. In 1958, along with McWilliam, Scott was commissioned to make an art work for the new Altnagelvin Hospital on the outskirts of Derry city. For the hospital he painted a large-scale mural, 9 feet high and 45 feet long. Scott was working on this commission when, in January 1959, the *New American Painting Exhibition* was held at the Tate Gallery, which included works by Rothko, Gottlieb, Pollock, Kline and Gorky. Mark Rothko travelled to London for the exhibition, and visited Scott in his studio. The mural, having been shown at Tate in 1961, was unveiled at Altnagelvin Hospital the following year. In 1967 Scott was commissioned to paint a mural for the new RTÉ radio and television centre in Dublin, designed by Scott Tallon Walker.

A number of Scott's abstract paintings from the early 1960s are based on a grid. His *Gaelic Landscape*, from around 1961 (private collection: no. 490 in the *Catalogue Raisonné of Oil Paintings*), is a strong composition, with areas of thick impasto oil paint helping to define the almost bas-relief structure of the work, in which ultramarine blue 'cells' are separated by white borders. The divisions might be taken as purely abstract formal devices, but the title suggests field divisions, particularly the dry-stone walls of the west of Ireland, Scotland or Brittany. Around this time, working with Stanley Jones of the Curwen Print Studios, Scott made a series of screenprints, inspired by the islands off the Scottish coast, with titles such as *Arran* (1960) and *Iona* (1961).

In the mid-1960s, Scott spent over a year working in Berlin. A retrospective exhibition of his work was shown at the Tate in 1972, the same year in which Leslie Waddington Prints displayed 'A Poem for Alexander', a series of sixteen screenprints based on Euclidian mathematics. During 1976/77, Scott produced 'Orchard of Pears', a series of seventeen small oils in which pears were arranged so as to emphasize their formal, but also their sensuous, qualities.

Although he never lived in St Ives, Scott's visit to Cornwall in the mid-1930s was the first of many there. In the context of the art of his time, his remains closely linked to the adventurous group of painters and sculptors who forged an abstract art of a more rigorous discipline than that found in London in those same years. Scott's own approach to painting was instinctive, lyrical and full of expression. While he eschewed Realism (qv), and restricted himself, for the most part, to a limited visual vocabulary, with the shapes and outlines of familiar objects, his painting, drawings and prints unify objects and their surrounding space. They are full of a sense of vitality and reveal their own making, without artifice or illusion.

Scott's work is represented in many permanent collections around the world, including Australia, Canada, the USA, Austria, Finland, France, Italy, Germany and Britain, and in Ireland it can be seen in the collections of the NGI, IMMA, HL and TCD. PETER MURRAY

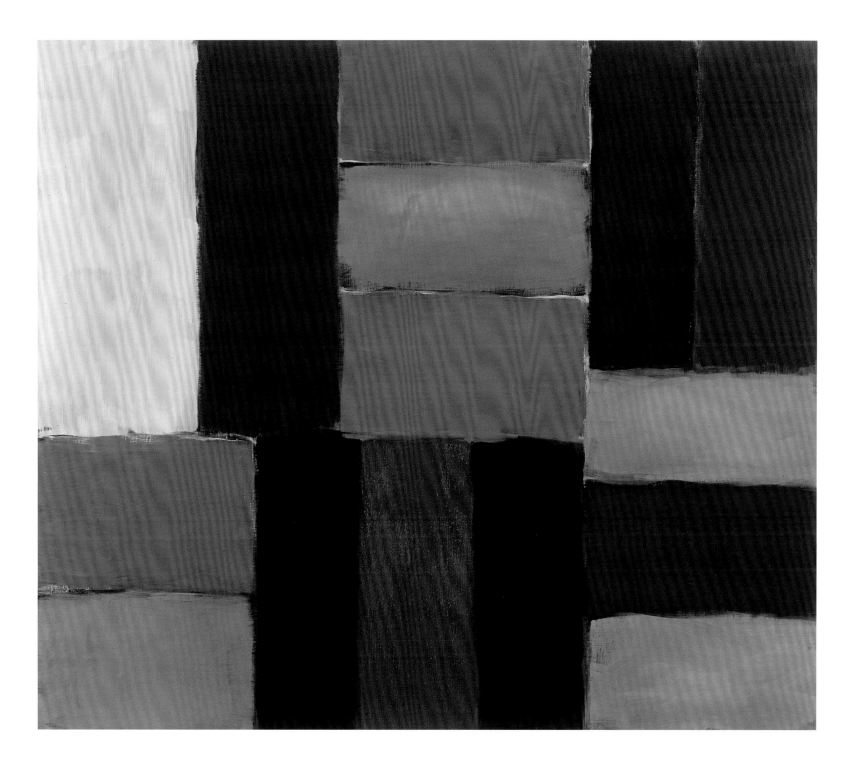

SELECTED READING Alan Bowness (ed.), *William Scott: Paintings* (London 1964); Alan Bowness, *William Scott*, exh. cat. Tate Gallery (London 1972); Michael Tooby and Simon Morley, *William Scott: Paintings and Drawings*, exh. cat. IMMA (Dublin and London 1998); Brian Balfour-Oatts, *William Scott: A Survey of his Original Prints* (London 2005); Norbert Lynton, *William Scott* (London 2004, 2007); Sarah Whitfield (ed.). *William Scott Catalogue Raisonné of Oil Paintings*, 4 vols (London 2013).

SCULLY, SEAN (b. 1945) [450, 451], painter. Born in Dublin, educated in England, and with studios in New York, London and Germany, Sean Scully fits the Modernist image of the artist who transcends place and national identity, making artwork that is relevant wherever he chooses to place himself. 'It's very important to me that in a certain sense I don't have a nationality', he said, 'And when people ask me what I am, I usually say nothing. I think "nothing" is a pretty good place to start from.' (Scully interview with Herzog, p. 105)

Scully recognizes the importance of migration in present-day life, with strong memories of his own dislocations,

450. Sean Scully, *Wall of Light, Summer*, 2001, oil on canvas, 182.9 x 213.4 cm, AIB Collection

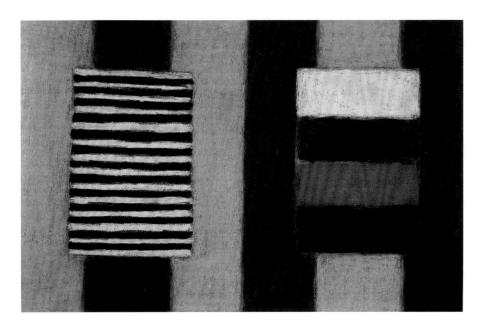

451. Sean Scully, *7/7/91 in memory of Robin Walker*, 1991, pastel on paper, 101 x 152 cm, Irish Museum of Modern Art

challenges in its history, accused of being a tool of racial and sexual discrimination, of commodification, and of being irrelevant in a world of new technology. Scully responded assertively, emphasizing the physicality and three-dimensionality of his paintings, deriving from add-ons and insertions, or by creating paintings that project from the wall at right angles. The physical process of painting gives the work a human surface, vitally important in a world of digitally generated images that are depersonalized, flattening and artificial.

For all its materiality, Scully's abstraction is interpreted by some commentators as a form of religious metaphysics. However, his view of spirituality is bound up with the human spirit, rather than the divine, having abandoned his childhood Catholicism in favour of humanism. 'It is as if the spirituality in art stepped off a pedestal … and joined the world of the living', he told R. Eric Davis (interview for the *Journal of Contemporary Art*, 1999, http://www.jca-online.com/scully. html, accessed April 2004). Since the human spirit is imperfect, uncertain and ill-defined, an art that reflects this cannot espouse perfection.

Scully believes that all abstraction (qv) is based on reality and that all reality is open to abstraction. Abstraction, he also believes, is generous and universally accessible. 'It's a nondenominational religious art. I think it's the spiritual art of our time.' (Higgins, p. 106) Reviewing the Mark Rothko retrospective in the Whitney Museum in New York in 1998, Scully quoted Rothko's claim that abstract shapes become performers, figures in a drama in which they can act without embarrassment or shame (Kennedy, 2006, p. 71 and footnote 3). He believed this to be Rothko's most radical statement, because it facilitated a form of representational narrative while remaining completely abstract. This attitude runs directly counter to current beliefs among other New York painters, such as Barnett Newman, that abstraction meant an end of the figure-to-ground relationship. Scully endorsed Rothko's belief as 'It allows you to think without making oppressively specific references, so that the viewer is free to identify with the work' (Kennedy, 2004, p. 10). He developed this point in a letter to Brian Kennedy: 'I'm very attracted to his [Rothko's] relationship with abstract art. Not the fluid style of his abstraction, but its relationship with the figurative. Even in his most resolutely abstract work the memory of the figure is embedded into the surface. This I could say of myself.' (Kennedy, 2006, 72)

Barnett Newman sought to find a way of painting as if painting had never existed before. Scully, by contrast, stresses continuity, represented in his paintings by the under-layers of paint that seep up between the surface stripes, and the smaller canvases inserted into larger canvas or metal grounds. He is happy to acknowledge the influence of the old masters on his work. Like van Gogh, Mondrian and Rothko, his use of colour is complex and emotional. He builds up his paintings in layers, each layer influenced by the one it obliterates, and likes to think the different bands and bars in his striped painting are pulsating, as if under pressure from the repressed layers of earlier paint underneath.

firstly with his parents from working-class Dublin to an Irish enclave in London, and later to New York, where he worked on building sites or shot pool for money. He identifies with artists such as Mondrian and Rothko, and the writer Joseph Conrad who, like him, emigrated from Europe to New York. While his affinities with Rothko's intense understanding of the expressive potential of colour and brushstroke are obvious, he likes Conrad for the occasional awkwardness in his prose. Believing that Conrad uses words in the wrong place, he says, 'this gives his writing an incredible power' (Kennedy, 2004, p. 19). Scully incorporates a similar crude strength and an ability to upset expected rhythms in his own work. While all too aware of the discontinuities experienced by most migrants, Scully is also quick to acknowledge migration's positive impact. His paintings belong within the Northern European Romantic tradition, as described by Robert Rosenblum. Like van Gogh, Mondrian and Rothko, key figures in Rosenblum's analysis, it is in the transposition from a culture embedded in tradition, through the process of migration, to a culture where change and difference are paramount that the charge in Scully's work emerges.

His Romanticism, therefore, is urban. 'I love urban mess and filth. It expresses human nature so poignantly.' (Carrier, p. 27) This marks a break with the European Romantics who were inspired by nature and the divine. Scully's notions of the spiritual are rooted in the modern world. His everyday landscape is urban and architectural, contemporary and material. His means of expressing this, by drawing on an uncompromisingly abstract vehicle for its delivery, is removed from the trivial and the specific and becomes universal. His chosen form is the stripe, presented in endless variation. 'I want to express that we live in a world with repetitive rhythms and that things are existing side by side that seem incongruous or difficult. Yet out of that is our truth …' (Herzog, p. 103).

When Scully graduated from Newcastle University with an honours BA in Fine Art in 1972, painting was facing the biggest

Surprisingly, given his adherence to one particular formal device, the stripe, Scully is vehemently opposed to formalism as an end in itself. The tension between the range of thoughts and emotions that the artist wants to express, and his severely limited means, is what gives his paintings their power. Not only does he restrict himself to the stripe, since the mid-nineteen-eighties he uses this device only in vertical or horizontal arrangements, having abandoned the diagonals he employed in the previous decade. He came to believe that the best way to represent whatever exists between the vertical and the horizontal is to imply, but never to state it directly. This, like his increasing use of chequerboard formats, compresses the emotional energies into ever more repressive situations, so that colour, application and ground become powerful vehicles of expression. Using diptych and triptych formats, and cut-outs with inserts, overlaid with vertical and horizontal stripes of varying depths and strengths, he explores different positions, visualizing a debate between opposing sets of polarities, such as living/dead, past/present, loss and retrieval.

The coincidence of the death of his mother at the same time as his rediscovery of an old friend, now director of Kunstverein, Aichach, Germany, led to an exhibition there in 2004 in which he decided to show works about his mother in the gallery, which resembled a church but is actually a restored cowshed. The four teen small paintings and one bigger one in this exhibition mimic the combination of Stations-of-the-Cross and altarpiece of Roman Catholic ritual. The final installation holds all these associations and meanings. Similarly, the 'Mirror' series allows the artist to explore ideas of reflection and narcissism, while paintings with windows (cut-outs) point attention away from the self and the now, into another time, another place.

Scully has been important as a role model in Ireland. His single-minded pursuit of a language of expression, and his international success in doing that, raises confidence in younger artists. His interest in the country of his birth becomes explicit in recent bodies of work, such as his print portfolio responding to James Joyce's *Pomes Penyeach* and his photographs of stone walls on the Aran Islands. Irish history may inform Scully's lack of interest in tragedy, preferring the melancholy so pervasive in Irish art since the Famine, and especially evident in the work of artists such as Gerard Dillon and Tony O'Malley (qqv). Donations of his work to IMMA and the HL, and his recent acceptance of membership of Aosdána (qv) provide further evidence of his relationship with his native country.

Sean Scully's work can be found in most major museums of contemporary art. CATHERINE MARSHALL

SELECTED READING Rosenblum, 1975; Judith Higgins, 'Sean Scully and the metamorphosis of the stripe', *Artnews*, LXXXIV, no. 9 (November 1985); Ned Rifkin (ed.), *Sean Scully: Twenty Years, 1976–1995* (London 1995); David Carrier, Danillo Eccher and Hans Michael Herzog, *Sean Scully*, exh. cat. Galleria d'Arte Moderna di Bologna (Milan 1996); Brian P. Kennedy (ed.), *Sean Scully: Body of Light*, exh. cat. NGA (Canberra 2004); B.P. Kennedy, 2006.

SEAWRIGHT, PAUL (b. 1965) [452], photographic artist. Seawright's art photographs (see 'Photography') are both understated, in their subject matter, and deeply subversive. At first glance they appear to be photographs of innocuous, familiar, often ignored scenarios, the things we see unconsciously out of the corner of an eye. Deeper examination, however, prompts searching questions about the seemingly innocent paraphernalia, places and rituals of our everyday lives. Writing of his exhibition *Orange Order* in Dublin in 1992, Lynne Connolly called attention to Seawright's 'insistent intentional cropping, [which] draws the viewer in, offering a closer and more claustrophobic viewpoint. These subjects and rites are not accustomed to being viewed in this manner. The usual viewpoint being extremes of distance or belonging. The viewer is left with an uneasiness not settled by the smoothness and richness of the images themselves.' (http://www.source.ie/issues/issues0120/issue01/is01revoraord.html, accessed 1 June 2012)

Although his practice is a photographic one, Seawright could be considered to be one of the modern heirs to the traditional genre of history painting (qv), but his history focuses on the lives of ordinary people in situations where conflict and neglect can be shown to have as pervasive an impact on society as the decisions and actions of politicians and military idols. His interpretation of history has more to do with evolution, usually in marginalized working-class situations, rather than the heroics of revolution.

452. Paul Seawright, *Gate*, 1997, C-type photograph on aluminium, 160 x 160 cm, Irish Museum of Modern Art

Seawright studied at the University of Ulster in Belfast and at West Surrey College of Art and Design where his tutors included the photographers Paul Graham and Martin Parr. He served as Dean of Newport School of Art, Media and Design of the University of Wales, where he was awarded a doctorate and honoured with a personal chair in 2001.

Since the late 1980s, Seawright's photographs of locations where sectarian murders had taken place, and the dehumanizing architecture of police barracks and protective security arrangements along the peace line in Belfast, aroused positive critical notice. By combining pictures of the murder sites with newspaper reports from which all references to the victim's religious affiliations were obliterated, in *Sectarian Murder* (1988) Seawright called attention to the numbers of civilians whose lives were sacrificed to politics, while images of rusting iron barriers and gates erected to prevent terrorist attacks pointed out the degree to which civilian life was constrained and brutalized in the name of ideology. Other bodies of work relating specifically to the 'Troubles' in Northern Ireland (see 'The Troubles and Irish Art') include *Orange Order* and *Conflicting Account* (2009). By photographing the bustle of an Orange parade from the level of a child's eye, Seawright subtly questions the stature of the participants, the glamour of the uniforms and their continuing influence over generations. The power of the environment to shape future action, suggested in *Police* (1997), for which he won the IMMA/Glen Dimplex Artists Award in 1997, and *Conflicting Account*, is explored again in a body of work, *Volunteer* (2011), photographed in American towns and cities where young people were recruited to volunteer for service in the gruelling wartime conditions of Iraq and Afghanistan. In 2002 he became one of several artists to accept a commission from the Imperial War Museum in London to travel to Afghanistan in the wake of the attacks on the World Trade Center in New York on 11 September 2001. His approach there was to take photographs of the breathtakingly beautiful landscape, reminiscent of those in archaeological travel books, but the ruins in his images bear subtle indications of recent military destruction, and the detritus in the desert reveals itself as either spent bullet casings or landmines.

Invited to create a piece of public art as part of the *In Context* programme in Tallaght in Dublin in 2000, Seawright produced *The Map*, a limited edition publication of day and night-time photographs of the sometimes fraught impact of urban development on a rural environment. The book was distributed to nearly 20,000 homes in the area, while one of the images in it, Horizon Night, inspired the musical composition Tallaght (Chiaroscuro) by Stephen Gardner in a later phase of the same public art programme.

Seawright has been Professor of Photography at the University of Ulster since 2007. He was awarded a residency at IMMA in 1999 when he also won the Artist Award of the Ville de Paris. He has served as a member of the ACNI. A thirty-minute documentary, *Profiles: Paul Seawright*, by Fintan O'Toole was broadcast by BBC4 in 2003, and a radio documentary, *Afghanistan: Ashes to Dust*, for BBC Radio Wales and the BBC World Service was broadcast in 2002.

His work has been exhibited widely in Europe, Asia, North America and Africa and in biennials in Tokyo (1998), Los Angeles (2001), Venice (2003) and Seoul (2005). He has been invited to participate in exhibitions alongside some of the most acclaimed names in photography internationally, including Sophie Calle, Willie Doherty (qv), Nan Goldin, Candida Höfer, Vik Muniz, Shirin Neshat, Martin Parr (his one-time tutor), Thomas Struth, Wolfgang Tillmans and Gillian Wearing.

Seawright's work can be seen in many of the major international art collections, including those of Tate, the San Francisco Museum of Modern Art, the British Council, the Imperial War Museum, London, the Art Institute of Chicago and the International Centre of Photography, New York, as well as at IMMA, CAG, UM, the Arts Councils of Ireland, Northern Ireland and the UK, and in many corporate and private collections. Catherine Marshall

SELECTED READING Mark Durden and John Stathatos, *Paul Seawright: Hidden*, exh. cat. Imperial War Museum, London; IMMA; Oriel Mostyn Gallery, Llandudno; Ffotogallery, Penarth (London 2003); Hartz and Bacik, 2003; John Reader, Russell Roberts and Christopher Coppock, *Paul Seawright: Invisible Cities*, exh. cat. Ffotogallery (Penarth 2007).

SEYMOUR, DERMOT (b. 1956) [453], painter. Although Seymour's paintings can be described as photo-realist, they are more an amalgam of Surrealist (see 'Surrealist Art') imagery within traditional landscape painting (qv). The figurative elements introduced into the canvases may not in themselves be surreal, but by juxtaposing emblematic devices, objects, artefacts and animals, the artist creates images resonant with meaning. Sheep, cattle, crucifixes and helicopters give these works an atmosphere not unlike the mixed-media art of Robert Rauschenberg, although Seymour's polished technique and finish is quite different to Rauschenberg's Expressionism. Freed from the confines of literal interpretation, Seymour's art explores the subconscious and the world of dreams. Poetry is an important influence on the work. Seymour is one of a number of artists whose paintings have been directly influenced by the 'Troubles' (qv) in Northern Ireland. However, they also explore wider territory in which social, religious and political identities are created and maintained through ritual, image and association.

Seymour's best-known works depict emblems of unionism, such as Lambeg drums and Union Jack flags, set in nightmarish landscapes often inhabited by levitating cows, flying rams, foxes and rats. The atmosphere of anxiety and unease is heightened by the titles of the works, such as *Dreaded Bovinical Trout Drought* or *The Tubular Croaking of Plastic*. *On the Balcony of the Nation* (1989, ACNI collection) depicts a cow standing on the edge of a rock that appears to be flying through space. *The Omnipotent Lt Zhdanov is Outside Cutting the Corn* (private collection) shows a woman lying on her back, her head resting on a sleeping pig, while a helicopter hovers outside an open doorway. *The Russians will water their horses on the Shores of Lough Neagh* (1984) again depicts a helicopter gunship, this time hovering over a landscape. The title is a misquotation of a line from a poem by Paul Muldoon. Seymour's more recent paintings have been less directly concerned with

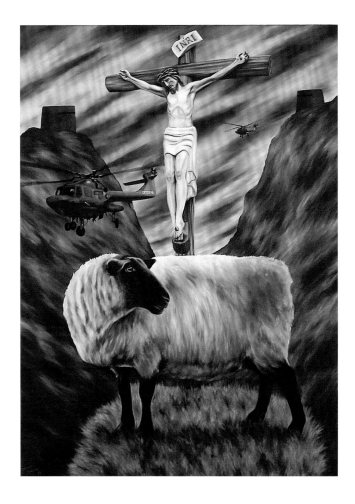

and 1993, and *On the Balcony of the Nation*, which was shown in venues in the USA in the early 1990s. A keen fisherman, Seymour lives and works in Partry, Co. Mayo.

Seymour's work can be found in the collections of the AC/ACE, ACNI and HL. PETER MURRAY

SELECTED READING Liam Kelly, *Dermot Seymour – Works 18* (Kinsale 1995); Ian Wieczorek, *Dermot Seymour: Dank*, exh. cat. Galway Arts Centre (Galway 2002); Megan Johnston, *The Bloated Inability to Eat Flags: Dermot Seymour Selected Paintings 1983–2004*, exh. cat. Millenium Court Arts Centre (Portadown 2004).

SHANAHAN, SEÁN (b. 1960), painter. Seán Shanahan, born in Dublin, is a painter of highly refined, formal abstractions (see 'Abstraction'). His work repeatedly references post-minimal aesthetics, incorporating visual and conceptual strategies associated with the idea of the 'specific object'. This has manifested itself redolently in his use of rigid supports which, constructed from both natural and man-made materials, emphasize the corporeal presence of his work. Despite the austere nature of his practice, Shanahan has developed a discriminating visual idiom, combining elegant compositions with the subtle architectonics and installation of each painting.

From 1979 to 1982, Shanahan attended Croydon College of Art and Design, London, before taking a residency at the Olivar de Castillejo Foundation, Madrid, from 1986 to 1988. He later moved to Montevecchia in northern Italy where he has lived and worked ever since. His first solo exhibition was at the Luigi Deambrogi Gallery, Milan (1983) and since then he has

453. Dermot Seymour, *The Queen's Own Scottish Borderers observe the King of the Jews appearing behind Seán McGuigan's Sheep on the Fourth Sunday after Epiphany*, 1988, oil on linen, 153 x 112 cm, private collection

iconography inspired by the Troubles and deal more with the artist's reaction to broader issues in society, particularly the damage caused to animals and the natural environment by the activities of mankind.

Born in Belfast, Seymour grew up on the Loyalist, working-class Shankill Road. He was still a teenager when riots, bombings and reprisals began to dominate Northern Irish life and politics. After studying at the University of Ulster, where he received a BA in Art and Design in 1978 and an Advanced Diploma in Art and Design in 1981, Seymour quickly established himself, along with painters such as Diarmuid Delargy, Fergus Delargy and Rita Duffy (qv), as an artist whose work explored the psychology and unconscious of Ulster. He is a member of Aosdána (qv), and his work has been shown extensively. He participated in *In a State*, curated by Jobst Graeve and held at Kilmainham Gaol (1991), and also showed at the Monaghan Museum (1999), the Orchard Gallery (2000), and the Galway Arts Centre (2002). A retrospective exhibition, *Fish, Flesh and Fowl*, was held in 2011 at the Golden Thread Gallery in Belfast and toured to the Solstice Arts Centre, Navan, Co. Meath, and the Centre Culturel Irlandais, Paris. In addition to regular showings of his work throughout Ireland, group exhibitions in which Seymour has participated include *The Fifth Province: Some New Art from Ireland*, which toured Canada between 1991

454. Seán Shanahan, *Untitled III, Jan–June*, 1994, oil on MDF, 200 x 170 cm, Irish Museum of Modern Art

exhibited his work throughout Europe, holding solo shows in Italy, the Netherlands and Germany. Since he adopted a rational approach to painting, his early works feature geometric compositions painted in plain colours on blocks of natural wood and sheets of folded steel.

When Shanahan held his first solo exhibition in Ireland at the Kerlin Gallery in 1991, this 'literal' form of abstract painting was not fully appreciated. One critic noted that the 'absence of emotional content makes these constructions seem somewhat anaemic, lacking any elemental force' (Desmond MacAvock, 'Abstracts at the Kerlin Gallery', IT, 10 September 1991). The apparent absence of expression in Shanahan's work is not the result of a strict purgative painting process but rather a side-effect of an acutely measured creative practice. Compositions are formed through a progression of specific, yet intuitive, reactions to the material factors unique to each support – the grain of natural wood or the polish marks on steel. Shanahan stresses, 'I try to find something absolute within each painting and to clarify that' (Dawson, p. 5). In works such as Untitled III, Jan – June [454], paint is applied in layers, stripped back and reworked. The result is a considered yet ambiguous balance of geometric elements that appear to have materialized from within the support itself.

As with other Irish abstract painters, such as Ciarán Lennon and Michael Coleman (qqv), Shanahan's individual method of working separates his practice from the objectives of Minimalism (qv). Rigorous formalism is consistently subverted by a discreet process of imbalance, a dichotomy the artist has cultivated into a refined aesthetic. Since the late 1990s, his compositions have been regulated to solitary fields of colour applied to board. Initially demarcated on three sides by areas of bare MDF, these rectangles later swelled into expansive monochrome fields. Seemingly intangible, the unmodulated surface of these paintings is ultimately fractured by a strip of bare MDF that borders at least one edge of the picture plane. The effect draws attention to the perceptual properties inherent in the edges and physical proportions of the object. In some cases, the edges have been tapered back at an acute or obtuse angle, emphasizing the subtle dynamic that exists between the pictorial surface and the supporting structure.

Since the millennium, Shanahan has focused on developing the theatrical possibilities of his work. In 2002 he was invited to produce a series of paintings in response to the eighteenth-century rooms of Charlemont House, HL. Entitled Vidar, the exhibition featured a collection of precisely measured compositions which, when juxtaposed with the interior architecture, established a visual rapport with their environment. Shanahan continues to explore this aspect of his practice, advancing the visual and conceptual relationship between his paintings, the viewer, and the architectural setting. His work is included in the collections of IMMA and the HL. DONAL MAGUIRE

SELECTED READING Joseph Coveney, Minimalism in Contemporary Irish Art, thesis (NCAD, Dublin 2001); Barbara Dawson, Mel Gooding and Jens Peter Koerver, Seán Shanahan: Vidar, exh. cat. HL (Dublin 2002); Gavin Morrison, 'Sean Shanahan: Marginal Ambivalence', in Jackson, 2008, pp. 71–4.

SHAWCROSS, NEIL (b. 1940) [455], painter. Born in Lancashire, Shawcross studied at Bolton College of Art. He taught at the College of Art, Belfast, from 1962 to 2004. In his early years in Belfast he was befriended by Mary O'Malley and Alice Berger Hammerschlag. He also met Seamus Heaney, Solly Lipsitz and David Hammond, and exhibited at the CEMA gallery.

Shawcross loves Americana, particularly as evidenced in its Garrison Keillor small towns: its graphics, commercial packaging and celebratory postcards of an earlier America. He also loves music, pulp fiction, film and sport. This delight in visual and popular culture was directly expressed in a series of 'Letter' paintings and also in the use of stamps in a woodcut series. Indeed, since 2005 he has produced an annual calendar for No Alibis bookshop in Belfast, reproducing in painterly form the book jackets of crime novels.

However, it is still life, the female nude and the portrait (qv) that have formed the mainstay of his practice for some fifty years. Shawcross's early nude paintings (late 1970s/early 1980s) were refined interpretations of figures in domestic settings, reminiscent of Bonnard or Vuillard. They were specific, naturalistic figures set into a decorative scheme where colour and pattern were important. The journey made by the artist since then has been one determined by release, technically and emotionally, as well as the abandonment of context. The figures through the years have become more and more abstract, weighty, fluid and playful. They are now emancipated archetypes shaped and developed by way of years of observation in the life room and the pull and push of painterly concerns. Strict anatomical truth has been replaced by painterly 'rightness'; form and feeling are conjoined and celebrated by the demands of paint.

This free development of paint in this nude series has come via cross fertilization from experiments in Shawcross's other subject interests, especially recent developments in his portrait painting. With the portraits, now life-size in scale, he moved progressively towards the general application of looser, thinner washes and tonal concerns with selected, contrasting, heavier impasto patches. In the case of the portraits, of specific individuals and mostly male, the subjects must be in front of him for the painting session. The nudes, by contrast, are conceived from memory or generalized shorthand-line drawings and are, any and all, women. Early portraits include Solly Lipsitz (1968) and Francis Stuart (1978). Later portraits include Stephen Rea as Oscar Wilde (1990), Seamus Heaney (2000), Michael Longley (2000) and Maeve Binchy (2008). In 2005 the UM mounted a major exhibition of his portraits covering a forty-year period.

If the nudes spring from the quick sketch, his still lifes are totally imagined. They come by way of the intuitive grasp of fruit and vessels, cups and saucers, tables and chairs. Their rhythmic lines mark time and space and are empowered by the artist's control of elemental lighting; shadows act as musical intervals and structural phrasing. All this is set within a blocked-in outer frame of reference in black and red, his recurring dyad of colours.

Shawcross exhibits regularly at the RHA and the RUA (qqv) and in commercial galleries in Belfast and Dublin. His work is represented in many private, public and corporate collections,

He was one of nine artists selected by Dorothy Walker for the exhibition *Without the Walls*, which was part of *A Sense of Ireland* (ICA, London, 1980) and served on the *Rosc '84* (see 'Rosc Exhibitions') committee.

Sheridan's art career began with painting. His early works were painterly abstractions, but reading John Banville's *Athena* prompted him to look at Old Master painting in a more conceptual way, although his interest in Conceptual art (qv) was influenced also by his familiarity with the New York art scene in the 1960s, when this movement was at its most energetic. Aversion to painting and technique at this time led Sheridan to look at canonical painting. Although Brian O'Doherty said of him, 'painting ... loved Noel for he was a natural painter and the stuff gratefully flowed from his fingertips' (O' Doherty, p. 29), his attempts to paint facsimilies of seventeenth-century pictures by Poussin and Claude proved to him that art must represent its own Zeitgeist. His RHA (qv) exhibition in 2001 set out to reveal this by combining performance with a frank revelation of his studio, his numerous failed attempts to paint as the Old Masters had done, and his solution: to create them digitally which, he said, were, ironically, closer to the original than his manual efforts (Ryan, p. 14). Not many people are aware of his early interest in the theatre. This prompted his joint presentation, with thc actor John Molloy, of the review *Tete at Eigh*t in New York in 1963 and influenced his subsequent interest in performance art.

455. Neil Shawcross, *Untitled (Chair)*, 1987, watercolour and pencil on paper, private collection

including Aer Rianta, Dublin, ACNI, Belfast City Council, RUA and the UU. LIAM KELLY

SELECTED READING Catto, 1977; Liam Kelly, 'To Dance in a Northern Temperate Climate' in *Neil Shawcross: New Paintings*, exh. cat. Tom Caldwell Gallery (Belfast 2002); Eileen Black (ed.), *Neil Shawcross: Forty Years of Portrait Painting* (Belfast 2005).

SHERIDAN, NOEL (1936–2006) [456], conceptual artist. Although he began his career as an actor and dancer, Noel Sheridan is recognized for his innovative work as an art educator and conceptual artist, two roles he felt were inseparable. Born in Dublin and educated at Synge Street CBS and TCD, he won the Macaulay Prize in 1961 which enabled him to study at Columbia University, New York. He became involved in art education during the 1970s, being appointed Professor of Conceptual Art in Sydney, the first such professor in the world, and served as director of NCAD between 1980 and 2002, interrupted by periods spent teaching and working in Australia where he continued to act as an advocate of progressive Irish art. He was director of the Experimental Art Foundation in Adelaide from 1975 to 1980 and, as inaugural director of the Perth Institute of Conceptual Art (1989–93), he showed the work of the young Irish group Blue Funk (qv) there in 1991. Sheridan represented Ireland at the UNESCO Convention of Young Painters in Paris in 1962 and won the Carroll Prize at the IELA exhibition (qv) in 1965 and 1969.

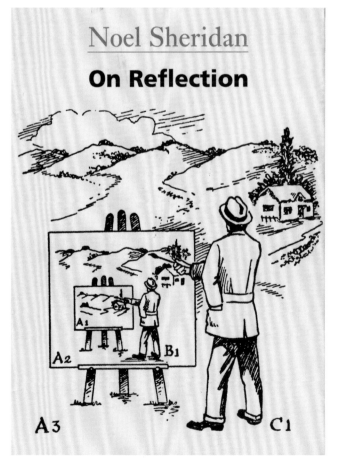

456. Noel Sheridan, cover of *On Reflection* (Dublin 2001)

Sheridan's art practice and his teaching were political from the outset. An early member of the Independent Artists with Michael Kane (qv) and James McKenna in the 1960s, he believed that art and art institutions should interrogate the status quo, not accommodate it. As director of NCAD, he oversaw the move from its historic position in Kildare Street to an obsolete distillery in Thomas Street, stoutly rejecting attempts to move it to a suburban green-field site. He worked to alter the colonial model of an art college which dominated art education in Ireland up to the 1970s, believing instead that the national art college should change consciousness and perceptions about the role of art. Art should help to heal the college itself and the nation. His endorsement of education in community art at the college and his role in the establishment of an Art in Prisons Scheme were among the practical and innovatory extensions of this belief (see 'Education in the Visual Arts'). A true populist, Sheridan embraced popular culture and challenged fellow artists and students to reconsider the responsibilities that being an artist entailed, as he himself did in his video *Why Be an Artist?* (Sydney Biennale, 1976).

In addition to his art practice, Sheridan was also a regular broadcaster in radio and television discussions of the arts. In 1996 he curated *NCAD 250: Drawings 1746–1996* celebrating the continuity of art education in Ireland from the eighteenth century to the present day. The accompanying book of the same title was compiled and largely written by him. Widely appreciated and influential on a generation of artists in both Ireland and Australia, Sheridan was awarded the Emeritus Medal for Cultural Contribution from the Australia Council for the Arts in 1994.

Following his retrospective show, *Missing it* (2001, RHA), the entire exhibition was purchased by the well-known collectors Lochlann and Brenda Quinn and donated by them to IMMA under a tax exemption scheme. Noel Sheridan retired as director of NCAD in 2002 and died in Australia four years later.
Catherine Marshall

SELECTED READING Brian O'Doherty, 'Assembling Sheridan', *The Recorder: Journal of the American Irish Historical Society*, XIV, no. 1 (Summer 2001); Noel Sheridan, *On Reflection* (Dublin 2001); Ryan, 2003.

SIMONDS-GOODING, MARIA (b. 1939) [264, 457], painter, printmaker. Maria Simonds-Gooding was born in Quetta, at that time part of India but now in Pakistan, into an Anglo-Irish family. The family returned to Ireland in 1947 and settled near Kenmare, Co. Kerry. She studied art at NCAD from 1962 to 1963, at La Centre de Peinture in Brussels from 1963 to 1964, and, following the advice of David Hendriks and Cecil King (qv), she spent two years at the Bath Academy of Art from 1966 to 1968. The years at Bath consolidated her anti-academic approach to image making and she was especially grateful for the advice of her teacher Adrian Heath, who challenged her to take a line from the model and show where it started and ended simply by emphasizing its tactile values. Simonds-Gooding extended that line through space from the model to the landscape and began to apply it to plaster surfaces as well as painted ones. Returning to Ireland in 1968, she established herself on the remote west coast of the Dingle Peninsula, which was to be a rich source of inspiration for her future work. The distinguished critic Roland Penrose selected her as the winner of the Carroll's prize for best artist under forty at the IELA (qv) in 1970 and in 1978 she was given the first of a number of exhibitions at the Betty Parsons Gallery in New York. Simonds-Gooding is best known for her unique paintings using plaster, which evolved from her earlier love of impastoed paint, but she is also a distinguished printmaker and tapestry designer (see 'Printmaking' and 'Stained Glass, Rug and Tapestry Design'). Since 2006 she has been experimenting with a combination of large metal sheets and three-dimensional line.

Maria Simonds-Gooding was elected to Aosdána (qv) in 1981 and became an associate member of the RHA (qv) in 2008. From her base in Dun Chaoin, in west Kerry, she has travelled widely in similarly remote parts of the world. Her search for situations where man's primal struggle with the landscape is most evident has led her to isolated areas of Greece and Lanzarote, Syria, India, the Himalayas, New Mexico, Georgia and Mali. Where other artists travel to remote locations in search of difference, Simonds-Gooding is driven to establish the common signifiers in man's history of survival over widely disparate landscapes and times. The simple, evocative shapes of habitations, fields and waterholes that this research yields have given her landscapes a minimalist feel, but it would be more accurate to consider her as essentialist rather than Minimalist.

Her relationship with west Kerry has been a major influence on Simonds-Gooding's development as an artist. It has given her a profound respect for the history and folk life of the area which is mirrored in her artwork. She bought the cottage she lives in from Mike Sé 'faight', a Blasket islander who moved to the mainland two years ahead of the official evacuation of the island, taking the roof, windows and door of his island home with him for his new house. Symbolically, *An File*, Micheál Ó Gaoithín, son of the legendary Peig Sayers, gave her the crane for hanging saucepans and kettles over the open fire from Peig's own house, while she in turn encouraged him to paint the details of life in the area as he experienced them. Her recognition and collection of his work and of the textiles of the traveller woman Ella Coffey is as important as her own artwork. It is not surprising, then, that Simonds-Gooding was invited to illustrate Tomás Ó Criomhthain's *An tOileánach* in 1972. Significantly, her illustrations are dominated by the drama of the Atlantic landscape which Ó Criomhthain takes as a given.

Simonds-Gooding's art practice is unique in Ireland. In a country in which landscape painting (qv) is often seen as the dominant form of visual art, her work is instantly recognizable. This is because her plasterworks, prints and tapestries celebrate the moment when man ceases to be a nomad and hunter and becomes a farmer, the moment where nature and culture meet in the landscape. That moment precedes territorial claims and power play over neighbours or between the sexes, and offers instead a glimpse into the most primitive statements about settlement. It transcends the local, concentrating on the universal heritage we share and our common dependence on an environment that is never static but constantly requires a

new level of interaction. Maria Simonds-Gooding is not interested in anything as superficial or as recent as national identity or a thousand years of colonization. In place of those concerns, she explores the interaction between man and the land, that continuous interactive relationship that is always in flux and has been mankind's most consistent challenge since the beginning of time.

Simonds-Gooding's work can be seen in the Hirshorn Museum, Washington DC, the Albuquerque Museum, New Mexico and the Metropolitan Library, New York, as well as IMMA, the AC/ACE and the RHA. CATHERINE MARSHALL

SELECTED READING Emily Mark-Fitzgerald, 'Maria Simonds-Gooding', in *Collaborations and Conversations: Stoney Road Press, 2002–07* (Dublin 2008), pp. 72–77; Catherine Marshall, 'The Soul Selects Her Own Society', in *Fields of Vision: The Work of Maria Simonds-Gooding*, exh. cat. Taylor Galleries (Dublin 2004); Y. Scott, 2005, pp. 38–39; Catherine Marshall, 'The Art of Reduction', *IAR*, XXIII, no. 3 (2006), 80–83.

SLEATOR, JAMES SINTON (1885–1950), painter. A private and reserved individual, the artist James Sleator left no diaries, wrote few letters, and throughout his life avoided publicity and controversy. His viewpoint was balanced, and while his paintings were academic in style, he admired the work of the Post-Impressionist painters such as Cézanne and van Gogh. His portraits and still lifes show him to have been a gentle and sensitive colourist. In many ways, the austerity and clarity of Sleator's artistic vision, while he never embraced abstraction, echoes that of William Scott (qv). References to the work of his teacher William Orpen (qv) dominate his own work, but there are also allusions to Vermeer.

Born in Portadown, Co. Armagh, Sleator grew up in a moderately strict Presbyterian household. Although the Sleator family background was in the linen industry, both his parents were school teachers. In 1903 he enrolled on a teacher training course at the Belfast College of Art, his parents having moved to Belfast some years previously, and in 1909 he was awarded a scholarship to attend the DMSA. Over the next five years, in the company of fellow students such as Seán Keating, Patrick Tuohy, Leo Whelan

457. Maria Simonds-Gooding, *Tigh na hInise*, 1974, etching, 20 x 25 cm, edn of 75

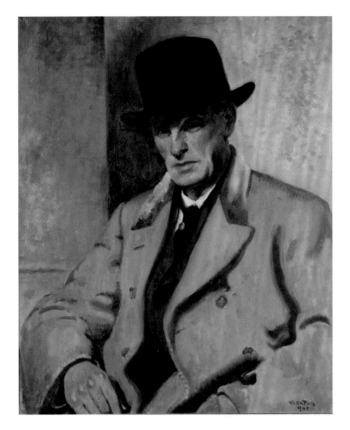

458. James Sinton Sleator, *Jack B. Yeats*, 1947, 76.3 x 63.5 cm, Crawford Art Gallery

and Margaret Clarke (qqv), Sleator absorbed and emulated Orpen's style to the point where Orpen employed him, from 1914 onwards, as a studio assistant in London (Kennedy, p. 2). In 1913 Sleator's *Still Life* was included in an exhibition of Irish art held at the Whitechapel Art Gallery, London, while he is said to have been the model for the head of Cúchulainn in Oliver Sheppard's heroic bronze sculpture *Death of Cúchulainn* (1911), now in Dublin's GPO. While working as Orpen's assistant in 1915, Sleator gave painting lessons to Winston Churchill; however, by the end of that year he was back in Dublin, where he lived firstly at 54 Upper Sackville Street, then at 149 Lower Baggot Street, before moving to 44 St Stephen's Green and, afterwards to 3 Fitzwilliam Place. He was a founder member of the SDP, although he exhibited only in the Society's first exhibition, held in August 1920, where he showed two works, *Falconer* and *Still Life*.

Sleator continued moving between Dublin and London before deciding to return to London in the early 1920s, where he took up his former job as assistant to Orpen. Two years later, following advice given to him years earlier by Sir Hugh Lane, Sleator travelled to Italy and spent several years copying and studying paintings in the museums of Florence, returning to Ireland from time to time. In June 1926, Sleator's first, and only, one-person exhibition was held at Rodman's Gallery in Belfast, and included portraits of prominent Belfast people, including the writer Forrest Reid. These portraits had probably been painted on return visits to his native city from Italy. By 1927 Sleator had settled in London and was still working with Orpen, although undertaking some

commissions on his own account. His portrait of *Sir George Makins* is in St Thomas's Hospital. On Orpen's death, in 1931, Sleator was asked to complete a number of his unfinished commissions. In the following decade, he lived and worked in a studio at 59 South Edwardes Square in Kensington. During these years he showed mainly still lifes and flower studies at both the RA and RHA. He spent time on holidays in Newcastle, Co. Down, where he stayed with his friend James Wilson, and in 1935 he was elected an honorary member of the Ulster Arts Club (Kennedy, p. 4).

During the Blitz, Sleator left London and moved to Dublin where he quickly settled in to artistic life, being appointed professor of painting at the RHA, and serving on the hanging committee there, along with Dermod O'Brien, Beatrice Glenavy (née Elvery) and Harry Kernoff (qqv). Among the numerous portraits Sleator showed in the 1944 RHA exhibition were *Lennox Robinson*, *Jack B. Yeats* (qv) [458], *Rutherford Mayne*, *Dr R.I. Best*, *Mr Justice Thompson*, the Minister for Agriculture *Dr James Ryan*, and a portrait of the Dean of St Patrick's Cathedral. The following year he succeeded Dermod O'Brien (qv) as president of the Academy, a position he held until his death. On 19 January 1950, Sleator died of a heart attack at his home, Academy House, in Ely Place. On his death, an artist's palette – a gift from his mentor, Sir William Orpen, many years before – passed to Sleator's friend Maurice MacGonigal (qv), the painter, who in turn later succeeded him as president of the Academy.

Sleator never married. A memorial exhibition of his work was held at the Waddington Galleries in Dublin in 1951, the second one-person exhibition of his work to be held during, or immediately after, his lifetime. PETER MURRAY

SELECTED READING S.B. Kennedy, *James Sinton Sleator PRHA, 1885–1950*, exh. cat. Armagh County Museum, Fermanagh County Museum and RHA Gallagher Gallery (Armagh 1989).

SLOAN, VICTOR (b. 1945) [459], photographic artist. Born in Dungannon, Co. Tyrone, and educated at Belfast and Leeds Colleges of Art, Sloan began his art practice as an abstract painter but turned to photography (qv) in his thirties. He also works with video, etching and screen printing.

Growing up within an Orange community in Northern Ireland as the 'Troubles' began to unfold, Sloan was keenly aware of political and sectarian tensions (see 'The Troubles and Irish Art'). Espousing photography as the primary means of exploring those tensions, he is acutely conscious of the ways in which the so-called 'objectivity' of the photographic image has been undermined by manual and digital processes and by the way it is used in press reporting.

His response to the turmoil in his immediate environment and his feelings about ways in which the camera can be misused have led him to make interventions into the photographic image himself, but to do this in a way that is clearly stated and highly personal. Sloan's process has been described by William Gallagher as 'brutally burlesquing the covert interventions behind the media image' (Gallagher, p. 352). Sequences of separate series of artworks, entitled 'Craigavon', 'Drumming', 'The

Twelfth' and 'Walls', explore the role of photographs and the social and political impact of the events at their centre. While Sloan is clear that he is not partisan, saying 'I don't care what they call us, whether it's Ulster or Ireland, I comment on what's here. I don't try to change it. It's not a Protestant or Loyalist viewpoint, but me as a human being' (Hewson, 106), he does not hide his emotional reactions to the violence around him. John Hutchinson said that Sloan's lacerated photographs, 'which seem to bear the scars of wanton destruction and haphazard violence, are a kind of corrective to the emotionally detached and supposedly "objective" press reportage of the Troubles' (Hutchinson, 41).

In 1998 Sloan had his first installation-based exhibition, *Stadium*, in which he used film projection for the first time, in a collaboration between Belfast's Context Gallery and the Old Museum Arts Centre, and in 2001 he held a retrospective at the Ormeau Baths Gallery, Belfast. Awarded an MBE in 2002, Sloan is a Fellow of the Royal Society of Arts and the Royal Photographic Society. He and the writer Glenn Patterson collaborated to produce the body of work, *Luxus*, at the Millennium Court Arts Centre, Portadown, in 2007. His work has been shown in Europe, North and South America, and Asia and been included in important group exhibitions of Irish art such as *Directions Out*, DHG (1987), *Divisions, Crossroads, Turns of Mind: Some New Irish Art* (1986) and *Irish Art of the Eighties*, DHG (1990). It can be seen in the collections of the UM, ACNI, NSPC at the UL, Imperial War Museum, London, and the Media Museum, Bradford. CATHERINE MARSHALL

SELECTED READING Hutchinson, 1990b; Brian McAvera, 'Marking the North: The Work of Victor Sloan' in *Victor Sloan: Marking the North*, exh. cat. Impressions Gallery, Bradford and Cornerhouse, Manchester (Dublin and York 1990); Aidan Dunne, *Victor Sloan: Selected Works*, exh. cat. Ormeau Baths Gallery (Dublin 2001); Hewson, 2005; Gallagher, 2006.

459. Victor Sloan, *Entering the Field* (from the series 'Drumming'), 1986, mixed media photographic work, 59 x 59 cm

SMITH, JOHN NOEL (b. 1952), painter. The art critic Aidan Dunne begins an essay on John Noel Smith with the sentence, 'John Noel Smith is a brilliant painter'. The words are startling because they are so untypical of this normally reticent writer. They point correctly to two things: Smith's technical skill, and his concentration on the visibility of painting, not as a vehicle to represent something else but as an element in its own right, capable of infinite expression and variety.

Smith was born in Malahide, Co. Dublin and worked for two years as a bank official before going to the Dun Laoghaire School of Art to study painting (1971–76). On graduation, he shared a studio with Graham Knuttel and worked for a couple of years on a series of paintings in black encaustic, his 'Block Icons', exploring light and form in space. An Alice Berger Hammerschlag award enabled him to go to Berlin on a study trip in 1977, and in 1980 a DAAD Scholarship from the German government paid for a further year there. Smith stayed until 2002 when he returned to live and work in County Wexford.

His paintings, always produced in series, test the limits of non-representational painting using the givens of its history from Cimabue and Rubens to Pollock and Philip Guston, as well as the immediate elements of context, space and materials to allow him to develop a personal identity. With the utmost seriousness, Smith plays with the format of the diptych and triptych in horizontal and vertical arrangements, and incorporates motifs that can be read as references to his own country, and to the language and mark-making repertoire of Modernism (qv) to define each series.

Smith lived in the divided city of Berlin, in a divided Europe, and comes from a divided Ireland, and this may have prompted his ruminations on the theme of unity embracing difference, in the 'United Field' [460] series where the same colours and patterns are applied to each panel of the diptych/triptych but sometimes in very different proportions. Earlier series, painted during his time in Berlin, introduced the motifs of the short, repetitive, but subtly varied lines of Ogham writing in the 'Ogham' series (1995–99), and something resembling the three-leaved shamrock in the 'Knot' paintings of the early 2000s, each of which could be read as references to Ireland.

Smith's ability to constantly develop his repertoire purely within the language of painting marks him out among abstract painters (see 'Abstraction'), not just in Ireland but in a wider context.

His work has been exhibited in solo exhibitions all over Ireland and in Germany, Denmark, Sweden, Greece and the USA, and in group exhibitions in Denmark, England, Germany, Ireland, Sweden and Wales. He is a member of Aosdána (qv) and is represented in the collections of IMMA and the AC/ACE, and in most important public collections and corporations in Ireland. CATHERINE MARSHALL

SELECTED READING Medb Ruane, *John Noel Smith*, exh. cat. Green on Red Gallery (Dublin 2005); Aidan Dunne and Medb Ruane, *Profile 26 – John Noel Smith* (Kinsale 2007); Caoimhín Mac Giolla Léith and John Daly, *Pandect Series*, exh. cat. Hillsboro Fine Art Gallery (Dublin 2009).

460. John Noel Smith, *United Field Painting I*, 2002, oil on canvas, 230 x 380 cm, Irish Museum of Modern Art

SOLOMONS, ESTELLA (1882–1968) [461], painter. Although by no means a well-known artist, and one whose approach to portraiture and landscape was old-fashioned even during her own lifetime, the paintings of Estella Solomons are of a high quality and deserve wider recognition.

Solomons was born into a prominent Dublin medical family and studied art at the DMSA under William Orpen (qv) and the RHA (qv) Schools where Walter Osborne was professor of painting. In 1903 her work was shown in Leinster Hall, Molesworth Street, in an exhibition entitled *Young Irish Artists* which also included works by Beatrice Glenavy, née Elvery (qv) and Frances Beckett. This was followed by a stay in Paris where she studied at Colarossi's studio. In 1906 Solomons visited Amsterdam where the tercentenary of Rembrandt's birth was being celebrated. She attended the Chelsea School of Art for a term, returning to Holland in 1911, where she sketched at Volendam and painted portraits such as *Dutch Girl*. Solmons took up printmaking (qv) and her suites of etchings of Dublin, published in 1917 and 1928, convey well the atmosphere of places such as Hoey's Court and Marsh's Library.

During the 1916 Rising, Solomons became a member of Cumann na mBan, a Republican women's organization, and she also served as a committee member of the Prisoners' Dependants' Fund. During the War of Independence she concealed guns and buried ammunition in her garden. A Republican activist, whom Solomons referred to as 'the butterman', taught her how to shoot a gun (Pyle, 1966, p. 22). Her sitters during these years included many leading figures in cultural and Republican circles, among them the writers Joseph Campbell, James Stephens, George Russell (qv), Thomas Bodkin, Padraic Colum, Darrell Figgis, Count Plunkett, the musician Arthur Darley and the playwright William Fearon. Her portrait of Alice Milligan is in the UM. During the Civil War, her studio at Great Brunswick Street (renamed Pearse Street in 1923) became a centre for harbouring Republicans on the run and was raided several times by soldiers of the Free State army (Pyle, 1966, p. 6). The events of the Civil War, especially the execution of Republicans, such as Erskine Childers, caused Solomons to become disillusioned, and from the mid-1920s she concentrated on her art.

In 1925 Solomons was elected an associate of the RHA and held an exhibition at her studio in Pearse Street (Pyle, 1966, p. 10). Three years later, she married the poet and publisher Seumas O'Sullivan. Solomons painted fewer portraits after her marriage and, increasingly, concentrated on landscapes, often staying with her husband at George Russell's house at Marble Hill, Co. Donegal. They also travelled to County Kerry where she painted landscapes at locations such as Mount Brandon, Derrynane, Ballinskelligs and Castlegregory, as well as parts of County Wicklow. In 1935 her work was shown in London at the Arlington Gallery, while fifteen years later she exhibited *A Tor, Devon* at the RHA annual exhibition. Solomons specialized in seascapes and many of her paintings are characterized by a fresh, wind-blown atmosphere.

When Seumas O'Sullivan founded the literary journal *Dublin Magazine* in 1923, their house became a centre for artists

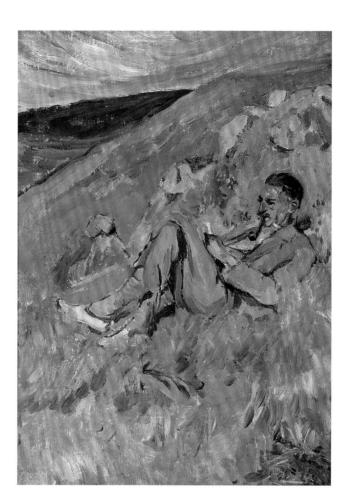

461. Estella Solomons, *Green Hollows*, c. 1920, oil on canvas, 37 x 27 cm, private collection

and writers, many of whom sat for Solomons. By the mid-1950s Solomons, affected by arthritis, had more or less stopped painting. In 1958 O'Sullivan died and while Solomons continued to exhibit annually at the RHA up to her death, most of the works she showed were from her earlier years. She was made an honorary member of the RHA in 1966, having shown at the Academy nearly every year over a sixty-year period. PETER MURRAY

SELECTED READING Pyle, 1966; Brian Fallon, 'Estella Solomons', in Miller, 1973a; Hilary Pyle, *Estella Solomons HRHA (1882–1968)*, exh. cat. Frederick Gallery (Dublin 1999).

SOUTER, CAMILLE (b. 1929), painter. Born Betty Pamela Holmes in Northamptonshire, England, Camille Souter has lived in Ireland since she was three years old. While she has fond memories of Miss Garret, the art teacher in Glengara Park School, Dun Laoghaire, the only other formal art instruction she received was for a few months, in Bray, Co. Wicklow, when she persuaded Yann Goulet to teach her sculpture. While happy to pick up some rudimentary technical training, Souter has always worked things out for herself, preferring to learn from trial and error and from looking at the work of other artists. As a teenager, she visited the NGI regularly, and during training as a nurse in Guy's Hospital in London, she was particularly impressed by the Rembrandt paintings in the National Gallery and enjoyed the

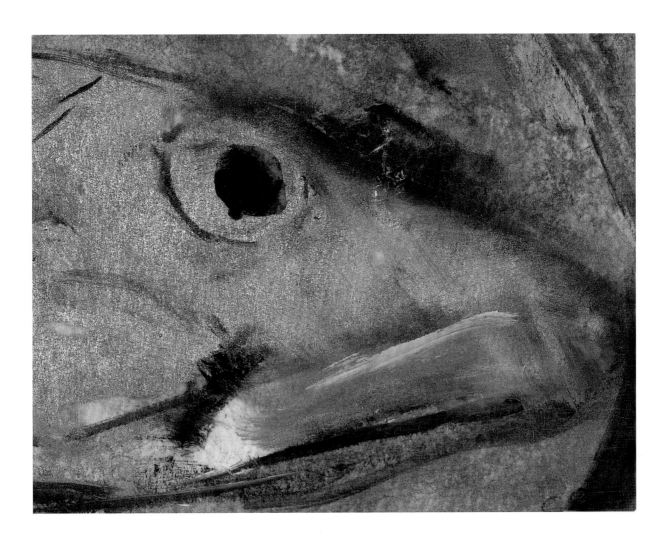

462. Camille Souter, *Self-portrait as a Cod's Head*, 1993, oil and aluminium paint on paper, 8.5 x 10.5 cm, private collection

action painting of Jackson Pollock. She also fully availed of the complimentary tickets to Covent Garden and the Wigmore Hall which staff at Guy's were regularly given. Post-war London was grim; she developed tuberculosis and was sent to the Isle of Wight to recuperate, where she read voraciously. In 1956, following her marriage to the actor Gordon Souter and the birth of her first daughter, she visited Italy for the first time. Initially attracted to sculpture, she turned to painting and this has remained her medium ever since. Souter had her first solo exhibition of paintings from Italy in Dublin in the El Habano Restaurant, Grafton Street, in 1956.

An Italian government scholarship enabled her to make a further visit to Italy in 1958. On her return she remarried, this time to the sculptor Frank Morris. She felt a powerful affinity with Achill which she visited in 1956 and again in 1959, but settled instead in Callary Bog in County Wicklow, where Frank Morris was engaged in work with the forestry service. It was only following Morris's untimely death, in 1970, at the age of forty that she returned to live in Achill with her five children.

Perhaps because she had nursed injured airmen after the war, Souter was interested in flying, and used a grant from the Arts Council (qv) to enable her to take flying lessons in Shannon for a short period in the 1980s. She describes the experience as making her feel 'like a Greek goddess' (conversation with author,

29 January 2010). Her imaginative connection to classical myths is matched by her unique affinity with nature. Rejecting an invitation to provide a self-portrait for the NSPC at the UL, she saw nothing untoward in casting herself as a fish in *Self-portrait as a cod's head* [462]. When asked to expand on this, she responded simply, 'Well, we're all related! Life is pretty big.' (Fallon and McMonagle, p. 21)

That appreciation of the natural and the mythic led Souter, in her seventies, to the Iraqi deserts to paint man's marks on the landscape in the aftermath of war, and to follow this with extensive travels in Iceland where the dramatic contrasts between the snow and bubbling hot water springs attracted her. It has equally inspired other favoured subjects, such as circus performers, raw meat and fish, the landscape, or the drama of flight.

Souter shows no interest in pursuing an international reputation or in time-consuming plans for exhibitions at home or abroad. Where other artists chase exhibitions, she views them as distractions that must be kept to a minimum, concentrating instead on her painting. Despite this, she was selected to represent Ireland in the 1961 Venice Biennale, and in 1977 she was awarded the Grand Prix de l'Art Contemporain, Monte Carlo. She is happy to participate in group exhibitions such as *2 Deeply, 100 Paintings by Barrie Cooke and Camille Souter*, Dublin and Kilkenny (1971), and the *Camille Souter/Nano Reid Retrospective*,

Drogheda and Castlebar (1999). She was given retrospectives at the DHG in 1981, at the Model and Niland Gallery, Sligo, and the RHA Gallagher Gallery in 2001. Even with the minimal promotion to which she agrees, Souter's work is eagerly sought after by collectors, and her critical reputation in Ireland has never flagged. She was elected to Aosdána (qv) in 1981, and in 2009 became the first woman artist to be made a Saoí of Aosdána. In 2000 she was awarded the Glen Dimplex Award for sustained contribution to the visual arts at IMMA. Other honours include an honorary Doctorate of Laws from the NUI.

Just as she is attracted to Achill [357], where she continues to live, Souter is also energized by the geology of Iceland, with its mixture of arctic and volcanic conditions, and the Kuwaiti landscape, with its residues of the Gulf War of 1990. What might at first glance appear to be abstract in her paintings is really an interpretation of the area from which the painting came. She insists on the primacy of the subject: 'It has to have a subject matter, otherwise it's just design.' (Fallon and McMonagle, p. 25) Referring to her Achill paintings, she goes on to say, 'All those early Achill paintings are absolutely rooted in the concealed geological order of rock forms here' (ibid.).

Souter works on a small scale, partly because her tiny studio would not allow for expansive canvases, but more particularly because she likes to work on paper or board, spread out horizontally on a table as she paints, rather than work with the buoyancy of canvas on an easel. She happily rises to the challenge of using all kinds of paint, from bicycle and aluminium paint to oil, on newspaper, tissue paper or any ground that is available, because she feels empowered when it works. The most important ingredient in her painting process is natural light. Souter paints only in daylight and insists that if a painting is executed under artificial lighting, then it should be viewed under the same conditions. Her work has been collected by the AC/ACE, IMMA, HL, OPW, Butler Gallery, Kilkenny, the Model and Niland Collection, Sligo, and many other public collections. CATHERINE MARSHALL

SELECTED READING Aidan Dunne and Paula Murphy, *Camille Souter Retrospective*, exh. cat. Model and Niland Gallery (Sligo 2001); Garret Cormican, *Camille Souter: The Mirror in the Sea* (Dublin 2006); Brian Fallon and Niall McMonagle, *Profile 28 – Camille Souter* (Kinsale 2009).

STAINED-GLASS, RUG AND TAPESTRY DESIGN

(see and *AAI* III 'Arts and Crafts'). The history of modern Irish stained-glass and tapestry art begins in the Arts and Crafts movement of the late nineteenth century (see 'Design and Material Culture'). In early twentieth-century Ireland the cultural quest for national identity fused with the aesthetic ideals of John Ruskin and William Morris in London, to give rise to innovation across a range of disciplines. Stained-glass and tapestry design were among these and some of the century's leading artists became prominently associated with them.

Stained Glass

In this context, An Túr Gloine, a pioneering cooperative-based stained-glass studio, was founded in 1903 by Sarah Purser (qv) to raise standards of design and workmanship. It was managed

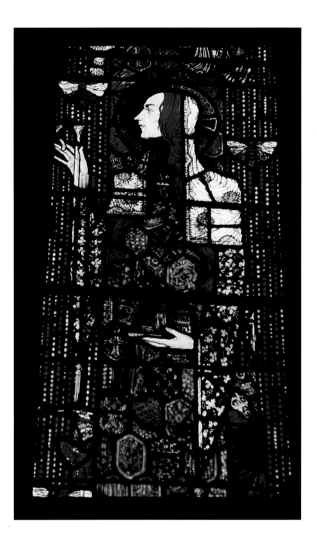

463. Harry Clarke, *St Gobnait*, 1915–17, detail of lancet window, stained glass, Honan Chapel, University College Cork

by A.E. Child who trained with Christopher Whall, leader of the stained-glass revival in England, who arrived in Ireland in 1901 to teach at the Dublin Metropolitan School of Art. Lacking a native stained-glass heritage, An Túr Gloine drew on an eighth- and ninth-century Irish iconography of manuscript illumination, sculpture and metalwork. Purser established the important founding principle that each artist should be entirely responsible for every stage in the design and creation of a window.

For fifty years An Túr Gloine provided facilities for many artists, including Wilhelmina Geddes, Evie Hone, Beatrice Glenavy (qqv), Michael Healy, Ethel Rhind, Catherine O'Brien and Hubert McGoldrick. In its heyday it eclipsed all the older Irish stained-glass studios except that of Joshua Clarke, whose son, Harry (qv), had a unique style and genius in this medium. In their synthesis of a recognizably Irish tradition with their own inventive vision, Harry Clarke, Geddes and Hone were the most significant stained-glass artists of the period, and their work was sought after worldwide.

Clarke's *fin de siècle* exoticism, artistic vision and technical prowess make him one of the world's leading Symbolists. Throughout his short life (1889–1931) he produced some of the most incomparable stained glass of the period, incorporating religious, secular and literary themes. Inspired by the rich decorative

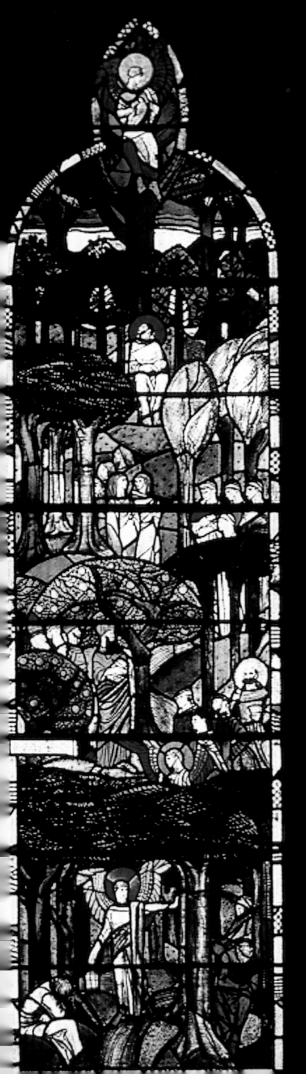

sources of Aubrey Beardsley, Art Nouveau, French Symbolism, Diaghilev's Ballet Russe, Celtic Romanticism, music and theatre, his complex imagination fused real and imaginary worlds. The characteristically gaunt-faced figures with intense gaze and attenuated hands, encircled by intricate and jewel-like decorative motifs so familiar in Clarke's stained glass, appear also in his book illustration and textiles (see 'Illustration and Cartoons'). Clarke's designs often combine the sublimely beautiful and the macabre in the same composition. Most impressive of all is the magnificent colour, including a signature cobalt blue, achieved by using double-layered glass, repeatedly acid-etched, a technique learned from Michael Healy, to create endless tonal nuances.

Some of Clarke's greatest works were commissions – eleven of the windows at the Honan Chapel, UCC, completed in 1917 [463], two unique secular windows, *The Eve of St Agnes* (1924) [62] and his last great work, *The Geneva Window* [365] finished a year before his early death. The Honan windows each portray an Irish saint with attributes and are a *tour de force* in their manipulation of the qualities of glass and the stylized interrelationship of the symbolic and the abstract. In *The Geneva Window*, commissioned by the Irish government for the International Labour Organization of the League of Nations, Geneva, Clarke pays tribute to modern Irish literature. A remarkable artistic achievement, with excerpts from fifteen pieces of prominent Irish literature, it was, nevertheless, rejected by the government because it represented a number of banned authors and books.

Wilhemina Geddes [464] worked at An Túr Gloine for twelve years, from 1912. Her practice of making lino cutouts of her potential designs informed her thinking about her stained-glass pieces. This can be seen in her first work, a small three-light window illustrating *Episodes from the Life of St Colman MacDuagh* (1911, HL). It shows both her absorption of the hieratic graphic qualities of archaic and Romanesque sculpture, as well as an understanding of the formal expressive power of drapery on the human figure. Geddes's reputation was established by the three-light window for St Bartholomew's Church, Ottawa (1919), a memorial to Canadians who perished in World War 1. Completed in London, it was exhibited there and in Dublin before its installation. In its dramatic contrast with Victorian images of passive sainthood, it had a riveting effect on audiences. Her powerful soldier-saints, ascetic and shorn of detail, their draperies articulated by strong linear rythms, with compressed energy and volume, seem to exceed their architectural boundaries. The effect is one of deep emotional power. London became Geddes's permanent home from 1925. Her work has yet to receive sufficient critical attention and in her day was overshadowed in Ireland by that of Evie Hone.

One of the pioneers of Cubism (qv) in Ireland, Hone came to stained glass in the last decades of her life. Taught initially by Geddes and Michael Healy [428], she was strongly influenced by the latter's use of strong black lines. She worked at An Túr Gloine from 1933 to 1943, later setting up a studio at her home in Rathfarnham, Dublin. A convert to Catholicism, Hone created mainly for religious buildings. Bringing her vision as an abstract painter to stained-glass design, she evolved a style of Expressionist intensity by reducing her

464. Wilhelmina Geddes, *The Leaves of the Tree were for the Healing of Nations*, 1920, lancet window, stained glass, St John's Church of Ireland, Malone Road, Belfast

subject matter to symbolic essentials enhanced by the intense vibrancy of the glass. She avoided aciding and undercutting the glass, giving the work a desired flatness, counteracted by the richness of colour and movement of the design. Her formative influences were medieval glass and architecture, early Christian crosses, and the art of Georges Rouault. In her early window *My Four Green Fields* [465], executed on commission for the Irish Pavilion at the New York World's Fair in 1939, she combines abstraction (qv) with symbolism. Measuring twenty-one feet by eight, it depicts the arms of the four Irish provinces, supported by powerful, rhythmic patterning. Hone's most significant and renowned commission, won through international competition, is the great east window of Eton College Chapel (1952).

Her works inspired several later artists, including Patrick Pollen (1928–2010), Helen Moloney (1926–2011) and Patrick Pye (qv) [415]. Pollen trained with Hone, adopting many of her techniques, and worked at An Túr Gloine. He completed a thirty-two-window commission for the new cathedral of Christ the King, Johannesburg (1957–59). Moloney, inspired by Hone's *Memorial Exhibition* in 1958, trained at the National College of Art (now NCAD) and at La Grande Chaumière, Paris. She worked as assistant to Pollen and later created windows for churches designed by Liam McCormick, including his renowned St Aengus Church, Burt, Co. Donegal. Pye trained in stained glass under Albert Troost at the Jan Van Eyck Academie, Holland. Inspired by El Greco, as well as by the Romanesque monumentality of Evie Hone, Pye works in a quasi-primitive style, focusing on the effects of light on colour in stained glass. His work can be seen in many churches, including Glenstal Abbey, Co. Limerick and Creagh Church, Ballinasloe, Co. Galway.

The stained-glass windows of An Túr Gloine and the Harry Clarke Studios particularly enhanced the spate of Hiberno-Romanesque style churches which briefly accompanied the Celtic Revival (the most successful of which is the Honan Chapel), but proved impracticably small for large urban congregations. They were supplemented by massive, mainly classical, revivalist-style churches, throughout the 1940s and '50s.

The achievement of An Túr Gloine and the Harry Clarke Studios in religious stained-glass art is all the more remarkable given the lack of appreciation of art among the emergent Catholic middle class and the conservatism of clerical patrons. In general, the church did not trust individual native subjectivity in visual culture when it came to matters religious, favouring instead the foreign and the mass-produced. Notable exceptions included the commissions Irish stained-glass artists received from the Jesuit Order, notably Father Donal O'Sullivan S.J. (he later became Director of the Arts Council from 1960 to 1973), who championed the stained glass of Evie Hone and an Irish religious art informed by the new approaches of Modernism (see 'Religion and Spirituality' and 'Modernism and Postmodernism'). The effect after 1962 of Vatican II, designed to encourage more participation by the laity, gave rise to changes in church architecture and less demand for stained glass, although the best exemplars, notably by Liam McCormick in the 1960s and '70s, contain fine works by Helen Moloney and Patrick Pollen.

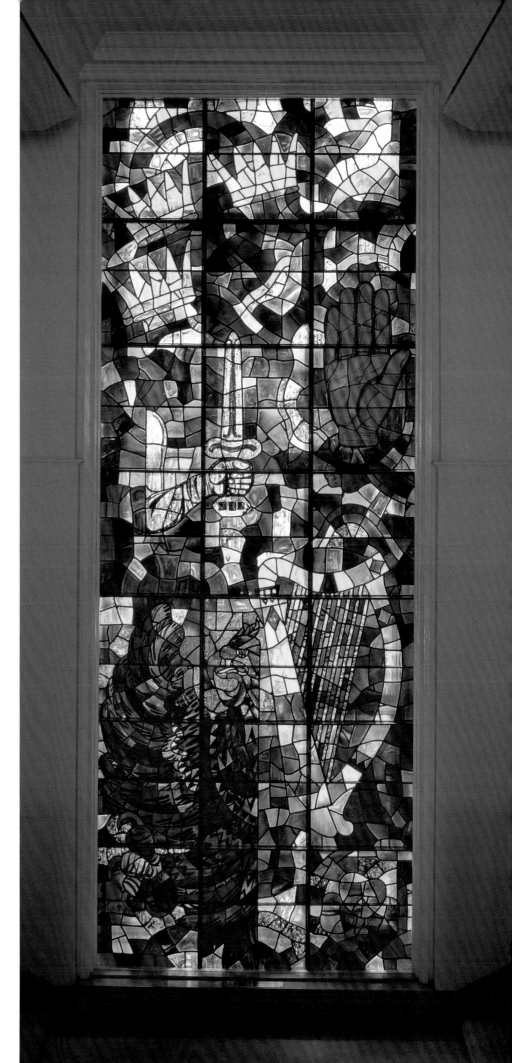

465. Evie Hone, *My Four Green Fields*, 1938, stained-glass window, Government Buildings, Dublin

In the late 1980s Cork artists James Scanlon and Maud Cotter began to show outstanding originality as a new generation of stained-glass artists. While both have worked with glass conventionally for windows, they also use it in combination with other materials in a free-standing way. Scanlon's most renowned work, a 'village' of stone structures, near Sneem, Co. Kerry, recalls the area's monastic beehive huts of some 1,500 years earlier. His approach to stained glass is gestural, with a spatial play that evokes an immersive corporeality.

Throughout her career Cotter has explored transparency, characteristically with fragile or temporary materials, seeking 'other' spaces intermediate between the body and the public realm. Her early exploration of glass distinguished her critically, and she established a glass department at the Crawford Art College, Cork. Always attracted to the material properties of her chosen medium, in glass she was drawn to its colour and intensity and its continuously light-transmitting properties. From the beginning she worked with the fluidity of glass in a sculptural manner, with layer upon layer of etching, gravitating towards free-standing pieces.

Rug, tapestry and textile design
Influenced by her training at the South Kensington School of Design and by William Morris, Evelyn Gleeson (1855–1944) produced hand-tufted carpets, rugs and tapestries at the Dun Emer Industries, which she founded in 1902. The Yeats sisters, Lily and Lolly, of whom Lily had worked in William Morris's Kelmscott firm in London, carried out embroidery and printing there for a period, after which they set up the separate Cuala Industries. In a major commission, they executed the banners designed by Jack B. Yeats (qv) for Loughrea Cathedral, Co. Galway which also contains a range of very fine stained-glass windows, with examples by almost all the leading practitioners.

Paris-based Eileen Gray (qv) experimented with tufting techniques in abstract Modernist rugs which, then as now, attracted international acclaim as key design objects of the twentieth century. Her *Ulysses* rug was completed for James Joyce, who is listed in her client book (V&A). Some of her rugs were produced by Donegal Carpets.

Before he turned to painting, Francis Bacon (qv) had been acclaimed by *The Studio* in 1930 for his avant-garde rug designs. They reflect his interest in Synthetic Cubism and Bauhaus design, as well as in the innovative tapestries of the French artist Jean Lurçat.

Ireland's leading exponent and promoter of European Modernism, Mainie Jellett (qv), simplified the highly abstract 'rotation and translation' technique she had developed in her painting and adapted it to her rug designs, some of which were woven at Dun Emer Industries.

Tapestry in its classic, fine flatweave form was explored by several great twentieth-century Modernists such as Picasso, Matisse, Miró, Calder and Le Corbusier. They were influenced by the work of Lurçat who, with François Tabard of the Atelier Tabard in Aubusson, revolutionized the tapestry industry in France from the 1930s. Lurçat simplified cartoon designs to mere stylizations; colours and dyes were numbered, standardized and clearly explained. He chose highly textured wools and

reintroduced a large visible warp. Distilling his imagery from French medieval tapestries, he treated all elements in a simplified manner with rich colour.

The outstanding exponents of tapestry in Ireland, from the mid-twentieth century onwards, were Louis le Brocquy and Patrick Scott, while Gerald Dillon (qqv) worked increasingly with a variety of media in his paintings from the 1960s and occasionally experimented with hand-weaving, even incorporating recycled textiles to highly original effect.

Le Brocquy's painting and tapestry work are quite separate. Although the themes and style of drawing may be related, his paintings of the period reflect an ascetic, monochrome interior world, while his tapestries are ablaze with exuberant mood and colour. He began to explore tapestry at the Edinburgh Tapestry Weavers in 1948, with fellow artists Stanley Spencer, Jankel Adler and Graham Sutherland. In the late 1940s he met and was influenced by Lurçat. Between 1948 and 1955 le Brocquy created seven outstanding works with Tabard in Aubusson, in which he distilled Lurçat's design principles and the influence of Picasso to create highly distinctive elemental forms and archetypes.

Le Brocquy's first tapestry, *Travellers* (1948) [275], was exhibited in 1950 at the Arts Council, London, alongside eighteen works by the Edinburgh Weavers, and was singled out for critical acclaim. Its ambiguous crescent-shaped leaf forms suggest both shadow and human form since the figures appear to blend with, and emerge from, nature. *Garlanded Goat* (1949/50) presents the figure of a goat framed by stylized leaves, variegated to suggest day and night, and symbolizes the pagan King Puck, hero of the ancient ceremony at Puck Fair in Killorglin, Co. Kerry. Marking a positive moment for tapestry in Ireland, this work was included in the artist's representation at the 1956 Venice Biennale. Other tapestries from this period are *Allegory* (1950), *Adam and Eve in the Garden* (1951/52), *Eden* (1952) and *Cherub* (1952), whose apocalyptic quality relates to the artist's paintings of 1948/49. All evince the surreal and vaguely menacing qualities also found in Neo-Romanticist works of the period by Graham Sutherland, Robert Colquhoun and John Piper. The final work in this group is *Sol y Sombra* (1955), le Brocquy's only abstract tapestry. Also shown in Venice in 1956, it was inspired by notes the artist had made on a visit to Andalucia that year when he was employed by the British export magazine *Ambassador* to explore Spanish culture and create free visual impressions for future design projects.

During the 1950s le Brocquy carried out a number of textile designs for mechanized screen printing, then a comparatively new technology, for David Whitehead Ltd., a leading manufacturer of furnishing fabrics, based in Wigan, Lancashire, who engaged avant-garde designers to produce furnishings with a 'modern' look throughout the 1950s and '60s. Three British textile firms produced le Brocquy's designs. In 1954 he was appointed visiting tutor to the Textile School of the Royal College of Art and in the same year he and architect Michael Scott set up the design agency, Signa Ltd., based in Dublin and London, to promote industrial design. Unlike the exuberance of his tapestries, the severe forms and starkly contrasting colours of his fabric designs are more in keeping with his paintings and

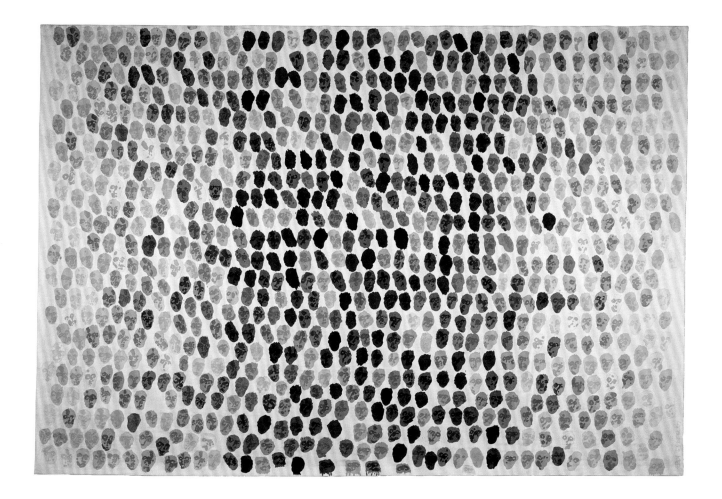

echo the sense of dislocation and turbulence of post-war Britain. In 1953 John Maguire of Brown Thomas, Dublin, was inspired to commission le Brocquy, Patrick Scott, Nevill Johnson and Thurloe Conolly (qqv) to produce designs for special editions of printed linens and he set up a company to manufacture artist-designed textiles, screen printed by hand in Belfast. The resulting fabrics were wonderfully innovative in design and quality but economically unviable and, as a result, the project was short-lived.

Tapestry production by Irish artists burgeoned again in the 1960s, directly related to the rise of Modernist architecture and economic and corporate growth. The association of textiles with the clean lines and poured concrete forms of the new architecture was to provide colour, texture and sound absorption to counteract their minimal, austere character. Architects Ronald Tallon and Robin Walker, of the firm Scott Tallon Walker, regularly commissioned tapestries from le Brocquy, Scott and, more occasionally, Cecil King (qv) for their Mies van der Rohe-inspired buildings.

Le Brocquy produced large-scale Aubusson-woven tapestries for a number of Scott Tallon Walker buildings, including the new cigarette factory of P.J. Carroll, Dundalk. *The Hosting of the Táin* (approximately 4 x 6 m) [403, 466] was located in the factory head offices, close to the site of the historic raid of *An Táin Bó Cúailnge* (The Cattle Raid of Cooley) as recounted in the ancient Irish saga. The concept for its design arose from a series of black brush drawings le Brocquy created in 1967 for Dolmen Press to accompany the translation of the ancient story by Thomas Kinsella (*The Táin*, 1969) [230]. Likening them to 'shadows thrown by the text', he described how in the tapestry he tried to create 'a sort of group mass emergence, of human presence' yet where each head is still self-contained (Dorothy Walker, *Louis le Brocquy*, Dublin 1981, pp. 48–51). Other variations are *The Massing of the Armies* (1969), commissioned by Tallon for the RTÉ headquarters in Donnybrook, Dublin, and the monumental (13.5 x 13.5 m) *The Triumph of Cúchulainn* (2002), commissioned for the National Gallery of Ireland's Millennium Wing. For the millennium year he embarked on a new realization in tapestry of twenty of the thirty Táin brush drawings in monochrome black and cream, a complete edition of which is now in the IMMA collection. These, and other late tapestry works, were realized by master *lissier* of the Aubusson region, René Duché.

Tapestry and architecture harmonize in the work of Patrick Scott, an architect himself until 1960 when he became a full-time artist. Since his teenage years, when he made his first loom, Scott had an abiding feeling for wool and weaving. He began to design tapestry in 1963 when his painting was in transition from the soaked canvases of the anti-H-bomb 'Device' series, to the taut aesthetic of tempera and gold leaf on

466. Louis le Brocquy, *Hosting of the Táin*, 1969, Aubusson tapestry, 410 x 609.6 cm, Irish Museum of Modern Art

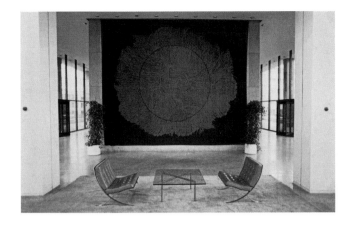

richly coloured, loose-weave rugs and wall hangings. Other works were woven by independent weavers Alice Roden and Leonora Fowler. Scott continues to design tapestries and was commissioned, in 2011, to design two large-scale tapestries for the Atrium of the extension to the Mater Misericordiae University Hospital in 2012.

The Aubusson technique suited the hard-edge aesthetic of Cecil King, who carried out designs for a small number of tapestries there. A superb tufted example woven by V'Soske Joyce was commissioned in 1974 for the National University of Ireland, Galway. Entitled *Galway Tapestry*, it echoes King's smaller-scale painting *Sounion*, made in the same period (IMMA, Gordon Lambert Trust).

Since 2000 another wave of artists, including Maria Simonds-Gooding, Barrie Cooke, Anne Madden, Gwen O'Dowd, Felim Egan and Seán McSweeney (qqv), have designed tufted wall hangings in collaboration with independent handweavers in response to a commission by the Four Seasons Hotel, Dublin.

To a younger generation of artists today, whose materials include textiles and natural fibres, such as Isabel Nolan and Mark Garry, or Corban Walker who variously works with glass, while they engage with architectural context, their respective practices do not respond to its imperative in the traditional sense, as an adjunct to it; rather their works argue their own place in the world. They stem from a questioning of the nature of materials, artistic processes and conceptual subtleties, in an attempt to construct personal aesthetic universes and convey their own intensity of experience and perception of the world. CHRISTINA KENNEDY

SELECTED READING Curran, 1957; Bowe, 1989; Dorothy Walker, *Louis le Brocquy Aubusson Tapestries*, exh. cat. Taylor Galleries (Dublin 2000); Christina Kennedy, 'An Intellectual Nature: Patrick Scott's Tapestries, Screens and Tables for Meditation', in *Patrick Scott: A Retrospective*, exh. cat. HL (Dublin 2002), pp. 89–95.

unprimed canvas. In contrast to the tonal and textural subleties of his paintings, the tapestries allowed the artist to indulge in glorious colours and dramatic textures. His first tapestry, *Paris*, really a hand-tufted work, was made in 1963 by V'Soske Joyce Carpet Handlooms, Co. Galway, with whom Scott produced more than fifty tapestries. The wide warp of their specialist hand-tufted techniques enable the sculptural potential of varying tufting possibilities, which exploit the surface, the pile and the differing lengths and densities of looped and cut wool. Early examples, such as *Berkeley* (1967, TCD), were inspired by prehistoric concentric motifs, displaying several tufting techniques and undulating surfaces reminiscent of Op art. Scott first began work with the Atelier Tabard at Aubusson in 1966, and over the next thirteen years realized nine tapestries there. Like le Brocquy, he was familiar with Lurçat's revival of tapestry, having seen his work in the Waddington Galleries, Dublin in the 1940s. Scott loved the tight classical weave of the Aubusson technique, making it an intrinsic element of his designs and allowing him great intricacy and subtlety. His cartoon designs of simple forms derived from the sinuous lines of his thumbprint, photocopied, cut and collaged to create abstract images of great variety and distinction, reveal his admiration for Matisse. In the tapestries *Kinsale* (1966), *Shanagarry* (1969), *Lansdowne* (1971) and *Device* (1972), the circular form (an enduring motif throughout Scott's career) is limited to a single colour, seen against a vivid contrasting ground.

Ronald Tallon commissioned two major tapestries for the Bank of Ireland headquarters, Dublin, from Scott, *Blaze* (1972) and *Eroica* (1979) [467], perfect examples of the blend of tapestry with minimalist architecture that characterized the era. *Blaze* (6 x 21 m), unfortunately no longer extant, featured a fiery red sun on a dark blue ground. *Eroica* portrays a huge semi-elliptical motif which shimmers with the full spectrum of colours against a deep blue ground and is the last of the artist's Aubusson works, following the closure of the Atelier Tabard in the early 1980s.

Scott was commissioned by the Kilkenny Design workshops in the late 1970s and early '80s to produce the renowned hand-tufted Rainbow Rugs, and also created designs for the weaving techniques of the Mexican weavers of Oaxaca, to produce ten

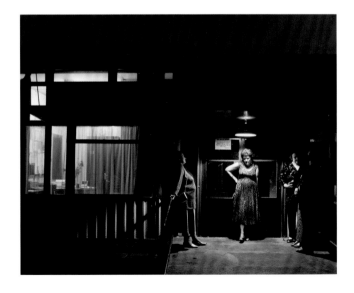

STARKEY, HANNAH (b. 1971), photographic artist. Born in Belfast and educated in England and Scotland, Hannah Starkey developed a reputation as a significant photographic artist with impressive rapidity (see 'Photography'). While still in her twenties she had solo shows in London at the Maureen Paley Gallery (1998), in Holland at the Netherlands Foto Institute, Rotterdam (1999), and at IMMA (2000). Since then, her large photographic works have entered such distinguished collections as those of the Tate Gallery, the V&A Museum and IMMA (*Untitled – August, 1999*) [468].

Starkey's photoworks, created using carefully constructed, generally urban scenarios and professional actors, reflect moments of absolute banality imbued with a sense of the before and after, of a narrative in which something momentous has just happened or is about to take place. Because they are constructed moments, with the artist acting more like a movie director than a photographer, her work questions the perception of photography as evidence, yet the very ordinariness of her scenes, and the scale on which they are presented, convey an impression of truth that more genuine photographs of reality often lack. Even if the immediate event of the photograph is fictional, however, the recognition with which we greet each of Starkey's works proves their authenticity, as the viewer acknowledges their own intimate experience of personal isolation in social settings.

Starkey consciously presents those moments from a woman's perspective, and while her settings do not generally contain recognizable topographical references, her images subtly convey notions of class, race and gender, through the poses of the actors and underplayed allusions in the physical surroundings. The universality of the image is reinforced by her refusal to add titles, other than the date on which the photograph was taken, frustrating the desire for narrative satisfaction.

While there is a strong Beckettian influence in the emphasis on those waiting moments which make up so much of urban life, Starkey's real antecedent in visual art is Vermeer. Like him, her chosen subject is women carrying out routine activities – in her case, shopping, waiting at the school, hanging out with friends. For both artists the accuracy of the observation conceals the fictitious nature of the tableaux, while similarly to Vermeer's work, the tension between the ordinariness of the event and the intensity of its mediation for the viewer, in Starkey's work, makes every light beam and the motes of dust they carry appear portentous. The sense that the viewer is a participant in an act of voyeurism increases the unease. CATHERINE MARSHALL

SELECTED READING Val Williams and Sarah Glennie, *Hannah Starkey*, exh. cat. IMMA (Dublin 2000); Iwona Blazwick, *Hannah Starkey: Photographs 1997–2007* (London 2007).

STEYN, STELLA (1907–87), painter. One of the most independent artists to have studied at the DMSA, Stella Steyn was born in Dublin into a German-Russian, Jewish family. At the age of eighteen she paid her first visit to Paris, where she developed an acquaintance with James Joyce, and befriended his daughter Lucia. Her accounts of her several meetings with Joyce, to whom she was introduced by Patrick Tuohy (qv), her former teacher in

469. Stella Steyn, cover of *Seachtain na Cathrach*, official handbook of Dublin Civic Week, ed. B. Hobson (Dublin 1927)

Dublin, are entertainingly and candidly described in her *Autobiographical Memoir*. Four years later, Joyce commissioned her to illustrate the Anna Livia Plurabelle section of *Finnegans Wake*, which was being published in serial form in *Transition* (*Transition*, no. 18, Paris 1929).

Steyn avoided the path laid down by other progressive Irish artists (Mainie Jellett, Mary Swanzy (qqv)) opting to pursue a form of expression more attuned to Fauvism than the Cubist approach followed in the studio of André Lhote. Instead, perhaps because of her German connections, she studied at the Bauhaus in 1931. That Steyn was already prepared for the work of this famous and innovative art school and the stimulating atmosphere engendered by Kandinsky, Paul Klee, and her teacher László Moholy-Nagy, is evident from her graphic design for the cover of the official handbook of Seachtain na Cathrach (Dublin Civic Week) in 1927 [469]. However she left the Bauhaus a year later as the Nazi presence in Dessau and its hostility to the distinguished art college became more overt.

Steyn divided her time between Dublin and London until her marriage in 1938 to David Ross, later Professor of French at London's Birkbeck College. She spent the remainder of her life in London, with a brief three-year interlude in Newcastle following World War II.

Steyn's work is not recognized in Ireland as it deserves to be. Resolutely figurative, she painted still lifes and human subjects, but her most groundbreaking work was not widely known until after her death, when a series of pictures of the female nude, including several self-portraits, were discovered. These paintings reveal an existential exploration of womanhood and the self. Her nudes, active and thoughtful, engage the spectator's gaze directly, critiquing traditional passive representations of the female body. In her *Memoir*, Steyn discusses James Joyce's attitudes to women. 'I don't think Joyce knew much about women He also said that it was enough if a woman could write a letter and carry an umbrella gracefully. He thought clothes and triviality were all that mattered to them. I think the women he was familiar with fell into two categories, those who were purely intellectual and those whom he had met in "night town" or its equivalent.' (Kennedy, pp. 16–17)

Steyn exhibited with the SDP, the RHA (qv), the New English Art Club, the Hackett Gallery, New York, and Grace Horne's Gallery, Boston, during the late 1920s and the 1930s. She was included in the *Exhibition of Irish Art*, Brussels (1930), group exhibitions in the Carnegie Institute, Philadelphia (1952), Tate and Leicester Galleries, London, throughout the 1950s, and in Liverpool, London, and Paris in the 1970s. Her work is in the collections of the HL and IMMA, and was chosen by Mrs Gordon Brown for 10 Downing Street. She had retrospective exhibitions in the Gorry Gallery, Dublin (1995) and the Merz Gallery, Edinburgh (2005). CATHERINE MARSHALL

SELECTED READING S.B. Kennedy (ed.), *Stella Steyn (1907–1987): A Retrospective View with an Autobiographical Memoir*, exh. cat. Gorry Gallery (Dublin 1995); Andrew McPherson, *Stella Steyn: The Female Self, Portraits and Nude Self-Portraits*, exh. cat. Merz Gallery (Edinburgh 2005).

SURREALIST ART. In 1929 the Belgian periodical *Variétés* published a special issue containing *The Surrealist Map of the World*. What is of interest, from an Irish point of view, about this map is that Ireland features in it, but neighbouring Britain and most of France and the Low Countries do not exist. Yet the art historian S.B. Kennedy denies that there has ever been a Surrealist movement in Ireland; he found this surprising, considering its dominance in European intellectual expression in the interval between the two world wars (Kennedy, p. 34). Kennedy might also have expressed surprise at the lack of a strong presence for Surrealist art in Ireland in view of the powerful legacies of Irish writers, such as Jonathan Swift and Laurence Sterne, whose scepticism, interest in the unorthodox, in strange shifts in scale and meaning, and streams of

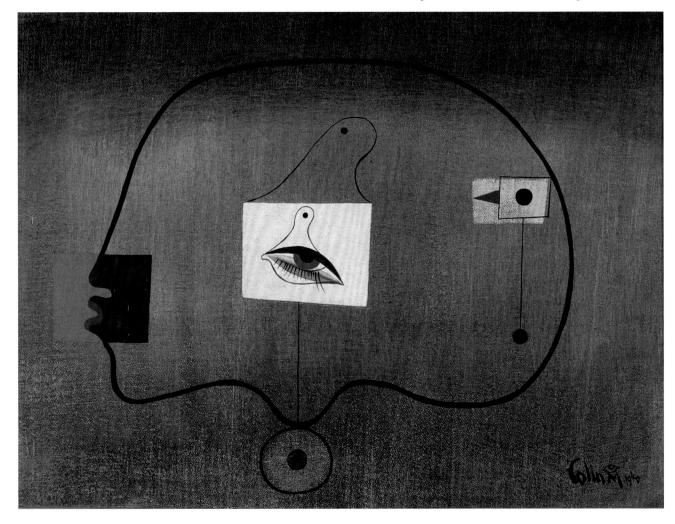

470. Colin Middleton, (*Opus 1, No. 16, Group II*) *The Child's Brain*, 1940, oil on canvas, 28 x 38 cm, Irish Museum of Modern Art

consciousness were revived in the twentieth century in the writings of J.M. Synge, James Joyce, Samuel Beckett and, above all, Flann O'Brien. As Kennedy describes it, the movement was not known in Dublin until it was introduced by the White Stag Group (qv) in the 1940s, since he claims early Irish Modernists (see 'Modernism and Postmodernism'), such as Mainie Jellett (qv), despite their keen interest in French art, did nothing to transmit it (Kennedy, p. 34). Bruce Arnold put forward a different view, claiming that 'Abstraction [qv] and Surrealism were a real and organic part of Irish art in the period between the two world wars' (Kennedy and Arnold, p. 52). Evidence to support the latter view is hard to find, although a small number of artists from Northern Ireland produced artwork from about 1936 which can be described as Surrealist and was clearly perceived as such by both artists and critics at the time. Their activities did not derive, as in Continental Europe, from either the Dada Movement or other absurdist trends in the 1920s. However, for those artists in Ireland who engaged with Surrealism, they shared with their Continental and British peers an interest in leftist political and philosophical beliefs, a deep hatred of burgeoning fascism, and the conviction that rationalism had failed, making it the duty of the artist to reveal the true reality beyond perceived facts and rational deduction. There is no evidence that Irish artists read André Breton's *Manifesto of Surrealism* (1924) which defined Surrealism as 'pure psychic automatism, by which it is intended to express … the real processes of thought'. Inspired by the psychoanalytical writings of Sigmund Freud and others, Breton claimed that reality was not governed by reason but by chance and demanded that Surrealists should develop a meta-reality that was guided by the irrationality to which the unconscious provided the best route.

There is no clear evidence of how the Belfast artist Colin Middleton (qv) [470] discovered Surrealism, but he could fairly describe himself retrospectively as 'the only Surrealist artist working in Ireland in the 1930s' (Snoddy, 2002, p. 421). Middleton rarely travelled outside Ireland, apart from a visit to London in 1928 (before the movement had taken root there) and Belgium in 1931 (admittedly a centre for Surrealism in the 1930s), and there were few illustrated art books or photographs in the newspapers. Thus, it is difficult to comprehend how he managed in the space of two or three years to incorporate into his work elements of the work of Salvador Dali (Spanish), Giorgio de Chirico (Italian) and Roland Penrose (British). However, an important ideological link between Middleton and the Continental movement can be found in their shared aversion to fascism and their deep concern at events of the Spanish Civil War. More personally, the emotional turmoil Middleton suffered in 1939 when his first wife died tragically, just four years into their marriage, and the German bombing of Belfast in 1941, were influential factors in his Surrealist work. As a young artist, relatively unscathed by traditional approaches to art, since he was largely self-taught, Middleton was active in the formation of the short-lived Ulster Unit, founded in 1934, a forum in which he and the poet, critic and later art curator, John Hewitt, and others held long discussions about socialism, psychoanalysis, politics, literature and art.

The International Exhibition of Surrealism, which launched the movement in England with 360 artworks by fifty-two artists, from eleven countries, at the New Burlington Galleries in London in June and July 1936, attracted unprecedented publicity, of which Hewitt and Middleton could not be unaware. Sheila Legge's dramatic appearance, with her head entirely covered in flowers, in Trafalgar Square, as Surrealist Phantom, attracted 25,000 visitors, while other events, such as Salvador Dali's near suffocation during a lecture he gave wearing a bolted diving suit, caused major derision. Publicity also attended the attempt by the British Union of Fascists to break up the exhibition.

Another likely connection between Belfast and events in London was the Northern Irish sculptor F.E. McWilliam. McWilliam, from Banbridge, Co. Down, had been a student at the Belfast College of Art while Middleton was there as a part-time student. Having moved to London in 1928, and discovered Surrealism on a visit to Paris in 1931, McWilliam became an active member of the British Surrealist Movement from 1937, during which time he also retained his very close contacts with Northern Ireland. Asked initially to participate in the Artists' International Association exhibition in London in 1937, McWilliam gravitated away from the abstract section, to which he was invited, towards the Surrealist one. As he later told Mel Gooding, he preferred the Surrealist camp 'because of its more liberal, non-doctrinaire attitude' (Buck, cat. no. 31). Close to Roland Penrose, one of the main spokesmen for Surrealism in England, McWilliam designed extraordinary 'Chamberlain Masks' and placards demanding the resignation of the Prime Minister, Neville Chamberlain, which he, Penrose, and others wore as they marched in London in protest at Britain's failure to stand against fascism. McWilliam showed in the Surrealist Objects and Poems exhibition in 1937, and in all further British Surrealists'

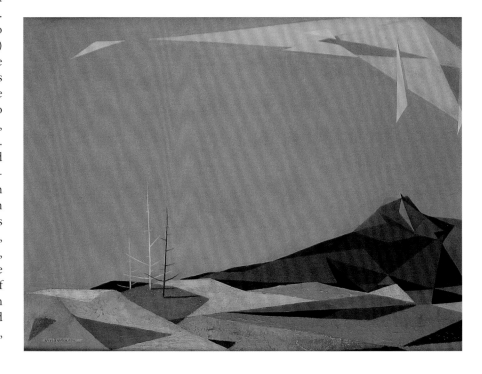

471. Nevill Johnson, *Landscape, Rockpool*, 1950, oil on canvas, 40.8 x 55.9 cm, Dublin City Gallery The Hugh Lane

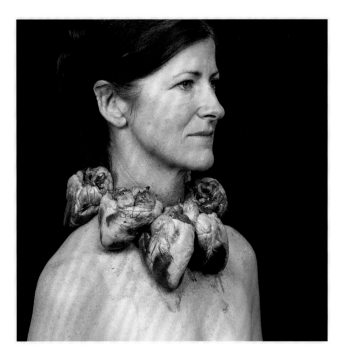

472. Alice Maher, *Collar*, 2003, lambda print, 61 x 61 cm

expression, telling Harriet Cooke that the Troubles had 'reactivated the old Surrealist bug, and it's coming up, this strong colour, that emotional colour' (Cooke, IT, 25 January 1971) (see 'The Troubles and Irish Art'). Apart from Middleton and F.E. McWilliam in his early work, the only other artist in Ireland to produce work that is unequivocally Surrealist was Nevill Johnson (qv) [471]. In his case, the impetus came directly from seeing a Surrealist exhibition in Paris and he produced his highly accomplished paintings in this vein in the mid-1940s, under the influence of Dali, Yves Tanguy and de Chirico. Beatrice Glenavy's (qv) painting *The Intruder* (1932, NGI collection) is redolent of the dream world, but Glenavy denied that she was a Surrealist and does not appear to have shared their ideological position. In the early 1970s, Maria Simonds-Gooding (qv), recently returned from a year in Brussels, painted in a very consciously Surrealist manner, inspired particularly by the work of Magritte and Paul Delvaux whose work she then admired. The critic Dorothy Walker saw elements of 'eerie surrealism' in the work of Patrick Hennessy (qv) (O'Doherty, 1971, p. 66), but his hyper-realism contains nothing of the disjunctions and strange juxtapositions of the Surrealists. Edward McGuire's predilection for stuffed birds and intrusive vegetation in the domestic settings of his portraits comes closer, but the spirit of Surrealism is more subtly and pervasively employed in the work of later artists such as Alice Maher [472], Kathy Prendergast, with her insertion of a heart-beat into a baby's jumper and Dorothy Cross's (qqv) subversion of gender roles in sport through the use of croquet and rugby balls made of stretched cows' udders.

Of all the artists referred to here, the person most consistently identified as Surrealist was undoubtedly Colin Middleton. But even Middleton's right to the description has been questioned. Dickon Hall believes that the wider implications of Surrealism were alien to Middleton, despite Middleton's obvious admiration for Dali and de Chirico, and his painted homage to Max Ernst (Hall, chapter 2). Hall quotes the artist's friend John Hewitt as saying that he was superficially Surrealist, but more structured in his symbolical content, 'avoiding the fundamental irrationality of that school'. Edward Sheehy, like Hewitt, also thought Middleton different to the Surrealists, citing his love of order over their desire to outrage (Sheehy, *Envoy*, no. 2, April 1950, 33–34). It must be agreed that few in Ireland, apart from the poet W.B. Yeats, were interested in the automatism of Jean Arp, the frottages of Max Ernst, or the question of language as René Magritte was, but Middleton did employ the juxtaposition of apparently unrelated objects to provoke unconscious associations, as Dali, Magritte and de Chirico did. Like them, also, he presented these strangely juxtaposed objects with a clarity designed to increase dislocation between idea and representation. When asked about the meaning of the strange assemblages of figures and objects in his work, he answered that he often had no idea what a figure symbolized until he had seen it recur in several paintings, at which point it frequently metamorphosed into quite different phenomena, related, as he would then discover, through their connection to unconscious Jungian archetypes (Michael Longley, 'Interview with Colin Middleton', *IT*, 7 April

exhibitions, holding his first one-man show at the London Gallery, their showcase venue in 1939. The British movement's dissolution at the outbreak of war coincided with McWilliam's personal need for greater independence than group affiliation afforded.

The artists of the White Stag Group, who came to Ireland in the 1940s to avoid War and conscription, were less stridently political and more willing to prioritize aesthetic concerns than the Surrealists, but their interest in psychoanalysis offered a parallel to the older movement, while their choice of Herbert Read, one of the leading voices of British Surrealism in 1936, to write the catalogue essay for their Exhibition of Subjective Art in Dublin in January 1944 stirred Irish interest in his writing. Here Read's exhortation to artists to reveal the reality under the 'superficial veil of appearances' repeated André Breton (Kennedy, p. 107). His essay was reproduced by Sean Ó Faoláin in *The Bell* (February 1944) and was widely influential in Ireland. Of the artists in the White Stag Group's several exhibitions in Dublin in the 1940s, Bobby Dawson, Brian Boydell, Ralph Cusack, Thurloe Conolly (qv) and Nick Nicholls show strong surreal tendencies in their approach to painting, something that was recognized by the Dublin critics. Gerard Dillon (qv) combined elements of folk art and Surrealism in much of his work, but especially in those paintings in which he adopted the persona of a pierrot, such as *Space Circus* and *Beach People* (n.d., formerly collection of George McClelland).

While Surrealism as a movement died out generally around Europe following the outbreak of World War II, Colin Middleton found himself drawn back to it at times of heightened emotion and conflict. During the 1950s he again produced bodies of Surrealist work and when the 'Troubles' broke out in Northern Ireland and he experienced personal tragedy with the death of his only son, he fell back on this form of

1967). And like de Chirico and Magritte, he too felt the need to reconcile the opposed dualities of dream/reality, society/individual, ideology/artistic activity. If he avoided the shock tactics of his louder mentors, his images still reverberated within his provincial society. CATHERINE MARSHALL

SELECTED READING Buck, 1988; S.B. Kennedy, 1991; Dickon Hall, *Colin Middleton: A Study* (Belfast 2001); Kennedy and Arnold, 2005; Stephens, 2008.

SWANZY, MARY (1882–1978), painter. An individual and highly committed artist, whose working life spanned more than seven decades, Swanzy is less easy to categorize than her contemporaries Evie Hone and Mainie Jellett (qqv). Like many Irish artists of the early twentieth century, Swanzy studied in Paris and absorbed the lessons of Modernism (qv), but her paintings thereafter fall into several distinct groups, influenced respectively by Fauvism, Cubism (qv) and Surrealism (qv). Skilled in the use of colour and stylish in her compositions, Swanzy's contribution to the quality of Irish art has been underrated. Apart from an early friendship with the older artist Sarah Purser (qv), who encouraged her studies, she remained single and, like her contemporaries Hone and Jellett, dedicated her life entirely to her art.

Born at 23 Merrion Square, Dublin, the second daughter of Sir Henry Rosborough Swanzy, an eye specialist and vice-president of the College of Surgeons, Mary Swanzy was raised within a strict Anglo-Irish milieu, attending school at Alexandra College and being sent to finishing schools at Versailles and Freiburg. Returning to Dublin, in 1900 she enrolled at a private art academy run by May Manning, where John Butler Yeats was a visiting tutor. She also attended evening classes in sculpture at the DMSA, where she was taught by John Hughes. Her artistic talents were recognized by Nathaniel Hone, Walter Osborne and Sarah Purser. In 1905, the year in which her *Portrait of a Child* was shown at the RHA (qv), Swanzy moved to Paris, continuing her education at the Académie Delacluse. In 1906 she was at the Académie de la Grand Chaumière and Colarossi's atelier, and attended soirées at Gertrude Stein's house where she encountered works by Picasso, Braque, Gauguin and other avant-garde artists. Julian Campbell suggests that her art during this period was influenced by her teacher Lucien Simon, and she also studied with the portrait painter Antonio de la Gándara (Campbell, p. 15).

After the death of her parents, Swanzy became financially independent. She moved on to Italy, painting mainly landscapes (qv) in a gentle Fauve style, before returning to Ireland, where she set up a studio at 18 Nassau Street, working as a portraitist, but also producing illustrations and designs for posters (see 'Portraiture' and 'Illustrations and Cartoons'). Her first one-person show was held at Mills Hall, 8 Merrion Row in 1913 and the following year her work was shown at the Salon des Indépendants in Paris. Five years later, she showed, along with Clare Marsh, at the Stephen's Green Gallery, and in 1921 was included in the *Dublin Painters Autumn Exhibition*. In 1918 she exhibited again at the Salon des Indépendants, and became a committee member of the Salon two years later.

473. Mary Swanzy, *Samoan Scene, c.* 1924, oil on canvas, 152 x 92 cm, Crawford Art Gallery formerly AIB Collection

Swanzy visited her sister, who worked as an evangelical missionary in the Balkan region, in 1920 and 1922, taking the opportunity to paint and sketch landscapes as she travelled. While her *Bâteau de Lecheur* (1921, private collection) can be dated to this period, most of Swanzy's oil paintings and watercolours are not dated and so constructing a definitive chronology is difficult. Her sketch portrait *Slovak Baby* probably dates from her travels during these years, as does *Sur la Côte Dalmatienne* (private collection). Swanzy moved on to Honolulu and Samoa two years later, producing a series of canvases depicting lush tropical landscapes, including *Samoan Scene* [473], one of her most ambitious paintings in terms of scale. An exhibition of her Samoan paintings was held in Santa Barbara, California in 1924. Swanzy then returned to Dublin, before travelling on to Paris, where she entered a more abstract (see 'Abstraction') and experimental phase, producing imaginative Surrealist and Cubist compositions, the latter inspired by the Orphic-Cubist work of Robert Delaunay, in particular his *Homage to Blériot* (1922, Kunstmuseum, Basel).

Paintings by Swanzy, such as *White Tower*, *The Storm* and *Spiral Composition (with Heads)* (all private collections), reveal

474. Mary Swanzy, *The Mêlée, c.* 1931, oil on canvas, 55.8 x 70.5 cm, private collection

an accomplished grasp of pictorial composition in a dynamic Cubist, or Italian Futurist, style. However these works are again undated, and as Swanzy continued to produce Cubist paintings late in her career, caution should be exercised in dating her works. The hallucinatory and nightmarish quality of *Mêlée* [474] is characteristic of Swanzy's very personal adaptation of the Surrealist style. The painting expresses the dehumanization and alienation she witnessed, as Europe descended towards the chaos of World War II. In *Mêlée*, a group of naked people fight wildly with each other in the street. From the door of a convent, a woman appears, hands outstretched. On the ground lie a crown and a shattered sword. Several of these Surrealist paintings were exhibited in Dublin in 1943 at the inaugural *IELA* (qv), and three years later Swanzy was represented at the St George Gallery in London, in an exhibition that also included works by Dufy, Chagall and William Scott (qv). Her *Street Scene* (1943), a nocturnal scene of revellers sitting on the steps of a tall building, evokes an Expressionist (see 'Expressionism') theatre set, and was probably inspired by sketches made in Dubrovnik. Painted in 1942, *Conflagration*

(LCGA) depicts a town in a mountainous valley, with flames in the distance, while *Prayer for Peace*, which dates from the last year of World War II (exhibited *Rosc '80*, Cork; private collection), depicts two stylized figures holding doves, standing in front of the columns of a ruined Greek temple. Surrealist and figurative works such as these represent probably the most important strand in Swanzy's art, one evoking the feeling of medieval sculpture. Swanzy was also capable of producing finely observed portraits of women and children, as in her *Reading Lesson* (1959), which can be compared to the work of Marie Laurencin.

In 1949, aged sixty-seven, Mary Swanzy was elected HRHA. Years of dedicated work followed, during which she lived in London, and exhibited little. However in 1968 a substantial retrospective was organized at the HL in Dublin, and a subsequent exhibition, at the Dawson Gallery in 1974, was equally well-received. Swanzy continued working up to her death in London in 1978. Four years later, a studio exhibition was held at the Taylor Galleries, Dublin, while in 1986 a retrospective was held at the Pyms Gallery in London. A subsequent exhibition of her travel

drawings from the 1920s was held at the Pyms Gallery in 2010. She is represented in the collections of the HL, LCGA, CAG, UM and NGI. PETER MURRAY

SELECTED READING Julian Campbell, 'Mary Swanzy: Biography', in *An Exhibition of Paintings by Mary Swanzy HRHA 1882–1978*, exh. cat. Pyms Gallery (London 1986); Fionnuala Brennan, *Mary Swanzy HRHA (1882–1978)* (London 1989); O'Connor, 2010.

SWIFT, PATRICK (1927–83) [475], painter. Perhaps because he spent most of the 1960s and '70s in the Algarve in Portugal, and exhibited on few occasions, there was relatively little recognition in Ireland, during his lifetime, of the considerable achievements of Patrick Swift. Born in Dolphin's Barn, Dublin, Swift was educated at the Christian Brothers School on Synge Street before going on, in 1947, to attend evening classes at NCA, where his teachers included Seán Keating (qv). During these early years, Swift shared a studio in Hatch Street with Lucian Freud, a frequent visitor to Dublin. While working as a clerk at the Dublin Gas Company during the day and studying art at night, Swift still found time to participate in literary gatherings at McDaid's pub and in the 'Catacombs', where he developed his theories on art and poetry, in discussions with writers and artists including Patrick Pye (qv), Patrick Kavanagh and Anthony Cronin. Within this milieu, emphasis was placed on artists remaining true to their own individual experiences, while avoiding the decorative or picturesque. Swift's work at this time demonstrates a responsiveness to the frugal, ascetic Realism (qv) of Lucian Freud, rather than to the then emerging vogue for abstraction (qv).

Swift's first exhibition, held at the Victor Waddington Gallery in 1952, was well received, with critics praising his Realist portraits and still lifes, while noting their austere and sombre qualities. The exhibition was covered in *Time* magazine and two years later Swift was awarded an Irish government grant to study art in Italy. He was accompanied by his future wife Oonagh Ryan, sister of John Ryan, founder of the Bailey pub and chronicler of literary Dublin in the 1950s. The following year, along with his wife and young family, Swift moved to England, spending a year at the Digswell Artists' Colony near Welwyn Garden City, before moving to a flat in Notting Hill, London. During his time in London, he edited a short-lived literary journal called *X*, maintaining close contacts with such writers as Patrick Kavanagh, Anthony Cronin, George Barker and David Wright. Swift's introduction to Portugal came about when Wright asked him to illustrate a travel book on Lisbon. His illustrations, confident essays in pen and ink, emphasized the traditional architecture, rural life and landscapes of the Iberian peninsula.

In 1962 Patrick and Oonagh Swift and their young daughters settled near the small village of Carvoeiro on the Algarve coast. They built a house and studio, Torre del Alfanzina, in the local vernacular style. Some years later Swift founded Olaria Porches Pottery, a business that continued to thrive after his death, producing traditional hand-painted pottery and azulejo tiles. Swift himself was involved in popularizing the region. He illustrated

David Wright's *Algarve, A Portrait and a Guide* (1965) and *Minho, A Portrait and a Guide* (1968) while *Lisbon, A Portrait and a Guide* was published in 1971. In terms of his own painting, Swift felt that both pure abstraction and academic Realism were inimical to his pursuit of an art that was accessible and that reflected truths about life and human creativity.

Swift's reluctance to submit works to exhibition either in Dublin or London contributed to his becoming isolated from

475. Patrick Swift, *Self-portrait in the Studio*, 1959, oil on canvas, 122 x 76 cm, Irish Museum of Modern Art

the Irish art world. Apart from a show in Lisbon in 1974, he effectively ceased showing his paintings, preferring to work privately, pursuing his own goals and setting his own exacting standards. In Dublin's art world, Swift, working away in the Algarve, was quietly forgotten. His death in 1983 went almost unnoticed. After his death, the contents of his studio were transferred to Ireland, and a series of exhibitions then took place, that enabled a more thorough appraisal of his life and work. In Portugal however, Swift had remained well-known as an artist and cultural figure. His friendship with the ill-fated Portuguese Prime Minister Francisco de Sá Carneiro, his illustrations for guidebooks to Portugal, and his revival of the traditional art of hand-painted ceramics had made him something of a national hero. His studio collection included hundreds of drawings and paintings, including several very large canvases. Inspired by the landscapes and rural life of Portugal, these paintings, Expressionist (see 'Expressionism') in style, but with roots in Classical Mediterranean and Iberian art, confirmed Swift's stature as one of the most individual artists to have emerged from Dublin in the post-war years. A retrospective exhibition was held at IMMA in 1993, accompanied by the publication of a biography, *PS... Of Course*, edited by Veronica Jane O'Meara. Eight years later, another retrospective was held at the Crawford Art Gallery which toured to the Palacio Foz in Lisbon. Swift is represented in the collections of IMMA, HL and the OPW.
PETER MURRAY

SELECTED READING Veronica Jane O'Mara (ed.), *PS... Of Course: Patrick Swift 1927–1983* (Cork 1993); Aidan Dunne and Anthony Cronin, *Patrick Swift (1927–83) Retrospective*, exh. cat. IMMA (Dublin 1993); Peter Murray, Brian Fallon and Fernando de Azvedo, *Patrick Swift: An Irish Painter in Portugal* (Kinsale 2001).

TALLENTIRE, ANNE (b. 1949) [476], artist. Anne Tallentire is highly regarded for her multifaceted and complex installations which can incorporate film, video, objects, sound, text, photography and performance (see 'Time-based Art' and 'New Media Art'). Her contribution to contemporary Irish art rests on her critical approach to her subjects, which draws on themes of topography, identity and everyday life.

Born in County Armagh, Tallentire has spent most of her career living outside Ireland and this context has informed her interest in exploring the socio-political ramifications of space and place. In the early 1980s she studied printmaking at the School of Visual Arts in New York and became engaged with feminist practice that consequently prompted her work in the medium of live art. She performed her first work, *Return the Gaze*, at the Woman One World Café in 1983. Tallentire moved to London in 1984 by which time she was also working in video and installation (qv). She completed postgraduate studies at the Slade School of Fine Art between 1986 and 1988, and subsequently took up a lecturing position at Central Saint Martins College of Art and Design and was appointed Professor of Fine Art in 2005.

Her interest in the politics of place first emerged in such early works as *Altered Tracks* (1987) and *The Gap of Two Birds* (1988/89), and later developed in *Resisting the Lullaby* (1991), *Drift* (2002–10) and *Field Study* (2010). Tallentire has maintained contact with the Irish art world and her work has been displayed in international exhibitions of Irish art such as *Irish Days II*, Ustka, Poland (1994), *L'Imaginaire Irlandais*, École des Beaux Arts de Paris (1996) and *0044*, CAG and PS1, New York (1999). She represented Ireland at the Venice Biennale in 1999 with a video installation titled *Instances*, which formed the departure point for a ten-year retrospective, *This and Other Things*, at IMMA in 2010. Tallentire has frequently exhibited experimental works in non-gallery sites such as *Trailer* (1998) for 'Off Site' at the Project Arts Centre, Dublin, *Inscribe I* (1994) at the Telecom Éireann offices in Dublin and *Inscribe II* (1995) at the Orchard Gallery. In these, Tallentire used communication technologies to engage with the material geography of the city, a concept similarly explored in *At Sea* (1996) and *Nowhere Else* (2010).

Collaboration is an important aspect of Tallentire's art practice; she has previously worked with Alanna O'Kelly (qv) in the performance *Forbidden Heroines* (1986/87), and with London-based artist and writer Siraj Izhar and the group Double Agents. Her most sustained collaboration has been with the British artist John Seth, which commenced in 1993 and was formalized under the name 'work-seth/tallentire' in 1997. As suggested in the title, the issue of work and the labour-intensive processes of art-making are significant concerns. Work-seth/tallentire often present their work in series, where themes are revisited and developed with subtle variations, as seen in *Interruptions* (1993–97), *Dispersal* (2000) and *Manifesto* (2001–04). Whether working individually or collaboratively, Tallentire continues to bring a captivatingly ambiguous tone to her work, all the while maintaining a balance between aesthetic and conceptual concerns.
JENNIFER FITZGIBBON

476. Anne Tallentire, *Instances*, 1999, video installation at the Irish Museum of Modern Art, 2010

SELECTED READING Barber, 1994; Valerie Connor (ed.), *Anne Tallentire* (Dublin 1999); Jaki Irvine and Brian Hand, *Instances: Anne Tallentire*, exh. cat. 48th Venice Biennale (Dublin 1999); Charles Esche, Rachael Thomas, Vaari Claffey, Hans Ulrich Obrist, *Anne Tallentire: This, and other things 1999–2010*, exh. cat. IMMA (Dublin 2010).

TESKEY, DONALD (b. 1956) [477], painter. Donald Teskey was born in County Limerick, into a family that came from the Palatinate in Germany. He studied at LSAD from 1974 to 1978 and won the RTÉ EV+A award for drawing in 1981. His early work consisted of graphic works illustrating interiors and figures, hovering between a quasi-expressionistic style and photo-realism. His talent was recognized at his first solo exhibition at the Lincoln Gallery, Dublin in 1980, when Patrick Hall (qv) bought one of his works, and again in 1984 when he was selected for Lucy Lippard's international touring exhibition of new Irish art, *Divisions, Crossroads, Turns of Mind*.

Following a twelve-year break from painting, Teskey's interests changed. He concentrated on urban subjects, until a period at the Ballinglen Arts Foundation in County Mayo, from 1996 to 1997, brought a change in emphasis from urban to rural themes. The shift in focus was decisive, resulting in a powerful series of seascapes exploring the dynamic qualities of the north Mayo coastline. Here, the tactile nature of his paint and high viewpoints creates a cinematic mood of suspense and restrained energy that recalls Turner. There is a creative synergy at work between Teskey's drawings and his paintings. His drawings are often finished works in their own right, though many are starting points for the paintings. As he sees it, drawing is an exploration of an idea which, crucially, facilitates the transfer of energy to painting.

Teskey's large-scale seascapes, dramatically rendered in muted tones, and his unpopulated, gritty cityscapes are all characterized by an improvisational, painterly handling. This is achieved with the filling knife, trowels and floats that he knew through his father's joinery business. Teskey rejected the vernacular of Neo-Expressionism, claiming he has no inner turmoil to express and his mature work is marked by the principles of individualism and authenticity.

Donald Teskey's latest body of work returns to the uncelebrated views of a city, on this occasion as seen from the window of a train in the USA. Time spent in the States has heightened his palette. Teskey has forged his own pictorial language, and fulfilled his intention: the creation of an assured body of work that belies its preparation. In 2002 he won the Keating McLaughlin Medal and Prize and the Don Niccolo d'Ardia Caracciolo Medal and Award at the RHA Annual Exhibition. Based in Dublin, Teskey was elected a member of the RHA (qv) in 2003 and Aosdána (qv) in 2006.

His work is included in the collections of the AC/ACE, IMMA and the LCGA. SUSAN KEATING

SELECTED READING Aidan Dunne, *Donald Teskey: Drawings*, exh. cat. AC/ACE touring exhibition (Dublin 1991); R. Kennedy, 2002; Brian McAvera, 'Tracking Donald Teskey', *IAR*, XXVI, no. 4 (2009), 64–71.

477. Donald Teskey, *St John's Point III*, 1999, oil on canvas, 109 x 127 cm, private collection

TIME-BASED ART (see 'New Media Art', and *AAI* III, 'Performance Art' and 'Time-based Art'). The term time-based art broadly encompasses art practices that share time as a key element in their conception, such as performance, film (qv), video and video installation. The genealogy of international time-based art can be traced through the 1950s' Fluxus movement and Allan Kaprow's conception of the 'happenings' as informal, non-structured performance events, to Nam June Paik, who is said to have shown the first video artwork in New York in 1965. In Ireland, the development of time-based art can be traced through a selection of artworks, artist-led initiatives and exhibitions that formed an emergent field in the 1970s.

Although opinion differs about the exact moment when time-based art appeared in Ireland, a number of milestones mark the emergence of a culture of reception for these new practices. The establishment of the Project Arts Centre in 1967 created a venue for experimentation and exchange for artists who generally gained support and sourced outlets for their work through an artist-led counter culture, rather than through commercial galleries (qv). Similarly, changes in cultural legislation in the 1973 Arts Act broadened the remit of the arts to include cinema and developed funding opportunities for artists to travel internationally, which indirectly paved the way for artists' departure into film and video.

Emergence

Brian O'Doherty/Patrick Ireland's (qv) name-change performance [337, 379] at the Irish Exhibition of Living Art (qv) in 1972 is cited by Dorothy Walker as the earliest public performance by an artist in Ireland (Walker, p. 39). The contribution of two important artists from Britain, Alastair MacLennan and Nigel Rolfe (qqv), strengthened this emergent interest in performance art in the 1970s. Rolfe was appointed to the role of visual arts director of the Project Arts Centre in the years following his arrival in Ireland in 1975, and set about establishing a platform for live art in Dublin. He performed *The Table: Open Hand,*

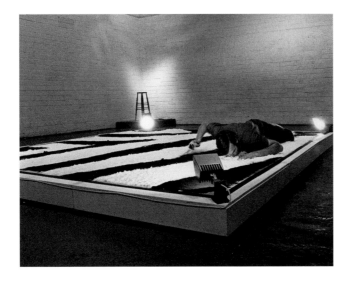

Closed Fist for a group of visiting artists led by the dynamic Scottish curator Richard Demarco at the National College of Art and Design in 1976. This was one of many instances of dialogue, exhibition and exchange between performance artists in Ireland and Britain, subsequently developed in events such as *Time/ Space/Performance/Installation* at the Project Arts Centre in 1978. Artwork by seven artists was presented over a five-week period, and included important durational installations by John Aiken and Adrian Hall, as well as Rolfe's ground-breaking performance *Zebra* (1978) [478]. Similarly, Alastair MacLennan has lived in Belfast since 1976 and contributed to the development of performance art in Northern Ireland through his founding involvement with organizations such as Art and Research Exchange (ARE), established in 1978, and his teaching at Belfast College of Art.

Based in Belfast, ARE housed the first headquarters of the Artists Collective of Northern Ireland and also served as a meeting and exhibition space for artists working at the forefront of performance and time-based art in Northern Ireland, such as John Carson and Willie Doherty (qv). Other art venues, such as the Crescent Arts Centre and, subsequently, Catalyst Arts in Belfast, along with the Project Arts Centre, provided an opportunity for performance artists to showcase their work. Another outlet for presenting experimental media was through festivals of performance art, such as *Work Made Live* (1981) in Dublin, *3 Days of Live Art* (1983) in Belfast and *Performance Art Now* (1985) in Cork. These festivals were significant in facilitating contact between artists interested in collaborating and developing performance as an art medium. They also regularly featured the same artists and hence, sustained a community of practitioners. This trend for presenting performance through artist-led festivals continued into the 1990s with events such as *Available Resources* (1991) in Derry and *Exchange Resources* (1995) in Belfast.

In the early 1980s, artists and curators generally used the terms live art and performance art interchangeably. There are some exceptions where critics note a distinction between these concepts, suggesting an emergent reflexivity towards the theorization of time-based media. For example, in a review of

Performance Art Now in 1985, Günther Berkus observes 'this is not performance art as we know it in Ireland. This is more like a form of art theatre, or theatre reflecting on itself.' (PAN, *Circa*, no. 24, 1985, 16) The conflation of live art and performance continued into the 1990s, with Martin McCabe and Michael Wilson noting that these definitions were 'seemingly intractable' (McCabe and Wilson, 19). Typically, live art is more closely aligned with theatre than with performance; however, attempts to delimit the boundaries between these terms has contributed to what the authors term 'a category anxiety' (ibid., 18).

The work of James Coleman (qv), who is regarded as an important figure in the development of international time-based art, defies neat classification. Writing about Coleman's work with technology since the 1970s, the art historian Rosalind Krauss has credited him with pioneering the slide-tape format, which comprises of multiple transparencies projected in succession with a synchronized audio tape (Krauss, ' "And Then Turn Away?" An Essay on James Coleman', *October*, LXXXI, Summer 1997, 5–33). In *So Different ... and Yet* (1980) [479], which was developed with Roger Doyle and Olwen Fouéré, Coleman draws on associations of installation and performed work while not conforming to one or the other. This work consisted of a performed element, using actors positioned within a stage-like setting, and a subsequent recorded element captured on video. Furthermore, in *Charon (MIT Project)* (1989) Coleman used the inherent temporality of audio and photography to explore the elisions between seeing and interpreting. While Coleman has been based outside of Ireland for much of his career and is better known internationally than nationally, this situation was redressed in 2009 with a major exhibition of the artist's work hosted at three of Dublin's leading cultural venues, the Irish Museum of Modern Art (IMMA), the Project Arts Centre and the Royal Hibernian Academy (qv). Nonetheless, Coleman's insistence on an expanded definition of media practices that consistently elude categorization importantly influenced a generation of Irish artists who sought to develop time-based art in the 1980s and beyond.

Development

Many artists who initially experimented with time-based formats gained formal training through a traditional art college curriculum that was divided into sculpture, painting and printmaking (qv). Artists working in expanded media practices mostly emerged out of sculpture departments. Una Walker attended art college in Belfast in the 1970s and notes that 'many undergraduates in sculpture were making conceptual art (qv)' (Slavka Sverakova, 'Elliptical Narratives: A Conversation with Una Walker', *Sculpture*, XXIV, no. 1, 2005). Given this context, time-based art in Ireland in the 1970s is characterized by a close alignment with sculptural practices. In the 1980s problems of access, logistics and the expense of new technologies meant there was significant cross-over between performance, installation (qv) and artists' use of film and video. Shirley MacWilliam has observed that 'moving-image art practices in Ireland have consistently been strongly marked by performance' (MacWilliam, 44). Additionally, documenting these ephemeral events became an important aspect of working in time-based

media. As evidenced in *Name Change* (1972), it is the preparation and recording of this key performance event that is widely exhibited and known.

As time-based media developed, a generational gap emerged between foundational practitioners like Rolfe and MacLennan and younger artists. This is evident in the festival brief of *Work Made Live* (1981), which proposed to be the first national festival for younger artists making live art-work. Artists active in Northern Ireland during the 1980s, such as Nick Stewart, André Stitt and Anne Seagrave, developed various approaches to engage with themes of political and personal identity. The role of the body (see 'The Body') was another significant concern, expressed with highly contrasted outcomes that ranged from Stitt's viscerally active works to MacLennan's meditative 'actuations', a neologism developed by MacLennan to refer to the combination of installation and live elements in his work. Artists Pauline Cummins, Alanna O'Kelly (qqv) and Louise Walsh engaged with contemporary feminist politics, and such issues remain important for performance artists such as Sandra Johnston and Amanda Coogan.

The founding of *Circa* in 1981, through the initiative of ARE, marks another important milestone in the development of the critical reception of time-based art in Ireland. The publication charts a transition from experimental into sophisticated multimedia approaches that combine film, video, photography, text, sound and performance. The temporary and ephemeral nature of time-based artwork has been the cause of both critical confusion and celebration over the years. This dialogue was played out in various letters to the *Irish Times* in the 1980s, where one critic referred to 'the hordes of untalented opportunists and self-deceiving phonies' (Brian Fallon, 'Next Rosc is on the Horizon', *IT*, 2 December 1987). In response, another critic countered by exposing the 'vitriolic and sweeping denunciation of conceptual and performance' contained within this position and continued to list 'reputable and internationally distinguished' artists in Ireland (Peter Jordan, 'Performance Art', *IT*, 11 December 1987). Not surprisingly, this list comprised artists working in time-based formats, such as MacLennan, Rolfe, O'Doherty/Ireland and Coleman.

Diversification

The gradual acceptance of time-based art by public audiences can be charted through the changing exhibition practices of galleries such as the Douglas Hyde (DHG), which started to exhibit

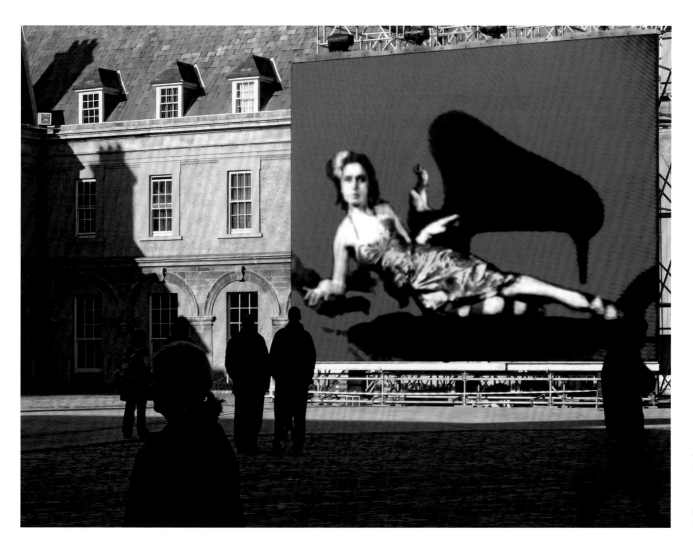

479. James Coleman, image still from *So Different...and Yet*, 1980, video installation, performed by Olwen Fouéré and Roger Doyle

paradigms of international contemporary video art by such artists as Judith Barry (1988) and Bill Viola (1989, 1997). Similarly, specialist events began to emerge; the Dublin Video and Film Festival in the 1980s, several video art festivals at the Triskel Art Centre, Cork, in the 1990s, and the Video Cats Festival, which premiered at Catalyst Arts in 1997. Reflecting on the number of moving image-based entries shortlisted for the GPA Award in 1990, Joan Fowler noted the absence of live performance in the selection while observing the ubiquity of video. The early 1990s marked a significant moment in the history of moving image media, which she observed had become 'a primary form, not only for recording time-based work but also as the concept and aim' (Fowler, 'GPA Awards', *Circa*, no. 56, 1991, 38).

The opening of IMMA in 1991 marked a much sought-after level of institutional recognition for time-based practices. Where artists had previously had problems accessing facilities, the large-scale exhibition spaces at IMMA could accommodate the presentation of national and international film and video artists. For example, the collaborative installation *Sounding the Depths* (1992, IMMA collection) by Pauline Cummins and Louise Walsh explored the potential of the gallery as immersive space, creating an installation that viewers encountered sequentially through the museum's interconnected rooms.

Despite evidence that time-based art was beginning to be recognized by national institutions and awarding bodies, artists continued to highlight the difficulties of presenting their work, particularly in commercial galleries. Blue Funk (qv) was an artist-led group formed in 1989 that shared theoretical and practical concerns about time-based media. The group formed a loose definition of the term 'time-based', which incorporated film, video, installation, sound, slide projections and text (Michael Wilson, 'Blue Funk', *Circa*, no. 63, Spring 1993, 51). In 1992 the group organized a two-day exhibition at the DHG entitled *A State of Great Terror*. The short duration of the exhibition had the properties of a temporary event and suggested that the group were critiquing conventions of staging extended, authoritative exhibitions.

In 1992, also, the artist-led group Random Access organized a conference with the specific aim of highlighting issues affecting time-based artists, identifying the major restriction of production costs and the perceived non-marketability of their work in commercial situations. Despite artists' increasing engagement with new technologies, the group argued that facilities and funding were still major issues. One member noted 'our common concerns were the perceived lack of debate and committed strategies towards the development of what we loosely termed "time-based art"' (Brian Connolly, 'Afterthoughts on Random Access', *Circa*, no. 63, 1993, 30). On historical reflection, the efforts of artist-led groups, such as Random Access in the 1990s, represents a cultural shift from an emergent to a matured phase of production.

Maturing
Although it is tempting to see the emergence of time-based art in Ireland as a radical movement, it is more accurately considered to be the outcome of various short and long-term efforts by artists who co-ordinated opportunities for dialogue, exhibition and exchange. What emerges is a piecemeal history of how artists have variously engaged with different media that share temporality as a characteristic, and which has developed in a number of identifiable stages. Shirley MacWilliam reflects on the maturing of time-based practices in Ireland that occurred in the mid-1990s, stating that 'video rapidly became simultaneously domesticated – easily available, no longer technically specialist nor prohibitively expensive – and assimilated within mainstream international art practices' (MacWilliam, 46).

This maturing process also occurred as artists began to engage reflexively with their chosen media, whether 8 mm or 16 mm film, video or slide-tape projections. The inevitable range and diversity of their work can be attributed to different uses of editing, finish, narrative, presentation and tone. This diversity of practices has continued beyond 2000 and the difficulty in defining trends or movements can be interpreted as part of a broader Postmodern resistance towards limiting art forms based on aesthetic criteria. Reviewing the approximately four decades of time-based practices in Ireland, it is possible to identify transitions in artists' use of the camera as a document and as a means of exploring themes of personal and national identity in the 1980s. As technology advanced, artists' work in the 1990s expanded into probing more lyrical and material aspects of film-making, refining their potential to create elaborate narratives using sophisticated technical strategies.

Approaches to time
Many Irish artists, including Paki Smith and Clare Langan (qv), have honed their technical skills by working in the commercial film-making sector. Langan's artworks develop concepts of the sublime landscape, using film, sound and the scale of cinema as an effective means of dealing with the enormity of nature. Themes of mystery, terror and beauty are presented in her post-apocalyptic film trilogy *Forty Below* (1999) [271], *Too Dark for Night* (2001) and *Glass Hour* (2002). Grace Weir's (qv) natural curiosity about science and philosophy has influenced her film-making practice in various and engaging ways, presenting work on a continuous loop in *The Clearing* (1999) and *Clock* (2000), while projects such as *Little Bang* (2001) and *Cloud* (2001) developed her interest in science by using interactive web technology.

Anne Tallentire's (qv) [480] video performances *Inscribe I* and *Inscribe II* represent an early example of an Irish artist using live communication technologies to engage with audiences located elsewhere. She created two performance events that were digitally transmitted via an ISDN video phone from the British Telecom offices in London to the Telecom Éireann offices in Dublin (1994) and from an office in London's city district to the Orchard Gallery, Derry (1995). Since 2000 the referent 'time-based' also relates to projects hosted on the internet and created through interactive computer technology, as seen in collaborations by Anne Cleary and Denis Connolly.

Willie Doherty is a key figure in the development of time-based formats in Ireland; in 1994 he was the first video artist to be nominated for the Turner Prize in Britain. Doherty's first nomination introduced a political dimension to the prize, which corresponded with the IRA's declaration of a ceasefire in

Northern Ireland. Doherty's use of two screens in the video installation *The Only Good One is a Dead One* (1993) [310] and multiple screens in *Somewhere Else* (1998) disrupt and support the inherent temporality of narrative. The use of voiceover draws on conventions of cinema and engages the viewer's spatial and sensory experience. Jaki Irvine (qv) also presents her work as complex multiple-screen installations, as evident in *The Silver Bridge* (2003, IMMA collection) and *The Hottest Sun, The Darkest Hour* (1999). Irvine typically interweaves image and sound elements to create complex and enigmatic narratives. Orla Barry creates similarly thought-provoking, disjointed and ambiguous narratives which recall the aesthetic and production qualities of cinema, in film works such as *Portable Stones* (2005).

Other artists use the ostensible veracity of film and video to complicate the relationship between autobiography and narrative (see 'Narrative and Anti-Narrative'). In a film about returning to her childhood home in Donegal entitled *A Skinny Little Man Attacked Daddy* (1994) [481], Vivienne Dick incorporates time as a central part of the editing process by cutting and pasting images from different sources and periods. Although the work can be read as an intimate family portrait, the artist uses narration and superimposed captions to disrupt the sense of diachronic development. Frances Hegarty (qv) [482] examines similar themes of family in *Turas* (1995) [135], which depicts a conversational exchange between the artist and her mother

performing a series of silent actions and gestures. The work is accompanied by a synchronized audio of conversational fragments in the Irish language that deliberately confound audiences who have no command of it.

Artists such as Martin Healy and Gerard Byrne (qv) draw on the semiotics of cinema to destabilize the production of visual meaning in their art work. Achieving an aesthetic of high production commercial film-making, Healy uses a double projection to examine themes of truth and fallibility in *Skywatcher* (2007). Similarly, Gerard Byrne used professional actors and a film crew in the format of a documentary interview in *Homme à Femmes (Michel Debrane)* (2004) to restage a 1977 interview between a journalist and Jean-Paul Sartre. This interest in conflating temporal experiences is also manifest in Byrne's photography, where images from the installation *1984 and Beyond* (2005) juxtapose the contemporary and the historical, creating unfamiliarity through a consciously historical sensibility. Images look as if they have come from another period, resulting in what the artist has termed a strange collapse of temporalities.

As time-based art became increasingly complex and refined in the 1990s, film and video prevailed at international biennales and was selected for Irish art prizes such as the AIB Art Prize and the Glen Dimplex Artists Awards. Events such as EV+A were instrumental in presenting the work of high-calibre Irish video artists, such as Patrick Jolley (1998), alongside international counterparts. Performance artists similarly expanded the boundaries of their practice and the presence of international figures in Ireland at various times, such as Joseph Beuys (1974), Marina Abramović (1980, 1995) and the Polish performance artist Wladyslaw Kazmierczak (1996, 1998), generated widespread discussion about the institutional acceptance of performance. Performance art naturally gave rise to the potential for collaboration with artists from other countries, which in turn generated opportunities for mobilizing Irish artists abroad, a point highlighted by Alastair MacLennan's involvement with the international group Black Market International. Recalling the clusters of activity generated by artists in the late 1970s and early 1980s, performance art since 2000 has strengthened through the collective efforts of the Belfast-based initiative *Bbeyond*, and the Dublin-based *Performance Collective*.

Clearly, many Irish artists have adopted time-based media since Dorothy Walker identified 1972 as the year that marked

480. Anne Tallentire, *Inscribe II* (detail), 1995, performance video, in association with Strike, London and Living Art, Dublin, transmitted live via ISDN, London Wall, London and Orchard Gallery, Derry

481. Vivienne Dick, *A skinny little man attacked Daddy*, 1994, video, 28 min

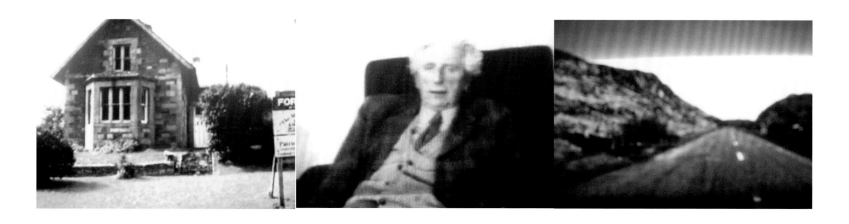

the first public performance in Ireland. Artists themselves were the catalysts in shaping the landscape of time-based art during this decade and beyond. Attracted to the potential for developing new modes of expression, the perception of time-based media as counter-cultural and avant-garde was also important. These factors are reflected in the early history of these practices where, before achieving institutional acceptance, time-based art was sustained through artist-led festivals and exhibitions, in conjunction with fora such as *Circa*. In various ways, these factors have contributed to the current strength of time-based art in Ireland. JENNIFER FITZGIBBON

SELECTED READING Walker, 1979; McCabe and Wilson, 1994; Sverakova, 1998/99; MacWilliam, 2002; Connolly, 2009; Fisher, 2009.

THE TORY ISLAND SCHOOL. As befits a school of 'naive' artists, perhaps the tale of the emergence of the Tory Island painters belongs as much in the realm of folklore as art history. There are slight variations to the story, but the essentials remain consistent and relate to the group's initiation through James Dixon (qv) [483], whose activities set an example for other islanders to follow, and began a process that has been handed down to this day among descendants of the original artists.

According to Derek Hill (qv), one Sunday in the mid-1950s, on one of his regular visits to Tory, he was engrossed in painting a view of the harbour at West End Town (Hill, 179–80). Among the islanders who stopped to observe him at work was Dixon, who commented that he could do better, but when invited to do so, pointed out that he did not have the materials. Hill responded with encouragement and support, offering to provide Dixon with what he needed in order to fulfil his challenge. By all accounts, Dixon accepted all but the brushes, preferring to rely on those he made himself from hair from his donkey.

Like most of the islanders, he earned his living in fishing and small farming, but arts and crafts provided a means of passing the time, and there is compelling evidence that

Dixon, while a late starter – he was touching seventy at the time of his encounter with Hill – had already been painting for a number of years with extant paintings dating from the 1940s and '50s (Glennie, p. 69). His creativity was evident, in fact, long before he began painting; at least since his early twenties, his skill in design and craftsmanship was revealed in his hand-made marketry boxes. Nonetheless, Hill was instrumental in the development of a coherent school in various ways. In addition to his general encouragement to the local population to embark on painting, Hill used his position in the wider art world to promote them beyond the island, creating opportunities for exhibition in Dublin, Belfast, London and Paris, and facilitating their recognition as a group of serious artists.

Dixon, who was the eldest and has become the best-known and acclaimed of the group, was almost eighty when he had his first solo exhibition in 1966. He was one of four whose work comprised the first public exhibition of the Tory Island painters, which took place in 1968, in the New Gallery in Belfast, and which included his younger brother, John, as well as Patsy Dan Rogers (b. 1945) [484], who was elected King of Tory Island, and James Rogers. The term 'first generation' for this initial cohort is somewhat misleading given their disparity in ages. Dixon was born almost sixty years before Patsy Dan, the last remaining artist of the initial group; he was consequently around eighty at the first Tory group show, while Rodgers was still in his early twenties.

These founding members, however, conformed to the Modernist idea of 'naive' artists; they had received no formal art education and their work exhibits a childlike simplicity in both technique and subject matter. Content is dominated by local scenes of landsape, people and events typical of, or noteworthy in, the locality. The nature of the lifestyle is identified as a crucial element in the production of art characterized as unspoiled and authentic, and Tory was an ideal location in that respect. The island is relatively remote, located nine miles or so off the north coast of County Donegal and, at that time, reachable only by boat or, during occasional emergencies, by

helicopter. During stormy weather, the island is regularly cut off from access to the mainland for weeks on end, a factor that has threatened the continued population of the island. The land mass is just around three miles long, and relatively narrow, supporting a small community of families with long associations with the island. The size of the population has fluctuated somewhat, from over 300 a century ago, to less than 200 in the early twenty-first century.

While the presence of a national school, at least since the start of the twentieth century, ensured that the artists could all read and write, they grew up in an environment where illiteracy was the norm for the older generations, as census returns for the time reveal; the Dixons' father signed his return with an 'x' in 1911. Employment was limited, until recently, to subsistence agriculture and fishing and, with little in the way of entertainment, painting and other crafts provided one of the few means to pass the time, particularly when the weather inhibited activity outdoors. For the older artists in particular, the fragility of existence and the battle for survival was a way of life. The Dixon brothers were among the seven surviving siblings of a total of fourteen children born to their parents. Such a pattern was commonplace at the time, particularly among the working classes of Britain and Ireland, but would have been keenly experienced on an island so far from medical help in times of emergency.

James Dixon's paintings are remarkable both for the elemental response to the power of nature that dominated the lives of islanders, and for the stoicism evident in the sturdy houses clinging precipitously, seemingly to the edge of civilization, so effectively portrayed in *Tory Island, East Town* [485]. The other artists, by contrast, have tended to work in a more detailed, linear, descriptive style that also typifies naive untrained artists in their desire for clarity and accuracy over emotion or drama.

The themes addressed by the Tory Island School are also typical of naive art, with landscapes (qv) and seascapes dominating, together with occasional representations of local characters. There are many images of ships, ranging from depictions of vernacular craft in daily use, like fishing boats or ferries, to those whose stories were sufficiently exciting to be relayed by word of

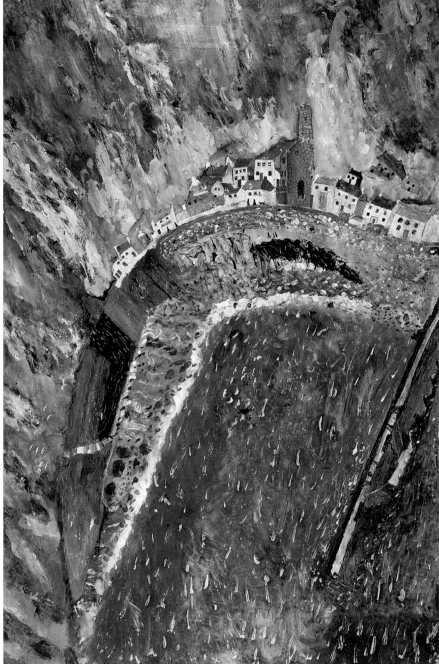

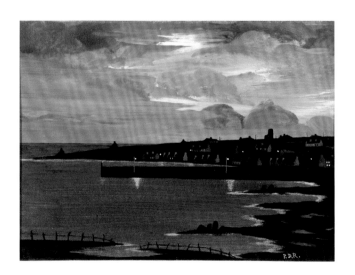

mouth, passed down from previous generations and as much legend as history. The *Cutty Sark*, for example, inspired several of the Tory Island artists, including Dixon and Patsy Dan Rodgers. A somewhat romantic theme, the clipper was famous for its speed in the era just before the steamship predominated. Dixon's version shows a general rather than precise familiarity with the rigging of the ship, essentially a scaled-down version of a four-master model he made around 1953. By contrast, Rodgers's rendition typifies his more crisp and literal approach. Unsurprisingly, the artists were also interested in historic shipwrecks, not just famous ones like the *Titanic*, but also disasters occurring closer to home. Dixon and Rodgers each completed images of the navy gunboat *HMS Wasp*, which struck rocks at

483 James Dixon, *West End Village, Tory*, 1964, oil on board, 96 x 66 cm, Office of Public Works, Glebe House

484. Patsy Dan Rogers, *Tory Island at Dawn*, 1989–90, oil on canvas, 33 x 43 cm, Office of Public Works, Glebe Gallery

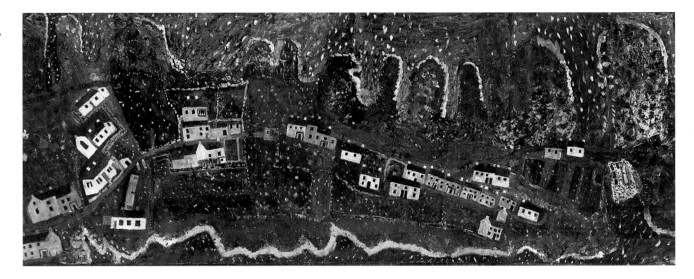

485. James Dixon, *Tory Island, East Town, c.* 1962, oil on paper, 107 x 293 cm, Office of Public Works, Glebe House

Tory in 1884 with significant loss of life. In the work of both artists, the depiction of three masts and aspects of the rigging indicate a knowledge of the structure of the ship, possibly from an image hanging in the local hotel. However, while Dixon's image shows the dramatic moment of the fateful collision, a small craft in a turbulent landscape of sea and rocks, Rodgers prefers to show the ship in full sail in relatively calm seas, with Tory visible in the distance and no sign of impending disaster. The sinking of the *Wasp* was a particularly significant story in the folklore of the island because the boat was reputedly transporting officials to carry out evictions. The locals, wishing to avert such an event, allegedly performed a ritual turning of a 'cursing stone', with dramatic effect.

The Tory artists also painted a number of portraits of friends and locals, as well as genre scenes depicting everyday activity typical of the island, or events that might be commonplace elsewhere, but notable on the island, such as the first helicopter or tractor. In Dixon's works, the paintings are explained in handwritten insets, often with the kind of lengthy, descriptive titles favoured in the previous century, and adding to the sense of a visual diary of life on the island.

The first generation paved the way for other artists who subsequently exhibited under the banner of the Tory Island School, including members of the Rodgers and Meenan families, namely Ruairí Sarah Rodgers, Seán J. Rodgers, Ruairí L. Rodgers, Michael Finbarr Rodgers and Anton Meenan (b. 1959), and these have been joined by a 'third generation': Christina and Majella Rodgers, Daniel Cullen, Noreen Meenan and Padraig Diver, amongst others.

The Tory Island School continues to be identified with a primitivist style, and the artists have elected to avoid formal art training in order to project the type of unaffected and authentic character on which a reputation as 'naive' artists depends. Whatever about the possibility of retaining the kind of visual insouciance that such an epithet requires on an island that receives thousands of tourists a year, and whose cultural reputation is projected internationally through internet websites, the first generation certainly experienced something of the kind of conditions more commonly associated with unconsciously naive art. YVONNE SCOTT

SELECTED READING Derek Hill, 'James Dixon', *IAR Yearbook*, IX (1993), 179–82; Glennie, 1999; Hunter, 2003.

THE TROUBLES AND IRISH ART 1970–2000 (see 'Politics in Irish Art 1900–2000'). The relationship between art and politics is rarely straightforward; that between the visual arts and the 'Troubles' in Northern Ireland is full of nuance, metaphor and indirect commentary. Some artists working during the Troubles attempted to effect changes in politics and society, creating artworks full of passion and anger. Others held back from commenting on what was a difficult and often fraught situation. Many were simply afraid of becoming involved, and preferred to remain as distant as possible from the conflict, pursuing their careers as best they could. However, apart from nationalist and unionist murals, with their strident and partisan messages, most art relating to the Troubles maintains a surprisingly balanced viewpoint, with the artists successfully avoiding the pitfalls of propaganda. Much of the work is serious, but there are occasional flashes of humour, albeit often dark. This sense of balance testifies to an awareness of social and political realities, an openness to possibilities of change, and an ability to understand the world as viewed from different perspectives, qualities that are an intrinsic part of Northern Irish society and which helped prevent far wider suffering and disruption.

In the late 1960s in Northern Ireland, the Troubles, having simmered for decades, flared up dramatically, and Ireland, following decades of relative peace, edged again towards civil war. The sequence of events leading to this deterioration had a grim inevitability. In France and the United States, student unrest and civil rights protests had attracted world-wide attention. The quest for political change also found echoes in Czechoslovakia, where a popular uprising against Soviet rule was brutally suppressed in 1968. The state of Northern Ireland, comprising just six counties, was set up in 1921, in response to the unionist wish to remain part of the United Kingdom. It was governed by a devolved administration and parliament at Stormont. Following The War of Independence there was an unwillingness to accede to demands from the Catholic minority for civil rights and a share in government. On both sides attitudes were maintained

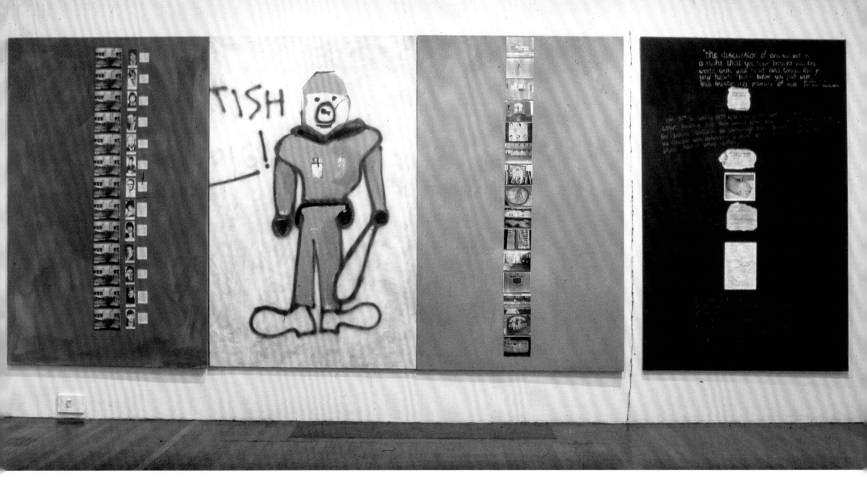

that made political compromise impossible. Paramilitary organizations, such as the IRA and the UVF, attracted members, particularly in inner city areas blighted by deprivation and unemployment. With the intensification of civil unrest, in 1972 the parliament was dissolved and political responsibility for governance of Northern Ireland transferred to Westminster. This situation continued until 1998, when self-government was restored, under terms set out in the Belfast Agreement. While religion did not absolutely determine how people voted, the majority of Protestants in the North favoured remaining within the United Kingdom, while the opposite generally held true for the Catholic minority. From the outset of the Troubles, politically motivated art, such as murals, poster campaigns and agit-prop, formed part of a conflict that was as much ethnic and cultural as it was political. Interwoven within a conflict that was dominated by male stereotypes, the position of women in Northern Irish society was also reflected, through artworks that dealt with feminist issues and gender discrimination.

Several exhibitions have documented the art of the Troubles. In 1975 Conrad Atkinson created *A Shade of Green, an Orange Edge* (ACNI Gallery, Belfast), an exhibition of his own work that included documentary material, such as posters and photographs. Two years later the Whitworth Art Gallery in Manchester organized a touring exhibition of works by Rita Donagh (qv) which mapped the areas of the Troubles and included images of the 1974 car bombing in Talbot Street, Dublin. In 1983 Donagh showed work relating to the H-Block (Maze) prison, at the Orchard Gallery in Derry. In 1991 *Shifting*

Ground, an exhibition of ten Belfast-based artists, toured to several galleries, while five years later *Language, Mapping and Power*, curated by Liam Kelly, was shown at the Orchard Gallery. Michael Minnis, represented in both these exhibitions, investigated the history of colonialism through association of artifacts, cartography and photographs. Buildings in Northern Ireland deemed to be politically sensitive and therefore not marked on official Ordnance Survey maps, were highlighted in Minnis's artworks. Although in 2003 the Ulster Museum organized the award-winning exhibition *Conflict: The Irish at War*, twenty-five years earlier that same institution had found itself in a controversy when attendants refused to hang Conrad Atkinson's *Silver Liberties: A Souvenir of a Wonderful Anniversary Year* (1977) [486], a work commissioned by Nicholas Serota commemorating the 'Bloody Sunday' of 1972, when fourteen protestors in Derry were killed by the British Army. The attitude of the attendants was linked to the fact that, perhaps more than any other single event, Bloody Sunday had catapulted the Troubles from being a civil rights conflict into a sustained campaign of violence involving paramilitaries from both nationalist and loyalist sides and the security forces of the state. Bloody Sunday transformed popular attitudes, not least because it took four decades for the British government to admit that the victims were unarmed and innocent (Fionola Meredith, 'Minimal Troubles at Ulster Museum', *IT*, 24 October 2009). Acquired by the Wolverhampton Art Gallery, where there is a substantial collection of art relating to the Troubles, *Silver Liberties* was included in the 2011 exhibition *Tears in Rain/Deora san Fhearthainn*, curated by Máirtín Ó

486. Conrad Atkinson, *Silver Liberties: A Souvenir of a Wonderful Anniversary Year*, 1977, acrylic, photographs, collage, 137.2 x 213.4 cm, Wolverhampton Art Gallery

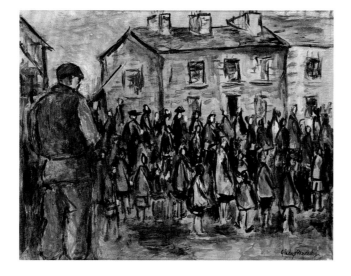

487. Gladys McCabe, *Street Incident, Londonderry*, 1973, oil on canvas on board, 43.1 x 53.3 cm, Imperial War Museum, London

488. Philip Napier, *Ballad No. 1 (View of Bobby Sands)* and *Ballad No. 1 (View of Car)* 1992–94, relief image, accordion buttons, motor, car power source, audio, National Museums Northern Ireland (see 390)

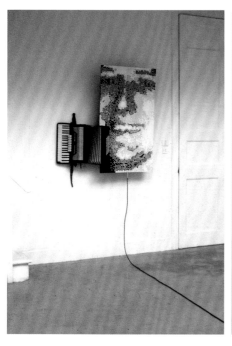

Muilleoir, one of a series of exhibitions organized by the Golden Thread Gallery in Belfast under the title *A Visual Force: Collective Histories of Northern Irish Art.*

In 2010, at the Millennium Arts Centre in Portadown, *Archiving Place & Time: Contemporary Art Practice in Northern Ireland since the Belfast Agreement*, curated by Fionna Barber and Megan Johnston, included work by Philip Napier (qv), Aisling O'Beirn and Mike Hogg. Again, much of this artwork was drawn from the collection at Wolverhampton Art Gallery. The holdings of the Imperial War Museum (IWM) are disappointing, probably because of a reluctance on the part of the British government to acknowledge that the conflict amounted to a war. In the IWM are several paintings by Gladys McCabe, including *Street Incident, Londonderry* (1973) [487], along with a series of paintings by Stephen McKenna (qv) entitled 'City of

Derry'. Also in the IWM are prints by Anthony Davies, who set up a printmaking studio in Belfast in 1986. In 2010/11, the IWM commissioned Roderick Buchanan to make a video installation *Legacy*, which documents flute bands from the republican and unionist communities in Northern Ireland.

The Troubles began in 1968. In that year, echoing the strategies of rebellious students, intellectuals and trade unions in Paris, linocut and screen-printed posters started to appear on the walls of Derry and Belfast, alerting the public directly to the political turmoil that was beginning to engulf the North. Newspaper cartoonists (see 'Illustrations and Cartoons'), such as Rowel Friers, Kenneth Mahood and Martyn Turner, made trenchant visual commentaries, while the artist John Kindness (qv) created pictures inspired by comic-book images and fine art, personal commentaries on social issues, which were clearly political. The range of artworks inspired by the Troubles over the years has been diverse. Working under the title 'Northern Ireland Workshop of the Free University', a community group from the working-class Ballymurphy estate, including Joe McWilliams, participated in the 1977 *Documenta VI* exhibition in Kassel, Germany. Invited by Joseph Beuys, who had visited Belfast three years earlier, the group was perhaps the most tangible outcome of Beuys's hopes of setting up a Free International University in Ireland (Ullrich Kockel, 'Celticity as Culture Criticism: German Utopias', in Ullrich Kockel and Máiréad Nic Craith (eds.), *Communicating Cultures*, Cork 2004, p. 97).

In a series of paintings created from the mid-1970s onwards and shown at the Orchard Gallery in 1990, Jack Pakenham (qv) employed simple visual metaphors to comment on the way in which strife affected ordinary people in the North (Catto, 1977, 133). Pakenham frequently introduces images of mannequins, ventriloquists' dolls and masked or gagged figures into his work. The ventriloquists' dolls are a commentary on widely held assumptions that equated religion with political cause. Pakenham's *Walking the Sky*, a nightmarish scene with figures walking through an urban streetscape, is in the collection of the Royal Ulster Academy (qv). Although better known for his abstract paintings, George Campbell (qv) also created ink-wash drawings of images redolent of urban warfare, such as burnt-out buses, while F.E. McWilliam, another Ulster artist who lived and worked outside the North, made a series of figurative sculptures depicting shoppers caught in bomb blasts. The fine modelling and casting of these sculptures is in marked contrast to the agonizing moments of death and injury they portray. In a provocative artistic intervention, organized by the Orchard Gallery in 1987, three Janus-like sculptures by Antony Gormley were positioned on Derry's city walls, a highly symbolic site. Not long afterwards, in an equally provocative installation, Locky Morris placed a series of sculpted figures on those same walls. In contrast to Gormley's austere figures, Morris's concrete forms were painted red and white, and embellished with metal reflectors.

Other artists from Northern Ireland whose work relates to the Troubles include the painters Brian Ferran, Dermot Seymour (qqv), Pat Coogan and Brendan Ellis; the sculptor Philip Napier; photomontage artist Seán Hillen; and photographers Paul Seawright (qqv) and Moira McIvor. A stark image of a rusted metal gate made of crisscrossing girders, Seawright's

Gate (1997) [452] echoes the design of a Union Jack, the British flag. However, the connection is not explicit, and Seawright's work allows for a variety of readings. A sense of the visceral and surreal, mixed with black humour, characterizes the work of Seymour, Hillen and Napier. Seymour's paintings often feature familiar landscapes inhabited by animals and nightmarish figures, while Hillen's photomontages are a surreal mixture of imagery, drawn from various sources, contrasting high and low culture, the everyday and the sublime. Hillen's titles, as in the 'Londonewry' series, are also often witty collages, but made using words rather than images. In Napier's *Ballad* (1992–94) [488] an image of the Republican hunger striker Bobby Sands, made from nails, is accompanied by a wheezing, haunting sound, created by an accordion. Napier's *Gauge*, commissioned by the Orchard Gallery in 1997, consisted of fourteen audio speakers suspended from weighing scales. The scales were rigged so as to register a litany of apologies that could be heard coming from the speakers. The apologies were non-specific but the location of the work in the Bogside, where the events of Bloody Sunday had taken place, was deliberate (Kelly, p. 147). In 2001 *Gauge* was shown, along with work by Willie Doherty (qv) and Locky Morris, in an exhibition organized by the Orchard Gallery. In a series of early works relating to the Troubles, Doherty superimposed text over photographic images, creating works that resonate with meaning, while remaining politically neutral. These early works, often employing grainy monochrome images of Derry city walls or working-class housing estates, bore large-font texts, often consisting of short phrases or single words. In one such photomontage, the word 'freedom fighter' is juxtaposed with 'psychopath', in a short but eloquent commentary on the power of language to describe the same thing in two totally different ways (CAG). Doherty's work is politically charged, even when dealing with issues such as urban development and aspects of individual and collective memory. In his work, guilt and innocence, perpetrator and victim, are held up as two sides of the same coin. This uneasiness also permeates the work of Paul Seawright whose 'Sectarian Murder' series depicted banal everyday locations, where bodies had been dumped or horrendous killings had taken place (Bracefield et al, pp.178–86). Artists could be quietly subversive in their response to the Troubles.

While these artists worked within recognizable boundaries of fine art practice, during the 1970s an upsurge in propagandist mural painting [489] caught the attention of both the world's media and the people of Northern Ireland. For the most part, these political murals were painted on the outside gable walls of terraced housing in urban areas such as the Shankill Road in Belfast, or the Bogside in Derry. The majority depicted sectarian images, and were painted either by loyalist or republican activists. The former tended towards mainly conservative images of 'King Billy' while the latter adopted a more original approach to propaganda, creating images designed to reinforce a sense of identity, often expressed as a religious affiliation, and notwithstanding the Catholic Church's active discouragement of the practice. In the early 1980s the artist Belinda Loftus, one of the founders of Art and Research Exchange (ARE) in Belfast, looked into the origins and iconography of murals in Northern Ireland

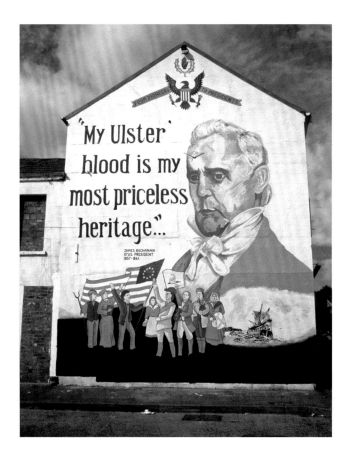

489. Street mural, portrait of James Buchanan, fifteenth president of the USA, with the text 'My Ulster blood is my most priceless heritage', 1999, Ainsworth Avenue, Belfast

(Loftus, 'Loyalist Wall Paintings', *Circa*, no. 8, January/February 1983, 10–14), while in 1992 Bill Rolston's book *Drawing Support: Murals in the North of Ireland* underlined the worldwide attention this popular art form had elicited. Rolston commented: 'For almost a century on the loyalist side, and for more than a decade on the republican side, they have been the products of a genuinely popular practice. As such, they provide a unique political insight. Through their murals both loyalists and republicans parade their ideologies publicly. The murals act, therefore, as a sort of barometer of political ideology.' (Rolston, 1992, p. i) The tradition of mural painting was maintained at a relatively high standard in loyalist murals, sometimes with fine artists such as John Luke (qv) and Romeo Toogood turning their hand to this art form. During the 1920s and '30s many of the murals in the loyalist Shankill area were painted by the sign-writer George Wilgaus, who combined the mural tradition and fine art, having received some training from William Conor (qv). In Derry, the 'Bogside Artists', Tom and William Kelly, and Kevin Hasson, created a series of murals commemorating both events and the people of the city.

Bill Rolston notes that the decline of the unionist mural tradition coincided with the Troubles: 'The civil rights campaign of the late 1960s and the British takeover of the 1970s and 1980s left Northern Ireland without a parliament. The mural painters faced the stark dilemma of painting monuments to the state in the absence of unionist control over the state.' (Rolston, 1992, p. II) The reaction of loyalist muralists was to paint simpler heraldic images, such as flags or the red hand of Ulster. The signing of

the Anglo-Irish Agreement in 1985, which many unionists regarded as a sell-out, resulted in a surge of militaristic images, such as men in balaclavas firing weapons. A decade later loyalist murals, such as the portrait of James Buchanan, fifteenth president of the United States, with the text 'My Ulster blood is my most priceless heritage', or another depicting George Washington, with the text 'If defeated everywhere else I will make my final stand for liberty with the Scotch-Irish (Ulster-Scots) of my native Virginia', sought to counteract the perception that all emigration from Ireland to the United States was by Catholics.

The republican mural movement that developed during the early 1980s was more contemporary and more in tune with the stark brutality of the times than the loyalist paintings. A series of hunger strikes, begun in March 1981, by IRA prisoners seeking political status denied to them by the British authorities, radicalized a generation, nationally and internationally. The period of the hunger strikes, during which ten prisoners starved themselves to death, was one of the most bitter in recent Irish political history. It catalyzed reactions of everything from repugnance to hero-worship but it also succeeded in creating an urgent awareness of the need to seek solutions to the endemic political problems of Northern Ireland, a process that, over a decade later, had begun to bear fruit. Part of the republican campaign to raise awareness of the issues involved the painting of murals, often on billboards and consisting of a large letter 'H', referring to the H-Block prison, where the hunger strikes were taking place. These evolved into murals, combining text and emblem, painted in the republican areas of west Belfast, initially in Lenadoon and Twinbrook, then in Andersonstown, Turf Lodge, Ballymurphy, the Falls Road and the Divis Flats. The deaths of hunger strikers Bobby Sands and Francis Hughes heightened tensions, not only in the North but throughout Ireland, and the murals assisted in further polarizing public opinion. The republican murals were documented by art historian and sociologist Noel McGuigan, who noted that, in contrast with other agit-prop mural painting programmes, such as those in Mexico or Cuba, the nationalist muralists of the 1980s were, for the most part, anonymous. Within a year, republican murals had evolved further and images of paramilitaries carrying Armalite rifles began to appear. Their explicit calls to armed revolution reflected the general hardening of attitudes caused by the hunger strikes (McGuigan, 'The Open Air Gallery of Political Art', *Circa*, no. 8, January/February 1983, 15–18). In the late 1980s, the republican muralist Gerard Kelly, inspired partly by the Celtic Revival illustrations of Jim Fitzpatrick (qv), painted a series of murals in west Belfast that became celebrated for their intricate detail and depiction of heroic figures from Irish mythology (Rolston, 1992, p. vi). A number of wall-paintings were sponsored by government agencies. One, of a jungle scene, was painted at Springhill Avenue in the Ballymurphy area, by Geraldine Jordan and Brendan Ellis. Ellis also painted a series of panel murals at Woodstock Road, Belfast, depicting the suffering of ordinary people. While some of these state-sponsored paintings were successful, others were greeted with a lukewarm response or even downright hostility. In the waiting room of Magilligan Prison, near Limavaddy, Co. Derry, a mural depicting Snow

White and the Seven Dwarfs added a surreal quality, while in 1978 John Carson and Maureen Davis painted another on Ainsworth Avenue, Belfast, depicting welders. However, the latter was shortly afterwards removed because the local community, many of them unemployed shipbuilders, were not pleased to be reminded of their prosperous industrial past (Julian Watson, 'Brightening the Place Up?', *Circa*, no. 8, January/February 1983, 4–8).

Although many of its traditional industries, such as linen and shipbuilding, were in decline, Northern Ireland benefited economically from its status within the UK, with the British government investing heavily in security, as well as in social and education programmes, in an attempt to normalize life for the people of Northern Ireland. As a result of being tied into third-level education in Britain with its strong critical tradition, the Belfast College of Art might have been expected to have been more progressive than its counterparts in the Republic. However, most staff shied away from becoming involved in the politics of Northern Ireland and the college favoured Modernist abstraction, rather than socially engaged art. In spite of this, many art students in the North were politicized through direct contact with the Troubles.

In the Republic, art education was equally conservative and unchallenging to both students and staff, the usual approach being to play to a complacent establishment and a status quo that did not encourage free or independent thinking (see 'Education in the Visual Arts'). Political debate about Feminism and Marxism was to a great extent led by Northern Irish intellectuals, and tied in with this was the founding of *Circa* contemporary art magazine in Belfast in 1981, the founding of ARE and the establishment in 1984 of the Queen Street Studios.

In Derry, beginning in 1978, Declan McGonagle curated a series of projects and exhibitions at the Orchard Gallery, transforming it into an institution recognized internationally for situating art in a political environment, not as a commentary, but as an active component of public life. In 1985 the Polish artist Krzysztof Wodiczko projected images on to Derry's Guildhall at night, highlighting the building's symbolic role as representing authority and tradition. In that same year, in association with the Artangel Trust, McGonagle invited artist Les Levine (qv) to create a billboard project for the Orchard Gallery. While shown in London to little adverse comment, Levine's 'Blame God' series [278, 430] proved too provocative for the billboard companies engaged to present the work in Northern Ireland. Far from being an assault on religious belief, Levine's messages were directed at the absurdity of citing religion as an excuse for killing and torture. The message on another Orchard billboard project, by Barbara Kruger, 'We don't need another hero', was less offensive to religious sensibilities, but seemed mild-mannered in a city that often teetered on the edge of civil war. McGonagle's work was recognized in his being nominated for the Turner Prize in 1987. That same year, the Orchard Gallery presented an exhibition, *Attitudes to Ireland*, that included work by Richard Hamilton, Rita Donagh, Hamish Fulton, Paul Graham, Martin Parr and others. Donagh and Hamilton were familiar with the Orchard Gallery; in 1983 they had shown work relating to Northern Irish politics and inmates of the Maze/H-Blocks prison.

There was also more interest in the North than in the Republic in exploring the emblems and iconography of the different communities. In the labyrinth of cultural meanings in Ireland, to describe someone as 'digging with the left foot' was shorthand for identifying someone as Catholic. Deriving from a type of spade introduced to Ireland during the seventeenth century, the phrase found visual expression in a performance by the Belfast artist Nick Stewart at the National College of Art and Design in 1982, where the artist stood still, arms outspread, for an hour, holding a half-spade in either hand. In her large-scale photographs, Moira McIver records in close-up the badges, sashes, costumes and paraphernalia associated with unionism. Emblems such as the Easter Lily and the bowler hat, the latter also a symbol of unionism, appeared in the paintings of Micky Donnelly (qv), while the lily formed the subject matter of a 1994 photo work by performance artist Nigel Rolfe (qv). In the exhibition *8 Weeks/8 Works, A Season of Installations*, held at ARE, Belfast in 1982, Deirdre O'Connell created an installation (qv) of plaster forms laid on the floor. Entitled *The Palatine's Daughter*, this work explored the meaning of terms such as 'territory', 'domain', 'wall' and 'enclosure'. This pattern of active investigation of political issues continued throughout the 1980s and '90s, with artists such as Alastair MacLennan (qv), John Carson, Anne Carlisle and André Stitt creating works in which politics and society were frankly addressed. MacLennan's performances often lasted for several days, testing the artist's powers of endurance but creating works of visceral power. In a series of gritty realist paintings and drawings, the artist Rita Duffy portrayed Northern Ireland's divided communities, using a style of Realism (qv) reminiscent of German Expressionist art, and also echoing the Surrealism (qv) of Jack Pakenham's paintings. Duffy's *The Legacy of the Boyne* (1989) [490], a work commenting on the Ulster unionist tradition, is in the collection of the University of Ulster. Although most art relating to the Troubles falls within a contemporary genre, a series of traditional tempera paintings by Major Christopher Miers of the Royal Green Jackets was published in 1973 in a book entitled *Northern Ireland: A Soldier's View*.

Art made in Northern Ireland during the 1970s and '80s often had a sense of urgency and purpose that was lacking in art produced in the Republic of Ireland. Motifs such as traps, maps, mazes and labyrinths appeared frequently in paintings and sculptures, as did boundaries and barriers, reflecting artists' responses to the everyday presence of security forces, armoured vehicles and armed soldiers on the streets of Northern Ireland. However, for the most part artists working within the fine art tradition in Northern Ireland actively sought to push back barriers and establish common ground between communities of differing religious and ethnic backgrounds. In John Carson's *Friend Map* (1976) images of his friends were overlaid on a map of Ulster, while Moira McIver's *Awaken* (1985), a four-screen video installation, shown in 2009 as part of the Golden Thread Gallery's *Collective Histories of Northern Irish Art*, dealt with the universally significant themes of sexuality and death. Artists such as Carson and McIver approached the medium of photography (qv) and video in a quite different way from news photographers and reportage. Internationally, an overly simple

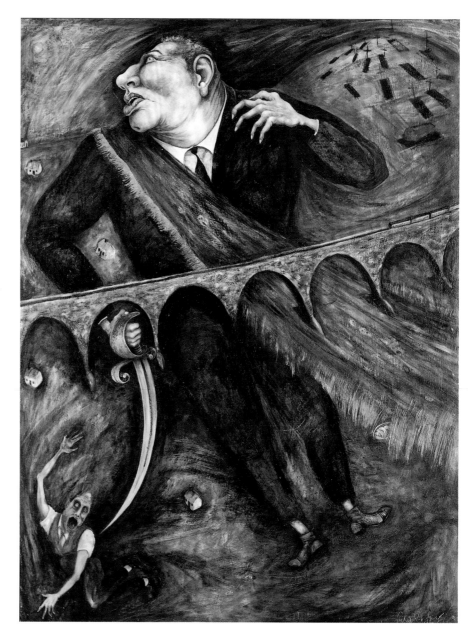

490. Rita Duffy, *The Legacy of the Boyne*, 1989, oil on gesso, 122 x 91.5 cm, University of Ulster

image of Northern Ireland was being conveyed by photographers and film-makers interested mainly in scenes of conflict, hatred and destruction. As Belinda Loftus outlined in 1983, even highly respected photographers such as Don McCullin, Philip Jones-Griffith and Christine Spengler produced clichéd and aestheticized images that concealed, rather than revealed, the nature of the conflict. In contrast, Loftus praised Gilles Peress, whose photographs appeared in the *Sunday Times* magazine (8 December 1974), for his insight into the realities of everyday life in Belfast (Loftus, 'Photography, Art and Politics: How the English Make Pictures of Northern Ireland's Troubles', *Circa*, no. 13, November/December 1983, 10–14). Another photographer, Maurice Hobson, critically wounded in a bomb blast in 1975, created a series of self-portraits in the 1980s that graphically portrayed his facial injuries. These photographs were included in an exhibition curated by Brian McAvera at the

Orchard Gallery in 1987; Hobson died shortly before the exhibition opened. This show also included photographs taken by the painter Victor Sloan (qv). While Sloan documents Orange parades and icons of unionism, his manipulation of the photographic negative, and use of printmaking (qv) techniques such as screen printing and etching, draws his work into a painterly/ expressive terrain. Artists worked to create a different understanding of the people, their country and, not least, the Troubles. The founding in the 1980s of the Belfast Unemployed Resource Centre and the Crescent Arts Centre were just two elements in the creation of 'alternative' institutions that rejected nationalist, loyalist and sectarian doctrines. These institutions were dependent on the people who ran them, and the work of Noreen O'Hare at the Crescent Arts Centre was an important factor in its survival and success. In like manner, the establishment in 1992 of Photo Works North, with its magazine *Source* and a gallery and studios in Belfast, provided an alternative to the established network of resources and photographers, and attracted Victor Sloan, Peter Neill, Errol Forbes, Terry Loane and others, enabling them to engage with politics while themselves remaining apolitical. Other significant initiatives included the founding of *Fortnight* magazine, the critical works of the Field Day Company in Derry, the development of the West Belfast Festival, exhibitions at the Engine Room in east Belfast and cultural and political debates in Conway Mill, Belfast.

While there was no shortage of art about the situation in Ulster, both in the public domain and in galleries and art colleges, the story was different in the Republic of Ireland. Until a series of public consultations was set up in 1980, successive governments in Dublin and the majority of the population either avoided confronting the Northern question, or engaged with the crisis in a more oblique way. The same held true for the visual arts in the Republic. With the exception of Robert Ballagh (qv), most Irish artists who created works referring to the political situation in the North, were themselves not resident in Ireland. Rita Donagh lived and worked in Britain, while in France Micheal Farrell (qv) created allegorical works that referenced the Troubles and Irish political history. In the United States, Brian O'Doherty (qv) produced works that examined the same subject matter but were more enigmatic and nuanced in their approach. In 1972, in protest at the Bloody Sunday massacres in Derry, O'Doherty changed his name to Patrick Ireland [337, 379]. The ceremony was witnessed by Ballagh, whose paintings are among the most directly political works created in Ireland during this period. The use of metaphor was frequent amongst artists in the Republic. In 1969 Ballagh began a series of paintings that, while stylistically paying homage to Pop art (qv), drew their iconography from the great history paintings of the nineteenth century. That same year Ballagh painted *My Studio*, which explicitly juxtaposes an image of Delacroix's *Liberty at the Barricades* with a contemporary Irish newspaper bearing the news of rioting in Derry. The 'Starry Plough', the flag of Irish socialism, replaced the French Tricolor in the hands of Liberty.

In Paris, the émigré Irish artist Micheal Farrell created graphic images of figures from Irish history and of marchers in Derry. His 'Pressé' series mocks the way in which the media misrepresented both the background issues and the everyday realities of the Troubles. 'Pressé Politique', a series of works from 1973, reveals a more definite politicization of Farrell's art, a process that began in 1969 when Farrell, along with Gerard Dillon (qv) and Ballagh, withdrew their work from the Belfast showing of that year's Irish Exhibition of Living Art (qv), in protest at civil rights abuses in Northern Ireland.

The most significant recent artist in the Republic to deal with issues of politics and the Troubles, Shane Cullen (qv) often addresses in his work the interplay between state and individual. Many of Cullen's paintings and sculptures emulate the processes and methods whereby corporations and governments create emblematic images. In 1992 his *Council for the Preservation of Monuments to Martyrdom and Resistance* was shown at the Limerick City Gallery, while the following year Cullen embarked on a more ambitious project, *Fragmens sur les Institutions Républicaines* [106] Based upon communications (comms) smuggled out of Northern Irish prisons during the 1981 hunger strike, this work consists of large panels onto which the artist laboriously transcribed, in formal hand-painted letters, the prisoners' covert messages. In his series of texts, Cullen appropriates iconographies and styles of 'official' devices of commemoration and converts them into an ironic commentary on the process of constructing concepts of nationhood. Sections of this work were first shown at the Douglas Hyde Gallery, Dublin, and then twenty-four panels, representing one quarter of the final work, were shown at the 1995 Venice Biennale. After being exhibited at the Orchard Gallery in 1997, and the following year at PS1 in New York, the work was acquired by the Irish Museum of Modern Art. A more recent work by Cullen, *The Agreement* [82, 491] consisted of a similarly monumental translation of the text of the formal political accord reached between the governments of Ireland and Britain on Good Friday, 1998, in relation to the governance of Northern Ireland.

In the 1990s, with the intervention of politicians and business leaders from the United States, as well as active engagement by the British and Irish governments, substantial progress towards peace in Northern Ireland was achieved. A ceasefire declared by the IRA in 1994, followed by a Loyalist one, was the prelude to a more lasting cessation of hostilities which saw the inclusion of Sinn Féin (the political wing of the IRA) in talks, and the setting up of a power-sharing executive. The historic return to self-government for Northern Ireland in 1998 was accompanied by an extended process of decommissioning of weaponry by both loyalists and republicans. Republican mural painters responded to this changed political landscape by depicting scenes that emphasized the success of nationalists in achieving equality and political representation, while also commemorating those who had lost their lives during the previous three decades of conflict.

Within the fine arts there was also a change of approach, with Willie Doherty broadening his practice to encompass a more generalized critique of modern urban society and its fears and uncertainties. The issue of the 'Disappeared', people who had been assassinated by paramilitaries during the Troubles and their bodies disposed of in unmarked graves, continued to haunt grieving relatives and the public imagination long after 1996 when the violence effectively ceased. The search for these graves was documented in a series of photographs by Anthony

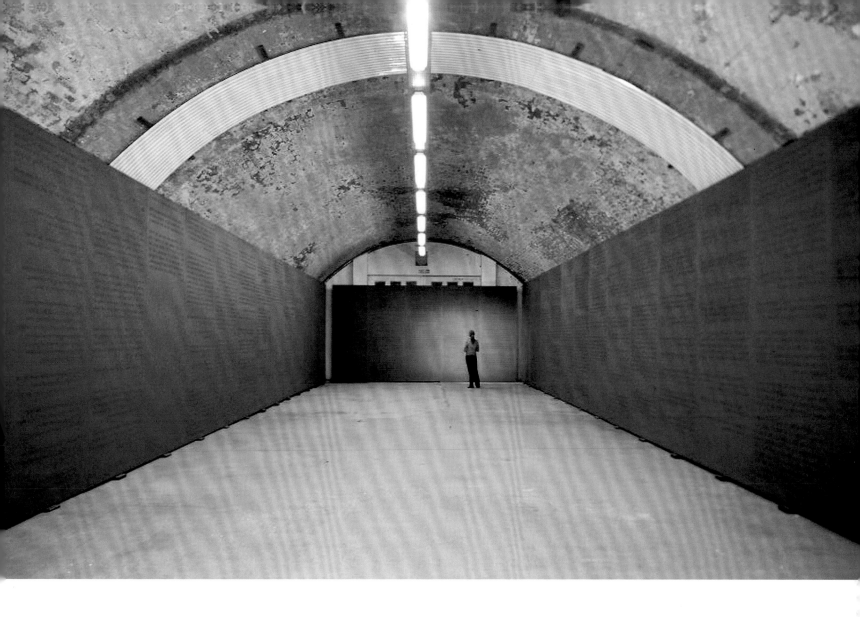

Haughey. In these images, innocuous-looking and often beautiful landscapes are in fact sites where victims are believed to be buried; the brutalities and injustices of the past, as is so often the case in Ireland, continue to cast a shadow over the present. As the Troubles ebbed, so also did much of the visceral immediacy that had characterized art in Northern Ireland from the late 1960s onwards. In programmes of urban regeneration, studios and galleries that had been set up in industrial buildings were gradually replaced by purpose-built arts buildings. Peace brought economic and social dividends to a province weary of conflict, and a welcome normalizing of affairs, but the fear, anger and despair that had become an intrinsic part of everyday life did not entirely disappear, and the role of the artist in encouraging and allowing people to live in community while holding different world views remained critically important as Northern Ireland faced a new century. PETER MURRAY

SELECTED READING Declan McGonagle (ed.), *Les Levine: Blame God Billboard Projects* (London 1985); Brian McAvera, 'The Limitations of Intelligence and Technique', in *Magnetic North*, exh. cat. Orchard Gallery, Derry and Impressions Gallery, Bradford (Derry 1987); Bracefield, Brett and Henderson, 1991; Rolston, 1992; Kelly, 1996; Rolston, 2003; Kelly, 2004.

TUOHY, PATRICK (1894–1930) [492], painter. Born into a Dublin medical family, Patrick J. Tuohy was one of three children of John Joseph Tuohy, a surgeon, and his wife, Máire Murphy. The family lived at 15 North Frederick Street and Tuohy attended St Enda's College at Rathfarnham, an Irish-speaking school founded and run by the poet and revolutionary leader Patrick Pearse. Although Tuohy had been born without a left hand, Willie Pearse, art master at St Enda's, encouraged him to enroll at night classes at the DMSA, where he came under the influence of William Orpen (qv). Painted when he was just sixteen years old, Tuohy's *Girl in a White Pinafore* (1910, NGI collection) demonstrates his precocious talents, as does *Mayo Peasant Boy* (1912, HL) painted two years later, after Tuohy had spent a summer at Tourmakeady, Co. Mayo. Tuohy's uncle had a farm at Lough Dan, Co. Wicklow, and some of the artist's earliest paintings are landscapes of this mountainous area.

In 1912 Tuohy was awarded the RDS Taylor scholarship for *Supper Time*, a watercolour now in the NGI. Two years later he was awarded a second Taylor scholarship, and he won the same award for an unprecedented third time in 1916 for the watercolour *The Little Seamstress* (HL). In 1913 the Jesuits commissioned him to produce a series of ten ceiling paintings for Rathfarnham

491. Shane Cullen, *The Agreement*, 2002, 11,500 words of the British-Irish Peace Treaty of 1998, carved into 55 panels, 67 m; work commissioned by Beaconsfield (see 82)

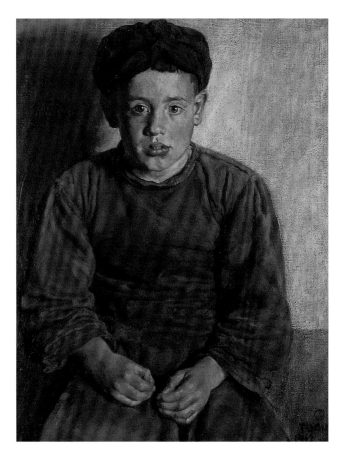

Castle, and three years later he painted the ceiling in the La Scala theatre (later the Capitol Cinema) beside the General Post Office. During the War of Independence he remained outside the fighting, and in 1916 he travelled to Spain with the aid of the Taylor scholarship (Mulcahy, p. 110). While in Madrid, he taught at a Loreto Convent and studied the art collection in the Prado. Returning to Ireland, in 1918 Tuohy began to teach at the DMSA and in the years following he painted portraits of many civic and political leaders, as well as writers and actors (see 'Portraiture').

His portraits are characterized by their directness and honesty. In 1922 his *Standing Female Nude* was exhibited in Paris, as part of the exhibition *L'Art Irlandais*, organized by Maude Gonne MacBride, and held at the Galerie Barbazanges. That same year, he began work on a large painting *The Baptism of Christ* (1922, on loan, HL) which was exhibited at the RA in 1925. An essay in religious imagery that includes portraits of Seán Keating, Seán O'Sullivan (qqv) and Thomas McGreevy, as well as Phyllis Moss, who was later to marry Tuohy, this ambitious work has rarely been exhibited publicly since it was painted. Another religious painting, *The Agony in the Garden* (c. 1920), commissioned as a reredos for the Loreto Convent (North Great George's Street, Dublin), is now in the Church of Christ the King, Cabra, and Tuohy also painted a series of Stations of the Cross for a church at Culmullen, near Dunshaughlin, Co. Meath.

After a trip to Italy, in 1924 Tuohy's portrait of John Stanislaus Joyce, father of James Joyce, was shown at the RHA (qv), along with portraits of James Stephens and Lord Fingall. That same year, returning from a second visit to Italy, Tuohy convinced Joyce to have his portrait painted. Completed in twenty-eight sittings over a period of a month, the portrait is now in the Library of the State University of New York at Buffalo. At one point, Tuohy mentioned the importance of capturing the sitter's 'soul' in a portrait. 'Never mind my soul', responded Joyce, 'just be sure you have my tie right' (Mulcahy, p. 115). The painter was immortalized as a character in Joyce's *Finnegans Wake* called 'Ratatuohy'.

Among Tuohy's students at the DMSA were Nano Reid, Hilda Roberts, Norah McGuinness, Seán O'Sullivan (qqv) and Christopher Campbell. Between 1922 and 1926, he did a series of pencil portraits of leading figures of the Irish theatre, including Ria Mooney, Seán O'Casey and Padraic Colum. In 1927, disappointed with his lack of commercial success in Ireland, Tuohy emigrated to the USA, where he painted portraits of Claudette Colbert and Walter Hampden amongst others. He showed his works several times at the Hackett Galleries, at 9 East 57th Street. Although his career in the USA was going well. Tuohy's time there was short. He died at his apartment on Riverside Drive, New York in 1930. PETER MURRAY

SELECTED READING Rosemarie Mulcahy, 'Patrick J. Tuohy, 1894–1930', *IAR Yearbook* (1989/90), 107–18; Patrick J. Murphy, *Patrick Tuohy from Conversations with His Friends* (Dublin 2004).

TYRRELL, CHARLES (b. 1950), painter. Aidan Dunne has described Charles Tyrrell as 'a sensible, rational, methodical painter' whose work demonstrated 'closely argued concentration and rigour' (Dunne, 'Visual Art', *IT*, 30 June 1999). Patrick T. Murphy has similarly described Tyrrell's working methods as 'almost industrial' and 'no-nonsense' (Murphy, n.p.). Few would contradict these assessments of an abstract painter with a Minimalist aesthetic (see 'Minimalism'), whose materials range from his customary acrylic on canvas to painting on aluminium, the slick, streamlined and industrial connotations of which seem appropriate to such descriptions.

Throughout his career, Tyrrell has consistently adopted a geometric framework composed of thin ruled lines and arcs to construct his resolutely two-dimensional abstractions, which stringently dissect the planes of the surface into proportionate, sometimes symmetrical, relationships. However, as most commentators observe, Tyrrell counterbalances such restraint with expressive gestures that deliberately breach his restraining armature and reflect his professed early interest in Abstract Expressionism (see 'Expressionism').

While many abstract painters begin with the observation of the physical world, distilling or distorting its forms, Tyrrell has proceeded in the reverse direction. Abstraction (qv) has always been his point of departure, preceding any development of an image towards references to physical reality. The extent to which his work can be read in relation to the visible world, in any case, has been effectively challenged. As Patrick Murphy asserts: 'For nearly thirty years now, critics have from time to time sought, without success, to root Tyrrell's

abstraction into his West Cork landscape. At times, Tyrrell seems to admit some oblique reference but then squeezes out any iota of that possibility.' (ibid.)

However, while abstaining from the representation of objects, his work is not without subject. Until the turn of the millennium, references to the topographies of landscape, to the seasons, and to the structures governing space, its control and habitation, are suggested both in the constructions of the images, and in the titles to his work. *Beara* (1980), *Mountain Shuffle* (1988, private collection), *Winter Pull* (1982) and *Holding* (1994) all demonstrate this point.

Mountain Shuffle [493] comprises a square canvas, divided into four triangles by thin, diagonal lines, like taut wire. The looser brushwork is almost restrained within the segregations but it challenges and trespasses the boundaries. This tension between control and transgression defines Tyrrell's practice, and is the key to the relationship of his abstraction with the empirical world. Growing up in rural County Meath, and living for many years in Allihies, Co. Cork, in a remote corner of the Beara Peninsula, with spectacular views of land and sea, his abstraction is informed by his acute awareness of the critical balances that exist between culture and nature, order and chaos, intellect and emotion, the rational and irrational. In the landscape, he observes human efforts at controlling the environment, marking it out and dividing it up, and nature's blind disregard for such man-made divisions (Tyrrell, interview with Scott, 10 July 2003). Tyrrell does not intend to illustrate literally such realities, but rather to reflect an incontrovertible condition of existence, an abstract idea that reveals itself in countless ways in practice. As he explains: 'I come to painting from an abstract standpoint. I build my paintings on pure simple formal, notions. I then allow the painting to develop and travel from its unassociative beginnings towards a painting that incorporates a real sense of human experience.' (Davoren, p. 12)

Interestingly, too, Tyrrell's adoption of aluminium as a medium was less for its hard-edged potential than for its challenges, as he explains: '… aluminium is extremely different from canvas. It comes with little tradition and I find that liberating.' He has also used wood as a painting support – cut into regular planks and allowed to reveal its organic qualities, while at the same time referencing the architectonic aesthetics of the urban structures from which the timber was salvaged.

Tyrrell's method can be understood in terms of his professed admiration for the work of artists as seemingly diverse as Chardin and Bonnard, who exemplify his desire to reveal, through the processes of painting, both honesty and the intensity of life experience. As he explains:

… [the] truth that I look for can be found in close reading of good painting, in its making, in the stuff of paint. Good painting should give the viewer a clear insight into itself, into the heart of the matter, into the performance of its making, the honesty of the thought process, the rigour of its determined journey, arriving at an image that can be loaded and revealing, revealing in a fundamental way, a way that might throw light on our humanity. (interview with Scott, 2003)

Born in Trim, Co. Meath, Tyrrell studied fine art at NCAD and has exhibited in Europe and the USA, as well as at numerous venues in Ireland. His earliest group shows include the IELA (qv), where he won the P.J. Carroll Award (1974), and he has featured in major group shows such as *The West as Metaphor* (RHA, 2005), *Irish Art of the Seventies* (IMMA, 2006) and *The Moderns* (IMMA, 2011).

Tyrrell was elected to Aosdána (qv) in 1982 and was awarded the Hooker-O'Malley Award from the IACI in 2008. His work is found in national and institutional collections throughout Ireland. YVONNE SCOTT

SELECTED READING Aidan Dunne, *Charles Tyrrell: Ten Years*, exh. cat. RHA (Dublin 2001); Davoren, 2002; Patrick T. Murphy, *Charles Tyrrell: A New Series*, exh. cat. Solstice Arts Centre, Navan and CAG (Navan 2011).

VAN STOCKUM, HILDA (1908–2006) [494], painter, writer and illustrator. From her youth Hilda van Stockum maintained a close association with Ireland. Born in Rotterdam, the daughter of a high-ranking Dutch naval officer, she had Irish family links and came to Dublin in her teens to study at the DMSA. Her contemporaries there included Seán O'Sullivan, Nano Reid and Stella Steyn, while Patrick Tuohy (qqv) was one of her teachers. Through her

493. Charles Tyrrell, *Mountain Shuffle*, 1988, acrylic on canvas, 178 x 178 cm, private collection

friendly assistance, Maurice MacGonigal (qv), another fellow student at the DMSA, was enabled to visit Holland in 1927 where he discovered and was influenced by the work of Vincent van Gogh. It was in Dublin, too, that she met a young American, Erwin ('Spike') Marlin, who was then a student at TCD and later became her husband. Marlin was a professional diplomat for much of his life, and also helped to introduce civil aviation to Canada, which meant that the couple lived for periods in various countries, including Switzerland and the USA. They had six children so, to augment the family's income, Hilda van Stockum wrote and illustrated many children's books, a number of which have been republished and are regarded as classics of their kind. Her reputation outside Ireland rests more on her literary achievements than on her art and one of her children's books, *A Day on Skates* (1934), was awarded the coveted Newbery prize (see 'Illustrations and Cartoons').

When the couple retired to live in Hertfordshire, van Stockum renewed her ties with Ireland and had a series of solo exhibitions at the Tom Caldwell Gallery in Dublin, as well as showing in the annual RHA (qv) exhibitions. These brought her paintings before a new, highly appreciative, generation. Hilda van Stockum was given a retrospective exhibition at the RHA

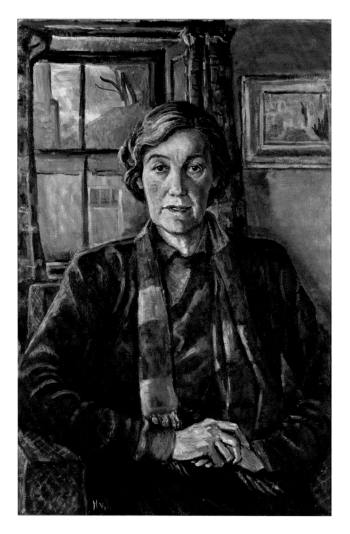

494. Hilda van Stockum, *Evie Hone (1894–1955)*, oil on canvas, 79 x 51 cm, National Gallery of Ireland

Gallagher Gallery in 1990. Her work is deeply traditional, with emphasis on still-life themes, but is never tamely academic and is essentially a continuation of the great Dutch traditions in a more modern sensibility. A sensitivity to light – usually warm, intimate light, rather than cold or acid – is one of its strongest characteristics.

She died at her Hertfordshire home in November 2006, aged ninety-eight. Always a committed craftswoman, she worked in tempera and other media besides painting in oils. Hilda van Stockum's work is to be found in many private collections and in the NGI. One of her paintings, *Pears in a Copper Pot*, was reproduced as an Irish postage stamp in 1993.

Apart from her paintings, one of her great contributions to Irish art is her lively account of her art-student days in Dublin which offers valuable first-hand descriptions of artists, art and art education in Ireland during very formative years.
BRIAN FALLON

SELECTED READING James White, Brian Fallon and Thomas Ryan, *Hilda van Stockum: Paintings and Drawings 1925–1990*, exh. cat. RHA Gallagher Gallery (Dublin 1991).

WADE, JONATHAN (1941–73) [495], painter. The tragic death of Jonathan Wade, in a road accident at the age of thirty-one, deprived Irish art of one of its most individual presences. Wade was born in Pelletstown, Co. Dublin and educated up to the age of thirteen at the local Christian Brothers School. Obliged to work in a variety of unskilled jobs, he managed to attend night classes at the NCA for three years. Following his marriage, Wade spent time in London, where he was encouraged by the sale of a painting from the railings in Green Park. Back in Ireland, he worked in the craft studios of Fergus O'Farrell and had his first solo exhibition there in 1966, attracting the attention of the critic Dorothy Walker. Wade exhibited widely during his short career, at the RHA, IELA (qqv) and the Oireachtas, and was included in 'The Young Artists' section of *Rosc '71* (see 'Rosc Exhibitions'), and the *Critic's Choice* exhibition at the Project Arts Centre, Dublin in the same year. He had a number of solo exhibitions in venues such as the RHA's small gallery in Ely Place and, in the biggest exhibition during his lifetime, at the Project Gallery, Abbey Street, where he showed thirty-seven of the Cubist-inspired, urban landscapes which were to be his singular contribution to Irish art.

Wade was a convinced Marxist and a formative figure in the establishment of the Project Arts Centre. Colm Ó Briain, the Project's first director, described him as 'a very important influence in the early years of the Project … [and] a great pragmatist' (Ryan, p. 264). His cityscapes increasingly prioritized the anonymous assemblages that go to make a modern city, presenting an environment utterly unsympathetic to human occupation. In this, Wade was breaking entirely new ground in an Ireland so embedded in its rural past that it failed to recognize urban alienation. Ó Briain was not alone in remarking: 'I found his urban landscapes, these works which were neither figurative not realistic, spoke very strongly to me, coming from an entirely urban background as I did.' Early in his career Wade invented an alter ego called Lucas Kingsley, a name with which he occasionally signed artwork. Following his death, the Project held a

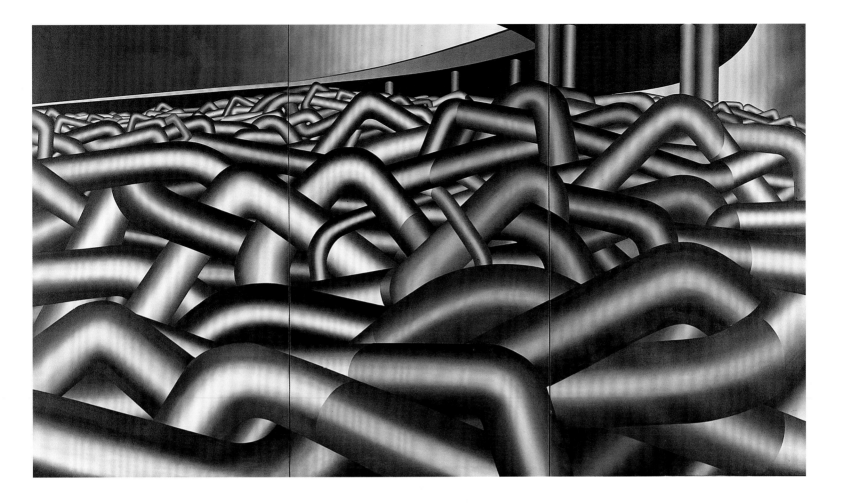

memorial exhibition to raise money for his family, to which £5,000 worth of paintings and sculptures by artists were donated. Commemorative exhibitions of Wade's paintings were held at the Green Isle Hotel, near his home in Clondalkin, and at TCD, in 1975.

His work is in the collections of the HL, AC/ACE, TCD, CIÉ and AIB. Catherine Marshall

SELECTED READING Henry Sharpe, *Jonathan Wade: His Life and Art* (Clondalkin 1977); *Jonathan Wade Retrospective*, exh. cat. TCD (Dublin 1975); Ryan, 2003.

WALSH, SAM (b. 1951) [496], painter. Born in London, Walsh moved to Limerick with his Irish parents in 1968 and, a year later, enrolled at the Limerick School of Art where he studied until 1974. An important element in his artistic education was a two-year period spent working for Decca, the record company, in London in the mid-1970s, which enabled him to visit the contemporary art exhibitions, where he was particularly drawn to British and American Op and Pop art (qv). He holds an MA in Fine Art and a Diploma in Philosophy. His presence in the Irish art world has been a strong one, not only for the integrity of his creative work but also for his active participation in organizations such as the Artists Association of Ireland; as a Toscaire in Aosdána (qv); his role in the foundation of the

Collection of Contemporary Drawing at the LCG; his early participation in EV+A; and his perceptive and courageous critical writing, especially in the pages of *Circa* throughout the 1980s and '90s.

Walsh's abstract painting (see 'Abstraction') and sculpture can be distinguished by his predilection for strong line and forms that defy easy identification. Always a talented draftsman, Walsh was challenged to use drawing to define the intangible – the space that flows freely between physical objects in the world whether moving or static. His early work showed a tendency towards monochrome, influenced, he said, by his experience of war memorials in the London of his childhood, where the absence of colour showed him the potential of other means of expression. He is not interested in symbolism or conventional narrative, but connects to certain narratives through their structure which is mirrored in the formal relationships in his compositions. Thus, *Fourteen Points of Entry* (1990–91, IMMA collection) has been linked to the Christian story of the Stations of the Cross, and from 2002 to 2006 he completed a series of paintings called 'The Divine Comedy', inspired by Dante's famous poem (interview with Brian McAvera). An underlying theme in these and other series is Walsh's exploration of the essential difference between drawing and painting, the former of which he describes as exploratory and the latter as 'arrogant', and his attempts to reconcile the two without making one the servant of the other.

495. Jonathan Wade, *Urban Landscape II*, c. 1972, oil on canvas, 227 x 336 cm, AIB Collection

496. Samuel Walsh, *Arena II*, 1987–88, oil on canvas, 119 x 152.5 cm, Scott Tallon Walker Architects, Dublin

Walsh's work can be seen in most public collections in Ireland, and in national collections in Croatia, England, France, Hungary and Switzerland. CATHERINE MARSHALL

SELECTED READING McAvera, 2005; Emma Tipton, *The Coercion of Substance*, exh. cat. Visual Centre for Contemporary Art (Carlow 2011); Catherine Marshall, 'The Coercion of Substance', *IAR* (Autumn 2011), 58–59.

WARREN, BARBARA (b. 1925), painter. Warren, a quietly influential presence in Irish art, links the figurative tradition of the RHA (qv) with the French-inspired Modernism (qv) of the IELA (qv). She presents figures, still lifes and landscape, asserting an individual Romantic sensibility combined with qualities of reflection and memory.

A Dubliner, Warren developed an early interest in drawing, and received lessons from Lillian Davidson and Dorothy Blackham. From 1943 to 1945 she served in the Women's Auxiliary Air Force in England. She studied at NCA (1946/47) and at Regent Street Polytechnic, London (1947–50), where she was encouraged by Norman Blamey, RA.

Warren worked in Connemara in 1949, when she joined a landscape course under Charles Lamb (qv), and again in 1955. In the 1950s she studied with André Lhote in Paris (1950, 1951), visited Italy, studying Renaissance frescoes, and Portugal and Spain, where she trained for nearly a year with the Catalan sculptor Luis Saumells. In Dublin, she studied the history of art under Françoise Henry and was awarded a travel bursary. Warren's one-person exhibition at the Dawson Gallery, Dublin (1957) included Connemara and Spanish subjects.

Following her marriage to fellow-artist William Carron in 1961, Warren settled in Howth, Co. Dublin, and turned, briefly, to the medium of slate-carving, teaching at NCAD from 1973 to 1984. She worked in Achill, Co. Mayo in 1991 and attended lithography and etching courses at the Graphic Studio, Dublin.

Warren's early paintings included still lifes, in the manner of Chardin. In Paris her work became more dynamic, influenced by Cubism (qv), as in her life drawings and the painting

497. Barbara Warren, *Pont du Carrousel*, 1954, oil on canvas, 25.1 x 35.6 cm, Irish Museum of Modern Art

Pont du Carrousel [497]. She was also influenced by Fauvism and the School of Paris, by the English artist Keith Vaughan, and in Ireland by Evie Hone, Mainie Jellett, Louis le Brocquy, Norah McGuinness and Gerard Dillon (qqv), while retaining a respect for the Italian Masters. In the 1990s Warren returned to a more representational manner of painting, often combining landscape and figure, or the interior of a room with still-life features. Portraits include those of her daughter Rachael (1968), Douglas Sealy (1987) and a *Self-Portrait* (1984, UL). Later work has become more narrative and symbolic, and the titles of many pictures, such as *Dreaming Figure*, *Solitude* and *Memories of Connemara*, epitomize her reflective and nostalgic tendencies.

A member of the RHA and Aosdána (qv), Warren has served on the Board of the NGI. A retrospective exhibition of her work was held at the RHA in 2002. JULIAN CAMPBELL

SELECTED READING Brian Fallon, 'Pictures by Barbara Warren', *IT* (22 September 1972); 'Barbara Warren, Paris – Barbara Warren RHA', *Martello* (1991), 62–65; Julian Campbell, *Barbara Warren RHA: A Retrospective*, exh. cat. RHA (Dublin 2002).

WEIR, GRACE (b. 1962) (qv *AAI* III), time-based artist. Weir is part of a generation of conceptually based artists guided by a desire to reinvigorate sculptural practices. Born in Dublin, Weir graduated from NCAD in 1984, having specialized in sculpture and ceramics. She achieved critical acclaim early in her career and in 1988 was commissioned to complete a public sculpture, *Trace*, on the corner of St Stephen's Green and Merrion Row, Dublin, to commemorate the city's millennium. The double arch form recalled the city's historic Georgian architecture, while the design suggested the presence of a third arch when viewed from different angles. Weir's stated aim was 'to achieve a sense of fluidity [and] of movement' (Helen Shaw, *IT*, 26 August 1988). When seen in context of the artist's later output, it is clear that these concerns have continued to gain artistic expression in her work.

Weir's early sculptures, such as *Celestial Mechanics* (1990) and *Phase* (1990), are characterized by an interest in process and scale, and incorporated a range of found objects. She first used

photography (qv) and video while participating in the prestigious fellowship at PS1, New York in 1992. Initially an aid to document her experiences, Weir soon began working in photographic and time-based media (see 'Time-based Art'). This process was consolidated in the exhibition *Man on Houston Street* at Temple Bar Gallery in 1996 which included Weir's first animation and a series of eponymously titled negative prints, depicting the skyscrapers and skylines of New York.

Weir graduated with an MSc in Multimedia from TCD in 1997. This experience shaped her subsequent trajectory into making complex digital and interactive artworks that married her ongoing interest in space and perception with new expertise. Weir's transition into multimedia was well received by Irish audiences, with one critic stating that her final project artwork, *And* (1997), was 'one of the most sophisticated works of electronic art yet to emerge in Ireland' (Luke Clancy, *IT*, 17 December 1997).

In 2001 Weir co-represented Ireland at the Venice Biennale with the artwork *Around Now* (2001). The work consisted of two five-minute films recording the circular transit around a cloud in clockwise and counter-clockwise directions. Weir's positioning of the films at opposite ends of the gallery deliberately thwarted one's ability to view both works simultaneously. As well as mobilizing the viewing experience, Weir's work draws out cinematic references through various configurations of light, subject and location.

In *Dust Defying Gravity* [498], the camera follows the gradual descent of a particle of dust filmed in the evocative setting of Dunsink Observatory in Dublin. The film draws out associations between the empirical context of a scientific laboratory and cosmic concepts of space, time and matter. In films such as *Déjà Vu* (2003), any sense of fixed meaning is continually deferred through the juxtaposition of a non-linear narrative between two unnamed protagonists, while the four-minute duration is designed to reflect the difference between a solar and a sidereal day.

Weir's practice has encompassed prototypical internet projects, such as *Event in Cyberspace* (1996), run in conjunction with the digital arts organization Arthouse. In 2007 she revisited her long-standing interest in science with an exhibition entitled *In My Own Time* at the Science Museum, London. Weir has also worked collaboratively on projects with artists and academics, in works such as *The Darkness and the Light* (2002) and *Sight Unseen* (2005). She is a member of Aosdána (qv) and has exhibited widely both nationally and internationally. Her work is represented in the collections of IMMA and the OPW. JENNIFER FITZGIBBON

SELECTED READING Fionna Barber, 'Grace Weir', *Circa*, no. 55 (January/February 1991), 39–41; Michael Cunningham, 'Grace Weir', *Circa*, no. 77 (Autumn 1996), 49; Tanya Kiang, *Man on Houston Street*, exh. cat. Temple Bar Gallery (Dublin 1996).

498. Grace Weir, *Dust defying Gravity*, 2003, 16 mm film transferred to DVD, Irish Museum of Modern Art

WHELAN, LEO (1892–1956), painter. Leo Whelan was 'arguably the best portraitist working in Dublin in his generation' according to S.B. Kennedy (1991, p. 166) but he is also remembered for a number of very evocative genre pictures (see 'Portraiture'). Crookshank and Glin believe that his genre pictures, usually containing a single figure in an interior setting, lack the imagination and high quality of his portraits (Crookshank and Glin, 2002, p. 282); yet it was a genre painting that first earned Whelan critical attention when he was awarded the RDS Taylor scholarship in 1916 for a painting entitled *The Doctor's Visit* (1916, NGI collection).

Born in Dublin and educated at Belvedere College and the DMSA, Whelan rarely left his native city and his genre pictures reflect the claustrophobia of that confinement and the dependence on his family which caused him to rely on them as models for much of his genre work. Most commentators reckon that Whelan, like a number of his fellow students at the DMSA, was trapped in the shadow of his teacher William Orpen (qv), and was, if anything, even more classically academic in his approach to painting than Orpen himself. He sent his first painting into the RHA (qv) in 1911, when he was nineteen, and remarkably, continued to show there every year, without fail, until his death. By 1924, when he was elected RHA to fill the vacancy caused by the death of John Butler Yeats, his place in Irish art was firmly established.

Whelan won the gold medal at the Aonach Tailteann for a portrait of Professor Claude-Louis Purser, Vice Provost of TCD, and in 1922, managed, thanks to the organizational skills of General Risteard Mulcahy, to paint a group portrait of the General Headquarters staff of the IRA, including the hectically busy Michael Collins, who could sit for him only for one hour, and Arthur Griffith, both of whom were to die before the year was out [386]. It is a measure of his skill as a draughtsman that Whelan was able to show a portrait of Michael Collins based on that brief sitting at the RHA. He went on to paint William T. Cosgrave, first President of the Irish Free State (1928), Eamon de Valera (1955, OPW, Leinster House) and later presidents Douglas Hyde and Seán T. O'Kelly (OPW, Áras an Uachtaráin). He was a visiting teacher at the DMSA, where his pupils included Maurice MacGonigal (qv).

Despite the political upheavals that were so much a part of the Dublin of Whelan's early career (two of his pictures were destroyed in the fire at the RHA in 1916), no visible trace of civil or military conflict disturbs the quiet atmosphere of his paintings of everyday life. The *Doctor's Visit* (1916) was followed by a handful of fine pictures including *The Kitchen Window* [499], *The Fiddler* (*c.* 1935, CAG) and *Reverie* (1920), a Vermeer-like study of light and texture, in which a woman (the artist's sister Lily), silhouetted against a window, runs her fingers over the keys of a piano. Generally, however, Whelan's genre pictures were thought to lack imagination and appeared formulaic. A possible reading of these pictures is that they were painted deliberately to counter the culture of post-revolution and civil war conflict and assassinations.

In 1931 the Haverty Trust commissioned Whelan and two other artists to paint scenes from the life of Saint Patrick, to mark the holding of the Eucharistic Congress in Ireland the

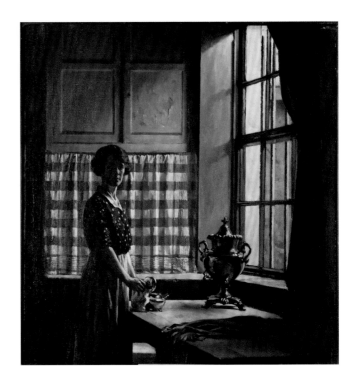

following year. Lacking Orpen's sense of history, Whelan was not up to this challenge, and his painting of *Saint Patrick lighting the Paschal fire at Slane* failed to impress. He was more successful with another official commission. In 1929, on the centenary of the passing of Catholic Emancipation, Whelan was invited to design the Free State's first commemorative stamp. His solution was to design a stamp based on a portrait of Daniel O'Connell, hero of that event. In addition to portraits of successful academics, politicians and churchmen, Whelan painted the celebrated Irish tenor John, Count McCormack (1930, National Concert Hall), who tried vainly to persuade the artist to accompany him to America. The formula Whelan adopted for these portraits was invariably the three-quarter view, showing particular skill in the treatment of hands.

William Gallagher perceptively describes Whelan as having 'the technical flair, devotion to tradition, and an emotional diffidence that suited perfectly the requirements of private and official portraiture' (Gallagher, p. 376). Whelan's *Self-Portrait* in the UL shows the full range of his technical repertoire and was clearly intended more as a display of expertise than an exploration of his face, barely visible against the light of the window behind. Whelan, retiring and private as ever, concealed himself behind his art.

Whelan's work can be seen in the collections of the OPW, NGI, NMI, Heraldic Museum, Dublin, CAG, HL, TCD and the NPGL. CATHERINE MARSHALL

SELECTED READING J. Crampton Walker, *Irish Life and Landscape* (Dublin 1927); Waddington, 1940; Gallagher, 2006.

THE WHITE STAG GROUP. The outbreak of World War II in 1939 saw an influx of refugees into Ireland which remained neutral during the Emergency, as the period of the second World War is often referred to in Ireland. These included Irish artists such as Louis le Brocquy and Norah McGuinness (qqv), who were forced to cut short their European travels, French artists like Georgette Rondel, and, most particularly, British figures such as Basil Rákóczi, Kenneth Hall (qqv), Stephen Gilbert and Nick Nicholls.

The White Stag Group had been founded by Rákóczi and Hall [500] in London in 1935 with the intention of combining notions of subjectivity and psychoanalysis in art. Rákóczi had earlier founded the Society for Creative Psychology and was deeply interested in the discipline. In Rákóczi's *Lost in a Forest* (1945, private collection), a figure appears to be walking a tightrope with tiny, twig-like arms spread out for balance. Although the figure is of an indeterminate age, a certain child-like quality is present, heightening the sense of insecurity or uncertainty implied by the painting's title. The sex of the figure is also uncertain. Although there is the suggestion of a skirt, the recurrence of this motif in paintings such as *Child Flying* [501] and *Three* (1943, private collection) might suggest that this is merely a compositional device. In these paintings, the wide staring eyes, which occupy a disproportionate area of the picture plane, are most striking. If the eyes are the 'windows to the soul', then this painting would offer rich rewards for psychoanalytical investigation. Even the physiological symptoms of the constricted pupil could be attributed to sadness, and the split, almost Janus-faced quality might be suggestive of a schizophrenic state. It was with their interest in creative psychoanalysis and subjectivity foremost in their minds that Rákóczi and Hall, who were pacifists and half-Irish, arrived to spend the war in neutral Ireland in August 1939.

They immediately went to Connemara where they began to paint figurative representations of the Aran Islanders and their surroundings, as shown in Rákóczi's *Islander on Inishmore* (c. 1940, private collection). These pictures are somewhat at odds with their professed aims, and ironic, considering that such paintings might have fitted well into a hegemonic orthodoxy that included Seán Keating's (qv) paintings of 'heroic' Gaelic Irishmen and women. Rákóczi and Hall soon moved to Dublin where they held their first Irish exhibition in April 1940 at 34 Lower Baggot Street, with eleven artists, including Mainie Jellett (qv), Patricia Wallace, Georgette Rondel and Nick Nicholls. The presence of Jellett might be an indication of the rapidity with which Rákóczi and Hall had become involved with the small avant-garde artistic community in Dublin.

The first exhibition was a critical success, with the *Irish Times* (16 April 1940) remarking on the 'fundamental freshness and originality' of the works. This critical success was to remain a feature of their time in Ireland, perhaps surprising considering the prevailing conservatism often noted by writers about this time. However, Bruce Arnold, in attempting to revise these somewhat fixed notions about the 1940s, stated:

The fact that they got on well, were received with critical analysis that was on the whole intelligent and sympathetic,

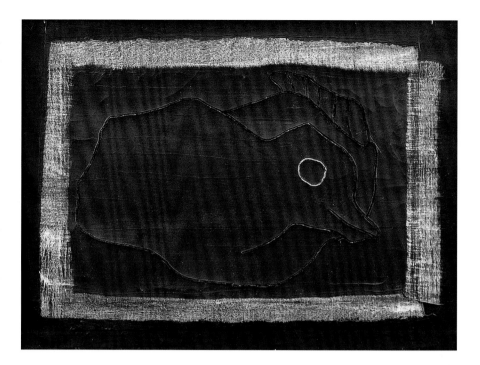

500. Kenneth Hall, *Drake Resting*, c. 1944–45, oil on canvas, 33 x 45 cm, private collection

is a measure less of the quality of the painting as it is a reflection of the liberal, broad-based and intelligent people with whom they found themselves living. Culturally the climate ... was attractive and exciting ... it was less isolated than history has made it ... in a Europe dominated by Fascism, it was free. (Kennedy, p. 55)

Their most important show was the *Exhibition of Subjective Art* in early 1944. Subjective art was described by Herbrand Ingouville-Williams as follows:

In Subjective Art ... order and emotion are synthesized ... but the theme, instead of being drawn from objects in the external world, is elaborated by the workings of the imagination turned inwards upon the memories, dreams and phantasies of the Unconscious. Objects which appear in Subjective paintings, such as a bird, a fish, a figure, or a garden, are not represented in a realistic manner, but as dream-images, as conceptual memories, as the eidetic phantasies of the child-mind. (Basil Rákóczi website, http://www.rakoczi.org.uk/rakoczi_biography.php, accessed 8 July 2010)

The influence of the White Stags was probably most pronounced on younger, emerging painters such as Patrick Scott (qv) [502], who was a regular contributor with his works in a distinctly delineated style, possibly influenced by Hall. Scott was encouraged by the support and praise he received, particularly from Rákóczi, and in 1944 had his first solo exhibition at the White Stag gallery on Baggot Street. In Dublin, between 1940 and 1945, the White Stags organized twenty-six exhibitions, as well as regular poetry readings, music recitals, and lectures on subjects as diverse as Surrealism,

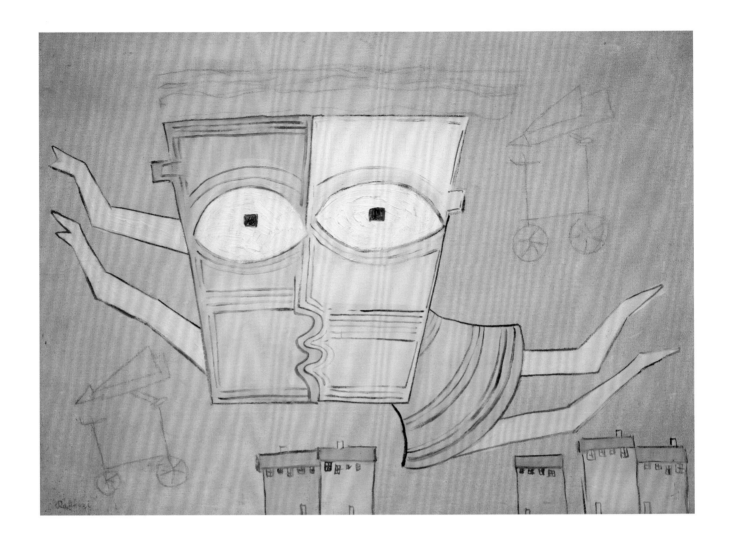

501. Basil Rákóczi,
Child Flying, 1943, oil on
canvas, 53.5 x 74 cm,
private collection

stained glass (qqv), architecture or psychic experiences. They also contributed to established Dublin exhibitions such as the Royal Hibernian Academy (qv) annual exhibition, the Society of Dublin Painters and the newly founded Irish Exhibition of Living Art (qv). That so much was achieved in a short time is surely testament to their boundless energy and enthusiasm. The White Stag's early association with the Bloomsbury Group has often been referred to, but it could be argued that, more than any particular style, it was the level of professionalism, internationalism and ambition which they brought with them from London that most affected the Irish art world. Alongside their frequent events they also attempted to catalogue their exhibitions. The highlight of their catalogues was their publication of *Three Painters* in 1945, a book on the work of Rákóczi, Hall and Scott with an introduction by Ingouville-Williams and a foreword by Herbert Read. It was through connections to critics like Read that exhibition reviews appeared in influential journals such as *The Bell* and Cyril Connolly's *Horizon*, further emphasizing the importance of these international contacts.

At the end of the war, the non-Irish members of the White Stag gradually left Ireland so that by 1946 there was only one further White Stag exhibition in Dublin. Soon after returning

to England, Kenneth Hall took his own life. Basil Rákóczi continued the work of the Society for Creative Psychology, had his last Irish exhibition, a solo show, in 1953, and settled in Paris. Patrick Scott practised as an architect until he became a full-time artist in 1960. Stephen Gilbert and his

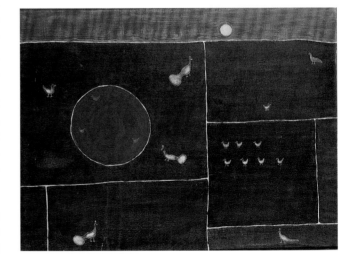

502. Patrick Scott,
Evening Landscape, 1944,
oil on canvas, 70 x 93 cm,
private collection

wife Jocelyn Chewett returned to Paris and he became a member of the CoBrA group. Brian Boydell stopped painting in 1944 but went on to become an important composer and academic. The influence of the White Stag Group on Irish art and intellectual life was not superficial, and its activities in Dublin during the Emergency temporarily made Ireland a vital, albeit peripheral, focal point for Modernist experimentation and thought (see 'Modernism and Postmodernism'). The Group brought a whiff of cosmopolitan professionalism to Ireland and offered Irish artists a viable alternative to the more traditional work that dominated Irish art before their arrival.

Artists associated with the White Stag Group include: Dorothy Blackham (born Dublin, 1896–1975), Brian Boydell (born Dublin, 1917–2000), Jocelyn Chewett (born Canada, 1906–79), Thurloe Conolly (born Cork, 1918), Ralph Cusack (born Dublin, 1912–65), Bobby Dawson (born Dublin, 1924–91), Hertha P. Eason (born Dublin, 1896–1974), Paul Egestorff (born London, 1906–95), Phelan Gibb (born Northumberland, UK, 1870–1948), Stephen Gilbert (born Scotland, 1910–2007), David Gommon (born London, 1913–87), C. Kenneth Hall (born Surrey UK, 1913–46), Phyllis Hayward (born Portsmouth, UK, 1903–85), Mainie Jellett (born Dublin, 1897–1944), Eugene Judge (born Galway, 1910), Helmut Kolle (born Germany, 1899–1931), Noel Moffett (born Cork, 1912–94), E.W. Nick Nicholls (born Wiltshire, UK, 1914–91), Basil Ivan Rákóczi (born London, 1908–79), Georgette Rondel (born France, c. 1915–42), Patrick Scott (born Cork, 1921–2014), Doreen Vanston (born Dublin, 1903–88) and Patricia Wallace (born Dublin, 1912–73). Seán Kissane

SELECTED READING S.B. Kennedy, 1991; Arnold, 1991; Kennedy and Arnold, 2005.

WOMEN AND THE VISUAL ARTS IN IRELAND
Introduction
Until the very end of the twentieth century, when asked about women and the visual arts, most people pointed to representations of women, rather than artwork by them. In that context, the situation in Ireland differed little from that revealed by the American art activists the Guerilla Girls, about the Metropolitan Museum in New York in 2004, when they did a count and discovered that 83 per cent of all the nudes on show in the Met were female, but 97 per cent of the artists were men. Irish percentages for the representation of women, by men, are in line with this, the only significant difference being that before the 1960s they were rarely nude. Journalist Marianne Hartigan posed a related question in 1989 when she challenged readers to name a single Irish woman artist (*U Magazine*, October 1989, 'Name an Irish artist?').

Yet in contradiction to the passive roles implied by this and untypically, when compared to the rest of the western world, women have played a particularly important part in the history of Irish art in the twentieth century. At key moments in that history they have been entirely responsible for change and development. Just as the English novel owes much of its development to Jane Austen and George Eliot, so the introduction of Modernism (qv) to Irish art was, virtually, the exclusive achievement of Mainie Jellett, Evie Hone (qqv) and those women who followed them abroad, seeking an alternative to the narrow academicism in vogue in Ireland in the first half of the twentieth century. Their promotion of a new kind of art in Ireland was supported by Sarah Purser's (qv) indefatigable espousal of fellow artists, her campaign to find a home and build a collection for the Hugh Lane Municipal Gallery of Modern Art (now the Dublin City Gallery The Hugh Lane (HL)), and her establishment of a co-operative to train stained-glass artists, An Túr Gloine [503]. Few people now dispute the importance of women artists such as Jellett, Hone, Mary Swanzy and Nano Reid (qqv) in the emergence of Modernism in Ireland in the 1920s, '30s and '40s and of a later generation (Alanna O'Kelly, Pauline Cummins, Kathy Prendergast, Alice Maher, Dorothy Cross (qqv), Louise Walsh) who were to the forefront from the 1980s onwards in instituting new practices and challenging traditional artistic hierarchies. But the part played by women in developing opportunities for public engagement (Ellen Duncan, Sybil le Brocquy, Jenny Haughton, Helen O'Donoghue, Ailbhe Murphy), education in art practice (Purser in An Túr Gloine, Mary Farl Powers (qv)), art history (Françoise Henry, Anne Crookshank) and art criticism (Joan Fowler, Dorothy Walker), and the contribution they made to the history of Irish art through their championship of their male colleagues (Lady Gregory, Purser, Jellet, Norah McGuinness (qv)) is less well known and acknowledged.

Any discussion of women's contribution to the history of art must begin with the question of definition. It is men who have defined what it is that constitutes Fine Art, and who, in the past, have decided that much of the work done by women did not meet their definition. Consequently, some spectacular artwork has remained undocumented and uncollected, condemned as mere craftwork, and, as such, not compliant with

503. Patrick Pollen, sketch from memory of An Túr Gloine studios before 1958, 1987, felt tip pen on paper, 21 x 30 cm

the standard male-defined canon. However, Irish women have worked to amend and subvert that canon. Any history of Irish art in our period must acknowledge the impact of colonization and its aftermath. As Joan Fowler has pointed out, Irish women have been doubly colonized (Fowler in Ryan-Smolin et al, p. 75). Colonization and the struggle to overcome it, involving the consolidation of a Catholic nationalist patriarchy, poverty and geographic isolation have all combined to create difficulties for Irish women irrespective of background or position. The legacy of colonization has also made it more difficult for women from Anglo-Irish backgrounds, however advantaged financially, to receive acknowledgement in post-treaty Ireland, while at the same time it has divided and restricted audiences, had an effect on the provision for the free development of art education (see 'Education in the Visual Arts') and museums, and reduced opportunities for all artists. Unlike countries such as the United States of America, where some women had personal financial resources that enabled them to influence the art market and to establish some of the most important art museums in America, no Irish women were so empowered. It was men who bought art and put it into private or public collections (see 'Private and Corporate Art Collecting' and 'Publicly Funded Collections'). Social changes in the last decades of the twentieth century mean that women are now beginning to establish their place in the market too, but development is slow in this regard.

Creating a place for Modern Art

It is a given that the establishment of the HL was central to the history of Irish art in the twentieth century for a variety of reasons (see 'Collecting Art'). It would not have been established without the pressure that Lady Augusta Gregory put on her nephew, Sir Hugh Lane, to interest himself in the art of his own country. When George Moore asked him why he, an expatriate, had given so much to the country of his birth, Lane replied, 'Well you see, I am Lady Gregory's nephew and must be doing something for Ireland' (Robert O'Byrne, *IT Weekend Review*, 19 January 2008). Fortunately, thanks to Sarah Purser, the pressure was applied just when there was some quality Irish art on public view. In 1901 Purser, notwithstanding the fact that John Butler Yeats was her rival for the limited portrait commissions on which they both depended, selflessly took it upon herself to revive the flagging careers of Nathaniel Hone and John Butler Yeats by organizing a substantial exhibition of their work. Impressed, Lane immediately initiated plans to establish a gallery for modern art in Dublin. Although they were not admitted to the Royal Hibernian Academy (RHA) (qv) for a further two decades, it was the women artists who promoted Lane's 1902 fund-raising exhibition at the RHA, and the Ladies Committee, including artists such as Constance Markievicz and Sarah Cecilia Harrison, who took responsibility for subscriptions for the gallery when it opened six years later. Indeed Harrison compiled the gallery's first catalogue, while out of the 300 artworks in the first exhibition (including Lane's personal loans and donations of approximately one hundred pieces), fifty of the artworks were either bought with money provided by women, or donated by them.

Hugh Lane became Founding Director of the gallery, but the first curator, appointed in 1913, was a woman, Ellen Duncan. Following Lane's death in 1915, the work of developing a collection and finding a permanent home for the gallery devolved once again to the women. Purser, always to the fore, founded the Friends of the National Collections of Ireland in 1924 to fund purchases of artworks and to lobby for a building, the ultimate choice for which, Charlemont House in Parnell Square, was her suggestion (Liz Sheridan in Ryan-Smolin et al, p. 16).

Modernist art practices

The biggest innovation in art practice during the first half of the twentieth century was the introduction of Cubism and abstraction (qqv) to Ireland by Mainie Jellett and Evie Hone. As Bruce Arnold described her, 'Mainie Jellett [504] was the single greatest force for change in art in Ireland between the two world wars. She bestrode those decades as a giant figure.' (Arnold in Ryan-Smolin et al, p. 30) Her achievements as a Modernist are all the more remarkable if we consider that she had been taught by William Orpen (qv), whose academicism was to prove stultifying to most of her successful male contemporaries (Seán Keating, Patrick Tuohy, James Sleator (qqv)). Jellett and Hone exhibited the first abstract paintings in Ireland in 1922 and 1923. Despite ridicule from the critic George Russell (qv) and others, Jellett not only produced abstract pictures, she lectured about abstraction, even broadcasting in favour of it on radio, a rather extreme measure since the vast majority of her listeners could have had little notion of what she was describing. Although they were dismissed as 'Lhote's Wives', a reference to their first teacher in Paris (Hartigan, p. 65), Arnold has shown that Jellett and Hone were anything but passive receivers of their teacher's wisdom. Having outgrown Lhote as a mentor, they sought out Albert Gleizes, whose form of Cubism they considered purer, and persuaded him to allow them to work alongside him. Gleizes himself acknowledged the dual learning that resulted: 'I began to understand the benefit I myself had derived from the effort which my determined young Irish girls had exacted of me.' (Arnold in Ryan-Smolin et al, p. 32)

Despite their prominence in the history of Modernism in Ireland, it must be admitted that neither Jellet nor Hone had any impact on its development internationally. No Irish visual artists in the first half of the twentieth century equal the contribution made by James Joyce and Samuel Beckett in literature, but of those who came close, it was women who were again most prominent. Of these, the architect and designer Eileen Gray (qv) was a major figure recognized by such international peers as Le Corbusier and Mies van der Rohe, but because of her reclusive life the full extent of her innovative practice was not known until after her death in 1976. Mention must also be made of the painter and lithographer Stella Steyn (qv), the only Irish artist known to have studied at the Bauhaus in Dessau, where she was taught by Kandinsky. As a twenty-two-year-old, she so impressed James Joyce that he personally invited her to illustrate a section of *Finnegans Wake*. The leading Modernist critic David Sylvester praised her unique 'way of seeing' in 1949, while her series of paintings of the female nude can be seen as precursors for later discourse on female representation.

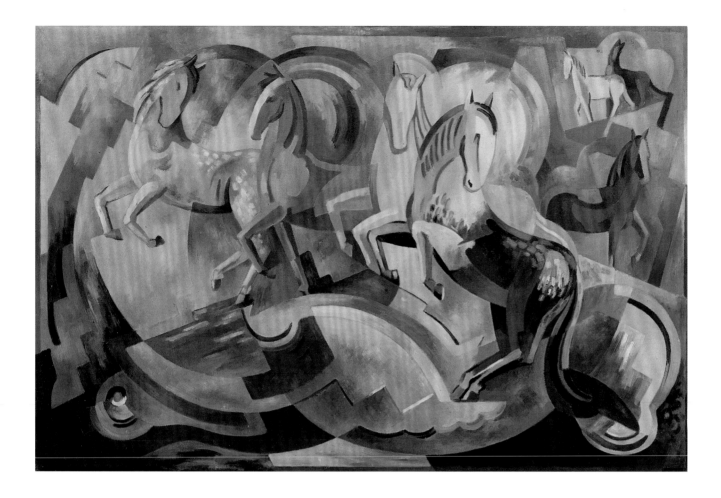

Jellett was more influential for opening up other approaches to art-making in Ireland through her passionate advocacy of Modernism, rather than for spawning immediate followers. Her distinctive paintings made her more visible than some of her colleagues, who were nonetheless equally anxious to create a freer environment for exhibiting art. S.B. Kennedy has pointed out that, in the absence of manifestos on Modernism, Jellett's statements are the nearest equivalent in Ireland. Kennedy also claims that she is responsible for the 'first piece of reasoned criticism of the RHA to be published' (Kennedy, p. 116). In 'The RHA and Youth' (*Commentary*, May 1942, pp. 5, 7), Jellett courageously argued that the work in the RHA annual exhibition was bad, vulgar, unimaginative and technically faulty, and demanded better exemplars for the sake of young artists.

Exhibiting Modernism
Founded in 1920, the Society of Dublin Painters (SDP) sought to continue the work done by Ellen Duncan in two seminal exhibitions in the United Arts Club, Dublin, in 1911 and 1912, in which she showed the work of such avant-garde artists as Cézanne, Derain, Gauguin, van Gogh, Matisse, Picasso and Gris. The SDP aimed to provide an alternative to the RHA, which it did with aplomb in 1923, showing *Decoration* by Mainie Jellett (1923), one of her earliest non-figurative paintings and, in so doing, attracting negative criticism from the *Irish Times*, in a review headed 'Two Freak Pictures' (Kennedy, p. 38). The SDP,

however, went on to enjoy critical success for another twenty-five years. Such was the strength of its female membership (May Guinness, Grace Henry, Letitia Hamilton (qqv), Eva Hamilton, Harriet Kirkwood, Swanzy, Jellett and Hone) that the *Irish Times* described the Spring show in 1935 as 'the first time that there has been a women artists' exhibition as this show may be taken to be' (S.B. Kennedy in Ryan-Smolin et al, p. 35). Stephen Rynne in 1942 thought them 'the liveliest of the living painters, explorers and experimentalists' (ibid.).

The contrast between the SDP and the RHA can be deduced from undated comments by the poet, art critic and Director of the National Gallery of Ireland (NGI) (1950–63), Thomas MacGreevy; writing about discrimination against women, he noted, 'Trinity College was the first university to grant degrees to women, the first woman elected to parliament in these islands was Madam Markievicz But the RHA can apparently only titter at the idea of a woman artist.' (Brown, p. 103) The foundation of the Irish Exhibition of Living Art (IELA) (qv), the most sustained organization for promoting Modernism, came about through the actions of another woman, Sybil le Brocquy, after a painting by her son Louis (qv) had been rejected by the RHA. In 1943, she brought together a small committee of five women, Mainie Jellett (chairman), Norah McGuinness, Evie Hone, Elizabeth Curran (secretary), Margaret Clarke (qv), and four men, Louis le Brocquy, Father Jack Hanlon, Ralph Cusack and Laurence Campbell. Sadly, Jellett died within the first year, and

the chairmanship, later presidency, passed to Norah McGuinness. Despite some troughs, the IELA was an important outlet for new talent until the 1970s when the situation for artists had changed greatly and McGuinness retired. Under Jellett and McGuinness, the IELA promoted the work of young artists, many of whom embraced practices very different to their own. The artist Patrick Scott (qv) was quick to acknowledge their importance for his own practice, while Jellett's recognition and encouragement of the impoverished young painter Gerard Dillon (qv) had a vital impact on his subsequent career. The official response to the IELA in its first decade was so positive that the Cultural Relations Committee of the Department of Foreign Affairs decided in 1950 to send Irish artists to the Venice Biennale for the first time. The first two artists chosen were women, Norah McGuinness and Nano Reid. This was followed in 1956 by another Irish entry of two artists, Louis le Brocquy and the sculptor Hilary Heron, described by S.B. Kennedy as 'the most radical of all women in the IELA' (Kennedy, p. 43). Thus, three of the first four Irish artists to be sent to Venice were women. As alternative exhibition venues began to emerge and opportunities to travel brought increasing awareness of international advances, the IELA went through a doldrums period in the late 1950s and early '60s, from which it was rescued in 1964 through a subvention scheme with P.J. Carroll & Company, which agreed to sponsor prizes, and paid distinguished international curators to nominate the winners. While all the adjudicators were men, some of the most important awards went to women, such as Anne Madden (qv) (nominated by Brian O'Doherty (qv)), Deborah Brown and Maria Simonds-Gooding (qv) (nominated by Roland Penrose). Following McGuinness's retirement in 1970 at the age of sixty-nine, the IELA was reformulated as the Brave New Living Art, run by a reduced, all-male committee under the leadership of Brian King. Dorothy Walker noted a decline in numbers of women artists exhibiting, from twenty-eight in 1961 to three in 1972. The new committee discontinued the practice of inviting outside judges and selectors. As a result, interest in the 'Living Art' exhibition declined, although it continued to function until the mid-1980s (Walker in Ryan-Smolin et al, p. 53). In changing circumstances for the arts and without the women who founded it, the IELA, it appeared, could not sustain itself. Even Brian Fallon, hostile in many ways to the founding women, acknowledged that 'The Living Art Exhibition was basically "their" show, and it remained so even when they were no longer there' (Fallon in Ryan-Smolin et al, p. 47).

A changing cultural environment
Since the 1960s, things have been changing for artists of both sexes, thanks to greater access to education, better international communications systems, increased travel, equality legislation, the relaxation of censorship law, and improved living conditions. Women have benefited from these changes, especially from access to fertility control. However, while improvements have taken place, the conditions that make it difficult for women to compete on an equal basis with men remain a serious issue.

The 1970s and '80s also saw a referendum to reinforce anti-abortion provisions in the Constitution, a failed attempt to introduce divorce, the wrongful conviction of a young woman for the murder of a baby following the death of her own new-born infant, and the sacking of a teacher who became pregnant outside of marriage. Women artists embraced Postmodernism (see 'Modernism and Postmodernism'), stressing the importance of the personal in their work and the need for social change. Despite this, they were seriously underrepresented in two large group exhibitions, *Directions Out* and *Making Sense*, both selected by men, promoted as cutting edge, and funded by the Arts Councils (qv) of Ireland and of Northern Ireland. A more positive moment was signalled in 1987 with the exhibition *Irish Women Artists*, presented in three venues, the NGI, the HL and the Douglas Hyde Gallery (DHG), to coincide with the seventh International Women's Conference, held that year in Trinity College, Dublin (TCD). The exhibition had two purposes, to write into history the contribution of Irish women artists, and to spotlight women's practice. The exhibition brought together women artists, feminist audiences and critics, male and female, from different backgrounds. In doing so, it led directly to the founding of the Women Artists Action Group (WAAG), which held its inaugural meeting in the same year. Writing about the Women Artists Exhibition, Aidan Dunne noted that women were more complex in their representations of themselves than their male colleagues (Dunne in Ryan-Smolin et al, pp. 61–70). Referring specifically to artists such as Pauline Cummins, Louise Walsh, Eithne Jordan (qv) and Alanna O'Kelly, Dunne called attention to the multifaceted interpretations of the self by women, to the openness with which they embraced such new practices as live performance and video, to their integration of the technical with the personal, their incorporation of recycled materials as part of greater environmental awareness, and their general technical adventurousness. Along with Patricia Hurl, Kathy Prendergast, Alice Maher, Dorothy Cross, Eilís O'Connell and others, they critiqued and embodied the conflicting situations in which women continued to find themselves [505]. Women were to the fore also in creating an important new forum for debate, with the emergence in 1981 of *Circa*, the most serious, regular, critical art journal ever to appear in Ireland. The initiative for *Circa* was largely owing to the labours of artists Ann Carlisle and Deirdre O'Connell, joined by the uncompromising, critical acumen of Joan Fowler. Postmodernist from the outset, it would be difficult to overestimate *Circa*'s contribution to visual arts discourse in Ireland in its first decade.

Networks and organizations
While WAAG was the first support organization specifically dedicated to exploring issues around women's practice, it was not the first one in which women were centrally involved. As early as 1903, Sarah Purser, looking for new opportunities for artists to make a living in Ireland, spotted the proliferation of new churches, schools and convents as Catholics gradually gained in prosperity. Noting that the demand for stained glass (qv) for these new buildings was met from abroad, she established An Túr Gloine (The Tower of Glass), to train Irish artists in this craft. Purser persuaded A.E. Child to supervise the training, and among those to benefit were Evie Hone and

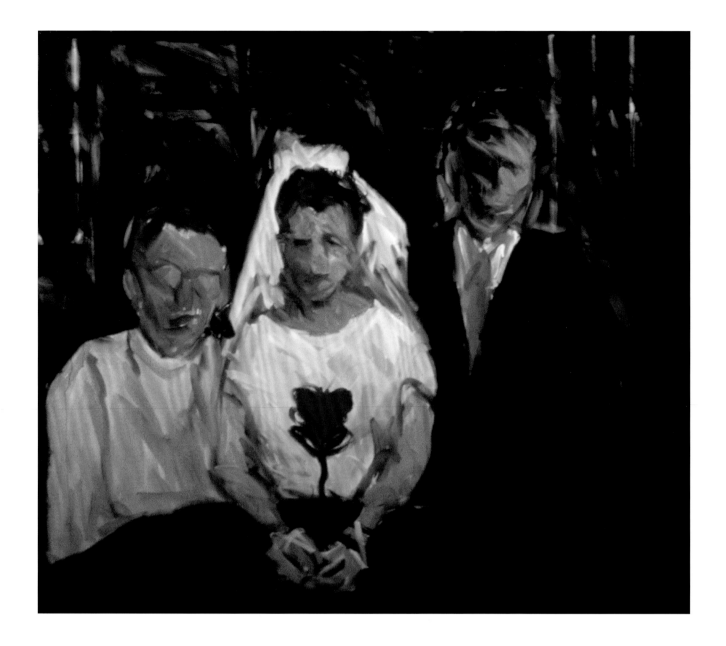

505. Patricia Hurl, *Once Upon A Time, The Living Room, Myths and Legends*, 1988, oil on canvas, 106 x 150 cm

Wilhelmina Geddes (qqv). Purser's aim, like that of the women so active in the SDP and the IELA, was to help artists in Ireland, irrespective of gender. Jane Eckett has shown that it was sales of popular still-life paintings by Moyra Barry which enabled Victor Waddington to show the work of less popular, but more experimental male artists such as Gerard Dillon and Daniel O'Neill (qv) (see 'Art Market'). Mary Farl Powers was more proactive in her efforts on behalf of fellow artists, female and male, working successfully to establish the first gallery for printmaking (qv), the Graphic Studios Gallery, Dublin, in the 1980s. Farl Powers was not, however, the first woman to play a prominent role in the development of print as an art form. Wexford artist Myra Hughes braved the disapproval of her colleagues in the Royal Society of Painter Etchers and Engravers in London, of which she was the first Irish member, to experiment with colour etching and became the first artist to hold a solo exhibition of modern prints in Ireland, which she did at the United Arts Club, Dublin in

1920. Her work was collected by the British Museum but, despite her influence on printmaking, no Irish public collection has examples of her work. In spite of this history and the more recent achievements of printmakers such as Maria Simonds-Gooding and Geraldine O'Reilly, the ratio of women to men in Stoney Road Press, established in 2002, does not acknowledge their contribution. Of eighteen artists in their inaugural catalogue, *Collaborations and Conversations*, only four were women.

Aosdána (qv), launched in 1981 by the Arts Council of Ireland to honour 'outstanding contributions and to encourage and assist members in devoting their energies fully to their art' (http://aosdana.artscouncil.ie/ consulted 11 May 2010), is regulated by a committee of ten *Toscairi*, elected biannually from within the 250-strong membership. Membership confers many benefits, financial and critical, but women have always been in a minority in Aosdána, although women visual artists are generally better represented numerically than women in

other art disciplines. The membership trajectory revealed by a graph of the period from 1981 to 2000, a period when Irish women artists were particularly successful, both nationally and internationally, shows that the number of male artists elected was almost twice that of women throughout the entire period (Christina Kinsella, *Aosdána and the Female Visual Artist*, MA thesis, TCD, Dublin 2008, ch. 7, p. 5). New members are elected to fill vacancies across all art forms. In 2000 eight women and thirteen men were nominated to fill eight vacancies; of these, only one woman was elected (Kinsella, ch. 7, p. 7). While this gap has narrowed occasionally, it remains the norm. The establishment of Temple Bar Galleries and Studios, largely the brainchild of Jenny Haughton, its first administrator and the force behind its programmes and services, was of central importance, as a successful model for similar artists' co-operative organizations (see 'Artists' Studios and Residencies') and also as a significant directional force in the regeneration of what has come to be known as Dublin's 'cultural quarter'.

The Women Artists Action Group and the Northern Ireland Women Artists Action Group
WAAG held its inaugural meeting on 4 April 1987, in Clonmel, chaired by Jenny Haughton; it was addressed by Una Walker, Louise Walsh, Fionna Barber and the Canadian artist Rochelle Rubinstein. NIWAAG, its Northern Irish counterpart, was founded a year later with a seminar in Derry, addressed by May Stevens and Moira Roth (USA), Helen Chadwick (Britain) and Fionna Barber. During their short lives, WAAG and NIWAAG organized seminars and exhibitions aimed at changing perceptions of women artists, created an archive of women's work, developed fund-raising skills, and debated whether or not they would continue to accept male criteria for quality judgements. They held debates on pornography, on the representation of women, and on the impact of the Northern Irish 'Troubles' on activism and art (see 'The Troubles and Irish Art'). They also gathered statistics about the ratios of women to men as heads of departments in the colleges, as full-time or part-time teachers, students and artists represented in exhibitions and recipients of bursaries and awards.

To ensure that it was not isolated from the rest of the art world, WAAG became an affiliate of the International Association of Women Artists. In the catalogue for its first touring exhibition, *Art Beyond the Barriers*, for which it received the support of the Arts Council, one of WAAG's leading activists, Pauline Cummins, wrote, 'I am convinced that feminism is the most important development in art and art making since Cubism' (WAAG file, NIVAL).

WAAG's big opportunity came in 1991 when Dublin was European City of Culture; an exhibition of work by ten women artists relating to the River Liffey was planned, together with a symposium at IMMA, launched as part of the City of Culture programme. Despite emergency funding from the Arts Council, these activities broke WAAG financially. Nevertheless, the organization achieved a new level of awareness, caught media attention, forged lasting international links, and above all learned from its own members. The symposium at IMMA was opened by Mary Robinson, Ireland's first woman president, and was addressed by the New York-based Guerilla Girls. WAAG was disbanded in 1991 but its founders felt confident that they had brought about a shift in subject matter, expanded the locations for exhibiting, developed their own practices, and, above all, learned the importance of combining feminism and activism.

The nineteen nineties
By the 1990s women artists were well established as leaders in the field of new media (qv) and performance art (see 'Time-based Art'), as well as in more traditional forms of practice. The most well-known artists, such as Alice Maher, Dorothy Cross and Kathy Prendergast, could command the same critical coverage and exhibition opportunities as male colleagues, so that Dorothy Cross could address a conference in ArtHouse in Dublin, organized by Random Access (1996) on the subject of Irish Women Artists, and say that she wished to be described simply as an artist, without the additional but limiting adjectives 'Irish' and 'Woman'. Significantly, women also emerged as important curators during the 1990s, occupying such directorships as those of the HL, the National Sculpture Factory, ArtHouse, and all the senior curatorial positions at IMMA.

Other breakthroughs for women in the 1990s include the exhibitions that emerged from the relationship formed between the newly established IMMA, a group of activist artists, and women from the North Inner City and the Family Resource Centre, Inchicore, facilitated by Helen O'Donoghue and Ailbhe Murphy. The first of these, *Unspoken Truths*, launched by President Mary Robinson at IMMA in 1993, presented the stories of thirty-two working-class women across the city. *Once is Too Much*, spotlighting the issue of violence against women,

506. Women from the Family Resource Centre, Inchicore and Joe Lee, detail of *Open Season*, 1998, hospital bed and video projection on hospital screen, Irish Museum of Modern Art

created by artists and women from the Family Resource Centre, Inchicore, took place at IMMA in 1996, alongside solo exhibitions of Andy Warhol and Kiki Smith. It travelled countrywide over the next decade, and one of the artworks made for it was purchased for the IMMA collection, becoming the first collaborative artwork purchased by the museum [506].

Art education

If, in the past, men defined what constitutes art, it was also 'usually men who educated women artists, and who select[ed] or reject[ed] their work for exhibition' (Fowler in Ryan-Smolin et al, p. 71). That was the case in the past and current statistics suggest that the status quo has changed but little. Irish art education has always been male-dominated, in both the art colleges and the RHA. The universities broke the mould by appointing women as founding heads of the History of Art Departments in TCD and University College Dublin (UCD) in the 1960s. Anne Crookshank [507] established and ran the Art History department in TCD for twenty-one years, while at the same time co-writing the first full colour history of Irish Art. Françoise Henry, first Professor of History of Art in UCD, travelled the length and breath of Ireland to study high crosses and church portals with a ladder strapped to the roof of her tiny car. These women, however, are the exceptions that confirm the rule. While the great majority of students taking courses in art history, theory and practice in the universities and art colleges throughout the island are female, tenured positions in teaching continue to be occupied predominantly by men.

The Art Market

Despite acknowledgment of their importance to Irish art, the work of Mainie Jellett and Evie Hone is still valued well below the work of their male peers, Paul Henry, William Leech (qqv), Tuohy and Keating, and of younger contemporaries, le Brocquy and Scott. It is still very under-represented in the major Irish collections; despite the fact that the NGI has one hundred artworks by William Orpen, a similar number by Nathaniel Hone, and a vast collection by Jack B. Yeats (qv), there is only a handful of works by Jellett and Evie Hone. Despite its role in relation to modern art and their place within that narrative, IMMA owns only minor work by them, which have been donated from private collections rather than purchased. Endorsement by these establishments also serves to influence art market evaluations and is reflected in sales' prices. If originality is a measure of quality and importance, Jellett, Hone and Swanzy were the only real contenders before 1945, so comparative sales' figures for 1999 can be described as baffling. In that year, Paul Henry, a conservative landscapist, peaked at €210,000, while Jellett managed only a modest €40,000. William Leech, another traditional painter, fetched €265,000, while his more challenging contemporaries, Mary Swanzy, peaked at €62, 000, Nano Reid, at a mere €4,000, and Evie Hone and Norah McGuinness each settled between €10-20,000 (Marshall, 'King Midas was a Man', *Antiques Ireland*, May/June 2001, p. 40).

Until the late 1990s, Irish buyers have been noted for their timidity and conservatism. They need the reassurance of official sanction to buy. Yet, however generous Jellett and McGuinness were in their support for artists whose practices differed from their own, they never received the sanction of membership of the academy. Perhaps to compensate for this, Swanzy and McGuinness were elected to honorary membership of the RHA, albeit late in their careers, and Norah McGuinness was proud of her honorary doctorate from TCD. Official commissions were also regularly given on advice from heads of the art colleges and the RHA, all of whom have been, and continue to be, men. In terms of commissions and sales then, the Irish public had little encouragement to put its confidence in women artists. Postmodernism brought opportunities for a new relationship between the market and Irish artists, new questioning about what art is and where it is going. That, and their own activism in social and artistic life, means that a new generation of Irish women artists are better positioned to charge and receive good prices for their work. Official recognition plays an important part in this. IMMA chose to launch the new millennium in 2000 with an exhibition of the work of a woman, Kathy Prendergast, the winner, five years previously, of the main prize at the Venice Biennale. Similar accolades, nationally and internationally, mean that some Irish women in the twenty-first century can expect to be recognized and paid as much as male colleagues for their work, but they are still some distance away from equal representation in exhibitions, collections, and in the official bodies that validate practice. CATHERINE MARSHALL

SELECTED READING Walker, 1980; Ryan-Smolin, Mayes and Rogers, 1987; S.B. Kennedy, 1991; B. Fallon, 1994; Walker, 1997; Hartigan, 1998; K. Brown, 2008.

507. Anne Crookshank, founding head of the Department of History of Art, Trinity College Dublin, photo Brendan Dempsey, 1984

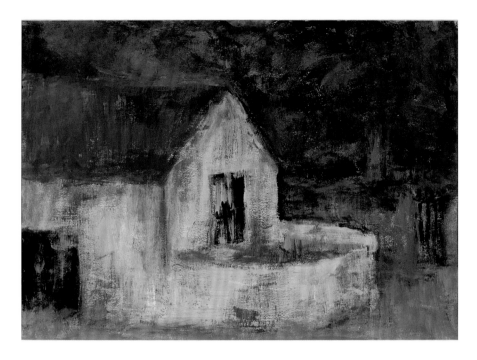

508. Nancy Wynne Jones, *The House by the River*, 1983, oil on paper, 29 x 41 cm, Arts Council/An Chomhairle Ealaíon

509. Anne Yeats, *Women and Washing, Sicily*, 1965–66, oil on canvas, 61 x 91.5 cm, National Gallery of Ireland

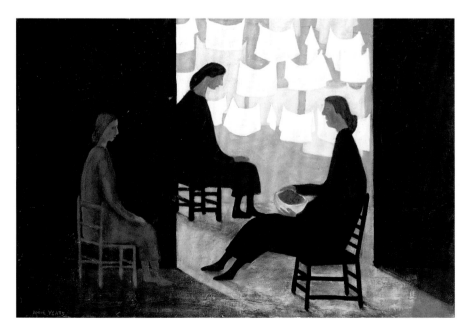

WYNNE-JONES, NANCY (1922–2006) [508], painter. Born at Dolgellau, north Wales, of landowning stock, Nancy (Esperance) Wynne-Jones originally studied music and had ambitions as a composer and violinist. The deaths of her two brothers, both older, on wartime service against Germany, lastingly affected her. She herself did wartime work for the Ordnance Survey and later ran a bookshop in London, but an early interest in art grew stronger and she studied for periods at the Heatherly School of Fine Art and at Chelsea Art College. Readings of Herbert Read and other Modernist critics encouraged her bent towards abstract art. On the recommendation of a friend, in 1957 she went to St Ives in Cornwall and became a pupil of Peter Lanyon, whom she grew to revere both as a teacher and a painter.

She formed friendships with other St Ives-based artists, including Roger Hilton, Patrick Heron and Tony O'Malley (qv), who recuperated from illness at her house, 'Trevaylor', and was included in important travelling exhibitions.

In 1966 Wynne-Jones married an Irishman Conor Fallon, later to win a reputation as a sculptor, and although he was sixteen years her junior, the marriage proved an exemplary one. In 1972 they moved to Ireland, living first in Kinsale and later near Rathdrum, Co. Wicklow. They exhibited together in group shows such as *Figurative Image*, which were held, more or less annually, usually at the Bank of Ireland headquarters in Baggot Street, Dublin, or Tulfarris House in County Wicklow, during the 1970s and '80s, and had regular solo exhibitions at the Taylor Galleries in Dublin.

Her later work was mainly figurative, with landscape themes predominating, though she also painted still lifes, portraits and figure subjects. However, she never quite abandoned her earlier loyalties and often employed the free brushwork and informal structures of Abstract Expressionism (see 'Expressionism'). This gave her work a strongly personal character; she was also very conscious of her Celtic blood and affinities. Visits to France and South Africa added to her landscape repertoire and in the last decade of her life she painted a good deal in County Mayo. A woman of exceptionally wide culture and interests, Nancy Wynne-Jones died at her Wicklow home in 2006 and is buried beside her husband, who survived her by less than a year. BRIAN FALLON

SELECTED READING Brian Fallon, *Nancy Wynne-Jones at Eighty* (Cork 2002); David Whittaker, 'Nancy Wynne-Jones, A generous painter bewitched by wild Celtic Landscapes', *Guardian* (29 November 2006).

YEATS, ANNE (1919–2001), painter, stage designer. Anne Butler Yeats was born in Dublin, the daughter of the poet W.B. Yeats and niece of the artist Jack B. Yeats (qv). She attended her aunt Elizabeth (Lolly) Yeats's drawing classes at age six, winning first prize in the RDS National Competition. Much of her childhood was spent abroad.

From 1932 to 1936 she studied at the RHA (qv) Schools, at the DMSA in 1937, at UCD, where she undertook the Purser Griffith Diploma in the History of European Painting and in the 1950s took classes with Nevill Johnson (qv). In 1935 she joined the Abbey Theatre as assistant to the stage set designer Tanya Moiseiwitsch and following a period training in Paris in 1938, she was appointed chief designer at the Abbey Theatre.

In 1941 Yeats became a full-time artist, influenced by the School of Paris, though continuing as a designer, book illustrator and teacher (see 'Book Art'). She developed a distinctive style and technique involving ink, watercolour and wax, exploring themes of marginalization, especially of women. In the late 1940s, when she turned to oil, her figure studies, particularly of women, showed the recurring theme of loneliness. The sombre tone of *Women and Washing, Sicily* [509], painted after a visit to the island in 1965, is achieved by contrasting the dark foreground figures with a bright, sunlit background, while the subject is portrayed with great sympathy.

Yeats held solo exhibitions with the SDP (1946, 1948), the Dawson Gallery, Dublin (1963, 1968), Belfast (1967), Sligo and Dublin in the 1960s, 1980s and 1990s, also participating in group shows in the USA, Canada, Germany, Monaco and Scotland. In 1949 the Haverty Trust acquired *Woman Watching*, followed in 1954 by *One Room*, which was presented to the UM in 1957.

Associated from inception with the IELA (qv), Anne Yeats exhibited annually with the organization, acting as its secretary from 1943 to 1973. A founder member of Graphic Studio Dublin (1960), her exploration in her paintings of a technique using cloth, string and fluid oil later entered her etchings, monotypes and lithographs (see 'Printmaking'), which remained figurative, despite the growing popularity of abstraction (qv), and which were represented in Graphic Studio Sponsor Portfolios (1963/64, 1966, 1968, 1970). She revived her aunt's Cuala Press during the 1970s, and in 1981 became a founding member of Aosdána (qv).

Yeats was commissioned by TCD to paint a tribute to her father for the Samuel Beckett Theatre in 1992. In 1995 a retrospective of her work was mounted at the RHA. Her death in 2001 was followed by a tribute exhibition at the NGI (2002).
MARIE BOURKE

SELECTED READING Hilary Pyle, *Yeats: Portrait of an Artistic Family* (Dublin 1997); Hilary Pyle, *The Horn of Plenty: A Tribute to Anne Yeats 1919–2001* (Dublin 2002); Valerie Alexander, *Anne Yeats (1919–2001): Out of shadows*, MPhil thesis (TRIARC, TCD, 2009); Lalor, 2011, pp. 41–48; National Gallery Yeats Archive.

YEATS, JACK B. (1871–1957) [510], painter, illustrator. Born in London, Jack Butler Yeats spent his childhood with his maternal grandparents in Sligo. In 1887 he rejoined his parents, the artist John Butler Yeats and his wife Susan Pollexfen, in London where he attended art school at Chiswick, South Kensington and Westminster. He quickly began a successful career as an illustrator (see 'Illustrations and Cartoons') of London magazines such as *Vegetarian*, 1888–92, and *Ariel*, 1891/92. From 1910 to 1948, Yeats contributed cartoons to *Punch* under the pseudonym W. Bird, which provided him with a regular income. The artist's individual style is not evident in these drawings, which are primarily commercial in nature, but they demonstrate an awareness of popular culture and current affairs, as well as a sense of humour.

In 1894 Yeats settled in Devon after his marriage to fellow art student Mary Cottenham White. He began making watercolours

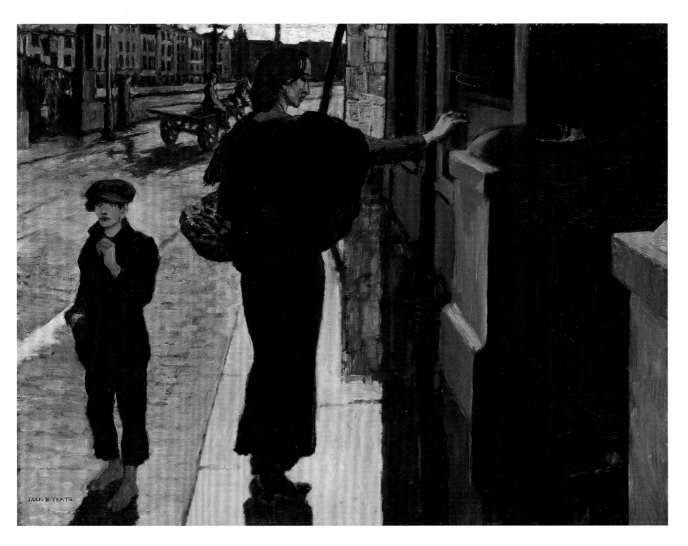

510. Jack B. Yeats, *Bachelor's Walk, In Memory*, 1915, oil on canvas, 45.7 x 61 cm, on long term loan from a private collection to National Gallery of Ireland

of English country life, in addition to his illustrations and cartoons. From 1899 Yeats painted and exhibited watercolours of the landscape (qv) and peasantry of Ireland in both London and Dublin. These reveal his understanding of Post-Impressionism and its impact on contemporary graphic art, in their use of strong colour and asymmetrical compositions, but above all by a primitive handling of form, which accentuates the exotic nature of Irish rural life. Yeats's novel depiction of the Irish peasant as stalwart, humorous and exuberant was based on scenes witnessed on his visits to the west of Ireland and recorded in his sketchbooks. This new representation was admired by figures in the Literary Revival and by Irish art critics and commentators. His understanding of the west of Ireland was deepened by his travels through Galway and Mayo with John M. Synge in 1905, whose articles on the Congested Districts Board for the *Manchester Guardian* and book, *The Aran Islands* (1907), were illustrated by Yeats. From 1908 to 1915, he worked with his sisters, Lolly and Lily, on the production of *A Broadside* [47], published by the Cuala Press, for which he supplied the illustrations and provided ballads and poems from his collections (see 'Book Art'). His interest in the theme of the West culminated in the 1912 book, *Life in the West of Ireland*, which reproduced forty black-and-white drawings and sixteen of his recent oil paintings (see 'Drawings').

In 1910 Yeats returned to Ireland permanently, settling initially at Greystones, Co. Wicklow, before moving to Dublin in 1917. At the same time he began painting in oils. His early oil paintings share the realism (qv) of his graphic work and concentrate on scenes of rural and urban life, as in *The Liffey Swim* [511]. His depiction of Irish life provided a positive image of Irish society and culture at a crucial period in the country's history. Memorable paintings of this time relate to the War of Independence and the Civil War, such as *Communicating with Prisoners* (1924, Model and Niland Collection, Sligo) (see

'Politics in Irish Art'). Yeats himself linked the role of the artist to the nationalist cause in 1922, when he wrote: 'When painting takes its rightful place it will be in a free nation, for though pictures speak all languages the roots of every art must be the country of the artist, and no man can have two countries.' (Yeats, p. 4) However, Yeats's 1929 comment that 'a painting is not a vehicle for anything except itself' is indicative of a more sceptical attitude to political art (*Daily Express*, 12 October 1929, quoted in S.B. Kennedy, 1991, p. 28).

Yeats's style changed radically in the later 1920s when he applied paint more loosely and showed a greater interest in the expressive qualities of colour, experimenting by juxtaposing complementary and contrasting hues. This coincided with a move away from realism, the reasons for which are unclear. He saw contemporary European Expressionist art in London and later corresponded with Oskar Kokoschka, whose work shares an emotional and subjective understanding of reality (G. Tallarico in Foley, pp. 103–08). But Yeats's development came out of the experimental and isolated nature of his own practice. Memory and the impact of dreams and the unconscious had a profound effect on his choice of imagery. Arguably the more unruly nature of his painting was also prompted by an increasing disillusionment with Irish life. Despite the seemingly avant-garde nature of the later work, its themes are closely linked to Yeats's early oeuvre. While the subject matter of the later paintings is more obscure, the work remains figurative.

As a young man, Yeats had written and produced plays for the miniature theatre from 1901 to 1903, and from 1930 to 1947 he wrote and published both novels and plays for an adult audience. This literary activity had a profound impact on his later paintings and is seen most obviously in the prevalence of theatrical settings and dramatic scenarios of such works as *This Grand Conversation Was Under the Rose* [512] or *About to Write a Letter* (1936, NGI collection). The literary titles encourage the viewer to see the paintings as poetic and often ambiguous, in contrast to the realism of the earlier work.

Yeats was a founding member of the SDP in 1920 but did not participate in its exhibitions after 1921. Like the majority of Irish artists, he did not confine his work to one exhibition forum, showing regularly at the RHA (qv) of which he became a member in 1915, and from 1943 he participated in the IELA (qv). In addition, he took part in various exhibitions in Britain and the USA throughout his career. In 1943 the art dealer Victor Waddington took on Yeats, holding seven one-man shows in his Dublin gallery between 1943 and 1955 and publishing Thomas MacGreevy's monograph *Jack B. Yeats: An Appreciation and an Interpretation* (Dublin 1945). This emphasized Yeats's representation of modern Ireland and showed a preference for his early realist style. Samuel Beckett challenged its narrow interpretation, arguing that the tracing of a national heritage was irrelevant to an understanding of the 'desperately immediate images' found in Yeats's paintings (Beckett in McHugh, pp. 75–76). The publication of MacGreevy's book coincided with the *Yeats National Loan Exhibition*, held at the DMSA in the summer of 1945. Attended by 20,000 people, the exhibition of 180

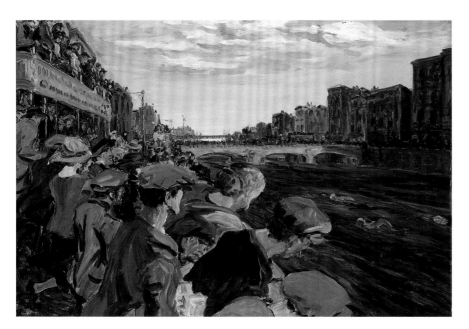

511. Jack B. Yeats, *The Liffey Swim*, 1923, oil on canvas, 61 x 91 cm, National Gallery of Ireland

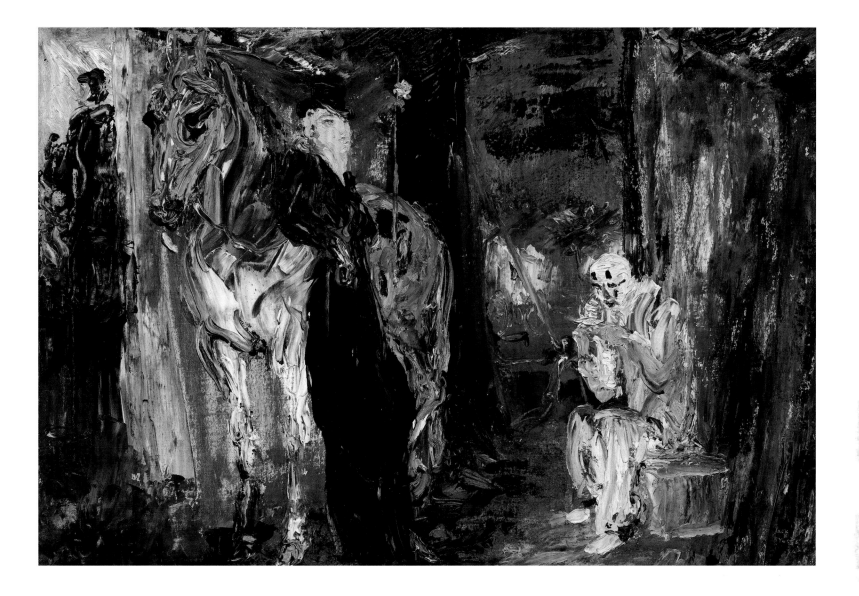

paintings spanned Yeats's entire career. Its popular and critical success established his reputation as Ireland's leading modern artist, whose work combined both national and universal themes. The catalogue essay, written by the former IRA activist and writer Ernie O'Malley, noted how closely Yeats's painting reflected the peculiarities of the Irish landscape, climate and vernacular culture. He praised the artist's unique handling of paint through which he was able to express his intense responses to these elements (O'Malley, 'The Paintings of Jack Yeats', in McHugh, p. 7). Yeats's reputation with the public had already accelerated as a result of a joint exhibition with William Nicholson, organized by Kenneth Clark, at the National Gallery, London, in January 1942, which received wide critical coverage in the English press. The sympathetic reception accorded to Yeats's later work further raised its standing at home.

Yeats was a prolific painter in the last two decades of his life when he increasingly reused earlier compositions and themes to create highly evocative works. In these the figures are often placed in landscapes or settings that suggest nostalgia, dislocation or euphoria. A central feature of these timeless and uncultivated vistas is the traveller or vagabond, a reincarnation of the circus performers, travelling players and itinerant ballad singers of his early watercolours and drawings. To the Irish bourgeoisie, they signified freedom, and their utopian connection to the land was in contrast to the negative realities of Irish cultural and economic life (Cusack, 1998, 201–18).

The figure of the traveller resonated with Republicans, who were now part of the political establishment and looked with nostalgia at the freedom and optimism of Yeats's figures (Brian O'Doherty, 'Jack B. Yeats: Promise and Regret', in McHugh, pp. 77–91). Ernie O'Malley felt that Yeats's preference for the outsider showed the artist's rejection of bourgeois respectability in favour of those on the margins of society. Hilary Pyle argues that the emotional content of these late works indicates Yeats's detachment from politics into more subjective concerns. His own mortality and the loss of his wife and siblings had a profound impact on his choice and treatment of subject-matter in the final years of his life.

512. Jack B. Yeats, *This Grand Conversation was under the Rose*, 1943, oil on canvas, 36 x 53 cm, National Gallery of Ireland

The handling of form and colour in these late works adds a significant dimension to their content. Through the use of thick impasto or barely covered canvas, Yeats draws attention to the physical creation of the painting. While his pictures are always representational, parts of the paintings are deliberately ambiguous and difficult to decipher, a Yeatsian strategy to draw the viewer into an engagement with the work and to recognize its artifice. It inhibits, or at least makes problematic, the otherwise sentimental nature of the subject matter.

Yeats died in Dublin on 28 March 1957, Ireland's most widely acclaimed visual artist of the twentieth century. His romantic images of Irish life and landscape have encouraged many to see him as the archetypal national painter. The English critic John Berger, who visited the artist just before his death, placed his work against the political and geographical peculiarities of Ireland (Berger, *Selected Essays and Articles – The Look of Things,* London 1972, pp. 57–60). However, the ambiguous and poetic juxtaposition of subject and form in his works suggest that their meaning extends beyond national boundaries. They can be understood as explorations of universal themes of memory, experience and creativity.

His work is included in the collections of the NGI, the Model and Niland Collection, Sligo, IMMA and Tate. Many of his personal papers and sketchbooks are held in the Yeats Archive, NGI.
Róisín Kennedy

SELECTED READING Yeats, 1922; Roger McHugh (ed.), *Jack B. Yeats: A Centenary Gathering* (Dublin 1971); John W. Purser, *The Literary Works of Jack B. Yeats* (Savage, Maryland 1991); Hilary Pyle, *Jack B. Yeats: A catalogue raisonné of his oil paintings* (London 1992); Bruce Arnold, *Jack B. Yeats* (New Haven and London 1998); Cusack, 1998; Yvonne Scott (ed.), *Jack B. Yeats: Old and New Departures* (Dublin 2008); Declan J. Foley (ed.), *The Only Art of Jack B. Yeats* (Dublin 2009).

CONTEMPORARY ART (IRL) (2000–10). IRL, the initialized form of 'in real life', is used by players of computer games to refer to events, activities and interests that exist outside the game, in real life. Players of the multiplayer online role-playing game 'World of Warcraft' might use this terminology. The risk of addiction to the WoW game is legion, with players satirized for their ambiguous grip on the competing realities of their online and offline worlds, fuelling a mythology so compelling, so contemporary, that in addition to its millions of enthusiasts, WoW quickly captured the imaginations of people who were not, nor ever intended to be, players of the game. Reports of another aspect of the wider gaming scene, nicknamed 'gold farming', also began to make the news. Gold Farmers earn their living by playing (working) to win items that have transferable symbolic value within the online world of the game, making them of value to games' subscribers in the real world, to sell at a profit, for real, as opposed to the games' symbolic money, to players who do not want to use their subscription and leisure time to get these things themselves. The allegorical value of the story of the 'Gold Farmer' would not have been lost on anyone making, or describing, art in Ireland since 2000; whether artist, educator, curator, editor, writer, researcher, facilitator, dealer, collector, director, gallery-owner, publisher, historian, administrator or policy-maker. Gaining in momentum in the mid-2000s, critiques of culture under 'neo-liberalism' and social 'precarity' were frequently the subject of public discussions, and workshops organized in relation to exhibitions, commissions, projects and academic research actively seeking to lead in the exploration of ideas.

As the Irish economy advanced weekly into a generalized 'crisis' from 2008 onwards, the whereabouts of culture and its use to us – the value of the arts – came under review from several angles. An example of actions taken to establish facts about the economic and social reality of artists' lives is provided by the report *The Living and Working Conditions of Artists* (2010) commissioned by the Arts Council of Northern Ireland (ACNI) and the Arts Council/An Chomhairle Ealaíon (AC/ACE) (qv). Statistics revealed Irish artists' average annual earnings to be around €14,000, less than half that earned on average across the service industries and less again than those in manufacturing. The year before, Visual Artists Ireland's *Survey of the Social, Economic and Fiscal Status of the Visual Artist in Ireland* published even more modest average income figures for visual artists, around €10,000. In the interim, a number of broad brushstroke recommendations, unsupported by evidence, were published by a group of economists at the behest of government in the so-called 'McCarthy Report', formally the *Report of the Special Group on Public Service Numbers and Expenditure Programmes* (2009). It outlined options to reduce in number and independence the national cultural institutions (see 'National Institutions of Visual Culture'), all with historical archives, most collections-based, museums, galleries, libraries and archives. Of greatest relevance to the visual arts were suggested changes to the legal and operational independence of the Irish Museum of Modern Art (IMMA), the National Gallery of Ireland and the Crawford Art Gallery, including a possible amalgamation of the three institutions. A proposed reduction in the independence of the international funding body, Culture Ireland, was also considered to be a retrograde step in the promotion of visual arts, regarded as long-internationalized. However, one event that gradually entered into the visual arts consciousness in 2006, eventually receiving the oxygen that would provoke it into life, encapsulated the feel of the preceding decade's art with all its competing ideas and values. That event, *Dublin Contemporary 2011*, will serve to conclude this survey, because it simultaneously represents and marks the transition from the struggle for hegemony that characterized the 2000s into the second decade of the century, a decade heralded by another branding exercise intended to put the state's political class at the centre of cultural programming to an unprecedented degree in modern times.

The question was whether or not advances in the visual arts in the preceding decade, which showed a robust and discriminating grasp of cultural politics and a confidence in the public position of the visual arts, could counter the tendency of officialdom towards cultural conservatism. Would the radicalizing ideas and actions taken in the first decade of the new century to increase public access to knowledge through art, the power to circulate and celebrate art in state collections, and the opportunities through local government arts schemes and grants offer protection against a half-life culture? The Decade of Commemorations, launched in 2012 to conclude in 2022 – the one-hundredth anniversary year of the foundation of the Irish Free State – was described as a series of events organized by the Minister for Arts, Heritage and the Gaeltacht, James Deenihan. The implied curatorial role for the minister might have been passed over except for public debate between government and representative organizations in the arts, which had

been unfolding since 2009. This came down to a stand-off on the matter of interference in direction and curatorial programming by government ministers or their Departments and became a particular issue in relation to Ireland's national cultural institutions. The validity of questioning the executive functions and board structures in these cases was ultimately resuscitated and re-legitimated by arguments made in relation to reforms aimed at lightening the payroll bill in the public sector, reducing the number of independent non-governmental organizations, and introducing changes in the authority of local government and their obligations to the state.

By the end of the 2000s, individuals and representative organizations in the arts and cultural sector were looking for a public language that would persuasively explain, on the one hand, the positive revenue benefits of the arts to the national economy and, on the other, the straitened 'pay cheque to pay cheque' reality that characterized the experiences of the majority of people working in the arts full-time or subsidizing their income with part-time work. Unsurprisingly, this was one of the issues that energized the revitalization of a grouping of bodies and individuals in the visual arts, the Visual Arts Workers Forum, in 2010. It began to offer a framework whereby the usually more vocal 'grassroots' could be joined by voices in public positions of authority, people appointed to lead organizations and to formulate ideas about the place of art in the culture. Similar initiatives had been short-lived in the past. Speaking on a panel about the 'Challenges and opportunities for cultural policy in times of economic crisis: Irish perspectives', organized by the Goethe Institute in Ireland in 2011, Eugene Downes, then the Chief Executive Officer of Culture Ireland, spoke about the lack of public intellectuals in Ireland as an obstacle to the development of a public discourse about culture to match that experienced in France, for example. A year later, among the questions asked in the anthology *Reflections on Crisis: The Role of the Public Intellectual*, edited by Mary P. Corcoran and Kevin Lalor and published by the Royal Irish Academy, was whether Irish society was anti-intellectual. Here were two different perspectives on the same problem, both in some way contributing to a crisis and a collapse in confidence in critical visual arts publishing from the mid-2000s. Much of the thinking publicly expressed about art, exhibition-making and criticism in the 2000s was derided. The internalization of this can be seen in the response to the decision of a core supporter, the Arts Council, not to fund *Circa* magazine in 2011. With *Circa*'s closure imminent after over twenty years of publishing – or so it seemed at the time – activity on its website focused on the problems with art writing. Anecdotally, to put this in context, the expression of dissent and critique among peers and insiders in the visual arts was recognized to have been artificially limited in the 2000s to allow for the consolidation of a seemingly coherent and confident scene in Irish art. As humane and genuine as many of the feelings generated in this atmosphere were, the price paid for consensus can be seen in the manner in which criticism of *Dublin Contemporary 2011* was handled.

Arguing for the intrinsic value of the arts, controversial at the best of times, was seen as being especially risky as the public conversation from 2008 onwards became unrelentingly preoccupied with economic matters. Economic austerity as a general policy driving all other social, educational, health and cultural policies before it, was simply abbreviated in the media to the single word 'austerity', separated from its real meaning in this actual context. In Ireland, as in other countries, there was plenty of evidence, that just as mainstream news reported on the doctrine of economic 'austerity', mainstream cultural activity returned it, more simply, in the form of middlebrow nostalgia. Under the copy line 'Remember Imagine', the national broadcaster Raidió Teilifís Éireann (RTÉ) celebrated fifty years of television, beginning in 1961, by rebroadcasting programmes from their archives or drawing on them, with hardly any critical assessment or analysis that was not framed by nostalgia. The pervasiveness of motifs of nation and the national in visual art through the contextual work done by critics and programmers in the 1980s is not exaggerated; likewise, the ghettoes of gender politics, common in criticism at that time, were apparently a distant memory twenty years later. The underlying impact of emigration and the realities of the Irish diaspora (qv) on Irish politics and the 'Irish imagination' were examined in the work of a number of artists, curators and critics in Ireland and from outside through the 1980s and 1990s. In stark contrast, at the Global Irish Economic Summit, organized by the Irish government in 2009, the conjuring of the word 'diaspora' transforms it into a trope for money, profile, influence and status, not the lack of these.

Writing about Anne Tallentire's (qv) *Inscribe 1*, made for the Living Art Diaspora projects in Dublin in 1994, Brian Hand described the location of the work in the new technology showroom for the telecommunications company Telecom Éireann's corporate customers (Brian Hand, 'Unseen Unsaid', in *Instances: 48th Venice Biennale*, CRC, Dublin 1999, pp. 19–28). Tallentire was able to perform live in London and broadcast simultaneously in Dublin on a video monitor using the (then) new technology of an Integrated Services Digital Network (ISDN) line. *Inscribe 1* included images of an area of London wrecked some years previously by an IRA bomb, the performative nature of the work permitting a representation of dislocation and disappearance which is the diasporic experience of many to different extremes. In his essay for Tallentire's retrospective in IMMA in 2010, Charles Esche begins by asking when will we discover some poetry in the GPS navigating system? (Esche et al, *Anne Tallentire: This, and Other Things 1999–2010*, exh. cat., Dublin 2010, p. 179). He describes Tallentire's work *Nowhere Else* (2010) as a response to its historical-technological development, by applying an absurd principle to direct movement, as it navigates London and Dublin. The same year as *Inscribe 1* was shown in Dublin, the state-owned Telecom Éireann (later Eircom) was privatized and the public were encouraged to buy shares in the company – ordinary public investors lost about a third of their investment as the stock tumbled and allegations emerged of risk-free gains being made by political and company insiders on the back of the public floatation.

An online brochure published by the multinational accountancy firm PricewaterhouseCoopers, entitled *Why Ireland?*, was devised to help potential inward investors evaluate the attractiveness of Ireland as a place to locate their business. The

brochure characterizes the Irish workforce as young, English-speaking and with a high level of education. Among a number of selected statistics, one states that of the top five gaming companies in the world, three have Irish offices. As a further plus, the point is also made that Ireland has a favourable Intellectual Property regime. An endorsement states that 75 per cent of Google's staff in Ireland have come from overseas to work at Google's European headquarters in Dublin. The penultimate page of the brochure contains information on senior advisers, while the final page offers 'a closer look' at Ireland, through the 'government system', 'infrastructure', 'airports and sea ports', 'education' and 'culture'. The cultural category includes examples of outstanding sportsmen in golf and rugby and celebrated individuals in film, music and literature, while a singled-out statistic declares that 33 per cent of the Irish population is aged under twenty-five. Among the cultural achievers, one woman, actor Saoirse Ronan, fits this statistic. Otherwise, among about a dozen men identified by name, all but one is middle-aged or older, others deceased. The brochure may be ephemeral, but it remains a snapshot of the kind of cultural signifiers perceived to have currency among foreign corporates.

Interviewed in May, 2001 about his experiences as the first politician to have a cabinet position with responsibility for arts and culture in Dáil Éireann (1993–97), Michael D. Higgins, a published poet, expressed his strong opposition to enterprise culture, criticizing 'neo-liberal savagery' for having no cultural theory (Alexandra Dilys-Slaby, 'Interview with Michael D. Higgins, Minister of Arts, Culture and the Gaeltacht between 1993 and 1997', Revue LISA/LISA e-journal, II, no. 4, 2004). To put culture at the centre of things, Higgins said, meant challenging the hegemony of the economic in matters that are 'properly cultural'. Ten years after the interview, Higgins successfully campaigned for the presidency of Ireland and was elected in October 2011, beating six other contenders including the nearest candidate, a professional entrepreneur and television personality.

Higgins's interest in the downside of neo-liberalism and the place of art in the wider culture resonates with a critique developed over the decade by the artist Gregory Sholette, primarily in relation to a similar aesthetic philosophy in America. Sholette was twice invited to Galway, the centre of Higgins's political constituency. On his first visit, in 2003, to the Galway Arts Centre as part of an AC/ACE-sponsored programme of talks and events to stimulate and internationalize critical dialogue and exchange with the arts in Ireland, he became involved in dialogue about the state of the visual arts in the city, ultimately preparing a set of discussion points that were presented to the local authority and arts communities for use in future policy development. In 2011 Sholette returned, this time at the invitation of the artist group G126, for the Tulca Festival of Visual Art, After the Fall, curated by Megs Morley. Over a period of months, which included the festival, Sholette worked with the group and undertook workshops with the general festival audience. The collaborative projects undertaken with G126 became the second part of his Imaginary Archive project, the first part having been completed the previous year with a group in New Zealand. Alluding to the contemporary Slovenian philosopher Slavoj Žižek's analyses of the decade's financial collapse, Sholette has posed the question

of what narrative will come out on top when, as Žižek puts it, the normal run of things is interrupted and the field opens up to 'discursive' ideological competition (Sholette). A repeat visitor himself, Žižek is no stranger to Ireland: he spoke in 2005, at the Clinton Institute for American Studies, University College Dublin, about 'Intellectuals and the Nation-State'.

In 2007 Blizzard Entertainment, the California-based company behind World of Warcraft, chose to open its European Customer Support Centre in a suburb of Cork. The number of people employed at the centre grew quickly. Reaching a capacity to supply WoW customer support services in over two-dozen languages, only five years later the company's language department, rather than those involved in game development, would be targeted for staff reductions as part of a global round of redundancies across the workforce. Writing in her Factory Journal in 1934, with war in Europe on the horizon and on everyone's lips, the philosopher Simone Weil described how the language of war, when normalized in a time of fear, entered into the everyday conversations of the workers, to the exclusion of everything else, occupying their private lives. One of the things she discovered, having placed herself as an unskilled factory worker so as to better understand the effect of the industrial production line on those who worked there, was how ideology colonized all aspects of the workers' lives and their complicity in making this happen through their conversations. According to Weil's observations in the pre-war factory, the abstraction of the arguments removed the workers from their real situation. She felt that the daily misuses of power by the factory's line managers and the dehumanization of 'the line' itself went unchallenged because the factory workers became embroiled in a competition for power and authority regardless of the fact they knew that the best they could expect was survival. Kennedy Browne's project How Capital Moves (2011) and Mark Curran's Breathing Factory (2006) and EDEN/Ausschnitte aus EDEN deal with the twenty-first century factory site and the effects on people of industrial decline.

In 2003 the National Sculpture Factory, under the directorship of Tara Byrne, invited curators Annie Fletcher and Charles Esche to devise a programme for Cork in 2005, when the city would be European City of Culture. Working as independents at the time, they were asked to curate a long-term project consisting of 'a variety of activities, including workshops, talks, new artistic productions and, finally, a large three-week meeting – the "caucus" proper' (Fletcher, 2006). These aims included the reconsideration of Cork as a location for contemporary art and the creation of new networks, audiences and partnerships with a lasting legacy. Cork City of Culture 2005 formally funded the project. A book, Cork Caucus: On Art, Possibility & Democracy, edited by Trevor Joyce and Shep Steiner, collated documentary material from photographs and audio recordings, with reflections written after the event by some of the participants. Overseas contributors who were especially interested in how the history of ideas takes shape in different cultures included Catherine David, Gerald Raunig, WHW and Chantal Mouffe. Extensions of the curatorial trajectory apparent in the Cork Caucus programme can be seen in Annie Fletcher's earlier project with artist and architect Apolonija Šušteršič for Visualize

Carlow in 2002, and her later programme for the 2012 EV+A International Biennial of Visual Art in Limerick, the first major reconfiguration of EV+A since it began in 1977. During the 2000s EV+A curators included Katerina Gregos, Dan Cameron and Salah M. Hassan.

The diaristic form and 'the interview' are familiar for their effectiveness in bringing the immediacy of captured speech, the manner of someone's way of thinking, to the reader. Transcribed, the interview imbues edited documentation with a sense of contemporaneousness, no matter how much time may have passed since the interview took place. The interview format has been used by Vera Ryan in *Movers and Shapers*, a trilogy of books of interviews with politicians, gallerists, collectors, policy-makers, artists, art historians and critics. She assembles a history of art in Ireland from 1940 to 2010, largely based on the memories of the interviewees, with explicit reference to biographical information that plays a part in the reports and stories in the books. Constructing dialogues on the times, the interview format was also used by the artist Sarah Pierce in her series *Metropolitan Complex Papers*, self-published between 2003 and 2008, featuring interviews with artists, critics, academics, curators and a gallerist. An example of an exhibition catalogue early in the decade using the interview format was *0044* (Cork, 1999). The meaning of the UK telephone prefix used in the title indicates the emigrant status of the artists in the exhibition, from Ireland, living in Britain, with some meta-commentary on the anxieties of some of them concerning the framing device used to give the selection coherence. Other variations on the interview appear in the art of the decade. Gerard Byrne's (qv) commission for the 52nd Venice Biennale of Art in 2007 was based on interviews

with minor celebrities in Andy Warhol's magazine *Interview*. A single-channel video projection, **ZAN-T185 r.1: (Interview) v.1, no. 4 – v.2, no. 6, 19 (1969 – Feb. 1972); (Andy Warhol's (Interview) v.2, no. 21 – v.3, no. 9)*, brings the printed word into speech and body language, using the representational codes of the moving image to muddle the viewer's sense of time past and time present. Cecily Brennan's (qv) *Black Tears* [513], a single-channel video projection from 2011, is an interview of sorts where no words are spoken; the look of the actor's face, grieving, lips moving but not speaking, elicits a look back from viewers, face to face, interrogating themselves.

Writing in *Circa*, the artist Noel Sheridan (qv) published a fictive account of a dossier allegedly bundled into his arms by a passing man on a bike as he walked to work at the National College of Art and Design (NCAD), where he was the director (Sheridan, 'The Secret Underground: The Missing Story of Irish Art', *Circa*, no. 93, 2000). Sheridan's conjured dossier, composed mainly of fading papers and audio recordings, appeared to detail forgotten movements and unknown artists on the periphery of the avant-garde and literary mainstream, dominated by one group's self-recordings: meetings, news, ideas and splits. We are told that the man on the bike assured the director that 'he'll know what to do with it'. A few years before Sheridan published this article, NCAD entered into a partnership with the Arts Council to create a National Irish Visual Arts Library (NIVAL). For NIVAL's part, the accession of personal and organizational archives through donors in the period from 2000 to 2010 included those of Artsource/Jobst Graves, the Friends of the National Collections, the Sculptors' Society of Ireland, the Irish Exhibition of Living Art/Anne

Yeats, the Dorothy Walker Collection, Temple Bar Gallery and Studios (TBG+S), Graphic Studio Dublin and the Kevin Kavanagh Gallery. NIVAL's enlightened and unique position has enabled it to collect complete archival projects, such as the Artist-led Archive (2006–08) [514]. When a narrative goes beyond biographical time, others, maybe strangers, come along, investigations are picked up, set down, and so it goes, for as long as someone is interested. It is no coincidence that several artist-led 'archival' projects emerged in the 2000s as artists sought to assemble histories that prefigured their interests, in order to consolidate a critical presence, an adequate representation of collaborative art projects and events.

Sheridan's story of 'The Secret Underground' continues at the artist's home rather than the director's office: same man, different place. From his house, overlooking the local authority housing in Dublin's O'Devaney Gardens, he sorted through the documents and concluded that he had in his possession nothing less than the history of radical art in Ireland from the turn of the twentieth century to recent times. Eight years later, after Noel Sheridan's death in 2006, the residents of O'Devaney Gardens were to be denied a long-awaited re-generation of their area when the developer involved walked away from their public/private partnership with the city council on foot of the property crash in 2008. The developer had incurred enormous losses as a site bought in Dublin's Ringsend area, known as the Irish Glass Bottle site, collapsed in value. Poignantly, Sheridan's fictional story reproduces an account from a fantastical dossier of radical art about the most active group's discovery of an ideal space to show their work – a bottle factory in Ringsend. Telling their story, Sheridan explains their account of starting work on their new space by replacing the men's urinals. Taking a break, the group sit in the debris of the factory; they argue for hours about what to do, eat ice cream, think art, and ponder what they phrase as the 'curatorial freezer' question until it numbs their minds. In real life, the decade saw unprecedented growth in curatorial knowledge and technical expertise because of improvements in built infrastructure, new networks of directors and curators and opportunities for progression and mobility across publicly supported arts programming in galleries, arts centres and local authorities, as well as ambitious independently curated projects outside the formal cultural infrastructure, across rural Ireland and in non-traditional communities. Significant contributions to this history were made by independents like Clíodhna Shaffrey, Sarah Searson, Lee Welch with FOUR, and Vaari Claffey with Gracelands.

The decade was also conspicuous for the amount of discursive opportunities open to artists, art students, curators of contemporary art and visual art audiences. These were facilitated by galleries, studios, festivals and public access postgraduate seminar programmes. *Fireside Conversations* (Fire Station Artists' Studios, 2009) records just one such programme, but it is indicative of the extent to which a deepening engagement with ideas and the place of art in society became the norm in and around formal cultural organizations having some form of local or state support. Significantly, artists contributed to the

514. Megs Morley, Artist-led Archive, Galway Arts Centre, 2007

critical discourse over the decade through criticism or other writing; the latter often incorporated into exhibitions and distributed from there. Some began with *Circa*: for example, artists Isabel Nolan, Sarah Browne, Michaële Cutaya, Michelle Browne, Susan MacWilliam (qv), Eoghan McTigue and Barbara Knezevic, and such writers as Joanne Laws, Chris Fite-Wassilak, James Merrigan, Sean O'Sullivan and Rebecca O'Dwyer. Print, online or print-on-demand publications, such as *Fugitive Papers*, *+Billion-*, *Paper Visual Art*, *Occupy Paper* and *Enclave Review* and their editors began to reshape the publishing landscape. In Belfast, in addition to *Source* magazine, which specialized in photography, the free monthly *The Vacuum* continued its mission to provide a unique perspective on all matters of artistic and cultural interest. The decade also stands out for the contribution made by artists and galleries to publishing, from once-offs and self-published series, such as the *Fold* and *Feint*, and to editions accompanying gallery programmes. Significant contributions to the history of the moving image in art and cinematic traditions were made by Maeve Connolly (2009) and discourse on the function of art and education in the research environment by Mick Wilson and Paul O'Neill (2010). The *Visual Artists Newsletter* (VAN), published by the advocacy and membership organization Visual Artists

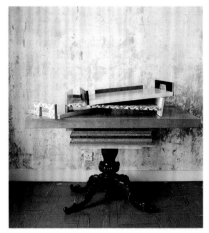

Ireland, expanded over the decade under the editorial direction of Jason Oakley.

While the reference website publicart.ie also remained on ice at this time, the participatory arts website practice.ie and the blog artsmanagement.ie continued to provide resource information and to accumulate digital archives. In 2002 serious concerns arose over the retention, ownership and access to such archive content when the multi-media centre for the arts, Arthouse, closed following a funding cut from the Arts Council. An extensive database of artists' information, as well as artworks, was made inaccessible as assets were sold and the company closed. When the Project Arts Centre decided to donate its written archives (1967–2003) in 2009, it did so to the National Library of Ireland, arguing that since it is a mixed archive across many art forms, this made more sense than separating the visual arts papers for donation to NIVAL.

Beginning in 2002, the Arts Council, under its director Patricia Quinn, initiated a flagship project, the Critical Voices programmes. This aimed to bring cultural practitioners and commentators to Ireland to think and talk about the critical and cultural links with intellectual and aesthetic traditions worldwide. A planned publication covering all three programmes of the project did not materialize, but the content and context for the programmes continue to have currency. The second Critical Voices programme ran in 2003, a year of cuts in arts funding, including a twenty per cent cut in the budget allocated to the Council. However, the Department's statistics show that subsequent funding to the Council increased by 71 per cent in 2008, from €47.67m to €81.62m. Also that year, the imprimatur of the individual artist in the making of policy was conspicuously endorsed by government with the appointment to the Council of more practising artists, from all art forms, than ever before, including Willie Doherty and Jaki Irvine (qqv). The 2003 Arts Act repealed Acts from 1951 and 1973, transferring direct responsibility for arts policy to the Department for Arts, Sport and Tourism, the new designation of the Department of Arts from 2002.

At a Critical Voices event in 2003, the cultural gravity of Boston, Berlin, London and New York for Ireland was debated. This was to resurface eight years later, at a discussion held at the Project Arts Centre during the Ulster Bank Dublin Theatre Festival. In the late 2000s, Berlin became home, or temporary second home, to several artists from Ireland, such as Fergus Feehily, Mark Curran, Seán Lynch, Michele Horrigan, Nina Canell, Robin Watkins, Declan Clarke, Eoghan McTigue, Ciarán Walsh, Cecily Brennan and Dennis McNulty. Aoibheann McNamara's Ard Bia Arts Space in Galway ran in Berlin as a residency programme, devised and run by the independent curator Rosie Lynch, from 2007 to 2009. Ciarán Walsh administrated later projects. The 'Apartment Viewings' created a way for artists to share documentation and ideas with Berliners and interested others passing through but not otherwise involved in the residency. Artists taking part in that important residency included Alice Maher (qv), Cecily Brennan, Seamus Nolan [515], Linda Quinlan, Niall De Buitlear, Sinéad Ní Mhaonaigh and Sonia Shiel. When in 2011, the second Global Irish Economic Forum was held in Dublin (under a new government), in Berlin the Berliner Künstlerprogramm displayed a banner by artist Martha Rosler and cartoonist Josh Neufeld, emblazoned with instructions to 'Pull Up Those PIIGS ... Blame it on the lazy Greeks ... and the Irish, and the Portuguese, and the Spanish and the Italians ...'. The image depicted the German chancellor and French president failing to get a puppet pig on its feet – sectioned into butcher's cuts labelled after each country.

Until the international financial crisis required greater diplomacy in Europe, the tone of inquiry implied in 'Boston or Berlin?' was often a sham, as the answer was usually anticipated to indicate distance from Berlin and traditional closeness to 'Boston'. In the 2000s artists and politicians appeared to be facing in opposite directions, with artists looking east, across the Irish Sea, past Britain to the Continent, and politicians looking west, across the Atlantic, towards 'Boston' and Irish-America. In a *Circa* article printed on the cusp of the new millennium, Caoimhín Mac Giolla Léith reported on a damning review in the *New York Times* of one of several survey exhibitions of Irish art on tour in the USA that year (Mac Giolla Léith, 'Playing the Green Card', *Circa*, no. 90, 1999). Putting the unfavourable review in context, he noted that survey exhibitions of art from an unfamiliar milieu are taken to be more comprehensive than they are; he concludes that the only option must be to abandon the model. When, in 2011, the promotional cultural programme *Imagine Ireland* was designed for the USA (involving art, theatre, music, opera, literature and film), Eugene Downes, Culture Ireland, pointed out that the aim of *Imagine Ireland* was to reach beyond the traditional Irish-American audience and the visual arts programme was conspicuously free of the large survey or overview exhibitions that had been so problematical before: in *Circa*, no. 91 (2000), Brian Hand referred to anecdotal evidence that Irish-America possessed low cultural capital or symbolic value in the art world in the United States.

Until 2002, the commissioning of the national participation at the two international biennial exhibitions of art in which Ireland took part – the Venice Biennale of Art and the São Paolo Biennial – was organized by a Cultural Relations Committee (CRC) operating under the aegis of the Department of Foreign Affairs. Responsibility for the biennials was moved to the Department of Arts, Sport and Tourism. In 2005 the work of the CRC was taken over by Culture Ireland, as set out in the Arts Act of 2003. Historically, the Arts Council also supported Ireland's participation in these biennials. In 2006 the São Paolo Biennial Foundation did away with national participations. Since the CRC and the AC/ACE did not formally review the value of past participation, no position or statement made on the decision of the São Paolo Biennial was recorded and so an account of the history of Irish participation is not easily available. A website including some history of participation in the Venice Biennale went online in 2011. From the outset, it was clear that the geographic priorities for Culture Ireland were very much aligned to those of government in the development of global trade and diplomacy. These priorities, by necessity, changed after the rapid shrinking of markets and services triggered by banking collapses in the USA and Europe. Subsequent anxieties surrounding the political future of the euro currency, future governance, and proposed revisions to the terms of participation in the European Union saw a parallel shift of geographical focus for Culture Ireland. After programmes of work in the United States in the years on either side of the decade, and one in China featuring thematic survey shows of Irish art, verbal indications from the Arts Minister in 2011 indicated that cultural projects in the decade ahead would prioritize Germany and also the economic collection of countries known as BRIC (Brazil, Russia, India, China). At the second Global Irish Economic Forum (Dublin Castle, 2011), novelist Colm Tóibín, a member of the Arts Council, testified to the reputational hazard he personally experienced while touring Germany after the intervention of the International Monetary Fund in Ireland's financial affairs.

Some of the most imposing buildings of the early 2000s were built using the EU Arts and Culture Capital Enhancement Support Scheme (ACCESS), allocated in 2001, 2004 and from 2007 to 2009. These schemes also enabled significant improvements to collection storage and exhibition rooms, as well as research and social areas within existing buildings, often involving new extensions to historic buildings. The Museum Standards Programme Ireland, run by the Heritage Council, began to provide for accreditation by standardizing and professionalizing collection management and conservation practices. The scheme involved national cultural institutions, such as IMMA, as well as others such as the Butler Gallery in Kilkenny and The Model in Sligo. ACCESS-funded projects included well-specified art galleries and multi-artform buildings. The quality of design at Visual [516], the centre for contemporary art in Carlow (2009), Solstice Arts Centre in Navan (2006), The Model in Sligo (2010), and the refurbishment of the Royal Hibernian Academy (2008) (qv) in Dublin bore no comparison to earlier art centres, where gallery spaces were notoriously compromised by having conflicting functions. In the *National Development Plan 2000–2006*, the need for more housing to cope with future demand was

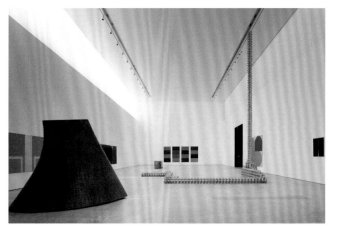

516. *The Weight of Light*, inaugural exhibition at Visual, Carlow, 2009, with work by Eilis O'Connell, Maud Cotter, Michael Warren, Sean Scully and Richard Gorman in the foreground

identified as an urgent, government priority. By the end of the decade, many artists were concerned with other architectural issues, representing the effects of the misjudged acceleration in house-building that had led to the property crash, often badly constructed and in inappropriate places. So-called 'ghost estates' received special attention during the TRADE (a collaborative visual arts programme between Roscommon and Leitrim County Councils) event in 2009, for example. They were also the subject of Anthony Haughey's 'Settlement' [517] series from 2010, which toured the USA in 2012, carrying with it insights gathered in public and private discussions and collaborations among a growing number of fellow travellers in architecture, Irish studies and journalism.

517. Anthony Haughey, *Settlement XI*, 2011, lambda digital C-type print, 50 x 40 cm

Actions by artists and curators to transform expectations about cultural space in smaller scale local situations was symbolically and tactically built upon throughout the decade by artists and curators who chose to work away from the larger population centres and formal art centres and galleries. This is something of an untold story insofar as the state's economic failure pushed other voices and stories out of the official and popular picture. There are many excellent examples. The curatorial project *X-PO* (2007–08), by artist Deirdre O'Mahony, combined her doctoral research with a project designed to continue on the initiative of locally based community organizations in the vicinity of the old post office in Kilnaboy, Co. Clare [408]. Commonage [518], based in Callan, Co. Kilkenny, was co-founded in 2010 by artists Jo Anne Butler, Tara Kennedy and curator Rosie Lynch as a curatorial research and design studio on invitation by the Abhainn Rí Festival and Callan Community Network, becoming an independent company in 2012. N55, established in 2002 by Marie Barrett and two core members of the Inishowen Development Partnership, based in County Donegal, and operating across the Inishowen Peninsula and the Derry hinterland, went from strength to strength through the decade.

Coming at another angle, Vagabond Reviews, established by artist Ailbhe Murphy and researcher Ciarán Smyth in 2007, initiates interventions and research processes to undertake socially situated projects. Jenny Haughton's cooperative company Artworking Ltd., established in 1991, assembled small project teams to produce projects, develop strategies, and advise local authorities on Per Cent for Art commissioning practices and approaches through the 2000s. For example, the *arc* commissions for Fingal County and Dublin City Councils, completed between 2003 and 2005, included Gerard Byrne's *Glasshouse Archive*, Amy Plant's *Multi Stop Shop*, Peter Fend/Ocean Earth's *Independence from Big Oil* and Tatsurou Bashi's *Moonrider*. Enlightened uses of the Per Cent for Art Scheme in the 2000s would add to this long project on many fronts by opening up new possibilities for cultural space through arts projects. Of course, as funding was drawn from publicly funded capital developments, the significant reduction in state spending on capital projects at the end of the decade impacted on such commissions. But an important legacy remained, based on the vision of certain arts officers and local authorities working closely with independent project managers with a good knowledge of the political system and attention to research into local issues. The huge Breaking Ground commissioning programme for Ballymun in Dublin, which delivered over forty-eight projects between 2002 and 2010, merits a full review in itself.

The 2003 Arts Act required local authorities to publish arts plans for their areas for the first time. In 2010 twenty-five years of partnership between the Arts Council and local authorities was celebrated at an event hosted by the University of Limerick. As early as 1998, the Sligo county manager looked forward to the structures of local government changing in tandem with a move away from a centrally based approach to one of facilitation, creating an environment where artists feel valued and respected. A few years later, a former county manager in Fingal recalled the misfortune of the first arts officers appointed being afforded little or no respect, little or no budget, and being impossible to place within the retraining organizational structure of resistant local authorities (Shane Hegarty, 'Shop Local is the New Message to the Arts', *IT*, 27 January 2003). In the last years of the decade, funding from local councils to their arts offices was exposed to a new risk. While the councils were obliged to publish arts plans, the funding was discretionary. With council revenue dwindling, however rigorous and proven the record of an arts office, councillors could legitimately reduce funding for their arts programmes without breaching their obligations. The public service moratorium meant that of the nineteen public art staff in 2007, only six remained in 2012, in Cavan, Donegal, Dublin City, Fingal, Mayo and Sligo. This also introduced risk for any infrastructure of national importance in local authority areas. An early example, of a complex and agenda-setting partnership, was the Placing Art programme in Sligo, between the County and Town Councils, with additional support from the EU Peace and Reconciliation Programme, as well as the AC/ACE, in 2000.

Launching Ireland's participation at the Venice Biennale in 2007, Arts Minister John O'Donoghue described the dramatic increase in funding by his Department to the arts as proof that there had been a cultural renaissance, and he ended his speech to loud applause. Something of a 'swan song' for the minister, ridiculed by his colleagues at his demotion to the arts portfolio from the heights of Justice a mere five years before, he had increased his department's budget year on year. The renaissance alluded to above was not, however, made of money. Sarah Browne's presentation at the subsequent Biennale, *Carpet for the Pavilion at the Venice Biennale* (2009), pulled the rug from beneath reckless hubris. Likewise, her later project, *How to use Fool's Gold (Pyrite Radio)*, (2012) is an example of how artists were tackling what was happening, as it happened, with critical and aesthetic skill. There is plenty of evidence, widely documented and on the record, that a strong foundation for cooperation and solidarity among artists, curators, academics, researchers, designers, independent policy advisers, architects and activists took shape in this

decade to an extent not achieved before in Ireland, in a genuinely positive way. The risk was that a side-effect of the culture of consensus which had boosted confidence across important networks in the visual arts also left them unsure of public support when the relationship with government became less friendly. Until an anonymous cyclist drops the report on *Dublin Contemporary 2011* into the hands of someone who will know what to do with it, the facts and figures concerning the organizers and curators claims for the event cannot be gathered. Billed as a five-yearly event, it is not clear if there is any desire to hold it again. Claims as to the formative contribution of the event in representing contemporary art in Ireland are easily contradicted: see the record of IMMA, the Rosc exhibitions (qv) and the many, many festivals, artist-led initiatives, galleries, art centres and public commissions in the years from 2000 to 2010 alone.

The public relations strategy of *Dublin Contemporary* set about something that was rare in the visual arts in Ireland – the extreme exaggeration and use of hyperbole to describe the achievements of the event in advance. The reason why this is problematic is that it underwrites reality with a fiction of success and delivers this as a historical document via normal archival processes. While a relatively cursory/objective examination uncovers contradictory lists of participating artists, the greater challenge is the important analysis of how the direct funding of the event affected its management and relations with the contemporary art sector, getting between it and its existing audience. VALERIE CONNOR

SELECTED READING Annie Fletcher, 'Introduction', in Joyce and Steiner, 2006; Connolly, 2009; O'Donoghue, 2009a; O'Neill and Wilson, 2010; Sholette, 2011.

GLOSSARY

ACRYLIC COLOUR Emulsion paint using acrylic resin that was first used in the 1940s. It is soluble in water, quick drying and can be used on many types of surfaces, and is often preferred to oil paint by modern artists.

ACTION PAINTING (GESTURAL ABSTRACTION, ABSTRACT EXPRESSIONISM) A technique of painting where paint is splashed or dribbled over the canvas.

ACTIVIST ART Art that aims to address particular cultural, political and social concerns with a view to producing concrete social change using demonstrations, protests, banners, signs and leaflet distribution.

AGIT-PROP Political propaganda disseminated through literature, drama, art or music. In the West the term has acquired a negative connotation that equates it with extreme left-wing politics.

AIRBRUSH A small tool that sprays various media including ink, dye and varnish, but most often paint, by means of compressed air.

ALLEGORY The representation of abstract ideas or principles through a series of characters, figures or events in narrative or pictorial form.

ALTARPIECE A piece of artwork, such as a painting or sculpture, that is placed above and behind an altar in a Christian church.

AONACH TAILTEANN The Aonach Tailteann, or Tailteann Games, was a revival of an ancient Irish sports-and-culture festival, initiated, briefly, by the government of the Irish Free State. Intended to rival the Olympic Games, the Aonach Tailteann was held in 1924, 1928 and 1932, and included open competitions in painting and arts and crafts, for which medals were awarded.

ANIMATION The rapid display of a sequence of images to create an illusion of movement, used in motion pictures or video production.

APPLIED ART Art that is created for practical use and remains subservient to that practical function. This includes ceramics, furniture, glass, leather, metalwork, textiles, arms and armour, and jewellery.

AQUATINT A tonal method of printmaking that is used with linear etching. The copperplate is eroded by immersion in acid and acid-resistant resin, leaving a fine patterning when the plate is inked and printed.

ART BRUT ('raw art') The French term initially used by Jean Dubuffet to describe art created outside the boundaries of official culture, especially in the work of psychotics, children and self-taught painters. In Britain and Ireland this work is usually referred to as outsider art.

ART DECO A decorative style of the 1920s and 1930s. The characteristic shapes were geometric or stylized, derived from the modernist forms of Art Nouveau.

ARTE POVERA (Italian: 'poor' or 'impoverished' art) It was made from everyday materials such as cement, newspapers or twigs, in deliberate contrast to the traditional sculptural materials of stone and metal. It was associated with the late 1960s and the 1970s, and can be applied to artists such as Joseph Beuys and Antoni Tapies.

ART NOUVEAU (French: new art). This style originated in the 1880s and lasted until the outbreak of the First World War, encompassing the decorative arts, design and architecture. It was characterized by flowing, expressive lines and whiplash curves, flower and leaf motifs, and female figures with long, undulating hair.

ARTS AND CRAFTS MOVEMENT A movement begun in England (flourished between 1860 and 1910) that revived handicrafts and raised the standards of design. It deplored the effects of mass production and mechanization, but the difficulty of producing handcrafted pieces for a mass market led to its decline.

ASSEMBLAGE Art produced by the assembling of disparate elements – objects often scavenged or bought by the artist.

ASSEMBLING An art form associated with artists' books in which various objects, images and texts are assembled in a box or book.

AUBUSSON TAPESTRIES Tapestries and carpets made in the workshops of Aubusson in central France, established in the early sixteenth century and granted the status of royal manufactory by Louis XIV.

AUTOMATISM A method of painting or drawing in which conscious control is suppressed, allowing the subconscious to take over.

AVANT-GARDE French term used to describe innovative, cutting-edge artists and movements.

BAS-RELIEF 'Low relief' sculpture in which the figures never project more than half their true depth from the background.

BATIK A technique for decorating cloth, which originated in Java, using a manual wax-resistant dying process.

BAUHAUS A German school, operating from 1919 to 1933, that combined architecture, crafts and the fine arts, and was famous for its approach to design. Bauhaus literally means 'house of construction', and reflects the concept of workshop training rather than academic studio education.

BIENNALE/BIENNIAL A large-scale exhibition of international contemporary art held every two years. The earliest and most famous was the Venice Biennale, first held in 1895.

BIOMORPHIC A term used to describe forms in abstract art that resemble or suggest living organisms rather than geometric shapes.

BLAUE REITER, DER (German: 'The Blue Rider') A loose association of painters formed in Munich that was active from 1911 to

1914 and led by Wassily Kandinsky and Franz Marc. They shared an interest in abstracted forms and prismatic colours, which, they felt, had spiritual values that could counteract the corruption and materialism of their age.

BODY ART A popular movement of the later 1960s and 1970s in which the body was the medium. The most common forms are tattoos and body piercings, but other types include scarification, branding, scalpelling, shaping (for example, the tight lacing of corsets) and body painting. More extreme body art can involve mutilation or pushing the body to its physical limits. Body art often manifested itself in public or private performance events that were recorded.

BRÜCKE, DIE (German: 'The Bridge') A group of German Expressionist artists formed in 1905 by students at the Dresden Technical School. The name suggested the group's faith in the art of the future, to which they would act as a bridge. Their art remained strongly figurative, with graphic art being a particular speciality. By 1911 most of the artists had moved to Berlin, and by 1913 the group had disbanded. It had a major impact on Expressionist art in the twentieth century.

BRUTALISM A term used in England to describe the poured, board-marked concrete with which the architect Le Corbusier constructed many of his post-Second World War buildings.

CALLIGRAPHY The art of fine writing in an expressive, harmonious and skilful manner with brush or pen and ink, frequently used as a means of artistic expression.

CAMERA LUCIDA (Latin: 'light chamber') An optical device used as a drawing aid whereby an image of the subject being viewed is projected upon the surface on which the artist is drawing.

CAMERA OBSCURA (Latin: 'dark chamber') A light-box with a small hole on one side, or a building with an aperture through which an image passes onto a mirror and is reflected onto a surface for drawing or painting. It was the precursor of the modern camera and used as an aid by many artists.

CARICATURE (from Italian caricare, 'to load, exaggerate') A form of two-dimensional visual art, usually portraiture, in which the characteristic features are exaggerated or distorted for comic effect.

CARTOON (from Italian cartone, 'strong or heavy paper') A non-realistic or semi-realistic drawing or painting intended for satire, caricature or humour.

CATALOGUE RAISONNÉ (French: 'reasoned catalogue') The complete published catalogue of an artist's work and generally viewed as the standard publication on the subject.

CELTIC REVIVAL A revival of interest in the ancient Celtic art of Britain and Ireland, which flourished c. 450–50 BC and lasted until c. 600. Manifesting mainly as a decorative style, it first appeared in the 1840s, and reached its peak in the 1890s and early 1900s.

CELTIC TIGER ECONOMY A term used to describe the economy of the Republic of Ireland during a period of rapid economic growth between 1995 and 2007. In 2008 the economy fell into recession with unemployment levels rising to fourteen per cent by 2010.

CHARCOAL A dark-grey/black crayon obtained by burning wood, usually willow or vine. One of the oldest known drawing materials, it smudges easily and can be manipulated on the drawing surface.

CHIAROSCURO (Italian: 'light-dark') The effects of light and dark in a work of art, especially when they are strongly contrasting.

CHROMOLITHOGRAPH A multicolour print that stems from the process of lithography.

CLASSICAL REVIVAL A style of contemporary architecture that uses the classical features of columns, keystones, porticoes and pediments to reference Greek and Roman civilization.

CLASSICISM A high regard for classical antiquity (ancient Greek and Roman art) that implies an adherence to certain fixed ideals or rules in art, as opposed to freedom of individual expression.

COBRA A group of Expressionist painters formed in Paris in 1948, which disbanded in 1951. The name is derived from the first letters of the capital cities of the three countries of the artists involved – Copenhagen, Brussels and Amsterdam. They were interested in art stemming from unconscious gesture and in the development of strange and fantastic imagery.

COLLABORATIVE ART A form of practice where two or more artists, often from different disciplines, collaborate in the creation of an artwork.

COLLAGE (from French coller, 'to gum') Technique whereby pieces of cut paper are stuck down onto another surface to create a design. It was adopted by major artists in the early twentieth century.

COMIC-STRIP ART Artwork derived from narrative cartoons. It has played a major role in popular culture throughout the world, and influenced Modernism.

COMMUNITY ARTS Artistic activity based in a community setting where emphasis is placed on the potential of art to bring about social change.

COMPOSITION The arrangement of visual elements in an artwork, referring to the formal relationship of such elements as volume, form, line and colour.

COMPUTER ART Art produced with the aid of a computer, which first appeared in the 1950s. Initially, it consisted of the random arrangement of geometric shapes, but increasingly sophisticated technology led artists to work interactively with displays on screens.

CONNOISSEURSHIP An approach to the study of art that focuses on the object itself and its stylistic features, attaching less importance, if any, to the context of its creation.

CONSTRUCTIVISM An artistic and architectural philosophy that originated in Russia around 1914 and spread to the West in the 1920s, which was characterized by its abstraction and its use of industrial materials. The movement advocated art as a practice for social purposes, and had a great effect on modern art, influencing major trends, such as the Bauhaus and the De Stijl movement.

CONTEMPORARY ART A term referring to current and very recent art practice. Since the 1970s the term has been sometimes used to distinguish between those artists who consciously endorse Modernism and those who reject it.

CRITICAL THEORY A range of theories taken mainly from the social sciences and humanities that adopt a critical approach to understanding society and culture.

DADA An anti-establishment and anti-war arts movement that flourished between 1916 and 1922, and ridiculed traditional notions of form and beauty. It used abstraction, nonsense texts and absurd performances to protest against the prevailing social and political conditions in Europe.

DAGUERREOTYPE The first commercially successful photographic process, developed by Louis Daguerre together with Joseph Niépce in the 1830s, where an image is etched onto a silver-plated copper sheet after lengthy exposure to light.

DECONSTRUCTION A philosophical movement and theory of literary criticism that questions traditional assumptions about certainty, identity and truth, encouraging an anti-authoritarian approach to the interpretation of artworks.

DECORATIVE ART Art that is used to decorate an object that has a practical purpose, as opposed to fine art, which exists as an end in itself.

DE STIJL (Dutch: 'The Style') A group of mainly Dutch artists founded in 1917 and the name of the journal they published to promote their ideas. Their aim was to find laws of equilibrium that would be relevant to life and society as well as art, and their style was one of austere abstract clarity with straight lines and primary colours.

DIALOGICAL AESTHETICS A term used to describe socially engaged arts practice where the emphasis is placed on dialogue rather than on the production of an object.

DIGITAL ART A term first used in the 1980s to describe computer-generated art.

DIPTYCH Two flat plates or panels sometimes attached by a hinge, often used in altarpieces.

DISTEMPER Paint made of water, chalk and pigment, bound with either an animal glue or casein, used for wall decoration or stage scenery.

DIVISIONISM Another name for Neo-Impressionism or Pointillism, the technique developed in the 1880s defined by the separation of colours into individual dots that interact optically. Divisionism refers to the general principle of the separation of colour, whereas Pointillism concerns itself specifically with the use of dots.

DOLMEN A Megalithic tomb consisting of three or more upright stones supporting a large flat stone to form a chamber and often covered by an earth mound (barrow).

DRIP PAINTING A technique in which paint is allowed to drip onto the canvas. It became popular in the 1940s when it was adopted by the action painters.

DRYPOINT A technique of printmaking where the design is scratched onto the copperplate with a sharp round point creating a deposit of burr that attracts a rich inking when printed.

EARLY CHRISTIAN The period dating approximately from the third century to c. 750.

ECLECTICISM A term used to describe the combination of different elements from various historical styles.

ÉCOLE DES BEAUX-ARTS (French: 'School of Fine Arts') An art school originally established in Paris in 1648 that was reformed in 1863. It became deeply conservative by the end of the nineteenth century, and it was eventually superseded by the Bauhaus (founded 1919) and other schools.

EDITION In printmaking, the number of prints struck from one plate, usually at one time. As a consequence of industrialized processes, the 'limited edition' became widespread in the later nineteenth century, with a limited number of prints, often signed and numbered by the artist to enhance value.

ELECTRONIC MEDIA Various technologies powered by electricity including digital, video and audio recordings, slide presentations, CD-ROM and online content, as well as the more traditional television, radio, telephone and computer.

EMULSION A suspension of two liquids that do not mix together – for example, oil and water. An emulsifier, such as albumen, is needed to bind both substances together. Egg yolk is a naturally occurring emulsion and is used in tempura painting.

ENAMEL Powdered glass, usually mixed with colourants, is fused under high heat to a metal surface for decorative purposes. The powder melts and hardens to a smooth, durable and vitreous coating.

ENGRAVING The main form of printmaking that became popular in Germany in the early fifteenth century. The design is made on a copperplate with a graver or burin, creating grooves. The plate is inked and printed so that the ink in the grooves is forced out onto the paper. In 1857 the steel-facing of copperplates was introduced to produce longer-lasting plates.

ENVIRONMENTAL ART (EARTH ART) An international movement that emerged in the 1960s in response to growing concerns about environmental and ecological issues. It took many different forms, including the landscaping of urban sites, massive earth sculptures in the desert, and the recording of journeys through the landscape.

ETCHING The process of using strong acid to cut into the unprotected parts of a metal surface to create a design in intaglio in the metal. It was one of the most important techniques for old-master prints and is in wide use today.

FAUVISM The first of the avant-garde movements that flourished in France during the early years of the twentieth century, the Fauve painters broke with Impressionism as well as with older, traditional methods of perception. Fauvist painting was distinguished by its concentration on the use of vibrant colour in bold, undisguised brushstrokes for expressive and emotional effect.

FEMINIST ART Artwork that appeared, mainly from the late 1960s onwards, that re-examined the representation of women and pursues an equality agenda.

FIGURATIVE ART Representational artwork that is clearly derived from real object sources, with human and animal figures being frequently used.

FINE ART Art created primarily for aesthetic reasons and not for functional use – for example, painting, drawing, printmaking and sculpture.

FLUXUS A loosely organized group of international avant-garde artists, writers, film-makers and musicians set up in Germany in 1962 and lasting until the early 1970s that created experimental multimedia work.

FORMALISM Strict adherence to external forms, such as line, colour, shape and texture, with other considerations – representational, moral or social – being considered redundant.

FRESCO (Italian: 'fresh') A technique of wall painting, practised since antiquity, consisting of the application of powdered pigments mixed in water onto a wet, freshly laid lime-plaster background. The colours penetrate into the surface and become a part of the wall.

FUTURISM An artistic and social movement that originated in Italy during the early twentieth century that emphasized and glorified themes associated with concepts of the future: youth, technology, machinery, speed and war.

GENRE (French: 'kind' or 'type') Denotes different categories of painting such as portraiture, landscape etc. specifically associated with scenes of everyday life.

GESTURAL A descriptive term to describe the painting of the Abstract Expressionists whereby the freedom of technique was seen to display inner states of mind.

GILDING The application of a thin layer of gold to the surface of an object, such as furniture, picture frames and ceramics, for decoration.

GLAZE A thin layer of transparent or semi-transparent colour laid over another colour.

GOUACHE Also referred to as body colour, gouache is an opaque form of watercolour obtained by adding white pigment.

GRAFFITI ART Originally meaning drawings scratched onto the surface of walls, it is now based on the popular spray can/aerosol artworks created in New York in the 1980s on walls and in communal urban spaces such as subways.

GRAPHIC ARTS In fine art, refers to the production of original prints. The term can also be used in relation to the production of text and artwork (commercial arts).

GRAPHITE Drawing material made from crystalline carbon, commonly found in pencils.

HAPPENING An artistic gathering combining elements of visual art, theatre and performance. Often spontaneous in part, they were originally a reaction to traditional art forms.

HARD-EDGE PAINTING A form of abstract painting, using (often geometric) forms with sharp contours and bold, flat colours. Developed as a reaction to the more painterly Abstract Expressionism.

HATCHING Drawing technique using finely drawn parallel lines to suggest tone and shade.

HYPER-REALISM (*SEE ALSO* PHOTOREALISM) A highly detailed and precise art form creating an extreme likeness that is often based on highly focused photography.

ICON Traditionally relating to the image of a religious figure. In popular culture, the term can refer to a popular or heroic figure.

ICONOGRAPHY An art-historical method used in relation to the identification, description and interpretation of symbols and subject matter in artworks.

IMPASTO Painting technique, referring to the thick application of (oil) paint with a brush or palette knife that stands above the canvas or other surface.

IMPRESSIONISM An influential nineteenth-century art movement in France based around a small group of artists. The style and technique then spread across Europe and North America. Impressionist artists championed a technique that allowed for a quick and immediate response to their environment, often focusing on the effects of light and weather.

INDEPENDENTS A group of artists who came together in Dublin in 1960 to lobby for opportunities to exhibit their work independently of established fora such as the Royal Hibernian Academy and the Irish Exhibition of Living Art.

INDUSTRIAL DESIGN Applied art, linked to the aesthetic improvement and manufacture of mass-produced goods.

INSTITUTIONAL CRITIQUE Artistic practice that seeks to examine the relationships between museums or galleries and the material they exhibit. Proponents of it often look to challenge the categorization and distinctions constructed by traditional displays, questioning the processes of taste and artistic sensibility.

INTAGLIO In graphic arts, a term used to refer to any printing process where the design or image to be reproduced is incised or recessed into the plate or block, rather than raised above it.

INTERDISCIPLINARY Applying the knowledge, skills and methodologies of other (academic) disciplines to a traditionally separate subject, where there are topics or subjects shared by all.

INTER-TITLE (FILM) Captions or graphics that appear as a separate sequence in film, rather than being superimposed on the footage (subtitle).

KINAESTHETIC ART The awareness of bodily movement and motion in art, it is often associated with Futurism.

KINETIC ART Used in reference to different art forms where motion is either suggested, or actually appears or occurs. Kinetic art can use electric, magnet or air-power elements to create movements.

KITSCH Used to refer to art or artefacts deemed vulgar or in bad taste. Subject of art critic Clement Greenberg's influential essay, 'Avant-garde and kitsch', published in the Paris Review in 1939.

LAND ART A type of art that emerged in the 1960s in reaction to an elitist and money-driven art market. Linked to other movements such as minimal art and conceptual art, it uses the land and landscape as well as its raw material, such as soil and rocks, to create artworks, often monumental in scale.

LINOCUT A relief printing technique, modelled on woodcut but using linoleum. Notably used by Henri Matisse and Pablo Picasso, it is a cheap and effective process.

LITHOGRAPH A print technique grounded in the fact that grease and water repel. The process involves the application of greasy ink to a smooth, moist limestone from which the print is then taken. It was often used in the nineteenth century for reproducing topographical drawings and watercolours.

LISSIER French: a term meaning tapestry weaver.

MACHINE ART Art that celebrated the imagery and subjects of the machine age using monumental forms and bold colours. Usually associated with the art of Fernand Léger.

MAGIC REALISM A style of painting, mixing photographic realism with flat colour, angular perspectives and odd juxtapositions. The term was first used in relation to aspects of German New Objectivity and was influential on Surrealist painting.

MAIL ART A term used to describe a practice dating from the 1960s whereby artists used the postal system to share artworks and images, rather than exhibiting in a traditional gallery space.

Mariolatry A term used to describe the veneration of the Virgin Mary in the Roman Catholic Church.

media, medium, mixed media, multimedia Individually, painting, drawing and sculpture are different artistic media, but the term 'media' also refers to the different materials and methods used by artists. Medium can refer to specific 'media', such as oil paint. It can also refer to the liquid used to suspend pigment, creating paint – such as linseed oil. Mixed media works are composed of different types or media. The term multimedia applies to mixed-media works that incorporate electronic elements, such as video or music.

memento mori (Latin: remember that you will die) symbol or object used to invoke thoughts about mortality or the transience of human life. Often used in sixteenth- and seventeenth-century painting, and later used in Victorian jewellery design.

menhir A tall, upright stone either found as a single element or arranged in regular rows, dating to prehistoric times.

mezzotint Printing technique based on a graduating tonal range working from light to dark. A copperplate is usually used, and it is first roughed with a spiked tool known as a rocker. Lighter tones are then scraped out using a burnisher; the more that is removed, the lighter the tone produced as there is little for the ink to adhere to.

montage The reassembling of cut-out, pre-existing pictorial images, often used in advertising.

motif A reoccurring image or theme, found either in a work of art or across an artist's oeuvre.

multiples A term used to designate works of art, excluding sculpture and prints, that are designed to be reproduced in large numbers. Popular in the 1960s and 1970s, the process experienced a revival in the 1990s, and is often linked to industrial processes.

mural A painting, usually large, completed either directly on a wall or on a surface to be mounted on a wall, and often used as part of a larger decorative scheme.

naïve art Paintings or sculpture, created within a Western art tradition, that do not conform to traditional representational practices, such as perspective or consistent use of light, and usually using bright and non-naturalistic colours.

naturalism An artistic approach whereby the artist seeks to represent objects as they are observed, without stylization. The term is often mistakenly used as a synonym for Realism.

Neoclassicism A movement in the eighteenth and early nineteenth centuries closely based on the art of ancient Greece and Rome. A reaction to the excesses of Rococo ornamentation, it was influenced by contemporary archaeological discoveries and was spread from Italy by people completing a Grand Tour. A revival in the 1920s and 1930s surfaced in response to the experimentation of early Modernism.

neo-Dada (junk and Pop art) An American term used to describe junk and Pop art. Junk art utilized worthless items or found materials in opposition to fine art and its traditional materials, while Pop art used the imagery of consumerism and popular culture, such as Andy Warhol's use of Campbell's soup cans.

neo-Expressionism Emerging in the 1970s and 1980s, the movement encompassed both painting and sculpture, focusing on large, rapidly executed and gestural works, sometimes based on mythical themes.

Neoplatonism A philosophical and religious system dating to the thirteenth century that combines ideas from Plato and other Greek philosophers with Christian beliefs.

neo-Romanticism British art movement in the mid-twentieth century, c. 1935–55, influenced by elements of nineteenth-century Romanticism and landscape painting.

Neue Sachlichkeit (New Objectivity) An artistic movement dating to the Weimar period in Germany, encompassing visual art, architecture, literature and music. Exponents turned away from the emotive subjects of Expressionism, using a hard, often gritty, style of realism to show contemporary events and life in post-war Germany.

new art history Encompassing term used to describe developments in the discipline of art history after the Second World War, drawing on Marxist, semiotic and deconstructionist theories.

New Realism/Nouveau Réalism Term with multiple meanings. Used to describe artists who include real or everyday objects in an artwork to make an ironic comment on modern life. It can also be used to describe developments in American art during the 1950s and 1960s that developed in reaction to Abstract Expressionism. It can also refer more generally to the new figuration and to super-realism in particular.

New York School The name given to denote a loose grouping of artists in New York in the 1940s and 1950s, linked to abstract Expressionism.

non-objective art Used to refer to purely abstract and non-representational art, it contains no reference to the world or other objects. The term was first used by artist Alexander Rodchenko.

Nouveau Réalisme – *see* New Realism

objet trouvé (French: found object) Inclusion of an object found by the artist in an artwork, with little or no alteration – for instance, in assemblage.

oeuvre (French: work) The total output or body of work of one artist.

offset Reproduction made by dampening a drawing, placing another damp sheet of paper on top of it and pressing them together, either by hand or by machine.

ogham lettering A form of writing dating from the third to the ninth centuries in Ireland and parts of Britain, based on about twenty letters or sounds. It is represented by groups of vertical or diagonal lines, running either above or below a base line.

Op (Optical) art Type of abstract painting that uses repetitive patterns to give the illusion of movement or shapes in a composition. Op art can also make use of constructions, overlapping in some respects with kinetic art.

Oireachtas The legislature, or national parliament, of Ireland, consisting of the president of Ireland and the two houses of the Oireachtas: Dáil Éireann (the lower house) and Seanad Éireann (the upper house). An annual Oireachtas Art Exhibition was founded in 1905.

pastel Drawing material made from a mix of pigment powder and a binder such as gum or resin, and shaped into a stick.

pastiche The imitation of the style of another artist or artwork, and the borrowing of motifs from authentic works, sometimes for fraudulent purposes.

PHOTOMONTAGE Reassembling of photographic pieces or fragments to create a new pictorial composition.

PHOTOREALISM (*see also* **HYPER-REALISM**) A style of painting that emerged in the 1960s, often using colour slides projected onto a canvas or surface and then painted, to produce a sense of heightened reality.

POSTCOLONIALISM/POSTCOLONIAL THEORY Academic field that considers the effect of Western imperialism on previously colonized countries, often focusing on issues of race, ethnicity, nationhood and marginalization. Postcolonial theory is strongly influenced by post-structuralism and deconstruction, seeking to examine and unravel the different positions, subjects and structures within the wider discourse of colonialism and imperialism.

POST-IMPRESSIONISM (*SEE ALSO* **IMPRESSIONISM**) General term used to describe artistic developments arising out of Impressionism. An umbrella term, it can refer to work using scientific colour theories, new techniques or themes, and as such can be used to describe a diverse range of artists.

POST-STRUCTURALISM Philosophy developed in France in the 1960s that challenged the structuralist approach to the relationships between signs and meanings. A central concept is that of deconstruction.

PRIMARY COLOUR Refers to the three chromatic colours, red, blue and yellow, which when mixed can create other (secondary) colours.

PRIMITIVE ART/PRIMITIVISM Generally refers to the art of Africa and the Pacific Islands. The forms of this art were of particular interest to artists in the early part of the twentieth century, such as the Fauves, Cubists and Die Brücke.

PROCESS ART A trend from the late 1960s that emphasized the processes involved in making an artwork and the processes of change it underwent after completion, rather than its formal qualities.

PROVENANCE Record showing the ownership of an artwork, tracing its whereabouts from creation to the present day. Often an important resource in attributing authorship to a particular work of art.

PSYCHEDELIC ART Linked to the 1960s and the use of hallucinatory drugs, it is characterized by the use of swirling patterns and of bright, often clashing, colours. Sometimes considered as an influence on the development of Op art.

QUEER AESTHETICS Art concerned with the imagery of gay and lesbian activity, which evolved in the 1980s, responding to contemporary feminist debates and the AIDS epidemic.

RELATIONAL AESTHETICS Linked to relational art as conceptualized by Nicolas Bourriaud in the 1990s, where the artist is a catalyst for a wider social engagement with art. Art is shared through a group or collective experience, rather than through an individual encounter and response.

ROCOCO Art and architectural style dating to the eighteenth century. Developed in response to the heavy Baroque style, it is characterized by a concern with light, grace and feelings of intimacy.

ROMANESQUE Architectural style in Europe, *c.* 1000–1200, which reached a highly developed stage in France and Germany. It is characterized by round arches, heavy piers and columns, and the compartmentalization of space.

'ROTATION AND TRANSLATION' TECHNIQUE Cubist technique championed by Albert Gleizes based on a two-step process. First, there was a 'translation' of various (usually rectangular) forms that corresponded to the shape of the canvas, using horizontal and vertical movement. Then, 'rotation' was employed to move these forms or planes by tilting them either to the right or left repeatedly, creating an essentially circular movement. This created a wholly abstract form of painting, where the interlocking forms and colour created a kind of movement within the composition.

ST IVES SCHOOL A group of British artists who settled in St Ives in Cornwall from the late 1930s. The leading figures were the painters Patrick Heron and Ben Nicholson and the sculptor Barbara Hepworth.

SCREEN-PRINTING A printing technique used by commercial and other visual artists. The print is created by forcing ink through a mesh screen with a rubber squeegee onto paper or other surfaces. Designs are created either by using stencils or by applying wax or resin directly onto the mesh before printing.

SEMIOTICS An analytical method, derived from linguistics, that studies different signs and sign systems used to produce meanings.

SITE-SPECIFIC A term used to describe an artwork created for a certain space or place, where the location is intrinsic to the meaning or effect of the piece.

SITUATIONISM Based around the Situationist International, a group of mainly European artists and thinkers in the late 1950s and 1960s. Rooted in Marxism and the writing of Guy Debord, the group sought an alternative to the capitalist system.

SOCIALIST REALISM Official term given to approved art in Soviet Russia and other communist countries. Common subjects showed sites or scenes of labour, either industrial or agricultural, portrayed in a conventional academic manner, and as such were meant to reflect the tenets of communism and to inspire the viewer.

SOCIALLY ENGAGED ART Art that seeks to provoke social change through an engagement with cultural production. Such work often takes the form of artist-led community or group projects, working with communities experiencing social difficulties.

SOCIAL REALISM A broad term used in relation to painting and other arts, such as literature and film, that reflect contemporary social, political or economic conditions. There is no one visual style, but a kind of non-academic realism is usually employed. Often confused with Socialist Realism, social realism is not tied to a specific time period, location or political ideology, although it is loosely affiliated with left-wing views.

SOUND ART Art that is concerned with, or experiments with, sound as an artistic subject or medium.

STUCCO A light plaster-like render, used for architectural or sculptural decoration.

SYMBOLISM A movement in late nineteenth-century art and literature, beginning in France with a manifesto by Jean Moréas published in 1886. Although there is no exact definition, Symbolist art is generally concerned with the idea that another world lies beyond the world of appearances.

SYNTHETIC CUBISM Second phase of the Cubist style, dating from *c.* 1912–14. In contrast to the fragmented planes of analytical Cubism, this style was based on the construction of an image from pre-existing images. It heralded the reintroduction of strong colour into Cubist compositions.

TACHISME (French: from tache, 'spot') Tachisme was an art movement that emerged in Paris after World War II and continued until the 1960s. Like Action painting, it featured the artist's spontaneous brushstroke and is, therefore, linked to gestural painting and to Abstract Expressionism.

TACTILE VALUES A term first used by Bernard Berenson (art historian and connoisseur) to describe the qualities in a painting that suggest or create a sense of touch, and which affect the tactile imagination.

TEMPERA A method of mixing paint by combining (tempering) pigment, dissolved in water, with an organic gum or glue – usually egg (egg tempera). Mainly associated with European painting from the thirteenth to fifteenth centuries.

TEXT-BASED ART The use of text as a motif in art began to emerge with Synthetic Cubism and the work of Vladimir Tatlin in Russia at the beginning of the second decade of the twentieth century. However, it was not until the advent of Conceptualism in the 1960s that text became accepted as a central motif in artwork, with the work of Joseph Kossuth and others.

TONE A term used to describe the qualities of colour – for example, its brightness, depth or hue.

TRIPTYCH A picture or carving composed of three parts, usually a central panel with flanking wings that often fold over the centre. Often used for altarpieces.

TROMPE L'OEIL (French: deceive the eye) A term used to describe a painting which tricks the viewer into thinking an object or the space represented is real, rather than a two-dimensional painting.

TURNER PRIZE Annual prize for contemporary art in Britain, awarded by the Tate's Patrons for New Art. Founded in 1984, the prize has had an often controversial history, but it is an important platform for promoting new art and artists.

UNIT ONE A short-lived British avant-garde group (1933–35) composed of painters and sculptors. Stylistically, the group promoted abstract and Surrealist art.

VIDEO ART An artistic medium rather than a style or movement. It emerged in the 1960s when visual artists started using Sony portable video cameras to create artworks.

VORTICISM A British avant-garde group influenced by Cubism and Futurism. Artists were drawn to the dynamism of the machine age, which they celebrated, while criticizing the complacency of pre-war Britain.

WARP A term used to describe the thicker threads in woven fabric, which are set on the loom to provide a framework for the weft threads.

WATERCOLOUR Type of paint where pigment, when mixed with gum arabic, is dispersed with water, producing semi-transparent colours.

WEFT Thin threads used in woven fabric, which run from side to side, interlacing with the warp threads to form the pattern.

WHITE CUBE Aesthetic used in galleries, dating from the early twentieth century, when it was used for displaying abstract art. The idea of the white cube was explored by Brian O'Doherty in his essay 'Inside the White Cube: The Ideology of the Gallery Space' (1976).

WOODCUT A printing technique that uses a block of wood where the grain runs lengthways across the surface. A reductive printing process, where areas to be left clear of ink are cut away, leaving a relief design on the block.

ZEITGEIST (German: spirit of the age) A term used to reference the atmosphere of a particular period or epoch.

ZOOMORPHIC ORNAMENT Stylized ornament, usually linear, based on animal forms.

SELECT BIBLIOGRAPHY

This is not intended as a definitive bibliography on the art of the period but has been compiled from references in the essays in this volume, together with additional selected reading.

Readers are referred to the many useful archives in Ireland and in Irish studies departments around the world. Of these, particular mention should be made of the National Irish Visual Arts Library at the National College of Art and Design, the National Gallery of Ireland, the Irish Art Research Centre at Trinity College, Dublin the Ulster Museum, the Arts Council/ An Chomhairle Ealaíon, the Arts Council of Northern Ireland, the RTÉ Archives and, in Britain, the Tate Archive.

PUBLISHED MATERIAL

'A is for Art: A Supplement on Art Education', *Circa*, no. 89 (Autumn 1999)

Abrams, Mike (ed.), *Revealing Views: Images from Ireland* (London 1999)

Alberro, Alexander, *Conceptual Art and the Politics of Publicity* (Cambridge, MA and London 2003)

Alberro, Alexander and Blake Stimson, *Conceptual Art: A Critical Anthology* (Cambridge, MA and London 1999)

Alberro, Alexander and Sabeth Buchmann (eds), *Art After Conceptual Art* (Cambridge, MA and London 2006)

Alternative Entertainments, *25 Years of Visual Arts with Alternative Entertainments* (Tallaght 2010)

Anglesea, Martyn, *The Royal Ulster Academy of Arts: A Centennial History* (Belfast 1981)

——, 'Easier than Cutting the Lawn', *Causeway* (Winter 1996)

Arnold, Bruce, *A Concise History of Irish Art* (London 1969; repr. 1977 and 1991)

——, *Orpen: Mirror to an Age* (London 1981)

——, *Mainie Jellett and the Modern Movement in Ireland* (New Haven and London 1991)

Arts Council/An Chomhairle Ealaíon, *Aosdána Annual Reports* (Dublin)

——, *Annual Reports* (Dublin)

——, *White Papers* (Dublin)

Baker, Robert, *The Art of Aids: From Stigma to Conscience* (New York 1995)

Barber, Fionna, 'Territories of Difference: Irish Women Artists in Britain', *Third Text*, no. 27 (Summer 1994), 65–75

——, *Art in Ireland since 1910* (London 2013)

Barrett, Cyril (ed.), *Collected Papers on Aesthetics* (Oxford 1965)

——, 'Irish Nationalism and Art', *Studies* (Winter 1975), 393–409

Barton, Ruth, *Irish National Cinema* (Oxford 2004)

Batt, Vivienne, Jane Conroy, Sheila Dickinson, Ann Lyons and Lorna Shaughnessy (eds), 'Making a Difference: Women and the Creative Arts', *Women's Studies Review*, VIII (Dec. 2002)

Battcock, Gregory (ed.), *Minimal Art: A Critical Anthology* (New York 1968; repr. Los Angeles 1995)

Bell, Clive, *Old Friends* (London 1956)

Benson, Ciarán, *The Place of the Arts in Irish Education* (Dublin 1979)

—— (ed.), *Art and the Ordinary: The Report of the Arts Community Education Committee* (Dublin 1989)

——, 'Towards a Cultural Democracy', *Studies*, LXXXI, no. 321 (Spring 1992)

——, 'Modernism and Ireland's Selves', *Circa* (Jan./Feb. 1992a), 18–23

——, *The Cultural Psychology of Self: Place, Morality and Art in Human Worlds* (Oxford and New York 2001)

Bewley, Jon and Simon Herbert (eds), *Locus Solus* (London 2000)

Bhreathnach-Lynch, Síghle, 'Framing Ireland's History: Art, Politics and Representation 1914–1929', in J.C. Steward (ed.), *When Time began to Rant and Rage*, exh. cat. Berkeley Art Museum (London 1998), pp. 40–51

——, 'Landscape, Pace and Gender: Their Role in the Construction of Female Identity in Newly Independent Ireland', in Steven Adams and Anna Gruetzner Robins (eds), *Gendering Landscape Art* (Manchester 2000)

——, 'The State and the Visual Arts (1922–1970)', in *Art in State Buildings, 1922–1970*, Office of Public Works (Dublin 2000a)

Black, Eileen (ed.), *Drawings, Paintings & Sculptures: The Catalogue— Museums and Galleries of Northern Ireland* (Belfast 2000)

Bodkin, Thomas, *Four Irish Landscape Painters* (Dublin 1920; repr. 1987)

——, *Twelve Irish Artists* (Dublin 1940)

——, *Report on the Arts in Ireland* (Dublin 1949)

——, *Hugh Lane and his Pictures* (Dublin 1956)

Bokslag, Paul and Barbara Wheeler Connolly (eds), *Art and Inclusion: The Story of KCAT* (Callan 2009)

Booth-Clibborn, Charles (ed.), *Forwards, Not Backwards*, print portfolio (London 2005)

Bourke, Maire, 'A Growing Sense of National Identity in the Visual Arts in the Early Twentieth Century', in N. Garnham and K. Jeffrey (eds), *Culture, Place and Identity* (Dublin 2005)

——, *The Story of Irish Museums 1790–2000: Culture, Identity and Education* (Cork 2011)

Bourriaud, Nicolas, *Relational Aesthetics* (Dijon 2002)

Bowe, Nicola Gordon, 'The Early Twentieth-century Irish Arts and Crafts Workshops in Context: An Túr Gloine and the Dun Emer Guild and Industries', *Journal of Design History*, II, no. 2/3 (1989)

—— (ed.), *Art and the National Dream: The Search for Vernacular Expression in Turn-of-the-Century Design* (Dublin 1993)

Bracefield, Hilary, David Brett and Lynda Henderson, 'The Arts in Northern Ireland', *Studies: An Irish Quarterly Review*, LXXX, no. 318 (Summer 1991), 178–86

Brighton, Andrew, 'Philistine Piety and Public Art', *Modern Painters*, VI, no. 1 (Spring 1993), 42–3

Brown, Karen E. (ed.), *Women's Contributions to Visual Culture, 1918– 1939* (Aldershot 2008)

Brown, Terence, *Ireland: A Social and Cultural History, 1922–2002* (London 1981; repr. Glasgow 2004)

Bruce, Campbell and Catherine Marshall, *Siar 50: 50 Years of Irish Art from the Collections of the Contemporary Irish Art Society*, exh. cat. IMMA (Dublin 2006)

Buck, Louisa, *The Surrealist Spirit in Britain* (London 1988)

Burke, Mary, 'Room with a View', in *New Art Studio Newsletter*, I, no. 1 (Nov. 1998), 1–2

Burns, John, *Sold! The Inside Story of How Ireland Got Bitten by the Art Bug* (Dublin 2008)

Butler, Patricia, *The Silent Companion: An Illustrated History of the Water Colour Society of Ireland* (New York 2010)

Cameron, Dan, 'Partial View: Transgressive Identity in Willie Doherty's Photographic Installations', in *Willie Doherty: Partial View*, exh. cat. DHG (Dublin 1993)

Campbell, Julian, *The Irish Impressionists: Irish Artists in France and Belgium, 1850–1914*, exh. cat. NGI (Dublin 1984)

Cappock, Margarita, *Francis Bacon's Studio* (London and New York 2005)

Carroll, Clare and Patricia King, *Ireland and Postcolonial Theory* (Cork 2003)

Carville, Justin, *Photography and Ireland* (London 2011)

Casey, Christine, *Folk Tradition in Irish Art: An Exhibition of Paintings from the Collection of the Department of Irish Folklore, University College Dublin* exh. cat. Newman House (Dublin 1993)

Catto, Mike, *Art in Ulster*, II (Belfast 1977)

Circa (Belfast 1981–2009)

Circa Index, 1981–1991 (Belfast 1992)

Clancy, Paula, Martin Drury, Anne Kelly, Teresa Brannick and Sheila Pratschke, *The Public and the Arts: A Survey of Behaviour and Attitudes in Ireland* (Dublin 1994)

Clark, Adrian, *British and Irish Art, 1945–51* (London 2010)

Coffey, Stella, *Visual Invincible: A Strategic Review of the Visual Art Market in Ireland* (Dublin 1999)

Condon, Denis, *Early Irish Cinema, 1895–1921* (Dublin 2008)

Conley, Alston and Jennifer Grinnell (eds), *Re/Dressing Cathleen: Contemporary Work from Irish Women Artists*, exh. cat. McMullen Museum of Art, Boston College (Boston, MA 1997)

Connolly, Maeve, *The Place of Artists', Cinema: Space, Site and Screen* (Bristol and Chicago 2009)

Coolahan, John, *Irish Education: Its History and Structure* (Dublin 1981; repr. 2000)

Corás Trachtála Teoranta, *Design in Ireland: Report of the Scandinavian Design Group in Ireland, April 1961* (Dublin 1962)

Cosgrove, Mary, 'Irishness and Art Criticism', *Circa*, no. 52 (July/Aug. 1990), 14–19

Cotter, Lucy (ed.), *Third Text: special Ireland issue*, XIX, 5 (Sept. 2005)

——, 'Mixed Messages: Ambivalence and Diaspora in Irish Art', *Contexts*, IV, 4 (2006), 51–5

——, 'Multiple Agendas, Impossible Dialogues: Where Irish Studies and History of Art Meet', *Variant*, no. 29 (Summer 2007), 18–20

Coulter, Riann, 'Hibernian Salon de Refusés', *Irish Arts Review*, XX, 3 (Autumn 2003), 80–5

——, 'Translating Modernism: Mainie Jellett, Ireland and the Search for a Modernist Language', *Apollo* (Sept. 2006), 56–62

——, 'The Transmutation of Art into Bread and Butter: Victor Waddington and Irish Art', in Yvonne Scott (ed.), *Jack B. Yeats: Old and New Departures* (Dublin 2008)

—— (ed.), *The Surreal in Irish Art*, exh. cat. F.E. McWilliam Studio (Banbridge 2011)

Coulter, Riann and Aoife Ruane (eds), *Nano Reid and Gerard Dillon*, exh. cat. Highlanes Gallery, Drogheda (Drogheda 2009)

Craig-Martin, Michael, 'The Teaching of Josef Albers: A Personal Reminiscence', *Burlington Magazine* (Apr. 1995)

Crampton Walker, J., *Irish Life and Landscape* (Dublin 1927)

Croft, Paul, *Stone Lithography* (London 2001)

Crookshank, Anne and the Knight of Glin, *The Painters of Ireland, c. 1660–1920* (London 1978)

——, *Ireland's Painters, 1600–1940* (New Haven and London 2002)

——, *The Watercolours of Ireland* (London 1994)

Crow, Thomas, *Modern Art in Common Culture* (New Haven and London 1996)

Cullen, Fintan, *Visual Politics: The Representation of Ireland, 1750–1930* (Cork 1997)

—— (ed.), *Sources on Irish Art: A Reader* (Cork 2000)

——, *The Irish Face: Redefining the Irish Portrait* (London 2004)

——, *Ireland on Show: Art, Union and Nationhood* (Ashgate 2012)

Cullen, Fintan and John Morrison (eds), *A Shared Legacy: Essays on Irish and Scottish Art and Visual Culture* (Aldershot 2005)

Cunningham, John and Taryn Gleeson, *Painting in the Noughties*, exh. cat. Letterkenny Arts Centre (Letterkenny 2008)

Curran, C.P., 'Evie Hone: Stained Glass Artist', in Stella Frost (ed.), *A Tribute to Evie Hone and Mainie Jellett* (Dublin 1957), pp. 23–37

Cusack, Tricia, 'Migrant Travellers and Touristic Idylls: The Paintings of Jack B. Yeats and Post-colonial Identities', *Art History*, no. 21 (1998), 201–18

Dalsimer, Adele (ed.), *Visualizing Ireland: National Identity and the Pictorial Tradition* (Boston and London 1993)

Dalsimer, Adele M. and Vera Kreilkamp (eds), *America's Eye: Irish Painting from the Collection of Brian P. Burns*, exh. cat. McMullen Museum of Art, Boston College (Boston, MA 1996)

Davison, David, 'The Talented Captain Bligh', *Irish Arts Review* (Spring 2006), 94–9

Davoren, Ann (ed.), *Living Landscape: European Topographies*, exh. cat. West Cork Arts Centre; An Tuireann, Skye (Cork 2002)

de Breffny, Brian and George Mott, *The Churches and Abbeys of Ireland* (London 1976)

de Courcy, Catherine, 'The History of the RHA', in Ann Stewart, *RHA Index of Exhibitors*, I (Dublin 1985)

Deepwell, Katy (ed.), *Dialogues: Women Artists from Ireland* (New York and London 2005)

Desmond, William, *Philosophy and Its Others* (New York 1990)

Dillon, Brian, 'Future Anterior', *Dublin Review* (Summer 2010), 18–28

Donoghue, Denis, *The Arts without Mystery* (London 1983)

——, *Speaking of Beauty* (New Haven and London 2003)

Downey, Karen (ed.), *Into the Light: The Arts Council – 60 Years of Supporting the Arts*, exh. cat. CAG, HL, Model Art Gallery, Sligo (Dublin 2012)

Duddy, Tom, 'Irish Art Criticism: A Provincialism of the Right?', *Circa*, no. 35 (July/Aug. 1987), 14–18

——, *A History of Irish Thought* (London 2002)

Duffy, Patrick J., *Exploring the History and Heritage of Irish Landscapes* (Dublin 2007)

Dukes, Órla and Catherine Marshall (eds), *The Irish Museum of Modern Art: Celebrating a Decade* (Dublin 2001)

Duncan, Ellen, 'The Irish National Portrait Collection', *Burlington Magazine* (Oct. 1907), 6–20

Dunne, Aidan, 'A Celtic Art?', *Crane Bag*, V, no. 2 (1981)

——, 'Saving the Phenomena: Formalist Painting in the 1980s', in *A New Tradition*, exh. cat. DHG (Dublin 1990)

——, 'Back to the Future: A Context for Irish Art of the 1980s', in *A New Tradition*, exh. cat. DHG (Dublin 1990a), pp. 21–7

——, 'Seminal Art', *Circa*, no. 70 (Winter 1994), 20–5

——, 'Politics', in James Christen Steward (ed.), *When Time began to Rant and Rage* (London 1998)

———, 'An Alternative History of Contemporary Irish Art', in Bruce and Marshall (eds), *Siar 50: 50 Years of Irish Art from the Collections of the Contemporary Irish Art Society*, exh. cat. IMMA (Dublin 2006)

———, *On Reflection – Modern Irish Art 1960s–1990s: A Selection from the Bank of Ireland Art Collection* (Cork 2007)

Durkan, Joe, *The Economics of the Arts in Ireland* (Dublin 1994)

Eckett, Jane, 'Under the Hammer: Collecting at Auction in Ireland', *Circa*, no. 108 (2004), 48–51

Elkins, James, 'The State of Irish Art History', *Circa*, no. 106 (Winter 2003)

———, 'The Fenton Gallery in the Context of International Art', in Nuala Fenton (ed.), *Representing Art in Ireland: The Fenton Gallery* (Cork 2008)

Everitt, Anthony, *The Creative Imperative: A Report on Support for the Individual Artist in Ireland* (Dublin and Belfast 2000)

Fallon, Brian, *Irish Art, 1830–1900* (Belfast 1994)

———, *An Age of Innocence: Irish Culture, 1930–1960* (Dublin 1999)

Fallon, Conor, 'The RHA and What it is About', *Art Bulletin*, XVII, no. 96, AAI (Dec. 2000/Jan. 2001), 11–13

Farley, Fidelma, *This Other Eden (Ireland into Film)* (Cork 2001)

Farson, Daniel, *The Gilded Gutter Life of Francis Bacon* (London 1993)

Fenton, Nuala (ed.), *Representing Art in Ireland: The Fenton Gallery* (Cork 2008)

Finlay, Sarah, *National Self-portrait Collection of Ireland: Volume 1, 1979–1989* (Limerick 1989)

———, *A Guide to Visual Arts Venues in Ireland* (Dublin 1992)

Fisher, Jean, *The Enigma of the Hero in the Work of James Coleman* (Derry 1983)

Fisher, Jean, 'So Different…and Yet', in *James Coleman*, exh. cat. IMMA, Project Arts Centre, Dublin RHA (Dublin 2009)

Fitzgerald, Sandy (ed.), *An Outburst of Frankness: Community Arts in Ireland—A Reader* (Dublin 2004)

Fitzgibbon, Marian and Ann Kelly (eds), 'From Maestro to Manager: Critical Issues in Arts and Culture Management', *Journal of Cultural Economics*, XXII, no. 1 (1998), 61–2

Folan, Andrew and Brian Fay, *Milestones: Black Church Print Studio, 1982–2007*, exh. cat. (Dublin 2007)

Foster, Roy, '"Old Ireland and Himself": William Orpen and the Conflicts of Irish Identity', *Estudios Irlandeses* (2005), 39–50

Fowler, Joan, 'Art and Independence: Aspects of Twentieth-century Irish Art', *Circa*, no. 14 (Jan./Feb. 1984), 6–10

———, 'Speaking of Gender…Expressionism, Feminism and Sexuality', in *A New Tradition*, exh. cat. DHG (Dublin 1990), pp. 53–67

———, 'Locating the Context – Art and Politics in the 80s', in *A New Tradition*, exh. cat. DHG (Dublin 1990a), pp. 117–29

Fried, Michael, 'Art and Objecthood', *Artforum*, no. 5 (June 1967)

Friers, Rowel, *Drawn from Life: An Autobiography* (Belfast 1994)

Frost, Stella (ed.), *A Tribute to Evie Hone and Mainie Jellett* (Dublin 1957)

Guinness Peat Aviation Awards for Emerging Artists (1981–89)

Gallagher, William, *National Self-Portrait Collection of Ireland: Volume 2, 1989–1999* (Limerick 2006)

Garnham, N. and K. Jeffery (eds), *Culture, Place and Identity* (Dublin 2005)

Gibbons, Luke, *Transformations in Irish Culture* (Cork 1996)

Gillespie, Raymond and Brian P. Kennedy (eds), *Ireland: Art into History* (Dublin 1994)

Giltrap, Catherine (ed.), *George Dawson: An Unbiased Eye. Modern and Contemporary Art at Trinity College Dublin since 1959* (Dublin 2010)

———, 'George Dawson's Legacy', *Irish Arts Review*, XXVII, no. 4 (Dec. 2010–Feb. 2011), 78–81

Glen Dimplex Artists Awards, 1994–2001

Glennie, Sarah (ed.), *Two Painters: Works by Alfred Wallis and James Dixon*, exh. cat. IMMA, Tate St Ives (London 1999)

——— (ed.), *Four Now: A Joint Exhibition of the Collections of the Arts Council/An Chomhairle Ealaíon and the Arts Council of Northern Ireland*, exh. cat. Lewis Glucksman Gallery, Cork (Dublin 2005)

Godfrey, Tony, *Conceptual Art* (London 1998)

Graeve. Jobst (ed.), *In a State: An Exhibition in Kilmainham Gaol on National Identity*, exh. cat. Kilmainham Gaol (Dublin 1991)

Graham, Colin, *Deconstructing Ireland: Identity, Theory, Culture* (Edinburgh 2001)

Granville, Gary (ed.), *Art Education and Contemporary Culture* (Bristol 2012)

Grattan, Patricia, Bonnie Leyton, *Human/Nature: Seven Artists from Ireland*, ACNI exh. cat. touring Newfoundland (Belfast 1999)

Greenberg, Clement, 'Poetry of Vision', *Artforum*, no. 6 (Apr. 1968); repr. in John O'Brian (ed.), *Clement Greenberg: The Collected Essays and Criticism*, IV (Chicago and London 1993)

Greenberg, Reesa, Bruce Ferguson and Sandy Nairne (eds), *Thinking about Exhibitions* (New York 1996)

Groarke, Vona, *Local Authorities, Local Arts*, AC/ACE (Dublin 2002)

Hall, Patrick, 'Notes on Painting', *Arena*, no. 1 (Spring 1963)

Hardy, Ken, 'Diaspora', *Circa*, no. 69 (1994), 43–5

Harmon, Maurice (ed.), *The Dolmen Press: A Celebration* (Dublin 2001)

Harries, Meirion and Susie Harries, *The War Artists* (London 1983)

Harris, Penny (ed.), *Art in State Buildings 1995–2005* (Dublin 2006)

Harrison, Martin, 'Points of Reference, Francis Bacon and Photography', in *Francis Bacon: Paintings from the Estate 1980–1991*, exh. cat. Faggionato Fine Art Gallery (London 1999)

Hartigan, Marianne, 'The Irish Exhibition of Living Art', *Irish Arts Review*, IV, no. 4 (Winter 1987)

———, 'Irish Women Painters and the Introduction of Modernism', in James Christen Steward (ed.), *When Time began to Rant and Rage* (London 1998)

Hartz, Jill and Susan Bacik (eds), *Re-Imagining Ireland: Irish Art Today*, exh. cat. University of Virginia Art Museum (Charlottesville 2003)

Heaney, Seamus and Hughie O'Donoghue, *The Testament of Cresseid* (London 2004)

Hearne, John M. (ed.), *Glassmaking in Ireland: From the Medieval to the Contemporary* (Dublin 2010)

Hewitt, John, *Art in Ulster*, I (Belfast 1977)

Hewson, Rachel, 'Conflicting Histories', *Irish Arts Review*, XXII, no. 4 (Winter 2005), 102–7

Higgins, Aidan, *Windy Arbours: Collected Criticism* (Dublin, London and Illinois 2005)

Higgins, Judith, 'Report from Ireland: Art From the Edge, Part 1', *Art in America*, LXXXIII (Dec. 1995), 37–40

Hill, Derek (ed.), *Tory Paintings in Irish Houses*, exh. cat. Kilkenny Art Gallery (Kilkenny 1972)

Hodge, Anne, 'Sound Judgements and Pure Taste', *Irish Arts Review* (Spring 2007), 92–7

Hunter, Jim, *Tory Island and its Artists* (Belfast 2003)

Hutchinson, John, 'Sense, Direction and Selected Images: Irish Art in the 1980s', *Circa* (Mar./Apr. 1990)

———, 'Myth and Mystification', in *A New Tradition*, exh. cat. DHG (Dublin 1990a), pp. 81–3

———, 'The Nature of landscape', in *A New Tradition*, exh. cat. DHG (Dublin 1990b), pp. 37–43

Ingouville-Williams, Herbrand, *Three Painters* (Dublin 1945)

Irish Arts Review (Dublin 1984–87, 2000–)

Irish Arts Review Yearbook (Dublin 1988–99)

Isaacs, Jeremy, 'Strong Eye', *Modern Painters* (Spring 1993), 77–9

Campbell, Laurence 27, 236, 491 (qv *AAI* III)
Campbell-Sharp, Noelle 25
canon of Irish art 74, 95, 208, 209, 317, 318, 343
Cantillon, Joanna 24
Caoineadh Airt Uí Laoire (The Lament for Art O'Leary) (film) 172–73
Capuchin Annual (periodical) 91, 92, 227, 399
Carlisle, Anne 477, 492
carpet design 127. See also rug design
Carr, Eithne 23
Carr, Tom 32, **62–63**, 429
 A Day at the Seaside 63
Carroll, Denis 18
Carroll, Don 370, 386, 387
Carroll's, P.J. (tobacco manufacturer) 18, 73, 319, 344, 354, 370, 386, *386*, 455
 sponsorship of Carroll's Art Awards 70, 94, 238, 354
Carson, Sir Edward 266
Carson, John 389, 476, 477
Cartier-Bresson, Henri 233, 357
Carton LeVert (graphic design studio) 134
Cartoon Saloon 133, 227
cartoons and caricatures *116*, 226–27, 319, 402, 431, 474, 497–98. *See also* animation industry
Carville, Justin 359
Casement, Roger, as photographer 356
Casey, Stephanie Condon 29
Castleisland Arts Centre 407
Castro, Jota 120
catalogues of exhibitions and collections 3, 160–61, 211, 308, 499
 critical writing in 91, 94, 95
 Rosc exhibition catalogues 94, 327, 420–21, 422, 423
 White Stag Group catalogues 488
Catalyst Arts, Belfast 24, 28, *28*, 119, 318, 466, 468
Catholicism. See Church and art; religion and spirituality in Irish art
CBT Systems 133
Celant, Germano 162, 235
Celtic art
 and abstraction 9, 11, 167, 218, 222, 243, 422
 and identity of Irish Free State 122, 123, 243, 297
 influence on Jim Fitzpatrick 177
Celtic Revival 2, 64, 121, 210, 298, 453, 476
'Celtic Tiger' economy 18–19, 79, 96, 182, 358
censorship
 and body in art 48, 66, 115, 337
 and Clarke's *Geneva Window* 66, 351, 364, 452
 influence of Church in society 412
 and public art 372
ceramic design 126, 127, 128, 130, 132
Charlesworth, Ian 24
Chaviré, Roger 207
Chester Beatty, Sir Alfred 71, 312, 354, 383–84, *384*, 392
Chester Beatty Library, Dublin 383
 Chogonka Scroll interactive kiosk 133, *133*
 role as national institution 310, 314
Chewett, Jocelyn 488–89
Child, A.E. (Alfred Ernest) 64, 121, 216, 234, 399, 451, 492
Childers, Erskine 79, 110, 372
Christie's (auction house) 18, 19, 20
Church and art. *See also* religion and spirituality in Irish art
 Arts and Crafts designs in 121
 and body and art 49–50, 51, 52
 and critical writing on art 91, 92
 design and public religious displays *124*, 125
 and Patrick Graham's work 188
 influence of Church in wider culture and society 412–13
 limited patronage 121, 351, 353–54, 413–14, 453
 support for stain-glass work 354, 399, 413, 414, 453
 suspicion of film-making 169, 170
Cill Rialaig, Ballinskelligs, Co. Kerry 25
Circa (journal) 3–4, 26, 147, 317, 476, 506
 artists and critical discourse 95, 210, 211, 389–90, 505

funding cuts 502
 and performance and time-based art 283, 467, 470
 women's role in 492
City Arts Centre, Dublin 120, 347
Civil Arts Enquiry project 120
Claffey, Vaari 505
Clare, Mark 23
Clarke, Carey **63–64**, 148, 373, 403, 428
 Reading the Headlines 63
 Substance and Shadow: Still life with a shelf 63, *63*
 The Tobacco Barn 63
Clarke, Declan 23
Clarke, Harry 13, 20, **64–66**, 213, 217, 248, 277, 339. See also Harry Clarke Studios
 as illustrator 64, 66, 225, 452
 stained-glass work 13, 64, 121, 216, 354, 413, 451–52
 The Eve of St Agnes 65, 66, 452
 Geneva Window 66, 310, 351, *351*, 364, 452
 Ligeia 64
 St Gobnait 451
Clarke, Joshua 276, 451
Clarke, Margaret (née Crilley) 26, 27, 64, **66–67**, 148, 159, 236, *237*, 491
 Orpen as influence on 339, 342
 Mary and Brigid 213
 Strindbergian 67, *67*, 213
Clear, Felicity 23
Cleary, Anne 468
Cleese, Brian 422
Clifden Arts Festival 406
Cloake, Mary 15
Clough, Prunella 191
cnuas funding from Aosdána 15, 34
Coda, Áine Nic Giolla 24
Coffey, Brian, *Monster: A Concrete Poem* 55, *55*
Coffey, Dennis J., 207
Coffey, Ella 342, 444
Coffey, Stella 29, 80
coin designs 122–23, *123*
Cole, Walter 79
Coleman, James **67–70**, 74, 78, 139, 153, delete 215, 318, 387
 as Conceptual artist 81, 82, 83
 installation and time-based art 228–29, 301, 316, 358, 466
 international profile 1, 6, 217
 Krauss on 220–21, 466
 politics and work 69–70, 223
 Outsider artists 340
 and portraiture 373
 and residency programmes 25, 55
 and Rosc exhibitions 421, 422, 423, 424
 Box (ahhareturnabout) 68, 222, 223, 316, 327, 424
 Charon (MIT Project) 466
 guaiRE: An Allegory 223, *224*
 Seeing for Oneself 68
 Slide Piece 67, 68
 So Different... and Yet 466, *467*
 Strongbow 68–69, *69*, 70
Coleman, Michael 70, 295
 Through Black 70
Coll, John (qv *AAI* III), 348
collecting art 17–18, 27, **71–74**, 158, 288. See also art market; patronage and awards; private and corporate art collecting; publicly funded collections
 artists' collections 193, 205, 216, 267
 background 71–72
 book art 56
 catalogues of collections 3, 160–61, 283
 collectors 73, 232
 identification of Irish canon 74
 initiatives for 72–73
 Quinn's resistance to collection 400
collectives and co-operatives 26, 162. *See also* Blue Funk
 and art market 21–22, 28–29
 furniture design 131
 performance and time-based art 466, 468, 469
 printmaking 22, 26, 28, 382
 and studio space 21–22, 22–23, 25
College Gallery Picture Hire Scheme 72, 208, 384

College of Marketing and Design, Dublin 130, 132
Collie, George 26, 371
Collins, Patrick 11, 17, 32, **74–75**, 85, 93, 238, 365
 landscape and Irish identity in work 75, 259–60, 343, 366
 Bird against the Window 74
 Children Playing 75
 Liffey Quaysides 74–75, 262–63, *263*
 The Rook: Bird in a Tree 75
 Travelling Tinkers 260, 344
Collins, Phil 137
Collins, Suzanne 23
Collis, Maurice 92
colonization experience and development of Irish art 5–6, 48, 219, 360
 and Irish diaspora 136, 137
 landscape 257
 and Modernism 297
 and public monuments 351, 388
 and scholarship and history of art 209
 women's experiences 490
Combridge's (picture-framers) 16, 76
Comerford, Helen (qv *AAI* III), 295–96
 96 Bag Piece II, 295
Comerford, Joe 172
 Down the Corner (film) 173
Comerford, Oliver **76**, 263
 Out Here III, 76
commercial galleries 16–17, 20, 73, **76–80**, 109, 162, 163. *See also* art market *and individual galleries*
 and printmaking 381
 support for artists 77, 142, 292, 334, 343–44
Commonage studio, Callan, Co. Kilkenny 508, *508*
community arts. *See* participatory arts
Community Arts Forum (CAF), 347
computers/computer peripherals and design 130
computer and video gaming 133, 184, 501, 503
Concagh, Jimmy (James) 97, 149
Conceptual art **80–83**, 106, 138, 228. *See also* installation art; Minimalism; time-based art
 and book art 54–55
 and collecting 386
 and curating 116
 influence on photography 358
 and map-making 418
 O'Doherty/Ireland as exemplar of 326
conferences on Irish art 4
Conn, W.H., 227
Connolly, Denis 468
Connolly, Maeve 505
Connolly, Sybil 126, 127, 128, 131, 385
 coat design 127
Connor, Valerie 44, 229
Conolly, Thurloe 10, 27, **83–84**, 127, 455, 460, 489
 Hall's Barn and Dovecote 83
Conolly, Yvonne (née Boydell) 83
Conor, William **84–85**, 140, 201–02, 262, 429
 The Jaunting Car (No. 1), 84
 Picture House Queue 20, *20*
 Ulster Past and Present mural 84
Conroy, Tom 347
consumerism and design 125, 126
contemporary art (IRL). *See also* new media art; time-based art
 recent developments **501–09**
Contemporary Irish Art Society (CIAS), 11, 72, 77, 303, 311, 354, 369, 385, 387, 393
Contemporary Picture Galleries, Dublin 17, 102, 160
Context Gallery, Derry 407, 409
Coogan, Amanda 368, 467
 Madonna in Blue 51, *51*
Coogan, Pat 474
Cooke, Barrie 17, 48, 54, **85–86**, 118–19, 139, 231, 252, 303
 and Independent Artists Group 28, 162, 238

landscape and environmental concerns 182, 262
 politics and art 366
 portraiture 373
 tapestry designs 456
 'bone boxes', 85
 Potatoes Underground 72
 'Sheela-na-gig' series 85, *86*, 344
 Siobhan McKenna 373
Cooke, Liadin (qv *AAI* III), 137
Cooke-Collis, Sylvia 26
Cooper, Tom 170
co-operatives. *See* collectives and co-operatives
Copper Reed (graphic design studio) 134
Coppock, Christopher 95, 370
copyright protection 22, 40, 400
Coracle imprint 55, 56, 139
Córas Tráchtála Teoranta (CTT) (Irish Export Board) 127, 128
Corcoran, Margaret 403
Cork. *See also* Crawford Art Gallery; Crawford College of Art; Crawford Municipal School of Art; Honan Chapel; National Sculpture Factory
 art education and colleges 154, 155
 Arts Council development of arts in 35–36, 405
 Church of Christ the King 414
 collectives and co-operatives 24, 35
 Cork Municipal Collection 396
 European City of Culture programme 503–04
 galleries 79, 119, 162, 310, 313, 397
 participatory arts 349
 printmaking co-operatives 22, 24, 26, 28, 382
 regional arts centres 35, 405, 407
 residencies 24
 societies 26, 27
 studios and facilities for artists 22, 24
Cork Arts Society 27, 35, 79
Cork Caucus initiative (2005), 96, 234
Cork Community Artlink 349
Cork Community Artsquad 341
Corkery, Daniel 109
Cork Printmakers and studios 22, 24, 28, 382
corporate branding and design 129–30, 131, 132, 134
corporate sponsors and collectors. *See* private and corporate art collecting
Corral, María de 235
Cosgrave, W.T., 16, 66, *249*, 383, 426
Cosgrove, Mary 4, 95
Costello, John A., 21, 30, 110–11
Costelloe, Paul 131
Cothú (arts business organization) 311, 354
Cotter, Lucy 5, 6, 140
Cotter, Maud (qv *AAI* III), 24, 137, 155, 454
Coughlin, Jack 380
Coulter, Riann 430
Council for the Encouragement of Music and the Arts (CEMA), 27, 30, 43, 62, 72–73, 85, 160, 393. *See also* Arts Council of Northern Ireland
Council of Design 128
Council of National Cultural Institutions (CNCI), 70, 157, 310, 315
'The Country Shop', Dublin 122, 141, 416
Courtney, Daniel 381
Coutard, Raoul 306
Cox, Gerard 28
Coyle, Brian 387
Coyle, Gary 23, **87**, 150, 234
 Death in Dun Laoghaire 87
 Scene of the Crime no. 38, 87
Coyle, Martina 390
Crafts Council of Ireland (CCoI), 130, 131–32
craftsmanship. *See* design and material culture
Craig, Harry Robertson 199, 200
Craig, James Humbert **87–88**, 202, 260, 429
 Going to Mass 88
Craig, Maurice 89, 210
Craig, Michael, (qv *AAI* III), **88–89**
 architectural drawings 89
 postage stamp designs 88, *88*, 89

INDEX

compiled by Jane Horton

The index includes only places, persons, organizations, objects or subjects of significance in this volume. Page references in bold indicate a main entry and page references in italics an illustration. Relevant cross-references to other volumes of *AAI* are indicated by (qv). Passing references and items in 'Selected Reading' are not normally included. Alphabetical order is letter-by-letter, e.g. Blackham, Dorothy files before Black Market International. Names beginning with the prefixes Mac, Mc, M' etc. are interfiled as though they all begin with Mac. Names of organizations are given in full; there is a list of Abbreviations on pages xviii–xix. Numbers in headings are filed as though spelled out.

The Irish Imagination: Rosc '71, 1959–1971, exh. cat. HL; New Boston City Hall Art Gallery; Philadelphia Civic Centre Museum; Corcoran Museum, Washington DC (Dublin 1971)

Irish Women Artists: From the Eighteenth Century to the Present Day, exh. cat. NGI; DHG; HL (Dublin 1987)

Knot: Alice Maher Draws from the Collection of the Hugh Lane Municipal Gallery, exh. cat. HL (Dublin 1999)

Literary Lives: Portraits from the Crawford Art Gallery and Abbey Theatre, Ireland, exh. cat. McMullen Museum of Art, Boston College (Cork 2010)

Living Landscape: European Topographies, exh. cat. West Cork Arts Centre, An Tuireann, Skye (Cork 2002)

Magnum Ireland, exh. cat. IMMA (London 2005)

Milestones: Black Church Print Studio, 1982–2007, exh. cat. (Dublin 2007)

Modern Graphics and Multiples, Bishop's Palace, Waterford, exh. cat. (Dublin 1971)

The Moderns, exh. cat. IMMA (Dublin 2011)

NCAD: 250 Drawings, 1746–1996, exh. cat. Gallagher Gallery, RHA (Dublin 1996)

Nano Reid and Gerard Dillon, exh. cat. Highlanes Gallery, Drogheda (Drogheda 2009)

A New Tradition: Irish Art of the Eighties, exh. cat. DHG (Dublin 1990)

Out of Order: Mapping Social Space, exh. cat. Colorado University Art Galleries (Boulder 2001)

Painting in the Noughties, exh. cat. Letterkenny Arts Centre (Letterkenny 2008)

Re/Dressing Cathleen: Contemporary Work from Irish Women Artists, exh. cat. McMullen Museum of Art, Boston College (Boston, MA1997)

Re-Imagining Ireland: Irish Art Today, exh. cat. University of Virginia Art Museum (Charlottesville 2003)

Rosc exh. catalogues, 1967, 1971, 1977, 1980, 1984, 1988

Royal Hibernian Academy exh. catalogues (Dublin 1900–99)

Siar 50: 50 Years of Irish Art from the Collections of the Contemporary Irish Art Society, exh. cat. IMMA (Dublin 2006)

Six Artists from Ireland, exh. cat. Arts Council touring exhibition (Dublin 1983)

Something Else: Contemporary Art from Ireland, exh. cat. Turku Art Museum; Amos Anderson Art Museum, Helsinki; Oulu City Art Museum; Joensuu Art Museum (2002)

The Surreal in Irish Art, exh. cat. F.E. McWilliam Studio (Banbridge 2011)

Terror and the Sublime: Art in an Age of Anxiety, exh. cat. CAG (Cork 2008)

A Time and a Place: Two Centuries of Irish Social Life, exh. cat. NGI (Dublin 2006)

Tory Paintings in Irish Houses, exh. cat. Kilkenny Art Gallery (Kilkenny 1972)

Two Painters: Works by Alfred Wallis and James Dixon, exh. cat. IMMA; Tate St Ives (London 1999)

Unique Act: Five Abstract Painters, exh. cat. HL (Dublin 2008)

Views from an Island: Contemporary Irish Art from the Collection of the Irish Museum of Modern Art, exh. cat. Millenium Monument Museum, Beijing; Shanghai Art Museum (Shanghai 2004)

When Time began to Rant and Rage: Figurative Painting from Twentieth-century Ireland, exh. cat. Berkeley Art Museum (London 1998)

The West as Metaphor, exh. cat. RHA (Dublin 2005)

The White Stag Group, exh. cat. IMMA (Dublin 2005)

Young Irish Artists, Kenny's Art Gallery, Galway, exh. cat. (Dublin 1971)

Sheridan, Noel (ed.), *NCAD: 250 Drawings, 1746–1996*, exh. cat. Gallagher Gallery, RHA (Dublin 1996)

Sherlock, Maureen P., *Out of Order: Mapping Social Space*, exh. cat. Colorado University Art Galleries (Boulder 2001)

Sholette, Gregory, *Dark Matter: Art and Politics in the Age of Enterprise Culture* (London 2011)

Slide, Anthony, *The Cinema and Ireland* (North Carolina 1988)

Snoddy, Theo, *Dictionary of Irish Artists: 20th Century* (Dublin 1996; 2nd edn. 2002)

Somerville-Large, Peter, *The Story of the National Gallery of Ireland, 1854–2004* (Dublin 2004)

Stairs, Susan, *The Irish Figuratists and Figurative Painters in Irish Art* (Dublin 1990)

Stephens, Chris (ed.), *The History of British Art, 1870–Now* (London 2008)

Steward, James Christen (ed.), *When Time began to Rant and Rage: Figurative Painting from Twentieth-Century Ireland*, exh. cat. Berkeley Art Museum (London 1998)

Suchin, Peter, 'Writing the Body', *Circa* (Summer 1995)

Sverakova, Slavka, 'Radical Therapies: Contemporary Performance Art in Ireland', art supplement in *Fortnight*, no. 375 (Dec. 1998/Jan. 1999), 7–9

Teahan, John (ed.), *Irish Decorative Arts, 1550–1928* (Dublin 1990)

Thiessen, Gesa E., *Theology and Modern Irish Art* (Dublin 1999)

Thorpe, Ruth (ed.), *Designing Ireland: A Retrospective of the Kilkenny Design Workshops, 1963–1988*, Crafts Council of Ireland (Kilkenny 2005)

Tipton, Gemma (ed.), *Space: Architecture for Art Including a Directory of Arts Spaces in Ireland* (Dublin 2005)

Townsend, Chris, *New Art from London* (London 2006)

Turner, Silvie (ed.), *A Printmaker's Handbook* (London 1989)

Turpin, John, 'The National College of Art under Keating and McGonigal', *Irish Arts Review*, no. 5 (1988), 201–11

——, 'The RHA Schools: The First Eighty Years 1826–1906', *Irish Arts Review* (1991/92), 198–209

——, *A School of Art in Dublin since the Eighteenth Century: A History of the National College of Art and Design* (Dublin 1995)

——, 'The Irish Design Reform Movement of the 1960s', in Dennis P. Doordan (ed.), *Design History: An Anthology* (Cambridge, MA 1995; repr. 2000); pp. 252–69

——, *Hugh Lane and the RHA's Winter Exhibitions of the Early Twentieth Century*, exh. cat. 172nd annual exhibition of the RHA (Dublin 2002)

Turpin, John and Noel de Chenu, *Art in State Buildings, 1985–1995* (Dublin 1995)

Upstone, Robert, *Modern Painters: The Camden Town Group* (London 2007)

Waddington, Victor, *Twelve Irish Artists* (Dublin 1940)

Wade, Gavin (ed.), *Curating in the 21st Century* (Wolverhampton 2000)

Walker, Dorothy, 'Installations and Performance in Ireland', *Flash Art* (Oct./Nov. 1979)

——, 'Portrait of the Artist as a Young Woman', *Crane Bag*, IV, no. 1 (1980), 106–11

——, *Modern Art in Ireland* (Dublin 1997)

Wilson, Mick, *What Is – Conceptual Art?* IMMA, What is…? series (Dublin 2009)

Wyndham, Andrew Higgins (ed.), *Re-imagining Ireland* (Charlottesville, VA and London 2006)

Wynne, Michael, *Irish Stained Glass* (Dublin 1977)

Yeats, Jack B., *Modern Aspects of Irish Art* (Dublin 1922)

Ziff, Trisha (ed.), *Distant Relations: A Dialogue between Chicano, Irish and Mexican Artists* (New York 1995)

EXHIBITION CATALOGUES

The Allied Irish Bank Collection: Twentieth-century Irish Art, exh. cat. DHG (Dublin 1986)

America's Eye: Irish Painting from the Collection of Brian P. Burns, exh. cat. McMullen Museum of Art, Boston College (Boston, MA 1996)

Art Unsolved: Outsider Art from the Musgrave Kinley Collection, exh. cat. IMMA (Dublin 1998)

Beyond the White Cube: A Retrospective of Brian O'Doherty/Patrick Ireland, exh. cat. HL (Dublin 2006)

Brian Ballard, Charles Brady, exh. cat. Tom Caldwell Gallery (Belfast 1984)

Chronoscope, exh. cat. Newman House (Dublin 2008)

Connected/Disconnected/Re-connected: The Art of Patrick Graham and John Philip Murray, exh. cat. West Cork Arts Centre (Cork 2010)

The Delighted Eye: Irish Painting and Sculpture of the Seventies, exh. cat. touring exhibition, Arts Councils of Ireland (Dublin 1980)

Distant Relations: A Dialogue between Chicano, Irish and Mexican Artists, exh. cat. Ikon Gallery, Birmingham; Camden Art Centre, London; Irish Museum of Modern Art; Santa Monica Museum of Art, California; Museo de Arte Contemporáneo de Carrillo Gil, Mexico (1995)

Divisions, Crossroads, Turns of Mind: Some New Irish Art, exh. cat. Williams College Museum of Art (Williamstown, MA 1985)

Folk Tradition in Irish Art: An Exhibition of Paintings from the Collection of the Department of Irish Folklore, University College Dublin exh. cat. Newman House (Dublin 1993)

Four Now: A Joint Exhibition of the Collections of the Arts Council/An Chomhairle Ealaíon and the Arts Council of Northern Ireland, exh. cat. Lewis Glucksman Gallery, Cork (Dublin 2005)

From Beyond the Pale: Art and Artists at the Edge of Consensus, exh. cat. IMMA (Dublin 1994)

Graphic Studio Dublin: Retrospective Exhibition 1961–1976, exh. cat. (Dublin 1976)

Hearth: Concepts of Home from the IMMA Collection in Collaboration with Focus Ireland, exh. cat. IMMA (Dublin 2006)

Helen Hooker O'Malley Collection, exh. cat. Custom House Studios, Westport Quay (Westport 2007)

Hugh Lane and the RHA's Winter Exhibitions of the Early Twentieth Century, exh. cat. 172nd annual exhibition of the RHA (Dublin 2002)

Human/Nature: Seven Artists from Ireland, ACNI exh. cat. touring Newfoundland (Belfast 1999)

L'Imaginaire Irlandais: Festival de Culture Irlandaise Contemporaine, touring France, exh. cat. (Paris 1996)

In a State: An Exhibition in Kilmainham Gaol on National Identity, exh. cat. Kilmainham Gaol (Dublin 1991)

Inheritance and Transformation, exh. cat. IMMA (Dublin 1991)

Into Irish Drawing, exh. cat. Limerick City Arts Gallery (Limerick 2009)

Irish Art, 1770–1995: History and Society, exh. cat. CAG (Cork 1995)

Irish Art, 1947–1974: The Great Southern Collection, exh. cat. CAG (Cork 2007)

Irish Art and Modernism, 1880–1950, exh. cat. HL, UM (Belfast 1991)

Irish Art Now: From the Poetic to the Political, exh. cat. IMMA, McMullen Museum of Art, Boston College; Art Gallery of Newfoundland and Labrador; Chicago Cultural Center (London and New York 1999)

The Irish Exhibition of Living Art catalogues (1943–45, 1947–82, 1984–87)

The Irish Exhibition of Living Art '82, exhibition in book form (Dublin 1982)

O'Brien, Harvey, *The Real Ireland: The Evolution of Ireland in Documentary Film* (Manchester 2005)

O'Byrne, Robert, *Dictionary of Living Irish Artists* (Dublin 2010)

O'Connor, Éimear (ed.), *Irish Women Artists, 1800–2009: Familiar but Unknown* (Dublin 2010)

O'Doherty, Brian, *Object and Idea: An Art Critic's Journal, 1961–1967* (New York 1967)

—— (ed.), *The Irish Imagination: Rosc '71, 1959–1971*, exh. cat. HL; New Boston City Hall Art Gallery; Philadelphia Civic Centre Museum; Corcoran Museum, Washington DC (Dublin 1971)

——, 'Inside the White Cube: The Ideology of the Gallery Space', *Artforum* (1976; repr. New Jersey and West Sussex 2000)

O'Donnell, E.E., *Father Brown: A Life in Pictures* (Dublin 1994)

O'Donnell, Jessica (ed.), *The Collection Revealed: Cubism*, exh. cat. HL (Dublin 2009)

O'Donoghue, Helen (ed.), *Curating Now* (Dublin 2009)

—— (ed.), *Access All Areas* (Dublin 2009a)

O'Donoghue, Helen and Catherine Marshall, 'Alternative Representations Create Alternative Possibilities', in Rebecca Phelan and Alan Hayes (eds), *Women Emerging* (Galway 2005), pp. 113–16

—— (eds), *Hearth: Concepts of Home from the IMMA Collection in Collaboration with Focus Ireland*, exh. cat. IMMA (Dublin 2006)

O'Drisceoil, Jerome and Ian Russell, *Chronoscope*, exh. cat. Newman House (Dublin 2008)

O'Kane, Marianne, 'Corporate Patronage of the Visual Arts in Ireland', *Circa*, no. 94 (Winter 2000), 39–42

O'Malley, Cormac and Nicolas Allen (eds), *Broken Landscapes: Selected Letters of Ernie O'Malley* (Dublin 2011)

O'Molloy, Marguerite (ed.), *Irish Museum of Modern Art: The Collection* (Dublin 2005)

O'Neill, Kevin, 'Looking at the Pictures: Art and Artfulness in Colonial Ireland', in Adele Dalsimer (ed.), *Visualizing Ireland: National Identity and the Pictorial Tradition* (Boston and London 1993)

O'Neill, Paul and Mick Wilson, *Curating and the Educational Turn* (London and Amsterdam 2010)

O'Neill, Timothy, 'From Fax to Vellum: Producing Manuscript Books in the 21st Century', in Peter Harbison and Valerie Hall (eds), *A Carnival of Learning* (Roscrea 2012)

O'Regan, John (ed.), *Edge to Edge: Three Sculptors from Ireland: Eilis O'Connell, Kathy Prendergast, Vivienne Roche* (Dublin 1991)

O'Reilly, Paul (ed.), *EV+A Compendium* (Limerick 1999)

O'Sullivan, Seán, 'What is a Portrait?', in *Irish Art: A Volume of Articles and Illustrations* (Dublin 1944)

O'Toole, Fintan, 'Light Rain and Governments Falling: Ireland in the Eighties', in *A New Tradition* (Dublin 1990)

——, 'Ireland', in Declan McGonagle, Fintan O'Toole and Kim Levin, *Irish Art Now: From the Poetic to the Political* (London and New York 1999), pp. 21–6

——, 'The 80s', in Birgitte Lardinois and Val Williams (eds), *Magnum Ireland*, exh. cat. IMMA (London 2005), pp. 150–1

Office of Public Works, *From Past to Present: Art from Public Buildings, 1815–2001* (Dublin 2001)

Olley, John, 'Sustaining the Narrative at Kilmainham', *Irish Arts Review Yearbook*, 1991/92, 65–72

Orpen, William, *Stories of Old Ireland and Myself* (London 1924)

Pearse, Pádraig, *The Murder Machine* (Dublin 1916)

Phelan, Rebecca and Alan Hayes (eds), *Women Emerging* (Galway 2005)

Popplewell, Sean, *Exploring Museums: Ireland* (London 1990)

Potterton, Homan, *National Gallery of Ireland, Illustrated Summary Catalogue of Paintings* (Dublin 1981)

Public Art Research Project: Steering Group Report to Government (Dublin 1992)

Purser, Michael, *Jellett, O'Brien, Purser and Stokes: Seven Generations, Four Families* (Dublin 2004)

Pyle, Hilary, *Portraits of Patriots* (Dublin 1966)

—— (ed.), *Irish Art, 1900–1950*, exh. cat. CAG (Cork 1975)

——, *Jack B. Yeats: A Biography* (London 1989)

——, 'The Hamwood Ladies: Letitia and Eva Hamilton', *Irish Arts Review*, XIII (1997), 123–34

Rains, Stephanie, *The Irish American in Popular Culture, 1945–2000* (Kildare 2007)

Robinson, Hilary, *Reading Art, Reading Irigaray* (London 2006)

Rockett, Kevin, Luke Gibbons and John Hill, *Cinema and Ireland* (Dublin 1987)

Rolleston, T.W., *Parallel Paths: A Study in Biology, Ethics and Art* (London 1908)

Rolston, Bill, *Drawing Support: Murals in the North of Ireland* (Belfast 1992)

——, *Drawing Support 3: Murals and Transition in the North of Ireland* (Belfast 2003)

Rooney, Brendan (ed.), *A Time and a Place: Two Centuries of Irish Social Life*, exh. cat. NGI (Dublin 2006)

Rosenblum, Robert, *Modern Painting and the Northern Romantic Tradition* (London 1975)

Rouse, Sarah, *Into the Light: An Illustrated Guide to the Photographic Collections of the National Library of Ireland* (Dublin 1998)

Royal Hibernian Academy special issue, *Martello Arts Review* (Dublin 1991)

Ruane, Frances (ed.), *The Delighted Eye: Irish Painting and Sculpture of the Seventies*, exh. cat. touring exhibition, Arts Councils of Ireland (Dublin 1980)

——, 'Modern Irish landscape Painting', *Recent Irish Art Series*, no. 1 (Dublin 1981)

——, *The Allied Irish Bank Collection: Twentieth-Century Irish Art*, exh. cat. DHG (Dublin 1986)

——, *AIB Art* (Dublin 1995)

Ruane, Medb, 'The *Circa* Interview: Intimate Spaces', *Circa*, no. 77 (Autumn 1996), 20–3

Ryan, Vera, *Movers and Shapers: Irish Art since 1960* (Cork 2003)

——, *Movers and Shapers 2: Irish Visual Art, 1940–2006* (Cork 2006)

——, *Movers and Shapers 3: Conversations in the Irish Art World* (Cork 2011)

Ryan-Smolin, Wanda, Elizabeth Mayes and Jenni Rogers (eds), *Irish Women Artists: From the Eighteenth Century to the Present Day*, exh. cat. NGI; DHG; HL (Dublin 1987)

Saorstát Éireann, Irish Free State Official Handbook (Dublin 1932)

Savage, Jim (ed.), *Drawing Texts* (Cork 2001)

Scott, David, 'Infinite Beginnings', *Irish Arts Review*, VIII (1991/92), 218–25

——, *European Stamp Design: A Semiotic Approach to Designing Messages* (London 1995)

Scott, Yvonne, 'Refreshing the Landscape', *Irish Arts Review* (Spring 2004), 60–1

—— (ed.), *The West as Metaphor*, exh. cat. RHA (Dublin 2005)

——, 'Art in State Buildings 1995–2005', in Penny Harris (ed.), *Art in State Buildings, 1995–2005* (Dublin 2006)

—— (ed.), *Crossing Boundaries: New Research in Irish Art History* (Dublin 2012)

Shaffrey, Clíodhna, *What Is – Public Art?* Irish Museum of Modern Art, What Is … ? series (Dublin 2010)

Sheehy, Edward, 'Recent Irish Painting: The IELA 1950', *Envoy* (Sept. 1950), 45–52

Sheehy, Jeanne, *The Rediscovery of Ireland's Past: The Celtic Revival. 1830–1930* (London 1980)

from Ireland, exh. cat. Turku Art Museum; Amos Anderson Art Museum, Helsinki; Oulu City Art Museum; Joensuu Art Museum (2002)

McGonagle, Declan, John Hutchinson, Hannes Von Gosseln and Michael Tarantino, *Inheritance and Transformation*, exh. cat. IMMA (Dublin 1991)

McGonagle, Declan, Pascal Neveux, Liam Kelly, Gil Jouanard, Jacques Blanc, Laurent Dréano, Joe Brennan and Patrick Mason, *L'Imaginaire Irlandais: Festival de Culture Irlandaise Contemporaine*, exh. cat. (Paris 1996)

McGonagle, Declan, Fintan O'Toole and Kim Levin, *Irish Art Now: From the Poetic to the Political*, exh. cat. IMMA; McMullen Museum of Art; Boston College; Art Gallery of Newfoundland and Labrador; Chicago Cultural Center (London and New York 1999)

McGonagle, Declan and Niall O'Baoill (eds), *Civil Arts Enquiry Documents*, 01–06, 07–08, 09–011, 012–013 (Dublin 2003)

McGookin, Colin, *Glimpse: Contemporary Visual Art by Artists Based in the Belfast Studio Complexes* (Belfast 1999)

MacGreevy, Thomas, 'Picasso, Mainie Jellett and Dublin Criticism', *The Klaxon*, 1 (Winter 1923/24), 23–7

——, *Jack B. Yeats: An Appreciation and an Interpretation* (Dublin 1945)

McHugh, John (ed.), *Helen Hooker O'Malley Collection*, exh. cat. Custom House Studios, Westport Quay (Westport 2007)

McLoone, Martin, *Irish Film: The Emergence of a Contemporary Cinema* (London 2000)

MacNally, Niamh, 'A Subtle Art', *Irish Arts Review* (Autumn 2002), 112

MacWilliam, Shirley, 'Screen and Screen Again', *Circa*, no. 100 (Summer 2002), 42–9

Maguire, Brian, Patrick Hall, Timothy Hawkesworth, Patrick Graham and Seamus Heaney, 'Irish Expressionist Painting', *The Irish Review*, III, no. 1 (Jan. 1988), 26–39

Maher, Alice, *Knot: Alice Maher Draws from the Collection of the Hugh Lane Municipal Gallery*, exh. cat. HL (Dublin 1999)

Mahon, Alyce, *Eroticism & Art* (Oxford 2005)

Mara, Tim, *The Thames and Hudson Manual of Screen Printing* (London 1979)

Marchant, Nick and Jeremy Addis, *Kilkenny Design: Twenty-one years of Design in Ireland* (London 1985)

Mark-Fitzgerald, Emily, *Collaborations and Conversations: Stoney Road Press, 2002–2007* (Dublin 2008)

Marshall, Catherine, *Irish Art Masterpieces* (Westport, CT 1995)

——(ed.), *Breaking the Mould: British Art of the 1980s and 1990s (The Weltkunst Collection)*, (London and Dublin 1997)

—— (ed.), *Art Unsolved: Outsider Art from the Musgrave Kinley Collection*, exh. cat. IMMA (Dublin 1998)

——, 'A Quiet National Treasure', *Irish Arts Review Yearbook* (1999) 71–160; republished as *Gordon Lambert: The Making of a Collection* (Dublin 1999a)

——, *Making Visual Arts Visible*, AC/ACE (Dublin 2002)

——(ed.), *The Tail that Wags the Dog: Outsider Art in the Expressionist Tradition*, IMMA (Dublin 2003)

—— (ed.), *Views from an Island: Contemporary Irish Art from the Collection of the Irish Museum of Modern Art*, exh. cat. Millennium Monument Museum, Beijing; Shanghai Art Museum (Shanghai 2004)

—— (ed.), *The Hunter Gatherer: The Collection of George and Maura McClelland at the Irish Museum of Modern Art* (London 2005)

——, 'In Search of the Bigger Picture: The New Irish Art', *Etudes Irlandaises, Les nouveaux Irlandais* (Autumn 2007)

——, *Connected/Disconnected/Re-connected: The Art of Patrick Graham and John Philip Murray*, exh. cat. West Cork Arts Centre (Cork 2010)

——, 'Mapping the Great Famine in Irish Art', in John Crowley, William Smyth and Mike Murphy (eds), *Atlas of the Great Irish Famine* (Cork 2012), pp. 632–7

Martel, Richard (ed.), *Art Action, 1958–1998* (Québec 2001)

Mayes, Elizabeth and Paula Murphy (eds), *Images and Insights: Hugh Lane Municipal Gallery of Art* (Dublin 1993)

Mays, J.C.C., *Fredson Bowers and the Irish Wolfhound* (Clonmel 2002)

Meany, John, 'Expressionism Revamped', *Circa*, no. 10 (May/June 1983), 4–7

Meyer, James (ed.), *Minimalism* (London 2000)

Miles, Malcolm, *Art for Public Places: Critical Essays* (Winchester 1989)

Miller, Liam, *The Dun Emer Press, Later the Cuala Press* (Dublin 1973)

—— (ed.), *Retrospect: The Work of Seumas O'Sullivan (1879–1958) and Estella F. Solomons (1882–1968)* (Dublin 1973a)

——, *Dolmen XXV: An Illustrated Bibliography of the Dolmen Press, 1951–1976* (Dublin 1976)

Moore-McCann, Brenda, 'A Poetry of Vision: The *Rosc* exhibitions', *Irish Arts Review Yearbook*, XVIII (2002), 124–32

Moran, Lisa and Sophie Byrne (eds), *What Is – Participatory and Relational Art?* IMMA, What Is…? series (Dublin 2010)

Morris, Robert, 'Anti Form', *Artforum*, VI, 8 (Apr. 1968), 33–5

Muldoon, Paul, 'Incantata', in *The Annals of Chile* (Dublin 1994)

Murdoch, Iris, *The Sovereignty of the Good* (London 1970)

Murphy, Gavin, 'Civic Matter: The Placing Art Public Art Programme', in *Placing Art: The Pilot Public Art Programme* (Sligo 2000)

Murphy, Tara (ed.), *Smurfit Art Collection* (Dublin 2001)

Murray, Peter (ed.), *An Illustrated Summary Catalogue of the Crawford Municipal Art Gallery* (Cork 1992)

—— (ed.), *Masterpieces from the Crawford Art Gallery* (Cork 1992a)

——, 'The Gilded Fish: Notes on Culture in Cork', *European Journal of Cultural Policy*, II, no. 1 (1995)

—— (ed.), *Irish Art, 1770–1995: History and Society*, exh. cat. CAG (Cork 1995a)

——, 'Irish Painting, Tradition, and Post-war Internationalism', in James Christen Steward (ed.), *When Time began to Rant and Rage* (London 1998)

—— (ed.), *0044 – Irish Artists in Britain*, exh. cat. CAG (Cork 1999)

—— (ed.), *Irish Art 1947–1974: The Great Southern Collection*, exh. cat. CAG (Cork 2007)

—— (ed.), *Irish Art of the Seventies: Modernist Irish Art 1960–1990* (Kinsale 2007a)

—— (ed.), *Literary Lives: Portraits from the Crawford Art Gallery and Abbey Theatre, Ireland*, exh. cat. McMullen Museum of Art, Boston College (Cork 2010)

Murray, Peter and William Laffan (eds), *Terror and the Sublime: Art in an Age of Anxiety*, exh. cat. CAG (Cork 2008)

Nash, Catherine, 'Remapping and Renaming: New Cartographies of Identity, Gender and Landscape in Ireland', *Feminist Review*, no. 44 (Summer 1993), 39–57

——, *Irish Geographies: Six Contemporary Artists*, exh. cat. Djonogly Art Gallery, Nottingham, Maclaurin Art Gallery, Ayr (Nottingham 1997)

——, *Of Irish Descent: Origin Stories, Genealogy, and the Politics of Belonging* (New York 2008)

New Hibernis Review, Center for Irish Studies, University of St Thomas (Minnesota 2001–present)

Newman, Michael, Sarah Glennie and Jaki Irvine, *Jaki Irvine: The Square Root of Minus One is Plus or Minus i: Assembled Works* (Sligo and London 2008)

Nordness, Lee and Allen S. Weller (eds), *Art USA Now*, 'Ad Reinhardt', (Lucerne 1962)

Jackson, Georgina (ed.), *Unique Act: Five Abstract Painters*, exh. cat. HL (Dublin 2008)

Jacob, Mary Jane and Michael Brenson, *Conversations at the Castle: Changing Audiences and Contemporary Art* (Cambridge, MA 1998)

Jewesbury, Daniel, 'The Agreement', *Art Monthly*, no. 261 (Nov. 2002)

Jordan, Peter, *The Waterford Municipal Collection* (Waterford 1987)

Joyce, Trevor and Shep Steiner (eds), *Cork Caucus: On Art, Possibility and Democracy* (Berlin 2006)

Judd, Donald, 'Specific Objects', *Arts Yearbook*, no. 8 (1965)

Kearney, Richard, *The Irish Mind: Exploring Intellectual Traditions* (Dublin 1985)

——, *Transitions: Narratives in Modern Irish Culture* (Manchester and Dublin 1988)

Keating, Seán, 'Painting in Ireland Today', *The Bell* (Dec. 1950), 17–18

Kelly, Liam, *Thinking Long: Contemporary Art in the North of Ireland* (Kinsale 1996)

——, 'Language, Memory and Conflict: Acts of Interrogation', in Brian Cliff and Éibhear Walshe (eds), *Representing the Troubles: Texts and Images, 1970–2000* (Dublin 2004)

Kennedy, Brian P., *Dreams and Responsibilities: The State and the Arts in Independent Ireland* (Dublin 1990; repr. 1998)

——, 'The Irish Free State 1922–49: A Visual Perspective', in Raymond Gillespie and Brian P. Kennedy (eds), *Ireland: Art into History* (Dublin 1994)

——, 'Drama Abstracted', *Irish Arts Review* (Spring 2006)

Kennedy, Christina and Enrique Juncosa (eds), *The Moderns*, exh. cat. IMMA (Dublin 2011)

Kennedy, Róisín, 'RHA 2002 Prizewinners', *Irish Arts Review*, XIX, no. 2 (2002), 64–7

——, 'Made in England: The Critical Reception of Louis le Brocquy's *A Family*', in Lucy Cotter (ed.), *Third Text: special Ireland issue*, XIX, 5 (Sept. 2005), 475–86

——, 'Divorcing Jack…from Irish Politics', in Yvonne Scott (ed.), *Jack B. Yeats: Old and New Departures* (Dublin 2008), pp. 33–46

——, 'The White Stag Group: Experimentalism or Mere Chaos', in Edwina Keown and Carol Taafe (eds), *Irish Modernism: Origins, Contexts, Publics* (Bern 2009), pp. 179–94

——, 'Lhote's Wives: Scapegoating Women Artists, 1962–84', in Éimear O'Connor (ed.), *Irish Women Artists, 1800–2009: Familiar but Unknown* (Dublin 2010), pp. 168–78

Kennedy, S.B., *British Art, 1900–1937: Sir Robert Lloyd Patterson Collection* (Belfast 1982)

——, *Irish Art and Modernism, 1880–1950*, exh. cat. HL, UM (Belfast 1991)

Kennedy, S.B. and Bruce Arnold, *The White Stag Group*, exh. cat. IMMA (Dublin 2005)

Kester, Grant, *Community and Communication in Modern Art* (Oakland, CA 2004)

Kiang, Tanya, 'The Photographic Fix', *Circa*, no. 74 (Winter 1995)

Kiberd, Declan, *Inventing Ireland* (London 1995)

King, Linda and Elaine Sisson (eds), *Ireland, Design and Visual Culture: Negotiating Modernity, 1922–1992* (Cork 2011)

Kinmonth, Claudia, *Irish Country Furniture, 1700–1950* (New Haven and London 1993)

Kirk-Smith, Ian, 'Over the Bridge: The Rise of Irish art', *Circa*, no. 54 (1990), 24–30

Knowles, Roderic, *Contemporary Irish Art: A Documentation* (Dublin 1982)

Koskinen, Maija, Valerie Connor and Declan McGonagle, *Something Else: Contemporary Art from Ireland*, exh. cat. Turku Art Museum, Amos Anderson Art Museum, Helsinki; Oulu City Art Museum; Joensuu Art Museum (2002)

Kosuth, Joseph, *Art after Philosophy and After: Collected Writings, 1966–1990*, ed. Gabriele Guercino (Cambridge and London 1991)

Kramer, Arno (ed.), *Into Irish Drawing*, exh. cat. LCGA (Limerick 2009)

Kreilkamp, Vera and Nancy J. Curtin (eds), 'Special Issue: The Visual Arts', *Éire-Ireland: A Journal of Irish Studies* (Morristown, NJ 1999)

Kuhl, Nancy and Erica Van Horn, *The Book Remembers Everything: The Work of Erica Van Horn* (Clonmel 2010)

Lalor, Brian, *Ink-stained Hands: Graphic Studio Dublin and the Origins of Fine-art Printmaking in Ireland* (Dublin 2011)

Lardinois, Birgitte and Val Williams (eds), *Magnum Ireland*, exh. cat. IMMA (London 2005)

Larmour, Paul, *The Arts and Crafts Movement in Ireland* (Belfast 1992)

Lewis, Gifford, *The Yeats Sisters and the Cuala Press* (Dublin 1994)

Lerm Hayes, Christa-Maria, *Joyce in Art: Visual Art Inspired by James Joyce* (Dublin 2004)

Lippard, Lucy, *Pop Art* (London 1966)

——, *Six Years: The Dematerialization of the Art Object from 1966 to 1972* (Berkeley 1973)

Lippard, Lucy and Paula McCarthy Panczenko (eds), *Divisions, Crossroads, Turns of Mind: Some New Irish Art*, exh. cat. Williams College Museum of Art (Williamstown, MA 1985)

Little, Arthur, *The Nature of Art or the Shield of Pallas* (London 1946)

Lloyd, David, 'After History: Historicism and Irish Postcolonial Studies', in Clare Carroll and Patricia King (eds), *Ireland and Postcolonial Theory* (Cork 2003), pp. 46–62

Loftus, Belinda, *Mirrors: William III and Mother Ireland* (Dundrum, Co. Down 1990)

——, *Mirrors: Orange and Green* (Dundrum, Co. Down 1994)

Loizeaux, Elizabeth Bergman, *Yeats and the Visual Arts* (New Brunswick and London 1986)

Long, Declan (ed.), *The Irish Review: Special Issue on Contemporary Art* (Cork 2008)

McAndrew, Clare, *The Art Economy: An Investor's Guide to the Art Market* (Dublin 2007)

McAndrew, Clare and Cathie McKim, *The Living and Working Conditions of Artists* (Dublin and Belfast 2010)

McAree, Paul (ed.), *Breaking Gound, 2001–2009* (Dublin 2009)

McArthur, Colin, 'The Cultural Necessity of a Poor Celtic Cinema', in John Hill, Martin McLoone and Paul Hainsworth (eds), *Border Crossing: Film in Ireland, Britain and Europe* (Belfast 1994), pp. 112–25

McAvera, Brian, *Art, Politics and Ireland* (Dublin 1990)

——, 'The Boundaries of Abstraction', *Irish Arts Review* (Summer 2005), 82–9

McBride, Stephanie, *The Place of Cinema/The Cinema of Place*, AC/ACE (Dublin 2003)

McCabe, Martin, and Michael Wilson, 'Art Discourse: Time Based Art', *Circa*, no. 69 (Autumn 1994), 18–23

MacCarvill, Eileen (ed.), *Mainie Jellett, The Artist's Vision: Lectures and Essays on Art* (Dundalk 1958)

McCormack, W.J. (ed.), *The Blackwell Companion to Modern Irish Culture* (Oxford 1999)

McCrum, Seán and Gordon Lambert (eds), *Living with Art: David Hendriks* (Dublin 1985)

McEvilley, Thomas, *The Triumph of Anti-art: Conceptual Art and Performance and the Formation of Postmodernism* (New York 2005)

——, 'Here Comes Everybody', in *From Beyond the Pale: Art and Artists at the Edge of Consensus,* exh. cat. IMMA (Dublin 1994)

McGonagle, Declan, 'The Necessary Museum: The Irish Museum of Modern Art', *Irish Arts Review Yearbook* (1991/92) 61–4

——, 'The Issue of Context in Ireland', in Maija Koskinen, Valerie Connor and Declan McGonagle, *Something Else: Contemporary Art*

PHOTOGRAPHIC CREDITS

Every effort has been made to credit the photographers and sources of all illustrations in this volume; if there are any errors or omissions, please contact Yale University Press so that corrections can be made to any subsequent edition.

Aberdeen Art Gallery & Museums Collections: 30 (© estate of Francis Bacon. All rights reserved, DACS 2013); **Adam's Fine Art Auctioneers and Valuers:** 417 (© estate of Basil Rákóczi), 500 (© estate of Kenneth Hall); **AIB Art Collection:** 188 (© Martin Gale), 248 (© Robert Janz), 267 (© estate of Tony O'Malley), 275 (© estate of Louis le Brocquy), 281 (© Clement McAleer), 356 (© estate of Patrick Collins, IVARO, 2014), 495; © **The Alastair MacLennan Archive**/Locus+/www.locusplus.org.uk: 290; © estate of **Albert Gleizes**, IVARO, ADAGP, 2014: 101; **Annie Dibble:** 157 (© estate of Rob Smith); **Arts Council/An Chomhairle Ealaíon Archives:** 24, 26, 423; © The artist, courtesy of Maureen Paley, London: 468 (Collection Irish Museum of Modern Art, donated by George and Maura McClelland, 2000 © Hannah Starkey).

Bill Rolston: 489; **Bonhams, London**/The Bridgeman Art Library: 269 (© estate of Harry Kernoff); **Boyd Cody Architects:** 309 (photo: Peter Cody); **Brenda Moore-McCann:** 80, 163, 234, 338, 379, 388 (© Brian O'Doherty), 436, 437; **Bryan Rutledge:** 255 (© estate of Seán Keating, IVARO, 2014), 442 (© Deborah Brown); **Butler Gallery, Kilkenny:** 68 (© estate of Barrie Cooke), 105 (© Michael Cullen), 168 (© estate of Micheal Farrell, IVARO, 2014), 191 (© John Gerrard), 240 (© Erik van der Grijn), 253 (© Michael Kane).

Catalyst Arts, Belfast: 21; **Circa Art Magazine:** 406; **Claire Tilbury:** 219; **Collection National Irish Visual Arts Library (NIVAL) NCAD:** 115, 126, 127, 154, 155 (photo © Ray Cullen), 244, 456 (© estate of Noel Sheridan); **Collection of Ireland's Great Hunger Museum, Quinnipiac University, Connecticut:** 169 (© estate of Micheal Farrell, IVARO, 2014); **Collection of the Arts Council/An Chomhairle Ealaíon:** 9 (estate of the artist and Black Church Print Studio), 36 (© Basil Blackshaw), 53 (© Brian Bourke), 58 (© estate of George Campbell), 73 (© estate of Patrick Collins, IVARO, 2014), 140 (© estate of Gerard Dillon), 142, 159 (© Felim Egan), 187 (© Martin Gale), 202 (courtesy of the artist and Green On Red Gallery, Dublin © Patrick Hall), 263 (© Gene Lambert), 285 (© estate of Norah McGuinness), 291 (© Seán McSweeney), 358 (© Richard Gorman), 419, 426 (© estate of Nano Reid), 508 (© estate of Nancy Wynne-Jones);

Commonage: 518; **Cormac O'Malley:** 226 (photo: Helen Hooker O'Malley); **Courtesy of the artist and Frith Street Gallery, London:** 318 (© Jaki Irvine); **Courtesy of the artist and Green On Red Gallery, Dublin:** 315, 316 © Gerard Byrne); **Courtesy of the artist and Matt's Gallery, London, photo John Riddy:** 235 (© Willie Doherty), 310 (©

Willie Doherty Collection Irish Museum of Modern Art, loan, Weltkunst Foundation, 1995 © Willie Doherty); **Courtesy of the artist and Rubicon Gallery, Dublin:** 94 (© Michael Kane), 199 (© Anita Groener), 252 (Collection Irish Museum of Modern Art, donation Maire and Maurice Foley, 2000 © Eithne Jordan), 302 (© Nick Miller); **Courtesy of the artist and Taylor Galleries, Dublin:** 143 (photo: John Searle © John Doherty), 304 (Collection Irish Museum of Modern Art, heritage gift, Bank of Ireland, 1999 © Helen Comerford), 397 (© Diarmuid Delargy); **Courtesy of artists:** front cover/3 (© Alanna O'Kelly), 5 (© Helena Gorey), 10 (© Steve Pyke), 17 (© Kathlyn O'Brien), 20 (© Andrew Duggan), 33, 111, 381, 382 (© Robert Ballagh), 34 (© Liam Belton), 42, 148, 166 (© Patrick Graham), 50 (© Caoimhghin O'Fraithile), 52 (© Erica van Horn and Simon Coutts), 55 (© John Breakey), 56, 513 (© Cecily Brennan), 74 (Collection Irish Museum of Modern Art, purchase, 2003 © Oliver Comerford), 77 (photo © Gwyn Metz), 82, 491 (© Shane Cullen), 86 (© Gary Coyle), 88 (reproduced by kind permission of An Post ©), 95 (© David Crone), 96 (© Brian Cronin), 112 (© Pauline Cummins), 129 (© Philip Treacy), 130 (© David Rooney/Druid Theatre), 135, 207 (© Frances Hegarty), 136 (© Hughie O'Donoghue), 146 (© Rita Donagh), 147 (© Micky Donnelly), 150 (© David Godbold), 152, 422 (© Gerda Teljeur), 153 (© Rita Duffy), 181 (© Mary Fitzgerald), 182 (Viva Che 1968 © Jim Fitzpatrick), 204 (© James Hanley), 206 (© Pat Harris), 271 (Collection Irish Museum of Modern Art, purchase, 1999 © Clare Langan), 278, 430 (© ARS, NY and DACS, London 2013), 282 (Collection Irish Museum of Modern Art, purchase, 1996 © Caroline McCarthy), 292 (© Susan MacWilliam), 297 (Collection Irish Museum of Modern Art, purchase, 1997 © Alice Maher), 306 (© Ciarán Lennon), 312 (© Paul Mosse), 314, 390, 488 (© Philip Napier), 331 (© Paul Nugent), 332 (Collection Irish Museum of Modern Art, purchase, 1996 © Abigail O'Brien), 339 (Collection Irish Museum of Modern Art, gift, American Ireland Fund, 2010 © Hughie O'Donoghue), 341 (© Gwen O'Dowd), 342 (photo: Aine Farrell © Alanna O'Kelly), 343 (© Mick O'Kelly), 346 (© Tim O'Neill), 360, 505 (© Patricia Hurl), 373, 517 (© Anthony Haughey), 407 (© Patricia McKenna), 429 (© Abigail O'Brien), 450 (© Sean Scully), 457 (photo: Denis Mortell Photography © Maria Simonds-Gooding), 472 (© Alice Maher), 476, 480 (© Anne Tallentire), 478 (© Nigel Rolfe), 481 (© Vivienne Dick), 482 (© Frances Hegarty and Andrew Stones), 493 (© Charles Tyrrell), 496 (© Samuel Walsh), 498 (Collection Irish Museum of Modern Art, purchase, 2004 © Grace Weir), 514 (© Megs Morley), 515 (Breaking Ground © Seamus Nolan); **Courtesy of artists' estates:** 8 (© estate of Richard Kingston), 231, 257 (© estate of John Kelly), 372 (© estate of Fergus Bourke), 383 (© estate of the artist 2007), 467 (© estate of Patrick Scott); **Crawford Art Gallery, Cork:** 54 (© estate of Charles Brady), 61, 87 (©

Elizabeth C.B. Foye), 99 (© estate of William Crozier), 134, 254 (© estate of Seán Keating, IVARO, 2014), p. xxiv/141 (© estate of Gerard Dillon), 167 (© Michael Mulcahy), 183 (© estate of T.P. Flanagan), 189, 224 (© estate of Evie Hone and with kind permission of Geraldine Hone and of the Friends of the National Collections of Ireland), 258 (part of AIB Art Collection donated to the State, 2012 © estate of Harry Kernoff), 262 (© Lallí Lamb de Buitléar), 287 (© estate of Frank McKelvey, 2013), 294 (© Elizabeth Magill), 303 (© John Minihan), 324, 345 (© estate of Daniel O'Neill. All rights reserved, DACS 2012), 357 (© Camille Souter), 375 (© estate of Maurice MacGonigal, IVARO, 2014), 380 (© Brian Maguire), 387, 394 (© estate of Patrick Hickey), 398 (© Brian Kennedy), 458 (© by permission of the estate of James Sinton Sleator), 473 (part of AIB Art Collection donated to the State, 2012 © estate of Mary Swanzy), 499 (© estate of Leo Whelan); © Crown Copyright: UK Government Art Collection: 222; **Currier Museum of Art**, Manchester, New Hampshire. Museum Purchase: Currier Funds, 1939.6: 237.

Dara McGrath: 83 (© Thurloe Conolly); © David Caron: 503; **Davison & Associates:** 193 (© estate of Beatrice Glenavy); **Denis Mortell Photography:** frontispiece/249, 102 (© estate of Mainie Jellet), 35, 46 (© University College Cork Library), 51 (© estate of Brian Coffey, design © John Parsons), 85 (© estate of Barrie Cooke), 132 (© estate of Jack B. Yeats. All rights reserved, DACS 2012), 201 (© estate of Kenneth Hall), 205 (© Charles Harper), 227 (© estate of Jack B. Yeats. All rights reserved, DACS 2013), 283 (© Dublin City Gallery The Hugh Lane), 337 (© Brian O'Doherty), 371 (© John Hinde Archive), 402 (© estate of Seán Keating, IVARO, 2014), 474 (© estate of Mary Swanzy), 501 (© estate of Basil Rákóczi); © **The Dorothea Lange Collection**, Oakland Museum of California: 239 (Gift of Paul S. Taylor).

© **Dublin City Council:** 220 (Dublin's City Hall), 469 (Dublin City Library and Archive © estate of Stella Steyn); **Dublin City Gallery The Hugh Lane:** 6 (© Albert Gleizes, IVARO, ADAGP, 2014), 31 (© estate of Francis Bacon. All rights reserved, DACS 2013), 37 (© Basil Blackshaw), 91 (Bridgeman Images, © ADAGP, Paris and DACS, London 2012), 100 (© André Lhote, IVARO, ADAGP, 2014), 104 (© Charles Cullen), 139 (© estate of E.M. O'Rorke Dickey), 160, 190 (© E.M.F. Kerr), 200 (© estate of May Guinness), 208, 209, 261 (© estate of Cecil King and Oliver Dowling), 272, 284 (© estate of Norah McGuinness), 296 (© Brian Maguire), 335, 349, 376, 393 (© estate of Robert Gibbings), 410 (© estate of Mary Swanzy), 411 (© estate of Patrick Scott), 414, 434 (© Tim Robinson), 443, 449 (William Scott Foundation), 471 (© estate of Nevill Johnson), 492; **Dublin Diocesan Archives:** 122, 366, 427.

© **E.M.F. Kerr**: 464; **ESB Archive and Gallery Oldham:** 418 (© estate of Seán Keating, IVARO, 2014).